Museum Studies
An Anthology of Contexts

Edited by Bettina Messias Carbonell

Blackwell
Publishing

Editorial material and organization © 2004 by Blackwell Publishing Ltd

BLACKWELL PUBLISHING
350 Main Street, Malden, MA 02148-5020, USA
9600 Garsington Road, Oxford OX4 2DQ, UK
550 Swanston Street, Carlton, Victoria 3053, Australia

First published 2004 by Blackwell Publishing Ltd

5 2007

Library of Congress Cataloging-in-Publication Data

Museum studies: an anthology of contexts / edited by Bettina Messias Carbonell.
p. cm.
Includes bibliographical references and index.
ISBN 0-631-22825-X (hardcover: alk. paper)—ISBN 0-631-22830-6
(pbk.: alk. paper)
1. Museums—Educational aspects. 2. Museums—Philosophy. 3. Museums—
Social aspects. 4. Museums—Historiography. I. Carbonell, Bettina Messias.

AM7.M874 2004
069—dc21
2003014048

ISBN-13: 978-0-631-22825-7 (hardcover: alk. paper)—ISBN-13: 978-0-631-22830-1 (pbk.: alk. paper)

A catalogue record for this title is available from the British Library.

Set in 10 on 12 pt Galliard
by Kolam Information Services Pvt. Ltd, Pondicherry, India
Printed and bound in Singapore
by COS Printers Pte Ltd

The publisher's policy is to use permanent paper from mills that operate a sustainable forestry policy, and
which has been manufactured from pulp processed using acid-free and elementary chlorine-free practices.
Furthermore, the publisher ensures that the text paper and cover board used have met acceptable
environmental accreditation standards.

For further information on
Blackwell Publishing, visit our website:
www.blackwellpublishing.com

Contents

Part I Museology: A Collection of Contexts

Part IV Locating History in the Museum

Part V Arts, Crafts, Audiences

Contents | Alternative Taxonomy

[In this arrangement, the majority of the texts appear in more than one category.]

Museum History

Museums in Theory

Museum Practices

Museum Poetics

Notes on Contributors

Louis Agassiz (1807–73) was Professor of Zoology and Geology, and founder and Director of the Museum of Comparative Zoology at Harvard University. His publications include:

Contributions to the Natural History of the United States of America. 4 vols. Boston: Little, Brown and Co.; London: Trübner & Co., 1857–62.

Louis Agassiz, His Life and Correspondence. 2 vols. Edited by Elizabeth Cary Agassiz. Boston: Houghton, Mifflin, 1885.

Methods of Study in Natural History. Boston: Fields, Osgood, 1871.

Principles of Zoölogy. Boston: Gould and Lincoln, 1856.

Grosvenor Atterbury (1896–1956) was an architect and urban planner who created working-class "housing groups" as well as residences for the wealthier classes. His publications include:

The Economic Production of Workingmen's Homes. New York: (no publisher), 1930.

Model Towns in America. New York: National Housing Association, 1913.

Jordanna Bailkin is Assistant Professor of History at the University of Washington. She will be working on her second project on visual culture and decolonization at the National Humanities Center (US) (2003–4). Her publications include:

Liberal Arts: Anarchy and Culture in Britain. Chicago: University of Chicago Press (forthcoming).

Henry Balfour (1863–1939) was President of the Museums Association (UK), Curator at the Pitt-Rivers Museum, and Curator of the Ethnographical Department (Pitt-Rivers Collection) at the University Museum, Oxford. His publications include:

Introduction to A. Lane-Fox Pitt-Rivers, *The Evolution of Culture.* Ed. J. L. Myres. Oxford: Clarendon Press, 1906.

The Evolution of Decorative Art. New York: Macmillan, 1893.

The Natural History of the Musical Bow. Oxford: Henry Frowde, 1899.

Georges Bataille (1897–1962) was co-founder, with Michel Leiris and Roger Callois, of the Collège de Sociologie, and editor of the journal *Documents*. His publications include:

Blue of Noon [Bleu du ciel]. Trans. Harry Mathews. New York: Urizen Books, 1978.
The Collected Poems of Georges Bataille. Trans. Mark Spitzer. Chester Springs, PA: Dufour Editions, 1999.
Death and Sensuality: A Study of Eroticism and the Taboo. New York: Walker, 1962.
Story of the Eye. By Lord Auch. Trans. Joachim Neugroschel. With essays by Susan Sontag and Roland Barthes. London and Boston: M. Boyars, 1979.

Germain Bazin (1901–90) held many positions in his long career including those of Chief Curator, Department of Paintings at the Louvre Museum, head of the painting and restoration section of France's national museum system, and Professor of Museology at L'École du Louvre. His publications include:

The Baroque: Principles, Styles, Modes, Themes. Trans. Pat Wardroper. New York: Norton, 1978.
Impressionist Paintings in the Louvre. 4th edn. Trans. S. Cunliffe-Owen. London: Thames and Hudson, 1963.
The Museum Age. Trans. Jane van Nuis Cahill. New York: Universe Books, 1967.

Maurice Berger is curator of the Fine Arts Gallery, University of Maryland, Baltimore County, a prolific cultural critic, and a senior fellow at the Vera List Center for Art and Politics of the New School for Social Research (New York). His exhibitions include *Adrian Piper: A Retrospective 1965–2000* (2000, Mount Saint Vincent University Art Gallery, Halifax, Nova Scotia) and *Ciphers of Identity* (1994, Fine Arts Gallery, University of Maryland and other venues). His publications include:

Ed. with Brian Wallis and Simon Watson. *Constructing Masculinity*. New York: Routledge, 1995.
Ed. *The Crisis of Criticism*. New York: New Press, 1998.
Minimal Politics: Performativity and Minimalism in Recent American Art. Baltimore, MD: Fine Arts Gallery, University of Maryland; New York: Distributed Art Publishers, 1997.
Ed. *Postmodernism: A Virtual Discussion*. [Proceedings of online discussion @ The Georgia O'Keefe Museum website, 2001.] New York: Distributed Art Publishers, 2003.
White Lies: Race and the Myths of Whiteness. New York: Farrar, Straus & Giroux, 1999.

Franz Boas (1858–1942) was Professor of Anthropology at Columbia University (New York), Curator of Anthropology at the American Museum of Natural History (New York) and Editor of the *Journal of American Folklore*. His publications include:
Anthropology and Modern Life. London: Allen & Unwin, 1929.
The Mind of Primitive Man. New York: Macmillan, 1927.
Primitive Art. Oslo: H. Aschehoug & Co.; Cambridge, Mass.: Harvard University Press, 1927.
Race, Language and Culture. New York: Macmillan, 1940.

Mary Bouquet is on the staff of the Royal Tropical Institute (KIT) Tropenmuseum, Amsterdam and the faculty of the University of Utrecht, the Netherlands. Her publications include:

Ed. *Academic Anthropology and the Museum: Back to the Future*. New Directions in Anthropology, Vol. 13. New York: Berghahn Books, 2001.

"The Family Photographic Condition." *Visual Anthropology* 16, 1 (2000): 2–19.

"Figures of Relations: Reconnecting Kinship Studies and Museum Collections." *Cultures of Relatedness*. Ed. Janet Carsten. Cambridge: Cambridge University Press, 2000. 167–90.

"Strangers in Paradise: An Encounter with Fossil Man at the Dutch Museum of Natural History." *The Politics of Display: Museums, Science, Culture*. Ed. Sharon Macdonald. London: Routledge, 1998. 159–72.

Pierre Bourdieu (1930–2002) was Professor of Sociology and Director of the Centre de Sociologie Européene (CSE) at the Collège de France (Paris), Director of Studies at the School of the High Studies in Social Sciences, Director of the review *Acts of Research in Social Sciences*, and Consulting Editor of the *American Journal of Sociology*. He often collaborated with colleagues, including **Alain Darbel** and **Dominique Schnapper**, in producing co-authored texts. His publications include:

Distinction: A Social Critique of the Judgment of Taste. Trans. Richard Nice. Cambridge, Mass.: Harvard University Press, 1984.

With Alain Darbel and Dominique Schnapper. *The Love of Art: European Art Museums and Their Public*. Trans. Caroline Beattie and Nick Merriman. Cambridge: Polity: 1991.

Outline of a Theory of Practice. Trans. Richard Nice. Cambridge and New York: Cambridge University Press, 1977.

Elizabeth Broun is the Margaret and Terry Stent Director of the Smithsonian American Art Museum. She received the Alfred H. Barr Award for Distinguished Scholarship for the exhibition catalogue *Albert Pinkham Ryder* (1989). Her publications include:

Albert Pinkham Ryder. Exhibition catalogue. Washington, D.C.: National Museum of American Art, Smithsonian Institution Press, 1989.

"Conversation in Cyberspace: An Online Chat with Elizabeth Broun." *American Art* 9, 1 (Spring 1995): 2–13.

"The Future of Art at the Smithsonian." *American Art* 8, 3–4 (Summer–Fall 1994): 2–7.

Annie E. Coombes teaches Art History and Cultural Studies at Birkbeck College, University of London, where she is Director of Graduate Studies in the School of History of Art, Film and Visual Media. She is on the Editorial Collective of *Feminist Review* and the Editorial Board of *Third Text*. Her publications include:

History After Apartheid: Memory, Monuments and Museums in a Democratic South Africa. Durham, NC: Duke University Press, 2003.

Ed. with Avtar Brah. *Hybridity and its Discontents: Politics, Science, Culture*. London and New York: Routledge, 2000.

Reinventing Africa: Museums, Material Culture, and Popular Imagination in Late Victorian and Edwardian England. New Haven: Yale University Press, 1994.

Lisa G. Corrin is Mary Shirley Curator of Modern and Contemporary Art at the Seattle (Washington) Art Museum; her previous positions include Chief Curator at the Serpentine Gallery, London, and Chief Curator at The Contemporary (Museum) in

Baltimore, Maryland. Her exhibitions include *Mining the Museum: An Installation by Fred Wilson* (1992, co-curator, The Contemporary, Baltimore), *Going for Baroque* (1995, Walters Art Gallery, Baltimore), and *Give & Take* (2001, Serpentine Gallery and Victoria and Albert Museum, London). Her publications include:

Give & Take: 1 Exhibition, 2 Sites. Exhibition catalogue. With Hans Haacke. London: Serpentine Gallery, 2001.

Ed. with Joaneath Spicer. *Going for Baroque: 18 Contemporary Artists Fascinated with the Baroque and Rococo.* Baltimore, MD: The Contemporary; The Walters, 1995.

"Installing History." *Art Papers* 18, 4 (July–Aug. 1994): 6–14.

Ed. *Mining the Museum: An Installation by Fred Wilson.* Baltimore: The Contemporary; New York: The New Press, 1994.

Susan A. Crane is Professor of History at the University of Arizona. Her publications include:

Collecting and Historical Consciousness in Early Nineteenth-Century Germany. Ithaca, NY: Cornell University Press, 2000.

Ed. *Museums and Memory.* Stanford: Stanford University Press, 2000.

"Writing the Individual Back into Collective Memory." *American Historical Review* 102, 5 (1997): 1372–85.

John Cotton Dana (1856–1929) was Head of the Free Public Library of Newark, New Jersey, and founder and Director of the Newark Museum. His publications include:

American Art: How it Can be Made to Flourish. Woodstock, VT: Elm Tree Press, 1929.

Changes in Library Methods in a Changing World. Newark, NJ: The Public Library, 1927.

The Gloom of the Museum. Woodstock, VT: Elm Tree Press, 1917.

The New Museum. Woodstock, VT: Elm Tree Press, 1917.

The New Museum: Selected Writings By John Cotton Dana. Ed. William A. Peniston. Newark, NJ: Newark Museum Association; Washington, D.C.: American Association of Museums, 1999.

Karen Mary Davalos is Assistant Professor of Chicana/o Studies at Loyola Marymount University (Los Angeles), a member of the Editorial Board of *Aztlán: A Journal of Chicano Studies*, and a co-editor of and contributor to *The Chicano Studies Reader: An Anthology of Aztlán, 1970–2000* (UCLA Chicano Studies Research Center, 2001). Her publications include:

Exhibiting Mestizaje: Mexican (American) Museums in the Diaspora. Albuquerque: University of New Mexico Press, 2001.

"In the Blink of an Eye: Chicana/o Art Collecting." *East of the River: Chicano Art Collectors Anonymous.* Ed. Chon A. Noriega. Santa Monica: Santa Monica Museum of Art, 2000. 42–54.

"Looking for 'Whiteness', Nation and Empire in All the Wrong Places: The Nelson A. Rockefeller Collection of Mexican Folk Art at the Mexican Museum." *Latino Studies Journal* 11, 3 (Fall 2000): 131–59.

James Deetz (1930–2000) was Professor of Anthropology at the University of Virginia and an Archaeological Adviser to Plimouth Plantation, Plymouth, Massachusetts. His publications include:

Flowerdew Hundred: The Archaeology of a Virginia Plantation, 1619–1864. Charlottesville: University Press of Virginia, 1993.

In Small Things Forgotten: The Archaeology of Early American Life. Expanded and revised edn. New York: Anchor Press/Doubleday, 1996.

Invitation to Archaeology. Garden City, NY: American Museum of Natural History; Natural History Press, 1967.

Robert W. de Forest (1848–1931) was donor of The American Wing at The Metropolitan Museum of Art (New York), President of the Russell Sage Foundation, and President of the Municipal Art Commission (New York). During his career he held the positions of Trustee, Secretary of the Board of Trustees, Vice President, and President of The Metropolitan Museum of Art. His publications include:

An American Wing for the Metropolitan Museum of Art. New York: Metropolitan Museum of Art, 1922.

The Importance of Art Museums in our Smaller Cities. New York: American Federation of Arts, 1913.

Ed. *The Tenement House Problem.* New York and London: Macmillan, 1903.

Paul DiMaggio is Professor of Sociology and Research Director of the University Center for Arts and Cultural Policy Studies at Princeton University. His publications include:

Ed. *Nonprofit Enterprise in the Arts: Studies in Mission and Constraint.* New York: Oxford University Press, 1986.

With Francine Ostrower. *Race, Ethnicity, and Participation in the Arts.* Washington, D.C: Seven Locks Press, 1992.

Ed. with Sharon Zukin. *Structures of Capital: The Social Organization of Economic Life.* Cambridge: Cambridge University Press, 1990.

Terence M. Duffy is Lecturer at the School of History and International Affairs, University of Ulster, Magee Campus, Londonderry, Northern Ireland. He is Director of the Taiwan Awareness Project at Magee College and Director of the Irish Peace Museum Project. His publications include:

"Civic Zones of Peace." *Peace Review* 9,2 (1997): 119–206.

"Exhibiting Human Rights." *Peace Review* 12,2 (2000): 303–9.

"The Holocaust Museum Concept." *Museum International* 49, 1 (Jan.–Mar. 1997): 54–8.

"The Peace Museums of Japan." *Museum International* 49, 4 (Oct.–Dec. 1997): 49–54.

"Towards a Culture of Human Rights in Cambodia." *Human Rights Quarterly* 16 (Feb. 1994): 80–104.

"Towards a Peace Memorial in Northern Ireland." *Peace Museums Newsletter* (Spring 1998): 2–5.

Carol Duncan is Professor of Art History, School of Contemporary Art, at Ramapo College of New Jersey. Her publications include:

The Aesthetics of Power: Essays in Critical Art History. Cambridge: Cambridge University Press, 1993.

Civilizing Rituals: Inside Public Art Museums. New York: Routledge, 1995.

"The MoMA's Hot Mamas." *Art Journal* 48 (Summer 1989): 171–8.

With Alan Wallach. "The Museum of Modern Art as Late Capitalist Ritual: An Iconographic Analysis." *Marxist Perspectives* 1, 4 (Winter 1978): 28–51.
The Pursuit of Pleasure: The Rococo Revival in French Romantic Art. New York: Garland, 1975.

James Fenton is a poet who has held the position of Professor of Poetry at Oxford University and has written from many perspectives, including that of political columnist, foreign correspondent, and literary critic. His publications include:
Children in Exile: Poems 1968–1984. New York: Random House, 1984.
An Introduction to English Poetry. London: Penguin, 2003.
Leonardo's Nephew: Essays in the History of Art and Artist. New York: Farrar, Straus and Giroux, 1998.
Out of Danger. London: Penguin, 1993.

Paula Findlen is Professor of Italian History and Director of the Science, Technology and Society Program at Stanford University. She is co-editor of the journal *Configurations.* Her publications include:
A Fragmentary Past: The Making of Museums and the Making of the Renaissance. Forthcoming (2003).
Ed. with Pamela Smith. *Merchants & Marvels: Commerce and the Representation of Nature in Early Modern Europe.* New York: Routledge, 2002.
Possessing Nature: Museums, Collecting, and Scientific Culture in Early Modern Italy. Berkeley: University of California Press, 1994.

Philip Fisher is Felice Crowl Reid Professor of English and American Literature at Harvard University. His publications include:
Making and Effacing Art: Modern Art in a Culture of Museums. Cambridge, Mass.: Harvard University Press, 1997.
Still the New World: American Literature in a Culture of Creative Destruction. Cambridge, Mass.: Harvard University Press, 1999.
Wonder, the Rainbow, and the Aesthetics of Rare Experiences. Cambridge, Mass.: Harvard University Press, 1998.

Sir William Henry Flower (1831–99) was Professor of Comparative Anatomy and President of the Anthropological Institute of Great Britain and Ireland. He served as Conservator of the Museum of the Royal College of Surgeons and Director of the British Museum of Natural History. His publications include:
Essays on Museums and Other Subjects Connected with Natural History. London and New York: Macmillan, 1898.
Fashion in Deformity, as Illustrated in the Customs of Barbarous and Civilised Races. London: Macmillan, 1881.
A General Guide to the British Museum (Natural History). London: British Museum, 1887.

Alice Friman is a poet. She was the winner of the 2001 James Boatwright Prize from *Shenandoah: The Washington & Lee University Review* and the recipient of a Creative Renewal Fellowship from the Arts Council of Indianapolis. She received the Ezra Pound Poetry Award from Truman State University and the Shelia Motton Prize from the New England Poetry Club for *Zoo.* Her publications include:

Inverted Fire. Kansas City, MO: BkMk Press, 1997.
Reporting from Corinth. Daleville, IN: Barnwood Press Cooperative, 1984.
Zoo. Fayetteville: University of Arkansas Press, 1999.

Benjamin Ives Gilman (1852–1933) was Secretary of the Museum of Fine Arts (Boston), President of the American Association of Museums, and an ethnomusic-ologist. His publications include:
Manual of Italian Renaissance Sculpture as Illustrated in the Collection of Casts at the Museum of Fine Arts, Boston. Boston: The Museum of Fine Arts, 1904.
Museum Ideals of Purpose and Method. 2nd edn. Cambridge, Mass.: Museum of Fine Arts; Boston: Harvard University Press, 1923.

Robert Goldwater (1907–73) was Professor of Fine Arts at Queens College, The City University of New York, and at New York University, as well as Director of the Museum of Primitive Art in New York City. His publications include:
Primitivism in Modern Art. Enlarged edn. Cambridge, Mass.: Belknap Press, 1986.
Symbolism. New York: Harper & Row, 1979.
What is Modern Sculpture? New York: Museum of Modern Art, 1969.

Stephen Greenblatt is Professor of English at Harvard University. His publications include:
Hamlet in Purgatory. Princeton: Princeton University Press, 2001.
Learning to Curse: Essays in Early Modern Culture. New York and London: Routledge, 1992.
With Catherine Gallagher. *Practicing New Historicism*. Chicago: University of Chicago Press, 2000.
Renaissance Self-Fashioning: From More to Shakespeare. Chicago: University of Chicago Press, 1980.
Shakespearean Negotiations: The Circulation of Social Energy in Renaissance England. Oxford: Clarendon Press, 1988.

Fabrice Grognet is an Assistant at the Musée de l'Homme in Paris and holds an MA in Ethnology from the Sorbonne as well as a diploma of Advanced Studies in Museology from the National Museum of Natural History, Paris. Publications include:
"Le 'Musée-Laboratoire': un concept à réinventer?" *Musées et Collections Publiques de France* no. 233 (1999): 60–3.

Eleanor Heartney is a Contributing Editor for *Art in America* and *Artpress*. She received the 1992 Frank Jewett Mather Award for art criticism. Her publications include:
"A Cabinet of Critiques." *Art in America* 87, 12 (Dec. 1999): 70–5.
Critical Condition: American Culture at the Crossroads. Cambridge and New York: Cambridge University Press, 1997.
Postmodernism. Cambridge and New York: Cambridge University Press, 2001.

Curtis M. Hinsley is Regents' Professor of Applied Indigenous Studies at Northern Arizona University. His publications include:

"Digging for Identity: Reflections on the Cultural Background of Collecting."
 American Indian Quarterly 20, 2 (1996): 180–96.
Ed. with David R. Wilcox. *Frank Hamilton Cushing and the Hemenway Southwestern
 Archaeological Expedition, 1886–1889.* 2 vols. Tucson: University of Arizona Press,
 1996–2002.
With Melissa Banta. *From Site to Sight: Anthropology, Photography, and the Power of
 Imagery.* Cambridge, Mass.: Peabody Museum Press, 1986.
*Savages and Scientists: The Smithsonian Institution and the Development of
 American Anthropology, 1846–1910.* Washington, D.C.: Smithsonian Institution
 Press, 1981.

Eilean Hooper-Greenhill is Director of Research/Director of the Research Centre
for Museums and Galleries (RCMG) at the University of Leicester. Her publications
include: Ed. *The Educational Role of the Museum.* 2nd edn. Leicester Museum Studies
Readers. London: Routledge, 1999.
Ed. *Museum, Media, Message.* London: Routledge, 1995.
Museums and the Interpretation of Visual Culture. London: Routledge, 2000.
Museums and the Shaping of Knowledge. London: Routledge, 1992.

Kenneth Hudson (1916–99) was a major voice in the evaluation and interpretation
of museum practices. In his role as Director of the European Museum Forum he
guided that organization in the formation of workshops and awards for museum
excellence. Hudson was also a correspondent and producer for the BBC, specializing
in industrial archaeology. His publications include:
Museums for the 1980's: A Survey of World Trends. Paris: UNESCO; London:
 Macmillan, 1977.
Museums of Influence. Cambridge and New York: Cambridge University Press, 1987.
A Social History of Museums: What the Visitors Thought. Atlantic Highlands, NJ:
 Humanities Press, 1975.
World Industrial Archaeology. Cambridge and New York: Cambridge University Press,
 1979.

Zora Neale Hurston (1861–1960) was a writer of fiction, folklore, and ethnography.
While a graduate student at Columbia University (New York) she studied with Franz
Boas. Her publications include:
Dust Tracks on the Road: An Autobiography. Philadelphia: Lippincott, 1942.
Moses, Man of the Mountain. New York: Lippincott, 1939.
Mules and Men. Introduction by Franz Boas. Philadelphia: Lippincott, 1935.
Their Eyes Were Watching God. Philadelphia: Lippincott, 1937.

Edward N. (Ned) Kaufman is an independent consultant in cultural heritage preser-
vation and is founding co-director of Pratt Institute's graduate program in historic
preservation. He was guest curator of the Canadian Centre for Architecture's inaug-
ural exhibition, founded Place Matters, and was Director of Historic Preservation for
the Municipal Art Society (New York). His publications include:
Ed. with Eve Blau. *Architecture and its Image: Four Centuries of Representation.*
 Montreal: Canadian Centre for Architecture; MIT Press, 1989.
"Heritage and the Cultural Politics of Preservation." *Places* 11, 3 (1998): 58–65.

"Moving Forward." *Giving Preservation a History: Histories of Historic Preservation in the United States.* Ed. Max Page and Randall Mason. London and New York: Routledge (forthcoming).

"Places of Historical, Cultural, and Social Value: Identification and Protection," Parts 1 and 2. *Environmental Law in New York* 12, 11 and 12 (2001): 211–12; 224–33; 235; 248–56.

Gaynor Kavanagh is Dean of Media and Culture, Falmouth College of the Arts, Cornwall (UK). Her publications include:

Dream Spaces: Memory and the Museum. London and New York: Leicester University Press, 2000.

Ed. *Making Histories in Museums.* London and New York: Leicester University Press, 1996.

Ed. *Museum Languages: Objects and Texts.* Leicester and New York: Leicester University Press, 1991.

Roger G. Kennedy has served as Director of the National Museum of American History, Smithsonian Institution, and Director of the National Parks Service. His publications include:

Architecture, Men, Women and Money in America 1600–1860. New York: Random House, 1985.

Hidden Cities: The Discovery and Loss of Ancient North American Civilization. New York: Free Press; Toronto: Maxwell Macmillan Canada; New York: Maxwell Macmillan Intl., 1994.

Editorial Director. *The Smithsonian Guide to Historic America.* By Henry Wiencek. 12 vols. New York: Stewart, Tabori & Chang, 1989.

Rediscovering America. Boston: Houghton Mifflin, 1990.

Barbara Kirshenblatt-Gimblett is Professor of Performance Studies and Hebrew and Judaic Studies at New York University. She is a member of the Performance Studies International Board, the Advisory Council of the Center for Folklife Programs and Cultural Studies (Smithsonian Institution), the National Foundation for Jewish Culture, and the YIVO Institute for Jewish Research, and a Fellow and Past President of the American Folklore Society. Her publications include:

Destination Culture: Tourism, Museums, and Heritage. Berkeley: University of California Press, 1998.

Fabric of Jewish Life: Textiles from the Jewish Museum Collection. New York: The Jewish Museum, 1977.

"Objects of Ethnography." *Exhibiting Cultures: The Poetics and Politics of Museum Display.* Ed. Ivan Karp and Steven D. Lavine. Washington, D.C.: Smithsonian Institution Press, 1991. 386–443.

Synagogues, Museums and Theaters: The Power of Live Performance. An Exchange with Barbara Kirshenblatt-Gimblett. Essays by Libby Garland and Jennifer Krause. Ed. Libby Garland. New York: CLAL, The National Jewish Center for Learning and Leadership, 2002.

Le Corbusier (Charles Edouard Jeanneret) (1887–1965) was an architect, painter, decorator, and prolific writer. His buildings include the Centre Le Corbusier (Zurich), the National Museum of Western Art (Tokyo), and two cultural centers in India. His

proposal for a "World Museum" or "Mundaneum" at the Geneva Cultural Center was never realized. His publications include:

Creation as a Patient Search. Trans. James Palmes. New York: Praeger, 1960.

Essential Le Corbusier: L'Esprit Nouveau Articles. Oxford and Boston: Architectural Press, 1998.

My Work. Trans. James Palmes. London: Architectural Press, 1960.

Mark P. Leone is Professor and Chair of the Department of Anthropology, University of Maryland, College Park, the Director of the University of Maryland Field School in Urban Historical Archaeology, and a member of the Editorial Board of *Winterthur Portfolio.* His publications include:

Ed. with Parker B. Potter, Jr. *Historical Archaeologies of Capitalism.* New York and London: Kluwer Academic/Plenum Publishers, 1999.

With Neil A. Silberman. *Invisible America: Unearthing our Hidden History.* New York: Henry Holt, 1995.

Ed. with Parker B. Potter, Jr. *The Recovery of Meaning.* Washington, D.C.: Smithsonian Institution Press, 1994.

Françoise Lionnet is Professor of French and Francophone Studies at the University of California, Los Angeles, and the Project Director for the Multicampus Research Group on Transnational and Transcolonial Studies. Her publications include:

Autobiographical Voices: Race, Gender, Self-Portraiture. Ithaca, NY: Cornell University Press, 1989.

Postcolonial Representations: Women, Literature, Identity. Ithaca, NY: Cornell University Press, 1995.

Barbara J. Little is an archaeologist with the National Register of Historic Places (Washington, D.C.). Her publications include:

With Donald L. Hardesty. *Assessing Site Significance: A Guide for Archaeologists and Historians.* Walnut Creek, CA: Alta Mira Press, 2000.

Ed. with Paul A. Shackel. *The Historical Archaeology of the Chesapeake.* Washington, D.C.: Smithsonian Institution Press, 1994.

Ed. *Public Benefits of Archaeology.* Gainesville: University Press of Florida, 2002.

Christopher Looby is Professor of English at the University of California, Los Angeles. His publications include:

Ed. *The Complete Civil War Journal and Selected Letters of Thomas Wentworth Higginson.* Chicago: University of Chicago Press, 2000.

"Phonetics and Politics: Franklin's Alphabet as a Political Design." *Eighteenth-Century Studies* 18, 1 (Fall 1984): 1–34.

Voicing America: Language, Literary Form, and the Origins of the United States. Chicago: University of Chicago Press, 1996.

Malcolm D. McLeod is Vice-Principal, External Relations and Marketing, University of Glasgow; he has held a number of professional positions in museums including: Director of the Hunterian Museum and Art Gallery, University of Glasgow; Keeper of Ethnography at the British Museum; Director of the Museum of Mankind (London);

and Assistant Curator at the Museum of Archaeology and Ethnology, Cambridge. His publications include:

The Asante. London: British Museum Publications, 1981.

With John Mack. *Ethnic Sculpture*. Cambridge, Mass.: Harvard University Press, 1985.

Treasures of African Art: Introduction and Commentaries. New York: Abbeville Press, 1980.

Kynaston McShine is Chief Curator, Department of Painting and Sculpture, Museum of Modern Art (New York). His many exhibitions include *Information* (1970, The Museum of Modern Art, New York), *Andy Warhol: A Retrospective* (1989, Museum of Modern Art), and *The Museum as Muse: Artists Reflect* (1999, Museum of Modern Art). His publications include:

Ed. *Andy Warhol: A Retrospective*. New York: Museum of Modern Art, 1989.

An International Survey of Recent Painting and Sculpture. New York: Museum of Modern Art, 1984.

The Museum as Muse: Artists Reflect. New York: Museum of Modern Art, 1999.

Ed. *The Natural Paradise: Painting in America, 1800–1950*. New York: Museum of Modern Art; Boston: New York Graphic Society, 1976.

Ed. with Anne Umland. *To Be Looked At: Painting and Sculpture from the Museum of Modern Art*. New York: Distributed Art Publishers, 2002.

Charles Willson Peale (1741–1827) was a painter, a collector, and the founder of the Philadelphia Museum. His publications include:

With A. M. F. J. Beauvois. *A Scientific and Descriptive Catalogue of Peale's Museum*. Philadelphia: Printed by S. H. Smith, 1796.

The Selected Papers of Charles Willson Peale and His Family. 5 vols. Ed. Lillian B. Miller. New Haven: Yale University Press for the National Portrait Gallery, Smithsonian Institution, 1983–.

Gaby Porter is a consultant working with arts, museums, and heritage organizations. She is a Visiting Lecturer in the Museology MA Program at the University of East Anglia and in the International Programme in Museum Studies at the University of Gothenberg, Sweden. She was formerly Head of Collections and Information at the Museum of Science and Industry (Manchester, UK) and has worked at the National Museum of Photography, Film and Television (Bradford, UK) and a number of smaller local museums. Her publications include:

"Gender Bias: Representations of Work in History Museums." *Bias in Museums*. Ed. A. Carruthers. *Museum Professionals Group Transactions* 22 (1987): 11–15.

"Partial Truths." *Museum Languages: Objects and Texts*. Ed. Gaynor Kavanagh. Leicester and New York: Leicester University Press, 1991. 103–17.

The Representation of Gender in British History Museums. Unpublished thesis. Leicester: Department of Museum Studies, University of Leicester.

Gyan Prakash is Professor of History at Princeton University. Publications include:

Ed. *After Colonialism: Imperial Histories and Postcolonial Displacements*. Princeton: Princeton University Press, 1994.

Another Reason: Science and the Imagination of Modern India. Princeton: Princeton University Press, 1999.

Bonded Histories: Genealogies of Labor Servitude in Colonial India. Cambridge and New York: Cambridge University Press, 1990.

Donald A. Preziosi is Professor of Art History at the University of California, Los Angeles. His publications include:
Ed. *The Art of Art History: A Critical Anthology.* Oxford and New York: Oxford University Press, 1998.
Brain of the Earth's Body: Art, Museums, and the Phantasms of Modernity. Minneapolis: University of Minnesota Press, 2003.
Rethinking Art History: Meditations on a Coy Science. New Haven and London: Yale University Press, 1989.

Mónica Risnicoff de Gorgas is Director of the Virrey Liniers Casa Museo Histórico Nacional, Alta Gracia, Córdoba, Argentina, and a deputy member of the Argentine Committee of ICOM. Her publications include:
"Importancia del Museo en la Educacíon."
"Museos de Hoy para el Mundo de Mañana."
"Los Museos y la Crisis de los Pueblos de Identidad Concurrente."
"Museos a la Búsqueda de la Memoria Perdida."

Sir John Charles Robinson (1824–1913) held positions as Curator at the Museum of Ornamental Art, Marlborough House (London), and Keeper of the Museum of Art and of the Art Library at the South Kensington Museum. His publications include:
Catalogue of the Soulages Collection. London: Chapman & Hall, 1856.
A Critical Account of the Drawings by Michel Angelo and Rafaello in the University Galleries, Oxford. Oxford: Clarendon Press, 1870.
On the Museum of Art. London: Chapman and Hall, 1858.

Elihu Root (1845–1937) was President of the Carnegie Endowment for Peace (1910–25) and received the Nobel Peace Prize (1912). He served as US Secretary of War, Secretary of State, and US Senator from New York, and he held the positions of Trustee and of First Vice President at The Metropolitan Museum of Art (New York). His publications include:
Men and Policies; Addresses by Elihu Root. Collected and edited by Robert Bacon and James Brown Scott. Cambridge, Mass.: Harvard University Press, 1924.
Miscellaneous Addresses, by Elihu Root. Collected and edited by Robert Bacon and James Brown Scott. Cambridge, Mass.: Harvard University Press, 1917.

Enid Schildkrout is Chair and Curator of Anthropology at the American Museum of Natural History (New York) and Adjunct Professor in the Department of Anthropology at Columbia University. Her publications include:
With Curtis A. Keim et al. *African Reflections: Art from Northeastern Zaire*. Seattle: University of Washington Press; New York: American Museum of Natural History, 1990.
"Royal Treasury, Historic House, or Just a Museum? Transforming Manhiya Palace, Ghana, into a Site of Cultural Tourism." *Museum Anthropology* 22, 3 (1999): 14–27.
Ed. with Curtis A. Keim. *The Scramble for Art in Central Africa*. Cambridge and New York: Cambridge University Press, 1998.

Thomas J. Schlereth is Professor of American Studies and Concurrent Professor of History at the University of Notre Dame. His publications include:

Ed. with Jessica H. Foy. *American Home Life, 1880–1930: A Social History of Spaces and Services*. Knoxville: University of Tennessee Press, 1992.

Cultural History and Material Culture: Everyday Life, Landscapes, Museums. Ann Arbor, MI: UMI Research Press, 1990.

Ed. *Material Culture Studies in America*. Nashville: American Association for State and Local History, 1982.

Victorian America: Transformations in Everyday Life, 1876–1915. New York: Harper Collins, 1991.

Alan Wallach is Ralph H. Wark Professor of Art and Art History and American Studies at The College of William and Mary, Williamsburg, Virginia. He was co-curator of the exhibition *Thomas Cole: Landscape Into History* (1994, National Museum of American Art and other venues), and co-editor of the exhibition catalogue. He is a member of the Board of Managing Editors of *American Quarterly*. His publications include:

"Class Rites in the Age of the Blockbuster." *Harvard Design Magazine* 11 (Summer 2000): 48–54.

Exhibiting Contradiction: Essays on the Art Museum in the United States. Boston: University of Massachusetts Press, 1998.

With Carol Duncan. "The Museum of Modern Art as Late Capitalist Ritual: An Iconographic Analysis." *Marxist Perspectives* 1, 4 (Winter 1978): 28–51.

"Thomas Cole's 'River in the Catskills' as Antipastoral." *The Art Bulletin* 84, 2 (June 2002): 334–50.

Janet Wolff is Associate Dean for Academic Affairs, Columbia University, School of the Arts. Her previous positions include Director of the Program in Visual and Cultural Studies at the University of Rochester (US) and Founding Director of the Centre of Cultural Studies, University of Leeds (UK). Her publications include:

Aesthetics and the Sociology of Art. Ann Arbor: University of Michigan Press, 1993.

Ed. with John Seed. *The Culture of Capital: Art, Power, and the Nineteenth-Century Middle Class*. Manchester: Manchester University Press; New York: St. Martin's Press, 1988.

Feminine Sentences: Essays on Women and Culture. Cambridge: Polity, 1990.

Resident Alien: Feminist Cultural Criticism. Cambridge: Polity, 1995.

The Social Production of Art. Washington Square, New York: New York University Press, 1993.

Acknowledgments

It goes without saying that the compiler of an anthology owes a great debt to the wealth of texts she has been privileged to draw upon; the debt seems even greater when the subject – museums themselves – must surely be counted as inspiration and source.

I am also indebted to the library collections and excellent library staff at Trinity College, Hartford, Connecticut, and to a number of institutions in the New York area, where most of this work was done. These include the New York Public Library Research Division and Schomburg Center for Research in Black Culture, Bobst Library at New York University, the Museum of Modern Art, the Metropolitan Museum of Art, the American Museum of Natural History, and the New-York Historical Society. The hospitable environment of the Wertheim Study at the New York Public Library, and its rare gift of a single shelf, mine to fill for the duration of this project, enabled me to gather, read, and make selections while surrounded by other researchers, equally absorbed.

There are several electronic discussion listservs which enable members around the world to share their work on the subject of museums. I am indebted to the H-Museum list and the Association for Museum History list for the breadth and depth of the discussions they facilitate.

I wish to thank the students at Trinity College, especially those in the Graduate Program in American Studies/Museums and Communities Concentration, and the students who have taken my interdisciplinary seminars at the NYU Gallatin School of Individualized Study, especially the participants in "Word & Image: Field Work" who traveled together on summer days to New York's museums. I have benefited greatly from your reactions, questions, and creative analytical work.

To those who have read parts of this manuscript, and/or have considered the project with me at various points along the way, I offer my deep appreciation for the comments and suggestions I may and may not have taken; I can name only a few, since a number of you remain anonymous: Bruce Altshuler, Ann Fitzgerald, Steven Holmes, Bruce Robertson, Enid Schildkrout, and Chris Suggs. I also share this project with Jayne Fargnoli, Annie Lenth, and Margaret Aherne at Blackwell Publishing, who brought their expertise, creativity, and humor to the production of the text.

To my family and friends, who have endured the absorption, absences, and intensities, my love and thanks.

Finally, I thank Paul Lauter, who is, without a doubt, the tenth Muse.

New York City
April 2003

The editor and publisher gratefully acknowledge the permission granted to reproduce the copyright material in this book:

1. Germain Bazin, "Foreword" from *The Museum Age*, translated from the French by Jane van Nuis Cahill, pp. 5–9. New York: Universe Books, 1967. © 1967 by Desoer S.A. Editions, Brussels.
2. Paula Findlen, "The Museum: Its Classical Etymology and Renaissance Genealogy" from *Journal of the History of Collections* 1:1 (1989), pp. 59–78. © 1989 by Oxford University Press. Reproduced by permission of the author and Oxford University Press.
3. Carol Duncan and Alan Wallach, "The Universal Survey Museum" from *Art History* 3:4 (December 1980), pp. 448–69. Reproduced by permission of Blackwell Publishing.
4. Donald Preziosi, "Brain of the Earth's Body: Museums and the Framing of Modernity" from Paul Duro (ed.), *The Rhetoric of the Frame: Essays on the Boundaries of the Artwork*, pp. 96–110, 288–9. Cambridge: Cambridge University Press, 1996. © 1996 by Cambridge University Press. Reprinted by permission.
5. Kenneth Hudson, "The Museum Refuses to Stand Still" from *Museum International* 50:1 (1998), pp. 43–50. © 1998 by UNESCO. Reproduced by permission of Blackwell Publishing.
6. Françoise Lionnet, "The Mirror and the Tomb: Africa, Museums, and Memory" from *African Arts* 34:3 (Autumn 2001), pp. 50–9, 93. Reproduced by permission of the University of California, Los Angeles.
7. Gaby Porter, "Seeing Through Solidity: A Feminist Perspective on Museums" from Sharon MacDonald and Gordon Fyfe (eds.), *Theorizing Museums: Representing Identity and Diversity in a Changing World* (a volume in a special monograph series published by Blackwell for the journal *The Sociological Review*), pp. 105–26. Oxford: Blackwell, 1996. © 1996 by The Editorial Board of The Sociological Review. Reproduced by permission of Blackwell Publishing.
8. Terence M. Duffy, "Museums of 'Human Suffering' and the Struggle for Human Rights" from *Museum International* 53:1 (2001), pp. 10–16. © 2001 by UNESCO. Reproduced by permission of Blackwell Publishing.
9. Alice Friman, "At The Holocaust Museum" from *North American Review* 286 (March/April 2001), p. 23. Reproduced by permission of the *North American Review*.
10. Charles Willson Peale, "To the Citizens of the United States of America," letter published in *Dunlap's American Daily Advertiser*, Philadelphia, Jan. 13, 1792. Public domain, available on microfilm at the Smithsonian Institution, Washington, D.C.
11. Louis Agassiz, "Letter of 1863 to Mr. Thomas G. Cary" from Elizabeth Cary Agassiz (ed.), *Louis Agassiz, His Life and Correspondence*, pp. 582–4. Boston: Houghton, Mifflin and Company, 1885. Public domain.

12. Robert Goldwater, "The Development of Ethnological Museums" from *Primitivism in Modern Art*. Cambridge, Mass.: The Belknap Press of Harvard University Press, 1986, pp. 3–5, 7–9, 11, 13–15. © 1938 by the President and Fellows of Harvard College; © renewed 1966 by Robert Goldwater; enlarged edition © 1986 by Ambrose Doskow, Trustee U/W Robert Goldwater. Reprinted by permission of the publisher.

13. Franz Boas, "Museums of Ethnology and Their Classification" from *Science* Vol. IX, No. 228 (June 17, 1887), pp. 588–9. Public domain.

14. Christopher Looby, "The Constitution of Nature: Taxonomy as Politics in Jefferson, Peale, and Bartram" from *Early American Literature* 22:3 (1987), pp. 252–73. © 1987 by the Department of English at the University of North Carolina, Chapel Hill. Used by permission of the University of North Carolina Press.

15. Curtis M. Hinsley, Jr., "'Magnificent Intentions': Washington, D.C., and American Anthropology in 1846" from *Savages and Scientists*, pp. 15–33. Washington, D.C.: Smithsonian Institution Press, 1981. © 1988 by the Smithsonian Institution. Used by permission of the publisher.

16. Fabrice Grognet, "Ethnology: A Science on Display" from *Museum International* 53:1 (2001), pp. 51–6. © 2001 by UNESCO. Reproduced by permission of Blackwell Publishing.

17. Enid Schildkrout, "Ambiguous Messages and Ironic Twists: *Into the Heart of Africa* and *The Other Museum*" from *Museum Anthropology* 15:2 (1991), pp. 16–23. Reproduced by permission of the American Anthropological Association. Not for sale or further reproduction.

18. Mary Bouquet, "Thinking and Doing Otherwise: Anthropological Theory in Exhibitionary Practice" from *Ethnos* 65:2 (2000), pp. 217–36. © Routledge Journals, Taylor and Francis Ltd, on behalf of the National Museum of Ethnography.

19. Gyan Prakash, "Museum Matters" from Alexander García Düttmann et al., *The End(s) of the Museum*, pp. 53–66. Barcelona: Fundació Antoni Tàpies, 1996. © 1996 by Gyan Prakash. Reproduced by permission of the author.

20. Zora Neale Hurston, "What White Publishers Won't Print" from *Negro Digest* (April 1950), pp. 85–9.

21. J. C. Robinson, selections (pp. 3–9, 16–17, 22–3, 28–9) from *On the Museum of Art*, No. 5 in a series of introductory addresses (on the Science and Art Department and the South Kensington Museum), delivered Dec. 14, 1857. London: Chapman and Hall, 1858. J(ohn) C(harles) Robinson was Keeper of the Museum of Art and the Art Library. Public domain.

22. Annie E. Coombes, "Museums and the Formation of National and Cultural Identities" from *Oxford Art Journal* 11:2 (1988), pp. 57–68. Reproduced by permission of Oxford University Press.

23. Eleanor Heartney, "Fracturing the Imperial Mind" from *Art in America* 7 (July 2001), pp. 51, 53, 119. Reprinted by permission of Brant Publications, Inc.

24. Henry Balfour, Presidential Address to the Museums Association, Maidstone Meeting, July 13, 1909 from *The Museums Journal* 9 (July 1909), pp. 5–18. Public domain.

25. Jordanna Bailkin, "Picturing Feminism, Selling Liberalism: The Case of the Disappearing Holbein" from *Gender and History* 11:1 (April 1999), pp. 145–63. Reproduced by permission of Blackwell Publishing.

26. Edward N. Kaufman, "The Architectural Museum from World's Fair to Restoration Village" from *Assemblage* 9 (June 1989), pp. 21–39. © 1989 by The Massachusetts Institute of Technology. Reproduced by permission.

27. Robert W. de Forest, Grosvenor Atterbury, and Elihu Root, Addresses on the Occasion of the Opening of the American Wing, The Metropolitan Museum of Art, New York, pp. 3–7, 17–21, 30–4. New York: Metropolitan Museum of Art, 1925.

28. Elizabeth Broun, "Telling the Story of America" from *American Art* 13:3 (Fall 1999), pp. 84–92.

29. Roger G. Kennedy, "Some Thoughts about National Museums at the End of the Century" from Gwendolyn Wright (ed.), *The Formation of National Collections of Art and Archaeology*, pp. 159–63. Washington, D.C.: National Gallery of Art, 1996 (distributed by the University Press of New England, Hanover and London).

30. James Fenton, "The Pitt-Rivers Museum, Oxford" from *Children in Exile*. New York: Farrar, Straus and Giroux, 1985. © 1985 by James Fenton. Reprinted by permission of Farrar, Straus and Giroux, LLC.

31. Sir William Henry Flower, "Local Museums" – from a letter in support of the establishment of a County Museum for Buckinghamshire (November 24, 1891), and an address at the opening of the Perth Museum (November 29, 1895) – published in *Essays on Museums and Other Subjects*. London: Macmillan, 1898. Public domain.

32. Susan A. Crane, "Memory, Distortion, and History in the Museum" from *History and Theory* 36:4 (1997), pp. 44–63. Reproduced by permission of Blackwell Publishing.

33. Thomas J. Schlereth, "Collecting Ideas and Artifacts: Common Problems of History Museums and History Texts" from *Roundtable Reports* (Summer/Fall 1978). Reprinted with permission of Museum Education Roundtable, all rights reserved. For more information contact: Museum Education Roundtable, 621 Pennsylvania Avenue, SE, Washington, D.C., 20003; or www.mer-online.org or email info@mer-online.org.

34. Gaynor Kavanagh, "Melodrama, Pantomime or Portrayal? Representing Ourselves and the British Past through Exhibitions in History Museums" from *International Journal of Museum Management and Curatorship* 6 (1986), pp. 173–9. © 1987 by Elsevier Science. Reprinted by permission of Elsevier Science.

35. Mónica Risnicoff de Gorgas, "Reality as Illusion, the Historic Houses that Become Museums" from *Museum International* 53:2 (2001), pp. 10–15. © 2001 by UNESCO. Reprinted by permission of Blackwell Publishing.

36. Mark P. Leone and Barbara J. Little, "Artifacts as Expressions of Society and Culture: Subversive Genealogy and the Value of History" from Steven Lubar and W. David Kingery (eds.), *History From Things: Essays on Material Culture*, pp. 160–81. Washington D.C.: Smithsonian Institution Press, 1993. © 1993 by the Smithsonian Institution. Used by permission of the publisher.

37. James Deetz, "A Sense of Another World: History Museums and Cultural Change" from *Museum News* 58:5 (May/June 1980). © 1980 by the American Association of Museums. All rights reserved. Reproduced by permission.

38. Lisa G. Corrin, "Mining the Museum: Artists Look at Museums, Museums Look at Themselves" from Lisa G. Corrin (ed.), *Mining the Museum: An Installation by Fred Wilson* (© 1994), pp. 1–22. The Contemporary, Baltimore in cooperation with The New Press, New York, 1994. Reprinted by permission of The New Press. (800) 233–4830.

39. Le Corbusier, "Other Icons: The Museums" from *The Decorative Art of Today*, translated and introduced by James I. Dunnett, pp. 15–23. Cambridge, Mass.: MIT Press, 1987. First published in Le Corbusier, *L'art décoratif d'aujourd'hui* (Paris: Editions G. Crès, 1925); second edition published 1958 by Editions Vincent & Freal, Paris, © 1959 by Foundation Le Corbusier. English translation © 1987 by Architectural Press. Reproduced by permission of MIT Press.

40. John Cotton Dana, "The Museum as an Art Patron" from *Creative Art: A Magazine of Fine and Applied Art* 4 (June 1929), pp. xxiii–xxvi. Public domain.

41. Benjamin Ives Gilman, "Aims and Principles of the Construction and Management of Museums of Fine Art" from *The Museums Journal* (July 1909), pp. 28–44. Public domain.

42. Georges Bataille, *Museum* (translated from the French [1930] by Annette Michelson) from *October* 36 (Spring 1986), p. 25. Translation © 1986 by October Magazine Ltd and the Massachusetts Institute of Technology.

43. Pierre Bourdieu and Alain Darbel with Dominique Schnapper, Conclusion to *The Love of Art: European Art Museums and Their Public*, translated by Caroline Beattie and Nick Merriman, pp. 108–13, 173. Cambridge: Polity, 1991. First published in *L'amour de l'art: les musées d'art européens et leur public.* © 1969 by Les Éditions de Minuit. English translation © 1991 by Polity Press. Reproduced by permission of Blackwell Publishing, except in the US, Canada, and the Philippines where permission is granted by Stanford University Press, www.sup.org.

44. Philip Fisher, "Art and the Future's Past" from *Making and Effacing Art: Modern American Art in a Culture of Museums*. Cambridge, Mass.: Harvard University Press, 1991, pp. 3–29, 255–6. © 1991 by Philip Fisher. Originally published by Oxford University Press and used by permission of Oxford University Press, Inc.

45. Malcolm McLeod, "Museums Without Collections: Museum Philosophy in West Africa" from Simon J. Knell (ed.), *Museums and the Future of Collecting*, pp. 22–9. Aldershot: Ashgate, 1999. Reproduced by permission of Ashgate Publishing Ltd.

46. Paul DiMaggio, "Cultural Entrepreneurship in Nineteenth-Century Boston, Part II: The Classification and Framing of American Art" from *Media, Culture and Society* 4 (1982), pp. 303–22.

47. Janet Wolff, "Women at the Whitney, 1910–30: Feminism/Sociology/Aesthetics" from *Modernism/Modernity* 6:3 (September 1999), pp. 117–38. © 1999 by The Johns Hopkins University Press. Reprinted by permission of The Johns Hopkins University Press.

48. Maurice Berger, "Zero Gravity" from Donna de Salvo (ed.), *Past Imperfect: A Museum Looks at Itself* (© 1993), pp. 46–51. Southampton, N.Y.: The Parrish

Art Museum, 1993. Reprinted by permission of The New Press. (800) 233–4830.

49. Kynaston McShine, Introduction to *The Museum as Muse: Artists Reflect*, pp. 11–23. New York: The Museum of Modern Art, 1999. © 1999 by The Museum of Modern Art, New York. Reproduced by permission.

50. Karen Mary Davalos, "Exhibiting Mestizaje: The Poetics and Experience of the Mexican Fine Arts Center Museum" from Antonio Ríos-Bustamante and Christine Marin (eds.), *Latinos in Museums: A Heritage Reclaimed*, pp. 39–66. Malabar, Fl.: Krieger, 1998. Reproduced by permission of Krieger Publishing Company.

51. Stephen Greenblatt, "Resonance and Wonder" from Peter Collier and Helga Geyer-Ryan (eds.), *Literary Theory Today* (1990), pp. 74–90. Cambridge: Polity, 1990. © 1990 by Stephen Greenblatt. Reproduced by permission.

52. Eilean Hooper-Greenhill, "Changing Values in the Art Museum: Rethinking Communication and Learning" from *International Journal of Heritage Studies* 6:1 (March 2000), pp. 9–31.

53. Barbara Kirshenblatt-Gimblett, "Secrets of Encounter" from *Destination Culture: Tourism, Museums, and Heritage*, pp. 249–56, 311. Berkeley and Los Angeles: University of California Press, 1998. Originally published in the *Journal of American Folklore* 107 (1994). © 1998 by Barbara Kirshenblatt-Gimblett. Reproduced by permission of the University of California Press.

Every effort has been made to trace copyright holders and to obtain their permission for the use of copyright material. The publisher apologizes for any errors or omissions in the above list and would be grateful if notified of any corrections that should be incorporated in future reprints or editions of this book.

Introduction | Museum/Studies and the "Eccentric Space" of an Anthology

An anthology is both an assertion and a collection, an encompassing gesture toward a subject which, if worth collecting, will resist our enclosing designs. The identification of the elusive nature of the museum itself, as expressed by Werner Hamacher in a "Quick Stroll Through Various Museums," seems well suited to re-use as an "apology" at the threshold of a collection of *Museum Studies*: "No assertion about the museum – and that means: no museum of the museum – can show us the truth of the museum."[1] Mindful of caveats against truth claims and, one might infer, against those who aspire to totalizing encyclopedic designs, this collector/compiler has tried to bring together here a representative, provocative selection of perspectives on the museum as (1) a literal gathering place for the representation and reception of histories, memories, natures, nations, cultures, and audiences, and (2) a topos or more abstract mental gathering place for analytical and creative thinking about our encounters with such representations.

In looking at Victorian photographic images of the museum, curator Kynaston McShine notes that, though it was a "special place," the museum was "not a religious" or "domestic space" but "a major place of convocation" where one might well expect to encounter "the marvelous." McShine goes on to explain (see the Introduction to *The Museum as Muse* included here in Part V) that artists in the twentieth century "have shown a desire to explore the frame within which that sense of wonder is maintained." From the vantage point of the beginning of the twenty-first century, one could argue that the *study* of the museum has developed along similar discursive lines: it is now less reverential ("religious"), less confined to a single domain of inquiry ("domestic" professional and/or academic spheres), more heterogeneous and dialogic, engendering work in a variety of fields from a variety of subject positions, becoming "a major place of convocation" for cultural and political debate.

However, it is equally important to recognize the emergence in earlier periods of what we credit as a post-modern analytical turn toward enlightened critique, and so this anthology brings together nineteenth- as well as twentieth- and twenty-first-century "museology": the study of museum history, theory, and practice. In addition to texts which address museums of many genres, and employ a number of modes – including description, analysis, argument, and prescriptive mediation – this book collects the meditations of poets and other "literary" sensibilities.

But why collect/create a text which could be designated a Museum of Museology? What purposes could it serve? The primary purpose of this book is to offer a cross-section of the rich, hybrid terrain of museum studies.[2] In fact "museum/studies" seems well represented in this more pointedly visual term, insofar as it is a composite place, united by the solidus/virgule/slash which marks an oscillation or crossing between locations: in this case movement takes place between the literal place and its reception or study. Some readers may seek an emphasis on the "objective" description of museum practices; some may prefer close attention to the larger contexts in which such practices have taken place; some may come with an appetite for the results of intricate critical methodologies. But each museum presents varied phenomena, some available to the senses and open to description, some available primarily through critical analysis. Like any exhibition, these collected texts will satisfy and/or engender critique and, whether in concert or discord, will hopefully bear the weight of diverse readers.

A related goal of this book is to foreground the museum's identity as a domain of cultural practices, and a magnet for the average visitor's and the professional critic's responses to those practices. Museums explicitly and also often unwittingly offer the "material conditions of existence," the "representations which produce meanings," and the "modes of production" and "signification" which constitute a sound basis for the study of culture.[3] This anthology contains texts which use the criteria of – and encourage further work in – "cultural studies," an approach comprehensively defined in terms of its commitment "to the study of the entire range of a society's arts, beliefs, institutions, and communicative practices."[4] Each museum site, whether it be the entire institution, the permanent collections and collecting policies, the special exhibitions, the individual galleries, the public programs, the retail store or the restaurant is, in the spirit of the preceding definition, a cultural "artifact."

A third reason for undertaking this collection is the fact that, though museums show no signs of self-destruction (thus we need be in no hurry to conserve them), discourses on the museum periodically demand a retrospective group exhibition. The voices are various: they include those for whom the museum is a "profession," those for whom it is a subject for study, those for whom it has traditionally seemed reductive, remote, exclusionary, or otherwise misrepresentative. These voices and versions speak of the museum as a place to encounter histories (natural, human, and cultural), nations (in states of formation, expansion, adaptation, and decline), more finite locations (regions, cities, towns, barrios) and manifold forms of cultural production. They suggest that the museum, as a general category or as a specific site, is in effect a palimpsest: when we remove the latest and most visible layer of its existence we find traces of earlier institutions, aesthetics, hierarchies of value, and ideologies. Some will argue that the majority of museums vary little from layer to layer (that traditions endure); others will find that material differences occur (that change has taken place). The geology of the museum as both actual place and concept invites inspection of its strata and yet may prove to be elusive, requiring further literal and analytical visits. The texts in this anthology attest to and provoke these expeditions.

Collecting Etymologies

A look at the etymology of the term "museum" and its variants underscores the range and complexity of the subject of this collection and one might argue, as Kenneth

Hudson once did, that "[w]hat a museum is attempting to achieve has become more important than what it is," making the definition "increasingly difficult and perhaps increasingly pointless" (Hudson, 1977: 1). However, in 1998 Hudson was still examining those (re)definitions, as we find in his assertion that "The Museum Refuses to Stand Still" (included here in Part I). A review of the etymology may in fact encourage the continuation of an enquiry begun by Alma Wittlin in 1949. In her survey of often imprecisely applied terms, including "Cabinet," "Kunst-Kammer," "Museum," "Study," and "Library," which were loosely employed prior to the formation of the first "public" museums in the late eighteenth century, Wittlin observed that: "The characteristics implied in those terms may potentially exist in the present Museum. The following qualities, both spiritual and material, seem to be inherent in them: interest in learning and encyclopaedic approach to inquiry; inspirational values; privacy and secrecy; rarity; boastful costliness; features connected with storage accommodation and with the hiding of things." She then asked: "Which of these connotations are still extant, which are missing, and which furthermore seem desirable in the Public Museum of our times, and which not?" (1949: 6). Years later, perhaps resigned to the endurance of those connotations, she added: "What order of priority are we to assign to each of them?" (1970: 1). These qualities and connotations, and the crucial matters of motivation, methodology, results, and prescriptions for change they represent, continue to expose key issues of inclusion, occlusion, and exclusion in the museum, in terms of both its constituencies and its objects. Fifty years after Wittlin, and in another century, museum studies are addressing even more explicitly those "qualities" and "connotations" of political, social, and ethical, as well as "spiritual and material" import already implied in her list.[5]

In an incisive survey of "The Museum: Its Classical Etymology and Renaissance Genealogy" (included here in Part I), Paula Findlen complicates the very notion of "linguistic construction" by investigating the social and intellectual roots of the verbal building blocks which offer "insight into the cultural processes of past societies." As she observes, during the Renaissance the *musaeum* was a "locating principle, circumscribing the space in which learned activities could occur"; it was an "etymologically ordained home of the Muses," either an arena or a barrier, depending on social position. This and other recent etymologies follow the trajectory but often profitably deepen the contexts of earlier attempts to collect usages. Many of these are preserved in the *Oxford English Dictionary*, which takes us from the "musaeum," a sanctuary for the Muses of classical mythology, to "mouseion," a library and research center at Alexandria (290 BCE), and to the Ashmolean Museum at Oxford University (1683). According to Findlen, the Ashmolean was the first museum "to proclaim its fully public status." It began with a Cabinet of Rarities collected not by a member of the aristocracy but by the "botanical traveler" and "well respected gardener to the nobility" John Tradescant. As Edward Alexander notes, this museum "set a precedent in Britain by admitting not only the privileged few but also the general public for a fee of sixpence" (1987: 338). Attitudes toward that "public" – including its tastes, its rights, and its abilities to benefit from the museum experience – were then and continue to be a subject of discussion in all museum provinces.

We might want to preface these public events with the compelling proposal of paleolithic origins for the natural history museum. Included in one approach to museum "nomenclatures" from "archives to zoos" are the Lascaux Grottoes, which Archie Key believes "could well form the oldest museum complex" of "intercommunicating subterranean galleries [which] depict the animal life" of that period

(1973: 14). In a brief world survey, Geoffrey Lewis (1992) points out that the term "museum" now "conveys concepts not only of preserving the material evidence of the human and natural world but also of a major force in interpreting these things."[6] Lewis also emphasizes the International Council of Museums (ICOM) definition of 1990, which insists that the museum should be operating in "the service of society and of its development." But can we arrive at a universal, natural, or value-neutral identification of good "service," worthy members of "society," or positive "development"?[7]

As the contents of this anthology demonstrate, several elaborations and additions can be made to Wittlin's valuable list of qualities and questions – and implied ethical imperatives. The emphasis on education raises epistemological and ideological questions, taking into account both the "body" of knowledge and the visitor as a critical/thinking/reactive subject who views the terrain from her own horizon of reception. The encyclopedic mission demands attention, both to its highly subjective master narratives and to its tendency to be evaluative, reductive, and exclusive. The goal of rapt attention carries with it an obligation to incorporate local as well as institutional aesthetic values. The private and the secret are culturally and politically charged domains, often involving the need to retrieve and/or repatriate objects, and at times to argue against public display. The storage space may be the unwitting analogue of a dead letter office, a space to be reanimated by periodic airing, reclassification, and renewed attempts to (re)locate both senders and intended recipients.

Interdisciplinarity: Literary/Cultural/Museum Studies

The frame narrator in Joseph Conrad's *Heart of Darkness* suggests that, for the compromised narrator-agent Marlow, whose pursuit of the enigmatic antihero Kurtz is a mixture of blindness and insight, the "meaning of an episode was not inside like a kernel but outside, enveloping the tale which brought it out only as a glow brings out a haze" (Conrad, 1969: 493). The museum visitor, especially one who would be inclined to "read" museums as the "debated sites" John G. Hanhardt (1996) describes, can take the wisdom of this position and do what the hesitant Marlow would not do: look at the exterior and interior of the museum as a physical site and as a text. The meaning of the episodes would then include responses to this constellation of museum activities, responses determined by pre-existing beliefs, fears, tensions, and stated or unstated claims. Similarly, museum studies today often tend to seek meaning in the light which the museum sheds on its immediate and its larger cultural and political surroundings, including the communities it serves and the ones it may be seen to disrespect or completely ignore. Some studies expose a depth of field which holds both the surroundings and the museum itself in sharp focus.[8] They treat museums/exhibitions as ends in themselves, not means to ends sought by ideology and/or theory. In essence, they find space to accommodate both museology and museography.

The difference between these two orientations was explained by the International Council of Museums (ICOM) in 1972 when they defined museology as "museum science": "It has to do with the study of the history and background of museums, their role in society, specific systems for research, conservation, education and organization, relationship with the physical environment, and the classification of different kinds of museums." In an attempt to draw a distinction, ICOM defined museography

as "the body of techniques related to museology. It covers methods and practices in the operation of museums, in all their various aspects."[9] It has now become even more difficult, and perhaps even less useful, to maintain putative distinctions between study and praxis, given that the "methods and techniques" assigned to the domain of "museography" are increasingly regarded as influenced by, addressed to, and otherwise intimately connected to museology.[10] As Peter Vergo notes in his Introduction to *The New Museology*, an examination of the "purposes" as well as the "methods" employed by museums must be undertaken; museology itself must more fully exploit its potential as a "theoretical and humanistic discipline" and attend to the "role of museums within society." This, Vergo argues, will entail an extensive analysis of the intricacies and forces embodied in the work of museums, including acquisition and deaccession policies, composition (the ways in which objects are grouped and juxtaposed), historical constructions (made, not found), and the subtexts which hover in virtually every text and action the museum undertakes (1989: 3). This call for reflexivity and circumspection extends of course to all those, including the editor of an anthology, who collect and exhibit, who interpret and call for interpretation. As Ivan Karp and Steven D. Lavine insist in the Introduction to their essential collection, *Exhibiting Cultures: The Poetics and Politics of Museum Display*, those who design exhibitions must bring "multiple perspectives" into view and/or admit the "highly contingent nature of interpretations" they present (1991: 7).

Narratologist Gérard Genette notes that voice is "larger than 'person'" and that a study of voice must attend to "the way narrating itself is implicated in the narrative" (1980: 31). The "poetics" of exhibition and the idea of "voice" emerge in many recent museum studies. Lavine formulates the issue of complicity as one which brings genre, let us say a literary biography or an ethnography, into direct confrontation with the speaker, and he raises formal and ethical questions for the museum professional: "Whose voice is heard when a curator works through an established genre of exhibition, such as the monographic account of an artist's career or the ecological and social explanation of the lives of 'primitive' peoples in the diorama of a natural history museum?" (1991: 151). And though Stephen Bann can locate "no law that states that, in this or any other age, a museum or a collection will exemplify the kind of systematic order which justifies the use of the term 'poetics'" (1984: 78), he uses figures of speech – of poetics – to describe the "two strategies" at work in the "modern museum": one is "reductive and mechanistic" in its use of a "metonymic sequence of schools and centuries," while the other is "integrative and organic" in its use of "'reconstructed' rooms" which offer "a synecdochic treat" (pp. 85, 91).

In each part of this collection we find aspects of the explicit turn to figures, to narratology, and to literary theory. This is particularly evident in Françoise Lionnet's discussion of narrative levels and Gaby Porter's formulation of an analogy between the dynamics of the relationship between text/author/reader and those of exhibition/curator/visitor (Part I); in Christopher Looby's discussion of "metaphorical exchange," Enid Schildkrout's analysis of the management of irony in exhibition, and Mary Bouquet's emphasis on metaphor as a way of making the unknown visible (Part II); in Eleanor Heartney's analysis of "telling juxtapositions" as a strategy of deconstruction and Edward Kaufman's discussion of the synecdochic and metonymic power of "mementos, material relics of lives lost and regretted" to "recall these things, and in some wordless way to hold their significance" (Part III); in Gaynor Kavanagh's characterization of history exhibitions as "history writing" and James Deetz's uneasy discussion of easy analogies in history museums (Part IV); in Philip Fisher's attention

to the negation or denial of voice in "suppressed or silenced" objects, and Stephen Greenblatt's adaptation of new historicist literary theory to unearth the dynamics of human psychology and agency embodied in museum encounters (Part V).

The frequent turn to these figures reveals that, in practice, the rhetoric of museology relies on the same four poetic "master tropes" – metaphor, metonymy, synecdoche, and irony – identified by Kenneth Burke (1945) in *A Grammar of Motives*. The analysis of their means and "motives" can be extremely useful, as Burke reveals, for interrogating both the role these figures of speech (or figures of visual display) might play "in the discovery and description of 'the truth'" and the role they play in strategies of misapplication, which can lead to misrepresentation. Evidence of this explicit figurative turn in museology – in the explication of museum practice – has always been implicit in the practice of museography, for example in the use of objects to "stand for" cultures. Increasingly, though, that figurative turn *has* become explicit in museography – in exhibition techniques – as well as in the critiques they generate. This may be seen as a logical development, given that museums are "expository spaces" (as Eilean Hooper-Greenhill argues in her essay, included here in Part V).

In his meditations on the operations of tropes, Burke describes metaphor as "a device for seeing something in terms of something else" (p. 503). In thinking about museum studies, the exertion of power through the structure of primary and secondary – or "tenor" and "vehicle" – positions in this trope bears notice. The potential consequences are revealed by Roy Wagner (1981), for example, when he argues that museums "form the logical point of transition or articulation between the two major senses of 'culture'; they metaphorize ethnographic specimens and data by analyzing and preserving them, making them necessary to our own refinement although they belong to some other culture" (pp. 27–8). Along these lines, Faith Davis Ruffins suggests that we should look more carefully at how form exerts a measure of control over interpretation, particularly in the translation of history. When "certain concepts, objects, images or sounds stand for something else" in an exhibition, the "accuracy" of the metaphor – "the precision of its ratio to the original" – becomes a crucial concern for interpretation (1985: 59).

Regarding his second "master trope," Burke observes that metonymy is a strategy of "reduction" used to bring "some higher or more complex realm of being [down] to the terms of a lower or less complex realm of being." It is employed "to convey some incorporeal state in terms of the corporeal or tangible" and enables us to "speak of 'the heart' rather than 'the emotions'" (p. 506). In such cases we choose comparisons based on putatively close associations between the elements compared. Burke then describes synecdoche, the third in his list of tropes, as a part-for-whole "conversion" which "stresses a *relationship* or *connectedness*" (p. 509); in such representations of similarity, a key part is made to stand for the larger, absent whole.

We find these tropes (metaphor, metonymy, synecdoche) appearing frequently in the analysis of the museum. But Burke's remarks on irony prove to be even more relevant to his complex aesthetic/ethical argument, and perhaps they explain the frequent turn to irony as the prevailing "master trope" of contemporary museology and museography. The use of irony as a tool in exhibition praxis promises to temper the inclination to be overly constructive (metaphor), overly reductive (metonymy), or overly simplistic (synecdoche). Ironic representations in museums, as some suggest, may recognize the intrinsic differences and contradictions which compromise their own positions. Irony is not an easy mode to manage, however, as the 1989–1990

exhibition *Into the Heart of Africa* at the Royal Ontario Museum – and its critics including Schildkrout – make clear.[11]

Burke points out that irony "arises when one tries, by the interaction of terms upon one another, to produce a *development* which uses all the terms. Hence, from the standpoint of this total form (this 'perspective of perspectives'), none of the participating 'sub-perspectives' can be treated as either precisely right or precisely wrong. They are all voices, or personalities, or positions, integrally affecting one another" (p. 512). Burke's elaboration of these points proves useful in the analysis, as it may be in the actual construction of museum narratives and modes of display. For example, he asserts the merits of "dialectic" in the presentation of history: "we should never expect to see 'feudalism' overthrown by 'capitalism' and 'capitalism' succeeded by some manner of national or international or non-national or neo-national or post-national socialism – but rather should note elements of all such positions (or 'voices') existing always, but attaining greater clarity of expression or imperiousness of proportion of one period than another" (p. 513). Advocating a similarly fluid method of representation, James Clifford looks at ethnographic studies as "constructed domains of truth, serious fictions" (1988: 10). In *The Predicament of Culture* he maintains that: "A modern 'ethnography' of conjunctures, constantly moving between cultures, does not, like its Western alter ego 'anthropology,' aspire to survey the full range of human diversity or development. It is perpetually displaced, both regionally focused and broadly comparative, a form both of dwelling and of travel in a world where the two experiences are less and less distinct" (p. 9).[12]

Peter Brooks may bring us even closer to the intersection of narratology, cultural, and prescriptive museum studies when, in *Reading for the Plot: Design and Intention in Narrative*, he raises and answers a key question: "If we ask what a meaning that is outside rather than within the narrative might be, what status it might have, we are forced to the conclusion that such meaning must reside in the relation between the tale's telling and its listening, in its reception, its transaction, in the interlocutionary relation" (1984: 257–8).[13] A model of ironic performance, Conrad's tale is densely layered, multivocal, ambivalent in its representation of and reaction to, among other things, cultural difference and self-knowledge. As Brooks observes, it "is ultimately most of all about transmission" and is a "far from innocent" act of narration which "implicates" its listeners (p. 261). In this sense Conrad's novel performs – and not always consciously – in a manner similar to that of an ethnographic display in a museum.

The matter and manner of transmission take on their own complicated colors in museums, and recent developments in education and visitor studies, outlined in the essay by Hooper-Greenhill, are less prone to take for granted the character of the viewer or the neutrality and/or transparency of the material to be conveyed. In concluding his Introduction to *Cannibal Tours and Glass Boxes*, Michael Ames offers a clear indication of reciprocity in (professional) transmission when he observes: "If knowledge of the self passes through others, then equal attention needs to be given to what returns: there lies a direction for reconstituting scholarly and curatorial relationships along more democratic, responsive, reciprocal, and critical lines" (1992: 14). To those relationships we must add the passage between visitor and museum.

The use of irony, in a literary text or a museum, might encourage us to acknowledge common elements of the human condition, and it might reduce the temptation to make easy binary distinctions between the "primitive" and the "civilized." However,

as a way of knowing and as a strategy of representation within and without the museum, irony brings problems of its own. A confluence of voices may produce dissonance, unsettling or confusing the audience. Neil Harris suggests that museums, which maintain positions and cannot by their nature be immune from controversy, might benefit from greater candor about their intentions. Rather than attempting to be less single-minded, less opinionated, perhaps less ironic, Harris notes, museums "should define more clearly and self-consciously their actual goals and relation to truth-seeking, and to learn more about how exhibitions function as sources of opinion" (1995: 57). Institutional and individual curatorial self-awareness and self-criticism, translated into circumspect strategies of (re)presentation, seem to be the directions irony will take in the "new" museology and museography.

In this respect, a number of museum exhibitions now appear inclined to emulate the "dialogic imagination" of the novel, finding ways to criticize the museum itself and to incorporate parody and travesty of its own and other canonical genres. Mikhail Bakhtin credits the novel, which began its rise in the late eighteenth century, as did the "public" museum, with establishing a "zone of contact with the present in all its openendedness" (1981: 8). This is possible because the novel recognizes the inevitability, and thus strategizes the unavoidable presence, of what Bakhtin terms its "heteroglossia" – that which insures the primacy of context over text: "At any given time, in any given place, there will be a set of conditions – social, historical, meteorological, physiological – that will insure that a word uttered in that place and at that time will have a meaning different than it would have under any other conditions; all utterances are heteroglot in that they are functions of a matrix of forces practically impossible to recoup, and therefore impossible to resolve" (Emerson and Holquist, 1981: 428). Danielle Rice finds that the "postmodernist depriviliging of any one discourse" has resulted in a "new model" for museum educators, one in which "interpretation is reciprocal" (1995: 18), and Hooper-Greenhill offers a detailed description of those changes. Another excellent description of progress toward a "dialogic museum" has already been collected in *Museums and Communities* (Karp et al., 1992) in Jack Tchen's account of "The Chinatown History Museum Experiment." Tchen describes the attempt to accommodate a "multivocal history" and to unite "members from our various constituencies" (1992: 286). A "dialogue-driven museum," he notes, will depend on "mutual exploration" of "memory and meaning" and the incorporation of the results in order "to become an ever more resonant and responsible history center" (p. 291).

Several texts in this anthology note the potential for these multiple "zones" of contact in the museum, but most explicit is the study by Karen Mary Davalos in Part V. As Davalos explains: "Through memories of particular experiences, spiritual connections to images, and the positioning of objects as familiar, Mexicanos move objects into a zone of their own complex, multisubject, personal history and homespace." Davalos makes clear in her rigorous analysis of the "ambiguities of representational practices" that ambiguity itself can be productive and unpredictable. Conscious attempts to avoid conventional hierarchies and strategies of representation can result in "unanticipated results that rupture the message." In this case, perhaps in all cases, the effective museum is not a strictly controlled environment but one that creates space for identification and reflection. It is significant that alternative, non-collecting institutions demonstrate the possibilities of the museum (more broadly conceived) as a zone of contact with contemporary art/events. As Ute Meta Bauer points out in her catalogue essay for *Documenta 11* (Kassel, Germany, 2002), they can exhibit

productive resistance to and rewriting of traditional narratives of art history, and they can explicitly address events in the life-worlds of artists, curators, and audiences.[14]

Yet, in addition to identification, estrangement also seems to be an important element in the museum encounter. If cultural differences are reduced or diluted, the result may be a false sense of universality at the cost of crucial "local" detail, a sacrifice of the local in service of the global, and we see this unfold in Lionnet's essay in Part I. In a recent "Introduction to Historic House Museums" Giovanni Pinna explains that "the more uniform the world tends to become, the more its individual communities look for their own roots and characteristics preserved in museums. The members of communities and countries would seem to be seeking refuge from globalization and uniformity in museums, symbolized in their minds at least as the last bastions of specificity and diversity" (2001: 5). Moreover, Pinna claims that the historic house is most resistant to the authority of the "ruling group" (and most in need of preservation – as a political act) because it is "the symbol of events, epochs and regimes which cannot be eliminated without destroying the house itself" (p. 7). Thus the preservation movement, often associated with the interests and accomplishments of the landed aristocracy in its many incarnations, even in democracies, has always contained the potential for protecting and displaying oppression, and resistance against oppression.

Resistance to such displays also remains visible, however. One manifestation of this is the reluctance to include slave quarters in historic preservations – or recreations. A notable exception is the exhibition and the process itself of *Mining the Museum*. Lisa Corrin's essay in Part IV describes this in detail, and Terence Duffy's survey of "Museums of 'Human Suffering'" in Part I provides an orientation for such innovative remedial acts. The ethical and pragmatic or consequence-oriented dimension of museum studies is quite clear in focused analyses like Duffy's, and this dimension is dispersed throughout the field and throughout this anthology.

Reading a Collection

Within the bibliographies of the individual texts contained here one may find the beginnings of many other possible anthologies. The Selected Bibliography similarly suggests other directions. Several areas of concentration within the field of museum studies have their own significant body of literature, including anthologies, and they are less directly addressed in this collection; among them are the history of collections; curatorship *per se* (although curatorial voices speak in this collection); recent trends in museum architecture (buildings themselves); alternative exhibition spaces; museum ethics; repatriation; museums on the web, and other manifestations of the "virtual" museum. A number of key texts in these areas can be found in the Selected Bibliography.

Any collection of museum studies aspiring to represent the hybrid nature of an interdisciplinary field must lend itself to many reading strategies. As Robert Harbison explains in *Eccentric Spaces*: "Instructions for using a dictionary or museum have not been written because they would be instructions for using the mind" (2000: 145). Instructions for a user of this book might suggest, however, that its organization can be viewed as a gradual narrowing of the field after the wide-angle exposition in Part I: *Museology: A Collection of Contexts*. Part II looks at *States of "Nature" in the Museum: Natural History, Anthropology, Ethnology*; Part III examines *The Status of Nations and the Museum*; Part IV considers ways of *Locating History in the Museum*; Part V

emphasizes what is immanent in each of the other sections: *Arts, Crafts, Audiences.* Each section is prefaced by a summary introduction of its contents. However, as Franz Boas and others have taught us, principles of organization and classification bear ongoing inspection. This might apply as much to anthologies as it does to museums, and so a second Table of Contents/Alternative Taxonomy suggests another organizing design for this material.

Notes

1 See Werner Hamacher, "Expositions of the Mother: A Quick Stroll Through Various Museums" (1996), p. 82.
2 In this regard, I want to acknowledge the work of W. J. T. Mitchell and the stated "educational" function of his book *Picture Theory: Essays on Verbal and Visual Representation*; through his text, Mitchell seeks to work against the "separation of 'faculties'" (corporeal and collegial) as he "attempts to suggest some questions, problems, and methods for a curriculum that would stress the importance of visual culture and literacy in its relations to language and literature." As Mitchell would no doubt insist, the collector should try not to be reductive; she should acknowledge differences but seek to connect them "with issues of knowledge (true representations), ethics (responsible representations), and power (effective representations)" (1994: 6). These goals, of course, are inflected with the collector's subjective criteria in the realms of truth, responsibility, and action.
3 See Michèle Barrett et al., "Representation and Cultural Production" (1979), p. 10.
4 See Cary Nelson et al., "Cultural Studies: An Introduction" (1992), p. 4.
5 For example, in striving to preserve and respect both objects and memories related to the devastating events of September 11, 2001 and its aftermath, we have much to learn from past efforts. Edward Linenthal suggests that the museum can be a place to negotiate the "pluralistic ownership of memory" (p. 5). If so, it has never been of greater social or personal value in the protection of what he, in the context of the United States Holocaust Memorial Museum, calls "burdensome memory" (p. 260).
6 Lewis also brings into focus the link between private Roman collections and "spoils of war," and includes the significant tradition of Islamic collecting, which was not carried out "in furtherance of the museum idea" but was motivated by religious belief and the idea of "*al-waaf*": the "preservation of cultural property" through gifts, "in perpetuity, for the public good and religious benefit" (1992: 5–7).
7 For the ongoing "Development of the Museum Definition According to ICOM Statutes (1946–2001)" see the ICOM web site *http://www.icom.museum.org*. For a continuation of this etymology see the Preface for the exhibition/text *The End(s) of the Museum* where John G. Hanhardt offers a definition which justifies the intense degree of interest in museum activities or episodes today. He describes the museum as "a debated site in which the scenarios of art and culture are played out" (1996: 14). Also see the debate about nomenclature and museum status as it has crystallized around the new "Museum of Sex" in New York City, outlined in advance of the museum's opening in N. R. Kleinfield's "Sex Sells, but Can It Sell a Museum?" (*The New York Times*, B4, May 30, 2002).
8 See for example the collection *Museum Culture: Histories, Discourses, Spectacles* and the introductory essay by editors Daniel J. Sherman and Irit Rogoff (1994).
9 See *Professional Training of Museum Personnel in the World* (Paris: ICOM, 1972), quoted in Woodhead and Stansfield (1994: 14).
10 The term "museology" is defined as the "theory, history, and role of museums" by Flora Kaplan in her reflections on the dual nature of museum studies: "At the frontiers of graduate education, programs such as ours at New York University and elsewhere in the

country, aim to raise consciousness among future professionals and to advocate a more reflexive view of the past – a view now being adopted in many museums" ("Growing Pains"; 1992: 51). This dualism seems to encourage a hybrid curriculum which combines museography and museology – perhaps a distinction with a lingering but eroding degree of difference.

11 Henrietta Riegel (1996) argues that this attempt at an ironic form of "public" ethnography (initially entitled "Into the Heart of Darkness") failed to problematize and subvert traditional "Western" exhibit strategies. Instead this exhibition seemed to repeat the very "political" stance it sought to critique, as we might say that Marlow does in Conrad's novel.

12 Noting that Conrad "takes an ironic position with respect to representational truth," Clifford finds that the "listener" (or frame narrator) in *Heart of Darkness* has a "certain ironic authority." But Clifford also suggests that this listener/narrator might be capable of "speaking without contradiction about relative truths, or deciding their undecidability" (p. 100) and therefore threatens to dilute his own reading of the scope of Conrad's irony.

13 Brooks finds that *Heart of Darkness* "displays an acute self-consciousness about the organizing features of traditional narrative, working with them still, but suspiciously, with constant reference to the inadequacy of the inherited orders of meaning." Brooks also observes that the text "engages the very motive of narrative" with its "complexly motivated attempt to recover the story of another within one's own, and to retell both in a context that further complicates relations of actors, teller, and listeners" (p. 238). The recovery and subsequent encapsulation of "the story of another" is clearly a major element in museum practice, and in the reception/critique of that practice.

14 See Ute Meta Bauer, "The Space of Documenta 11"; my thanks to Steven Holmes of Real Art Ways (Hartford, CT) for pointing out the relevance of events like *Documenta 11* to the study of re/active and pro/active museum work.

References

Alexander, Edward P. (1987) "Early American Museums: From Collection of Curiosities to Popular Education." *International Journal of Museum Management and Curatorship* 6: 337–51.

Ames, Michael M. (1992) *Cannibal Tours and Glass Boxes: The Anthropology of Museums.* Vancouver: University of British Columbia Press.

Bakhtin, Mikhail M. (1981) *The Dialogic Imagination.* Ed. Michael Holquist. Trans. Caryl Emerson and Michael Holquist. Austin: University of Texas Press.

Bann, Stephen (1984) *The Clothing of Clio: A Study of the Representation of History in Nineteenth-Century Britain and France.* Cambridge: Cambridge University Press.

Barrett, Michèle, Philip Corrigan, Annette Kuhn and Janet Wolff (1979) "Representation and Cultural Production." In *Ideology and Cultural Production.* Ed. Michèle Barrett et al. London: Croom Helm, 9–24.

Bauer, Ute Meta (2002) "The Space of Documenta 11." Trans. Steven Lindberg. In *Documenta 11, Platform 5: Exhibition/Catalogue.* Ed. Okwui Enwezor, Documenta und Museum Fridericianum Veranstaltungs-GmbH et al. Ostfildern-Ruit: Hatje Cantz, 103–7.

Brooks, Peter (1984) *Reading for the Plot: Design and Intention in Narrative.* New York: Knopf.

Burke, Kenneth (1945) *A Grammar of Motives.* Berkeley: University of California Press.

Clifford, James (1988) *The Predicament of Culture: Twentieth-Century Ethnography, Literature, and Art.* Cambridge, MA: Harvard University Press.

Conrad, Joseph (1969) *Heart of Darkness.* In *The Portable Conrad.* Revised edn. by Morton D. Zabel. New York: Viking Penguin, 490–603.

Emerson, Caryl and Michael Holquist (1981) Glossary for M. Bakhtin, *The Dialogic Imagination* (1981), 423–34.

Genette, Gérard (1980) *Narrative Discourse: An Essay in Method*. Trans. Jane E. Lewin. Ithaca, NY: Cornell University Press.

Hamacher, Werner (1996) "Expositions of the Mother: A Quick Stroll Through Various Museums." In *The End(s) of the Museum*. Thomas Keenan et al. Barcelona: Fundació Antoni Tàpies, 81–134.

Hanhardt, John G. (1996) Preface. In *The End(s) of the Museum*. Thomas Keenan et al. Barcelona: Fundació Antoni Tàpies, 13–15.

Harbison, Robert (2000) *Eccentric Spaces*. Cambridge, MA: MIT Press.

Harris, Neil (1995) "Exhibiting Controversy." *Museum News* 74 (Sept.–Oct.): 36–9, 57–8.

Hudson, Kenneth (1977) *Museums for the 1980s: A Survey of World Trends*. Paris and London: UNESCO and Macmillan Press.

International Council of Museums [ICOM]. "Development of the Museum Definition According to ICOM Statutes (1946–2001)." Available at *http://icom.museum/hist_def_eng.html*

Kaplan, Flora S. (1992) "Growing Pains." *Museum News* 71(1): 49–51.

Karp, Ivan and Steven D. Lavine (1991) "Introduction: Museums and Multiculturalism." In *Exhibiting Cultures: The Poetics and Politics of Museum Display*. Ed. Ivan Karp and Steven D. Lavine. Washington: Smithsonian Institution Press, 1–9.

Karp, Ivan, Christine Mullen Kreamer, and Steven D. Lavine (1992) *Museums and Communities: The Politics of Public Culture*. Washington: Smithsonian Institution Press.

Key, Archie F. (1973) *Beyond Four Walls: The Origins and Development of Canadian Museums*. Toronto: McClelland and Stewart.

Kleinfield, N. R. (2002) "Sex Sells, but Can It Sell a Museum?" *The New York Times*, May 30, B4.

Lavine, Steven D. (1991) "Museum Practices." In Karp and Lavine, *Exhibiting Cultures*, 151–8.

Lewis, Geoffrey (1992) "Museums and Their Precursors: A Brief World Survey." In *Manual of Curatorship: A Guide to Museum Practice*. Oxford: Butterworth-Heinemann, 5–21.

Linenthal, Edward T. (1995) *Preserving Memory: The Struggle to Create America's Holocaust Museum*. New York: Viking Penguin.

Mitchell, W. J. T. (1994) *Picture Theory: Essays on Verbal and Visual Representation*. Chicago: University of Chicago Press.

Nelson, Cary, Paula A. Treichler, and Lawrence Grossberg (1992) "Cultural Studies: An Introduction." In *Cultural Studies*. Ed. Lawrence Grossberg, Cary Nelson, and Paula A. Treichler. New York: Routledge, 1–16.

Oxford English Dictionary (1989) 2nd edn. 20 vols. Oxford: Clarendon Press.

Pinna, Giovanni (2001) "Introduction to Historic House Museums." *Museum International* 53: 4–9.

Rice, Danielle (1995) "Museum Education Embracing Uncertainty." *Art Bulletin* 77 (March): 15–20.

Riegel, Henrietta (1996) "Into the Heart of Irony: Ethnographic Exhibitions and the Politics of Difference." In *Theorizing Museums: Representing Identity and Diversity in a Changing World*. Ed. Sharon Macdonald and Gordon Fyfe. Oxford: Blackwell Publishers/The Sociological Review, 83–104.

Ruffins, Faith Davis (1985) "The Exhibition as Form: An Elegant Metaphor." *Museum News* 64 (Oct.): 54–9.

Sherman, Daniel J. and Irit Rogoff, eds. (1994) *Museum Culture: Histories, Discourses, Spectacles*. Minneapolis: University of Minnesota Press.

Tchen, John Kuo Wei (1992) "Creating a Dialogic Museum: The Chinatown History Museum Experiment." In Karp et al., *Museums and Communities*, 285–326.

Vergo, Peter, ed. (1989) *The New Museology*. London: Reaktion Books.

Wagner, Roy (1981) *The Invention of Culture*. Chicago: University of Chicago Press.

Wittlin, Alma S. (1949) *The Museum, Its History and Its Tasks in Education*. London: Routledge & Kegan Paul Ltd.

——(1970) *Museums: In Search of a Usable Future*. Cambridge, MA: MIT Press.

Woodhead, Peter and Geoffrey Stansfield (1994) *Keyguide to Information Sources in Museum Studies*. 2nd edn. London: Mansell.

Part I
Museology: A Collection of Contexts

Introduction

The texts in this section address the history of the museum idea and the formation of museums, and offer an introduction to contemporary museological and museographical issue-oriented discourse. Germain Bazin's "Foreword" to *The Museum Age* (1967) presents a perspective on the "metaphysics" of the museum. Bazin goes beyond the explicit subject of museum formation and evolution to study the nature of humanity's need for museums and to observe signs of the museum's impending demise. From the point of view of a museum curator and Professor of Museology, the museum – as he has come to know it – is an endangered species. Bazin notes that the concept of the museum is closely aligned with the evolving concept of passing as opposed to cyclical or waiting time, with a desire to escape into the past, and with a desire to preserve the endangered present. His observations also prove relevant to later critical and more politically pointed work on the preservation movement; for example, he notes that it is only "when men sense the waning of a civilization" that "they suddenly become interested in its history," and that "Man consoles himself for what he is by what he was."

In "The Museum: Its Classical Etymology and Renaissance Genealogy" (1989) Paula Findlen presents a detailed survey of the museum as "an epistemological structure which encompassed a variety of ideas, images and institutions that were central to late Renaissance culture." These ideas concern collection, organization, and classification motivated by the need to achieve encyclopedic knowledge. Moreover, Findlen demonstrates that "the use of the term *musaeum* was not confined only to the tangible; museum was foremost a mental category and a collecting and cognitive activity that could be appropriated for social and cultural ends." An analysis of the active interplay among objects, ideas, and socio-political goals, as enacted within the museum, will reappear in many of the texts in subsequent parts of this collection.

Carol Duncan and Alan Wallach approach the museum as a "social institution" whose primary function is ideological. In "The Universal Survey Museum" (1980) they chart the often subtle "architectural rhetoric" which "organizes the visitor's experience"; by following the scripted spatial itinerary, they explain, the visitor will "internalize the values and beliefs of the state." Duncan and Wallach offer the

cartography of the Louvre as a case in point, noting how this museum both "glorifies France" and "transcends France" as it "celebrates universal genius." The Louvre's "final claim," however, is that the "universal is embodied in the state." Their map of the Louvre's architectural teleology articulates the potential connection between any nation and its museums, and they leave us at the National Gallery in Washington, D.C. which, at the time of writing, was "the last great universal survey museum."

"What kind of object, then, is a museum?" asks Donald Preziosi in his conclusion to "Brain of the Earth's Body: Museums and the Framing of Modernity" (1996). Preziosi creates a basis for the reader's response by examining the museum as a theater – a staging ground for particular versions of history and marks of identity – and by explaining how Europe "fashioned its own modernity as in one sense it had always proceeded: by linking its identity and distinction to the opposite of what it imagined its Others to be (for a millennium, the world of Islam, and more recently also those of Africa, Asia, and the Americas)." In presenting a series of subject and object positions for the museum visitor (and reader of his essay), Preziosi challenges us to recognize our positions, assumptions, and ever-changing status in relation to the museum as a "framing institution," a role it retains when "modernity" has been succeeded by the postmodern. Preziosi plays with the possibilities of the mirror-image and seems to challenge us to locate ourselves on the expansive museum stage, or in the confines of the gallery, or even in one of the glass cases. Having read his text, when we enter the actual museum we might wonder whether we are the seer or the seen.

In a survey of directions and trends since the Second World War, Kenneth Hudson finds that "The Museum Refuses to Stand Still" (1998). He considers some of the social and economic contexts for modifications of the professional definition of the museum and other terminologies, perceptions of institutional responsibility, preparation for museum careers, and attitudes toward and programs created for visitors – who have come to be perceived as active participants rather than "passive observers." Hudson ends with the proposal that the influence of the "Western model" has declined and may continue to erode, and that in search of new directions we might look to South America and Africa.

This re-location of focus is achieved in "The Mirror and the Tomb: Africa, Museums, and Memory" (2001). Françoise Lionnet offers another encounter with the figure of the mirror as she animates the art/artifact distinction, questions the strategies of identification, classification, and estrangement employed in the museum, and examines the "anthropological gaze" from the point of view of the tourist and the "native." Lionnet employs the concept of narrative levels, borrowed from literary interpretation, to discuss the proximity – or, equally important, the distance – be-tween events and their narration. In this case the events involve not only the activities and cultures for which objects stand but also the experience of a visitor who is both a "native" of the culture on display and a stranger to the museum as an institution. Using Michel Tournier's novel *La Goutte d'or* (*The Golden Droplet*) as a way into "the problematic relationship of the 'native' spectator to the traditional anthropological museum exhibit" she finds that "the museum becomes an unusual point of intersec-tion of two axes: the axis of recovery of what is perceived as past (for the tourists looking *at* this past) and the axis of loss of that so-called past" for the Berber shepherd who enters the museum, sees his own culture on display, and "discovers self-consciousness and alienation in its purest form." Through Lionnet's alternations between art and life, the power of the museum to frame, to hypostasize, and to distort is brought into focus.

In "Seeing Through Solidity: A Feminist Perspective on Museums" (1996) Gaby Porter demonstrates how theory can be used to read existing exhibition as well as broader institutional practices, and how the critical positions and methodologies of deconstruction and feminist theory might help to generate more enlightened museographical practice. She is also self-reflexive in examining the implications of her own analytical practice, or the effects of her theoretical apparatus. In Porter's narrative we feel the tension in those moments when museology meets museography, when scholarly critical analysis – informed by the vested interests of a feminist agenda – engages with the practical development of a museum exhibition. Porter suggests that the academy and the museum professions should be in dialogue; she also shows how difficult that may be to sustain. Porter makes a structural analogy between the dynamics of the text/author/reader relationship and those of the exhibition/curator/visitor as she interrogates the poetics of the museum, or how museums make meanings. Using actual but temporary exhibitions, she offers evidence that "museums can become the sites for active and creative production, the presentation and exchange of diverse viewpoints, and the dynamic (re)interpretation of collections and histories."

In "Museums of 'Human Suffering' and the Struggle for Human Rights" Terence M. Duffy introduces a pragmatic, consequence-oriented analysis of the power of the museum to effect change. Initially published in the January–March 2001 theme issue of *Museum International* entitled "Dossier: Museums of Social History," Duffy's brief world survey of "national tragedies" as preserved in museum collections makes the claim that "human rights museums" may signal, or at least create hope for, "a human rights culture – the very antithesis of human suffering." Within nine months of its publication we have suffered further lessons in the urgency of that claim.

This section closes with a poem by Alice Friman which gives voice to the physical and psychological experience of being "At The Holocaust Museum" (2001). The poem may seem to doubt, though it precedes, Duffy's argument for positive museum effects. Yet, it ends with a question and thus opens the door to multiple possibilities – as many as there are readers.

Chapter 1 | Germain Bazin
From *The Museum Age* | Foreword

To write a history of the museum is to give account of the evolution of two concepts: that of the Museum and that of Time. Regarding the nature of Time, our age has accumulated all kinds of studies: metaphysical, psychological, sociological, and ethnological and scientific; excepting the two last mentioned, which treat another aspect of the problem, all arrive at more or less the same conclusion, at the presence in the human consciousness of two notions of time: that of a time which passes and that of a time which endures. Archaic civilizations, with their denial of history, know only the second, which ethnologists have termed "absolute time" and in which primitive peoples, who by recourse to ritual and myth seek to abolish temporality, believe. Individual human existence becomes, then, so intimately integrated with that of the group that it is seen as part of a natural, universal continuum. One can rediscover this notion of absolute time within oneself by trying to recapture one's childhood where the role of games is comparable to the role of myth among primitives.

The burden of time increased when humanity became conscious of individual destiny – of secular destiny – holding itself responsible for its own actions, when the individual, disengaged from the group, thought of himself as cause and no longer just as effect.

The historical sense was engendered by a sequence of great political events which shook that masterpiece of the human conscience – the Greek city, of which Athens, at a given moment, had been the most accomplished example. If the Medic Wars confirmed the city's existence, the Peloponnesian Wars compromised it and the Philippic Wars ruined it. Chaeronea ended the life of a State established by the mutual consent of its citizens and replaced it with a monarchic State founded on personal power acquired by trickery and violence. Alexander's conquests brought to the concept of temporality the dimension of space, requisite for its evolution.

Cyclic time, by definition always returning upon itself, was a profound conception of the Greeks; it was valid, however, only within the confines of the city-state, where even conflicts – of a fraternal nature – could not project the citizen beyond the perception of the tutelary group into the perspectives of history.

Germain Bazin, "Foreword" from *The Museum Age*, translated from the French by Jane van Nuis Cahill, pp. 5–9. New York: Universe Books, 1967. © 1967 by Desoer S.A. Editions, Brussels.

Deprived suddenly of the history of their city, estranged from the familial life on a grand scale that it had meant, men felt like atoms lost in vast empires, no longer citizens but subjects. When the present becomes unbearable, there are two means of escaping it: the past and the future. Plato chose the second, assigning happiness a place in his utopia, and thereby gave to an immediate problem of the State an ideal Solution. During the Hellenistic period, one sought refuge in intemporal spheres which simultaneously abolished both novelty and the anguish it caused; religions of salvation prospered in this world thirsting for hope, as did the utopias of Plotinus who conceived of two beings in man: one in time, the other beyond time. But humanity equally indulged in the *"espérance à rebours"*[1] which is nostalgia. Established as an absolute, the past also becomes a refuge. Only when men sense the waning of a civilization do they suddenly become interested in its history and, probing, become aware of the force and uniqueness of the ideas it has fostered. Hegel said that the owl of Wisdom appears only at twilight. Hellenism, become conscious of its historical reality, turned to introspection and self-analysis; archives were consulted, documents compiled, writings collected in colossal libraries that were the bitter rivals, like Alexandria toward Pergamum, of each other. Museums coveted the artistic products of this classicism, judged inimitable, and even its earliest expressions generated interest. Man consoles himself for what he is by what he was.

Rome inherited from Greece museums and libraries; the historian and Hellenist, Polybius, viewed the achievements of the Greek civilization as a prelude to the historical climax wrought by Rome – the rationalization of Empire. If, as our contemporary historical philosophers Spengler, Toynbee and Mumford claim, the tendency toward the universality and hypertrophy of cities announces the decline of a civilization, Rome, at the moment when her empire reached the farthest, nurtured that instinctive feeling of recoil before the future which throws man back on his past. Museums and libraries sprang up all over Rome until the City of Cities was filled with them. The libraries have perished with their treasures but our museums are stocked with art recovered from the ruins of Rome's museums.

Perhaps we have been too insistent upon a rectilinear conception of time, inherited from the Hebraic religion, which makes each man responsible for realizing his destiny within the brief course of a lifetime. Adoring one God who is an historical personage, does not the Church live entirely in expectation of the Parousia to occur in a transcendent moment which will abolish at once both time and history? But Christianity has buried an historical past and the one it proposes as an antecedent, the span between Genesis and the Gospels, strays somewhat from the main artery of time. This past is set forth in the Holy Books which, because they are such, impart to this evolution a mythical character. Elsewere, too, is Christianity weighed down by the Hebraic notion that history is an act of God which man assumes the responsibility to work out.

Medieval men lived in the shelter and moral comfort of a cyclic time – for the agricultural population, the cycle of the seasons and for the ecclesiastical world, the cycle of the liturgical year. Museums had no part in their lives, except those which held vestiges of the only past to which they ascribed, that is, the treasuries with their relics of saints.

The Renaissance cut through ten centuries to exhume the past denied by Christianity. Involution was necessary to any evolution. Following a new route of responsibility to oneself rather than to God, Renaissance man turned to antiquity for confirmation of the destiny he proposed for himself. The Past again became a refuge, this time not

from a discredited present but from a recent past one sought to break with. Museums, sanctuaries of forgotten classicism, experienced a rebirth. The intense curiosity to know tormented the human conscience to advance its once limited horizon to the ends of the earth. Study of the antique led to the study of nature. From the Mannerist period on, museums developed in two directions: science museums with collections that included authentic discoveries as well as more or less fabulous "curiosities" believed to contain the secret of nature; and art and history museums, more limited in their scope, with no other objective than to affirm this longed-for identity with the classical world despite the immense difference in time.

There were few changes of principle in the history of this prosperous institution, the museum, until the French Revolution, with the exception of the slow metamorphosis during the course of the eighteenth century of princely or royal collections into public museums, open to all for the advancement of knowledge and the artistic education of the people.

The nineteenth century was the Century of History. Museums were flooded to the point of overflowing with products created by all kinds of human endeavor, by all peoples of all periods. Thus was initiated a great idolatry of the past, a counterbalance to a certain complaisance toward the present, a present that passed like a moment in the accelerated race toward the future, the perspectives of which were nightmarish.

The appetite for museums, still unabated in the twentieth century, is a complex phenomenon to analyze. A temple where Time seems suspended, the museum procures for today's man those momentary cultural epiphanies in which, since Gide, he has delighted. An entire literature for half a century has celebrated the supreme detachment from all appurtenances which makes of the instant a transcendent moment, lived in the innocence of a sensuality restored to its place as a virtue anterior to Original Sin. To detach from Time one of these contiguous fibers that is an instant, to make it vibrate like the string of a violin, is to give the being the illusion of knowing intuitively his essence and his strengths. The contemplation of the masterpieces of art or nature, listening to musical or theatrical works and reading great literature can induce in our contemporaries, educated by the Immoralist, this trance which can develop into a neurosis, as in the spectacle of the "happening." Since Taine, who considered the work of art a product of its time, the philosophies of art, which in the twentieth century have defined it as having its own existence, favor this tendency which in the museological situation manifests itself as the taste for ascetic presentation. All modern art is, moreover, founded on the supreme value placed on shock, the discharge of which assumes the value of a revelation.

This is a means through which the museum offers escape from time and even from absolute time. But very often today's visitors to museums seek a way to elude the relative time of the present. If the nineteenth century was the century of history, the twentieth devoted itself to prehistory. The enormous success of the latter after the Second World War is one of the most unexpected phenomena of contemporary psychology. This attraction of the prehistoric man, is it not indicative of a certain weariness with historical time and a profound aspiration for resurgence?

This taste for prehistory, for the period before recorded time, does it not derive from confused desire for a reunion with absolute time, the time of the myths? On the part of modern men, little by little cast out from all private groups – religious, familial, national, social – which served as frameworks for human life for millennia, to see themselves massed together like atoms, this call to the farthest reaches of space – does it not indicate at the same time a need to escape from the vertigo caused by the

acceleration of time, some secret nostalgia for the past when man lived protected from history by the communal bonds of private groups? The evolution of the historical sense itself reveals a similar orientation. Does the prodigious success of popularized historical novels toll the knell for the real history of battles and heroes in order to affirm the contemporary interest in and concentration on the *uomo qualunque* through the centuries, whose "happy life" we seek to evoke in our antique-filled interiors? Museums, barometers of current taste, have yielded to this desire by installing "Period" rooms, which have enjoyed such success in the United States. But the museum has penetrated into private life. Nothing is better proof of the need to flee the present, to seek refuge in the warmth of an ancestral *ambiance* than this denial of modern furniture and the concomitant vogue for "period" interiors – quick money for antique dealers and copyists. Thus in his appeal for precedents, modern man seeks to regain his humanity even as it tries to escape him.

Each year, when the sun bathes the beaches, humanity, as if bewitched, flees the city with its gradually more and more intolerable framework of life and races to vacation places, to temporary paradises. Lacunae in the inevitable procession of days when time seems suspended, vacations, which tend to become "real life," are united from one year to the next in the memory and constitute in the time which passes an oasis of everlasting time which man – uprooted, deprived of myth and religion, cut off little by little from all his traditions – neither can nor will renounce. In these temporal oases, museums number among the enchanted places; they are besieged by crowds of vacationers and thus the paradox arises that the museums of a country are often visited more by foreigners than by its own citizens (who cultivate their artistic tastes in other countries during their annual vacations).

However, while masterpieces of art and nature have become the object of a growing fervor, they appear to be more and more endangered. Two worlds are at odds today, the one slowly devouring the other; technology threatens to engulf art and nature, both allied in defense against a common peril. Oddly, poverty preserves and wealth destroys; peace, more than war, is a consumer of "cultural goods." A commission established in Italy to study the means of preserving the cultural patrimony of the country has disclosed that it is in the process of rapid destruction; in 1962, two hundred university professors sent an urgent letter to the Minister of Public Instruction, entreating him to act with haste. Half of Italy's 5,000 miles of shoreline had become such an eye-sore that even the tourists were fleeing; in three years 100,000 trees were cut down along the highways; from 1957 to 1964 about fifty museums and seventy churches sustained robberies and some 900 pieces had disappeared from museums, galleries and private collections; in 1963 alone 3,000 antique tombs were destroyed by clandestine excavators. Until a few years ago, the Church was the bulwark of beauty and tradition; now, devitalized by recent innovations in the liturgy and by the vertigo of "progressism," a once inviolable patrimony is collapsing. All over Europe priests are liquidating the artistic treasures of their churches; in Italy, where this negotiation is particularly fruitful, the police recently discovered store-houses where monasteries had been accumulating works of art – building up stock for an eventual auction house. In France, one can foresee the disaffection of 18,000 churches. It is not always the hope of profit which motivates the ecclesiastics but an iconoclastic spirit which recalls that of the Huguenots; in a village in the Landes district in France, a curate, in a move to "modernize" his church, dismantled a baroque retable and, leaving to nature the task of destroying a once sacred object, interred it in a field.

The progress of erosion, accelerated in an industrial society, is threatening the most prestigious monuments and sites of the past. The Ravenna mosaics and the buildings on the Acropolis are shaken by the roar of airplanes; the needle-thin heels on women's shoes have damaged the parquetry in the Grande Galerie of the Louvre and the marble pavements of the Parthenon; the cave paintings of Lascaux and of Tarquinia are suffering effacement at the hands of their admirers; in Italy, acres of frescoes are about to break away from their walls; the cities of unbaked brick in the Middle East piously exhumed by archeologists, are disintegrating; Mohenjo-Daro is menaced by the inundations of the Indus; the *pietra serena* of Tuscan edifices is dissociating; sand dunes are building up and in time will re-bury Leptis Magna and Sabrata; the enchanting Renaissance gardens of the Château de Villandry are in danger of dying because a neighboring factory has deflected their source of water; Venice is sinking into the sea, the waves churned up by motor boats having weakened the pilings on which she rests – besides the fact that the water level in the lagoon has changed considerably; fine old cities – even those which are protected – are encumbered with dismal apartment buildings whose tenants are quick to flee them for houses in the country or resorts; 400 French cities have been designated as sites for preservation but thus far only twenty-one have instituted protective measures; Rome's pine trees are being asphyxiated by the fumes from automobiles. Can one imagine Rome without her pines? Rome, the city of seven hills, become the city of seven bald promontories, occupied only by the white bones of its ruins? If the men to whom the preservation of art works has been entrusted are worried, those who guard the riches of nature are at wit's end; they foresee a rapid sterilization of flora and fauna, the very same flora and fauna sought so eagerly by men on their vacations or even on brief weekends.

The danger is graver than is yet realized, especially by the political mind; in 1962 the German architectural magazine *Bauwelt* criticized a foreign government "for failing to express a feeling of tragedy at the destruction of one of the most beautiful countries in the world." The international solidarity behind the movement to save, through Herculean efforts, the temple of Abu Simbel from the waters backed up by the Aswan Dam is heartening. But which Head of State interpreted the proclamation as a call to safeguard the beauty of his own country? There was one. But was it the leader of one of the nations which boasts of being a "cradle of art"? It was President Johnson.

If he does not take heed, man will one day live in a world demolished by six billion insects, with the only remaining "culture" confined to a few geographical reserves and a scattering of museums where the imprisoned remains of the world's beauty will slowly perish.

Note

1 The only original seen by Pausanias which would have been rediscovered *in situ* would be the Hermes of Praxiteles at Olympia but the present tendency of experts is to see it as a copy of great quality.

Chapter 2 | Paula Findlen

The Museum | Its Classical Etymology and Renaissance Genealogy

It is never a waste of time to study the history of a word.
Lucien Febvre

'*Museum*,' wrote the Jesuit Claude Clemens, 'most accurately is the place where the Muses dwell.'[1] To investigate the museums of the late Renaissance, we must first begin with the word itself. *Musaeum*. How did it function in contemporary usage and to what sort of structures – intellectual, institutional and otherwise – did it allude? On a general level, this study explores the ways in which *musaeum* structured significant aspects of sixteenth- and seventeenth-century culture. As a concept which expressed a pattern of activity transcending the strict confines of museum itself, the idea of *musaeum* was an apt metaphor for the encyclopaedic tendencies of the period. Most compelling about the usage of the term *musaeum* was its ability to be inserted into a wide range of discursive practices. Linguistically, *musaeum* was a bridge between social and intellectual life, moving effortlessly between these two realms, and in fact pointing to the fluidity and instability of categories such as 'social' and 'intellectual', and 'public' and 'private', as they were defined during the late Renaissance. From a philological standpoint, its peculiar expansiveness allowed it to cross and confuse the intellectual and philosophical categories of *bibliotheca, thesaurus*, and *pandechion* with visual constructs such as *cornucopia* and *gazophylacium*, and spatial constructs such as *studio, casino, cabinet/gabinetto, galleria* and *theatro*, creating a rich and complex terminology that described significant aspects of the intellectual and cultural life of early modern Europe while alluding to its social configuration.[2] Mediating between private and public space, between the monastic notion of study as a contemplative activity, the humanistic notion of collecting as a textual strategy and the social demands of prestige and display fulfilled by a collection, *musaeum* was an epistemological structure which encompassed a variety of ideas, images and institutions that were central to late Renaissance culture.

Paula Findlen, "The Museum: Its Classical Etymology and Renaissance Genealogy" from *Journal of the History of Collections* 1:1 (1989), pp. 59–78. © 1989 by Oxford University Press. Reproduced by permission of the author and Oxford University Press.

My purpose here is to consider the social and cultural definitions of *musaeum* and the vocabulary of collecting. In organizing my discussion initially around the language of collecting and then around the conceptual spheres within which such terms circulated, I base my work on the premise that a detailed socio-linguistic analysis of certain key words – in this instance those encompassing the experience of collecting – provides insight into the cultural processes of past societies.

The word *musaeum*, however, is merely a starting point: a means of entering a wide range of philosophical discussions of knowing, perceiving and classifying that emerged in the humanistic and encyclopaedic traditions which collectors embraced and ultimately transformed during the sixteenth and seventeenth centuries. Through this approach, a manifest taxonomy of terms emerges. Although scores of words described collecting, collections and museum-like activities, no *one* term was as comprehensive as *musaeum* itself. While the rich and variegated vocabulary of collecting emerged from a multitude of social practices and intellectual traditions, the use of these terms was regulated by their relationship to *musaeum* – the most expansive model for the activity of collecting. The idea of *musaeum* provided the syntax in which the grammar of collecting could be played out; to borrow Baudrillard's phrase, it was structured as 'an immense combinatorial matrix of types and models' that expanded, as needed, to incorporate the new and diverse paradigms of collecting which arose.[3]

Examining a word as rich and complex as museum – a word very much in transition during this period – we learn much about the society that transformed its definition and the territorial implications of its usage. For the museum was certainly an attempt to make sense of the collector's environment; hence its structure was inherently dependent on contemporary discursive practices. As Robert Harbison argues, the museum was – and still is – an 'eccentric space', a setting peculiarly susceptible to the cultural strategies of its creators.[4] As a repository of past activities, created in the mirror of the present, the museum was above all a dialectical structure which served as a meeting point in which the historical claims of the present were invoked in memory of the past.

Our current use of the term 'museum' places it entirely within the public and institutional domain. Yet the original usage emphasized its private and exclusionary functions. The transition of the museum from private to public, from an exclusive to an inclusive construct, in a period in which the relationship between 'private' and 'public' activity was significantly redefined,[5] suggests that the museum did not evolve in isolation, but was deeply and profoundly formulated by the pattern of sixteenth- and seventeenth-century society.

The Humanists Rediscover the Muses

'At last my little Museum merits such a name,' wrote Giacomo Scafili to Athanasius Kircher upon receipt of his book, 'now rich and complete with the *Musurgia*, the great work and gift of you, Father; even if there were nothing else in it save for this lone book, it could rightfully be called the room of the Muses [*stanza delle Muse*] because the book contains them all.'[6]

The etymology of museum is itself a fascinating subject for study. While the practice of collecting emerged primarily in the sixteenth and seventeenth centuries, we need to understand its background to appreciate the role of medieval and early Renaissance learning in setting the stage for the widespread appearance of museums in the early

modern period. Rejecting the classification of the collection at the Roman College as a *galleria*, a term referring primarily to its physical organization and to collections 'made solely for their magnificence', the Jesuit Filippo Bonanni, who restored Athanasius Kircher's museum to its original splendour at the end of the seventeenth century, explained:

> Nor is the collection in question here of this kind, because it is improperly named *Galleria*. One should more properly say *Museo*, a term originating from the Greek according to Pliny, which means the same as *Dominiculum Musis dicatum pro diversorio eruditorum*, which Strabo refers to in his last book, *apud Alexandriam fuisse Museum celebratissimum*. Spartan discusses it in his life of Adrian, saying: *Apud Alexandriam in Musio multas questiones Professoribus proposuit* . . . or, as *musaeum* alludes, one says a place dedicated to the Muses . . .[7]

Originally *musaeum* had two definitions. It was most traditionally the place consecrated to the Muses (*locus musis sacer*), a mythological setting inhabited by the nine goddesses of poetry, music, and the liberal arts.[8] 'They are called *Muses*,' wrote the Chevalier de Jaucourt, 'from a Greek word which signifies "to explain the mysteries", μύειν, because they have taught men very curious and important things which are from there brought to the attention of the vulgar.' And, as the *Encyclopédie* article continued, 'The name of Muses, goddesses and protectresses of the Fine Arts, was uncontestably the source of museum.'[9] More specifically, *musaeum* referred to the famous library at Alexandria, the μουσεῖον described by Strabo, which served as a research centre and congregating point for the scholars of the classical world.[10] Even in its original usage, *musaeum* was transformed into an institutional setting in which the cultural resources of a community were ordered and assembled, implying that the classical writers too had recognized the expansiveness of museum as a category of experience.

The fact that the classical conception of museum did not confine itself either spatially or temporally was important for its later usage. As Pliny and Varro remind us, nature was the primary haunt of the Muses, and therefore a 'museum' in the most literal sense. Pliny's conflation of grotto and museum in his *Natural History* further emphasized the image of museum as a potentially pastoral setting, a contemplative place found in nature.[11] Given the passion for constructing grottoes in the gardens of Renaissance Europe, it is obvious that nature's potential to be perceived as a museum expanded in the intricate interplay between art and nature that unfolded in the famous gardens – Boboli, Bomarzo and Pratolino to cite only a few – of the sixteenth and seventeenth centuries.[12]

In a seminal study of late Renaissance and Baroque culture entitled *L'Anti-Rinascimento*, Eugenio Battisti characterized the garden as a 'conceptual system.'[13] The same might well be said of the museum as it evolved during this period; in its crystallization as a category which incorporated and ultimately unified a variety of – from our own perspective – seemingly disparate activities, the museum was indeed a central organizing principle for cultural activity by the late sixteenth century. It was a conceptual system through which collectors interpreted and explored the world they inhabited. 'Those places in which one venerated the Muses were called Museums,' explained Teodoro Bondini in his preface to the 1677 catalogue of Ferdinando Cospi's museum in Bologna. 'Likewise I know you will have understood that, although a great portion of the Ancients approved of the name Muse only for the

guardianship of Song and Poetry, none the less many others wished to incorporate all knowledge under such a name.'[14] Thus the museum, as the nexus of all disciplines, became an attempt to preserve, if not fully to reconstitute, the encyclopaedic programme of the classical and medieval world, translated into the humanist projects of the sixteenth century, and later the pansophic vision of universal wisdom that was a leitmotif of seventeenth- and early eighteenth-century culture.

If *musaeum* was indeed a place consecrated to the Muses, then the Renaissance itself can be described as a 'museum'; more than any other period, the cultural and intellectual programmes of the period from the fourteenth to the seventeenth century manifested an overwhelming concern with the very disciplines patronized by the Muses. Tellingly, *musaeum* was a term little used during the Middle Ages; at best it was related to the idea of *studium*, for it does not seem to have had any independent meaning of its own, save for scattered references to its classical roots, until the late sixteenth century. As Liliane Châtelet-Lange points out in her study of sculpture collections, as late as the sixteenth century *musée* did not appear in any French dictionary.[15] In reviving the liberal arts, the humanists self-consciously placed themselves in the grove of the Muses, creating 'museums' as they did so, to stress their direct ties with ancient wisdom. 'Almost all other rich men support servants of pleasure,' wrote Marsilio Ficino to Lorenzo de' Medici regarding his patronage of humanists, 'but you support priests of the Muses.'[16] References to the Muses are abundant in the texts of the fourteenth and fifteenth centuries. 'The woodland pleases the Muses,' observed Petrarch, 'the city is hostile to the poets.'[17] The attitude that decreed it necessary to separate oneself from public life in order fully to engage in intellectual activity – a monastic ideal translated into the language of humanism – persisted well into the sixteenth century. As Augustine queried of Petrarch in their imagined dialogue in Petrarch's *Secretum*:

> Do you remember with what delight you used to wander in the depth of the country? ... Never idle, in your mind you would ponder over some high meditation, with only the Muses as your companions – you were never less alone than when in their company...[18]

For Petrarch and his contemporaries, the image of the Muses, and concomitantly of *musaeum*, was directly tied to their personal and collective attempts to enter the world of antiquity, regardless of temporal and physical constraints.

More than the claims of erudition or the revival of classical texts through philology, humanism was structured around the objects that served as a basis for most intellectual and cultural activities. Whether it was the Roman ruins that occupied Ciriaco d'Ancona and Francesco Colonna,[19] which gradually emerged as more than just a clutter of objects to define 'antiquity' from the late fourteenth century onwards, or the jumble of natural objects that served as the basis for a new reading of nature in the works of Renaissance natural philosophers such as Aldrovandi, Cesalpino, Gesner, and Mattioli, the philosophical programmes that constituted Renaissance humanism could not have existed without the proliferation of artefacts that provided food for thought. Humanism was primarily an archaeological enterprise in the sense that it reified scholarship by translating vague antiquarian and philosophical concerns into specific projects, whose existence was predicated upon the possession of objects. From this perspective, the proliferation of museums in the sixteenth and seventeenth centuries can be seen as a logical outcome of the desire to gather materials for a

text. The pursuit and revival of classical language, literature, and philosophy that have most commonly been identified as the core of the humanists' programmes could not have arisen without the recognition that the piles of information, scattered throughout the world, might be shown to mean something were they to be brought into the study and compared: collecting was about the confrontation of ideas and objects, as old cosmologies met new ways of perceiving, that fuelled the learned and curious discourses of early modern Europe.

More importantly, the museum fulfilled the new sense of history as sketched by the humanists. 'Antiquity' could only serve as a reference point to 'modernity' once the two had been defined as being inherently more 'advanced' (and therefore compatible) than the intermediary period that Petrarch would call the Middle Ages. Thus the direct link between contemporary museums and the ancient *musaeum* stressed the classical images of erudition and learning to reinforce the image of the Renaissance as a newly constituted version of the etymologically ordained home of the Muses.

Reviewing the classical literature on *musaeum*, it is evident that the idea of collecting was simultaneously an open and a closed concept. While gardens and groves were museums without walls, unlocatable in time or even place, the conflation of study with *musaeum* spatially confined it. The comparative and taxonomic functions of humanist collecting needed a defined space in which to operate, in part to identify the producers of and the audience for the museum, that is, the intellectual elite of the Renaissance who identified themselves as patrons of learning; thus *musaeum* was a locating principle, circumscribing the space in which learned activities could occur.

The growth of humanist circles in the courts, churches, academies and publishing houses of fifteenth- and sixteenth-century Europe signalled the beginnings of a more social and contemporaneous setting for the Muses. Praising the writing of Lorenzo de' Medici inspired by the 'vernacular Muses', the philosopher Giovanni Pico della Mirandola clearly delineated the difference between professional and amateur notions of scholarship within a humanistic framework. 'To them [Dante and Petrarch] the Muses were their ordinary and principle employment,' remarked Pico, 'to you, an amusement and a relaxation from cares.'[20] Developing the Ciceronian theme of intellectual activity as the complement of and ideal preparation for the *vita activa*, Pico lauded Lorenzo's ability to combine *studium* with *otium*.

By the sixteenth century, museums as studies proliferated throughout Europe, claiming direct inheritance from their classical antecedents. Perhaps the most explicit example of the Muse-Museum analogy occurred in the decoration of Paolo Giovio's museum near Como. Built on the supposed ruins of Pliny's fabled villa at Borgo Vico between 1538 and 1543, Giovio's *museo* fulfilled its classical paradigm to the letter and became the prototype for many other museums which followed. Visiting the villa shortly after its completion in 1543, Anton Francesco Doni wrote to Agostino Landi of its wonderous contents. He particularly praised 'a most miraculous Room depicting all of the muses one by one with their instruments . . . [which] . . . one calls properly the Museum.'[21] Equally we can point to Leonello d'Este's *studio* at Ferrara, decorated with images of the Muses, or Federigo da Montefeltro's *Tempietto delle Muse*, strategically located below his famous *studiolo* at Urbino.[22] In all of these instances, form revealed function; for the images reinforced the contemplative and literally 'museal' purpose of the rooms.

The culmination of this phase of humanism, emphasizing the dialectical relationship between active and contemplative purposes of study, is best illustrated by a famous and often-cited passage from Machiavelli. In a letter of 1513 to the

Florentine ambassador to Rome, Francesco Vettori, Machiavelli elegantly suggested the ways in which his personal relationship with the study of antiquity shaped his intellectual and political life. Describing his daily activities in exile, Machiavelli underscored the facility with which he translated his *persona* from one context to another:

> In the morning, I get up with the sun and go out into a grove that I am having cut; there I remain a couple of hours to look over the work of the past day and kill some time with the woodsmen, who always have on hand some dispute either among themselves or among their neighbours...When I leave the grove, I go to a spring, and from there into my aviary. I have a book in my pocket, either Dante or Petrarch or one of the minor poets, as Tibullus, Ovid and the like. I read about their tender passions and their loves, remember mine, and take pleasure for a while in thinking about them. Then I go along the road to the inn, talk with those who pass by, ask the news of their villages, learn various things, and note the varied tastes and different fancies of men...In the evening, I return to my house and go into my study [*scrittoio*]. At the door I take off the clothes I have worn all day, mud spotted and dirty, and put on regal and courtly garments. Thus appropriately clothed, I enter into the ancient courts of ancient men, where, being lovingly received, I feed on the food which is mine alone and which I was born for; I am not ashamed to speak with them and to ask the reasons for their actions, and they courteously answer me. For four hours I feel no boredom and forget every worry; I do not fear poverty, and death does not terrify me. I give myself completely over to the ancients.[23]

What is particularly interesting to note here is the way in which Machiavelli utilized both the pastoral and monastic ideals of *musaeum*, interspersing his moments of intellectual reprieve with more sociable practices, to develop one of the most politically aware statements of the early sixteenth century, *The Prince* (1514).

Yet at the same time it is obvious that he considered his study an inner sanctum – '*cubiculum secretius, ubi quis studio vel scripturae vacat*', as Du Cange described it.[24] More closely, Machiavelli's *scrittoio* resembled the *cubiculum* in which Poggio Bracciolini conducted his studies of antiquity in the early fifteenth century.[25] Like Tasso's Malpiglio, Machiavelli entered his *studio* to flee the multitude (*fuggir la moltitudine*).[26] We are still far from the institutional ideal of cultural activity as connoted by the current use of museum. None the less it is important to note the specific grounding of intellectual (or rather museum-like) activities in the context of the *studio*. 'I wish to bring together all of my books, writings and materials for study [*cose da studio*],' wrote the prelate and papal nuncio Ludovico Beccadelli in 1555 to his cousin, who was planning a *studio* for Beccadelli's secretary, Antonio Giganti, upon his return to Bologna. Later in the century, the humanist Giganti described his collection as 'my *studio*, more than *studio* one calls it a collection of various foreign and natural trinkets.'[27] For the sixteenth- and seventeenth-century humanists and collectors, more than their predecessors, it was the explicit identification between *musaeum* and *studio*, and a number of other terms discussed below, that shaped the social and ultimately the public function of the museum.

Encyclopaedic Strategies

At first instance, the Renaissance notion of museum defined imaginary space. Born of the humanist desire to codify the intellectual experience of the self-proclaimed scholar,

it was a methodological premise that translated itself into a wide variety of social and cultural forms.

One of the most important intellectual traditions with which the practice of collecting aligned itself was that of encyclopaedism. While the medieval encyclopaedic tradition emphasized knowledge as a continuum, an unbroken plane of information, the sixteenth- and seventeenth-century encyclopaedic tradition delighted in discontinuities.[28] Nowhere was this more evident than in the structure of the museum. Using the term *musaeum* as a starting point, we can trace the foliation of this structure, as word after word from the encyclopaedic corpus – theatre, treasure, mirror, forest, and microcosm to list only a few – became identified with the language of collecting. My purpose here is to relate the presence of museums to the explosion of encyclopaedic traditions, both old and new, that supported and shaped the activity of collecting through the explicit identification of *musaeum* with encyclopaedic paradigms.

On a more abstract level, the process of widening the horizons of *musaeum* operated in a fashion similar to the premise of the Renaissance encyclopaedia. *Musaeum* became the axis through which all other structures of collecting, categorizing, and knowing intersected; interweaving words, images, and things, it provided a space common to all.[29]

The use of the term *musaeum* was not confined only to the tangible; museum was foremost a mental category and collecting a cognitive activity that could be appropriated for social and cultural ends. As an ironic comment on the construction of collections in the late seventeenth century, Sir Thomas Browne created a guidebook to an imaginary museum entitled the *Museum Clausum, or Bibliotheca Abscondita* ('The Enclosed Museum or Secret Library'). 'I am Bold to present you with a list of a collection, which I may justly say you have not seen before.'[30] Dismissing the encyclopaedic projects of Aldrovandi, Gesner, Kircher, and other subscribers to the Aristotelian and Plinian paradigms, Browne invoked the mental structure of collecting to attack its premise, creating a museum so complete and so closed that no one had ever penetrated it. Filling in the gaps in his hypothetical museum of knowledge with improbable marginalia – a cross made out of a frog's bone, the works of Confucius in Spanish and the like – he criticized the epistemological framework of the museum which gave a macrocosmic gloss to every object it encountered. 'I have heard some with deep sighs lament the lost lines of Cicero; others with as many groans deplore the combustion of the library of Alexandria: for my own part, I think there be too many in the world, and could with patience behold the urn and ashes of the Vatican.'[31]

In asking ourselves to what extent the language of collecting penetrated other activities, we need first to consider the fact that the descriptive models of collecting co-opted the linguistic paradigms of encyclopaedism. Certainly the expansion of categories such as *teatro* and *cornucopia*, words relevant in a much more general context which initially held little or no meaning for collecting, suggests that the collectors of the sixteenth and seventeenth centuries drew on a broad humanistic heritage in developing more precise and differentiated ways to articulate the experience of *musaeum*. A museum was not the only 'theatre of nature'; Kircher described Sicily in exactly the same words due to the natural diversity and fecundity that he observed in his visit to the island during the eruption of Vesuvius in 1660.[32] From the same perspective, the microscope was 'both receptacle and Theatre of the most miraculous Works of Nature' because the lens created a panoramic effect, reinforcing the relativity between museum as theatre and the *theatrum mundi*.[33]

The language of collecting during this period also supported the conflation of museum and theatre. Francesco Calzolari's natural history collection was a museum because it was gathered 'dum uno in theatro, aut Musaeo.' Or as Giovanni Porro wrote of the museum in the botanical garden at Padua, 'And in this little Theatre, almost a little world, one will orchestrate the spectacle of all of nature's wonders.'[34] Similarly the ideal of a *studio* was a closed space: a room without windows that achieved completeness through closure.[35]

Musaeum was a classificatory structure for a wide variety of texts, whose sorting and organizing processes fulfilled the taxonomic principle of collection. Numerous books – ranging from collections of poetry such as Lorenzo Legati's *Musei Poetriarum* (1668) to Mabillon and Germain's famous guidebook, the *Museum Italicum* (1687–89) – utilized the image of museum to denote the process of compiling and collating.[36]

Similarly the logic of collecting supported the use of parallel structures to describe the mental process of collecting. In 1549 Ulisse Aldrovandi (1522–1605) was called to Rome on suspicion of heresy. Quickly cleared of the charges, Aldrovandi spent the rest of the year exploring the ancient ruins of the city. The resulting book, *Delle statue romane antiche* (1556), was one of the first guidebooks to antiquarian collections in Rome. Reflecting on the process of writing the treatise, Aldrovandi emphasized the ways in which the creation of the book itself had taken the shape of a 'museum' (*scrivere et raccogliere, come in un Theatro*).[37] Written and collected in the 'theatre' or rather museum of the mind, Aldrovandi's words gave expression to the breadth of the encyclopaedic spirit that guided the collecting projects of the sixteenth and seventeenth centuries.[38]

Emphasizing the diversity, variety, and above all the copiousness of the *Museum Hermeticum* (1678), the anonymous editor assured his readers that they were about to enter a museum of alchemy that reduced the literature on this subject to a manageable entity.[39] Similarly the emerging scientific journals often included words such as 'repository', 'collection', and 'museum' in their titles to underline the reductive nature of the enterprise, for the pages formed intellectual walls in the same way that the perfect shape of the theatre closed and completed a concept. If a dictionary, a collection of words, could be called a *galleria di parole*, as the first Crusca vocabulary was, then it was evident that almost any book which functioned in a similar manner would also fall under the rubric of 'museum'.[40]

The language used to describe museum catalogues best illustrates the flexible relationship between text and context. If nature, for example, was the text from which the Renaissance naturalists chose their materials, then their museums were literally the 'con-texts'; likewise the textuality of the artefacts was borne out by the catalogues which described and represented them. The apothecary Ferrante Imperato was described by contemporaries as the 'author of so rich and celebrated a Museum' – an authorship attested not only by the publication of his *Historia naturale* (1599), but more concretely by the existence of his theatre of nature. Aldrovandi described his fellow collector Calzolari's catalogue as 'his printed Museum', again to distinguish it from the equally tangible one that he visited in Verona in 1571; similarly Kircher's assistant Gaspar Schott asked for the *Galleria descritta* while writing his book on universal magic. The Milanese cleric Manfredo Settala, on the other hand, distinguished between his 'vernacular Museum' and his Latin museum as texts for two different types of audiences.[41] The catalogue as 'a reduced Museum' or 'little Museum' functioned as the museum's own microcosm.[42] The encyclopaedic process

was one that needed to unfold from beginning to end; like Russian dolls or Chinese boxes, there was always the anticipation of an even smaller, overlapping version of the preceding object.

Beyond museum catalogues, most collectors understood their writings to belong to the larger vision of the encyclopaedic enterprise. Remarking on the richness of Hernandez's descriptions of Mexican flora and fauna, which had recently come into the possession of the Accademia dei Lincei, Marc Welser commented that the manuscript 'merits the name of treasure [*thesoro*] and not of book'. The founder of the same academy, Federico Cesi, described his own research as a 'Theatre of Nature', a term most frequently used for the natural history collections of the period.[43]

Aldrovandi designated his own publication schemes as 'the history of my Museum'. At times his manuscripts were referred to more simply as the *musaeum* itself, and they were certainly remarked upon by visitors as being one of the richest aspects of his legacy.[44] The text, as *storia*, furnished what the collection could not, completing it in the process. 'Besides what I have lately observed in my Museum, I have also written a history entitled the *Thesaurus rerum naturalium*...here one will find all of the things...that are not in our Museum.' Urging his brother Francesco to underwrite the publication of Aldrovandi's texts as early as 1576, Ferdinando de' Medici praised the manuscripts as 'almost a part of that *studio*'.[45] The museum was located neither in the text nor in the context; rather it was the interplay between the two that shaped its function and completed its purpose.

Museums were textual structures both in a literal and figurative sense. Created from the materials available to the Renaissance collector, they served as reference points for the reading that the humanist educational programme required of the educated élite. In understanding why a collector acquired or coveted a particular object, one needed to participate in the textual strategy of encyclopaedism. 'Moreover how much light would we glean from interpreting the passages of writers, principally Pliny, if we had in sight those things which he told only with words,' lamented Federico Borromeo in his *Musaeum* (1625).[46] The existence of the museum testified to the memory of the texts which shaped it, creating copies of 'originals' that had long since disappeared.

In a classical and medieval sense, most compendia were museums because, like Pliny's *Natural History* or the medieval encyclopaedias, they compiled and stored knowledge in a comprehensive fashion. As Pliny outlined in the preface to his monumental work:

> [It] is not books but store-houses [*thesauros*] that are needed; consequently by perusing about 2000 volumes, very few of which, owing to the abstruseness of their contents [*secretium materiae*] are ever handled by students, we have collected in 36 volumes 20,000 noteworthy facts obtained from one hundred authors that we have explored, with a great number of other facts in addition that were either ignored by our predecessors or have been discovered by subsequent experience.[47]

Such a literal and quantitative schematization was also evident in the acquisitive nature of Renaissance collecting. Surely Aldrovandi's and Gesner's dreams of an alphabetically organized, perfect universe fulfilled (or at least attempted to fulfill) Pliny's encyclopaedic paradigm. Like Pliny, Aldrovandi was obsessed with the size of his collection; not a week passed without his re-counting the total number of 'facts' he had accumulated. 'If I wanted to describe the variety of fish observed, depicted and dried by me, that can be seen by everyone in our microcosm, truly it would be

necessary to consume many pages simply to name them . . .'[48] The collector's activity was one that absorbed him completely; when Jacopino Bronzino described Aldrovandi as 'consumed in the history of natural things'[49] he aptly summarized the encyclopaedic passion for working within one's material, allowing it to absorb the scholar in the process.

'[I am] hoping to see something beautiful in your care,' wrote Aldrovandi to Alfonso Pancio, physician to the d'Este family in Ferrara, 'not ever being sated by the learning of new things. Not a week passes – I will not say a day – in which I am not sent something special. Nor is it to be wondered at, because this science of nature is as infinite as our knowledge.'[50] Drawing upon Pliny's list of Greek titles in the manner of Giovio, Aldrovandi named his largest project, under which all others were to be subsumed, the *Pandechion Epistemonicon*, which he defined as 'a universal forest of knowledge, by means of which one will find whatever the poets, theologians, law-makers, philosophers and historians . . . have written on any natural or artificial thing one wished to know about or compose.'[51] Throughout the half-century in which Aldrovandi was active as a collector he constantly strove to fill the space he had created. Words, images, and texts were all incorporated into the universal encyclo-paedia of knowledge that he visualized.

The omnipresence of Aldrovandi's pandechion evidenced itself in his flexible use of the term. Like other encyclopaedic terms, it was a semantic structure organized to include 'not only the notion of abundance itself but also the place where abundance is to be found, or, more strictly, the place and its contents.'[52] On the most general level, Aldrovandi described his collection of objects as a '*cimilarchio* and *pandechio* of the things generated in this inferior world'. Thus the encyclopaedia was tangible, defined by the experiential data which constituted one part of his collection. Although he rarely used this term to refer to any but his own collection, the Tuscan Grand Duke's collection also merited such a name, because it was 'full of an infinite number of experimental secrets'.[53] Not surprisingly, the principle of plenitude was operative in his decision to designate it as an encyclopaedic structure. In similar fashion, the first cataloguer of Francesco Calzolari's natural history museum in sixteenth-century Verona called it, among other things, a cornucopia.[54] If nature was the 'cornucopian text' which held the interest of the naturalist, then the museum itself was the recep-tacle of *copia*.

Discussing with Matthias Lobel some of his rare dessicated plants, 'which I conserve pasted in fifteen volumes in my Pandechion of nature for the utility of posterity', Aldrovandi reiterated the textual nature of the artefacts, which became 'books' organized according to his taxonomy of nature. 'For a full supply of facts [*copia rerum*] begets a full supply of words', counselled Cicero.[55]

Most importantly, there was the *Pandechion* proper: eighty-three volumes contain-ing scraps of paper which Aldrovandi and his assistants had meticulously cut and alphabetically organized until 1589.[56] Almost unintelligible to the modern reader, this compendium functioned as a lexicon on almost any known subject. Responding to Lorenzo Giacomini's questions on wine-making in a letter of 1587, Aldrovandi quoted Pliny but could not remember the exact citation. 'But where he [Pliny] teaches it, for now I can't recall, though I have seen it and glossed it from head to foot. And if you were able to run through my *Epistemonicon*, you would have found it and infinite other observations . . .'[57] For Aldrovandi the encyclopaedia was located neither in the text nor in the object alone; rather it was the dialectic between *res* and *verba* that fully defined the universality of his project.

The Jesuits Put Their World in Order

While Aldrovandi's encyclopaedic schemes confined themselves to the territory that the Aristotelian corpus had previously defined, his commentary serving as a gloss on predefined categories, the speculations of seventeenth-century natural philosophers moved beyond this realm. In contrast to sixteenth-century encyclopaedism, which attempted to fill the paradigms prescribed by the classical canons, the logic of seventeenth-century collecting precluded such an unmitigated acceptance of earlier categories, particularly because the frustrated attempts of predecessors such as Aldrovandi and Gesner to flesh out ancient collecting projects indicated that new methods needed to be found and new questions needed to be asked.

The influx of artefacts from the New World and other parts of the globe now reached by Europeans paved the way for new models of knowledge, as collectors found traditional explanations to be increasingly unsatisfactory for the information that they could now incorporate in their museums.[58] Simultaneously, events such as the Reformation and the ensuing religious and political battles waged across Europe from the early sixteenth century until the Peace of Westphalia in 1648, destabilized the social, political, and religious order that had seemed unshakable only a century before (although its roots had certainly eroded long before 1517 in anticipation of these changes). Thus the seventeenth-century natural philosopher, the creator of the new encyclopaedia, was in search of a new model to explain a perplexing, increasingly illogical and pluralistic world.

'How truly enormous is the field of knowledge', exclaimed Federico Cesi, founder of the Accademia dei Lincei at the beginning of the century, 'large in the copiousness of speculations as in the copiousness of readings.'[59] While the activities of Cesi and his academicians aligned themselves firmly with the camp of Galileo and the 'new' science of the period, a response that effectively eliminated the significance of the encyclopaedic project by refashioning it into a heuristic category,[60] the speculations of Jesuits such as Athanasius Kircher (1602–80) and Gaspar Schott took a more eclectic turn. As R. J. W. Evans describes in his study of Habsburg intellectual life, the philosophical trajectories of Catholic Reformation culture lent an exoticism to intellectual discourse that was not evident in scholarship of the previous century.[61] The Jesuit response to the relativity of their world was to expand outward, in ever-increasing concentric circles, incorporating both old and new within a traditional yet flexible framework, as attested by their missionary activities in Europe, the New World and Asia. The quest for *pansophia* reached its apex in the eclectic attempts by the Jesuits (and later, in a different context, Leibniz and Wolff) to develop universal structures that synthesized humanist philosophies and non-Western cultures with the more programmatic and dogmatic policies of the post-Tridentine church.

The encyclopaedic impulse was not confined to the Catholic world alone, although it was undoubtedly more pervasive in an atmosphere in which the retention of ancient models of knowledge was linked to the persistence of orthodoxy and tradition. For the purpose of limiting my study, due to the richness of material on Italian collecting and the readily apparent links between the persistence of encyclopaedic models and the role of collecting in the seventeenth-century courts and ecclesiastic circles, I have chosen to focus on Catholic collecting rather than looking at both Protestant and Catholic activities together. While I do not believe that collecting and religious affiliation were inevitably intertwined, in many instances – particularly in the case of

Kircher in Rome and his contemporary and fellow cleric Manfredo Settala in Milan – religious conviction *did* play a part in the shape and function of seventeenth-century museums.

Spending most of his life in Rome, clearing-house for the Jesuit missionary activities, Kircher was able to draw on the resources of an entire order to state his thirst for knowledge of non-Western civilizations; books, artefacts, and reports from all corners of the globe flowed into his museum at the Roman College weekly. From these Kircher derived his theories on universal language and the universality of many other aspects of the natural and supernatural world, all part of the Christianizing mission of the post-Tridentine church.[62]

One of his most interesting (and, in the minds of modern Egyptologists, most infamous) projects concerned the decipherment of hieroglyphs. Happening upon a book on the obelisks of Rome, probably the one written by Michele Mercati (keeper of the Vatican mineralogical collection and sculpture garden) in 1589, Kircher recognized the value of the mysterious emblems for his studies of language and religion. 'Immediately my curiosity was aroused and I began to speculate on the meaning of these hieroglyphs', he wrote in his autobiography. 'At first I took them for mere decoration, designs contrived by the imagination of the engraver, but then, on reading the text of the book I learned that these were the actual figures carved on ancient Egyptian monuments. From time immemorial these obelisks and their inscriptions have been in Rome and so far no one has been able to decipher them.'[63]

Like so many other things studied by the Jesuit, the hieroglyphs were signs, richly encoded, that promised to unlock the mysteries of past civilizations and, most importantly from his theological perspective, would prove to be a means of demonstrating the inherent compatibility of Christianity with ancient pagan wisdom. A symbol, Kircher posited, 'leads our mind through a kind of similitude to an understanding of something very different from the things which offer themselves to our external senses; whose property is to be hidden under a veil of obscurity.'[64] Thus Kircher's studies of Egyptian symbols, like his investigations of Chinese philosophy, ciphers and musical theories of universal harmony, and his attempts to draw forth a theory of universal magnetism or *panspermia* from the natural world, were shaped to fit a hermetic and metaphoric image of the world which assumed that every object was coded with a larger, more universal significance. Applied to the passion for collecting, hermeticism postulated that the museum would be a visually coded presentation of occult knowledge. The world itself was a tangled web of meanings; it remained only for the collector to penetrate its layers through the comparative, taxonomic, and ultimately encyclopaedic nature of his project.

The social configuration of such grandiose projects could only have been the libraries and museums created to organize and assimilate the explosion of knowledge experienced by the sixteenth and seventeenth centuries. What was a *bibliotheca* but a collection of books, a 'multitudo librorum' as Comenius defined it?[65] Libraries formed an essential part of collections; rarely did a museum not have a library attached to it.[66] Carlo Antonio del Pozzo's library in Rome was described as a 'true hotel of the Muses', reinforcing the idea that the library was indeed a museum; likewise the Medici library in Florence was described by Diderot as so copious that 'only the [term] *musaeum Florentinum* can justly represent this magnificent cabinet.'[67]

While the emergence of public libraries during the seventeenth and eighteenth centuries signalled the creation of a public sphere of reading, as Roger Chartier has argued,[68] truly the most magnificent examples of book collecting remained the

private libraries of papal Rome, and in general those within the monastic orders throughout Europe, as evidenced by the Biblioteca Angelica in Rome and the Bibliothèque de Sainte Geneviève in Paris.[69] The papal *nipote* Francesco Barberini, favourite of Urban VIII and an active member of Cesi's Lincean Academy, amassed a collection that was still the wonder of Rome a century later. 'There are other wonderful libraries in Rome,' observed Diderot after surveying the Vatican holdings, 'particularly that of Cardinal Francesco Barberini, which is reputed to contain 25,000 printed volumes and 5000 manuscripts.'[70] Barberini's collection of books, as well as art and natural objects, was so well known that scholars vied with each other to give him their books. Over the course of several years the Paduan Aristotelian Fortunio Liceti presented Barberini with his most recent publications, hoping that the Cardinal would honour him by making place for them in his 'most noble Museum'.[71] As Liceti recognized, Barberini's collection was truly a *musaeum*, his own small offering about to be subsumed within its universal and universalizing structure.

Not surprisingly, collectors who prided themselves on their ability to organize knowledge also turned their attention to the classification of books. Aldrovandi, for example, dissected the subject organization of libraries with the same passion that he catalogued nature and every other part of the human experience. Like the Swiss naturalist Conrad Gesner, Aldrovandi perceived his encyclopaedia of nature to be dependent on his more general encyclopaedia of knowledge itself. Thus bibliographies were hoarded as if the names of the books themselves symbolically conveyed the possession of their contents.[72]

Strategies for collecting were not only designed to fulfil the humanistic desire for *prisca scientia*: museums and libraries of this period also conveyed political and religious messages. Claude Clemens, librarian to Philip III of Spain, described the Escorial as 'this Museum of Christendom'; attuned to the rhetoric of the Catholic Reformation he proposed a library that collected and ordered knowledge in order to control it. Not only were libraries necessary for their public utility for a growing community of scholars; they also protected the Catholic world from false erudition.[73] In an age in which even the Jesuits had been refused their privilege to use prohibited books that had not been corrected by the official censors (though one wonders how Kircher was able to transgress this rule), there was a great fear of information falling into the wrong hands. A number of times during his career, Aldrovandi had to submit his library for Inquisitorial inspection, and found many of his books – those by Cardano, Della Porta and Pomponazzi for example – confiscated as a result.[74]

The encyclopaedic vision of knowledge, born of the humanist desire to recapture the knowledge of the ancient world, was used for a variety of purposes by the seventeenth century. The museum had become not only an instrument of erudition, but a means for proselytizing. While Kircher's brand of intellectual pyrotechnics was undoubtedly too eclectic (and potentially philosophically dangerous) for the mainstream Catholic Church, none the less his work was allowed to coexist alongside more orthodox philosophy in an atmosphere fraught with the tension of the Galileo condemnations.[75] While we cannot pretend to do anything more than speculate on the reasons for such laxity, it is possible that the Church, already overly dependent on the Jesuit educational programme, recognized the social value of a highly public figure such as Kircher, even if they were suspicious of the intellectual premise of his research. Most importantly, Kircher's willingness to submit all of his findings to a strictly hierarchical notion of the universe, was in keeping with the Thomist basis of the Jesuit teachings.

From the universal strategies of the sixteenth-century natural philosophers such as Aldrovandi, Cardano, and Gesner to the Christian strategies of their seventeenth-century counterparts within the Catholic Church, the museum was designed as the most complete response to the crisis of knowledge provoked by the expansion of the natural world through the voyages of discovery and exploration, the concomitant explosion of information about the world in general and, more particularly, the moral and social imbalance created by the religious and political events of the sixteenth and seventeenth centuries. In an age of religious plurality, to 'know' was fraught with tensions; the humanist response of Aldrovandi and his contemporaries was to be open to any available strategy for framing the world, an openness that frequently brought them into trouble with the institutional church, as attested by Aldrovandi's, Cardano's and Della Porta's brushes with the Inquisition and the actual condemnations of Bruno and Campanella.[76] The seventeenth-century response diffused potentially 'black' magic through the purification rituals of the Jesuit scientific work in the case of Kircher and his disciples, subsuming natural philosophy to Christian theology, while still leaving the encyclopaedic framework intact. This was most apparent in the structure of museums which, until the end of the eighteenth century, continued to conjoin art and nature in fulfillment of Pliny's premise that everything in this theatre of the world was worthy of memory. From mental to textual to actual museums, the structure of *musaeum* was designed to intermingle harmoniously the natural and the artificial, the real and the imaginary, and the ordinary and the extraordinary, to underscore not only the fecundity of the universe but the breadth of the human faculties for comprehending and explaining the *theatrum mundi*.

Texts and Contexts: Defining Museal Space

Returning to an earlier theme – how did the museum make the transition from private to public? – we need to re-enter the social world of collecting to trace briefly the development of the 'public' museum. While Machiavelli, encamped in his *scrittoio*, conceived his intellectual pursuits to be a means of re-entering public life *in absentia* through the medium of literature, he did not conceive of scholarship *per se* as a socially-grounded enterprise. Despite the imprint of the Alexandrian museum as a paradigm of collective intellectual activity, manifested in the formation of humanist circles around the *musaei* of Pietro Bembo and Guillaume Budé for example, the idea of study outside of the university *studio* was predominantly an isolated and isolating process.[77] In contrast to the notion of the academy, one of the most important centres for extra-university intellectual and cultural activity from the sixteenth century onwards (whose emergence was distinct from the museum though later influential in its institutionalization), the museum was at first defined by the domestic, and therefore private, space which it inhabited.[78]

In his will of 5 March 1604 the apothecary Francesco Calzolari left 'the *studio di antichità* that is in my house in Verona' to his nephew.[79] Certain aspects of collecting reinforced the notion that a museum needed to be circumscribed by domestic activity. 'And he who delights in letters must not keep his books in the public study [*scrittoio comune*], but must have a *studiolo* apart, in the most remote corner of the house. It is best and healthy if it can be near the bedroom, so that one can more easily study.'[80] Surviving plans for late Renaissance museums support such an organization. The *studio* of Antonio Giganti in Bologna, secretary to Ludovico Beccadelli and to

Gabriele Paleotti and a friend of Aldrovandi, testifies to the conscious placement of a collection within the interior space of a house; its only entrance was the 'door that opens into the bedroom'.[81] The collector, called by the Muses, retired to his study in the same way that he retired to his bedroom. Similarly *cabinet*, as it evolved in seventeenth-century French, connoted the closet beyond the main bedchamber.[82] As Carlo Dionisotti points out, however, the distinctions between public and private need to be considered with care in order to understand their relevance for the early modern period; a bedroom, theoretically the most intimate of spaces, was not fully private, nor for that matter was a museum.[83]

Advice to construct museums, libraries and studies in proximity to the most 'personal' space in the home drew not only on contemporary experience with the arrangement of such rooms, but also on Alberti's classically inspired designs. Describing the layout of a country house in his *Ten Books on Architecture* (1415), Alberti specified that 'The Wife's Chamber should go into the Wardrobe; the Husband's into the Library.'[84] While Alberti sharply defined the *studio* as exclusively masculine space, an image borne out by the relative absence of women in the sphere of collecting, we can point to several noteworthy exceptions – the *Grotta* and *studiolo* of Isabella d'Este at Mantua being one of the most famous examples.[85] For the most part, however, collecting emerged out of a private and domestic culture that was almost exclusively male: a space reserved within the home for scholarly activity (analogous to the contemplative space of the private family chapel) whose purpose was not entirely divested of public life. A museum was created as much for self-promotion as out of genuine interest in the artefacts assembled in it: in this respect it was at once public and private, masculine space within the domicile, and therefore by nature public in the broadest sense of the term.[86]

The museum, as *orbus in domo*, mediated between public and private because it quite literally attempted to bring the world into the home. The endless flow of goods, information, and visitors that appeared on the doorsteps of the most well-known museums determined that the collections of the sixteenth and seventeenth centuries could no longer be the hidden worlds suggested by medieval and monastic images of *studium*.[87] 'If after the arrival of my scribe, Giovan Corneglio, I have not responded to your letter as quickly as you wished,' wrote Aldrovandi to the humanist Giovan Vincenzo Pinelli from his museum, 'Your Most Illustrious Signor will excuse me for having been continuously occupied in various negotiations, public as well as private.'[88] The antiquary Giovan Vincenzo della Porta, 'a man no less learned than unusual for the vast knowledge which he possesses', was singled out for 'having through his own efforts created a most noble Museum to which scholars come from the furthest corners of Europe, drawn by its fame.'[89] As we know from the inventories of his brother's home in 1615, the Della Porta collections were indeed private yet open spaces, publicized through the informal networks of correspondence that formed the basis of the scientific and intellectual communities of late Renaissance Europe. In asking ourselves how did the 'private' become 'public' we need to dissect the sociological process of collecting that identified collectors to each other as well as for a larger audience.[90]

The constellation of terms used to describe collecting by the late sixteenth century created a unified conceptual sphere that fully demonstrated the museum's roles in the public and private realms. By now 'study' connotes a room for private study with 'museum' as its public counterpart. Yet the polarization of these two categories has evolved only in the nineteenth and twentieth centuries, as the images of 'public' and

'private' have also become fixed opposites. Conversely, as discussed earlier, it was only in the fifteenth and sixteenth centuries that the social and philosophical purposes of museum and *studio* were conjoined; it remained for the seventeenth and eighteenth centuries to begin the process of extraction that ultimately set the two words apart. Aldrovandi's collection of natural rarities in Bologna was called simultaneously *museo, studio, theatro, microcosmo, archivio,* and a host of other related terms, all describing the different ends served by his collection and, more importantly, alluding to the analogies between each structure.[91] In the mid-seventeenth century, Ovidio Montalbani, superintendent of the Studio Aldrovandi, distinguished between the public Aldrovandi collection which he oversaw (*Museum*) and his personal, and therefore private, collection through the use of the diminutive (*privatum Museolum; Museolum meum*).[92]

As Claudio Franzoni suggests in his study of antiquarian collecting, one of the most important linguistic divisions within the vocabulary of collecting concerns the distinction between terms which defined a collection spatially and those which alluded to its philosophical configuration.[93] Words such as *stanza, casa, casino, guardaroba, studiolo, tribuna, galleria,* organized the domestic and civic terrain of the museum. 'One can truly call your *Casino* a house of nature, where so many miraculous experiments are done', wrote Aldrovandi to Francesco, alluding to the Grand Duke's domestication of nature in his alchemical laboratory at San Marco.[94] The famous collection of Flavio Chigi in seventeenth-century Rome was described as a 'room of curiosities'; again the collection was defined by the space which it inhabited as well as by the nature of its contents.[95] Through a similar process, the idea of *musaeum* became associated increasingly with the physical space of the *studio.* Many letters of the sixteenth and seventeenth centuries, most notably those of Aldrovandi and Cesi, are signed 'ex Musaeo nostro' or 'written from the Cesi museum'.[96]

Equally intriguing is the well-documented confusion over the naming of the famous *studiolo* of Francesco I (1569–87) in Florence. The humanist Vincenzo Borghini, who designed the literary *topoi* of the room, called it a *stanzino,* 'by which I mean that it serves as a wardrobe [*guardaroba*] of things rare and precious both for their value and for their craftsmanship'. As Lina Bolzoni and Scott Schaefer have pointed out, the room was most often identified as *stanzino* or *scrittoio* by contemporaries.[97] *Studiolo,* a microcosm of museum, described a cabinet, the *Kunstschrank* that populated the Renaissance courts of northern Europe. 'The Grand Duke has had an ebony *studiolo* made of his own design, which is composed according to all of the rules of Architecture', wrote Raffaelo Borghini.[98] Thus the *studiolo* was literally a piece of furniture, not unlike a *cassone* in its function, containing the treasures of its owner in miniature; accordingly it was located within a domestic context, albeit a courtly one, and therefore reinforced the private image of collecting.

The transformation of *studiolo* from a domestic concept to a more public one perfectly illustrates the ways in which the museums of the late Renaissance continued to incorporate both private and public notions of space in their conception and utilization. While the *studiolo* of Federico da Montefeltro at Urbino served largely personal functions and the *Grotta* of Isabelle d'Este, entered only through her *studio,*[99] was secreted within the palace at Mantua, the *studiolo* of Francesco I operated in both contexts. Situated in the Palazzo Vecchio in Florence, the seat of government, off the *Sala Grande* and leading into the private family chambers, it was a striking transition point: a room in which the Grand Duke could seclude himself without entirely leaving the realm of public affairs.[100] Yet, on the whole, Francesco's

study was more private than public; very few descriptions exist of it because few people – besides the court humanist Borghini who designed the original iconographic program of its *invenzioni*, Vasari, and the other artists who worked on the room – were ever allowed access to it. Surrounded by the political intrigues of the Tuscan court, the *studiolo* and its contents were for the Grand Duke's eyes alone.

The privatizing tendencies of *musaeum* in a court context created hermetic space. From a social perspective, the princely *studio* was hermetic because its function was exclusionary. Equally, museums were hermetic because they were primarily intellectual rather than social constructs, fabricated out of the eclectic humanistic schemes of the Renaissance *virtuosi*. '*Museum* is a place where the Scholar sits alone, apart from other men, addicted to his Studies, while reading books', wrote Comenius.[101] Scholarship was a process which absorbed its participants (*studiis deditus*) and the locus of study, the museum, created an impermeable physical barrier between the scholar and the outside world.[102] Even as late as the eighteenth century, an age in which the museum had truly become a public spectacle, illustrations of museums reinforced their image as secretive and engrossing environments.[103] Interestingly enough, the most important and elaborate of the *scrittoii* built by Vasari for Cosimo I between 1559 and 1562 was called, among other things, the *scrittoio segreto* and seems to have been the main precursor to his son Francesco's *studiolo*.[104] From this perspective, the scholar, as frequenter of the museum, was as much alchemist as humanist, enhancing his reputation by the hidden nature of his work.

The conflicting demands of the civic and hermetic notions of a museum, both different strands of the humanistic goals of collecting, allowed the museums of the sixteenth and seventeenth centuries to vacillate between openness and closure, depending on the individual goals of their creators. Explicitly contrasting his own civic designs for a chemical laboratory with Tycho Brahe's aristocratic laboratory and astronomical observatory at Uraniborg, the chemical philosopher Andreas Libavius placed the discourse on secrecy versus openness within its scientific context:

> Thus we are not going to devise for him [the ideal natural philosopher] just a *chymeion* or laboratory to use as a private study and hideaway in order that his practice will be more distinguished than anyone else's; but rather, what we shall provide for him is a dwelling suitable for decorous participation in society and living the life of a free man, together with all the appurtenances necessary for such an existence.[105]

Libavius's attack on the private *studio* indicated his participation in, and more importantly awareness of, the debate on secrecy versus openness that entered a wide range of discursive practices in the early modern period.[106] The laboratory, argued Libavius, was a civic and not an aristocratic construct; thus the museum had to answer to the humanistic and later Baconian notions of utility that placed knowledge within the public sphere through its service to society.

The advent of printing and the development of an expanding literate culture outside of the courts, universities and the church signalled the decline of the notion of intellectual privacy presupposed by the medieval and, to a lesser extent, Renaissance notion of collecting. By the seventeenth century the museum had become more of a *galleria* than a *studio*: a space through which one passed, in contrast to the static principle of the spatially closed *studio*. Describing the importance of Aldrovandi's collecting projects to Vincenzo Campeggi, one of the *gonfaloniere* of Bologna, Fra Giovanni Volura praised 'his Theatre of nature, visited continuously by all of the

scholars that pass through here...'[107] The civic notion of museum placed it in motion; forever opening its doors to visitors, the museum as *galleria* – a term standardized by the public character of the Galleria degli Uffizi and made linguistically normative through the Crusca dictionaries of the seventeenth and eighteenth centuries – was the antithesis of the hermetic and individually defined *studio*, ironically promoted by the same creators of the former category.

The *gallerie* of Kircher and Settala in seventeenth-century Rome and Milan perfectly exemplified this addition to the tropes of collecting, for the two museums were mentioned in most of the major travel journals of the day as 'must-sees' on the serious traveller's itinerary. '[N]o foreign visitor who has not seen the museum of the Roman College can claim that he has truly been in Rome', boasted Kircher.[108] The *galleria* was set in motion by the constantly changing selection of objects as well as visitors that continuously filled the space it created – public in conception, due to the expanded realm of sociability that the museum promised and to the open-ended nature of the contents that it revealed to the gaze.

Despite frequent avowals of the utilitarian ends of the museum, made particularly by scientific collectors, it is obvious that the emergence of a public strategy of collecting did not fully eclipse the private one. Unlike the Medici, Aldrovandi and Kircher depended on patronage for the survival of their projects, and this patronage most often came from rulers who themselves had a personal interest in collecting. While Aldrovandi proclaimed that his *studio* was 'for the utility of every scholar in all of Christendom', borne out by its accessibility during his lifetime and by the donation of the museum to the Senate of Bologna in 1603, he had nothing but praise for the more self-serving activities of his patron Francesco I.[109]

In defining a collection as 'public' versus 'private', what sort of criteria can we use that would be applicable to an early modern context? Certainly museums such as those of Aldrovandi, Kircher, and Settala were not public in the sense that they were open to people from all walks of life. The first museum to proclaim its fully public status was the Ashmolean Museum at Oxford, which opened its doors in 1683. Given to the university by Elias Ashmole, a dabbler in chemistry, magic, and natural philosophy, the accessibility of the collection was remarked upon with disfavour by certain educated visitors in the seventeenth and eighteenth centuries. 'On 23 August we wished to go to the Ashmolean Museum,' wrote the German traveller Zacharias Conrad von Uffenbach in 1710, 'but it was market day and all sorts of country-folk, men and women, were up there (for the *leges* that hang upon the door *parum honeste & liberaliter* allow everyone to go in). So as we could have seen nothing well for the crowd, we went down-stairs again and saved it for another day.'

Von Uffenbach's displeasure at the literal openness of the Ashmolean translated into pointed comments about the general definition of 'public' institutions in England. Not only did the open admission standards disintegrate the gender and class barriers that defined the private, hence exclusive, nature of the museum – 'even the women are allowed up here for a sixpence' – but the establishment of the price of admission commodified the experience of scholarship. His experience in the 'world-famed public library of this University', the Bodleian, only confirmed his worst fears about the dangers of the public in a scholarly setting:

> But as it costs about eight shillings and some trouble to gain an entrance, most strangers content themselves with a casual inspection. Every moment brings fresh spectators of this description and, surprisingly enough, amongst them peasants and women-folk, who gaze

at the library as a cow might gaze at a new gate with such noise and trampling of feet that others are much disturbed.[110]

The pinnacle of his trip to England, a visit to the famed Royal Society, provoked equal disillusion. Finding the Society and its museum to be in complete disarray, Von Uffenbach commented on the inevitability of its state.

> But that is the way with all public societies. For a short time they flourish, while the founder and original members are there to set the standard; then come all kinds of setbacks, partly from envy and lack of unanimity and partly because all kinds of people of no account become members; their final state is one of indifference and sloth.'[111]

The discomfort of Von Uffenbach and other visitors with the public agenda of Baconian science only reinforced the perception that the relationship between private and public that existed on the continent, as far as education was concerned, was more subtly gradated. 'In Italy one finds hardly any fully public museums', commented Michael Bernhard Valentini in his *Museum museorum* (1714).[112] Beyond Valentini's distinction between rulers and 'Privat-Personen', museums such as Aldrovandi's *studio* were 'public' because they were open to any scholar with an appropriate introduction or to anyone of exalted rank. '[Everything in my museum] is seen by many different gentlemen passing through this city, who visit my *Pandechio di natura*, like an eighth wonder of the world', boasted Aldrovandi. In many instances visitors arrived with a letter of introduction. 'This [man] is my dear friend,' explained Alfonso Cataneo, professor of medicine and natural philosophy at the University of Ferrara, to Aldrovandi, 'whom I have directed to Your Excellence upon his arrival in Bologna, since he is a doctor and a gentleman, worthy of seeing certain little things [*cosette*] that interest him. I know that you will not neglect to show him the usual courtesy for love of me.'[113]

The humanist notion of utility also distinguished the public yet inaccessible nature of court collections from the privately owned yet open museums of collectors such as Aldrovandi, whose university affiliation gave his collection a public use through its pedagogical utility, and Kircher, who also conducted experiments and demonstrations in the Roman College museum as part of his teaching duties. The Roman patrician Alfonso Donnino cited his 'desire for public good' as one of the reasons for the gift of his collection to the Roman College in 1651.[114] Equally Filippo Bonanni, Kircher's eventual successor as keeper of the Jesuit science museum, praised the British collector James Petiver for making his private museum public through the publication of his *Centuries*, inexpensive guidebooks to his ever-expanding natural history collection.[115]

Certainly Aldrovandi's desire for the establishment of a *Biblioteca pubblica* was prompted by a sense of civic obligation. 'And therefore, wishing that my many labours be continued after my death, for the honour and utility of the City, and so that they may not have been for nothing, I have elected to conserve this Museum and Library of printed books and my own works, leaving it to the most Illustrious Senate of Bologna...'[116] The Senate, responding in kind, transferred Aldrovandi's collection to their most public building to underline its part in the *res publica* of the city. In 1660, when the Bolognese senator Ferdinando Cospi requested that his own collection be added to the civic museum, the decree ratifying this addition described the location as the 'Studio Aldrovando in Pubblico Palatio Bononae'.[117]

The visitors' books that have survived intact provide unique and important documentation on Aldrovandi's museum as a public institution. Upon seeing the museum in 1604, shortly before Aldrovandi's death, Pompeo Viziano marvelled at the number of people who had visited the naturalist's *studio*:

> [I]n two large books, that he conserves among the others, an infinite number of Princes, Cardinals, Prelates, *Cavallieri*, and other people of note [*alto affare et di elevato ingegno*] that have passed through Bologna, attest in their own hand to having seen and diligently considered [the museum] with great satisfaction.[118]

To begin with, it was not common practice in this period to have a list of visitors; most collectors did not have such a well-defined sense of their audience, or more importantly, such a public image of their own posterity through their collections, as to record who had visited their museums. 'Cardinal Enrico Gaetano, legate to Bologna, saw the *mirabilia* of nature in the *studio* of doctor Ulisse Aldrovandi', read one entry for 1587.[119] Besides the book for exalted guests, commemorating their visits, there was also a book which recorded all of the visitors to the museum. Composed mainly of signatures, written on scraps of paper by Aldrovandi, his assistants and the visitors themselves, and later pasted into the sections which organized the names by location and profession, the sheer number of visitors testifies to the Bolognese naturalist's willingness to open up his Theatre of Nature to the world.[120] Aldrovandi, however, not only kept records throughout his lifetime, but specified that the names should continue to be recorded after his death. 'It would also please me', he specified in his gift of 1603, 'if the Gentlemen and Men of Letters who have visited and will visit the Museum after my death will continue to write their names in my two books designated for this purpose.'[121] The visitors' books, rendering a degree of eternity to the museum through the *memoria* of their lists, testified to the public nature of the scientific collecting enterprise, emerging out of the universities, academies, and professional organizations of the doctors and apothecaries in the sixteenth and seventeenth centuries.

While the idea of a fully public museum would not emerge in Italy until the early eighteenth century, with the establishment of the museum of the Istituto delle Scienze under Luigi Ferdinando Marsili's sponsorship, subsuming both Aldrovandi's and Cospi's collection in the process, and the formation of Scipione Maffei's 'public Museum of Inscriptions' in Verona,[122] the collections of the sixteenth and seventeenth centuries set the stage for this development. During the late Renaissance the parameters of *musaeum* expanded to include more public connotations. No longer simply hidden worlds, a growing number of collections foreshadowed the utilitarian and didactic tendencies of the late seventeenth- and eighteenth-century ideals of the museum. The most obvious change in this realm was the increased institutionalization of the museum, which became a pervasive social artefact in the courts, academies, and universities of early modern Europe. The success of the social grounding of *musaeum* was due in no small part to its coordination with the long and complex intellectual tradition of collecting outlined above. The museums of the late Renaissance mediated between public and private space, straddling the social world of collecting and the humanistic vocabulary which formed its philosophical base. In its ability to transcend cultural and temporal boundaries the museum stood apart from other institutions, synthesizing new cosmologies with old. The synthetic process that forged the Renaissance notion of *musaeum* reflected not only the syncretic abilities of sixteenth- and

seventeenth-century culture, emphasizing the flexibility of humanism as a *modus operandi*, but also its desire to collect and be collected. Drawing on Du Cange's false etymological comparison between museum and mosaic, Bonanni defined the newly reconstituted museum at the Roman College. 'Let us say with Du Cange that, since by the word *Opus Musiuum dicitur illud quod tessellatum est lapillis variorum colorum*, thus in the places designated to the meanderings of the erudite there may be various things, which not only delight the eyes with the Mosaic, but enrich the mind.'[123] The museum, as mosaic, brought together the pieces of a cosmology that had all but fallen apart in the course of several centuries. Organizing all known ideas and artefacts under the rubric of museum, the collectors of the period imagined that they had indeed come to terms with the crisis of knowledge that the fabrication of the museum was designed to solve.

Notes and references

1 C. Clemens, *Musei sive bibliothecae tam privatae quam publicae extructio, cura, usus* (Leiden, 1634), sig. *4ᵛ.

2 Regarding the appearance of these and numerous other terms considered analogous to *musaeum*, see L. Berti, *Il principe dello studiolo* (Florence, 1967), pp. 194–5, and L. Salerno, 'Arte e scienza nelle collezioni del Manierismo', in *Scritti di storia dell'arte in onore di Mario Salmi* (Rome, 1963), II, pp. 193–214. Other words that should be considered are *arca, cimelarchio, scrittoio, pinacotheca, metallotheca, Kunst- und Wunderkammer*, and *Kunstschrank*.

3 J. Baudrillard, *Selected Writings* (ed. Mark Poster) (Stanford, 1988), p. 15. Michel Foucault's comments on 'the vast syntax of the world' also suggest that *musaeum*, as a framework of activity, can be placed within a general framework, stressing resemblance and repetition, that was the main organizational tool of late Renaissance discourse; see his *The Order of Things* (English tr., New York, 1970), p. 18.

4 R. Harbison, *Eccentric Spaces* (New York, 1977). Harbison's notion of an eccentric space implies permeability and fluidity – it is a space specifically designed to hold marginalized information and to be easily reshaped by the particular strategies of its users while still retaining its normative function.

5 See P. Ariès and G. Duby (eds.), *Histoire de la vie privée* (Paris, 1985–7), esp. vols. III–IV; both R. Sennett's *The Fall of Public Man* (New York, 1977) and J. Habermas' *Strukturwandel der Öffentlichkeit* (1962) [French edn.: *L'espace publique*, tr. M. B. de Launay (Paris, 1978)] see the eighteenth century as a critical turning point in the expansion of the public sphere. Though little work has been done to elucidate directly the relations between public and private (as opposed to looking at simply one or the other), the inference that can be drawn by comparing the work on private life to that on the public sphere is that the two domains are intimately and necessarily intertwined, something I hope to demonstrate in my discussion of the entrance of museums into the public sphere in the period from the sixteenth to the eighteenth century.

6 Pontificia Università Gregoriana (hereafter PUG), *Kircher*, MS 568 (XIV), f. 143ʳ (Trapani, 15 June 1652).

7 Archivum Romanum Societatis Iesu (hereafter ARSI), *Rom.* 138. Historia (1704–29), XVI, f. 182ʳ (Filippo Bonanni, *Notizie circa la Galleria del Collegio Romano*, 10 January 1716).

8 *Thesaurus Linguae Latinae* (Leipzig, 1936–46), VIII, p. 1702; *Lexicon Totius Latinitatis* (Padua, 1871), III, p. 318.

9 Chevalier de Jaucourt, 'Musée', in *Encyclopédie* X (1765), pp. 893–94.

10 Ibid., *Thes. Ling. Lat.* VIII, p. 1702; C. Neickelius, *Museographia* (Leipzig, 1727), pp. 1–2; J. Alsop, *The Rare Arts Traditions* (New York, 1982), p. 163.

11 *Lex. tot. lat.* II, p. 318; C. T. Lewis and C. Short, *A Latin Dictionary* (Oxford, 1958), p. 1179; Felice Feliciano, in his description of a trip taken by Mantegna and the antiquary Ciriaco of Ancona in 1464 described their arrival at 'green-swards like heavenly gardens in the most delicious dwelling places of the Muses', in C. E. Gilbert, *Italian Art 1400–1500* (Englewood Cliffs, NJ, 1980), p. 180.

12 J. Dixon Hunt, *Garden and Grove: The Italian Renaissance Garden in the English Imagination 1600–1750* (London, 1986); D. Coffin (ed), *The Italian Garden* (Washington, DC, 1972); L. Zangheri, *Pratolino: il giardino delle meraviglie* (Florence, 1979); M. Fagiolo (ed.), *La città effimera e l'universo artificiale del giardino* (Rome, 1980).

13 Cited in L. Tongiorgi Tomasi, 'Projects for botanical and other gardens: a sixteenth-century manual', *Journal of Garden History* (1983), p. 1.

14 'Protesta di D. Teodoro Bondini a chi legge', in L. Legati, *Museo Cospiano* (Bologna, 1677), n.p.

15 L. Châtelet-Lange, 'Le "museo di Vanres" (1560). Collections de sculpture et musées au XVIe siècle en France', *Zeitschrift für Kunstgeschichte*, 38 (1975), p. 279; see also Du Cange's definition of museum which, aside from a brief reference to the museum at Alexandria, does not give the term the broad framework alluded to by later definitions.

16 *The Letters of Marsilio Ficino* (New York, 1985), I, p. 28.

17 Petrarch, *Epist.* 2.3.43, in E. Cochrane and J. Kirshner (eds.), *The Renaissance, Readings in Western Civilization* (Chicago, 1986), V, p. 66.

18 Ibid., pp. 51–2.

19 C. R. Chiarlo, ' "Gli fragmenti dilla sancta antiquitate": studi antiquari e produzione delle imaggini da Ciriaco d'Ancona e Francesco Colonna', in *Memoria dell'antico nell'arte italiana*, ed. Salvatore Settis (Turin, 1984), I, pp. 271–87.

20 Giovanni Pico della Mirandola, 'Praise of Lorenzo', in D. Thompson and A. F. Nagel (eds.), *The Three Crowns of Florence: Humanist Assessments of Dante, Petrarch and Boccaccio* (New York, 1972), pp. 148, 152.

21 A. Doni, *Tre libri di lettere* (Venice, 1552), p. 81 (Como, 20 July 1543); see also the conference proceedings of *Paolo Giovio: il Rinascimento e la memoria* (Como, 1985).

22 S. J. Schaefer, *The Studiolo of Francesco I de' Medici in the Palazzo Vecchio in Florence*, unpublished Ph.D. dissertation (Bryn Mawr College, 1976), pp. 116–17; C. Franzoni, ' "Rimembranze d'infinite cose": le collezioni rinascimentali di antichita', in *Memoria dell'antico nell'arte italiana* (Torino, 1984), I, p. 309.

23 Letter to Francesco Vettori, 10 December 1513 in Cochrane and Kirshner, op. cit. (note 17), pp. 183–4; for the Italian see N. Machiavelli, *Lettere*, ed. F. Gaeta (Milan, 1961), pp. 301–6.

24 D. Du Cange, 'Scriptorium', in *Glossarium Mediae et Infimae Latinitatis* (Paris, 1846), VI, p. 132. This definition corresponds well with the medieval image of *privatus* as a monastic ideal, as discussed in G. Duby, 'Private power, public power', in P. Ariès and G. Duby (eds.), *A History of Private Life*, tr. Arthur Goldhammer (Cambridge, MA, 1988), II, p. 5.

25 *Epist*, III, ep. XV to Niccolo Niccoli, in Franzoni, op. cit. (note 22), p. 305; see also *Two Renaissance Bookhunters: The Letters of Poggius Bracciolini to Nicolaus de Niccolis*, tr. P. Gordan (New York, 1974).

26 T. Tasso, 'Il Malpiglio Secondo, overo de fuggir la moltitudine', in his *Dialoghi* (ed. E. Raimondi) (Florence, 1958), II, tome 2, esp. pp. 569–70.

27 Parma, Biblioteca Palatina, MS Pal. 1012, fasc. 1, c. 13v (Beccadelli to Petronio Beccadelli, 20 October 1555); Florence, Riccardiana, Cod. 2438, parte I, lett. 66r (Giganti to Lorenzo Giacomini, Bologna, 11 December 1584); for details of the history of these collections, see G. Fragnito, 'Il museo di Antonio Giganti', in *Scienze, credenze occulte, livelli di cultura* (Florence, 1982), pp. 507–35; L. Laurencich-Minelli, 'L'indice del Museo Giganti', *Museographia scientifica* 1 (1984), nos. 3–4, pp. 191–242.

28 See L. Thorndike, 'Encyclopedias of the fourteenth century', in his *A History of Magic and Experimental Science* (New York, 1923–41), III, pp. 546–67; R. Popkin, 'Theories of knowledge', in Charles B. Schmitt and Quentin Skinner (eds.), *The Cambridge History of Renaissance Philosophy* (Cambridge, 1988), pp. 668–84.

29 Foucault, op. cit. (note 3), p. 38.

30 S. Wilkin (ed.), *Sir Thomas Browne's Works* (London, 1835–6), IV, p. 239.

31 Sir Thomas Browne, 'Religio Medici', II, p. 35. In an earlier passage (p. 31) he attacked such literary curiosities as 'pieces fit only to be placed in Pantagruel's library'.

32 A. Kircher, *The Vulcano's: or Burning and Fire-Vomiting Mountains... Collected for the most part out of Kircher's Subterraneous World* (London, 1669), p. 34.

33 Legati, op. cit. (note 14), p. 215.

34 G. B. Olivi, *De reconditis et praecipius collectaneis* (Verona, 1584), p. 2; G. Porro, *L'orto dei semplici di Padova* (Venice, 1591), sig. +5ʳ.

35 This was particularly true of Francesco's *studiolo*, though it is also evident in the design of other studies.

36 Legati, professor of Greek at the University of Bologna, discussed his 'Museo delle Poetesse' in his correspondence with the Tuscan scientist Francesco Redi; Florence, Laurenziana. *Redi*, 222, c. 34ʳ (22 November 1667) and c. 42 (27 April 1668).

37 Biblioteca Universitaria, Bologna (hereafter BUB), *Aldrovandi*, MS 21, III, c. 428ʳ. For the details of Aldrovandi's brush with the Inquisition, see G. Olmi, *Ulisse Aldrovandi: Scienza e natura nel secondo Cinquecento* (Trento, 1976), pp. 44–66, *passim*; C. Renato, *Opere, documenti e testamonianze* (ed. A. Rotondo) (Florence, 1968), pp. 224–7 (Frammenti del processo di Ulisse Aldrovandi).

38 C. Vasoli, *L'Enciclopedismo del Seicento* (Naples, 1978), esp. p. 27.

39 *Museum Hermeticum* (Frankfurt, 1678), preface, n.p.; 'De hac vera transmutatione metallorum, quae solo Elixire seu lapide philosophorum perficitur, hic nobis potissimum sermo est, de quo etso multorum authorum libri exstant, ut hic ipse liber Musaeum hermeticum nuncupatum, qui iam aliquot abhinc annis in lucis prodiit, attamen cum haud parva authorum chemicorum sit copia, magnaque scriptorum diversits & varietas, ita ut unus altero clavius & apertius scribat, aliusq.'

40 D. Kronick, *A History of Scientific and Technical Periodicals* 2nd edn. (Metuchen, NJ, 1976), p. 27; G. Nencioni, 'La "Galleria" della lingua', in Paola Barocchi (ed.), *Gli Uffizi: quattro secoli di una galleria* (Florence, 1983), I, pp. 18, 34.

41 Stelluti, *Persio*, p. 170, quoted in G. Gabrieli, 'L'orizzonte intellettuale e morale di Federico Cesi', *Rendiconti della R. Accademia Nazionale dei Lincei* ser. 6, 14 (1938-9), fasc. 7–12, pp. 678–9; 'La vita d'Ulisse Aldrovandi (1586)', in L. Frati (ed.), *Intorno alla vita e alle opere di Ulisse Aldrovandi* (Imola, 1907), p. 16; PUG, *Kircher*, MS 567 (XIII), f. 45 (Herbipoli, 16 June 1657); Florence, Biblioteca Nazionale, *Magl. Cl.* VIII, 1112, c. 13 (Settala to Magliabecchi, Milan, 11 March 1665).

42 L. Moscardo, *Note overo memorie del Museo del Conte Moscardo* (Verona, 1672), sig. SSS3ʳ; Bondoni, 'Protesta', in Legati, op. cit. (note 14), n.p.

43 G. Gabrieli, 'Il Carteggio Linceo, I', *Memorie della R. Accademia Nazionale dei Lincei. Classe di scienze morali, storiche e filologiche* (hereafter *Cart. Linc.*), ser. 6, 7 (1938), fasc. 1, p. 168 (Welser to Faber, 29 July 1611); ibid. II, (1939), p. 778 (Cesi to Faber, 19 November 1622); Calzolari's collection, for example, was called a *rerum... omnium naturalium Theatrum* by its cataloguers B. Ceruti and A. Chiocco, in *Musaeum Franc. Calceolarii* (Verona, 1622), p. 97.

44 BUB, *Aldrovandi*, MS 21, IV, c. 33ʳ; MS 92, c. 11ᵛ; see also A. Sorbelli, 'Contributo alla bibliographia di Ulisse Aldrovandi', in Frati, op. cit. (note 41), p. 72, which produces an agreement between Aldrovandi and his printers 'di fare stampare l'historia del Museo d'esso signor Aldrovandi in Bologna'.

45 BUB, *Aldrovandi*, MS 70, c. 66ᵛ; Florence, Archivio di Stato, *Mediceo del Principato*, f. 689, c. 1, in S. De Rosa, 'Alcuni aspetti della "committenza" scientifica medicea prima di

Galileo', in *Firenze e la Toscana dei Medici nell'Europa del '500* (Florence, 1983), II, p. 713.

46 A. Quint, *Cardinal Federico Borromeo as a Patron and Critic of the Arts and his Musaeum of 1625* (New York, 1986), p. 233; I have modified her translation somewhat to make it more readable.

47 Pliny, *Natural History*, tr. H. Rackham (Cambridge, MA, 1938), I, p. 13 (pref., 17–18).

48 U. Aldrovandi, 'Discorso naturale' (1572–3), c. 511ᵛ, in S. Tugnoli Pattaro, *Metodo e sistema della scienze nel pensiero di Ulisse Aldrovandi* (Bologna, 1981), p. 184.

49 BUB, *Aldrovandi*, MS 136, XXVIII, c. 126ʳ. (Viadanae, 29 June 1599).

50 Modena, Archivio di Stato, *Archivio per le materie. Storia naturale*, busta 1. Aldrovandi to Panzio (Bologna, 16 December 1577).

51 O. Mattirolo, 'Le lettere di Ulisse Aldrovandi a Francesco I e Ferdinando I', *Accademia Reale delle Scienze di Torino* (1903–4), p. 381 (Letter to Ferdinando, 1588); regarding the origins and use of the term *Pandechion*, see Pliny, *Natural History*, pref., 28, p. 15, where he discusses the πανδέκται ('Hold-alls'); Lewis and Short, op. cit (note 11), p. 1296. It is important to note that the idea of a forest, a *selva universale*, was a common trope in the language of sixteenth- and seventeenth-century natural philosophy. It was used frequently, for example, by Tommaso Garzoni, as P. Cerchi notes in his *Enciclopedismo e politica della riscrittura: Tommaso Garzoni* (Pisa, 1980), cf. 32–3; equally, Zenobbio Bocchi's botanical garden and museum at the Gonzaga court in Mantua was described by contemporaries as a *naturalium rerum selvam*; Ceruti and Chiocco, op. cit. (note 43), sig. *4ᵛ.

52 T. Cave, *The Cornucopian Text: Problems of Writing in the French Renaissance* (Oxford, 1979), p. 6. I have taken this passage from his discussion of the definition of *copia* which defined not only plenitude but also functioned as *thesaurus*.

53 BUB, *Aldrovandi*, MS 91, c. 522ʳ; Venice, Biblioteca Marciana (hereafter BMV) *Arch. Mor.* 103 (*Marc.* 12609), f. 9.

54 Olivi, op. cit. (note 34), sig. + + 4ᵛ, p. 2.

55 Cicero, *De oratore* III.xxi.125, quoted in Cave, op. cit. (note 52), p. 6.

56 BUB, *Aldrovandi*, MS 105; Pattaro, op. cit. (note 48), p. 15.

57 Florence, *Ricc.* Cod. 2438, I, f. 1ʳ (Bologna, 27 June 1587).

58 L. Laurencich-Minelli, 'Museography and ethnographical collections in Bologna during the sixteenth and seventeenth centuries', in O. Impey and A. MacGregor (eds.), *The Origins of Museums* (Oxford, 1985), pp. 17–23; M. Hodgen, *Early Anthropology in the Sixteenth and Seventeenth Centuries* (Philadelphia, 1964); D. Lach, *Asia in the Making of Europe* (Chicago, 1972).

59 F. Cesi, 'Del natural desiderio di sapere et instituzione de' Lincei per adempimento di esso', in M. L. Biagi and B. Basile (eds.), *Scienzati del Seicento* (Milan, 1980), p. 48.

60 Lynn Joy's comments on Gassendi, as a man between the humanistic and Galilean-Cartesian models of knowledge, are particularly suggestive and convincing; see her *Gassendi the Atomist: Advocate of History in an Age of Science* (Cambridge, 1987).

61 R. J. W. Evans, *The Making of the Habsburg Monarchy: An Interpretation* (Oxford, 1979).

62 Ibid., p. 429; D. Pastine, *La nascita dell'idolatria: l'Oriente religioso di Athanasius Kircher* (Florence, 1978), p. 112.

63 In C. Reilly, *Athanasius Kircher S.J. Master of a Hundred Arts 1602–1680* (Studia Kircheriana, Band I) (Wiesbaden, 1974), p. 38.

64 A. Kircher, *Oedipus Aegyptiacus* (Rome, 1652–4), ii, I, classis I, p. 6, quoted in Evans, op. cit. (note 61), p. 437.

65 J. Comenius, *Orbis sensualium pictus* (London, 1659), p. 193.

66 See, for example, Ceruti and Chiocco, op. cit. (note 43), p. 721; P. Terzago, *Musaeum Septalianum* (Tortona, 1664), p. 151: 'Atque dicendum de bibliotheca non immerito, quod Dei, & scientiarum prorsus omnium recondat mysteria, de Musae, quod artis & naturae contineat arcana . . .'

67 G. P. Bellori, *Nota delli musei, librerie, gallerie, et ornamenti di statue e pitture ne' palazzi, nelle case, e ne' giardini di Roma* (Rome, 1664), p. 45; D. Diderot, 1751, 'Bibliothèque', in *Encyclopédie*, I (Paris, 1751), p. 235.

68 See R. Chartier, 'Urban reading practices 1660–1780', in *The Cultural Uses of Print in Early Modern France* (Princeton, 1987), pp. 183–239.

69 See Diderot's survey of libraries to the eighteenth century in the *Encyclopédie*, and C. du Molinet, *Le cabinet de la bibliothèque de Sainte Geneviève* (Paris, 1692).

70 Diderot, op. cit. (note 67), I, p. 235.

71 Biblioteca Apostolica Vaticana (hereafter BAV), *Barberini Lat.* 6467, f. 64 (Padua, 5 September 1642); see also ff. 64–5 (28 May 1641 and 8 November 1642) and f. 51 (21 May 1635): 'restera servito di honorarmi a farle haver luogo nel suo Museo'.

72 BUB, *Aldrovandi*, MS 97, cc. 440–3ʳ; see also his *Bibliologia* (1580–1), MS 83 and his *Bibliotheca secondum nomina authorum*, MS 147.

73 Clemens, op. cit. (note 1), pp. 2–4, 523; Pietro Redondi observes in his *Galileo Heretic*, tr. R. Rosenthal (Princeton, 1987), pp. 80–1: 'As instruments of intellectual monopoly, the great libraries created at the beginning of the century expressed the strength and prestige of traditional humanist and theological culture, which was forging new instruments of erudition and exegesis: the most modern weapons for sustaining, on all intellectual fronts, the effort of Catholic reform and religious struggle.'

74 The Jesuit privilege to censor their own books was revoked by the College of Cardinals in 1596; Thorndike, op. cit. (note 28), V, p. 151; BUB, *Aldrovandi*, MS 136, XXV, c. 122ʳ (*Index librorum quos concessit Ulyssi Aldrovando SS. Inquisitio romano*, June/July 1596) and cc. 135ᵛ–7ʳ (*Catalogus librorum prohibitorum meorum datus Episcopo et Inquisitori*).

75 William Ashworth's remarks on the problems of defining a 'Catholic' science and also on the church's attack on natural magic and, to a more limited extent, alchemy, represent the most useful overview of science, theology, and the institutional church in the post-Tridentine era, in his 'Catholicism and Early Modern Science', in D. Lindberg and R. Numbers (eds.), *God and Nature: Historical Essays on the Encounter between Christianity and Science* (Berkeley and Los Angeles, 1986), pp. 136–66.

76 See note 37; there is an extensive literature on heresy and natural philosophy; Thorndike, op. cit. (note 28), 8 vols.; L. Amabile, *Il Santo Officio dell'Inquisitione in Napoli* (Citta di Castello, 1892); Tommaso Garzoni, for example, was accused of discussing authors prohibited by the *Index* in his *Piazza universale* (1585), an example of the sort of indiscriminate curiosity that got many other natural philosophers in trouble; Cerchi, op. cit. (note 51), p. 43.

77 Châtelet-Lange, op. cit (note 15), pp. 279–80; Franzoni, op. cit. (note 22), p. 333.

78 As Duby notes in his 'Private power, public power' (op. cit. (note 24), p. 3), *priver* means to domesticate. There is an extensive literature on academies in Early Modern Europe, so only a few of the most basic works are indicated here: E. Cochrane, 'The Renaissance academies in their Italian and European setting', in *The Fairest Flower* (Florence, 1985), pp. 21–39; ibid., *Tradition and Enlightenment in the Tuscan Academies 1690–1800* (Chicago, 1961); M. Maylender, *Storia delle academie d'Italia*, 5 vols. (Bologna, 1926–30); F. Yates, *The French Academies of the Sixteenth Century* (London, 1947).

79 U. Tergolina-Gislanzoni-Brasco, 'Francesco Calzolari speziali veronese', *Bolletino storico italiano dell'arte sanitaria* 33 (1934), fasc. 6, p. 15.

80 B. Cotrugli, *Della mercatura e del mercato perfetto* (1573), p. 86, quoted in Franzoni, op. cit. (note 22), p. 307; Du Cange's definition of *studiolum* – 'Cellula, museum, conclave, ubi studetur. Gall. *Cabinet d'Etude*: museolum, scrinia, *Estudiole* dicimus' – also gives several examples that locate the museum next to the bedroom (Du Cange, op. cit. (note 24), VI, p. 395.

81 Milan, Biblioteca Ambrosiana, MS S. 85, sup., f. 235ʳ (*Forma dello studio*, 1586).

82 C. R. Hill, 'The cabinet of Bonnier de la Mosson (1702–1744)', *Annals of Science* 43 (1986), pp. 148–9. A glance at the *Encyclopédie* article on 'cabinet' confirms its entry into the public sphere a century later.

83 C. Dionisotti, 'La galleria degli uomini illustri', in V. Branca and C. Ossola (eds.), *Cultura e societa nel Rinascimento* (Florence, 1984), p. 452.

84 L. B. Alberti, *Ten Books on Architecture*, tr. James Leoni (1715), ed. J. Ryckwert (London, 1956) [V. 17], p. 107; Pliny the Younger's description of his villa at Laurentium [*Epist.* II. 17] places his own library/study near the bedrooms.

85 See C. M. Brown, ' "Lo insaciabile desiderio nostro di cose antique": new documents on Isabella d'Este's collection of antiquities', in C. H. Clough (ed.), *Cultural Aspects of the Italian Renaissance* (New York, 1976), pp. 324–53. Saint Catherine of Siena, another exceptional woman, also had a *studio* in which she composed her voluminous correspondence. I would like to thank Karen Scott for this information.

86 J. B. Elshtain, *Public Man, Private Woman: Women in Social and Political Thought* (Princeton, 1981), 3–16, *passim*.

87 The inscription above Pierre Borel's museum in Castres read: 'Siste gradum (curiose) hic enim orbem in domo, imo in Musao, id est microcosmum seurerum omnium rariorum Compendium cernes...'; *Catalogue des choses rares de Maistre Pierre Borel* in his *Les Antiquitez, Raretez, Plantes, Mineraux, & autres choses considerables de la Ville, & Comte de Castres d'Albigeois* (Castres, 1649), p. 132.

88 Forli, Biblioteca Comunale, *Autografi Piancastelli*, 51, c. 486r (15 June 1595).

89 BUB, *Aldrovandi*, MS 143, X, c. 284r.

90 Steven Shapin's perceptive analysis of the location of experiment in seventeenth-century British science deals with the transit from private to public, and vice-versa, by similarly considering the spaces in which Royal Society members such as Boyle and Hooke conducted their experiments. His comments on the self-conscious nature of 'publicity' in post-Baconian science further illuminate the background to the contrasting perceptions of the Ashmolean Museum and Continental collections of the seventeenth century discussed later in this paper; see S. Shapin, 'The House of Experiment in seventeenth-century England', *Isis* 79 (1988), pp. 373–404.

91 References to the interchangeability of terms are voluminous; see, for example, BUB, *Aldrovandi*, MS 38^2, I, c. 229, c. 259; MS 41, c. 2r; MS 136, XXVI, cc. 38–9; Bologna, Archivio di Stato, *Assunteria di Studio. Diversorum*, tome X, no. 6.

92 O. Montalbani, *Curae analyticae* (Bologna, 1671), pp. 5, 15. The use of the diminutive, a linguistic device that played with the macrocosmic potential of the museum, a world in miniature, appears in other texts as well. G. B. Cavallara, for example, described the Mantuan physician Filippo Costa's collection as *suo Studiolino*; 'Lettera dell'eccell.mo Cavallara', in *Discorsi di M. Filippo Costa* 2nd edn. (Mantua, 1586), sig. Ee.3v. Gallileo's often-cited comparison between *Orlando Furioso* and *Gerusalemme Liberata*, which described the two works in the language of collecting, disparaged the latter as a *studietto* (as opposed to the *galleria regia* of Ariosto); in Nencioni, op. cit. (note 40), pp. 18–19.

93 Franzoni, op. cit. (note 22), p. 358.

94 BMV, *Arch. Mor.* 103 (= *Marciana* 12609), f. 29.

95 G. I. della Rocchetta, 'Il museo di curiosità del Card. Flavio Chigi seniore', *Archivio della societa romana di storia patria*, ser. 3, 20 (1967), a. 89, p. 141. Gardens, it should be noted, as a subset of the category *musaeum*, also evidenced the same transition from private to public space. The Biblical image of the Garden of Eden, a closed and perfect space, and the allegorical image of the *hortus conclusus* were transformed in the sixteenth and seventeenth centuries into the more open image of *selva*, the forest whose contents were limitless.

96 Milan, Biblioteca Ambrosiana, MS D. 332 inf., ff. 68–9 (Aldrovandi to Asciano Persio, 17 November 1597); BUB, *Aldrovandi*, MS 21, IV, c. 347r; *Cart. Linc.*, I, p. 403; 1942, III, pp. 1046, 1076.

97 K. Frey, *Der literarische Nachlass Giorgio Vasaris* (Munich, 1923–40), quoted in Schaefer, op. cit. (note 22), p. 22 [Borghini to Vasari, 20 September 1569]; L. Bolzoni, 'L'"invenzione" dello stanzino di Francesco I', in *Le Arti nel principato Mediceo* (Florence, 1980), p. 264; Schaefer, op. cit. (note 22), p. 9; R. Borghini, *Il riposo* (Florence, 1584), pp. 610, 635.

98 Borghini, op. cit. (note 97), p. 610; H. O. Boström, 'Philipp Hainhofer and Gustavus Adolphus's *Kunstschrank* in Uppsala', in O. Impey and A. MacGregor (eds.), *The Origins of Museums* (Oxford, 1985), pp. 90–101.

99 Franzoni, op. cit. (note 22), p. 311.

100 Both Lina Bolzoni and Luciano Berti concur on the ambiguity of the *studiolo*'s position; Bolzoni, op. cit. (note 97), p. 264; Berti, op. cit. (note 2), p. 83.

101 Comenius, op. cit. (note 65), p. 200.

102 For an interesting discussion and definition of 'absorption', see M. Fried, *Absorption and Theatricality: Painting and Beholder in the Age of Diderot* (Berkeley, 1980), pp. 7–70, *passim*.

103 See, for example, the frontispiece of Neickelius' *Museographia* (op. cit., note 10).

104 K. Levin, *A Topological Inversion in the Studiolo of Francesco I* (unpublished MA thesis, University of Colorado, 1982), pp. 9–10.

105 A. Libavius, *Commentarium...pars prima* (1606), I, p. 92, quoted in O. Hannaway, 'Laboratory design and the aim of science: Andreas Libavius and Tycho Brahe', *Isis* 77 (1986), p. 599. As Hannaway notes (p. 585), citing Du Cange, *laboratorium* is a post-classical term, probably of monastic origin, that developed its more modern connotations from the sixteenth century, paralleling the expansion of museum.

106 See for example, W. Eamon, 'From the secrets of nature to public knowledge: the origins of the concept of openness in science', *Minerva* 23 (1985), pp. 321–47.

107 BUB, *Aldrovandi*, MS 25, c. 304r (8 April 1574); Franzoni, Nencioni, and Dionisotti note how the entry of *galleria* into the language of collecting from French in the late sixteenth century heralded a new spatial framework for the museum, as, according to one contemporary description, 'un luogo da passaggiare'; Franzoni, op. cit. (note 22), p. 335; Cellini describes *galleria* as a *loggia* or *androne* in his autobiography; Dionisotti, op. cit. (note 83), p. 449; the Crusca dictionary did not define *galleria* until 1691; Nencioni, op. cit. (note 40), p. 17; in his work on the fall of public man, Richard Sennett defines 'public' as motion, literally space to be moved through – a definition certainly in keeping with the historical development of *galleria*; Sennett, op. cit. (note 5), p. 14.

108 PUG, *Kircher*, MS 560 (VI), f. 111 (Kircher to G. B. Olivi, 23 October 1671), quoted in V. Rivosecchi, *Esotismo in Roma barocca: studi sul Padre Kircher* (Rome, 1982), p. 141.

109 BUB, *Aldrovandi*, MS 34, I, c. 6r. Aldrovandi's lack of a clear distinction between public and private activities evidences certain similarities with what Jürgen Habermas, from a Marxist perspective, has described as the first stage in the formation of the 'bourgeois' public sphere, that is, the pre-capitalist exchange of goods and information that coexisted with the established public order; Habermas, op. cit. (note 5), p. 26.

110 W. H. and W. J. C. Quarrell (eds.), *Oxford in 1710* (Oxford, 1928), pp. 2–3, 24, 31; see M. Welch, 'The foundation of the Ashmolean Museum' and 'The Ashmolean as described by its earliest visitors', in A. MacGregor (ed.), *Tradescant's Rarities: Essays on the Foundation of the Ashmolean Museum* (Oxford, 1983), pp. 41–69. The image of the Ashmolean as the prototype for the 'public' museum appears in the emphasis on this word in contemporary descriptions of it. Borel singled it out as 'Le Cabinet publique' in his list of museums in 1649, alluding to the earlier Tradescant collection that formed the basis (indeed the bulk) of Ashmole's gift to Oxford in 1683; the Chevalier de Jaucourt described it as the museum 'that the University had had built for the progress and the perfection of the different branches of knowledge': 'Musée', in *Encyclopédie*, X, p. 894. The entry in the *Oxford English Dictionary* under 'museum', like the Crusca reference to Aldrovandi, underlines the normative function of the Ashmolean in shaping the use of

museum in English, as does reference to it in seventeenth- and eighteenth-century dictionaries.

111 W. H. Quarrell and Margaret Mare, *London in 1710* (London, 1934), p. 98.

112 M. B. Valentini, *Museum museorum, oder der allgemeiner Kunst- und Naturalien Kammer* (Frankfurt, 1714), sig. xx2r.

113 BAV, *Vat. lat.* 6192, vol. 2, f. 657r (Aldrovandi to Cardinal Sirleto, Bologna, 23 July 1577); BUB, *Aldrovandi*, MS 138^2, c. 37 (Modena, 12 October 1561).

114 ARSI, *Fondo Gesuitico*, 1069/5, III, no. 1.

115 British Library, Sloane MS, 4063, f. 231r (Bonanni to Petiver, Rome, 26 December 1703); R. Stearns, 'James Petiver, promoter of natural science ca.1663–1718', *Proceedings of the American Antiquarian Society*, new ser. 62 (1952), pp. 243–365.

116 G. Fantuzzi, *Memorie della vita di Ulisse Aldrovandi* (Bologna, 1774), pp. 76, 84.

117 BUB, Cod. 738 (1071), vol. XXIII, no. 14 (*Decreto per la concessione di una sala al marchese Ferdinando Cospi appresso lo Studio Aldrovandi* [28 June 1660]).

118 Biblioteca Comunale dell'Archiginasio, Bologna, B. 164, f. 301r (Pompeo Viziano, *Del museo del S.r Dottore Aldrovandi*, 21 April 1604).

119 BUB, *Aldrovandi*, MS 41, c. 2r (*Liber in quo viri nobilitate, honore et virtute insignes, viso musaeo quod Excellentissimus Ulyssis Aldrovandus Illustriss. Senatus Bononiensi dono dedit, propria nomina ad perpetuam res memoriam scribunt*). The book, however, was started in Aldrovandi's lifetime, since the entries date from 1566 – significantly the first signature was Gabriele Paleotti's – until March 1644. 'Ego Carolus Gonzaga die 22. Mensii Aprilis, 1619 et particular gratia D. Co. Pompei Aldrovandi [one of the two executors named in Aldrovandi's will] in visi nobiliss.a haec bibliothecu properata grati animi ergo scripsi' (c. 6).

120 BUB, *Aldrovandi*, MS 110.

121 Fantuzzi, op. cit. (note 116), p. 84.

122 M. Spallanzani, 'Le "Camere di storia naturale" dell'Istituto delle Scienze di Bologna nel Settecento', in W. Tega (ed.), *Scienza e letterature nella cultura italiana del settecento* (Bologna, 1984), pp. 149–83; S. Maffei, *Epistolario (1700–1755)*, ed. Celestino Garibotto (Milan, 1955), I, p. 238 (Maffei to Anton Francesco Marmi, Verona, end of March 1717); p. 273 (Maffei to Muratori, Verona, 20 September 1718).

123 ARSI, *Rom.* 138. *Historia* (1704–1729), XVI, f. 182r.

Chapter 3 | Carol Duncan and Alan Wallach

The Universal Survey Museum

For over a century the museum has been the most prestigious and authoritative place for seeing original works of art. Today, for most people in Western society, the very notion of art itself is inconceivable without the museum. No other institution claims greater importance as a treasure house of material and spiritual wealth.

The museum experience is usually described in terms of aesthetic contemplation. Yet studies show that the average visitor comes to the museum with no fixed purpose or perspective and usually looks over the entire collection rather than focusing on individual works. (One curator estimated that the average visitor devotes 1·6 seconds to each of the works he or she looks at.)[1] Clearly, museums offer an experience that cannot be described simply in terms of contemplation. Yet very little is known about the museum experience as a totality. Peter Kyron, Deputy Chairman of the United States National Council on the Arts, recently observed that although museums have demonstrated their ability to draw millions of visitors, they have yet to say 'what they are about [and to] analyse the core experience of going to a museum'.[2] Our primary aim is to understand the way the museum's ensemble of art, architecture and installations shapes the average visitor's experience.

Our approach draws upon the methods of traditional art and architectural history as well as anthropology. We begin with a close examination of the immediate visual and spatial experience of the museum. From this evidence, we attempt to deduce the beliefs and values museums communicate. These values and beliefs refer not only to aesthetic experience but also to the visitor's social experience. We believe this approach allows for an examination of the dialectic between the museum experience and the forces and conditions that gave rise to and sustain the museum as a social institution.

Carol Duncan and Alan Wallach, "The Universal Survey Museum" from *Art History* 3:4 (December 1980), pp. 448–69. Reproduced by permission of Blackwell Publishing.

Museums as Ceremonial Architecture

Museums belong to the same architectural and art-historical category as temples, churches, shrines and certain types of palaces. This comparison is not simply a convenient metaphor: museums share fundamental characteristics with traditional ceremonial monuments.

The museum's primary function is ideological. It is meant to impress upon those who use or pass through it society's most revered beliefs and values. Past societies devoted substantial wealth to constructing and decorating temples and cathedrals. Similarly, our society lavishes enormous resources on creating and maintaining museums of art. The museum's physical prominence and monumental appearance signal its importance. Absorbing more manual and imaginative labour than any other type of architecture, the museum affirms the power and social authority of a patron class.

Museums built during the first great age of museum building deliberately recalled past ceremonial architecture. The forms that were chosen evoked temples, palaces, treasuries and tombs.[3] This eclectic and often pedantic architecture drew upon the complex of interconnected meanings associated with the ceremonial architecture of the ancient world. Museums were simultaneously temples, palaces, treasuries and tombs – buildings filled with echoes of ancient ceremonial practices of accumulation and display. The use of traditional forms represents not only a revival of architectural styles, but also a modern adaptation of those ancient practices. The museum thus recalls what might be termed the museum functions of earlier architecture – the ceremonial display of votive offerings in temple treasuries or of relics in cathedral chapels and crypts.[4] These displays of revered objects were arranged as deliberately as any museum installation.

Today's universal survey museum might be compared to Roman displays of war trophies. The loot that was paraded through Rome in triumphal procession was often donated to the Roman public by wealthy benefactors and placed on public exhibition.[5] The early Louvre deliberately evoked the Roman tradition of triumphal display: captured enemy arms were exhibited along with works of art, and cartloads of art pillaged from conquered nations arrived at the Louvre in triumphal processions designed to recall those of ancient Rome.[6] The visitor entering Napoleon's Louvre passed through triumphal arches decorated with trophies and victories.[7] In today's European and American museums, exhibitions of Oriental, African, Pre-Columbian and Native American art function as permanent triumphal processions, testifying to Western supremacy and world domination.

Museum architecture often recalls the architectural tradition of mausoleums and royal temples. For example, the Metropolitan Museum's Robert Lehman wing has about it the spirit of an ancient royal tomb. Its windowless, subterranean chambers contain precise reconstructions of the ornately furnished rooms in which Lehman spent his days. The architecture echoes funereal and religious building types: the circular mausoleum or palace chapel. A glass, pyramid-shaped roof is the structure's most striking external feature. All that is lacking is a sarcophagus.[8]

In common with ancient ceremonial monuments, museums embody and make visible the idea of the state. They do so in part through the use of a Roman-derived architectural rhetoric. This rhetoric has been used in public buildings since the Renaissance to symbolize state authority.[9] By employing such forms as the

Greco-Roman temple front, the dome of the Pantheon, or coffered ceilings, the museum, along with other public buildings, asserts its descent from the ideological, historical and political reality of imperial Rome. Located at the centre of the modern city like a temple facing an open forum or, in the United States, as part of a municipal park complex, the museum stands as a symbol of the state, and those who pass through its doors enact a ritual that equates state authority with the idea of civilization.

We use the word ritual deliberately. The museum, like other ceremonial monuments, is a complex architectural phenomenon that selects and arranges works of art within a sequence of spaces. This totality of art and architectural form organizes the visitor's experience as a script organizes a performance. Individuals respond in different ways according to their education, culture and class.[10] But the architecture is a given and imposes the same underlying structure on everyone. By following the architectural script, the visitor engages in an activity most accurately described as a ritual. Indeed, the museum experience bears a striking resemblance to religious rituals in both form and content. According to the anthropologist Victor Turner, such art forms as theatre, the novel and art exhibitions provide scripts or 'doing codes' to be performed by individuals. The reader or viewer enacts a ritual whose structure may be compared to those found in simpler societies.[11] The architectural historian Frank Brown developed the idea of architecture as ritual form. In his *Roman Architecture*, Brown argued that Roman ceremonial buildings not only originated in ritual activity, but 'required it, prompted it, [and] enforced it'.[12]

Of course, the ritual nature of the museum experience may not be self-evident. Although writers often describe museums as 'temples' and 'palaces', they use these terms metaphorically. We live in a secular age and museums are deemed secular institutions. But the separation between the secular and the religious is itself a part of bourgeois thought and has effectively masked the survival in our society of older religious practices and beliefs. From the beginning bourgeois society appropriated religious symbols and traditions to its own ends. The legacy of religious patterns of thought and feeling especially shaped the experience of art. While Winckelmann and other eighteenth-century thinkers were discovering in art all the characteristics of the sacred, a new kind of cultural institution, the public art museum – 'Temples of Art', as the age styled them – was evolving a corresponding ritual. When, in 1768, Goethe visited the Dresden Gallery, he described it as a 'sanctuary'. Its splendour and richness, he recalled, 'imparted a feeling of solemnity' which 'resembled the sensation with which one treads a church', but was here 'set up only for the sacred purposes of art'.[13]

We are not suggesting that museum visitors think of their experience as a ritual process. Rather the museum itself – the installations, the layout of rooms, the sequence of collections – creates an experience that resembles traditional religious experiences. By performing the ritual of walking through the museum, the visitor is prompted to enact and thereby to internalize the values and beliefs written into the architectural script. Here, works of art play the same role as in traditional ceremonial monuments.

In a church, temple, or palace, paintings, statues and reliefs affixed to or embedded in the walls constitute an integral part of the monument; they are, in a sense, its voice. These architectural decorations articulate and enlarge the meaning of the ritual activities that take place on the site. In most traditional architecture, the various decorative elements, taken together, form a coherent iconographic programme. Such programmes usually rest upon authoritative literary sources – written or

orally-transmitted myths, litanies, sacred texts, epics – and they frequently evoke a mythic or historical past that informs and justifies the values celebrated in the ceremonial space. As visual commentaries, they elucidate the purpose of the consecrated ground and often provide a scenario for ritual.[14] Thus images of John the Baptist on the walls of baptistries gave meaning to the ritual of baptism; the Last Supper related the monastery or convent dinner to Christ's sacrifice. Similarly, medieval choir screens, illustrating the life of a martyr, gave meaning to the pilgrim's walk round the choir.

The museum's space and collection form an ensemble that functions as an iconographic programme. However, art historians have ignored the role art plays in the museum context. Museums almost everywhere sanction the idea that works of art should, above all, be viewed one-by-one in an apparently ahistorical environment. According to prevailing beliefs, the museum space, apart from the objects it shelters, is empty. What in our approach appears as a structured ritual space – an ideologically active environment – usually remains invisible and is experienced only as a transparent medium through which art can be viewed objectively and without distraction.

Architectural historians classify ceremonial monuments according to type. For example, in the field of Medieval art, they distinguish between abbey churches, palace chapels and cathedrals. We have found that there is also a typology for museums. The most important museum types are the large municipal or national museum devoted to surveys of old masters and monumental art through the ages, and the museum devoted primarily to modern art. Other types include specialized regional collections and the robber-baron mansion. The universal survey museum may also incorporate other museum types housed in special wings or sections. Each of these museum types has its own characteristic iconographic programme. Indeed, the programme of any particular museum is as predictable as that of a medieval church and is equally dependent upon authoritative doctrine. The art history found in encyclopedic textbooks – in the United States, Gardner, Janson and Arnason – supplies the doctrine that makes these modern ceremonial structures coherent.

These different museum types reflect changing historical circumstances and needs. Universal survey museums such as the Metropolitan claim the heritage of the classical tradition for contemporary society and equate that tradition with the very notion of civilization itself. In this type of museum, the visitor moves through a programmed experience that casts him in the role of an ideal citizen – a member of an idealized 'public' and heir to an ideal, civilized past. Smaller museums belonging to this type, for example the New Orleans Museum of Fine Arts, may lack collections of classical art, but they none the less communicate the classical ideal through their architecture and décor. The prototype for this kind of museum is the Louvre, the first and still the fullest statement of the ideal of civilization.[15]

The Origins of the Universal Survey Museum

The Louvre, the National Galleries in London and Washington, and the Metropolitan Museum of New York exemplify the universal survey museum. Such museums present a broad range of art history. They are the indispensable ornaments of any great city, and even smaller cities with claims to civic and cultural importance must have their versions of a universal survey museum. When people use the term art museum, it is this type of museum they usually have in mind. The universal survey museum is not only the first in importance, it is also the first museum type to emerge historically, and

from the beginning it was identified with the idea of the public art museum. In what follows, then, we shall often use the term public museum to mean the universal survey type.

The public art museum evolved in the eighteenth century from another kind of collection that resembled it in many ways, the princely art gallery. It is in this period that royal collections all over Europe were being turned into public collections. In France, the Revolution would declare the Louvre a museum, but even before the Revolution, plans for the new museum were well underway. In several other countries, royal collections had been turned into public museums by royalty itself. Outstanding examples are the Viennese Royal Collection, handsomely installed and opened to the public in the 1770s; the Dresden Gallery, so much admired by Goethe; and the Uffizi donated to the state in 1743 by the last princess of the Medici house.[16]

The conversion of royal and princely art collections into public museums should be seen as part of a larger historical process. The new institution – the public art museum – would inherit some of the basic ceremonial functions of the princely collection from which it arose. But under the pressure of new historical forces, those ceremonial functions would be reshaped and redefined, and eventually the public art museum would develop its own distinctive forms and its own characteristic look. Certainly a sharp line cannot always be drawn between the two kinds of state collections; as we shall see, lurking behind the façade of the public art museum, there are often memories and sometimes even the reality of royal ceremony. Some museums, especially those established very early by monarchs, seem poised between the two identities. Later universal survey museums do not suffer from such confusion of identity.

Typical princely art collections were those of the Emperor Rudolf II, the Archduke Leopold-William of Brussels, Phillip II of Spain, Cardinal Mazarin and Cardinal Geronimo Colonna.[17] From the Renaissance through the eighteenth century, such collections were often housed in magnificent galleries that served as official reception rooms – state ceremonial spaces that were meant to impress both foreign visitors and local dignitaries with the ruler's magnificence. Collections of this kind that were famous for their richness often attracted foreign travellers much as museums today attract tourists. Yet even for the curious art lover of the seventeenth or eighteenth centuries, a visit to such a gallery was a visit to the prince, whether or not the prince was there to receive him. In the eighteenth and nineteenth centuries, many of these collections were opened to the public as 'museums', and some were even given their own buildings. Nevertheless, they retained their character as royal reception halls.

The Glyptothek in Munich, for example, built by Ludwig of Bavaria in the early nineteenth century, looks like a typical museum building of the modern era – indeed, its Neo-classical forms were a prototype for later museums.[18] It was opened to the public free by the Crown Prince himself. Yet, as Neils von Holst points out in his study of museums, the splendid liveries of the museum guards made clear that the visitor was, in fact, the prince's guest. The same was true of the Hermitage later in the century. Although opened as a public museum in 1853, it kept much of the character of a princely art gallery. As Germain Bazin describes it,

> The [Hermitage] museum was completely integrated with the palace, being used for evening receptions and after-theatre suppers. ... The Czar permitted the public but on conditions recalling those of the *Ancien Régime*. One visited the emperor, not the museum; full dress was de rigueur and visitors were announced.[19]

In Russia as in Munich, the collection very clearly belonged to the monarch and identified the state with his person.

In France, in the mid-eighteenth century, the royal collection was hidden away in inaccessible storage rooms. Enlightened opinion began calling for the creation of a royal gallery in the old Louvre palace. Although abandoned as a residence, the Louvre was still a powerful symbol of the state, and critics saw its potential as a museum.[20] In a pamphlet of 1747, Lafont de Saint-Yenne proposed that the Louvre be restored and transformed into a royal art gallery.[21] It is a disgrace, he said, that this building, 'the first of the royal buildings', had fallen into neglect and disrepair. As a gallery, it would be a monument to the king and a 'sanctuary' for art that would augment 'the glory of our nation'. It would impress foreigners by its display of wealth and inspire modern artists to create noble works.

Lafont, and after him Diderot, Voltaire and other *philosophes* were calling for something like a traditional royal art gallery – a ceremonial royal reception hall. It would receive not only foreign visitors but also the French public. And it would speak not only of the King's glory but of the nation. In effect, Lafont and the *philosophes* were beginning to think of the royal art gallery as a ceremonial space belonging collectively to the people – a gallery with the function of a public museum, but still clothed in royal robes. Of course, the 'public' Lafont and the others envisioned represented only a small segment of the population – the aristocracy and the educated bourgeoisie. In demanding a state reception hall for this public and by insisting that the royal collection symbolized the 'nation', the *philosophes* were in effect demanding acknowledgement for the bourgeoisie and its claims to a share of the official state.

Under Louis XVI, the monarchy also concluded that it had something to gain from a royal art gallery accessible to the public. Under attack from all sides, the government was anxious to legitimize itself by identifying its special interests with those of the French nation as a whole. To this end, the foundation of a royal museum became official policy. The Comte d'Angiviller, the King's Director General of Buildings, intent upon shaping public opinion, was already involved in centralizing and controlling art production and exhibitions. In 1777, he formed a committee to plan for the transformation of the Louvre's Grand Gallery into a royal art gallery. Meanwhile, through his agents, he enlarged the royal collection, especially strengthening its holdings in Italian Renaissance art, but also – like a modern museum curator – filling in art-historical gaps (for example, Dutch and Flemish art). Despite his efforts, the transformation of the Louvre into a museum was still in the planning stage at the time of the Revolution.[22]

With the Revolution, the transformation of the Louvre became urgent. In a series of decrees of 1792 and 1793, the new state nationalized the King's property, confiscated his art collections and declared the Louvre a museum.[23] This declaration dramatically made visible the reality of the new Republican state. What had been the King's by right was now decreed the property of the nation. In a letter to David of 17 October, 1792 Minister of the Interior Roland spelled out the meaning of the new museum:

> As I conceive of it, it should attract and impress foreigners. It should nourish a taste for the fine arts, please art lovers and serve as a school to artists. It should be open to everyone. This will be a national monument. There will not be a single individual who does not have the right to enjoy it. It will have such an influence on the mind, it will so elevate the soul, it will so excite the heart that it will be one of the most powerful ways of proclaiming the illustriousness of the French Republic.[24]

On 27 July 1793 the convention designated the Louvre The Museum of the French Republic and set its opening for 10 August, 'the anniversary of the fall of the Monarchy'.[25] The meaning that the Revolution gave to the ancient palace is still commemorated in the heart of the Louvre in the Apollo Gallery, a magnificently decorated reception hall dating from the reign of Louis XIV. In its centre a glass case displays three royal crowns: a medieval one, the coronation crown of Louis XV, and the coronation crown of Napoleon. All now belong to the French people.

In principle, the public art museum and the royal art gallery imply sharp political differences. Both institutions make the nation a visible reality. The royal gallery identifies the nation as the king's realm, while the public art museum identifies the nation as the state – an abstract entity in theory belonging to the people. For this reason, public art museums could serve the needs of enlightened or modernizing monarchs as well as the new republican state. The sudden flowering of art museums all over Europe in the late eighteenth and early nineteenth centuries testifies to the bourgeoisie's growing social and political power. In order to grasp more fully what the public art museum does and why it is a necessity to the modern state, we must understand the ways in which the art museum reorganizes the experience of art.

Princely collections celebrated the power and wisdom of the prince.[26] Visitors to the court were meant to be dazzled and impressed by the display of richness and splendour. Works of art were used decoratively, often as elements in complex architectural ensembles.[27] Paintings were sometimes put in narrow, unobtrusive frames and made to cover the entire wall in order to produce a tapestry-like effect. Leopold-William's collection, frequently depicted by Teniers, was installed in this manner, as was the famous Colonna Gallery, which inspired Pannini's many fantasy paintings of art collections. In these decorative schemes, size, colour and subject matter determined the arrangement, and paintings were often cut down or enlarged to fit into the ensemble. Studies have shown that princely collections were sometimes carefully selected and arranged as iconographic programmes that glorified the ruler and his realm. For example, the seventeenth-century collection of the Hapsburg Emperor Rudolf II formed an iconographic programme portraying the emperor as the centre of a harmonious microcosm and illustrating the beneficent effects of his rule.[28] The Antiquarium of Albert V of Bavaria featured portraits of emperors and illustrious men of the past whose virtues the prince claimed as his legacy.[29]

The creation of the public art museum did not merely involve opening up a royal ceremonial space to a newly constituted public. To serve the new needs of the state, the collection had to be presented in a new way. One of the earliest examples was the Viennese Royal Collection.[30] In 1776 it was moved out of the Stallburg, where it had hung since the 1720s, to the Belvedere Palace. Despite protests from those favouring traditional installation practices, the works were now arranged according to Enlightenment ideas. The paintings were divided into national schools and art-historical periods, put into simple, uniform frames, and clearly labelled. A guide to the museum directed the visitor's tour of the collection. A walk through the gallery was an organized walk through the history of art. In other words, the royal collection was organized into a new iconographic programme. In the guide, Christian von Mechel, the art expert in charge of the Belvedere, proclaimed his pedagogical aims; the new museum, he wrote, was to be 'a repository where the history of art is made visible'.[31] The Royal Collection in Düsseldorf had been given an art-historical programme in 1756, and a similar programme had been in place in the Uffizi since 1770. In 1810,

Vivant Denon imposed the new programme at the Louvre. Thereafter, almost all museums would adopt some version of the new scheme.

The museum not only reorganized the collection but also transformed the experience of art. In 1785, an aristocratic connoisseur, von Rittershausen, complained about the organization of the Belvedere: 'One who desires an art history can enter [the museum] but the sensitive man is kept away.'[32] In the museum, the work of art now represented a moment of art history. It exemplified a particular category within the new system of art-historical classification. From now on museums would feel obliged to possess works illustrating key moments of that history. Hence the competition to own a painting by Raphael or a classical Greek statue. The new art-historical programme partially democratized artistic experience since in theory anyone could learn the system of classification and the unique characteristics attributed to each school and each master. Without the museum, the discipline of art history, as it has evolved over the last two hundred years, would be inconceivable. Viewed historically, art history appears as a necessary and inevitable component of the public museum.

Germain Bazin and Neils von Holst have described the invention of art history and the role it plays in structuring the museum experience as a product of Enlightenment thought.[33] To be sure, art history rationalizes the experience of art. But it signals more than a new intellectual style. With art history, the middle class could appropriate the experience of art and put it to its own ideological uses. In the museum, whatever meaning a work of art owed to its original context was lost. Now a part of the museum's programme, it could only appear as a moment of art history. For the middle class, cultural achievement and individual genius were the essence of human history. The history of art – primarily understood as the history of artists – demonstrated the claim that history was the history of great men. The museum, organized as an art-historical monument, not only made this claim visible, it also enforced it as a universal truth: as defined by art history, art could speak *only* of individual genius and achievement. The museum thus institutionalized the bourgeois claim to speak for the interests of all mankind. In theory, the spiritual wealth it contained belonged to everyone. The museum gave substance to the theory by making that wealth accessible to anyone who cared to see it. Even though not everyone went to the museum, and, of those who did go, not everyone could grasp the spiritual meanings of the art, it could be said that the *values* celebrated in the museum's programme 'belonged' to everyone. Finally, art history could justify in the name of humanity the appropriation and exhibition of art by the state: since art appeared as art history only in the museum, and since only art history made visible the spiritual truths of art, the museum was its only proper repository.[34]

The public art collection also implies a new set of social relations. A visitor to a princely collection might have admired the beauty of individual works, but his relationship to the collection was essentially an extension of his social relationship to the palace and its lord. The princely gallery spoke for and about the prince. The visitor was meant to be impressed by the prince's virtue, taste and wealth. The gallery's iconographic programme and the splendour of the collection worked to validate the prince and his rule. In the museum, the wealth of the collection is still a display of national wealth and is still meant to impress. But now the state, as an abstract entity, replaces the king as host. This change redefines the visitor. He is no longer the subordinate of a prince or lord. Now he is addressed as a citizen and therefore a shareholder in the state. The museum does this not in an explicit fashion but symbolically. It displays spiritual wealth that in theory belongs to everyone – or rather spiritual wealth that is publicly owned through the medium of the state. Because the

state is abstract and anonymous, it is especially in need of potent and tangible symbols of its powers and attributes. Art can be used to realize the transcendent values the state claims to embody. It can make good the state's claim to be the guardian of civilization. It lends credibility to the belief that the state exists at the summit of mankind's highest attainments. In the museum, the visitor is not called upon to identify with the state *per se* but with its highest values. The visitor inherits this spiritual wealth but only on the condition that he lay claim to it in the museum. Thus the museum is the site of a symbolic transaction between the visitor and the state. In exchange for the state's spiritual wealth, the individual intensifies his attachment to the state. Hence the museum's hegemonic function, the crucial role it can play in the experience of citizenship.

From the beginning, the museum's role in securing state power was well understood. In response to the ideological threat of the French Revolution, states throughout continental Europe quickly moved to establish their own national museums. For example, in Prussia the foundation of a museum was considered at the highest levels of government. In the 'Riga Memorandum' of 1807, the Prussian minister von Altenstein advised the king that 'the fine arts are the expression of the highest condition of mankind' and that the state has the duty to make them accessible to everyone.[35]

Because it belongs to the nation and therefore to all citizens, the museum helps foster the illusion of a classless society. Of course, there is almost always a contradiction between the ideal visitor as defined by the museum and the actual visitor. While in theory the visitor possesses a share in the spiritual wealth of the nation, in practice his possession of that wealth is dependent upon his class, sex and cultural background.[36] To lay hold of that wealth requires the education and leisure available only to a narrow elite. The museum prompts the visitor to identify with an elite culture at the same time it spells out his place in the social hierarchy. As the sociologists Pierre Bordieu and Alain Darbel have observed,

> Even in their smallest details . . . museums reveal their real function, which is to reinforce among some people the feeling of belonging and among others the feeling of exclusion.[37]

The Louvre

The Louvre is the largest and most influential of the universal survey museums, the prototype for scores of national galleries and municipal art museums. Despite its rivals in both Europe and America, it is still the biggest and the best of its type. Even though it has been altered, expanded and reorganized many times, it still embodies most fully the values and beliefs that inspired the first universal survey type. As it stands today, the Louvre not only preserves that early moment of bourgeois ideology, it also testifies to its continuing relevance in contemporary society. This part of our paper traces the experience of an ideal visitor to the Louvre – the visitor as defined by the museum's ritual script.[38]

The Denon Pavilion – the museum's main entrance – begins the ritual. From the outset the visitor faces impressive spaces and grand vistas. The architecture with its allusions to classical antiquity and the Italian and French Renaissance provides the historical framework for the museum's iconographic programme. The visitor enters the vestibule and proceeds to the Daru Gallery, which is lined with Roman sculpture including a statue of Augustus to the left of the entrance.

This gallery is the prologue. It performs several functions. The classical sculpture and the classicizing architecture address visitors and simultaneously define them as members of a larger community – the nation – which has inherited and maintained the legacy of Western civilization. The idea of community is inherent in the architecture. In the Louvre, visitors are drawn along marked axes and through monumental halls and corridors designed for the reception of crowds. In other words, the architecture prompts one to join, along with everyone else, a ceremonial procession through the museum.

The Daru Gallery ends in a grand staircase. This staircase is perhaps the most critical and ideologically-laden moment in the entire museum ritual. Under Napoleon, the architects Percier and Fontaine constructed an ornate monumental staircase, reluctantly torn down when the Louvre was enlarged under Napoleon III. The architect Lefuel submitted eight plans to the Emperor before the present staircase was approved. He was aware, as he later said, that the rejected plans were not impressive enough and did not fulfil the complicated set of tasks the stairway had to perform.[39]

Before the visitors reach the foot of the staircase, they see the *Victory of Samothrace* magnificently framed in an archway. The statue marks the end of the prologue and the first major moment in the ritual walk. After this, one may go in one of several directions, but everyone is first confronted with the *Winged Victory.*

At the staircase's first landing, visitors face a number of possible routes. Here they may descend back to the ground floor collection of ancient Greek and Roman art, where a long corridor leads to the *Venus de Milo*, another culminating moment in the iconographic programme. If they climb the grand staircase to the *Victory*, as most people do, they must again choose their route. The stairs to the left of the *Victory* lead to the Rotunda of Apollo where they can either go on to the collection of Greco-Roman and Egyptian antiquities in the Old Louvre or enter the Apollo Gallery with its crown jewels. The stairs to the right of the *Victory* take them to the Percier, Fontaine and Duchâtel rooms which connect with the Salon Carré, where French Renaissance painting is displayed. These rooms, built as part of the Musée Napoléon, are mainly devoted to Italian Renaissance art and form a connecting link between classical antiquity and French painting. As visitors pass through them, they can look down at examples of Roman sculpture and mosaics in the Court of the Sphinx below. These loggia-like rooms constitute one of several north–south bridges linking the Grand Gallery, on the river side, to the Louvre of Napoleon II. Like the Daru staircase, these bridges are connecting points in more than a physical sense. The Salle des États, the largest and most central, holds the Louvre's most important Italian old masters – Raphael, Titian, Veronese, Correggio and, above all, Leonardo, whose *Mona Lisa*, enshrined in a bullet-proof case, is the focus of the room if not of the entire museum. Our point is that no matter which route visitors take, within a few minutes they experience an iconographic programme in which the heritage of antiquity and the Renaissance leads to French art.

French painting is organized chronologically. It begins in the Salon Carré, which contains fifteenth- and sixteenth-century works, and continues into the Grand Gallery. This impressive space, its niches embellished with Roman statues, begins with French painting from the seventeenth century – Poussin, Le Brun, Le Nain – and continues through the eighteenth century up to the time of the Revolution. A final section of the Grand Gallery contains Italian primitives; but at that point visitors must choose between going on through the Grand Gallery and following the French school, which makes a right turn. A series of rooms devoted to eighteenth-century

French painting takes one around to the third side of the rectangle and to the beginning of an axis that runs through three enormous rooms and ends with the *Winged Victory*. In these rooms one walks through the history of monumental French painting from the Revolution to the mid-nineteenth century – David, Gros, Géricault, Ingres, Delacroix, Courbet – the last paintings in the grand tradition, the tradition that began in the Italian Renaissance.

Looking back as one exits these galleries, the view from the *Winged Victory* sums up the circuit. This is the heart of the iconographic programme. There are other important ceremonial statements elsewhere in the Louvre, for example the Hall of the Caryatids or the cycle of history paintings Rubens created for Marie de' Medici, displayed in a monumental space beyond the Grand Gallery. But the great classical moments of the past – Greece, Rome and the Renaissance – take priority and will be seen in parallel and linked relationships to each other and to France even by the visitor who comes only for a brief tour. No one can miss the point of the iconographic programme: France is the true heir of classical civilization. The visitor may not be prepared to articulate this idea; but this is the meaning written into the museum's iconographical programme and lived in the visitor's ritual walk. From the central landing at the base of the *Winged Victory*, the programmatic juxtaposition of the French grand tradition of painting and the Greco-Roman sculptural tradition provide the ritual's grand finale.

The Louvre's iconographic programme thus dramatizes the triumph of French civilization. In the context of the museum, the *Winged Victory* symbolizes that triumph. She stands for France Victorious – the everlasting triumph of the nation and the state, presented in the guise of the triumph of culture.

So far, we have confined our observations to the general character of the architectural spaces and the way in which the collections unfold around the museum's main entrance. But the Louvre's iconographic programme involves more than the collections and their arrangement. Because of the ideological importance of the site, every regime, beginning with the First Republic, lays claim to the museum, first by renaming it – the Musée de la République, the Musée Royale, etc. – and then by inscribing its signature on the museum's walls and ceilings. With the Republic, all marks of royalty were removed and, when possible, replaced with ears of wheat, rosettes and other republican symbols.[40] Under Napoleon, Percier and Fontaine created sumptuous decorative schemes overflowing with imperial insignia. In the Grand Gallery, newly decorated for Napoleon's marriage to Marie-Louise, imperial eagles decorated the arches. The Hall of the Caryatids, left unfinished by the *Ancien Régime*, was now completed with the addition of an elaborate marble fireplace incorporating figures attributed to the sixteenth-century sculptor Jean Goujon. The fireplace also displayed Napoleon's initial, sets of trophies and, above, a portrait of the Emperor with the imperial eagle. With the Restoration, the Bourbons immediately set to work removing the more obvious reminders of Napoleon's reign. Fleurs de Lys reappeared, for example in the former apartments of Anne of Austria, and Percier and Fontaine obligingly changed certain features of Napoleon's fireplace: the N turned into an H (for Henri II), and the head of Napoleon became a Jupiter (later removed). The tradition of signing walls and ceilings continued. The Second Republic left its mark, among other places, on the new ceilings of the Hall of Seven Chimneys. Under Napoleon III, Ns once again proliferated. The Third Republic was not very zealous about removing the Ns but it did remove an 1862 tapestry of Napoleon III as builder of the Louvre from the Apollo gallery.[41]

Aside from the insignia, the Louvre has always deliberately preserved and perpetuated older practices of architectural decoration. As in traditional ritual structures, ceiling decorations play a major role. In older monuments, the roof or ceiling was often reserved for the representation of the powers that presided over the building – the gods in the pediment of a Greek temple, the figure of the Pantocrator looming out of the dome of a Byzantine church, or an allegory of the prince's virtue, wisdom and generosity on the ceiling of a Renaissance or Baroque palace. In the ceremonial space, the presiding earthly power is translated into heavenly power; hence the frequency of sky imagery in pediments and on roofs and ceilings.

Since the Louvre's transformation from palace to museum, an enormous amount of attention has been given to the ceilings. Old decorations have been restored or adapted to new programmatic uses (most notably in Napoleon's Museum of Antiquities);[42] new ceiling decorations have been created and, in some cases, later suppressed. These ceiling campaigns were, in their different ways, dedicated to the same end: they made visible the state power presiding over the museum's ceremonial space.

In traditional princely iconography, the ruler claimed, among other things, the special favour of the gods and the legacy of illustrious predecessors; he had himself portrayed as benefactor of the arts and protector of civilization. Such imagery was a common feature of the Old Louvre, for example, Michel-Ange Challe's allegorical ceiling representing *Louis XV as Protector of the Arts*, now in Fontainebleau.[43] With Louis XVI's downfall, the new state inherited the monarchy's need for ideological self-justification, but it also had to distinguish itself from the monarchy. In other words, it occupied the place of the monarch while trying not to look like the monarch. Thus on the ceilings of the Louvre the old forms reappear wearing new costumes. The prince's heritage is now the heritage of Western civilization, while the state, formerly identified with the person of the king, now appears as La France, as in Meynier's ceiling, *France in the Guise of Minerva Protecting the Arts*. This painting embellished the ceiling above the grand staircase of the Musée Napoléon. Although the staircase was demolished, the painting still occupies its original ceiling (now in the Fontaine room). An especially telling example of La France is Gros' ceiling, *The Genius of France Giving Life to the Arts and Protecting Humanity*, in the Musée Charles X. This painting was commissioned to replace an earlier work by the same artist which celebrated Charles X's princely generosity. The earlier work was entitled *The King Bestowing upon the Arts the Musée Charles X*.[44]

Whoever claimed state power also claimed the ceilings. After 1830, Gros' first effort would no longer do, not only because Charles X had been forced to flee France but also because this type of princely iconography was now outmoded – at least for the moment. Louis-Phillipe, the new monarch, wanted to be known as the citizen king. Gros' old ceiling had reclaimed the Louvre as an extension of the royal palace. The new work reinstated it as a public museum, the collective property of the nation. The question of who owned the Louvre – the people or the ruler – would not be clearly settled politically or on the museum ceilings for some time to come. Later in the century, in the Louvre of Napoleon III, palace functions would once again be emphasized. In the newly built Salle des États, where the Emperor convened the Legislative Assembly with great pomp and ceremony, the ghosts of Charlemagne and Napoleon I, together with the figure of La France, would watch over the proceedings from the ceiling and walls. When the Emperor fell, his ceiling came down with him. The Salle des États was taken over by the museum in the '80s and given elaborate new decorations honouring the French school.[45]

The imagery of the Old Louvre palace could also serve the ideological needs of the Republican state. In 1848, the Second Republic voted funds to restore and complete the decoration of the Apollo Gallery – the gallery had been only partially decorated by Le Brun in the seventeenth century.[46] The decoration of the monumental rotunda next to the gallery was finished in the eighteenth century and was also dedicated to Apollo, the god with whom Louis XIV was identified. The Second Republic commissioned from Delacroix a new ceiling, *The Triumph of Apollo*, and the two rooms became a sumptuous memorial to the Sun King. By appropriating the image of Apollo, the Republic appropriated French history and proclaimed itself as the guardian of the nation and its heritage. The Republic, in the guise of Louis-Apollo, now occupied the ceilings as a bringer of light, order and civilization. The prince's civilizing mission now became the mission of the French state.

This theme unifies the museum's entire iconographic programme. While many ceilings emphasize the state's role with insignia or allegories of monarchs or the figure of France encouraging and protecting the arts, others focus on the arts themselves and their historical development. In the nineteenth century, the history of art increasingly came to stand for humanity's highest achievements. The idea of civilization became identified with the history of high culture, and high culture was taken as tangible evidence of virtuous government. In the museum, art history began to supplant the history of the state.

An early example of this kind of iconography is the ceiling of the Rotunda of Mars, formerly the main entrance of the Musée Napoléon. The theme chosen was the history of sculpture. The museum commissioned *The Origins of Sculpture, or Man Modelled by Prometheus and Given Life by Minerva* for the centre of the ceiling. Lower down, four medallions were dedicated to the principal schools: Egypt, Greece, Italy and France. In 1884, a similar programme was created for the Daru staircase. The two central cupolas were devoted to antiquity and the Renaissance. Allegorical figures of the schools filled the pendentives while the medallions were dedicated to representative great masters: Phidias, Vitruvius, Raphael, Poussin and others. Smaller cupolas celebrated other schools – the Dutch, the English, Post-Renaissance France and so on.

The Second Republic commissioned two even more conspicuous ceilings devoted to the history of art. The Salon Carré, which had been used to exhibit modern French art was turned into a gallery of masterpieces from different schools. An elaborate programme with allegorical figures executed in gilded stucco celebrated great masters whose names were inscribed on the supporting frieze. Nearby, the Hall of Seven Chimneys was being turned into a 'Salon Carré' of the modern French school with an equally elaborate Neo-baroque ceiling that included fourteen winged figures holding crowns set between hexagons containing the profiles of such artists as Gros, David and Géricault as well as the architect Percier. In 1886, the theme of French art appeared with even more ostentation on the ceiling of the Salle des États.[47]

The Salle des États' ceiling and the Daru staircase mosaics bring us to the modern museum. In the twentieth century, both programmes were suppressed and the ceilings left bare.[48] This final development is consistent with the evolving ideology of the earlier ceilings. As we have seen, the ceilings portrayed a state whose benevolence was demonstrated by the patronage and protection it offered the arts. The ceilings proposed an equation between the goodness of the state and the cultivation of the arts. In the nineteenth century, the first term of the proposition – the state – began to disappear from the ceilings, and the second term, elaborated as art history, was then used to imply the missing first term. As familiarity with art history became increasingly

widespread, the ceilings' allegorical lessons in art history became superfluous. Consequently, the second term of the proposition could also be suppressed. Now both terms of the original proposition – the state and what it gives – are implied. The modern visitor touring the museum thus enacts the state ceremony subliminally.

Today's visitor to the Louvre seldom looks up to read the messages inscribed on the ceilings. The ceilings are now of interest only to the extent that they belong to the history of art. Ingres' *Apotheosis of Homer* exemplifies this change. Originally painted for the Musée Charles X, in 1855 it was removed from its ceiling and added to the museum's collection of modern French masters.[49] Of course a visitor might make a point of looking at Delacroix's *Triumph of Apollo*, not as an emblem of the state but as a moment in the history of art.[50]

The Louvre collection now does its work unaided by commentary from above. What the visitor sees is the idea of civilization spelled out in terms of national schools and individual artists. In these terms, the history of art boils down to a celebration of national and individual genius. The idea of artistic genius has a long history but only becomes a dominant idea in the middle-class societies of the nineteenth century. It is nineteenth-century individualism that inscribes the names and images of artist-geniuses on the Louvre's ceilings. And it is the nineteenth century that writes art history in almost purely biographical terms. Individual genius is celebrated at the Louvre as perhaps nowhere else, epitomized by the way Leonardo's *Mona Lisa* is enshrined, and demonstrated, again and again, by the world-famous masterpieces that line the museum's walls – or rather, masterpieces made world-famous by the Louvre and by art history.

Indeed, as art history still insists, works of art are little more than evidence of individual genius mediated by national spirit. The museum environment forces the experience of art into its art-historical mould and generally excludes other meanings. Stripped of all references to their original function, portraits, altarpieces, allegorical statues and other artefacts become individual cultural triumphs, each labelled with special attention to the artist, his dates and nationality. Even when the artist's name has been forgotten, his 'hand' is carefully distinguished, and he enters art history and the museum as a recognizable 'master'. The museum thus certifies individualism as a primary and universal value. Having idealized history as the history of high culture, it further defines the nation's cultural heritage as a record of unique and individual achievement.

In summary, the Louvre embodies the state and the ideology of the state. It presents the state not directly but, as it were, disguised in the spiritual forms of artistic genius. Artistic genius attests to the state's highest values – individualism and nationalism. It demonstrates the nation's historical destiny and the state's benevolence. As a ritual structure the Louvre is complex because it must reconcile the reality of the state's varying historical fortunes with an ideal history. On the one hand, it is a monument to imperial claims that portray France as principal heir to civilization's highest achievements. On the other hand, it extols a republican nationalism that acknowledges other nations. The museum glorifies France and it transcends France in its celebration of universal genius. Its final claim, however, is that the universal is embodied in the state.

The Universal Survey Museum in America

In the nineteenth century, when other nations began to feel that a public art museum was a pressing ideological need, they naturally turned to the example of the Louvre.

The Louvre's architecture was imitated in one of America's earliest museum buildings, Washington's Renwick Gallery, begun in 1859.[51] But because the new museums were usually built from scratch, it was not the Louvre's architectural style (so closely associated with French history) but rather its ceremonial programme that they emulated. The architects who designed the new museums used a variety of architectural styles to evoke the theme of civilization.[52] Greek, Roman and Italian Renaissance forms proved almost equally serviceable. In 1815, Leo von Klenze presented Ludwig of Bavaria with a choice of these three styles for the Munich Glyptothek.[53]

Besides the problem of finding appropriate styles, nineteenth-century museum architects also faced the problem of organizing the museum's interior as a new type of ritual space. Often, museum spaces were arranged around a central Pantheon-like rotunda, an atrium, or some other monumental space recalling a classical prototype. This central space was the beginning and end of the ritual walk through the galleries to the right and left. Such architectural practices, originating in Europe and later common on both sides of the Atlantic, would dominate museum design until World War II.

The idea for a universal survey museum for New York was first proposed by John Jay, an eminent lawyer, at a Fourth of July party held in Paris in 1866.[54] The date as well as the place are significant. With the triumph of industrial capital in the Civil War and the consolidation of the United States as a modern nation-state, the Americans, talking in the shadow of the Louvre, felt the United States could now put in its claim to the heritage of Western civilization. Three years later, at a meeting of three hundred prominent New Yorkers, William Cullen Bryant, president of the museum's organizing committee, set forth the reasons for founding a museum in New York.

> Our city [he said] is the third greatest city in the civilized world. Our republic has already taken its place among the great powers of the earth; it is great in extent, great in population, great in the activity and enterprise of her people. It is the richest nation in the world. [With a museum of art] we might have, reposited in spacious and stately buildings, collections formed of works left by the world's greatest artists which would be the pride of our country.[55]

National pride was a critical issue. Even small and weak European nations, like Saxony, had museums, Bryant noted. Spain, he said, 'a third-rate power of Europe and poor besides [has] a Museum of Fine Arts at her capital, the opulence and extent of which absolutely bewilder the visitor. [Belgium and Holland] have their public collections of art, the resort of admiring visitors from all parts of the civilized world.'[56]

Bryant spoke for some of America's wealthiest and most powerful industrialists. By proposing to establish a museum that would compete with the Louvre and the other great museums of Europe, they were not simply asserting national pride. They were also calling for the creation of a monument that would equate their interests with those of the public and symbolize their class's domination of the state. The relationship between this group of citizens and the state was implied in the way the museum was to be owned and administered. Public would mask private – or try to. The museum building would be located on city land and owned by the city. However, the museum collection would be owned and controlled by the concerned citizens who made up its board of trustees.[57]

The first museum building, designed in an Italian Gothic style and opened in 1880, was expanded and then finally hidden behind a monumental Roman revival structure designed in the 1890s. With millionaire backers, the building of the museum edifice was easily accomplished. Acquiring an impressive collection proved more difficult. In its early years, an assortment of American Neo-classical sculpture filled the museum's monumental entry hall, supplementing the meagre holdings of Greek and Roman works. It was not until the 1920s that the museum became, through numerous gifts and benefactions, a world contender. Only then did it realize the ceremonial programme implicit in its grandiose façade.[58]

Visitors to the museum reach the entrance by climbing a monumental staircase. The Neo-imperial façade proclaims the importance of the Greco-Roman tradition. This theme continues in the interior. Entering the Great Hall, the visitor stands at the intersection of the museum's principal axes. To the left is the collection of Greek and Roman art; to the right, the Egyptian collection. Directly ahead, at the summit of a grand staircase that continues the axis of the entranceway, is the collection of European painting beginning with the High Renaissance. Canova's statue of *Perseus*, based on the *Apollo Belvedere*, provides the classical accent. The Metropolitan's iconographic programme establishes at the outset the overriding importance of the Western tradition, starting with Egypt, continuing with Greece and Rome, and climaxing with the High Renaissance. The collections of Oriental and other types of non-Western art, as well as the Medieval collection, are invisible from the Great Hall.

The Metropolitan was built in the epoch of the Spanish-American war – a time when the United States was embarking upon a course of overseas conquests. Like other public monuments of the period – for example, Penn Station in New York, designed as a replica of the Baths of Caracalla – the museum symbolized the new imperialist ideology. Like the Louvre, the Metropolitan was a monument to the state, but it attested to a different national history. There was no need for the state to sign the ceilings since the building's official architectural style already stamped them with the seal of the state. In effect, the ceilings were signed by the invisible hand of the state. But if the state is now anonymous, the wealthy citizens whose gifts the museum houses, are not. Plaques and doorway inscriptions serve as reminders of their donations.

On the Metropolitan's façade, as in the Louvre, art history replaces the actual history of the state. Caryatids symbolize painting, sculpture, architecture and music, while medallions celebrate artistic genius: Bramante, Dürer, Michelangelo, Raphael, Velazquez and Rembrandt.

The Metropolitan was America's first great universal survey museum. The National Gallery in Washington, D.C., completed in 1941, was the last. It represents perhaps the most complete realization of the universal survey museum idea in America. Earlier public art museums began with impressive buildings and little more. The National Gallery began with magnificent collections of painting. The museum was the creation of Andrew W. Mellon, a former Secretary of the Treasury and an avid art collector. Mellon persuaded fellow millionaires Chester Dale, Joseph E. Widener and Samuel H. Kress to donate hundreds of outstanding works. He also chose the architect and paid for the building. When Mellon promised the museum to a grateful U.S. government, an act of Congress stipulated that a self-perpetuating board of trustees would run it.[59]

If the Washington National Gallery is the last important universal survey museum, it also recalls, in the purity of its design, the first museums of the eighteenth and nineteenth centuries. John Russell Pope's cool, utterly impersonal Neo-classical

design, in combination with the logical arrangement of the collection, epitomizes the idea of the universal survey museum. The building, reminiscent of von Klenze's and Schinkel's designs, is a Pantheon flanked by two windowless wings. Everywhere, clean marble surfaces emphasize the structure's heavy, abstract shapes and enforce a mood of ritual solemnity. Compared to the older, gaudier temple fronts along the Washington Mall, the National Gallery communicates the idea of the state as a pure, almost frozen abstraction outside of time and beyond the accidents of history. This museum, which could be anywhere in the Western world, claims the heritage of Greco-Roman civilization as an abstract and universal value.[60] All this is so blatantly written into the architecture itself that a collection of Renaissance and post-Renaissance art is all that is needed to complete the building's ritual meaning. The absence of Greek and Roman art goes unnoticed.

The iconographic programme follows a relatively strict historical sequence, beginning with Renaissance Italy in Room One and ending with nineteenth-century France in Room Ninety-three. Visitors are given maps and guidebooks which reinforce the architectural programme. Inevitably, visitors begin in Room One, right off the Rotunda, and make their way along the historical mainstream. The installation asserts the importance of the entire collection. Only a small number of works are allowed in each room. They appear in the midst of rich but highly restrained decorative schemes. Every work is presented as a masterpiece, but some works, framed by doorways or hung along major axes, are given greater emphasis within the overall scheme. One work in particular is proclaimed supremely important. Leonardo da Vinci's *Portrait of Ginevra de' Benci* appears in isolation on a free-standing, velvet covered wall located on an axis that runs through two doorways and terminates in a large niche directly behind the painting. Visitors experience this work as a culminating moment in the history of Renaissance art and – despite the inevitable comparison with the *Mona Lisa* – as a high point in the history of Western art. According to the guidebook, 'this early work is the only painting in the Western hemisphere accepted by scholars as indisputably by Leonardo, one of the true geniuses of the Renaissance'.[61] As the Louvre and the London National Gallery attest, nothing better than the genius of Leonardo certifies the claim to civilization and universality.

Notes

1 Michael Compton speaking at a symposium of museum curators in 'Validating Modern Art', *Artforum*, January 1977, p. 52.
2 New York *Times*, 5 June 1979.
3 See Nikolaus Pevsner, *A History of Building Types*, Princeton, 1976, pp. 111–38.
4 Ranuccio B. Bandinelli, *Rome, the Center of Power, 500 B.C. to A.D. 200*, trans. Peter Green, New York, 1970, *passim*: Germain Bazin, *The Museum Age*, trans. Jane van Nuis Cahill, New York, 1967, pp. 12–34; and William L. McDonald, *The Pantheon*, Cambridge, Mass., 1976, pp. 125 f.
5 Bandinelli, *op. cit.*, pp. 36–8.
6 Christiane Aulanier, *Histoire du Palais et du Musée du Louvre*, Paris 1945–64, II, p. 42, and VII, p. 87; Cecil Gould, *Trophy of Conquest, The Musée Napoléon and the Creation of the Louvre*, London, 1965, pp. 30–9; and André Blum, *Le Louvre, du Palais au Musée*, Geneva, Paris and London, 1946, pp. 160 f.
7 Aulanier, *op. cit.*, II, pp. 55–6.

8 The symbolism went unnoticed when the wing opened in May 1975. However, critics were almost unanimous in their condemnation of what one of the museum's own trustees called 'a monument to human vanity'. See Grace Glueck, 'Lehman Collection Opens for Private Viewing', New York *Times*, 13 May 1975.

9 Giulio C. Argan, *The Renaissance City*, New York, 1969, pp. 22–9; and McDonald, *op. cit.*, pp. 87–132.

10 For a critical sociological study of the museum public, see Pierre Bordieu and Alain Darbel, *L'Amour de l'art: les musées d'art européens et leur public*, Paris, 1969.

11 Victor Turner, 'Frame, flow and reflection: ritual drama in public liminality', in Michael Benamou and Charles Carmello (Eds), *Performance in Post-Modern Culture*, Milwaukee, 1977, pp. 333–55, and *The Ritual Process*, Ithaca, 1977, pp. 94 ff.; and Arnold van Gennep, *The Rites of Passage*, trans. Monika B. Vizedom and Gabrielle L. Caffee, Chicago, 1960.

12 Frank E. Brown, *Roman Architecture*, New York, 1961, p. 10.

13 *The Autobiography of Johann Wolfgang von Goethe*, trans. John Oxenford, New York, 1969, pp. 346 f. Bazin, *op. cit.*, p. 160, noting this new religious attitude towards art, writes: 'No longer existing solely for the delectation of refined amateurs, the museum, as it evolved into a public institution, simultaneously metamorphosized into a temple of human genius.' See also Niels von Holst, *Creators, Collectors and Connoisseurs*, trans. Brian Battershaw, New York, 1967, pp. 215 f.

14 For examples, see Thomas W. Lyman, 'Theophanic iconography and the Easter liturgy: the Romanesque painted program at Saint-Sernin at Toulouse', in Lucius Grisebach and Konrad Renger (Eds), *Festschrift für Otto von Simson zum 65 Geburtstag*, Frankfurt, 1977, pp. 72–93; O. K. Werckmeister, 'The lintel fragment representing Eve from Saint-Lazare, Autun', *Journal of the Warburg and Courtauld Institutes*, XXXV, 1972, pp. 1–30; and Andrée Hayum, 'The meaning and function of the Isenheim altarpiece: the hospital context revisited', *Art Bulletin*, LIX, 1977, pp. 501–17.

15 The museum devoted to modern art is the latest museum type. Modern art museums reflect the ideological needs of a later phase of Western society and have developed ritual forms that differ sharply from the older, more common universal survey museum. The older type celebrates an ideal of civilization based upon belief in an objective external world and a tradition of humanistic values. The newer museum negates traditional values and the importance of external reality. With its more intense ritual, it celebrates subjectivity and alienated experience. See Carol Duncan and Alan Wallach, 'The museum of modern art as late capitalist ritual: an iconographic analysis', *Marxist Perspectives*, I, Winter, 1978, pp. 28–51.

16 Bazin, *op. cit.*, pp. 158 f., 162 f.; von Holst, *op. cit.*, pp. 171, 205–7.

17 Bazin, *op. cit.*, pp. 129 ff.; von Holst, *op. cit.*, pp. 95–139 and *passim*; and Hugh Trevor-Roper, *Princes and Artists, Patronage and Ideology at Four Hapsburg Courts, 1517–1633*, London, 1976.

18 Bazin, *op. cit.*, pp. 198 f.; von Holst, *op. cit.*, pp. 228 f.; and Pevsner, *op. cit.*, pp. 124 f.

19 Bazin, *op. cit.*, p. 215.

20 *Ibid.*, pp. 150 f.; Blum, *op. cit.*, pp. 115 f.

21 De la Font de Saint-Yenne, *Réflexions sur quelques causes de l'état présent de la peinture en France*, The Hague, 1747 (Collection Deloynes, Bibliothèque Nationale, Paris), II, pp. 69–83.

22 Jean Locquin, *La Peinture d'histoire en France de 1747 à 1785*, Paris, 1912, pp. 41–68; Blum, *op. cit.*, pp. 133 ff. For the ideological needs of the crown see Albert Boime, 'Marmontel's *Belisaire* and the Pre-Revolutionary Progressivism of David', *Art History*, III, March 1980, pp. 81–101.

23 Blum, *op. cit.*, pp. 147 ff.; Alexander Tuetey and Jean Guiffrey (Eds), *La Commission de Muséum et la Création du Louvre (1792–1793)*, Paris, 1909 (Archives de l'Art français, III), *passim*.

24 Blum, *op. cit.*, pp. 151 f. See also Tuetey and Guiffrey (Eds), *op. cit.*, for numerous statements by government and museum officials about the symbolic and political importance of the new museum.

25 Blum, *op. cit.*, p. 153.

26 Trevor-Roper, *op. cit.*; Thomas da Costa Kaufmann, 'Remarks on the collections of Rudolf II: the Kunstkammer as a form of representation', *Art Journal*, XXXVIII, Fall 1978, pp. 22–8; and Kurt W. Foster, 'Giulio Romano's "Museum" of sculpture in the Palazzo Ducale at Mantua', paper delivered at the Annual Meeting of the College Art Association of America, 1978, New York City.

27 von Holst, *op. cit.*, pp. 111–68; and Bazin, *op. cit.*, pp. 129–39.

28 Kaufmann, *op. cit.*

29 Bazin, *op. cit.*, pp. 72–4; von Holst, *op. cit.*, pp. 96–8.

30 Bazin, *op. cit.*, pp. 157–9; von Holst, *op. cit.*, pp. 205–7.

31 In Bazin, *op. cit.*, p. 159.

32 In *ibid.*

33 Bazin, *op. cit.*, pp. 141–67; and von Holst, *op. cit.*, pp. 204–14.

34 In the twentieth century, this highly political use of art is often rationalized in the name of pure, disinterested aesthetics. See, for example, Jean Cassou, 'Art museums and social life', *Museum*, II, no. 3, 1949, pp. 155–8. Cassou argues that art is most 'free' and therefore most itself in the museum precisely because it is liberated from all but its purely 'artistic' meaning. Still, politics slips back into the argument since art can reveal its essential neutrality only in modern liberal states that create museums. André Malraux, *Museum Without Walls*, trans. Stuart Gilbert and Francis Price, Garden City, 1967, pp. 9–10, also observes that museums strip art of its previous functions and, like Cassou, fails to see the new social and political meaning art acquires in the museum. However, Malraux regrets the apparent neutrality of the museum context.

35 In von Holst, *op. cit.*, p. 230.

36 Bordieu and Darbel, *op. cit.*, *passim.*

37 *Ibid.*, p. 62.

38 The Louvre's iconographic programme has varied little in essentials since World War II. However, the museum is constantly in the process of renovating its galleries and reshuffling its collection. This results in slight changes of emphasis in the programme. Our analysis assumes the installation that was in place in the spring of 1980.

39 Aulanier, *op. cit.*, IV, p. 35.

40 *Nouvelles Archives de l'Art française*, Ser. 3, XVII, 1901 (Procès-Verbaux de la Commission des Monuments, I, 8 November 1790–27 August 1793), pp. xviii–xx, 349–50; Tuetey and Guiffrey (Eds), *op. cit.*, p. 332.

41 Aulanier, *op. cit.*, I, pp. 20, 22, plate 36; IV, plates 4 and 5; VI, pp. 62 f., 69.

42 *Ibid.*, V, p. 70.

43 *Ibid.*, VII, p. 75 and plate 30.

44 *Ibid.*, VIII, pp. 36, 50 and plate 24.

45 *Ibid.*, III, pp. 81 ff.

46 *Ibid.*, VII, pp. 96 ff.

47 *Ibid.*, II, p. 66 (for the Salon Carré); VII, p. 98 (for the Hall of the Seven Chimneys); III, pp. 88–9 (for the Salle des États). The new programme of 1886 consisted of medallions with portraits of Claude Lorrain, Lesseur, Rigaud, Boucher, Poussin, etc. The figure of *France ançienne*, flanked by Jean Cousin and François Clouet presided over one end of the Salle; at the other end, *France nouvelle* flanked by Delacroix and Ingres. See wood engravings by E. A. Tilly and A. Normand, and Ch. M. [*sic*], 'La Nouvelle Salle de l'École Française au Louvre', *L'Illustration*, LXXXVIII, 30 October, 1886, pp. 288 f., 292, 296.

48 Aulanier, *op. cit.*, IV, p. 38; and Germain Bazin, 'Musée du Louvre: La Salle des États', *Museum*, V, no. 4, 1952, p. 204.

49 Aulanier, *op. cit.*, VIII, p. 51.

50 The official guidebook directs the visitor's attention to Delacroix's ceiling (*Le Louvre* [Petits Guides], Paris, 1978, p. 14).

51 See Nathaniel Burt, *Palaces for the People, A Social History of the American Museum*, Boston, 1977, pp. 58–9.

52 Pevsner, *op. cit.*, pp. 111–38.

53 *Ibid.*, pp. 124–6; and von Holst, *op. cit.*, pp. 228 f.

54 See Winifred E. Howe, *A History of the Metropolitan Museum of Art*, New York, 1913, I, pp. 99 f.; Burt, *op. cit.*, pp. 86 f.; and Calvin Tomkins, *Merchants and Masterpieces*, New York, 1973, pp. 28 f.

55 In Howe, *op. cit.*, I. pp. 104 f.

56 *Ibid.*, p. 105.

57 See Howe, *op. cit.*, pp. 175–81; Tomkins, *op. cit.*, pp. 38–41; Daniel M. Fox, *Engines of Culture, Philanthropy and Art Museums*, Madison, 1963, pp. 40–2.

58 Tomkins, *op. cit.* pp. 121–5, details the history of the museum's acquisitions. See also Howe, *op. cit.*, II, *passim.*

59 See David Edward Finley, *A Standard of Excellence, Andrew W. Mellon Founds the National Gallery of Art at Washington*, Washington, 1973, pp. 53–5.

60 Otto R. Eggers and Daniel Paul Higgens, the architects who executed Pope's design, claimed, somewhat defensively, that the National Gallery was 'built in the thought that it may serve its purpose for many centuries' (cited in 'Marble Marvel', *The Architects' Journal*, LXIII, 5 June 1941, p. 370). Most contemporary critics believed the design represented the Beaux Arts tradition's swan-song. Many thought the building 'lifeless'. See, for example, Lorimer Rich, 'A Study in Contrasts', *Pencil Points*, XXII, August 1941, p. 499.

61 *Brief Guide: National Gallery of Art*, Washington, 1979, p. 6.

Chapter 4 | Donald Preziosi

Brain of the Earth's Body | Museums and the Framing of Modernity

You're standing in the middle of a small room. The wall ahead of you is all mirror. That behind you is also mirrored. Where you are standing is where the object in a museum is located; where your reflections are is where you, as a subject, as a museum user, are. Once outside the museum, all this is reversed.

Nothing could be more expected, in a volume devoted to the "rhetoric of framing," than an essay on one of the most central and indispensable framing institutions of our modernity, the museum. The following, however, will not be a capsule history of the institution, nor will it be another "reading" of this or that museum institution constru(ct)ed as significant because poignantly "illustrative" of some hypothesis regarding the evolution of aesthetic ideologies or philosophical systems. It will be an attempt to sketch out a number of basic issues, problems, and predicaments that in my view need to be addressed in order to properly set traps for some of the most intractable habits we have acquired in speaking of museums in the contemporary world.

The following, then, will be a *derangement:* a derailing of what might have been the expected or imagined trajectory of an essay on museums as "framing devices," and an *estrangement* of some of our more familiar, unvoiced (or unmarked) assumptions about what museums are and do; about what (and whom) they "frame." Perhaps *derailing* might be an apt image here – I'd like us to derail much as one might use the derailing mechanism of a bicycle (*dérailleur*) to disengage from the machinery of museums for a bit: to freewheel out of gear and to try to catch clearer glimpses of that machinery in action than might be easily managed while still "engaged."

I want to position you, as reader, between the two mirrored surfaces of the room just mentioned. It is often the case that when you stand in such a room, watching your image seemingly reflected ad infinitum, you can usually see, after about a dozen

Donald Preziosi, "Brain of the Earth's Body: Museums and the Framing of Modernity" from Paul Duro (ed.), *The Rhetoric of the Frame: Essays on the Boundaries of the Artwork*, pp. 96–110, 288–9. Cambridge: Cambridge University Press, 1996. © 1996 by Cambridge University Press. Reprinted by permission.

repeated reflections, a gradual and cumulative curve on one or another spatial axis, such that your images recede in one direction or another (up, down, on a side); and after a while the reflections do not approach infinity at all, but rather disappear behind one of the room's structural frames, or behind one's own figure. Nevertheless, at a quick glance, you *do* seem to go on forever.

This chapter is about such reflections, deflections, and framings, about what is given to be seen, what is seen, and what is hidden by what we see, in the museum.

We begin, then, with the academically conventional leading quotation. It consists of two short passages from a book published a decade ago entitled *How to Visit a Museum*. Written by David Finn, a distinguished art photographer who for many years was associated with the British sculptor Henry Moore, the book can be found in the shops of virtually every major museum in the English-speaking world. The book begins this way:

> There is no right or wrong way to visit a museum. The most important rule you should keep in mind as you go through the front door is to follow your own instincts. Be prepared to find what excites you, to enjoy what delights your heart and mind, perhaps to have esthetic experiences you will never forget. You have a feast in store for you and you should make the most of it. Stay as long or as short a time as you will, but do your best at all times to let the work of art speak directly to you with a minimum of interference or distraction.

Those are the opening words of the book. The closing words are:

> Commune with a work of art to see what you personally can find in it that is meaningful or moving, and talk to someone close to you about what makes a special impact. Listen to others talk about their feelings and see whether that helps you appreciate something that you could not see before.
>
> Museums are there for *you*. They can give you something that only kings and queens had in days gone by, an opportunity to be with the greatest masterpieces of all time. If you know how to make the most of your adventures, you can even take some record of your favorite works home with you and make them a permanent part of your life.

We live today in a profoundly museological world – a world that in no small measure is itself a product and effect of some two centuries of museological mediations. Museums are one of the central sites at which our modernity has been generated, (en)gendered, and sustained over that time. They are so natural, ubiquitous, and indispensable to us today that it takes considerable effort to think ourselves back to a world without them, and to think through the shadows cast by the massive and dazzling familiarity of this truly uncanny social technology. Our world is unthinkable without this extraordinary invention.

Two hundred years ago, in a world undergoing massive social and political upheavals, the public institution that we now commonly call "the museum" came to be an important component of the social, political, and pedagogical transformations of various European nation-states. The public or civic museum was literally invented at this time in a manner not unlike the ways in which its sibling Enlightenment institutions such as hospitals, prisons, and schools achieved their modern formations, by reformatting a variety of recent and received practices taken from many aspects of social life, and by synthesizing these in concert with, and in order to engender, revised and redirected social missions.

Each of these social institutions replaced earlier versions of themselves in powerful new ways as instruments of the Enlightenment enterprise of *commensurability* – the rendering of all facets of social life and "nature" visible, legible, rationally ordered, charted, staged, and, above all, intertranslatable.

Hospitals became complex theatrical, optical, and semiotic instruments for the discernment of disease and for the delimitation of a healthy social body. Prisons became panoptic instruments for the isolation, measurement, and observation of social deviancy and for its redress. And schools came to be ordered and systematized according to models of military conduct and discipline, of reward and punishment, which gave rise to the educational systems we know today, and to the fields or "disciplines" we have come to construe as natural or given.

What, then, did museums illuminate, discipline, address, and redress? Just what came to be *visible* in these new museological spaces, in this new disciplinary machinery?

What follows is concerned with how museums do what they do; with *what was at stake* when they began doing whatever this is, with *why* in the world they might be doing such things, and with what *what they do* does. In other words, how and why they work and what that "work" itself accomplishes more broadly.

Let's derail, then, and go back to the beginning. Listen once again to what David Finn says in his perfectly unremarkable set of instructions to the museum-goer:

> There is *no right or wrong way* to visit a museum. The *most important rule* you should keep in mind as you go through the front door is to *follow your own instincts*. Be prepared to *find what excites you*, to enjoy what delights *your heart and mind*, perhaps to have *esthetic experiences* you will never forget. You have a *feast* in store for you and you should *make the most of it*. Stay as long or as short a time as you will, but *do your best at all times to LET THE WORK OF ART SPEAK DIRECTLY TO YOU with a minimum of interference or distraction*.
>
> *Commune with a work of art* to see what you personally can find *in it* that is *meaningful* OR *moving*, and talk to someone close to you about what makes a special impact. Listen to others *talk about their feelings* and see whether that *helps you appreciate something that you could not see* before.
>
> Museums are *there for YOU*. They can *give you something that only kings and queens had* in days gone by, an opportunity to *be with the greatest masterpieces of all time*. If you *KNOW HOW TO MAKE THE MOST of your MUSEUM-GOING ADVENTURES*, you can even *take some record* of your favorite works home with you and *make them a permanent PART OF YOUR LIFE*.

The book starts off with a contradiction: having just said there's no right or wrong way to "visit" a museum, Finn proceeds to outline the one right way – to "follow one's own instincts" (never mind that any "instincts" here are perforce already highly framed and conventionalized). The point, as he goes on, is to have "esthetic experiences" (nowhere is this defined), and to enjoy oneself at this "feast," for if you do not, you only have yourself to blame: get that object to "speak directly to you," eschewing interference or distraction by other aesthetic grazers. One is exhorted to "commune" with works of art – that is, to find something "meaningful *or* moving" (again that old Western metaphysical duo); if you're having trouble, get someone nearby to "talk about their feelings" (if you can stomach this) so that you, too, can learn to do it. After all, it's all there for *you* – a fact you should appreciate since in olden days only royalty or the rich could have what you now "have" – the opportunity to "be with"

(whatever that could mean) the "greatest masterpieces of all time." "Making the most" of this "adventure" (are we really not at Disneyland?) entails also taking a "record" (replica, reproduction, or souvenir) of a favorite piece to make (the experience, the emotion, the "significance") a "permanent part of your life."

This is all absolutely extraordinary. What the book doesn't mention – rather surprisingly, since they've been a feature of museum-going since the 1950s – are those Acoustiguide cassettes that can insulate you from the noises of other shoppers. This insulation comes at a price, however (even in free museums things come at a price) – that of submitting your personal communing with the artwork to the droll commentaries of some museum curator, some anonymous and probably underpaid art historian, or perhaps an actor with a posh accent mumbling woolly inanities in your ear. (Could it be time, in the United States at least, to give poor Peter Ustinov a rest?)

It should be clear that Finn presents us with a view of the institution that is by far the most *ordinary* one in modern life – that museums are repositories of unique objects whose principal value is private enlightenment, entertainment, fetishization, and vicarious possession. You may not be able to own one (like those long-gone kings and queens); you most certainly can't touch them; but you can if you wish buy a copy of one and paper your existence with what for *you* can become "a permanent part of your life." (Elsewhere in the book, Finn relates a story about the late Sir Kenneth Clark, whose country house and London flat were filled with "original works of art," while on his mantel in London was a set of postcards of artworks, which he would rotate from time to time to "refresh his tastes.")

The fact of the matter is that for most of us museums – and in particular, of course, "art museums" – are taken to be archives of what we are commonly exhorted to construe as clever visual texts to be read or interpreted or communed with and admired by museum users: in essence, nonlinguistic visual and/or spatial puzzles whose solutions lie in the cobbling together of the smartest words.

There is so much social history, political ideology, and ethical admonishment in these brief passages from this perfectly ordinary, unsurprising, and genuinely honest little book that we could occupy ourselves with it for some time longer. I would rather note here in passing the importance of such unregarded things; that the very ordinariness and naturalness of such simple, keen texts carries the burden of some of the most deeply entrenched and effective ideological work. Here, the work done consists in unremarking a particular and concerted staging of subjects and objects both equally divorced from their social and historical situations. Finn's text – and of course it's but one of hundreds with which our lives are framed today – makes perfectly normal and natural what is in truth the end result of nearly two centuries of the massive disciplining of whole populations to see and to read in particular – and in this case politically particular – ways. The ordinariness of this text is part and parcel of the disciplining of modern populations to construe history as the unproblematized or even natural evolution or progression of styles, tastes, and attitudes from which one might imaginatively choose as one's own. (One thinks of all those Rizzoli volumes on "Santa Fe style" or "deconstructivist interiors.") Is it any wonder that virtual reality comes as no surprise?

So what exactly *is* at stake, then, in museological stagecraft, dramaturgy, or framing? And what might have been at stake two centuries ago at the beginnings of the modern museum?

It is often quite difficult today to appreciate just how revolutionary this invention was at the end of the eighteenth century, for (as is often the case with inventions of

sheer brilliance and deceptive simplicity) its full potential and indispensability came to be realized only over time through use and experimentation. During the nineteenth century, the museum became an indispensable feature of the modern bourgeois nation-state; by about the middle of the century in Europe, and increasingly elsewhere, in its colonies and spheres of political and cultural influence, the institution achieved its more or less constant articulation, from which it has not substantially deviated down to the present day.

The most dramatic and catalytic event in the invention of the museum in its modern form was the French Revolution.[1] As a direct result of the revolution there came about the opening up and reformatting of the formerly royal and princely collections. While the principal venue of these changes was of course the Louvre, a number of new museum sites around Paris pioneered new stagecraft techniques.[2]

Some techniques had earlier precedents. The notion of the gallery had its origins (and its name) in the long corridors common to royal houses and châteaus, within which were typically arranged sequentially chronological family portraits. More often than not, attempts were made to frame each individual picture in an identical fashion, thereby emblematizing genealogical continuity and permanence through visual unity. Such techniques served explicitly pedagogical ends for the younger members of families.

Not a few of the visual and optical formatting techniques that became commonplace in the new museums were pioneered by the Jesuits as part of their programs of religious education, propaganda, and missionary work during the Counter-Reformation. Lantern-slide projection, for example, had a specifically religious function in its seventeenth-century origins, and the division of exhibitionary space according to measured time periods was used quite early on.[3] The point here is that during the last years of the eighteenth century, and in the early years of the nineteenth, a number of parts of what was to become the new public museum institution came to be systematically integrated and put to explicitly political uses in order to (re)educate a newly democratized citizenry.

Many of the principles of the new institution were first clearly articulated by Alexandre Lenoir in connection with his Museum of French Monuments, situated in the disused convent of the Lesser Augustine Order in Paris. In a text published in 1806 but written earlier, Lenoir called for the arrangement of all museum materials to be in chronological order, by century, so that the institution would serve as a school and an encyclopedia (his word), that citizens might learn to measure the degrees of perfection and imperfection in the historical evolution of monuments up to the present.[4] A museum, Lenoir argued, has a double orientation. It is an explicitly political institution, whose collections and the objects forming them should be chosen to highlight the evolving magnificence and splendor of the state. It is at the same time a pedagogical institution in that it is to be organized to make it unmistakably clear to the general public, but especially to the young, that one can gain knowledge from observing all the arts and sciences arranged together in their properly articulated relationships (Enlightenment commensurability).

What distinguished these new public institutions from earlier private collections, cabinets, curio closets, treasure houses, and the like was the heightened linkage of structure to chronology – chronology considered as both genealogy and evolutionary progress. Objects and artifacts were selected for their documentary value in staging a historical narrative or story that would lead to its inevitable culmination in the present – a present(ness) construed as an anamorphic point that made sense of history, of the

past. The new museum was a state-scaled microcosmos that was both a one-point perspectival tableau and also a trajectory or journey of bodies and souls; a discipline and a *cursus*.

This *dis*memberment of the traces of the past was thereby *re*-membered, rewoven into artifactual narratives that had orientation and episodic sense. The museum presented documentary evidence of a state-sanctioned evolutionary history outlining in a bold and materially palpable (and aesthetically sensible) manner just how we, as citizens of a brave new world, were what the past was aiming at all along (sound familiar?).[5]

The new museum institution became, in short, a site for the staging of what subjects might be induced to desire as their patrimony: a place for the inciting, launching, and deployment of sociohistorical longings and desires of all sorts. Recall Lenoir's aim: that the new museum should be a place where true knowledge could be gained by affording every citizen the opportunity to see, as he put it, "all the arts and sciences" (that is, the culture of the state in toto) arranged in their *true and proper* relationships, all their parts cohering in a systematic, encyclopedic manner. The significance or import of any given item or specimen in this synoptic assemblage, this encyclopedic theater of memory, was a function (an "artifact" indeed) of its place and position in the array. Like the custom-fitted components of a classical Greek temple, each item may be read for signs of its true and proper (and only) place in the construction.

Chronology becomes genealogy, which in turn becomes evolution and progress, and everything becomes oriented and *arrowed* with respect to its pertinence, its contribution, to the fabrication of the present – of that new, "modern" place that in turn guarantees the import and significance of the past. The past is what the present needs to legitimize, naturalize and sustain itself; in and by museography, the past becomes a monument in the present.

It has been a commonly held assumption in the (now vast) literature on museums and their history that there was a more or less smooth evolution of the institution out of earlier collections, *kunstkammern*, *wunderkammern*, and idiosyncratic and private museums. This is normally portrayed as somehow speeding up in the direction of greater order and rational systematization in the early years of the nineteenth century. In such a view, the early private collection or curiosity cabinet was a *dis*ordered, *dis*organized, or idiosyncratic kind of museum rather than a differently formed kind of orderly assemblage. The new civic institutions could thus be portrayed as obsolescing earlier idiosyncratic institutions. Virtually every history of museology takes such a position, explicitly or covertly.

But the more that careful attention is paid to those years, the more it becomes apparent that we are not dealing with system and order for their own sake (as if there could be such things anyway), but rather with what in some places is a radically new ideological orientation on the formatting of knowledge and the access to information stemming from the needs of a newly emerging sociopolitical order. At the same time, it is becoming clear that the evolution of social, political, epistemological, and technological orders is proceeding in tandem and without easily discernible unidirectional causal linkages. The situation is most palpable (and most dramatic) in France, but is no less real in England, Italy, Scandinavia, and Germany as part of the Enlightenment enterprise of affording potentially universal access to knowledge and to (some of) the techniques of rendering societies in some measure transparent to themselves. At the same time, clearly, there are palpable continuities between the new and old regimes, particularly in some of the details of stagecraft and display.[6]

The historical museum was both product and effect of this revolutionary enterprise, as well as one of the factories for the production of new social, political, and epistemological orders. In constructing the present, the "modern" world, the old one(s) had to be dismembered and re-membered in new ways: the past was put to work in telling the story of how the present came to be. History, genealogy, and teleology are thereby conflated: a monument literally (and etymologically) gives warning of its genealogy and descent, warning of its historicity. The mere things of the world come to be filtered through (and become in no small measure fabricated by) the epistemological grids and screens of the museum, through the spaces of its imaginary order, to emerge as *objects* to be read always and everywhere as object-*lessons;* as evidentiary material with respect to something absent or previous. The museum comes to be an optical instrument for the refracting of society and its history or histories into biography and narrative, into the prologue to our presentness. Indeed, the very existence of such an institution transforms most things into museological material – into objects that, whether or not they might come to be placed in (or be worthy of) a museum, now come to bear a concerted relationship to what is or what might be museologized. The entire made (and to some extent the not-made-by-us) environment and its parts are perforce museological objects. In short, things in the world are no longer what they were; they are now things *not* in a museum. In a manner not unlike the way that the theater's existence problematizes and ironicizes the belief in a distinction between natural behavior and acting, so museums, by marking the world into the museological and the nonmuseological, ironicize this very distinction. At the same time, the distinction between original and copy is rendered problematic.

Of course these ideological transformations proceeded apace at multiple sites in the social body, and the effectiveness of any one – say, museums, novel writing, newspapers, schools, or the evolution of a "public" (that is, intertranslatable or commensurable) urban domain – was enhanced by its positioning in a large matrix of codefining social practices.

Historicism itself in many of its guises (the ideological activity of the emergent profession of art historicism comes to mind) is particularly a product of how museums stage knowledge and how they elicit understanding. Museums, after all, came to be nineteenth-century versions of smart machines; active instruments for staging and reconfiguring history and for producing new social subjects *for* that history. A history, like a museum, is an articulated place or site within the present where one can observe the great historical gesture: the attaching of ideas to places, and the spatio-temporal distribution and deployment of objects as documents and as symptoms of whatever might be plausibly imagined (or "proven") to have produced them. History-writing and museums create realistic illusions through a similar and complementary (and mutually supportive) deployment of names, descriptions, objects, relationships, and metonymies of all kinds, in a grand montage of predication, thereby serving as models or paradigms of cause–effect relationships. In both technologies, meaning or signification is a function of place, position, and siting (sighting; citation) in genealogical strings of materials. And in a similar manner, both museography and historiography shape things – all manner of things (indeed potentially *every*thing) – into evidentiary material, into things that do different work now than they once did in other contexts.

All this is astonishing. Museography becomes, after the French Revolution, a paradigmatic institution and instance of social memory – of memory construed as a simultaneous forgetting *and* remembering; of an active refashioning of the things of

the world into the world's past, formatted as a story that leads up to, culminates in, implies, and somehow even prefigures or contains the (seeds of the) present.

You may well ask what all this might have to do with David Finn's museum objects as occasions for private meditation, communion, and enlightenment apparently divorced from whatever historical grounding might be attributed to them (or, where such grounding comes in, as part of the aura or semiotic halo of some object). How does that relate to the museum object as evidentiary or documentary material; as illustration, representation, or trace of some history, some state of affairs absent or distant? Are these the same or different kinds of museological objects? Different branches of the museographic enterprise? And where, in all of this, does art come in?

This is, in fact, precisely where what in the modern world is termed "art" does in fact come in, and centrally. Art, one of the most extraordinary and profoundly important inventions of recent history, is the very keystone of this historiographic and museological edifice, the backbone of the world in which we live and of the subject positions we learn to desire to take up in that world.

By way of explanation, let me first insert a quotation:

> A work of art can be defined as a man-made object of aesthetic significance, with a vitality and reality of its own. Regardless of the medium of expression, a work of art is a unique, complex, irreducible, in some ways even mysterious, individual whole.[7]

Having now had the experience of David Finn's text, it should come as no surprise that the work being done by this commonplace and almost universal definition of the work of art by Eugene Kleinbauer in his (once-ubiquitous) introduction to the discipline of art history is equally astonishing. What is being described here is no ordinary object or thing; it is in fact a *disciplinary object*, that dazzlingly obscure object of art historical desire. It is at once a definition of artistry and a paradigm of the artist itself (I say "it" here because we are not dealing with real men and women, but rather with an ideological subject that is itself the object of modernist yearnings – of desires deployed and fielded both by museography and historiography).

It is here that we may begin to understand just why art and artisanry come to be so central to the fabrication and maintenance of the modern world. Art in fact becomes crucial to the very framing of the Enlightenment project with the fielding of the Kantian "aesthetic" as a separate and distinguishable realm of cognition, and it becomes increasingly construed as an organizing concept in the service of a particular construction of the modern subject and its agency. What I mean to suggest is this.

The work of art that came to be sited in the new historically organized museums of the early nineteenth century was in fact staged as a model of the new bourgeois social subject. In other words, the work of art came to be constru(ct)ed as a simulacrum, model, maquette, ideal vision, emblem, metaphor, or sign (or...) *of the modern subject* and its agency. At the same time, the museologized artwork was a paradigm (and paragon) of objecthood as such – of the ideal object, a model of artisanry, skill, creativity, manufacture, and of genius itself. The man and his work came to be staged as the man and/as his work. I'll return to these points in a moment.

An extraordinary set of phenomena is in play in the new museum institution. The order of the museum can be seen as a model of "emplotment" as such, of the staging of objects relative to other objects in a plotting system that transforms juxtaposition and simple succession into an evolutionary narrative of influence and descent, into a configured story culminating in our present. At the same time, the museum's order is

an emplotment system for staging objects in contrast to each other on an ethical, moral, or aesthetic plane, as exemplars of this or that individual mentality, period, race, place, gender, ethnicity, and so forth.

Museum objects, in other words, are staged to be apprehended as if they were subjects in their own right – and they did in fact so deploy themselves, emblematically contrasting this artist's work with that of another – the Florentine with the Venetian, the Greek with the Roman, the moderns with the ancients, and so on. In short, museum objects display their own agency as simulacra of the subjects of which they are the symptoms.

The ideological work being done by this museological technology concerns in no small measure the fabrication of the modern citizen (that is, the citizen of a newly fashioned public space and a sociohistorical time) – a new social subject, an emplotted agent; a person with a history or life narrative, a cursus or curriculum vitae that must be tended carefully; a life that must come to resemble a work of art, an ethical and moral masterpiece in its own right. Art thus comes to be an instrument of that (bourgeois) self-fashioning in the sense that artworks, as museological objects of desire, are constru(ct)ed as objects whose style or grace is worthy of emulation; whose spirit and vivacity one might well admire; whose uniqueness is worthy of remembering. Recall Kleinbauer's definition: "a unique, complex, irreducible, in some ways even mysterious, individual whole." What is being (un)said in this defin-ition is that the work of art is a palimpsest on a characteristic sense of the modern(ist) individual, not simply a reflection. One need not do a detailed word count of the terminology of art criticism to discover that the language of art history and criticism was and is the ethical language of the self. David Finn was right to suggest that one has only oneself to blame if one doesn't get it.[8]

Museums became places that enabled subjects to become masters of their lives by providing both the raw materials (the master pieces) and the technology, the methods of constructing templates or scaffolds on which to build one or another form of the new socially sanctioned selfhood or subjectivity, according to class or station in life. What the museum accomplished, in concert with its sibling Enlightenment insti-tutions or technologies, was nothing less than the circulation of modern populations in(to) an ethically refashioned history composed of things transmuted into objects that were object lessons in at least two principal ways – as documentary indices of a history of the world legible as teleological dramaturgy, as having a direction and point; and as simulacra of a seemingly endless number of subject positions in social life that might be admired, desired, emulated, escaped, or eschewed.

This is all extraordinary, a truly brilliant strategy for democratizing and secularizing modern social life, for (appearing to) displace theology by masquerade and palimpsest. Just as the museum object comes to serve as a perspective or window on history and evolution, so also is the new modern social subject a (post-Renaissance, one-point) perspective on (and more specifically an *anamorphosis of*) the bits and pieces of its life, of its experience. This is the value of the "museum-going adventure" that David Finn was attempting to capture in his book.

What the subject sees in museological space, in the "picture" or in the "frame" of the museum, is a series of possible ways in which it can construct its own life as some kind of centered unity or perspective that draws together in a patterned and telling order all those diverse and contradictory experiences and desires. It is in this sense that the new museum can be seen as working to put all things into a perspectival system of new and clearly related positions. The museum is in fact as brilliant an invention as was

one-point perspectival rendering three centuries earlier in Europe. Museums put us in the picture by putting us together as centered, unique, self-identical subjects.

In this regard, they are in no way merely collections or assemblages of objects; they constitute orderings of objects and their projective (and prospective) subjects – the subjects that such objects "afford" – affordances that engage with what are constru(ct)ed as opportunities of the subject to orchestrate and compose its own subject world (*Innenwelt und Umwelt*). The museum became, during the nineteenth century, a "centering device" and in fact a whole optical instrumentality for the positioning, the siting (and the sighting, the rendering visible, the framing) of modern(ized) populations in and for a history that was itself deployed, both museographically and historiographically, as the unfolding of transcendent truth. This situated subject (re-)marks historical understanding as the temporal emergence and exemplification of seemingly transcendent truths. Like Moses come down from his mountain announcing with complete conviction that "it wasn't me who wrote these tablets, it was . . ." (points heavenward), the museum could well persuade us to believe that there was a real history out there independent of our historiographies, our museographies, our devices and desires.

Or to persuade us to believe in an art history independent of our museologies. There has been a lot written in recent years refamiliarizing us with the remarkable variety of optical instruments, devices, games, experiments, and toys with which the nineteenth century was so fascinated, so obsessed.[9] It may be suggested that in a very real sense, the modern museum was the most extraordinary optical instrument of all: the veritable summa of opticality, of visuality; an instrument on the scale of the state; a vehicle that at the same time contained the state. It was an instrument for the manufacture, on individual and collective horizons, of societies, ethnicities, races, classes, genders, and individuals; of history, progress, and moralities; of nature itself, and of the future(s) towards which all of what is contained therein might be moving.

If the museum is the veritable house of opticality, of vision, it is at the same time, and consequently, a place of blindness and masquerade, where what is visible is also invisible. Recall the impossibility commonly cited by art historians (Gombrich among others) of seeing the plane of a picture and what is being depicted in the picture at the same time; there is an oscillating visibility here similar to that of the famous Necker cube illusion. The object in the museum may be said to operate in a similar manner, as we shall see in a moment. What, then, do museum objects do, mean, or show? And what do museum users (visitors) come to know in attempting to reckon with such things?

In a general sense, the museum artifact has a distinctly hybrid epistemological status, staged in an illusory space of oscillating determinacy and causality. On the one hand, the object's significance is perpetually deferred across a network of associations defined by formal, stylistic, or thematic relationships. In an increasingly systematized fashion in the nineteenth century, the artwork was staged as a specimen of a class of like objects, each of which seemed to provide evidence for the progressive solution to like problems of representing. In short, the object's meaning was literally elsewhere, disseminated through a historicist field.

On the other hand, the new museum object is foregrounded as unique and irreducible (and nonreproducible), its meaning rooted in its emblematic and expressive properties relative to its maker, origin, or provenance. In this respect, the very form of the work was always in some manner the figure of its truth – a truth linked directly to the vision, mission, personality, mentality, or the aesthetic (ethical) character of its

maker or source (which could be connected with equal plausibility to an individual artist, a studio, a school, or a people). In this manner, museological dramaturgy afforded and entailed a seemingly wide spectrum of paradigms of (art-) historical causality with equal or equivalent persuasiveness. (Art, after all, and over and above its subject matter, is about causality as such.) Anything from the ambient circumstances of production and reception to the social, political, or economic forces said to characterize or typify a given moment in time and space, to the collective mentality of an age, place, race, gender, class, or nation could be (and has been) adduced with equal plausibility in this museological stagecraft as a final or determinant cause of the way an object appears.

(It should be said [not so parenthetically perhaps] that most of the debate in the complementary exegetical discipline of art history regarding the relative merits of different interpretative methods are almost invariably played out on a superficial level [feminism vs. Marxism, or formalism vs. deconstruction, etc.], and rarely address issues of substance and epistemological structure, since nearly all art-historical methods have been and remain complicit with the technologies they purport to critique.)

In regard to the simultaneously differential and referential character and formatting of art-historical explanation and museological object staging, it should be clear that this simultaneity is akin to the optical illusion just mentioned, where there is an oscillating determinacy of signification or reference. In terms of the confrontation of object and subject (or beholder), there emerged a paradoxical, enigmatic, and indeterminate field of legibility.[10] In rendering the visible legible, the museum object is both there and not there. Furthermore, it is both there and not there in two distinct ways.

On the one hand, the object is both palpably or materially part of its place in the historiographic theater of the museum – that is, it is physically present – and it is unnaturally borne there from its original place or milieu. On the other hand, the object's significance is both present – the object's form is the figure of its truth (recall Finn or Kleinbauer) – while its meaning is indirect, differential, or contrastive, deferred to some absent circumstances of causality – its historiographic or positional truth, as it were, its place in (art-) historical evolutionary time.

For the spectator (the museum subject), then, in a very literal sense the artwork's materiality and significance are simultaneously present and absent. In being induced to reckon with the truths of a work by imagining what might plausibly lie behind it (it is interesting how thoroughly spatial and visual our most ordinary language is at times like this), the subject is equally bound to it as containing its own explanation.

It is here that we may begin to understand the sleights of hand on which museological stagecraft is dependent, or upon which being a subject in a museum is so caught up. Constituted by lack, the staged and storied (historiographed) artwork becomes the emblem of and catalyst for the subject's own desire. And the subject comes to understand or see itself as constituted by a lack that may be filled only by acceding to the object's own otherness. Some implications of this follow.

On the one hand, the subject is induced to imagine (by any number of means in museological stagecraft) a gaze which is outside the field of vision – normally, the purview of something one understands to be the history of art located as a future vanishing point at which all of history comes to completion and sense, where answers are to be found. Somewhere, in other words, the full significance of the object is believed to be known and fixed in place once and for all. Some art historian somewhere, it is imagined, knows.

In a sense, then, for the subject, the object is in the position of the blur in an anamorphic (art-historical) picture that is always resolvable, that comes into clear view from some (imaginary) elsewhere. Legibility, in other words, is deferred to a point at which everything but the original blur becomes misaligned and indistinct. Again, we are in the situation of an oscillating determinacy: an either/or opticality. (I hesitate once again to use the phrase "optical illusion," for the fact of the matter is that, strictly speaking, there is no illusion here because there is only illusion.)

In short, the subject's identity is subjected to an otherness whose own identity is both present and absent. The object can confront the subject only from a place where the subject is not. It is in this fascination with the museum object that the subject-spectator is bound over to it, laying down his or her gaze in favor of that of the (so-called) object. And it is in this fascination that we find ourselves, as subjects, remembered (remembering as the opposite of dismembering). I use the term "fascination" here specifically because of its doubled and antithetical meanings – on the one hand, an attraction; on the other, a trapping (perhaps not so antithetical after all). Our fascination with the museum, our desire or need to reckon with it (that is, to both cope with its constraints and to learn to think with it) – all this is an analog of the fascination of the child with its mirror image(s), which coincides with its (and our) recognition of lack. Museums in this sense serve a decidedly autoscopic function, providing external perceptions of the subject and its agency (recall the opening paragraph of this chapter).

It becomes clear that we are dealing here with an invention, an institution, a technology, indeed an agency of extraordinary power and brilliance. The museum is a theater of anamorphic (and autoscopic) dramaturgy; a place in which it is not so easy to tell which is the spider and which the web, which the machinery and which the operator. It is a place at the center of our world, our modernity, in the image of which those worlds continue to proliferate. It is the means by which modern Europe fabricated itself as the mirror of sense and the brain of the earth's body, submitting and *objectifying* (object is etymologically a "throwing behind" oneself) the rest of the world to a place outside the presentness, the modernity, of Europe. The rest of the world was its prologue or anteriority, which related to Europe as the past relates to the present (and of course as the future of European opportunity). Submitting the rest of the world to a lack by being staged as non-European (recall how the museo-logizing of things into objects makes things outside the museum into non-museum objects, that is, part of the same museologized system of things), the museum constructs our present out of this other-past.

Such a "frame(-up)" has been astonishing. Through the epistemological (and optical and psychical) technologies instantiated so powerfully by the museum, and in concert with a nexus of complementary and auxiliary disciplines such as historiog-raphy, Europe fashioned its own modernity as in one sense it had always proceeded: by linking its identity and distinction to the opposite of what it imagined its Others to be (for a millennium, the world of Islam, and more recently also those of Africa, Asia, and the Americas).

Works of fine art became in this museographical order the most telling products of the human mind, and a universal standard against which all that was not Europe might be measured, graded, and ranked down along the slopes of European modernization. In their panoramic deployment in imaginary historiographic space, artworks took on episodic and directional weight in specific relationship to Europe's modernity – a modernity increasingly defined, throughout the nineteenth and twentieth centuries,

by imaginary ethnic, cultural, gender, linguistic, and racial homogeneities, and by numerous retrojected fictions, each one of which continually proves as dangerous as it may be comforting (Frenchness, Germanness, Hellenism, Jewishness, Arabness, Americanness, Englishness, or any equally phantasmic modes of "aboriginality").

Museums and their objects have always been catalysts for our desires as individuals and as citizen-subjects; mirror-stage machineries for modern subjects in which unity and identity always seem on offer, always a little out of reach. I hope to have made it at least a little clearer here that this extraordinary invention, this most powerful and central instance of what we have been induced to make of ourselves as socially competent individuals since the eighteenth century, cannot be well understood unless we attempt to reckon with what *what it does* has done historically, and continues to do both with and for the modernist subjects it pedestals.[11]

I also hope to have clarified that such an understanding in fact involves a derangement from some of the entrapments of our discursive practices – not a few of which, it will be seen, are museographic and historiographic artifacts and effects in their own right. And I hope that it has been shown that a focus upon the ideological fabrication of the subject–object opposition and its entailments is a useful and potentially powerful and productive place to start. Subjects, of course, are simultaneously conscious and unconscious, and any theory of agency or of social construction that omits that fullness is in danger of becoming an idealist and reductivist fiction. Objects are only such in relationship to a projected and coconstructed field of agent positions, of subjectivities.

What can it mean, then, to be a subject in a world in which there exist museums of anything, and where virtually anything can serve as a museum? What kind of object, then, is a museum? To engage substantively with such questions necessarily entails a critical derangement of the commonplace modes of inquiry (and the rhetorical terms of such inquiry such as subjects and objects) that frame modernist certainties, so that we may learn to ask questions that might be more than modernist double-binds.

Not, of course, that such a place would be "post" anything, let alone modernity, any more than the museum, once having been invented, has an outside.[12]

Notes

1 An excellent and useful discussion may be found in Andrew McClellan, *Inventing the Louvre: Art, Politics, and the Origins of the Modern Museum in Eighteenth-Century Paris* (Cambridge University Press, 1994), with good bibliography.

2 See Stephen Bann, *The Clothing of Clio* (Cambridge University Press, 1984), esp. pp. 77–92, "The Poetics of the Museum: Lenoir and Du Sommerard"; and Eilean Hooper-Greenhill, *Museums and the Shaping of Knowledge* (London: Routledge, 1992). See also Donald Preziosi, "The Question of Art History," *Critical Inquiry*, 18 (Winter 1992), pp. 363–86, for additional bibliography.

3 In fact there are many similarities between the political programs of the new public museums and the religious programs of certain ecclesiastical institutions. This has been little studied, although a conference held at Dartmouth College in 1993 on aspects of this subject suggests the emergence of fresh insights (as yet unpublished); see Donald Preziosi, *Brain of the Earth's Body: Art, Museums, and the Phantasms of Modernity* (Minneapolis: University of Minnesota Press, 2003), and two recent and excellent studies on the early beginnings of European museums and collections: Adalgisa Lugli, *Naturalia et mirabilia: Il collezionismo*

enciclopedico nelle wunderkammern d'Europa (Milan: Mazzotta, 1983); Oliver Impey and Arthur MacGregor (eds.), *The Origins of Museums: The Cabinet of Curiosities in Sixteenth- and Seventeenth-Century Europe* (Oxford University Press, 1985), with extensive bibliography. See also, in connection with the Jesuits, Adalgisa Lugli, "Inquiry as Collection: The Athanasius Kircher Collection in Rome," in *RES*, 12 (Fall 1986), pp. 109–24.

4 Alexandre Lenoir, *Description historique et chronologique des monumens de sculpture réunis au Musée des monumens français* (Paris n.p., 1806); reprinted in part in François Dagognet, *Le musée sans fin* (Paris: Editions Champ Vallon, 1993), p. 112.

5 A useful discussion of this and related matters may be found in Richard Terdiman, "Deconstructing Memory: On Representing the Past and Theorizing Culture in France since the Revolution," *Diacritics*, 15, no. 4 (Winter 1985), pp. 13–45.

6 This is a vast subject, touched on only in outline form here. It is developed in greater detail in the writer's recent volume, alluded to in note 3.

7 W. Eugene Kleinbauer, *Modern Perspectives in Western Art History* (New York: Holt, Rinehart & Winston, 1971), p. 1.

8 This and related issues are taken up in Donald Preziosi, *Rethinking Art History: Meditations on a Coy Science* (New Haven, Conn.: Yale University Press, 1989), esp. pp. 21–53 and 80–121.

9 A useful place to begin would be Jonathan Crary's *Techniques of the Observer: On Vision and Modernity in the Nineteenth Century* (Cambridge, Mass.: MIT Press, 1990), which, while weak on the historical and philosophical implications of the instrumentalities discussed, has the virtue of providing a good survey of the material and a good sense of some of the nineteenth century's obsessions. The best contemporary study of perspective and its historical functions is that of Hubert Damisch, *L'origine de la perspective* (Paris: Flammarion, 1987), now in English translation by John Goodman [*The Origin of Perspective* (Cambridge, Mass.: MIT Press, 1994.)]

10 The operative syllable here is "front," which should remind us that museum objects do have fronts that, as objects prior to their museologization, they might not have had, or, if they had, they also had "backs" of significance, which museum space doesn't often afford. It should be recalled that what the first new civic museums did in appropriating private and princely collections was to situate these objects on the "sides" of spaces so as to permit a uniform flow of traffic of groups through institutional space (rather than in maze-like fashion). Some of these issues are discussed by Bann, McClellan, and Dagognet.

11 These issues are taken up in detail in Preziosi, *Brain of the Earth's Body.*

12 An earlier version of this chapter was presented as the keynote address in the symposium *New Art Museums: Revis(ion)ing Architecture, Art, and Culture*, held in December 1993 in commemoration of the opening of the Frederick Weisman Museum of Contemporary Art, designed by Frank Gehry, in Minneapolis.

Chapter 5 | Kenneth Hudson
The Museum Refuses to Stand Still

Over the past fifty years ICOM [the International Council of Museums] has tried to define a museum in a way that might be found reasonably satisfactory from Canada to the Congo. It has been an unenviable task – ICOM has always had its fair ration of nitpickers – and inevitably the official definition has had to be modified from time to time, with a diplomatic phrase added here and a word capable of provoking an international incident removed there.

But, in attempting to analyse what has been happening to museums since ICOM was set up in 1946, one has to have some point of reference and the law as laid down by ICOM is as likely to receive general agreement as any other. According to the latest version of its statutes, approved by the sixteenth General Assembly of ICOM in 1989 and amended by the eighteenth General Assembly in 1995, a museum is 'a non-profit-making, permanent institution in the service of society and of its development, and open to the public which acquires, conserves, researches, communicates and exhibits, for purposes of study, education and enjoyment, material evidence of people and their environment'.

An earlier definition, drawn up in 1971, spoke of 'the community', not of 'society'. This soon ran into difficulties. Who was to decide whether a museum is serving the community or not? What proportion of the community does it have to serve in order to justify its existence? What limits were to be set to such a vague concept as the community? On the whole, 'society' was felt to be a safer word than 'community', partly, no doubt, because it is even vaguer.

But, whichever word or phrase one uses, one can assert with confidence that the most fundamental change that has affected museums during the half-century since ICOM was set up is the now almost universal conviction that they exist in order to serve the public. The old-style museum felt itself to be under no such obligation. It existed, it had a building, it had collections and a staff to look after them, it was reasonably adequately financed, and its visitors, usually not numerous, came to look, to wonder and to admire what was set before them. They were in no sense partners in the enterprise. The museum's prime responsibility was to its collections, not to its visitors.

Kenneth Hudson, "The Museum Refuses to Stand Still" from *Museum International* 50:1 (1998), pp. 43–50. © 1998 by UNESCO. Reproduced by permission of Blackwell Publishing. (Reprinted without illustrations.)

It is worth remembering that since the end of the Second World War the number of museums in the world has increased enormously. Three-quarters of the museums we have today were not there in 1945. This massive growth has been accompanied by a remarkable broadening of the types of museum available and by the creation of a completely different kind of public. During the past thirty years especially, the museum-going public has changed a great deal. Its range of interests has widened, it is far less reverent and respectful in its attitudes, it expects electronics and other modern technical facilities to be available as a matter of course, it distinguishes less and less between a museum and an exhibition, and it sees no reason to pay attention to the subject-boundaries so dear to academically minded people. Its basic question is always, 'Does it interest me or not?' People are no longer content to have their lives and their thoughts controlled by an élite of powerful and privileged groups and individuals. They are increasingly demanding a say in the planning and organization of what they choose to do and especially of the way in which they spend their leisure time.

This means, inevitably, that phrases like 'serving the community' and 'in the service of the community' bring problems of their own. Any institution that sets out consciously and deliberately to do these things will find itself compelled to find ways of measuring its success. It will have to discover, as a continuous process, what its customers think about the goods that are offered to them. The use of the word 'customer' in connection with museums would have been unthinkable fifty years ago but it causes little or no surprise today. Museums are competing in a leisure market and every market has customers.

The successful exploitation of markets involves market research, but merely to monitor the results of what one has already done is inadequate and uncreative. The true skill of any form of market research, and that practised by museums is no exception, lies, first, in asking the right questions and, second, in using the results to produce something which is closer to what the customer really wants. The process has to be continuous and, in those museums which rely on a system of continuous assessment by the public, the traditional distinction between permanent and temporary exhibitions is breaking down. The concept of a 'permanent exhibition' has become increasingly obsolete. Social attitudes, educational standards and methods of communication are constantly changing and in their displays and assumptions museums have to keep pace or lose customers. A museum exhibition that remains unaltered for as long as five years and still retains its power to attract and stimulate is remarkably fortunate.

Forces for Change

Fifty years ago no museum was considered to be a business in the commercial sense, and the notion that museum directors and curators should possess management skills would have been considered absurd. Working in a museum was, quite justifiably, regarded as a quiet, sheltered occupation for men and women with scholarly tastes. It was, like working in a bank or in the Civil Service, a safe job in which one could expect to remain until retirement. Museums were run either by municipalities or by the state, and those in charge of them were usually under no pressure to produce results, either in the form of a steadily increasing number of visitors or of a more efficient use of funds; the modern practice of obtaining commercial sponsorship for

new projects was almost completely unknown. Money was not part of the museum atmosphere, as it has since become.

Local authorities, like the state, regarded it as part of their duty to run museums and libraries. Very few museums charged for entry and amenities like museum shops, cafés and restaurants were a great rarity. It was generally accepted that museums should be peaceful places in which visitors of all ages were free to roam about, to look at what interested them and to ignore what did not. Attendance figures were, by modern standards, very low, but nobody seemed greatly bothered by this. What is now known as 'museum education' hardly existed in any organized form. Teachers took groups of their pupils to the larger museums and took responsibility for their behaviour during the visit. Museums, with very few exceptions, did not have 'education departments' and 'education officers'.

Why have these changes taken place? What social forces or historical accidents have brought them about? There seem to have been four main causes. The first is the rise in people's social expectations and consequently in what they expect their governments to provide for them. These governments in turn have to balance the various financial demands that are made on them and to look for every possible saving that can be effected without causing serious political trouble. The second cause, at least in the Western world, is the increase in the amount of disposable income. This has led to a demand for more, and more expensive, leisure activities and to an unwillingness to be satisfied with simple pleasures. The third is the development of professionalism among those who work in museums and a corresponding inclination to say, 'There must be a better way', defining 'better' in terms that will be approved both by other museum people and by the authorities that have to meet the costs. And the fourth cause is the remarkable increase in the number and proportion of what are often known, some-what misleadingly, as 'independent museums', that is, museums that do not derive their income mainly from public funds. Most of the museums in this category have to think very carefully about getting and spending money from the time they are born and their unavoidable attention to the business aspect of their work has influenced the atmosphere of the museum world as a whole.

Generalizations are as dangerous in talking about museums as in discussing any other field of human activity, but it is, even so, possible to distinguish certain broad trends and movements which have crossed national boundaries and made themselves evident in each of the five continents. What one should never do is to invent an imaginary phenomenon called 'the museum'. It is a meaningless abstraction. The reality is that the world contains hundreds of thousands of establishments called museums and each of them has its special characteristics, its own problems, its own opportunities and its own pace of growth and decline.

Even so, it is fair to say that fifty years ago there was much more common agreement as to what a museum should be than there is today. A speaker at a conference in the United States two years ago said, 'When I was a boy, I knew a museum when I saw one. Now I'm not always sure.' It is not difficult to understand what he meant.

ICOM itself has not helped very much to produce an answer to a question that is heard more and more with every year that passes, 'Is it a museum?' The following, it has decreed, qualify as museums for the purposes of definition:

(i) natural, archaeological and ethnographic monuments and sites and historical monu-ments and sites of a museum nature that acquire, conserve and communicate material

evidence of people and their environment; (ii) institutions holding collections of and displaying live specimens of plants and animals, such as botanical and zoological gardens, aquaria and vivaria; (iii) science centres and planetaria; (iv) conservation institutes and exhibition galleries permanently maintained by libraries and archive centres; (v) nature reserves; (vi) international or national or regional or local museum organizations, ministries or departments of public agencies responsible for museums as per the definition given under this article; (vii) non-profit institutions or organizations undertaking research, education, training, documentation and other activities relating to museums and museology; . . .

Not everyone connected with museums appears to have the same liberal views as ICOM itself and there are certainly plenty of people today who find it difficult to accept that either a zoo or a science centre is entitled to be called a museum. After fifty years of definition-broadening, it is probably still true to say, however, that museums are essentially places in which objects – 'real things' – are used as the principal means of communication. But is it reasonable, without straining ordinary language too much, to call a living plant, fish or animal an object? Does it have to be dead in order to be an object and, if so, why? Is it carrying empire-building too far to call a zoo, a botanical garden or an aquarium a museum? Is a library a museum? It certainly contains objects and it might perhaps be described as a museum of books, but somehow it seems more sensible to continue to call it a library.

It has been said that theologians thrive best when people cease to believe in God. For 'God' read 'museum'. Fifty years ago museums were in a strong position because everyone knew what a museum was, but today, after decades of wrangling, there is increasing uncertainty. If there is no consensus of opinion as to the nature of what one is defending, how can one defend it? But, for want of a better cause, 'objects are a must' seems to be a battle worth fighting. To insist that an institution without a collection of objects is not a museum is not the same as saying that a museum must be object-centred. A very important feature of the majority of museums today, in contrast to what characterized them in the mid-1940s, is the extent to which they have become visitor-centred. This amounts to saying that, as good shopkeepers, museum directors are slowly coming to think of the customers first and of the goods on sale second.

Marketing the Museum

This takes us back to the major causes of changes which were outlined above. Since the end of the Second World War, many of the traditional class distinctions have faded or disappeared, the lives of those who are conventionally referred to as 'ordinary people' have become more complicated and social expectations have risen to levels that would have seemed ludicrously impossible in the 1930s. Luxuries formerly out of the reach of all but a small section of society have become necessities demanded by everyone as a right. Pleasures have become more sophisticated and more expensive, and inexpensive satisfactions are almost a thing of the past. Governments are expected to provide more for their citizens and to be more concerned with their everyday welfare, without raising taxes, though quite how this economic miracle is to be achieved is never made clear.

Within this new atmosphere museums have increasingly been forced, however unwillingly, to market and sell themselves. This had been the case for a long time in

the United States, where the tradition of public provision is not so deeply rooted, where people have expected to pay for a large part of their social amenities and where the salesman has always enjoyed much higher prestige than he has in Europe. The idea of a museum having to sell itself and to discover its own sources of finance is relatively new outside North America and has met with a good deal of reluctance and hostility, especially in Europe. The museum curators of the 1940s, 1950s and 1960s were prepared to allow the customers to enter the shop, provided they observed acceptable standards of behaviour, but they were not inclined to go out and look for them or to persuade them to return.

In some respects the task of those who were anxious to promote museums was more difficult in the 1970s and 1980s, when the museum revolution really began, than it would have been in the 1930s, when there were fewer alternative ways of spending one's leisure time and much less spare cash after the cost of necessities had been met. What might be termed the centre section of society, the upper working class and the lower middle class, was becoming prosperous to an extent that would have been hard to imagine before the war. Commercial interests were quick to exploit this new and highly profitable situation and, as a consequence, museums found themselves in the wholly unaccustomed and unwelcome position of having to compete for the leisure hours of what ICOM thought of as 'society' or 'the community'.

This led to the rapid growth of what is, often flatteringly, called 'professionalism' among museum employees. A professional, in any occupation, might perhaps be defined as a person who has followed a recognized course of specialized training and who accepts a recognized pattern of working practices and agreed ethical standards. Such people did not exist in the museum world until the 1970s. Before that time, those who worked in museums had found their way into their jobs largely by accident. They might have become teachers or craftsmen/artists or civil servants or, in some cases, university professors, but fate and an inclination towards the quiet life led them into museums. During the 1980s and 1990s, museum training courses, like museums themselves, have proliferated all over the world, producing more qualified students than museums can employ. These courses fall into two categories: those that provide instruction of a technical nature and those that aim at producing more competent curators and managers. Whether they and other innovations have succeeded in creating anything that could be accurately described as a 'museum profession' remains an open question.

ICOM exists primarily in order to serve the interests of 'museum professionals', but defining a museum professional is almost as difficult as defining a museum. A major part of the problem is that there is no simple word to describe someone who works in a museum at the responsibility-bearing level. A person who plays or composes music is a musician, someone who practises the law is a lawyer, someone who is trained to fight wars is a soldier, but the only museum equivalent we have so far managed to invent is 'museum professional', which is clumsy and slightly ludicrous. 'Museologist' certainly will not do, because a museologist is essentially a builder of theories, not a practitioner. Perhaps 'museumist' is usable. 'Curator' is certainly not adequate, because, like 'conservator', it does not reflect the complex pattern of administrative, financial and political duties that anyone in charge of a museum has to perform today. Twenty years ago the director of a large and well-respected art museum in France, when announcing her early retirement, told the press and the museum world that she had been 'trained to look after pictures', not to 'persuade people with money to give it to the museum', and her predicament illustrated a major change in the international

museum situation, a change that has hit museum directors in the former socialist countries particularly hard, as they have struggled to adjust themselves to the economic realities of the capitalist world.

Small, Specialized and Successful

A very high proportion of the museums that have been created since the 1940s have had to face hard financial truths from the beginning. They have had to create and sustain a market for themselves in order to exist. Their names often provide a guide to their problems and opportunities. Traditional museums had such titles as the Montreal Museum of Fine Art, Rochdale Museum, the Municipal Museum of Natural History, the National Ethnographical Museum, the Museum of Transport and Technology of New Zealand, and the Indian Museum. The new, post-1950 crop is rich in museums with names like The Irish Whiskey Corner Museum, The Museum of Immigration, The Hall of Champions, The German Carburettor Museum, the Gas Museum, the London Toy and Model Museum, The Museum of the Olive, The House of Wheat and Bread, and the European Museum of Asparagus.

Most of the pre-1950 museums everywhere in the world had a very limited range of exhibits. They were concerned, for the most part, with art, broadly interpreted, archaeology, ethnology, natural history and, within limits, local history. With few exceptions, they depended entirely on public finance, they operated on what would nowadays be considered ridiculously low budgets, they paid very little attention to the attractiveness of an exhibit and they tended to feel that once objects had been put on display, the arrangement should last more or less for ever. What has happened since amounts to a revolution – the word is not an exaggeration – in museum philosophy and in its practical applications. Some, but not many, of the new museums have been relatively large, employing 100 to 200 people, but the vast majority have a total staff of not more than ten or so. Reliable figures are at the moment impossible to obtain, but those, like the members of the jury of the European Museum of the Year Award, who travel regularly and extensively have the impression that three-quarters of the museums in Europe provide a living for fewer than ten people, and there is no reason to suppose that the same is not true on a world scale. The large municipal and state museums are completely untypical, an important truth which is obscured by the fact that the people who appear at international museum conferences are nearly always representatives of large museums. Anybody who was in a position to take a bird's-eye view of the museum world as it was in 1947 would have been able to perceive a very thin scattering of museums in what are known as the 'developed countries' and only a tiny number in the poorer or, to use today's preferred term, 'developing' countries. The museums in these developing countries had nearly all been established by the foreign ruling power in colonial times, and they were of the traditional European type. A similarly privileged observer-from-above today would find a much more widespread distribution of museums in all countries and it would soon become clear to him or her that the average size of a museum today is considerably smaller than it was fifty years ago.

There is plenty of evidence to show that visitors like small museums, museums that one can look round satisfactorily in a couple of hours or less, especially if they are concerned with a single subject or a single person. Most people have experienced the psychological condition known as museum hopelessness, the feeling that is almost

normal in a very large museum, where the complexity and sheer size of the place present a series of impossible and discouraging challenges. The proliferation of small, single-subject museums is due partly to the lower financial investment and risk that is involved, but also to a realization that many interesting types of collection were previously not represented in museums at all. Where, in the 1940s, could one have gone to find a museum wholly devoted to the story of pasta, the gas industry or the development of the umbrella? It is possible, but difficult to prove, that Petrarch is more significant than pasta and that Whistler or Wagner are more important than wine or Wurlitzers, but the fact that we now have thriving wine, Wurlitzer and pasta museums is sufficient evidence of the extent to which the academic walls around museums have been broken down during our lifetime.

There are those who believe, and say, that more inevitably means worse, those who lament the passing of the old type of scholarly curator, those who feel that sponsorship is necessarily a vulgarizing and corrupting influence, those who long for the old days where museums were adult-centred places of peace and quiet, in which children knew their place. But looking at the situation from a world point of view, as both ICOM and UNESCO must, there can be no harm in suggesting that the most important change of all is one that is only just beginning, an attempt to make museums a part of the living culture of their time, and in this way to cease to regard members of the public as passive observers of exhibitions that have been supposedly created for their benefit. Such a change of attitude involves regarding what have hitherto been thought of as museums much less as treasure-houses and much more as centres of activity and discussion, where the past and the present are inextricably mixed. This kind of development is taking place throughout the 'developing' countries, in which museums on the Western model have increasingly come to be seen both as irrelevant and as impossibly expensive. It could be that the ideas that will characterize and inspire the museum revolution of the next fifty years will arise from poverty, not riches. There is nothing automatically right about the Western type of museum and it may well be that the well-endowed countries of the world will find their museum road to sanity and satisfaction by studying what is happening in Africa and South America, regions in which, in cultural matters, everyone is both an amateur and a professional at the same time.

Chapter 6 | Françoise Lionnet

The Mirror and the Tomb | Africa, Museums, and Memory

In Michel Tournier's 1987 novel *La Goutte d'or (The Golden Droplet)*, Idris, a Berber shepherd, leaves Tabelbala, his Saharan oasis, in search of a snapshot of himself taken by a blond Parisian female tourist. His journey north to Paris produces a series of encounters that lead to a progressive loss of innocence, his handsome features being appropriated time and time again by a visual culture, quite unlike his own, that puts a premium on images. On the road, his first experience of radical depersonalization occurs in a nearby village. As he wanders through the streets looking for food, he walks past an exclusive resort hotel from whose outskirts he is banished without ceremony; eventually he finds himself "at the door of the Saharan Museum, an offshoot of the Arid Zones Laboratory funded by the French National Center for Scientific Research" (or CNRS) (p. 65). Slipping unnoticed into a group of senior citizens on a tour, Idris enters the museum and discovers to his astonishment that utensils and objects used daily by his fellow oasis dwellers are part of a scientific exhibit that describes their habitat, beliefs, and customs:

> Idris opened his eyes wide. All these objects, of unreal cleanliness, frozen in their eternal essences, intangible, mummified, had surrounded his childhood and adolescence. Less than forty-eight hours before, he had eaten from that dish, watched his mother using that grinder (p. 67).

These simple and familiar objects are suddenly transformed into symbols. Behind the glass of the display case, the mortar and pestle, the grinder, the pitchers, and the leather bottles suddenly arrest the "native" viewer's attention, produce a sense of wonder and defamiliarization. Idris is fascinated, captivated by the seeming uniqueness of a perfectly ordinary kitchen utensil, now transformed into its remarkable and "eternal essence," frozen in time. He experiences a sense of estrangement and wonder that shatters his usual frame of reference, reshapes his world, makes him see it anew as though for the very first time. Yet, listening to the tour guide explain his people's cultural codes and rules for living, he discovers self-consciousness and alienation in its purest form. The guide turns the oasis dwellers' existence into an exotic scenario,

Françoise Lionnet, "The Mirror and the Tomb: Africa, Museums, and Memory" from *African Arts* 34:3 (Autumn 2001), pp. 50–9, 93. Reproduced by permission of the University of California, Los Angeles. (Reprinted without illustrations.)

while the museum presents the material elements of their lives and the photographed faces of their women "covered with ritual paintings" (p. 68) to the attentive scrutiny of this group of foreign visitors. Spontaneous or ritual activities of ordinary life are now transformed into formulaic knowledge, mouthed pleasantly and humorously by a tour guide who remakes Idris's world in front of his astonished eyes:

> Idris listened attentively to a speech whose every phrase, every word, concerned him.... "Here, mesdames et messieurs, you will look in vain for the head of a dog, the silhouette of a camel, a scarab, and especially for a man or a woman. No; Saharan jewels are nonrepresentational. They are abstract geometrical forms whose value lies in signs, not images. Here are solid-silver crosses, crescents, stars, rosettes.... The anklets are supposed to prevent the demons of the earth from climbing up a person's legs and invading the whole body" (pp. 65, 68).

As Idris takes in the lessons being dispensed to the group, including the ones about the "supernatural or superstitious aspects of his religion, he "had the impression that he was being forcibly removed from himself, as if his soul had suddenly left his body and was observing him from outside with astonishment" (p. 68). As the visitors leave, Idris lingers behind in order to approach the display case, still fascinated and full of wonder. But as he approaches, he sees his own reflection in the glass, and now becomes, like the other objects, an item within this ethnographic collection. Tournier concludes the scene with this extraordinary comment:

> Finally, as he was moving away from the glass, he saw the reflection of a head of unruly hair and a thin, vulnerable, anxious face; it was himself, his evanescent presence in this taxidermist's version of the Sahara (p. 68).

The display is thus both a mirror and a tomb: Idris's features and culture are no sooner reflected back to him than they are split off from each other. His presence is but an ephemeral, "evanescent," and transparent human one, superimposed onto an ossified culture, represented under glass by inanimate, soulless objects which have only stereotypical meanings.

This early episode of the novel captures brilliantly, and in the form of an entertaining narrative, what has since become theorized as the problematic relationship of the "native" spectator to the traditional anthropological museum exhibit. Tournier's story sums up the politics of representation within a discipline that concentrates on "typical" or "authentic" cultural artifacts in order to synthesize a given culture's "heritage." Postmodern anthropologists (Clifford 1988; Clifford & Marcus 1986; Karp 1991) have since exposed the limits of such museum practices and articulated the complex links between spectatorship, subjectivity, and ethnographic authority and desire. For Tournier the ethnographic approach turns human subjects into dead animal specimens, similar to those prepared by taxidermists for a natural history display. A gently patronizing attitude is thus encouraged by the museum, and temporal as well as spatial distance is firmly established between the modern viewers and the objectified "traditional" culture. Tournier uses the following exchange between the guide and one of the pensioners to recapitulate the problem:

> "I see neither spoons nor forks," an old lady said in astonishment.

"That, madame, is because the oasis dweller, like our ancestor Adam, eats with his fingers. There is no shame attached to that. Everyone picks up a little handful of food with his right hand, transfers it into the hollow of his left palm, rounds it into a little pellet, and then with the thumb of his right hand pushes it to the tip of his fingers and puts it into his mouth" (p. 67).

As he proceeds to demonstrate the gesture, the guide is "imitated by a few of the tourists, whose clumsiness raised some laughter." The "clumsiness" of the tourists underscores the unsurmountable gap between these modern travelers and the oasis dwellers who represent the pre-history of mankind ("like our ancestor Adam"), that is, a premodern approach to everyday life and feeding practices. Johannes Fabian (1983: 31) has eloquently shown how this anthropological gaze implies a denial of coevalness that situates the viewed and living culture in another temporal framework: one that belies its status as contemporary, evolving, and dynamic, and thus reinforces the Western viewer's false sense of superiority.

As Tournier's anecdote makes clear, both spectatorship and performance take place at the site of display, and although the border between the viewer and the viewed seems to be easily crossed as the tourists try their hand at a "primitive" style of feeding, this activity only serves to buttress the viewers' sense of their own advantage over such clumsy beginnings. Indeed, the visitors enact the alimentary behavior of the oasis dwellers, but in so doing, they experience their own civilized difference from and advantage over the "natives." Finally, they receive from the guide a perfectly composed and succinct ethnographic lesson on the virtues and system of values of this belated – i.e., temporally "remote" – Saharan culture, about which he must nonetheless talk in the *present* tense, since they exist in the here and now of the Saharan universe:

> But you must not believe that the oasis dweller is therefore lacking in civility. The elementary rules of politeness in the Sahara are well known. Before every meal, one must wash one's hands, and not in stagnant water.... Allah's blessing must also be invoked. One does not drink while eating, but after the main dish ... (p. 67)

Respectful understanding of the other thus serves to reassure the modern spectator that despite the (constructed) temporal and geographic distance, these peoples are indeed the human ancestors we seek to comprehend so that we might understand ourselves better. Their existence and their religious beliefs are contextualized before our now deferential eyes. Their culture is given a certain degree of "thick description" (Geertz 1973: 3) as the tour guide's narrative completes and gives meaning to the objects presented. Reassurance about the role of difference in the human community is then the ultimate outcome of the exhibit. The spectators are reconfirmed in their own sense of identity; they have safely evolved beyond the archaic stages of primitive behavior represented by these cultural or human specimens to whose values they can also now relate.

The emotions produced in the museum-goer are thus uncannily parallel to those we have associated, since Aristotle's *Poetics*, with the ones produced in the spectator of Greek tragedies. According to Aristotle, the theater-goer undergoes a catharsis as he experiences fear and pity: fear when he identifies with the tragic hero; and pity when he realizes that the hero's fate is different from his own, and this reconfirms him in his present sense of identity and security. Identification is followed by differentiation and separation, and he feels fortunate to be spared, grateful to be safe.

It is this sense of reassurance, and what it might mean to be "reassured" by ethnographic exhibits, that I am interested in exploring in this essay. As a facet of the museum-goer's experience, reassurance can be analyzed alongside other emotions such as "resonance" and "wonder" or "resonance" and "reverberation," two pairs of concepts that form the contours of a spectator's reactions to objects and images, and that have been theorized, respectively, by Stephen Greenblatt (1991) and by Gaston Bachelard (1969) and Patrick T. Houlinan (1991). I want to think about what is "reassuring" and, by contrast, what might be "threatening" in certain types of exhibitions about Africa in particular, and I will do so by focusing on two exhibitions of African art and culture, both held in the United States in 1998. The first, "Treasures of the Tervuren Museum," traveled to several North American cities in early 1998, in celebration of the Belgian museum's centenary. I saw it at the Museum for African Art in New York in May. In April of the same year, the Program of African Studies at Northwestern University commemorated its fiftieth anniversary and the legacy of its founder, Melville J. Herskovits, who, with his wife Frances, was instrumental in establishing "continuities between the cultures of Africa and those of descendants of African slaves in the Americas" (Block Museum of Art 1998: 1). This second exhibition will provide a useful counterpoint to the first and allow me to make my point about the contrasting feelings of reassurance and anxiety that I will associate here with both Aristotelian catharsis and ethnomuseographic performance.

In his essay "Resonance and Wonder," Stephen Greenblatt distinguishes between what he calls "two distinct" models of museographic practices. Resonance, he argues, corresponds to "the power of the displayed object to reach out beyond its formal boundaries to a larger world, to evoke in the viewer the complex, dynamic forces from which it has emerged and for which it may be taken by a viewer to stand" (1991: 42), thereby creating its own context despite the fact that it has been removed from its original site. By "wonder," he means "the power of the displayed object to stop the viewer in his or her tracks, to convey an arresting sense of uniqueness, to evoke an exalted attention." Greenblatt demonstrates that both qualities, wonder and resonance, have a history, are culturally specific, can change over time, and are tied to decisions made by curators to choose certain forms of display over others. These include what he calls "boutique lighting" (p. 49) as a way of aestheticizing or giving a mysterious aura to certain chosen objects meant to "evoke the dream of possession" and to "displace [this dream] onto the museum gift shop."

Gaston Bachelard, on the other hand, makes a distinction between "resonance" and "reverberation," or what he calls the "resonance-reverberation doublet" (1969: xix) in his phenomenological analysis of the poetic image. For him "resonances are dispersed on the different planes of our life in the world," and they are linked to "the outpourings of the mind" toward broad contexts. Resonance suggests the possibility of understanding and making connections with other feelings and echoes; by contrast "reverberations bring about a change in being" (p. xviii) that is effected through a transformation of consciousness and of the deepest aspects of our being. The end result of resonance and reverberation is that together they produce an identification with the image and thus are the means by which a subversion of the subject–object duality occurs. As Bachelard puts it: "At the level of the poetic image, the duality of subject and object is iridescent, shimmering, unceasingly active in its inversions" (p. xv).

For Patrick Houlinan (1991) it is Bachelard who allows us to understand the confusion of roles and the reversals that can occur between visitor and object, as is

the case in certain Native American museums of the Northwest in which exhibitions have been designed and *controlled by* those whose culture is on display. Thus, he argues, at the U'mista Cultural Centre in British Columbia it is the objects that appear to be observing the spectators, who become objectified by the masks whose eyes seem to be following their movements. There, the subject-position of visitors is threatened as they walk through a hall in which their presence is a form of intrusion. This experience is radically different from that elicited by the traditional ethnographic museum like the one in the Sahara, where the viewer's status as a full subject is reinforced. I noted earlier that in Tournier's narrative a blurring also occurs when the tourists are encouraged to act out the behavior of the oasis dwellers. But in that case, the blurring is only a necessary and fleeting moment of identification of the spectator with the "native." Once the moment is transcended, this temporary blurring ultimately serves to reinstate and reinforce the prevailing hierarchies and the existing relations of power.

For Idris, however, the experience of depersonalization that can accompany the first stage of spectatorship is a radically new one, and he never recovers from it. He experiences resonance because these objects are familiar and he is able to contextualize them immediately. He is also full of wonder at the way the objects are showcased: they become, like Bachelard's poetic images, a means for him to feel *de*familiarization and *dis*identification. Idris sees his world in a new light, but rather than being transformed and eventually reassured by his passage through this moment of catharsis, he feels lost and numb. The unity of his being is never recovered. It is within himself that the split between subject and object, viewer and viewed, happens; he becomes a presence-absence, in Tournier's words, an "evanescent presence." In fact, in the museum, Idris is invisible to all the tourists – transparent, as it were. Whereas the displays serve to buttress the identity of these tourists, they steal Idris's. For the French visitors, the museum is a way to remember the beginnings or prehistory of civilization, and what has since been gained for them; but it forces Idris to remember his village, his mother's cooking, and what he is now in the process of losing forever: his culture and identity as an oasis dweller. In Tournier's novel the young man is set on a course from which there will be no return, and the museum becomes an unusual point of intersection of two axes: the axis of recovery of what is perceived as past (for the tourists looking *at* this past) and the axis of loss of that so-called past (for Idris looking *for* absent meaning).

That these two axes are able to intersect at all is a result of the museum's location. It is situated in Idris's own geographical territory, but it is conceived by and aimed at those who are external to that space and who possess the means of representation and interpretation. It is thus a heterodiegetic site of cultural memory, whereas the U'mista Cultural Centre in British Columbia discussed by Houlinan, similarly situated in close proximity to the culture it seeks to represent, is a homodiegetic site that addresses the local culture and attempts to coincide with it.[1] Actively engaging the spectator, it neither mirrors nor entombs the viewer (or the objects viewed). Its displays simply unsettle and destabilize the visitor's gaze, resisting every effort to construct the culture as inanimate. The encounter becomes truly dialogical, and a space is created in which both the spectator and the culture on display seem to be equally balanced.

Ethnographic museums are seldom established in the midst of the cultures they aim to show off or make known. The location of the CNRS Saharan laboratory is unusual. It thus makes the conflicting dynamics of identification more clearly visible, and the problems of viewer reception more acute. One can both look *at* and look *for* Africa on this site. This museum embodies perfectly the dialectics of representation – the "ways

of seeing" that John Berger (1972) equates with unequal power relations, and that, I suggest, are implicit in the distinctions between "at" and "for." At the U'mista Cultural Centre, by contrast, an object looks *back* and establishes a presence. Its gaze is without epistemological or memorial purpose; it is simply there and real. It follows the viewer, establishing its undeniable existence and its ability to exceed the process of objectification.

Let me now turn to the two exhibitions of African art and culture that are my case studies. They are useful for examining the dynamics of spectatorship described above and for understanding Bachelard's "resonance-reverberation doublet." I will borrow Bachelard's twin formulation and reframe it in terms of what I would rather call a cathartic "reassurance-threat doublet." I will argue that these emotions can be triggered in the viewer by the accumulation of objects of ethnographic knowledge. As I focus on these two exhibitions and on the emotions they seem to have been programmed to elicit in the spectator, my purpose is neither to provide a critique of the curators' policies and goals nor to presume to make a general statement about museum practices and their general role as "*lieux de mémoire*" (Nora 1989). I rather wish to interrogate my own existential and phenomenological reactions with regard to the means by which Africa was being re-presented and remembered in these two commemorative exhibitions at the turn of the second millennium. The Tervuren Museum (Musée Royal de l'Afrique Centrale) invited us to look *at* its rich collection of objects, but it also made a case for the need for scholars to look *for* lost history and meaning. Northwestern's display, by contrast, sent one looking *for* traces of a living African culture, one that exists in the present of the Americas, and whose traces literally look *back* at the viewer, who is compelled to relate to them directly and dialogically.

The Tervuren Museum, like the CNRS Saharan lab, was considered to be a "scientific institute" at the time of its founding in 1897–98 by King Leopold II of Belgium. Its director, Dirk Thys van den Audenaerde, states in the preface to the catalogue of the "Treasures" exhibition (Verswijver et al. 1996: 7):

> From the beginning, the scientific policy and methodology of Tervuren were directed toward the collection and comparative investigation of large groups of objects from all over Central Africa; this principle held for cultural anthropology as well as for the natural sciences. Thus was the foundation established for the important series of scientific collections for which the Museum is so well known . . .
>
> The importance of the Museum's extensive ethnographic collections lies in the completeness of these series – which makes stylistic analysis possible – and the age of the objects. Many of these old examples exhibit stylistic traits that no longer exist, and they may be counted as products of disappearing or extinct cultures . . .
>
> The pace of economic and sociocultural evolution in Central Africa, along with the conditions imposed by a tropical climate – where humidity, mould, termites, and other destructive elements all work against the long-term preservation of wooden objects – have resulted in a situation whereby the majority of venerable pieces have most likely disappeared from their places of origin. By means of this exhibition, the Tervuren Museum hopes to demonstrate the extent of the contribution made by the first collectors and scientists at the turn of the century to our knowledge of Central Africa's cultural heritage.

True to the pattern of loss and retention I outlined above, and that James Clifford has termed the "allegory of salvage" (Clifford & Marcus 1986: 112) so central to anthropology's concerns, the exhibition provided a rich resource that served to

reassure us about the museum expert's role as *conservateur*, in other words, about such a person's ability to "preserve" and curate the past, a past that has been all but eradicated by the experience of colonialism in Africa. The introduction to the catalogue echoes the preface: Gustaaf Verswijver states that the museum possesses "an enormous treasure trove of ethnographic dossiers," that "the [exhibited] pieces' histories can be recovered on the basis of archives and other documents," and that "the quest for the lost identity of objects must continue!" (Verswijver et al. 1996: 9). This "treasure trove" is available to researchers, who are urged to study these documents, and to do so critically in order to contribute to the "understanding of the societies concerned," since, Verswijver adds, "recent fieldwork has shown that the current generation of various ethnic groups can no longer supply specific data concerning the use, fabrication, symbolism, and content of the ingeniously elaborated masks and sculptures that their ancestors made and possessed." The museum's mission, then, we are reassured, has been to salvage what colonialism and climate conditions would have otherwise destroyed: the combined aesthetic, cultural, ritual, and sacred elements of the past.

The Tervuren exhibition showcased beautiful objects that produce "wonder" (Greenblatt) and "reverberation" (Bachelard). Shown under glass and lit in the "boutique" way described by Greenblatt, they projected an undeniable authority and power. The extensive commentaries which accompanied the displays furnished the appropriate elements of "resonance." There were exquisitely carved statuettes, masks, musical instruments, staffs and walking sticks, spears, cups, a drinking horn, a pipe, and an anthropomorphic coffin. The function of certain objects was immediately recognizable: a very fine anthropomorphic *sanza* or lamellophone in the shape of a female body with extended arms is a musical instrument that mimics those who dance to its tune; a drummer figure with rounded, benevolent features colored in red pigment is an elegant statue with harmonious proportions, its slightly lowered eyes denoting a meditative or respectful mood. Nothing was particularly unusual or disturbing about these two figures: they seemed to suggest the universality of music, dance, and creative or religious contemplation. They provided their own context of understanding, and offered a definite level of "reassurance": the activities and emotions they portray conveyed a safe level of (cultural) difference and (human) similarity, since it was easy to see past their aesthetic and ethnographic specificities toward the larger context of collective human endeavors. Like the fictitious tourists of Tournier's tale, we – as viewers – could relate to these two statues and to their contexts without difficulty. These objects confirmed us in a traditional humanist understanding of the world beyond our own.

Other objects, however, immediately struck the Western viewer as "strange." Their appearance was perhaps disquieting, startling, even suspect. They provoked a degree of fear and terror. This was especially true of the *nkondi* statues known as *mangaaka*, a Kongo word that means "one who strikes fear into the beholder." To understand and situate them, we required some explanatory narrative – which was provided, to a certain extent, by the curators. The figures stared back at the viewer, they seemed to frown and shout, and they carried "medicine packs." These "fetishes," the curators explained, were meant to frighten off evil or punish enemies. The white paint on their faces indicated that they represent spirits with supernatural and curative powers. The sacred nature of these figures was thus established by an explanatory narrative that did not succeed in containing their meaning within a completely familiar context. Something vaguely threatening remained. A sense of radical difference emanated from these

strange shapes that expressed fear or anxiety, and conjured it up in the viewer. The glass eyes of one *nkondi* established it as a presence that the spectator could not ignore or subsume within a familiar interpretive framework. This statue thus seemed to observe us and follow our movements.

If I put myself in the position of the stereotypical and fictitious Western spectator, however, I experienced "wonder" and "reverberation": on the one hand, I could identify with the feelings generated in and by these figures; but on the other hand, I felt *de*familiarization because of their sacred and alien nature. My reactions illustrate Bachelard's sense that there is an inversion or subversion of the subject–object duality when we are confronted by a "poetic" image or aesthetic object. The beauty and mystery of the *nkondi* figures were alarming, but at the same time I knew, as do Tournier's French visitors in the Saharan museum, that the strength these objects embody is contained within a sphere of cultural and religious beliefs that does not intersect with my own sense of rationality. It was thus easy, in a second stage, to discount their troubling elements. After an initial shock of recognition, followed by disidentification, I was finally reconfirmed in my own sense of being a full subject, different from the one the statues address, distant in both geographical and temporal terms from the central African culture that produced these beliefs, and safe from the reach of its "fetishes." The boutique lighting in which the figures were bathed thus served to reorient my response in the aesthetic direction rather than the supernatural one, and it reassured me: by adding to the aura of artistic mystery, the lighting undermined the purely sacred power immanent in the objects and set them apart as more inanimate than enduring and spiritual; they were "mummified," like the objects that Idris looks at under glass, and they exemplified what Annie Coombes has called the "museological process of othering" (1994: 221). The cultural recovery per-formed by the exhibition was thus geared to a heterodiegetic viewer, and it did not create a space for the "native" spectator who might share a world view similar to the one embodied in the statues.

The overall impression created by the Tervuren traveling collection remains one of great power and beauty – removed from the everyday concerns of a contemporary viewer. The patina of the well-preserved wood, the intricate designs, the use of pigments, raffia, beads, cowrie shells, nails, copper, leather, horns, and feathers gave the ritual objects a sensory quality that resonated in a coherent and authoritative fashion, but were dated and marked as past. Their artistic, historical, and ethnographic significance was proven beyond a doubt. Taken individually, each object may have provoked some unsettling reactions and reverberations, but those were fleeting and ephemeral. Looking *at* these objects and looking *for* their meaning in the curators' narratives, we could reconstruct their function in historical context. If we did perceive them as looking *back* at us, it was but a momentary experience that was subsumed within the overall appeal of aesthetic distance, and one that produced no lasting sense of anxiety or threat.

The Program of African Studies at Northwestern University had very different goals in its jubilee celebration. A major "didactic" exhibition, "Living Tradition in Africa and the Americas," was organized at the Mary and Leigh Block Museum of Art on campus. Its purpose, as the title indicates, was precisely to show how cultures survive through transformations, accommodations, and adaptations. The goal, in keeping with Herskovits's own career, was to stress the retentions of past African cultures "living" in the present of what Paul Gilroy (1993) has termed the Black Atlantic. Intended both as a testament to the work of the past and as a resource for the future

(Guyer & Mack 1998: 1), the exhibition featured recordings, photographs, books, letters and personal papers as well as art and artifacts bequeathed by Herskovits to Northwestern University and other institutions. A multimedia experience, it documented the cultural connections established between Dahomey (now Benin) in west Africa, and Suriname, Haiti, Trinidad, and Brazil, where the Herskovitses did fieldwork between 1928 and 1963. In contrast to the Tervuren collection, "all the art pieces in the [Block] exhibition entrance are contemporary, created from elements of a living tradition for the commercial art markets of the world" (Guyer & Mack 1998: 28). Here too, aesthetic and ethnographic elements merged, but the emphasis was on "retention," "survival," and "syncretism," not on the loss and disappearance of cultural traditions. The continuing importance of Africa to the New World was presented in meticulous details that undermined the stereotypical view that confines African history and geography to a distant realm. African material culture was presented in a way that disrupted the traditional binary dyad, the one that posits a clearcut distinction between the West and its other. The exhibition thus departed from the pattern established by prestigious European institutions such as the Tervuren Museum. From the Block Museum brochure (1998):

> The Herskovitses described a great variety of retentions in all domains of culture but found some of the most striking examples in religious life. Rituals of death, burial, and commemoration revealed similarities throughout the Africa-descended world. Even belief itself and its expression in the intimate daily round of life – in shrines for example – were seen as African in contrast with a Western age marked by skepticism . . .
>
> The variety of configurations and innovations the Herskovitses found in their research defied theorization: In Haiti, practitioners of *vodou* incorporated both African *vodou* and French Catholic elements; in Brazil, *candomblé* rituals retained African sacred language; in Trinidad, the descendants of slaves had adopted European music . . . but they also "shouted" in African style in their religious ceremonies . . .

The approach used by the American anthropologist was revolutionary at the time, and it did not fit into standard explanatory frameworks. But in light of contemporary theories of hybridity, *métissage*, and *mestizaje*, it now appears unproblematic and visionary. African material cultural practices were shown to exist all around us, as Frances Herskovits observed in 1929 (quoted in the brochure):

> A Sunday or two ago, a student took us to the Sanctified Church here in Evanston. . . . What we found was practically a Paramaribo [Suriname] "winti" dance. The same dancing, the same trembling of the body, the hand-clapping. . . . It was astonishing.

Knowledge was presented as embodied, and performed in gestures, rituals, and activities as well as self-representations and artistic objects. The exhibition forced the visitor to take stock of that past in relation to both the present and the future, since it made clear that the patterns of survival and retention of African traditions have only begun to be studied and that "the road is open" for new research. As an invitation to participate in just such a research project, the exhibition eschewed the aesthetic as well as the functionalist pitfalls into which curators who provide static explanatory paradigms might fall. By giving the broad historical contexts of the Herskovitses' research, this event allowed for an open and dialogical encounter with the means of representation and knowledge production that it actually put to use: each viewer was encouraged to participate in the search for the traces of a "living" tradition, to become an actor in

the scenario of recovery of these cultural patterns which are present in the New World, even when they are not always noted as such. The Herskovitses emerged as the most innovative precursors of postcolonial and diaspora studies, their work a model to be emulated by younger scholars.

While the commemorative intent of "Living Tradition" made such a conclusion inevitable, a question remains about its overall ideological impact and engagement with different classes of spectators. One important aspect is that the narrative of "progress" articulated by Tournier's CNRS guide cannot obtain here. The exhibition's model of survival, retention, and transformation undermined the traditional anthropological denial of coevalness (Fabian 1983) and made cathartic disidentification impossible. Reverberations (Bachelard) occurred, and the viewer's consciousness was raised by a convincing demonstration of the dynamic quality of African cultures. Looking at past practices as they inform present performances made the viewer aware of his or her own involvement in diasporic culture. Commonalities could be drawn with all New World cultures and their diasporic origins – whether from Africa or elsewhere. I would argue that this exhibition thus created a strong sense of reassurance about the past. It set in motion the desire for historical knowledge and cultural memory, but not just in the Black Atlantic, since it aimed to implicate all of us in its effort to reconnect the "broken threads" (Du Bois 1969 [1903]) of the social histories of slave societies. It thus empowered all agents to become producers of new knowledge about this past, quite unlike the Tervuren curators who insist that their collections are examples of "disappearing or extinct cultures."

Yet a puzzling image closed the exhibition and its brochure. The back cover features photographer Tony Gleaton's *Un hijo de Yemayà*. This stunning 1992 photograph of an Afro-Belizian youth's head partially submerged and reflected against the calm surface of a lake conveys an ambiguous message. Is his frowning look an expression of worry? Or does he appear threatening? The face seems slightly hostile, yet it also appears to be in danger of being engulfed in water. Like Idris, the boy seems out of place in this exhibition, and no explanation is given.

The photograph is a poetic image that creates, for me, wonder and reverberations. The frowning face appears to interrogate the photographer and beyond him, the visitor. It is tempting to see it as that of the prototypical "native" gazing *back* at the observer, his "vulnerable, anxious face" (Tournier 1987: 68) oscillating between presence and absence, his distorted, liquid reflection symbolizing better than words "the complex interests at stake in representation of culture contact in western museums" (Coombes 1994: 220). Since no context is provided, we may speculate endlessly about it. Is the youth a figure of emergence and resistance, asserting his subjectivity as Gleaton's lens captures his assertive, questioning – perhaps menacing – gaze? Given the general thrust of the exhibition, this may be the intent. But the face may also be expressing puzzlement, fear, or concern before the camera, in the same way that Idris worried about the blond photographer who "stole" his image. The expressive eyes lock with our own and force us to acknowledge him. But his mouth is under water, and this suggests that no voice can or will be heard. He is thus an interesting counterpoint to the *nkondi* figures of the Tervuren with their open, silently shouting mouths.

It is a testament to the artistic quality of this photograph that it refuses to allow itself to be contained within a transparent ideological and "didactic" purpose. Like Bachelard's poetic image, it evokes wonder and reverberation, not resonance, and it is "iridescent, shimmering, unceasingly active in its inversions" (1969: xv), since it

becomes impossible to fix its meaning. No catharsis is possible here: there is no easy identification with the subject of the image, nor identification of its purpose. Staring *back* at the visitors, this image of "un hijo de Yemayà" (a son of Yemayà) seems to take back the power of representation, assert its otherness, and prevent its contours from being set into an explanatory narrative. It conforms to the dynamics Houlinan outlined with regard to the U'mista Cultural Centre. It also marks the space opened up by the contradictions this essay has briefly tried to address. Between mirror and tomb, recovery and loss, ethnography and aesthetics, reassurance and threat, the photograph charts a set of possibilities, an aporia, and a sense of uncertainty that could be the salutary beginning of a more humble approach to knowledge and representation than is usual in academic and museographic contexts. This is the approach that Zora Neale Hurston, who, like Herskovits, was a student of Franz Boas, tried to inject in her highly personal and poetic approach to field research. Her surprising absence from Northwestern's commemorative exhibition is all the more regrettable, as she could have been the one to provide the "voice" that the submerged face from Yemayà cannot.

Hurston's sense of narrative, her understanding of ambiguity, and her belief in "autoethnography" provide me with a useful contrapuntal conclusion. As she once put it, "There is no agony like bearing an untold story inside you" (1984: 213). Museums can help tell some of these untold stories. But it is perhaps in that space of radical alterity evoked by poetic images that we can enter into a productive dialogue with the subjects of these exhibitions. This would enable us to engage with the gaze and the voice of the other, with the traces of the past and the needs of the future – in other words, with the unformulated questions posed by the eyes of the children of Tabelbala and Yemayà as they too silently ponder the power of knowledge and representation.

Note

1 The terms *heterodiegetic* and *homodiegetic* are used in narrative theory to classify stories. A heterodiegetic narrative is one told by a narrator who is not a character in the story; a homodiegetic narrative, on the other hand, features a narrator who also participates in the events she or he recounts. To the extent that museum exhibits and other forms of installations and performances tell "stories" about peoples and cultures, I feel that it is appropriate to borrow these two narratological terms to distinguish between exhibits mounted by peoples who are representing themselves and exhibits prepared by experts who are external to the story they tell.

References

Bachelard, Gaston. 1969. *The Poetics of Space*, trans. Maria Jolas. Boston: Beacon.
Berger, John. 1972. *Ways of Seeing*, London: Penguin.
Block Museum of Art. 1998. *Living Tradition in Africa and the Americas*. Evanston, IL: Northwestern University.
Clifford, James. 1988. *The Predicament of Culture: Twentieth-Century Ethnography, Literature, and Art*. Cambridge, MA: Harvard University Press.
Clifford, James and Steven Marcus. 1986. *Writing Culture: The Poetics and Politics of Ethnography*. Berkeley: University of California Press.

Coombes, Annie E. 1994. *Reinventing Africa: Museums, Material Culture, and Popular Imagination*. New Haven: Yale University Press.

Du Bois, W. E. B. 1969. *The Souls of Black Folk*. New York: New American Library. 1st pub. 1903.

Fabian, Johannes. 1983. *Time and the Other: How Anthropology Makes Its Object*. New York: Columbia University Press.

Geertz, Clifford. 1973. *The Interpretation of Cultures: Selected Essays*. New York: Basic Books.

Gilroy, Paul. 1993. *The Black Atlantic: Modernity and Double Consciousness*. Cambridge, MA: Harvard University Press.

Greenblatt, Stephen. 1991. "Resonance and Wonder," in *Exhibiting Cultures: The Poetics and Politics of Museum Display*, eds. Ivan Karp and Steven D. Lavine pp. 42–56. Washington, DC: Smithsonian Institution Press.

Guyer, Jane L. and Deborah L. Mack. 1998. "Living Tradition in Africa and the Americas," *PAS Working Papers* 4. Evanston, IL: Northwestern University.

Houlinan, Patrick. 1991. "The Poetic Image and Native American Art," in *Exhibiting Cultures: The Poetics and Politics of Museum Display*, eds. Ivan Karp and Steven D. Lavine, pp. 205–11. Washington, DC: Smithsonian Institution Press.

Hurston, Zora Neale. 1984. *Dust Tracks on a Road*. Urbana: University of illinois Press.

Karp, Ivan and Steven D. Lavine. 1991. *Exhibiting Cultures: The Poetics and Politics of Museum Display*. Washington, DC: Smithsonian Institution Press.

Lionnet, Françoise. 1989. "Autoethnography: The An-Archic Style of Dust Tracks on a Road," in *Autobiographical Voices: Race, Gender, Self-Portraiture*, pp. 97–129. Ithaca, NY: Cornell University Press.

Nora, Pierre. 1989. "Between Memory and History: *Les Lieux de Mémoire*," *Representations* 26 (Spring).

Tournier, Michel. 1987. *The Golden Droplet*, trans. Barbara Wright. New York: Doubleday.

Verswijver, Gustaaf, Els De Palmenaer, Viviane Baeke, and Anne-Marie Bouttiaux-Ndiaye (eds.) 1996. *Masterpieces from Central Africa*. Munich: Prestel Verlag.

Chapter 7 | Gaby Porter

Seeing Through Solidity | A Feminist
Perspective on Museums

> Our previous history is not the petrified block of a singular visual space, since,
> looked at obliquely, it can always be seen to contain its moments of unease.
> (Jacqueline Rose, 1986, *Sexuality in the Field of Vision*)

Rose's allusion to history as a petrified block, material and solid, resonates with history as found in museums – the residues and solid, hardened traces of histories of which their collections are formed. Because they are full of such things, museums themselves appear to share these material and physical characteristics, and to escape or resist critical readings which might suggest that they are other or less than solid, certain, and complete. Museums have not received the attention of those who might look 'obliquely', and with a different perspective: one which unsettles the certainty of the museum discourse and suggests that these solid histories and arrangements can soften to become more flexible and malleable. Feminist critics, in particular, have focused on other media such as history, television, cinema and magazines and have overlooked or avoided museums. Even with people who have undertaken feminist criticism in, say, literature or technology, my proposition of a feminist critique of museums may be met with surprise or even mild dismay: 'well, I actually *liked* that museum . . .'. Until very recently, few people have undertaken critical research about museums, and there have been few occasions where they have come together with people working in museums to share and openly explore critical issues of representation, sexual difference and identity or cultural diversity.

Like many others entering museum work, I had no awareness of such critical issues, nor a theoretical or practical grounding in material culture studies. While working in different museums, I increasingly felt that their displays and collections did not represent the histories and experiences of women as fully and truthfully as those of

Gaby Porter, "Seeing Through Solidity: A Feminist Perspective on Museums" from Sharon MacDonald and Gordon Fyfe (eds.), *Theorizing Museums: Representing Identity and Diversity in a Changing World* (a volume in a special monograph series published by Blackwell for the journal *The Sociological Review*), pp. 105–26. Oxford: Blackwell, 1996. © 1996 by The Editorial Board of The Sociological Review. Reproduced by permission of Blackwell Publishing. (Reprinted without illustrations.)

men. I sought to understand more fully why and how this happened: eventually, I registered as a part-time postgraduate student to undertake research on the representation of women in history museums in Britain.[1] My goal in this research was programmatic, to increase and improve the representation of women in museum displays and collections. Initially, I felt that this could be achieved simply by adding material which reflected women's experience in the past to the collections and displays. As I studied further, I began to understand that the differences between the histories of men and women as represented in the museum lay at much deeper levels. I recognized that the whole structure of museums – abstract knowledge and organization as well as concrete manifestations of buildings, exhibitions and collections – was built upon categories and boundaries which embodied assumptions about men and women, masculine and feminine (Porter, 1987). As a further step, I recognized that these assumptions about men and women were interdependent and relational; they could not be anchored by reference to any 'real' men and women but were constructed, positional and constantly in the making (Porter, 1991).

In this chapter, I describe the broad approach and conclusions of the research which I undertook. I address the challenge of applying theory in museums, where people are strongly anti-theoretical, or empirical, in their practice and approach. This challenge is greater because a theoretical reading is difficult to sustain when the museum is such a complex, layered text of space, things, texts, images and people; its sheer scale and persistent physical presence constantly threaten to topple fragile concepts of subjectivity and positionality. This challenge was greater for me because I chose to use a feminist approach, with its equivalent tensions between the abstract, theoretical concepts and the material, physical body – anxious to avoid any appeal to biology and essences, yet struggling to maintain a concept of femininity which is always and only abstract and positional. I question whether theory, and the theories which I used, helped or hindered my intention at the outset, to effect change in museums. I employed poststructuralist and deconstructive methods, where the temptation has been to allow the endless play and deferral of meaning and to avoid any closure. I also examine the benefits and costs of such engaged research, where I have been both 'inside' the museum text as curator/author, and 'outside' the text as reader. Is such research of greater benefit than 'academic' research; and what are the costs and consequences for the professionals involved? Finally, I suggest some directions for feminist exhibition-making.

Theorizing Museums

The focus of my research was not history itself, but representation: not the content of displays and collections, but their production and meaning. My concern was not whether something is true, but how it comes to be true in the museum text. Thus in my research I challenged the traditional, humanist and empirical, ways of thinking and working which permeate the professional framework and everyday practice of museum workers. Theory became central to my work, providing the tools to move beyond the obvious and evident presence of these displays and collections and to develop a critical understanding of the processes and relations through which they are constructed and maintained.

The theories which I used for this feminist critique of museums were not themselves new: they are, broadly, structuralist and poststructuralist and developed most fully in

literary criticism and cultural studies, particularly in visual and popular culture such as advertising, films and magazines. (For example, in the work of John Berger, 1972 and Judith Williamson, 1978; also of Ros Coward, 1984; Jacqueline Rose, 1986 and John Tagg, 1988, among others.) What was new was that I applied these theories to museums, taking the relation of text, author and reader and translating these into the museum forms of exhibition, curator and visitor. Museums claim to show the past as it really was – to re-present history. In this simple claim, the medium of the museum and the process of making collections and displays are rendered invisible in a relationship of authenticity and truth. Many museum workers believe that the 'real thing' they are dealing with carries intrinsic, essential and universal truths – material facts. Their professional codes and day-to-day practice are built on the premise of objectivity and neutrality, eschewing bias or influence. This practice is empirical – attributing concepts and knowledge to common sense and experience. Empiricism posits itself as obvious and natural, and rejects theory as distorting or, at best, unnecessary. Critics since structuralism have put into question such a practice: from this critical perspective, the 'obvious' and the 'natural' are not givers of meaning, but are produced within a specific society by the ways in which that society talks and thinks about itself and its experience. In such a critique, the realist text depends as much as any other text on an underpinning theory or ideology, despite its apparent invisibility or transparency. It is intelligible as 'realistic' precisely *because* it is familiar, recognizable and taken for granted: it reproduces what we already seem to know. Thus, in the realist text of museums, empiricism is not a sufficient response to, or defence against, critical analysis.

The term 'structuralism' derives from Ferdinand de Saussure's linguistic studies in the early part of [the twentieth] century. His work demonstrated that the meaning of signs is not intrinsic but relational: each sign derives its meaning from its difference from all the other signs in the language chain. Thus structuralism insists on the primacy of relations and systems of relations. Saussure's work was taken up and applied in other areas from the middle of this century: in scientific, social, anthropological and cultural studies. In such studies, structuralism displaced nineteenth century empiricism, which gave ontological primacy to objects, with a 'theory of relativity'. Whereas empiricism stressed the endurance of objects and materials, in the new theory the only endurances are structures of activity (Culler, 1981:141).

Saussure located meaning in the language system, but saw it as single, fixed, prior to its realization in speech and writing. Critics since Saussure have taken his underlying concern with relations further to suggest that meaning is constantly changing. These poststructuralist critics disregard the conventional respect for the authority and intentions of the author, the hierarchy of text and reader. They insist on the autonomy of the text and show how conflict between the reader and the author/text can work productively to expose the underlying premise of a work and to release new meanings and interpretations in the text.

The move from structuralism to poststructuralism has been associated with the work of the French philosopher Jacques Derrida. Moving from a focus on speech to a concern with writing and textuality, Derrida saw all meaning as produced by a dual process of difference and deferral. This process is, respectively, spatial and temporal: meaning is never fully present but is constructed through the potentially endless process of referring to other, absent signifiers; through the interplay of presence and absence (Derrida, 1976). The effect of representation, in which meaning is apparently fixed, is only temporary and retrospective in its fixing.

If meaning is constructed in the text through the interplay of presence and absence, then it may also be deconstructed. Deconstruction locates meaning in texts and their relation with other texts. It is based on the premise of hierarchical oppositions, in which one side of the opposition is the key concept in relation to which the other is defined negatively. Deconstruction works to reverse these oppositions and, in doing so, is able both to show how discourses achieve their effects and to displace their systems. It is both subversive *and* productive, releasing new and unintended meanings. Precisely *because* meaning is incomplete and contradictory, it is open to challenge and redefinition.

In developing a critique of museums, I took the relation of text, author and reader from poststructuralist studies and translated these into the museum forms of exhibition, curator and visitor. In developing a feminist critique, I examined the relations between men and women, masculine and feminine, as they are constituted in the museum. I examined these gender relations[2] as hierarchical oppositions, central to the ways in which museums organize their identity, collections, space and exhibitions to make stories and meanings, both shaping and shaped by notions of masculinity and femininity. I used the position of a woman reader in order to reverse these oppositions, reading against the grain of the text to reveal its sexual codes, assumptions and omissions. From this position, the museum text no longer appears sexually neutral and full with meaning, but restricting and narrow. I read 'as a woman', not with reference to any essential qualities or experience of women, nor in the belief that my conclusions were limited to women; rather, as a position of otherness, at the margins of the text, to explore what is not represented, not shown and not said. This position reverses the usual hierarchy of dominant/masculine and subordinate/feminine to demonstrate that conventional interpretations are limited and limiting.

I traced the gendered identities of 'man' and 'woman', masculinity and femininity in such relationships as subject/object; self/other; progressive/static; public/private; production/consumption; culture/nature. Underlying all of these are the associations of active/passive and male/female. In museums, and in this discourse, 'woman' becomes the background against which 'man' acts. These representations are formed around idealized and stereotypical notions of masculinity and femininity, which are rendered as 'real'. I concluded that, as produced and presented in museums, the roles of women are relatively passive, shallow, undeveloped, muted and closed; the roles of men are, in contrast, relatively active, deep, highly developed and articulated, fully pronounced and open. 'His' existence and ascendance depend on 'her' presence and subordination. Together, they provide a thread for museums in the histories and narratives which they make. The critical project is thus to deconstruct the whole process in which these notions are both given and giving meaning, and to build new ways which are more productive, diverse and open to re-reading.

Museums use sexual identity and difference as a firm and persistent referent on which to build the narratives of exhibitions. Yet feminist critics have drawn on psychoanalysis to unsettle the notion that sexual identity is certain and complete; rather, they suggest, it is hesitant and incomplete. Following this thread, I looked for the placing of sexual difference in the narrative of museum exhibitions; and at the moments of unease – the hesitations, contradictions, unconscious slips and awkward silences – in that narrative. Much of what we present as knowledge in collections and exhibitions is speculative – yet, when attached to material, physically evident, objects, it 'reads' as known, certain, authoritative. From the psychoanalytic perspective, these speculative attributions and ascriptions may be seen as projections – imbuing the

environment and/or other people with an aspect of the self which is disowned, either because it is unconscious, unknown, or because it is suppressed. Sexual identity and difference are so strongly charged with meaning, and vice versa, in museum narratives, precisely *because* these identities, for each of us, are incomplete, unsettled and unsettling.

For the psychoanalyst Jacques Lacan, masculinity and femininity were fictional, constructed identities – the result of social and symbolic, rather than biological, difference. The symbolic order is achieved in the passage from the imaginary – the relationship between mother and child – into the symbolic – the recognition of the father and his law. The child passes from a maternal, natural or experiential, bond into a symbolic order of resolution and closure, rational and cultural, with its own laws and taboos. For boys, this journey is one of transition, separation, rejection: male identity is formed through a split and maintained through suppression and discontinuity. Rationality is established through the exclusion of the feminine: the knower (subject/masculine) splits himself from the known (object/feminine) and establishes dominance over it/her. At the same time, 'he' idealizes the lost 'mother' – eternal, ahistorical, feminine, with a child at her breast, and also available to men. For girls, the journey is one of inversion and loss: recognition of and subjection to an order in which she has no position in her own right, but only in relation to men. For Lacan, the negativity of the feminine is a symbolic and psychical necessity.

For both men and women, this journey is never perfected but always remains partial and precarious. Subjectivity is always in the making. As in Derrida's critique of textuality, Lacan states that meaning can only occur in specific locations and in a relation of difference from other locations. The mechanism of desire, rather than the principle of difference, prevents any final fixing of meaning: the individual is driven by desire for control, satisfaction and completeness which can never be achieved. The subject is never fully in command of his/her identity: rather, a complex network of conflicting structures *produces* the subject and its experiences.

The value of psychoanalysis to feminism is that it offers a specific account of sexual difference, and describes the psychic law to which we are all subject, but only in terms of its failing. If representations serve to maintain a particular and oppressive mode of sexual recognition, they do so only partially and at a cost.

Applying this analysis in literary texts, critics have traced women and the feminine as the necessary frontier between man and chaos: as 'the limit of the symbolic order [they] will share in the disconcerting properties of *all* frontiers: they will be neither inside nor outside, neither known nor unknown' (Moi, 1985: 167). Applying the same analysis in museums, women and the feminine can equally be seen as the boundary and frontier. In museums, knowledge and collections are split into disciplines and hierarchies of classification; specimens are separated from their context, isolated from other specimens, and dissected into individual parts; the parts are ordered and brought together with other parts into new associations and groupings. All these methods are presented as objective, neutral and rational, their goal to create completeness and a comprehensive historical and material record. From a critical and feminist perspective, these practices appears to construct and maintain the male order, with women at its margins. At first, representations of women and the feminine may seem haphazard and inconsistent, frustrating to those who wish to follow their traces in the material culture, but arbitrary. With closer inspection, through detailed study of the application of such methods in specific examples and case studies, I traced the ways

in which these representations are different for activities and modalities associated respectively with the masculine or the feminine, to the relative disadvantage and marginalization of the latter. In exhibitions, in the selection and preparation of items from the collections and in classification systems, women and the feminine become, literally, the frontiers by which space and knowledge are defined: they are the more distant and imprecise elements, in the background and at the edges of the picture. The figures and activities in the foreground, more fully developed and with greater consistency, are those of men and the masculine attributes. 'Reading' across museums, to compare different types of museums and different subjects (industry/ technology, social history, the media), I noted the discontinuity *between* them: positioned at the margins of each, representations of women did not 'fit' together coherently, whereas those of men were relatively congruent. I noted that, throughout, representations of women and the feminine are generally vague and idealized. Where narratives and incidents or materials relating to women do not 'fit' these ideals, they are couched in terms which show discomfort and unease: for example, where women worked in heavy and male-dominated industries (Porter, 1991); where they continue to do paid and unpaid domestic work; where women are independent of men. In these places, the terms of the representation may become more sharply focused, shrill or humorous; or they may appear to deny women and the feminine altogether so that these have to be teased out from oblique references in other messages and materials. At the same time, the expressions of a feminine identity and subjectivity in different terms than these is almost inaudible/invisible and scarcely articulated as 'woman' searches for a language which 'she' can use in order to express herself. This may come through more pluralistic forms of representation which recognize and suggest the complex and contradictory formation of identity, and which explore the interior, immaterial life of the symbolic, emotional and imaginary as well as the exterior, material world of events and things.

In the research which I undertook, I acknowledged that museums are changing: that the materials and methods which they use are bringing people into a closer relationship with museums, and identification with the histories on display. But I argued that the ways in which museums communicate and connect with their visitors are ultimately constrained by the underlying premise of empiricism. This positions the reader/visitor as consumer, who gazes at the finished product and appreciates the creativity of the maker or the authenticity and truth of the setting. The mode of address is declarative; the process of production is mystified or suppressed.

Instead, I proposed that the poststructuralist approach produces a more dynamic and productive culture: it turns the reader/visitor from passive consumer to active producer of meaning, and sees meaning as constantly being made afresh. Its form of address is interrogative, inviting response and dialogue. Through drawing attention to the processes of production, and making them visible, the critical approach suggests that things can be made again, and made differently: that meanings are plural and negotiable. Applying this approach to museums, they can uncover the processes of selection, acquisition, ordering and arrangement of collections, which underlie the public expressions of identity and exhibition. Through presenting themselves as workshops and studios rather than shrines, and supporting others to use their tools and methods with different outcomes, museums can become the sites for active and creative production, the presentation and exchange of diverse viewpoints, and the dynamic (re)interpretation of collections and histories.

The Museum as 'Text' – Entangled in Complexity

In 'reading' the museum exhibition as representation and text, I confronted its complexity – its many layers of production and meaning. These reside in (at least) the exhibition themes; the physical layout of space and design; the sources and choices of objects, images, texts and other materials; the position, condition and presentation of these elements; the light, movement, sounds and smells created in the exhibition. The exhibition is produced and meaning is made also at the point when visitors enter it: in the expectations that they bring with them; the way that they enter, move around, use and leave the exhibition space; whether the exhibition is at the beginning, or the end, of a longer visit or whether it is the main purpose of their visit; whether they have opportunities to discuss or comment on the exhibition with museum staff. This complexity at the level of the exhibition is compounded by the complexity of the museum as a much larger system of production: its objectives, resources, constitution and hierarchical organization; the function and physical separation and devolution of departments and disciplines; the competing demands and pressures to raise visitor numbers and income, and to care for collections; the staff, the role of external specialists, consultants and opinion formers. In choosing to analyse the museum process through detailed research and case studies, I found it difficult to decide where to pitch the research project: which site and materials to select? which staff to interview? I initially pitched these at the level and in the area of my own professional position – at the level of the exhibition; the curators and interpreters who worked with collections and made exhibitions; the collections and research materials; visitor studies when available; published accounts and articles. As the research programme developed, my questions and the objects of study became broader and deeper, to place these exhibitions, people and materials more firmly within their institutional framework and context. With so many different layers and facets to the project, I easily became overwhelmed by detail and description, losing sight of my vision and analysis. This was compounded because, in all of the projects studied, research files and background materials were lacking and I conducted personal interviews in order to collect the data which I felt was essential to the study. In these interviews, especially, immediate concerns, constraints and problems – of people, buildings, collections and resources – were brought to my attention. It was difficult to step back from these 'causes' and to sustain a more abstract and less personalized analysis and overview: to 'read' and write at another level than the familiar, descriptive and chronological, cause-and-effect account.

Similarly, in using a feminist critique, I struggled to maintain a reading based on masculinity and femininity as fragile constructions, and to resist the appeal to experiences and essences, to biology and the body, to 'real' women and men – as subjects in history, as museum staff and as museum users or visitors. The studies from which I drew inspiration lay outside the museum sector, with culture as it is constituted in language, writing and the image – areas with a less solid and immediate physical presence than museums themselves and the collections with which they work. I was more familiar with the realist terms and goals of those striving towards a feminist practice in museums: to expose the gender-blindness of existing work and to reveal and represent other realities in which women were both visible and active. Just as the physical presence of collections and museums threatened to topple my analysis, so the flesh-and-blood beings of men and women seemed at times to overwhelm and intrude

into the notion that gender is socially and symbolically constructed, not physically determined.

As feminist studies of technology, environmental and medical issues have developed, the domain of cultural studies has broadened to include studies which link the material and physical world with the symbolic and imaginary dimensions of identity and culture, showing that things both give and are given meaning through the interactions and movements between the concrete and the abstract (e.g. Cockburn and Ormrod, 1993; Traweek, 1988). These move away from the notion of text and textuality, and are more immediately applicable to material culture studies. Yet museums are more than this: they work on the 'received' material culture and make stories with it: thus both directions in cultural studies are helpful in making a critical analysis of museums.

I return to the question: did theory, and the theories which I used, help or hinder my project to effect change in museums? I believe that the development and application of a theoretical analysis shifts the terms and scope of any such project. Rather than looking for opportunities to 'add' women and the feminine to museums and museum practices, theoretical analysis emphasizes that the feminine and the masculine are interdependent and relational, and must be addressed together. Through the theories which I chose to use, I saw that the museum project is not simply to arrange and re-arrange histories and things which are already fully formed and cast, but to make meanings through the choice, placing and displacing of histories and things. The project thus becomes less determined and constrained; more complex and challenging; ultimately, more creative and fluid. From the critical perspective, the realist project – to achieve a more accurate and life-like representation of reality – seems limited in its scope and tied to the terms and expressions of the existing discourse. The critical project suggests new languages and releases new possibilities for museums, which I shall explore in the final section. First, though, I explore the advantages and disadvantages of engaged research.

Standing Both Inside and Outside the Museum Text

While undertaking this research, I continued to work in museums and in the specific areas of work which were the subject of my study. There were many strengths in this. I understood the 'building blocks' through which the whole structure of museums – knowledge and expertise, professional and public – is constructed, and maintained an overview of a complex and changing field. The research itself, and my work in museums, were strengthened because I moved constantly between research, reflection and writing, and the application of theories and hypotheses in everyday practice: testing whether a particular analysis can be sustained, revising or refining the analysis as a result. The more dubious benefits are: that I was able to access some materials and sources for case studies which are not easily available to people without contacts in museums; and that, because I speak with professional knowledge and experience, my work is less easily dismissed as 'ill-informed' or irrelevant than critiques which are offered by people working outside the profession.

There were, however, disadvantages in my position as both 'inside' and 'outside' the museum. I was very close to the situations which I was studying: as I explained above, I often felt overwhelmed by detail and individual circumstance. I was seen by colleagues to be excessively critical of the people, and institutions, which I chose to study. In the absence of a critical culture and open forum for debate, many museum

workers are unfamiliar and uncomfortable with the experience of being exposed to criticism: they see it as personal and counterproductive or destructive. In the initial, 'realist' phase of my work I received support and encouragement from others working in museums – particularly from women, individually and in the network of Women, Heritage and Museums – which compensated for the more negative responses to my work. However, many of these same people began to feel bemused as I moved towards a more analytical and theoretical project. I began to speak a different – and unfamiliar – language; I focused on issues which were less immediate, contained and actionable, more diffuse and beyond their control.

At the same time I faced the practical difficulty of doing research part-time while working full-time, and in relative isolation. I always felt on the edge of academic study, not quite or only just understanding the theories; not able to keep up with leading edge/relevant theories and studies; constantly interrupted, so that I was unable to dwell with the theories and ideas for long enough to work them through fully. I also worked very slowly, and was worried that my work would be superseded at the intellectual and theoretical level before I completed it. (These same worries surface again as I write this chapter.) The people who supported and sustained my journey into theory were on the outside/edge of museums, in cultural and critical studies, particularly in the field of visual representation; latterly, in technology studies; and my supervisor and fellow postgraduate students. Through publishing material in the early stages of the research, my work became known and I was invited to visit and speak at museum events in northern Europe. In Sweden, Denmark and Germany, I discovered and heard of different possibilities for museums which connected with my work: investigations into theory and detailed research into museum collecting and interpretation; fresh approaches to collecting, and to themes and methods of display, which in their turn placed new expectations on museum visitors and built new relationships with them; strong attention to exhibition-making as the synthesis of form and content; and a willingness to experiment and take risks in public and touring exhibitions. These visits gave me renewed energy to continue my research, and new ideas to invigorate it. Some of the projects were particularly relevant to my research findings and the implications for museum practice: I describe them below.

Putting Theory into Practice: Some Feminist Exhibitions

Those exhibitions which I call 'feminist' call into question many of the things which are taken for granted in conventional museum exhibitions: they are irreverent and interdisciplinary in both the forms of knowledge and the methods of display which they employ. Rather than accepting the dualistic notion that knowledge or science forms the content of exhibitions and art provides their shape and presentation, the makers of such exhibitions synchronize and blend these elements into an integrated whole. They work across the divides and disciplines of art and science, social history and natural history, work and home. They choose to make exhibitions around abstract, immaterial and integrating themes more than linear, typological and chronological sequences; they do not hesitate to use feelings and emotions as a point of departure. Such exhibitions draw on and mix different forms and conventions – historical and contemporary, 'found' and constructed, factual and fictional. They are often impermanent – with a much shorter lifespan than the ten or fifteen years expected in most museum displays.

Because they are organized around themes which are lateral rather than chronological, such exhibitions may produce plural, and often contradictory, discourses and representations. For instance, in many museums 'period room' displays are used as set pieces to declare and illustrate a historical period, and to demarcate it from another. They are an exhibition convention, bringing together collections of the same period and style into a generalized arrangement, rather than a specific case study based on fieldwork and detailed research. Such displays are rarely used to make contrasts between social classes and circumstances. At the Geffrye Museum in London, however, the temporary exhibition *Putting on the Style* (1990) constructed roomsets from different homes in the 1950s to explore the expectations and lives of the people who had lived in these homes: a council flat, a room in a lodging house, an architect's home. These stories were not text narratives set apart from the displays, but were articulated and given shape in the choice and detailed arrangements within each display. Here, the home was not a static set piece, standing for a historical period and a generalized 'working class' or 'middle class' family, but a more dynamic place for investigation of other, more personal, messy and sometimes painful stories (Macdonald and Porter, 1990). The permanent exhibition at Hull, *The Story of Hull and Its People*, uses a time-based linear structure, but one which explores stages in the life cycle from birth to death, rather than using historical periods or centuries. The exhibition traces these stages in the lives of individual people in Hull, choosing personal histories drawn from the last two centuries; these are not the histories of public figures and notable people, but the histories of people whose lives are often not recorded or recognized (Kavanagh, 1994: 373).

The examples cited above begin to unsettle some of the assumptions of mainstream exhibitions while using similar forms; they do so through thoughtful exploration of their subjects and collections, from different perspectives and with different voices. In Denmark and Sweden, I visited exhibitions which use a new language, different from any in Britain: more impressionistic and abstract, yet at the same time more provocative and expressive. Such exhibitions are unashamedly personal and subjective: their makers use personal material and histories not to flesh out or substantiate the official histories and narratives, but as the point of departure.

The Women's Museum in Aarhus, Denmark, is explicitly political in its purpose, critical of mainstream museums in their presentation of women as subjects in history, and seeking to create new forms of history and expression. Jette Sandahl, a former member of the collective directorate, describes this:

> Turning to museums as mirrors of identity, women must fade into the background and freeze in passivity. The founders of the Women's Museum thought, however, that museums were uniquely qualified and equipped to fill just the opposite purpose. Material collections give museums an unequalled opportunity to provide counter-images, to de-naturalize, to de-mystify the present order. As a museum we wanted to accentuate the dimensions of change and choices in history, to convey a sense of power to intervene in history, to influence decisions and affect the direction of development. (Sandahl, 1993)

Many of the staff are not trained in museum work and not bound by its conventions and limitations. Many work at the museum on temporary employment schemes, giving the museum an active base and network in the local community, which contributes to every aspect of the museum:

> This embeddedness manifests itself in untraditional types of audiences, in the kind of exhibitions done by the museum as well as in the kind of objects donated to the collections. We are entrusted with the improper objects and stories, the shameful and private objects, the hopefulness, the grief, the cynicism, the shadow selves, the knowledge that is usually hidden or kept back. (Ibid)

The museum has mounted over thirty exhibitions since it was established in 1982, always about women; they may be concerned with women's experiences – such as mothering – or seen from women's perspective – such as the exhibition in 1993, *At Night*. Every element of these exhibitions, from the choice of themes to the specific voices of text and orientation of models and figures, transmits the overall message and viewpoint of the exhibition.

Many exhibitions are concerned with the working lives of women, and show women's skills – even where these are difficult to convey through the usual 'language' with which museums communicate work. For example, in one exhibition, the producers chose to emphasize the work of women in a household to extend the useful life of everyday things – darning stockings and clothes, repairing china and furniture. The clothes were encapsulated in plastic and hung in a room with light shining through them – emphasizing that they were worn through almost to the point of transparency. In another exhibition, about changes in housework, exhibits focused on the different skills and senses which women employed before mechanization and automation: preserving food; choosing different woods to create different oven temperatures; testing heat with their hand or arm; smelling to judge the freshness of food.

In the exhibition *At Night* (1993), feelings and associations common to women were explored: fear; desire and pleasure; dreaming; nursing the very young and very old; working at night, in factories and theatres. The exhibition began in a small dark room with the sounds, smells and animals of the night: an owl, a nightingale and a wolf. Visitors then passed through a town gate, symbol of locking the night out and locking people in to the town. In a stark white 'room of fear', harsh high-pitched sounds were triggered by people's movements. The floor was painted with a geometric pattern in black and white, and a bicycle lay across it; on the walls, small perspex boxes contained small tools and weapons which women carried with them for protection, and their testimony. In the room of caring, a chair was placed in the centre of a dark room. Screens on each side of the chair half-hid objects behind them: a coffin and a crib respectively. Near the chair were a book, knitting, a cup, a jug and towels and cloths – things used to pass the hours and to nurse the sick. In the dark room of love at the end of the exhibition, classical sculptures were juxtaposed with anatomical teaching torsos to suggest the shift from romantic love to explicit and physiological sex. The exhibition ended with the wolf in bed.

At the Museum of Work in Norrköping, Sweden, any kind of work can become the subject of an exhibition. Museum staff have mounted exhibitions about social workers; office cleaners; people living in an institution: all these have called for different approaches to collecting and exhibition-making. The museum's inaugural exhibition, *Sixth Sense* (1991–94), cut across different kinds of work and was concerned with the interaction of the material world and immaterial world, explored through the different senses of sound, sight, touch, taste and smell. In the exhibition, produced by Eva Persson, the different experiences of rich and poor, skilled and unskilled, rural and industrial, men and women were juxtaposed in eloquent and

powerful arrangements; there were many objects to hear, see, touch and smell but few words or texts (Persson, 1994).

In her exhibition work at the Museum of Work and at the Swedish Travelling Exhibition Service (Rikstutställningar), Persson wanted to create a new kind of exhibition, shifting from 'a scenic to a sculptural language . . . where form and content are one' (Persson, 1994: 170). Whereas the scenic arrangement is static and two-dimensional, the sculptural exhibition is seen in the round; the structure is an integral part of the exhibition. This led her from chronology to space as the underlying principle for exhibitions.

In the exhibition *Sixth Sense*, Persson conceived installations such as that on 'Taste', concerned with the extremes of famine and wealth in Sweden in the 1860s. A row of stepped tables, laid with linen, silverware, china, glass and dishes for three set courses of a dinner held by a local grain merchant, were interspersed with rifles pointing out of the window. On the last of these tables, a paving sett lay among broken dishes; slogans were painted on the wall and window behind. In a showcase nearby, a handbill calling for a strike was laid on similar setts. In another part of the exhibition, 'Smell', huge anthropomorphic shapes suggested the connections between the nose and the brain; on each of these, a decorated perfume bottle stood which, when sprayed, emitted a smell – anything from spice to machine oil. Visitors were encouraged to enter another exhibit which described how the sense of smell may not protect workers from lethal inhalations. In the semi-darkness of this cylindrical structure, a skeleton lay hunched on a central plinth. Around the walls, small glass phials were labelled with the names of substances which have no smell but which have been identified as toxic and lethal substances in the workplace. At the centre and end of the whole exhibition was a series of screens with contemporary photographs of women working in Norrköping. The 'uniformity of the photographs, and a conveyor belt effect, lit by bluish neon lighting [were used] in order to emphasize the soul-destroying work which annually inflicts thousands of industrial injuries' (Persson, 1994: 180).

In these exhibitions, the themes are matched with equivalent forms and methods of exhibition-making: open, fluid and flexible in their arrangements; more sculptural than scenic in their forms. Factual forms such as documents and testimony may be mixed with obviously fictional and fantastic forms such as artworks. They may use light, movement such as turntables or conveyor belts, projected sound and images, to create an ambience of shifting, changing states.

These exhibitions are unashamedly personal, too, in the relations between exhibition-makers and exhibition visitors – stimulating conversation and exchange; encouraging identification or differentiation. They avoid the unequivocal, categorical statement and didactic presentation of most museum exhibitions (Sandahl 1995).

The most remarkable of these exhibitions have been temporary – using the greater opportunities that short-term exhibitions provide for exploring themes and issues, less driven by the institution's collections and the drive to get material out from stores and on show, or responding to it by providing more frequent changes of the material shown. This rhythm and cycle of exhibition-making provides greater opportunities to explore, experiment and learn for exhibition makers and visitors than the conventional practice of 'permanent' displays with a life of five, ten or fifteen years. It acknowledges that things are 'of their time', and change/are changed over time. Its disadvantage is that these exhibitions are, like women's traces in the collections of museums, marginal and less enduring: the chances to learn from them may be marginalized or 'lost' within institutions as their circumstances change; or overlooked by other professionals

because they do not recognize such short-term projects as a valid alternative. Thus the visible record and tangible legacy of museum work may omit these bold, challenging and suggestive projects.

Notes

1 I completed a postgraduate degree at the Department of Museum Studies, University of Leicester in 1994 (Porter, 1994). I wish to acknowledge the guidance and encouragement given by my supervisor, Dr Eilean Hooper-Greenhill, and the support of my employers while completing the research, the National Museum of Photography Film and Television/ National Museum of Science and Industry, and the Museum of Science and Industry in Manchester.
2 I use the term gender to refer to the social and cultural meanings attached to the biological differences between men and women.

References

Berger, J., (1972), *Ways of Seeing*, London, Penguin.
Cockburn, C. and Ormrod, S. (1993) *Gender and Technology in the Making*, London: Sage.
Coward, R., (1984), *Female Desire*, London, Paladin.
Culler, J., (1981), 'Semiology: the Saussurian legacy' in Bennett, T., Martin, G., Mercer, C. and Woollacott, J. (eds), *Culture, Ideology and Social Process*, 129–44, London: Batsford.
Derrida, J., (1976), *Of Grammatology*, Baltimore: Johns Hopkins University.
Kavanagh, G., (1994), 'Looking for ourselves, inside and outside museums', *Gender and History*, 6:3, 370–5, Oxford: Blackwell.
Macdonald, S. and Porter, J., (1990), *Putting on the Style: Setting up Home in the 1950s*, London: The Geffrye Museum.
Moi, T., (1985), *Sexual/Textual Politics: Feminist Literary Theory*, London: Methuen.
Persson, E., (1994), *Utställningsform: I Kroppen på en Utställare 1967–1993*, Stockholm: Carlssons.
Porter, G., (1987), 'Gender bias: representations of work in history museums' in Carruthers, A. (ed.), *Bias in Museums*, Museum Professionals Group Transactions 22: 11–15.
Porter, G., (1991), 'Partial truths' in Kavanagh, G. (ed.), *Museum Languages: Objects and Texts*, 103–17, Leicester: Leicester University Press.
Porter, G., (1994), 'The representation of gender in British history museums', unpublished thesis, Leicester: Department of Museum Studies, University of Leicester.
Rose, J., (1986), *Sexuality in the Field of Vision*, London: Verso.
Sandahl, J., (1993), 'Tangled up in love: the Women's Museum in Denmark', *European Museum of the Year Award News*. 9.
Sandahl, J., (1995), 'Proper Objects among Other Things', *Nordisk Museologi*, 2, 97–106.
Tagg, J., (1988), *The Burden of Representation*, London: Macmillan.
Traweek, S., (1988), *Beamtimes and Lifetimes: the World of High Energy Physicists*, Cambridge, Massachusetts: Harvard University Press.
Williamson, J., (1978), *Decoding Advertisements*, London: Marion Boyars.

Chapter 8 | Terence M. Duffy

Museums of 'Human Suffering' and the Struggle for Human Rights

Museums of 'human suffering' and human rights cover a broad field, and 'suffering' is, moreover, a relative concept, ranging from the poverty of arriving immigrants at Ellis Island or the cramped apartments of the Lower East Side Tenement Museum (both in New York City), to the mass violence of genocide museums like the one at Tuol Sleng in Cambodia. This article concentrates on museums and projects whose exhibitions make a resounding appeal for the protection of human rights. Many of these exhibitions are implicitly controversial, since human rights cannot easily be separated from the political domain. National tragedies loom large in the permanent collections of museums throughout the world – from war museums to national galleries, from natural disasters to diaspora. And remembrance is certainly an emotive issue, fraught with socio-political implications, as was seen in Northern Ireland during the discussion process to create a Memorial Museum to the victims of conflict.[1] We look at different types of museums that commemorate human suffering and tragedies, and discuss the emergence of distinct 'human rights museums' as related to the concept of creating a human rights culture – the very antithesis of 'human suffering'.

Museums of Remembrance

The Palestinian Life and Remembrance Museum will be located in Jerusalem, and already possesses an embryonic exhibition in the Palestinian Authority. The project has received funding from Palestinian donors, the European Union and the World Bank for a programme devoted to Palestinian history in the context of what Palestinians see as their *Nakba*, or 'national catastrophe of exile'. The museum defines its primary role as exhibiting the Palestinian struggle for political and human rights, and completion is important for the Palestinian sense of national identity.

The 'Deir Yassin Remembered' Information Centre shows the events of 9 April 1948, when commandos of the Israeli Irgun attacked Deir Yassin, a Palestinian village.

Terence M. Duffy, "Museums of 'Human Suffering' and the Struggle for Human Rights" from *Museum International* 53:1 (2001), pp. 10–16. © 2001 by UNESCO. Reproduced by permission of Blackwell Publishing. (Reprinted without illustrations.)

Over 100 Palestinians were killed and the village was destroyed. The project has a virtual programme on the Internet and envisages a museum on the site. There are at present no plaques or exhibits at Deir Yassin itself. Yet its task is to perform the same role for the Palestinian people as Yad Vashem does for Jewish citizens: to act as a memorial for suffering. For Palestinians, it is a chilling fact that the Deir Yassin massacre took place within sight of Yad Vashem. The subject-matter is impassioned and reveals the continued stark political divisions in Arab–Israeli relations.

The Museum of the Nanjing Massacre in Tokyo presents Nanjing as a symbol of Japanese atrocities committed during the war against China. The founder, Guo Peiyu, a Chinese artist, exhibits some 3,000 'faces' in clay, to 'express the souls of the 3,000 victims of the Nanjing massacre'. The museum is a powerful statement against war and violence, and an articulate protest against Japan's imperialist adventuring as well as a statement to those who deny that Nanjing ever happened. It is a unique museum offering a presentation of Chinese suffering in a gallery located in the Japanese capital.

Holocaust and Genocide Museums

Holocaust museums exist throughout the world. These include the above-mentioned Yad Vashem in Israel, the national Holocaust Museum in the United States, and interpretative centres at many former concentration camps. New initiatives include the Holocaust Education Center in Tokyo; and the Lithuanian Museum of Victims of Genocide in Vilnius, complemented by the exhibitions of the Lithuanian State Jewish Museum and the Jewish Memorial. An innovative new programme is the New York Holocaust and Genocide Project (HOP). In 1998, a Jewish museum dedicated to the Holocaust opened in Berlin, and it hopes to acquire Steven Spielberg's Shoah Archive of interviews of Holocaust survivors. Other museums on genocide worldwide are as follows:

- On 24 April 1915, hundreds of Armenian leaders were massacred by Turkish police; hundreds of thousands of Armenian civilians were 'escorted' away from their homes and across the borders in what amounted to death marches. This date is still commemorated by Armenians worldwide as Genocide Memorial Day. After the First World War, the Turkish government held 'genocide trials' during its investigation into the fate of the Armenian minority, but the episode still remains one of considerable sensitivity in Turkish and Armenian history. The Vatran Armenian Research Center at the University of Michigan exhibits these events. In recent years international attention has focused on the Armenian tragedy and the importance of its remembrance. This genocide was carried out by the Central Committee of the Young Turk Party and directed by a special organization, the Teshkilati Mahsusa. In recent years, international attention has been drawn to this tragic event, and, on 18 June 1987, the European Parliament voted to recognize the Armenian Genocide. American President Bill Clinton, among other national leaders, has commemorated the 'tragedy'. There are plans for the creation of a Genocide Museum in Yerevan.
- A proposal has been made to establish a Museum of the Genocide of Gypsies in Bucharest, Romania. Some 250,000 gypsies perished in Second World War concentration camps (Dachau, Belsen and Buchenwald; 16,000 were held at Auschwitz). There is comparatively limited coverage of their extermination in the

Holocaust, because the diasporic nature of gypsy communities has militated against any comprehensive collection of their wartime heritage. There are a number of Holocaust memorials to gypsies, especially in the Netherlands, but the Romanian project appears to be the first tangible step towards the creation of a distinct museum exhibiting the genocide of European gypsies.

- The Nigerian peace activist Prince Samuel Adebowale has written of the importance of creating an Ogoni genocide museum to record the events that took place in Ogoniland between 1993 and 1995, which he describes as a 'systematic annihilation' of the Ogonis. During these years MOSOP (the Movement for the Survival of Ogoni People) confronted Nigeria's military dictatorship through non-violent struggle. The present Nigerian political situation would now seem to be more favourable for the establishment of the genocide museum envisaged by the prince.

- During the Spring of 1994 at Ntarama, south of Kigali, Rwanda, followers of the Hutu-led Rwandan government massacred approximately 5,000 ethnic Tutsis inside the Ntarama Catholic Church. Today a sign on the road announces the site. Ntarama, like hundreds of churches, stadiums and gathering places around the country, is a place of genocide, where civilians were slaughtered in a genocidal campaign organized by Hutu hardliners. This place constitutes a frightening indictment of human suffering and the violation of human rights.

- The Tuol Sleng Genocide Museum in the Cambodian capital, Phnom Penh, documents the history of the S-21 interrogation compound set up by the Khmer Rouge in April 1975. In 1979, Tuol Sleng became a museum documenting those tragic years and contributed to the process in which Cambodian people have confronted their history. At the Choeung Ek 'killing field' where the victims of Tuol Sleng were murdered and buried, a memorial stupa was erected in 1988 in the form of a traditional Cambodian pagoda. Tuol Sleng and Choeung Ek have been exploited by successive Cambodian governments in their manipulations against the Khmer Rouge. Somehow Cambodians must extricate themselves from the 'ghosts of history' so that these sites may one day contribute to a culture of peace and human rights.[2]

- The Concentration Camp Museum at Jasenovac, Croatia, stands as witness to one of the most tragic of the many Second World War concentration camp museums. Immediately after occupying Yugoslavia, the Nazis organized a system of concentration camps under the command of the Ustasha Supervision Service, of which Jasenovac was the largest. In Croatia during this period, Orthodox Serbs, Jews and gypsies, and pro-Yugoslav Croats were systematically massacred. It would seem that in an effort to 'erase' the events of these years the Jasenovac Memorial Museum was targeted by Croatian artillery during the recent conflict in the Balkan region. In September 1991 Croatian paramilitary formations occupied the memorial grounds for one month before the area was taken by Serbian forces. Before leaving, Croat forces blew up the bridge on the Sava River which unites the two parts of the memorial grounds. Archives concerning the history of the genocide, the museum and the exhibition premises were demolished. Most of the 8,000 exhibits were destroyed or removed as Croatian troops retreated. Jewish war veterans and Jasenovac survivors appealed to the international community, reporting that 'the execution grounds of Jews, Serbs and Romany... with the documentation about the genocide, have been devastated'. However, two months later on 22 December 1991, Croatian armed formations, disregarding a cease-fire, once more fired on the Jasenovac Memorial Grounds for several hours.

The museum and cemeteries at Donja Gradina were further damaged. In January 1992, the Yugoslav Government submitted a 'Memorandum on the Crimes of Genocide in Croatia in 1991 and 1992, and the Outrages Committed against the Jasenovac Memorial-Grounds' to the United Nations. This document stated that Jasenovac was the only war monument in Europe which has been subjected to ruthless outrages since the Second World War, and that the Croatian Ministry of Education, Culture and Religion had previously abolished the Jasenovac Memorial Grounds, 'to erase the scene of the worst crime of genocide from the historical memory'. Today the entire Jasenovac site, battle-scarred and disused, constitutes a compelling reminder of the power of history and of how important it is for certain dominant regimes to erase and rewrite history. And this sobering fact alone calls for constant vigilance in the face of forgetting and denial of the past.

Museums of Slavery and the 'Slave Trade'

Americans need national sites to record the legacy of slavery. By 1820 some 10 million Africans had been transported across the Atlantic to the Americas. Most slaves lived on small farms and so their experiences are poorly documented. Nevertheless, some progress towards exhibiting the lives of slaves has been made, and there are proposals for creating museums on the sites of the 'Underground Railroad' that operated from 1830 to 1865 to help slaves escape from the South to the non-slave states.

There is also a 'slave ship' museum in Florida. In 1972 the Mel Fisher Maritime Heritage Society discovered the wreck of the *Henrietta Marie*, which sank in 1701. Despite nearly three centuries of seaborne encrustation, divers identified the ominous shapes of iron shackles. The Mel Fisher Society meticulously prepared the remains from the ship for a touring exhibition, and the *Henrietta Marie* made her true entry into American (and international) consciousness. Her sparse but history-laden artefacts confront us squarely with the tangible evidence of a past that can be neither changed nor denied.

An African 'slave museum' has opened at Gorée, off the coast of Senegal, near Dakar. This was the largest slave-trading centre on the African coast from the fifteenth to the nineteenth centuries, and was ruled by the Portuguese, Dutch, English and French respectively. The museum site juxtaposes bleak slave quarters with the elegant houses of the slave-traders. Today it continues to serve as a reminder of human exploitation. The Gorée Museum of Slavery is a powerful indictment of the exploitation of the Senegalese and the human legacy of the 'slave trade'.

A comparable European museum is William Wilberforce House in Hull. The United Kingdom's first slavery museum, it opened in 1906. It illustrates the campaigns of the famous anti-slavery campaigner and the history of the Committee for the Abolition of the Slave Trade, formed in 1787. As a result of Wilberforce's efforts, slave trading was abolished by the English Parliament in 1807.

Museums of African-American Civil Rights

In recent years, more museums on African-American Civil Rights have been set up, in Birmingham (Alabama), Memphis (Tennessee), and Atlanta (Georgia); and there are collections in the Museum of African American History in Detroit, the Museum of

Afro-American History in Boston, The Museum of Slavery in the Atlantic, Maine, and the Slave Voices Library at Duke University.

New York's Afro-American Black History Museum offers interactive exhibits on the history of slavery; the Tuskegee Airmen, the first Black American combat pilots; the Black Panther Party; and the 'Million Man March' of the Nation of Islam which has vigorously opposed racial inequalities in the United States. These museums share the common theme of defining the struggle of African-Americans for human rights seen through African-American eyes and show the continued concern with 'Sankofa' – the search for roots.

Prison Museums and Museums of Torture

Prison and torture museums present a somewhat difficult subject: the serious study of human rights, and their abuse, is their primary *raison d'être*. Although varied in the quality of their collections, torture museums make an important contribution to our thinking about human rights. Evidence of the history of punishment from ancient times is archived in Rome's Museum of Criminology. Likewise, the Guillotine Museum at Liden, Sweden, holds an exhibition on the inhuman practices in prisons in the past. In France, Carcassonne's Museum of Torture presents a collection of medieval torture instruments.

The Salem Witch Trials of 1692 in New England are documented in the Peabody Essex Museum in the state of Massachusetts. Witch House, home of Judge Jonathan Corwin, who presided over the hearings which condemned twenty innocent people to death, contains other archives. The exhibits reveal much about the hysteria and brutality of colonial America, but are likely to interest a general rather than an academic audience.

Among the prison museums is Robbin Island in South Africa where President Mandela and his ANC comrades were incarcerated. The museum's austere courtyard and tiny cells speak of Nelson Mandela's decades of endurance and the brutality of South Africa's apartheid regime. Another equally bleak exhibition is offered by the notorious Alcatraz Prison in the United States, the remote maximum-security prison whose goal was punishment rather than rehabilitation. It was finally closed on 21 March 1963. Prison museums do, in fact, encourage a sense of empathy with prisoners and raise important questions concerning liberty and standards of custodial treatment.

Exhibiting Human Rights

All of these categories of museum, through their exhibitions and their presentation of human experience, make a significant contribution to the struggle for human rights. It is encouraging that recent years have seen the emergence of distinct 'museums of human rights' in various parts of the world:

- The World Centre for Peace, Freedom and Human Rights opened in Verdun (France) in 1994.
- Liberty Osaka, with a focus on civil and human rights, has been open in Osaka (Japan) since 1990.

- Sakai City opened a Human Rights Museum in 1994.
- The Kochi Liberty and People's Rights Museum was founded in Japan, in 1994.

Human rights are also a concern of the burgeoning family of peace museums whose collections and exhibitions range across the spectrum of peace, justice and human rights. In the exhibits of all of these institutions the personal impact of 'human suffering' is paramount. As Mary Robinson, United Nations High Commissioner for Human Rights, has recently said in respect of Kosovo, 'Every violence is a personal and family tragedy, regardless of the age, sex or nationality of the victim.'[3]

The museums discussed in this article envisage a genuine human rights culture and the extension of its protection for everyone. These museums exhibit historical and contemporary situations involving gross violations of these rights. It is encouraging that there is an emerging group of museums of human rights that might be custodians of what one could term a 'human rights culture'. UNESCO's programmes have made an enormous contribution to education for human rights and to their dissemination and protection. It is hoped that human rights museums might also contribute to this process. It is certainly the privilege of these museums of 'human suffering' to show the worst moments in the experiences of peoples in the hope that such portrayals will contribute to the advancement of human rights worldwide.

Notes

1 T. M. Duffy, 'Towards a Peace Memorial in Northern Ireland', *Peace Museums Newsletter*, spring 1998, pp. 2–5.

2 S-21 is discussed in greater detail in T. M. Duffy, 'The Killing Fields Revisited: The Tuol Sleng Museum and the Memorial Stupa of Choeung Ek', *Museum International*, No. 177 (Vol. 46, No. 1, 1993), p. 411.

3 Mary Robinson, 'Statements Regarding Developments in Kosovo'. United Nations Human Rights Website, 11 February 1999.

Chapter 9 | Alice Friman
At The Holocaust Museum

December, 1999

Like Dante, we too are led
down. The elevator that swooped us up
and spewed us out, leaves us –
clusters of strangers – to the inexorable power
of no way to go but with each other
and the relentless spiral of design.

We shuffle, slow as sludge
in a drain, winding to the bottom.
We gawk, not in disbelief but believing
this has little to do with us – our comfort
in the face of explanations that explain
nothing, the old jackboot footage
of rantings, book burnings, and the car
that waits for us, rattling with ghosts
on its siding, and the glass case
big as Germany, knee-deep in human hair.

We grow quiet. We have crawled
into our eyes. There is nothing
but what we see. And at base bottom,
what's to see but the dredged-up bottom
of ourselves that belongs only to ourselves
and the moving tide of each other.
We crowd in to look. The eye is hungry –
a dog dragging its belly through streets,
sniffing out its own vomit, not getting enough:
the experiments, the ovens, and all their

Alice Friman, "At The Holocaust Museum" from *North American Review* 286 (March/April 2001), p. 23.
Reproduced by permission of the *North American Review.*.

tattooed histories fidgeting in smoke
that rose like bubbles in a fish tank
to dissipate in air. Fingers pluck
at our sleeves. Gold teeth hiss
in their case. What do they want of us,
we who can give nothing, reduced to nothing
but dumb pupils staring at evidence –
the starved and naked dead, the bulldozers,
the British soldier throwing up in his hand?
We press to the TV monitors, mob in,

fit our bodies together like multiple births
in the womb, wanting the heat of each other,
the terrible softness beneath clothes.
Excuse me, Pardon, and the knot of us
slips a little, loosens to make room.
In the smallest of voices, *Sorry* we say
as if battered back to three again,
all we have is what Mother said was good.
Pinkie in a dike. Band-aid on a gusher.
But what else do we know to do

at the end of another century that retrospect
will narrow to a slit, if this holocaust –
this boulder big as Everest – isn't big enough
to change the tide that ran through it?

Part II

States of "Nature" in the Museum: Natural History, Anthropology, Ethnology

Introduction

This section includes three "primary" texts, by artist and museum founder Charles Willson Peale, naturalist and museum founder Louis Agassiz, and anthropologist Franz Boas, to offer direct access to the issues, problems, and goals underlying early museum practice. Other "analytical" essays place these early museum representations of natural history, anthropology, and ethnography in their historical – including political, social, and racial – contexts and create a foundation for discussions of museums and nation-building and/or nation-preserving in Part III. The topics in this section include the representation of hierarchies within the human and animal "species," the creation of narratives of progress from "primitive" to more "civilized" human forms, and the relationship between narrative goals and the collection, classification, and display of specimens. These texts are followed by discussions of recent strategies in anthropological, ethnological, and "art" museum practices, prescriptions for change, a critique of the putative divide between museums of science and of history, and a challenge to museums to "matter" in new ways. Literary meditations then illuminate and undermine the assumptions of museum science, politics, and aesthetics.

Charles Willson Peale's "To the Citizens of the United States of America" (1792) is a short but multifaceted address to late-eighteenth-century readers on behalf of his Philadelphia Museum. Moving rapidly between rhetorical modes, he explains his motives and methods of collection and display, appeals to a "patriotic" audience for contributions of objects and funds, promotes his museum – which to his knowledge "far surpasses its counterparts" – and calls upon his colleagues at other institutions to share their expertise. Peale's advertisement presents a museum-maker's perspective on competing goals, which include a collection of "all that is likely to be beneficial, curious or entertaining to the citizens of the new world." In this prototype of position papers on how and why a museum should establish its international, national, and local profiles, the rhetoric of nation-building via cultural nationalism is evident. Peale in fact attempted but failed to "raise his tender plant" to the status of a "national" museum.

In a letter to his brother-in-law Thomas G. Cary in 1863, Louis Agassiz appeals for support to broaden the collection of objects in his Museum of Comparative Zoology at Harvard and outlines an argument on behalf of anthropology as the next logical step in the progress of the museum: "Every day the history of mankind is brought into more and more intimate connection with the history of animal creation, and it is now indispensable that we should organize an extensive collection to illustrate the natural history of the uncivilized races." Agassiz is aware that authenticity must be a guiding principle in collecting objects of material culture, and he is aware of the tension between the values of the collector and the values of the cultures he hopes to study and display. This may be of particular interest since repatriation is a matter of ongoing debate, although legislation such as the Native American Graves Protection and Repatriation Act (NAGPRA) in the late twentieth century attempts to move us beyond the uncritical use of terms such as "savage," "primitive," and "uncivilized" toward a comprehensive cultural sensitivity.

Robert Goldwater's *Primitivism in Modern Art* (1938, 1986) offers an extensive study of the changing status of the "art" of "primitive" peoples as seen by Western eyes. In "The Development of Ethnological Museums" he considers the "problem of primitivism" in the "wider setting of the scientific, and more generally extra-artistic conditions of an aesthetic manifestation." These include expeditions, expositions, and world markets, in addition to Darwinian evolution and other incentives to the widening of "aesthetic horizons."

A statement from anthropologist Franz Boas published in the journal *Science* under the rubric "Museums of Ethnology and Their Classification" marks a discrete point in a professional and philosophical discussion carried on, in part, in volume 9 of the journal from May through June 1887 in which Boas, Otis T. Mason (Curator of Ethnology at the Smithsonian), and Smithsonian anthropologist William H. Dall submit their positions. The stakes are various, involving principles of classification and methods of display in the emerging museum-based fields of anthropology and ethnology. Engaged in similar projects of collecting, comprehending, and exhibiting the "state of culture of man," these key figures disagree on the merits of deductive and inductive methods. Mason advocates the grouping of like objects together in the museum, in what Boas terms a deductive "argument from analogy." Alternatively, Boas advocates an inductive method, a tribal arrangement of objects in order to "understand the phenomena ... in their physiological and psychological foundation." (Boas alludes to, but does not entirely agree with, the concept of a "psychological museum" suggested by Italian anthropologist Paolo Mantegazza.) Arguing that "individuality" and nuance are more important than outward similarity, that "civilization is not something absolute" but relative and constantly under modification, Boas searches for means to achieve his "ideal of an ethnological museum."

Christopher Looby examines the "metaphorical exchange between images of natural order and ideas of social and political order" in eighteenth-century America. In examining the formative stages of American nationality, Looby thus makes explicit the building of the "national" order. In "The Constitution of Nature: Taxonomy as Politics in Jefferson, Peale, and Bartram" (1987) Looby makes the connection between taxonomic order – relating to "the names and qualities of the beings in nature" – and political order – relating to "the foundation of the collective life of the new nation." Looking at ways in which the putative "visible order" of nature was appropriated by William Bartram in his travel writings, by Thomas Jefferson in his expansive *Notes on the State of Virginia*, and by Charles Willson Peale in his natural/

history museum, Looby argues that the museum's "political design," much like the texts of Bartram and Jefferson, was "calculated to inspire the most perfect harmony." Looby's text does not offer an extensive look at Peale's museum efforts, but provides a context for Peale's deliberate designs, a context which may deepen our understanding of "The Artist in His Museum" (the critically infamous Peale self-portrait) and the activities of Peale as a museum-maker.

In "'Magnificent Intentions': Washington, D.C., and American Anthropology in 1846" (1981) Curtis Hinsley describes key "issues in the politics of antebellum American science" and exposes the connections between the rise of anthropology and ethnology, the workings of "cultural capital," and the goals of nation-building. He introduces the "divergent conceptions of 'museum'" which marked the divide between the increasing professionalism of men of science, who advocated the collection and preservation of specimens for research (not incompatible with personal gain), and the vision of "amateurs" who saw the museum as a public institution dedicated to display and entertainment. Crucial to these efforts, as Hinsley illustrates, were the political and ideological grounds of "the study of man in America," which proved inseparable from an understanding of the "national teleology" as a "picture of the American continent waiting through the ages, pristine and nonhistorical." The result was the refusal to allow indigenous peoples the "integrity of their own histories."

Fabrice Grognet briefly reviews the evolution of ethnography as a professional discipline and as a museum designation. In "Ethnology: A Science on Display" (2001) he foregrounds key issues involving the competing yet often reciprocal realms of aesthetics and science, the connection between developing scientific methods and museum practice, the ways in which objects might best be allowed "to speak for themselves," the all-too-reductive construction of "the general public," and the unexamined definition of concepts and terms; his observations then lead to questions and compelling directions for future museographical practice.

Enid Schildkrout's "Ambiguous Messages and Ironic Twists: *Into the Heart of Africa* and *The Other Museum*" (1991) offers a review of two exhibitions which "question the authority of the museum as an institution." In the process she closely examines intentions (of the museum/curators), assumptions (about audience), reception (by the media, indigenous peoples, and the general public), and other underlying complexities, including the management of irony, at work in the aesthetics and aspirations of self-critical, dialogic exhibitions. Schildkrout both commends and condemns the Royal Ontario Museum's efforts in mounting *Into the Heart of Africa* and offers multiple perspectives on the phenomena of the exhibition and its reception. In her account of *The Other Museum* (one of two parts in the exhibition *Power and Spirit* at the Washington Project for the Arts/WPA Gallery) she examines a more successful use of irony in an exhibition of works of art, as opposed to artifacts, and reflects on the "basic differences between didactic exhibitions and works of art." This "review" goes beyond the descriptive and critical demands of that genre to arrive at the demands and challenges faced by curators who seek to offer a coherent interpretation while creating conditions hospitable to critical, individual thinking.

In "Thinking and Doing Otherwise: Anthropological Theory in Exhibitionary Practice" (2000) Mary Bouquet unites theory and practice while also noting the divide between the museum and the academy. Bouquet advocates the use of anthropological theory in the development of museum exhibitions and is especially interested in the "preliminary use of text and theory that *precedes* and accompanies the construction of exhibitions." Metaphor and other figures of speech help to make

visible the knowable (but as yet unknown), as Kenneth Burke explains, and Bouquet makes a similar claim for anthropological theory, which can be "fed into the process of making culture materialise in the form of exhibition." She observes "the abstraction of theory" and the "concrete components of exhibition" in their dialectical relationship, and applies her observations to the scripting and design of actual exhibitions.

Gyan Prakash plays with the linguistic construction "Museum Matters" (1996) and the productive possibilities of "impropriety" to suggest that museums still matter and might exercise their inherent powers in new ways. He unites museums and other forms of history in their tendency to "assemble fragile fragments, often erasing marks of violence on them" and their attempts to "reinstate cultural wholeness" at the expense of complexity. Citing examples as diverse as Kipling's *Kim* and the status of the Lahore Museum in the novel, efforts in the collection of cultures at the Madras Museum in the late nineteenth and early twentieth centuries, and more recent examples of museums and special exhibitions in the West, including *Into the Heart of Africa*, he illuminates the frailties of authoritative interventions and hints at the gains to be made from more reflective praxis.

This section ends with a "meditation" or metatext on the museum by Zora Neale Hurston. "What White Publishers Won't Print" (1950) addresses the lack of serious attention to "Negro" culture. Hurston (who studied with Franz Boas at Columbia University) asks: "Why this indifference?" and responds with the metaphorical presence of "THE AMERICAN MUSEUM OF UNNATURAL HISTORY." She extends the metaphor in order to critique the display of "the convenient typical" and its utility in representations of a number of culturally specific minority groups who have suffered the fate of reductive representations.

Chapter 10 | Charles Willson Peale

To the Citizens of the United States of America

Mr. Peale
Begs leave to present the following Respectful Address:

Having formed a design to establish a MUSEUM, by a Collection, Arrangement, and Preservation of the Objects of Natural History, and things useful and curious, in June 1785, he began to collect subjects, and to *preserve* and *arrange* them in the Linaean method; his labours herein have be[en] great, and disappointments many; especially respecting proper methods of preserving dead animals from the ravage of moths and worms. In vain he hath sought from men, information of the effectual methods used in foreign countries: and after experiencing the most promising ways recommended in such books as he had read, they proved inaffectual to prevent depredations by the vermin of America. But in various other experiments, *he has at length discovered a method of preservation*, which he is persuaded will prove *effectual:* it has a very favourable appearance in practice, and far surpasses all others that have come to his knowledge: nevertheless, it will be obliging in gentlemen to inform him of the best practices in Europe or elsewhere.

The difficulties of preserving subjects being thus overcome, and the Museum having advanced to an object of earnest attention to many individuals, with sentiments of gratitude he thanks the friends to the Museum, who have generously added to his collection a number of precious curiosities from many parts of the world – from Africa, from India, from China, from the islands of the great Pacific Ocean, and from different parts of America; some whereof are the more curious, as they have been but very recently discovered, even by the great voyagers of Europe. He respectfully requests a continuance of their favours, and the assistance of all persons who may be possessed of things curious that they can spare, whether they be of America, or any other part of the world: all will command his grateful acknowledgments as valuable presents to himself, to the public, and to future generations.

Charles Willson Peale, "To the Citizens of the United States of America," letter published in *Dunlap's American Daily Advertiser*, Philadelphia, Jan. 13, 1792. Public domain, available on microfilm at the Smithsonian Institution, Washington, D.C.

He is the more earnestly bent on enlarging the collection with a greater variety of beasts, birds, fishes, insects, reptiles, vegetables, minerals, shells, fossils, medals, old coins; and of utensils, cloathing, arms, dyes and colours, or materials for colouring, or for physic, from amongst the Indian, African, or other savage people; and all particulars, although but in model or delineation, promising to be useful in advancing knowledge and the arts; in a word, all that is likely to be beneficial, curious or entertaining to the citizens of the new world. But alas! a design so vast, and, he is bold to say, so important, is far beyond the slender abilities of an individual whose professional industry is necessary for the support of a numerous family.

Animated by the generous patronage he has already received, and by the magnitude of the object, which he fondly hopes will procure the attention of the public, he now respectfully solicits their aid to enable him to raise this tender plant, until it shall grow into full maturity, and become a *National Museum*.

With harmony little things become great: all the splendid Museums of the great European nations have risen from the foundations laid by individuals. America has in this a conspicuous advantage over all other countries, *from the novelty of its vast territories*. But a small number is yet known of the amazing variety of animal, vegetable and mineral productions, in our forests of 1000 miles, our inland seas, our many rivers, that roll through several states, and mingle with the ocean.

A Museum stored with these treasures must indeed become one of the first in the world; the more so, as the principal naturalists in Europe, will be anxious to acquire our productions, by an exchange of whatever is most valuable in their respective countries and foreign colonies.

Mr. Peale means personally to solicit the assistance of gentlemen whose regard for science is well known: if there are those who would become *Inspectors* or *Visitors* of the Museum, their united aid and influence, he is confident, would greatly promote a design that is truly worthy of American patriots and citizens of the world.

CHARLES W. PEALE.
Philadelphia Museum, Jan 13, 1792.

Chapter 11 | Louis Agassiz
Letter of 1863 to Mr. Thomas G. Cary

CAMBRIDGE, *March* 23, 1863.

DEAR TOM, – For many years past your aid in fostering the plans of the Museum in Cambridge has greatly facilitated the progress of that establishment in everything relating to the Natural History of California, and now that it has become desirable to extend our scheme to objects which have thus far been neglected I make another appeal to you.

Every day the history of mankind is brought into more and more intimate connection with the natural history of the animal creation, and it is now indispensable that we should organize an extensive collection to illustrate the natural history of the uncivilized races. Your personal acquaintance with business friends in almost every part of the globe has suggested to me the propriety of addressing to you a circular letter, setting forth the objects wanted, and requesting of you the favor to communicate it as widely as possible among your friends.

To make the most instructive collections relative to the natural history of mankind, two classes of specimens should be brought together, one concerning the habits and pursuits of the races, the other concerning the physical constitution of the races themselves.

With reference to the first it would be desirable to collect articles of clothing and ornaments of all the races of men, their implements, tools, weapons, and such models or drawings of their dwellings as may give an idea of their construction; small canoes and oars as models of their vessels, or indications of their progress in navigation; in one word, everything that relates to their avocations, their pursuits, their habits, their mode of worship, and whatever may indicate the dawn or progress of the arts among them. As to articles of clothing, it would be preferable to select such specimens as have actually been worn or even cast off, rather than new things which may be more or less fanciful and not indicate the real natural condition and habits of a race.

Louis Agassiz, "Letter of 1863 to Mr. Thomas G. Cary" from Elizabeth Cary Agassiz (ed.), *Louis Agassiz, His Life and Correspondence*, pp. 582–4. Boston: Houghton, Mifflin and Company, 1885. Public domain.

With regard to the collections intended to illustrate the physical constitution of the races it is more difficult to obtain instructive specimens, as the savage races are generally inclined to hold sacred all that relates to their dead; yet whenever an opportunity is afforded to obtain skulls of the natives of different parts of the world, it should be industriously improved, and good care taken to mark the skulls in such a way that their origin cannot be mistaken. Beside this, every possible effort should be made to obtain perfect heads, preserved in alcohol, so that all their features may be studied minutely and compared. Where this cannot be done portraits or photographs may be substituted.

Trusting that you may help me in this way to bring together in Cambridge a more complete collection, illustrative of the natural history of mankind than exists thus far anywhere,

I remain, ever truly your friend and brother,

LOUIS AGASSIZ.

Chapter 12 | Robert Goldwater

The Development of Ethnological Museums

The artistic interest of the twentieth century in the productions of primitive peoples was neither as unexpected nor as sudden as is generally supposed. Its preparation goes well back into the nineteenth century, as the history of ethnology and the subsequent outline of the parallel interest within the history of art will show.[1] What follows is not a detailed story of museums of ethnology throughout Europe. Such a project would require a discussion of the development of general ethnological theory in the various home countries and of work in the field in many countries abroad.[2] It would demand as well an investigation of the political and economic conditions that encourage and discourage ethnographical activity. But though we can only sketch in the results of such a history as it affects the arts, this will at least by implication place the problem of primitivism in its wider setting of the scientific, and more generally extra-artistic conditions of an aesthetic manifestation.

The most superficial account of the history of discovery and exploration makes it clear that Africa and Oceania were explored at an unequal pace.[3] During the eighteenth century, while the various islands of Melanesia and Polynesia were becoming familiar to European navigators, Africa enjoyed an almost complete neglect. Though a trade in slaves, gold, ivory, and other products was carried on with the West Coast tribes, this was done through peripheral trading stations, and there was no attempt at entry into the interior.[4] There were many circumstances – geographical, climatic, religious, and commercial – which produced at the beginning of the nineteenth century a relative ignorance of African tribes and a relative knowledge of the Oceanic islands. Isolated African objects had appeared in Europe much earlier. The Dukes of Burgundy owned a few such works as early as the fifteenth century; the Ulm museum, some time before 1600; the Dukes of Brunswick, during the seventeenth century (they are now in the Hanover museum); and the imperial Austrian collections, somewhat later. Nevertheless, in general – and in any quantity – Oceanic objects preceded those from Africa, in storerooms and exhibits. Thus Vienna began with

Robert Goldwater, "The Development of Ethnological Museums" from *Primitivism in Modern Art*. Cambridge, Mass.: The Belknap Press of Harvard University Press, 1986, pp. 3–5, 7–9, 11, 13–15. © 1938 by the President and Fellows of Harvard College; © renewed 1966 by Robert Goldwater; enlarged edition © 1986 by Ambrose Doskow, Trustee U/W Robert Goldwater. Reprinted by permission of the publisher. (Reprinted without illustrations.)

pieces brought back by Captain Cook; the collection in Hamburg, as a result of South Sea connections with its trading city, was chiefly of Oceanic origin; and in England both the London and Cambridge museums had many Polynesian and Melanesian specimens before Africa was well represented.[5]

These were, however, but slight beginnings. How slight we may judge from a "letter" written in 1843 by P. F. von Siebold in favor of ethnographical museums: Von Siebold urges their importance, and particularly "the importance of their creation in European states possessing colonies," because he sees in them a means of understanding the subject peoples and of awakening the interest of the public and of merchants in them – all necessary conditions for a lucrative trade.[6] Toward this end the science of ethnology is indispensable. Von Siebold gives us, too, a glimpse of a more curious and less scientific age, the eighteenth century, which picked out of its rarity cabinets, where it "kept cult objects and other savage utensils," the most hideous examples in order to testify to "the strangeness and inhumanity of their customs."

> Some products of the art and the industry of half-civilized peoples were also preserved, but much less in the interests of science than out of regard for the great perfection of the technical arts which had been found among these barbarians.[7]

Though a few years in advance of his contemporaries, Von Siebold was on the right track, and the almost simultaneous founding of ethnographical museums in the decades immediately following was due at least as much to the political and economic competition for world markets as to the Darwinian theory of evolution. This was especially true in Germany, which was further behind, and thus more conscious of the supplementary activity necessary to advance its commercial ambitions.

The chronology of the museums shows that the greater number of the beginnings of the important collections is confined to the third quarter of the nineteenth century.[8] The nuclei of the museums of Berlin, London, Rome, Leipzig, and Dresden go back to this period.[9] The attitude of the founders of these museums is best indicated by the fact that the three museums of Berlin, Paris, and Rome were originally parts of museums of "antiquities" (i.e., prehistoric and unclassifiable objects), and that in each case it took some time to get the ethnological section separated from the remainder of the museum.[10] The Berlin museum had previously been part of the *fuerstliche Kunstkammer* for which Japanese arms and armor were already being bought at the time of the Great Elector.[11] In Paris the project of an ethnological museum was first conceived during the preparations for the Universal Exposition of 1855, the year after New Caledonia had been annexed, and while Senegal and Gabun were being penetrated by France; it was therefore natural that the museum desired, but never achieved, by E. F. Jomard, whose idea it first was, should have been one of "*géographie et voyages*," which was to include a "methodical classification of extra-European industry and of objects brought back from distant travels."[12] In the Exposition of 1878, which finally gave the impulse for the foundation of an ethnographical museum – the Trocadéro – separate from the museum at St. Germain-en-Laye, and largely inspired by the Nordiska Museet in Stockholm, by far the largest part of the objects came from America, whence they had been brought from Mexico by Charles Wiener, and from Colombia by Eduard André.[13] (Peruvian pottery and ornaments had been introduced during the previous century into the Cabinet des Médailles by Dombey.) Africa was represented by "antiquities from the

Canary Islands...and two panoplies from Gabun," and Oceania by "popular objects" from the Celebes, and some "ancient and modern pieces" sent from the Hawaiian Islands, all scant enough.[14]

Nine years after the foundation of the Trocadéro, E.-T. Hamy, its instigator, went to London to report on the Colonial Exposition which was being held there. It is significant that none of the reproductions which illustrate his account are of objects of art, nor are any of the collections which he mentions as being in the Exposition made up of such objects; and he reports that objects were installed helter-skelter, without any regional classification.[15] In the Paris Exposition of 1889, harpoons, arrows, oars, and axes predominated, although a few pieces were shown for their artistic interest: prow ornaments from New Guinea, a "heraldic statue" from New Zealand, a sculptured box from the Ashanti.[16] This evidence of the purely technical and curiosity interest in objects of art, which were exhibited simply as indications of mechanical development and skill among exotic peoples, is relevant to a contemporary survey of the ethnological museums of Europe. This survey, written by Kristian Bahnson in 1888, shows that the principal museums were by this time well established and had in their collections objects from most of the South Sea Islands and from the Gabun, Loango coast, Congo, Senegambia, Guinea, and Ashanti regions of Africa.[17] Work now highly prized for its artistic qualities comes from all of these areas, and so it was not because of lack of opportunity that such work was either not collected, or not exhibited in a manner calculated to make for its appreciation. If few art objects were shown in the museums, it was due to the attitudes of the ethnologists, influenced, as we will show below through the study of their writings, by the misapplication to the arts of general evolutionary theory, which was in its turn influenced by a naturalistic aesthetic.[18]

From this time on until after the First World War there was little change. Among museum officials, it was only Felix von Luschan, at that time in Africa himself, who recognized the importance of the art of Benin, revealed to the world in quantity through the British Punitive Expedition of 1897. The English museums were only tardily stirred into the acquisition of the bronzes and ivories through German activity in the London market.[19] In 1892 the Leipzig museum held a special African exhibition, but it was 1921 before there was an exhibition of Negro sculpture.[20] The Congo was represented for the first time in the Antwerp international exposition of 1894, and again in 1897 was an important part – in a special section at Tervuren – of the Exposition Universelle de Bruxelles. But this was purely in the interests of commerce; and the small knowledge of Congo art may be shown from the surprise of Torday and Joyce – as much as ten years later – at finding the excellent work of the Bushongo.[21] Yet the Museum of the Congo, the basis of which was the Tervuren exhibition, was not without influence upon taste; for the work of the German scholars there during the occupation of Belgium was of considerable aid to Carl Einstein in his subsequent propaganda for the aesthetic recognition of Negro sculpture.[22]

In 1918, René Verneau – giving an account of the uses of a museum of ethnography – mentions how artists who treat exotic subjects find its documents indispensable, and how exotic fashions have been borrowed from the Trocadéro; but he subordinates these to the knowledge which exporters may gain of the tastes of the peoples with whom they wish to deal.[23] In 1919 the first commercial exhibition of primitive art was held in Paris, though long before this the dealers had been active. And by 1923 an *exposition de l'art indigène des colonies françaises*, having no particular interest for business or commerce, could be held at the Pavillon de Marsan.

The changes which have since taken place, while they are comprehensive neither in the museums they include nor in their action within individual museums, have been in the direction of the enhancement of the aesthetic values of the productions of the primitive peoples. The British Museum and the museum of the Congo long adhered to the "principle of the precedence of collecting over exhibiting," but more recently a modification has occurred. Not only are typical objects less crowded in their cases, so that they may be better seen, but aesthetic standards are invoked by isolating certain works for separate exhibition on the basis of their individual excellence.[24] Other museums have considerably modified their original purely documentary purpose. In Munich, for example, where the installation was carried out on an "art-historical-aesthetic" basis, "the best pieces were so emphasized, through their placing and lighting, that they could be grasped by the hasty visitor who had only an artistic interest."[25] At the Trocadéro, the reorganization instituted by Paul Rivet and Georges-Henri Rivière in 1928 separated public halls from study rooms, and included in the former the "unique objects," shown as such, as well as the "most characteristic objects" of various regions. And although Rivière protested that the ethnographer must treat all his objects alike, the Trocadéro held numerous exhibitions which in effect were exhibitions of art.[26] (Benin, 1932; Dakar-Djibouti, Marquesas, 1934; Eskimo, 1935.) These divisions were preserved in its reorganization as the Musée de l'Homme in 1937–39 and "excellent" objects continued to be singled out for their aesthetic qualities at the same time as their use and meaning were carefully explained. In Vienna the collecting principle was exchanged for a "cultural-documentary" one, which, while satisfying scientific necessity did not neglect contemporary aesthetic demands.[27] In Cologne during the early thirties the orientation shifted in the same direction, with an emphasis on the individual objects.[28]

What conclusions may be drawn from this brief history? It is clear that the consideration of the aesthetic values of primitive art comes late in the development of museums of ethnology. It comes, indeed, not only considerably after the beginning of such an appreciation on the part of artists and private collectors, but, as a comparison with the second part of this chapter will show, and as is only natural, not until some time after the ethnologists themselves had begun to revise their low opinion of primitive art.

One cannot say, then, that the museums led and guided the taste of artists and private collectors. But the large body of material assembled in the museums and ready for the inspection, even if only with great difficulty, of the aesthetically minded should not be neglected. Not only was it there to be examined when taste became ready for it, as in Dresden and Paris; but it is probable that such a long and unconscious association – it can hardly be called familiarity – with the objects of primitive art was one of the elements in the preparation of this taste.

Interrupted by the war, the trend toward the complete artistic acceptance of primitive artifacts has accelerated in the ensuing two decades. It was undoubtedly hastened by the establishment of the former colonies as independent nations and the accompanying transformation of their traditional cultures under the impact of modern technology and economy. The result was that with only a few exceptions the primitive arts became arts of the past (in some cases the very recent past), and thus lost part of their previous function as documentation of contemporary primitive cultures. This both freed and emphasized their purely formal values and the expressive power inherent in their formal organization, and permitted a more relaxed and therefore more detailed examination of their social and psychological meanings.

Thus the museums of ethnology, while not neglecting documentation and "functional" considerations, have increasingly presented their objects (or at least some of them) as worthy of purely formal study. They have been willing to take the "ethnocentric" risk of making judgments which separated the finer objects from the more everyday ones in their permanent exhibits, and have also organized exhibitions to call attention to these special products of material culture as works of art.

A parallel development has occurred in the museums of art (especially in the United States) which have begun to widen their aesthetic horizons to include works from primitive cultures around the globe, both through temporary loan shows and in their permanent collections.[29] Moreover, museums concentrating on the primitive arts have been founded in Zurich, New York, and Paris. Thus the artistic creations of the primitive cultures have entered fully into the world history of art, to be, like those of any other culture, understood and appreciated on their own merits.

Notes

1 See below [*Primitivism in Modern Art*, hereafter *Primitivism*], Chap. II.
2 For an account of the general theoretical development of ethnology *cf.* Paul Radin, *The Method and Theory of Ethnology* (New York: McGraw-Hill, 1933). Also H. H. Freese, *Anthropology and the Public: The Role of the Museums* (Leiden: Brill, 1960), Chap. I.
3 For good accounts of this process *cf.* Charles P. Lucas, *The Partition and Colonisation of Africa* (Oxford: University Press, 1922); and G. H. Scholefield, *The Pacific: Its Past and Future* (London: John Murray, 1919).
4 Alfred Moulin, *L'Afrique à travers les âges* (Paris: Ollendorf, n. d.)
5 See the chronology given below [*Primitivism*].
6 Ph. Fr. de Siebold, *Lettre sur l'utilité des Musées Ethnographiques et sur l'importance de leur création dans les états européens qui possèdent des Colonies* (Paris: Librairie de l'Institut, 1843), p. 10.
7 *Loc. cit.*
8 See the Appendix [*Primitivism*].
9 Kristian Bahnson, "Ueber ethnographischen Museen," *Mittheilungen der Anthropologischen Gesellschaft in Wien*, XVIII (1888), 109–64. K. Weule, "Das Museum fuer Voelkerkunde zu Leipzig," *Jahrbuch des Museums fuer Voelkerkunde zu Leipzig*, VI (1913–14), 23–8. *British Museum, Handbook to the Ethnographical Collections* (London: British Museum, 1925), p. 1.
10 Bahnson, *op. cit.*, p. 116. E.-T. Hamy, *Les Origines du Musée d'Ethnographie. Histoire et Documents*, (Paris: E. Leroux, 1890), p. 53. Note that the foundation of the Trocadéro falls just outside the third quarter of the century (1878).
11 Bahnson, *loc. cit.*
12 Hamy, *op. cit.*, p. 52.
13 The Nordiska Museet was founded by Arthur Hazelius in order to show the popular art tradition of Sweden.
14 *Ibid.*, pp. 55–60.
15 E.-T. Hamy, *Etudes ethnographiques et archéologiques sur l'Exposition Coloniale et Indiènne de Londres* (Paris: E. Leroux, 1887), pp. 13–14, and *passim*.
16 *Exposition Universelle Internationale de 1889*, "Catalogue d'Ethnographie," *Catalogue Générale* (Lille: L. Daniel, 1889), pp. 126–30.
17 Bahnson, *op. cit., passim.*
18 See below [*Primitivism*], Chap. I, Part 2; especially concerning the Semperians and the Darwinians.

19 Felix von Luschan, *Die Altertuemer von Benin* (3 vols.; Berlin: W. de Gruyter, 1919), Introduction.

20 Fritz Krause, "Das Museum fuer Voelkerkunde zu Leipzig," *Ethnologische Studien* (Leipzig: Verlag der Asia Major, 1929), pp. 106–33.

21 E. Torday and T. A. Joyce, "Les Bushongo," *Annales du Musée du Congo Belge*, Ser. 3 (1910), Vol. 2, No. 1, p. 204.

22 J. Maes, "L'Ethnologie de l'Afrique Centrale et Le Musée du Congo Belge," *Africa*, VII (1934), 174–90.

23 R. Verneau, "Le Musée d'Ethnographie du Trocadéro," *L'Anthropologie*, XXIX (1918–19), 547–60.

24 The Pitt-Rivers Museum in Oxford perhaps preserves most purely the "original" state of an early ethnological collection. It is an unforgettable sight, particularly in contrast with modern installations.

25 Walter Schmidt, "Das Museum fuer Voelkerkunde in Muenchen," *Die Form*, V (1930), 398.

26 Georges-Henri Rivière, "Musée de Beaux-Arts ou Musée d'Ethnographie," Georges Hilaire, ed., *Musées: Enquête internationale sur la réforme des galéries publiques* (Paris: Cahiers de la République, n. d.), p. 67.

27 Kurt Blauensteiner, "Bildwerke aus Benin im Wiener Museum fuer Voelkerkunde," *Belvedere*, X (1931), No. 9, p. 36.

28 Julius Lips, verbally, October, 1935.

29 This is also now true of many private collections in both Europe and America, especially among those interested in modern art.

Chapter 13 | Franz Boas

Museums of Ethnology and Their Classification

Prof. Otis T. Mason's reply to my remarks on his views of the methods of ethnology is mainly a justification of his plan of arranging the collections of the national museum. As this plan is the outcome of his philosophical view of the problems of ethnology, we must scrutinize these in order to judge as to the merits of his system.

His principal object is the study of each and every invention among peoples of all races and countries. I am well aware that this idea was and is shared by many scientists; and at this very moment I read with interest Mantegazza's proposal of erecting a 'psychological museum,' i.e., a museum of ethnological objects arranged according to the ideas to which they belong. Professor Mason's rank among American ethnologists, however, and the weight he can give to his opinions by the arrangement of the large collections of the national museum according to his theories, induce me to criticise his views more particularly.

My view of the study of ethnology is this: the object of our science is to understand the phenomena called ethnological and anthropological, in the widest sense of those words, – in their historical development and geographical distribution, and in their physiological and psychological foundation. These two branches are opposed to each other in the same way as are biology and the so-called systematic 'organology,' or, as I have called it in another place (*Science*, ix. No. 210), when treating on the study of geography, 'physical science and cosmography;' the former trying to deduce laws from phenomena, the latter having for its aim a description and explanation of phenomena. I tried to show that both branches are of equal scientific value.

Let us inquire which method must be applied to carry on ethnological researches of either kind. Ethnological phenomena are the result of the physical and psychical character of men, and of its development under the influence of the surroundings: therefore two problems must be studied for attaining scientific results. The preliminary study is that of the surroundings: the final aim of the researches is the knowledge of the laws and history of the development of the physiological and psychological character of mankind. 'Surroundings' are the physical conditions of the country, and the sociological phenomena, i.e., the relation of man to man. Furthermore, the study

Franz Boas, "Museums of Ethnology and Their Classification" from *Science* Vol. IX, No. 228 (June 17, 1887), pp. 588–9. Public domain.

of the present surroundings is insufficient: the history of the people, the influence of the regions through which it passed on its migrations, and the people with whom it came into contact, must be considered. All of these are phenomena which may directly be observed by a well-trained observer, or may be traced with greater or less accuracy by historical researches.

The second part of ethnological researches is far more difficult. The physical and psychical character of a people is in itself the result of the action of the surroundings, and of the way in which the present character was attained. Each stage in the development of a people leaves its stamp, which cannot be destroyed by future events. Thus it appears that the elements of the character of a people are extremely complex. There are two ways of treating this problem.

One of the remarkable features of such problems is the occurrence of similar inventions in regions widely apart, and without having a common origin. One method of studying them – and this is Professor Mason's method – is to compare the phenomena, and to draw conclusions by analogy. It is the deductive method. The other method is to study phenomena arising from a common psychical cause among all tribes and as influenced by their surroundings: i.e., by tracing the full history of the single phenomenon. This is the inductive method. For this method of study, the tribal arrangement of museum specimens is the only satisfactory one, as it represents the physical and ethnical surroundings.

I will explain these ideas by giving an example. It has frequently been proposed to establish a museum illustrating the adaptation of organisms to surroundings. The aim of this study is to find the physiological laws or the combination of causes which have the effect of causing these adaptations. The classification and arrangement must, of course, be made according to surroundings, in order to show their influence on different kinds of organisms.

An ethnological collection is analogous to this. The objects of study are researches on psychology. The method of researches is a study of the surroundings. The surroundings are physical and ethnical: therefore the arrangement must also be physical and ethnical, as this is the only way to show the single phenomenon in its peculiar character and surroundings.

It has been the tendency of science to confine the domain of deductive methods more and more, and not to be content with arguments from analogy, which are the foundation of most errors of the human mind, and to which may be traced the religious and other ideas of man in a primitive state of culture, and, to a certain degree, even in a state of advanced civilization. Science is constantly encroaching upon the domain of the argument from analogy, and demands inductive methods.

Nevertheless the psychological and scientific value of the argument from analogy cannot be overrated: it is the most effective method of finding problems. The active part it plays in the origin of philosophical systems and grand ideas which sometimes burst upon scientists is proof of this. But, as far as inductive methods can be applied, – and we believe that their domain will continue to increase, – induction must scrutinize the ideas found by deduction. Therefore I should call Professor Mason's system a suggestive one, but not fit for scientific researches, as it does not allow the application of the inductive method.

But even this acknowledgment must be limited. The technological idea, which Professor Mason has made the leading one in the arrangement of the collection of the national museum, is only one side, and a very limited one, of the wide field of ideas which must be leading in a 'psychological museum,' as Mantegazza calls it.

The rattle, for instance, is not merely the outcome of the idea of making noise, and of the technical methods applied to reach this end: it is, besides this, the outcome of religious conceptions, as any noise may be applied to invoke or drive away spirits; or it may be the outcome of the pleasure children have in noise of any kind; and its form may be characteristic of the art of the people. Thus the same implement belongs to very different departments of a psychological museum.

Furthermore, let us inquire what is the psychological principle upon which Mason's system is founded. The leading idea is technology. The foundation of technics is the faculty of acting suitably: consequently the purpose of the implement must be made the principle of division. For instance, all kinds of cooking pots and other arrangements for cooking would belong to one class. The mere fact that certain pots are made of clay would not justify the establishment of a pottery department. This quality of being made of clay is incidental, and does not agree with the psychological basis.

There is one point of view which justifies a classification according to inventions in a psychological museum. This is the extent to which each invention is used by a people: for instance, in what branches of life pottery is made use of, which may be limited in one tribe, very wide in another. But in this case the purpose of the object will not be the principle of division, but the principal invention applied in its manufacture; and thus the specimens would not be arranged according to Professor Mason's system, objects serving widely differing purposes belonging to one class. Therefore I cannot consider it justifiable to make technology, in the sense Professor Mason does, the basis of arranging ethnological collections.

One reason ought to make us very cautious in applying the argument from analogy in ethnology as well as in other sciences of similar character; biology, for instance. Former events, as I have already said, leave their stamp on the present character of a people. I consider it one of the greatest achievements of Darwinism to have brought to light this fact, and thus to have made a physical treatment of biology and psychology possible. The fact may be expressed by the words, "the physiological and psychological state of an organism at a certain moment is a function of its whole history;" that is, the character and future development of a biological or ethnological phenomenon is not expressed by its appearance, by the state in which it *is*, but by its whole history. Physicists will understand the important meaning of this fact. The outward appearance of two phenomena may be identical, yet their immanent qualities may be altogether different: therefore arguments from analogies of the outward appearance, such as shown in Professor Mason's collections, are deceptive. These remarks show how the same phenomena may originate from unlike causes, and that my opinion does not at all strive against the axiom, 'Like effects spring from like causes,' which belongs to that class of axioms which cannot be converted. Though like causes have like effects, like effects have not like causes.

From my statement it will be understood that I cannot content myself with Mr. Dall's remark, in the letter contained in to-day's issue, that both standpoints contain part of the truth. I have expressed in another place (*Verh. Ges. für Erdkunde*, Berlin, 1886, No. 7) my opinion on Dall's ethnological method, and emphasized, as I have here also, the necessity of studying each ethnological phenomenon individually.

In conclusion I have to add a few words on the practical side of the question upon which Professor Mason and Mr. Dall touch. In regard to this question, I concur with Mr. Dall, and believe that the public will be much more benefited by the tribal arrangement of ethnological collections.

I cannot agree with Professor Mason's proposal of arranging the cases like a checker-board. In ethnology all is individuality. We should be compelled to leave long rows of cases empty, as certain phenomena occur but in very few tribes. It would be almost impossible to show in this way all important ethnological phenomena, the historical development of tribes, the influence of neighbors and surroundings, etc. It is my opinion that the main object of ethnological collections should be the dissemination of the fact that civilization is not something absolute, but that it is relative, and that our ideas and conceptions are true only so far as our civilization goes. I believe that this object can be accomplished only by the tribal arrangement of collections. The second object, which is subordinate to the other, is to show how far each and every civilization is the outcome of its geographical and historical surroundings. Here the line of tribal arrangement may sometimes be broken, in order to show an historical series of specimens: but I consider this latter point of view subordinate to the former, and should choose to arrange collections of duplicates for illustrating those ideas, as it were, as an explanation of the facts contained in the tribal series. Of course, it is generally impossible to do this, on account of the lack of specimens, or, more frequently, on account of the lack of our knowledge; but it is my ideal of an ethnological museum. I wish to state here again that I am not at all opposed to Mantegazza's psychological museum, which will be very suggestive and important for the development of science, but I consider the ethnological museum indispensable for controlling the ideas suggested by the analogies shown in the psychological collection, and as the only means of showing the state of culture of man.

Chapter 14 | Christopher Looby

The Constitution of Nature |
Taxonomy as Politics in Jefferson, Peale, and Bartram

In every perception of nature there is actually present the whole of society. The latter not only provides the patterns of perception in general, but also defines nature a priori in relation to itself.

T. W. Adorno (101)

Natural history," Benjamin Rush wrote, "is the foundation of all useful and practical knowledge." He made this remark in 1791, in the context of designing the proper education for the citizens of the new American republic. "By making natural history the first study of a boy, we imitate the conduct of the first teacher of man," Rush continued. "The first lesson that Adam received from his Maker in Paradise, was upon natural history. It is probable that the dominion of our great progenitor over the brute creation, and every other living creature, was founded upon a perfect knowledge of their names and qualities" (47–48). What Rush did not explicitly say – but what was implicit in his discussion, and in similar discussions of taxonomic natural history by other leading writers of early republican America – was that knowledge of the names and qualities of the beings in nature was not only the basis of the American's control over his environment, but might also be, in some sense, the foundation of the collective life of the new nation of which he was a member. Not only could it serve to make the elements of the new world familiar to him and render them useful for his purposes, but it could also help him to imagine the shape of the new society that he was then in the midst of making. Like the biblical Adam, whose precedent they commonly invoked, and who (Genesis 2:18–20) immediately upon naming the creatures became aware of his need of a companion – that is, commenced his life as a social being – so too did Americans in the early years of the republic engage in taxonomic construction as a rehearsal, so to speak, of social and political construction.[1] "In designating a thing I designate it *to the Other*," as

Christopher Looby, "The Constitution of Nature: Taxonomy as Politics in Jefferson, Peale, and Bartram" from *Early American Literature* 22:3 (1987), pp. 252–73. © 1987 by the Department of English at the University of North Carolina, Chapel Hill. Used by permission of the University of North Carolina Press.

Emmanuel Levinas has written; the act of designation precedes *and founds* the social relation (209; emphasis added). This relation between the natural and the social – the grounding of social order in a posited natural order – is distinctly present in such early national writers as Thomas Jefferson, Charles Willson Peale, and William Bartram.

In the thought of cultural leaders of the early national period, there is a kind of automatic metaphorical exchange between images of natural order and ideas of social and political order.[2] The period is one of cultural "constitution" in a broad sense, and it is important to place the making of the written instrument of government – the Constitution – within the context of larger constitutive cultural processes. Certainly it was evident to an individual like Madison, for instance, that the logical problems affecting the construction of legitimate natural taxonomies were essentially the same as those affecting the delineation of legitimate political institutions. In the *Federalist* No. 37, Madison treated the construction of political forms – e.g., "marking the proper line of partition, between the authority of the general, and that of the State Governments" – as a version of the general epistemological effort "to contemplate and discriminate objects, extensive and complicated in their nature" (234–35). "The boundaries between the great kingdoms of nature, and still more, between the various provinces, and lesser portions, into which they are subdivided, afford another illustration of the same important truth," he continued.

> The most sagacious and laborious naturalists have never yet succeeded, in tracing with certainty, the line which separates the district of vegetable life from the neighboring region of unorganized matter, or which marks the termination of the former and the commencement of the animal empire. A still greater obscurity lies in the distinctive characters, by which the objects in each of the great departments of nature, have been arranged and sorted. When we pass from the works of nature, in which all delineations are perfectly accurate, and appear to be otherwise only from the imperfection of the eye which surveys them, to the institutions of man, in which the obscurity arises as well from the object itself, as from the organ by which it is contemplated; we must perceive the necessity of moderating still farther our expectations and hopes from the efforts of human sagacity. Experience has instructed us that no skill in the science of Government has yet been able to discriminate and define, with sufficient certainty, its three great provinces, the Legislative, Executive and Judiciary; or even the privileges and powers of the different Legislative branches. (235)

Madison's expressed pessimism as to the probability of successful political delineations on the model of those of natural scientific taxonomy should not obscure for us, however, the ease and satisfaction with which he entertains such a possibility. *Kingdom, province, district, neighboring region,* and *empire* are the terms – all of them borrowed from the political register – that he instinctively employs to characterize natural taxonomic differences. They enable his mind to pass smoothly from one realm to another, and they indicate a desire to constitute, despite the difficulty of such a project, a political order in which "all delineations" would be as "perfectly accurate," as "natural" and as certain, as those inherent in the order of nature itself. To observe that such a project seeks to claim for the "institutions of man" an authority transcending the human is to recognize a familiar ideological device, one that has a particular power in the early American republic.

"A Society," Durkheim wrote, "is not made up merely of the mass of individuals who compose it, the ground which they occupy, the things which they use and the movements which they perform, but above all is the idea which it forms of itself" (470). This observation – that a society needs to represent itself to itself in order to certify its existence and its legitimacy – is illustrated by the American republic in the immediate post-revolutionary period. As the heroic excitements of the Revolution receded into the past and were replaced by the domestic convulsions of the succeeding decades, it became apparent to observers that America lacked a compelling idea of its own coherence, a self-conception that would make it a genuine society – a nation – rather than a mere mass of individuals. Diversity characterized the American population, and instability characterized the state that had been formed to govern it. Operating after 1776 under a bad constitution that was not even adopted until 1781, and then replaced by 1789, the viability of the republic was very much in question for several decades following independence. The threat of monarchical counter-revolution or military putsch, local insurrections like Shays' Rebellion and the Whiskey Rebellion, several secessionist movements, a series of treasonous plots against the state, and regular eruptions of mob violence were the conspicuous features of political life in the early republic. And there were, of course, even among the leaders who had joined to prosecute the Revolution, fundamental differences as to the proper form the state should take – differences that are sufficiently indicated by invoking the names of Jefferson on the one hand, and Hamilton on the other; Paine on one side, Adams on the other.

These differences of political conviction, which were articulated with increasing insistence as the memory of the Revolution faded, were probably less threatening in the short run than the incidents of actual violence, but they were potentially at least as dangerous to the future of the republic. The linguistic violence of the 1780s and '90s – the "wordy battle, and paper war" that Irving satirized so effectively in *Salmagundi* (144) – was the audible evidence of the Americans' lack of a common idea of the kind of society they wanted. Dissensus then was as deep, as general, and as powerful as it has been at any other time in American history. The American republic was as yet a factitious entity, a concocted political framework that gathered together people whose primordial loyalties were attached to local, ethnic, sectarian, and linguistic communities, rather than to the vaguely conceived national society. Having established a new state, the revolutionary leaders discovered to their dismay that they had not succeeded in creating a new nation.

It occurred to some of them, in this situation, that nature might aid them in constituting the nation. A society that is in need of a collective self-conception will ordinarily find some ready-made structure close at hand that can provide a model of coherence – a *form* that, when apprehended, can be transferred to society itself. I want to claim that after the American Revolution, men like Jefferson, Peale, and Bartram found such a structure in nature; or, to be more precise, they found it in the taxonomic order that they represented nature as exhibiting: the visible order of identities and alterities that they believed nature displayed to the eye. The search for a total conceptual order is common to several of the well-known texts of post-revolutionary America. Let me begin with a characteristic exclamation from William Bartram's *Travels*, a passage that typifies not only his usual attitude toward nature, but that of many of his compatriots. "We admire the mechanism of a watch, and the fabric of a piece of

brocade, as being the production of art," he wrote, because they show the obvious presence of *design*: all parts in them appear to conspire toward a single end or effect. A similar kind of inner intentionality, he believed, was plainly to be seen in nature. "The animal creation also, excites our admiration. . . . [H]ow wonderful is the mechanism of these finely formed, self-moving beings, how complicated their system, yet what unerring uniformity prevails throughout every tribe and particular species!" (xliv). The evidence of design was written on the face of nature, Bartram believed; in this he anticipated the view that Emerson would later take in his address on "The Method of Nature," where he claimed that "the spirit and peculiarity of that impression nature makes on us, is this, that there is in it no private will, no rebel leaf or limb, but the whole is oppressed with one superincumbent tendency" (121). What is striking about such a claim, I think, is that it assumes that this singleness of purpose is spontaneously presented to the eye and to the mind by nature in its ordinary appearance. There is very little in our everyday experience, I would say, to suggest that nature in all its parts is involved in a single task, that it is moving as a whole toward some goal; there is, on the contrary, everything to suggest otherwise. And the testimony of numerous others who recorded their impressions of American nature was that the appearance it presented was that of "the incredible, the immeasurable, the unpredictable, and the horrifying," to quote the apt summary of Howard Mumford Jones (61). Indeed, Bartram frequently found it so too; but here, at the beginning of his book, he assumed and claimed, nevertheless, that nature's surface was beautifully ordered. And he went on with utter confidence to draw inferences from his *a priori* assumption:

> If then the visible, the mechanical part of the animal creation, the mere material part is so admirably beautiful, harmonious and incomprehensible, what must be the intellectual system? that inexpressibly more essential principle, which secretly operates within? (xliv)

This is an *a priori* assumption because, despite the determination with which he asserts it, Bartram nevertheless, in those places where he seems to have transcribed most faithfully (or unselfconsciously) in his prose the impressions nature made on him, described not a harmonious order of things, but a nearly random set of motions, a concatenation of fortuitous processes, an intersection of unpredictable transformations. That is, he observed a world of things that moved, a world of change and becoming, rather than one of static being.

This is not to say that the world appeared to Bartram in fact as a total flux of colored spots, strange noises, and sensations of warmth and cold – a world that would resist all logical formulation. But it appeared to him as something like the world John Dewey described as the "colored, resounding, fragrant, lovable, attractive, beautiful" world of objects as they are disclosed to the prescientific consciousness (98). That is, it appeared to him as it appears to us before science and philosophy abstract, simplify, reduce, quantify, control and possess it. I make a point of emphasizing here that the world is never present to us as a sheer chaos of shifting impressions; even in the "natural attitude," as the phenomenologists call it, we perceive a world composed of somewhat coherent arrangements of relatively well-circumscribed objects having more or less determinate properties. We are born into a world already largely preconceived: all perceptions, as William James said, are *acquired* perceptions (2:78). Perceptual chaos, when it is invoked – and here I anticipate my argument a little – is not a report of what the senses detect in the world, but is rather a *figure* for social anarchy – a trope of perception, as it were – and it is employed as such for particular rhetorical purposes.

Likewise, a hard-set and fixed conceptual system is a figure for social order. The stiff and immutable world that men like Jefferson, Peale, and Bartram constructed was their rhetorical invention: it was a figure for social stability and – as I wish to claim – for an intensely desired end to the flux of revolutionary social-historical change.

But if the world as we know it is composed of objects that are relatively stable, those objects do, however, despite our best intellectual preventions, tend to change over time and even vanish. They do not form a reality fixed and complete, rigidly categorized and statically exhibited to the eye of the mind. They form a world of some uncertainty, for a world in motion is a world about which people may hold conflicting opinions. A world that changes is one that invites different individuals to form different and perhaps incompatible judgments, and it invites even the same individual to form different, perhaps incompatible judgments at different times. In such a world, we are liable to lose faith in the unity of truth: as Melville asks in *Clarel*, "That stable proof which man would fold, / How may it be derived from things / Subject to change and vanishings?" (112). And if a more or less uncontroversial stock of knowledge is a necessary social resource – the foundation of basic agreement among men – then the transformations in nature, which inhibit the acquisition of uncontroversial knowledge, constitute a threat to social well-being. The scientifically formulated world, however, is essentially inert and is therefore a world about which there can be certain knowledge and about which there ought to be no disagreement. At least this is what the enlightened eighteenth-century philosopher believed: refusing to be distracted by the mutability of natural objects, he held that the Linnæan intellectual system represented the one true world, the fixed order of nature as it objectively subsisted. He was, we may say, mistaking the unchangeability of his concepts for the invariance of nature: we find him, in the person, for instance, of Bartram, in what may seem the rather comical act of strolling through the wilderness of Georgia, reciting to himself the scientific nomenclature of the animals and plants he finds, not interested in them in their contingent and mutable specificity, but only in their conceptual universality: "Magnolia glauca, Itea, Clethra, Chionanthus, Gordonia lasianthus, Ilex angustifolium, Olea Americana, Hopea tinctoria," and so on (24).[3] This incantation, this ritual prophylaxis, invoked the complete and consistent set of categories that the eighteenth century employed to describe and construct nature. As such, it united Bartram, alone there in the wilderness, with the minds of other men, whom he met, as it were, in the integrated world of stable ideas that the Linnæan classifications constituted. As Durkheim said, the crucial fact about such a total intellectual system is that the world it describes is a world that no individual knowing subject, with his limited perspective on things, can contemplate; only society as a whole, the putative collective subject, can regard it. The Linnæan system, since it represents the whole natural world, necessarily exceeds the experience of any single knowing subject, since such an individual subject, no matter how extensive his acquaintance with the plants and animals of the earth, could still know only some of them. The natural world *in toto*, then, according to Durkheim, is "an object [that] can be embraced only by a subject which contains all the individual subjects within it." It is, we might say, an imaginary object, only visible to an imaginary subject – the collective subject. Durkheim, of course, in this connection concluded with a famous dictum: "The concept of totality is only the abstract form of the concept of society" (490).

It is taxonomy in this respect – as a total system of concepts exhaustively representing the world of natural things, and corresponding to the total form of society – that was particularly important to post-revolutionary America. Collective unity in the

social moment of the synthesis of thought was what Bartram, along with Jefferson and Peale, aimed to stimulate. It might be possible to study certain particular parallels between specific social classes and specific natural categories, such as many cultures draw; such correspondences seem, however, to be severely attenuated in developed Western cultures. (They survive vestigially in such totems as the donkey and the elephant, representing the two established political parties in the United States.) It seems, rather, that the compelling feature of the Linnæan taxonomy was its comprehensive unity, and that in the modern West the expressive relation between nature and society operates almost exclusively at the level of the whole. This is where men like Jefferson, Peale, and Bartram focused their attention, anyway: they felt deeply the lack of social unanimity in late eighteenth-century America, and they imagined that in nature – prearranged nature – they saw a powerful totality that might be of use in constructing the collective American subject. This was the natural world that Bartram went to Georgia, the Carolinas and the Floridas to find, and he found it; this world promised to be the unifier of minds. Implicitly present in Bartram's perception of nature, *actively determining* it, was the whole of society; or, since my argument is that we can't properly speak of a coherent society in America at the time, but only of a set of communities that cultural leaders were trying to tie together as a single society, I should say that what was present in Bartram's perception of nature was an *idea* of the whole of society, a *wish* for social unity that found its expression vicariously in his determination to see *in* nature the taxonomic scheme he brought *to* it.

In this connection, Bartram's obsessive habit of describing groups of animals and even plants as social groups is relevant: flowers "associate in separate communities" (14), fish comprise "nations" (101) and "bands and communities" (105), butterflies rally to their "kindred tribes" (106). Sometimes the metaphors are those of specifically military societies: "armies" of fish (111), "well disciplined squadrons" of cranes (121), a "company" of wolves (126).[4] And Bartram never hears the lowing of cows and fails to comment on their "cheerful, social voices" (120). He goes so far as to imagine that "different tribes and bands" – deer, wild horses, turkeys, cranes – will, upon the appearance of a predator, "draw towards each other . . . as it were deliberating upon the general good" (120). That verbal hedge – "as it were" – barely disguises the wish, discreetly present here, that diverse human groups may also find it possible, in America, to agree upon a general good or a common interest. But Bartram only imagines that the animals do so when confronted with the danger of an attack; and this circumstance recalls, without examining, the political problem American leaders faced in the period in question. For Americans – like Bartram's several species – *had* united when faced with a threat from outside; but when that threat was eliminated, their unanimity had dissolved. It is the restoration of that unanimity that Bartram seeks as he gazes at nature, subsuming its objects under his conceptual scheme, executing an act of consciousness on behalf of the society that he intended thereby to call into being, the society that alone could complete the act of total cognitive synthesis he was proposing. Bartram's contemplation of nature was the self-contemplation of the American nation at the moment of its creation.

II

In the first, formative stages of American nationality, as I have said, cultural leaders had to confront the threat of social disintegration that was posed by the conflicting racial,

ethnic, religious, linguistic, sectional, local, and ideological categories of self-definition and social loyalty that were inhibiting the formation of a genuinely national identity. As Jefferson wrote, "During the war of Independance . . . the pressure of an external enemy hooped us together. . . . The spirit of the people, excited by danger," produced a unanimity that "was a supplement to the Confederation," which was otherwise an inadequate political instrument (*Writings* 70–71). It was this inadequacy that the Constitution was intended to remedy, but the decades of reciprocal violence that followed the ratification of the Constitution showed that it was not the deficiency of the particular instrument of government that was the real problem, but rather a deficient "spirit of the people." There was no collective identity, no collective subject whose will the state could be considered to be expressing. In traditional societies, the existence of such a collective subject is a product of history and custom. All kinds of primordial attachments – blood ties (real or presumed), common racial characteristics, linguistic community, geographical concentration, religious orthodoxy, shared usages and practices – all of these enable spokesmen for historically-grounded, organically-evolved nations to use the first person plural with confidence: "We" do this or do that, are this or are that, believe this or believe that.[5] However, for Americans after the Revolution, too many kinds of cultural heterogeneity stood in the way of establishing an integral national self. Despite the grandiloquent gesture of the Constitution's opening – "We the People" – there was no "People" of whom "We" could speak.

It is in this context of threatened social disintegration that we must consider the meaning of the Jeffersonian generation's special affinity for natural history. Men like Jefferson, Peale, and Bartram saw in nature – nature as Linnæus constructed it – a promise of social unanimity that held a profound fascination for them. More often than not, ethnologists tell us, societies in search of images of ideal order will have recourse to zoological and botanical taxonomies, which are presumed to be objectively given in nature and which seem to provide man with what Lévi-Strauss has called "the most intuitive picture at his disposal" of a permanent order of things (137). We should not, then, be surprised to find that in the post-revolutionary period, Americans had such recourse. In so doing, it may be, they were acting in obedience to an essential human impulse that seeks to organize society as a reflection or projection of the natural world; and while we don't usually treat the Linnæan taxonomy of nature as the equivalent of the so-called "ethno-taxonomies" of other (presumably less "enlightened") cultures, it served much the same purpose. Like other collective representations or world-views, it was directed not only against cognitive dissonance, but against social disintegration as well. In so functioning, it realized a particular late eighteenth-century conviction, part of the myth of enlightenment: the conviction that institutionalized science, as the organized discovery of truth, could serve as a model for the organization of state and society (Habermas 146). The advantage of science as a social model was its established procedures for reaching understanding, its methods for overcoming disagreements. Scientific societies were "always in peace," as Jefferson said, "however their nations may be at war. Like the republic of letters, they form a great fraternity spreading over the whole earth" (*Writings* 1201). In the 1780s and '90s, as it happened, classificatory natural science exemplified for Americans the ideal of scientific inquiry.[6] Jefferson remarked that while it was "impossible for a man who takes a survey of what is already known, not to see what an immensity in every branch of science yet remains to be discovered" (*Writings* 1064), natural science had the advantage over other branches of inquiry of having in the Linnæan scheme a "Catholic system," a "universal language" that had obtained "the general consent," thus

"rallying all to the same names for the same objects, so that they could communicate understandingly on them" (*Writings* 1330–33). That is, while other sciences were as yet plagued by fundamental disagreements as to their proper objects and proper methods, natural history had what we might today call a paradigm or research program – what Jefferson called a "universal language" – that united its practitioners in an effective community of inquiry. Although he would eventually come to admit, with Buffon, that "Nature has, in truth, produced units only through all her works," and that "classes, genera, species, are not of her work" but are constructions of human intelligence that "fix arbitrarily on such characteristic resemblances and differences as seem to us most prominent and invariable in the several subjects," he nevertheless believed that to abandon the "received, understood, and conventionally settled" system of Linnæus would mean that we could "no longer communicate intelligibly with one another" (*Writings* 1329–31). And although his recognition of the arbitrary status of the Linnæan categories led him to confess that it was not "intrinsically preferable" to any other classification,[7] he definitely preferred it to what he derisively called "the no-system of Buffon, the great advocate of individualism in opposition to classification" (*Writings* 1331–33). This reference to *individualism* tells us something, for Jefferson began the letter from which I have been quoting by expressing his reluctance to discuss the "comparative merits of the different methods of classification adopted by different writers on Natural History," since (as he said) his had been "a life of continued occupation in civil concerns," which had taken him away from natural science (*Writings* 1329). Relenting, however, he expressed himself on the subject anyway, and, when doing so, those "civil concerns" were still clearly present to his mind. Having concluded that "classes, genera, species" are human institutions, the simple basis upon which he decided the "comparative merits" of the different taxonomic systems was therefore necessarily a social one. "I adhere to the Linnæan because it is sufficient as a ground-work, admits of supplementary insertions as new productions are discovered, and mainly because it has got into so general use that it will not be easy to displace it, and still less to find another which shall have the same singular good fortune of obtaining the general consent" (*Writings* 1332–33). An attempt to replace it would lead, he said, "directly to the confusion of tongues of Babel" and to "schism" (*Writings* 1330–33). The one substantive merit of the Linnæan scheme that Jefferson was willing to specify was that it dwelt more consistently upon the surface appearances of things: it assigned particular things to particular categories according to outward features. This choice of "such exterior and visible characteristics as every traveller is competent to observe, to ascertain and to relate" (*Writings* 1331) made it that much easier for the principles and procedures of scientific cooperation to become the principles and practices of social intercourse in general, since the orthodox Common Sense epistemology of the Jeffersonian generation held that the act of knowing was analogous to the act of seeing.[8] Hence if a science that would yield certainty, and yield it to everyone, was needed, natural history of the Linnæan sort would be the best choice.

This preference for natural history, based on political considerations, was also present in the Reverend Nicholas Collin's *Essay on those inquiries in Natural Philosophy, which at present are most beneficial to the UNITED STATES OF NORTH AMERICA*, in which Collin, a Swede, posed as an appointed messenger of "the great Linnæus" himself: "I often heard [him] wish that he could have explored the continent of North America," Collin attested; "[M]ay this wish animate American philosophers" (xv). "Patriotic affections" were behind the privilege Collin granted to taxonomic investi-

gations; he thought it relevant to refer to the "convulsion of public affairs, for a considerable time past, which occasioned many and great domestic distresses: the natural events of the late war are universally known" (vi). The inner relation between natural and political history emerged, as if automatically, within Collin's language: the "events of the late war" are called "natural," and when he goes on to remark that "numbers of virtuous citizens have also felt the dire effects of the succeeding anarchy, especially in the loss of property," he is preparing a set of political connotations that will be in place when, turning to nature proper, he stigmatizes the "apparent disorders" that are observed in nature. He insists that they are merely that – *apparent* – and that nature in fact obeys "fixed principles," so strongly fixed that "there can be *no chance* in it" (vi–xxvii). We encounter, once again, the strong prejudice in favor of the identical, the persisting, the solid – as opposed to the self-differing, and changeable, the chaotic – that operated nearly everywhere in American science at the time, a prejudice that is regularly reinforced by the ritual repetition of moments of transformation, turbulence, and sheer motion, moments which place the conceptual scheme (and the social order) at risk, but which provide the opportunity for its reassertion. I want to refer to some of these moments presently, but let me prepare my remarks by quoting again from Durkheim, who illustrates his thesis on the social reference in all natural classifications by means of imagery that uncannily repeats some of Bartram's most vivid imagery. Durkheim is concerned to characterize the *concept* by defining it in opposition to sensual representations – sensations, perceptions, images – as basically *stable*:

> Sensual representations are in perpetual flux; they come after each other like the waves of a river, and even during the time that they last, they do not remain the same thing. Each of them is an integral part of the precise instant when it takes place. We are never sure of again finding a perception such as we experienced it the first time; for if the thing perceived has not changed, it is we who are no longer the same. On the contrary, the concept is, as it were, outside of time and change; it is in the depths below all this agitation; it might be said that it is in a different portion of the mind, which is serener and calmer. It does not move of itself, by an internal and spontaneous evolution, but, on the contrary, it resists change. It is a manner of thinking that, at every moment of time, is fixed and crystallized. In so far as it is what it ought to be, it is immutable. (481)

Durkheim's diction is very precise: "In so far as it is what it *ought* to be, it is immutable." That is, in the permanence of the concept is invested a measure of society's conviction that its ways are morally right. And Durkheim's water imagery – the "flux," "agitation" and "waves" versus the "depths" which are "serener and calmer" – jibes nicely with a typical feature of Bartram's writing, for Bartram also characteristically uses imagery of watery flow and agitation (on the one hand) and glassy stillness (on the other) to represent, respectively, the intrinsic changeability of sensual experience and the relative permanence of conceptual order. Many times in the course of his travels he finds himself admiring the "polished surface" of a "peaceful stream," looking through its "pellucid" waters at the objects below (49). But almost without fail, the smooth surface then becomes "ruffled," and its "wavy surface disfigures every object, presenting them obscurely to the sight, and they at length totally disappear" (51). Inevitably, however, the "waters are purified" once again, "the waves subside, and the beautiful river regains its native calmness." And "so it is with the varied and mutable scenes of human events on the stream of life," Bartram

adds, perhaps too explicitly. The "well contrived system at once becomes a chaos . . . every pleasing object is defaced, all is deranged . . . a gloomy cloud pervades the understanding" (52). At another place in the text it is not the ruffled surface of a stream but a heavy rain that interferes with Bartram's comfortable and secure relation to the world of objects: "such floods of rain fell . . . that every object was totally obscured . . . all seemed a frightful chaos. When the wind and rain abated, I was overjoyed to see the face of nature again appear" (142). Instances could be multiplied, but the essential point is, I trust, clear: in a book devoted to establishing the authority of a conceptual scheme, occasional ritual moments of perceptual disorientation are produced, then quickly followed by the restoration of conceptual security, which is an affirmation of the social structure to which the concepts belong.

III

A similar affirmation can be seen in Jefferson's *Notes on the State of Virginia*. The book's ostensible motive is to record and promulgate a certain organized body of knowledge respecting the flora, fauna, geography, and human and social institutions of Virginia. It illustrates the standard anthropological dictum that "Any culture is a series of related structures which comprise social forms, cosmology, the whole of knowledge and through which all experience is mediated" (Douglas 128). There is a relation between the concepts of nature that are so prominent in the book and the ideas of historical self-understanding that Jefferson adhered to. We know that the dynamics of social change often aroused in Jefferson a reactionary anxiety. Despite a few well-known expressions of a contrary opinion, he could scarcely conceive of social process – the movement of a nation through time – except in negative terms, that is, as decay, corruption, and degeneration (McCoy 13–47). The only kind of society that had any chance to forestall the process of corruption was one that was conflict-free: a homogeneous, egalitarian, agricultural republic. "It is for the happiness of those united in society to harmonize as much as possible in matters which they must of necessity transact together. Civil government being the sole object of forming societies, its administration must be conducted by common consent" (*Notes* 84). It was therefore crucial that the American population not be "a heterogeneous, incoherent, distracted mass," as it might very well become if emigrants, who "will bring with them the principles of the governments they leave," were allowed to "warp and bias its direction" (*Notes* 85). In order that the republic might be "more homogeneous, more peaceable, more durable," it was necessary that precautions be taken to insure uniformity of sentiments and conceptions among the people.

It is this uniformity that the overwhelmingly static, synchronic presentation of knowledge in the *Notes on Virginia* was intended to foster. The predominant manner of presentation was in the form of charts, diagrams, tables, and lists – that is, in graphic, two-dimensional formats – all of which explicitly exclude the possibility of change or development. Indeed, we know that Jefferson, in his one scientific paper, on the megalonyx or great-claw (an animal known only from its fossilized remains), could not bring himself to believe that this particular species was no longer in existence. Having discussed its bones, one by one; having classified it with "the unquiculated quadrupeds"; having estimated its size, and given it a name, he finally had to face the "difficult question" that he conceded "now presents itself. What is become of the greatclaw?" ("Memoir" 251). His conclusion: "In fine, the bones exist; therefore

the animal has existed," and since the only motions present in nature are movements "in a never ending circle," it followed that "if this animal has once existed, it is probable on this general view of the movements of nature that he still exists" ("Memoir" 255). Jefferson reasoned along the same lines with respect to the mammoth, when he discussed it in *Notes on Virginia*: "It may be asked," he wrote to justify his having included the mammoth in the table that exhibited the hierarchy of species of quadrupeds, "why I insert the Mammoth, as if it still existed? I ask in return, why I should omit it, as if it did not exist? Such is the oeconomy of nature, that no instance can be produced of her having permitted any one race of animals to become extinct; of her having formed any link in her great work so weak as to be broken" (*Notes* 53–54). The same taboo on change in the order of nature informed Jefferson's refusal to countenance Buffon's theory that the species degenerated in America. Although it is usually thought that Jefferson's response to Buffon was a simple expression of resentment at the suggestion that nature in America was smaller and weaker than nature in Europe, I think, instead, that it is best interpreted as a rejection of the possibility of change or evolution *per se*, since such change would imply that the supposed invariability of nature, and hence the stability of its conceptualization, were in error. And what was at stake in such a matter was not only the validity of the intellectual system, but also that of the social regime of which the intellectual system was the abstract equivalent.

In addition to this general theme running through the *Notes on Virginia*, there is a specific occasion when Jefferson allows the world of natural objects to appear in its changeability, a moment when the adequacy of his concepts is at risk. The moment comes under the head of Query VII, which asks for "A notice of all what can increase the progress of human knowledge?" (*Notes* 73). "Under the latitude of this query," Jefferson wrote, "I will presume it not improper nor unacceptable to furnish some data for estimating the climate of Virginia" (*Notes* 73). This may seem a peculiar choice; why should information about the climate contribute especially to the total of human knowledge? The chapter is perhaps the most curious in the book, since it calls into question the validity of assertions that are made prominently in the rest of the work. That is, in this chapter, ostensibly devoted to increasing knowledge, Jefferson instead, perversely, includes a passage that calls the very possibility of certain knowledge into question. He describes the strange optical phenomenon of "*looming*," a familiar phenomenon at sea, but one that is unaccountable, Jefferson says, in the present case. Standing upon the elevation of Monticello – which, in this passage, and, indeed, in Jefferson's life in general, represents for him the neutral, disinterested standpoint posited by the specular rationality of the Enlightenment – he finds that "in opposition to the general law of vision" that makes distant objects diminish in apparent size, looming makes them appear larger, and it makes them change their shapes:

> There is a solitary mountain about 40 miles off, in the South, whose natural shape, as presented to view here, is a regular cone; but by the effect of looming, it sometimes subsides almost totally into the horizon; sometimes it rises more acute and more elevated; sometimes it is hemispherical; and sometimes its sides are perpendicular, its top flat, and as broad as its base. In short it assumes at times the most whimsical shapes, and all these perhaps successively in the same morning. (*Notes* 80–81)

Philosophy has not accounted for this phenomenon, Jefferson says; it is behind the seamen, no less, for philosophy has not even *named* this phenomenon officially. And

despite having introduced this discussion under the rubric of climate, he says he can "remark no particular state, either in the weight, moisture, or heat of the atmosphere, necessary to produce this.... Refraction will not account for this metamorphosis. That only changes the proportions of length and breadth, base and altitude, preserving the general outlines," while in this case it is the very shape itself that appears to change (*Notes* 80–81). So not only is this a phenomenon that tends to defeat the project of knowledge-acquisition, it is also a phenomenon that it is, evidently, impossible to know in itself. It interferes with the relation of mind to object, and it is itself also an obscure object. Jefferson is present in this passage as the ideal knowing subject, whose effort is directed toward taking what is presented to sight and assimilating it to several ideal categories of objects – in this case, certain geometrical forms (cone, hemisphere, square). That is what knowledge consists in, for him; and it is a view of knowledge that the book as a whole tries to promote: to know is to overrule the sensibly intuited bodies in nature by means of a universally-available, all-encompassing conceptual system that, not incidentally, makes time stand still.

Charles Willson Peale is the taxonomist par excellence. And his natural history museum, installed in the Pennsylvania State House, made most explicit the relation between taxonomic natural science and political order. He hoped, in fact, that his museum would serve as an effective apparatus of the national state, and he was bitterly disappointed when its efficacy went unrecognized by the government. The specimens he mounted and displayed were arranged, in the museum's rooms, in the perfect visual order of the Linnæan pattern. And at the top of the hierarchy – in two rows along the ceiling above the cabinets – were displayed the portraits Peale had painted of the heroes of the Revolution, presiding over the rational order of things, of which they were the superior extension. The portraits recalled the lost unanimity of the Revolutionary moment, but Peale seems actually to have believed that the majestic taxonomy of his exhibit would have the effect of restoring that unanimity if people came to see it and allowed it to impress its message upon their minds.

> One very important effect may be produced, – persons having different sentiments in politicks, being drawn together for the purpose of studying the beauties of nature, while conversing on those agreeable subjects, may find a concordance of sentiments, and most probably from a slight acquaintance, would think better of each other, than while totally estranged. (*Discourse* 39)

But this was not mere conjecture on his part, as he attested:

> An instance of this is in the memory of my hearers. The chiefs of several nations of Indians, who had an historical enmity to each other, happened to meet unexpectedly in the Museum in 1796...surrounded by a scene calculated to inspire the most perfect harmony, the first suggestion was, – that as men of the same species they were not enemies by nature; but ought forever to bury the hatchet of war. (*Discourse* 39–40)

The political design of the museum is clear: it was "calculated to inspire the most perfect harmony." And within the museum, as within the texts of Bartram and Jefferson, there were produced certain ritual dissolutions and restorations of its conceptual order. In Peale's case, he devised a magic lantern show – an "Exhibition of Perspective Views, With Changeable Effects; or, Nature Delineated, and in Motion" – which represented a series of scenes (both natural and social) involving

perceptual transformations. By means of painted transparencies illuminated from behind, and shifted in a coordinated manner, illusions were created involving the coming of dawn, the arrival of dusk and the lighting of street lamps, a storm gathering over a view of architectural forms, a rushing stream turning a water-wheel, a battle between ships at sea, and, tellingly, the raising of Pandemonium as described by Milton (*Descriptive Catalogue*). Each sequence of images delineated a movement, but ended (when the final image was resolved) in stasis; a stasis that returned the viewers, when the show was ended, to the ordered environment of the museum itself. The museum, of course, was a display of certainties: it was a world free of ambiguities, obscurities, and difficulties, and hence a world about which there was no reason ever to disagree: a world of perfect consensus. "Facts, and not theories, are the foundation on which the whole superstructure is built," Peale claimed. "Not on theoretical, speculative things, but on the objects of our sight and feelings" (*Discourse* 41). But even Peale – otherwise the least likely individual to entertain nominalistic doubts – wondered, perhaps unconsciously, whether his assured, static view of the world wasn't, in fact, an illusion. When the trustees of the museum commissioned him, late in his life, to paint a self-portrait that would then form part of the museum's exhibit, he complied by producing the painting known as "The Artist in His Museum," which depicted him, full-length, standing before the main room of the museum, raising a curtain with his right hand to reveal, at his back, the ordered realm of knowledge it had been his long effort to construct. The portrait is dramatically lighted, and the attitude in which Peale placed himself is less that of a scientist than that of a showman; the whole composition, in fact, is governed by a theatrical metaphor that insinuates a terrible doubt of appearances into what is meant to be a reassuring picture of the world as it really, indubitably exists. And this again raises the question of whether all these attempts to present something as reconciled that actually is not – whether it be the heterogeneous elements of nature, or the social diversity and conflict that natural disorder represented for the authors I have treated – isn't one of the standard ideological reflexes of the period. For each of the writers I have con-sidered, classificatory schemes are figures for social order, and while the pragmatic status of those schemes is here and there conceded – more willingly by Jefferson than by either Bartram or Peale – they are nevertheless held to be necessary, and whatever would falsify them is held to be dangerous. The watery dissolutions of perceived objects in Bartram, the looming in Jefferson, and the unwitting confession of the artificiality of classification in the theatricality of Peale's representation of his museum – these moments operate to reinforce the mind's attachment to the images of order they temporarily put at risk.

The obsession with natural harmony that marks this period in America would seem to mask an anxiety about the political dissonance that also marks the period. The power of the cultural presence of natural classification as a representation of social order may be best appreciated when we observe that it makes possible the elaborate humor of Hugh Henry Brackenridge, when, in *Modern Chivalry*, he has Teague O'Regan, the "bog-trotting Irishman" who is his figure of social transgression, be mistaken for "a monster in creation, or at least a new species of animal, never before known in these woods" (317) when he is found, tarred and feathered, by two hunters who see him in a tree. He is captured, caged, and exhibited as a natural curiosity; the Philosophical Society hears of him, and sends two representatives to examine him scientifically and make a report to be published in their transactions; in a preliminary determination of his genus, they offer the opinion that "it is an animal of a species

wholly new, and of a middle nature between a bird and a beast," and that it "would seem to form the link between the brutal and the human species" (320). He is shipped to France to be exhibited to the learned societies, but upon coming ashore the tar and feathers have worn off his backside; he is mistaken for a sans-culotte, and the mob rises and frees him. The narrator concludes the episode by remarking of this unclassifiable creature that it is not certain "whether he joined the army of the patriots, or is on his way home again to this country" (324). But evidently a being that disrupts the ordered categories of nature is bound to make political trouble somewhere.

Notes

1 The myth of Adamic naming is a familiar and persistent one in American culture and in studies of American culture. It is usually identified, of course, with writers of the American Renaissance like Emerson, Thoreau, and Whitman; but it is present even in less obviously imaginative writers – like those under discussion here. It survives even in recent academic studies. In his otherwise quite prosaic narrative of American scientific developments in the early republic, Greene opens his chapter on "Natural History in a New World: Botany" with these words: "Like Adam in the garden of Eden, the naturalists of the infant American republic faced the exhilarating task of naming, classifying, and describing the plants and animals of a new world" (253). Needless to say, this sort of wholesale appropriation of the Adamic myth is intellectually suspect, for it perpetuates several fallacies: that there were no human subjects on the scene before European settlers arrived; that the objects of the natural world were therefore unnamed until those settlers arrived; that the scientific project of those settlers – their taxonomic construction – was undertaken *de novo*. Of course there were human subjects on the scene, and they had their own names for things; and the scientific project of the later settlers consisted mostly in reconciling new objects to old categories.

2 Since writing this essay, I have found that a recent historian of the early republic has reached similar conclusions. Robert H. Wiebe characterizes the mental habits of the cultural leaders of the early republic in these terms: "The gentry reasoned by formulating broad categories, sorting information into them, then explaining the information through the rules governing their categories. . . . Nothing better exemplified their ideal than the magnificently arching branches of biological classification: phylum down to genus to species to subspecies, ordering all of life in one grand pattern. . . . Whatever rules governed the natural sciences covered politics and the arts as well. . . . Just as categories of knowledge molded their data, so in the end structures of government would mold their people" (7–11).

3 As Prigogine and Stengers have maintained, the trajectory of modern physical science has been away from the "rather naive assumption of a direct connection between our description of the world and the world itself" (54–55), which had been the assumption of classical science, and toward a recognition that "randomness, complexity, and irreversibility" (54) – that is, temporality – are proper objects of natural scientific knowledge, not just illusions of a phenomenal order that distract us from true knowledge of substances. Classical science, they say, is "the mythical science of a simple, passive world" (55), while modern science is "rediscovering time" (xxviii) and studying a world that is intrinsically active. On the importance of the concept of temporality for the transition to modern scientific inquiry, see also Collingwood.

4 As John Arthos shows, the conventional diction of eighteenth-century English poetry includes countless such figures; poets of the time "exploited a stable language because they believed that the design of the world was stable" (vii), and, since the "sure constancy of things was the charm of nature" (viii), political and social terms could both lend and borrow connotations of stability from the natural objects they were made to represent. See his Appendix A for instances of the use of such words as *Band* (106), *Citizen* (114–15), *Empire*

(156–57), *Kingdom* (232–34), *Nation* (255–56), *People* (271–73), *Race* (281–82), *Reign* (294–95), *Tribe* (332–34), and *Troop* (334), among other terms.

5 See Geertz, "After the Revolution," for an illuminating analysis of the cultural politics of post-revolutionary nationalism. I have found this essay, and also his study of the "Integrative Revolution," particularly suggestive and helpful for the present study.

6 Boorstin *passim*; Sheehan ch. 1.

7 Taxonomic realism – the view that there is one unambiguously correct taxonomic theory, which could successfully distinguish "real essences" or "natural kinds" – has been largely given up by scientists, in favor of an attitude that recognizes the pragmatic value of a commonly-accepted system of classification while granting the arbitrary status of its terms and their extensions. This pragmatic-relativistic position was the result, obviously, of the competition between taxonomic representations that commenced in the late eighteenth century. The secondary literature on this development is extensive but fragmentary.

8 The reign of Common Sense philosophy in eighteenth-century America has been extensively documented in recent works by White, Wills, and others. The privilege enjoyed by the faculty of sight – its status as a figure for certain knowledge – is perhaps most unambiguously stated in Thomas Reid's *An Inquiry into the Human Mind*, where it is claimed that sight is "without doubt the noblest" of the senses. But "it is looked upon, not only as more noble than the other senses, but as having something in it of a nature superior to sensation." Reasoning from ordinary language, Reid goes on to notice that the "evidence of reason is called *seeing*, not *feeling*, *smelling*, or *tasting*" (145, 147–48). A general study of "the domination of the mind of the West by ocular metaphors" (13) is Rorty, *Philosophy and the Mirror of Nature*.

Works Cited

Adorno, T. W. *Aesthetic Theory.* Trans. C. Lenhardt. London: Routledge & Kegan Paul, 1984.

Arthos, John. *The Language of Natural Description in Eighteenth-Century Poetry.* Ann Arbor: Univ. of Michigan Press, 1949.

Bartram, William. *Travels through North & South Carolina, Georgia, East & West Florida . . .* Philadelphia, 1791.

Brackenridge, Hugh Henry. *Modern Chivalry.* New York: Hafner, 1962.

Collin, Nicholas. *An Essay on those inquiries in Natural Philosophy, which at present are most beneficial to the UNITED STATES OF NORTH AMERICA. Transactions of the American Philosophical Society.* Vol. III. Philadelphia, 1793. iii–xxvii.

Collingwood, R. G. *The Idea of Nature.* London: Oxford Univ. Press, 1960.

Dewey, John. *The Quest for Certainty: A Study of the Relation of Knowledge and Action.* New York: Paragon, 1979.

Douglas, Mary. *Purity and Danger: An analysis of the concepts of pollution and taboo.* London: Routledge & Kegan Paul, 1966.

Durkheim, Emile. *The Elementary Forms of the Religious Life.* Trans. Joseph Ward Swain. New York: Free Press, 1965.

Emerson, Ralph Waldo. *Essays and Lectures.* New York: Library of America, 1983.

The Federalist. Ed. Jacob E. Cooke. Middletown, Conn.: Wesleyan Univ. Press, 1961.

Geertz, Clifford. "After the Revolution: The Fate of Nationalism in the New States." *The Interpretation of Cultures.* New York: Basic Books, 1973. 234–54.

——. "The Integrative Revolution: Primordial Sentiments and Civil Politics in the New States." *The Interpretation of Cultures.* 255–310.

Greene, John C. *American Science in the Age of Jefferson.* Ames, Iowa: Iowa State Univ. Press, 1984.

Habermas, Jürgen. *The Theory of Communicative Action.* Vol. 1, *Reason and the Rationalization of Society.* Trans. Thomas McCarthy. Boston: Beacon, 1984.

Irving, Washington. *History, Tales and Sketches*. New York: Library of America, 1983.

James, William. *The Principles of Psychology*. 2 vols. New York: Dover, 1950.

Jefferson, Thomas. "A Memoir on the Discovery of certain Bones of a Quadruped of the Clawed Kind in the Western Parts of Virginia." *Transactions of the American Philosophical Society*. Vol. IV. Philadelphia, 1799. 246–60.

——. *Notes on the State of Virginia*. Ed. William Peden. New York: Norton, 1972.

——. *Writings*. Ed. Merrill D. Peterson. New York: Library of America, 1984.

Jones, Howard Mumford. *O Strange New World: American Culture: The Formative Years*. New York: Viking, 1964.

Levinas, Emmanuel. *Totality and Infinity: An Essay on Exteriority*. Trans. Alphonso Lingis. Pittsburgh: Duquesne Univ. Press, 1969.

Lévi-Strauss, Claude. *The Savage Mind*. Chicago: Univ. of Chicago Press, 1966.

McCoy, Drew R. *The Elusive Republic: Political Economy in Jeffersonian America*. New York: Norton, 1982.

Melville, Herman. *Clarel: A Poem and Pilgrimage in the Holy Land*. Ed. Walter E. Bezanson. New York: Hendricks House, 1960.

Peale, Charles Willson. *A Descriptive Catalogue of Mr. Peale's Exhibition of Perspective Views, With Changeable Effects; or, Nature Delineated, and in Motion*. Philadelphia, 1786.

——. *Discourse Introductory to a Course of Lectures on the Science of Nature*. Philadelphia, 1800.

Prigogine, Ilya, and Isabelle Stengers. *Order out of Chaos: Man's New Dialogue with Nature*. New York: Bantam, 1984.

Reid, Thomas. *An Inquiry into the Human Mind*. 6th ed. Glasgow, 1804.

Rorty, Richard. *Philosophy and the Mirror of Nature*. Princeton: Princeton Univ. Press, 1979.

Rush, Benjamin. "Observations upon the study of the Latin and Greek languages; as a branch of liberal Education, with hints of a plan of liberal Instruction, without them, accomodated to the present state of society, manners and government in the United States" [Aug. 24, 1791]. *Essays, Literary, Moral, and Philosophical*. Philadelphia, 1798. 21–56.

Sheehan, Bernard. *Seeds of Extinction: Jeffersonian Philanthropy and the American Indian*. New York: Norton, 1974.

White, Morton. *The Philosophy of the American Revolution*. New York: Oxford Univ. Press, 1978.

Wiebe, Robert H. *The Opening of American Society: From the Adoption of the Constitution to the Eve of Disunion*. New York: Knopf, 1984.

Wills, Garry. *Inventing America: Jefferson's Declaration of Independence*. Garden City, N.Y.: Doubleday, 1978.

Chapter 15 | Curtis M. Hinsley, Jr.

"Magnificent Intentions" | Washington, D.C., and American Anthropology in 1846

In the closing years of the nineteenth century, aging, well-traveled American men of letters were fond of looking back, with condescension and nostalgia, to an unformed, innocent antebellum America. Reliving his first visit to Washington in 1849, Henry Adams remembered a sleepy, isolated outpost where "the brooding indolence of a warm climate and a negro population hung in the atmosphere heavier than the catalpas." The early national capital had lacked physical, social, and moral structure: here "the want of barriers, of pavements, of forms; the looseness, the laziness; the indolent Southern drawl; the pigs in the streets; the negro babies and their mothers with bandanas; the freedom, openness, swagger, of nature and man" had lulled and soothed tight Boston nerves. Even twenty years later, amid the chaos and crush of the first Grant administration, Washington still seemed "a mere political camp" to Adams. His fellow Bostonian, Edward Everett Hale, recalled the capital city of the 1840s as a "mud-hole" where "everything had the simplicity and ease, if you please, of a small Virginia town." The capital was so isolated from the larger society that the visitor of the forties seemed to come "out of America into Washington."[1]

Visiting Europeans reserved special spleen for the capital city. Here in "the head-quarters of tobacco-tinctured saliva" Charles Dickens noted in 1842 the "spacious avenues, that begin in nothing, and lead nowhere; streets, mile-long, that only want houses, roads, and inhabitants; public buildings that need but a public to be complete; and ornaments of great thoroughfares, which only lack great thoroughfares to orna-ment." With little trade and a meager permanent population, Washington seemed to Dickens only a "City of Magnificent Intentions." Anthony Trollope, following in the footsteps of his famous mother, commented no less caustically. He arrived in the first, dismal winter of the Civil War to find a pretentious failure of a city, three-fourths of it "wild, trackless, unbridged, uninhabited, and desolate." Trollope saw little nobility of taste in the sparse government structures, still less in the "bastard gothic" architecture

Curtis M. Hinsley, Jr., " 'Magnificent Intentions': Washington, D.C., and American Anthropology in 1846" from *Savages and Scientists*, pp. 15–33. Washington, D.C.: Smithsonian Institution Press, 1981. © 1988 by the Smithsonian Institution. Used by permission of the publisher.

of the Smithsonian "Castle." But it was the sight of the unfinished stump of the Washington Monument on a bleak Sunday afternoon that evoked a summary judgment of the city and the nation:

> There, on the brown, ugly, undrained field, within easy sight of the President's house, stood the useless, shapeless, graceless pile of stones. It was as though I were looking on the genius of the city. It was vast, pretentious, bold, boastful with a loud voice, already taller by many heads than other obelisks, but nevertheless still in its infancy, – ugly, unpromising, and false.[2]

Jibes of European and American cosmopolites notwithstanding, antebellum Washington was not so much a swampy wilderness as a study in American contrasts. Here the unfinished dreams of civic and national splendor and the boisterous, brutal realities of American politics, commerce, and racial conflict coexisted in "a curious combination of sophistication and small-town simplicity."[3] Washington shared in the revival of the national economy following the panic of 1837, and local business prospered as more government officials brought their families to live in the capital during the 1840s. But Washington, like other American cities, was also plagued by widespread poverty, restlessness among low-paid workers, grossly inadequate sanitary facilities, and a distressing level of lawlessness. Furthermore, despite the general prosperity of the official city, trade remained largely local. By the end of the thirties it was apparent that the earlier dream of local merchants and investors of a major commercial metropolis on the Potomac was not to be realized. With or without the highly touted Chesapeake and Ohio Canal, Washington would never rival Baltimore or Philadelphia in manufacture or national trade.[4]

In the midst of prosperity, moreover, the capital had a unique racial situation that produced ambivalent feelings among Whites, northern or southern. Until its abolition in 1850, a lively slave trade existed in the District; indeed, as James Renwick's Smithsonian building began to rise on the Mall in the late forties, construction workers could view across the street from its rear entrance the slave pens of two of the major traders of the District. In 1840, the Black population of the District comprised nearly a third of the total; over the next decade the general population increased by twenty percent. The Black population increased somewhat more slowly, dropping to twenty-seven percent of the District by 1850. But within the Black populace, a significant change occurred, as the number of free Blacks increased by seventy percent during the decade; in 1850, the Black free/slave ratio had reached nearly four to one. The established free Black community of Washington continued to draw from outside.[5]

The response of Whites in Washington was revealing. As the issue of slavery extension began to arise in the late forties, the capital was caught between the sensitive national debate and equally delicate local conditions. By 1848 the slavery issue was the "all-absorbing topic of the day."[6] But interest focused chiefly on the District slave trade, and after its abolition two years later, the city relapsed into a strange quiet. By a kind of tacit agreement, Constance Green has suggested, Washingtonians decided to "say nothing, do nothing, that might upset the precarious sectional balance." The capital was "like the stillness at the eye of a hurricane" throughout the prosperous, turbulent 1850s.[7]

Growing scientific and artistic reputation perhaps made it easier to ignore political tempests. If the vision of commercial greatness had evaporated by midcentury, there

had always been an older dream, shared by presidents Washington, Jefferson, and John Q. Adams, of "a cultural capital" spreading enlightenment to the nation by roads, canals, and rivers.[8] This vision of Washington as the source and sponsor of internal cultural improvements took several major strides toward realization in the forties, with the firm establishment of the Coast Survey under Alexander Dallas Bache; the Naval Observatory; and the Smithsonian Institution. In 1848 a newspaper correspondent could observe that "if there be one question set at rest in this community, it is that public opinion has decided that the national metropolis shall be distinguished for the cultivation of the mind."[9] Perhaps science and art would bring glory to Washington.

Early efforts provided little ground for optimism. The federal scientific agencies of the early republic did not owe their existence to any commitment to science as such – President Adams's call in 1825 for vigorous support of science met with no positive response in Congress but resulted from either practical needs or the exigencies of exploring and taming the continent. Local scientific societies also fared poorly. William Stanton has observed that, until the 1840s, Washingtonians "had founded a dreary train of institutions – the United States Military Philosophical Society, the Metropolitan Society, the Columbian Institute, the American Historical Society, to name only those of most imposing mien – only to see them crumble through apathy and neglect."[10] The Columbian Institute, founded in 1816, received a charter and five acres of swamp from Congress, but little else. The Institute membership, mainly of local businessmen, civil servants, and military men, managed to limp along through the next two decades, until its records and property were absorbed by the National Institution for the Promotion of Science in 1840.

In its brief burst of activity in the early 1840s, the National Institute (as it was called after 1842) demonstrated both the possibilities and limits of Washington science. The Institute, founded in 1840, resulted directly from two contemporary events: the prolonged public debate over Englishman James Smithson's bequest of $500,000 to the United States to found in Washington an institution "for the increase and diffusion of knowledge among men"; and the United States Exploring Expedition under Charles Wilkes, the country's first such large-scale effort, which began its four-year voyage in 1838. Joel R. Poinsett, who had been secretary of war under Martin Van Buren and was an amateur scientist from South Carolina, had successfully launched the Wilkes Expedition in the face of congressional apathy. Two years later, when the first crates of materials began to arrive in Philadelphia and Washington, Poinsett saw that some organization would be necessary to care for the specimens in order to prevent their dispersal and destruction. But Poinsett also had his eye on the Smithsonian funds. He hoped that the Englishman's money would support a national museum, for which the Wilkes materials, along with the National Institute's own circulars, would provide the basic collections. Between 1840 and 1845, Poinsett, Francis Markoe, and J. J. Abert – all government officials – lobbied to establish the Institute as the heir to the Wilkes collections and the Smithsonian monies. Like its ill-starred predecessor, the Columbian Institute, the National Institute received a charter but little money from Congress. Ultimately it lost both the collections and the Smithsonian funds, but its failure exposed central issues in the politics of antebellum American science.[11]

The debate over the Smithson bequest revolved around several alternative institutions, including a library, university, observatory, and an agricultural experimental station. Poinsett argued for a "National Museum, with Professors who shall perform

the double office of Curators and Lecturers," as an important component of a respectable national culture.[12] After the arrival of the first massive shipment of 50,000 specimens, Congress appropriated $5,000 for their care, and the Institute hired as curator Dr. Henry King, a geologist and mining expert employed in the Ordnance Bureau. The secretary of state made the new Patent Office Building, with its spacious hall, available for display of the treasures. Here King valiantly attempted to organize the swelling Wilkes materials, which soon crowded out the Institute's own growing collections. But when the ships came home in 1842, Wilkes, Charles Pickering, and others of the Expedition's scientific staff, far from showing gratitude for the Institute's labors, complained of the disastrous incompetence of King and the museum-keepers. Wilkes and Pickering argued to a parsimonious Congress that, with the gathering completed, the scientific enterprise was barely under way; preservation, research, and publication now required further public outlay, and these functions must be performed by the scientists familiar with their own collections. They had little patience with the amateurs of the Institute, who saw themselves as a "clearing-house for natural history."[13]

The Wilkes Expedition presented serious issues of private and public interests in science. The Institute men noted, for instance, that the Expedition's zoologist, Titian Peale, had labelled many valuable pieces as his private property, and they suspected that several barrels had been emptied in his Philadelphia museum before coming on to the capital. On the other hand, both Congress and the Expedition scientists expressed concern that the Institute, a private group of "friends of science," should control and possibly damage public collections.[14]

The dispute, furthermore, involved divergent conceptions of "museum." The Institute men clearly envisioned a museum chiefly as an institution of preservation and display, not without a certain element of public entertainment, while the Expedition scientists saw the museum essentially as a locus of study and the collections as a permanent research base, an extension of the Expedition itself. When they ruefully recorded that Dr. King had dismembered their specimens and otherwise violated their collections, behind the charge lay a perception of the museum as an ongoing scientific enterprise. Within such a vision, it is worth noting, lay a significant concept of the specimen as scientific property. Legally, of course, the collections belonged to the government; but, in a second and increasingly important sense, they were peculiarly the property of the collector-scientist, for only he knew them in their entirety and could elicit their full meaning for the public. The problem was both philosophical and proprietary, for it involved the very definition of a scientific object.

The appreciation of the scientist's unique, continuing interest in the objects of his study distinguished the Expedition staff from that of the amateur Institute. Similarly, the clue to the ultimate failure of the National Institute lies in the two chief complaints lodged against it: ignorance and unworthy purposes. Despite King's ineptitude, the second complaint was more crucial. The Institute men showed primary concern for national greatness as exhibited in collections of exotic objects – a kind of scientific and cultural boosterism – but little sympathy for patient, loving understanding of the specimens themselves. Externally oriented showcases could only undermine quiet, internal scientific growth – so the American experience seemed to indicate. In 1829, one John Varden had opened to the public a commercial enterprise, the "Washington Museum of Curiosities," complete with stuffed birds and Egyptian mummies. When the free National Institute drove him out of business, he sold out to it – and promptly became its assistant curator.[15] The Varden case was symbolic and instructive. The

Institute men lacked an essential respect for the natural world, a nineteenth-century form of piety that set the true scientist apart from the amateur or the pandering commercial popularizer.

The attitudinal gulf was real and determinative. Through much of the nineteenth century, the number of men who shared serious scientific aspirations exceeded the capacity of the society to provide opportunities for full-time pursuit of those interests.[16] As Alexis deTocqueville perceived at the time, organization for power and promotion of individual and group interest was a central dynamic in American life; but historically this has occurred unevenly. Scientific (like artistic) interests came relatively late to organizational maturity. Consequently, members of the scientific community of mid-century were often forced to rely as much on personal judgments of character as on formal organizational affiliation for identity and mutual recognition. This was especially true in the disparate collection of studies that comprised anthropology.

In August 1846, the New Confederacy of the Iroquois assembled around the light of their "emblematic council fire" in Rochester, New York, to hear the respected ethnologist Henry Rowe Schoolcraft. In a stirring paean to American distinctiveness, Schoolcraft urged Lewis Henry Morgan and the other young men of Rochester to devote themselves to the study of America's "free, bold, wild, independent, native race." America was unique. Without European patronage, Americans depended exclusively on "personal exertions, springing from the bosom of society" for the pursuit of history, literature, and science. Morgan's New Confederacy was such a voluntary effort, a "brotherhood of letters" to advance historical research, promote antiquarian knowledge, and cultivate polite literature.

The time had come, said Schoolcraft, to develop an American scientific and literary tradition: "No people can bear a true nationality, which does not exfoliate, as it were, from its bosom, something that expresses the peculiarities of its own soil and climate." In constructing its "intellectual edifice" America must draw "from the broad and deep quarries of its own mountains, foundation stones, and columns and capitals, which bear the impress of an indigenous mental geognosy."

The native American Indians had borne this distinctive "mental geognosy," and the present tribes, "walking statues" of their progenitors, were monuments far more worthy of study than the antiquarian remains of the Old World. The White man had superseded the Red in America, which obliged him to preserve the memory of the aborigine. After all, Schoolcraft reminded his audience, "their history is, to some extent, our history," a past full of deep tragic and poetic events. "The tomb that holds a man," he concluded, "derives all its moral interest *from* the man, and would be destitute of it, without him. America is the tomb of the Red man."[17]

Eight days after his address in Rochester, Schoolcraft sent to the Board of Regents of the new Smithsonian Institution a "Plan for the Investigation of American Ethnology," presented at its first meeting in September. In a far less effusive style than the Rochester speech, the veteran ethnologist proposed several major areas of activity for the Institution: support for a "Library of Philology"; archaeological investigation, particularly of the ancient earthworks of the Mississippi Valley; and material collections from living tribes to create a "Museum of Mankind."

Schoolcraft soberly outlined a field of inquiry open for exploitation and ripe for the application of scientific techniques. After a brief, tantalizing reference to the mysteries of the continent, he urged "the scrutiny of exact observation and description . . . under the lights of induction and historical analysis . . . to enable us to appreciate and

understand our position on the globe." As investigators applied scientific method to ethnology, the boundaries of mystery and conjecture would certainly recede before established facts. Schoolcraft's optimism embraced various subfields of the science of man: physiology, history, archaeology, geography, and geology. But he stressed language as a "more enduring monument of ancient affinities than the physical type" and called attention to the study of mythology.[18]

Taken together, Schoolcraft's prospectus to the Smithsonian and his Rochester address of the preceding week reflect the undefined state of anthropology in 1846. Inspired in part by a romantic attachment to the natural wonders and vast beauty of America, but embracing a wide range of both established and developing branches of inquiry, the study of man in America stood somewhere between the amateur enthusiasm of Rochester and the scientific standards soon established at the Smithsonian, between a past marked by speculation and an anticipated future of scientific precision.

Created by the conflux of several distinct traditions, mid-century anthropology comprised a series of questions, pursued through methods that cut across various fields and traditions. In Joseph Henry's words, anthropology enjoyed a unique status as a "common ground" for students of the physical sciences, natural history, archaeology, language, history, and literature. All could contribute; all could draw intellectual enlightenment and moral inspiration.[19] Furthermore, if anthropology was institutionally and methodologically fractured, the inquiry nonetheless addressed issues that were crucial to American national and cultural identity.

"Great question has arisen from whence came those aboriginals of America?" Thus Jefferson expressed, in his *Notes on the State of Virginia* of 1784, the central historical question that impelled American anthropology until the Civil War. To be sure, for most Americans the significance of the question was never apparent. John Adams wrote his blunt opinion to Jefferson in 1812:

> Whether Serpents Teeth were sown here and sprung up Men; whether Men and Women dropped from the Clouds upon the Atlantic Island; whether the Almighty created them here, or whether they immigrated from Europe, are questions of no moment to the present or future happiness of Man. Neither Agriculture, Commerce, Manufactures, Fisheries, Science, Literature, Taste, Religion, Morals, nor any other good will be promoted, or any Evil averted, by any discoveries that can be made in answer to those questions.[20]

In part Adams predicted accurately, for anthropologists struggled for decades to find an acceptable utilitarian rationale. But in a more important sense, his skepticism was misplaced. Between the Revolution and the Civil War, Americans groped for an understanding of their republican experiment, their civilization, and their destiny. The creed that gradually emerged from this introspection placed the new nation outside the ravages of human history, freed from the burdens of corrupt European institutions, as a new, perhaps final hope and home for man. Schoolcraft succinctly expressed this providential vision in 1846, when he described America as "a region destined for the human race to develope itself and expand in . . . a seat prepared for the re-union of the different stocks of mankind."[21]

Integral to the national teleology was a picture of the American continent waiting through the ages, pristine and nonhistorical, for the White man's arrival in order to play out a providentially assigned role. The freshness of America lay in the continent's great natural age without historical and moral blemish. It possessed, in other words,

no human burdens, since before Columbus the continent had never known civilized institutions.[22] Accordingly, Americans lent no moral significance to Indian "history," which was, as they saw it, not history at all, but the meaningless meanderings of a benighted people. In retrospect it is apparent that the American Indians presented nineteenth-century White Americans with the challenge and opportunity of expanding accepted notions of history so as to embrace radically different human experiences. This proved impossible. Instead, the anthropologist commonly functioned as a variant of the historian, studying and justifying his own history and civilization through the Indian. In the end, few escaped the degradation of denying peoples the integrity of their own histories.

Jefferson's query suggested a second purpose, however, more religious than political in import. George Stocking has identified in British ethnology of the early nineteenth century a central goal: "to show how all the modern tribes and nations of men might have been derived from one family, and so far as possible to trace them back historically to a single source."[23] Like their contemporaries in various fields of natural history, students of anthropology in England and the United States were engaged in a strenuous effort to contain the exploding diversity of the human world within the explanatory framework of the Mosaic account. Defense of monogenism – original human unity in divine creation and descent from a single pair – lay at the religious core of American anthropology into the twentieth century, especially in Washington circles. In service of this goal, Joseph Henry generally excluded from the Smithsonian discussion of physical anthropology as politically explosive and morally repugnant.

For American no less than for British ethnologists, the study of man was a historical and geographical search of deep religious import. Furthermore, as discussed below, while the historical orientation lost ground in succeeding decades to systems of evolutionary classification, beneath these developments the central concern with human unity persisted. In the American context, the significance of Native Americans to White historical identity and national destiny, and the progressive annihilation of these peoples, compounded and complicated the religious impulse in anthropology, lending an urgency to Indian studies that emerged in Americans' frequent expressions of "salvage ethnology": a unique blend of scientific interest, wistfulness, and guilt.

In their national and religious quest, American investigators at mid-century followed three distinct routes: archaeology, philology, and physical anthropology. The lack of consensus on method, untapped sources of data, and the relative lack of institutional structures and professional criteria created a sense of openness and lively competition that would characterize the subfields of anthropology in this country to the end of the century.

Americans had first encountered the earthworks of the Ohio and Mississippi River valleys in the 1780s, but it was not until after the War of 1812 that Caleb Atwater, of Circleville, Ohio, undertook a systematic investigation.[24] The American Antiquarian Society published his results in 1820. Atwater saw in the earthworks evidence of early occupation by a sedentary, law-abiding people. He hypothesized a migration from northern Asia at a remote period; a long, fixed abode in North America; and movement southward to found the ancient civilizations of Peru and Mexico. A subsequent migration from southern Asia by ancestors of the modern Indians supposedly superseded these original occupants of the American continent.[25]

Less systematic, more speculative observers followed Atwater. Most attempted to account for the differences between the supposed high civilization of the ancient Americans and the more primitive condition of the historical Indians by positing waves of migration and displacement. James H. McCulloh was among the more cautious in arguing against affinities based on the superficial artifacts of the mounds, which might be simply the products of a common human nature. McCulloh's *Researches*, a compilation of the work of others, concluded that ancestors of the present Indians came from the south and built the mounds. Despite disagreements over the identity of the mound-builders, most archaeological investigators agreed that the ancient inhabitants of America had originated elsewhere; and that "physical, moral, and traditionary evidence" pointed to Asia.[26]

Thomas Jefferson provided one of the first accounts of opening a mound, but he predicted that language would ultimately offer "the best proof of the affinity of nations which ever can be referred to." Schoolcraft, too, writing in his diary in 1823, observed that "Philology is one of the keys of knowledge which, I think, admits of its being said that, although it is rather rusty, the rust is, however, a proof of its antiquity. I am inclined to think that more true light is destined to be thrown on the history of the Indians by a study of their languages than of their traditions, or any other feature."[27] As the mounds explorers displayed more imagination than rigor, the predictions of Jefferson and Schoolcraft took on credibility. In the late 1840s, John R. Bartlett expressed a common judgment of archaeological labors when he wrote that "the practical investigations made from time to time by various individuals, have not been sufficiently thorough and extensive, nor have they developed sufficient data to warrant or sustain any definite or satisfactory conclusions."[28] Not until the 1860s would archaeology begin to attain the theoretical respect and academic establishment that philology had enjoyed since the eighteenth century. Faced with the "bewildering visions" of migrations,[29] a number of individuals turned hopefully to philology for the solution to the puzzle of American man.

In 1819 Peter Stephen Duponceau first announced his discovery that all American Indian languages appeared to demonstrate a uniform grammatical structure and underlying plan of thought, which he labeled "polysynthesis."[30] In Duponceau's view, the polysynthetic form permitted expression of many ideas in few words by consolidating the most significant sounds of simple words into compounds rich in meaning, and by combining various parts of speech into verbal forms to express "not only the principal action, but the greatest possible number of the moral ideas and physical objects connected with it."[31] Duponceau seemed to have penetrated to the "vital principle" controlling American Indian languages, a fact which, he hoped, would raise American philology out of the miasma of vocabulary comparisons to a respectable place beside European comparative philology. In America, grammatical structure would become the "true key to the origin and connection of the varieties of human speech."[32]

Duponceau's polysynthesis was more than a description of linguistic connection. He implied as well a single stage of mental development, thus subtly moving the question of Indian identity from the realm of historical affinity to one of developmental stages. The change was further encouraged by the tendency of philologists to borrow the prestige of natural-science method and terminology. Thus, when John Pickering adopted Duponceau's theory a few years later, he stressed the unity of form, noting that the languages exhibited a "uniform system, with such differences only as constitute varieties in natural objects."[33]

Albert Gallatin, Swiss-born statesman and student of Indian languages, similarly accepted polysynthesis as a demonstrated characteristic of American languages, but made allowance for exceptions, such as Basque in Europe, and held out the possibility of undiscovered connections across the oceans. To Gallatin, common structure indicated common origin, while diversity in vocabulary suggested a long time-span since dispersion across the continent – a principle that Jefferson had espoused. Gallatin speculated that the first inhabitants of America arrived at a remote time, "probably not much posterior to that of the dispersion of mankind." As he saw it, American languages showed clear signs of primitive origins; their form derived from "natural causes," indicating that the Native Americans had not degenerated from a higher state, as Schoolcraft and the mounds explorers maintained. Gallatin thus contributed another support to a paradigm of progressive development, though not yet of evolution.[34]

By mid-century the discovery of a single "antique plan of thought" in the structure of aboriginal tongues seemed destined to exert a significant influence on ethnology. With obvious satisfaction, the popular historian George Bancroft announced that a "savage physiognomy" characterized all Indian dialects; each was "almost absolutely free from irregularities, and is pervaded and governed by undeviating laws." The unreflecting American savage, like the bee building geometrically perfect cells, demonstrated "rule, method, and completeness" in his language. Far from indicating degeneration, the aboriginal tongues of America showed unmistakable signs of being "held in bonds of external nature." The Indian thought and spoke in terms of concrete experience, apparently lacking powers of abstract expression. Linguistic evidence showed, said Bancroft, that the American aborigines were still in "that earliest stage of intellectual culture where reflection has not begun."[35]

Bancroft conveyed to a wide audience the optimism (and ethnocentrism) of students of American languages at mid-century. They saw a certainty and regularity lacking in other approaches to anthropology. The precision, it should be noted, did not derive from the fact that language was a human phenomenon. Quite the opposite: linguistic regularities occurred in spite of man's efforts, indicating the operation of general principles of divine origin. Just as men could cultivate and adorn but not fundamentally alter the geology of the earth, so "language, in its earliest period, has a fixed character, which culture, by weeding out superfluities, inventing happy connections . . . and through analysis, perfecting the mastery of the mind over its instruments, may polish, enliven, and improve, but cannot essentially change."[36]

The work of the philologists pointed strongly toward aboriginal American unity and threw into question the ancient civilizations imagined by archaeologists. Both groups agreed, though, that the first inhabitants of America, whoever they were and whenever they had arrived, had migrated from somewhere else; thus they supported the orthodox view of the unity of mankind. As Bancroft summarized their findings, the "indigenous population of America offers no new obstacle to faith in the unity of the human race."[37]

Others were less sure. In the two decades prior to the Civil War, researchers in physical anthropology – notably Samuel George Morton, George Robins Gliddon, and Josiah Clark Nott – aided by the impressive scientific support of Louis Agassiz and the explorations of Ephraim George Squier, demonstrated that Native Americans, with the exception of the Eskimo, possessed a uniform and apparently unique physical type. This "American School" of anthropology directly challenged the Mosaic

account by hypothesizing an indigenous, isolated American race, created in and fitted to the climate of America.[38]

Physical anthropology as systematic scientific inquiry in America began with Morton, a Philadelphia physician and anatomist. In the 1830s he began assembling a collection of crania, mainly of North American natives, that was unsurpassed and totaled nearly 1,000 by his death in 1851. In 1839 he published *Crania Americana*, based on his skull collection. This landmark in physical anthropology, the result of a decade of work, exhibited a consistency, precision, and thoroughness that established Morton as the leading American authority in the field.[39]

Morton hoped to determine "whether the American aborigines of all epochs have belonged to one race or to a plurality of races."[40] His conclusion was straightforward: the American Indian peoples, excluding the Eskimo tribes, belonged to a single race. This race Morton divided into two families, the Toltecan and Barbarous (American). The culturally superior Toltecan had built the North American mounds and also established the semi-civilizations of Central America; the historical Indians had descended from the inferior Barbarous (American) branch. In other words, Morton denied racial separation of the mound-builders from the modern American Indians but distinguished between two "families" in terms of cultural development. He emphasized that physically, morally, and intellectually this "separate and peculiar" race of America exhibited no connections with the Old World; even if apparent connections were discovered in the arts and religions, he maintained, the "organic characters" of the Indians would prove them a single, distinct race.[41]

Morton's strength lay in an unprecedented number of cranial measurements; but in fact he relied on only one or two indices, notably the formation of the occipital portion of the skull, in determining an ideal dominant type of American cranium. Repeatedly he noted exceptions and wide variation, but in his conclusions he either ignored them or attributed them to cultural factors.[42] Morton's opinions underwent little modification; he repeated them in his *Inquiry* of 1842, his "Account of a Craniological Collection" in 1848, and his "Physical Type of the American Indians," contributed posthumously to Schoolcraft's *Indian Tribes* in 1852.[43]

Morton's work provided the empirical base for polygenist arguments in the searing slavery-related controversies of the antebellum decade. The polygenist implications of Morton's theories required only time and encouragement to emerge fully. They received both. Louis Agassiz found in Morton important confirmation of his own theories of uniform distribution and local diversity that he found characteristic of the natural history of the New World. Nott and Gliddon drew heavily on Morton in introducing the basics of polygenist doctrine to a popular audience. Their ambitious *Types of Mankind* marshaled the evidence of Morton, the archaeologists, and the philologists to drive their points home. The languages of America, uniform in structure but diverse in vocabulary (as Gallatin had argued), indicated great age and common origin. The mounds similarly suggested long occupation of the continent. But physical anthropology was conclusive: "American crania, antique as well as modern, are unlike those of any other race of ancient or recent times." Other ethnological data – an increasing number of fossil human bones; the apparent lack of alphabet, domestication practices, indigenous agriculture, astronomy, or calendar systems – all seemed to confirm the antiquity, unity, and isolation of the Native Americans.[44]

The work of Nott and Gliddon circulated widely, but it stimulated more vituperation than research and consequently discredited physical anthropology for decades.

As Samuel F. Haven, librarian of the American Antiquarian Society, noted in 1856, Morton's theories had become hopelessly enmeshed in "polemical associations."[45] Because of the theological and political complications, physiologists busied themselves in other pursuits, and Morton at his death in 1851 left no disciple to carry on his researches. The Academy of Natural Sciences in Philadelphia inherited his collection of crania.[46]

The National Institute had a "special duty," Joel Poinsett wrote in 1841, to "inquire into the history of the people we have dispossessed." But the structure of the Institute hampered the inquiry: philology was subsumed under the department of geography; physical anthropology fell under natural history: and the department of American history and antiquities embraced all studies of "the Indian races, now fading from the earth; their mounds and pyramids, and temples and ruined cities," as well as questions of their origins and subsequent "degeneration."[47] The fractured anthropology of the Institute epitomized the methodological and disciplinary confusion that both plagued and enriched the inquiry. But within the flux of theory and observation, certain long-term, significant trends emerged. Interwined in the anthropology of the first half of the century were two distinct traditions of reaction to the phenomena of human variety, each a function of individual temperament and intellectual and religious commitment. For pious Christians fully committed to human unity through the biblical account, historical inquiry backward through time promised to reconcile present diversity with single creation. One suspects that classical philology derived much respect as a humanistic discipline from recognition of this potential service. Others, less satisfied with historical connections than with the categories of the powerful natural sciences, sought to order man rather than track men. Indeed, the development of Duponceau's idea of polysynthesis illustrates the ease with which questions of historical affinity transformed themselves into categories of mental and moral development. Whether one followed Morton or the philologists, the North American aborigines emerged as distinct and uniform, due either to "savage physiognomy" of thought and language or to autochthonous creation.

Morton's school, and physical anthropology generally, fell into disrepute in the second half of the century. The reasons were as much political as scientific. As noted earlier, during the 1850s Joseph Henry consistently steered the Smithsonian away from racial debates, even refusing to permit abolitionist lectures at the Institution. Personally he maintained a discreet silence on such matters, and the Smithsonian largely ignored physical anthropology through the rest of the century.[48] The policy was more than a function of local racial conditions, though these may have heightened sensitivity. The polygenist controversy nearly tore apart the American Ethnological Society of New York during the fifties. Ephraim Squier reported that "the question of human unity could not be discussed without offense to some of the members and its casual introduction was made a ground of impassioned protest."[49] Henry could not afford such bickering. His attempt to establish a nationwide scientific network and to bring together in common effort both missionaries and atheistic polygenists like Squier, required absolute neutrality.

With racial categories discounted and even institutionally suppressed, historical speculations of archaeologists suspect for lack of theoretical grounding (and control in the field), and masses of observations and data annually accruing, developmental schemes emerged in the middle decades of the century – independently of Darwinian biology – as a means of meeting both the commitment to unity and the observed

diversity. The work of Lewis Henry Morgan, the dean of nineteenth-century American evolutionism, is particularly instructive in this regard. Morgan's career (1851–1881) spanned the decades during which American anthropology moved from primarily historical inquiry into the origins and early relationships of the different peoples of the globe, to "scientific" classifications, or rankings, of humanity in evolutionary stages of social, mental, and moral development. Morgan's own career, from *Ancient Society* (1851) to *Systems of Consanguinity and Affinity of the Human Family* (1871) to *Ancient Society* (1877), marked milestones in this transition from history to stage classification.[50]

While *Ancient Society* has been justly remembered as the full statement of Morgan's three-stage model of social and mental development (savagery, barbarism, civilization), it was *Systems of Consanguinity*, his massive empirical work on kinship published by the Smithsonian, which established Morgan's inquiry as a science and himself as an institution. Morgan conceived *Systems of Consanguinity* as a survey in the tradition of comparative philology but rooted in what he hoped would prove less mutable human phenomena than language: ideas of kinship. Philologists had reduced mankind to a number of linguistic families, but they had been unable to take the final step, to the "vital question" of origins. Ultimately, Morgan hoped, his "new instrument in ethnology" would prove to be "the most simple as well as the compendious method for the classification of nations upon the basis of affinity of blood."[51]

The vitally important truth about *Systems of Consanguinity* is that Morgan did not find the unity he had presumed and sought. Faced with two apparently distinct concepts and systems of kinship, he adopted a developmental explanatory framework in order to preserve a presumed original human unity. In effect, Morgan moved from a vision of man in historical and geographical migration and contact to a comparatively rigid, static construction devoid of historical fluidity.

Morgan's schema of human development, further elaborated in *Ancient Society*, did embrace notions of change and progress, but these were, like Schoolcraft's visions, strongly teleological and bound to a system of unfolding ideas rather than to the immediate historical experiences of peoples. Morgan's legacy to the next generation – Powell and the Bureau of American Ethnology – was the subordination of historical probings to the greater explanatory power and aesthetic satisfaction of ordering man in value-laden stages. Following Morgan's lead, Powell grounded BAE anthropology in the principle that the American Indians must be understood not as a racial type but as representatives of a single stage of human development. In escaping the tyranny and politics of racial typing, and in the name of science, Powell also denied history to the American aborigines. The resulting flatness of historical perspective was costly for all fields of anthropology, but especially so for archaeologists, who did not discard such assumptions and begin to develop concepts of cultural micro-change and methods of tracing cultural forms through space and time until the twentieth century.[52]

The divergent roots of anthropology in the traditions of the humanities and natural sciences, which by 1850 already reached down deeply, produced an inquiry whose unity lay not in method but in subject matter and in purposes that transcended the inquiry itself. With few exceptions, Native Americans constituted the subjects of American anthropology through the nineteenth century. This occasions no surprise, since the natives of the Western Hemisphere, and of the North American continent particularly, posed critical historical and providential questions for White Americans. The central, nagging, political and religious dilemmas were these: Are these people in any sense our brothers? By what right can we claim this land as our own?

Over the middle decades of the century, the various approaches to these problems lost or gained prestige and followers as a result of various factors: new theoretical breakthroughs (especially if originated in Europe); domestic political and racial currents; the growing status of the natural and physical sciences in general in this country; and individual and institutional decisions. Broadly sketched, physical anthropology declined for nearly a half-century as a method; while in archaeology (and to some extent linguistics), the purpose of inquiry shifted away from historical questions to "scientific," formally nonracial classifications of mankind that nonetheless in essence preserved the moral placement system of discredited racial categories. The Smithsonian was a critical institutional focus of these developments, and decisions of Joseph Henry were often determinative. His decision to support ethnology (the general term for anthropological work at the time) as part of his program of providing the experience of science to a wide section of the American citizenry provided tremendous stimulus in numerous directions.

Notes

1 Henry Adams, *The Education of Henry Adams: An Autobiography* (Cambridge, 1961), pp. 44–45, 256; E. E. Hale, *Tarry at Home Travels* (New York, 1906), pp. 377, 381, 387.
2 Charles Dickens, *American Notes* (Philadelphia, n.d.), pp. 111–12, 116; Anthony Trollope, *North America* (New York, 1862), pp. 301–2, 306, 314–15.
3 Constance McLaughlin Green, *Washington: Village and Capital, 1800–1878* (Princeton, 1962), p. 148.
4 Ibid., pp. 152–66.
5 Ibid., pp. 21, 175–80.
6 Ibid., p. 177.
7 Ibid., p. 180.
8 A. Hunter Dupree, *Science in the Federal Government: A History of Policies and Activities to 1940* (Cambridge, 1957), p. 40.
9 Quoted in Green, *Washington*, p. 170.
10 William Stanton, *The Great United States Exploring Expedition of 1838–1842* (Berkeley, 1975), p. 290.
11 For treatment of the National Institute see Stanton, *Exploring Expedition*, pp. 281–304; Sally G. Kohlstedt, "A Step Toward Scientific Self-Identity in the United States: The Failure of the National Institute, 1844," *Isis* 62 (1971); and George Brown Goode, "The Genesis of the U.S. National Museum," USNM, *AR for 1891* (Washington, D.C., 1891), pp. 273–380.
12 Stanton, *Exploring Expedition*, p. 292.
13 Ibid., p. 297.
14 Ibid., pp. 295–96.
15 Ibid.
16 Nathan Reingold, "Definitions and Speculations: The Professionalization of Science in America in the Nineteenth Century," in A. Oleson and S. C. Brown, eds., *The Pursuit of Knowledge in the Early American Republic* (Baltimore, 1976), pp. 33–69.
17 Henry Rowe Schoolcraft, *An Address, Delivered before the Was-Ah Ho-De-No-Son-Ne, or New Confederacy of the Iroquois, at its Third Annual Council, August 14, 1846* (Rochester, 1846), pp. 3–7, 29. For similar but less poetic sentiments, see Schoolcraft's "Incentives to the Study of the Ancient Period of American History," an address to the New-York Historical Society, 17 November 1846 (New York, 1847).

18 Henry Rowe Schoolcraft, *Plan for the Investigation of American Ethnology: to include the facts derived from other parts of the globe, and the eventual formation of a Museum of Antiquities and the peculiar Fabrics of Nations: and also the collection of a library of the Philology of the World, manuscript and printed* (New York, 1846), pp. 5, 12–13. Schoolcraft's *Plan* was reprinted in the SI, *AR for 1885* (pp. 907–14), with the note that although it was never officially adopted by the Institution, "even after the lapse of forty years it possesses sufficient interest and suggestiveness to justify its publication."

19 SI, *AR for 1860*, p. 38.

20 Adams to Jefferson, 28 June 1812, in *The Adams–Jefferson Letters*, ed. Lester J. Cappon (New York, 1959), pp. 308–09.

21 Schoolcraft, *Address*, p. 34.

22 Fred Somkin, *Unquiet Eagle: Memory and Desire in the Idea of American Freedom, 1815–1860* (Ithaca, 1967).

23 George Stocking, "From Chronology to Ethnology: James Cowles Prichard and British Anthropology, 1800–1850," in J. C. Prichard, *Researches in the Physical History of Man*, ed. Stocking (Chicago, 1973), p. XCIV.

24 The history of interest in the earthworks of North America, and of the theories adduced to account for them, has been treated extensively in several works, notably Robert Silverberg, *Mound Builders of Ancient America: The Archaeology of a Myth* (Greenwich, Conn., 1968); and Leo Deuel, *Conquistadores Without Swords: Archaeologists in the Americas* (New York, 1967). A recent regionally oriented survey is James E. Fitting, ed., *The Development of North American Archaeology* (Garden City, 1973). For further background, see Lee Eldridge Huddleston, *Origins of the American Indians: European Concepts, 1492–1729* (Austin, 1967). Gordon Willey and Jeremy Sabloff's *A History of American Archaeology* (San Francisco, 1974) places the archaeology of this period in historical and professional context. The most thorough account of the subject, however, remains unpublished: Thomas C. Tax's "The Development of American Archaeology, 1800–1879," Ph.D. diss. (University of Chicago, 1973). I have relied especially on Samuel F. Haven's valuable historical review, *Archaeology in the United States*, published as part of vol. 8 of Smithsonian Contributions to Knowledge (Washington, D.C., 1856).

25 Caleb Atwater, "Description of the Antiquities of Ohio and Other Historical States," *Transactions and Collections of the American Antiquarian Society* 1 (Worcester, Mass., 1820).

26 James H. McCulloh, *Researches Philosophical and Antiquarian Concerning the Aboriginal History of America* (Baltimore, 1829); see also John Haywood, *The Natural and Aboriginal History of Tennessee, up to the first Settlements by the White People* (1823); Constantine S. Rafinesque, *Ancient History, or Annals of Kentucky: with a Survey of the Ancient Monuments of North America, and a Tabular View of the Principal Languages and Primitive Nations of the Whole Earth* (Frankfort, 1824); John Delafield, Jr., *An Inquiry into the Origin of the Antiquities of America* (New York, 1839); William Henry Harrison, *A Discourse on the Aborigines of the Valley of the Ohio* (1838); and Alexander W. Bradford, *American Antiquities and Researches into the Origin and History of the Red Race* (New York, 1843). Some of these popular expositions enjoyed wide circulation; according to Haven (*Archaeology*, p. 41), one book on the "Moundbuilder Race" (by Joseph Priest) sold 22,000 copies by subscription in thirty months.

27 Thomas Jefferson, *Notes on Virginia*, in *Basic Writings of Thomas Jefferson*, ed. Philip Foner (Garden City, 1944), pp. 116–19; H. R. Schoolcraft, *Personal Memoirs of a Residence of Thirty Years with the Indian Tribes on the American Frontiers* (1851; reprint ed., New York, 1975), p. 176.

28 John R. Bartlett, "The Progress of Ethnology, an Account of Recent Archaeological, Philological, and Geographical Researches in Various Parts of the Globe, tending to elucidate the Physical History of Man," *Transactions of the American Ethnological Society* 2 (New York, 1848): 4.

29 Haven, *Archaeology*, p. 97.

30 Peter Stephen Duponceau, "Report of the Historical and Literary Committee to the American Philosophical Society, January 9, 1818," *Transactions of the Historical and Literary Committee of the American Philosophical Society* 1 (Philadelphia, 1819): xi–xvi. Quoted in Mary Haas, "Grammar or Lexicon? The American Indian Side of the Question from Duponceau to Powell," *International Journal of Anthropological Linguistics* 35: 239–55. The discussion here is based on Haas's article.

31 Duponceau, "Report," p. xiv; quoted in Haas, "Grammar or Lexicon?" p. 240.

32 Haven, *Archaeology*, pp. 56, 54.

33 John Pickering, "Indian Languages of America," *Encyclopedia Americana* 4 (appendix): 581; quoted in Haas, "Grammar or Lexicon?", p. 241. See also Haas, p. 242; and Regna D. Darnell, "The Powell Classification of American Indian Languages," *Papers in Linguistics* (July 1971), pp. 73–76.

34 Albert Gallatin, "A Synopsis of the Indian Tribes within the United States East of the Rocky Mountains and in the British and Russian Possessions in North America," *Transactions and Collections of the American Antiquarian Society* (Cambridge, 1836), p. 6. Quoted in Haas, "Grammar or Lexicon?", p. 243.

35 George Bancroft, *History of the United States*, 14th ed., vol. 3 (1854), pp. 254–66.

36 Ibid., pp. 256, 264–65, 318. Schoolcraft also found ground for optimism in the slow mutability of language; see his "Incentives," p. 23.

37 Ibid., p. 318.

38 The following discussion is based on William Stanton, *The Leopard's Spots* (Chicago, 1960); George M. Fredrickson, *The Black Image in the White Mind: The Debate on Afro-American Character and Destiny, 1817–1914* (New York, 1971), pp. 71–96; Paul A. Erickson, *The Origins of Physical Anthropology*, Ph.D. diss. (University of Connecticut, 1974), p. 66–80; Haven, *Archaeology*; Daniel Wilson, "Lectures on Physical Ethnology," SI, *AR for 1862–63*, pp. 240–302; and Aleš Hrdlička, "Physical Anthropology in America," *American Anthropologist*, n.s. 16 (1914): 508–54.

39 Samuel George Morton, *Crania Americana, or a Comparative View of the Skulls of the Various Aboriginal Nations of North and South America. To Which is Prefixed an Essay on the Varieties of the Human Species* (Philadelphia, 1839).

40 Hrdlička, "Physical Anthropology," p. 515.

41 S. G. Morton, "Account of a Craniological Collection," *Transactions of the American Ethnological Society* 2 (1848): 219.

42 For a critical account of Morton's work and conclusions by a near-contemporary, see Daniel Wilson, "Lectures," pp. 240–65. On reexamination of Morton's collection, Wilson denied the existence of Morton's ideal type – the rounded, brachycephalic "Peruvian" head – among the North American skulls.

43 S. G. Morton, *An Inquiry into the Distinctive Characteristics of the Aboriginal Race of America* (Boston, 1842: Philadelphia, 1844); H. R. Schoolcraft, *Indian Tribes* 2 (Philadelphia, 1852): 316–30. See also, in Schoolcraft, Morton's "Unity of the Human Race," vol. 3, pp. 374–75.

44 J. C. Nott and G. R. Gliddon, *Types of Mankind, or Ethnological Researches, based upon the ancient monuments, paintings, sculptures, and crania of races, and upon their natural geographical, philological, and Biblical history* (Philadelphia, 1854); quoted in Haven, *Archaeology*, p. 85.

45 Haven, *Archaeology*, p. 81.

46 Hrdlička noted ("Physical Anthropology," pp. 524–26) that Joseph Leidy and J. Aitken Meigs, both of Philadelphia, considered picking up the mantle of the great Morton, but while each contributed in his own way to the advancement of physical anthropology and anatomy, Meigs and Leidy went in other directions. Of Leidy's more than 500 publications in natural science, Hrdlička found only thirteen related directly to anthropology.

47 Joel R. Poinsett, *Discourse on the Objects and Importance of the National Institution for the Promotion of Science, Established at Washington, 1840. Delivered at the First Anniversary* (Washington, D.C., 1841), pp. 19–20, 42–43. On the formation and early activities of the various departments, see the *Bulletins* of the Institute, 1840–42.

48 Green, *Washington*, p. 287.

49 Robert E. Bieder and Thomas G. Tax, "From Ethnologists to Anthropologists: A Brief History of the American Ethnological Society," in John V. Murra, ed., *American Anthropology: The Early Years* (St. Paul, 1976), p. 17.

50 George W. Stocking's essay, "Some Problems in the Understanding of Nineteenth Century Cultural Evolutionism," in Regna Darnell, ed., *Readings in the History of Anthropology* (New York, 1974), pp. 407–25, has been suggestive for the following discussion.

51 L. H. Morgan, *Systems of Consanguinity and Affinity in the Human Family*, Smithsonian Contributions to Knowledge 17 (Washington, D.C., 1871), pp. 9, 506.

52 Willey and Sabloff, *History of American Archaeology*, p. 88.

Chapter 16 | Fabrice Grognet

Ethnology | A Science on Display

Does ethnology have something to tell us? The question may appear odd: ethnologists communicate publicly in symposia, radio broadcasts and television shows, they publish books and articles and – most of them – lecture. But what public do they really reach?

It has to be acknowledged that ethnologists' discourse and knowledge are usually intended for a small circle of individuals who share a particular level of education and culture (scientific 'peers', or trainees, cultural initiates, connoisseurs of 'primitive arts', college and university graduates who are consumers of 'culture'). What then becomes of the notion of popularizing ethnology among the 'general public', the lay public? Is such popularization even possible?

One place appears suited to achieving it: the museum, and in particular the Musée de l'Homme in Paris (which will serve as the reference point for these considerations), the only museum in France that presents human beings and their works throughout the world (whereas the Musée des Arts et Traditions Populaires covers ethnology in France). The museum is open to all, admittance to the exhibition in the entrance hall even being free of charge. In addition, the Ministry of Education, which is responsible for the museum, arranges visits by school groups. In such circumstances, the museum, as a public educational facility, may be regarded as the ideal context for popularizing ethnology.

In France, ethnology, museums and popular science share a long history. Everything really began in 1880, when the then Ministry of Public Instruction decided to establish the Musée d'Ethnographie du Trocadéro (MET), using collections and a building that had originally served for the Universal Exhibition of 1878. At that time ethnology had not yet become institutionalized in France, then a major colonial power that needed a museum that would serve as a 'showcase' for its expansionist policy, and would bring together, on a single site, the ethnographic objects in its possession. At the same time, the museum corresponded to the need felt by this fledgling science which, in France as elsewhere in Europe, required its own institution, one that the French capital lacked. From then on, the museum and ethnology had a

Fabrice Grognet, "Ethnology: A Science on Display" from *Museum International* 53:1 (2001), pp. 51–6. © 2001 by UNESCO. Reproduced by permission of Blackwell Publishing. (Reprinted without illustrations.)

shared destiny, thanks to the action of political forces, involving a proclaimed ambition to promote public education as a sort of social *raison d'être* for the new institution.

From Artefact to Showpiece

In a nutshell, three major periods may be identified as regards the changing manner in which ethnographic items are presented.

During the first period (from the end of the nineteenth century to the 1930s), museum practice was to display artefacts in exhibitions that gave prominence to arrays of particular objects (for example, sets of weapons or pottery). Such presentations were intended to be exhaustive, and followed a classification based on the level of industry of cultures (from the most 'archaic' or 'primitive' to the most 'developed' or 'evolved'). The halls and rooms thus became repositories for the objects as much as places for their display, as in a library. Associated with these arrays of objects were hyper-real wax models portraying 'the other': 'primitive man', clutching an assegai. Such displays, which owed a great deal to the colonial context of the time, as well as to evolutionist theories, made a visit to the museum akin to 'a trip into the heart of barbarism', as a journalist of the time pointed out.[1] While the initial ambition of the museum was to instruct, it must be acknowledged that it made a rather poor showing in this respect:

> There is in Paris, in a wing of the Trocadéro, a museum that is little known and little frequented as a result of its remoteness. . . . We regret that the spirit which informs the exhibition is not fuelled by the notion that a museum must instruct, that it is not enough to line up items in carefully dusted showcases; in short, that the public should carry away from its visit some lesson, and retain a lasting impression thereof.[2]

In point of fact, ethnology as a body of knowledge remained to be built. The 'study-bound ethnologist'[3] was not in a position to supply information on an artefact that he had not himself collected. As a result of the gaps in a branch of science still in its infancy, particulars concerning the objects displayed could be only minimal; such a situation, associated with a museum practice focused on spectacular, imposing displays of 'exotica' (models, reconstructions, arrays of 'trophies'), could arouse interest ultimately only in the aesthetic qualities of these objects, to the detriment of their cultural dimension. In many respects, humankind became a show, or more exactly, one part of humankind became a sort of attraction for the other. All these factors combine to make us see the MET, in retrospect, as a museum of 'exoticism', a 'quasi-art museum', since it had moreover 'played a role in the discovery of American art which in the 1880s enjoyed a vogue equivalent to the craze that arose for African art at the beginning of the century'.[4]

Subsequently, with the professionalization of ethnology (establishment of the Institut d'Ethnologie in 1925), the exhibition itself became more 'scientific', introducing an educational dimension, in order to make the sheer diversity of cultures more widely known to a public of inquiring spirits in whom the French colonies had already aroused a curiosity about all things exotic. To displays that aped or mimicked reality, Georges-Henri Rivière, who took over responsibility for museum practice at the MET in 1928, preferred a presentation that foreswore all staged effects and was illustrated rather by photographs taken in the field, supplemented by texts written by

ethnologists. By splitting up its displays into geocultural areas, the museum illustrated and reflected the monographs being produced by scientists. It thus made the transition from exhibitions of ethnographic objects to the exhibition of the science of ethnology. This constituted a revolution in museum practice, museography becoming the visible part of current research undertakings.

More recently, as a result of two museographical trends developing from the 1960s on, the ethnographic exhibit has been presented as a showpiece and an art work in its own right. With the advent of these two trends, we can no longer claim to be dealing with exhibitions focused on ethnology as a science, even though the texts and, in a general manner, the ethnological discourse are produced by scientists.

The first trend effects a reconstruction of reality even more radical than that sought in the nineteenth century, putting the object back in context in a setting or 'atmosphere'. Such 'as-if-you-were-there' presentations rely, for example, on life-size recreations of an actual street or house. Generally speaking, this approach tends not to involve a great deal of explanatory material. Moreover, the attempt to recreate a setting may give a confusing impression of being there without really being there. Can such a re-creation enable the museum visitor to gain greater insight into a culture than an ordinary tourist who has actually passed through the village? Furthermore, this type of approach tends to present large numbers of objects created specially for the exhibition, interspersing such items created for purely decorative or recontextualizing purposes with 'authentic' artefacts created for reasons quite remote from museum display. Indeed, it will be noted that this museographical trend is today frequently equated by the scientific community with the 'disneylandization' of museums.

The second trend aims to display ethnographic objects as a visual artistic experience (*Masterpieces from the Musée de l'Homme*, 1965; *Primitive Arts in the Artists' Workshop*, 1967). Such presentations of objects in isolation, accompanied by only minimal explanations, may be described as the 'aesthetic' approach. The visitor's interest is sustained by the display of isolated 'highlights', creating a sort of 'aesthetic shock', which is customarily justified by referring to the delight experienced by the beholder.

Missions and Professionalization

Leaving aside the ideological and political dimensions inherent in any attempt to create a new museum institution, these three museographical periods would seem to be akin to three stages in the life of the museum or, more precisely, to a sort of gradual maturing of the museum in its functions.

The Musée d'Ethnographie du Trocadéro was initially established in order to bring together ethnographic items that had hitherto been dispersed. First and foremost, the museum sought to conserve series of artefacts that it did not fully understand (inadequacy of scientific theory), just as the collectors had before it with their cabinets of curiosities.

Subsequently, ethnological science became institutional, the professional field ethnologist superseding the enlightened armchair amateur. A new understanding of the same ethnographic objects became possible. Museography thereupon proceeded to apply this new understanding, selecting objects on the basis of the theoretical divisions or breakdowns of the era. The 'laboratory-museum',[5] a unique institution of ethnology, thus gave a high profile and cultural import to a new science that could not fail to

prevail (in particular *vis-à-vis* physical anthropology), while at the same time display-ing cultural realities that were doomed to become extinct as a result of colonialism.

Thereafter, ethnological research gradually lost interest in the artefacts themselves, and was thus able to establish itself and develop in institutions that lacked ethno-graphic collections. The museum thus ceased to present science in the making, and bore witness rather to 'traditional' and 'pre-industrial' ways of life, and hence to the past history of societies. In a way, the presentation was thus made for its own sake, since it was subject neither to the duty of conservation (existence of reserve collec-tions) nor to the requirement to display a science (the shift of ethnological interest away from the artefacts as such towards a structuralist approach). The exhibition had acquired a measure of autonomy *vis-à-vis* conservation and research, and accordingly allowed itself to entertain, or to attend more closely to matters of layout.

This brief historical survey clearly reveals that the presentation of ethnographic objects is contingent upon museographical fashions, which are themselves dictated by the links between museums and ethnological research. The one constant is the avowed goal, namely, to educate the public about alien cultures. But is this objective, however clearly proclaimed, always attained?

If ethnology has something to tell us, the ethnographic object remains, for its part, all too frequently silent. How then can it be made to communicate? 'First and foremost by ridding ourselves of the notion of art work. The object must shed its invasive aesthetic dimension!'[6] Without rejecting the object's aesthetic nature, we can attempt to define it in terms of its use, its usefulness; for, before it ended up as a museum exhibit, it served a purpose, had a life of its own. However, in aesthetic displays, information concerning past use is generally limited and hazy. In such cases, the descriptive cards in fact usually have four headings (object identification, region or origin, collector, item number), of which only the first two are of any use to most of the museum's non-professional visitors. Attention may also be drawn to the unin-formative nature of such formulae as 'anthropomorphic statuette', 'zoomorphic mask' or again 'small dish in semihard wood', which are all too frequently the sole particulars serving to identify the artefact.

Display Is Not Enough

However, is an exhibition of ethnographic items, sustained by a scientific discourse, any better able to provide an understanding of the culture of other peoples, which is the purpose of a museum of ethnology such as the Musée de l'Homme? In point of fact, only an understanding of the ethnological discourse accompanying it enables an artefact to speak for itself. But what grasp do the different categories of visitors have of ethnological concepts? How do visitors to the Musée de l'Homme represent, or perceive, such concepts as 'culture', 'ethnic group', 'religion', 'rites of passage', 'traditions', 'institution', 'identity', 'acculturation', 'kinship', 'family', and so on? These are so many terms, frequently used in their everyday sense, with which the visitor will be confronted. At a more fundamental level, what conception do visitors to the Musée de l'Homme have of ethnology *per se*? Do they see it as a science, or as an occupation that combines travel with adventure? Do they have the impression of being in a science museum or (already) in a museum of 'ethnographic arts'?

Here we touch upon the conceptions and preconceptions of the various sectors of the public. For, if there is one notion that deserves to be challenged, it is indeed that of

the 'general public' or the 'public at large', expressions intended to characterize the average visitor. Visitors are not interchangeable 'empty boxes' that need only to be stuffed full of ethnological facts in order for understanding to dawn. On the contrary, each individual is the bearer of more or less precise, socially determined ideas and notions that define his or her vision of things, or 'representation of the world' (in which ethnocentricism is never very far away). However, such representations may very frequently be built up on the basis of outdated scientific concepts and data that have found their way into common parlance, as for example that of 'race'. As a result, a proper understanding of the message of an exhibition of ethnological artefacts can frequently be gained only by overcoming the stereotypes and notions entertained by visitors prior to their visit to the museum. To return to our example of the idea of 'race' as conceived by an 'imaginary visitor', it may be wondered what the impact must be of the sort of museum practice that presents cultures by geocultural areas and not in a thematic manner. Is this museographical approach, which has persisted since the earliest days of museum exhibitions of ethnographic artefacts, the one that is best suited to putting across the idea of the unity of humankind amid the diversity of cultures? Or, put more simply, why, in the final analysis, should two museographical principles that may prove to be complementary be pitted against one another: the geocultural approach being capable of arousing both wonder and curiosity; and the thematic approach replacing it in a more synoptic framework, one that can call into question the seeming singularity or exoticism of a particular practice?

Thus the aesthetic exhibition and the ill-focused educational exhibition could, paradoxically, have the same result: that of providing no further insight or knowledge about an alien culture, or of failing to alter a mistaken perception of the diversity of cultures. In the final analysis, there is thus no 'miracle' definition of what an exhibition of ethnographic artefacts should be. The debate that pits 'aesthetic' presentation against 'ethnological' presentation of the same collections must today be regarded as outmoded: neither can guarantee a better understanding of an alien culture.

The historical evolution of the museum's task structure, which has today led to the primacy of the exhibition and a concern to cater to the different sectors of the public, might well indeed trigger a metamorphosis of the museum as an institution, one in which we would see the emergence of occupations connected with cultural mediation (museum public monitors, museologists) alongside strictly ethnological occupations. Such a metamorphosis would lead to the development of two distinct yet complementary professions and practices: on the one hand, ethnologists and fieldwork undertaken through and for research: and, on the other, museologists and the practice of a discourse conducted in the field of activity of the former, through and for exhibitions. More than a division between research and the museum, the aim would be to professionalize the work of popularization in the same way as research work.

Yes, ethnology has something to say. But to whom and how? These are the questions to which a contemporary museum of ethnology must provide the answers.

Notes

1 N. Dias, *Le Musée d'Ethnographie du Trocadéro (1878–1908). Anthropologie et muséologie en France*, Paris, Éditions du CNRS, 1991.
2 *La Tribune des colonies*, 24 March 1898, archive of the Musée de l'Homme.

3 In the nineteenth century, the term 'field ethnographer' or 'field ethnologist' had yet to be coined; anthropologists and ethnologists remained confined to their studies, scholars theorizing in a museum context on the basis of travel tales and objects usually brought back from the colonies by missionaries, soldiers and travellers.

4 A. Dupuis, 'Anthropologie et muséologie, un aspect de l'histoire du regard anthropologique'. *Œil anthropologique*, No. 8, 1997, pp. 43–57.

5 The idea of the laboratory-museum dates from the early 1930s, when the MET was reorganized; however, the idea would only be fully realized with the simultaneous creation in 1937 of the Musée de l'Homme and the Musée des Arts et Traditions Populaires. This concept of the laboratory-museum boiled down to treating the museum and ethnology as equivalent by combining museum-based activities with research activities. In other words, a new structure intermeshing the activities of collection, research, conservation and display was set up, with the ethnologist as the central figure in its organization. In point of fact, the museum was defined more by its professional scientific dimension than by its cultural and educational dimension. More than a 'laboratory-museum', the institution was a 'museum-laboratory'. See F. Grognet, 'Le "Musée-Laboratoire": un concept à réinventer?', *Musées et Collections Publiques de France*, No. 233, 1999, pp. 60–3.

6 A. Vitard-Fardoulis, 'L'objet interrogé ou comment faire parler une collection d'ethnographie', *Gradhiva*, No. 1, 1986.

Chapter 17 | Enid Schildkrout

Ambiguous Messages and Ironic Twists
Into the Heart of Africa and *The Other Museum*

[*Review article of the exhibition and catalogue*, Into the Heart of Africa, *Royal Ontario Museum, Toronto, November 16, 1989–August 6, 1990 and* The Other Museum, *an installation by Fred Wilson, Washington Project for the Arts, February 9–March 17, 1991.*]

Just about everything that could go wrong with an exhibition seems to have gone wrong with *Into the Heart of Africa* at the Royal Ontario Museum (ROM) in Toronto.[1] The controversy that erupted was quite extraordinary, and made many of us working in the field of ethnographic exhibitions, particularly African exhibitions, tremble with a sense of "there but for the grace of God go I." How could an exhibition have gone so wrong? How could an exhibition offend so many people from different sides of the political spectrum?

Another exhibition that recently dealt with similar themes of collecting, representation, and colonialism was the installation piece by artist Fred Wilson called *The Other Museum* at the WPA (Washington Project for the Arts) gallery in Washington, D.C. Comparing these two exhibitions suggests some thoughts on the problems facing curators in science museums, especially ethnographic and natural history museums, in dealing with that most problematic of constructs, "the fact."

I visited *Into the Heart of Africa* in June, 1990, the month that *African Reflections: Art from Northeastern Zaire* opened at the American Museum of Natural History in New York. Probably because I was a curator of *African Reflections*, a packet of press clippings sent by the Coalition for the Truth About Africa (the organization that had coalesced around the protests against the ROM) was passed on to me. Thus, although I have never spoken to Jeanne Cannizzo, the guest curator, about the ROM affair, I knew about the ordeal she was undergoing and originally had no intention of adding my comments to the debate. It has, in fact, been difficult for journals to find

Enid Schildkrout, "Ambiguous Messages and Ironic Twists: *Into the Heart of Africa* and *The Other Museum*" from *Museum Anthropology* 15:2 (1991), pp. 16–23. Reproduced by permission of the American Anthropological Association. Not for sale or further reproduction. (Reprinted without illustrations.)

colleagues who were willing to review such a controversial exhibition, since most of us were aware of the pain that the public protests had brought upon the curator. However, several months have now passed and the issues raised by the exhibition, the catalogue, and the ensuing controversy are so important for our field that I have finally decided to broach the subject in these pages. It is not my intention, however, to add insult to injury, and hopefully I can phrase my critique in such a way that it will be helpful in future attempts at mounting exhibitions with similar themes. My comments are based on seeing the exhibition, reading the catalogue, and reading a compilation of widely circulated press clippings and critiques of the exhibition.

The fact is that *Into the Heart of Africa* was meant to be a provocative exhibition, although I question whether either the ROM or the curator was certain whom it was intended to provoke. Although the organizers obviously thought that *Into the Heart of Africa* would be seen as a critical portrait of colonial collecting and museum ethics, the exhibition was seen by many people as a glorification of colonialism. What was it about the exhibition that led to such gross miscommunication? In my view there are two main issues. The first issue has to do with unrealistic, and untested, expectations about the audience and what kind of awareness it would bring to the exhibition. The second has to do with muddled intentions about the central idea of the exhibition and its failure to address consistently the themes the curator attempted to define.

The ROM had certainly had warnings that there were problems with *Into the Heart of Africa*. For instance, the museum changed the brochure for the exhibition after a small group of community representatives reviewed it shortly – perhaps too shortly – before the opening. After the exhibition opened, public protests gradually escalated: there were complaints to the ROM, then letters to newspapers, then pickets and street demonstrations, and finally, violent encounters involving the Toronto police. The ROM eventually obtained a court injunction to keep protesters from picketing within 15 meters of the museum's entrance. There were more arrests, a few injuries, and finally a statement by the Toronto Board of Education declaring the exhibition "unsuitable for Primary and Junior Division students" and "permissible for students in the Intermediate and Senior Divisions" only with structured preparation and follow-up instruction. In the end, *Into the Heart of Africa* probably received more press attention, most of it negative (although it had its defenders as well), than any other exhibition shown in Canada, with the possible exception of the Glenbow's *The Spirit Sings, Artistic Traditions of Canada's First Peoples*. In my files, which are by no means complete, there are more than 30 newspaper articles – news reports, magazine articles, letters to editors, and interviews, above and beyond the usual press releases and exhibition reviews.

Many people have claimed that one reason the controversy escalated the way it did was due to political conditions in Toronto and a generally tense racial situation that was searching for an issue. There are, undoubtedly, unique issues in Toronto, and unique issues for the ROM. There is no question that the appropriate bridges had not been built, that the public relations organized for the exhibition were poor, and that racial tensions in Toronto were high and could easily be galvanized by an exhibition at a major cultural institution. On the other hand, most North American cities have equally serious racial tensions, and many major museums, including the American Museum of Natural History, have monumental entrances which can serve as platforms for publicity-seeking protesters.

The controversy reached beyond Toronto. It reached other museums when all four slated to take the exhibition canceled – the Canadian Museum of Civilization, the

Vancouver Museum, the Los Angeles County Museum of Natural History, and the Albuquerque Museum of Natural History. Although I do not know exactly what went into these decisions, I assume that all the museums sent representatives to see the exhibition. What was most amazing was that the exhibition offended audiences from all parts of the political spectrum: missionaries whose colleagues were depicted in the exhibition, the descendants of colonial officers whose collections were shown (see Crean 1991: 23–8), and most strongly, Africans and people of African descent who saw the exhibition as racist and insulting. The exhibition was also offensive to some within another, somewhat less vocal group, that is, historians of Africa, art historians, and anthropologists working in universities and museums.

The one party that had the grace not to express dismay with Jeanne Cannizzo was the ROM itself. The administration of the ROM defended Cannizzo and the exhibition throughout the controversy, at least in print, as well they should have. Without an Africanist on their regular staff to oversee possible changes, and with no intention of making major alterations in the exhibition, the ROM responded to criticism by portraying the controversy as an issue of free speech and academic freedom. Cannizzo, the Director, and later the Acting Director, of the ROM, all claimed in various public statements that the exhibition was a carefully researched portrayal of historical fact.

Although ultimately unsuccessful, *Into the Heart of Africa* can be commended for its attempt to invoke multiple voices, to be self-reflexive, and to explore new ways of contextualizing a museum collection. However, deconstructing the museum within an exhibition is not a simple matter since it puts the curator in an almost impossible position. In this case, not until she was forced to defend the exhibition several months after it opened did the curator seem to accept the fact that her voice was actually apparent in the exhibition and that, as curator, she appeared to be speaking for the museum. Only after the ROM and the curator realized that their voice was camouflaged inadvertently into those of the imperialist collectors, did they seek refuge in the notion of curatorial authority.

The whole series of events at the ROM was tragic and the violence that was directed against the curator is something no one can condone. I do not believe that the curator or the ROM had any intention of presenting a racist exhibition. In fact, if there was any subtext, it was one of self-criticism, although "self" was defined as the museum and not the curator. The exhibition intended to be critical of colonialism, missionaries, collectors, and museums. Embedded in *Into the Heart of Africa* was a debate between the curator and the very idea of the museum, identified here – in the exhibition and in the catalogue – with imperialism itself.

Curiously, to judge from public statements, the ROM seems to have been unaware of the extent to which *Into the Heart of Africa* was an attempt to use the exhibition format to deconstruct the institution of the museum. The exhibition was, in fact, an invitation to look beyond conventional museum attributions and to reevaluate the ROM's own history, not simply the history of Canadian imperialism. In attempting to share with the public her critique of museums as repositories of colonial loot, while trying at the same time not to offend the ROM, Cannizzo unwittingly sabotaged her own enterprise.[2]

One reason for this may be that the ideas of post-modernism and deconstruction have not entered the consciousness of the general public to the extent that they can be relied upon to provide a matrix of understanding upon which one can mount such introspective exhibitions, at least in ethnographic or natural history museums. In

visiting such institutions people still look for narrative stories; docents still need to tell such stories; and people still "read" exhibitions as texts even if they do not read the text on labels.

Whether or not she recognized the inherent difficulty of doing such an introspective exhibition, it is clear from a number of published statements that the curator felt that the approach taken was the obvious, and perhaps only, presentation that could encompass the geographical spread and "lack of chronological depth" of the collection. She explicitly stated that because of its age the collection could not be used to address issues of change in modern-day Africa. Moreover, Cannizzo, the guest curator, an anthropologist with some background in African art history, but with little or no previous experience mounting major exhibitions, seemed to believe that such an approach would demonstrate the ROM's ability to mount "innovative exhibitions." As she put it,

> the nature of the collection determined the themes of the exhibition, which are a reflexive analysis of the nature of the museum itself and an examination of the history of its Africa collection. This places the exhibition at the forefront of scholarly research in studies of African art. The ROM has chosen to take the museological lead in having an exhibition which makes clear the origins of some of its collections. (Cannizzo 1990)

As suggested above and in the catalogue, *Into the Heart of Africa* was an attempt by Cannizzo to present the stories that came into her mind as she viewed the objects. On the first page of the catalogue, she stated that in going through the storerooms of the ROM various "dialogues seemed to emerge from the masks, baskets, sculptures, and beadwork in which they had been embedded for generations." These supposed dialogues determined the basic format of the exhibition: the use of the "life history of objects" approach, and the presentation of objects in different contexts such as collectors' curio cabinets, a diorama of an African village, and a 1920s-style lantern slide show.

Into the Heart of Africa was divided into five sections beginning with "The Imperial Connection," followed by "Military Hall," "Missionary Room," "Ovimbundu Compound," and "Africa Room." The first three sections focussed on Western views of Africa, while the last two were meant to celebrate African life and art. The Ovimbundu compound was intended to show part of Africa as missionaries would have seen it, whereas the final section showed objects as they have conventionally been presented in Western museums. Every one of these sections included text that was meant to reflect one or another voice in the curator's imagined storeroom dialogues. Thus after visitors stood before the imperial flag, stared at a dazzling and much restored Canadian officer's helmet spotlighted in a pedestal vitrine, and gaped at an enlarged engraving of one Lord Beresford spearing a prostrate Zulu, they came upon the African "answer" to colonial exploits: a case full of beautiful Asante gold objects and brass gold-weights, with a very standard ethnographic description of goldweights in Asante culture. As the ROM's press release described the exhibition,

> *Into the Heart of Africa* is designed in five distinct sections, each with artifacts and historical photographs. The introduction established 'the Imperial connection', outlining why and how Canadians undertook their travels into what was then called by some the 'unknown continent.' Highlights of this section include a spectacular Asante gold necklace from Ghana and a world renowned 17th-century Benin Bronze [*sic*] from Nigeria.

In the Military Hall, the visitor will be able to understand Zulu warfare from the other side of the battlefield and discover how West African traders weighed their gold dust. (ROM News Release, 1 May 1990)

The relationship between Asante weights and Zulu warfare, from whatever side of the battlefield, is certainly not clear to me, and seems to have been unclear to most of the audience.

The goldweight case, one of many intended to show how objects can communicate to the viewer the beauty of African culture, was presented in the beginning of the exhibition to represent the African "answer" to the opening section on colonialism. "Naturally," Cannizzo wrote, "these same collections also reveal much about the cultures of Africa: the beauty of their artistry, the variety of their subsistence patterns, the cosmological complexities of their philosophies, and the power of their political hierarchies" (1989: 62). It was at this point in the exhibition, however, that the visitor needed to hear the African response to colonialism. In a dialogue about colonialism and the history of collections a showcase celebrating the artistry of goldweights was irrelevant and confusing, especially since the viewer has just seen, moments before, the red-ribboned, feather-plumed Canadian officer's helmet in its solitary glory in the center of the dark opening gallery. The message that came across with the helmet, was the same as that with the goldweights: all were treasured objects. For most people, the display of the helmet did nothing in itself to condemn colonialism.

By using the "life history of objects" approach, yet by necessity filtering all of the stories through the mind of the curator, many stories – including the most controversial ones about colonialism, appropriation, and exploitation – were raised and left unresolved. It was easy to leave the exhibition wondering what the "dialogue" was about. There were murmurs and innuendoes, but there really was no topic of conversation. Where we should have had an African voice answering the imperialist collector, we had instead a dense filter of anthropology, ethnography, and art history shrouding the African side of the objects' life histories.

One of the major problems in *Into the Heart of Africa* is that Africans were presented as passive in this exhibition. They were never given the opportunity to answer the insults quoted in the labels from the Canadian soldiers and missionaries. Having conceived the exhibition as a dialogue, the curator should have carried on with this approach. Instead, the exhibition switched tracks in the middle and it appeared that colonialist-collectors were being allowed to speak for themselves (although, even here many observers felt words were being put into their mouths), while Africans were not.

As Cannizzo was well aware, tracing the life history of objects from Africa takes one through many minefields of history. As the guide on this excursion, it was the museum's responsibility to reveal the location of these mines, whether through the invocation of multiple voices or through the use of curatorial authority. The exhibit developers, or curator in this instance, assumed that the audience would distinguish between the voices represented in the labels and the voice of the museum. This did not happen and derogatory comments in the exhibition text that were meant to represent the attitude of missionaries, soldiers, and collectors were interpreted to represent the view of the museum. Asking the public to draw its own conclusions from something inherently inflammatory is a risky business.

One of the elements that distinguishes museum work, exhibition work in particular, from academic work is the nature of the audience and the problems associated with

finding ways to address that complex and amorphous entity, "the general public," without sacrificing intellectual honesty and scholarly research. The degree to which this exhibition was misinterpreted from the point of view of the ROM suggests that the exhibit developers failed to understand the nature of the audience. The ROM ignored the sensitivity of the African and black Canadian population and made erroneous assumptions about the entire audience's prior knowledge and political opinions.

The format of the catalogue – 92 pages of captioned photographs, without references, citations, or discussion of current research – suggests that it was meant to be read by a general audience with no special knowledge of Africa or anthropology. At the same time, both the catalogue and exhibition raised issues of particular interest to a fairly small group of academics and museum professionals. Current debates about museums, the politics of representation, and the history of ethnographic collecting, as found in the writings of scholars like Jim Clifford, George Stocking, Sally Price, and Christraud Geary, provided a hidden and inchoate sub-text for the catalogue and the exhibition, although it is curious that none of these works were cited in the "selected bibliography."

The catalogue opens with a statement that immediately shifts the focus away from a consideration of African culture, African art, or African history and towards more arcane, and more academic, epistemological considerations:

> Anthropology is frequently described as a kind of dialogue between the ethnographic other and the cultural self. This characterization is meant, among other things, to suggest the "fictional" nature of anthropology, for the work is generated in the interaction of the anthropologist's own cultural preconceptions and ideological assumptions with those of the people among whom he or she works. As such, the dialogue reveals something of the other as well as the self. (1989: 10)

Raising these questions opens a Pandora's box of issues that should not be trivialized, even in a work meant for the general public. By opening the box just a crack, Cannizzo armed the public with powerful ammunition that was then turned against her and against the museum.

The attempt to use the exhibition and catalogue as a way of deconstructing the ROM collection and museum exhibitions in general, and at the same time to mount a celebratory exhibition about African art, resulted in a presentation that lacked thematic coherence. However, there is reason to believe that Cannizzo deliberately attempted to avoid thematic coherence. As she wrote, "The accidental or serendipitous nature of many museum collections is obscured when exhibitions with clearly distinguished 'storylines' and carefully developed sequences of cases impose a unity on a miscellaneous collection of objects" (1989: 85). Eschewing curatorial authority, Cannizzo strung together the bits of information that could be found in accession records, published accounts, archives, and interviews with the descendants of the collectors. This inevitably made for a very strange, impressionistic and incomplete story. Thus instead of finding an account of Canadian involvement in the colonization of Africa, the audience got snippets of biographies and general statements that suggested colonial attitudes. The audience is told little about the history and effects of British military exploits in Africa, but is given a powerful hint of exploitation and violence – e.g., the enlargement and caption of "Lord Beresford's Encounter with a Zulu."

The visitor was expected to understand that this image of a white man spearing an African was not intended to offend because the image and its caption were "historical documents." Instead of a discussion of the various missions active in Africa in the early colonial period, the visitor saw a mission map titled "The Dark Continent" and a lantern slide show with a derogatory commentary about saving the heathens. The brief disclaimer that accompanies the lantern show was easily missed. In each instance the commentary with the objects reiterated a stereotype supposedly held by the missionary-collectors. These remarks piqued some visitors' curiosity, engendered anger and disgust in others, but they did not provide enough information for the audience to make informed judgments about the role of Canadians in the colonization of Africa. Predictably, many critics asked whether an exhibition on the Holocaust from the point of view of the Nazis would be acceptable.

Where there were opportunities to relate African objects to the theme of colonialism these were not taken. Islam, for example, is presented primarily as one form of artistic embellishment, whereas it could have been presented as a political, religious, and ideological movement that came into direct confrontation with European conquest and Christian evangelism. In the final section of the exhibition, where perhaps half of the objects are installed, there was an old-fashioned display of the more commonplace pieces in the ROM collection. The point here was to show how objects, once collected, would have been displayed in Western museums in the two or three decades after they were removed from their original context. This point might have been made effectively in one or two exhibit cases; instead there was a very large room filled with dozens of cases containing poorly displayed objects arranged in geographic, ethnic, functionalist, and object-type exhibits. Obviously, the reflexivity in this section was lost on most visitors and the only "voice" speaking was that of a rather pedestrian anthropology.

The approach of the curator of *Into the Heart of Africa* to the objects she found in ROM storage is exemplified in the caption and illustration on page 24 of the catalogue, quoted here in its entirety. Note how the tense used changes from the past tense (history) to the ethnographic present (anthropology?) at the end of the second paragraph:

> Objects, like people, have life histories. But this four-headed figure remains something of a mystery. It was collected by Gore Munbee Barrow, who died the principal of a boys' school in the quiet Ontario town of Grimsby. As a young man, however, he was an officer in the imperial army. He fought in the Transvaal during the Boer War and by 1902 was a lieutenant in the West African Frontier Force. The next year he took part in the British campaign against the Sokoto Caliphate, an Islamic state in northern Nigeria.
>
> Somewhere in Nigeria he acquired this statue. It was almost certainly made by an Igbo artist about the turn of the century in a village in the southeastern part of the country and probably depicts a spirit or supernatural being. A white face is found on many representations of Igbo deities and is often interpreted as an indication of moral purity.
>
> Many years later Barrow's family gave the statue to the Royal Ontario Museum. They believed that one of his men had been sacrificed to this "death fetish." The inscription "No. 80. Lagos, W.A.F.F." on the metal tag that accompanied the figure was thought to be the victim's military identification.
>
> Historical archives have not revealed reports of such an event. Whether or not the story is accurate, the alleged barbarity of "savage customs" often attracted collectors to certain kinds of artifacts, which now fill our museums.

Is it surprising that among the many problems faced by the ROM after this exhibition were rallying cries for repatriation (Asante 1990)? This caption, typical of many in the catalogue and exhibition, raises another troubling problem. That is, how often, as in the third paragraph above, were sensational tidbits interjected into the text, left hanging, and ultimately used for no obvious purpose? The conclusion of too many people was that such descriptions represented the voice of the ROM. The charges leveled against museums in the passage above and others like it are serious; once raised in an exhibition catalogue, they require an answer. In this instance, the curator asked the questions and let the public, armed with incomplete information, respond. Clearly the ROM was not well served by this approach.

The critique of museums embedded in the text for *Into the Heart of Africa* backfired because it was presented in the context of a muddled exhibition. It ignited the very resentments that all sorts of cultural vandalism have, justifiably, produced. Whether the ROM ranks high on the list of cultural vandals is another matter and one that was addressed in some depth by the protesters in Toronto. Cannizzo seemed to assume that a like-minded public would understand that the exhibition was meant to criticize colonialism (but not particular colonialists), missionaries (but not particular missions), museums (but not necessarily the ROM). In the end, what was meant as critique was seen as a nostalgic memorialization, and questions of museum propriety conveyed, at best, only guilt.

Despite the claims of the curator, the objects selected for *Into the Heart of Africa* were not, of course, speaking for themselves and ultimately only one voice emerged in the exhibition: that of the Canadian collectors whose sentiments were expressed by the selection of derogatory, patronizing, and racist remarks, many of which were paraphrases and not actual quotes. Despite disclaimers that these people were speaking in the context of another epoch, the overall impression given to many visitors was that the ROM endorsed their views. After the protests began, the ROM and the curator went to great pains to explain that this was not the case, but clearly the wrong impression had been created.

It is patently absurd for the museum to blame the audience for misunderstanding the exhibition. In the opening section, the exhibition should have included a description of colonialism, its history, its effect on Africa, and most importantly, the African response it engendered. By failing to do this, the exhibition appeared to endorse the loudest voice to emerge. As Susan Crean, a descendant of one of the collectors, put it:

> By presenting the African collection through the history of its donors, by giving pride of place to the personal stories of the white Canadians who happened to bring them to Canada, Cannizzo creates a context in which that history is claimed rather than criticized and rejected, showcased even while she tut-tuts from between the lines. "Well, Great-uncle certainly was a scoundrel, and who knows what he got up to in Africa; but, well, you can't blame the old boy for being a product of his time." That seems to be the sentiment. (Crean 1991: 25)

There is no doubt that archival material always presents special methodological problems – how to simultaneously contextualize the words of those who "made history" and at the same time disclaim their actions and attitudes. In this instance, the exhibition required the public to supply too many missing "facts"; it assumed that people were familiar with not only the history of Canadian imperialism but also with the ROM's attitude toward it. So little context was provided, however, that even

modern-day missionaries and the descendants of latter-day missionaries were offended. They resented the way in which colonial soldiers, officials, and missionaries of all kinds were given a unanimous voice. The defense of the curator and the ROM – that these bits of "dialogue" were an accurate presentation of history – sounded particularly hollow to many people in view of their knowledge that none of Canada's distinguished Africanist historians had been invited to consult on the project.

In both text and image, the exhibition attempted to use irony in order to present its condemnation of the colonial point of view.[3] In addition to the unfortunate quotations and pseudo-quotations, the exhibition contained section titles that were meant to be read as ironic cues. For example, the ROM assumed (wrongly) that the audience would understand the irony intended in the use of the word "Commerce" as a title for an exhibit case devoted to artifacts of the slave trade. In the controversy that followed, the ROM acknowledged that the trope had failed, but the tone of the apology suggested that the fault was with the audience, which was not sophisticated enough to get the point.

In *Into the Heart of Africa* the curator and designer seem to have assumed that it was acceptable to present verbal disclaimers to visual messages. I believe this is always a risky business and moreover, it may be a requirement of the exhibition format that visual messages and verbal texts convey the same idea. This caveat clearly limits the use of irony. For one thing, many people do not read labels. Labels and images, whether photographs or objects, must reinforce one another. The opening of *Into the Heart of Africa* was designed deliberately as a visual and experiential sanctum to colonial conquest. In this it succeeded magnificently, even though the ROM and the curator must have assumed, and hoped, that the audience would understand that this was intended as ironic or tongue-in-cheek – something like an off-color joke told with a knowing wink.

Was it the use of irony itself or was it the context of the ROM that made this an impossible undertaking? Given the difficulty of using irony, the ROM would have been well advised to consider whether there really was a need to couch a critique of colonialism in ironic terms?

While the protests were going on, the media printed many discussions about the need for the ROM to carry on a dialogue with the black community in Toronto. In the same period, some protesters wrote newspaper articles complimenting a much less ambitious African art exhibit being shown in a private Toronto gallery. What made the art exhibit acceptable? I tend not to think that the issue was prior community involvement, since it is unlikely that the art gallery held pre-exhibit community consultations. The protesters were genuinely insulted by *Into the Heart of Africa* because they had picked up on the fact that Africans were not, after all, given a voice in the dialogue that the exhibition set up. Had the exhibition text dealt in an even-handed way with the African response to colonialism and racism these concerns might have been addressed. The art exhibition, on the other hand, avoided this problem since it did not set up this incomplete dialogue with colonialism. The audience, therefore, could feel that the objects were speaking to them directly, as art.

It is instructive to compare *Into the Heart of Africa* with a recent exhibition at the WPA Gallery (Washington Project for the Arts).[4] In the two-part exhibition, *Power and Spirit*,[5] the artist Fred Wilson created an installation called *The Other Museum*. This work was a bold critique of colonialism, racial stereotyping, and various kinds of misrepresentation of colonized peoples. The first thing the visitor saw on approaching the entry to the installation was a huge wall map of the world, turned upsidedown. A

brochure distributed at the entrance, designed with a yellow and black cover parodying the prewar *National Geographic*, explained that

> Fred Wilson, in his installation *The Other Museum*, exposes the prejudices still inherent in these [Western religious, scientific, and artistic] institutions by critically re-examining the colonialist roots of Western ethnography. Wilson "curates" his own exhibitions, using artifacts such as African masks, period photographs, taxidermic birds, natural specimens, and human remains. He labels these with ironic text and assembles them into a setting mimicking a natural history museum. (Alan Prokop, Brochure notes)

Throughout the installation, the text turned on its head the words "other" and "ourselves." A series of clinical photographs of colonized peoples, including a set of four showing a woman removing her clothes at the photographer's behest, were labeled "Photographed By Others" whereas more sensitive portraits by African, Latino, and Native American photographers were labeled "Photographed By Ourselves." In this installation the use of irony was crystal clear as in the original caption "The Sons of Cannibals Contemplating the Passion of the Redeemer" on a photograph showing a group of children in Uganda admiring a picture of the crucifixion. The visitor already had been prepared to find reality – the original quote as caption – used as a weapon against itself.[6] Irony permeated *The Other Museum*, so much so that if anything it could be faulted for being a bit heavy-handed. Still, there was no confusion when the visitor saw a line-up of Dan and Ibo masks, from former French and British colonies, each mask blind-folded and gagged with imperial flags; or when visitors were lured to face a Kifebwe mask and peer through its eyes at film clips of Hollywood's Africa.

The success of *The Other Museum* in communicating its message raises the question of whether it isn't easier, or perhaps even more appropriate, to use irony in a work of art than in an ethnographic, scientific, or historical exhibition. Curators of ethnographic exhibitions may want to see themselves as artists, but this is probably a false conceit. Wilson's agenda was straightforward, cleverly presented, and unambiguous. He used the African art objects and the photographs in the exhibition to make a personal statement about colonialism. He never attempted to talk about the particular works of art on their own terms, for they were simply elements in his construction. Yet in some respects Wilson's agenda was not very different from Cannizzo's.

The caption "The Sons of Cannibals Contemplating the Passion of the Redeemer" would be horribly misconstrued in an ethnographic installation. Why? Here I think we come back to some basic differences between didactic exhibitions and works of art. The former are still assumed by most people to be presentations of "facts." Although Disney-like displays have blurred the distinction in the public mind (whatever that is) between fact and fiction, most people still expect to find a difference between works of art versus curated museum exhibitions, and between museums and exhibitions that deal with "facts" versus those that exhibit works of fantasy or an artist's subjective interpretation of reality. Disney World is the quintessential post-modern experience: there is no reality; fact is fiction and fiction is more real than fact. Yet it is not clear that visitors to ethnographic museums approach them as they approach Disney World. The protesters in Toronto clearly wanted a major cultural institution like the ROM to "tell the truth." There is something literal-minded in how people approach ethnographic

exhibitions. Natural history museums are still thought to present interpretations of "reality" – history, culture, or biology, just as art museums are expected to present "real" if not beautiful objects. Whereas the public may intuitively understand the Disney experience, simply because they live in the post-modern age, few are sufficiently familiar with the deconstructivist approach to ethnographic exhibitions to appreciate the self-reflexive tone and ironic twists in *Into the Heart of Africa*.

Into the Heart of Africa and *The Other Museum* attempted, in different ways, to question the authority of the museum as an institution. The former failed and the latter succeeded, but the comparison may unfairly obscure the constraints faced by curators but not faced by artists. In *The Other Museum*, Fred Wilson had no restrictions in his choice of material. He was not operating in the didactic setting of a science museum. Jeanne Cannizzo argued that her selection of objects was determined by the activities of prior collectors and that her choice of themes was suggested by the objects themselves. Curators in ethnographic museums face an onerous challenge (see Freed 1991): how to invoke multiple voices, present diverse points of view, and at the same time convey information and deal with the public's expectation of hearing a curatorial voice. Many curators would argue that the best, although not necessarily safest, approach these days is to unabashedly accept the responsibility of curatorial authority, try to base an exhibition on solid research, and hope that not too many people are offended. This approach is consistent with the notion, or fiction, of scientific objectivity and disengagement but it is something that many curators find increasingly difficult to accept.

Notes

1 I am grateful to the following friends and colleagues who have been kind enough to read and comment on earlier drafts of this article: Mary-Jo Arnoldi, Robert Carneiro, James Clifford, Elizabeth Flinn, Stanley Freed, Chris Geary, Laurel Kendall, Tom Miller, Craig Morris, Phyllis Rabineau, Chris Steiner, Sam Taylor, Susan Vogel, and Tom Wilson. I am also grateful to Colleen Kriger for sharing with me some of her knowledge of the ROM collection.

2 There is some question about whether or not much of the ROM collection can in fact be considered "loot." The most important pieces for the opening section were, in fact, borrowed for the exhibition from the Royal Canadian Military Institute in Toronto and indeed, as one commentator has pointed out, very few of the objects in the ROM were actually taken as loot. Only two of the 19 Canadian collectors represented in the exhibition were actually soldiers directly involved in colonial battles (Colleen Kriger, personal communication).

3 The Oxford English Dictionary defines irony as follows: "1. A figure of speech in which the intended meaning is the opposite of that expressed by the words used; usually taking the form of sarcasm or ridicule in which laudatory expressions are used to imply condemnation or contempt. 2. A condition of affairs or events of a character opposite to what was, or might naturally be, expected; a contradictory outcome of events as if in mockery of the promise and fitness of things."

4 Originally exhibited at White Columns, New York City, May 18–June 10, 1990.

5 The other part of the exhibition was *Spirit House #2* by Renée Stout.

6 The artist found this photograph with its caption in *Africa Then* by Nicholas Monti, 1987. It was taken in Uganda around 1910 and is from the collection Archivio Provinciale dei Padri Cappucchini. Personal communication, Fred Wilson.

References

Asante, Molefi Kete (1990) Arrogance of White Culture Ignores African Achievement. *Now,* July 19–25.

Cannizzo, Jeanne (1989) *Into the Heart of Africa*. Ontario: Royal Ontario Museum.

—— (1990) Into the Heart of a Controversy. *Toronto Star.*

Crean, Susan (1991) Taking the Missionary Position. *This Magazine* 24(6):23–28.

Freed, Stanley (1991) Everyone is Breathing on Our Vitrines: Problems and Prospects of Museum Anthropology. *Curator* 34 (1):58–80.

Chapter 18 | Mary Bouquet

Thinking and Doing Otherwise |
Anthropological Theory in Exhibitionary Practice

The last fifteen years or so have seen the publication of a number of influential anthologies, which have been decisive for the analysis of museum practice (e.g., Lumley 1988; Karp & Lavine 1991; Karp, Kreamer & Lavine 1992). Furthermore, increasing numbers of ethnographers are involved with museums, particularly in the United States, Canada, Australia and New Zealand where there are extant indigenous populations. This is quite a turnabout in the relationship between academic anthropology and the museum, which reached an all-time low around the middle of the twentieth century (see Ames 1992). However, the sense of difference between these two institutions in their respective practices of making and transmitting knowledge remains sharp – certainly in parts of Europe – perhaps *because of* the new relations developing between them. Doing ethnographic fieldwork, writing and teaching, can seem light years away from curating collections and making exhibitions. This sense of difference can sometimes assume such proportions that there almost seem to be two populations involved: museum people and academics. Museum people can be vitriolic about recent academic interest in museums, and about what seems to them the naivety bordering on ignorance with which the theoreticians pronounce on their new-found territory. Some academics still appear to regard museums with a disdain comparable to philosophers of science and historians of ideas, who prefer to avoid the laboratory – 'that repugnant kitchen in which concepts are smothered in trivia' (Latour 1993:21).

This paper examines how anthropological theory can be used in concrete ways in museums, and more specifically in the making of exhibitions. The proposal problematises both the nature of the exhibition as form, and anthropologists' possible objectives. As Baxandall (1991:34) has put it, 'there is no exhibition without construction'. The exhibition can, he suggests, be understood as a field with three distinct terms in play: the (original) users, the exhibition makers, and the viewers. Just as the original

Mary Bouquet, "Thinking and Doing Otherwise: Anthropological Theory in Exhibitionary Practice" from *Ethnos* 65:2 (2000), pp. 217–36. © Routledge Journals, Taylor and Francis Ltd, on behalf of the National Museum of Ethnography. (Reprinted without illustrations.)

users of objects and the contemporary viewers constitute often separate populations with distinct purposes and values, so too are exhibition makers ('museum natives', as Handler [1993] calls them) 'laden with theory and contaminated by a concept of culture not shared' by users or (necessarily by) viewers (Baxandall 1991:36).

The focus here is limited to exhibition makers, and how anthropological theory (see below) could be incorporated in making exhibitions. The argument is that theory can make a concrete difference to the palpable structure that is called an exhibition. What should such a concrete use of theory be called? I simply call it 'anthropological theory', extending the notion of cultural translation from lived experience to written ethnography (see Asad 1986), which is characteristic of academic anthropology, to what might be understood as a form of built ethnography. Ethnographic text is usually seen as the final product of anthropological labour, whereas public exhibitions are nowadays commonly considered as museums' *raison d'être* (cf. Macdonald & Silverstone 1991). My proposal is that the process of exhibition making, certainly for Baxandall's second group, involves a second step of translation, beyond the text, into space and design, using objects, images and (again) texts in another form.

This kind of built structure is obviously different from written ethnographies *of* particular museums, such as Handler's and Gable's (1997) of colonial Williamsburg, which brings anthropological methods to study the production and consumption of museum messages in their institutional context. The approach also differs from the (rare) ethnographies of collecting that include an account (albeit brief) of exhibit-making, such as O'Hanlon's (1993) *Paradise*. *Paradise* was both the title of the exhibition held at the Museum of Mankind in London, and that of the accompanying publication. Exhibition catalogues and guides, in extending the life of an exhibition beyond its physical term, could be seen as vindicating the centrality of text in contemporary anthropology (cf. Wright 1998:19). This relationship between durable text and temporary exhibition contributes to what might be called 'retrospective in/ fame': certain exhibitions get singled out as examples of 'how not to do it' (see, e.g., Clifford 1997; and Riegel 1996, on *Into the Heart of Darkness*), whilst others become famous by virtue of academic attention (see, e.g., Lidchi 1997; and Clifford 1997, on *Paradise*).

My interest, by contrast, is in the much more preliminary use of text and theory that *precedes* and accompanies the construction of exhibitions. Anthropological theory refers here less to putting a specific theory, such as exchange theory or kinship theory, on display – although that is precisely what Jacques Hainard and his colleagues at the Musée d'Ethnographie in Neuchâtel did with Marxist theory (see Jeudy 1995; Hainard 1995; Benthall 1994); or *Liens de Famille* at the Musée National des Arts et Traditions Populaires in Paris (see Segalen 1991). If anthropological theory, in explaining why something is the way it is, involves transforming something that is unknown into something that is possible to know, then such theory has an intrinsic part in the practice of exhibition making.

This admission raises some interesting questions about the nature of text and its finality in the anthropological project. Clearly anthropological perspective derives more or less directly from ethnographic texts that describe and analyse other ways of doing things. Concern with the crafting of ethnographic texts, ushered in by *Writing Culture* in 1986, was certainly influenced by an interest (from outside the discipline – in philosophy, literary criticism, and architecture) in deconstruction: for example, in Derrida's analysis of the structural nature of omission in writing. This perspective opened up new readings of existing ethnographic texts, as well as their

writing, although it has been criticised for remaining imprisoned at the level of discourse (see Latour 1993).

All this discussion of ethnographic text need not, however, limit the potential of anthropological perspective to that medium. My argument is that it can, for example, be fed into the process of making culture materialise in the form of exhibition. Theory, in the sense outlined above, could serve equally well to de-familiarise what is thought to be known (obvious), literally turning it into an object for inspection. This view envisages a more dialectical relationship between the abstraction of theory and the concrete components (objects, images, and texts) of exhibition. This is not to say that exhibition is text; it is clearly more than that. It is however to argue that the script (or 'storyline'), which precedes design and production in the professional methodology developed by some exhibition or presentation departments of certain museums,[1] deserves closer scrutiny. The next section briefly presents an analysis of the script or scenario in the context of the (art) museum as a ritual site. From a view of the museum script as a *fait accompli*, the following sections pursue exhibition script-writing as both theoretical and concrete parts of exhibition-making through two case studies.

Recycling Anthropological Theory: The Museum as a Ritual Site

Carol Duncan (1995) has analysed the art museum as a 'ritual site' or 'ritual artefact'. By this she means that an art museum is more than simply its collection of pictures and sculptures: it is a carefully constructed combination of architecture (and landscaping) *and* a collection of art objects. She argues that the combination of place, non-neutral spaces and objects has to be seen in its totality as a script, score or dramatic field. As a totality, it prompts visitors to enact a performance as they move into, through and out of the site. Visitors directly and vividly experience values and beliefs (about social, sexual and political identity) put on display for them by the museum. This experience is structured through a kind of secular ritual. Duncan borrows the concept of *liminality* (from Arnold van Gennep [1960], developed by Victor Turner [1969:81] as a mode of consciousness), to elucidate the kind of attention we bring to art museums. Liminality in the museum entails being outside of or betwixt and between the normal world, just as it does in ritual. She compares liminal experience with aesthetic experience, as that mode of receptivity thought to be appropriate before works of art – where the viewer is communing with the spirits of (often dead) artists.

Use of the term ritual is especially interesting in the context of art museums, and indeed museums more generally,[2] since it indicates that the Enlightenment division between Reason and Belief was anything but a clean break. The reincorporation of religious structures into the secular, public space exemplifies the continuing importance of other-worldly experience, such as contact with ancestors of various kinds. Duncan connects her analysis of art museum ritual with Leach's discussion (in *Time and False Noses*) of the way cyclical rituals attempt to circumvent the fact of death.

Duncan's application of concepts originally developed for analysing others' rituals to western art museums, provides an inspiring case of anthropological theory being recycled. In this instance, an art historian adapts such notions as 'liminality' to examine one of the core institutions of western elite culture. The logic of Duncan's analysis, whereby she collapses the boundary between 'us' and 'them' by applying anthropological concepts such as 'ritual' and 'artefact' to one of the most prestigious spaces of western culture can, I think, be taken one step further. Instead of analysing

faits accomplis, anthropological theory can be used actively to organise various kinds of exhibition 'otherwise'. 'Organise' means here the work of thinking and doing that precedes the opening of an exhibition, and not merely the managerial logistics, important though these may be to the finished product. The term 'otherwise', which is deliberately connected with 'thinking' and 'doing' in the title, rather than 'writing' (see Mason 1990:4), is meant to underline ways in which an exhibition exceeds text.

Anthropologists who are invited to write the storyline, referred to earlier, are uniquely positioned not just to observe, but also actively to harness that perspective gleaned through anthropological analysis, to conceptualise an exhibition. This is not only a matter of using what is conventionally seen as ethnographic knowledge of this or that people or culture. It could be said that making exhibitions representing 'x' or 'y' culture, is ethnographic in the narrow sense of the term. The broader capacity to put even familiar things on display in such a way as to defamiliarise them, would open up avenues for understanding all kinds of materials otherwise: from those normally classified as 'aesthetic' right through the spectrum to those normally considered 'scientific'. Duncan's use of the terms 'script' or 'score', which visitors are supposed to perform, relies on a rather passive view of the public. It must be said that despite the directive function of the script in the performance it intends, visitors are agents rather than performers who may embroider, subvert or reject their role in unexpected ways (see Beard & Henderson 1994; Cannizzo 1991). Exhibition makers increasingly (although to varying degrees) take into account both original users and visitors when scripting an exhibit.[3] It is, however, impossible to predict how people will react to quite minor details.

Anthropological theory could, for example, inform the exhibition of an object such as the million-year-old *Pithecanthropus* fossil, which resides in a natural history museum and occupies a specific position in (the history of) evolutionary theory. The culturally and historically specific view of ancestry embedded in evolutionary theory could be made to materialise within an exhibition. However, exactly because of the almost sacred nature of the story of human ancestry, an old board from outside the depot where the fossil used to be kept announcing the Dubois Collection as inaccess-ible for the public was interpreted literally by some people – just as some of the labels in Beard and Henderson's exhibit were. The framing of such a notice as a museum object, placed immediately before the section of the exhibit where the fossils were blatantly on display, had a disorienting effect on some visitors. They had been promised and come looking for the real thing, only to find access seemingly denied by the sign on the wall; and subsequently to discover that they had been deliberately 'misled'.

Such an artefact is literally a text, although belonging to a period (the early twenti-eth century) which is itself now history. The effect of such an object could not be known in advance of the exhibition. The fact that some members of the public could see the joke and others could not is part of the uncertainty of performance that fits rather well with Duncan's perception of the museum as a ritual site. Although the *Pithecanthropus* is now a 'type specimen', an object of science, we can be expected to feel some trepidation at the display of these ancestral remains from Java in their museum shrine. An old museum notice board could evoke a whiff of authoritarianism which surrounded objects of science, on the threshold of an exhibit in the new-style, public-friendly museum. It secured a hint of drama, a moment of uncertainty (limi-nality perhaps), before the *Pithecanthropus*. Particular objects, then, may be paced to

build up a ritual structure at certain points within an exhibition – or to deflate it. If museums can be analysed as ritual sites, then anthropological ideas about ritual may be deployed in the process of scriptwriting exhibitions. This means modelling on paper beforehand the way an exhibition separates its audience from the outside world, builds the story up towards some 'revelation' (a masterpiece or the *Pithecanthropus* or whatever), before building down and returning the visitor to ordinary life again. This is one example, then, of how anthropological theory can be explicitly recycled in practice.

A second way of doing this might involve a more implicit use of theory to think a storyline into a specific architectural, historical and social/cultural space. My proposal is that something as abstract as Bruno Latour's theory that 'we have never been modern' can be instrumental in conceptualising an exhibit. One may not necessarily start out with Latour in mind. He may only be encountered in that serendipitous way of ethnographic fieldwork as the stories, the objects and the images are gathered together in the concept phase. We might then distinguish between more and less explicit uses of anthropological theory in exhibition making. These proposals involve taking a closer look at the trivial practical processes of making exhibitions and how they are implicated with theory. To this end, I shall discuss explicit and implicit uses of theory from my own work in museums.

Between Shopping and Ritual:
The Anthropologist as Exhibition Maker

The early 1990s saw a remarkable change of direction in many Dutch museums (as elsewhere) regarding the status of Presentations Departments. Exhibition design came to be conceived as somehow more central even to science museums than it had been. In part this reflects what Macdonald and Silverstone (1991) refer to as a 'cultural revolution' in their analysis of the making of the 'Food for Thought' exhibit at the Science Museum in London. It was also a response to the perceived crisis as state support was modified (through *verzelfstandiging*, or 'privatisation') and museums faced the prospect of sinking or swimming. This applied as much to 'heritage' museums, such as the famous Dutch Open Air Museum near Arnhem (see Vaessen 1995), as to 'science' museums. There was a shift in emphasis from collections in the hands of the curators, to collections made available (and thus on display but also 'brought to life') to an entrance-fee paying public (van Hamersveld 1998).

Macdonald has compared the fun-loving, hands-on, non-specialist visitor to the Science Museum in London to the supermarket customer loading their trolley with goodies according to what takes their fancy. This raises the question of whether the exhibition (and museum) modelled on the supermarket *de*-ritualises (in Duncan's specific use of that term) the science museum. One wonders whether the effects of such deritualisation would be purely technological, in the style experienced by Harvey's visitors to Expo 92 (Harvey 1996). The visitor is deliberately allowed to choose his/her own route through the exhibit, in a sense taking curation into their own hands, like good shoppers (Macdonald 1998). The shop or department store model for the museum coincides strikingly with current theoretical interest in consumption in much museum critique. Although as Bennett (1995) has demonstrated, department stores and museums already shared many concerns in making the ordered

display of valued objects visible to spectators who, as they became part of the spectacle, were also cast as a new self-regulating citizenry. Food is a good candidate for presentation in terms of familiar consumption habits such as shopping, especially when there is no particular museum piece for display.

However, a vast proportion of museum collections, including science museums, is historical and not necessarily familiar. The type specimen *Homo erectus*, the fossil formerly known as *Pithecanthropus erectus*, in the Dutch National Museum of Natural History is a case in point.[4] Classified by its very presence in a natural history museum as an object of science, its exhibition entailed the structuring of public experience in a way comparable to Duncan's art museum.[5] Presenting the (pre-)historical *Pithecan-thropus* fossils in 1993 was conditioned by the exhibition space then available (the seventeenth-century Pesthuis, built in a large square and divided into eight rooms). The object had to be scripted into a pre-existing, partitioned space, which already militated against an exhibition modelled on the shopping precinct. As already noted, the object occupies a key position in the almost sacred narrative of human evolution. Duncan (1995:14) has argued that there was a transference of spiritual values from the sacred realm into secular time and space, as a result of the eighteenth-century inven-tion of aesthetics. Even if science and rationality replaced the 'crossed-out God' (Latour 1993), this does not mean that objects of this science when put on display in museums can do without some form of secular ritual. The *Pithecanthropus* was an obvious candidate for beatification on the occasion of his one-hundredth-nameday. The question was how to introduce, present, and then extract visitors from their encounter with the fossil.

It is not difficult (for an anthropologist) to see the narrative of human evolution as being deeply embedded in European popular culture as well as scientific theory; just as it is easy to see how palaeoanthropological phylogenies resonate with Judeo-Christian representations of Christ's earthly ancestry.[6] The challenge was to make the cultural specificity of evolutionary theory visible within an exhibition. For the many people involved in making a major temporary exhibition of this kind, such anthropological perspective was anything but obvious. The exhibition concept went through several versions as a written document: first as an idea, then becoming ever more specific, developing the exhibit on paper, section by section, with inventories of objects and images, descriptions of atmospheres, and culminating in a joint document with the exhibition designer known as the 'sketch design'. These pretexts involve a complex procedure comparable to Callon's (1988) sociology of translation. Many people contribute to the making of the exhibition through this vetting procedure. However the basic assumption, which involved a plurality of perspectives on the 'same' object, did not change. And as the basic assumption behind the exhibition, it informed the use of space, the modelling of the narrative, the distribution of objects, inviting the public to think about the cultural nature of evolutionary theory rather than just instructing them about it. In this particular instance, the fossils were located almost exactly in the middle of the exhibit, which occupied seven rooms. It is particularly interesting to observe how concept becomes design and later exhibition through the medium of a whole series of documents. A brief description of the exhibition illus-trates the use of different perspectives on the ape-man.

The exhibition took off from the popular figure of the ape-man in cartoons, films, and other vernacular media: thus the first 'scene' was called 'The Movies'. The second scene moved to the nineteenth century, and a (re)construction of Dubois' (who found and named *Pithecanthropus erectus*) library, as a way of explaining the intellectual

background to the search for concrete evidence of the missing link. The third 'act' presented top pieces from Dubois' Pleistocene fossil collection ('The Fossil Collection') with, as its climax, the *Pithecanthropus* fossils displayed in a bomb- and bullet-proofed vitrine. The fourth act ('The Island and the World') explained, from a contemporary perspective, how mankind was able to cross to the island of Java from the south-east Asian continent one million years ago due to sea level changes caused by the ice ages. This act also presented (casts of) human fossil finds postdating Dubois' *Pithecanthropus*, whereby the fossil became the type specimen of *Homo erectus* – preceded by the Australopithecines and succeeded by *Homo sapiens*. The phylogeny implicit in the fourth part was explored in the fifth ('The Forest'), where graphic phylogenies were juxtaposed with historical family trees, and Trees of Jesse (showing Christ's earthly ancestry); but also with Asmat and Sepik overmodelled skulls and carvings of ancestral animals invoking other ways of conceiving of ancestry. The sixth section ('The Art Gallery') considered changes in the artistic depiction of the ape-man since the nineteenth century. The seventh act ('The Depot') concluded with a 'thick' display of historic prosimian, monkey and ape taxidermic specimens, with which the visitor would catch him- or herself mirrored whilst inspecting.[7]

The basic structure of the exhibit went as follows: the first act forms a bridge with popular culture and asks what it has to do with the scientific story told in the next three acts. These three acts develop a scientific narrative conventional in its upward tale of progress. The last three acts qualify that triumphalism by exhibiting the way science and popular culture are mutually interactive and historically specific: in views on – literally, ways of seeing – ancestry; in the historically specific results of collaboration between artists and scientists to make particular ideas materialise (for example, the Australopithecines, Neanderthal Man, *Pithecanthropus* himself, *Homo sapiens*). And finally, in the storehouses and workplaces of the museum itself, where images of the natural world were (and are) quite literally forged from the raw materials collected.

If the basic concept was to make people think about the assumptions involved in evolutionary theory, little could be done without the collaboration (more and less willing) of scientists and curators of various collections, on the one hand, and designers and interior architects, on the other, to make this scenario materialise. The movement from concept to design involves a complex process of translation; it goes from a two-dimensional story in words involving some objects, such as the *Pithecanthropus* fossils, becoming ever more detailed until it reaches the final, three-dimensional production. The making of a major exhibition is a collective undertaking for the museum itself almost as much as for the public, in much the same way that Handler and Gable (1997) speak of the internal audience for Colonial Williamsburg (cf. Baxandall 1991).

The specificity that an anthropologist can bring to this process of conceptualisation and translation is closely related to that involved in the transition from ethnographic fieldwork to ethnographic text. Invited to 'conceive of' an exhibit around a certain theme or object, one collects a sort of ethnography concerning that object and the various groups of people who have been involved with it, in addition to its current museum context. In *Pithecanthropus'* case, these included Eugène Dubois plus a selection of nineteenth- and twentieth-century fossil hunters and writers on evolution. Each of these figures can in turn be associated with a further set of artefacts, which can be used to evoke their ideas and at the same time provide a spectacle – for an exhibit must also be that. You have to be able to walk through it, it has to be exciting and

interesting to look at; it must make you curious to know more, to want to go further; to start asking questions you had never thought of before.

So alongside a concept, or narrative, develops a list of desired objects, some of which have to be borrowed from other institutions, and all of which have to be staged in terms of design. Indeed, sometimes design considerations require a certain kind of object (not on the concept-maker's list) in order to tell the story visually. A model ship, for example, may be necessary to a designer to concretise a particular part of the story, whereas such a prop might never have occurred to the concept-maker. Interior architecture, graphic design and photography (for example, reproductions of portraits of the people involved, of pictures or other kinds of illustrations), are all central to the process of translation from concept to design. The ever-expanding network of people, objects, images and texts, generate another class of material: made to measure vitrines, panels, and plinths in, upon or against which to display the collection. And between the collection of objects and images, the sets created for them, and their ultimate realisation is a second process of translation, from the technical design to production (with constraints like materials, humidity, and light). A separate lighting plan has to be made, depending on whether and how natural light, darkness with spot illumination, and various kinds of vitrine lighting will be accomplished. These technical and other aids are supposed to fade into the background, enabling the stars of the show to shine. But the show in fact depends for its aesthetic impact upon this second order of devices and their creators. Like true Latourian quasi-objects, these are the elements that multiply behind the scenes, helping to produce what Alpers (1991) calls the 'museum effect'.

What was the point of *not* taking the theory of evolution for granted as a universal truth? It was, amongst other things, an attempt to explain the motivation for removing an object such as the *Pithecanthropus* from Trinil, Java and interring it in Leiden, the Netherlands. It was also an answer to the Indonesian state which would very much like to reclaim the fossil. The point was to show the enormous drive for evidence of evolution from the nineteenth century onwards. It was an acknowledgement that these European ideas require explanation and presentation. They are part and parcel of what needs to be examined when discussing repatriation, and as well the newer calls for sharing global patrimony in truly innovative ways (see ICOM 1997).

'Hands-on' ideology does not extend to the 'real thing': children may be encouraged to handle and even make all kinds of models around and about the ape-man, but they will not be invited (even with gloves on) to fondle the genuine article. This fundamental distinction, still in place today, makes the sense of historical collections, which are after all what museums have been acquiring since the nineteenth century and earlier by various means, exactly the most difficult to convey by means of object-sparse, hands-on exhibition styles. And access to complete collections by virtual means, while a godsend to the scholar, makes any experience of the 'real thing' (other than digital) even more remote than the supposedly fusty, object-dense cabinets from before 'the revolution'. It is not difficult to predict that demands for access to the 'real thing' may be forthcoming from several different directions in the future. The reality of an object is increasingly conditioned by the complexity of its setting – the country (of origin/of residence), the town, the museum, the complete exhibition, the particular section of the exhibit, or depot, in which it rests. Recognising that the stories we choose to tell (and not to tell) fundamentally affect object reality renders exhibition making a highly charged opportunity for thinking and doing otherwise.

The exhibition scriptwriter, together with the designer and production manager, appear to occupy key positions in 'post-revolutionary' museums. I have tried to show through the example of the *Pithecanthropus* centennial exhibition that anthropological perspective may be an important component for the group of specialists who make the museum into a ritual site. This perspective can help to broaden or at least unsettle the kinds of stories being told, which could also be a way of unsettling the hegemonic narrative of the modern art gallery analysed by Duncan.[8] This explicit use of anthropological theory in exhibition making contrasts with the more implicit use I shall analyse below.

We Have Never Been Modern: The Agency of Objects

The argument so far has been that anthropological perspective can be used to tell exhibition stories differently. Among the ritual specialists behind the scenes at the museum is a place for anthropologists as scriptwriters. As we have seen, Duncan drew upon anthropological theory concerning ritual to understand the way the museum works. Going one step further than this, we may look at agency behind the ritual site through and as anthropological ideas. This section will consider some ideas used for conceptualising an exhibit in a very specific place in a museum.[9] The object for exhibition and for reflection in this instance was a relation: the relation between a modern department of social anthropology, and its historic museum (dating, as a public institution, to 1857). Here anthropologists are on home territory in more ways than one. Making relations explicit, drawing them out, finding evidence for them – this is surely what some anthropologists have been doing in their writing for most of this century (see Strathern 1995). However, this interest in relations has not usually been symmetrical, according to Latour (1993:129); it has not brought 'delegates, mediators and translators back home, into their own community'. The exhibition *Bringing It All Back Home* attempted to evoke the mediatory relations, normally hidden from view in ethnographic museums, in the three-dimensional space of the museum staircase, using objects, images and texts (Bouquet 1996).

The site of the exhibit was the art nouveau building (1902), known as the Historical Museum, which houses the University Ethnographic Museum, part of the Archaeological Museum, and the Numismatic Collection. The only part of the building available for such a temporary exhibit was the central staircase, spanning five different levels. The concern in mid-1990s Oslo was that although the Institute and Museum had been reunited since 1990,[10] in practice the two seemed to be different worlds, leading largely separate lives. This was the main motivation for making the relation and its history explicit: making social relations materialise forces exploration and reflection, turning routine into an issue. The work of conceptualisation required, in effect, a little ethnography beforehand.

One of the striking differences to emerge between the academic anthropologists and the museum anthropologists in Oslo, in 1995–96, was what counted as 'modernity'. For the social anthropologists, it seemed to an outsider at least, modernity was associated with doing ethnographic fieldwork and writing it up with the latest word processing equipment. For the museum, modernity had to do with systems of conservation, storage, air-conditioning, and (the absence of) a computerized catalogue for the collections. The museum represented the past for most of the academic anthropologists.

Latour's (1993) theorization of the condition of never having been modern is one which corresponded uncannily with many aspects of the divergence between *social* anthropology and its *material* residue in Oslo. Latour rejects the very possibility of postmodernity since, as he put it, we have never managed to be modern in terms of what he calls the 'Modern Constitution', dating from the seventeenth century. The modern constitution aimed at separating the political from the scientific worlds, as illustrated by Hobbes' and Boyle's respective experiments with the air pump. Latour argues, however, that these experiments cannot be understood without taking into account a range of actors – from the King, to the feather in the air pump. Modernity would imply proper mediation of the elements separated out by science into the social (or political) and the material (or natural). It would also mean a history of things as well as persons. Unless this mediation takes place, we are left with proliferating hybrids, which do not fit into our categories and with which we cannot deal.

The historic museum collections, including the troublesome category of curiosities, correspond rather neatly with the kind of material that has been problematic for modern social anthropology. Separated, or purified in Latour's terms, from the populations that made and used such objects, the modern way of dealing with them (that is, from about the 1970s, although sometimes even earlier) was to use them as timeless decor illustrating other ways of life in ethnographic tableaux. What could not be fitted into such frames – such as materials from closer to home – had to be repressed in inaccessible depots or other nooks and crannies. The fate of a collection of (probably nineteenth-century) ethnological wax busts given to the museum by a German wholesaler in the early 1920s, is especially revealing in this respect. These busts were never catalogued, presumably because they could not be made to correspond to any ethnographic area, but also because they clearly refer to 'past' ideas about the 'family of man' which are remote for contemporary anthropologists and which they would prefer to forget about (see Bouquet 2000).

The problem with such material, as Latour (1993:75) elucidates, is that short of destroying it it tends to come back to haunt the present. The wax heads, for example, had been relegated to the attics assigned to graduate students of social anthropology writing up their theses. Some were curious about these strange objects that had been tidied away from public sight onto the tops of cupboards in their working space. Perhaps this is a good example of what Latour means by the agency of non-humans: the wax heads have a trajectory, just as the air's spring has a history (1993:86). The heads, abandoned to their own devices in the attic, used the students as spokespersons. They reestablished contact with the world by means of student curiosity about them. This was how they entered the exhibition which, predictably, they came to occupy at every level.

Conceptualising an exhibition about the relationship between institutions through time did not set out with the idea of using Latour's theory about never having been modern. The two encountered each other part-way through sifting the ethnography. Among many inspiring ideas, Latour's contestation of the modernist notion of time as an arithmetical progression, consigning things to the past and to museums, proved remarkably consistent with the shape the exhibition was taking. I use the term 'implicit theory' to refer to this discovery of theory in the process of exhibition making. Labour prefers to conceive of time as a spiral, whereby different times reapproximate and get all mixed up:

once the quasi-objects are seen as mixing up different periods, ontologies and gen-res ... [t]hen a historical period will give the impression of a great hotchpotch. Instead of a fine, laminary flow, we will most often get a turbulent flow of whirlpools and rapids. Time becomes reversible instead of irreversible (1993:73).

It could be argued that this is exactly what happened to the heads. Latour's suggestion of regrouping contemporary elements along a spiral rather than a line could actually be concretised. The spiral view of time could be transposed onto the stairwell, which is also a spiral, to represent the time span with which the exhibit was concerned. Latour concedes:

we do have a future and a past, but that the future takes the form of a circle expanding in all directions, and the past is not surpassed but revisited, repeated, surrounded, protected, recombined, reinterpreted, reshuffled. Elements that appear remote if we follow the spiral may turn out to be quite near if we compare loops (1993:73).

The five landings were used to stage the five directorships spanning the period from 1857 to the present. The exhibit went up the staircase from the present (first landing) into the past, through various levels which indeed produced some unexpected juxta- or superimpositions, descending again in reverse order back to the present. This was no celebration of modernity's progress. The purpose was to table some of the unanswered questions about the direction of modernity. Located exactly in the intermediary space between galleries with permanent exhibits where culture corres-ponds with geographical area ('Africa', 'Asia', 'North America', 'Circumpolar Regions', etc), the exhibit on the staircase tried to address the (absent) relation between the place of origin and the museum. This tactic brought a whole population of missionaries, traders, consuls, sailors and explorers – however fleetingly – into the picture. These were the normally invisible agents who were bringing it all back home. Normally invisible, that is, in ethnographic accounts focusing only on origins. Their invisibility had, of course, to do with the fact that they were mostly Norwegian, and therefore would not qualify as ethnographic except in the kind of 'symmetrical' anthropology advocated by Latour.

The implication of issues such as modernity, time, mediation/purification, hybrids, in the very fabric of exhibition-making again brings us back to the gulf between certain academic and museum anthropologies. The process of scriptwriting reveals the imbrication of both anthropological perspective and text in the process of exhib-ition making. The process of conceptualising an argument in three-dimensional space reveals a further dimension of overlap, which could be called the 'serendipity of field research' (Handler & Gable 1997:14). To Latour's (1993:108) enumeration of collectives ranging from a hole in the ozone layer to a genealogy, I would add the exhibition as the form *par excellence* that can unite academy and museum. The exhibition is both a collective (of humans and non-humans) and an event: tracing the trajectories of its component quasi-objects involves an intensely theoretical and at the same time intensely concrete set of practices.

Such ideas need not be explicitly stated in an exhibition: that is, indeed, the beauty of spatialising and concretising theory. However, implicit theory such as Latour's does make a difference to what the public gets to see, to walk through and to experience – in any kind of ethnographic museum. Latour's networks, applied to the museum, make the workings of this extraordinary collective both fascinating and suddenly fair

game for exhibition. The novelty of applying Latour to the museum resides in the fact that it renders intelligible some of the seemingly intransigent items which, left to themselves, might otherwise deepen entrenched attitudes on both sides of the fence.

End Note

This paper has argued that contemporary anthropology has more to offer various kinds of museum than regional ethnographic expertise. This brings the anthropologist as exhibition-maker closer to the conceptual artist, in one way (see Sayre 1986). In other respects, however, it makes symmetrical the work of cultural translation that has long been the mainstay of anthropology. A conventional account of the difference between cultural translation in text and in exhibition might emphasise that the latter is literally making culture materialise, and in a form accessible to many more people than those who would normally read ethnographies. My own conviction is that text is imbricated at several levels and in several different ways in the exhibitionary process – in both the explicit and the implicit uses of anthropological ideas.

The process of making culture materialise involves as many people and skills as conventional ethnography, as well as the many non-human actors in the network that is an exhibition. Creating such a scenario need not only reaffirm visitors' identity or citizenship, or educate them. Anthropologists as scriptwriters can, and perhaps should on occasion use the perspective that is so specific to their subject, to *un*settle established meanings. Ethnographic skills are certainly needed to make explicit the connections between artefacts and many other actors that have been expunged from so many museum exhibitions and depots. And in this respect museums have as much to offer contemporary anthropology as a place for the built ethnography of the future, as anthropological ideas can offer the museum.

Notes

1 For example, the National Museum of Natural History, Naturalis, in Leiden, the Netherlands, which opened the doors of its brand new premises to the public in May, 1998.
2 Vakimes (1996:389) observes that science exhibits (especially physics) have lagged behind in the museological field: 'It is as if physics should appear sacred and religionable to museumgoers by remaining unquestioned, quasi-magical and thus incomprehensible'.
3 A number of museums have attempted/are attempting to attract new audiences in 'multicultural' societies such as the Netherlands (see Belinfante 1996; Konsten 1998; Reedijk 1998; van de Sande 1998); as well as the long-standing work of consultation with indigenous populations by, for example, the Museum of Anthropology at the University of British Columbia, Vancouver (see Ames 1992); and the collaborations initiated by Anita Herle and her colleagues with a Nepalese shaman and Torres Strait islanders in Cambridge (see Herle 1994; Herle & Philp 1998).
4 For a view of the 1993 centennial exhibition of this fossil, see Bouquet 1993, 1998.
5 The former National Museum of Natural History was not open to the public on a regular basis at the time of the centennial exhibition. Temporary exhibitions were regularly held in the seventeenth-century Pesthuis building, at a distance of a couple of kilometres from the main nineteenth-century building on the Ramsteeg. This situation altered in April 1998, when the museum opened under a new name – Naturalis – in a new tower building which houses depots and a large new exhibition area.

6 Donna Haraway (1984/85) deconstructed Carl Akeley's Hall of African Mammals at the American Museum to uncover a vision of American manhood there. The question here would be how that analytical insight could be engaged in making an exhibit.

7 The obligatory 'educational' section of the exhibition followed on from the depot. Here, for example, children could make masks, sculptures and drawings of prehistoric man.

8 See also the kinds of collaboration with artists initiated by Anthony Shelton and his colleagues at the Royal Pavilion, Art Gallery and Museums in Brighton (Hilty *et al.* 1995).

9 Again, I draw from my own experience – this time at the Institute and Museum of Anthropology at the University of Oslo, 1995–1996.

10 By the end of 1997 the situation had changed again, with plans for a University Museum separate from the various Faculties.

References

Alpers, Svetlana. 1991. The Museum as a Way of Seeing. In *Exhibiting Cultures: The Poetics and Politics of Museum Display*, edited by Ivan Karp & Steven D. Lavine, pp. 25–32. Washington and London: Smithsonian Institution Press.

Ames, Michael, 1992. *Cannibal Tours and Glass Boxes: The Anthropology of Museums.* Vancouver: University of British Columbia Press.

Asad, Talal. 1986. The Concept of Cultural Translation in British Social Anthropology. In *Writing Culture: The Poetics and Politics of Ethnography*, edited by James Clifford & George Marcus, pp. 141–164. Berkeley: University of California Press.

Baxandall, Michael. 1991. Exhibiting Intention: Some Preconditions of the Visual Display of Culturally Purposeful Objects. In *Exhibiting Cultures: The Poetics and Politics of Museum Display*, edited by Ivan Karp & Steven Lavine, pp. 33–41. Washington and London: Smithsonian Institution Press.

Beard, Mary & John Henderson. 1994. Please Don't Touch the Ceiling: The Culture of Appropriation. In *Museums and the Appropriation of Culture*, edited by Susan M. Pearce, pp. 5–42. London: The Athlone Press.

Belinfante, Judith. 1996. De multiculturele samenleving, tijdelijk of blijvend? In *Publiek in het jaar 2000: musea in de multiculturele samenleving*, edited by R. de Leeuw. Leiden: R.M.O.

Bennett, Tony. 1995. *The Birth of the Museum: History, Theory, Politics.* London and New York: Routledge.

Benthall, Jonathan. 1993. Museums of the Underside. *Anthropology Today*, 9(2):18–19.

——. 1994. Marx in 3-D. *Anthropology Today*, 10(5):1–2.

Bouquet, Mary. 1993. *Man-Ape/Ape-man: Pithecanthropus in het Pesthuis, Leiden.* Leiden: Nationaal Natuurhistorisch Museum.

——. 1996. *Sans og Samling . . . hos Universitetets Etnografiske Museum/Bringing It All Back Home . . . to the Oslo University Ethnographic Museum.* Oslo: Scandinavian University Press.

——. 1998. Strangers in Paradise: An Encounter with Fossil Man at the Dutch Museum of Natural History. In *The Politics of Display: Museums, Science, Culture*, edited by Sharon Macdonald, pp. 159–172. London: Routledge.

——. 2000. Figures of Relations: Reconnecting Kinship Studies and Museum Collections. In *Cultures of Relatedness*, edited by Janet Carsten, pp. 167–190. Cambridge: Cambridge University Press.

Callon, Michel. 1988. Some Elements in a Sociology of Translation: Domestication of the Scallops and Fishermen of St. Brieu Bay. In *Picturing Power: Visual Depiction and Social Relations*, edited by G. Fyfe & J. Law. London: Routledge.

Cannizzo, Jeanne. 1991. Exhibiting Cultures: 'Into the Heart of Africa'. *Visual Anthropology Review*, 7(1):150–160.

Clifford, James & George Marcus (eds). 1986. *Writing Culture: The Poetics and Politics of Ethnography.* Berkeley: University of California Press.

Clifford, James. 1997. *Routes: Travel and Translation in the Late Twentieth Century.* Cambridge, Mass. and London: Harvard University Press.

Duncan, Carol. 1995. *Civilizing Rituals: Inside Public Art Museums.* London: Routledge.

Hainard, Jacques. 1995. Marx 2000. In *Exposer/ Exhiber*, edited by Henri-Pierre Jeudy, pp. 57–65. Condé-sur-Noireau: Éditions de la Villette.

Hamersveld, Ineke van (ed.). 1998. *Nieuwe Nederlanders en Musea.* Amsterdam: Boekmanstudies/Mondriaan Stichting.

Handler, Richard. 1993. An Anthropological Definition of the Museum and its Purpose. *Museum Anthropology,* 17(1):33–36.

Handler, Richard & Eric Gable. 1997. *The New History in an Old Museum: Creating the Past at Colonial Williamsburg.* Durham: Duke University Press.

Haraway, Donna. 1984/85. Teddy Bear Patriarchy: Taxidermy in the Garden of Eden, New York City, 1908–1936. *Social Text: Theory/Culture/Ideology,* 11:20–64.

Harvey, Penelope. 1996. *Hybrids of Modernity: Anthropology, the Nation State and the Universal Exhibition.* London: Routledge.

Herle, Anita. 1994. Museums and Shamans: A Cross-Cultural Collaboration. *Anthropology Today,* 10(1):2–5.

Herle, Anita & Jude Philp. 1998. *Torres Strait Islanders: An Exhibition Marking the Centenary of the 1898 Cambridge Anthropological Expedition.* Cambridge: The University of Cambridge Museum of Archaeology and Anthropology.

Hilty, Greg, David Reason & Anthony Shelton. 1995. *Hold. Acquisition, Representation, Perception: Work by Shirley Chubb.* Brighton: The Green Centre for Non-Western Art and Culture at The Royal Pavilion, Art Gallery and Museum.

ICOM. 1997. *Working Documents. Workshop on the Protection of the African Cultural Heritage.* Amsterdam: K.I.T.

Jeudy, Henri-Pierre (ed.). 1995. *Exposer/Exhiber.* Condé-sur-Noireau: Éditions de la Villette.

Karp, Ivan & Steven D. Lavine (eds). 1991. *Exhibiting Cultures: The Poetics and Politics of Museum Display.* Washington: Smithsonian Institution Press.

Karp, Ivan, Christine M. Kreamer & Steven D. Lavine (eds). 1992. *Museums and Communities: The Politics of Public Culture.* Washington: Smithsonian Institution Press.

Konsten, Marie-Thérèse. 1998. De wereld in het Amsterdams Historisch Museum. In *Nieuwe Nederlanders en Musea,* edited by Ineke van Hamersveld, pp. 88–98. Amsterdam: Boekmanstudies/Mondriaan Stichting.

Latour, Bruno. 1993. *We Have Never Been Modern.* Hemel Hempstead: Harvester Wheatsheaf.

Leach, E.R. 1971. Time and False Noses. In *Rethinking Anthropology,* pp. 132–136. London: The Athlone Press/New York: Humanities Press Inc.

Lidchi, Henrietta. 1997. The Poetics and Politics of Exhibiting Other Cultures. In *Representations: Cultural Representations and Signifying Practices,* edited by Stuart Hall, pp. 199–219. London: Sage.

Lumley, Robert (ed.). 1988. *The Museum Time Machine: Putting Cultures on Display.* London and New York: Routledge.

Macdonald, Sharon & Roger Silverstone. 1991. Rewriting the Museums' Fictions: Taxonomies, Stories and Readers. *Cultural Studies,* 4(2):176–191.

Macdonald, Sharon. 1996. Introduction. In *Theorizing Museums: Representing Identity and Diversity in a Changing World,* edited by Sharon Macdonald & Gordon Fyfe, pp. 1–18. Oxford: Blackwell.

——. 1998. Supermarket Science? Consumers and the Public Understanding of Science. In *The Politics of Display: Museums, Science, Culture,* edited by Sharon Macdonald, pp. 118–138. London: Routledge.

Mason, Peter. 1990. *Deconstructing America: Representations of the Other.* London and New York: Routledge.

O'Hanlon, Michael. 1993. *Paradise: Portraying the New Guinea Highlands.* London: The British Museum Press.

Phillips, Ruth. 2000. APEC at the Museum of Anthropology: The Politics of Site and the Poetics of Sight Bite. *Ethnos*, 65(2):172.

Reedijk, Hein. 1998. Investeren in team, talent en toekomst. In *Niewe Nederlanders en Musea*, edited by Ineke van Hamersveld, pp. 110–125. Amsterdam: Boekman studies/Mondriaan Stichting.

Riegel, Henrietta. 1996. Into the Heart of Irony: Ethnographic Exhibitions and the Politics of Difference. In *Theorizing Museums: Representing Identity and Diversity in a Changing World*, edited by Sharon Macdonald & Gordon Fyfe, pp. 83–104. Oxford: Blackwell.

Sande, Agniet van de. 1998. Geen doelgroep te ver: Nieuwe Nederlanders in het Rijksmuseum voor Volkenkunde. In *Nieuwe Nederlanders en Musea*, edited by Ineke van Hamersveld, pp. 99–109. Amsterdam: Boekmanstudies/Mondriaan Stichting.

Sayre, Henry M. 1989. *The Object of Performance: The American Avant-Garde since* 1970. Chicago: University of Chicago Press.

Segalen, Martine (ed.). 1991. *Jeux de Familles*. Paris: Presses de C.N.R.S.

Strathern, Marilyn. 1995. *The Relation*. Cambridge: Prickly Pear Pamphlets.

Turner, Victor. 1969. *The Ritual Process: Structure and Anti-Structure*. Harmondsworth: Penguin Books.

Vaessen, Jan. 1995. Een bewogen verbeelding van het leven: het Nederlands Openluchtmuseum in de jaren '90, *Jaarboek* 1995: *Nederlands Openluchtmuseum*. Arnhem: Nederlands Openluchtmuseum, pp. 10–19.

Vakimes, Sophie. 1996. *Science in American Life* (Exhibit Review Essay). *American Anthropologist*, 98(2):398–391.

van Gennep, Arnold. 1960. *The Rites of Passage*. Chicago: University of Chicago Press.

Wright, Chris. 1998. The Third Subject: Perspectives on Visual Anthropology. *Anthropology Today*, 14(4):16–22.

Chapter 19 | Gyan Prakash
Museum Matters

A sense prevails today that museums have become history – finished, exhausted, lifeless, and now a part of the very history they monumentalize. To infuse them with life once again, it is suggested, museums must be shaken loose from the stillness of history; they must become the locus and the instrument of undoing and redoing history. Consider, for example, the long-standing controversy over the Elgin Marbles. To this, we could add the furor over the *Into the Heart of Africa* exhibition of the Royal Ontario Museum in Canada; the threat of the African boycott of the Barcelona Olympics over the bushman exhibit at the Museu Municipal Darder d'Història of Banyoles; and the recent eruption of the German demand that Russia return the paintings it seized from the Nazis. If these events position museums as an arena for unmaking history, museums also become the stage for the enactment of history. It is in this light that we can understand the desire of regimes in the nonwestern world to monumentalize themselves with museums: Imelda Marcos assembled a new art museum within a few weeks of the meeting of the International Monetary Fund in Manila in 1975; the Shah of Iran opened a new museum of contemporary art shortly before his regime fell; and India witnessed the establishment of a new museum and arts complex in Bhopal in 1981, just before the city was devastated by the explosion in the Union Carbide chemical factory. Many more examples could be added, but my purpose is not simply to reiterate that museum matters matter; rather, it is to explore and reflect on the representation of history in the museum and the museum as an historical institution.

Fragility and Solidity

There is something strikingly similar about the museum's recontextualization of objects torn from their contexts and the rejoining of fragments into narratives about the past practiced in the discipline of history. Stephen Greenblatt writes:

Gyan Prakash, "Museum Matters" from Alexander García Düttmann et al., *The End(s) of the Museum*, pp. 53–66. Barcelona: Fundació Antoni Tàpies, 1996. © 1996 by Gyan Prakash. Reproduced by permission of the author.

"Museums function, partly by design and partly in spite of themselves, as monuments to the fragility of cultures, to the fall of sustaining institutions and noble houses, the collapse of rituals, the evacuation of myths, the destructive effects of warfare, neglect, and corrosive doubt."[1] They assemble fragile fragments, often erasing marks of violence on them, including "the act of displacement that is essential for the collection of all older artifacts."[2] The wounded objects, tenderly restored, not only bear witness to the frailty of cultures but also vindicate their re-presentation. Something of the same process is visible in the historian's careful reconstruction of fragmentary evidence into a narrative of the past. Documents from wars, inquisitions, rebellions, famines, epidemics, or from the daily practices of governance – census, tax-rolls, land records – stored in archives are placed carefully, one in relation to another, to present portraits of events and structures from the ever-elusive past.

Re-presentations of history cannot be escaped, and neither museums nor historians need apologize for the act of re-framing dislocated objects. But something important occurs when this reframing operates as restoration. I speak of frayed objects and fragmentary data assembled to reinstate cultural wholeness, the staging of remnants and residues to stand in for unity and fullness. Such a project of restoration invents the aura of fragility and incompleteness that surrounds exhibits and evidence: frailty and impermanence are not simply encountered in all their rawness but produced in the interest of their regulation. If this sounds too Hegelian, I hasten to add that what I have in mind is not ontology but strategy, that is, a scheme that appropriates the fragmentary and the discontinuous by domesticating them as dialectical opposites of the solid and the continuous. In such an operation, the representation and meaning-making of dislocated objects and fleeting pasts become charged with domination and myth-making.

Nowhere does this strategy appear with more startling clarity than in the ethnographic and comprehensive museums functioning as institutions of Western historicism. For it is in these museums' historicist representations that other cultures and other times become collections-in-order at the center of which is the West. This becomes manifestly clear not only in the dark and shabby halls of ethnographic museums but also in the radiant galleries of grand comprehensive museums. There, the historical and historicist functioning of the museum as a Western institution operates by accumulating exotic artifacts, by appropriating difference. Such accumulations of otherness produce cultural difference, but disguise them as pre-existing cultural diversity; they arrange patches of cultural exchange, interaction, domination, market transactions, and historical encounters into atomistic and naturalistic human and cultural diversity. Appropriation of alterity is an integral part of the humanist and historicist representations of difference encountered in ethnographic museums.

James Clifford suggests that both anthropology and modern art must view collecting as an important historical form of Western subjectivity; that anthropology and modern art were invented by appropriating "exotic things, facts, and meanings." He emphasizes the word appropriation – "*Appropriate:* 'to make one's own,' from the Latin *proprius*, 'proper,' 'property'."[3] It is in this sense of appropriation that museums have gathered up, made their own, exotic objects and meanings, weaving the frayed remains of other peoples and other times into a proper, seamless whole, called mankind. Like historicism that collects and arranges discrepant histories into History, museums have wrested fragments from elsewhere to reassemble and resemble the story of Man.

If fragments are gathered up to constitute a whole, they are also marked by the stamp of authenticity. Exotic artifacts are positioned as authentic residues of myths, practices, values, and forms of organization that are thought to underlie the wholeness and integrity of other cultures. Such projections of authenticity and wholeness project the exhibition of exotic cultures as entirely separate from and unaffected by the structure that gathers and stages them. Thus, ethnographic displays represent their exhibits as objects saved from the inevitable decay of time, protected from the certain fate of impurity that awaits them. Rescued from history and authorized as authentic remains, they become collections-in-order that represent other cultures as integrated wholes, unaffected by the structure of power that collects and exhibits them. They are wrenched from the history of unequal relations within which they have entered the museum and placed in the frozen time of tradition. Encased and exhibited in separate halls devoted to a slice of time or to a part of the history of Man, discrepant histories are entombed as tradition, continuity, essence. This representation is enshrined, not undone, in multicultural projects to display the "traditional cultures" of Africa, Asia, and the New World in "their own terms." Notions of authenticity and wholeness of cultures remain predominant as objects bearing the history of the West are collected and exhibited as expressions of cultural diversity.

Curiously enough, the West is nowhere displayed in the gathering up of dislocated and delicate objects to narrate the history of Man. Museums have categorized, classified, and exhibited objects from nonwestern cultures according to universalist aesthetics and history, but nowhere in this display is the West itself exhibited. Consider, for example, the establishment of the Musée de l'Homme in Paris in the late 1930s. Ethnographic humanism, employing the notion of a single "humanity," organized the foundation of the museum when it opened its doors to the public in 1938, but its displays omitted, as James Clifford remarks acutely, the founding source of this projection. In classified halls, the viewers were asked to appreciate the creative spirit of mankind, but the creations of the modern West were nowhere in display. And yet the West was pervasive, as Clifford points out: "The orders of the West were everywhere present in the Musée de l'Homme, except on display."[4] The West forms the pervasive background of what is displayed and what is not, it gives to things their look. Yet, the West cannot be described or captured as a set of beliefs: it shows up in offering an understanding of otherness, in giving it coherence and meaning.

What are we to make of a mode of representation that performed the West almost surreptitiously, clinging to the bits and pieces of nonwestern cultures? How should we understand the institution of ethnographic humanism's universalist history and aesthetics in the shreds of other times and other cultures? At issue here is the delicacy and danger of restoring the West-as-History in vanished pasts and decayed cultures, the perils of performing the West in the intimacy of the other and the archaic that are always imagined to be rapidly disappearing, endangered, soon to be extinct. I want to revisit what may appear as an old and exhausted issue to suggest that re-viewing the museum's historical functioning may reveal ways to revise how it matters; that the history of the museum's appropriation of otherness contains "inappropriate" possibilities.

The Risk of the Other

To begin examining the risks entailed and contained in the appropriation of difference, I find no better place to turn than to Rudyard Kipling's fabulous novel of the

empire, *Kim* (1901). The novel opens outside the Lahore Museum in Punjab, now in Pakistan. Containing Greco-Buddhist sculptures, friezes of figures in relief, fragments of statues and slabs, books, manuscripts, and maps, it stores, as Kipling tells us a little later, the labor of European scholars. Here, Europe's guiding vision brings to light the authentic map of the Buddhist holy places; books and photographs supplement stones and slabs in telling the story of Buddhism. "Tis all here. A treasure locked," acknowledges the Lama, a Tibetan holy man in search of knowledge.

Outside this treasure of Western knowledge but, as it were, supplementing its authority stands the Zam-Zammah, an eighteenth-century cannon. Young Kim O'Hara, the chief protagonist of the novel, sits astride the gun standing on a brick platform opposite the old Ajaib-Gher – "the Wonder House, as the natives call the Lahore Museum." The eighteenth-century cannon had seen years of service in wars waged by local kings, but did not serve a military purpose any longer. Its symbolic value, however, was another matter. Kipling writes: "Who hold the Zam-Zammah, that 'fire-breathing dragon,' hold the Punjab; for that green-bronze piece is always the first of the conqueror's loot." As Kim sat astride the cannon, kicking an Indian boy off it, he did so as a conqueror, for, as Kipling writes, "the English held Punjab and Kim was English." But how was Kim English? Kipling tells us of Kim's shadowy parentage and imperfect upbringing under a "half-caste woman" with whom his Irish father had drifted into a friendship. It was from this "half-caste" woman that Kim discovered that he was English, as she, confusedly remembering the Irish sergeant's prophecies in his "glorious opium hours," told Kim that everything would come all right for him: "There will come for you a great Red Bull on a green field, and the Colonel riding on his tall horse, yes, and – 'dropping into English' – nine hundred devils."

Such a fabulous tale of Kim's identity is not altogether surprising because it falls into a certain pattern of constituting European authority. The intimacy with otherness is central to this strategy of authorization; Europe makes its appearance in the museum collection of native statues and stones; it can be sighted sitting astride the Zam-Zammah; and it can be identified in a boy raised by a half-caste woman and indistinguishable in appearance and speech from the native boys. Europe can be locked in the loving embrace of the other and yet emerge unscathed. "Though he was burned black as any native; though he spoke the vernacular by preference, and his mother-tongue in a clipped uncertain sing-song; though he consorted on terms of perfect equality with small boys of the bazaar; Kim was white." Note Kim's "burned as black" skin bleached white, consider how the museum's native artifacts become the sign of Western authority – "Tis all here. A treasure locked." As the novel proceeds, India unlocks itself to Kim who, passing off as an Indian, reveals the country as a museum: Europe emerges in its functioning as a secret agent that purveys and discloses India. It is a dangerous operation that is secured only by assuming the power of the native, by reclaiming the power of that "fire-breathing dragon," the Zam-Zammah.

If the novel risks the loss of the West in the native material that stages it, then so did Edgar Thurston, the Superintendent of the Madras Museum from 1885 to 1910. Thurston's interest was ethnological, and he used his long tenure as the head of the Madras Museum to turn it into a major collection of anthropological objects. One of his methods of collecting was to undertake tours of south India. Reporting on one of his tours, Thurston humorously described the rumors that punctuated his visits: "The Paraiyan women of Wynaad, when I appeared in their midst, ran away, believing that I was going to have the finest specimens among them stuffed for the museum. Oh, that this were possible! The difficult problem of obtaining models from living subjects

would be disposed of.... An Irula of Nilgiris, who was 'wanted' for some ancient offence relating to a forest elephant, refused to be measured on the plea that the height-measuring standard was the gallows. A mischievous rumour found credence among the Irulas that I had in my train a wizard Kurumba, who would bewitch women and compel me to abduct them. The Malaialis of Shevaroys got it into their heads that I was about to annex their lands on behalf of the Crown, and transport them to the penal settlement in the Andaman islands."[5]

The wry humor of "Oh, that this was possible" and the amused inflection in Thurston's prose presents rumors as wild stories of wild people; there is something of "the natives will remain natives" in his report that seeks to recover the loss of his authority to the reckless indeterminacy of rumors.

We find this loss and the attempt to recover from it once again in another incident that Thurston reports. This incident occurred in the museum itself, and during the course of his daily routine. Pursuing his interest in anthropometry, Thurston would pull out his calipers and other measuring instruments every day, using them on native visitors – sometimes paying them, sometimes not. One day, as he followed his routine, the crowd gathered as usual to watch him: "Quite recently, when I was engaged in an enquiry into the Eurasian half-breed community, the booking for places was almost as keen as on the occasion of a first night at the Lyceum, and the sepoys of a native infantry regiment quartered in Madras, entered heartily into the spirit of what they called the *mujeum gymnashtik shparts* [Museum Gymnastics Sports] cheering the possessor of the biggest hand-grip, chaffing those who came to grief over the spirometer."[6] Evident in the *mujeum gymnashtik shparts* is the scientific project of the museum gone awry. This is a risk that Thurston could not avoid, for his museum of ethnology was put together with native skulls and limbs. But once the project was turned into a game by the very natives that Thurston needed for his ethnological collection, ridicule was the only strategy left to rescue it. Listen to him describing the visitors to the museum: "For the great mass of visitors to the museums in India, who come under the heading of sight-seers, and who regard museums as *tamásha* [show] houses, it matters but little what exhibits are displayed, or how they are displayed, provided only that they are attractive. I am myself repeatedly amused by seeing visitors to the Madras museum pass hurriedly and silently through arranged galleries, and linger long and noisily over a heterogenous collection of native figures, toys, painted models of fruit, etc."[7]

Here, Thurston brings to light an unresolvable dilemma for the museum's functioning as an institution of Western authority. Western knowledge, organized in native objects, sought recognition in the alterity of the native eye because it was only then the natives could be appropriated. But this meant admitting Indians as knowing subjects. Forced into this intimacy with the other, the museum became a *tamásha*, a *Jadoo-Gher* (the House of Magic), the Wonder House, as Kipling noted. There is an instability here that surfaces in the image of the "Wonder House"; it punctuates Thurston's narrative of collection with rumors; and it turns the scientific collection of ethnographic material into a sport and the museum into a house of magic. Faced with this inevitable indeterminacy, the "fire-breathing dragon" guarding the Lahore Museum, and the dry humor of the colonial master who knows that natives will remain natives emerge as strategies that seek to recover the museum from the imbalance it is thrown into by its own operation.

What are we to make of this instability and indeterminacy? How should we understand these accounts of *Ajaib-Gher* and *tamásha*?

It is tempting to read in these the eruption of the native point of view. This seems all the more inviting today because it answers the contemporary demand to let the native speak. Colonialism is gone, and so is the old museological view of culture and cultural difference. This is music to the museum's ears. What could be more convenient than to dust off displays of other objects and other pasts and re-present them in all their authenticity: "Traditional cultures" can now be exhibited without the distorting mirror of colonialism. But this is an elaborate hoax that treats history as something that can be just peeled off to reveal the true native at last, before history. This sense of the belated disclosure of the nonwest, of "people without history," is not new: belatedness surrounded nineteenth-century historicism as well. Europeans discovered other cultures after their purity and authenticity appeared to have decayed, always belatedly. Indeed, even the contemporary lives of nonwestern peoples were thought to be caught up in another time. No wonder, the native's point of view always fell short of the advanced West. Gripped by the fanciful ideas and myths of earlier times, the native was bound always to misunderstand the museum, regard it as a house of magic, as a *tamásha*. To read these as instances of indigenous speech, then, is to repeat Thurston's claim to represent otherness.

Instead of treating the *mujeum gymnashtik shparts* as the appearance of otherness in all its rawness, now recoverable because the distorting lens of colonialism is gone, I want to suggest that it constitutes a moment of crisis in the representation of difference. It brings into view the effect on discourse produced by the intimacy with the other; it draws attention to the risk of "going native" that the strategy of appropriating otherness runs. Such an understanding resists stories of beginnings and ends, of origins and falls. In the aporia produced by the process of appropriation, the birth of the West appears divided, shadowed by a ghostly double; and the end of colonialism does not permit the other to emerge in itself – if such a thing were possible – but *in medias res*, caught in history, appearing contingently and contentiously.

To put it quite simply, the history of the museum as a Western institution is not, and never was, a closed issue; it is riddled with points of crisis and openings that threaten to make the West "go native" and frustrate the desire to seize the native in all his nakedness.

Anachronism and Openings

Now that the modern West is without colonial power, dispossessed of the Zam-Zammah and deprived of the power to seize otherness in stereotypes, the failure to achieve the historicist appropriation of otherness shows up in the expression of exhaustion and anachronism. Thomas Keenan quite rightly analyzes the apocalyptic image of the end of the museum as an interested defense of the notion of origins and traditions. "The museum that loudly proclaims its own devastation, from end to end, rests comfortably at the core of this [humanist] tradition,"[8] he writes. Mournings of loss imagine a time of undivided origin and empower projects for its recovery.

But what has brought about this specter of death and extinction? In a certain sense, this constitutes a structural condition of Western humanism; with difference and discord functioning as the media of its performance, the project to gather alterity in a "common humanity" has always carried the risk of failure. The West was always, as I have suggested, shadowed by the alterity in which it was projected. Now, these shadows have taken on darker hues. The reasons for this are not hard and far to

seek – decolonization, movement and migrations of people, porous national and cultural boundaries, the changing complexion of public and museum viewers, criticisms arising within and without museums, etc. These render the appropriation of otherness more problematic than ever. Controversies erupt regularly over the representation of ethnographic and historical fragments that museums have gathered in order to narrate the West. Well-intentioned exhibits become charged with racism and misrepresentation. Thus, the *Into the Heart of Africa* exhibit at the Royal Ontario Museum in Toronto, Canada, mounted in 1989 to display colonialism, spilled outside the museum in newspapers and protest rallies that accused it of racism and ethnocentrism. If nothing else, the debate over the exhibit illustrates the changed conditions of display and viewership in which museums function.

Humanism responds to its inability to secure the appropriation of difference by proclaiming the end of museums, by declaring that they are out of joint with time, and imagining that there was a period when the appropriation of alterity was uncontested and unproblematic. In these announcements of beginnings and ends of museums, we can read universal "humanity" forced to face its own provinciality, historicism compelled to confront its own historicity. What we witness is not the end of the museum, but humanism's response to its own finitude brought to light in the museum.

The material that stages this confrontation, that foregrounds humanism's finitude, are museum objects. Encased objects from the colonial and postcolonial worlds exert pressure, in a manner reminiscent of Thurston's Madras Museum, on the frame that contains them. The controversies that erupt, the undoing and remaking of history that are attempted and demanded, center on the collection and arrangement of artifacts. Museum matters participate in telling tales on the museum, objects embodying "the orders of the West" function as the loci for producing disorder. It is thus that Thurston's Madras Museum, now wearing a sorry look – dust-laden, neglected, and in dire need of a face-lift – appears to display colonialism in its fossilized displays. Crowds still throng to it, but the objects that seek to arrange India according to the story of mankind also become capable of being read as the history of British colonialism. The Museum of Mankind in London and the American Museum of Natural History in New York, though better maintained, also lend themselves now to be read as meta-museums, exhibiting in their ambitious collections the historicity of ethnographic humanism. The West's masquerade in other guises is there for all to see in its collection of other times and other tribes.

We cannot, however, rest content with the recognition that museums themselves display the anachronism of their humanist frame; that would be to freeze them as the history of the West that is closed, beyond revision. Such a strategy would also amount to repeating monotonously the criticism of the museums' role in the history of Western domination – a criticism that museums acknowledge freely. Humanism's anachronism constitutes an opening that invites re-arrangement and re-presentation of objects and histories, not a tedious reiteration of their dominated existence. This is, of course, not news to museum curators who have used this opening to experiment with a number of different strategies of representation. It is not my intention to describe these, but I do want to underscore that attempts to remake museums must devise strategies to make appropriated objects tell "inappropriate" stories. This entails reflections on the rearrangement of objects and the reorientation of the experience of walking through a museum space to enable artifacts from other cultures to perform a critical function.

Using nonwestern objects critically, however, does not mean that they should be wrenched from history to tell their own story in "their own terms," in equality with the West. Commenting on such a notion of parallelism of cultures that enframed the exhibit *Circa 1492: Art in the Age of Exploration*, at the National Gallery in Washington D.C., in 1992, Homi Bhabha points out there can be "no simple parallelism or equidistance between different historical pasts." He adds: "A distinction must be maintained – in the very conventions of presentation – between works of art whose pasts have known colonial violence of destruction and domination, and works that have evolved into an antiquity of a more continuous, consensual kind, moving from courts to collectors, from mansions to museums."[9] Bhabha is right to caution against overlooking different histories, however compelling may be the desire to see cultures in themselves, however well-intentioned may be the attempt to view them as equal. For losing sight of discrepant histories amounts to inserting nonwestern cultures surreptitiously, once again, into the "orders of the West." In the current context of globalism and market integration, an amnesia about contentious and contingent histories cannot but render objects of cultural difference into commodities for cosmopolitan consumption.

A mode of representation that seeks to represent, not appropriate, alterity must keep in sight the history of conflict, interaction, domination, displacement, and resistance within which nonwestern objects have come to represent human diversity; it must scrutinize the history of aesthetics and notions of cultural and human diversity that have framed the representation of difference. Quite simply, the "orders of the West" cannot be undone by turning away but by revisioning the organization of cultural difference. This means using the discordant presence of nonwestern objects to disclose incommensurable cultural difference, to reveal the distance between cultures that has been mapped historically by conquest, domination, interaction, and appropriation. It is then that the liminal and intertwined histories lodged in museum matters, and kept at bay by humanist and historicist appropriations, will realize their potential as aporetic material for rethinking history, for revising how museums matter.

Notes

1 Stephen Greenblatt, "Resonance and Wonder," in *Exhibiting Cultures: The Poetics and Politics of Museum Display*, Ivan Karp and Steven D. Lavine eds. (Washington and London: Smithsonian Institution Press, 1991): 43–4.
2 Ibid., p. 44.
3 James Clifford, *The Predicament of Culture: Twentieth-Century Ethnography, Literature, and Art* (Cambridge, Mass.: Harvard University Press, 1988): 221.
4 Ibid., p. 145.
5 Edgar Thurston, "Anthropology in Madras," *Nature* (26 May 1898); reprinted in Government of Madras, Education Department, *Administration Report of the Government Central Museum for the Year 1898–99* (Madras, 1899), appendix F.
6 Ibid., p. 26.
7 Government of Madras, Revenue Department, *Administration Report of the Government Central Museum for the Year 1894–95* (Madras, 1895): 1.
8 Thomas Keenan, "No Ends in Sight," in *Els límits del museu* (Barcelona: Fundació Antoni Tàpies, 1995): 27.
9 Homi Bhabha, "Double Visions," *Artforum* 30, 5 (January 1992): 89.

Chapter 20 | Zora Neale Hurston
What White Publishers Won't Print

I have been amazed by the Anglo-Saxon's lack of curiosity about the internal lives and emotions of the Negroes, and for that matter, any non-Anglo-Saxon peoples within our borders, above the class of unskilled labor.

This lack of interest is much more important than it seems at first glance. It is even more important at this time than it was in the past. The internal affairs of the nation have bearings on the international stress and strain, and this gap in the national literature now has tremendous weight in world affairs. National coherence and solidarity is implicit in a thorough understanding of the various groups within a nation, and this lack of knowledge about the internal emotions and behavior of the minorities cannot fail to bar out understanding. Man, like all the other animals fears and is repelled by that which he does not understand, and mere difference is apt to connote something malign.

The fact that there is no demand for incisive and full-dress stories around Negroes above the servant class is indicative of something of vast importance to this nation. This blank is NOT filled by the fiction built around upper-class Negroes exploiting the race problem. Rather, it tends to point it up. A college-bred Negro still is not a person like other folks, but an interesting problem, more or less. It calls to mind a story of slavery time. In this story, a master with more intellectual curiosity than usual, set out to see how much he could teach a particularly bright slave of his. When he had gotten him up to higher mathematics and to be a fluent reader of Latin, he called in a neighbor to show off his brilliant slave, and to argue that Negroes had brains just like the slave-owners had, and given the same opportunities, would turn out the same.

The visiting master of slaves looked and listened, tried to trap the literate slave in Algebra and Latin, and failing to do so in both, turned to his neighbor and said:

"Yes, he certainly knows his higher mathematics, and he can read Latin better than many white men I know, but I cannot bring myself to believe that he understands a thing that he is doing. It is all an aping of our culture. All on the outside. You are crazy if you think that it has changed him inside in the least. Turn him loose, and he will revert at once to the jungle. He is still a savage, and no amount of translating Virgil

Zora Neale Hurston, "What White Publishers Won't Print" from *Negro Digest* (April 1950), pp. 85–9.

and Ovid is going to change him. In fact, all you have done is to turn a useful savage into a dangerous beast."

That was in slavery time, yes, and we have come a long, long way since then, but the troubling thing is that there are still too many who refuse to believe in the ingestion and digestion of western culture as yet. Hence the lack of literature about the higher emotions and love life of upper-class Negroes and the minorities in general.

Publishers and producers are cool to the idea. Now, do not leap to the conclusion that editors and producers constitute a special class of un-believers. That is far from true. Publishing houses and theatrical promoters are in business to make money. They will sponsor anything that they believe will sell. They shy away from romantic stories about Negroes and Jews because they feel that they know the public indifference to such works, unless the story or play involves racial tension. It can then be offered as a study in Sociology, with the romantic side subdued. They know the scepticism in general about the complicated emotions in the minorities. The average American just cannot conceive of it, and would be apt to reject the notion, and publishers and producers take the stand that they are not in business to educate, but to make money. Sympathetic as they might be, they cannot afford to be crusaders.

In proof of this, you can note various publishers and producers edging forward a little, and ready to go even further when the trial balloons show that the public is ready for it. This public lack of interest is the nut of the matter.

The question naturally arises as to the why of this indifference, not to say scepticism, to the internal life of educated minorities.

The answer lies in what we may call THE AMERICAN MUSEUM OF UNNATURAL HISTORY. This is an intangible built on folk belief. It is assumed that all non-Anglo-Saxons are uncomplicated stereotypes. Everybody knows all about them. They are lay figures mounted in the museum where all may take them in at a glance. They are made of bent wires without insides at all. So how could anybody write a book about the non-existent?

The American Indian is a contraption of copper wires in an eternal war-bonnet, with no equipment for laughter, expressionless face and that says "How" when spoken to. His only activity is treachery leading to massacres. Who is so dumb as not to know all about Indians, even if they have never seen one, nor talked with anyone who ever knew one?

The American Negro exhibit is a group of two. Both of these mechanical toys are built so that their feet eternally shuffle, and their eyes pop and roll. Shuffling feet and those popping, rolling eyes denote the Negro, and no characterization is genuine without this monotony. One is seated on a stump picking away on his banjo and singing and laughing. The other is a most amoral character before a share-cropper's shack mumbling about injustice. Doing this makes him out to be a Negro "intellectual." It is as simple as all that.

The whole museum is dedicated to the convenient "typical." In there is the "typical" Oriental, Jew, Yankee, Westerner, Southerner, Latin, and even out-of-favor Nordics like the German. The Englishman "I say old chappie," and the gesticulating Frenchman. The least observant American can know them all at a glance. However, the public willingly accepts the untypical in Nordics, but feels cheated if the untypical is portrayed in others. The author of *Scarlet Sister Mary* complained to me that her neighbors objected to her book on the grounds that she had the characters thinking, "and everybody know that Nigras don't think."

But for the national welfare, it is urgent to realize that the minorities do think, and think about something other than the race problem. That they are very human and internally, according to natural endowment, are just like everybody else. So long as this is not conceived, there must remain that feeling of unsurmountable difference, and difference to the average man means something bad. If people were made right, they would be just like him.

The trouble with the purely problem arguments is that they leave too much unknown. Argue all you will or may about injustice, but as long as the majority cannot conceive of a Negro or a Jew feeling and reacting inside just as they do, the majority will keep right on believing that people who do not look like them cannot possibly feel as they do, and conform to the established pattern. It is well known that there must be a body of waived matter, let us say, things accepted and taken for granted by all in a community before there can be that commonality of feeling. The usual phrase is having things in common. Until this is thoroughly established in respect to Negroes in America, as well as of other minorities, it will remain impossible for the majority to conceive of a Negro experiencing a deep and abiding love and not just the passion of sex. That a great mass of Negroes can be stirred by the pageants of Spring and Fall; the extravaganza of summer, and the majesty of winter. That they can and do experience discovery of the numerous subtle faces as a foundation for a great and selfless love, and the diverse nuances that go to destroy that love as with others. As it is now, this capacity, this evidence of high and complicated emotions, is ruled out. Hence the lack of interest in a romance uncomplicated by the race struggle has so little appeal.

This insistence on defeat in a story where upper-class Negroes are portrayed, perhaps says something from the subconscious of the majority. Involved in western culture, the hero or the heroine, or both, must appear frustrated and go down to defeat, somehow. Our literature reeks with it. Is it the same as saying, "You can translate Virgil, and fumble with the differential calculus, but can you really comprehend it? Can you cope with our subtleties?"

That brings us to the folklore of "reversion to type." This curious doctrine has such wide acceptance that it is tragic. One has only to examine the huge literature on it to be convinced. No matter how high we may *seem* to climb, put us under strain and we revert to type, that is, to the bush. Under a superficial layer of western culture, the jungle drums throb in our veins.

This ridiculous notion makes it possible for that majority who accept it to conceive of even a man like the suave and scholarly Dr. Charles S. Johnson to hide a black cat's bone on his person, and indulge in a midnight voodoo ceremony, complete with leopard skin and drums if threatened with the loss of the presidency of Fisk University, or the love of his wife. "Under the skin . . . better to deal with them in business, etc., but otherwise keep them at a safe distance and under control. I tell you, Carl Van Vechten, think as you like, but they are just not like us."

The extent and extravagance of this notion reaches the ultimate in nonsense in the widespread belief that the Chinese have bizarre genitals, because of that eye-fold that makes their eyes seem to slant. In spite of the fact that no biology has ever mentioned any such difference in reproductive organs makes no matter. Millions of people believe it. "Did you know that a Chinese has . . ." Consequently, their quiet contemplative manner is interpreted as a sign of slyness and a treacherous inclination.

But the opening wedge for better understanding has been thrust into the crack. Though many Negroes denounced Carl Van Vechten's *Nigger Heaven* because of the title, and without ever reading it, the book, written in the deepest sincerity, revealed

Negroes of wealth and culture to the white public. It created curiosity even when it aroused scepticism. It made folks want to know. Worth Tuttle Hedden's *The Other Room* has definitely widened the opening. Neither of these well-written works take a romance of upper-class Negro life as the central theme, but the atmosphere and the background is there. These works should be followed up by some incisive and intimate stories from the inside.

The realistic story around a Negro insurance official, dentist, general practitioner, undertaker and the like would be most revealing. Thinly disguised fiction around the well known Negro names is not the answer, either. The "exceptional" as well as the Ol' Man Rivers has been exploited all out of context already. Everybody is already resigned to the "exceptional" Negro, and willing to be entertained by the "quaint." To grasp the penetration of western civilization in a minority, it is necessary to know how the average behaves and lives. Books that deal with people like in Sinclair Lewis' *Main Street* is the necessary metier. For various reasons, the average, struggling, non-morbid Negro is the best-kept secret in America. His revelation to the public is the thing needed to do away with that feeling of difference which inspires fear, and which ever expresses itself in dislike.

It is inevitable that this knowledge will destroy many illusions and romantic traditions which America probably likes to have around. But then, we have no record of anybody sinking into a lingering death on finding out that there was no Santa Claus. The old world will take it in its stride. The realization that Negroes are no better nor no worse, and at times just as boring as everybody else, will hardly kill off the population of the nation.

Outside of racial attitudes, there is still another reason why this literature should exist. Literature and other arts are supposed to hold up the mirror to nature. With only the fractional "exceptional" and the "quaint" portrayed, a true picture of Negro life in America cannot be. A great principle of national art has been violated.

These are the things that publishers and producers, as the accredited representatives of the American people, have not as yet taken into consideration sufficiently. Let there be light!

Negro Digest, April 1950

Part III

The Status of Nations and the Museum

Introduction

As many of the texts in Parts I and II indicate, museums can play a key role in the representation of the wealth and power of well-established nations, and in the work of nascent nation-building. This section focuses on explicit manifestations of these national impulses and agendas, their ethics, aesthetics, and repercussions. Elements of identity formation through discrimination also emerge and are taken up in several of the critiques.

Excerpts from a lengthy (1857) Address by J. C. Robinson, Keeper of the Museum of Art and Art Library at the South Kensington Museum, indicate the enormous influence of London's Crystal Palace Exhibition (1851) on the development of the museum idea and on specific museum goals, collections, and displays. In fact, claims Robinson, the Exhibition was itself a "museum, of necessity limited in its teaching functions from representing only the art of the present day," and it offered a clear indication of the need for a more permanent institution. No longer should "the [Far] East," he declares, "be still our mistress in industrial design." The competitive nature of this international exhibition, the first of several major fairs and expositions between 1851 and the onset of the First World War, created a prime site for the display of manufactured goods, arts, and other "cultural" products. The arts of painting and sculpture had an established place in the catalogue of Britain's "national" treasures but, as Robinson notes, the industrial arts lagged behind. The healthy moral as well as manually practical, educational, and recreational effects of viewing the arts could be extended to "objects of utility"; thus the display of what we now call "material culture" – distinct from the display of the decorative arts of antiquity at, for example, the British Museum – was assigned a new legitimacy, tied to a growing world economy. We also see here the connection between design, manufacture, and national progress, as well as Robinson's sense of an imminent museum complex of which the South Kensington should be a part. In 1899 the South Kensington became the Victoria and Albert Museum, hailed as the great national museum of applied art.

Annie Coombes looks at "Museums and the Formation of National and Cultural Identities" (1988) by closely examining the early twentieth-century roots of "the concept of a homogeneous national identity and unity within Britain." This issue, as

Coombes notes, was of great concern to Henry Balfour, whose 1909 Presidential Address to the Museums Association is included later in this section. Through an analysis of the evolving concept of multi-culturalism, Coombes traces several ongoing relationships: between political and "social imperialism"; between "massive purpose-built exhibition sites" and a more generalized "heady rhetoric of education and national coherence"; and between ethnographic displays in contemporary museums and those found in earlier international and colonial exhibitions. In the process of this argument, the connection between "states of nature" (the subject of Part II) and the "status of nations" becomes quite clear. Coombes also considers the survival of "vicarious tourism" and the "authority of the museum as an institution" capable of providing a more influential encounter with the "other" than an actual visit beyond the geographical boundaries of home. The Pitt-Rivers Museum, Oxford, becomes a case in point as Coombes establishes the connection between classification of ethnological specimens, education of the "masses," and the preservation of the "existing social order." But as we find later in James Fenton's visit to this museum, objects and visitors may refuse to cooperate in these designs.

In a review article by Eleanor Heartney (2001) we have access to very recent museological developments in which "Fracturing the Imperial Mind" is accomplished with the help of the Victoria and Albert (formerly the South Kensington) Museum collections. Heartney fairly observes that "It has become a commonplace to assert that museums embody ideologies" and that they are most often "viewed as artifacts in themselves whose practices reveal the unspoken [and we might add spoken] assumptions of their founders or custodians." However, as Heartney notes, the V & A has become much less rigid in its strategies of display; moreover, "things got even more complicated" when the museum "submitted to an artistic deconstruction in the form of an exhibition entitled 'Give and Take.'" In this hybrid form of self-reflexive exhibition (there are other examples in Parts IV and V), Heartney locates one in a series of efforts that entail "the unearthing and reshuffling of historical and artistic objects from a specific museum collection in order to bring out sublimated attitudes toward race, class and political power." In a detailed description of this two-part exhibition she explains how new and "telling juxtapositions" of objects can unearth previously unseen social meanings and thus contribute to a project of revisionist history, and how "ambushing" the viewer can create conditions sympathetic to new readings of that history.

Henry Balfour's Presidential Address at the Maidstone Conference, marking the twentieth anniversary of the Museums Association (1909), confronts the issue of his "own nation" and its national history and ethnology. He notes that, though there are many local museums which preserve the "pre- and proto-historic antiquities of Great Britain," there is no institutional sense of the "connected whole." Balfour calls for a "National Folk-Museum" dedicated to the British Nation and claims that, until this is done, "there will remain a very serious *lacuna* in the list of our museums." He reviews folk and open-air museums of other countries as models and advocates a singular rather than a "comparative method" in the study of ethnology, making it easier to trace the "local evolution" of the national culture, which is to a great extent connected to climate and topography. From the point of view of the curator (at the Pitt-Rivers Museum) Balfour also includes some museographical, critical moments addressed to elements of collection and display.

In "Picturing Feminism, Selling Liberalism: The Case of the Disappearing Holbein" (1999) Jordanna Bailkin focuses on a discrete series of events surrounding a

Holbein portrait on display at the National Gallery in London in 1909 (shortly before Balfour's Address at the Maidstone Conference). The announcement of the intended sale of the portrait, *Christina of Denmark, Duchess of Milan*, raised an outcry and, according to a contemporary newspaper report, "a collective 'condition of mourning.'" Bailkin analyzes the constellation of elements and special interests put in play by this transaction, including "questions about the dynamic between gender, patrimony, and patriotism, reflecting changing relationships between women and property and between Liberal and Radical frameworks of property in prewar Britain." These questions prove relevant not only to events surrounding the National Gallery but, Bailkin argues, they can serve as "a lens for examining the interaction between museology and feminism more generally." Intricacies of that interaction prove resistant to any simple evaluation of the "flexibility" and "limits" of the museum in the face of change.

Interconnections between the establishment of worldwide, national, and local identities through exhibition are explored by Edward Kaufman in his study of "The Architectural Museum from World's Fair to Restoration Village" (1989). Kaufman's analysis of "national pavilions" at international expositions leads him to local outdoor architectural museums, theme villages, and period rooms within larger institutions; he also notes representations of what would become known as "Third World" countries, and the issue of cultural difference as it is revealed in an often simultaneous mixture of curiosity and boundary-setting through difference and strategies of exclusion. In the process of his survey Kaufman offers a wide-ranging discussion of the markers of national, local, domestic, and "alien" identities.

In the context of his survey, Kaufman discusses the creation of the American Wing at The Metropolitan Museum of Art in New York. The Addresses delivered by the museum's President, Director, and several other key members of the initiative at the opening of the Wing in 1924 offer direct statements of the motives and hopes behind this key national cultural moment. Included in this section are Addresses by the Metropolitan's President, Robert W. de Forest, Grosvenor Atterbury, the architect of the Wing, and the First Vice-President of the Board of Trustees, Elihu Root. De Forest observes that this is the "first time an American museum is giving a prominent place to American domestic art"; he then raises prevailing questions about the place of decorative arts in a fine arts museum and "awaits, with interest, the verdict" of the public. Atterbury's description of the ability of objects to "tell their own stories" and, by association, those of the nation – if given the right setting – leads to a metaphysical, and surprisingly romantic, rumination on the creation of appropriate housing for the ghosts of the past. Elihu Root comes to "speak for the common people" on behalf of American achievements and their rightful place in a museum of mostly "foreign" art, and suggests that close contact with American materials will be a corrective to those who misperceive the particular nature of the American founding spirit.

In another approach to "Telling the Story of America" (1999) Elizabeth Broun reflects on the ability of the collection of the Smithsonian American Art Museum – and other American museums originally founded "in a confluence of national pride and cultural anxiety" – to tell the national story. Broun also considers other contemporary attitudes toward such narratives and toward national pride itself. In a virtual tour of the Smithsonian she admits that each of her colleagues "could construct a valid and completely different thread through the same collection." This would seem to suggest that the "deep structures of society" these works embody and express are open to subjective interpretation and the construction of multiple national narratives.

An underlying provocation in Broun's commentary emerges when personal identity and cultural diversity – and the role of an American museum in the representation of multiple stories – rises to the surface. Her response to the question "What, then, is the legitimate new purpose for American art museums?" is to begin again with a new strategy of inclusion, a prescription not limited to American museums, despite her distinctions in tracing that national museum history.

It is particularly important to heed the tone as well as the content in Roger G. Kennedy's "Some Thoughts about National Museums at the End of the Century" (1996). Kennedy begins with his direct experience at the National Museum of American History, previously named the "National Museum of History and Technology" but known by Washington cab drivers, he asserts, as the "Museum of Science and Technology." He examines the evolution of ends and means for museums engaged in nation-building, image-making, and narrating "significant stories," analyzes the concept of nationhood itself, offers yet does not endorse "some prototypes for contemporary museum practice," and ends with a brief consideration of terms, including "museum," "nation" (and "nationhood"), "culture," "anxiety," and "snobbery."

James Fenton gives us a poet's perspective on museum encounters in "The Pitt-Rivers Museum, Oxford" (1985), where the intentions of the exhibitor are perhaps lost on the visitor, or perhaps productively misread. Objects speak in a tongue which eludes a science of signs and allows for the gloss of personal memory. In this museum visit, no trope – be it a controlling metaphor, metonymy, synecdoche, or irony – can preside over the rather unruly language of the unconscious and/or its response to the provocations of objects which speak for themselves.

Chapter 21 | J. C. Robinson

From *On the Museum of Art* |
An Address

As the memorable Exhibition of 1851 drew towards its close, and the completeness of its success became apparent, the desire that some permanent institution of an analogous nature should be established was very generally entertained. While justly proud of our country's preeminence in industrial pursuits, it was yet felt that in one particular, namely, in industrial design, we were outstripped by our neighbours. Some accounted for this inferiority on the old hypothesis of the natural inaptitude of Englishmen in matters of art, while others, with more truth, ascribed it to the want of those aids and appliances to industrial art-education, which other countries had long enjoyed.

As to our supposed natural inaptitude, this hackneyed opinion was no longer to be endured; a thousand indications at the Exhibition itself pointed to a contrary conclusion; and in particular it could not be denied, that the preeminent arts of painting and sculpture, although with less of academic aid, flourished as in no ungenial soil, nay even gave evidence of distinctive originality, and a healthy exemption from traditional influences, manifested in no other country. But hitherto painting and sculpture had alone been deemed worthy of serious national regard; schools of design had not flourished, mainly because it was impossible to make people believe that the high and abstract art of their imaginations could have anything in common with manufactures, or the every-day concerns of life. Our manufactures and workmen never realised the fact that art could be their practical concern, until 1851 opened their eyes and aroused at once their sympathies and their fears.

Then practical England found out that her nearest neighbour and most formidable industrial rival, France, had made this discovery at least a century ago, and in the superior art-power displayed in the French contributions to the Exhibition, recognised the results of a hundred years national encouragement of the study of industrial design. The true cause of our relative inferiority was thus evident, and that we were not utterly beaten in this unequal competition was matter for congratulation. Instead of being disheartened, therefore, the general feeling was that of the necessity for

J. C. Robinson, selections (pp. 3–9, 16–17, 22–3, 28–9) from *On the Museum of Art*, No. 5 in a series of introductory addresses (on the Science and Art Department and the South Kensington Museum), delivered Dec. 14, 1857. London: Chapman and Hall, 1858. Public domain.

redeeming lost time by redoubled activity; and schools and museums of art were felt to be the objects towards which the material resources, as well as the moral influences resulting from the Exhibition, might with especial propriety be directed. The Government Schools of Design, although their action had been languid and irregular, had already exercised an appreciable influence on industrial art; they were, however, experiments only, on a most limited scale: but now something far more extensive and practical was desired. The education of the industrial artist, moreover, was not all, – manufacturers complained that their exceptional productions from the designs of eminent artists found but little favour with the general public, who perversely preferred the worthless designs they were accustomed to, and it thus also became evident that the education of the public at large in matters of taste was as essential as that of the artist. School teaching here was inapplicable, or, at any rate, it could only reach the rising generation, and the gradual but sure influence of museums was the only other means. The Exhibition of 1851 itself was a museum, of necessity limited in its teaching functions from representing only the art of the present day; and yet if on this restricted footing its influence had been so remarkable, what might not be expected from a permanent institution, on the widest and most liberal basis, comprising specimens of all periods and countries, specially directed and arranged with a view to the promotion of taste in ornamental or industrial art? Such an institution it was determined to found.

An application to Government for funds for the purchase of specimens from the Exhibition was immediately responded to, the sum of 5,000£. being granted, and a commission entrusted with its expenditure.

The nucleus of a museum was in this manner speedily got together, and its further development was appropriately entrusted to the new Government Department which had been established for the better administration of the Schools of Design.

Although its ultimate object was a perfectly definite one, the exact nature of the institution to be created was not so clearly conceived at the outset, and it will not be out of place to briefly specify the manner in which a purely industrial collection, in fact a colossal bazaar of modern manufactures, such as the Exhibition of 1851, was made subservient to the establishment of a collection like the present, differing in so many essential respects from it. The acquisition of a number of the finest specimens in design in the several sections of the Exhibition was obviously the first step to be taken; it was thought that such a selection would, in the first place, be of practical use in furnishing proper models for study, and, in the next, that it would constitute a valuable historical record of the standing of art in alliance with industry at an epoch likely to remain for ever remarkable. Now, as regards the former object, the judgment of competent persons was not favourable to modern industrial art. Very little originality or real merit was perceptible in any of the European contributions, and, consequently, in an educational point of view, they could be of but little value; but in the oriental division, in which the qualification of *modern* must be considered rather nominal than essential, the case was different: for the first time the paramount merit of eastern design was universally acknowledged. The East, where every form and motive in design has a traditional and prescriptive permanency, where the patterns of the textile stuffs of India, the lacquered work and enamels of Persia, the painted porcelain of China and Japan, have remained in fashion for a thousand years unchanged, and ever popular, – the East was, by common consent, allowed to be still our mistress in industrial design, and so the admiration of oriental works was in reality a tacit homage to antiquity, to the art of former times. Thus, the Exhibition itself,

though virtually a gathering of exclusively modern productions, afforded the strongest evidence that, in an educational point of view, the study of precedent art was of primary importance.

This conviction seems to have forced itself on the members of the commission entrusted to make the selections, inasmuch as the objects chosen from the oriental side of the Exhibition (chiefly from Hindustan) actually exceeded in number those from all the European nations. Nevertheless, such was the prestige of the Exhibition, that long after the installation of the new Museum at Marlborough House,[1] it was regarded by the public merely as a continuation of that undertaking on a reduced scale, and subsequent additions to the collection, which for a considerable period were made almost exclusively in the category of ancient European art, were at first regarded almost as unwarrantable innovations on its supposed object.

We will not at this moment go further into detail respecting the nature of the collection already acquired, nor the method of classification adopted: we shall return to these subjects again. It may be generally stated, that during the six years that have since elapsed, the Museum has advanced concurrently with the other branches of the Science and Art Department, and has now attained to the proportions of a great national collection. From what has been already stated respecting its origin, it will be evident that from the outset this Museum had a different and more methodic direction than most national collections, which in the beginning have been generally more or less fortuitous gatherings of things rare and curious; only assuming more definite character after long periods of time; whilst it is equally obvious that practical utility in an educational point of view is its most important function.

It may here indeed be objected that museums will always be rather places to which to pay holiday visits, when relaxation and the pleasurable influence of curious novelties will be more thought about than any definite instruction the objects may be capable of conveying. It will, therefore, be well to inquire in what way collections of works of art can be made to exercise special educational influences, and in what respect the constitution of the present institution is in advance of others.

Beginning then with negative testimony: – in almost every country museums are too much surrounded by a sort of exclusive repellent atmosphere. People visit them with the attitude of being admitted on sufferance; the very want of sympathy with the ignorance of the general public, shewn in the absence of any provision for their special instruction, being construed as an indirect intimation that such establishments are not intended for them, and that they are, on the contrary, to be regarded as costly foundations for the abstract encouragement of knowledge, meant only for the use and benefit of a favoured few.

It may be true that the imaginary prestige thus created, even though it be the merest sham and delusion, is of some benefit to the cause of learning and science in the abstract; inasmuch as uneducated persons admire and respect much more that which is exalted, and apparently beyond their sphere of comprehension, than that which, being brought down to their own level, loses this charm of dignified mystery; while, at the same time, it may be urged that in endeavours at popular explanatory illustration there is danger of imparting only that little knowledge which is a dangerous thing.

But the two influences of museums here hinted at are compatible with each other. To elucidate and explain a work of art down to even the capacity of a child is not necessarily to vulgarise it. The refined connoisseur may enjoy the choicest specimen none the less because it is made the vehicle of instruction to the unlearned, while,

whatever may be the effect on the irretrievably ignorant, it may be safely asserted, that if the general public are inclined to reverence that which being truly noteworthy they yet do not understand, their respect will not be lessened when they do.

Generally speaking, in all public collections the following points are, in an instructional aspect, of vital importance: – First, a well-ordered division of the collection into classes, in each of which methodical series of specimens should be got together, shewing their historical or chronological and technical development; while in addition casts, drawings, engravings, and photographs, of remarkable analogous specimens in foreign or private collections, or of complete monuments or objects *in situ*, of which the specimens in the collection may be fragments or details, should be arranged together with them. Every specimen, also, should be accompanied by a label-card amply yet succinctly describing it.

Catalogues full and complete, and also judiciously abridged, should be prepared, accompanied by historical and descriptive essays, and illuminated by engravings; by these aids each section of the collection would be as it were a standing treatise, designed to allure and lead on the observer to the methodic study of the subject; and the most indifferent observer would perforce be taught something.

In the next place the collection should be fully accessible to all without distinction, every day, as early and as late as possible; this as a matter of public right, remembering that the slightest impediment thrown in the way of the visitor, anything in short which gives to admission the aspect of a favour conferred, is striking at the root of all success. Students and others should be afforded all possible facilities for copying, under regulations involving no unnecessary forms of application or delay; and finally, every object susceptible or worthy of it should be reproduced by moulding, the electrotype process, photography, or engraving, and be made available to the public at a minimum price.

[Editor's Note: Robinson goes on to critique existing collection and exhibition practices, defend the "popularisation" of public museums, offer a brief history of the "taste for collecting," analyze the effects of "modern technology" on the lives and works of artisans, and discuss the differences between the collections at South Kensington and the National Gallery.]

[...] The substantive design of this Museum may be described as *the illustration, by actual monuments, of all art which is materially embodied or expressed in objects of utility.* This comprehensive scheme obviously includes works of all periods and countries, from the earliest dawnings of art in classical antiquity to the elaborate products of contemporary art-industry. And a historical or chronological arrangement has been especially, though not exclusively, adhered to. It is not desirable to enter on a lengthy disquisition as to scientific methods of arrangement, and a free description of some of the leading sections of the Collection will alone be possible within the limits of this lecture. It will be as well previously to state, however, that in a chronological point of view few of the specimens hitherto acquired actually go further back than the commencement of the middle ages, and for this reason, that in the British Museum the nation already possesses a most extensive collection illustrative of the arts of antiquity; not, it is true, selected or arranged from the point of view of art, but still mainly valuable in that aspect. We have, then, taken up the chain of development at the point where it has been left by that institution, and which may be broadly said to end with the era of Pagan antiquity.

The decorative arts in immediate alliance with architecture are of the highest importance, and objects of an architectural nature in stone, marble, wood, terracotta, bronze, &c., under the general head of sculpture, may very properly first be noticed. An enumeration of some of the leading specimens will, perhaps, be the best mode of illustration. On entering the new galleries now being arranged, the visitor will remark the great chimney-piece from Padua, in the Soulages Collection, is erected in the main building, and at the present time a magnificent specimen of the same period, is it is hoped, on its way from Italy. In the same room is one of the finest and most important works extant of the Florentine sculptor, Luca della Robbia; this is the large altar-piece in glazed terracotta representing the Adoration of the Kings. In the iron building is the elaborate stone *retable* or altar-piece from Troyes, in Champagne, and the equally beautiful one in carved oak from the cathedral of St. Bavon, at Ghent; a door, with its architrave, pediment, &c., in marqueterie, from the Hotel de Ville at Antwerp; the complete carved oak panelling of a room, from an ancient house at Exeter. Minor specimens, fragments of architectural works, are, of course, too numerous to specify.

[Editor's Note: Robinson offers several pages of additional detail on the South Kensington collections.]

[. . .] From this enumeration it will be evident that very considerable progress has been made towards the formation of a collection worthy of the nation; indeed, the chief work has been the acquisition of specimens. It is to be regretted, however, that this work did not commence earlier; the nation inevitably follows the lead of individuals, but unfortunately it has also been the last competitor in a field in which other countries have long laboured. In an economical point of view this is to be regretted, inasmuch as for nearly every work of art now acquired the nation pays in pounds where, a few years ago even, the price was shillings. Works of art of former periods have, generally speaking, within the last few years risen in pecuniary value in a ratio, which will scarcely be credited by those not conversant with the records of sale-rooms. This advance in value, though of course much more extraordinary in some categories than in others, is still very general, and has arisen from causes which it will be interesting to specify: – First, all ancient works of art are obviously limited in number, and therefore, as mercantile commodities they do not come within the usual laws of supply and demand; the supply, contrary to the usual rule, gradually decreasing, whilst the demand is augmenting in a much quicker ratio. The effect of this, of course, need not be specified. Accident and natural decay are slowly but surely reducing the number of ancient works of art, whilst the withdrawal from circulation of specimens by their permanent location in public museums is a far more effectual process; and one which, such is the activity in this direction throughout Europe, is becoming sensibly felt. But more than this, these very museums have been the means of stimulating a host of wealthy amateurs, who, unfettered by the delays and difficulties impeding all governmental action, undeterred by any fears on the score of responsibility, step in, and by the power of ready money, beat out of the field the unlucky curators of our public collections.

During the period of the exhibition of our Collection at Marlborough House even several specialties there for the first time represented became favourite objects of research by a new race of connoisseurs: the dealers followed every movement of the taste or caprice of their clients with the keen eye of gain, and the specimens in these classes, as a matter of course, have speedily doubled or trebled in value; thus the

nation, as it were, becomes its own principal opponent. Economical reasons of this kind, however, are really unworthy of serious discussion. This great and wealthy nation can readily afford to spend even five times the pittance it now disburses on works of art; and it will be a national disgrace to us if we are content to allow our collections to remain, as is at present the case, inferior to those of many a third-rate continental State. Why should not England aim at being first here, as in every other branch of national progress?

[Editor's Note: Robinson goes on to discuss contemporary tastes and values, the market for objects, the use of public funds, the importance of loans/exhibitions from private collections, the value of reproductions, and the potential relationship between the South Kensington and local museums.]

[...] It now only remains to say a few words on the general aspect of the National Art Collections in the metropolis, in respect to their present and ultimate relation to each other. The Museum at South Kensington, as the most recently created, may without arrogating any superiority either of direction or design, naturally be presumed to have the greatest share of that expansive spirit of progress, that practical activity which new undertakings naturally engender. It has had the advantage, moreover, in commencing from the first with a definite object in view, but it has ever been regarded as but a portion of a great national whole, an integral part of an imperial and universal art collection, which, dealing with all our national acquisitions in art, irrespective of previous interests or arbitrary schemes, sanctioned though they may be by the weight of years and manifold authorities, will one day consolidate the now scattered and disconnected treasures into a noble unity worthy of a great country. It may be found advisable to consolidate all our national art acquisitions in actual juxtaposition, or a well ordered scheme may be devised, admitting of a logical classification or theoretical union, whilst an actual severance as respects locality may be allowed to continue; but, however accident or the mature decision of the nation and its rulers may determine, it is hoped that, whenever this great work is seriously undertaken, the South Kensington Museum will be found to be a well-ordered and coherent institution, ready to merge itself without disruption into a grander whole, or else worthy to become that central nucleus around which other establishments may be aggregated. Meanwhile its mission is present and immediate utility, the active collection of works of art, and the complete and unrestricted rendering of them available to the public.

Note

1 Editor's Note: Marlborough House was the home of the "Museum of Manufactures" (opened in 1852); the newly located "South Kensington Museum" was opened in 1857; it became the "Victoria and Albert Museum" in 1899.

Chapter 22 | Annie E. Coombes

Museums and the Formation of National and Cultural Identities

And so it is interesting to remember that when Mahatma Gandhi...came to England and was asked what he thought of English civilization, he replied, 'I think it would be a good idea.'[1]

Multi-culturalism has become, albeit belatedly in England, one of the buzzwords of the educational establishment. Exactly three years on from the Swann committee report, optimistically entitled *Education for All*, and in the wake of the ensuing debates on the relative merits of an initiative that may be 'multi-cultural' but is not necessarily always actively 'anti-racist', the controversy continues.[2] By April 1986, multi-culturalism was also on the agenda of the museum ethnographic establishment, at the annual conference of the Museum Ethnographers Group. In addition, specific proposals were advanced that a policy decision be made by the Group concerning dealings with the apartheid régime in South Africa.[3]

This essay is written then, in the context of what might be interpreted as the moment of a more self-consciously political conception of the roles available to museums in general. It also comes at a moment of renewed interest in the ethnographic collection as a possible site for academic anthropology's engagement with the multi-cultural initiative inspired by documents like the Swann Report. Moreover, such an involvement has the potential, acknowledged by both the anthropological establishment and its critics, of redeeming the discipline's tarnished reputation as a product and perpetrator of the colonial process.[4]

In order to understand some of the difficulties and contradictions arising from implementing a multi-cultural initiative in the display of material culture already designated 'ethnographic', I want to elaborate a case study situated at a comparable historical conjuncture in 1902, when the Education Act of that year announced the same objective of 'Education for All'. More specifically, the 1902 Act also made provision for school children accompanied by their teachers, to count visits to museums as an integral part of their curriculum; an early indication of government recognition of the educational potential of such institutions.[5] Another effect of this

Annie E. Coombes, "Museums and the Formation of National and Cultural Identities" from *Oxford Art Journal* 11:2 (1988), pp. 57–68. Reproduced by permission of Oxford University Press. (Reprinted without illustrations.)

Act was to generate a series of debates within a professional body which is still the official organ of the museums establishment today: the Museums Association.[6] The focus of these discussions was threefold: concern with the problem of attracting a larger and more diverse public, providing the museums' capacity as a serious educational resource and, in the case of the ethnographic collections, as a serious 'scientific' resource. While the existence of such debates cannot be taken as a measure of the efficacy of any resultant policies, it does give a clear sense of the self-appointed role of museums within the State's educational programme at this moment.

1902 was a significant year in other respects since it marked the renewal of concerted strategies by both contending parliamentary parties to promote the concept of a homogeneous national identity and unity within Britain. Imperialism was one of the dominant ideologies mobilised to this end. The Empire was to provide the panacea for all ills, the answer to unemployment with better living conditions for the working classes and an expanded overseas market for surplus goods. Through the policy of what was euphemistically referred to as 'social imperialism', all classes could be comfortably incorporated into a programme of expansionist economic policy in the colonies coupled with the promise of social reforms at home. It was in this context that museums and in particular the ethnographic sections, attempted to negotiate a position of relative autonomy, guided by a code of professional and supposedly disinterested ethics, while at the same time proposing themselves as useful tools in the service of the colonial administration.

The degree to which the museum as a site of the production of scientific knowledge and as the custodian of cultural property can claim a position of relative autonomy from the vagaries of party politics and State intervention, is an issue central to an understanding of the ethnographic collection's actual and possible role today.

<center>I</center>

The specific roles assigned to ethnographic collections in the discourses on museums and education produced from within the more catholic membership of the Museums Association needs to be seen in relation to another site producing knowledges of the colonial subject. Between 1900 and 1910 Britain hosted a number of National and International, Trade and Colonial exhibitions. Designated as both 'scientific demonstration' and 'popular entertainment', these 'spectacles' were the physical embodiment of different and sometimes conflicting imperial ideologies.[7]

Particularly relevant here is the fact that these extremely popular and well-attended events, held on massive purpose-built exhibition sites, nationwide, often mobilised the same heady rhetoric of education and national coherence which was to become the hallmark of the museum's appeal to the public at this time. While it is beyond the scope of this article to deal in detail with these events, they are an important element in gauging and comprehending the terms on which the ethnographic curators sought to define their domain and to establish their distinctive contribution to the national education programme after the 1902 initiative. In the face of the much greater popularity of the International and Colonial Exhibition, such a differentiation was only expedient.[8]

The obstacles that faced museum ethnographic curators in their efforts to acquire the same mass audience as the Exhibitions without relinquishing any academic credibility, are exemplified through contemporary debates concerning the problems posed

by the museum building. Through the internal organisation and classification, in conjunction with the inevitable restrictions imposed by the architecture itself, the museum guided its public through its collections in a specific though not always linear narrative, encouraging implicit, if not explicit, associations. In view of ethnographic curators' claims to the popular (albeit 'scientific') accessibility of the presentation inside the building, it is significant that the external 'shell' – in the case of the larger municipal and national collections – was the 'temple' type. The imposing and distancing connotations of this type of public building were fully appreciated by many contemporary curators and resulted in a series of novel architectural schemes which were designed to overcome this obstacle.[9]

The Colonial exhibitions were notable for precisely the absence of such a monolithic structure and an apparent lack of rigorously imposed control over the viewing space. This semblance of endless choice and unrestricted freedom was an important factor in the effectiveness of these exhibitions in obtaining a broad basis of consent for the imperial project. Through the rhetoric of 'learning through pleasure', the exhibitions achieved the sort of popular appeal that the museums could only dream of. Far more successfully than the museum, whose exhibits could only signify the colonised subject, the exhibitions literally captured these potentially dangerous subjects and reproduced them in a 'safe', contained and yet accessible and supposedly open environment.

This usually meant constructing mock 'villages' stocked with items that were purportedly characteristic and representative of a particular culture. Often peopled by troupes of professional performers from different African societies, Ceylon or other participants from Ireland and Scotland, these 'villages' were always favourites for press attention. Railway and other transport networks within the exhibition grounds had the effect, reinforced by the text in the guidebooks, of allowing the visitor to travel metaphorically from one country to another without ever having to leave the site.[10] Consequently, they cultivated at one and the same time, both a sense of the availability *and* the containability of those societies represented. The 'villages' successfully fostered a feeling of geographical proximity, while the sense of 'spectacle' was calculated to preserve the cultural divide.[11] The possibility of possession as well as a sense of being an active participant at an 'event' rather than simply a passive observer were other aspects of the Exhibition that were lacking in the museum experience. The vicarious tourism on offer was available to all who passed the turnstile at the entrance to the exhibition site, providing they had the sixpenny fee that allowed them access to the so-called 'villages'.

The ensuing competition for the same broad public necessitated the implementation of certain policies in order for the ethnographic curators, in their capacity as museum administrators, to distinguish their appeal from that of the Exhibition. Such strategies served not only to differentiate the two institutions but, more importantly, to legitimise the museum as the domain of the 'authentic' educational experience in the face of the 1902 initiative.

The debate around the use of 'curio' and 'curiosity' as generic terms for ethnographic material is a case in point. Throughout the first decade of the twentieth century these terms were a bone of contention amongst museum officials and early acknowledged by them as one of the major hindrances to any effective educational use of ethnographic material. As evidence of the severity of the problem, the journal of the Museums Association published the following comments by an early visitor to the Liverpool County Museum's ethnographic rooms.[12] The visitor contended that one of the main troubles lay in the unfortunate fact that the public ' ... regard it as a

storehouse of curiosities arranged to please and amuse. Certainly there are curiosities in every museum . . . though the fact may be insisted that their original and foremost purpose is to educate.'[13] The solution advised by the influential body of the League of Empire in 1904 was the 'orderly arrangement and the transformation of mere curios into objects of scientific interest by appropriate classification.'[14]

An early guide from the Horniman Museum in London provides a colourful illustration of the eclectic display policy that the Association was up against. Prior to the Museum's transference into the hands of the London County Council in 1901, descriptions of the Ethnographic Gallery focussed on the slave trade or social groups like the Dahomeyans or the Zulu, both of whom were identified in the popular consciousness as aggressive African fighters with a penchant for human sacrifice and gratuitous violence.[15] Prior to entering the 'African and Japanese Room' the visitor would have passed through the Annexe where a collection of 'deities' from China, India, Scandinavia and Peru were on offer, together with a Buddhist shrine and 'a Chinese banner fixed on the wall, as also a 'skeleton in the cupboard, the bones and ligatures all shown and named; it is labelled: – "the framework on which beauty is founded".'[16] Glass table cases in one room contained Swiss, African, Eskimaux (sic.) Indian, Japanese and Chinese ivory carvings and a collection of Meerschaum pipes, while on top of such cases, 'are ranged glass Jars, containing Snakes, Lizards, Chameleons and a strange looking spiny lizard from Australia, together with a chicken with four legs and four wings but only one head, hatched at Surrey Mount' (the Museum's earlier name).[17] The visit culminated with a walk through the 'Zoological Saloon' and a meeting with the much publicised Russian bears, Jumbo and Alice and the Sal monkey, Nellie!

II

The debates in the Museums Association over the classification of ethnographic material were considerably more complex and comprehensive than the resultant displays. The proposals revolved around the choice between a geographical or a typological organisation and the relevance of either for different types of anthropological museum. The general consensus delegated the former as the responsibility of the national collections and the latter as that of the local museums. The material at hand was broadly recognised as falling into the two categories of a biological unit and a cultural unit. Ideally, since 'Man's physical evolution and anatomical structure related directly with all his activities', race and culture were assumed to be 'intimately connected'. The objective for the curator was to demonstrate the relationship between the two.[18]

Sub-divisions according to tribe and nation, however, provoked discussion that provides us with a particular insight into the function of ethnographic collections in Britain. In this case, colonies as a category acquired the status of a homogeneous 'nation', as part of the British Empire. Evidently, by this definition 'nation' was too large a grouping to be practically implemented in a museum! Nevertheless, the fact that a territorial possession of the British Empire had no recognised status as a nation outside of the Empire as a whole, had particular ramifications for any colony represented in the displays. Clearly, material culture from these countries functioned primarily as signifiers of British sovereignty. Above all, in this search for the perfect classification system, there was the certainty that somewhere there existed a 'natural'

grouping. Since culture was seen to vary according to geographical and regional factors and since environmental factors created regional affinities within the same groups, the 'natural' choice was thought to rest with a geographical classification. This was the arrangement selected by most large British collections.

The other system advocated for smaller local collections was morphological or typological; the most exemplary, then as now, being the Pitt Rivers Museum in Oxford. The theoretical premise that the past could be found in the present was explicitly laid out here by inclusion of archaeological exhibits (mainly weapons and implements) from the Stone, Bronze and Early Iron Ages, alongside typological 'series' of material culture from various colonies. It was this type of organisation that was thought to illustrate more specifically the evolutionary nature of man. It concentrated on series of objects from all over the world, grouped according to function and divided into small exhibition groups with the aim of suggesting an evolutionary progression, by placing those forms classified as more 'natural' and organic at the beginning of the series culminating in more 'complex' and specialized forms. A feature of Pitt Rivers' collection which set it apart from others originally the property of one collector (such as Frederick J. Horniman), was that it was widely acknowledged as being 'no mere miscellaneous jumble of curiosities, but an orderly illustration of human history; and its contents have not been picked up haphazard from dealers' shops, but carefully selected at first hand with rare industry and judge-ment.'[19] The classification system employed was the touchstone of the collection, and it was this aspect that recommended it as a model for so many other museums.

This comparative and evolutionary system of classification, which placed the value of anthropology as 'tracing the gradual growth of our complex systems and customs from the primitive ways of our progenitors' through the use of material culture from extant peoples (all of whom were colonised), was the chosen taxonomy throughout this period.[20] Despite academic anthropology's increasing disenchantment with evo-lutionary theory at this time, it remained the most prevalent means of displaying ethnographic material. Even where this was not necessarily the case in museums, it is clear that this principle had acquired a considerable currency amongst many members of the museum public. In 1902 for example, the British Museum erected an exhibition in the prehistoric room to demonstrate the use of tools and weapons prior to the use of metals. A review of the exhibition in *The Standard*, drew the readers' attention to the ethnographic galleries, 'which should be visited, in order to study perishable objects still in use among races in a stage of culture corresponding more or less closely to that of the prehistoric races by whom the objects in this (the prehistoric room) were made.'[21] It is important to recognise that, whether intended by the British Museum or not, it is symptomatic of the conjuncture that existed in the 'public' consciousness that the reviewer was able to make such a comparison between the two rooms.

III

Moreover, there is also evidence that the evolutionary paradigm served as a direct means of promoting support for that concept of class unity which was so essential to the ideology of social imperialism. Although the primary objective of the Oxford museum was to facilitate academic research, Pitt Rivers was no newcomer to the conception of the museum as an institution with a broad educational role, appealing to a diverse public. Indeed he actually saw himself as one of the main progenitors of

this initiative. The early history of the collection included a short sojourn in 1897 at the Bethnal Green Museum in London's East End. It is not insignificant that it was located in an area of social deprivation and class conflict. In line with other similar institutions during the 1870s, the exhibits were used as an aid in the task of 'improving the masses'. Pitt Rivers' own intentions towards the working classes were quite explicitly set out in relation to the use of his collection. His lecture to the Society of Arts in 1891 makes it clear that not only was it important that the schema of the display conform to a 'scientific' classification, but that it was designed to educate 'the masses' to accept the existing social order:[22]

> The masses are ignorant . . . the knowledge they lack is the knowledge of history. This lays them open to the designs of demagogues and agitators, who strive to make them break with the past . . . in drastic changes that have not the sanction of experience.[23]

In the light of this statement, the persistent preoccupation with evolutionary theory takes on new and more explicitly political overtones. Through its tangible exposition in the physical arrangement of ethnographic collections, it was a paradigm which emphasised the inevitability and indispensibility of the existing social order and its attendant inequalities, while also stressing the need for a *slow* move towards technological advancement.[24]

Where Pitt Rivers is explicit in his political affiliations in relation to class interests (while still maintaining that science was essentially 'objective' and non-partisan), later uses of evolutionary theory were less overtly concerned with social control. Nevertheless, it was one of the most long-lived paradigms for the organisation of displays of material culture from non-western societies and there are certain features of later applications which reproduce the political assumptions of this earlier model. In both typological and geographical arrangement, for example, cultural elements characterised in the museum's literature as 'the intrusive, generalised elements of civilisation' of the non-European cultures, were deliberately eliminated. The curator was well aware that 'modern civilisation, has broken over all natural limits and by means of railroads and ships carries its generalised culture to the ends of the earth'.[25] But the resultant transformations brought about by this contact was not the designated domain of the ethnographic curator.[26] For the material in these displays, then, and by implication the cultures they represented, time stood still.

As a means of validating the expansion of ethnographic collections, the rhetoric often employed was one of the necessity of conservation and preservation in the face of the inevitable extinction of the producers of the material culture in their custody.[27] Paradoxically, of course, anthropology's desire for government funding in the museum context as in the academic sphere, necessitated its aiding and abetting this extinction by proposing itself as the active agent of the colonial government. By speeding the inevitability of such destruction, anthropologists encouraged the expansion of the market in ethnographia and boosted the already multiple values assigned to the discipline's objects of study thus enhancing the status of anthropological 'knowledge', while simultaneously ensuring that those societies who produced such material culture maintained their position at the lower end of the evolutionary scale, since they were destined not to survive.

Since, unlike the International and Colonial Exhibition, the colonised subject was not available in the 'flesh', their presence had to be signified by some other means. By 1902, the principle that physiognomic characteristics were accurate indicators of

intellect and morality (early ingested as a tenet of certain anthropological theses) acquired new potency through its association with the eugenics movement, now marshalled more deliberately to the aid of the state. If evolutionism had ever looked like wavering, it was now here to stay. Consequently, in museum displays of material culture from the colonies, it was common practice to include photographs, casts of the face or of the figure, or even skeletons and skulls. These were supposed to demonstrate more nearly the relationship between the inherited and cultural features of any race since:

> The man himself as he appears in his everyday life, is the best illustration of his own place in history, for his physical aspect, the expression of his face, the care of his person, his clothes, his occupations . . . tell the story with much clearness.[28]

In 1903, the Physical Deterioration Commitee had recommended the setting up of an Imperial Bureau of Anthropology, whose anthropometry section was to be responsible for the collating of data on the physical measurements of those races coming under the jurisdiction of the British Empire.[29] Despite the fact that by 1908 the Royal Anthropological Institute was still fighting for some government support for the scheme, anthropometry had already been put to considerable use by anthropologists working within the British Isles.[30] The Physical Deterioration Committee, under whose aegis anthropometry came into its own in the following years, had originally been set up in response to medical reports on the poor state of health of the working class.[31] While this generated concern about the social circumstances of the mass of the population, the ensuing debate around the issues of deterioration versus degeneration was fuelled by the eugenists, who were still mostly convinced of the biological and inherited, rather than environmental, determinants of such a deterioration. If this complex 'scientific' philosophy had ambiguous implications for the working classes, its implications for colonised peoples are as insidious.[32]

The ethnographic curators' insistence that a person's physiognomy and the expression of the face could designate their position in history takes on particular significance in the context of this preoccupation with and popular visibility of the 'science' of anthropometry. The emphasis on the body as a feature of museum display would have made it difficult to avoid an association with the work of Francis Galton or Karl Pearson, especially at a time of increasing government advocation of eugenics (often in conjunction with 'anthropological' investigations) as a means of strengthening the national stock. Evidently, the Museums Association were fully aware of eugenics policies and the means by which the ideology of selective breeding was implemented as part of a policy of national regeneration. That the 1907 Presidential Address of the Association reads like a eugenics tract, therefore, comes as no surprise. At this meeting, a proposal was put forward for an Institute of Museums where once again the emphasis was educational, but where, significantly,

> of equal importance would be a regard for heredity teaching, seeing that the teaching of evolution must be based upon it. Here the endeavour would be to instruct the public in the part that inherited traits, character, virtues, vices, capabilities, temper, diseases, play in the destinies of men . . . and to popularise such branches of the subject of heredity as selection, variation and immunity.[33]

The fact that this practice of scrutiny so close to the prevalent eugenic ideology is present to such a degree in the discourse of the Museums Association, is another

indication of the museums' willingness to participate in the state's concern for national regeneration, and points to a further complex of meanings inscribed in the objects in their collections that was far closer to home.

<p style="text-align:center">IV</p>

One means of gauging the potential of the ethnographic collections, both as vehicles for a nationalist ideology *and* as sites for the proliferation of contradictory and therefore productive knowledges concerning the colonial subject, is through an examination of the discourses around education in the literature of the Museums Association for the period 1902–1910. It is through these discourses that museums constituted their 'ideal' publics and consequently the 'ideal' function of the collections in their custody.

Much of the discussion was formulated as a result of renewed interest in a concept known as the 'New Museum Idea'. The primary objective of this 'idea' was to 'afford the diffusion of instruction and rational amusement among the mass of the people' and only secondly 'to afford the scientific student every possible means of examining and studying the specimens of which the museum consists'.[34] The museum was thus designated as provider of both 'rational amusement' and 'scientific study' for two distinct publics while prioritising one. What is particularly interesting here is that the 'New Museum Idea' was anything but new by 1902. Between 1902 and 1910, however, the need to attract what was loosely referred to as 'the mass of the people', is revived as one of the central concerns for museum curators. How then was this purportedly liberal extension of the democratic principle of 'education for all' transformed through the institution of the museum, into a discourse inextricably implicated in imperial ideologies?

The notion of an educational practice based on the careful observation and study of museum collections had already been integral to both the Victoria and Albert Museum and the National Gallery from their inauguration in the 1850s. And here also it was designed to attract a certain sector of the working class. Although this early initiative came primarily from a left middle-class intelligentsia, demands from within the working classes for effective educational provision were later met by workers themselves through the Social Democratic Federation and other socialist organisations.[35] The fact that 'rational amusement for the mass of the people' was reintroduced as a focus of debate within the museums establishment in 1902, by which time the composition and strength of the working class had altered considerably, indicates a new function for this concept. With the rise of socialism and the subsequent organisation of a large proportion of the working class, it presented enough of a constituency to be a major target in the electoral campaigns of both the Liberals and the Conservatives throughout the period under discussion. If the museums wanted to carve out a role for themselves compatible with either party's campaign, it was essential that they were seen to address a broad public.

By 1902 it is possible to determine more precisely the publics that were sought by museums in Britain. The Education Act of that year had made provision for time spent in museums by children accompanied by their teachers to count as time spent in school. The *Museums Journal* of the same year expressed the hope that museums could occupy a territory 'neutral' enough to provide a common meeting ground for

children from 'different class backgrounds' in so far as those from private, board and voluntary schools were seen to benefit from the Act in this respect. Furthermore, in conjunction with such adjectives as 'neutral' and 'objective', the museum was proclaimed as:

> the most democratic and socialistic possession of the people. All have equal access to them, peer and peasant receive the same privileges and treatment, each one contributes in direct proportion to his means to their maintenance and each has a feeling of individual proprietorship.[36]

The notion of the museum as an institution that transcended class barriers is particularly significant, not only in the light of the persistent claims for class unity made by organisations dedicated to juvenile education reform, but also in view of the constancy with which this rhetoric was applied in organisations dedicated to the 'ideal' of Empire, who also mobilised the pedagogic apparatus. The Primrose League, for example, was a society that specialised in popularising Empire through lectures in rural districts and was founded in 1883 with the aim of 'joining all classes together for political objects . . . to form a new political society which should embrace all classes and all creeds except atheists and enemies of the British Empire'.[37] By 1900 the League claimed to include in its membership one and a half million workers and agricultural labourers. The special role of the museum for that sector of society described as having no life 'but this life of making money so that they can live', was 'to elevate [them] above their ordinary matter-of-fact lives'.[38]

By 1904 both the Horniman and the Manchester Museum were making claims for the conspicuous presence of both school groups and working-class participation. An exchange in the *Museums Journal* of the same year indicates the degree to which this was now a sensitive issue, in this instance, in the case of ethnographic collections. Free public lectures by A. C. Haddon, the Cambridge anthropologist, now advisory curator of the Horniman, had come in for sharp criticism since, 'The time for delivery . . . is 11.30 a.m. which showed that they were not altogether intended for the labouring classes'.[39] The Horniman felt this rebuff keenly enough to respond that despite this unfortunate time schedule 'large parties of workmen from various institutions . . . visited the museum'.[40]

Obviously one should not take the intention as a measure of its effectiveness, but it is important to point out here that the fact that both museums and other public displays of material culture from the colonies felt in some way obliged to define their publics as having a large working-class component, and in terms of an educational priority, is significant in itself, whether or not it was successfully implemented. The emphasis on this priority is more easily understandable in the context of social imperialism, whereby the working classes were wooed by both Liberals and Conservatives on two fronts: imperialism and social reform. As a principle, this policy was designed to unite all classes in the defence of nation and empire by focusing its campaign on convincing the working classes that their interests were best served by the development and expansion of Empire.[41] And it is evident as early as 1902 that museums' concern with constructing their image as an organ for popular education was, indeed, specifically calculated to ensure that they had a recognised part to play in what was acknowledged at the Museums Association annual conference that year, as the 'one great national work, the building up of the Empire through the elevation of the communities and the individual'.[42]

In 1903 this declared allegiance was compounded by the formation of the League of Empire, founded with the aim of bringing children from different parts of the Empire into contact with one another, and 'getting them acquainted' with parts of it other than those in which they lived, through correspondence, lectures and exchanges. The museums played a crucial role in this organisation and one which was clearly signalled by the distinguished line-up of museum directors and officials heading a sub-committee entitled 'School Museum Committee'. By 1907 the Museums Association was congratulating itself on the rather ambitious and dubious achievement of 'splendid success in educating and refining the masses of the population'.[43]

Museums' assumed role as specifically 'popular' educators concerned with encour-aging working-class participation, received a further fillip of approval through a symposium organised under the aegis of the Empire League Educational Committee. This eight day conference, held in London in 1907, had a special interest for those involved in museum work. A section was inaugurated specifically to deal with museums and education. Even outside of the parameters of its own professional caucus, the museum was clearly recognised as an important element in furthering the objectives of the Empire. Any interpretation of this educative principle advocated by both Leagues as simply a benevolent paternalism making use of Empire as a potential 'living geography lesson', should be dismissed after 1908. By this time it had been transformed into a more specific call for the recognition of the superiority of the European races:

> The progress of colonisation and commerce makes it every year increasingly evident that European races and especially those of our own islands, are destined to assume a position in part, one of authority, in part, one of light and leading, in all regions of the world.[44]

Consequently since the British assumed the position of the world's teachers, it was essential that they were themselves well taught.

As late as 1909, the relevance of education, especially through the use of ethno-graphic collections, was as persistent a theme in general museums discourse as it was in the discourse of the professional body of academic anthropology, the Royal Anthro-pological Institute:

> Heaven-born Cadets are not the only Englishmen who are placed in authority over native races ... There are Engine Drivers, Inspectors of Police ... Civil Engineers of various denominations ... to mention only a few whose sole opportunity of imbibing scientific knowledge is from the local museum of the town or city in which they have been brought up.[45]

Clearly, certain class sectors were seen as an indispensable means of promoting an image of the museum as the site of the consummation of a seamless and unproblem-atic national unity. Furthermore, the fact that the terms of this address are borrowed in no small measure from a 1907 speech by that ardent exponent of social imperialism, the Liberal M.P. Viscount Haldane, places it firmly within this political discourse.[46]

V

Part and parcel of this ideology of national unity was the constitution of the concept of a National Culture, and here too the ethnographic curator played a particular role. As

early as 1904, Henry Balfour, Curator of the Pitt Rivers Museum in Oxford and President of the Anthropological Institute, laid plans for what he called a museum of national culture. Balfour went as far as specifying that this museum would denote 'British' in nature rather than possession, which was rather the function of material culture from the colonies as well that in the larger survey museums. 'We want a National Museum', he said, 'National in the sense that it deals with the people of the British Isles, their arts, their industries, customs and beliefs, local differences in physical and cultural characteristics, the development of appliances, the survival of primitive forms in certain districts and so forth.'[47] Although this objective was not realised in the museum context until much later, the proposal for a national, or, more accurately, 'folk' museum, is a persistent element in museums' discourse, throughout the years 1902–1912.[48]

Paradoxically, the same rhetoric of extinction and preservation, once applied by academic anthropologists to specifically colonised races as a means of validating anthropology's expansion, was now systematically applied to certain communities within the British Isles. The conception promoted by this rhetoric of a national British culture as a resilient 'folk' culture, surviving in rural communities, was a popular fantasy shared by those at both ends of the political spectrum, and it was assumed by certain members of the middle-class intelligentsia to be their responsibility to bring it to light in the common cause of national unity.[49] Since 1905 supposed 'folk' culture had already been officially mobilised in the sphere of juvenile education to instill a correct patriotic spirit. By October 1907, Cecil Sharp, that untiring middle-class campaigner for the revival of 'folksong', had published his collection of what he defined as 'authentic' folk music since it was

> not the composition of an individual and as such, limited in outlook and appeal, but a communal and racial product, the expression, in musical idiom, of aims and ideals that are primarily national in character.[50]

While the effects of this discourse were visible through anthropological practice by those working within the discipline, it was not incorporated into museum practice. Its visibility in the public domain lies rather in the sphere of the 'amusement' section of the International and Colonial Exhibition. Here, Irish and Scottish Villages were reconstructed together with Dahomeyan, Somali, and Senegalese Villages. Without exception these are all produced through the official guidebooks as quaint 'survivals' in the anthropological sense. But while both European and African villages were produced as 'primitive', it was a 'primitiveness' that had already been clearly qualified in both cases, in terms that would have been familiar to a large proportion of the exhibition public through the discourse on national tradition constructed through the renewed interest in folklore. Consequently the proximity of these villages on site had the inverse effect of accentuating the distance between the European 'primitive' and their colonial counterpart. This was further reinforced by the suggestion in the guidebooks that, even in these supposedly simple European communities, there was evidence of an inherent superiority in relation to the colonised races represented. The predominance of adjectives such as 'healthy', 'beautiful' and 'industrious' together with descriptions of the Irish and Scottish living quarters as 'spacious', compare favourably with the constantly repeated assurances that the Africans are in fact much cleaner than they look.[51] Similarly, while the guidebooks are full of references to the

ancient traditions of the Irish and the Scots, the Africans are accredited with no such history or tradition.[52]

Thus, what at first appears to constitute an irreconcilable contradiction – the construction of certain 'British' communities as themselves essentially 'primitive' – must be understood as a means by which both museums and exhibitions established the notion of an intrinsically national culture through the discourse of orgination. In addition, by emphasising the relative 'difference' of the black colonised subject, both the museum ethnographic collection and those 'villages' in the International and Colonial Exhibitions representing these peoples reinforced the illusion of a homogeneous British culture.

Because the educational policies adopted by the museums over the period 1902–1910 could be appropriated by either the more conservative ideology of national efficiency or the more liberal ideology of social reform, the ethnographic collections were able to negotiate a particular space for themselves. In an educational capacity they operated in the conjuncture between popular and scientific theories of race and culture, and thus acted as an agency for different imperial ideologies. There was, however, an ambivalence underpinning the relationship of the ethnographic curators to the colonial government. By declaring that their aim was to provide 'objective' education on 'neutral' territory, those anthropologists working within the museums establishment claimed a degree of independence from specific government policies. The emphasis on the 'scientific' nature of the knowledge produced through the classification and organisation of their collections on the other hand, was calculated to reinforce their role as purveyors of 'objective truth'. At the same time, as a deliberate strategy of survival, the new academic discipline of anthropology relied on the argument that anthropological knowledge as produced through museum collections, was an essential training for the colonial civil servant and an indispensible facilitator in the subjugation of the colonies. Furthermore, the focus on evolutionary paradigms as a means of representing material culture from the colonies to British publics reinforced some of the worst aspects of those racial stereotypes disseminated through the more propagandist International and Colonial Exhibitions.

VI

Now, nearly a century later, we find ourselves on the threshold of another educational initiative, equally optimistically referred to as 'Education for All' under the rubric of multi-culturalism.[53] It is a moment when debates on the restitution of cultural property take up prime time in the media. It is also a time dominated by the euphemism of 'rationalisation' for the Arts, Humanities and Education and by a government characterised by the outright hostility to ethnic minorities of Margaret Thatcher's infamous aliens speech and by the jingoism of her Falklands victory speech on the 2nd of July 1982:

> We have learned something about ourselves, a lesson which we desperately needed to learn. When we started out, there were the waverers, and the fainthearts ... There were those who would not admit it ... but – in their heart of hearts – they too had their secret fears that it was true: that Britain was no longer the nation that had built an Empire and ruled a quarter of the world. Well, they were wrong.

How does a museum displaying the material culture of other nations negotiate a position of relative autonomy from the rabid xenophobia characterised by Thatcher's speech, while at the same time justifying its expansion and maintenance?

The controversy generated over an exhibition at the Museum of Mankind, 'The Hidden Peoples of the Amazon', is a useful marker of the problems involved in working towards any self-critical representation of other cultures within a museum context. It also demonstrates how difficult it is to escape the legacy left by the historical formation of the institution itself.

On the 8th August 1985, the Museum was picketed by representatives from Survival International and two Indian representatives from different Indian rights organisations. The demonstration concerned the absence in the display of any evidence of the ongoing struggle between the Indians and the Brazilian government or indeed of any resistance or self-determination by Indian groups such as themselves. According to Richard Bourne (Chairman of S.I.), one of the objections against incorporating evidence of such resistance into the exhibition was that it would have disrupted what was an essentially '*objective*' account.[54] It is also true to say that without the goodwill of the Brazilian Government it would have been extremely difficult to have carried out the extensive fieldwork necessary for the exhibition.

Evidently today, more than ever, the public ethnographic museum is caught between two stools. On the one hand, the museum still perceives itself as both purveyor of 'objective' scientific knowledge and as a potential resource centre for a broad-based multi-cultural education. On the other hand, it is clearly hostage to and sometimes beneficiary of the vagaries of different state policies and political régimes, and aware of the necessity of being seen to perform some vital and visible public function to justify its maintenance, while fighting to preserve a measure of autonomy.

A surprising degree of correspondence still evidently exists between the International and Colonial Exhibitions of old and certain contemporary ethnographic display practices. Now that both scientific exegesis and popular entertainment are contained within the same edifice, the invitation to partake of a vicarious tourism is as strong as ever an incentive to visit the Museum.

Furthermore, despite any criticism levelled at the museum as an institution, its authority speaks louder than the voices of those represented within its walls, as this passage from a recent *Arts Review* testifies:

> During a week in or around the Amazon, I found it difficult to escape from the other tourists and enjoy even a semblance of the jungle . . . This was all white man's territory and for a truer description of life with the Hidden Peoples of the Amazon I would recommend both this exhibition and the fascinating book that accompanies it.[55]

Notes

1 Salman Rushdie, 'The New Empire Within Britain', *New Society,* vol. 62, no. 1047, 1982, p. 417.

2 *Education For All: the Report of the Committee of Inquiry into the Education of Children from Ethnic Minority Groups*, H.M.S.O., March 1985. The Committee was initially chaired by Anthony Rampton until 1981 when Lord Swann took over. A. Sivanandan's comments on the distinction between a multi-culturalist education initiative and one that is actively anti-racist, are worth citing in full here:

'Now there is nothing wrong with multiracial or multicultural education as such, it is good to learn about other races, about other people's cultures. It may even help to modify individual attitudes, correct personal biases. But that ... is merely to tinker with educational methods and techniques and leave unaltered the whole racist structure of the educational system. And education itself comes to be seen as an adjustment process within a racist society and not as a force for changing the values that make that society racist. "Ethnic minorities" do not suffer "disabilities" because of "ethnic differences" ... but because such differences are given a differential weightage in a racist hierarchy. Our concern ... was not with multi-cultural, multi-ethnic education but with anti-racist education. Just to learn about other people's cultures is not to learn about the racism of one's own.' A. Sivanandan, 'Challenging Racism: Strategies for the 80's', *Race and Class*, vol. xxv, no. 2, Autumn 1983, p. 5.

For an excellent analysis of the multi-cultural experiment in one case study see also, Sneja Gunew, 'Australia 1984: A Moment in the Archaeology of Multiculturalism', in *Europe and its Others*, eds., F. Barker *et al.*, vol. 1, University of Essex, 1985, pp. 178–93.

3 *Agenda of the Annual Conference of the Museum Ethnographers Group* (a Sub-Committee of the Museums Association), held on 25 April 1986, at the Bristol Museum and Art Gallery. Item 9.2 reports a discussion on the 'new' (my emphasis) importance of multi-cultural education and a request from some members that the M.E.G. form a policy regarding dealings with the apartheid régime in South Africa.

4 See, for example, the recent debates in one of the two journals of the Royal Anthropological Institute (*Anthropology Today*); Jean la Fontaine (President of the Institute), 'Countering Racial Prejudice: a Better Starting Point', vol. 2, no. 6, 1986, pp. 1–2; Mary Searle-Chatterjee, 'The Anthropologist Exposed: Anthropologists in Multi-Cultural and Anti-Racist Work', vol. 3, no. 4, 1987, pp. 16–18; Stephen Feuchtwang, 'The Anti-Racist Challenge to the U.K.', vol. 3, no. 5, 1987, pp. 7–8; Brian V. Street, 'Anti-Racist Education and Anthropology', vol. 3, no. 6, 1987, pp. 13–15.

5 For a detailed analysis of the 1902 Education Act, see G. R. Searle, *The Quest For National Efficiency* (Berkeley and Los Angeles, 1971), pp. 201–16; E. Halevy, *History of the English People* (*Epilogue: 1895–1905. Book 2*) (Harmondsworth, 1939), pp. 114–129; B. Simon, *Education and the Labour Movement 1870–1920* (London, 1965), pp. 208–46.

6 The Museums Association was founded in York in 1888 at the initiation of the York Philosophical Society as the professional body of museum curators and administrators. *The Museums Journal*, founded in 1901, was to represent the interests of all types of museums within Britain mainly, but also the Empire and later the Commonwealth and Dominions. The aim of the monthly publication was inter-communication between the museums in the association.

7 One of the largest purpose-built exhibition sites in England was London's 'White City' built in 1907 by Imre Kiralfy and so called because it covered approximately 140 acres. For more details concerning these exhibitions in Britain see Annie E. Coombes, ' "For God and For England": Contributions to an Image of Africa in the First Decade of the Twentieth Century', *Art History*, vol. 8, no. 4, 1985, pp. 453–66 and 'The Franco-British Exhibition: Packaging Empire in Edwardian England', *The Edwardian Era* (Oxford, 1987), eds. J. Beckett and D. Cherry, pp. 152–66; Paul Greenhalgh, 'Art, Politics and Society at the Franco-British Exhibition of 1908', *Art History*, vol. 8, no. 4, 1985, pp. 434–52; John M. MacKenzie, *Propaganda and Empire* (Manchester, 1984), pp. 96–121.

8 The distinction was implicit rather than explicit and is demonstrated through the absence of almost any discussion or mention of exhibitions in the pages of the *Museums Journal* despite the active participation by members of the Museums Association and in particular by anthropologists. Such silence is stranger in view of the fact that many museums including the Horniman, Liverpool County Museum and the Pitt Rivers Museum acquired ethnographic material from such sources.

9 See, for example, B. I. Gilman, *Museum Ideals of Purpose and Method* (Boston, 1923), pp. 435–42.

10 See, for example, *The Imperial International Exhibition, Official Guide* (London, 1909), p. 43. Describing the 'amusement' entitled the 'Dahomey Village', the writer says, 'Entering the Gateway here, we are at once transported to Western Africa'. The entry for the 'Kalmuck Camp' in the same guide (p. 45) began, 'Entering their camp, we first detect them coming down the distant steep mountains with their camels and horses'.

11 This division was clearly not maintained as rigorously as the authorities would have wished. See Ben Shephard, 'Showbiz Imperialism: The Case of Peter Lobengula', in *Imperialism and Popular Culture*, ed. John M. MacKenzie (Manchester, 1986), pp. 94–112. This examines an instance of marriage between an African 'performer' and a white woman and the ensuing furore over miscegenation in the press.

12 *The Museums Journal* contained regular comments from visitors to the various collections.

13 *Museums Journal*, vol. 2, March 1903, p. 269.

14 *Ibid.*, vol. 2, Sept 1904, p. 101.

15 *First Guide to the Surrey House Museum*, n.d. (pre 1901), p. 9.

16 *Ibid.*

17 *Ibid.*, p. 19.

18 W. H. Holmes, 'Classification and Arrangement of the Exhibits of an Anthropological Museum', *Journal of the Anthropological Institute*, vol. xxxlll, 1902, pp. 353–72, p. 353; Christine Bolt, *Victorian Attitudes to Race* (London, 1971), p. 9.

19 *University Gazette*, January 1883, p. 4.

20 William H. Flower, 'Inaugural Address to the British Association for the Advancement of Science', *Nature*, vol. 40, Sept 1889, p. 465.

21 *The Standard*, 3 March 1902.

22 Lieutenant General Pitt Rivers, 'Typological Museums as Exemplified by the Pitt Rivers Museum at Oxford, and His Provincial Museum at Farnham, Dorset', *Journal of the Society of Arts*, vol. XL, 18 Dec. 1891, pp. 115–122. This was also the theme of an address to the British Association For the Advancement of Science at Bath, 1888. For a history of the Pitt Rivers collection up to 1900 see William Ryan Chapman, *Ethnology in the Museum: A.H.L.F. Pitt Rivers (1827–1900) and the Institutional Foundation of British Anthropology*, 2 vols. (unpublished D.Phil. dissertation, University of Oxford), 1981.

23 Lieutenant General Pitt Rivers, *op. cit.*, p. 116.

24 See Lieutenant General Pitt Rivers, *op. cit.*, p. 119. Evolutionary theory as applied in Pitt Rivers' collection clearly also had implications for the 'new woman'. In this passage Pitt Rivers describes a series of crates shown carried by women from various countries. According to him these were 'collected expressly to show the women of my district how little they resemble the beasts of burden they might have been if they had been bred elsewhere.'

25 Holmes, *op. cit.*, p. 355.

26 *Ibid.*

27 See for example, *Annual Report of the Committee of the Public Libraries, Museums and Art Galleries of the City of Liverpool* (Liverpool, 1894), p. 15; *Museums Journal*, vol. 10, Nov. 1910, p. 155.

28 Holmes, *op. cit.*, p. 356.

29 See *Man*, vol. 11, 1911, p. 157; A. Watt Smyth, *Physical Deterioration: Its Causes and the Cure* (London, 1904), pp. 13–14.

30 *Journal of the Royal Anthropological Institute*, vol. xxxvlll, 1908, pp. 489–92; *Man*, no. 9, 1909, p. 128 describes the 'science' as demonstrating 'how measurement of physical and mental characteristics are a reliable test of physical deterioration and progress'.

31 See Watt Smyth, *op. cit.*

32 G. R. Searle, *Eugenics and Politics in Britain 1900–1914* (Leyden, 1976); G. R. Searle, 'Eugenics and Class', in *Biology, Medicine and Society 1840–1940*, ed. Charles Webster (Cambridge, 1981), pp. 217–43; David Green, 'Veins of Resemblance: Francis Galton, Photography and Eugenics', *Oxford Art Journal*, vol. 7, no. 2, 1984, pp. 3–16, provides a

useful documentation of the interrelation between photographic techniques of recording social 'deviancy' and the classification deployed by some eugenists; Anna Davin, 'Imperialism and Motherhood', *History Workshop Journal*, 5, 1978, pp. 9–65, gives an excellent analysis of the contradictory implications of eugenic theory for British women. See also Jeffrey Weeks, *Sex, Politics and Society: the Regulation of Sexuality since 1800* (London, 1981); Frank Mort, *Dangerous Sexualities, Medico-Moral Politics in England Since 1830* (London, 1987).

33 *Museums Journal*, vol. 7, Dec 1907, p. 203.

34 William H. Flower, Presidential Address to the Museum Association, London, 1893. Reprinted in W. H. Flower, *Essays on Museums and Other Subjects Connected with Natural History* (London, 1898), p. 36.

35 For a detailed analysis of educational initiatives from within the working class see Brian Simon, *op. cit.*

36 *Museums Journal*, vol. 2, Sept 1902, p. 75.

37 See J. H. Robb, *The Primrose League, 1883–1906* (London, 1942), p. 148.

38 *Museums Journal*, vol. 2, July 1902, p. 11.

39 *Museums Journal*, vol. 3, Feb 1904, p. 266.

40 *Museums Journal*, vol. 4, Jan 1905, p. 235.

41 For a fuller discussion of the policy of social imperialism see Bernard Semmel, *Imperialism and Social Reform* (London, 1960), and G. R. Searle, *op. cit.*, 1971.

42 *Museums Journal*, vol. 2, July 1902, p. 13.

43 *Museums Journal*, vol. 7, July 1907, p. 8.

44 *Museums Journal*, vol. 8, July 1908, p. 12.

45 *Museums Journal*, vol. 9, Nov 1909, p. 202.

46 Viscount Haldane, *Universities and National Life* (London, 1912), p. 69 (given as a Rectoral Address in 1907). See also Viscount Haldane, *Education and Empire* (London, 1902); Brian Simon, *op. cit.*, ch. 5, 'Imperialism and Attitudes to Education'.

47 Henry Balfour, 'Presidential Address', *Journal of the Anthropological Institute*, vol. xxxlv, 1904, p. 16.

48 See, for example *Museums Journal*, vol. 3, June 1904, p. 403; *Museums Journal*, vol. 1, 1901–2, p. 173; *Museums Journal*, vol. 9, July 1909, pp. 5–18.

49 D. Harker, 'May Cecil Sharp Be Praised?', *History Workshop Journal*, vol. 14, Autumn 1982, p. 54.

50 C. Sharp, *English Folk Song: Some Conclusions*, Privately printed, 1907, p. x, quoted in D. Harker, *op. cit.*, p. 55.

51 See, for example, *Franco-British Exhibition Official Guide to the Senegalese Village*, London, 1908, p. 8.

52 See, for example, *The Franco-British Exhibition Official Guide*, London, 1908, p. 53. This lists no less than five 'realistic reproductions' of 'ancient monuments' included in the 'Irish Village' of Ballymaclinton.

53 See note 2.

54 R. Bourne, 'Are Amazon Indians Museum Pieces?', *New Society*, 29 Nov 1985 (my emphasis).

55 B. Beaumont-Nesbitt, 'The Hidden Peoples of the Amazon', *Arts Review*, 24 May 1985, p. 253.

Chapter 23 | Eleanor Heartney
Fracturing the Imperial Mind

It has become a commonplace to assert that museums embody ideologies. Today one rarely hears them extolled as neutral temples of timeless art, exemplars of the disinterested study of art history or monuments to informed consensus. Instead, they are more likely viewed as artifacts in themselves whose practices reveal the unspoken assumptions of their founders or custodians. Nowhere are such ideological origins more obvious than at London's Victoria and Albert Museum. Founded in 1857 in the wake of the Great Exhibition of the Works of Industry of All Nations (1851), the V & A, as the museum is popularly known, echoed that event's faith in progress, modernity and science. Like the Crystal Palace, the exhibition hall that was the crown jewel of the Great Exhibition, the V & A was created to affirm the superiority of British culture, while demonstrating the beneficial impact of Western civilization on the rest of the world. Nowadays, the museum houses a rather eclectic collection of applied and fine arts displayed according to shifting categories: objects are arranged at times by material, at times by country of origin and at times by function. The effect resembles the strange classification system of that "certain Chinese encyclopedia" Borges famously wrote about.

This spring things got even more complicated as the V & A submitted to an artistic deconstruction in the form of an exhibition titled "Give & Take." A collaboration with the nearby Serpentine Gallery, the show was a two-part project overseen by the Serpentine's chief curator, Lisa Corrin. At the Serpentine, visitors could view "Mixed Messages," an installation by New York-based artist Hans Haacke of over 200 objects from the V & A. Simultaneously at the V & A, works by 13 artists or artist teams were integrated by Corrin into the existing galleries of the museum. Together the two experiments shed light on the ways that the V & A has participated in the creation of a sense of esthetic history and national identity.

Both Haacke and Corrin have previous experience with this sort of exhibition. In 1992, Corrin organized Fred Wilson's "Mining the Museum," a project in which Wilson installed elements from the Maryland Historical Society at the Contemporary Museum in Baltimore. For a 1996 exhibition titled "Viewing Matters: Upstairs,"

Eleanor Heartney, "Fracturing the Imperial Mind" from *Art in America* 7 (July 2001), pp. 51, 53, 119. Reprinted by permission of Brant Publications, Inc. (Reprinted without illustrations.)

Haacke similarly recontextualized elements of the collection of the Museum Boijmans Van Beuningen in Rotterdam. Common to these and other such shows (another example being Joseph Kosuth's "Play of the Unmentionable" at the Brooklyn Museum in 1992) is the unearthing and reshuffling of historical and artistic objects from a specific museum collection in order to bring out sublimated attitudes toward race, class and political power.

In the holdings of the V & A, Haacke had a rich trove of material to draw on. Mimicking the museum's own eclectic installation techniques, he transformed the more austere Serpentine galleries into rooms that loosely reflected historic and current British attitudes toward race, gender, colonialism and religion. Far more playful in spirit than many of his previous critiques of the culture industry, Haacke's installation was full of telling juxtapositions and blatantly politically incorrect objects. In the entry gallery, for instance, a grand celebration of British imperialism was subtly undermined by various discordant elements. The centerpiece (deliberately placed slightly off center to break down the expected symmetry) was an elaborate Victorian mirror flanked by vases emblazoned with the images of Queen Victoria and Prince Albert. Created for the Great Exhibition of 1851, these vessels were in fact the first items acquired for the V & A collection. Alongside this tableau were other elements: a staged Victorian photograph of an ascendent Britannia in classical military garb, a potted palm (signaling the emphasis on exotic colonial lands in the rooms to come), a commemorative Chinese fan and a photograph by the contemporary artist Richard Billingham. The latter, part of the artist's photographic chronicle of his own dissolute, working-class family, depicts his overweight mother in a flowered mumu piecing together a jigsaw puzzle. Breaking through the mythology of triumphant progress that suffuses the other objects, this image introduced issues of economic and social inequality and raised the specter of England's post-WWII decline.

The rooms that followed were governed by different themes. One gallery was devoted to the intersection of gender, sexuality and race. Academic marble sculptures of naked women shared space with fashionably decadent models in Helmut Newton's fashion shots. A third version of sexuality was introduced by a lithograph of Edvard Munch's wraithlike *Madonna*, apparently in the throes of orgasm. In a vitrine, a Ken doll could be seen sticking his hand up Barbie's dress before a backdrop of erotic Japanese ukiyo-e prints. Chinese export figurines depicted dalliances between Western men and Chinese women. A Versace mesh dress hung next to a 16th-century suit of Saracen armor that might have been its inspiration. Dante Gabriel Rosetti's 1880 painting *The Day Dream* presented a wan and otherworldly Jane Morris, while a late-19th-century game board instructively offered "The Path to Matrimony." Taken together, the objects played the Victorian vision of woman as Madonna or whore against the fantasy of exotic sex promised by Orientalism.

Another room was devoted to the contradictions of colonialism. The centerpiece here was a large painting by Henry Courtney Selous titled *The Opening of the Great Exhibition* (1851). It represents Queen Victoria and family surrounded by imperial dignitaries gathered inside the pavilion of the Great Exhibition. Markers of colonial exoticism abound, including the giant palm tree sheltering the royal family, a Chinese envoy in native garb and a uniformed Indian officer. Haacke flanked this august gathering with small aquatints that emphasize the dissonance between native street life and European architecture in 19th-century Calcutta. A more dramatic counterpoint to Selous's painting was supplied by a crude painted-wood sculpture created by

a Vietnamese teenager. This unusual toylike object (whose presence attests to the wild variety of the V & A's collections) depicts two brothers, the elder of whom raises his arms in horror as his oblivious younger sibling drops a turd on the ground.

The room also contained other remarkable objects and juxtapositions. There were 19th-century South Indian paintings of Westerners participating in tiger hunts, smoking hookahs and otherwise "going native." An elaborate "Inca" headdress created for the 2000 Notting Hill Carnival hung on one wall. August Sander's photographs of various socioeconomic types in pre-Nazi Germany were juxtaposed with Carl Dammann's album of South African Racial Types and with photographs by 19th-century photographer Felice Beto of scenes from "native life": a coolie in full dress, a Japanese girl at her toilet, two Indian grooms displaying their tattoos.

Again, toys were instructive. Vitrines contained such curiosities as a 19th-century doll of European origin that could be made into a white girl or a black boy with the addition of assorted heads, arms and legs; an inflatable golliwog from the 1950s; various mammy dolls and a board game from 1822 whose name seemed to sum up the official British position on the colonial world: "The Noble Game of the Elephant and Castle, or Traveling in Asia, Combining Amusement with Instruction for Youth of Both Sexes."

A third theme was religion, more reverently treated than Haacke's other subjects. Here he gathered artifacts representing the great religious traditions from various V & A galleries where they had been segregated and let them coexist in a single space. The arrangement of this gallery was spare and chapel-like. A tortured Christ from 13th-century Tuscany hung opposite an 18th-century Burmese Buddha. Another wall was dominated by a 17th-century Dutch Torah mantle, and the fourth contained a pair of 19th-century Islamic prayer rugs from Turkey. In the center of the room was a plaster cast of Michelangelo's *Dying Slave*, whose transported expression served to suggest both religious ecstasy and mortal suffering.

In interviews about the show, Haacke has noted that he had in mind the Surrealist game of Exquisite Corpse, in which a folded piece of paper is passed around to various participants, each of whom must produce a section of a drawing without knowing what his companions have drawn. It is not a completely satisfying analogy since, of course, Haacke is the sole author of these arrangements. However, the reference does suggest the sense of disjuncture that resulted from some of his juxtapositions. But in the end, it all did add up to something – a fractured picture of the imperial mind which re-creates the surrounding reality to suit its purposes.

Among the 13 installations at the V & A, three were commissioned specifically for this show. The other interventions involved previously created works in settings that gave them new resonance. Some blended in so artfully that they appeared to be part of the usual display. For instance, Xu Bing's red and yellow banner hanging above the museum entrance appeared to be announcing some special exhibition in Chinese characters, but in fact was an example of his "New English Calligraphy" (Roman letters artfully disguised as Chinese ideograms). An astute visitor could read, in the exoticized English letters, the slogan: "Art for the People." Just inside the museum, a monumental black-and-white photographic portrait of Queen Victoria turned out to be one of Hiroshi Sugimoto's photographs of wax effigies from Madame Tussaud's.

Within the galleries, the contemporary works often provided a modern twist to the fine- and applied-arts traditions celebrated in the surrounding space. For instance, Liza Lou's 1991–95 *Kitchen*, an extravagantly beaded replication of a typical Ameri-

can kitchen, was placed opposite the cafeteria, where its magical nature contrasted with the banality of the real thing. Wim Delvoye's contribution, placed in the entry to a gallery devoted to 16th-century European art, was an elaborately carved teak object which resembled, at first glance, an enormous Baroque bell. In fact, it is a cement mixer carved to Delvoye's specifications by artisans in Indonesia. Marc Quinn, who gained considerable notoriety in the "Sensation" show with a refrigerated cast of his head made of his own blood, here infiltrated the idealized marble statues in the Sculpture Hall. Playing off the missing appendages of classical sculptures, his marble figures depicted real, imperfect individuals who have lost limbs through accident or congenital defect.

A room of the museum devoted to "Fakes and Forgeries" hosted Roxy Paine's *SCUMAK*, a computer-programmed machine that created a bulbous polyethylene sculpture daily. In the Baroque and Rococo period rooms, visitors discovered four stainless-steel Jeff Koons sculptures from 1986 sitting on elaborate pedestals and sideboards: a bust of an 18th-century Italian woman, a pail, a kitschy drinking accessory caddy and a deliberately tasteless rendering of a doctor giving a shapely woman a shot in her derriere. These pieces were effectively returned to the sphere of decorative arts that they were created to satirize, but while the period bust fit in almost seamlessly, Koons's other items jarred by introducing issues of class and social status into an environment meticulously designed to render such realities invisible.

Meanwhile, in both the entrance hall and ceramic gallery, viewers could hear the specially commissioned audio installation *Use Value* by Neil Cummings and Marysia Lewandwoska. An audiotape brought the normally isolated sounds of the museum's restaurant – diners conversing, dishes being washed and stored, plates breaking – into the museum proper, where one was left to ponder the difference between functional objects in use and on display.

Other works were more overtly subversive of the social meanings embedded in the exhibitions and collections of the V & A. For instance Yinka Shonibare's much-exhibited *Mr. and Mrs. Andrews without Their Heads* (1998) was set in a vitrine in the "Textiles and Dress" section of the V & A. An altered re-creation of Thomas Gainsborough's famous portrait, it presents headless mannequins in the poses of a prosperous couple on the grounds of their country estate. By using black mannequins and making the hunting clothes they wear out of "African" fabric (actually produced in Holland), Shonibare highlights the racial segregation which underlies the British class system.

Also in the "Dress" galleries was a specially commissioned version of J. Morgan Puett and Suzanne Bocanegra's *The Manhattan Tartan Project* from 1999–2001. Dozens of tartan suits and tartan-covered objects were set up in a vitrine. Dense didactic labels explained that the weave and colors of the tartans were created according to a formula which allows different colored threads to represent relationships of ethnicity, income and Manhattan address. Improbably, the tartans thus became abstract charts of demographic statistics, an idea that gained an extra layer of absurdity when displayed in a British museum, where the subtle, clan-based language of real tartans is more generally understood.

The third commissioned piece was by Ken Aptekar. The only work involving community participation, it consisted of a series of digital re-creations of fragments of historic works hanging in the European painting galleries. Aptekar invited a diverse group of museum visitors to speculate about the artist, iconography or narrative

suggested by the paintings. As in a similar project Aptekar undertook several years ago at the Corcoran Gallery, excerpts from their statements were sandblasted on glass sheets laid over his painting fragments, and, in most cases, the new versions of the paintings were placed alongside the corresponding originals. The work was somewhat reminiscent of Sophie Calle's museum interventions. However, here the issue was not the memory of an absent work, but the kinds of meanings read into paintings by nonexperts. Not surprisingly, the untutored readings tended to be empathetic and story based.

While most of the interventions at the V & A set up an often comic dissonance between contemporary art concerns and those of the historical artists and artisans represented in the museum, two works were very different in tone. Philip Taaffe's abstract, Islamic-inspired paintings were installed in the section of the V & A devoted to "Arts of the Islamic World." There they played off against exactly the kind of carpets, mosaics and architectural fragments which inspired them in the first place. Andres Serrano's contribution operated in a similar manner. Set amid the galleries devoted to European religious art from the 12th to the 17th century, his lush photographs paid homage to the esthetic tradition that gave rise to them. Works like *Milk Christ*, several of his morgue photographs and a mother and child from the Budapest series seemed perfectly at home amid pietas, sarcophagi, reliquaries and crucified Christs.

Taken together, the two parts of "Give & Take" provided a variety of insights both into the V & A specifically and museology in general. Haacke's "Mixed Messages" underscored the ideological foundations of the museum, while the other works commented on everything from the institution's tendency to estheticize functional artifacts to the social meanings embedded in apparently neutral decorative objects. By deliberately ambushing the unsuspecting viewer with alterations of normal patterns of display, both parts of the exhibition provided a reminder that history, like the museum itself, is continually up for renegotiation.

Chapter 24 | Henry Balfour

Presidential Address to the Museums Association, Maidstone Meeting, 1909

There is frequently experienced a difficulty in selecting a subject upon which to deliver an address to a Society, and many a president has passed through an anxious period of bewildered indecision, ere he has determined upon a theme for his discourse. This, naturally, applies more especially to one who succeeds to a presidential chair which, owing to the prolonged existence of his society, has been occupied already by an imposing succession of predecessors. In the case of this Association, there have been already 15 occupants of the presidential chair, and each of these has, I believe, delivered an address upon a subject of special interest to the members of the Association. In dealing with such a subject as museums, one's bewilderment in selecting a theme is, however, not traceable to any apparent lack of unexhausted material, but rather to the vacillations provoked by an *embarras de richesses*. The subject is one which pre-eminently affords ample and varied choice, whether it be treated from a general standpoint, or whether the survey be focussed down so as to be concentrated upon some more special and restricted topic. I may confess to having been considerably exercised in my mind, in making choice of a *motiv* for the address which it is my privilege to inflict upon you.

The subject upon which I finally decided is one which for many years I have had in mind, and the present occasion is a peculiarly favourable one upon which to air the subject, since I am especially anxious to enlist the sympathies of the Museums Association, in furthering a scheme which is, I venture to think, not without interest to the Museum World, and, indeed, to our country at large.

If we pass in review the museums of the British Islands, those, that is to say, which are devoted wholly or in part to Man and his handiwork, we cannot fail to be struck with the vast mass of valuable ethnological and archæological material which is available in this country. Even in the less progressive institutions, which still retain the old order of things – disorder, perhaps, would better express it – and which, fortunately, are becoming rarer every year, there are often to be seen individual objects of high interest to the student of mankind. But, if we review in detail the available ethnological material, whose collective value is so great, we cannot fail to become

Henry Balfour, Presidential Address to the Museums Association, Maidstone Meeting, July 13, 1909 from *The Museums Journal* 9 (July 1909), pp. 5–18. Public domain.

cognizant of one fact, which is that only a comparatively insignificant proportion of the whole has any direct bearing upon the ethnology of Great Britain, and, further, it must be remarked that such British material as is preserved and exhibited usually lacks organization and continuity in its arrangement, and as a necessary consequence, its educational value remains comparatively undeveloped. Even the British Museum – of whose magnificent collections we are justly proud – is everything except British as far as ethnology is concerned. The ethnology of most regions of the World is there represented, frequently in great profusion, and there may be studied the art and industrial products, customs and beliefs, chiefly of primitive peoples, from all parts of the Globe, but, except in regard to a few classes of objects, there is a reticence in dealing with our own nation which is specially noteworthy in view of the name which is applied to this great institution. The pre- and proto-historic antiquities of Great Britain have received due attention, and are represented by rich series, but the student who wishes to form a more or less complete picture of the mediæval and post-mediæval life of these islands in particular, and he who would investigate the gradual development of our later culture and the survivals of early conditions in recent times, will be compelled for the most part to seek his material for study far and wide and often in vain.

In a general atmosphere of reluctance to deal at all comprehensively with our national culture and characteristics, there are, it is true, certain exceptions amongst our museums, and one may refer with pleasure to the praiseworthy efforts to illustrate local folk-culture, in such institutions as the Museum of the Society of Antiquaries in Edinburgh, the Welsh Museum in Cardiff, which promises to be strictly national, as far as Wales is concerned, and the Guildhall Museum in London, and in some other museums, in which more or less definite attention is paid to obsolete and even obsolescent industries, customs and appliances of the British Islands. Indeed, most of our museums contain a certain number of relics of the kind. But, such exhibits are for the most part dispersed all over the country, and are usually unconnected and individual, and it is only by much labour and trouble that the scattered and often tangled threads of evidence can be gathered together and arranged, so as to enable them to be woven into a connected fabric, conveying an intelligible conception of their inter-relationship and their relative position in the sequence of stages through which our culture has developed. The frequency with which such objects of local interest are exhibited testifies to an interest taken by the public in these matters, and I have myself frequently noticed that objects used by our forefathers appeal more readily to the ordinary museum visitor, than far more showy and more valuable specimens from, say, the South Seas or other foreign regions.

If interest is readily aroused in the individual and more or less isolated reminders of past conditions in our Islands, how much more real would be the appreciation of these relics if it could be shown in an intelligible manner that they form part of a connected whole, that each is to a certain extent dependent upon others which belonged to and helped to form the same environment, and that the whole when taken together and studied chronologically as one organic whole, would supply an illustrated developmental history of our national culture and characteristics.

Mere casual interest would surely give way to something approaching enthusiasm, and I cannot but believe that, were the culture-growth of the people of Great Britain adequately represented, the reward would be reaped of public appreciation and enlightenment.

The literature of the subject has outstripped the museums and there is a wealth of published material, dealing attractively and instructively with the various phases and phenomena of the culture of bygone days, a further testimony to the existence of a wide-spread and genuine interest in the subject of our national development.

If the pages of Green's "History of the English People" could be supplemented by illustrations of the social habits and domestic economy of our predecessors, through the medium of a systematic exhibition of the objects dealt with, how greatly would be enhanced the well-deserved popularity of this work. Under like favourable conditions, such popular works as Strutt's "Sports and Pastimes," Pepys' "Diary," Mitchell's "Past in the Present," or the more recent "Old West Surrey" (to mention but a few of the innumerable works dealing with folk lore and old-time customs), would acquire added significance and attractiveness. There would, moreover, be developed a fresh stimulus to research in the investigation of the culture-history of our nation.

What is required is a National Folk-Museum, dealing exclusively and exhaustively with the history of culture of the British Nation within the historic period, and illustrating the growth of ideas and indigenous characteristics. Until such an institution is founded, there will remain a very serious *lacuna* in the list of our museums, and we shall remain open to the fire of just criticism from other countries, on the score of our almost pathetic anxiety to investigate and illustrate the ethnology of *other* races and peoples, while we neglect our own. Others have, indeed, a perfect right to criticize us, since our comparative neglect of national ethnology, in which we have persisted, has in very many cases been remedied elsewhere, for in most European countries national pride has found expression in the formation of national collections, and a folk-museum is a prominent and patriotic feature in very many of the continental cities and towns. I have but to recall those of Berlin, Buda-Pesth, Sarajevo, Moscow, Paris, Helsingfors, Copenhagen, Bergen, Christiania; and last but most important of all Stockholm. In all these cities (and there are other cases which I do not now recall or with which I am not personally acquainted) a folk-museum exists, either as a separate institution, or as a special department of a more comprehensive museum. These folk-museums and departments are devoted to the preservation of objects of strictly national interest, and serve as repositories in which may be seen and studied not only the domestic and other appliances and the various material relics of bygone centuries, but also characteristic features of the more recent culture and social economy of the peasantry, the backbone of every nation. There is in these exhibitions ample precedent, and we have the certain assurance that in other countries such national ethnographical collections are a popular success, appreciated all the more for being easily understood by the uninitiated and for appealing to local patriotism.

If we seek for a model upon which to base a national folk-museum of our own, we cannot do better than accept as such the famous Nordiska Museum in Stockholm, which is not only a magnificent national record, but also a splendid monument to its founder and organizer, the late Dr. Artur Hazelius, to whose devotion and energies Sweden owes this most valuable possession, of which she has every reason to feel proud. Starting with but small encouragement and still smaller funds, Dr. Hazelius, by the sheer force of his personality and his cast-iron determination to achieve the ends which he had in view, contrived gradually to build up the nucleus around which the collection was to grow. Few men could have been as successful as he in loosening the strings of unwilling purses, in persuading sceptical people that the great work to which he had set himself was worth achieving, or in wheedling from their owners possessions which he coveted for his steadily developing collection. A "Prince of beggars" he has

been called – well! certainly his mendicity has yielded princely results! It required years of unceasing and devoted labour before his scheme was fully matured and many more before his full object was attained. The collection grew in spite of many vicissitudes, lack of adequate financial support and unsuitable housing in scattered and inappropriate buildings. Its persistent development in spite of obstacles ensured its ultimate success. Fortunately, Dr. Hazelius lived to see full recognition of his self-sacrificing labours, and the erection of a substantial and imposing building for the vast collection which he had accumulated. In this building may now be studied in detail the domestic and social economy, arts, industries and amusements, ceremonies, beliefs and superstitions of the Swedish people, and to a lesser extent of the other Scandinavian peoples. The national characteristics are illustrated and the lines upon which Swedish culture has developed are rendered apparent. This was a truly great achievement. But Hazelius was not satisfied merely with a museum in which his collections could be arranged and exhibited on the ordinary lines. Long before the new building was erected, he had developed another idea, which aimed at endowing the subject with greater realism and giving to it a living interest. He acquired a large piece of park-land and established thereon his celebrated *open-air* museum. He caused typical peasant dwellings and other buildings to be transported thither from the country districts, and had them re-erected with careful attention to accuracy in detail. These were furnished in the old style and fitted with all appropriate utensils to give complete realism. Primitive agricultural appliances, early types of boats and vehicles, and other objects associated with the life of the peasantry, were brought there. Nor were the local fauna and flora neglected, since these were important elements in the environment in which Scandinavian characteristics and culture had developed. The zoology and economic botany of the region were both allotted space under the comprehensive scheme laid down for this open-air museum. Lastly, arrangements were made for the performance of characteristic country dances, songs and games, in the old style, to the accompaniment of musical instruments now to a great extent obsolete. Thus the memory of the old order of things is maintained and a most picturesque and instructive presentation of national life-scenes is effected, affording a relief to the more sedate exhibits of the indoor museum, with which, however the out-door exhibits are in perfect harmony. Both in Christiania and in Copenhagen there are open-air museums which are admirably organized and form highly attractive and educational complements to the folk-museums of those cities.

I am only able to give but a brief and very imperfect description of a typical continental folk-museum. I have selected that at Stockholm more especially, as it is the most fully developed and exhibits most of the features which are desirable in such an institution and which spell success.

Are we to believe that a permanent exhibition on similar lines, dealing exhaustively with the life and culture-history of the British people, would be less acceptable to us, than such exhibitions in other countries are to the inhabitants of those countries? Are we to suppose that the foreign visitor to such a folk-museum in England would be less interested than is the British visitor to foreign collections illustrative of local characteristics? I think not. I feel sure, indeed, that a well-organised and carefully arranged folk-museum, standing in grounds which could be adapted for an open-air exhibition, would be as much appreciated by students and as popular with the masses as any institution in the country.

Although the brief sketch which I have given of the Hazelius Museum in Stockholm is quite inadequate to convey any real idea of this notable institution, I have been

desirous of calling particular attention to this museum, not only as affording a model worthy of imitation, but also as illustrating what may be accomplished by a single determined individual who knows what he wants and who has perfect faith in the validity and ultimate success of his scheme. The effective realization of his plans was due, not only to the vigour with which he pursued them, but also to a very great extent to his having worked upon a perfectly well-defined plan from start to finish. The object which he had in view was clear from the beginning, and he did not diverge from it, nor was he tempted by the allurements of side-issues to depart too far in any direction from his main objective. Concentration of purpose is an all-important factor in the successful development of a museum. There is always a tendency to wander along by-paths which lead to diffuseness. Much as I am in sympathy with the "comparative method" in ethnological study, I still feel that a national folk-museum should be devoted *exclusively* to national products and objects of national use. In exhibiting the various objects of the material culture of a given country, there always must be a temptation to place alongside of them similar objects from other countries, for the sake of comparison and of the light which may be thrown upon the evolution and relative technological position of the art or object in question. There is much to be said in favour of so doing, but there is the inevitable risk of the museum becoming modified by the introduction of alien material, which, to be effective, would require to be in strong force. The exotic specimens, at first added to the collection to give additional interest and significance to the indigenous objects for which the museum was primarily designed, would be liable soon to outnumber and overwhelm them, and would rapidly obscure the original *national* character of the collection, and tend to convert or pervert it into a museum of comparative technology. A parasitic growth once introduced is liable to thrive too luxuriantly and to develop at the expense of its host. In spite of interesting suggestions which have been made to the contrary, I firmly believe that it is advisable to keep the two ideas separate; to restrict a national collection of the kind referred to exclusively to national objects, and to leave to the museum of comparative technology the function of dealing with the evolution and geographical distribution of human arts and appliances on the wider basis of a broad comparative system. If a strictly national collection develops as it should and, within its special limits, is treated upon broad scientific lines, there will be no lack of lessons which may be learnt from it. The "comparative method" would by no means be excluded from it, but its light would be concentrated upon ideas and products of the limited region, and, by being so concentrated, would illumine the subject the more searchingly and in minuter detail. The development of culture within the geographical region would be illustrated by chronological series depicting the general life and habits of the people at successive periods. The way in which we as a people have responded to our special environment, or, put another way, the effect of environment upon the development of our physique, culture and national characteristics, might be made clear. Or again, the local peculiarities in custom and character, observable in different parts of the country, might be compared and accounted for, the question of environment again coming in. Or further, the stages in the local evolution of the various utilitarian and aesthetic arts and industries, their products and appliances, would give very wide scope for instructive classification of the material of such a museum, even though the geographical area be a restricted one. An open-air exhib- ition in connection with the main museum, organized after the manner of Skansen (the open-air museum in Stockholm), would enable obsolete types of habitations and other large structures to be erected, and would also admit of the exhibition of many

features of the older domestic and social economy which cannot be shown within a museum building. It would, further, supply a permanent centre for the performance of the folk-dances, songs and old-time ceremonies of the British people, in the recent revival of which so keen an interest has been displayed.

If the efforts of one enthusiastic man can, starting from nothing, bring to a successful issue so vast an undertaking as the formation and organization of the Northern Museum in Stockholm, it surely should be possible for a similar project to be undertaken in a country such as ours, which teems with antiquaries, folk-lorists and ethnologists, and where money, if sometimes difficult to secure for purely scientific purposes, is at least not lacking. Once started upon the right lines and equipped with a clearly defined objective, a well-schemed plan of campaign, reasonable funds and suitable premises capable of being extended in the future, such a museum would, I feel sure, rapidly develop and more than justify its existence. There is much material eminently suited to the formation of a national collection, scattered sporadically about the country.

It is not only with old and entirely obsolete appliances, industries, and customs that we have to deal, although it is undoubtedly with the relics of past conditions that we are principally concerned. We must on no account neglect the highly interesting group of "survivals" – that is to say, objects and habits which, although they must be regarded as essentially *primitive* when viewed from the standpoint of the *general* culture-status of the day, have nevertheless survived in use up to the present time. So long as a simple and even rudimentary appliance has a use, it will continue to be made and used, and primitive types whose origin may date back many centuries tend thus to persist in spite of the general advance in civilization which has been achieved since they were invented. In pre-historic times the use of stone persisted far into the Age of Bronze, and the primitive functions of bronze did not die out until the Iron Age was old-established. So it is in modern times. Efficiency when combined with cheapness is no doubt the principal factor which admits of these survivals, but the point of interest to us is that primitive conditions *do* survive as seeming anachronisms in an environment of higher culture.

By a study of these survivals of early appliances and persistencies of ancient customs, we may throw much light upon points which are obscure in the archæological and historical record, and, just as the palæontologist is able to clothe the, literally, dry bones of his science, from a comparative study of those living forms of animals which are nearest akin to the fossil types, so, too, may the archæologist and antiquary reconstruct to a great extent the ancient conditions of human life and industry, by not disdaining to learn from primitive survivals in modern times the lesson which they have to teach.

We must concede that even in these islands early types of appliances are often associated with conditions of relatively primitive *general* culture. In many parts of the British Islands, as, for instance, in the extreme north, in Western Ireland, and in many mountainous districts, poverty of soil, adverse climatic conditions, isolation, and other causes have militated against progress, and the development of culture in general has been arrested or retarded. Under such environmental conditions "survivals" are necessarily numerous; habitations, agricultural and other appliances, all exhibit rudimentary characteristics; but, although they are in strict harmony with their environment of persistently primitive culture, and *locally* do not appear to contrast with the general conditions, they are none the less useful to the student of the

evolution of our national characteristics, since they are survivals from stages which are long since past in the history of the higher culture of Great Britain. They are, indeed, of the greater value by reason of the persistence of some of their old-time culture-environment, since the picture of the past is the more complete.

For instances of primitive survivals amid conditions of the highest civilization, we need not seek far afield. The neighbourhood of Maidstone itself affords at least one interesting and suggestive case. In the hop-gardens of Kent it has been the custom until quite recently, and still is, possibly, in a few districts, to keep the accounts between the overseer and the hop-pickers (recording piece-work) by means of pairs of *notched tally-sticks*, a primitive method of keeping an accurate two-sided number-record which forms an interesting link with the past, and whose retention is due, no doubt, to its absolute efficiency. This practice is now nearly obsolete in Kent, but still persists to some extent in Herefordshire and perhaps elsewhere. Similarly, the formerly universal method of keeping count of runs made at cricket, by cutting a notch upon a stick for every run made, is still kept up by the boys in a few country villages, though in the higher forms of the game nowadays the memory of this practice is kept alive only by the use of such terms as "score," or such expressions as "notching runs," whereby the journalist of to-day still seeks to vary the monotony of a stilted terminology. Numberless other instances of "survivals" might be cited, and it behoves us to secure in a permanent and suitable institution examples of these, ere they finally join the ranks of the obsolete and, perhaps, the unobtainable. They have a definite place to fill and a valuable lesson to teach in a national museum.

Fortunately, there has been a growing tendency to preserve old and obsolete objects, partly upon sentimental grounds, partly as a matter of antiquarian interest, and thousands of specimens have been rescued from destruction and more or less cared for, whose utility has ceased. In the case of more or less isolated specimens, however, their interest is only partially evident, and sentiment is the dominating factor in their retention. Were it fully realized that such specimens acquire a greatly aug-mented scientific value when they are associated with a suitable context, and are made to take their place in organized series, there is little doubt that a large proportion of these isolated specimens would find their way into a museum capable of, and, indeed, designed for supplying that context. Many of the existing museums of this country would, I cannot but believe, be willing to part with specimens whose full significance cannot be developed where they are, owing to their not fitting into the general main scheme of the museum, where such exists; and by direct or indirect exchange, two institutions might mutually benefit each other, since both would gain specimens which are specially suited to their respective schemes of classification. Indirectly, this would help in the promotion of individuality in museums, for the policy of exchan-ging the comparatively superfluous for the comparatively necessary might with ad-vantage become very far-reaching, and would lead to greater specialization of function among the museums, and with it to an increasing vitality and purposefulness. The tendency to monotonous uniformity and lack of organized system in museums, is due in part to their aiming at covering too much ground, to their *diffuseness*, in other words, but also very largely to their being regarded as convenient dumping-grounds for forlorn and miscellaneous "curios" so-called. The evil effects of this can only be met by rigid elimination of the undesirable and incongruous specimens, those, that is, which are out of harmony with the general scheme of the museum. With the develop-ment of special aims and special functions for the various museums, objects undesired in one institution would be hailed with acclamation in another. An organised system

of exchanges would lead not only to active and beneficial co-operation amongst museums, but it would tend to promote that kind and healthy rivalry, which aims not at the mere selfish possession of rare objects which are lacking and wanted elsewhere, but rather at filling a gap effectively, at maintaining a high standard of efficiency and, in fact, at occupying a definite and useful position in the museum world.

I must not, however, detain you unduly with these generalities which are incidental to my main theme. I have elsewhere enlarged upon the benefit to be derived from the individualization of collections and from systematic and unselfish co-operation amongst museums. Therein, in my opinion, lies to a very great extent the hope of museums in the future, and if as the main topic of my address to you, I have dwelt upon one conspicuous gap in the list of our museums, I must conclude by expressing the hope that the filling up of the gap in question may be the prelude to a general scheme of concerted action on the part of museums at large, whereby they may work in harmony, with a common object in view and with a thorough understanding of each other's aims.

Chapter 25 | Jordanna Bailkin

Picturing Feminism, Selling Liberalism | The Case of the Disappearing Holbein

In the early spring of 1909, the Duke of Norfolk announced that he was placing Hans Holbein's *Christina of Denmark, Duchess of Milan* – displayed at the National Gallery in London since 1880 – on sale in the international art market.[1] The painting was a portrait of Christina, the young Danish widow whom Henry VIII had romanced while Holbein painted in Henry's court; the Gallery therefore classified the work as 'British school', though neither the painter nor the sitter was British.[2] The public response to the Duke's announcement was immediate and dramatic. The potential loss of the Holbein portrait – most probably to an American millionaire – produced what one newspaper termed a collective 'condition of mourning' in Britain, with aesthetes holding daily vigils at the Gallery.[3] Charles Holroyd, the director of the Gallery, swore that if Mary Tudor had Calais written on her heart, he had Holbein written on his.[4]

British art lovers promptly began a campaign to 'save the Duchess' by meeting the Duke's purchase price of £72,000, with women and noted feminists playing a prominent role in the subscriptions drive. At the same time, the press debated the value of the Holbein in respect of patrimony: could female portraiture be considered a truly 'national' form of art, as long as British women lacked full political rights? Did the Duke have the authority to sell and export his *Duchess* despite its special merits in the British art historical canon? Should the salvation of the *Duchess* be a masculine endeavour, following the Victorian convention of characterising the public gallery as a 'boy's pocket', or individual male property writ large?[5] Or, was the National Gallery being reinvented as a feminine, even a feminist space? What did the sexual politics of the Holbein campaign signify about feminism's relationship to the Gallery, to public museology, and to the larger political nation?

The Holbein debates raised important questions about the dynamic between gender, patrimony, and patriotism, reflecting changing relationships between women and property and between Liberal and Radical frameworks of property in

Jordanna Bailkin, "Picturing Feminism, Selling Liberalism: The Case of the Disappearing Holbein" from *Gender and History* 11:1 (April 1999), pp. 145–63. Reproduced by permission of Blackwell Publishing. (Reprinted without illustrations.)

prewar Britain. This article treats 'the case of the disappearing Holbein' not only as a focal point in the history of art, gender, and citizenship, but also as a lens for examining the interaction between museology and feminism more generally. The historical relationship between feminism and the museum has been largely over-looked,[6] and feminist scholarship has tended to treat the museum primarily as an agent of exclusion and oppression.[7] Contemporary studies have focused overwhelmingly on 1980s radical criticism of the museum by the Guerrilla Girls and the Women's Action Coalition, which allied the under-representation of women artists in public institutions with broader feminist agendas.[8] According to this body of scholarship, feminism exists in relation to the museum only as an ideology of opposition: a reminder of what the museum is not.[9]

More recently, however, *Gender & History* posed an important challenge to this set of assumptions in its 1994 special issue on public history. Patricia West's discussion of the nineteenth-century American house museum movement, for example, explored some of the ways in which the museum could function as a potent public medium for women to communicate political ideology without departing from 'woman's sphere'.[10] West's analysis of the intersection between house museums and the discourse of bourgeois domesticity pointed to the need for a more extensive analysis of the gender politics of museum history, not only for what this examination might reveal about various national histories of culture, class, and citizenship, but for what it could contribute to ongoing institutional practices and activism.

While this article is generally concerned with the historical dynamic between constructions of gender and the museum, it is more particularly focused on the prewar development of a feminist museology and on the response to this museology by public, state-supported institutions such as the National Gallery. By the phrase 'feminist museology', I allude not only to debates on the inclusion of women into the professions of connoisseurship and curatorship, but also to efforts by prewar feminists to construct museum practices that would promote the political ideology of feminism: an ideology, as this article suggests, with which the museum has contended from its inception. For the purposes of this article, 'feminism' refers primarily to nineteenth-century Liberal feminism, based on a Lockean conception of the rational, rights-bearing individual and centred around a progressive programme of education for women.[11] Yet while prewar feminist museologies were clearly rooted in a Liberal conception of individual enlightenment, the Holbein controversy prompted a new series of disjunctions between Liberalism and feminism – calling the ideological underpinnings of feminism itself into question.

The invention of feminist museology – or, more accurately, of competing feminist museologies in Britain from the mid nineteenth century to the First World War – played a critical role in reformulating public perceptions of feminism and its relationship to an institutionalised national culture. The museum was understood both as a compensatory institution for women – a cultural offering for the denial of political rights – and as a central force in the creation of female political identity. My intention here is not simply to add museums to the list of organisations to which British women have gained access, nor to rehabilitate the museum as a proto-feminist institution. Rather, I am seeking to examine the ways in which the prewar museum was constituted by feminists not only as a microcosm of gender relations in the larger social and political world, but as a site for remaking these relations.[12] More generally, I hope to interrogate the seeming dichotomy of 'institution' and 'critique' that has dominated museum studies scholarship.[13] The 'case of the disappearing Holbein' was as much

about the National Gallery's memorialisation of feminism as it was about its effort to contain radical feminist politics; the two processes were wholly interdependent.

The history of feminist museology in Britain can be traced back to Anna Jameson, one of Britain's first feminist art historians[14] and an important proponent of Liberal feminist thought in the 1850s.[15] Jameson's exploration of feminist museology began as early as 1826 with the publication of her fictionalised journal, *Diary of an Ennuyée*. Although her works predated the Holbein controversy by more than half a century, it is worth a brief detour here to demonstrate the ways in which feminism, public art, and British identity were already linked by the time the Duke of Norfolk made his disturbing announcement in 1909. Jameson positioned the museum as her single most important institution for the elaboration of feminist principles: a laboratory or potential haven of sexual equality and independent feminine judgement. She cast the relationship between citizenship and womanhood in museological terms, re-evaluating the museum as a crucial site of interaction between cultural and political life. Her works were aimed at two key questions: what, precisely, were the gender politics of the museum, and how might these politics be incorporated into the world beyond its walls?

The nameless narrator of Jameson's *Diary of an Ennuyée*, a laudanum-addicted governess recovering from a broken heart, travels through the Continental museums mocking the sexual and aesthetic vagaries of men. Male connoisseurship, she suggests, is of an uncertain morality and banal eye; the men of the *Diary* become romantically enthralled by the artworks they analyse, gazing at statues or paintings like 'love-sick maiden[s] upon the moon'.[16] Disinterestedness, the quality prized above all others by contemporary art critics,[17] is defined here as the province of women. Yet the *ennuyée* is also prone to inertia, depression, and sexual mishap. Ultimately, she implodes, committing suicide at the age of twenty-six. In Jameson's first experiment with feminine anti-connoisseurship, the rejection of male taste and tutelage results in an ultimely death.

In the 1840s, Jameson abandoned her alter ego of the *ennuyée* and embarked on a series of gallery guides for British women. She acknowledged that works like her *Companion to the Public Galleries of Art in and Near London* might strike Continental women as simplistic. German galleries, for example, were so well organised that no intermediary between visitor and institution was needed. But, as Jameson wrote to her friend Ottilie von Goethe, 'what do I care of that? I write for English women, to tell them some things they do not know.'[18] According to Jameson, Britain's dependence on private patronage in the arts had created an eclectic and chaotic institutional culture – reflecting the individual collector's caprice rather than the state's desire to illustrate key phases in the history of art and human development. For women, who often lacked formal art education, British galleries were incomprehensible without feminist translation and mediation. The female readers of Jameson's *Companion* guides were positioned both as art critics and, implicitly, as critics of the government that had produced this museological state of affairs.

Jameson's elision of feminist rhetoric and public museology was most evident in her analysis of the National Gallery in London, the future site of the Holbein controversy. She attacked the Gallery's corrupted vision of femininity, which warped national taste through its promotion of 'those meagre, wiry ringleted, meretricious, French-figurante things, miscalled women'.[19] The source of British women's ignorance and pathology – of their *ennui* – had shifted from the individual psyche to the external conditions of museology itself: where, and at what, was the worthy feminist supposed

to look? In Jameson's framework, only feminine perception could restore integrity to the National Gallery. Her readers must encourage the de-accession of inferior or morally suspect works, redeeming the Gallery and the larger political nation from the miscalculations of male connoisseurship.[20] The existing collection and its masculinised 'lies' of taste were opposed to a future Gallery of feminist truth, justice, and faith – a Gallery that would uplift British women instead of demeaning them.

Despite this critique of the National Gallery, Jameson's model of feminist museology was also resolutely British. In her *Sketches of Germany,* the protagonist Alda – again, an emphatic anti-connoisseur – praises German women's artistic education, but suggests that higher knowledge is meaningless outside of a British feminist context. An Englishwoman need not tolerate the circumstances Alda describes in Germany, where 'the wife of a state minister excused herself from going with me to a picture gallery, because on that day she was obliged to reckon up the household linen'.[21] Art might be richer elsewhere, but the conjunction of art, feminism, and Liberal personhood was, for Jameson, uniquely British. Ultimately, Jameson's project was to return the *ennuyée* to native soil, to live out the joint promises of British feminism and a reformed National Gallery.

While Jameson established an important basis for discussions about the role of feminism in public culture, her association of feminism and museology was only one of several options for defining the museum's gender politics. Museums were invoked throughout the prewar period as sites of nostalgia for former standards of feminine behaviour. The art critic John Ruskin suggested that the ideal public art gallery would house an exhibit on the history of needlework in its entrance room as a testimony to the female artisanship of the past.[22] He lamented the fact that British women had lately been distracted into less 'salubrious' pursuits than needlecraft, imagining his archetypal museum both as a monument to lost womanhood and as an institutional critique of changing roles for women: a joint project of conservation and conservatism.

But this Ruskinian model of curatorship, in which a masculine institution preserved and regenerated a pre-feminist culture, met constant challenges from within and outside the museums profession.[23] Professional debates on the role of women and feminism in museum culture intensified throughout the last quarter of the nineteenth century,[24] and by the 1880s – the era of the Married Women's Property Acts – women had begun to play an important role both in art collecting and in the donation of art to public institutions.[25] In particular, women's contributions to the National Gallery – the ultimate repository of artistic patriotism – increased dramatically. Gifts to commemorate women began to appear in the Gallery reports,[26] women artists made efforts to bequeath their own works,[27] and the Gallery became increasingly careful about distinguishing women's gifts as their own property.[28]

Letters from women donors to Britain's public galleries drew heavily on the language of national pride.[29] Lady Charlotte Schreiber, the collector and eventual donor to the Victoria and Albert Museum, described her own public connoisseurship as a conjunction of aesthetic appreciation and Liberal sentiment. Referring in her journal to her hope that the Liberal party would win the battle to extend the vote to working men, Schreiber wrote,

It is odd that I should care about this – but the love of the Old Country continues strong ... How curious that love of country is! On my way I called at Liberty's to learn how their Exhibition had prospered and to Kerridge's where I fell in love with a large

Worcester basket of the old decoration – but so perfect and so characteristic. Really, I must stop these morning rambles into curiosity shops – or I shall be ruined – another £5 – but then it is all going into South Kensington Museum. Love of country again.[30]

Schreiber's brand of participation in national life, her proposed donation of English china to the central storehouse of British decorative arts, is elided with the state's extension of male suffrage. Her personal 'ruin' is an offering to Britain's stock in art and industry. Schreiber self-consciously creates a feminine democracy within the public museum, a collection of 'perfect' and 'characteristic' pieces to instruct the new voting populace. This populace might exclude women from the franchise, but its moral and visual education is crafted through womanly judgement and sacrifice.

Although women's gifts to the National Gallery and elsewhere were important in shifting the Gallery's perception of its audience and leadership, none of these donations attracted major public attention. The question of feminine – and, ultimately, feminist – museology first struck the British press as a significant topic of political debate in 1909, with the Gallery's proposed de-accession of Holbein's *Christina of Denmark*. Jameson's *ennuyée* recurred in a changed social and museological environment, as the rise of radical feminist politics and suffragette attacks on art provided a new context for Jameson's theories. The Holbein campaign marked another phase in the feminisation of museum politics: one culmination, of a particularly contradictory kind, of Jameson's vision of a feminist Gallery.

As an episode in the cultural history of Liberalism, the Holbein case encompassed many of the key political questions of the prewar period; namely, how would Liberalism meet the challenges posed by an increasingly vocal audience of socialists and feminists?[31] The Duke of Norfolk claimed that he was forced into the sale by Lloyd George's 'People's Budget' of 1909: a new set of Radical taxes that financially strained the aristocracy and prompted the sale of many country-house art collections to Continental and American buyers.[32] This intertwining of the Radicalisation of British economics and the Holbein sale was taken as a sign of the changing political character of the British nation and the waning fortunes of Liberalism. The question of who really 'owned' the *Duchess* – the Duke, the Gallery, or the nation at large – provoked an outpouring of anti-socialist vitriol: a fervent defence of *laissez-faire* principles in the realm of art. As the *Globe* argued, the picture was the Duke's property, to be taken away at will regardless of its sentimental value for the British public:

> The fact seems elementary enough; but your latter-day Radical is apt to be a little vague as to the distinction between *meum* and *tuum*. He has drunk so long from Socialist wells that it is perhaps not very surprising if he confuses private with national property, and pictures which are only lent with pictures that have been paid for.[33]

The portrait of a Danish widow became a litmus test for determining the boundaries between public and private property, between older loyalties to the freedom of the individual and the rising claims of the British nation-state. The Holbein campaign thus took part in Liberalism's own epistemological shift from *laissez-faire* to intervention, complicating the debate over which party 'owned' free trade.

As the dreaded sale of the Holbein drew closer, the controversy expanded beyond competing notions of ownership to include the gendered category of patriotism itself. Many newspapers and journals questioned whether female portraiture could ever inspire the kind of nationalistic zeal that warranted large Treasury expenditures. One editor argued against heroic measures to retain the *Duchess*:

It is not as though the picture speaks any lessons of patriotism, raises any historic memories of which we are proud, nor inspires any exaltation of morals. It is a portrait of a woman, executed by a foreigner long dead, and of no conceivable advantage to the nation except as a museum specimen of mastery in technical art.[34]

This report highlighted the incompatibility of patriotism and femininity, opposing the portrait of an individual woman to national ethics and history. Worst of all, the *Sheffield Independent* published a series of unflattering comments by Gallery visitors on the *Duchess*'s utter lack of physical charm, culminating in one man's observation, 'Wot an ole puddin'-face'![35] As part of the nation's capital in beauty – real or painted – the *Duchess* was pronounced worthless.[36]

The campaign to retain the *Duchess* rested less on the painting's aesthetic appeal than on the manufacturing of a sexualised American threat to British cultural property. The stereotype of the rapacious American millionaire who bought up England's patrimony was underscored by the Holbein case. One striking *Punch* cartoon depicted an evil, money-bag clasping Uncle Sam molesting the virtuous Duchess as he declares, 'Once aboard the liner, and the gyurl is mine'![37] Christina clings in horror to the British frame of her painting, even as the American villain drags her out of the sanctified realm of the art museum into the sullied, prostituting world of the international market. Of course, the cartoon also plays on the threat of an elision between the museum and the market; Christina's body is both the boundary and the link between the Gallery and the anti-national world of commerce.[38] Next to Christina's head, a small placard in the style of a museum label reads, 'Please Spare £70,000'. The label evokes a visual connection between Britain's 'fallen women' – who were at the mercy of individual and state philanthropy as well as unscrupulous male suitors – and Christina herself, now bereft of her virginal white gloves. The *Duchess* figured in the British press as a victim and a pawn, a symbol of the ways in which irresponsible aristocrats and nation-states traded in the most vulnerable members of their society.

Punch's invocation of the malevolent American was especially topical since much of the Holbein controversy focused on the counter-example of American Protectionism, particularly American tariffs on imported art that were intended to shield native artists from foreign competition. Several politicians and journalists suggested that Britain should also adopt a protective tariff on artworks, though it would interfere with the sacred power of the British male subject to dispose of his property as he chose.[39] The *Punch* cartoon countered that there was nothing from which Britain needed so much protection as Protectionism itself. The withdrawal of the United States from the world of artistic free trade had reduced it to this sexualised act of kidnapping. Liberalism was the virtuous woman who struggled to exist in Britain: Christina's counterpart in the world of international political thought. The rumour of an American buyer for the painting thus constituted an attack not only on the property of a British individual, but an ideological assault on the traditional Liberal conception of property: the right of British men to participate in an open market, and especially a market of women.

Alongside this discursive masculinisation of the struggle for the Holbein portrait, British women contributed heavily to the subscriptions campaign. Their letters to the Holbein Fund administrators were explicit about the honour of participating in the retention of a national art treasure. One donor, Dorothea Moore, wrote apologetically, 'I should so much like to give something towards the subscription for buying the Duchess of Milan for the nation . . . I enclose a cheque for one Guinea with much

regret that it is not for more – but most girls's bank balances may be reckoned in shillings – if they are not overdrawn!'[40]

The fund's subscriptions proved insufficient to meet the Duke's purchase price, however, and the press began to despair of rescuing the *Duchess* from foreign buyers. Suddenly, in early June, an eleventh-hour anonymous donor gave the remaining £40,000, and the nation rejoiced: the *Duchess* was saved. The *Westminster Gazette* published a cartoon of Christina clinging tenderly to John Bull, the embodiment of triumphant British masculine patriotism, as she declares, 'I ne-ver – will – desert – Mr. Bull'! He flings one arm wide, and announces gratefully that 'something HAS turned up'![41] Similarly, a *Western Mail* cartoon titled 'American Covetousness' pictured the donor as a faceless man climbing out of the Atlantic Ocean with the painting in hand; he then rushes to meet John Bull, who exclaims, 'Saved'!

The real donor, shrouded in mystery, was reputed at first to be a 'wealthy Bristol gentleman'. But within a week after the retention of the *Duchess*, an astonishing fact was revealed to the British public: the anonymous donor was a woman.[42] At first described simply as a 'patriotic lady', the unnamed female donor provoked a series of public debates about the gendered nexus of art, property, and nationalism. While the Holbein episode had initially encapsulated contemporary concerns about changing property relations among men – namely, from traditional Liberal to Radical or socialist forms of proprietorship – the discovery of a woman donor shifted the focus of the Holbein debates from male ownership of female portraiture to feminist ownership of British patrimony.

This revelation about the donor's sex clearly disconcerted the British press. One women's newspaper, *Lady*, reflected on the nation's ambivalence about accepting the gift of patrimony from a woman:

> But for her [the donor's] unparalleled generosity, the 'Duchess' would have gone to America. The presence of women at the Chemistry Conference, and the appearance of this anonymous lady coincide, and emphasize the lesson that everywhere women are taking an active part in public work. Only the other day they received what is known as the 'commercial' vote in Italy. But this is dangerous ground.[43]

The assumption that the donor was a feminist pervaded the Holbein press even before individual women were presented as potential 'suspects', and the trajectory from a feminised public connoisseurship to female suffrage seemed inexorable. The 'patriotic lady' would inevitably metamorphose into a female citizen, effecting the risky transformation from civic sentiment to political participation. Given the earlier construction of the Holbein campaign as a project of masculine Liberal identity, the 'discovery' of female leadership in this transaction was indeed dangerous ground. Not only did Liberalism need to be rescued from the Radicals and American Protectionists, but from the encroachment of its own – possibly feminist – British women. Feminism had intervened as a new player in the Liberal crisis of mine and yours – or *meum* and *tuum*, as the *Globe* had put it – placing gender at the heart of these competing definitions of property and politics.

Around a dozen different possibilities for the donor's identity were suggested, including Lady Tate, the widow of the sugar manufacturer and gallery founder Henry Tate, and Lady Harriet Wantage, the daughter of art collector Lord Overstone. These speculations about the lady donor's secret identity spawned irate letters of denial from Britain's wealthiest heiresses, satirised in *Punch* throughout the summer

of 1909. *Punch* drew on the Holbein episode to suggest that feminine self-importance, as well as women's financial success in the arts and letters, had grown unchecked in Britain to a comical degree. The journal included a fictive letter from the writer Marie Corelli that stated, 'I could of course have given the £40,000 with the greatest ease – simply by writing a short story – but as a matter of fact I didn't. It is of no interest to me to provide the nation with pictures at which ignoramuses and toads are free to look.'[44] Again, this type of spoof suggested to *Punch*'s readers that feminine taste was incompatible with the patriotic goals of the National Gallery.

Although the predominantly male leaders of the Holbein crusade, particularly Lord Balcarres of the National Art Collections Fund, were praised for their public-spirited efforts on the *Duchess*'s behalf, the anonymous woman donor's intentions were repeatedly challenged and censured. The *American* reported that the donor was Consuelo Vanderbilt, the American heiress who had lately become the Duchess of Marlborough, and that 'the motive is said to have been to fortify her social position.'[45] The Holbein gift was thus presented not as the outcome of an individual English-woman's patriotism, but as a reflection of a larger social pattern of the British aristocracy's dependence on American millionairesses to buttress their fortunes through marriage. And what was actually for sale in the Holbein campaign? Where the lecherous Uncle Sam of the *Punch* cartoon assaulted the painted *Duchess*, the putative American woman donor shamelessly swapped the painting for her own duchessdom: a disturbing feminine commodification of aristocratic privilege and Britishness itself.

The elision of real and painted duchesses was a frequent theme in the Holbein press. *Vanity Fair* suggested that expenditures on this type of portraiture were wasted, since Britons could see their own live duchesses for free and 'to any patriot they are quite as good. Why, then, pay £72,000 to see dead duchesses? It is all nonsense.'[46] The contested meaning of duchessdom within the context of an Americanised British upper class added another layer of complexity to the Holbein debates. The portrait came to symbolise an era of uncorrupted intermarriage between nations: a Renaissance utopia of purified aristocracy where foreign wives merged seamlessly into British 'high' culture instead of contaminating it.

The identity of the Holbein donor remains a mystery to this day. But perhaps one of the most likely candidates was not an American millionairess, but herself a British aristocrat, a staunch Liberal, and a feminist: Lady Rosalind Carlisle. Lady Carlisle – a distant relative of the Duke of Norfolk[47] – was the only one of the women suggested by the press as a possible donor who did not deny the rumour, though the National Art Collections Fund never publicly acknowledged her as the Holbein 'saviour'. Since she had opposed her Unionist son and husband by becoming an influential figure in many Liberal platforms, Lady Carlisle had more often been associated in the public mind with politics than with art.[48] She was until 1898 the president of the Women's Liberal Association and corresponded often with her son-in-law Gilbert Murray on the role of women within the Liberal party. Lady Carlisle was also well known in the art world for her supervision of the collections at Castle Howard and for her efforts to train women in the field of art history.[49]

Carlisle was responsible for several other major prewar gifts to the National Gallery,[50] and was mentioned in one Gallery report as the only example of a 'purely' patriotic and public-spirited donor.[51] She continually vexed the Gallery trustees despite her generosity, insisting that she be included in curatorial decisions about her gifts.[52] To this extent, it is tempting to read Carlisle as the *ennuyée* cured and

reborn: a victorious incarnation of Jameson's anti-connoisseur who remakes the National Gallery as a feminist enterprise. But Lady Carlisle's participation in the Gallery was far from a simple story of feminist teleology and triumph. Her discourse of feminine anti-connoisseurship was accepted, if not appreciated by the Gallery curators, but the problem of the Gallery's debt to a woman who embodied the principles of feminism and an outdated mode of Liberalism proved overwhelming to the British press.[53]

In 1911, Carlisle sold the *Adoration of Kings*, painted by Jan Goessart or Mabuse and known as the Castle Howard Mabuse, to the National Gallery for £40,000: a price well below the painting's market value. The press on the Mabuse sale ranged from praise for the countess's 'patriotic unselfishness as a vendor' and thanks for avoiding the 'usual alternative' of purchase by an American millionaire to the very opposite.[54] One particularly irate letter to the *Morning Post* referred to the purchase as

> just a Liberal job to buy off or pension a lady who, with the best intentions no doubt, had done much already to make her own class thoroughly un-popular. And this not least by her strenuous work for a man-made and sectarian Liberalism by which she has for years disgusted all moderate-minded people both of her own and the other sex.[55]

Other, less vitriolic critics also centred their discussion of the Castle Howard gift around Carlisle's feminism. The *Gloucester Journal* took the Mabuse acquisition as an occasion to outline the more 'radical' components of Carlisle's political platform, including her belief that women should be paid for their labour at the same rates as men.[56] Further, the *Journal* reported, Lady Carlisle believed that men had ousted women from their traditional forms of employment. In accordance with these beliefs, her estate kept no footmen, no chef, and no butler – much to the *Journal*'s dismay. The editor concluded that Carlisle's philanthropy in the art world would inevitably lead to greater attention for her political projects, particularly feminism.

The controversies over Carlisle's real and reputed gifts – both the 'anonymous' Holbein and the highly public Mabuse – crystallised public anxiety that the National Gallery could function as an institutional mouthpiece for feminism. The intertwining of feminism and the Gallery was perceived by the press as a destructive event, which would de-nationalise the Gallery rather than equating feminism with nationalism. The feminisation of Liberal Britishness, which Jameson had envisioned as a key element of her museology, was strongly resisted. According to the *Post*, Carlisle's gifts had brought down the status of the Gallery, the reputation of womanhood, and the future of Liberalism in one blow. As the Holbein case had demonstrated, the drama of gender and citizenship was enacted in the museological sphere, threatening to deliver the Gallery and British political power into the hands of women.

The museological frameworks proposed by Jameson and Carlisle, among others, illustrated the use of cultural property as a critique of social and sexual norms – recasting notions of ownership, possession, and selfhood in explicitly feminist terms. When Jameson wrote in her *Companion* guide that she was trying to tell her female compatriots 'some things they do not know', she referred not only to museum education but to political identity, and to the bond between the two. She stressed the museum's creative potential for remaking relations between women and men, women and property, and women and the nation-state. Clearly, Jameson and her successors pointed to a range of feminist museologies rather than a single politics of museum-making, and professional expectations of the museum tended to work

against a feminist agenda. But the variety of efforts to recraft the museum as a feminine and feminist space highlights the flexibility of the museum as a historical site of gendered political power even as it reveals the limits of this flexibility.

In the end, what had been saved and what had been lost in the 'case of the disappearing Holbein'? The National Gallery had retained its *faux*-British portrait, but the gendered parameters of public connoisseurship, patriotism, and Britishness itself had shifted in the process of retention. By the end of 1909, the Gallery was compelled to contend with feminism's role in preserving the British art historical canon; feminism had been incorporated into an institutionalised national culture, however reluctantly. But this experience of 'canonisation' or 'integration' also destabilised the prevailing terms of feminist discourse, signalling feminism's point of departure from Liberalism. The Gallery had lost its bearings between the two poles of Liberal institution and feminist critique, as the central museological concept of property – individual and collective, patrimonial and matrimonial, cultural and political – was called into question. Ultimately, the Gallery's memorialisation of feminism placed Christina's portrait squarely at the centre of the prewar crisis of property rights and British identity, raising important questions about the future of a demasculinised 'patrimony' in a post-Liberal age. This complex history of the museum's gender politics would suggest that the current scholarly and activist perception of the museum as a bastion of anti-feminism is due for further analysis.

Notes

1 The Gallery had apparently considered the Duke's loan to be permanent, and many journalists were surprised to learn that the Gallery did not own the painting outright. (*Western Mail*, 3 May 1909).

2 Several observers objected to this classification of Holbein as a 'British' painter. As one editor commented, 'I always thought Holbein was a Bavarian. Ought not the picture to go back to the Bavarians?' (*Bystander*, 12 May 1909).

3 *Daily Graphic*, 4 May 1909.

4 *Daily Graphic*, 6 May 1909.

5 The Scottish sociologist Patrick Geddes assured his readers in 1905 that 'no great museum was but once a boy's pocket!', and the scientist William Henry Flower described his curatorial work at the British Museum as a natural extension of his earlier 'boy's collecting' practices. As this article suggests, however, the Victorian model of the public gallery as a collective embodiment of masculine property was never universally embraced. William Henry Flower, *Essays on Museums and Other Subjects Connected with Natural History* (Macmillan and Company, London, 1898), p. 67; Patrick Geddes, *The World Without and the World Within: Sunday Talks with My Children* (Saint George Press, Bournville, 1905), p. 27. For a fuller account of women's responses to the Victorian art world, see Clarissa Campbell Orr (ed.), *Women in the Victorian Art World* (Manchester University Press, Manchester and New York, 1995).

6 For example, see Jane Glaser and Artemis Zenetou, *Gender Perspectives: Essays on Women in Museums* (Smithsonian Institution Press, Washington and London, 1994), which focuses entirely on the mid- to late-twentieth century. Important exceptions are studies of early suffragette attacks on art, which nonetheless indicate a feminist narrative of anti-museology. For example, see Rowena Fowler, 'Why Did Suffragettes Attack Works of Art?', *Journal of Women's History*, 2 (1991), pp. 109–25; and Lynda Nead's insightful analysis of Mary Richardson's 1903 attack on the National Gallery's *Rokeby Venus*, in *The Female Nude: Art, Obscenity and Sexuality* (Routledge, London, 1992).

7 Barbara Joanne Black notes that in Charlotte Brontë's *Villette*, 'the museum represents for Lucy the space of the cultural, the other or non-self, the masculine. The museum is the arena of male prerogative and desire' (Barbara Joanne Black, 'Fragments Shored Against their Ruin: Victorian Museum Culture', PhD thesis, University of Virginia, 1991). Similarly, see Carol Duncan, 'The MoMA's Hot Mamas', *Art Journal*, (1989), pp. 171–8.

8 Suzi Gablik, ' "We Spell it Like the Freedom Fighters": A Conversation with the Guerrilla Girls', *Art in America*, 82 (1991), pp. 43–7; Loraine O'Grady, 'Dada Meets Mama', *Artforum*, 31 (1992), pp. 11–12; *Confessions of the Guerrilla Girls* (Harper-Perennial, New York, 1995).

9 Anne Higonnet has described the National Museum of Women in the Arts as a failed institutionalisation of feminism, arguing that the Museum depoliticises feminism by relegating it to the nostalgic sphere of the museum. She concludes that the Museum 'makes painfully aware the discrepancy between feminist ideals and the concrete possibilities for acting on them' (Anne Higonnet, 'A New Center: The National Museum of Women in the Arts', in *Museum Culture: Histories, Discourses, Spectacles*, ed. Daniel J. Sherman and Irit Rogoff, University of Minnesota Press, Minneapolis, 1994, pp. 250–64).

10 Patricia West, 'Gender Politics and the "Invention of Tradition": The Museumization of Louisa May Alcott's Orchard House', *Gender & History*, 6 (1994), p. 457.

11 Melissa A. Butler, 'Early Liberal Roots of Feminism: John Locke and the Attack on Patriarchy', *American Political Science Review*, 72 (1978), pp. 135–50; Susan Hekman, 'John Stuart Mill's *The Subjection of Women*: The Foundations of Liberal Feminism', *History of European Ideas*, 15 (1992), pp. 681–6.

12 Susan Pearce, *On Collecting: An Investigation in the European Tradition* (Routledge, London, 1995).

13 Again, Nead's account of the Mary Richardson attack (n. 6), in which the radical feminist critique of the National Gallery is fixed outside the institution itself, is instructive. I am drawing on the 'case of the disappearing Holbein' in order to suggest a different model of protest politics, in which institution and critique are intertwined rather than opposed.

14 I use the term 'feminist art historian' to indicate that Jameson intended women to gain political benefits from the acquisition of art historical knowledge. She criticised Harriet Martineau for neglecting the question of women's aesthetic education, and considered training in 'the delight in beauty' essential to women's development. Jameson's project for improving the condition of women predicated social and political progress on individual education, particularly in the fields of art and aesthetics (Geraldine Macpherson, *Memoirs of Anna Jameson*, Roberts Brothers, Boston, 1878, p. 332).

15 Jameson's tracts on women's rights, including *Sisters of Charity* (1855) and *Communion of Labour* (1856), are both reflective and constitutive of nineteenth-century Liberal feminism in their focus on education. Jameson also presided over a salon that included some of the leading lights of Victorian feminism, such as Bessie Parkes, Barbara Leigh Smith, and Emily Faithfull. With these women, Jameson helped to initiate the Married Women's Property Bill in 1857 (Claire Sherman and Adele Holcomb, eds, *Women as Interpreters of the Visual Arts, 1820–1979*, Greenwood Press, Westport, CT, 1981, p. 16).

16 Anna Jameson, *Diary of an Ennuyée* (Houghton and Mifflin, Boston and London, 1885), p. 298.

17 Ann Bermingham, 'The Aesthetics of Ignorance: The Accomplished Woman in the Culture of Connoisseurship', *Oxford Art Journal*, 16 (1993), pp. 3–20.

18 Anna Jameson, *Letters to Ottilie von Goethe* (Oxford University Press, London, 1939), p. 101.

19 Jameson, *Handbook to the Public Galleries of Art in and Near London* (John Murray, London, 1842), p. 156.

20 'There should be no deception permitted in a gallery intended for the pleasure and instruction of the people' (Jameson, *Handbook*, p. 286).

21 Jameson, *Sketches of Germany: Art, Literature, Character* (Charles Jugel, Frankfurt, 1837), p. 131.

22 *Art Journal*, 42 (1880), p. 226.

23 By 1914, the art collector and political hostess Lady Dorothy Nevill had located the origins of British museum culture in eighteenth-century ladies' collections and temporary exhibitions. She described Miss Linwood's exhibition of needlework pictures in Linwood Square (1787–1847) as the prototypical public exhibition, retelling the history of curatorship as a feminine endeavour (Lady Dorothy Nevill, *Under Five Reigns*, Methuen and Company, London, 1914, p. 250).

24 The Museums Association, the professional organisation of museum workers in Britain, hosted a panel on women curators in 1896. One speaker, Clara Nordlinger, noted with surprise that the female director of the Schleswig-Holstein Museum in Kiel did not support 'women's rights'. Implicit in Nordlinger's consternation was the assumption that women's participation in museum work would lead to the general adoption of feminist principles (*Museums Association Report of Proceedings*, 7, 1897, p. 133).

25 For a discussion of the Married Women's Property Acts, which allowed women to retain control over property owned before marriage, see Lee Holcombe, *Wives and Property: Reform of the Married Women's Property Law in Nineteenth-Century England* (Martin Robertson, Oxford, 1983).

26 One potential donor, Mrs Cheale, instructed her husband to write to the Gallery trustees on several occasions to promote the Lawrence painting she had inherited from her mother. Her husband was unconvinced of the work's value, but claimed that his wife would not rest until she had made the public gift in her mother's memory. Her dying wish was to accomplish 'the great scheme of getting her mother's picture into [the] National Gallery' (Mr Cheale to W. M. Sturt, National Gallery Archives, London, 4 February 1885). Similarly, see Clare Atwood to the Trustees of the National Gallery (National Gallery Archives, London), 26 December 1906.

27 Douglas Hall to the Trustees of the National Gallery (National Gallery Archives, London), December 1910.

28 Edward Ricketts to the Trustees of the National Gallery (National Gallery Archives, London), 4 February 1885.

29 For example, Sarah Solly, the daughter of the art collector Edward Solly, donated five paintings from her father's collection to the National Gallery in 1879. While she had played no direct role in forming the original collection, her letter stressed that the rest of the paintings had been sold to Berlin; she and her sister Lavinia had 'saved' five of the works for England by drawing funds from their inheritance (Sarah Solly to the Trustees of the National Gallery, National Gallery Archives, London, 21 March 1879).

30 Montague J. Guest (ed.), *Lady Charlotte Schreiber's Journals: Confidences of a Collector of Ceramics and Antiques Throughout Britain, France, Holland, Belgium, Spain, Portugal, Turkey, Austria and Germany from the Year 1869 to 1885* (John Lane, London, 1911), p. 457. For a more extensive discussion of Schreiber's collecting practices, see Ann Eatwell, 'Private Pleasure, Public Beneficence: Lady Charlotte Schreiber and Ceramic Collecting', in *Women in the Victorian Art World*, ed. Orr, pp. 125–45. I am grateful to Ann Eatwell for directing me to Lady Charlotte Schreiber's journals.

31 The classic account of prewar Liberalism and its dissenting voices of feminism, socialism, and Irish nationalism is still George Dangerfield, *The Strange Death of Liberal England* (1936; repr. Stanford University Press, Stanford, 1997). Here, I hope to develop the historiography on the crisis of Liberalism by illuminating the ways in which this particular contest for British cultural property further complicated the relationship between Liberalism and feminism.

32 Lloyd George stated publicly that he recognised the importance of the Holbein portrait, and the government offered a £10,000 gift for the painting (*Daily Graphic*, 6 May 1909). On the introduction and passage of the 'People's Budget', which established the structure

for modern progressive taxation in Britain, see Bruce K. Murray, *The People's Budget 1909/10: Lloyd George and Liberal Politics* (Clarendon Press, Oxford, 1980).

33 *Globe*, 11 May 1911.

34 *Hospital*, 15 May 1909.

35 *Sheffield Independent*, 2 June 1909.

36 Prewar exhibitions were often organised around the theme of female beauty. In 1909, for example, the Grafton Gallery in London hosted an exhibition titled 'Fair Women', which included miscellaneous portraits of aristocratic women from the Renaissance to the eighteenth century, portraits of Queen Victoria, a painting of Aphrodite, and a portrait of Lady Jane Grey with a description of her as a 'small and prettily-shaped' heretic (*Fair Women: An Exhibition Held in the New Gallery*, Ballantyne and Company, London, 1909).

37 *Punch*, 12 May 1909.

38 For a more extensive analysis of the connection between public museums and institutions of consumer culture, particularly department stores, see Neil Harris, *Cultural Excursions* (University of Chicago Press, Chicago, 1990).

39 *Observer*, 16 May 1909.

40 Dorothea Moore to David Alexander, Lord Balcarres (National Art Collections Fund Papers 97/18–35, National Library of Scotland), 5 May 1909, reproduced by permission of Lord Crawford.

41 *Westminster Gazette*, 7 June 1909.

42 *Observer*, 6 June 1909.

43 *Lady*, 10 June 1909.

44 *Punch*, 16 June 1909.

45 *American*, 6 June 1909. The *Sun* published the same report about the Duchess of Marlborough, but attributed the alleged gift to the Duchess's 'love of art' rather than social climbing (*Sun*, 5 June 1909).

46 *Vanity Fair*, 19 May 1909.

47 I am indebted to Peter Stansky for pointing out this connection to me.

48 *Leeds Mercury*, 2 November 1911.

49 Gilbert Murray to Rosalind Francis Howard, Countess of Carlisle (MSS Gilbert Murray 476, Bodleian Library, Oxford), 30 April 1894.

50 Lady Carlisle was one of several celebrated feminists who memorialised their private art collections in the National Gallery during this period. The noted feminist Lady Wolesley gave a succession of gifts over the prewar years, and Elizabeth Twining, the social reformer and art critic, gave a series of watercolours to the Tate Gallery in 1898 (*Annual Reports of the National Gallery*, 1899–1914).

51 *Report of the Committee of Trustees of the National Gallery to Enquire into the Retention of Pictures in this Country* (London, 1913), p. 121.

52 Rosalind Howard, Countess of Carlisle to Charles Holroyd (National Gallery Archives, London), 11 August 1912.

53 It is important to note that the British press often praised instances of women's collective contributions to art institutions; it was the discovery of an *individual* female donor that seemed to disrupt curatorial and public notions of connoisseurial philanthropy. See *Museums Journal*, 1 (1901), pp. 135 and 275.

54 *Standard*, 1 September 1911; *Athenaeum*, 2 September 1911.

55 *Morning Post*, 2 September 1911.

56 *Gloucester Journal*, 9 November 1911.

Chapter 26 | Edward N. Kaufman

The Architectural Museum from World's Fair to Restoration Village

We might perhaps, on former occasions, by viewing the products of various nations, . . . [have conceived] some idea of their manners and customs, but never had we before such an opportunity of studying their every-day life in its most minute details. Without undertaking long and perilous journeys, without running the risk of being frozen in the North, or melted in the South; we have seen the Russian drive his *troika* drawn by Tartar steeds, the Arab smoke the *narghilé* or play the *darbouka* under his gilt cupolas, the fair daughters of the Celestial Empire sip their tea in their quaint painted houses; we have walked in a few minutes from the Temple of the Caçiques to the Bardo of Tunis, from the American log-hut to the Kirghiz tent.[1]

The writer, Eugene Rimmel, leading perfume manufacturer and Assistant Commissioner of the Paris International Exposition of 1867, alludes here to what he, and indeed every commentator, regarded as the chief novelty of the 1867 Exposition: the proliferation of national pavilions. Though writing about buildings, his attention fixes only with difficulty upon architecture. Rimmel is entranced by the power of the fair's architecture to simulate the experience of travel, the object of which, however, lies less in the buildings than in the social customs they support. All of this is perfectly symptomatic of the dawning mood of the international expositions. These grandiose displays, launched in London's famous Crystal Palace in 1851, fostered intense concentration on national representation through architecture, food, and the display of all manner of agricultural, industrial, and even intellectual productions; they nurtured an insatiable curiosity about the life of foreign peoples; they gave a tremendous boost to the study of ethnography; they bestowed new meaning and allure on the art of travel; and, in the process, they established the collecting and exhibition of architecture on a new footing.

Alfred Normand, in his learned monograph on the foreign pavilions of the 1867 Exposition, claimed that this was the first exposition at which architecture had been represented other than by drawings and small models.[2] This was not strictly true: the various courts (Medieval, Grecian, Alhambra) built within the Crystal Palace for the

Edward N. Kaufman, "The Architectural Museum from World's Fair to Restoration Village" from *Assemblage* 9 (June 1989), pp. 21–39. © 1989 by The Massachusetts Institute of Technology. Reproduced by permission. (Reprinted without illustrations.)

Great Exhibition of 1851 had already contained large-scale mock-ups of architecture. But the 1867 Exposition was the first to include a significant number of buildings outside the main exhibition palace. Egypt, Tunisia, Morocco, Russia, Austria, Great Britain, Prussia, Holland, Spain, all staked out parcels of the Champs de Mars; there were also a Roumanian church, an American schoolhouse, an Italian villa, a replica of the temple of Xochicalco, and many other exotic structures. And in this motley collection of national pavilions, the 1867 Exposition perhaps mounted the first museum of architecture to present entire buildings. In doing so, it laid the groundwork for both the period room and the outdoor architectural museum of the twentieth century.

The magic of the Paris Exposition was not completely novel, however. The principle of arrangement adopted at the Champs de Mars was essentially that of the English landscape garden, which George Wightwick had already adapted to an imaginary architectural museum in his *Palace of Architecture*, published in 1840.[3] Moreover, as Rimmel's rhapsodic travelogue suggests – and other commentators on other fairs return repeatedly to this theme – the success of the national pavilions was based upon their ability to capture and recapitulate the experience of travel, long an important component of both popular and professional critiques of architecture. Finally, like the casts and fragments of earlier architectural museums, the national pavilions invoked the rhetorical power of fragments to suggest grand but invisible generalities, which were now sought in the abstract but emotionally laden sphere of nationhood and the march of civilization. In what broad terms these little pavilions could indeed speak is suggested by the words of an American commentator who found embodied in the tiny American schoolhouse "the great secret of the general intelligence of the American people, the source of their astonishing material progress," and who reported that "Republican institutions have never had more eloquent advocates abroad than the two unassuming structures on the Champ de Mars."[4] Nor were the Americans alone in such rhetoric. The Commissioner General of the Egyptian exhibition remarked that the four buildings under his jurisdiction offered, "in miniature and as if condensed into a very small space, all of Egypt, brilliant, splendid, revealing the grandeurs of its past, the rich promises of its present, leaving to public opinion itself the responsibility of drawing conclusions about the future."[5] One might think that the net of representation could hardly be cast more broadly, yet Normand himself claimed that the same four buildings "summarized in a sense all of oriental life. . . ."[6]

We can, nonetheless, be a little more specific about how and what the national pavilions represented. Most obviously, as the examples quoted above suggest, they stood for national identity, a function that would be strengthened and regularized at later fairs: at those of 1878 and 1900, both in Paris, national pavilions were grouped to form impressive "Rues des Nations," each pavilion performing essentially as a logotype for its respective nation. The pavilions of rich Western countries such as Prussia and Great Britain also stood for modernity and progress. But Normand's attention was not directed toward these prosperous modern pavilions but rather toward those from what would now be called the Third World. In his text, he identifies two distinct categories among the foreign buildings: first, those of "oriental nations" such as Egypt, Tunisia, and Morocco, which were "emerging from their isolation for the first time," and, second, those of northern countries such as Russia, Norway, Sweden, and Austria, "where wood was the principal element of construction." True, there existed a third group, too, which included Great Britain, Spain, and Prussia, but it held little interest for Normand. And this is precisely the point: what the

oriental and northern nations had in common was that both maintained traditional cultures untouched by modern Europe's inexorable march of progress. The architecture of the pavilions articulated this cultural difference quite clearly; they represented foreignness, ethnicity, difference.

In order to see the image of difference, the architects and organizers of the fairs had first to construct it. This they quite literally did in 1867, for a great many of the national pavilions were designed by Parisian architects. But more significant, they had to reach an agreement about what lay within and what without their own civilization. This distinction was articulated in two ways: first, by drawing a spatial line around the perimeter of modern Western culture; second, by drawing a temporal line across its threshold. The first defined a realm of foreignness that included Egypt, the Far East, North Africa, Russia, Scandinavia, and the American West; the second created a realm of pastness that stretched backward from around 1800 into the furthest mists of time. What was left over, the residual area consisting of western Europe after about 1800, belonged to the realm of the fair organizers themselves and their public.

To understand how difference was constructed and displayed, it must be remembered that the fair goer of the late nineteenth century was not primarily interested in buildings but rather in the kind of experience suggested in Normand's phrase "all of oriental life." As Burton Benedict has pointed out, in the organization of the fairs from 1867, there was a rapid proliferation of categories relating to social life.[7] This development had a profound impact on the display of architecture. On the one hand, the official interest in social welfare prompted a rapid rise in the popularity of exhibits of workers' housing. These had already been introduced at the Great Exposition of 1851 but would culminate only much later in independent exhibitions such as the Weissenhof Seidlung in Stuttgart begun by the Deutsche Werkbund in 1925. On the other hand, increasing attention was paid to the texture of popular life in the past. One of the great attractions of the Paris Exposition of 1867 was a "History of Labor," which set forth the development of human skill in a display of well over five thousand tools and craft objects dating from the Stone Age to about 1800. Even more entrancing were the exhibits of native costume. Rimmel particularly enjoyed the Swedish exhibit, which featured "figures of life-like expression engaged in all sorts of occupations." So anecdotally suggestive were these that around them one could "build a little story illustrating Swedish manners and customs": first, a "lightly clad" young maid mows hay in a field; she returns home, where her companion dresses her hair; her lover enters, leading to a tender scene of avowal; in due course, a baby arrives; and finally the happy family (whose father is an itinerant clock maker) departs on a business tour of Lapland.[8]

In exhibits such as these, an attempt was made to involve a broad range of artifacts in a total picture of human life; at the same time, the artifacts were animated by a warmly human presence. The house itself was the most complete and expressive of domestic artifacts – after all, as had been expressed by many, including the antiquarian John Britton in his description of Sir John Soane's museum, the house was a portrait of its owner[9] – and so the display of foreign, ethnic, or historic architecture came to be deeply affected by this preoccupation with social customs. Already at the 1867 Exposition, some of the national pavilions were peopled by characteristic figures: at the Egyptian *okel*, Rimmel noted that "*real* natives, varying in shade from light brown to ebony black, work at several trades," including turning, jewelry making, and barbering. "In the recess behind the stall," he added, "is sometimes seen an Egyptian cooking his dinner...."[10] In the expositions that followed, the importance

of native figures to the display of architecture increased significantly: at the Philadelphia Centennial Exposition of 1876, a hunter's cabin was not only equipped with "all the paraphernalia that a pushing and ingenious pioneer would be likely to provide" but also occupied by several real hunters who gave demonstrations of fishing and beaver hunting, "lounge on the rough log couch, smoke, dress skins, cook and eat, thereby illustrating their manner of living in the West";[11] at the Paris Exposition of 1889, meticulously reproduced pavilions and villages housed over four hundred Indochinese, Senegalese, and Tahitians;[12] and at the Chicago Exposition of 1893, such displays of native life proliferated as amusements of the most popular sort.

Another spectacular manifestation of the concentration on domestic architecture and domesticity encouraged by the fairs was the "History of Human Habitation" presented at the Exposition of 1889. This was a series of twenty-three full-scale houses designed by Charles Garnier, the famed architect of the Paris Opera. While few of Garnier's houses pretended to any great accuracy (a flaw noted apologetically by the architect himself), this hardly mattered: the differences registered by the buildings on exhibit were not really architectural at all but were rather constructed on the level of popular life and culture – and here Garnier's exhibit worked brilliantly. Like the "Histories of Labor" mounted in both 1867 and 1878, it demonstrated the steady rise of civilization, but it also told the story of human lives that differed from those of its viewers, and in such tableaux as the house of a Phoenician sea captain, with its canopied roof gallery from which (we are told) the proprietor might watch his ships sailing off across the blue Mediterranean, it told the story with anecdotal verve and imagination.[13]

If exhibits like these used architecture to invite the viewer's participation in alien forms of culture, other kinds of exhibits encouraged consumption of a much more literal sort. Alongside the pavilions of 1867 sprang up a host of national restaurants and bars, which worked hand in hand with the national pavilions to provide an access to foreign modes of life. The Viennese brewer Dreher set up an immense beer hall in the midst of the Austrian village, where the enjoyment of Austrian and Hungarian national dishes, wines, and beer was enhanced by the "blue-eyed *madchen* in national costume," who served fair goers and contributed to the "*couleur locale.*"[14] Local color was evidently the main attraction: the Russian restaurant caused such a "great sensation" with its booted and pantalooned waiters that "many visitors, in order to have a nearer view of the denizens of the place, venture to dive into the horrors of Russian cooking. . . . Others less bold, or less wealthy, content themselves with staring in through the windows."[15]

In exploiting food as a medium of cultural consumption, the Paris Exposition of 1867 was not absolutely novel: across the Atlantic, theme restaurants had already formed a popular attraction in the local fairs mounted three years earlier by the United States Sanitary Commission.[16] Known as New England or Olde Tyme Kitchens, these restaurants were evocatively decorated to suggest the ambience of a colonial kitchen, and they were furnished with a bill of fare to match. The New England Kitchens differed from the national restaurants of the Paris fair in that the *couleur locale* they offered was that of the past, rather than of a foreign country; yet, as always, it was difference that was emphasized, and the techniques for the display of that difference remained essentially the same. And, indeed, in the late-nineteenth-century fairs, the increasingly elaborate presentation of foreign culture was paralleled by an ever more loving exaltation of national tradition.

The chief vehicle for presenting the national past was the historical theme village. Paris in 1867 had an Austrian village, as well as Russian and Egyptian compounds, all obviously foreign, but native villages soon appeared as well. Two exhibitions held in 1886 featured historical recreations based on local topography: Old Edinburgh and Old London. For the Manchester Royal Jubilee Exhibition of 1887, Alfred Darby-shire and Frederick Bennett Smith designed another large theme village called Old Manchester and Salford, whose putative site was adjacent to the site of the exhibition itself. The exhibit's most prominent feature, the cathedral tower, replicated the existing tower of Manchester Cathedral, so that the connection between Manchester within and without the fair could hardly be missed. Yet the Manchester exhibited was Manchester of the past, and the traveler who entered it found himself caught up in a strange sort of chronological collage. "It was a sort of dreamland," wrote Walter Tomlinson, the fair's official commentator, "a wonderfully delightful jumble of incongruities" where "nothing happened but the unexpected."

> The Roman gateway, guarded by Roman soldiers in full costume, led to Tudor houses. You had stocks and pillory, and hideous ancient crosses, and Chetham College, and the first Exchange, all in a heap; a fine old bridge, spanning a river of cobble stones; a cathedral tower ninety-three feet high, without any cathedral attached. Edward the Third's crossbowmen wandered about the streets; the terribly fierce and warlike body-guard of the Young Pretender was for ever on parade; and anon you came full tilt upon the ghost of a Georgian watchman, bill-hook and all. There was a post-office where you didn't post; a coach-office from which no coaches started. . . . [17]

From Tomlinson's impressions three distinct themes can be extracted, and these themes were to remain important in the architectural presentation of the national past and, indeed, in the conception of outdoor architectural museums right down to the present. First was the fracturing of time and space that ensured that no coherent picture of Manchester at any given time could ever come into focus. This chrono-logical instability thrust even the most apparently complete architectural specimens firmly into the realm of fragments: it opened them up and gave them the power of suggestive completion on a higher level, which was not the historical Manchester of a particular epoch but the ideal Manchester of all past epochs – Old Manchester. Second was the mixing of heroic and quotidian elements in the tableaux: the cathedral tower and the coaching office, the intrigue of the Young Pretender and the daily life of the streets. Third was the populating of this generalized image of Old Manchester with just the sort of ethnic figures and amusements that had become familiar in national pavilions, restaurants, and costume displays. One could dine at Beaumont's Eating-House, or buy ices, creams, and chocolates from a "bevy of maidens charmingly dressed in the style of Queen Anne's days"; or one could purchase a souvenir from one of the many craftsmen – jewellers, glass engravers, printers, pipe makers, umbrella makers – "all at work, busy as bees, and dressed in the most charming of old-world costumes." One could watch "Master Caxton and his assistants, all correctly cos-tumed," working an ancient wooden printing press, or a group of "Elizabethan maidens . . . , very pretty and neat in white caps and with cockscomb frills, and brown dresses with white bodices and shoulder puffs," binding books.[18] The visitor could, in short, consume both the process and the product of traditional handicraft.

The main themes and procedures of Old Manchester were soon developed at other fairs, especially at the Paris Exposition of 1900, where a great swath of land along the

river was given over to a display of "Le Vieux Paris," whose fruitcake richness of effect exceeded even that of Old Manchester. But tradition was also subjected to other kinds of display. At the Exposition of 1867, the "History of Labor," the costume exhibits, and the various examples of domestic architecture had all focused attention on ethnic patterns of domestic life; the Vienna Fair of 1873 helped to articulate these themes into a definite architectural shape. Part of the fairgrounds along the Danube was reserved for a display of rural houses from various Austro-Hungarian regions. As usual, the emphasis was on the demonstration of differences: traditional timber construction was marveled at, while, of a peasant house from Hungary, one illustrated chronicle commented, "The contemporary inhabitants of the province of Haudorf take no part in the great progress owing to the immense conquests of modern civilization."[19] Yet a well-developed attempt at national self-description was also at work, for these were not the peasants of some foreign country but rather of the homeland: they and their cottages therefore represented a repository of fast-disappearing native traditions.

Within the same general area of the Vienna Fair stood another noteworthy group of buildings. Though individually, the timber houses and church that made up the Transylvanian Village hardly differed in principle from the Haudorf house, or for that matter from the Polish, Alsatian, or Russian farmhouses, their disposition did. For instead of being singly disposed, they were grouped into a rough semblance of a village: to be sure, there was little accuracy in the arrangement, but the ethnographic intent was at least more serious than that of the Austrian Village, with its bustling beer hall, at the Paris Exposition of 1867. This new emphasis on the entire settlement was carried further at the next great Austro-Hungarian fair, the Budapest Millenium Exposition of 1896. Here, the "Ethnographic Group" consisted of two segments, a "Hungarian Street" and a "Nationalities Street," both displaying rustic or peasant houses and both offering craft objects for sale.[20] The nationalities of the latter street comprised Rumanians, Swabians, Bosnians, and the inhabitants of neighboring regions, so that the entire ethnographic group formed an open-air museum of Austro-Hungarian regional folk life and architecture.

A few years prior to the Budapest Exposition, however, the world's first permanent outdoor architectural museum had opened in a capital city at the other end of Europe's great timber belt, Stockholm. In order to understand its genesis and its relationship to developments at the international expositions, we must go back to 1872. In that year, a Stockholm philologist named Artur Hazelius had taken a holiday trip to the Swedish province of Delecarlia. There he became aware of the encroach-ment of industrialization on the traditional peasant culture and, filled with that sense of impending loss that had motivated architectural collectors from Alexandre Lenoir at the end of the eighteenth century onward, he began to accumulate old costumes and implements. Within the same year, he exhibited his new collection in Stockholm; in the following year, he founded the Skandinavisk-etnografiska Samlingen; and in 1876, helped by generous government subsidies, he was able to take his growing collection to the Philadelphia Centennial Exhibition. There his "admirable groups of costumed figures illustrating peasant life" won particular praise. Arranged in anec-dotal tableaux, they must have been very similar to the Swedish costume exhibits in the Paris Exposition of 1867, most likely the source of his inspiration. But Hazelius's tableaux were especially remarked for their verisimilitude. The costumes themselves had all been purchased directly from their peasant wearers. And instead of the usual wax mannekins, Hazelius used plaster figures modeled by a well-known Stockholm

sculptor, with hands and faces painted in an "exceedingly lifelike" manner. Indeed, such great care was taken to assure "absolute correctness in detail" that when a hand was broken in shipping, it was replaced by another modeled from a Swedish girl employed by the exhibition commission.[21] In 1878 Hazelius again took his collection on tour, this time to the Paris Exposition, where his tableaux scored another great success. By now they were even more ambitious, with backdrops painted by a leading Stockholm theatrical painter and with much more fully developed anecdotal narratives.

Had Hazelius's story ended with the Paris Exposition of 1878, it would have been merely an incident in the history of the fairs. But Hazelius had greater ambitions. In 1880 his ethnographical collections became the national property of Sweden, and a grand structure, the Nordiska Museum, was built to house them. Still Hazelius was dissatisfied, for he now wished to exhibit not just the costumes and artifacts of traditional farm life but that life itself, or at least whole farms, complete with buildings, animals, and people. And so, in 1891, he opened the world's first permanent outdoor architectural museum, Skansen. This was a seventy-five-acre park in Stockholm, furnished with a collection of Swedish village buildings, supplemented by traditional crafts, peopled by guides in traditional costume, and animated by demonstrations of folk song, dance, and crafts. It was at once a costume tableau and an ethnographic theme village.

Outdoor museums caught on rapidly in Scandinavia: Denmark's first, in Copenhagen, opened in 1897 (then moved to Sorgenfri in 1901); Norway's first, the Norwegian Folk Museum at Oslo, in 1902; its second, the Sandvig Collections near Lillehammer, in 1904; Finland's first, at Folis, in 1908. Yet others followed, all pursuing essentially the same ethnographic or folk-oriented lines laid down by the Nordiska Museum and Skansen: by 1928 it was estimated that approximately one hundred fifty such outdoor museums existed in Sweden alone.

If the outdoor architectural museum grew out of the international expositions of the late nineteenth century, changes in the indoor display of architecture were also bringing traditional art museums in line with the expositions. Throughout the nineteenth century, museums had grouped decorative art objects according to material – silver with silver, glass with glass, and so forth. This was equally true of the exhibits mounted by decorative arts manufacturers at the fairs. But during the 1890s this practice began to break down. At the Swiss National Museum in Zurich, for example, the collections were rearranged more naturalistically in sixty-two rooms designed to evoke period settings; the same procedure was followed in Munich, Nuremberg, and elsewhere. In Brussels, London, and Paris, avant-garde galleries of decorative arts adopted a parallel principle of quasi-domestic installations, and at the Paris Exposition of 1900, Siegfried Bing's Pavillon de l'Art Nouveau presented the most up-to-date home furnishings in a convincing approximation of a house. And though the new methods were not immediately appropriated by English or French museums, the period room – the more or less authentic but always evocative architectural setting for the display of domestic furnishings – was well established in museums throughout the Germanic and Scandinavian lands by the turn of the century.

Both the period room and the outdoor museum caught on and multiplied in the United States as well. It has been generally believed that the first period rooms in America were the three installed by George Francis Dow at the Essex Institute in Salem, Massachusetts, in 1907; yet recent research has shown that Charles Presby Wilcomb anticipated him.[22] Born in 1868, Wilcomb grew up in the equivalent of

Hazelius's Delecarlia, rural New Hampshire, surrounded by just the sort of relics that incited the Swede's desire. Some time in the 1880s he began to collect those relics, but it was his move to California in 1888 that gave him the requisite distance to see his collections in perspective. He was struck suddenly by a perception of cultural difference and, like Hazelius, by a sense that valued traditions were slipping away. Having convinced the commissioners of San Francisco's Midwinter Fair of 1894 to appoint him curator of the museum that would be the fair's permanent memorial, he opened his New England collections to the public in 1896, displayed in two period rooms, a colonial kitchen and a bedroom. Wilcomb's association with the Golden Gate Park Memorial Museum was unhappy, and in 1905 he resigned. But three years later, after a brief stint in the East during which he furnished more period rooms in private houses, he returned to California as curator of the Oakland Public Museum, where he built up yet another colonial collection and, in 1910, opened yet another pair of period rooms.

By this time, however, George Francis Dow had opened his rooms at Salem. Dow himself would later claim that his were the first period rooms in America;[23] yet whether or not he actually knew of Wilcomb's work, his assertion was an interesting one. Dow was certainly not averse to acknowledging precedents; indeed, he referred liberally to those of Munich, Zurich, Nuremberg, and Stockholm, lauding in particular the outdoor museums of northern Europe. But as a cultivated easterner in one of America's oldest cities, Dow probably wished to be seen as an importer of European fashions. He may simply have been blind to native precedents.

Dow's rooms – a bedroom, a parlor and, as always, a kitchen – deserve a brief description. They were constructed in the typical exposition manner out of a mix of original elements, reproductions, and approximations. In the parlor, for example, a genuine mantel by Samuel McIntire consorted with wainscot, cornice, and other woodwork "reproduced from the finish of a house known to have been designed by him."[24] Rather than the authenticity or historical integrity of the rooms, Dow emphasized the texture of life that was lived in them.

> An effort was made to heighten the illusion of actual human occupancy by casually placing on the table before the fireplace in the parlor a Salem newspaper printed in the year 1800 and on it a pair of silver-bowed spectacles, as though just removed by the reader. Elsewhere was placed a work basket with a half-knitted stocking on the top of other work, the knitting needles in place; and in other ways the illusion of daily occupancy was created.[25]

The scenes lacked only figures in old-fashioned dress, and these were soon provided. In 1908 Dow spotted an important late-seventeenth-century house about to be demolished; he had it moved to the back of the Essex Institute, furnished "as though occupied," and peopled with caretakers in seventeenth-century costume. He then dug a well (dry but equipped for operation), planted an old-fashioned garden, set up a "fully equipped shoemaker's shop," attached the porch of Hawthorne's famed House of Seven Gables to the rear of the institute (as well as a porch by McIntire), and planted a cupola from the roof of a Salem merchant's house in the garden.[26] The resulting ensemble must have been rather bizarre and was doubtless amateurish compared to Skansen. Yet it had a better claim to priority than Dow's period rooms: it was almost certainly the first permanent outdoor museum in the United States.

The importance of Dow's work, however, lies in the fact that at the Essex Institute the two new methods of architectural display, period room and outdoor museum,

were introduced into the mainstream of American museology at the same time. Together they would take root and proliferate during the 1920s, though the period room caught on more quickly. Professional interest in period-room installations began very rapidly indeed, particularly at the Metropolitan Museum of Art, where significantly, there was a European connection in the person of W. R. Valentiner, who had been named curator of the new Department of Decorative Arts in 1907. Before coming to America, Valentiner had assisted Wilhelm Bode, Director General of the Royal Museums of Berlin and a leader in the movement toward period installations, and in arranging the Metropolitan's new collection of French decorative arts in 1908, he naturally followed the latest European fashion.

Though Valentiner returned to Germany during World War I, his impact on American museums was just beginning. After the war, he became Director of the Detroit Institute of Art, where period settings were introduced in 1923. In the meantime, his former assistant, Joseph Breck, had become Curator of Decorative Arts and Assistant Director of the Metropolitan Museum. Valentiner and Breck would wield considerable power at the museum throughout the formation of what were arguably the most important period-room installations in America, the American Wing and the Cloisters; and after Breck's death in 1933, it was his close associate, James J. Rorimer, who guided the Cloisters to completion.

The story of the American Wing began two years after Valentiner's arrival, with a major exhibition of American decorative arts mounted by the Metropolitan in connection with the Hudson-Fulton Celebration of 1909. At the same time, the museum purchased a collection of over four hundred objects – a daring move, for received opinion held that American craft objects had no place in a serious art museum. The exhibition's success proved otherwise, and demand grew for a permanent display of the museum's new collection. This was to be at once a "complete exemplification" of the "Zurich method" and a vindication of Dow's work at Salem.[27] Accordingly, the museum began to purchase rooms from old houses to serve as period settings, and in 1919 Grosvenor Atterbury was hired to design a new wing to contain them. The American Wing opened in 1924, complete with seventeen period rooms, to great acclaim.

The evocative settings of the American Wing, which captured public and professional imagination alike, had immediate repercussions. At the Metropolitan Museum itself, Edward Robinson's Roman Court, a large Pompeian atrium stocked with Greek and Roman sculpture, followed within two years. Far more important, though, were the Cloisters, the celebrated collection of medieval architecture and sculpture amassed by George Gray Barnard, bought for the museum with a gift from John D. Rockefeller, Jr., in 1925 and magnificently housed a few years later in a romantic compote of genuine and reproduction medieval settings, poised high above the Hudson River. But by now museums in Detroit, Brooklyn, and other cities were also following the Metropolitan's lead. Nor was the triumph of the period room restricted to museums. Even shops now sold luxury goods in period-room settings (indeed, Neil Harris has shown that museums were strongly influenced by innovations in shop display).[28] More significant, private collectors had discovered the attraction of period settings for their collections: George Gray Barnard and George Blumenthal, much of whose collections went to the Metropolitan; William Randolph Hearst, who spent a lifetime and a fortune building San Simeon in California, itself now a museum; James Deering and John Ringling, who built splendid mansions in Florida, Villa Vizcaya and Ca d'Zan, both now museums; Electra Havemeyer Webb, whose

collection of decorative arts and transplanted buildings is now the Shelburne Museum; and Henry Francis Du Pont, whose enormous collection of American period rooms and furnishings, begun in 1918 and inspired by the examples of Shelburne and the American Wing, opened to the public in 1951 as the Winterthur Museum. And here we must also remember Mrs. James Ward Thorne, who in the late 1920s began to build period rooms in miniature: some of her marvellous rooms, after being shown at the Chicago World's Fair of 1933 and the New York and San Francisco World's Fairs of 1939–40, became part of the Art Institute of Chicago, whose curator of decorative arts called the thirty-seven American examples "a fully developed American Wing in miniature."[29] By this time, the Cloisters had finally opened: it was perhaps a coincidence, but a significant one, that in 1938, the year of the opening, the skylit cast court of the old Metropolitan Museum was rebuilt and the entire collection of architectural casts and models swept away. The triumph of the "Zurich method" was complete.

Complete, too, was the triumph of the fairs, for the similarities between the twentieth-century period room and the nineteenth-century fairground exhibit are too striking to overlook. One was the tendency to treat "rooms" as three-sided stage spaces, a conception enforced in the Thorne Rooms by their miniature, peep-show presentation, but elsewhere by ropes and barriers (or even by the removal of whole walls), and always redolent of the fairground tableaux. Along with this reorientation of historical material to the exigencies of display came a willingness to alter original proportions, arrangement, and lighting; the results were frequently reminiscent of the Alhambra Court at London's Great Exposition of 1851, reduced in scale (but the ornaments reproduced at full size) and shorn of one story in the elevation. Then, too, period rooms were generally cobbled together out of the most disparate bits and pieces of decoration and furnishing – Hudson Valley portraits, Virginia paneling, London wallpaper – often quite genuine in themselves but historically incompatible. These assemblages, above all, recalled such fairground exhibits as the Tunisian palace of the 1867 Exposition, which closely resembled none of the Bey's three residences yet was somehow typical of all three. Of course, the collage effect of many period rooms also significantly recalled the architectural environments constructed out of fragments by Alexandre Lenoir well over a century before in his Musée des Monuments Français.

The reemergence of the outdoor museum in American museology paralleled the rise of the period room in the 1920s; again wealthy private collectors were in the vanguard. But here the emphasis differed slightly. The growth of interest in American decorative arts had played a central role in the development of the American period room; in the outdoor museum, the celebration of native tradition was all-important. It has been suggested that the first museum village in the United States was begun in 1925 when a group of log cabins were moved to Decorah, Iowa, and opened to the public.[30] Yet in 1923 Henry Ford had already purchased the famous Wayside Inn in South Sudbury, Massachusetts, along with over two thousand acres of land, a church, schools, and houses, all of which he proceeded to restore as a showcase village.[31] More ambitious schemes followed rapidly. In 1924 the city of Williamsburg, Virginia, offered itself to Ford as a restoration project on the largest scale; and though he turned down the proposal, two years later John D. Rockefeller, Jr., began to rebuild the town, providing it with all the accoutrements of an outdoor museum. In 1927 Ford began to construct his own outdoor museum, originally called the Early American Village (and now known as Greenfield Village), which would open in Greenfield,

Michigan, in 1929, in conjunction with a vast indoor museum of American decorative and industrial artifacts. After 1929 the popularity of restoration villages climbed rapidly, and by 1955 over thirty were estimated to exist east of the Mississippi alone; but then the enthusiasm for American tradition had also increased phenomenally, so that by 1967 these restoration villages could take their place among "more than six hundred thirty museums, historical houses turned museum, and townlike enclaves – conserved, restored, or reproduced – that concentrate on the wherewithal of everyday living as our ancestors lived it."[32]

The outdoor museum, as well as the period room, represented a reaction against the traditional museum presentation of architecture through casts and fragments. Again, the debt to the nineteenth-century fairs is clear. Like the Champs de Mars at the Paris Exposition of 1867, American outdoor museums were frequently laid out along the lines of a romantic landscape garden (though often, as at Ford's Early American Village, with a touch of suburbia). And like the ethnic villages, they presented a varied array of costumed guides, craft demonstrations, and traditional foods, while, like the fairs in general, providing a sophisticated range of tourist services. Finally, as did most of the national exhibits, they focused attention not on architecture but on the details of "old-fashioned" life contained within the buildings' frame, and in doing so encouraged anecdotal interpretation. "Of houses, Vermont House is conceived as the retirement dwelling of a much-voyaged sea captain," remarked *House Beautiful* of an exhibit at the Shelburne Museum, invoking a vein of narrative invention reminiscent of such fairground exhibits as the "History of Human Habitation," with its Phoenician sea captain's house, at the Paris Exposition of 1889.[33]

The tremendous debt to the fairs shared by all of the great Americana collections of the 1920s, period rooms as well as outdoor museums, was as great on the ideological as on the technical level. For though in celebrating national traditions these collections seemed to display the common experiences of Americans, their focus was really that of the fairs, namely cultural difference, the differences between past and present; and just as it had been for Hazelius, the attempt to commemorate or retrieve vanishing traditions was fueled by an acute sense of loss. Once again, this conjunction of loss and retrieval raises the issue of architectural preservation: for both indoor and outdoor museums have repeatedly claimed to be motivated by its spirit, and what they have accomplished in this regard must not be minimized. But as with architectural collectors ever since the days of Lenoir and Lord Elgin, destruction was as central to their work as salvation: by 1955, for example, Colonial Williamsburg had restored 82 buildings, reconstructed 375, and destroyed 616.[34] If no one thought to criticize this ledger, it was not only because the buildings destroyed were less esteemed as architecture than those restored, but, more important, because, as with Hazelius and the other organizers of ethnic fairground displays, the preservation urge was rooted in a deeper sense of loss concentrated not on architecture but on a way of life. Henry Ford professed to despise history as taught in books and to value instead the stories of everyday life told by artifacts: his Early American Village was designed to expound that life, and visitors understand this quite clearly. A writer in *House Beautiful*, commenting as recently as 1967 on the proliferation of restoration villages and house museums, noted the "delightful preoccupation with domestic archeology" that "now pervades the land": "Great-great-grandmother's quilts never seemed more precious, and everyone is avid to learn how she cooked her griddle cakes, churned her butter, hung her curtains, entertained her friends, spent her vacations."[35] Abbott Lowell Cummings, too, could put architecture and preservation in the proper perspective:

"For those many Americans who have been troubled successively by the vanishing of the Indian, the buffalo, and the familiar locomotive, with its beloved steam whistle there can be added a new cry, 'lo the poor American village!' "[36]

As Cummings suggests, the way of life "preserved" by open-air museums was an idealized preindustrial culture that revolved around the traditional handcrafts. This was the ideology promoted at the fairs, institutionalized at Skansen, and quite universally followed in open-air museums throughout Europe (and in recent decades in the U.S.S.R). In the United States, the hostility to industry was at times palpable, as at Old Deerfield, whose director in 1955 admiringly ticked off a list of stalwartly Anglo-Saxon names – Abercrombie, Allen, Ashley, Childs, Fuller, Hawks, Wells, Williams – who had "had the vision to keep industry off the quaint old Street."[37] But elsewhere, this nostalgia for a preindustrial culture subsisted in strange harmony with the symbols of industrialism. Thus when Henry Ford opened his Edison Institute, no conflict was perceived between the adulation of traditional handcrafts and village ways of life, which dominated part of the complex, and the adulation of industrial pioneers such as Edison, the Wright brothers, and Ford himself, which dominated the rest. Indeed, so strongly held was the belief in an ideal preindustrial culture that the geniuses of industrialism were simply ruralized: even Ford's automobile factory was so reduced in scale that it appeared hardly out of context with the surrounding craft shops, the miniature town hall, and the old-fashioned inn.

All the same, this bucolic ideology of the village everyman was seriously complicated by other factors, and not only by the adulation of industrial heroes. There were also political heroes to commemorate. The saintly virtues of relics had always enlivened architectural museums, but in the United States the concept of the secular relic formed the very foundation of the architectural preservation movement. In 1850 Washington's revolutionary headquarters in Newburgh, New York, had become the first historic house museum in this country. Ten years later, Mount Vernon – replete with such relics as the shaving stand presented to Washington by the first French Minister and a chair that "stood in the room the night of his death" – also became a national shrine, soon followed by Washington's headquarters at Morristown and Valley Forge.[38] Not all of the ethnographic enthusiasm of the late-nineteenth-century fairs, not all of Ford's agrarian populism, could dim this national cult. On the contrary, Ford went to great lengths to acquire a building dignified by association with Abraham Lincoln. Other collections, like Colonial Williamsburg, played this theme with flourishes, splashing brilliant touches of fame and honor against the more subdued background of everyday life in a way closely reminiscent of nineteenth-century theme villages such as Old Manchester and Salford.

In the Americana collections, however, the two levels of representation shared a somewhat special significance that was not exactly prefigured by the nineteenth-century fairs. Those fairs had, of course, done a great deal to emphasize concepts of nationhood. But American craft collections had to expound not only a uniquely American tradition but one that was quite specifically independent of European values. Royal Cortissoz, commenting on the Metropolitan's new American Wing, drew the lesson that "these ancestors of ours" were "people of good breeding and consequent good taste."[39] Others, too, spoke of "taste and culture" and portrayed the past as an idyll. This sat poorly with the equally popular depiction of early Americans as rugged conquerors of a hostile land, but relative to the construction of American traditions and the demonstration of their achievements, these contradictions must have seemed niggling. In consequence, the distinctions between the heroic

and the quotidian, between high-style production and rustic craft, were not nearly so well articulated as in European folk museums.

In propounding native traditions, the American collections were driven by the same sense of loss that had propelled their European predecessors. But in the United States, the entire issue of lost or threatened traditions took on a peculiar and paranoid intensity. "Traditions are one of the integral assets of a nation," intoned the official chroniclers of the American Wing in 1925:

> Much of the America of to-day has lost sight of its traditions. . . . Many of our people are not cognizant of our traditions and the principles for which our fathers struggled and died. The tremendous changes in the character of our nation, and the influx of foreign ideas utterly at variance with those held by the men who gave us the Republic, threaten us and, unless checked, may shake its foundations.[40]

The danger so darkly hinted at here was quite specifically the threat of immigration. The 1920s indeed witnessed strenuous attempts to stem the influx of immigrants, as well as elaborate programs to Americanize those who continued to arrive. Such programs as Greenwich House or the University Settlement in New York frequently relied upon colonial architecture and design as environmental influences.[41] And the American Wing, born in 1909 as an artistic adventure, came to maturity in 1924 as an abettor of this rootedly conservative political ideology. Nor did its promoters express their hostility to non-Anglo-Saxon peoples in mere generalities. In evoking a cozy family scene in the New England kitchen, its chroniclers quite gratuitously conjured up an image of "the war-painted ferocious face of an Indian, tomahawk in hand," who "may have leered in at the little family gathering around the fire."[42] Henry Ford perhaps ought to be remembered rather for his many educational ventures in Americanization, served not only by his Early American Village but also by his museum at Greenfield – its vast industrial spaces entered through an accurate full-scale replica of Independence Hall – nonetheless, he was in fact briefly engaged in the 1920s in a public campaign of anti-Semitism.

Given their political ambitions and the scale of their funding and layout, enterprises such as the Early American Village might have become vast and impersonal ideological machines. Yet the many great American collections of the 1920s begun by private collectors – Greenfield, Shelburne, the Thorne Rooms, Winterthur – long preserved that quality of idiosyncracy and personal vision peculiar to the private collection. This was true of other architecture and period room collections of the time as well. Indeed, Winterthur shares with San Simeon, Villa Vizcaya, Ca d'Zan, even George Gray Barnard's original Cloisters, the signally important fact that each was not just a museum but a home; and if the Winterthur Museum seems distinctive by virtue of its well-articulated scholarly purposes, the arrangement of its interiors was no less influenced by Du Pont's domestic predilections, and the stories of how he imposed his imperious and refined taste upon them are legion.

Such collections clearly have little in common with the institutional cast collections of the preceding half century. For Du Pont, Ford, Hearst, Webb were all collectors in the grand manner, neither museum curators nor public servants, but individuals at once passionately acquisitive and opinionated. They became fiercely identified with their collections, living in them and shaping them to their own prejudices; and it was most decisively in this intimacy that they denied the heritage of the institutional cast collections, returning instead to the obsessive, egotistical brilliance of the very first

architectural collections founded in England and France over a century earlier. If indeed they have a model, it is to be found in the house museums of the early nineteenth century: Sir Walter Scott's Abbotsford, Lord Stuart de Rothesay's Highcliffe, or Soane's house at Lincoln's Inn Fields. Only by returning to these earliest architectural museums can we discover a comparable fusion of decor and collection.

At the same time, it must be recalled that the ideal of domesticity was also heavily reinforced by the farmhouses, fishermen's cottages, and old-time kitchens of the world's fairs; and twentieth-century architectural museums continued to feed that "delightful preoccupation with domestic archeology" that we have already noted. The primary difference was that, whereas the fairground exhibits had been designed as mere stage sets for a simulation, or at best a transitory recreation, of bygone ways, the new museums were in many cases conceived as habitats for ongoing life. Thus Hearst and Du Pont ensconced themselves within their collections. Even more interesting, Henry Ford, though not himself living among his furniture and farm implements – they filled his office and overflowed into Ford Company warehouses – nevertheless tried to establish a fully functioning community of some three hundred people within his Early American Village. The similar attempts at Old Deerfield and Colonial Williamsburg were rather more successful, since they were founded upon living communities that had only to be redesigned and redefined as outdoor museums.

In such villages, the nineteenth-century fascination with the past was transformed into a quite practicable strategy to inhabit it: the theme village thereby became an open-air extension of the romantic house museum, complete with the entire romantic apparatus of self-revelation through objects. Of course, it was not the village's inhabitants whose tastes and beliefs were so depicted. They were mere surrogates for the absent collector, to whose personality the open-air museum could, in extreme cases, become just as intimately formed as any romantic house museum. Perhaps Henry Ford's combination of indoor and outdoor museum at Greenfield, Michigan, *is* the extreme case: certainly its history provides a remarkable illustration of how collecting on the grandest scale could be used to articulate an image of the self.[43]

Ford's first act as a collector can be dated quite precisely to 1904, when he repurchased his own Quadricycle of 1896 for sixty-five dollars. But the onset of collecting mania took place ten years later. A casual remark by his wife prompted a recollection of verses learned in childhood from McGuffey's *Eclectic Readers*, and this, in turn, set off an intensive search for second-hand copies of the old books: in the end, Ford's collection would include not only over four hundred fifty volumes of the *Readers*, but also a "McGuffey School" built out of the timber from an eighteenth-century barn, and even McGuffey's Pennsylvania birthplace, transported to Greenfield and reerected in 1934.

By this time Ford was collecting architecture on an ambitious scale. His introduction to the field had come in 1919, when, in order to save the Ford family's old farm near Greenfield from the approach of a new road, he moved the house and reerected it some two hundred feet from its original site. He then set out to restore it to its condition as remembered from 1876 – a difficult task, as crucial items were out of production and not readily available through the antiques market. Next he commissioned a Ford Company draughtsman to design a replica of the original windmill (the draughtsman would soon become the architect of Ford's Early American Village). Finally, in a move prescient of the domestic archaeology that would become so important a part of Colonial Williamsburg, he began to sift the dirt for evocative fragments of his childhood – broken plates, hardware, rusty skates – which he shared

with his brothers and sisters. At no time during this campaign of recollection and recreation did Ford intend to move back into the house, which was always conceived as a form of exhibition space. Yet he used it as a domestic background for certain aspects of his personality, donning old-time costume to dance there with family and friends to old-time melodies, and even threshing with old-time farm equipment.

Such were the origins of Ford's architectural collecting: essentially domestic, auto-biographical, and intensely centered on childhood memories. Rarely indeed can the architectural collector's sense of loss have been more acute, more personal, or ultim-ately more productive than Ford's. For his need to discover and expose his own childhood could not be satisfied by the reconstruction of his house; on the contrary, this same autobiographical urge motivated the shaping of Ford's grandest architec-tural endeavor, the Edison Institute at Greenfield. We have already seen how the Early American Village's program of hero worship fit in with the political ideology of Americanization widely espoused in the 1920s, but its particular hagiography was shaped by personal enthusiasm. There was, of course, McGuffey. There was also Edison, Ford's boyhood idol and longtime friend, whose miscellaneous relics he had begun to collect in 1905. Edison was commemorated not only in the institution's name and in its dedication ceremonies, which lavishly dramatized "Light's Golden Jubilee," but also in a meticulous reconstruction of Edison's Menlo Park research complex, complete with truckloads of New Jersey soil. Ford even bought the little country station where Edison was once thrown off a train – an anecdotal touch that reminds us of the essential intimacy of history as told in the architectural museum.

Finally there was Ford himself, present in the scaled-down replica of his first assembly plant, and, of greater significance, in a range of more intimate settings. The mill where Ford and his father had taken the wool from their farm was reerected in the Early American Village; so, too, was the Ford farmhouse itself. Even more interesting was the addition of a chapel dedicated to Martha and Mary – not, however, the biblical women, as might be supposed, but Ford's mother and mother-in-law. Moreover, though the chapel's design was very loosely based on a colonial church in Massachusetts, the building itself incorporated materials taken from the house in Greenfield where the Fords had been married. So in this central icon of American values, the visitor to Greenfield confronted neither a genuine historic building nor an abstract symbol, but rather a complex artifact in which history, country, and religion were inextricably mingled with personal mementos – relics, really, of Henry Ford's family life.

In its interweaving of private and public narrative, the Martha-Mary Chapel at once epitomizes the spirit of Ford's architectural collecting and reveals its kinship with that of the greatest early collectors of architecture, Sir John Soane and Alexandre Lenoir. They, too, had seen architectural collecting as a form of autobiography, and if the intimacies that Ford proffered were essentially banal, he was nonetheless using his collections as Soane had used them, to articulate a self-portrait. More particularly, he used them to mediate a relationship between himself and the public and to claim a personal stake in the national history. Thus, like Lenoir, Ford treated his objects as trophies, public demonstrations of triumphs both personal and national; indeed, the distinction between the two realms seems especially obscure in Ford's case, since prominent among the incentives that the Early American Village offered to public belief was the illusion of a kind of camaraderie with Ford himself.

Most of all, however, the buildings in the Early American Village were mementos, material relics of lives lost and regretted, of self and family, of friends, of heroes, of

everyman. They had the power to recall these things, and in some wordless way to hold their significance. This power was not magic: it was invested in fragmentary objects through the rhetorical conventions of metonymy and synecdoche, and it operated at McGuffey's birthplace or Edison's country train station just as efficaciously as it had on so many earlier occasions in the history of architectural museums. But perhaps the best analogy to the fragments that made up Ford's museum, the rusty skates, the childhood books, the buildings with their anecdotes and associations, is a more contemporary and a very familiar one. At the beginning of Orson Welles's film *Citizen Kane* of 1939 – based on the life of another great architectural collector, William Randolph Hearst, and set in a fantasy of San Simeon – the dying Kane drops a little glass globe filled with snowflakes, murmuring as he does so the single word "Rosebud." The globe prefigures the wintry scene of that pivotal day in Kane's life, told in flashback, when he was simultaneously informed of his inheritance and torn from his parents: in relinquishing this treasured fragment of the past, Kane relinquishes life itself. In the last moments of the film, as the servants toss the heaped remnants of Kane's life onto the fire, a reporter wonders – and it is the central question of the film – whether the meaning of that life might somehow have been revealed by his enigmatic last word. As the film closes, the viewer sees the flames licking about Kane's long-forgotten childhood sled: ROSEBUD.

Notes

1 Eugene Rimmel, *Recollections of the Paris Exhibition of 1867* (London [1868]), 1–2.
2 Alfred Normand, *L'Architecture des nations étrangères: Etude sur les principales constructions du parc à l'Exposition universelle de Paris* (1867) (Paris, 1870), I.
3 George Wightwick, *The Palace of Architecture: A Romance of Art and History* (London, 1840).
4 Quoted in Ellen Weiss, "Americans in Paris: Two Buildings," *Journal of the Society of Architectural Historians* 45 (1986): 166.
5 Normand, *L'Architecture des nations étrangères*, 3.
6 Ibid.
7 Burton Benedict, "The Anthropology of World's Fairs," in *The Anthropology of World's Fairs: San Francisco's Panama Pacific International Exposition of 1915* (Berkeley: Scolar Press, 1983), 29ff.
8 Rimmel, *Recollections*, 205.
9 John Britton, *The Union of Architecture, Sculpture, and Painting* (London, 1827), vii.
10 Rimmel, *Recollections*, 238.
11 Frank Norton, *Illustrated Historical Register of the Centennial Exhibition, Philadelphia, 1876, and of the Exposition Universelle, Paris, 1878* (New York, 1879), 86–87.
12 Benedict, "The Anthropology of World's Fairs," 48.
13 Frantz Jourdain, *Exposition universelle de 1889: Constructions élevées au champs de Mars par M. Ch. Garnier. Pour servir à l'histoire de l'habitation humaine* (Paris, n.d.), 8–9.
14 Rimmel, *Recollections*, 41.
15 Ibid., 42.
16 See Rodris Roth, "The New England, or 'Olde Tyme,' Kitchen Exhibit at Nineteenth Century Fairs," in *The Colonial Revival in America*, ed. Alan Axelrod (New York: Norton, 1985), 159–83.
17 Walter Tomlinson, *The Pictorial Record of the Royal Jubilee Exhibition, Manchester, 1887* (Manchester, 1888), 127–28.
18 Ibid., 129–31.

19 Edoardo Sonzogno, ed., *L'esposizione universale di Vienna del 1873 illustrata* (Milan, 1873–74), 182.

20 Zoltan Balint, *Die Architecktur des Millenniums-Ausstellung* (Vienna [1897]), 22 ff.

21 Norton, *Illustrated Historical Register*, 87.

22 The following discussion is based on Melinda Young Frye, "The Beginnings of the Period Room in American Museums: Charles P. Wilcomb's Colonial Kitchens, 1896, 1906, 1910," in *The Colonial Revival in America*, 217–40.

23 George Francis Dow, "Museums and the Preservation of Early Houses," *Metropolitan Museum of Art Bulletin* 17, pt. 2 (1922): 16–20.

24 Ibid., 17–18.

25 Ibid., 18.

26 Ibid., 18–19.

27 H. W. K., "The American Wing in its Relation to the History of the Museum Development," *Metropolitan Museum of Art Bulletin* 17, pt. 2 (1922): 14–16.

28 Neil Harris, "Museums, Merchandising, and Popular Taste: The Struggle for Influence," in *Material Culture and the Study of American Life*, ed. Ian M. G. Quimby (New York: Norton 1978), 140–74.

29 Meyric R. Rodgers, preface to Mrs. James Ward Thorne, *American Rooms in Miniature*, 4th ed. (Chicago: Art Institute of Chicago, 1941), 3.

30 Abbott Lowell Cummings, "Restoration Villages," *Art in America* (May 1955): 12.

31 Geoffrey C. Upward, *A Home for Our Heritage: The Building and Growth of Greenfield Village and Henry Ford Museum, 1929–1979* (Greenfield, Mich., 1979), 3–4, 15.

32 Marion Gough, "Little Journeys to the Way We Used to Live," *House Beautiful* 109 (1967): 148.

33 Ibid., 203.

34 Singleton P. Moorehead, "Problems in Architectural Restoration: Colonial Williamsburg," *Art in America* (May 1955): 64.

35 Gough, "Little Journeys," 148.

36 Cummings, "Restoration Villages," 64.

37 Henry N. Flynt, "Old Deerfield: A Living Community," *Art in America* (May 1955): 41–42.

38 Paul Wilstack, *Mount Vernon: Washington's Home and the National Shrine* (Garden City, N.Y., 1916), 275.

39 Royal Cortissoz, "Appreciation," in R. T. H. Halsey and Elizabeth Tower, *The Homes of Our Ancestors as Shown in the American Wing of the Metropolitan Museum of Art* (Garden City, N.Y., 1925), viii.

40 Ibid., xxii.

41 See William B. Rhoads, "The Colonial Revival and the Americanization of Immigrants," in *The Colonial Revival in America*, 341–62.

42 Halsey and Tower, *The Homes of Our Ancestors*, 9.

43 The following discussion is based on facts provided in Upward, *A Home for Our Heritage*, and James S. Wamsley, *American Ingenuity: Henry Ford Museum and Greenfield Village* (New York: Abrams, 1985).

Chapter 27 | Robert W. de Forest, Grosvenor Atterbury, and Elihu Root

Addresses on the Occasion of the Opening of the American Wing, The Metropolitan Museum of Art, New York (November 10, 1924)

Address

By the President, Robert W. de Forest in the Chair

The reason for opening our American Wing with this degree of formality is not because of its extent – it is small compared with other extensions which have been thrown open without ceremony. Still less is it because of the gift with which it has been built. This gift is insignificant in comparison with other recent gifts. It is because our Museum is sounding a patriotic note. It is because we are honoring our fathers and our mothers, our grandfathers and our grandmothers, that their art may live long in the land which the Lord hath given us. It is because for the first time an American museum is giving a prominent place to American domestic art and exhibiting it in such a way as to show its historical development.

Nearly fifty years ago, shortly after our marriage, Mrs. de Forest and I began to fit out our house with American furniture. This was at a time before American art had found any place in the antiquity shops or had become, as it now is, a marketable commodity. It was a time when such furniture had to be searched out in the garrets of old farmhouses. We thought we had made a new discovery – we soon found that we were not alone in our appreciation of it. We began to ask ourselves whether American domestic art was not a chapter, or at least a paragraph, in the history of art.

The Hudson-Fulton Celebration occurred in 1909. I was chairman of the art committee. It was desirable somehow to illustrate the art of the Fulton period. It seemed to me and to my friend, Henry W. Kent, an opportunity to test out the

Robert W. de Forest, Grosvenor Atterbury, and Elihu Root, Addresses on the Occasion of the Opening of the American Wing, The Metropolitan Museum of Art, New York, pp. 3–7, 17–21, 30–4. New York: Metropolitan Museum of Art, 1925.

question whether American domestic art was worthy of a place in an art museum, and to test it out not theoretically but visually. The result was our Hudson-Fulton Exhibition of American furniture.

Not a single piece was then owned by our Museum. Everything was borrowed for the occasion. A large part of the earlier examples came from the collection of Mr. Eugene Bolles of Boston; Mr. R. T. H. Halsey supplied later ones; even the de Forests contributed something. To me and to some others of our Museum family, the demonstration was complete – American domestic art was worthy of Museum recognition. But I recall the skepticism of my friend, the late John L. Cadwalader, when I suggested it. He said, "What do you mean, de Forest, by American art? Do you mean English or French or what? There is nothing American worth notice." Cadwalader was wrong. No one going through our American Wing would recognize his error more quickly than Cadwalader himself.

True, the foundation of our art is European – so were our ancestors. But applying European traditions to their own practical needs and the raw materials abundantly at hand, notably wood, they developed a style of their own – simple, it is true, but beautiful in its simplicity – a style which we may justly call American.

Before the Hudson-Fulton Exhibition had closed, we succeeded in acquiring, through the generosity of Mrs. Russell Sage, the entire Bolles Collection. Our attempt to exhibit this collection in our large Museum galleries made it perfectly clear that in such environment our American art lost its distinctive charm of simplicity and that it could be adequately shown only in the modest rooms for which it was made. Since then we have consistently planned to obtain a number of original American rooms in which we could show it in historic sequence, and to frame them in a small annex located in a prospective court. A modest Colonial garden in that court and the introduction of the façade of the old Assay Office as an exterior exhibit have been later developments of our plan.

What you see today is the consummation of an effort to show in our Metropolitan Museum American domestic and decorative art in the environment for which it was intended, and to show its development from the earliest period through the first quarter of the nineteenth century. This effort has extended through fifteen years. It has enlisted the increasing interest of our Museum staff and our Museum trustees. It has been fortunate in having a leader in the person of Mr. R. T. H. Halsey, Chairman of our Committee on American Decorative Art, from the time of its first appointment in 1913.

Some of you when you see our original interiors, such as the beautiful ballroom from Alexandria where Washington was entertained, may be tempted to accuse us of vandalism. Not so; we have brought these rooms to our Museum to preserve them. There is not a single one of them which we would not have gladly left in place if there had been any reasonable chance of preserving it there. Like the beautiful façade of the Assay Office, built just one hundred years ago, which was doomed to be torn down, all would have been destroyed sooner or later unless we had given them a refuge.

Since our plans were first made, there has been a growing appreciation of American decorative art. It has come into its own and perhaps into even more than its own. It has been crowding the antiquity shops and invading the auction rooms. It has become a commercial product. Perhaps we have helped to make a market for it to our own undoing. On the occasion of a recent visit to Salem, I was guided through the tortuous streets of that bewitched and bewitching town by a bright boy who volunteered to act

as guide. After dutifully visiting the House of the Seven Gables and the Essex Institute, one of my party said that she (it was a "she") now wanted to go to an antiquity shop. That bright boy, who was standing on the running board of my motor, promptly exclaimed, "I can take you there! I can take you to the best antiquity shop. I know it is the best because I know they make all their antiques on the premises." But none of the antiques you see in our American Wing were made in that Salem art factory.

And now our American Wing is open to the public. We await, with interest, the verdict. We will be satisfied if we have helped to rescue the modest art of our forefathers from undeserved oblivion and have proved that their zeal for liberty did not obscure their sense of beauty.

Address

Mr. Grosvenor Atterbury

I am appalled to see before my name the word "address." Evidently Mr. de Forest has forgotten the old adage that "architects should be seen and not heard." To speak frankly, in this particular instance I think they should not even be seen, because, as a matter of fact and above all else, the American Wing aims to be not an architectural history but an autobiography.

The problem, as I see it, is to restore to all of the old works of art – architectural and decorative – collected by the Museum during many years, such a background and an atmosphere that, recognizing their old homes and each other, they will settle down contentedly in one building, under one roof, in friendly relations, and be tempted, themselves, to tell their own stories.

You may ask why under such circumstances the architectural profession was called upon at all. And I think I can best answer that question by quoting the definition of the Sunday School scholar when the teacher asked him about a lie. "A lie," he said, "is an Abomination in the sight of the Lord, but a Very Present Help in case of Trouble." And we had a pretty clear case of it in the American Wing.

If you have ever tried to persuade an assemblage of twenty-five or thirty old Colonial rooms – each with his or her very definite idea of the proper ceiling height to have, the best location of windows and doors and fireplaces – to live together amicably in a rectangular building of fixed dimensions, in three stories, each representing more or less accurately their chronological sequence, and, at the same time, so arranged that they can all look out through the original windows of the old Assay Office – you will find that the most diabolical cross-word puzzle ever concocted is mere child's play in comparison. It is the evil habit of such puzzles to read both up and down and crosswise. But the American Wing must be so arranged that you can read it also diagonally and "every-which-way," and yet always spell the same words, "The Spirit of Colonial Art."

Now, I don't mean to say that we have succeeded. We haven't even finished, as Mr. Halsey will doubtless tell you. Indeed, no building is really finished until it has had appropriate use; until its walls and furniture have acquired the *patine* of an owner who appreciates and loves them. In that sense, I doubt whether there are very many of our great modern houses in this country that ever have been, or ever will be, finished.

So, quite aside from the problem of general arrangement, perhaps the most important part of our task is to restore to the old rooms which have come down to us, some complete, many only partly extant, that livable and lived-in quality which they originally possessed. And that takes time.

Now, however much we appreciate your opinion and however much we should like to have your praise today, the supreme test, after all, will come only when we have entirely finished. Then it will be for the ghostly owners of Colonial times to say whether they recognize their old homes and find their aspect so natural, their atmosphere so unchanged, their quality so untainted by any of our strange modern innovations – that they will flock back like homing pigeons to their old nests.

Of course, nothing could please me better than if, when you go into the American Wing this morning, you were to run into John Alden kissing Priscilla on the top floor. I should be immensely tickled if you could surprise Madame Jumel and Aaron Burr sipping camomile tea on the floor below, or find Alexander Hamilton sitting in the very much unfurnished garden in the front, looking at the façade of one of the first banks in this country, established largely at his instigation and at the time creating a situation of great seriousness, because the people, even then, thought that the money powers were to be feared, and protested against such a thing as a bank being established in Manhattan.

If you see these sights, it will, I think, prove that we have managed to eliminate, or at least conceal, any institutional quality in the American Wing; so that you will forget the Metropolitan Museum of Art as you enter the first low-ceiled room and not remember it again until you are fairly out on the street and find you have forgotten the umbrella you had to leave in the checkroom on Fifth Avenue. For no sensible ghost wants to live in a museum; it's a wonder the pictures and things can stand it. Nor do they like to pass through such terrifying vastness to get to their own cozy rooms, which explains, of course, why we have made a separate entrance to the American Wing, opening directly on what I hope will some day have the semblance of a Colonial garden.

Now, from the point of view of a designer, both of this period and of the future, the object of the American Wing seems to me to be primarily that of a corrective. Our sense of beauty is like the magnetic compass. It does not always point true north. It needs to be corrected from time to time. Some day we may have a gyroscopic sense of beauty. But until that time comes, an exhibition of Colonial art, such as you will find in the American Wing, may furnish a very healthy corrective, if we heed its teachings.

And, to my mind, the most vital one is that magnitude and magnificence do not spell beauty; that a dollar's worth of good taste, with ten cents' worth of material, makes a finer and more beautiful product than ten cents' worth of art and a dollar's worth of material.

Remembering my opening text, I am going to say only one word more. If, in passing by some night, returning, perhaps, at crack of dawn from one of our marble-lined, electrified, steam-heated, "jazz-racked" hotel ballrooms, I chance to see, through the windows of the old Gadsby's Tavern room, the flickering light of tallow candles and hear the faint sound of a spinet marking the stately measure of a minuet, or the none too certain strains of "Sally in our Alley," then, whatever you and the critics may say, I shall know that we have really made a success of the American Wing.

Address

Honorable Elihu Root

All men who have put feathers in this wing have been heard and I can speak only as an observer and a much interested observer. I speak for the common people and you and I are the common people.

In 1785 when Jefferson was in Paris he busied himself in getting plans for the new capitol for the State of Virginia, which was then projected, but before he got them the impatient people in Richmond started building and he wrote back a letter of protest against this unwillingness to wait for the architect. In it he said, "How can a taste for this beautiful art be formed in our countrymen unless we avail ourselves of every occasion when public buildings are to be erected of presenting to them models for their study and imitation?"

There is the reason for the museum. There is no slight authority of the great apostle of democracy, no slight testimony to the existence of a quality in the American democracy which calls for study and imitation of products of art; and that is the office of the museum, to form in our countrymen a taste for all the beautiful arts by presenting to them models for their study and imitation, not as a repository to which curiosity may repair for its gratification, but as a means of enlightenment and growth, to enlarge the capacity for human happiness, to discourage the self-sufficiency of ignorance, to elevate the standard of manners, and to establish human contacts between the present generation and all the greatest and noblest of the past. So this Museum was formed a half-century ago with all its departments, paintings, sculptures, textiles, tapestry, porcelains, jades, armor of knights of chivalry, armor of the Japanese, carvings, and prints throughout the range of the art by which the spirit of man ennobles matter. This Museum has grown to be one of the great institutions of our country, creditable and honorable, to the honor of all our people, but it has been a foreign museum, it has been a museum in which American people could study the foreign sources of art and achievement, Italian art, French art, Dutch art, English art, Oriental art, rooms from Pompeii, sarcophagi from Egypt, porcelains and jades from China, and except for contemporary productions not at all a record of American spirit or American achievement.

Here and there, it is true, discriminating vision had found creditable productions in special articles of household use or ornament, but the effect produced by them was trifling until the Hudson-Fulton Exhibition, which Mr. de Forest has referred to, and when that came there was, I think, for the first time realized the extraordinary argumentative effect caused by the arrangement of such facts in due relation to each other.

Any experienced advocate will tell you that when in a great and complicated cause the presentation to the court has made clear all the facts in their relation to each other the case is argued and the right conclusion proceeds inevitably without further comment, and from that suggestion of the Hudson-Fulton Exhibition came this new wing. One of the things apparent at the time of that exhibition was that the homely productions of American household art quarreled with the great rooms of the Museum. They were like fishes out of water. They could not be appraised under this strange and inappropriate environment. One of the charms of American household art was that it was so appropriate to the purposes for which it was designed, that it fitted

so perfectly into all the surroundings of American life, and that made it all the more impossible that it could be judged justly in these great and spacious halls of the Museum, and so came the wing.

Mr. de Forest and Mrs. de Forest, acting in the noble spirit which has actuated their lives, and Mrs. de Forest inspired doubtless by the spiritual legacy that came to her from her father, undertook to provide the atmosphere in which the products of American household art were born and had their being, and into that enterprise entered with fine enthusiasm Mr. Halsey, the Chairman of the Committee on American Decorative Art, and Mr. Kent and Mr. Atterbury and Mr. Robinson, and all of his staff. They formed an old-fashioned American community, and in their spirit was born again the atmosphere that produced whatever was fine and warming and delightful in old American life. The result of providing again that atmosphere is that we have the story told not by what anybody says of our forebears, not by what anybody has written or printed about them, but the story told in the facts, the deeds, the documents they have left, arranged in due and argumentative order, from the little low-ceilinged room of the seventeenth century all the way down, answering in nature to the changing and enlarging conditions of life, to the ballroom where Washington danced and the fine rooms of the early nineteenth century.

In that story we can find a remedy for a defect in our education. We have heard much about our ancestors, much of their strength, their courage, their fortitude, their religious fervor, their independence of character, their love of liberty, their capacity for self-control, for law and order with liberty; but that has been a story which has left an impression also of cold, hard, dry lives, without much beauty or much human sympathy. No one can go through that exhibit in the new wing now without learning that there was warmth in their lives, that there were interests centered about the hearthstone, that there were qualities in their character that made for love of beauty, for symmetry of form, for purity of line; and as we realize in these old surroundings that the men and women who used these rooms and these beautiful things were the same men and women whom we have heard extolled for their cold, hard virtues, we know them better. We have a human relation established between us and our great-grandfathers. We respect them more. We have a strengthening element put into our respect and our love for our country. We get a new idea of the character of that wonderful formative power that has shaped the development of this great nation from the Atlantic to the Pacific, a power transcending the proportions of numerical relation and asserting itself over the vast multitudes of other races that have come in. We get a better understanding of that as we begin to understand the humanity of the people from whom it sprang.

And we learn the lesson of simplicity which characterized their lives, simplicity in art. We learn that lives wholly without softness or luxury can express a love of beauty. We learn that native refinement can adapt to its uses the possibilities of comparative poverty. We learn that in our people is an inheritance by right of those qualities which substitute nobler tastes for the gross and brutal appetites and we learn that art is no hothouse plant and that its flowers can bloom close against the snow.

Chapter 28 | Elizabeth Broun
Telling the Story of America

When I take visitors through the Smithsonian American Art Museum, I begin by saying we have a wonderful collection that tells the story of the country and its people. We start with John Singleton Copley's showy portrait of *Mrs. George Watson* (1765), where the red satin gown and blue-and-white vase allude to Mr. Watson's import business in colonial Boston, a major trading center. Then we move to John Trumbull's portrait of *The Misses Mary and Hannah Murray* (1806), two would-be muses with drawing pencil and musical score, signaling new cultural ambitions in the early Republic. Next we stop near *Daniel La Motte,* Thomas Sully's young aristocrat seated before his Maryland estate (1812–13), and I mention Jefferson's idea that America should have a *representative* democracy, managed by wise landowners on behalf of the broader population. Soon Frank Mayer's *Independence* (1858) comes into view – a rugged, self-made man lounging on his rough-hewn porch – inspiring words about Andrew Jackson's Era of the Common Man, which ushered in a more *direct* democracy. These are obvious points to make, but to people who have never studied art, it comes as a revelation that artists express deep structures of society in seemingly incidental portraits and landscapes.

Once it's pointed out, people easily see that paintings from the 1850s about the Gold Rush highlight the dramatic physical change in the California landscape, while, paradoxically, later western vistas by Albert Bierstadt and Thomas Moran seem pristine and "untouched by man," despite increasing numbers of miners, settlers, and tourists flooding into the West. This makes the useful point that artists sometimes paint a subject the way people wish it were, indulging in an active form of forgetting, glossing over harsh realities. Gradually, we understand that the artworks present a subtle but powerful kind of evidence about larger issues. They are emissaries from their age, and we can actually *see* how ideas work in them.

But soon the rewarding sense of certainty evaporates. The first problems arise in the room featuring works made during Reconstruction. These artworks really are complex, and the idea that artists might be manipulating the message suddenly seems a possibility. It's even more perplexing to see how Winslow Homer's *A Visit from the Old Mistress* (1876) eludes any clear reading. Homer leaves the meaning of the picture

Elizabeth Broun, "Telling the Story of America" from *American Art* 13:3 (Fall 1999), pp. 84–92. (Reprinted without illustrations.)

open by setting up a fragile balance – or a defiant standoff? – between the former mistress in her prim dress and the powerful black woman, occupying center stage with her family in her own house. Because we cannot resolve this scenario, it makes us uncomfortable. Is the old mistress paying a social call? Or does she still presume on her former role to enter their home at will? Is the black woman welcoming or resistant? I try to recover my "tour-guide authority" by saying it was Homer's genius to capture the tension of Reconstruction, when relationships all had to be renegotiated, without lapsing into an easy narrative that would allow us to dismiss the image too readily. We move on, but unease follows us. Instead of taking pride in the progress made since Emancipation, and viewing this room with smug historical distance, every visitor seems acutely aware that race remains the deepest divide in America today.

Soon after come rooms featuring artworks by African Americans. It should be uplifting, for the works by Edmonia Lewis, Edward Bannister, Robert Duncanson, and Henry Tanner are wonderful. But the consciousness created in the Reconstruction room forces a realization that we've seen no works by black artists until now. Lack of opportunity for fine art surely was not the worst of slavery's many evils – but for many visitors it is a fresh and disturbing insight.

A museum devoted to a nation's art provides a unique perspective on the issues and people of that country. As Robert Hughes has written, "Americans like any other people inscribe their histories, beliefs, attitudes, desires and dreams in the images they make." The story I tell is personal to me as much as it is a record of the country. Each of my museum colleagues could construct a valid and completely different thread through the same collection, and visitors too bring experiences to these artworks that create a framework for understanding without guidance from professionals. The narratives shift with individuals and the times, but the objects continue to prompt new interpretations and insights. When museum people speak reverentially about collections, it's because they are endlessly fascinating mysteries, tightly sealed packages that open to offer insights and then, magically, reopen a year or a generation later to offer fresh perspectives, when we are wise enough to ask new questions.

Local, National, or Global?

More than three hundred years ago, poet John Dryden assured painters that art is universal, saying, "Thy pencil speaks the tongue of every land." Today we're more apt to agree with Charles Burchfield's idea that "An artist, to gain a world audience, must belong to his own peculiar time and place." The problem comes in locating the time and place that give rise to the sense of belonging. Personal selfhood; family relationships; ancestry, heritage, and clans; township or city; section and region, nation – these identities are like widening circles in water, most defined at the center, blurring at a distance. But in America, unlike countries with more homogeneous populations, our *national* identity is the sum of innumerable other identities. Each person, family, or cultural group has an "origin myth" about coming to the United States and becoming, soon or late, in sum or in part, a participant in this many-cultures society. Our social contract makes all who come here shareholders in the country's culture, which accounts for the vitality and richness of this society. Who would go back to an America of the 1950s without reggae and sushi, or without the fundamental freedoms won in a generation-long struggle for civil rights? Acceptance of others as a way of life means the fulfillment of America's promise.

Over three centuries, this country has defined itself through immigration, whether the goal was the complete assimilation of newcomers as in earlier centuries or the more accommodating multiculturalism of recent years. There are other democracies in the world, but ours is distinguished from those more homogeneous societies by its history. The United States was founded as a place for immigrants who enjoy equal rights and protections of the law and for their children and descendants. British, Scotch-Irish and Irish, Africans, Scandinavians, Mexicans, Chinese, Germans, Italians, Jews, Poles, and many other large groups left a distinctive stamp on United States culture following a large migration of their people. So did less well-known groups like Acadians and Mennonites and many more. Today we struggle, in our neighborhoods and as a nation, with the differences that arise. How can we forge an American identity that embraces such variety as Cuban Americans and Mexican Americans, first- and third-generation Chinese Americans, rich and poor, East and West Coasters, and rural Southerners and urban Northerners? Which portrayal of American culture do we accept – the one we live daily? the one we see in movies and on TV? the one we idealize from childhood? the one promised by politicians?

Some now argue that a strong national identity is a negative in today's world. One curator of a recent art biennial decided not to reveal the nationalities of the artists represented, saying national identity is obsolete and limiting. According to this line of thinking, it necessarily invokes its "evil twin" of nationalism – a jingoistic, xenophobic, and destructive force that engenders persecution, isolationism, warfare, and environmental devastation. Saving the earth, it is said, requires actions that transcend national self-interest. Telecommunications beam across borders to help topple nationalistic ideologies, contributing to the breakup of the Soviet bloc. If we need evidence that the old way is over, we need only note that Josef Stalin's daughter and Nikita Khrushchev's son are now citizens of the United States! Global economics and multinational corporations are displacing protectionist philosophies, and after decades of "Buy American" sloganeering, there's not a single automobile wholly made in America. The mass culture promoted by media conglomerates is losing ground to the "many to many" model of Internet users. Prophets of the New Economy call for dismantling governmental regulations that limit systemic change. Everywhere the way seems paved for a new era based on "acting locally, thinking globally."

What then is the appropriate, reasonable, and deeply meaningful role for a museum dedicated to a nation's art, now that we are poised at the beginning of this brave new world? Many museums dedicated to American art – at the Pennsylvania Academy, the Smithsonian, the Butler Institute, the New Britain Museum, the Addison Gallery, the Whitney, the Amon Carter – were founded in a confluence of national pride and cultural anxiety to trumpet the news that America had an art worthy of notice. Never mind that Europeans continued to regard this country as a cultural outpost, no matter how many museums sprang up. The striving to prove American art equal to that of Europe inspired generations of artists, collectors, and museum people, but playing to a foreign jury meant that a lot of idiosyncratic work that didn't look much like European art was edited out of the story. Yet finally the battle for recognition of American art seems won, in the half-century since abstract expressionism, and the quarter-century since the Bicentennial. What, then, is the legitimate new purpose for American art museums?

One answer is to go back to the beginning and retell the American story from the start. This time, let's put the missing chapters back into the narrative, the ones that flesh out the heartwarming and heartbreaking story of this country. My museum tour

should include the Hispanic colonial art of the Southwest and the Caribbean, along with the British colonies on the Atlantic coast. And let's *not* suggest that African Americans had no art before Emancipation; they were responsible for many craft traditions and much folk art in early America. But let's pause here, lest it seem that I'm pleading on behalf of a "politically correct" museum oriented around ethnic groups most in the news today.

There are so many untold chapters, so many artists left out – not because the work is poor but because we have streamlined the story. As a native Midwesterner, I know there are many wonderful artists, historical and contemporary, who drop between the cracks when shows are organized and books are written, because they're not immediately before us in the trade. Half-German, I'm also aware that wide dispersal of Germans and two world wars have discouraged a German-American identity in this country, obscuring the crucial contribution of this huge group. In fact, from Severin Roesen and Emanuel Leutze to Henry Steinway and others, liberal German Americans shaped by the revolutions of 1848 helped democratize our culture through their dedication to fine workmanship, whether construed as a well-made picture, a public mural, or a piano in the parlor. There is so much more to know about who we are as a people, about our tumultuous and inspiring history, and our contentious but exciting present. Because art is a special kind of record of experience, offering new insights and raising new questions, American art museums have a unique opportunity.

Many European museums began as royal collections, sometimes affiliated with royal art academies. Even after monarchies gave way to republics and democracies, the national academies, annual salons, and world's fairs fostered a top-down national art, serving the interests of the state. Many early Americans would gladly have emulated this model, but this country was too vast in geography, too fluid in social structure, too anarchic in politics, too neglectful of its cultural ambitions, and too protective of state and regional interests to achieve a centralized culture. Although we are only now recognizing it, our history is one of almost unparalleled freedom – read "necessity" – to invent, and only a small fraction of those with the urge to make art were channeled into academies.

A Unique Value-Set

The tour of our galleries is most fun in the great, vaulted Lincoln Gallery, a room where you can well imagine the music and excitement of Abraham Lincoln's second inaugural party, held here in 1865. It's also easy to imagine the dying Civil War soldiers who were laid on cots in this block-long room, when it served as a temporary hospital after the battles of Bull Run. This huge space is where we display art made since 1945. There's such wide stylistic variation that, no matter what the designers do, your eye immediately senses variety bordering on chaos. Maybe this is as it should be.

Today's art is in part a celebration, but it's also a field of struggle for identity and acceptance. We're in another peak immigration period, making us feel both energized and fearful, just like a century ago. There's no denying that some of the most beautiful, moving, and urgent art today responds to the sense of possibilities and openness that has always attracted artists here. Masami Teraoka's *Geisha and Skeleton* (1989) is a haunting and dangerously seductive meditation on AIDS. Carlos Alfonzo's *Where Tears Can't Stop* (1986) uses symbols drawn from Santería as if they are

stigmata, expressing painful memories of his own "way of tears" – his escape from the Mariel Harbor in Cuba.

I don't mean to suggest that contemporary reality and issues are only available to ethnic and immigrant artists. Eric Fischl and Jennifer Bartlett are represented by studio interiors, and both portray that sacred space as disturbed or violated by the world beyond, which intrudes without invitation. As always, much art continues to be preoccupied with formal aspects of seeing, though as we discovered in the early museum galleries, even seemingly neutral artworks have a basis in experience that yields valuable insights. David Hockney's *Double Entrance* (1993–95), a cubist-inspired landscape, offers two ways of creating pictorial space. When I see it, though, my first thoughts are of a car speeding around Los Angeles' hills and canyons, with shifting vistas of sea and rock at every turn. Just as Bierstadt's *Among the Sierra Nevada* (1865) provided a glorious, pristine invitation to settlers, Hockney's California landscape expresses the heady experience of actually living among the canyons.

Some have asked, is Hockney really an American artist? Why not, if he has lived much of the time since 1964 in California and responded emphatically to its light and color, landscape and people? One museum member wrote, "What is notable to me is not the birthplace of artists, but their subscription to the American idea. We are wrestling with a value-set that has fostered – uniquely – immense talent now for centuries."

The more I work with American art, the more I admire this unique value-set that comprises the "American democratic experiment." Our national ideal – creating a fair and equal society, with as many freedoms as possible – is a kind of case study for the larger world. Our struggles with competing interests mirror the problems of peoples and nations around the globe. The ideas of Ralph Waldo Emerson, Henry David Thoreau, Walt Whitman, and Martin Luther King Jr., which all began as specific to a region, cause, or people, came first to symbolize our country's ideals and now have universal meaning for people searching for freedom everywhere. I'm inspired that this country from the beginning was meant to be home to people, including artists, who could not be reconciled to life in their native land. It's interesting that among the grievances against King George III cited in the Declaration of Independence are "obstructing the laws for Naturalization of Foreigners; refusing to pass others to encourage their Migrations hither." I like knowing that the Constitution provides that someone may serve in the Congress who is "seven years a citizen" – an open door for immigrants to help shape society.

Artists shape this society through their work rather than by passing legislation. They preserve and challenge traditions that enliven the mix in this country, and they create our cultural memory. Today's artworks, no less than the historical works, are containers for rich experience, waiting to be unpacked, each holding ideas that can be traced through experience and history. Gene Young, a fine photographer living in Washington, D.C., explained it this way: "When I was in Africa in 1974, I was at this festival. And I saw this woman who was dancing. She was very young, maybe fifteen years old. But for some reason, as I watched her dancing, I could see that she was really much older than that. I saw that she wasn't dancing alone. There were generations of musicians, dancers, ancestors, and traditions dancing with her. For the first time I understood that life is not just about the present. It's about what you don't see as well as what you do see. I realized then that, through my camera, I could see into the mysteries, the past, behind everything."

So the challenge for a national art museum today is to see through the art to the "mysteries behind everything" and, in so doing, deepen our understanding of the whole. The United States remains the most dramatic experiment anywhere in the difficult art of living together in freedom and respect, exactly because the mix of peoples is greater here than elsewhere. Nancy Pelosi, congresswoman from California, has said, "Tolerance of extraordinary diversity is the mystery that lies at the heart of our origins and our destiny, the magnificent quality that renders the American project unique in human experience." Today's language about diversity and tolerance is really just a new translation of the idea of "freedom of expression," and that seems pretty close to a definition of art. The nature of our art is profoundly shaped by the nature of our society, just as that society is also shaped by the artists within it, and in that complex relationship lies a path to the future.

Postscript

For several months last year, the Lincoln Gallery was pulsing with energy from Nam June Paik's enormous *Megatron/Matrix* (1995). Paik is another citizen of the world, with his Korean heritage, German education, and, since 1964, New York residency. If any artist has come to symbolize globalism at the beginning of the new millennium, it's Paik – prophet of technology in art.

The *Megatron*, a huge rectangle of stacked TV monitors, randomly presents images drawn from a wealth of ethnic, national, and international sources, such as the Seoul Olympics. Every few minutes, the entire ensemble flashes with the flag and name of a single country, cycling through "AUSTRIA," "JAPAN," "FRANCE," and so on, asserting national interests. But equally as often, a giant bird flies across the field, just as telecommunications travel across borders, transcending those artificial divisions between people.

Next to this arena of social identities stands the *Matrix*, a square stack of smaller TV monitors which cycles images in a pinwheel clockwise movement. Those images are brighter and more hotly colored than the *Megatron* images, and all are somehow distorted, making for a dazzling painterliness. They flash more rapidly than those of the *Megatron*, pulsing in rhythm to the music. Just at the *Matrix*'s center is a tiny monitor, not flashing or pulsing, but lazily panning across two female nudes lounging on a bed. If the *Megatron* is an emblem of our multiple social identities, the *Matrix* is the ultimate private self – smaller, hotter, distorted, emotional, pulsing with energy that revolves around that absolute called the body. It's an exciting way to think about who we are, and what we belong to, as we start over in a new century.

Chapter 29 | Roger G. Kennedy

Some Thoughts about National Museums at the End of the Century

Fifteen years ago, Washington cab drivers were in agreement that the correct name of the National Museum of American History was the "Museum of Science and Technology," because its official title then, the National Museum of History and Technology, was incomprehensible both to them and to most visitors.

Cab drivers are cosmopolitans, often thoughtful and highly educated. It is likely that they eschewed the composite history and technology title because it smelled to them of the ambitions of techno-imperialism. This is not to charge those who applied that title as intending to imply that all history is ordained by technological change. Instead, they were probably exhausted by the museum's institutional history. It had become the museum of everything else, intended to house all national collections not readily comprehended by art or what was then called "natural history," once "air and space" had its apotheosis in a museum across the Mall.

In reducing that name to American history we were moved by two not always harmonious intentions: to do right by our objects (which range across postage stamps, silver, harpsichords, Stradivarii, sharecroppers' cabins, Ku Klux Klan costumes, trains, organs, and bandstands) and at the same time to do right by the six million visitors who come each year seeking to learn about their national history.

If we have done a few things right, visitors are a little less likely now to come by chance upon cairns of objects, like those of Arctic explorers, wondering at them without hope of learning how they came there. By now those objects should be more purposefully juxtaposed and may, by sheer propinquity, impart something of their relationship. They can now be found in sequences offering equivalents at best to "story windows" of cathedrals, or at worst to comic strips or illustrated computer manuals.

We strove to convert a storage facility with visitorship into a place where significant stories are told by the arrangement of objects. That is as good a definition of a history museum as any. We supplemented that narrative format with many other modes of storytelling: interactive videos by the hundreds, drawing on discs whirring shyly in the

Roger G. Kennedy, "Some Thoughts about National Museums at the End of the Century" from Gwendolyn Wright (ed.), *The Formation of National Collections of Art and Archaeology*, pp. 159–63. Washington, D.C.: National Gallery of Art, 1996 (distributed by the University Press of New England, Hanover and London).

basement; performances of song (which is pitched discourse) and dance; cooking for presentation on instructive place mats; sound-pools and video walls.

We also attempted to extend the experience in the museum by providing mnemonic "take-aways" or party favors: pamphlets, discs, cassettes, and even catalogues. Everybody knows by now that few museums, these days, issue mere listings as catalogues. Most feel an obligation to accompany iterations with essays, doing what exhibits strive to do, which is to link objects and labels into a coherent set of ideas.

The goals at the Museum of American History are several. The intention is to protect the collections (about fifteen million objects, including twelve million postage stamps, sixty-one pianos, and a dozen trains). One tries at the same time to study them and to learn from them. Thereafter, one goes forth to discuss what has been learned with academic scholars who write about the circumstances within which these objects are created. Together, the curators, with their things, and the scholars, with their words, make new words, which are digitalized for print, sound, and images. In recent years we in the museum have been striving to achieve new means of storing, conveniently and together, objects, words, still images, and those which move, so that future scholars may be able to draw on them all for exposition if not for exhibition.

What we do now is not necessarily what was contemplated when the collections came to the National Museum in the first place. In the United States, the first museums were in private hands, intended for the approbation and instruction only of persons certified to be seriously interested in them *and* to have been instructed in good manners. This was the way with Thomas Jefferson's Indian Hall, the nation's first museum of the American Indian. People who had neither slaves nor land to support their museums, such as Rembrandt Peale and P. T. Barnum, charged admission. After that, though in most places not until this century, public museums came to be considered civic assets, a story hardly requiring further discussion. It may, instead, be useful to reflect on the agglomerating tendency which, in Europe and America, was concurrent in politics and in museum-making while these transitions were in progress.

The relatively small number of people who organized what were called, until quite recently, "nation-states," often formed, simultaneously, national museums. By so doing, they aspired to assist the world (meaning equivalent elites elsewhere) to think well of them. Generally speaking, they were cosmopolitans, sharing the taste of others elsewhere who were of equivalent education and prowess. They shared gossip; on Hungarian hunting parties, they shared peasants; and in museums they shared a taste for Italian Renaissance painting.

Americans were at a great distance from most of the institutions built by these people, but, as Henry James has instructed us, some of them made every effort to come closer. One means of doing so was by assembling collections of paintings which, when subsequently given to art museums, have been of incalculable benefit to millions of fortunate people who would otherwise have had no opportunity to examine what the richest people in the world, served by the most expensive of advisers, would have accumulated for their own houses.

History and folk museums (related phenomena) tended to be bureaucratic rather than haut-bourgeois. Their taste was, therefore, more thoughtful and systematic, though less lively, than that represented in art museums. Art museum directors have their own ways of explaining themselves, and so do science museum directors, especially when a new museum is invented and someone has to explain to donors or legislators why they are necessary – being endearing or instructive to the rich is seldom sufficient anymore. History museum directors are not often asked why history is

important, but they contend against the view that movies or books will do the job as well as buildings in which they are thought to preside over keepsakes.

My own response has been to begin with a refutation of the notion expressed by some senators that the objects in history museums – perhaps in all museums – "speak for themselves." (This view is given unwitting confirmation by the smugness of some curators.) Objects stand mute, except that their messages may be imparted to people who live with them all the time and have learned their silent language. It may be wonderful to feel oneself such a connoisseur, but no national museum would last long if it relied only on this group.

Besides, objects speak most powerfully in intentional juxtaposition. Great designers of museum exhibitions are narrators making respectful use of sequences. They need more furniture than easels.

Without claiming any universal application of the categories that follow, I suggest that a sharper sense of what has been found useful in national museums may emerge from a listing of some prototypes for contemporary museum practice. These may be useful even to those who preside over museums dealing only with objects convention-ally allocated to art, natural history, and science. The prototypes are set forth here because giving them occasional thought has helped us to consider how we wish to benefit from their successes as we seek to avoid their frailties.

(1) *The Schatzkammer.* Halls of treasures are often sufficient in themselves, even when unexplicated. The evolution of art and history museums in the 1980s repre-sented a movement toward clumping and explaining the treasures.

(2) *The Iconostasis.* Assemblages of objects not to be looked *at* but looked *through*, significant not so much for themselves but for what they represent – apertures to another world – are most familiar to us in Eastern Orthodox churches. There are equally important examples in most Mission churches, in Mexico and the American Southwest. Elsewhere such ordered symbols may be seen in the stained or painted glass "story windows" of Europe, and in any collection of personal mementos. But symbolism goes dead when there are no memories to illuminate it or when there ceases to be a community sharing its meanings. History museums are large iconosta-ses, more important for what they imply than for what they present.

(3) *The Triumph.* Hauling after you possessions taken from others – indeed, hauling *them*, too, in chains, cages, or in effigy – is a practice of many imperial peoples. Museums that present the artifacts taken at gunpoint from aborigines, or museums demonstrating the superiority of the collector to the collected, are vestiges of the triumphant school of museum-building.

(4) *The Gallery.* Two-dimensional objects arranged on walls with identifying labels serve a vastly important social function. They disperse and sometimes elevate concepts of taste, by making available to many what might otherwise be restricted to the delectation of the few. (Lest I be misunderstood, again, I like galleries. I wish we had more and better ones.)

(5) *The Academy.* The academy is a place where objects are dissolved into discourse. It is sometimes useful. Even semiotics and deconstructionism and new criticism have on occasion justified the ink spent on them by providing piquant notions, though they have passed over museum practice in the last five decades without much effect. Essentially, however, the academy is about ideas and groups of words (not always the same thing). It is not about objects. People trained in academies may be refreshed by enlarging their consciousness to three dimensions, and may refresh museum profes-sionals by suggesting values of juxtaposition not inherent in the objects themselves.

(6) *Shrines to the Muses.* It is not easy to know what was done in the museums of the classical age. My guess is that there was plenty of conversation, some of it, one hopes, on beat and on pitch. These seem to have been places where people met to pay special attention to the history of one or another mode of human communication over space or over time (as in history). Sometimes the worship of one or another muse called for a liturgy using just vocal sound. Sometimes that liturgy required the entire body. Sometimes it deployed objects of two and three dimensions. All these modes of discourse belong in museums.

(7) *The Basilica.* A rectilinear processional way, with stated places to pause for especially rapt attention to one aspect or another of a story, is a good format for any museum activity. So are mood-setting devices such as incense or its auditory equivalents, together with occasional instruction by persons of authority and special training.

(8) *The Rotunda.* When Hadrian placed his judging bench in the center of a building contrived to suggest the city, the state, and the universe, he wished to draw attention to what he was doing. Museums should do the same. We employ trumpets and drums, but we can also employ architectural devices implying that the visitor has arrived at a place of special importance to do something that matters. John Russell Pope never did that better than in the rotundas at the Jefferson Memorial and the National Gallery of Art, which hold solemn discourse with each other about their mutual importance.

(9) *The Hogan.* Smaller round forms have been used in many cultures to imply a unity of the community formed about a source of wisdom. Museums, also, can unify communities around very wise people or around ideas shared widely by the members of that community. Roundness, in European architecture and that of Native Americans, implies a time dimension: that is to say, roundness connotes continuity. Within roundness, a central point may be the source of lines reaching out beyond the walls, but with known terminations, thereby implying a larger circle. At the core of all geometry, in a hogan, is *authority.* Authority comes from knowing something of use to the community, something justifying people coming to learn it. Museums, at their best, may be such places.

(10) *The Field of the Cloth of Gold.* The kings of France and England met to demonstrate how rich each was, *and* how each retained, amid the opulence, his capacity to function intellectually, by statecraft, and physically, through jousting. Thus those kings, Francis and Henry, set a proper standard for museum directors. Otherwise directors would suffer even earlier than they do the boredom that comes of self-importance within a small world, and the infirmities of indolence that afflict those who may have meals without getting the exercise of hunting.

Museums are still places in which people think. They are also places where serious people exert themselves to transcend the deadening routine of what is expected of them.

I cannot aver that all museums manifest the effects of all these prototypes. Especially do I doubt that all are Fields of the Cloth of Gold, but some are.

This is especially important these days. Directors of national museums are emerging from a period in which it was widely assumed that people knew what they were describing when they employed either the term "nation" or its derivative "national." Before we can consider the future usefulness of the experience of national museums of the past, we may well give further consideration to what is happening to the concept of nationhood.

It is one of the many ironies of the career of Woodrow Wilson that an American president should bring a childish notion of that concept to the attention of the world. Wilson, for all that he knew, knew very little about the multifariousness of American society.

The irony in this is, I believe, that citizens of the United States have a responsibility to bring to other peoples the benefits of their special experience in diversity. The best elements of their history demonstrate that, despite our foolishness and cruelties, we have learned from many peoples fiercely determined to retain their apartness while respectfully learning from each other.

A national museum in the United States is, or may be, a vastly different place from a national museum in a country more uniform racially or historically. It is a place demonstrating that diversity of cultures can be as fecund of blessings as diversity of species.

We know better than many others what horrors may be perpetrated when "national" is taken to be descriptive of homogeneity. If we seek our best selves, we can bring to Europe the experience of many peoples of diverse cultures living together without seeking to eradicate the most recently arrived or least opulently endowed among them.

In the nineteenth century, the word *nation* was even employed to describe accidental polities encompassing a multitude of disparate groups. Wilson's nationalism was, on the other hand, useful only to very small countries with homogeneous peoples. In large polities, each person or group of persons strives for fulfillment in their own terms, united only by whatever degree of mutual respect can be summoned out of the darkness of mutual distrust, ignorance, and prejudice.

A national museum in such a polity cannot be the same sort of place as one appearing after the jostling of nations produced the cracking apart of many of them. The breakup of some agglomerations in 1918–1921 divided the Austro-Hungarian consortium into smaller agglomerates, two of which were called Yugoslavia and Czechoslovakia. Between the two world wars, the dissolution of the Second British Empire caused a sharp reduction in the call for dusty-rose paint on the part of mapmakers. (The First British Empire had been depleted between 1775 and 1783 by the secession of thirteen of the fifteen North American colonies.) And, in recent years, the Soviet Union has gone the way of the Ottoman Empire after 1878.

The American experience is full of examples of political arrangements made to accommodate resistance to homogenization, and it does require us to be clear about *which* nations we are talking about when we speak of a National Gallery or a National Museum of American History.

We were invited to consider the role of national museums. The word "museum" has been found to have many meanings, arising from many antecedents. Conscientious people are striving to reconcile these meanings, and the lessons with which each is incandescent, as they tend the objects precious to those who came before them.

The word *nation* and its derivative *national* are even more problematic. The best I do, as a citizen of the United States and therefore of many barely and precariously united polities, is to seek for those characteristics of our own culture that may benefit from reinforcement in an institution serving us all. Chief among them, I think, is a capacious concept of culture and an inclusive definition of nationhood. The worst enemy to both is anxiety, and only slightly less pernicious than anxiety is snobbery.

Chapter 30 | James Fenton
The Pitt-Rivers Museum, Oxford

Is shut
22 hours a day and all day Sunday
And should not be confused
With its academic brother, full of fossils
And skeletons of bearded seals. Take
Your heart in your hand and go; it does not sport
Any of Ruskin's hothouse Venetian
And resembles rather, with its dusty girders,
A vast gymnasium or barracks – though
The resemblance ends where

Entering
You will find yourself in a climate of nut castanets,
A musical whip
From the Torres Straits, from Mirzapur a sistrum
Called Jumka, 'used by aboriginal
Tribes to attract small game
On dark nights', a mute violin,
Whistling arrows, coolie cigarettes
And a mask of Saagga, the Devil Doctor,
The eyelids worked by strings.

Outside,
All around you, there are students researching
With a soft electronic
Hum, but here, where heels clang
On iron grates, voices are at best
Disrespectful: 'Please sir, where's the withered
Hand?' For teachers the thesis is salutary

And simple, a hierarchy of progress culminating
In the Entrance Hall, but children are naturally
Unaware of and unimpressed by this.

Encountering
'A jay's feather worn as a charm
In Buckinghamshire, Stone',
We cannot either feel that we have come
Far or in any particular direction.
Item. A dowser's twig, used by Webb
For locating the spring, 'an excellent one',
For Lord Pembroke's waterworks at Dinton
Village. 'The violent twisting is shown
On both limbs of the fork.'

Yes
You have come upon the fabled lands where myths
Go when they die,
But some, especially the Brummagem capitalist
Juju, have arrived prematurely. Idols
Cast there and sold to tribes for a huge
Price for human sacrifice do
(Though slightly hidden) actually exist
And we do well to bring large parties
Of schoolchildren here to find them.

Outdated
Though the cultural anthropological system be
The lonely and unpopular
Might find the landscapes of their childhood marked out
Here, in the chaotic piles of souvenirs.
The claw of a condor, the jaw-bone of a dolphin,
These cleave the sky and the waves but they
Would trace from their windowseats the storm petrel's path
From Lindness or Naze to the North Cape,
Sheltered in the trough of the wave.

For the solitary,
The velveted only child who wrestled
With eagles for their feathers
And the young girl on the hill, who heard
The din on the causeway and saw the large
Hound with the strange pretercanine eyes
Herald the approach of her turbulent lover,
This boxroom of the forgotten or hardly possible
Is laid with the snares of privacy and fiction
And the dangerous third wish.

Beware.
You are entering the climate of a foreign logic
And are cursed by the hair
Of a witch, earth from the grave of a man
Killed by a tiger and a woman who died
In childbirth, 2 leaves from the tree
Azumü, which withers quickly, a nettle-leaf,
A leaf from the swiftly deciduous 'Flame of the
Forest' and a piece of a giant taro,
A strong irritant if eaten.

Go
As a historian of ideas or a sex-offender,
For the primitive art,
As a dusty semiologist, equipped to unravel
The seven components of that witch's curse
Or the syntax of the mutilated teeth. Go
In groups to giggle at curious finds.
But do not step into the kingdom of your promises
To yourself, like a child entering the forbidden
Woods of his lonely playtime:

All day,
Watching the groundsman breaking the ice
From the stone trough,
The sun slanting across the lawns, the grass
Thawing, the stable-boy blowing on his fingers,
He had known what tortures the savages had prepared
For him there, as he calmly pushed open the gate
And entered the wood near the placard: 'TAKE NOTICE
MEN-TRAPS AND SPRING-GUNS ARE SET ON THESE PREMISES.'
For his father had protected his good estate.

Part IV
Locating History in the Museum

Introduction

Just as it has become a "commonplace to assert that museums embody ideologies" (Eleanor Heartney), it has also become a commonplace to assert that, whether the history represented in a museum is "natural," national, local, art-historical, revisionist, or otherwise alternative to existing constitutions of "the past," that history is not simply found: it is constructed. History involves selection, juxtaposition, and narrative fashioning. The texts in this section consider these crucial matters of adjustment and what underlies their use; they also consider the nature of history itself as driven in part by objects, documents, and other traces, in part by ideology, in part by memory – a much harder constructive mechanism to embody or analyze.

Sir William Henry Flower, Professor of Anatomy and Director of the British Museum of Natural History, emphasizes the importance of "Local Museums" and the preservation of local history. In his compilation of two separate texts, a letter supporting the establishment of a County Museum for Buckinghamshire (1891) and an address delivered at the opening of the Perth Museum (1895), he expresses the broader problem of preservation and selection: "historical documents and objects of interest" will not last indefinitely unless a deliberate effort is made to save them, and things, including "customs" themselves, which are apparently unimportant today may be "of great value in after time." Clearly the heritage and preservation movements are still making these arguments today, with an emphasis on the fact that previously ignored histories, customs, and objects are still an endangered species due to neglect, bias, and misplaced "aesthetic" judgments. Flower's attention to economics ("endowments"), collections, exhibition strategy, education, the belief that teachers "should assist in the curatorial work," the value of museum libraries, and the essentially "unfinished" quality of a good museum still seem timely, if overly confident in an ability to correctly define and limit the scope of museum work.

In "Memory, Distortion, and History in the Museum" (1997) Susan Crane complicates the concept of "history" as the province of nations or institutions by adding that history is also the more "local" province of personal memory, that the "museum-site" is as much "located in the mind" as in "geographical space." She also introduces

the third term "distortion" to discuss what occurs when "members of publics find that their memories of the past or their expectations for museum experiences are not being met." Crane analyzes several contemporary museum efforts to present new possibilities for "a redefined relationship between personal memory and history." The "key term" in recent debates about the representation of history, Crane notes, "is historical consciousness – a personal awareness of the past as such and a desire to understand experience with reference to time, change, and memory." Museums which attempt to represent human suffering are especially cognizant of this responsibility to the victims but, she claims, are lagging behind in the representation of those responsible for causing the suffering. (The intentions, realities, and controversies surrounding the exhibition *Mirroring Evil: Nazi Imagery/Recent Art* at The Jewish Museum in New York in 2002 reveal many examples of the tensions underlying this hesitation.) Crane's concentration on reception by the museum visitor is a crucial element in this theoretical and practical – museological and museographical – study.

Going behind the practical scenes of representation, Thomas Schlereth looks at "Collecting Ideas and Artifacts: Common Problems of History Museums and History Texts" (1978). He outlines "six historical fallacies" faced by anyone engaged in research, interpretation, or communication and offers some alternatives for the future. Elements of national and local history are most susceptible to these fallacies, which involve if not directly espouse narratives of progress and patriotism. However, domestic histories are equally susceptible to romanticized notions and other over-simplifications. Schlereth also considers the absence of minority voices, not only in what is represented but in who is making the representations. Twenty-five years after his study we are still taking note of this disparity.

Gaynor Kavanagh anatomizes specific practical as well as theoretical issues encountered by those who represent the past in museums. Raising questions of motives, genres, and methods in "Melodrama, Pantomime or Portrayal? Representing Ourselves and the British Past through Exhibitions in History Museums" (1986), Kavanagh reviews developments in the study of history as a discipline and develops a comparative approach, in order "to consider how evidence is handled, analysed and interpreted in the exhibition form and to draw parallels with history production and criticism employed elsewhere." This involves looking at history exhibitions as "history writing," the "limits of objectivity" in historical inquiry, horizons of reception and the impossibility of recreating "an historical moment as it was experienced by the people at the time," and the need for those who do history in a variety of media to "glory" in controversy.

The visitor's experience in a historic house is examined by Mónica Risnicoff de Gorgas in "Reality as Illusion, the Historic Houses that Become Museums" (2001). She notes the ostensible transparency of the house/museum effect – these houses "are perceived as 'true reality' and therefore free of any kind of manipulation" as if "almost untouched" – but argues that, in fact, "each object is displayed as an interpreted object." She looks at the connection between house museums and the communication of "ideologies as simplified messages" using sites in Argentina and Brazil as comparative cases in point and, in a lyrical but prescriptive conclusion, explores the potential for openness in these "theatres of memory" or "dream spaces."

Mark Leone and Barbara Little offer their analysis of "Artifacts as Expressions of Society and Culture: Subversive Genealogy and the Value of History" (1993) by

combining political theory (Foucault and the concept of "surveillance mechanisms"), philosophy (Rousseau and Nietzsche on social inequality and the slave spirit), historical archaeology (the redesign of the Maryland State House and its surroundings), and the didactic potential of museology and museography (three paintings by C. W. Peale). They present methodological as well as theoretical points about the value of objects in interrogating the past, "not as opposed to documents" but as a "parallel," and argue that some of the strategies employed in the early years of the Republic are still found in American museums and other domains of history as an (often unwitting) "prop of the status quo." Leone and Little analyze the placement of the Maryland State House, its status as a centering mechanism for "official" history, its "aim to provide universal views of life," and its function as a "panopticon, an all-seeing eye of the state." They analyze Peale's *The Artist in His Museum, The Long Room,* and *The Exhumation of the Mastodon* as didactic moral messages which represent human and "natural" materials in a prescribed order. One of their crucial focal points about location and genre-designation involves the representation of Native Americans in "natural" history museums and the actions indigenous peoples have taken toward correction and reclamation.

In "A Sense of Another World: History Museums and Cultural Change" (1980) James Deetz considers the possibility that objects "can be understood as part of a larger cultural system" and cautions against the easy analogy between "then" and "now." An object had a social and cultural meaning in its time of original creation and use, Deetz explains, which is different from the meaning and use of a similar object in our own time: "Is a delft plate to be interpreted as a simple analog to a piece of modern dinnerware – modern culture projected unchanged into the past . . . ?" The loss of difference is also a loss of history. We might contrast Deetz's view with that of architect Grosvenor Atterbury and others who believed that objects in the Metropolitan Museum's American Wing could communicate their history fairly easily. However, Deetz does agree that, when well interpreted, historic houses "can become an ideal tool for exploring dramatic changes in the American mind and American society." The issue of the visitor's, not to mention the curator's and/or interpreter's, horizon of reception clearly emerges; Deetz gradually widens his focus to consider these issues in terms of single artifacts of American material culture, period rooms and historic houses, and live interpretation, while carefully arguing against "misplaced quaintness," and he evaluates successes and failures in achieving effective "living history."

In "Mining the Museum: Artists Look at Museums, Museums Look at Themselves" (1994) Lisa Corrin offers a valuable history of self-reflexive exhibitions and contextualizes them as evidence of the museum's "crisis of identity" and the museum community's response to "enormous pressure . . . to consider the relation between what it does and the historical, political, and social context in which it operates." However, she argues that issues of race still seem to have eluded this progress toward circumspection. Fred Wilson's *Mining the Museum,* an exhibition which Corrin co-curated at The Contemporary in Baltimore, is a notable exception. As artist-in-residence at the Maryland Historical Society, Wilson was able to study the collection and the institution's archives, and then create an exhibition "to raise questions about the ways museums represent (or fail to represent) African-Americans and Native Americans." The account of Wilson's working relationship with staff at the Historical Society is of particular interest as a model of collaborative exhibition-making and the rethinking of professional norms.

As a coda to this section, Le Corbusier's brief musings in the form of theses on "Other Icons: The Museums" (1925) offer playful aphoristic fragments which instigate as they interrogate. He asks us to question hierarchies of value, "elements of judgment," truth claims, and encyclopedic knowledge. In its ambiguity of tone, the text seems to challenge our positions as both visitors and perhaps makers of our own museums.

Chapter 31 | Sir William Henry Flower

Local Museums

Attention has already been directed, in several letters which have recently appeared in the newspapers, to the desirability of a central institution in which the numerous historical documents and objects of interest connected with the county might not only be preserved from destruction, but also made available for study and reference. Many of these, which may be considered trifles now, will be of great value in after time, as illustrating the history and mode of life of generations passed or passing away. Many customs change with great rapidity, and all evidences of their existence disappear, or only remain in literary allusions, often difficult to understand without actual illustrations. Take for instance the old flint and steel and brimstone match, the universal source of illumination in even my early days. Most living people, accustomed to the daily use of one of the greatest triumphs of applied science, know nothing of the difficulties their grandfathers had to contend with in supplying this most necessary want of common life. I doubt if many of our generation were to see the old apparatus, whether they would know what it was for or how used, and though one must have existed in every cottage in the country fifty years ago, it is possible that it would be very difficult to procure one, even for a museum, at the present time. The candle-snuffers, without which we could not exist in my childhood, are now as extinct as the Dodo. Take again the threshing-flail, an instrument in universal use, with little change for thousands of years, now rapidly disappearing in many districts; or the stocks, once such an important social institution in rural life, but of which I know now only one in the neighbourhood of Aylesbury, – that which still remains in the picturesque village of Dinton. Specimens of all these, and many others which will readily suggest themselves, should be preserved in every local museum.

Then again, the natural history, the birds, the butterflies, the wild flowers, and the fossils and minerals of the neighbourhood, so arranged and named that any one can identify every creature or plant he may chance to meet with in his walk, are essential features in a local museum.

Sir William Henry Flower, "Local Museums" – from a letter in support of the establishment of a County Museum for Buckinghamshire (November 24, 1891), and an address at the opening of the Perth Museum (November 29, 1895) – published in *Essays on Museums and Other Subjects*. London: Macmillan, 1898. Public domain.

But now let me give a necessary warning. There are museums and museums. A good one well arranged, and well kept, clean, neat, and attractive, may be the means of conveying instruction and giving interest and pleasure to the lives of thousands of our fellow-creatures. But such museums do not grow of themselves; money, time, knowledge, and loving and sympathetic care must be expended upon them, both in their foundation and their maintenance, and unless all these can be provided for with tolerable certainty, it is useless to begin. Voluntary assistance is, no doubt, often valuable. There are many splendid examples of what it may do in country museums, but it can never be depended on for any long continuance. Death or removals, flagging zeal, and other causes tell severely in the long run against this resource. A museum must have an endowment adequate to defray its expenses, and especially to ensure the staff of intelligent, educated, and paid curators required to maintain it in a state of efficiency. You might as well build a church and expect it to perform the duties required of it without a minister, or a school without a schoolmaster, or a garden without a gardener, as to build a museum and not provide a competent staff to take care of it.

It is not the objects placed in a museum that constitute its value, so much as the method in which they are displayed, and the use made of them for the purpose of instruction.

The scope of the museum should be strictly defined and limited; there must be nothing like the general miscellaneous collection of all kinds of "curiosities," thrown indiscriminately together which constituted the old-fashioned country museum. I think we are all agreed as to the local character predominating. One section should contain antiquities and illustrations of local manners and customs; another section local natural history, zoology, botany, and geology. The boundaries of the county will afford a good limit for both. Everything not occurring in a state of nature within that boundary should be rigorously excluded. In addition to this, it may be desirable to have a small general collection designed and arranged specially for elementary instruction in science. This part might be brought into connection with the technical instruction given in the county, and will be a valuable – indeed, a necessary adjunct to it. Every branch of such instruction should have its special collection of objects to illustrate it; the teaching will then be made far more real and practical than it otherwise would be.

Agricultural chemistry and geology, dairy-farming, fruit-growing, and such like subjects, might each have its collection. And these various collections, though kept quite distinct, in different rooms if possible, might be all associated in the County Museum and under the same general management. Thus some of the funds devoted by the county to the purposes of technical education might most profitably assist in the formation and maintenance of the County Museum; indeed, I think myself that if a portion of this money had been in the first place directly allocated to the endowment of a museum in each county more good would have been done for the advancement of education than by most of the schemes at present under discussion. At any rate, the classrooms and laboratories required for the teaching now contemplated should be associated with the museum, if possible under the same roof, and the staff of teachers should assist in the curatorial work, thus forming a sort of central college in every county for technical education, which might send out ramifications into the various districts in which the need of special instruction was most felt, and also might be the parent of smaller branch museums of the same kind wherever they seem required.

This is the kind of institution which I hope will, before long, be established in every county in the land. The marvellous spread of state-supported and rate-supported libraries which has taken place during the last few years appears to be only the prelude to museums supported in the same way. The underlying idea of a library and a museum is precisely the same. They are both instruments of intellectual culture, the one as much as the other. We have this illustrated on a magnificent scale in our great National Library and Museum in London. Before long a well-arranged and well-labelled museum will be acknowledged as a necessity in any well-considered scheme of educational progress. The museum and library will go hand in hand as essential complements to each other in the advancement of science and art, and intellectual development generally. A book without illustrations is of comparatively little value in teaching many of the most important subjects now comprised in general education. A museum should be a book or rather library of books, illustrated not by pictures only, but by actual specimens of the objects spoken of. The great principle of expending public money upon purposes of education, though a comparatively new one, is now conceded upon all sides. The cost of supporting really efficient museums in all our principal local centres would be but a trifling addition to the millions spent upon other methods (some probably of far less value) of educating and elevating the people. But in all cases let us remember, as Professor Brown Goode, the Director of the United States National Museum, in an admirable essay on "The Museums of the Future," says, "One thing should be kept prominently in mind by any organisation which intends to found and maintain a museum, that the work will never be finished, that when the collections cease to grow they begin to decay. A finished museum is a dead museum, and a dead museum is a useless museum."

Chapter 32 | Susan A. Crane

Memory, Distortion, and History in the Museum

Those who insist only on their own memories of the past are condemning the rest of us to avoid it.

Martin Sherwin[1]

What kind of service [can] historians, or people with an education in history... perform to support the subjectivity of individuals in their historical perception of themselves[?]

Lutz Niethammer[2]

I have become an inveterate reader of museum guestbooks. Whenever visitors are invited to write their comments at the end of an exhibit in a blank book, I flip through the pages to see what kinds of remarks have been made. Generally, one finds school groups' scribbles and drawings, inscriptions of names and hometowns, often only single words of approval or disapproval. Occasionally an exhibit will provoke stronger responses. A few years ago I visited an exhibition of "the masterpieces" of Pacific Northwest Native American jewelry and art, both contemporary pieces and historical artifacts, in The Museum of Anthropology at the University of British Columbia. The visitor book was crowded with complaints. One visitor angrily recorded, "I expected to learn something from this exhibit, not be confused by it." This response was echoed throughout the book. Visitors complained about tags in each display case which asked them to think about why that artifact was being included in a "masterpieces" exhibit.

Since my own reaction to this strategy had been quite positive, the memory of the disaffection in the guestbook has lingered with me. Surely individual museum-goers have the right to expect to be educated, since this is part of their desire to visit the museum. And yet, just as surely, it cannot be assumed that education has not transpired, even if the visitor exits angry or feels defrauded. Part of the educational intention of the curators (students, in this case, in a cross-listed art history and

Susan A. Crane, "Memory, Distortion, and History in the Museum" from *History and Theory* 36:4 (1997), pp. 44–63. Reproduced by permission of Blackwell Publishing.

anthropology course at the University of British Columbia) was to ask visitors to think about how knowledge is constructed, both by curators and by the audience. By challenging visitor expectations, and therefore the memories associated with previous museum visits, the exhibit offered visitors the opportunity to create new meanings for themselves. The disgruntled visitor has indeed reflected on what his/her museum expectations were, ironically enough, and in this sense the curator's goals were achieved. But the visitor left confused and possibly angry, disappointed in the expect-ation of education or entertainment. These expectations had been distorted at the museum; like a radio signal distorted in transmission, what the visitor expected was not what was received. What effect does this distortion have on the experience of history, of knowledge about the past in its effects on the present, for the visitor in the museum?

At stake is the trustworthiness of the museum as a memory institution. If a museum "messes with your mind," is memory – particularly historical memory – fundamen-tally at risk? These anxieties about today's museum discourse – from the battles over the Enola Gay exhibit at the Smithsonian to the deliberately artificial "historical" exhibits appearing in contemporary museums – will be explored here. We are more familiar with concerns and complaints about the distortion of history or memory by interpretation; but it may be that the distortion of expectation is what characterizes recent public debates about museums. And although the manifest content of history is often the explicit core of the debate, it is historical consciousness – a personal awareness of the past as such and a desire to understand experience with reference to time, change, and memory – which has emerged as the unmentioned key term in a changing museal discourse.

The sites most associated with historical consciousness have been studied as "*lieux de mémoire,*" but the process of making historical consciousness exceeds any single combination of place or time, and occurs as "locally" as a person's private thoughts.[3] Historians can describe the history of historical consciousness, the places and times where the people who cared about the past spoke about it or acted on that caring, and yet the phenomenon of historical consciousness continually exceeds those documen-table moments which result in texts and narratives, precisely because it refrains from or resists incorporation in institutions, texts, and practices. Some historians may have anxiety about, or disdain for, the unincorporated realm of personal historical memory, seeing it as evidence of ignorance, willful prejudice, emotional needs, or lack of understanding of the knowledge and interpretations available from competently performed historical study. This "excess" of memory, personal and yet publicly formed, complicates historical practice and creates a new object of historical study at the intersection of the personal and the public. I want to pursue this unusual notion of "excess" in relation to the distortions of expectation that visitors experience in museums by looking at specific installations which highlight an awareness of these phenomena.

The museum is not the only site where subjectivities and objectivities collide, but it is a particularly evocative one for the study of historical consciousness. A museum is a cultural institution where individual expectations and institutional, academic inten-tions interact, and the result is far from a one-way street. A range of personal memories is produced, not limited to the subject matter of exhibits, as well as a range of collective memories shared among museum visitors. Visits to museums – whether of history, art, ethnography, or technology – are ordinary, everyday events in modern western societies; they place museums within the living memory of many people, the

majority of whom do not consider themselves professionally responsible for the contents or existence of the museum, much less for historical memory.

Museums are sponsored by governments and privately, and figure in the education of millions of children, including myself. Busloads of school groups form some of the most regular audiences, and the museum visit is a token of childhood, whether the visit is experienced as a singular and unusual event, or just another field trip. Museums can be crowded as a token of their importance, or empty and neglected, but the idea of a museum disappearing or closing does not even occur to most visitors: so clearly do they seem to be a fixed aspect of the cultural landscape, so certain does their purpose seem to be. In these mundane ways, museums become familiar to us. We learn how to behave in museums, what to expect from them, what to buy, and how to remember the occasion. Our museum experiences instruct us in social codes of behavior, condition a sense of cultural literacy, and instill the value of art, the past, and science. I can assume that there exists a public or set of collectives to whom I may speak of museums with an expectation of shared understanding – your own museum memories being different from but related to mine. Such is the prevalence of this institution in modernity, and this is precisely why it plays such a large role in the experience of historical consciousness. We approach museums with certain well-founded expectations, even on the first visit, and thereafter museums exist as much in our memories as on their sites.

What transpired in the guestbook of the Vancouver museum was a collision between personal expectations, based on memories of museums past, and the present museum's intentional obliteration of the line demarcating institutional authority from visitor experience. The exhibit responses revealed a lingering excess of memory from other times, other museums, and other knowledge which neither I, as the peruser of the guestbook, nor a curator would otherwise have access to, an excess of memory which is the trace of a historical consciousness that exceeds the immediate exhibit and yet is intimately connected to the conceptual entity "museum." This excess of memory need not be related to the literal content of the exhibit (Native American artifacts): it may also derive from the memory of museums as historical institutions known and experienced over time. What I am calling an "excess" is neither extra nor supplementary to a fictive whole of collective or historical memory; it is what characterizes individual experiences at museums and individual memories of "the museum" which then shape the public discussion of what museums are, and what they could or should be.

This excess has been most visible at the sites where modern western cultures construct public domains for memory, such as monuments, the media, and museums.[4] Visitors' expectations, shaped by consumer culture and tradition, have been recognized as valuable resources for museum educators and curators, visible in the use of guestbooks for feedback and documentation of a particular exhibit, and studies of museum attendance and education. An awareness of the audience's expectations and a desire to meet them have had a profound influence on museum exhibition practices in the later twentieth century.[5] This attempt to create a dialogue between museums and their publics reflects a change in attitudes since the nineteenth century. One hundred years ago, museum professionals began to replace connoisseurs as the shapers of collections, and established an ethic of professionalism which led visitors to expect a pedantic approach to exhibitions: museums were providers of instruction, first and foremost.[6] What had begun as an elite undertaking to save, record, and produce the cultural heritage of the past and the present in the Romantic era (begun

by but not limited to the intellectuals and artists of the time) had exploded into a popular public project.[7]

Public controversy over museum collections, displays, and the role of museums was not and is not confined within the discourse of intellectuals. People who otherwise might not worry about the content or purpose of a museum may come to care quite passionately when their expectations, based on their own experience and memory, are thwarted, and they will express those passions publicly. Whether expectations are thwarted deliberately (as may be the case when museums attempt to educate the public to see things "differently" than has been common practice) or not, visitors to museums, like members of any public or collective, will express their disappointment or disapproval as readily as if they were in fact responsible for the meanings produced by the exhibit. Personal feelings and memories, whether accurate or appropriate or not, indeed are always a factor in the contexts in which historical consciousness is made, because they shape how an experience is remembered.

Visitors are interlocutors without discussion partners in the museal conversation: they usually have only objects and text to respond to, rarely curators, historians, or experts. The interrogatory text of the Vancouver exhibit unsettled visitor expectations and placed them in virtual discussion with absent curators; some found this experience unnerving, suited neither to past experience nor current expectations. Indeed, since visitors could have no expectation of a reply, only their own or their companions' thoughts to engage in conversation, the explicit reference to a curator's presence may ironically have reinforced the sense of distortion, confounding both expectation and experience by offering an absent presence where there had previously been an absent, but apparently omniscient and reliable, narrator. Such "pathetic" exhibits, according to Ralph Rugoff, are not to be confused with sorry attempts at good exhibits, but are instead deliberate attempts to mangle conventional notions of display or museum orthodoxies real and imagined.[8] The more curators or historians make themselves visible to museum visitors, the more the visitors react warily, unsure if they are really being asked to engage in discussion (which would necessarily involve opinion), or whether they are simply being instructed in a new way. The appearance of conversation may lead visitors, like the angry one in Vancouver, to voice expectations or beliefs that curators do not want to hear; it may also lead a museum public to believe that they have a right to a voice in determining how exhibits are staged.

What happens when an ordinary visit to the museum produces distortion – when not only are expectations not met, but they are unpleasantly, disturbingly confounded? when an institution such as the Smithsonian Museum of Air and Space is reported to be presenting World War II in a way that is unrecognizable, that does not confirm personal memories? when the Museum of Jurassic Technology in Los Angeles presents a book whose provenance is uncertain? when a historic house in San Francisco fabricates a historical personage, claiming that this person lived in the house which now contains his artifacts? I've been confounded by museums several times since 1990, and it delights me, frustrates me, makes me tired, and makes me want to write; overall, I see this as a positive response. But I am aware of others, who have left their traces in museum visitor books and in conversations, in publications and in the press, who resent being, as they see it, duped. And they are not alone. Scholars, particularly historians, have expressed similar distaste or outrage at what they perceive to be distortions of the (arti)fact-providing and scholarly-veracious functions of the museum's educational goals and duties. Members of both the general public and interested professionals have serious objections to having their expectations thwarted.

Although visitors may fully expect and desire to be educated, instructed, to learn "something new," as soon as that knowledge conflicts with memory and experience, trouble begins. At this juncture, the confounding which occurs when museums are called upon to mediate different registers of memory, experience, and knowledge is the same in both actual historical museums and in historically conscious art installations.

Memory in the museum operates at several levels; as a resource and a product in perpetual stages of flux, memory is no more static in the fixed space of a museum than it is in the fertile depths of our brains. In his recent book, *Searching for Memory*, psychologist Daniel Schachter describes the multiple ways in which memory functions within the brain, and the multiple sites and interactions which are required for memories to be created and revived.[9] He emphasizes the "cues" for memory, that is, the context in which memories are recalled, as well as the contexts in which the previous memories were shaped. Each memory, rather than being a single artifact of the past or unique imprint, Schachter describes as a production that emerges over time and in the present, in response to and through the integration of memory cues and memories. While the Freudian notion that memories are not trustworthy and that their unreliability has to do with an individual's emotions and desires has become a commonplace, the notion that memory is actually a positive process of distortion has not. Some psychologists and others continue to hold onto the possibility that the "real" memory of the past, whether of trauma, joy, or something more prosaic, is accessible. And yet for museums, it may be more useful to look beyond the notion of mnemonic veracity and look instead at the interactions which produce, reduce, and conflate memory. If we assume that the nature of memory is change and distortion over time, rather than expect memory to be a distorting faculty which abuses the historical past, then memory can be seen as a historical process which is frequently interrupted by interpretation to create the present. Thus we have a model of memory which functions rather like a museum: one which confounds as much as it synthesizes information, by bringing together "cues" or artifacts and historians or rememberers to interact in the production of memory.

One such confounding exhibit appeared in 1993 at the Haas-Lillienthal House in San Francisco, an architectural historic landmark from the late nineteenth century, where Fred Wilson created an installation entitled "An Invisible Life: A View into the World of a 120-Year-Old Man." My sister, a neighbor of the house, visited it and described her delight at the consternation it caused.[10] Waiting for her tour, she overheard two women docents, volunteers from the Heritage Society, complaining in hushed and bitter tones that "their" tour was being undermined. "Their" tour included a historical overview of the Haas family, German emigrants and grocers, and the architectural features of the quintessentially San Francisco house. The "counter-tour,"[11] conducted by a young man wearing a plastic-coated name tag – a reassuring indication of normalcy – began on the second floor and introduced Baldwin Antinious Stein, a.k.a. Baldy, "a guest of the Haas family from 1906–90" who had arrived on the most inauspicious date in San Francisco history, that of the 1906 earthquake. He stayed for what by any measure was a rather long visit (in a rather long life), remaining until his death. The new docent noted Baldy's personal effects "left the way he wanted it" in each room, including a copy of Proust on the table (described as evidence of Baldy's personal relationships with authors of the period). The ashes of Baldy's parents, killed in the fires of the earthquake, resided with him in his (unusually but not implausibly) old age. Baldy's innovations in the bathroom, photographed by

Architectural Digest, were described and viewed, as well as his activities as a photographer. Included in his photography collection was the famous series by Edward Muybridge depicting motion over time; they were said to admire each other's work. Baldy's collection also contained sepia-colored images primarily of male figures. The original docent now returned and the counter-tour docent receded as the woman resumed her description of Arts and Crafts furniture and refused to comment on or answer questions about Baldy.

Baldy was the creation of Fred Wilson, and the artifacts attributed to him were installed by Wilson to create the effect of historical presence. In a handout available after the tour, the artist's work and biography were detailed, opening with the statement, "You may or may not be aware that the tour you have just taken included a contemporary art installation," and continuing: "Using the format and language of museum presentation, the installation raises questions about how history gets told, what gets left out, and how we as audience members interact with institutions such as art and history museums."

The nametag on the counter-tour docent and the display labels offered authenticity where none existed. All of the objects in this part of the house were as well-marked, professionally labeled, and carefully displayed as those in the rest of the house. The reference to Proust, obligatory in memory discourse, was presented as merely period-specific, and the allusion to the technological breakthrough of depicting motion over time in Muybridge's work was couched as a "personal effect" of someone interested in photography. Personal historical consciousness also came through in the form of Baldy's "queer" identity, as the counter-docent noted later, framed in the photography collection and specifically intended to refer to San Francisco's gay history and its reputation for tolerance. His (imaginary) affiliation with historical personages also lent credibility to the installation for an audience who can be presumed to have heard of Proust, if not of Haas; history was personalized for the viewer through Baldy. Those most upset by this shift in perspective were the docents, whose routines had been interrupted. The counter-tour docent admitted that some regular docents were willing to work with the artist, creating their own "Baldy-faced lies," but most were not. The docents' role was key to the visitors' historical experience: only the narrative told by the docents created a context in which the real objects on display took on (false) historical meaning. Objects, visitors, docents, and narrative "cues" interacted to produce a memory of a nonexistent person – a memory which persists in different forms in my sister, in me, and now in my readers.

Museums are not supposed to lie to us; this act seems a breach of faith. Assuming that our own memories are fallible, we rely on museums as well as on historians to get the past "right" for us. Even if we don't remember every museum experience, we know that that "straight" version of the past is available to remedy our "queered" or distorted memories. But perhaps we can also enjoy museums which confound and confabulate. David Wilson's Museum of Jurassic Technology (MJT) in Los Angeles, founded in 1989, playfully combines real and imaginary natural-historical objects which defy expert analysis.[12] Part installation art-performance, part curiosity cabinet, part testimony to the fact that truth is stranger than fiction, and purely David Wilson's creation, the museum is housed in a nondescript building on a busy street far from other Los Angeles cultural centers. Inside, the museum provides an eclectic selection of professionally-designed, interactive displays (Mr. Wilson's other business is special effects design) of natural history, historical objects, and visiting exhibitions drawing on such sources as the Mt. Wilson Observatory and the Mutter Museum of

Philadelphia. In another museological tribute to that icon of memory work, Proust, Wilson suggests the powers of olfactory stimulus in an exhibit which allows the visitor to inhale the essence of a madeleine. An entire hall is dedicated to the "famous memory researcher" Geoffrey Sonnabend whose theory of the decay of memory is conveniently encapsulated in a museum-produced pamphlet, "Obliscence: Theories of Forgetting and the Problem of Matter."[13]

One of my favorite MJT memories is of watching the video presentation at the entrance to the exhibits, its narrative tongue firmly in cheek as it presents the historical antecedents of the MJT, from the *Ur*-collector Noah (a replica of his ship lies just beyond) to Wilson. One barely has time to wonder what technology could have existed even metaphorically in the Jurassic world imagined by Steven Spielberg, much less the Jurassic period. The museum pays homage to the prehistory of museums and yet I felt confounded by the museum precisely because I was in the midst of a project on the history of modern museums and my professional sense of expertise was in jeopardy: even I couldn't tell immediately where the history ended and the imagination began. It is not impossible to separate fact from (arti)fact at the MJT, but the distinction is beside the point. The MJT represents one man's fascination with museums and history, made visual and palpable, and fans of the museum revel in its sleights of hand, its hints and hidden sources.

Numerous art exhibits and performances which "played" with history and historical consciousness were produced in the 1980s.[14] David Wilson's museum is perhaps a superlative example of the ironic museum produced by such self-consciousness. Part of Wilson's collection now resides at the Karl-Ernst-Osthaus Museum in Hagen, Germany, where director Michael Fehr has oriented the museum of contemporary art towards the theme of historical consciousness, particularly regarding the recent history of Germany.[15]

Art which comments on historical consciousness is never merely creative and fictional: such art deliberately references a body of knowledge and experience shared by historically conscious viewers. Never quite completely separate from historical scholarship despite its lack of scholarly apparatus, historically conscious art is in fact competent for a performance of history in the museum, thus further complicating the interactions between the personal and the public, the historical and the historically conscious, the excess of memory and the experience of the museum.

The Karl-Ernst-Osthaus Museum collection also includes a work by Hamburg artist Sigrid Sigurdsson entitled "Vor der Stille: ein kollektives Gedächtnis" (Before the Silence: A Collective Memory).[16] Sigurdsson created an archive which is installed as floor-to-ceiling shelves around an entire room, filled with oversize, handmade bound books which resemble the archival materials found in German state archives, and clear glass containers which hold other artifacts. Her artifacts are found objects, recovered from trashbins and attics: photographs, letters, labels, and military memorabilia from World War II; odd bits of household materials and everyday objects, mostly dating from the 1920s–1950s and of German provenance. She filled both the bound books and glass cases with artifacts and her own drawings or plastic work in response to them.

The exhibit provoked hostile criticism from the Hagen public not so much for its emphasis on historical consciousness, or its invention of a format for the detritus of the past, as for choosing to foreground the memory of a particular historical era, namely the Third Reich. The exhibit opened in 1989, and rather than celebrating the present and the potential for German unification, it apparently reopened old wounds

never completely healed and losses never mourned. Public response in the press and in the guestbooks of the museum, while often supportive, questioned the artist's choice of topics; anonymous postcards accused her of "dredging up the past" and indeed of being a "Jewish pig" for bringing up associated memories of the Holocaust.

The exhibit does not overtly address either the Holocaust or the Nazi regime; no accompanying narratives, no labels on the walls, direct the visitors' interpretations or provide a historical guideline. Instead, visitors select bound books or boxes from the shelves and look at them as they choose. Some books and boxes, open on the tables placed for reading at the center of the room, are most readily available, but by leaving the visitors the choice of objects, the artist ensured that each visitor's experience must be as different from another's as their memories would be. Equally, any visitor could make multiple visits and never visit the same exhibit in exactly the same way twice – which simply highlighted a fact Heraclitus stated long ago, that no one ever duplicates an experience exactly – that time, memory, and change intervene to produce different people at different moments in the same individual's life. Thus Sigurdsson made explicit the way that museum experiences build over time to create expectations and memories in visitors. Additionally, Sigurdsson illustrated some pages in the "visitors' books" but left others to be filled by exhibit visitors or schoolchildren, whose teachers received the books and were instructed to let the children fill them as they pleased.

These kinds of meditations on history lead to mediations in history, requiring the audience to draw on their own memories and knowledge and affirming what they bring with them to the exhibit. Rather than providing them with new information or reinterpreting the past, and rather than insisting on one interpretation or directing response towards feelings of guilt or culpability, Sigurdsson opens a door and invites visitors to furnish the archive with their memories, whether good or bad, whether from that time or about that time. The controversy about this exhibit arose because all of its artifactual references inexorably led the viewer to one particular past and forced the memory-aspects of museum work to become active and participatory. The exhibit called upon personal historical memory – but the audience was hesitant to focus their memories on an era whose history is so emotionally and politically charged.

As is by now well-known, the Germans have a particular term for this failure to come to terms with the Nazi past, "*Vergangenheitsbewältigung.*" The word functions as a shorthand for speaking about repression. The term has also come to express the complications of collective memory at local historical sites such as Buchenwald, where descendants and interested parties compete for commemoration of the victims of multiple traumatic events of the twentieth century.[17] The discourse on memory is particularly fraught in Germany, and apparent in the public media forums which track the *Zeitgeist* of the recombined German states. The slogan of 1990, "bringing together what belongs together," belies the vast differences of experience and memory which people of the same generations bring to the new state from east and west. Sigurdsson's work might represent one way to create a public forum for discussion of repression, national identity, and historical consciousness across the formerly divided Germanies. Given the historical importance of museums in Germany, from the "museum island" of Berlin to the collections of art in Dresden, Munich, and Nuremberg and the smaller historical museums around the country, could museums take advantage of their special status as mediators of historical consciousness to offer exhibits which might take the lead in dealing with the memory crisis?

In fact, two new historical museum projects had been underway prior to the fall of the Wall, both of them controversial. In Bonn, a "House of the History of the Federal

Republic" had been founded in 1982, as a pet project of Chancellor Helmut Kohl. Discussion of another historical museum had begun in the 1970s, and in 1987 the German Historical Museum (DHM) was founded in West Berlin. Critics had questioned the necessity of history museums in the Federal Republic, fearing that such museums would be sources for resurgent nationalism. When "*Wir sind das Volk*" (we are the people), the rallying cry of the Leipzig demonstrations in the fall of 1989, was quickly transposed to a new key in 1990, "*Wir sind ein Volk*" (we are one people), in a rhetorical attempt to deny the separations that remained after the Wall came down as well as opening up the possibility of a "safe" new nationalism, the two museums followed suit. The Bonn museum quickly adapted itself to the new political reality and made arrangements for exhibits on the history of the German Democratic Republic to be presented in tandem with that of the Federal Republic, culminating in reunification; it opened in 1994. The DHM, still in the planning stages when the Wall fell, changed its venue from the western bank of the Spree River and decommissioned an elaborate museum plan from architect Aldo Rossi in favor of annexing an existing historical building in the old center of the city, the former arsenal on Unter den Linden in east Berlin. This arsenal, not coincidentally, had housed the Museum of German History since 1967, and many critics of the earlier DHM project had argued that it was intended simply as an ideological counter to the East Berlin museum.[18] The former East German museum's exhibits featured narrative texts which changed according to the party's needs over the years and was ideologically offensive to the west, but its artifacts effectively represented an emphasis on social history. Exchanging titles with the new DHM, the old museum's exhibits were dismantled (although some effort was made to document the old exhibits and to preserve their contents), and a series of new floating historical exhibits was installed, beginning with a giant retrospective on the career of Otto von Bismarck.

Historical museums were now "safer" for Germany, but it remains to be seen whether the discourse on historical consciousness and memory will become any more open and fruitful. The Cold War, now enclosed in chronological brackets, presented a more recent past in need of reconciliation and museum representation. Within days if not minutes of the fall of the Berlin Wall, I remember from my time there in 1990, comments began to emerge about the former East Germany being perceived as a virtual museum of itself and of the West German 1950s (since East Germany seemed to many idealizing West Germans to have remained at the economic, social, and moral level of those *Heimat*-film days). This sort of wayward nostalgia among West Germans was met by a wariness on the part of East Germans, as the disappearing wall eliminated the last excuses for a lack of communication between two peoples who had learned very different lessons about the Third Reich. Wolfgang Ernst suggests that the now-absent Wall "represents both the lessons of history and the emptiness of history simultaneously" ("*Geschichtslehre und-leere*"); the simultaneous paucity and superfluity of historical consciousness that had been figured in the Berlin Wall now constituted an empty space which needed to be filled with real historical work.[19] As the former East German history exhibits were removed and temporary DHM exhibits moved into the Arsenal building, the emptiness of history stood in bold contradiction to the lived experience of people immediately outside. Regardless of whether visitors to the former Museum of German History had received its message skeptically or enthusiastically, the terms of their museum experience had been erased. From an American perspective, for those who had been to the museum and would come again, it was as if an institution such as the Smithsonian had

closed down over the Christmas holidays and reopened with an entirely new collection, exhibitions, and narrative tags. The memories of the old exhibits lingered, but one felt that they were to be discarded as unworthy of the new institution, which was in fact new to both east and west and therefore stood an optimistic chance of successfully redirecting memory discourse.

If critics had questioned the need for an institution representing national identity prior to the opening of the DHM, some now saw an opportunity to integrate east and west through a common history and a joint effort at coming to terms with the past. The DHM commissioned photographs of eastern Germans by the west German photographer Stefan Moses, who created an exhibit of his work featuring eastern Germans posed simply against bare backdrops in their everyday work clothes and bearing tokens of their work – cooks with food, intellectuals with horn-rimmed glasses. In Barbara Ann Naddeo's study of public response recorded in the guestbooks of this transitional exhibition, she notes that none of the visitors commented on what was missing from the museum, focusing instead on the new exhibit and its typological portraits.[20] Eastern Germans tended to react more favorably than westerners; indeed, where westerners saw the photographs as demeaning or stereotypical, the easterners embraced the stereotypes or thought that the "feel" was right. One visitor wrote, "The chaos is depleted; it was the most wonderful time."[21] Memory work here could quickly and too easily be dismissed as mere nostalgia. Historians may be skeptical of this too-easy transition from past to present, but it was precisely in response to the sudden emptying of east German history from the museum and its replacement with images of the rememberers as they might remember themselves, which allowed a recognition of the presence of their own memories to slip into place, with both its positive and negative influences.

Theodor Adorno wrote, "The German word 'museal' has unpleasant overtones. It describes objects to which the observer no longer has a vital relationship and which are in the process of dying."[22] An inverted sense of the term "museal" has come into use recently, referring now to a process in which the awareness of the museum's functions is internalized. The "*musealisierung*" or museumification of both Germanies and the new Federal Republic took place not only in state-sponsored institutions but in the minds of individuals for whom museums were a naturalized site for memory cues and memory work.[23] Metaphorically, the museal process occurred in the minds of individuals who continued to visit new museums, but scripted their own memory narratives to go along with those of national identity. This kind of understanding of history through memory – that is, through an excess of memory that appears to be counter-historical and distorted by the lens of personal interest – is precisely what causes historians so much anxiety.

At stake, then, in the current politically charged arena of museums and memory is distortion: distortion of "the past," distortion of the museum experience, memory distortions, and the negative charge associated with "distortion" in cultural discourse on memory and identity. To return to Daniel Schachter's presentation of memory as distortion process, we can suggest now that the understanding of history through memory represents the combined influences of personal experience and education in a mirroring activity of *musealisierung*. The museum-site, located in the mind rather than in geographical space, reproduces the memory experiences by working through expectations for museums, memories, knowledge, and experience. We may tend to assume that distortion in the museum must refer to misappropriated facts or ideologized interpretations. I am looking instead at the distortion process of *musealisierung*

as a means of achieving a constructive, interactive museal experience even in the face of explicit resistance and controversy.

If this sounds too abstract to be either practical or serviceable to historians in rethinking the relationship between memory and history via museums, consideration of the battles over the Smithsonian's National Air and Space Museum and the foundation of the Holocaust Memorial Museum may yet shed light on the complex of museum/distortion/memory. America's own experience with coming to terms with the past of World War II in the debates over the Enola Gay exhibit was every bit as stunning (and unsuccessful) for those involved as it has been for Germans.

If Germany is a country fraught by an inability to come to terms with the past, it is because the past in question, the one referenced by Sigrid Sigurdsson, is the era of World War II, the Third Reich, and the Holocaust. This single largest event-complex/ complex event in the living memory of our eldest generations, of world-shaping significance, continues to figure most prominently in public memory work. Public interest in popular and scholarly work on this era remains high; perhaps more so in regard to this historical topic than any other, a risk of offense to public sensibilities is ever present. It should have come as no surprise that Daniel Goldhagen's recent book *Hitler's Willing Executioners* became a bestseller. No one who has studied German history in this country is unfamiliar with the charge that the Germans are an exceptionally anti-Semitic people and natural perpetrators of the Holocaust, however much we may want to explain our own more nuanced approaches to the issue, because that argument appears to be what many Americans think anyway; what was unusual was to hear it from an academic who professed to have no "personal" relationship to the subject. Historians have bemoaned the fact that the public still wants to hear what it wants to hear, and not what historians could tell it. Historians' dislike of Goldhagen's book contrasted sharply with public perceptions, and the resultant dichotomy epitomized the difficulties historians face when treating subjects so close to the personal memories of the public. Was Goldhagen's message in fact closer to popular and personal memory than what historians had concluded based on decades of ever more complex research?

Given public sensitivities to representations of World War II, museum exhibits about this period carry an extraordinary burden of responsibility. The aborted Enola Gay exhibit at the National Air and Space Museum created controversy by confounding memory as well as expectations without ever coming to fruition in anything like its proposed form.[24] The public controversy in 1993–1994, conducted through media and government forums, touched raw nerves as the nation approached the fiftieth anniversary of the end of World War II. Veterans became incensed, congresspeople demanded revisions, historians defended their right to interpret the past, and the result was that curators produced an exhibit all but devoid of content, prompting cartoonist Dan Wasserman's pithy depiction of a museum spokesman standing in an empty hall, announcing that "we're returning to our original mission as the Air and Space Museum." At stake was an issue of national pride: did the Enola Gay, a B-29 bomber, represent the triumph of technology over tyranny and the end of a brutal war? Or did this airplane signify the beginning of the nuclear age, a new use of technology for mass destruction and the obliteration of a civilian population? Further: was the crew of the plane somehow being put on trial by the scripted presentation in the National Air and Space Museum? Were individuals being held accountable not only for the decisions of their superiors, but for the "politically correct" historical interpretations developed without their knowledge? Regardless of the moral issues

surrounding "acting under orders," is it possible to separate the actions of soldiers under orders from the policies of governments at war in displaying the historical objects which necessarily reference both these things at once? Veterans and their representatives were offended by these implications, speaking as survivors and eyewitnesses. Personal historical memory met institutional memory head on, and the collision was catastrophic.

The distortion perceived by opponents of the exhibit thwarted their historical memories of victory and expectations for a heroic, commemorative story line about the victorious American forces in the Second World War. Americans, wrote military historian Richard Kohn, were used to experiencing the Smithsonian as a "celebratory institution."[25] Proponents of the exhibit were deliberately challenging that norm, and they in turn felt thwarted by public resistance to education: they perceived a distortion of history in the persistence of public misinformation.

Not coincidentally, another museum on the Mall had been facing the same issues and was struggling with decisions which pitted commemoration against education and interpretation: the newly opened Holocaust Memorial Museum.[26] Both museums worked with representatives of concerned public groups in shaping their exhibitions, and both faced serious difficulties in aligning or co-presenting survivor testimonies and memories along with historical interpretations. As Sybil Milton noted in regard to Holocaust memorials in general, there is "a universal willingness to commemorate suffering experienced rather than suffering caused."[27] Historians and curators of the Holocaust Memorial Museum were concerned about limiting the amount of space dedicated to Nazi memorabilia and the historical context of the Third Reich (evidence of "suffering caused"), because of its dangerous allure and because of their preference for honoring the dead and survivors ("suffering experienced"). The original Enola Gay exhibit, with its images of Hiroshima and Nagasaki bombing victims and artifacts from "ground zero," would have transgressed the bounds of acceptable American memory by emphasizing "suffering caused." This suffering is not what the crew of the Enola Gay saw, and it is therefore not part of the excess of memory held by these historical actors or by the generations that subsequently heard about them. The feelings of other visitors, whose personal experience of World War II might be limited to popular memory and some historical instruction, had to be respected as well. Exhibit opponents feared that the Enola Gay exhibit "could provoke feelings of guilt and shame among American visitors, including veterans" for suffering caused not only by the bombing of Hiroshima but by the nuclear age and Cold War in general.[28]

Historians and curators at both museums had paid attention to public opinion by actively consulting, from the beginning of the process, with survivors, veterans, and succeeding generations who wanted to pay tribute to them. In addition, survivors and veterans were included among the historians and curators: Martin Harwit of the National Air and Space Museum, for example, had both lost family in the Holocaust and participated in atomic testing in the South Pacific; the advisory council of the Holocaust Memorial Museum included several survivors of the Holocaust. Regardless of personal experience, however, Enola Gay exhibit organizers tended to discount the emotional validity attached to survivors' and veterans' beliefs. As Preble Stolz wrote in a review of the Enola Gay exhibit development process, "It is probably asking too much of people who have thought for fifty years that they owed their life to President Truman's decision to drop the bomb to reflect objectively about whether his decision was morally justified. At its core that asks people to consider the possibility that their

life was not worth living."[29] Historical reevaluation (which is not what senators refer to when they denounce "revisionism"[30]) affects not only what later generations think they know about the past, it also affects the historical actors themselves, when contemporary history is at stake. Historians may hope that the effect is always one of positive, beneficial education, but as we see here, personal memory may reject historical information. Who wants to tell Holocaust survivors that their memories are "wrong"?

Emotional aspects of memory played another important role in both museums as each made decisions about the types of artifacts of atrocity that should be exhibited. The National Air and Space Museum had been seen primarily as a display site purely for technology, yet in 1990 its V-2 rocket exhibit had included, for the first time, a picture of the body of a rocket victim.[31] Holocaust Memorial Museum curators faced an emotional decision regarding the display of human hair from Auschwitz, and worried that visitors would avoid a museum on the Mall which appeared to offer a "house of horrors," or that visitors would come for the wrong, voyeuristic reasons.[32]

Controversy about the appropriateness of a Holocaust museum on the Mall also emerged from fears that the American public would be perceived to be somehow responsible for not having intervened to prevent the destruction of the European Jews.[33] The museum had to decide how to present the historiographical issue of whether strategic bombing could have been used to interfere with the destruction process – while further down the Mall, a strategic bomber's effectiveness would be all too clearly on view. The issue of American culpability in both cases would play a part in any historically responsible exhibit, and yet the suggestion of moral fault-finding would be an intolerable accusation to an American public which perceived itself to be "the good guys." Curators at both museums had to be concerned with how a postwar American audience should experience an exhibit which would assault their expectations and memories regarding the history they had learned: would the images at either museum constitute a "physical experience" of horror for viewers?[34] How visceral did such an exhibit need to be, before viewers could comprehend genocide? As Elie Wiesel put it, the experience could not possibly be visceral enough, and yet it could have a drastic effect on viewers: "I want those people who go there to come out 2,000 years old."[35]

Only a personal, physical, yet distanced experience of the horrors of genocide and atomic bombing could constructively distort the excess personal historical memory carried by postwar generations. Having had no personal experience of either nuclear bombs or the Holocaust, such viewers still had historical knowledge and expectations built into an excess of memory which would be difficult to dislodge without the supplement of a personally meaningful, perhaps visceral experience. Thus the Holocaust Memorial Museum, by making choices regarding the degree rather than the kind of horror which would be exhibited, succeeded in creating a learning site of memory, while the Enola Gay exhibit was purged of horrors to such an extent that the final exhibit contained only a partial fuselage of the plane and minimal information about the crew.

The perspective of veterans was given unique precedence at the Holocaust Memorial Museum: visitors begin by viewing photographs from the liberation of the camps and hear the words of American soldiers who were aghast at the immensity of what they faced, a technique which has the effect of situating viewers among the "good guys" and among those striving to make sense of the historical horror.

The Holocaust Memorial Museum also apparently succeeded in bringing histor-ians' debates to the public by actively depicting the relationship between survivor testimony and historical analysis. Although both the Holocaust Memorial Museum and the Air and Space Museum had attempted to defer to veterans and survivors wherever possible, the Holocaust Memorial Museum was able to retain a representa-tion of historical analysis which was almost completely discarded from the Enola Gay exhibit.[36] Horror devoid of voyeurism is a powerful teaching tool which draws on personal experience and creates memory; insistence on either superior historical knowledge or undistorted personal memory, each to the exclusion of the other, is not.

What the Enola Gay controversy exposed were the scars of memory which historical interpretation and education have not helped to heal. It exposed the gap between public or collective memory, shaped by personal experience and exposure to inter-pretation over a period of some fifty years, and changing historical scholarship. It exposed scholars' and museum professionals' naive disregard for public perceptions of the nature of history and historical scholarship, despite what historians correctly perceived as unfair characterization of their work by journalists who repeated inaccur-ate information about the exhibit.[37] While those involved in historical scholarship and museums may continually hope to educate the public about the past, they may have neglected to demonstrate to the public how they go about this project. Air Force specialists, brought in to review the Enola Gay script at the height of the controversy, noted that "it 'could lead the viewing public to conclude that the decision to drop the A-Bomb was questionable (perhaps unjustified?) rather than debatable (still open to question).' "[38] If so, the script failed to present historians' real sensitivity to multiple interpretations and the process of historical revision, and public disapprobation was appropriate.

Historians have yet to make their most abstract and theoretical work accessible to a general public. The metahistorical approaches of Hayden White or Jörn Rüsen are not inappropriate ways to present history to the public, particularly with a recognition of what Rüsen calls the "intersubjectivity" of historical memory and public participation in the construction of collective memory; but how can we present such notions to a public which expects to learn "facts" about history? In other words, how can histor-ians share ideas about historical consciousness with similarly interested people, rather than "educate the public" about history? This, it seems to me, is what the historian of everyday life, Lutz Niethammer, meant when he suggested that the challenge facing historians (and by implication, anyone connected with museums) today consists in asking "what kind of service historians, or people with an education in history, can perform to support the subjectivity of individuals in their historical perception of themselves[?]" (quoted in the epigraph at the beginning of this essay).

Even where museums or educators actively depict the process of historical inter-pretation, they may have discounted active public resistance to this operation. That certain members of the press and the American government chose to denounce the Enola Gay exhibit based on flawed information and inaccurate reporting, receiving considerable support in doing so, only demonstrates the mistrust with which academ-ics are regarded in this era of "culture wars." But this is not only media hype. The sad success of the Enola Gay exhibit was that it brought this public resistance to historians to the foreground of debate, and demonstrated that while historical scholarship is dedicated to the production of knowledge for a larger public, publics continue to harbor and develop their own collective memories which justifiably resist historical re-interpretation and which form an active component of public life. The unfortunate

lesson of the Enola Gay controversy was just how little publics know about what historians "really do" despite what they may have learned from historical sources, and just how little-used historians are to having to defend their interpretations before non-academic publics.

Before historians complain about the distortions "out there" among the public, we need to articulate the distortion process that is memory in ways accessible to individuals who have a personal, rather than a professional, interest in history. Historically conscious individuals may turn out to be quite interested in the study of historical consciousness, but it will take time and patience on the part of historians and a willingness to engage personal memories in the production of history.

Museums are flexible mirrors whose convex potential for multiple interpretations and participation (that is, by those who have either kind of personal historical consciousness: as veterans and survivors, or as historians) will continue to make them appropriate venues for active memory work, either "on site" or in the minds of those whose historical consciousness has been activated, nourished, challenged, and revived.

Notes

1 Quoted in Edward Linenthal, "Anatomy of a Controversy" in *History Wars: The Enola Gay and Other Battles for the American Past*, ed. Edward Linenthal and Tom Engelhardt (New York, 1996), 60.
2 Lutz Niethammer, *Posthistoire* (London, 1992), 149.
3 The term *"lieux de mémoire"* is drawn from the collective project conducted under the supervision of Pierre Nora and published as *Les lieux de mémoire* (Paris, 1984–1992); and selected translations published as *The Realms of Memory* (New York, 1996).
4 Marita Sturken's *Tangled Memories: The Vietnam War, The AIDS Epidemic, and the Politics of Memory* (Berkeley, 1997) provides a framework for discussion of media, memory, and history as "entangled, conflictual, and co-constitutive" (43). The extensive literature on monuments and museums is noted as appropriate further on.
5 See Eilean Hooper-Greenhill, *Museum, Media, Message* (London, 1995); Susan Pearce, *Museums, Objects and Collections* (London, 1992) and *Objects of Knowledge* (London, 1990); Kenneth Hudson, *A Social History of Museums* (Atlantic Highlands, N.J., 1975) and *Museums of Influence* (Cambridge, Eng., 1987).
6 Neil Harris charts this change as being significant particularly in the past twenty-five years; see his "Museums and Controversy," *Journal of American History* 82 (December 1995), 1102–1111. On nineteenth-century German art museums, see *Museumsinszenierungen: Zur Geschichte der Institution des Kunstmuseums. Die Berliner Museumslandschaft 1830–1990*, ed. Alexis Joachimides *et al.* (Dresden/Basen, 1995); Walter Grasskamp, *Museumsgründer und Museumsstürmer: Zur sozialgeschichte des Kunstmuseums* (Munich, 1981).
7 On Romantic museum practice, see Stephen Bann, *The Clothing of Clio: A Study of the Representation of History in Nineteenth-Century Britain and France* (Cambridge, Eng., 1984); Bann, *Romanticism and the Rise of History* (New York, 1995) and his "History as Competence and Performance: Notes on the Ironic Museum" in *The New Philosophy of History*, ed. Hans Kellner and Frank Ankersmit (London, 1994). See also Susan Crane, "Collecting and Historical Consciousness: New Forms for Historical Consciousness in Early 19th-Century Germany" (PhD. dissertation, University of Chicago, 1992).
8 Ralph Rugoff, "The Nintendo Holocaust" in his *Circus Americanus* (New York, 1997).
9 Daniel Schachter, *Searching for Memory: The Brain, the Mind and the Past* (New York, 1996).

10 Elizabeth E. Crane, private communication, 4 October 1993. Fred Wilson, "An Invisible Life: A View into the World of a 120-year-old Man," August 20–October 3, 1993; presented at the Haas-Lillienthal House, San Francisco by Capp Street Project. All further quotations are taken from her report.

11 The term "counter-tour" is derived from James Young's influential discussion of Holocaust "counter-monuments" in Europe, Israel, and America. See James Young, *The Texture of Memory* (New Haven, 1995).

12 On the Museum of Jurassic Technology, see Lawrence Wechsler, *Mr. Wilson's Cabinet of Wonders* (New York, 1995); Ralph Rugoff, "Beyond Belief: The Museum as Metaphor" in *Visual Display: Culture Beyond Appearances*, ed. Lynne Cooke and Peter Wollen (Seattle, 1995), 68–81; Mario Biagioli, "Confabulating Jurassic Science" in *Technoscientific Imaginaries: Conversations, Profiles, and Memoirs*, ed. George Marcus (Chicago, 1995), 399–432; see also my "Curious Cabinets and Imaginary Museums" in *Museums and Memory*, ed. Susan Crane (Stanford, 2000).

13 The word may be related to "obliviscence," which is defined in the Oxford English Dictionary as "the fact of forgetting or state of having forgotten." The Sonnabend/Delani halls have been described in greater detail in Rugoff, "Beyond Belief"; Crane, "Curious Cabinets"; Biagioli, "Confabulating Jurassic Science." The exhibit and others may be visited at http://www.mjt.org.

14 Jean-Hubert Martin, "The Musée Sentimental of Daniel Spoerri" in Cooke and Wollen, *Visual Display*, 51–66, describes some of the forerunners of this movement, particularly those which addressed both the museum as institution and historical consciousness. See also *Exhibiting Cultures: The Poetics and Politics of Museum Display*, ed. Ivan Karp and Steven Lavine (Washington, D.C., 1991); Jon Elsner and Roger Cardinal, *The Cultures of Collecting* (Cambridge, Mass., 1995); *Museum/Culture*, ed. Daniel Sherman and Irit Rogoff (New York, 1995); *Geschichte sehen: Beiträge zur Ästhetik historischer Museen*, ed. Jörn Rüsen, Wolfgang Ernst, and Heinrich Theodor Grütter (Pfaffenweiler, 1988); *The Anti-Aesthetic: Essays in Postmodern Culture*, ed. Hal Foster (Seattle, 1983).

15 See Michael Fehr, "Text and Context: Developing a Museum by Reflecting its History," in Crane, *Museums and Memory*.

16 *Sigrid Sigurdsson: Vor der Stille. Ein kollektives Gedächtnis*, ed. Michael Fehr and Barbara Schnellewald (Cologne, 1995). See also Monika Wagner, "Sigrid Sigurdsson und Anselm Kiefer: Das Gedächtnis des Materiels" and Stefan Grohe, "Erinnern als Handlung" in *Gedächtnisbilder: Vergessen und Erinnern in der Gegenwartskunst*, ed. Kai-Uwe Hemken (Leipzig, 1996), 126–134; 156–168. Sigurdsson's exhibit and others may be viewed virtually at http://www.hagen.de/KEOM/welcome.html.

17 See James Young, *The Texture of Memory* and *Writing and Rewriting the Holocaust* (Bloomington, Ind., 1988); *In Fitting Memory: The Art and Politics of Holocaust Memorials*, ed. Sybil Milton (Detroit, 1991); Sarah Farmer, "Symbols that Face Two Ways: Commemorating the Victims of Nazism and Stalinism at Buchenwald and Sachsenhausen," *Representations* 49 (Winter 1995); Rudy Koshar, "Building Pasts: Historic Preservation and Identity in Twentieth Century Germany" and Claudia Koonz, "Between Memory and Oblivion: Concentration Camps in German Memory" in *Commemorations: The Politics of National Identity*, ed. John Gillis (Princeton, 1994).

18 On the Museum of German History, see H. Glenn Penny, "The Museum für Deutsche Geschichte and German National Identity," *Central European History* 28 (1995), 343–372. On the DHM, see Charles Maier, *The Unmasterable Past: History, Holocaust and German National Identity* (Cambridge, Mass., 1988), 121–159; *Deutsches Historisches Museum: Ideen – Kontroversen – Perspektiven*, ed. Christof Stoelzl (Frankfurt am Main/Berlin, 1988); Hartmut Boockmann, *Geschichte im Museum? Zu den Problemen und Aufgaben eines Deutschen Historischen Museums* (Munich, 1987); Ekkehard Mai, *Expositionen* (Munich, 1986), 89–90. See also the museum's web site: http://www.dhm.de/.

19 Wolfgang Ernst, "Keine Frage: Musealisierung der DDR" in *Musealisierung der DDR? 40 Jahre als kulturhistorische Herausforderung*, ed. Ernst and Katharina Flügl (Leipzig, 1992), 13.

20 Barbara Ann Naddeo, "If Angelus Novus were a Geo-photographer: The Reception of 'Abschied und Anfang' – The German Historical Museum's Inaugural Exhibition in the Zeughaus Berlin," *Radical History Review* 60 (1994), 88–131.

21 *Ibid.*, 105.

22 Theodor Adorno, "The Valery Proust Museum," in his *Prisms* (Cambridge, Mass., 1981), 173.

23 See Ernst and Flügel, *Musealisierung der DDR?*; *Zeitphänomenon Musealisierung*, ed. Wolfgang Zacharias (Essen, 1990); Gottfried Korff, "Musealisierung Total?" in *Historische Faszination: Geshichtskultur heute*, ed. Klaus Füssmann *et al.* (Cologne/Weimar/Vienna, 1994); Andreas Huyssen, "Escape from Amnesia" in his *Twilight Memories* (New York, 1995), 13–36.

24 The plight of the exhibit and the extent of the controversy are amply documented. See the special issue of the *Journal of American History* (December, 1995); *History Wars: The Enola Gay and Other Battles for the American Past*, ed. Edward Linenthal and Tom Engelhardt (New York, 1996); Mike Wallace, *Mickey Mouse History and Other Essays on American Memory* (Philadelphia, 1996); "Remembering the Bomb: The 50th Anniversary in the United States and Japan," special issue of the *Bulletin of Concerned Asian Scholars*, 27:2 (1995) also includes the best sampling of editorial cartoons on the subject.

25 Richard Kohn, "History and the Culture Wars: The Case of the Smithsonian Institution's Enola Gay Exhibit," *Journal of American History* 82 (1995), 1038.

26 See Edward Linenthal, *Preserving Memory: The Struggle to Create America's Holocaust Museum* (New York, 1995). Linenthal was a member of the advisory councils for both museums, and his commentaries on the coincidence and similarity of the issues facing the museums in 1993 appear in this book as well as his article, "Anatomy of a Controversy" in *History Wars*, 9–62.

27 Quoted in Linenthal, *Preserving Memory*, 199.

28 Kohn, "History and the Culture Wars," 1046.

29 Quoted in Linenthal, *History Wars*, 39.

30 Senate Resolution 257, Sept. 19, 1994 includes the following: "Whereas the current script for the National Air and Space Museum's exhibit on the Enola Gay is revisionist and offensive to World War II veterans." The entire text is reproduced in the Documents section of *Journal of American History* (December 1995), 1136.

31 Linenthal, *History Wars*, 24.

32 See Linenthal, *Preserving Memory*, 158 ff; 211 ff.

33 See *Ibid.*, 63–64.

34 Linenthal argues that the commission for the Holocaust Museum saw itself as a "kind of public health worker" conducting therapy through such contained horrific experiences; *Preserving Memory*, 112.

35 Quoted in Linenthal, *Preserving Memory*, 122.

36 See *Ibid.*, 127.

37 See Wallace, *Mickey Mouse History*, 278 ff; 297 ff. See also Linenthal, *History Wars*, 50.

38 Quoted in Linenthal, *History Wars*, 43.

Chapter 33 | Thomas J. Schlereth

Collecting Ideas and Artifacts |
Common Problems of History Museums and History Texts

Most Americans consider their major contacts with "the past" to be twofold: the history texts that they labored over in various courses during their classroom schooling; and the historical museums, monuments, and sites that they occasionally visit on a weekend outing or an extended vacation. Both history texts and history museums reinforce that perception by subtly suggesting that historical reality is found only between the covers of a book or within the glass cases of an exhibition.

History museums, like history textbooks, have proliferated in almost geometric progression in the past three decades. Outdoor museum villages alone number more than 120 complexes of many sizes and descriptions in forty-two states.[1] Despite competition from numerous other forms of popular history (historical novels, like *Ragtime*; films, like *Gone with the Wind*; or television specials, such as *Roots*), historical texts and historical villages exert an inordinate influence on the average American's views of the national past and on his understanding of history as a way of knowing.

Recently, it has happened that several constituencies (museum curators, history teachers, interested citizens) have been "collected," on occasion, to exchange ideas and techniques for improving and expanding our mutual sense of the past.[2] The opportunity to come together in a sustained way and share perspectives about and approaches to a humanistic study that intrigues us all has been most helpful and encouraging.

With that in mind, I take this opportunity to raise some questions about common problems of history museums and history texts. In the process I hope to be something of a deliberate gadfly, an agent provocateur, and a devil's advocate, prompting all of us to evaluate our attitudes toward, our distortions about, and our uses of the American past. Thus, I would first like to offer a critical assessment of six "historical fallacies"

Thomas J. Schlereth, "Collecting Ideas and Artifacts: Common Problems of History Museums and History Texts" from *Roundtable Reports* (Summer/Fall 1978). Reprinted with permission of Museum Education Roundtable, all rights reserved. (Reprinted without illustrations.)

that we all face in the researching, interpreting, and communicating of the past.[3] Then, having fired my verbal salvos, I'd like to make a few suggestions as to how we might work to mitigate these problems.

Fallacy 1: History Is Progressive

The assumption that American history is singularly progressive pervades history texts and museums alike. Since their origins in the nationalistic fervor of the early nineteenth century, American textbooks have been the histories of winners, of individuals who succeeded in *The March of America, The Victory of Freedom*, or *The Triumph of Democracy*, all current contemporary text titles. Given their beginnings in the isolationist post-world war eras, the 1920s and the 1950s, it is not surprising that historical museum villages have been equally addicted to promulgating a view that the American past has been one success story after another. Such a fallacy is bolstered in various ways. For example, authors of history texts usually follow a chronology of political or military history. Despite an excess of artifactual survivals that should force an extensive study of social, economic, and cultural history, historical museums are prone to similar time-line interpretations that define all their activities as being either before or after the Revolutionary or the Civil War.

The tendency to organize American history around the watershed "dates" of warfare and politics is further reinforced and distorted by many of the battle re-enactments of which we are so fond. We may have eventually won the Revolution, but we tend to forget how many battles we lost along the way or, at best, how many prudent retreats we beat. But in Bicentennial America, defeats became draws, routs were hailed as steadfastness. Thus Germantown officials explained, "We're not celebrating a defeat; we're talking about George Washington and history." American forces fled Long Island after suffering casualties twenty times that of the British, but Brooklyn's official historian pointed out that Washington was able to extricate his men, so "it was not the spectacular British victory it might have been."

When Baltimore's mayor was reminded that a bicentennial staging of a mythical battle of the War of 1812, in which British soldiers supposedly arrested the city fathers, had no basis whatsoever in historical fact, he replied, "So what? Just because it never happened doesn't detract from it." And it's not just Baltimore: of the modern version of Lafayette's desperate flight from Conshohoken, Pennsylvania, town officials confessed, "It was a re-enactment of sorts, but we didn't run like Lafayette's men did." And in White Plains, New York, city fathers similarly admitted, "Yes, we got thrown off the hill, but," they added, "we stood our ground."[4]

Museum villages, perhaps biased by the associational aura of the houses of "Great White Men" that often form the nucleus of their sites, tend to champion an inevitable and triumphal evolution of democratic principles, a glorious series of technological advancements, and a continual rise in the American standard of living and material progress. In the reconstructed landscapes of most living history farms, for instance, one hardly ever sees an abandoned farmstead, dilapidated, rusty machinery, unmended fence rows, or an uncultivated field. Likewise, museum villages are not highly populated with Loyalists or Luddites, Anti-Federalists or Knights of Labor, Molly Maguires or Copperheads.

Fallacy 2: History Is Patriotic

Various observers accuse textbooks and museums of being over patriotic. Ruth Miller Elson, for example, has written an excellent history (*Guardians of Tradition*) of the rampant regional hagiography – the New Englanders wrote all the books! – and filial pietism in American history texts. Frances Fitzgerald's *America Revised* documents similar oversimplification and chauvinism throughout twentieth-century history school texts.[5]

In the same way, sophisticated curators and museum visitors are aware that cultural nationalism in some form or other is probably inevitable in most historical museums. Many historical sites are shrines to which visitors are beckoned to make pilgrimages, particularly on the national holy days – Memorial Day, July Fourth, Thanksgiving – when the American democratic faith is reiterated in numerous secular homilies. Historical villages often inculcate, in ritual and symbol, a worship of the national scriptures – the Declaration of Independence, the Constitution – as well as the republic's civic saints, prophets, and martyrs, particularly Revolutionary and Civil War heroes. The log cabin where Lincoln was born is enclosed in a Greek temple that the worshiper of the common man's president must approach by way of an imperial, baroque staircase that would do credit to the autocracy of Louis XIV's Versailles. Plymouth Rock is similarly encased in a ciborium of classicism.

We need to be cognizant of how much we use the past to reinforce what Robert Bellah and other sociologists define as the "American civil religion."[6] Such civic piety dominates many museum exhibits and much interpretation. In fact, one theoretician of museology has openly admitted that his colleagues often "borrowed the techniques of early religious instruction" in designing their exhibitions.[7] Hence, we all need to identify the subtle as well as the obvious chauvinism to which museum installations, like textbooks, are invariably subject.

Perhaps one small way to reduce such idolatry would be a simple change in terminology: that is, to begin referring to houses, sites, and villages as simply *historical* rather than *historic*. The latter label, as applied to most sites, is pretentious, over-emphasizing an area's uniqueness in the *past* as well as distorting its distance, in terms of common human experience, from the *present*.

We might also distribute brochures, such as was done at the Sun Oil Company's exhibition in 1976 to test the political and social attitudes of visitors to Revolutionary Boston of 1776. From a multiple-choice question ballot relating to the Stamp Act, the Boston Massacre, and the Tea Party, the vast majority of the nation's bicentennial visitors emerged ideologically and temperamentally much more Tory than Patriot.[8] Such devices should be more extensively used by teachers of history, curators of historical societies, and professional historians to expose instances of history distorted by an overzealous or naive patriotism. We might even consider mounting more museum counter-exhibitions such as Jesse Lemisch's collection of "Bicentennial Schlock."[9]

Fallacy 3: History Is Nostalgia

The myths and icons that Americans have often made of their history are usually rooted in a nostalgic wish for a previous golden age that in reality never existed. Yet

the compulsion to invest historical landscapes with such intense emotional freight is so strong that one observer in Denmark has even concocted a "Nostalgia Index" to help residents and tourists to enjoy all phases of that nation's past.[10] Antique dealers have recognized, with obvious capitalistic delight since the end of the Second World War, that nostalgia has become a growth industry. Moreover, we all convert our contemporary environments into "historical" ones by the incorporation or fabrication of assorted memorabilia. Hence, modern fireplaces, heated electrically if at all, simulate true warmth with Victorian coal or rustic birch-log effects. Fake diamond-shaped "medieval" sashes are pasted on windows with nonfunctional shutters; electric fixtures resemble candles and kerosene lamps. Modern plastic, stainless steel, and reinforced concrete may have their advocates, but for every contemporary tubular chair or curtain-walled building, two traditionals are manufactured.[11]

Most of us, nonetheless, recognize such anachronisms for what they are. History texts and historical museums, however, we take much more seriously. Too seriously, in fact, when, in the case of outdoor museum villages, we are beguiled into believing that every landscape was always mowed and tidy; that all products were lovingly handicrafted; that no one's calico or gingham was ever soiled; and that life proceeded in an orderly, eternally happy, blissfully secure environment. If this were historically accurate, who would not be nostalgic about the loss of such a utopia?

In fact, the past is otherwise. The title of Otto Bettmann's most recent book – *The Good Old Days: They Were Terrible!* – sums up another, if equally exaggerated, side of American history that is only slowly creeping into the interpretive framework of textbooks and exhibitions. To counter the rose-colored-glasses view of our over-romanticized perception of the past, we need something like what I call – for want of a better term – an "anxiety/insecurity quotient."

In the sanitized environment of most living history farms, for instance, we need artifacts, exhibitions, and simulations that help us experience something of the isolation, the monotony, the scarcities, the high mortality rate of a frontier prairie existence. How does one convey, to a museum visitor, the overwhelming dread of drought or mortgage foreclosure? The anxiety of frequent childbirth? The uncertainty of fluctuating grain prices? The haunting seizures of depression and chronic loneliness? The instances of insanity and suicide that also characterized nineteenth-century American rural life? Might there be a *Wisconsin Death Trip* for every *Little House on the Prairie?*[12] We need to ask how hardscrabble an existence is actually portrayed within the settlement confines and how sensitive it is, in historical verisimilitude, to life as lived in the past.

Fallacy 4: History Is Consensus

Walking through many outdoor museums or living history farms, the casual observer would conclude that America in the 1800s was a relatively tranquil, even idyllic, place. Few artifacts or interpretations suggest the need for any legal or civil authorities to adjudicate, much less punish domestic or criminal disorder. In fact, there is little significant material culture evidence of conflict or dissent.

I make this point to call to our attention our common failing as historians in homogenizing and bowdlerizing the past. In Chicago, for instance, much attention is lavished on the few remaining mansions of Prairie Avenue's merchant princes, while

forty blocks away, the 75th Street Viaduct, scene of one of the most major American labor conflicts, the 1877 national railroad strikes, goes totally unnoticed.

Textbooks and museums have remained lodged too long in the consensus historiography of Louis Hartz, Daniel Boorstin, and David Potter of the 1950s.[13] Historical museums are still, with a few exceptions, remarkably peaceable kingdoms: planned communities with overmanicured landscapes that, in the words of geographer David Lowenthal, have "the flavor of a well-kept suburb," or picturesque small towns wherein the entire populace lives in tranquil harmony. Since the visitor to such sites usually does not see the artifacts of convict laborers, domestic servants, hired hands, or slaves in the statistical proportion in which such material culture would have cluttered most communities, he or she comes away from the museum village with an over-sentimentalized, even utopian perspective.

Deliberate utopian ventures constitute an inordinately large proportion of American outdoor museums. There are more Shaker villages in the United States presently than there are Shakers. Unfortunately, the acute social and religious radicalism of these dissenters and their consequent ostracism by society at large is never adequately portrayed in the twentieth-century restorations of their life styles, which are now, ironically, organized into a National Historic Communal Societies Association. In fact, more often than not, the once bitterly maligned "counter-cultures" of earlier eras have been homogenized into respectable middle-class cultural establishments.

Russell Handsman, based upon his experiences in Litchfield, Connecticut, and elsewhere, has noted that the historical-consensus mentality is also influencing the historic preservation movement. Instead of looking to their own past as an indication of uniqueness, regional identity, ethnicity, and even eccentricity, "towns involved in preservation actions are predominantly opting for homogenization," more often than not of a Colonial or Victorian style.[14]

Homogeneity pervades American history textbooks, in part because of pressure from local school boards, in part because the authors tend to plagiarize from one another, but particularly because they have traditionally omitted from their historical surveys the large components of the population who tend to be documentarily inarticulate. The same holds true for museum villages. Despite the increased scholarship and availability of materials on racial and ethnic minorities, historical texts and historical villages alike are still largely populated by white, Anglo-Saxon, nondenominational, Protestant male historical figures.

In the museum context, Old World Wisconsin is aspiring to be multinational, multiethnic, and multicultural, and the black experience is slowly being integrated in some plantation site interpretations, but a great deal remains to be done. Likewise, trends in American religious history have not been translated into museum village installations which, while they invariably have a single Georgian or Federal white clapboard church, are hardly suggestive of the extensive religious pluralism (and conflict) that existed in most American communities. To be sure, women's work has been depicted, but only that centering around the home and hearth, particularly in kitchens furnished with more equipment than any cook could ever have used. Although a few museum exhibits, such as the Corcoran Gallery's *Remember the Ladies*, have aspired to show that colonial women, for example, were shopkeepers, fur-traders, printers, farmers, artisans, and medical practioners,[15] most villages project colonial America as primarily a man's world. If it is any comfort to museum curators, textbooks have been even more resistant to women's studies; the typical US history text

devotes only about one or two of its five hundred to eight hundred pages to women's lives and contributions in all historical periods of the American past.

Fallacy 5: History Is Simple

To embalm *any* single version of the past, however, would be the opposite danger of redressing these heretofore neglected dimensions of American history. As teachers of history, whether in a classroom or in a museum gallery, we realize that we are constantly perched on the proverbial horns of a pedagogical dilemma. On one hand, we all search for attention-getting lecture titles or exhibit scripts, for relevant time-lines and interpretive themes, even for mnemonic devices where possible, in order to communicate our knowledge and understanding of the past to others. Perforce, we resort to generalizations, abstractions, simplifications. Yet we all know that we are doing the past a grave injustice, and we realize that, on the other hand, we must somehow simultaneously revive for students and museum visitors the enormous complexity and interrelatedness of past human activity.

American history was not so simple as portrayed by most history texts and outdoor villages.[16] Most colonial outdoor museums subtly nurture the assumption that their sites depict, *in situ*, the totality of more than two centuries of colonial America, despite the similar claims of every other colonial village. Ubiquitous pioneer settlements do the same for the post-eighteenth-century era. Yet the United Empire Loyalist Farms (Upper Canada) or Plimoth Plantation (Massachusetts) are obviously not the same colonial environments as Historic Saint Augustine (Florida) or Williamsburg (Virginia). Nor are Old Sturbridge Village (Massachusetts) or Greenfield Village (Michigan) the same early nineteenth-century rural settlements as New Salem (Illinois), Conner Prairie (Indiana), or the Living History Farms (Iowa). I would venture that much could be learned by having visitors compare and contrast these sites. Such a museological perspective would encourage more interinstitutional staff co-operation, more interinstitutional team research, more meaningful collective visitor experiences, and, hopefully, less provincial, simplistic, interpretation concepts and exhibit designs.

For, as Kevin Lynch reminds us, the major "danger in the preservation of [a historical] environment lies in its power to encapsulate some image of the past, an image that may in time prove to be mythical. . . . We should expect to see conflicting views of the past, based on conflicting views of the present."[17] Otherwise we create the false impression that the past was one simple, singular story. Thus Newburyport, Massachusetts, and Alexandria, Virginia, appear to have had only one past, and that for a brief moment in the eighteenth century. Similar distortions could be cited from towns that, in Walter Muir Whitehall's words, "celebrate rather than cerebrate" their history[18] as solely that of the misnamed "Gay Nineties" – a decade of the Populist revolt, the violent Pullman and other labor strikes, and Coxey's army protest march on Washington, D.C.

Selective preservation, restoration, and reconstruction in a museum village, like selective arrangement of chapters and the number of pages allotted in a textbook, promotes a discontinuous perspective on the past. Moreover, that practice often deliberately denigrates the excluded historical periods as inferior and unworthy of study and understanding. Consider, for instance, how little attention is given, either in textbooks or in historical museums, to the era between 1660 and 1730, the so-called glacial age of American history.

To enshrine any one version of the American past violates historical truth. Instead, city museums might show divergent Yankee, Irish, Negro, and Chinese views of what, say, Boston or San Francisco was like in the 1870s; rural museums, likewise, should not merely demonstrate assorted pioneer crafts – rug pulling, butter-churning, goose plucking, candle-dipping, etc. – but also show visitors the complex interrelationships of land law, crop choice, farm-making costs, tenancy, changes in agricultural technology, and the vicissitudes of money markets and stock exchanges. Living history farms need to give more attention to the role of women, children, and hired hands in agricultural endeavors, to the physical health of the rural population, as well as to the symbiotic relationship of farm and small town.[19]

Fallacy 6: History Is Money

My final historical fallacy, that history is money, is actually very much a reality in our consumer-oriented society. As has been pointed out by many observers, clever entrepreneurs have constantly found an abundance of ideas and materials in American history.[20] Best-selling novels, popular films, and television series adapt historical themes constantly. Commercials use historical motifs as well: old Quakers sell oatmeal, log cabins sell syrup, "great American homes" such as Monticello sell paint.

The search for a marketable past understandably was the motive of the investors who transplanted the London Bridge to the Arizona desert at Havasu – only to discover that they now must use chemical agents to keep the landmark looking suitably "ancient" because the clean, arid air strips the bridge's stones of their centuries of accumulated grime and soot. Similar pecuniary objectives motivate commercial promoters who have developed "History-Lands" and "Frontier-Towns," not to mention Walt Disney, the creator of two of America's greatest make-believe landscapes, Disneyland and Walt Disney World.

God must have loved the historical souvenir, since He made so many of them. I have often wondered why the popular-culture enthusiasts have not turned their attention to this omnipresent material culture evidence of our attitudes toward the past. Each of us can recall a more outlandish example: the lucrative market for the wood chips and sawdust that came from repairs to Independence Hall in 1975 – fragments of the true cross? or Walter Knott's "authentically cracked" – *i.e.*, frozen in dry ice and a heli-arc torch applied to a built-in fracture line instead of being drilled out like most replicas – Liberty Bell; or the plastic toy "Minutepeople," "Uncle Samwiches," "Patriot Pink" lipstick. The list is endless.

Historical replicas fill the public landscape, hawking goods and services and celebrating civic pride. Ersatz Independence Halls and Mount Vernons of every size and material have sprung up all over the country, serving as banks, schools, libraries, courthouses, shopping centers, prisons, and even, as at the Henry Ford Museum in Dearborn, Michigan, as exhibition halls.[21] One of my favorite reproductions is Emilio Capaldi's 1955 creation of Independence Mall on the Concord Pike outside of Wilmington, Delaware, which attempts to replicate all of historic Philadelphia in a U-shaped shopping center. My own home city of South Bend claims credit for originating the idea of painting its fireplugs in the likenesses of Revolutionary War soldiers and other American heroes – all males, despite the project's originator being a woman – and other cities such as Niles, Michigan, and Columbus, Ohio, have followed suit. The fireplug troops now outnumber the combined forces of

Washington's several ragtag, eighteenth-century armies, although they lack their prototypes' capacity for strategic withdrawals.

As Peirce Lewis rightly points out, it is easy to scoff at the historical merchandising of the "buy-centennial," at the Disneyland gaucheries, to excoriate them as fantasies for escapists, garish frauds sold by itinerant peddlers of historic snake-oil.[22] I think, however, it is the responsibility of museum curators, historian-teachers, and anyone with a serious interest in the past to expose and analyze what such artifacts reveal about our communal attitudes toward tradition, leisure, consumerism, social inter-action, and, of course, American history.

One place to start is to show that the commercialization of the past is hardly new. Thomas H. Pauley's recent essay tracing the hundred-year history of the most over-used symbol of the bicentennial, the trio of revolutionary musicians from the picture known as "The Spirit of '76," demonstrates this point. By following the work, first known as "Yankee Doodle," from its beginnings as a chromolithograph sold at the Centennial Exposition in 1876, Pauley finds modern usage to be an appropriate tribute to a work that immortalizes the spirit of the industrial revolution of the nineteenth century more than the political upheaval of the eighteenth. This icon has become so familiar that the American public recognizes it even when the revolution-aries are played by three salesgirls renting cars, puppets promoting children's televi-sion, costumed cows selling milk, or three comic characters (Mickey Mouse, Donald Duck and Goofy) at the head of "America on Parade" in Main Street, U.S.A., Disneyland.[23]

Such a historiography of usage of a popular historical artifact points up the long-standing tendency of Americans to look upon history not as a dimension, not as a context, not as a continuum along which we live and, in the words of the psalmist, have our being, but instead as a thing, a commodity to be bought and sold in the public market place like a piece of real estate.

What should we do about all of this? Is Clio to be a muse or just to be amusing? How might we work toward mitigating some of the common problems that beset all of us who care about history both as the community's collective autobiography and as a personal means of self-identity and understanding? Like most self-appointed gad-flies, I am long on critique but will be mercifully short on correctives. I have three tentative suggestions that I hope will be useful.

Reflection 1: History Should Be Inquiry

We all can benefit from continually assuming a critical, self-evaluative stance in our historical work and our view of the ways that history is depicted all about us. My list of fallacies is but a starting point to which others could – and should – add their own special concerns about what David Lowenthal calls "the museumization of history."[24] To help develop this analytical perspective, I can endorse several other readings that have sharpened my own critical eye as a historian and as a frequenter of history museums. They would be my required reading in any course in American museology and history teaching. In addition to the marvelous essays of geographers like Peirce F. Lewis and David Lowenthal,[25] I would recommend that we all reread Thorstein Veblen's collected works, particularly his classic on *The Theory of the Leisure Class*. Equally worthy of our attention are Erving Goffman's *The Presentation of Self in Everyday Life*; Roland Barthes, *Mythologies*; Daniel Boorstin, *The Image: A Guide to*

Pseudo-Events in America; Edward T. Hall, *The Hidden Dimension* and *The Silent Language; Icons of America*; edited by Ray Browne and Marshall Fishwick; Russell E. Richey and Donald G. Jones, *American Civil Religion*; W. Lloyd Warner, *The Living and the Dead: A Study of the Symbolic Life of Americans; Recycling the Past: Popular Uses of American History*, edited by Leila Zenderland; Dean MacCannell, *The Tourist: A New Theory of the Leisure Class*; and, finally, two works by historians on the doing of history: Gene Wise, *American Historical Explanations*, and J. P. Hexter, *The History Primer*.[26]

Reflection 2: History Should Be Communal

My second suggestion is equally painless. I would strongly urge that we do much more of the "collecting" of ourselves – museum professionals, teaching historians, the general populace, volunteer historians – in order to improve the quality of individual and institutional historical study. As a person who has long been interested in bridging the world of the museum and the academy, I have been struck by two opposite deficiencies that the two guilds appear to share in the tripartite enterprise (research, analysis, communication) that I take to be history. Historians tend to be big on research, whereas curators like to emphasize communication.

C. R. Elton nicely summarizes the typical historian's myopia in claiming that "too many supposedly 'real' historians seem to think that their work is done when they have completed the finding-out part of it."[27] On the other hand, many of the past technical leaflets of the American Association for State and Local History tended to overemphasize the sheer how-to-do-it aspects of museology and consequently do not give detailed research its just due. Obviously, both groups would benefit from working the other side of the fencerow and learning more about each other's turf.

I know, for instance, that the staff of the Conner Prairie Pioneer Settlement at Noblesville, Indiana – which works in concert with the historians at Earlham College, who, in turn, employ the skills of the curators in their history teaching – fully recognize the abundant research time, energy, and patience involved in ferreting out just the basic facts about rural life in a southern Indiana hamlet in the 1830s. The department of research in many history museums, however, often regards the research process as its special prerogative. I would argue that historical research is everyone's responsibility – docents, volunteers, interns, even visitors.

Why, then, shouldn't interpreters at a historic site be encouraged to keep a research diary or log, wherein they might record and later research whatever questions they are struck by or were asked by visitors as they husk corn, dye yarn, repair a harness, or explain a settlement pattern? Why shouldn't volunteers be prompted to post interpretive problems or research topics – *e.g.*, the price of flax in 1837, or the variants in barn types in northern Indiana – on the staff-room bulletin board, where colleagues could see what they are studying and hence share information and insights about bibliography, research design, or other approaches to the problem?

For that matter, why shouldn't a seriously motivated visitor to a historical site be given the opportunity to research a question that the museum's exhibitions or artifacts raised for him or for her in the institution's library of books, staff research reports, laboratory analyses of artifacts, minutes of curator/designer meetings, or the registrar's records that are the documentation on which the interpretation of a historical environment is based?[28] Might there not be a marquee somewhere in the museum or a

listing in the official guidebook where a visitor could see posted the entire staff and their research specialties and where and when these individuals might be located for consultation? Why not have monthly seminars at which volunteers and interns as well as members of the research staff make presentations on work in progress and receive communal critique and suggestions? Assuredly, one of the delights of historical scholarship, it should not be forgotten, is that it *is* social as well as solitary.

The academic historical profession has, unfortunately, only slowly begun to move outside our traditional classrooms, with our supposedly prerequisite textbooks, and into the world of films, slides, and educational media.[29] We have entered the museum world even more reluctantly, despite various manifestos by historians and curators alike.[30] Once we do use museums more extensively, we will quickly realize that the creative process of exhibition – a museum's most fundamental means of communication – is one of the best contexts for exploring the intersection of material culture and its larger constellations of meaning in the American experience. We will also recognize that the exhibition process offers the teaching historian an amazingly diversified range of pedagogical approaches to understanding the past. Lastly, since museum exhibitions are primarily collaborative ventures – more analogous to architecture of film production than to personal forms of art, such as writing a historical monograph, that usually require only a solitary artist for their execution – we historians will hardly be able to escape more exposure to multidisciplinary scholarly teaching endeavors.[31]

As a cultural historian within the cross-disciplinary field of American Studies, I cannot help but endorse such a perspective. It implies a diversified mental style, a mode of discovery, a way of understanding that encourages us to think about the interrelations between literature, folklore, music, painting, and history.

Reflection 3: History Should Be Personal

Indeed, such an interdisciplinary perspective is also a major part of my third and last recommendation. It is one that grows out of my current teaching and writing interests as well as my collaboration with several museums and historical societies.[32] For several years I have been extremely interested in exploring the history outside as well as inside the history classroom and history museum. I have been trying to teach myself and my students what I have described [in the previous essay] as "the history on the land," through the techniques of what John Cotter and I call "above-ground archaeology."[33]

I end on a populist note, not only because my own technique of "above-ground archaeology" strives to enable anyone literally to do history on his or her own, but also because I would like to see "people's history" as the primary agenda for history teachers and museum curators: to show average citizens various ways of knowing themselves and their communities through an understanding of their own past and the pasts of others. Of course, outside history classrooms and history museums, many Americans are already doing this: they are discovering their heritage in family albums, Bibles, and genealogies; in the built-environment of their own homes and localities; and in the oral histories of childhood and parental memories.

We all need such tangible reminders of the people we have known, the places where we have traveled, the experiences that we have had, in order to remember who we are. So strong is this fundamental human need that, in East Africa, when the Masai were

moved, they took with them, in addition to their personal artifacts, "the names of their hills, plains and rivers in the new country. . . carrying their cut roots with them as a medicine." Such portable symbols of the past, like the permanent artifacts of any landscape, aid in maintaining human continuity.[34]

Loading their jalopies for the trek to California, the uprooted Okies in John Steinbeck's *The Grapes of Wrath* are told there is no room for their personal letters, for a religious icon, a china dog from the 1904 St. Louis Fair, or a copy of *Pilgrim's Progress* – the physical remnants of their arduous lives in the Depression dustbowl. But they knew, as should we, that "the past would cry to them in the coming days." For, as Tom Joad, one of the novel's characters, poignantly reminded them, and us: "How can we live without our lives? How will they know it's us without our past?"[35]

Notes

1 Nicholas Zook, *Outdoor Museum Villages* (Barre, Mass.: Barre Publishers, 1971); Irvin Haas, *America's Historic Villages and Restorations* (New York: Arco Publishing Co., 1974).

2 For an overview of these developments, see the experimental text *Museum Studies Reader: An Anthology of Journal Articles on Open-Air Museums* (Noblesville, Ind.: Privately printed, 1979) developed by Ormond Loomis and Willard B. Moore at the Museum Studies Institute held at the Conner Prairie Pioneer Settlement, Noblesville, Indiana, June 12–30, 1978.

3 For this approach, I am indebted to David Hackett Fischer, *Historians' Fallacies: Toward a Logic of Historical Thought* (New York: Harper, 1970).

4 Calvin Trillin and Edward Koren, "The Inquiring Demographer; This Week's Question: What Are You Doing to Celebrate the Bicentennial?" *New Yorker*, May 10, 1976, p. 34–35; and Israel Shenker, "U.S. Bicentennial Cures History's Wants," *International Herald Tribune*, July 5–6, 1975, p. 5, as quoted by David Lowenthal, "The Bicentennial Landscape: A Mirror Held up to the Past," *Geographical Review 67*, no. 3 (July 1977): 259.

5 Ruth M. Elson, *Guardians of Tradition: American Schoolbooks of the Nineteenth Century* (Lincoln, Neb.: University of Nebraska Press, 1964); Frances Fitzgerald, *America Revised: History Schoolbooks in the Twentieth Century* (Boston: Little, Brown: 1979).

6 See, for example, Robert Bellah, *The Broken Covenant: American Civil Religion in a Time of Trial* (New York: Seabury Press, 1975) for the most recent analysis of the phenomenon; and Russell E. Richey and Donald G. Jones, *American Civil Religion* (New York: Harper and Row, 1974) for a bibliography and the best summary of the discussion to date.

7 Thomas R. Adam, *The Civic Value of Museums* (American Association for Adult Education, 1937), p. 8.

8 Margot Hornblower, "Would You Side with the British?," *International Herald Tribune*, December 10, 1975, p. 5.

9 " 'Bicentennial Schlock' Given Its Due in U.S. Exhibition," *International Herald Tribune*, October 15, 1976, p. 5; D. Lowenthal, "Bicentennial Landscape," p. 263–264.

10 Robert M. Newcomb, "The Nostalgia Index of Historical Landscapes in Denmark," in W. P. Adams and F. M. Helleiner, editors, *International Geography*, 2 vols. (Toronto: University of Toronto Press, 1972), I: 441–443.

11 David Lowenthal, "Past Time, Present Place: Landscape and Memory," *The Geographical Review* 65, no. 1 (January 1975): 6.

12 Michael Lesey, *Wisconsin Death Trip* (New York: Pantheon Books, 1973); Laura Ingalls Wilder, *The Little House on the Prairie* (New York: Harper and Row, 1971).

13 Louis Hartz, *The Liberal Tradition in America* (New York: Harcourt, Brace, 1955); Daniel Boorstin, *The Genius of American Politics* (Chicago: University of Chicago Press,

1953); David Potter, *People of Plenty: Economic Abundance and the American Character* (Chicago: University of Chicago Press, 1954).

14 Russell G. Handsman, "Muddles in the Movement: The Preservation of Masks in Litchfield, Connecticut," *Artifacts* 6, no. 2: 6–7; also see his extended analysis, "Machines and Gardens: Structures in and Symbols of America's Past," an unpublished paper presented at the Annual Spring Meeting of the American Ethnological Society, Laval University, Quebec City, March 19, 1978.

15 Linda Grant Depauw and K. Conover Hunt, *Remember the Ladies* (New York: Viking, 1976); Phyllis Arlow and Merle Froschl, "Women in High School History Textbooks," in *Women in the High School Curriculum* (Old Westbury, N.Y.: Feminist Press, 1975).

16 Thomas J. Schlereth, "It Wasn't That Simple," *Museum News* 56, no. 3 (January 1978): 36–44.

17 Kevin Lynch, *What Time Is This Place?* (Cambridge, Mass.: MIT Press, 1972), p. 53.

18 Walter Muir Whitehall, "Cerebration versus Celebration," *The Virginian Magazine of History and Biography* 68, no. 3 (July 1960): 259–270.

19 Robert Swierenga, "Rural Studies in America," in *Farming in the Midwest, 1840–1900*, edited by James W. Whitaker, (Washington, D.C.: Agricultural History Society, 1974), p. 42.

20 *Recycling the Past: Popular Uses of American History*, edited by Leila Zenderland (Philadelphia: University of Pennsylvania Press, 1978), "Introduction," pp. viii–x; Christopher D. Geist, "Historic Sites and Monuments as Icons," in *Icons of America*, edited by Ray B. Browne and Marshall Fishwick (Bowling Green, Ohio: Popular Press, 1978) pp. 57–65; David Lowenthal, "Bicentennial Landscape," pp. 261–262.

21 John Maass, "Architecture and Americanism, or Pastiches of Independence Hall," *Historic Preservation* 22 (April–June 1970): 17–25.

22 Peirce F. Lewis, "The Future of the Past: Our Clouded Vision of Historic Preservation," *Pioneer America* 6, no. 2 (July 1975): 5.

23 Thomas H. Pauley, "In Search of 'The Spirit of '76'," in *Recycling the Past: Popular Uses of American History*, edited by Leila Zenderland (Philadelphia: University of Pennsylvania Press, 1978), pp. 29–49.

24 David Lowenthal, 'The American Way of History,' *Colombia University Forum* 9, no. 3 (Summer 1966): 27–32.

25 Lewis, "The Future of the Past," p. 5; Lowenthal, "The Bicentennial Landscape," p. 259, and "The American Way of History, pp. 27–32, as well as his essays "Past Time, Present Place," pp. 1–36, and "The Place of the Past in the American Landscape," in *Geographies of the Mind: Essays in Historical Geosophy in Honor of John Kirtland Wright*, edited by David Lowenthal and Marilyn H. Bowden (New York: Oxford University Press, 1976), pp. 89–117.

26 Thorstein Veblen, *The Theory of the Leisure Class* (New York: Macmillan, 1899); Erving Goffman's *The Presentation of Self in Everyday's Life* (Garden City, N.Y.: Doubleday, 1959); Roland Barthes, *Mythologies*, translated by Annette Lavens (New York: Hill and Wang, 1972); Daniel Boorstin, *The Image: A Guide to Pseudo-Events in America* (New York: Harper and Row, 1961); Edward T. Hall, *The Hidden Dimension* (New York: Anchor, 1969) and *The Silent Language* (New York: Anchor, 1973); *Icons of America*, edited by Ray Browne and Marshall Fishwick (Bowling Green, Ohio: Popular Press, 1978); Russell E. Richey and Donald G. Jones, *American Civil Religion* (New York: Harper and Row, 1974); W. Lloyd Warner, *The Living and the Dead: A Study of the Symbolic Life of Americans* (New Haven: Yale University Press, 1959); *Recycling the Past: Popular Uses of American History*, edited by Leila Zenderland (Philadelphia: University of Pennsylvania Press, 1978); Dean MacCannell, *Tourist: A New Theory of the Leisure Class* (New York: Shocken, 1976); Gene Wise, *American Historical Explanations* (Homewood, Ill.: Dorsey Press, 1973); J. P. Hexter, *The History Primer* (New York: Basic Books, 1971).

27 C. R. Elton, *The Practice of History* (London: Collins, Fontana Library, 1969), p. 152.

28 Schlereth, "It Wasn't That Simple," pp. 41–42; also see E. McClung Fleming, "The Period Room as a Curatorial Publication," *Museum News* 50, no. 10 (June 1972): 39–43.

29 See, for example, the audiovisual materials section of the journal, *The History Teacher* (Long Beach, Cal., 1967); and the newsletter *Film and History*, published by the Committee on Film and Historians (Newark, N.J.: Newark University, 1972–).

30 Linda F. Place, *et al.*, "The Object as Subject: The Role of Museums and Material Culture Collections in American Studies," *American Quarterly* 26, no. 3 (August 1974): 281–294.

31 For the analogue of architecture, film production, and museum exhibition, I am indebted to Harold Skramstad's fine essay "Interpreting Material Culture: A View from the Other Side of the Glass," in *Material Culture and the Study of American Life*, edited by Ian Quimby (New York: W. W. Norton & Company, Inc., 1978), pp. 184–185.

32 To date, we have devised programs using the concept of the "city as artifact" for the Indianapolis Museum of Art (1978), the Chicago Historical Society (1979), the Cincinnati Historical Society (1980), and the Delaware Museum of Art (1980).

33 John L. Cotter, "Above-Ground Archaeology," *American Quarterly* 26, no. 3 (August 1974): 266–280; Thomas J. Schlereth, "The City as Artifact," *American Historical Association Newsletter* (February 1977), pp. 7–9.

34 Isak Dinesen [Baroness Karen Blixen], *Out of Africa* (London: Putnam, 1937), p. 402.

35 John Steinbeck, *The Grapes of Wrath* (New York: Viking Press, 1939), pp. 117 and 120.

Chapter 34 | Gaynor Kavanagh

Melodrama, Pantomime or Portrayal? | Representing Ourselves and the British Past through Exhibitions in History Museums

A Social Need for Social History?

'History' can mean what happened in the past or the representation of that past in the work of historians. This paper concerns itself with how historians working in museums represent a British past through the medium of exhibition.

Consciously or not, human societies continually interpret their experiences in time perspective. Marwick has explained how 'without knowledge of history, man and society would run adrift, rudderless craft on the uncharted sea of time'.[1] By identifying both the individual and the group, Marwick alludes to what is commonly accepted, that history is needed and is employed selectively by different units of society. The state requires a positive, pride-provoking past to consolidate nationhood. Political forces require histories rich in apposite precedents to service, validate or, if necessary, refute contemporary arguments and positions. The individual requires a sense of place derived from family identity and history: devices to denote belonging and justify station. To service these and many other needs history has to be produced. In one form or another a selection of 'truths' deemed worthy of note are gathered together, judged and made available. The social production of history lays great responsibility on those who carry out this selection process.

Unfettered historical inquiry will challenge and provoke. It will confront assumptions and reveal the ignored and forgotten. It can undermine present-day complacency by proposing that to know the past is to know that 'things have not been always as they are now, and by implication need not remain the same in the future'.[2] For these reasons history has been described and seen as 'subversive'. Even historians of differing political views will acknowledge that the study of the past requires a sceptical, critical and anti-authoritarian approach to both subjects and sources.[3]

Gaynor Kavanagh, "Melodrama, Pantomime or Portrayal? Representing Ourselves and the British Past through Exhibitions in History Museums" from *International Journal of Museum Management and Curatorship* 6 (1986), pp. 173–9. © 1987 by Elsevier Science. Reprinted by permission of Elsevier Science.

Because society is deemed to need a 'usable past', and because there are differing conceptions of society and social order, rival histories are produced. The study of history is alive with controversy and challenge. Pieter Geyl described history as 'an argument without end'.[4] Thus historians in the main, although not exclusively, see their purpose as the analysis of causes and consequences, the illustration of history as a process and not just a series of tableaux. History museums are just one of the many agencies involved in the social production of history. Museums reveal the histories they produce principally through exhibitions. One means of probing museums and the views of the past they offer is to consider how evidence is handled, analysed and interpreted in the exhibition form and to draw parallels with history production and criticism employed elsewhere.

The 'History' in History Museums

History museum curators have concentrated particularly and steadfastly on recording and explaining a material, physical past – indeed on a passive, redundant past. (They seem to ignore an active and lively past.) The present has rarely been considered worthy of study: the view is nearly always retrospective. Thus their work can be referred to in a rather loose sense as 'history' curatorship.

The museums they have created and curated come in many different shapes and sizes. More importantly they appear under a number of different titles. Social history, industrial history, local history, rural life and folk life museums now exist in many parts of Britain. At best this variety could denote healthy diversity of approach and a thriving intellectual drive. At worst, and perhaps this is more pertinent, it could be evidence that the study and explanation of a British past through museums is an uncertain subject, staggering about in search of a usable name and viable philosphy. A kind of intellectual chaos reigns.

History museum curators have a lengthening record of concern about document-ing and representing the 'people who matter'.[5] But who these people are and how they should be seen has not always been clear. Nor is it certain whether history museums are concerned with the history of people or places, activities or objects. Some of the language employed to denote fields of interest has suggested popular ownership: thus 'our past' and 'your heritage'. Whereas in fact the histories given to using these terms may have already been appropriated and may not be 'ours' or 'yours' at all.

The Emergence of the History Museum

The history museum as a form in Britain has been developing since the beginning of this century. It has seen haphazard progress, not without lurches up blind alleys in search of new areas and methods. However, the history museum has come into its own in the last 40 years. The post-war developments can be ascribed to a number of different factors which together have fostered this form of museum and, in part, have substantially influenced the directions taken, particularly in styles of presentation.

It has been much acknowledged that post-Imperial Britain has strongly sought and maintained conceptions of a softer, more secure and socially ordered past (which never really existed) as a contrast and comfort in our present times. This is expressed in a

number of ways, not least in the colourful and historically bizarre references from politicians, and in a whole range of media forms and current trends in consumption, everything from Hovis to Laura Ashley. There appears to be a need much greater than just to recall and view the past; there is a widespread need, particularly in a political sense, for a pappy, well-edited memory of British history.

In a way complementary to this has been a heightened consciousness amongst the public, at a personal level, of a more individualistic past. This varies greatly according to both class and geography. But it owes much to historical drama on television, the genre, from the *Forsyte Saga* to *Roots*, which more than anything else has brought history to the individual and taught that objects can be historical signifiers. It is no accident that the growth in history museums has been accompanied by a terrific multiplication in the number of people studying genealogy and a considerable growth of interest in the antique trade.

Of course there have been other influences too, such as the growth of 'leisure' and tourism, the emergence of both industrial archaeology and the school of local historians inspired by W. G. Hoskins, and a growing consciousness of people's history. Altogether these make history museums possible in Britain in the 1980s. In such circumstances the production and manipulation of history in museums, and all that exists in the 'heritage industry' can do nothing other than prosper. Sadly, the absent factor has been a well-established academic base on which to found and from which to stimulate, develop and sharpen the nature of history in history museums.

The Raw Materials

The historian's craft in the museum centres on the use of material evidence, and latterly oral evidence, alongside the more conventional use of primary and secondary two-dimensional source material. This emphasis differentiates museum historians from other practising historians and places them in a unique and advantageous position, as it extends and enhances the scope of inquiry. Theoretically the emphasis on material evidence necessitates a specific set of approaches to the study of the past. Practically, even though there is a different emphasis in the nature of the work, much remains the same. There are no grounds on which curatorial work should be less vulnerable to the criticism enjoyed and experienced by historians elsewhere. For example, the identification and use of evidence, whatever its form, is no less a political act and of crucial concern for the history curator as it is for any other practising historian.

History museums in Britain are nothing if not monuments to the effects of changes in consumption and consumerism over the last 150 years or so. It has been mainly these forces that have released the range of objects that now constitute history collections (regardless of whatever social or community roles such collections may play later). From this position some museums, perhaps too few, have studied how people have lived and worked, taking as indicators and evidence not only visual and material reminders of the quality and nature of these experiences, but also oral testimony, frequently in the form of dominant memory. Other museums have elected to take note of those objects or groups of objects that appear to escape disposal or are the product of certain redundant practices already well established as being of legitimate museum interest, such as wheelwright shops.

Either way, there is much evidence that in the use of source material historians in museums face and operate within the same alternative approaches available to other historians: that is, either a source-oriented approach to research and acquisition (e.g. 'milk churns this century') or a problem-orientated approach (e.g. 'how and why did dairy farming in this area alter between 1918 and 1939?'). The use of source material varies enormously. As Marc Bloch has pointed out, 'the struggle with documents is what distinguishes the professional historian from the amateur'.[6] This holds true for museum curators too. The problems are very much the same, whether with a two- or three-dimensional material or the process of criticism. The need for 'external' criticism (authenticity, circumstances of production and availability, date) and 'internal' criticism (form, use, context, experience, relationships) is no different. Neither are the degrees of bias or scepticism to be found in the resulting views of the evidence.

The museum historian is anything but a 'passive' observer. Besides the cultural and ideological pressures under which all historians work, there may be further practical and intellectual limits. The availability and use of source material will depend upon the curator's willingness to track down a range of available material, much of which will be in out-of-the-way and improbable places. Important too will be the social skills brought to the task, and the ingenuity and flair required to grasp and appreciate the full range of uses to which a source may be put. Finally, much will depend on the museum historian's ability to judge and weigh both the value and relationships of the evidence to hand.

History Exhibitions as History Writing

For any historian the significance of source material begins to become apparent when evidence is juxtaposed and related through coherent exposition. In this nothing can be predetermined about the way pieces fit together: life rarely yields such logic. Interpretation will be conducted through artificial parameters of time, geography or form and will therefore create breaks and ruptures, precluding views of a multi-faceted past.

History writing has taken three literary forms: descriptive, narrative and analytical. The dominant form is analytical, the means by which historians seek to show connectedness of events or to give systematic assessments of causes and results. It is hard to arrive at a similar classification of exhibition forms in Britain. However, the author is of the opinon that in the main they are used as descriptive, although quite clearly exhibitions can be analytical, as for example some of the work at Nordiska Museet in Stockholm.

In terms of history production, the museum is in a privileged position. The scope for inquiry and expression is tremendous. The most important medium of all is that curious curatorial shorthand called exhibition, a language of signs and symbols, of subtext and occasional subplot. Most other forms of history production in museums are related to or based on that contained within exhibition. Much will depend upon the creative, literary and visual flair applied to the production of an exhibition. Literary flair is needed for the choice and form of words employed. Curators need an eye for detail and the creative ability to provoke mood, ambience and temperature and the illusion of suspense. Without these, regardless of how socially relevant and well researched, exhibitions will be inert.

Curators working in this field have learnt their craft almost informally, through a number of available avenues, regrettably not equally available to all. One of the results has been that many have learnt to curate and exhibit through personal and political convenience. This is most apparent in the various methods of analysis (or their absence) and modes of presentation adopted. Thus there are museums casually called museums of transport that say nothing about travel; museums of industry that say nothing about work; and museums of rural life that say nothing about the environment or agricultural depression. Perhaps worst of all are museums based on poorly researched and ill-considered reconstructed rooms and workplaces, that can offer little more than a curatorial fantasyland. These fool many, not least the curator, into believing that what is on offer has meaning and historical validity. Such stingy parameters and chronic restriction of intent have become hallmarks of some museum provision.

The best exhibitions can be seen to suggest times as vibrant though no more important than our own, rich in human error and experience. The worst offers the odd and the weird, often highly derivative of poor exhibitions elsewhere, and suggest a disconnected and disembowelled past, the sole purpose of its recall being to titillate us now.

There is much evidence that through the range of media available to a museum the representation of aspects of a lived past can be an exciting and dynamic possibility. These media extend beyond the exhibition form and its manipulation and expression in (hopefully) original and relevant two- and three-dimensional material. The wide variety of opportunities available in public performance, including film and museum teaching in all their forms, and publications, give the museum tremendous scope in which to produce and examine its histories. Through these means a history museum can facilitate many levels of access to its subject. Thus a museum has a potential that other institutions and forms of communication, including television, do not have in entirety. But there is evidence too that if the media are misunderstood, and the histories created by museums are poor, then the representation of the past through museums becomes a nonsense.

Limits to Objectivity

The limits to objectivity in representation lie not only in the construction of knowledge itself and in cultural perspective. In museums devoted to aspects of British history there are specific problems. Here the limits of objectivity can be traced back to problems associated with most forms of history inquiry and can be ascribed in part to the peculiar nature of historical exposition-in-museum exhibitions.

History is not an exact science. The historian works from inference, reading both on and between the lines; or at least those lines made available or selected. The reading and resulting views will inevitably be conditioned by present-mindedness. History cannot be dissociated from the contemporary scene. Thus an historian can neither observe nor prove facts or opinions as a scientist might. The view can never be pure or innocent.

A museum is in a very specific position in this regard because it can determine for itself the very nature of evidence to be made available, through its own collections and collecting policies. In a sense the construction of histories in a museum begins with its own construction of evidence. In turn this will be dependent on whether the museum

collects actively or passively and to what degree it chooses to root acquisition in a firm and relevant research programme. Through this process a musem edits and, to some extent, determines what it will represent and what it will omit about the British past. It also decides in part how that past should be seen.

With modern, that is 20th century, material increasingly comprehensive in its availability, the choices and criteria affecting acquisition become more complex. Without a methodology firmly grounded in the study of spatial relationships or contexts, the material gathered can be nothing other than a haphazard range. Some objects become 'museum worthy' and are collected widely, as had been the case with craft tools. Other objects and activities fail to achieve this accolade. It is a sobering thought that if bank managers, midwives, secretaries, teachers and ministers of religion had gone out of business earlier this century, and the poor old wheelwright had gone from strength to strength, museum collections in Britain today would be entirely different. But which of these activities lacks relevance in this history of any community? Objectivity then may be affected by curatorial fad.

It may also be affected by the willingness to accept that a particular historical period has relevance. Historians have long had difficulty viewing the present, but the problem is more complex than this. Interest in a period is often determined by the individual's distance from it. This is why certain periods become fashionable whilst others are neglected. Equally periods in time can pass beyond comprehension because of lack of experience of similar conditions. It is too much to expect that an object existing amongst these changing forces can satisfactorily and absolutely stand as symbol, recalling in some mystical way the context from which it originally derived. The skill of a history curator is tested to the extreme when employed trying to explain periods or activities with which the public (or the curator for that matter) have no conscious links, and through objects that have limited impact.

Although 'recreative history' in museums is seen as a legitimate pursuit, it is a mistake to suppose it can actually be realized or that it can be a vehicle for objective knowledge about the past. It is impossible to recreate an historical moment as it was experienced by the people at the time. Both the curator's and the visitor's judgement is swayed by knowledge of 'what came next', different cultural norms, and the distance of time which affects levels of appreciation. For example, a reconstruction of a 19th century farmhouse in a musem context cannot afford absolute recreation of life in such a dwelling for visitors. Knowledge, however variable, about agricultural change and modern housing standards; the absence of integrated domestic economies which means most families do not kill their own chickens or slaughter and process their own pigs; and the variation of the view of the house and the existence it represents from great-grandmother to great-grandchild will preclude any 'authentic' experience through 'recreation'.

This is not to invalidate exhibitions. The responses described above can be anticipated and encouraged, though clearly recognizing that they can form the basis of stimuli to learn. However, the limitations of 'recreating' and 'representing' the past have to be recognized and means of redress undertaken. All historians, as a matter of course, should be required to scrutinize their own assumptions and values to see how they relate to their subject. Appropriate means of interpretation have to be selected: in the museum context this means questioning whether the exhibition form is always suitable for the subjects chosen, and vice versa.

The absence of challenge to the views of the past offered by museums may further inhibit incentives for a more rigorous approach. The legitimization of the museum as a

force for good precludes change, even when change is most needed. The fact that history museums have at their disposal the easy triggers of memory and experience, to be found to some degree in all visitors, reduces still further the incentive to change and improve. Even a poor museum exhibition can elicit some response from say a grandparent to a child or between children. This makes the museum's task somewhat simpler than, for example, that of an art gallery. It also makes it easier not to bother with more complicated messages and subjects. Indeed what really matters, and is in a sense at issue, is the quality and relevance of that response and the access that it can allow to the museum's subject. A fair and accessible representation of the past can sometimes come down to a curator's willingness to bother, and to bother in an appropriate fashion. A museum may choose to represent as much or as little about the past as suits it.

Because the media available to a museum are so varied and flexible, the limits to their employment may be set by the curator's own imagination. To excuse a lack of critical approach by arguing that it is not possible to represent an animate, lively, changing past through inanimate, rigid and unchanging objects is to ignore the possibilities that exist within a museum framework. The availability of the full range of educational activities, plus film, sound and publications, provides the outlets for museums to make more comprehensive and available the histories they create. These various forms have to be recognized and taken into account before limitation can be fully assessed. In any event no history can provide the final word or the definitive statement. This is what makes history so exciting. If offered as a challenging and thought-provoking subject it can prompt the visitor to question and challenge too. For however rigorously professional the approach, there will always be a plurality of interpretation. New evidence and revised views will, in time, emerge, enlarging our knowledge and correcting the conclusions derived from earlier research.

History, whether in museums, books, television programmes or site records, will never be beyond controversy. It should glory in this. In museum terms, the exhibition form can at best offer a strong sense of memory and record. But without this what is on offer is 'amnesia swaggering out in fancy-dress'.[7] In the long run that does the museum profession and the representation of the past no good at all.

Acknowledgements

The original version of this paper was presented at the Symposium *Making Exhibitions of Ourselves: The Limit of Objectivity in the Representation of Other Cultures*, organized by Dr Brian Durrans, Deputy Director, Museum of Mankind, for the Museums Ethnographers' Group and the Association of Social Anthropologists, and held at the British Museum, London, 13–15 February 1986.

Notes and references

1 Arthur Marwick, *The Nature of History* (London, 1970), p. 278.
2 John Tosh, *The Pursuit of History* (London, 1984), p. 2.
3 Debate between Gareth Steadman Jones and G. R. Elton on 'Open to Question', BBC2, January 1986.
4 Pieter Geyl, *Napoleon: For and Against* (London, 1964), p. 16.

5　This phrase appears to have originated with Herbert John Fleure. It was much repeated by Iowerth Peate, for example in his paper 'Some Thoughts on the Study of Folk Life', in C. Donachair (ed.), *Folk and Farm* (Royal Society of Antiquaries, Dublin, 1976), p. 229. This philosophy has been repeated by later commentators, from J. W. Y. Higgs, *Folk Life Collection and Classification* (London, 1963); to Roy Brigden, 'Research: Social History Collections', in J. Thompson *et al.*, *Manual of Curatorship* (London, 1984).

6　Marc Bloc, *The Historian's Craft* (Manchester, 1954), p. 86.

7　Patrick Wright, *On Living in an Old Country* (London, 1985), p. 78.

Chapter 35 | Mónica Risnicoff de Gorgas

Reality as Illusion, the Historic Houses that Become Museums

Atmosphere

It is difficult for visitors in house museums not to be captivated by their highly evocative power. The historic house which is converted to a museum calls up feelings and memories in visitors more than does any other type of museum. It possesses a special 'atmosphere' which takes visitors back to other times and makes them wonder what other persons had transited through the same spaces they are now passing through. They cannot help wondering if the people who used to live in the house at times felt the same joys and sorrows they themselves have felt. More than a monument that celebrates a lost past, a historic house is seen as a place where people have lived out their life.

This impact on the public, along with a particular type of mental and emotional reaction are produced by the presence and absence of the people who once lived in the house. But, above all, these houses are perceived as 'true reality' and therefore free of any kind of manipulation. As if in a time machine, visitors feel they are travelling to a 'frozen' past which also offers the possibility of a day of self knowledge during which they can learn about themselves. Coming face to face with the past gives us the opportunity to ascertain who we are and, more importantly, who we are not. As in perhaps no other type of museum, the house museum 'successfully generates a combination of cultural images which can convey feelings-perceptions, in addition to knowledge'.[1] It thus produces an intimate link between collective memory and personal memory.

Presentation or Representation?

But this kind of sensitivity should not make us forget that, when objects are displayed in the context of an exhibition, they become transformed and acquire new meanings.

Mónica Risnicoff de Gorgas, "Reality as Illusion, the Historic Houses that Become Museums" from *Museum International* 53:2 (2001), pp. 10–15. © 2001 by UNESCO. Reprinted by permission of Blackwell Publishing. (Reprinted without illustrations.)

And although each event encapsulates its own original characteristics and brings with it a full set of primary meanings, from the perspective of the present such original meanings are well-nigh ineffable. Annis Sheldon has said that museum symbols are '"multi-vocal" and "polyvalent" – that is, they speak with many meanings and in many combinations. They change with backdrop and grow with use. And it is precisely their plasticity, rather than their capacity to represent directly, that makes them central to human thought and action.'[2] Retrospective readings of past events end as constructions encumbered with the evaluations of the present.

The historicity of concepts is the historicity of both the historical and social meanings and modes whereby reality is constructed and expressed. We may return tirelessly to the events of the past, but they cannot be recovered in a definitive and well-defined way from the past in any single instance of retrospective return. On the contrary, they will remain the same happenings, albeit understood in each specific present time in a new and specific way. They are reconceptualized because every time that we return to them we take them back and update them with novel meanings dictated from the present, because it is from the present that we retrieved them.

Although the house museum seems to be almost untouched (which is never completely true, given that it must have passed through different hands, different uses and different restorations) and derives its atmosphere (for the most part) from the original objects of its owners, the fact that it is organized as a museum portrays a more or less clear purpose. Its objective is not history or life *per se*, but portrayal of history or life; not the past *per se*, but its representation. Each room is stage managed in order to portray à theme. This choice of scenography as the driving force of communication is aimed at surprising visitors in a framework of strong sensory impressions which are to accompany the viewing of the object and strengthen its impact and message. Objectivity does not exist in the exhibition given that each object is displayed as an interpreted object, with emphasis being placed, in some form or other, on certain aspects.

It is important, almost vital, to place the object as much as possible in its original setting, in terms of the times in which it was produced. None the less, the past cannot be reproduced because it is not a concrete entity that can be re-created, nor are the objects hermetically sealed, with only the seal to be broken for everything to be revealed. 'We are more interested in processes than in objects, and we are interested in them not for their capacity to remain pure, always authentic, but because they represent certain ways of seeing and experiencing the world and life *per se*. . . . As a result, the quest for authenticity is not the final purpose of research in, and the restoration and dissemination of, heritage. What is aimed at is the reconstruction of historical verisimilitude.'[3]

Spaces of Legitimization

As opposed to other types of museums in which emphasis is put on the signifying power of the objects and collections, and the building as container has to be adapted to the possible discourses and narratives, the chief purpose of the historic house museum is to ensure that the building is in all aspects at one with the more or less original collections. The symbolic value of this unity makes it a realistic benchmark of past time.

Seen as active or discursive social objects, house museums express values and meanings which are not shared by everybody living in the same period, but which have been used as representing the essence of historical identity. It is interesting to observe the way in which different social groups capture and set in order the events taking place on the basis of specific canons. 'Spaces which sanctify power reveal a tacit acceptance of an even more complex historical process: that of the emergence, in Western societies, of memory spaces regulated by civil society on the basis of specific criteria and to specific ends.'[4] In the exercise of this kind of control over historical knowledge, groups have always insisted that what they seek to do is to narrate things exactly as and when they happened, thus presenting heritage as an indisputable testimony.

The high symbolic value of historic house museums has led to their being used by different ideologies as simplified messages portraying cultural identity. 'In fact, they have often been used both to recover legitimate rights and to deny them to others.'[5]

In Argentina in the 1940s, for example, and because of a great migratory influx, the rulers of the time decreed what they called National Historic Monuments and transformed a number of historic houses into museums which were to serve as paradigms of national unity, embodying a certain concept of national consciousness and with a system representing the values of the state. This was a more or less covert form of political illusionism whereby the complexities of culture were changed into simplified messages concerning cultural identity, which were focused exclusively on highly symbolic objects at the expense of popular forms of cultural expression.

Although changes have taken place in the ways in which power relationships are expressed in present-day society, the museum *per se* favours the development of internal mechanisms of control of the reasoning and emotions of the 'public' at which it is theoretically aimed. The recognition that house museums customarily contribute to the process of manufacturing cultural myths would prepare the ground for realizing their great potential to examine and call into question invented traditions, distorted myths and conventional values.

The Symbolic Power of the Container and Other Discourses

La Casa

'The marks of the sins which were committed here have rubbed off on me, making me dirty, corrupting me, and slowly stripping away from me, room by room, everything I possessed that was funny, beautiful and splendid.'[6] This citation is taken from the novel *La Casa* (*The House*) by the Argentine writer Manuel Mujica Lainez, who anthropomorphizes places by describing a mysterious relationship, almost one of complicity, between people and the place where they live. In *La Casa*, as a huge house which had belonged to the nobility is being torn down in Buenos Aires, he tells its story in the form of simultaneous narratives about the beings who once lived in it: ghosts and objects which contribute to the dialogue with its strange experience. Paradoxically, a few years after the death of the writer, his summer residence 'El Paraíso', located in a beautiful spot in the mountains of Córdoba, was converted into a house museum. Now the ghosts of not only the writer himself but of all the characters that he ever created live, including the phantom of *La Casa* in Florida Street.

As a result of campaigns waged for emancipation, civil wars, pauperization and the lack of interest in a past which was late in being reclaimed, many of the present-day house museums in Latin America have suffered from deterioration, changed owners many times, changed purpose at other times and, depending on the house, lost all or part of the original objects belonging to the owners. In these containers of what are mostly historical museums, an attempt is being made to create narratives which are consistent with the symbolic charge of the buildings housing them. What is narrated is not history, but different histories which often confront each other in a multiplicity of meanings that coexist in a single signifier.

The Museo de la Inconfidencia

The Museo de la Inconfidencia (Museum of Treason) in Minas Gerais (Brazil) is a good example of what is stated above. The building in which it is housed, the Casa de Cámara e Cadeia, was the headquarters of the old administration and housed the prison, and is one of the outstanding examples of the civil architecture of the colonial period. Built between 1785 and 1855, its extraordinary size and the fact that it was set among shacks built of mud and reeds led to violent criticisms of the colonial government. It was used as a state penitentiary during the twentieth century, and underwent a variety of changes. The museum was established in 1937 in homage to the proto-heroes of the new fatherland.

It should be explained that the name 'Inconfidencia Mineira' (Mining Treason) was given to the patriotic movement led by Second Lieutenant Tiradentes, who in 1789 sought to liberate Brazil from Portuguese colonial control. Tiradentes was hanged, and his body was exposed in the pillory at the entrance of the Casa de Cámara e Cadeia, the same house that today serves as a powerful symbol in the struggle against oppression.

Virrey Liniers house museum in Alta Gracia, Córdoba, Argentina

The priests of the Society of Jesus arrived in the territory of present-day Argentina in the sixteenth century, and in only a few years had established a system that left an indelible mark on the extensive area over which it exercised its influence. The city of Córdoba, which was founded a few years before their arrival, was the capital of what they called the Jesuit Province of Paraguay. They constructed the oldest church of Argentina in Córdoba, and built schools for the maintenance of which they organized Estancias (Jesuit farms) that were agricultural, stockbreeding and industrial establishments.[7]

The Estancia in Alta Gracia was one of the main Estancias which the Jesuits set up in the countryside of Córdoba. A house museum was created here in 1977, and is now named after another of its important proprietors, because its story did not end with the expulsion of the priests of the Society of Jesus. Rather than history being considered as a narrative of 'outstanding' events to be memorized, in this house museum priority is given to the concept of continuous process. The characters who once lived in the house are not presented as heroes to be venerated, but as social actors immersed in the social environment in which they were active.

The beautiful seventeenth-century Jesuit building plays the premier role. The contents of the exhibition it contains are designed to provide the visitor with the tools with which to understand and interpret the significance of the Jesuit farms

in the context of the region. How did they function as units of production? What was daily life like for the Blacks, Indians and Creoles who worked in them, and how did the farms evolve over time?

The use of period pieces (such as iron tools and implements, seventeenth-century toilets and bathroom installations, nineteenth-century highland bedroom and Liniers kitchen), complete with dioramas, scale models, graphs, drawings and photographs, enable visitors gradually to discover who the successive owners were, how they lived and how their relationship with their environment changed over time.

What is most noticeable about this house museum is the emphasis put on displaying the types of work and aspects of everyday life whereby visitors can appreciate economic and social processes in a context devoid of ornament. As a result, the museum possesses an atmosphere which takes visitors back to other times in which they can identify with the social actors who have gone before them.

Meeting the Other

Fiction is portrayed as reality in these 'theatres of memory' that are house museums. This kind of stage-management provides, on the one hand, the indelible traces of those who lived and used the original objects and whose ghosts can still be felt, and, on the other, the meanings ascribed by conservators, researchers and museographers.

The object *per se* has no intrinsic value. The object is defined instead by its relationships with humankind which attributes different values to it. Moreover, these values change with time. When the objects are displayed in the context of the exhibitions, they are transformed and attributed to new categories. In terms of the meaning of the object as symbol, they oscillate between two worlds, namely the world from which they come, and the world created by the display. In the context of the house museum, an object's significance depends not on its stylistic, artistic or technological values, but on its capacity to be consistent with a narrative or discourse, and to transmit a message.

The challenge is to be able to show that such conceptualizations and their respective meanings can be communicated, since it is from the narrow and inherent background of our experiences that culture assumes fluent expression. The original context is never recovered in the house museum because we look at things with the eyes of today. None the less, the symbolic value of the objects on display is not an inherent quality, but one produced by the interaction between a subject, namely memory and the imagination, and the exhibition which is, at one and the same time, concrete reality and the representation of reality.

'Even though the visitor is assured that museum objects are praiseworthy, personal meaning remains *personal*. It is something that exists largely independently of the designer's message ... In a fashion, each member writes his own script. The visitor travels in, about, and through a set of symbols, seeking to tie them together with associations and meanings – as if each visitor were author and star in his own play.'[8]

The challenge which this special type of museum must meet is to make constant efforts to draw near to the meaning of the objects which it exhibits by constructing discourses which should not confuse education with didacticism. Excessively structured discourses aimed at showing us the right way to see do indeed rob the museum of its quality of being a space of freedom and inner quest. 'Given that the house museum is a dream space, perhaps drawing near to the meaning of objects should be

accomplished through poetics. The private world within dwellings yields a variety of different ways of collecting objects which can be subjected to historical analysis. The poetics of space would be a choice vein for understanding the state of dreams that museography creates with its collections of objects.'[9]

And in the final analysis, the magic that makes museums so appealing could come from 'the meeting with the Other, with what is hidden and can be intuited but not fully grasped by the intellect'[10] in the plastic framework in which the public creates their own spaces.

Notes

1 Morales Moreno and Luis Gerardo, '¿Qué es un Museo?', *Cuicuilco* (Mexico City), Vol. 3, No. 7, May–August, 1996.
2 Annis Sheldon, 'The Museum as a Staging Ground for Symbolic Action', *Museum*, No. 151 (Vol. 39, No. 3), 1986.
3 Néstor García Canclini, *Culturas Híbridas*, Mexico City, Grijalbo, 1991.
4 Morales Moreno and Luis Gerardo, '¿Ensayo histórico. Museografía e historiografía?', *Cuicuilco* (Mexico City), Vol. 3, No. 7, May–August, 1996.
5 UNESCO, *Our Cultural Diversity: Report of the World Commission on Culture and Development*, Paris, UNESCO/Oxford and IBH, 1995; 1996.
6 Manuel Mujica Lainez, *La Casa*, Buenos Aires, Editorial Sudamericana, 1978.
7 This is one of UNESCO's new World Heritage sites, inscribed at the meeting in Cairns, Australia in December 1999. It is officially known as the Jesuit Block and the Jesuit Estancias of Córdoba. The Jesuit Block in Córdoba, heart of the former Jesuit province, contains the core buildings of the Jesuit system: the university, the church and residence of the Society of Jesus, and the college. Along with the five *estancias*, or farming estates, they contain religious and secular buildings that illustrate the unique religious, social, and economic experiment carried out by the Jesuits in South America for a period of over 150 years in the seventeenth and eighteenth centuries – Ed. *Museum International.*
8 Sheldon, op. cit.
9 Morales Moreno and Luis Gerardo, *La colección museográfica y la memoria histórica*, Second Symposium Reflecting on Historic Museums, Alta Gracia, Córdoba, Argentina, October 2000.
10 Norma Ruseconi, *Logos e identidad: retórica y semiología de fin de siglo*, Coro, Venezuela, 1999. (ICOFOM Study Series ISS 31.)

Chapter 36 | Mark P. Leone and Barbara J. Little

Artifacts as Expressions of Society and Culture | Subversive Genealogy and the Value of History

This essay has three purposes. One is to show that using artifacts enables us to ask questions and produce tentative answers that would not typically arise through the use of documentary materials; thus, we hope to establish the primary importance of objects, not as opposed to documents but as parallel to written material. Our second aim is to work with two important products of the Federal era (c. 1780–1825): (1) the Maryland State House and its surroundings as redesigned after the American Revolution and (2) paintings by Charles Willson Peale, including those of his natural history museum in Philadelphia in the 1820s. We argue that the similarity of these artifacts is based on a dual assumption: first, that the citizens of the new state were to teach themselves a way of thinking, or a discipline, that was to make each one a self-watching individual under his or her own surveillance; and, second, that acceptance of this way of thinking was so complete as to be thought natural and beyond challenge. Our third aim is to consider how surveillance mechanisms, to apply Foucault's (1979) term, have come down to us today, particularly in the descendants of Peale's natural history museum, which not only imprison us through their presentations of history but also enable others to challenge successfully our own integrity.

When addressing the matter of the primacy of objects, we serve two constituencies. One is a group of scholars, some of whom are associated with museums, who attempt to teach and learn through objects as a source of primary knowledge. These scholars all know that meaning is established in a scholarly or scientific dialogue in which people and objects are treated as independent data with separate epistemologies. They also know that artifacts by themselves do not produce questions, discourse, or answers. But since museums of all kinds feature things, how do we use these things

Mark P. Leone and Barbara J. Little, "Artifacts as Expressions of Society and Culture: Subversive Genealogy and the Value of History" from Steven Lubar and W. David Kingery (eds.), *History From Things: Essays on Material Culture*, pp. 160–81. Washington D.C.: Smithsonian Institution Press, 1993. © 1993 by the Smithsonian Institution. Used by permission of the publisher. (Reprinted without illustrations.)

to produce new knowledge? This question is more serious than asking how a library produces knowledge, since we have accepted answers to the second question, but we do not have a set of well-defined answers, discipline by discipline, for the first question. The dilemma facing scholars who use artifacts as their primary source of information no longer confronts prehistoric archaeologists with much force since effective methods leading to widely respected results exist in that field.

This observation leads us to historical archaeology, also a field within anthropology, and our second constituency. Historical archaeology struggles with how it creates knowledge. What is the epistemological role of historic artifacts within this field? How does the field create knowledge? Our response, like that of others (for example, Deetz 1988), is that our contribution is to provoke questions and provide data not anticipated by other scholars and unavailable through other disciplines. This ability provides the reason for studying both the Maryland State House and Peale's paintings as artifacts.

We argue that our data – the State House in Annapolis and its landscape, as both were redesigned in the 1780s, and Peale's paintings – have as their conscious aim to provide universal views of life. The objects we have chosen may seem unrelated, but they are closely connected in time and philosophy. We hold that the State House dome, built after the Revolution and in response to the triumph of the theory of individualism embodied in the Bill of Rights, is a panopticon, an all-seeing eye of the state watching and being watched by fellow citizens who are liberty-loving and liberty-endowed individuals. Peale's museum, on the other hand, offers a view unrestricted to a particular place: a universal view, over both space and time in the present and the past. In our argument, then, these artifacts represent the totalizing institutions of the new state, those institutions that intend to affect all of social life. They were intended as surveillance mechanisms to see everyone and everything in every place and through all time.

Our third argument is that the theory behind these artifacts is alive today. Since most of us still believe these theories and their representations, we do not use the past to see through the arbitrary claims they sustain or the surveillance they establish. Nor are we able to respond successfully to claims made against our values by others who *do* see through the arbitrariness of our two-centuries-old official history.

This third issue is, we acknowledge, the most difficult and probably the most controversial. It has several parts but begins with the assumption that the purpose of knowing about things historically is to be able to know consciously or criticize the society we live in now. This purpose is not the only reason to know things historically, but in our opinion without this kind of knowledge the rest of the reasons do not stand easily on their own. Therefore, the purpose of historical knowledge, including that of things, is to allow for critical knowledge of our own society.

Because we Americans are still embedded in Peale's philosophy about how to think and behave as citizens by learning from an "accurately" and "naturally" presented past, which has led inevitably to our present condition, we as "naturally free" and "independent" individuals are trapped in a social presentation of history that forecloses an ability to use history to see our own society in a different way. Furthermore, and this is our most practical point, our imprisonment within an old and conventional presentation of history has enabled others – for example, Native Americans seeking the return of museum collections and the closing or redesigning of exhibits – to indict our uses of these collections by indicating our own origins as portrayed within the collections. Because our natural history presentations rank Native Americans as

natural rather than as heroic or aesthetic, Native Americans have been classed with and presented alongside whales and geodes, not with George Washington, for example, or Peale's art. This intellectual artifact of our own history, this function of our own self-created and self-imposed genealogy, when turned against us indicts us by saying that we think Native Americans have more in common with natural species than with the rest of American citizens. At least this was the case before the passage of P.L. 101–601, the Native American Graves Protection and Repatriation Act, in November 1990.

Let us turn to Annapolis as we have come to know it as archaeologists since 1981. The plan for the city of Annapolis was created by Maryland's second royal governor, Sir Francis Nicholson, after he moved the colony's capital from St. Mary's City in heavily Catholic southern Maryland to Protestant Annapolis in 1694. This move was accomplished after William and Mary became sovereign and Protestants consequently assumed power in England. Lord Baltimore, a Catholic, temporarily lost his proprietary right to the colony founded by the Calvert family in 1634.

Annapolis had existed as a small town under other names as early as the 1650s (Baker 1986: 192), but it had no special status. In 1683, as part of an effort to encourage the growth of towns, the legislature declared the settlement a port of entry (Papenfuse 1975: 8; Baker 1986: 192). Richard Beard surveyed the existing streets in 1684. His survey does not represent a planned town, but it does describe some of the layout with which Nicholson had to work. Beard was commissioned to do another survey and lay out Nicholson's plan in 1694. Although the survey was burned along with other public records in the State House fire of 1704, enough references to it remain to confirm that the major features of the Nicholson plan were surveyed in the 1690s (Baker 1986: 193).

Reps (1972: 121) notes that the Nicholson plan for placing streets and buildings follows the concept of baroque design, with certain classic features: formal symmetry, imposing open spaces, vistas leading to important structures, and major buildings placed on commanding sites. Reps (1972: 123) also comments that the baroque principles were imperfectly applied in Annapolis. Although he attributes the geometric imbalance to Nicholson's incomplete understanding of the principles (1972: 125), it is perhaps more likely that Nicholson was accommodating his understanding of baroque design to preexisting streets (Ramirez 1975: 38 ff).

The best existing representation of the early town plan is a copy of the Stoddart survey done in 1718. The most obvious feature of the town plan is the placement of two circles on two hilltops with the larger circle enclosing the State House and the smaller enclosing the Anglican, or state, church. From these circles radiate streets, creating vistas that lead to the centers of royal and religious authority.

We know a good deal about this plan through archaeology. As a result of digging at almost two dozen locations on the larger circle surrounding the State House, we know that over the centuries the circle has been shifted to the north and east and at least since the 1830s has been a nearly perfect geometrical egg. To be more precise, it has been made up of four connected arcs drawn from four centers, three of which make a triangle and one of which is in the middle of the triangle's base. The smaller circle that encloses the Anglican church has been constricted into an ellipse whose true geometry we do not yet know. The State Circle hill had its top leveled in the eighteenth century and its sides steeply terraced in the nineteenth century to provide the appearance of height. The land around the church has been lowered and the street level of Church Circle raised, effectively lowering the church's locale, especially in

relation to the State House grounds (Leone and Stabler 1991; Read 1990; Shackel 1988; Leone and Shackel 1986).

Neither the circles nor the major streets radiating from them have been interrupted to block the vistas. In one case a street off Church Circle was blocked when William Reynolds built on top of it in 1747, but the view from other streets was not compromised. Other streets occasionally have been added. We know from archaeological evidence gathered from monitoring hundreds of yards of utility trenches in the streets in the city's core that the streets have been raised, extended, and crowned but not bent, curved, or otherwise changed so as to alter the vistas. Therefore, except for the land encompassed by the U.S. Naval Academy after 1845, the basic plan of the whole town has stayed virtually intact for three centuries.

The Nicholson plan, with its foci on the structures of church and state, is an artifact of baroque urban planning. It concerns institutions that were hierarchical, with the parts being subordinated to the whole (that is, to the authority of state and church). The plan taught and reminded inhabitants and visitors of the centrality and ultimate authority of the state and church. It presented an order for political and social life that appeared inevitable.

Nicholson's plan served as a vehicle for placing Maryland's State House at the highest point in the town, visible to the waterfront, as a focal point of the built environment. There have been three state houses on this rise of land since the 1690s. The current building is the third, built originally in the early 1770s. The building is not in the center of the surrounding circle; rather the circle, which is an egg that appears circular to the traveler on the ground, is looped unevenly around the building. Eight streets and alleys radiate from the circle and control the view, especially as one approaches the State House on foot.

In the 1780s the current eight-sided, multistoried domed tower was placed on the building, replacing a lower, open lantern. The tower still offers commanding views of the town and can be seen everywhere from within the city. We focus here on the combination of the 1780s tower with the continued use of the 1690s baroque street plan to argue that until the Revolution the idea of the state expressed in Annapolis was to focus the views of people upward to authority. But with the acceptance of a theory about the state based on assuming individual rights of citizenship, the opposite view – the view down from centers of authority – became equally and possibly more important.

Our suggestion is that the multisided, panoptic State House was intended to express and simultaneously create the view that a citizen's obligation was both to watch the state and to act as the watchful state, since the citizen was embodied in the very nature of the state's foundation. The discipline of self-watching, or self-discipline, was essential in the citizen's role; an individual took it upon himself or herself to learn how to think and behave in a disciplined way. Not coincidentally, during this time in Annapolis lessons were advertised and taken in arithmetic, penmanship, horticulture, music, dancing, physics, medicine, and almost anything else that could be learned, including etiquette and rules for being a lady, a gentleman, a noble citizen. The people doing all this were self-watching individuals, who as the foundation for the new government needed to be ever watchful of both self and other citizens.

The second major artifact is a trio of pictures by Charles Willson Peale. Peale was born in Maryland, was raised on its Eastern Shore, and did his early painting in Annapolis. He finished his life's work in Philadelphia, having founded the nation's first natural history museum. That museum is the subject of the first painting of the

trio, *The Artist in His Museum*, done in 1822. The preliminary sketch that accompanies this painting is *The Long Room*, also done in 1822; it shows the main museum room, which appears as one of the subjects of the Peale masterpiece. The third picture is Peale's *The Exhumation of the Mastodon*, 1806–8. We argue that in this trio of pictures Peale showed his contemporaries how to apply the rules of equality, graduation, and predictability to the living animal world, the past of the natural world (that is, fossils), and human personality and moral standing, using as examples revolutionary war heroes.

Peale created his museum for the public to use for its education. Without much difficulty, it is possible for us to look at his two pictures of this museum's central hall and see that what he intended is a version of what we still think of as a natural history museum. It seems old-fashioned now, but it is clearly recognizable. Both the museum cases and the arrangement of them to order the world in a graduated way are familiar and important elements. Actual measurements of Peale's cabinets are not necessary to see that the cabinets are in rows, are all the same size in any one row, and tend to get smaller as they ascend. There is a basic measure and orderliness that encompasses all the units in the overall plan. At the top of Peale's Long Room are two rows of revolutionary war heroes. These are his own paintings, which make the room a major intellectual and artistic *tour de force*. We believe that a key to understanding the room is that all the paintings are in identical frames, so they too are a function of the same basic desire to measure, which orders the museum cases. The geodes, rocks, and sea shells, as well as Native American artifacts, are in cases that have compartments all the same size for each kind of item, so that all such items are in equal rows, are fronted by equal panes, and are equidistant from one another. They are either equal or in spaces that are multiples of each other. The paintings of heroes are also equal in scale and size.

"With this museum, Peale set out 'to bring into one view a world in miniature'" (Richardson et al. 1982: 83). Since everything except the paintings was the size it was in nature, except stuffed or preserved, "miniature" meant that the whole order of nature was so comprehensive that it was possible to use a sample of natural forms to encompass and teach the rules of similarity, graduation, and natural precision in one space. His effort was to array many parts of nature so that the Great Chain of Being was visible with rocks, insects, shellfish, birds, Native Americans, and heroes having precise relationships to one another. The museum was a model of the world. Peale was putting nature on display so that people could learn the natural principles, obey them, and use them to shape nature. One could either let nature speak through one and accept one's role humbly or encounter nature as an adversary and shape it aggressively using its own rules (Penn, pers. com. 1988). In any case it is clear that Peale intended his museum to be a place for citizens of the new republic to learn the rules of nature so that they could play an active and enlightened role in shaping the republic, which could also be seen as a natural form.

Peale attempted to order all of living nature in his museum, but he did more. He ordered both the paleontological past and the human character, and he used and taught the principles by which all could be unified. *The Exhumation of the Mastodon* and the place of the assembled mastodon in *The Artist in His Museum* are enough to show us his attempt to introduce systematics into North America's past. Peale was the first person in North America to excavate a major fossil in a scientific way. He reassembled it with the missing pieces restored so that the whole could be appreciated.

Richardson, Hindle, and Miller comment on Peale's intent and originality:

When the French scientist Cuvier published the mastodon as a representative of an extinct species, it was a dramatic demonstration of the fact that over geologic time species could become extinct, an issue that was still being debated at that time. Peale, through his own perseverance, had found scientific information that had not been known before. (Richardson et al. 1982: 85)

We argue that Peale was attempting to create a paleontological past for North America. His drawings, notes, mounting of the skeleton, and parading of a reconstructed mastodon through Europe demonstrate this point. Peale's paleontology can be linked to the archaeology of Thomas Jefferson, his friend and correspondent, who is credited with the first systematic excavation of a Native American mound. Jefferson's excavation and investigation of the hypothesis that modern and ancient indigenous peoples formed a cultural continuum are well known (Jefferson 1787). Crucial here is the link between fossils and Native Americans in Peale's museum and Jefferson's archaeology. As new categories were being created for past time in the New World, both the fossils and the Native Americans were thought to be part of "native" natural history. Obviously the histories were not native from the viewpoint of the subjects, nor were they tied to the present through any device offering to explain continuity or disruption. Peale and Jefferson were rationalizing past time for the natural order, which included Native Americans. They created an orderly precision in their plan for building a history of nature. At the same time, however, what they perceived as natural for themselves were their rights, especially their liberty, rather than their history or historical tie to the North American continent.

A final categorization made by Peale is one of his most innovative. His paintings of revolutionary war heroes were to be sketches of character, meant to teach the personal attributes needed by citizens in the new republic. Peale's portraits are still considered sharp, incisive studies of personalities, and most of them will still convince a viewer that the subject has a set of traits that *are* interesting. The point is that Peale intended his heroes to teach character traits such as leadership and scientific thoughtfulness to the visiting public. Peale's objective was to enumerate human characteristics and then put them on display with the assumption that they could be copied and mastered by individuals. With this effort Peale was attempting to segment and rationalize the human personality. Thus, we can see that Peale's museum displays were not only shapes; they also implied rules for equivalencies, gradations, and precise divisions whose rules probably aimed to exclude nothing from their domain. Here was expressed an explicit hierarchy of physical beings, past and present, progress, and individuals' moral standing.

Peale's representation of the order of natural and human life and the State House of Annapolis as redesigned after independence are similar in several ways. Both create and present a way of categorizing based on the individual as well as a vision of order. Both used volume: one to control space, the other to use objects to present a realistic view of time and all nature juxtaposed to its own parts. Nicholson's plan of 1694, as it remained in use with the renovation of the State House in the 1780s, intended to use vistas to direct sight and in doing so appeared to alter space so as to make objects appear bigger or smaller, taller or shorter, than they were. Peale's painter's quadrant, a *camera obscura*, allowed the representation of three dimensions in two with the appearance of accuracy. Thus, one technique involved in both artifacts was the use of Renaissance rules of perspective to control vision. To include Peale's museum in

this argument we must assume that vision includes seeing *into* nature, the past, other cultures, and the human character.

We believe it is fair and necessary to ask, If the State House and Peale's museum were organized as we suggest, were they recognized as such, were they successful, and did they create protests against their totalizing intent? Given diverse social classes – including enslaved and free African Americans, paupers, women as well as men, country people and city dwellers – who did and who did not accept and reject these surveillance mechanisms? We are not now able to establish for whom this surveillance worked. We do not attempt answers to these important questions here; the questions are themselves new to us. Our originality stems from the question itself, which comes from our discovering that the State House and its surrounding landscape not only were planned and executed as a unit but also were planned and reexecuted several times, probably using different ideas of what their purpose was. Our novel contribution, which raises these other questions about impact and influence, is what the postrevolutionary State House and Peale's museum have in common, not yet whether or not they worked in their time in the way we suggest. We argue that these questions reveal the fruitfulness of historical archaeology.

On the other hand we are firmly convinced that they have worked in our own day and for many generations preceding ours just as we have hypothesized they were supposed to have in the Federal era. We believe that both artifacts have served in particular ways to represent the genealogy of two key elements of American ideology. Both have been made into historical statements not only about the way things were but also about how they came to be that way. This point represents the third part of our argument. It contains a dual proposition: first, that the State House and the descendants of Peale's museum philosophy are effective today; and, second, that because they are used to ground our rights as citizen-individuals (as the State House does in self-watching) and our dominant position on the continent in nature (as natural history museums do), these are imprisoning ideological devices.

Our argument is based in part on a provocative article by Shklar (1971), who explores creation myths as subversive genealogies that in themselves hold the possibility of subverting the society they were intended to uphold. She examines the caricatures of creation myths written by Hesiod, Rousseau, Nietzsche, and to some extent Freud, all of whom expressed bitter disgust with the pervasive suffering of humankind and tried to account for it with their explanations of the origins of that sad condition. Questioning the origins of social relations and authority is subversive and dangerous because it calls into question the status quo. Shklar writes:

> Since Hesiod's day the myth of origins has been a typical form of questioning and condemning the established order, divine and human, ethical and political. The myth of creation that Hesiod devised out of the depth of resentment has been a model for writers of similar inspiration.... In the modern age both Rousseau and Nietzsche, to name the most notable, used creation myths to express their unlimited contempt for their world. (Shklar 1971: 130)

In his genealogy of the gods of Olympus, Hesiod found the origins of human suffering in the character of Zeus and in the fourth age, that of the Men of Iron, who were doomed to suffer. Much later Rousseau traced humanity's lot to the inequalities that came about in the fifth age, that of grain and iron, with the development of a division of labor and the gap between wealth and poverty. For Rousseau

society was the evil ancestor that determined humankind's fate. Nietzsche attributed nihilism to the age of the "men of iron...the age of the slave spirit triumphant" (Shklar 1971: 142).

In Nietzsche's philosophy, memory, an awareness of the past and of history, is an illness and a torment (cf. Lowenthal 1985: 65; Nietzsche 1873–76). Yet it is part of a persistent desire for control. Memory is argued to be necessary to understand and dominate society and control the future (Shklar 1971: 144). Knowledge of history provides the power to create genealogy, and such power is the key to control. Genealogy here is to be seen as the version of history that suggests the inevitability of the present social order. Thus genealogy becomes a political necessity because it legitimizes the tie between the present and the past. Shklar's argument recognizes that within genealogy the past and the present are identical. Connections between past and present are inevitable, determined, or epigenetic, implying that the present could not be other than it is. These are ties that appear to be central because they are based on assumptions such as biological kinship, natural right, or evolutionary development.

Peale's museum and the Maryland State House fit into this model of genealogy. Peale was not an evolutionist; he represented the hierarchical and static Great Chain of Being and humanity's place in it. Nonetheless, all succeeding such museums from the 1870s and 1880s not only used his organization but also added the dynamic of evolutionary development to explain how all those items in all those cases merged into one another over eons of time, culminating in European humanity. The inevitability of the arrangement is the genealogical aspect; the arrangement still dominates museum presentations of evolutionary development. Peale is important here because he initiated the process of explaining to the public, with reference to the surrounding world in space and time, why they as people were here now. While the Great Chain of Being has been rejected as an idea, most of Peale's ideas are so completely intact that it is virtually impossible today to imagine any alternative museum presentation of the things, creatures, and cultures within them, their interrelationships, or reasons for being. In this implied inevitability lies a problem.

The Maryland State House in the 1780s was a political rather than a historic statement. However, since early in this century, when the building was subject to the colonial revival style and some of its original eighteenth-century appearance was restored, it has become historical. We do not know whether the original panoptic intention of its prominent tower was ever known or realized. Instead, the tower is now thought of as a remnant from another era, and this essence, plus its prominence, constitutes its chief meanings. But because it is a product of the revolutionary period, it has been made into a direct ancestor for modern government. As such it cannot invite a question about origins, because the origin is given. Thus it is a historical citation that can neither illuminate its own origins nor explain any of the problematical relationships that may come from current circumstances.

Such genealogical history is uncritical, which is why both Rousseau and Nietzsche had contempt for history as a self-justifying form of knowledge (Shklar 1971: 142) and why they wrote their own creation myths as a subversive way of questioning the origins of human suffering. They expressed their outrage at life's circumstances by writing genealogical histories that communicated the inevitability of the evils of the world. However, "both saw the inescapability of the inheritance whose origins they had so mercilessly exposed" (Shklar 1971: 146). When genealogical creation myths insist that the past could have led to one and only one possible present, they allow for no human choices in history. Thus, we suggest that history and genealogy do not

necessarily serve the same purpose. Shklar notes that the creation myth has to appear to be "prehistorical" – that is, not part of history – otherwise the contingencies and accidents of history would be apparent and humans would have freedom and choice and thus power.

Genealogy, as Shklar explains it, expresses the past as an integral part of the present: "Genealogy deals with the ever-present, indestructible actualities" (1971: 146). Through effective genealogy the present is inevitable and was contained in the origin. When stated this way, this view implies that there is no effective challenge to the present through precedent. There are instead the pessimistic creation myths that recognize necessary evils: "It [the myth] permits defiance and rejection, without arousing the slightest hope or impulse to action" (1971: 141). History, however, may illuminate current conditions whereas genealogy merely justifies them.

As Barbara Clark Smith (pers. com. 1989) suggests, Jacoby's (1975) idea of social amnesia may be useful for characterizing the uncritical nature of creation myths. Afflicted with social amnesia, people forget that their own society has a historical past and must conclude that whatever is is natural and inevitable. It must be understood, however, that personal shortcomings do not create social amnesia. People do not actually forget; they never know.

Marxian critical theory holds the possibility of human action and people's control of their own history as they come to understand the self-justifying genealogies that have been taught to them. Feenberg writes:

> The ultimate dialectical "mediation" of reified social reality consists in the real practical subversion of the social order through the breakdown of the boundaries of its partial subsystems. Making connections between the artificially isolated subsystems is the most threatening oppositional strategy for this reified social order. . . . It is through such subversive mediation that the human community, conscious of itself, assumes control of its own history. (Feenberg 1981: 70)

Making connections both among artifacts and between our genealogies and artifacts, therefore, is one way of exposing origins and laying claim to history.

Shklar suggests that genealogical myths may be an enduring form of polemical discourse, which in turn must be expressed metaphorically to be shared and understood. She argues that creation myths make evident what is abstract, that these myths act as "psychological evocation." They are mnemonic devices that must rely on familiar experience and are effective because of a shared cultural literacy. In our argument those devices are the museums and the State House, which are widely shared although by different audiences, by experience, and by being the centers of continuous "historical" discourse. Myths express, evoke, and translate cultural pretensions into realities through common experiences. This insight allows us to connect objects with presumed genealogies where both are created to be believed and obeyed and where both are effective social and political statements. With such connections we can return to the artifacts described earlier, indeed to material culture in general, and ask how political discourse, social rules, and cultural literacy were expressed.

How were the rules that created a social order expressed in material culture? How were they lived out and realized? And who rejected them? They were internalized through designing, constructing, and inhabiting buildings; eating according to certain rules; and looking, seeking, talking, and keeping time in equal, graduated units

that covered and included potentially all things. They composed a way of life, a "version of everything," to use Peale's own term.

Most modern Americans do not see natural history museums as pessimistic or imprisoning, but Native Americans, Aleuts, and native Hawaiians do, because in them they inevitably rank below modern Western human beings. The ranking is inevitable because through genealogy it has been made to appear so, as if it were the natural consequence of evolutionary progress. What Native Americans have success-fully done to natural history museums and disciplines such as anthropology used within them is to attack the museums by attacking the origins of the evolutionary and genealogical tie within them. Their argument has been that they are not like stones, insects, fish, or birds. They are not below other Americans; instead, as fellow citizens, they have equal rights. Thus, as fellow citizens not only are they to be treated equally, but also the very material used to prove their naturalistic status was stolen property, another violation of their natural rights. Their indictment has been powerful because they could use their status as liberty-loving and liberty-endowed individual citizens to say that if this was how we classified them – that is, as equals – then they could not also be inferiors, as our American genealogical myth told us they were. Thus, our genealogy was not just incorrect; it was corrupt. They took the institutions in which we housed, celebrated, taught, and demonstrated our natural history, our reasons for being here now, and indicted the conditions society placed them in. The indictment stuck, is recited in P.L. 101-601, and is addressed throughout the provi-sions of the law. This is, of course, our reading of the situation and the complex new law whose regulations have not yet been finalized.

Although we cannot be sure how Peale's museum, the 1780s Maryland State House, modern natural history museums, and the modern Maryland State House actually communicate their ideas, we assume they are significant in the process as artifacts and institutions, particularly since millions of people annually are told about them and their meanings by guides, teachers, films, guidebooks and maps, docents, and other means. What, then, do people know about them? The central fact is that in neither a natural history museum nor the Maryland State House is its own history presented. Those histories are rarely open for examination.

There are two points to be drawn from an archaeological view of the artifacts we have chosen. The first point is methodological. Using historical archaeology within the discipline of anthropology, the aim of this analysis has been to take material culture and analyze it along with parallel written material. The archaeology shows material representations and reifications. The documents provide ethnographic intention and some meanings. Working with several sources we created hypotheses about the rules that certain parts of society used to create order and sense and about how these rules were experienced and internalized. Work yet to be done involves showing how the rules operated and on whom.

The second point is that the work we have begun challenges existing genealogies. Material culture might support the subversion or criticism of self-justifying geneal-ogies by making criticism concrete, understandable, and testable. Such endeavors might make the structure of our artificial surroundings understandable at different levels. The Maryland State House is currently lightly interpreted, its long history totally ignored. But there are questions to be asked of that history. Why should the building sit within a surrounding circle that has twice been redesigned as an egg shape? Why do seven of the eight streets and alleys leading to it narrow or converge to highlight the view when no other streets in town do? Why is it the centerpiece of an

optical illusion? And why, after 1780, did an all-seeing eye get mounted on top of the structure? We believe that the purpose of this latter occurrence in particular was to encourage surveillance – that is, to convince the new citizens that they were the power behind the state, rather than the power base under those who ran the state. Thus, it is possible that the newly redesigned State House deepened the illusionary basis for authority and then, when in the first decade of the twentieth century it all became washed with historicity, the illusion was buried in the wisdom of the founding generation and enhanced by the still-present ideology of individualism and citizens' rights. In this way the State House became a genealogical artifact.

Just as Hesiod's genealogy of the Olympian gods can be understood as either innocent mythology or a subversive challenge to the gods and the order of things, material culture can be understood in a straightforward, functionalist manner or in a way that integrates symbolism and the appropriate cultural associations that place things in their cultural context. The audience for criticism need not be universal, although every individual may claim some understanding and reaction.

The redesigners of the State House in the 1780s used antiquity and Palladian proportion to justify their plans, and Peale cited nature to show a unified system. Both were based on a particular vision of rationalized order and a categorization that enclosed, segmented, and judged both natural and artificial phenomena. Both started to universalize order by imposing it on time and space.

These artifacts are early illustrations of a process that by the late nineteenth century was taken as inevitable: the seamlessness of the continuity between past and present and the acceptance of Darwinism as characterizing the social world, including the idea of cultural evolution. The implication was that the past was somehow present now, so that genealogy referred to both past and present simultaneously. The artifacts we have analyzed are quite different in form, yet they are both concrete expressions of the value of the individual citizen and the individual's place in nature. The artifacts themselves do not call such values into question, but they can provide evidence of their origins and thus provoke a critique of these values.

It is possible for those frustrated with such current presentations to subvert the genealogies presented and use them as an indictment of parts or all of social life today:

> To destroy the prestige of convention, nothing will do so well as to show that it really is not what it appears and pretends to be. If beginnings were sordid, surely its essence cannot be worthy. To unmask is to display an ambiguous parentage at best. Since we accept the origins, that is the motives, of actions as their moral definition it makes sense to show up these less than admirable beginnings. (Shklar 1971: 148)

To summarize and conclude: Native American claims to museum collections have drawn their force from attempting to show the scientific worthlessness of the use of the remains. In addition, Native Americans have claimed that both scientific practices and the holding of collections violate the First Amendment guarantees for freedom of religion. They also have indicted the morality of archaeologists and physical anthropologists. These accusations depend for their force on their ability to indict the foundations of the disciplinary claims that justify the collections, including the associated sciences. A challenge has been made to an Anglo-American way of categorizing and ordering the world in such a way that Native Americans are linked with birds and sea shells and not treated as equal citizens. These claims constitute a subversive genealogy that invokes history to critique the present. Since the now successfully

subverted genealogies depend for their own origins on such creations as the Maryland State House of the 1780s and the organization offered in Peale's paintings, the claim can be analyzed, questioned, and transformed.

Our final point concerns the place of history within our society, particularly its political function. To begin, we make two assumptions. The first is that history can be used to illuminate current conditions, to explain current circumstances, to ground our understanding of modern life, and, in short, to educate. This education includes offering critiques of our own society. History has the capacity to tell us why we are here now. Second, to achieve this aim we argue that history has to be able to criticize itself, since it is frequently turned into the sort of self-justifying genealogical myths we have associated in this essay with Peale and the uses of the Maryland State House. We already know that it can be made subversive, since Native Americans have recently done this.

One problem is that many historians associated with museums or operating in local historical contexts focus so completely on accuracy and completeness that they are unwilling to see their work as so embedded in the status quo that it is obfuscating rather than illuminating and, indeed, basically a prop of the status quo. We claim to be able to situate artifacts, or things, within their genealogical contexts so that their self-justifying qualities are seen more clearly and their potentially subverting qualities can be called on and developed. Thus, our position is not antihistorical, nor is it unpatriotic; it is both optimistic and quite traditional.

References

Baker, Nancy T. 1986. "Annapolis, Maryland, 1695–1730." *Maryland Historical Magazine* 81, no. 3:191–209.

Deetz, James. 1988. "American Historical Archaeology: Methods and Results." *Science* 239:362–367.

Feenberg, Andrew. 1981. *Lukacs, Marx, and the Sources of Critical Theory.* Totowa, N.J.: Rowman and Littlefield.

Foucault, Michel. 1979. *Discipline and Punish.* New York: Vintage Books.

Jacoby, Russell. 1975. *Social Amnesia: A Critique of Conformist Psychology from Adler to Laing.* Boston: Beacon Press.

Jefferson, Thomas. 1787. *Notes on the State of Virginia.* London: John Stockdale. Reprint. Chapel Hill: University of North Carolina Press, 1954.

Leone, Mark P., and Paul A. Shackel. 1986. *Archaeology of Town Planning in Annapolis, Maryland.* Final report to the National Geographic Society. NGS grant no. 3116–85.

Leone, Mark, and Jennifer Stabler. 1991. "The City Center of Annapolis and the Kind of Economy It Reflects." Presented at the annual meeting of the Society for Historical Archaeology, Richmond, Virginia.

Lowenthal, David. 1985. *The Past Is a Foreign Country.* Cambridge: Cambridge University Press.

Nietzsche, Friedrich. 1873–76. *The Use and Abuse of History.* Reprint. Indianapolis: Bobbs-Merrill, 1957.

Papenfuse, Edward C. 1975. *In Pursuit of Profit: The Annapolis Merchant in the Era of the American Revolution, 1763–1805.* Baltimore: Johns Hopkins University Press.

Ramirez, Constance Werner. 1975. "Urban History for Preservation Planning: The Annapolis Experience." Ph.D. diss. Ann Arbor, Michigan: University Microfilms.

Read, Esther Doyle. 1990. *Archaeological Excavation of State Circle, Annapolis, Maryland.* With contributions by Jean Russo, George Logan, and Brett Burk. Principal investigators:

Mark P. Leone and Barbara J. Little. Report for the City of Annapolis submitted by Archaeology in Annapolis, a cooperative project between the Historic Annapolis Foundation and the University of Maryland, College Park. On file at the Maryland Historic Trust.

Reps, John W. 1972. *Tidewater Towns: City Planning in Colonial Virginia and Maryland*. Williamsburg, Va.: The Colonial Williamsburg Foundation.

Richardson, Edgar, Brooke Hindle, and Lillian Miller. 1982. *Charles Willson Peale and His World*. New York: Abrams.

Shackel, Paul A. 1988. *Excavations at the State House Inn, 18AP42, State Circle, Annapolis, Md.* A final report with Joseph W. Hopkins and Eileen Williams. On file with the Historic Annapolis Foundation, Annapolis, Md.

Shklar, Judith N. 1971. "Subversive Genealogies." In *Myth, Symbol, and Culture*, edited by Clifford Geertz, 129–154. New York: W. W. Norton.

Chapter 37 | James Deetz
A Sense of Another World | History Museums and Cultural Change

History museums of all kinds and sizes, from the Smithsonian's Museum of History and Technology [now the National Museum of American History] to the smallest, most modest historic house, are assuming an increasingly significant role in telling Americans about their past. This past is ever subject to interpretation, and we will never be able to re-create it completely, with all of its subtleties and texture, or to know the past as a participant in it might have done. It is the task of the museum to choose those aspects of an earlier time that are worthy of interpretation and to devise effective methods to make that interpretation work.

American culture has been characterized by both continuity and change over nearly four centuries. Whether we are exhibiting a collection of delftware in a formally labeled case or creating a living context in which delftware can be understood as part of a larger cultural system, the problem remains the same. Is a delft plate to be interpreted as a simple analog to a piece of modern dinnerware – modern culture projected unchanged into the past – or should it be interpreted more in terms of the period and circumstances of its use? Both approaches have merit. To understand the longer traditions of a culture provides a valuable perspective on continuity, but to interpret differences in the functions of commonplace items at different times addresses the question of cultural change more directly. Such change has indeed been profound since early colonial times, but history museums often do not acknowledge the changes as much as they might. While continuity seems to be emphasized more than change, a consideration of differences might well provide a different and more sophisticated kind of interpretation. To discern the differences, one must not look at material culture – the built environment – merely as a simpler version of what we have today.

Fortunately, museums deal with one of the most eloquent legacies from the past, the actual objects used by people to organize and expedite their lives. Far more than documents, things have a special kind of immediacy. It takes little imagination to picture a smoke-blackened cooking pot in its original place over the fire in the huge fireplace of a 17th-century house. After all, it once *was* there, and it forms a powerful

James Deetz, "A Sense of Another World: History Museums and Cultural Change" from *Museum News* 58:5 (May/June 1980). © 1980 by the American Association of Museums. All rights reserved. Reproduced by permission. (Reprinted without illustrations.)

link between then and now in a way a written account cannot, Likewise, an old timber-framed house can place the visitor in the same space used by the original inhabitants, a space that reflects their attitudes about social living. Properly interpreted, the hall of a 17th-century house can convey a sense of another world, one very different from that which we inhabit.

The basic building block of any exhibit, whether in a small table case or in a full re-creation of an early community, is the individual artifact. The term "artifact" is somewhat vague, and while a house can be thought of as an artifact as well as a thimble can, normal usage restricts "artifact" to smaller objects, usually portable: furniture, ceramics, firearms, toys, clothing, books and tools, for example. The artifact is the material correlate of the individual. An artifact is often made by a single person and used at any given time for a specific purpose. Thus, artifacts are useful indicators of individual behavior and can be used to interpret that behavior. Exceptions to the individuality of artifacts are also informative and shed light on important aspects of the way in which people functioned together. For example, if a 17th-century wooden trencher is simply interpreted as a container from which food was taken, its obvious relationship to a modern dinner plate is apparent. Such an interpretation emphasizes the continuity between the 17th century and the 20th century. However, fundamental differences can also be interpreted, and an important statement of the change in culture over three centuries may be made. Contemporary descriptions of 17th-century food customs and probate inventory evidence make it clear that trenchers were used corporately. More than one person ate from a single container; such persons were known as trenchermates. This fact highlights differences, but it also serves as an example of the corporate nature of 17th-century society. Sharing trenchers was not an isolated practice, but rather a reflection of a larger pattern of shared living space and burial space, as well as attitudes and responsibilities.

The corporate nature of 17th-century society contrasts with American culture during the later 18th century. Accordingly, the interpretation of a dinner plate in the context of the first decades of the 19th century can better be done from the perspective of culture change. By that time, every person had his or her own dinner plate, cutlery, chair and, to a greater degree than before, private living space. Rather than simply view this individualization as similar to our use of artifacts today, it is better to bring it into relief by contrasting it with an earlier, quite different pattern.

Another way in which the interpretation of historical artifacts can focus attention on culture change is through a consideration of their function. The most obvious, and most interpreted, function of artifacts is their technical function, their practical use in everyday life. Axes cut, needles sew, beds are slept in, and plates hold food. Yet, beyond their technical uses, artifacts served other functions. Objects that appear, from 20th-century perspective, to have had only technical functions had social functions as well. Large delft plates called chargers probably served an almost exclusively social function in the earlier years of the 17th century in America. Their rarity in most households as indicated by probate data and archeological excavations shows that they were not used for serving food, even on a shared basis. When these plates are analyzed, again through the use of inventories, on a room-by-room basis, they are most commonly located in the parlor, a room which served a highly social function. The parlor was a place where important visitors might be received, where bodies were laid out before funerals, and where objects of visible wealth were publicly displayed. Large delft chargers were such objects, and they often served the social function of making a statement to the community about the means of their owners. It was not until late in the 17th century,

and then only among people of higher than average means, that delft plates seem to have been standard equipment for food consumption. Any interpretation of such artifacts, whether through passive museum labels or active live interpretation, should take these differences into account. Merely to describe the object in terms of its physical attributes and a function derived from a 20th-century analog not only masks important differences that reflect culture change, but also is incorrect.

What is true of plates and chargers is true of all the other material aspects of early American life. We can perceive differences in individuality of use or of social function only if we resist the tendency to describe earlier, different cultural patterns in terms of our own modern ones. Historical museums can deal effectively with culture change only when interpretation is freed, at least in part, from the imposition of 20th-century categories and values. This can be a difficult task; it requires considerable research and probably can never be done completely. Yet it must be attempted, since even a few perspectives of change over time can be very powerful aids in communicating an understanding of cultural differences and the changes that brought them about.

If single artifacts tend to mirror individuals and their behavior, collections of them organized into systematic and functional groupings mirror the behavior of groups of people. The commonest such grouping of artifacts is the so-called "period room." Properly created, such an exhibit can be very useful in interpreting familial roles, division of labor, and the integrated relationship of a wide variety of artifacts. Modern period rooms tend to concentrate a careful selection of artifacts from a single place and a very brief period of time. The period rooms at the Winterthur Museum are examples of this kind of exhibit. They show the viewer a selection of furnishings that have primarily esthetic appeal, and their interpretation tends heavily to an art history perspective. Yet the earliest period rooms installed in this country seem not to have been made with this end in mind, but rather were groupings of artifacts designed to help the viewer better appreciate the interior environment in which early Americans lived. Charles P. Wilcomb was responsible for these assemblages, installing the first of a series he was to create in the New England Hall of the Golden Gate Park Museum in San Francisco in 1895. Later, Wilcomb installed such rooms in the Hall Museum of Anthropology in Pittsburgh and the Oakland Public Museum. All were very similar, and Wilcomb did not call them period rooms, but "colonial kitchens" and "colonial bedrooms." His stated intent was to convey to the viewer what such an interior looked like, and he emphasized the commonplace over the finer quality pieces. After Wilcomb's death, his successor at the Oakland Museum, John Rowley, wrote:

> Group installation methods lend themselves to many classes of objects....A good example of a historical group, for instance, is the colonial kitchen installed in the Oakland Museum by the late C. P. Wilcomb....
>
> How much better this is than simply to have arranged all the articles displayed in these rooms in a glass case. No matter how carefully and artistically they might have been arranged, nor how explicitly the descriptive labels might be gotten up, the average visitor would not carry away with him the details of the mental pictures of those rooms and the purpose and character of the objects displayed therein. (John Rowley, *Taxidermy and Museum Exhibition*, 1925)

Rowley's statement describes the advantages to be gained from a well-executed interior re-creation. As with the exhibition of individual artifacts, such an exhibit can contribute to a better understanding of culture change in America. When the function of a room is at least somewhat clear, critical omissions can be dealt with. It is known

that even people who left sizable estates in 17th-century New England often did not own bedsteads. Beds, the 17th-century term for what we would today call mattresses, were laid directly on the floor. With a room exhibit, this difference can be illustrated and interpreted. The difference is related to what the people themselves felt had value, and clearly bedsteads were rather low on such a scale. If this fact is not taken into account, and a 20th-century view is taken, most if not all re-created bedrooms would include a bedstead, since they did exist in quantities at the time.

Wilcomb's pioneering period rooms had an element to them, however unwittingly arrived at, that would serve as a good model for museum curators of the late 20th century. Since he collected widely and included objects of a broad range of time, his rooms were a wonderful mixture of the new and the old. Adherence to a strict time limitation in a period room's furnishings overlooks the obvious fact that in the past, as today, people had both heirlooms and articles that were brand new. Inventories show this in many cases. Probate records also shed light on the clutter that marked living spaces in earlier times, a clutter that few if any period rooms replicate. Not only does the close adherence to probate records help us to put the right things in the right places, but the variety of objects attests to the different activities carried on in a single area then and now. In his introductory chapter to *A Guide to the Artifacts of Colonial America*, Ivor Noel Hume comments on a Virginia inventory that lists several axes in a lady's bedchamber, and he goes on to remark, quite correctly, that no curator would ever dream of including them in a bedchamber recreation. Yet, if inventories are followed closely and combined with period graphics (paintings, woodcuts and engravings), re-creations can be achieved that strike the viewer with a sense of the exotic. Such re-creations say, "This is a different world; these people did things differently than people today." This realization is a first critical step to an awareness that our national culture has changed profoundly since its beginnings centuries ago.

A number of "period rooms" placed together under a single roof make up a historic house. Historic houses are perhaps the commonest type of historic museum in America today. Nearly every community has one, and it is not unusual to find many in a town of modest size. Unlike period rooms and static, glass-encased exhibits in formal museums, historic houses are often explained by interpreters. Live interpretation is a mixed blessing. Done well, it allows flexibility and positive interaction with the visitor. Done badly, it can be repetitive, stale and uninspiring (even wrong). An affliction that is more apparent in live interpretation than in written text is what might be called misplaced quaintness. The symptom is a tendency to see everything in the past as quaint or very ingenious. This is but one more case of a 20th-century view being imposed on an earlier time. What is "quaint" to us was commonplace to those who did it. To complicate matters, much of the perceived quaintness is a 19th-century legacy. Large numbers of 17th-century historic houses in New England have "borning rooms," where, visitors are told, expectant mothers repaired to give birth. Yet no such term appears in any room-by-room inventory or any other 17th-century primary source. In fact, the idea of such use of space is from a later time. Such semantic and factual distortions work directly against an appreciation of the changes that were worked on society as a whole. In a more subtle way, the use of period dress for interpreters of historic house museums creates a similar distortion. It is confusing to hear a person dressed in 18th-century costume speaking in modern colloquial idiom about what "they" did in the past. (First-person interpretation has its problems as well, but that approach works better in "living history" programs, under certain special conditions.)

Interpreted well, historic houses can achieve a level of explanation not possible with period rooms. Since the entire house, or a large portion of it, is the subject of interpretation, it provides an ideal opportunity to explore changes in building and social space over time. As recent studies of the social and psychological aspects of folk housing, such as Henry Glassie's *Folk Housing in Middle Virginia* (University of Tennessee Press, 1975), make clear, the historic house can become an ideal tool for exploring dramatic changes in the American mind and American society from the 17th century onwards. A hall and parlor house addresses the corporate nature of 17th-century America just as a wooden trencher does, and for the same reasons. The rise of Georgian-inspired central hall houses during the 18th century parallels the appearance of individual dinner plates. These two house types, and variants of them, probably account for the majority of historic house museums in America. Viewing them as containers for people whose ideas about the world shaped them in turn opens an exciting avenue of interpretation.

Explaining a central hall house from this perspective would involve calling attention to the way in which the hall separates the people in the house from the world beyond. This withdrawal by the inhabitants from the community contrasts with the practice, typical of houses in an earlier time, of having direct access into the hall, or main working room of the house. The trend again is toward privacy, and central hall houses no larger than their hall and parlor antecendents were usually more divided within, producing both specialized and private spaces.

Earlier hall and parlor houses can also be interpreted in terms of room function. If probate inventories are consulted, the furnishings of each room will probably look quite different, and the parlor's role as a social and quasi-ceremonial room can be stressed. By comparison, the furnishings of the hall (usually a room that housed a number of functions, mostly of a technical nature) can create a strong contrast. While some of this space use resembles that of today – parlors have only recently vanished from the American house – the strict separation of functions tended to be more distinctive of 17th- and early 18th-century building use. Both of these examples of interpretation stress cultural change and transformation, and both use a combination of houses and furnishings to impress the dimension of this change upon the visitor.

The most ambitious of America's historic museums are the full-scale community re-creations, such as Colonial Williamsburg, Old Sturbridge Village, Conner Prairie and Plimoth Plantation. All that has been suggested relating to artifacts, room re-creations and house interpretation applies to these museums as well. Another dimension is added, however – that of exterior space and the relations between structures. Such re-created communities have the potential of conveying the strongest sense of change in America since its early years, but, at the same time, the highest possibility of failure if not done with skill and a feeling for the time that is being represented. A community re-creation can immerse the visitor in the entire world of the past, or at least some approximation of it. In truth, the possibility of any such simulation being true to what it is attempting to re-create is exceedingly slim. There are just too many variables that are beyond control. If Myles Standish were to reappear in modern Plimoth Plantation, it is certain that he would not quite know where he was, any more than James Geddy would recognize resurrected Williamsburg as the town where he had worked. But in each case, one would like to think, and with good reason, that such time travelers would feel at home. Again, the differences that centuries of change have worked on the American physical and social world are more important to convey to the public than the way earlier American communities were similar to ours of today.

Creating this kind of ambience is a difficult task. In the case of full-scale community re-creations, a whole slice of the world is being simulated. Unlike traditional museums and their period rooms, or historic houses, the exhibit statement is no longer being made within walls. This difference requires that the space surrounding the buildings in the community be made to appear as we know such areas did in the past. Once again, in many cases, 20th-century landscaping concepts are applied, including carefully mowed grass, foundation plantings around houses, and small garden plots, which seem to grow little more than an assortment of herbs and flowers. Such a treatment of grounds conveys a false sense of the past – prettified and clutter-free. Anyone who has done archeological excavation around a 17th- or 18th-century house knows well that the amount of exterior clutter must have been far more than we are usually shown in "living history" communities.

Interpretation in a community re-creation also has its special problems. The problem of interpreters clothed in period dress while speaking in third person applies here as well. One approach that seems to correct the paradox is to involve the interpretive staff in as many tasks as possible in a genuinely productive way. If the interpreters have done most of the things they are supposed to discuss, they will automatically employ first-person interpretation in a natural way. After all, if one has been riving shingles to attach to the roof of a house, it is more natural to say "*we do* it this way" than "*they did* it that way." The shift from third-person past to first-person present, if done well, goes a long way toward making the interpretation convincing to the visitor. After all, if the visitor is given to believe that the houses are the way they were, why shouldn't the interpreters also fit into this plan? Such considerations naturally lead to first-person interpretation in a systematic format, or "role playing." That approach has been in use at Plimoth Plantation for several years, and the effect has been excellent. It requires that interpreters keep actively busy at all of the tasks that life in the community required in the past. Interpreters actually build houses and outbuildings as an interpretive activity (thus, exhibits are built more economically); they cook food, and even eat it in period fashion. They often get dirty and tousled in their work in the fields and houselots, but the sense of reality is truly impressive. It is significant that demonstrations do not work in this context, if demonstration is taken in its usual sense as the constant repetition of a single process. Such repetitive action, whether dipping candles only to melt them again for the next turn, or splitting hundreds of rails, none ever to be used, is damaging to morale. Much better to involve the interpreters in productive activities *when needed*. It is much more faithful to the real world as it was, since early Americans did not demonstrate crafts in their houses.

All of these considerations lead to the conclusion that effective "living history" must be just that. Every effort must be made to create a world so convincing that the visitor comes to it much as an anthropologist would come to a community that he wanted to study. Only then can a historical re-creation on the scale of a whole community be used effectively to convey a sense of cultural change. All of the pieces must fit systematically. A re-created community is far more than a collection of historical houses, each interpreted on its own. The community is a single exhibit, and must be treated as such. Live animals and their droppings, dusty streets, the smell of wood smoke and cooking, and the sound of active workers all contribute to the reality that we who work with such re-creations wish to achieve. Done well, such an exhibit has no equal in placing visitors in another time and giving them a sense of the great and complex change that has marked the progress of American culture.

Chapter 38 | Lisa G. Corrin

Mining the Museum | Artists Look at Museums, Museums Look at Themselves

If the love of art is the clear mark of the chosen, separating, by an invisible and insuperable barrier, those who are touched by it from those who have not received its grace, it is understandable that in the tiniest details of their morphology and their organization, museums betray their true function, which is to reinforce for some the feeling of belonging and for others the feeling of exclusion.

<div align="right">

Pierre Bourdieu and Alain Darbel,
The Love of Art: European Art Museums and Their Public

</div>

> History, despite its wrenching pain,
> Cannot be unlived, and if faced
> With courage, need not be lived again.
>
> <div align="right">Maya Angelou,
On the Pulse of Morning, 1993</div>

To speak of the ideological apparatus underlying museum practices is to speak of the relation among power, representation, and cultural identity; of how history is written and communicated; of whose history is voiced and whose is silenced. Behind their often-cavernous halls of cultural relics, museums are places where sacrosanct belief systems are confirmed on the basis of hierarchies valuing one culture over another. Art and artifact, style and period, high and low, dominant and marginal – these are the boundaries museums rely on to sustain "society's most revered beliefs and values."[1] This tidy formula for codifying human experience has provided museums with a comfortably detached position from which to observe the revisionist dialogue that has reshaped art history and cultural studies over the past decade. Until recently, the museum community has been resistant to the issues raised by this dialogue, fearful, apparently, of controversies that have always arisen whenever critical art history has been translated into museum practice.[2]

However, it has become increasingly difficult for them to sustain this detachment because museums are in the midst of a severe crisis of identity. Shrinking resources, bouts over the First Amendment, pressures by native populations to return their cultural heritage, and calls for a renewed commitment to multiculturalism have raised a host of questions about the purpose of museums; the definition of "audience"; and the process by which critical decisions of acquisition, conservation, interpretation, and presentation are made.[3] Under enormous pressure, the museum community has been forced to consider the relation between what it does and the historical, political, and social context in which it operates.[4] "What am I?" asks the museum today. "If I am not to be a metamuseum, interred within my own history, what do I do?"[5]

Thus with much breast beating, the American museum has lately performed a public purge of its past, owning up to the social inequities it reinforced through its unself-critical practices. Reinstallations of permanent collections and museological exhibitions have extended the dialogue outside the museum profession to include museum audiences, inviting them to join in a "group therapy" exercise aimed at recharting the futures of these institutions. Since 1990, the National Museum of Natural History has been involved in a seven-year effort to bring a greater degree of consciousness to the museum visitor about the ways in which our views of the natural world and the "family of man" are skewed by the language of the museum. Interim "dilemma labels" have been designed to negotiate the "outdated" displays until the collection can be reinstalled. These labels openly admit to past racist, sexist, and colonialist attitudes on the part of the museum. For example, a lioness depicted passively reclining in the shade with her cubs while the male gazes at a prospective hunt, a group of zebras in the distance, implies that only the male is the hunter in the pride. The "dilemma label" points out the contradiction between the original label, which states that the female is the primary hunter in the group, and the viewer's perception, which suggests otherwise. The project is particularly aimed at exposing and discouraging the tendency to exoticize other societies in order to maintain a colonialist domination over them.[6]

Art/Artifact (1988), at the Center for African Art in New York, was a seminal project which argued that museum practices rather than just museum objects are a legitimate subject for an exhibition. Art/Artifact showcased typical environments created by museums to display collections and pointed out the various ways our perceptions of the "other" are governed by those environments. A smaller exhibition, Worlds in Miniature, Worlds Apart (1991–94), at the Peabody Museum of Archaeology and Ethnology at Harvard University, explored the use of dioramas, models, and mannequins in exhibits at the Peabody through the beginning of the twentieth century. This history of museum techniques also included a discussion of how the perceptions of the anthropologists who worked in the heyday of the museum's development guided the museum's representations of native New World cultures. Because the exhibit was mounted during the redesign and reinstallation of the Peabody's permanent galleries, one surmised it was intended to supply a counterpoint to the new presentation of the museum's permanent collections. Into the Heart of Africa focused on the history of the museum's African collection and documented the means by which particular objects found their way into the museum – in this case, primarily through missionaries and colonial officers.[7]

Other revisionist readings of collection and exhibition practices by art museums include The Desire and the Museum (1989) at the Whitney Museum of American Art, Downtown (1989), Art Inside Out (1992) organized by the Department of

Education at the Art Institute of Chicago (1992), and A Museum Looks at Itself: Mapping Past and Present at the Parrish Art Museum, 1897–1992 (1992). The Desire of the Museum illuminated the subliminal subtext of the museum, exhibiting contemporary art about the institution using visual and textual devices that revealed the unconscious agendas of the curators and the audience as part of the exhibition. Art Inside Out introduced a contextual treatment of a concise selection of objects both as "art" *and* as historical artifacts. A preface to the exhibition provided a behind-the-scenes view of how objects get into collections and raised questions about how choices are made and by whom. The Parrish exhibition incorporated objects once esteemed by the museum's founder into new, critically reflexive displays in "an attempt to examine the museum itself as a historical artifact."[8] The exhibition looked at the way in which the values and political stances of those in power dictated the collecting practices of the museum, which is located between an elite summer playground and a year-round rural community that is home to many Native Americans and other people of color.[9]

Whether the Museum of Man or Art Inside Out, the objective of these exhibitions has been to demystify the museum institution, to raise questions about the relationship among power, context, reception, and meaning. While updating labels and dioramas or historicizing the museum is no doubt valuable, are these changes enough? Museums must consider the infrastructure and value systems that generated prejudicial practices to begin with and *use* this self-study to change daily practices in programs, management, and governance. The "new museology," or critical museum history, argues that we cannot separate the exhibition from the museum or the method from the meaning of the institution. It is time for a radical examination of the museum's role in society, or else museums are likely to "find themselves dubbed 'living fossils.' "[10] This means broadening the definition of who is "qualified" to offer alternative paradigms for the museums of the future.

In their continued efforts at self-examination, museums might also consider the work of artists who have already attempted broad critiques of the institution or of the social "frame" that makes art "Art." Since Duchamp signed an ordinary urinal, *Fountain* (1917), the uneasy relationship between art and its contextual frame has been a distinct subject matter for artists.[11]

The early conceptual art and earthworks of the 1960s and 1970s strove to collapse the boundaries between the "white cube" and the world. Members of the Fluxus group, for example, "were bent on subverting the very notions that are central to a museum's identity: permanence, posterity, quality, authorship."[12] Daniel Buren also wrote substantial treatises on the function of the museum in preserving, collecting, protecting, and giving status to works of art, questioning, as did Fluxus artists, whether art can exist independently of the institutions that support it.[13] Beginning in 1968, Buren placed his painted striped canvases in everyday contexts to consider "the gap between an art and non-art context."[14] Robert Smithson, whose *Spiral Jetty* transcended the boundaries of the museum environment, took a critical position on museums in his writings. To Smithson, the work of art must resist the aesthetic anemia induced by the antiseptic whiteness of the gallery walls. He predicted that "the investigation of the apparatus the artist is threaded through" would become a subject of art itself.[15]

This was indeed what transpired. During the 1970s and 1980s it became a given that the white cube could no longer be regarded as a neutral space.[16] Work by Michael Asher, Louise Lawler, Judith Barry, Andrea Fraser, and Hans Haacke, among others,

have critiqued the power structures, value systems, and practices governing galleries and museums and illustrated how context is inseparable from the meaning of an art work and the meaning of the museum experience itself.

How individual choices "frame" the meaning and perceived value of objects has been the subject of work by Michael Asher and Louise Lawler. Asher's installations in museum settings, such as projects at the Museum of Contemporary Art (Chicago, 1979) and the Art Institute of Chicago (1979), have consistently questioned assumptions inherent in museum presentation, turning the museum process inside out and questioning the contradictions between art and its context. Lawler's photographs of "icons" of modernism as well as her installations using objects from permanent museum collections also consider how the context of the museum, the private collection, or the commercial gallery confers meaning on objects and governs our relationship to art. For the exhibition A Forest of Signs (1989), Lawler exhibited her choices from the permanent collection of the Los Angeles Museum of Contemporary Art, adding her own photographs, labels, printed cards, and paperweights. The project placed a selection of well-known modern art objects from the collection in unexpected contexts, inviting the viewer to ask questions about his or her relationship to the works.

The exhibition Damaged Goods: Desire and the Economy of the Object (1986), at the New Museum of Contemporary Art, brought together art works that examined what the critic Hal Foster called the "art/commodity dialectic." The exhibition design was an "intervention" by artist Judith Barry, known for her highly theoretical environmental installations that focus on the structure of the relationship between art objects and the viewer. In the case of Damaged Goods, Barry drew on the language of the "highly orchestrated environment" of the department store, thereby underscoring the complicitous relationship between artists/museums and the marketplace.

The silent agenda of the museum was further explored in this exhibition by Andrea Fraser, alias "docent, Jane Castleton." Fraser provided guided "tours" not only of what one sees in the museum but also what is not readily exposed: the implications of the preoccupation with protecting works of art. Her "tour" of the museum's security systems raised questions about the connection between protecting artifacts and destroying cultures. Fraser's audio installation for the Austrian pavilion at the 1993 Venice Biennale considered how nationalistic agendas are expressed through a museum's choice of objects as representative of a particular culture. The piece consisted of conversations by visitors commenting on other pavilions – not on the works of art they contained but on this hidden nationalistic agenda.

Hans Haacke's explorations of "what the benevolent facade of cultural patronage is intended to conceal" take full advantage of the museum vocabulary: museum banners, excerpts from public relations materials, board lists, and packing crates.[17] Haacke's work traces the movement of art through the art world "system," a system governed by social, economic, and political interests.

Recently there has been a reconciliation between artists and the museum, suggesting that, "notwithstanding its ideological characteristics," it "might still be preferable to much else as a space for imaginative, contemplative, and critical experiences."[18] Indeed, artists have returned to the museum, no longer just looking at it as the "apparatus the artist is threaded through" but using its format to create their own "exhibitions" and "museums," or acting as "curators," manipulating permanent collections to question the boundaries of the museum and its usefulness for addressing contemporary aesthetic and social issues.

Orshi Drozdik creates collections of objects reminiscent of those found in the first science museums – objects that resemble inventions, experiments, and models. Drozdik's work has often focused on the inadequacy of scientific language and investigation to describe physical phenomena. Works such as *Natural History – Botanic, Tubuli (Naming Nature)* (1989), and *Adventure in Technos Dystopium* (1986–89) use as their basis a virtuoso display of the artist's knowledge of eighteenth- and nineteenth-century science, including its paraphernalia. In addition, the resemblance of her objects to actual antiques gives them a sense of authenticity. Consequently, her work causes one to meditate on "the fate of all things to end up as curiosities in an unknowable future" – not unlike what happens in the average museum.[19]

Mike Kelley's *The Uncanny* (1993), created for Sonsbeek '93, included historical artifacts, photographs, art objects, toys, and film stills all linked by their oblique reference to the current vogue for exhibitions about the body. Showing blatant disregard for traditional categories of objects and taste, all of the objects, artfully arranged, were given the same value and importance. Their sheer quantity numbed the viewer to the obvious fetishistic quality of the artifacts. By extension, Kelley's installation became an ironic metaphor for the fetishizing of curators.

If artists as curators of their own exhibition is no longer uncommon, neither is the artist-created museum or collection. Early examples include Marcel Duchamp's *La Boîte-en-Valise* (first version, 1941), Marcel Broodthaers's *Musée d' Art Moderne, Département des Aigles* (1968–1972) and the Fluxus Group's invented museums, which existed on paper or in concept but nowhere else.

The artist-exhibition, an installation with the characteristics of a "real" exhibition, often takes museology as its theme. Barbara Bloom's *The Reign of Narcissism* (1989) was a parody of a famous writer museum using what appeared to be a collection of furniture and miniatures belonging to a "great" author. Images of the artist herself took the form of chocolate cameos, porcelain teacups, and a leatherbound set of books with the artist's name on their spines. This "vanitas exhibition" illustrated the complicity of the artist and the museum in perpetuating myths of authorship.

More recent artist-created museums include Christian Boltanski's *Inventory of Objects Belonging to a Young Woman of Charleston* (1991) and *La Réserve du Carnegie International 1896–1991* (1991), Sophie Calle's *Ghosts* (1991–92), Lawrence Gipes's *Century of Progress Museum* (1992) and Ann Fessler's *Art History Lesson* (1993). Judith Barry has even posited a museum entirely in the mind. As part of the 1991 Carnegie International, she created a mnemonic museum, one created within the memory, using an ancient recall system activated by the viewer.[20]

These artists use museological practices to confront the ways in which museums rewrite history through the politics of collecting and presentation. However, their work often inadvertently reasserts the validity of the museum. A case in point is *Incident at the Museum, or Water Music* (1992) by Ilya Kabakov. Kabakov's fictitious Barnaul Art Museum was home to the works of Stepan Yakovlevich Koshelev, an equally fictitious social realist painter. Water leaked from a damaged roof over the Barnaul's dark, luxuriant, and deserted spaces. The viewer could not separate Koshelev's art from the dank surroundings and the music created by the dripping water. Only in the quiet of the museum could this "orchestral event" be experienced. Kabakov's installation questioned the validity of painting, but it also affirmed the sanctity of the museum. Commenting on the importance of its sacred quality, Kabakov insists that this work "does not treat museums ironically. It is an apotheosis of the museum and should be considered as such."[21]

One particular artist-museum goes further than any other in resisting the critical vocabulary of either museology or museumist art. With its official nonprofit status, engraved formal letterhead, museum shop, and exhibitions with "scholarly" publications, David Wilson's storefront Museum of Jurassic Technology in Los Angeles provides all the evidence required to pass muster as a "proper" museum. In its usurpation of museological language and its defiance of the objective rationalism of the modern museum, Wilson's museum validates the contradiction, ambiguity, and idiosyncracy found in early natural history museums, with their relics, curios, and specimens. Wilson's method is to lead the museum visitor from the familiar to the unfamiliar by presenting quasi-scientific exhibitions that redefine the concept of what knowledge is. It achieves this by caricaturing traditional scholarship and re-invoking the slightly sham oddness and exhibitionism of early museological ventures: the displays of relics and curiosities in medieval parish churches (such as the Abbey of Corbie), universities (such as Leyden), and early public collections (such as Elias Ashmole's and, of course, Mr. Peale's museums). But Wilson also subverts postmodern notions of a metamuseum. Is his curiosity collection the first serious museum of museology? An anachronistic rendering of eighteenth-century science museums? A parody of "museumism"? Wilson has shrewdly contrived to so thoroughly conflate the boundaries of his institution as a museum of science and as a postmodern art installation that the Museum of Jurassic Technology defies critical language.[22]

It is now common for artists to "raid the icebox" – as Andy Warhol did at the Rhode Island School of Design Museum in 1970 – curating exhibitions drawn from the museum's permanent collection and using personal criteria to determine what will be seen and how. Drawing from the museum's storage vaults, Warhol found in the inaccessible and over-stuffed closets of objects a treasure trove of endlessly fascinating bric-a-brac – the more ordinary the better. His exhibition included jars, shoes (slippers, pattens, mules, oxfords, pumps for the opera, pumps with straps, colonial pumps, wedding pumps, riding boots and ice skates, sandals and socks, storm rubbers, bathing shoes, tennis shoes, clogs), parasols, Windsor chairs, and other nearly forgotten bits and pieces that hadn't seen the light of day in decades. Warhol chose merely what he liked, his actions mimicking the subjective criteria of the curatorial staff. He was very specific about his requirements, requesting that catalogs for each item include as much data as possible. In the end, Warhol's own choices became part of the registrar's files on each object and thus "part of their ever expanding meaning."[23]

The objective of *At Home with the Collection* by Simon Grennan and Christopher Sperandio (1992) was also to show that the selective criteria used by museum curators are in fact based on personal taste and judgment. The series of three projects used the permanent collection of the Lakeview Museum of Art in Peoria, Illinois. The artists asked members of the museum staff to select their favorite object from the collection and choose a site for it in their own home. In February 1992 the objects were removed from the museum to the chosen home sites and were photographed for a follow-up exhibition. In addition, the artists devised "The Lakeview Questionnaire," requesting staff to respond to personal questions about their work, tastes, habits, and emotions. Charts and graphs of their responses were hung in the galleries.[24]

Joseph Kosuth's pointed political installation, *The Play of the Unmentionable* (1992), resembled a traditional exhibition, juxtaposing wall texts and objects from the Brooklyn Museum's permanent collection to review the history of art censorship in the wake of the American "culture wars" over National Endowment for the Arts

funding. To create this "exhibition," Kosuth culled artifacts from many departments of the museum, crossing cultures and time periods, acting as both artist and curator. The result clearly illustrated that by deploying rather than denying its position as a site of ideological contest, the museum provides an arena for engaging contemporary issues.

For Sonsbeek '93, Mark Dion worked with the collection of the Bronbeek Royal Veterans Home, a quirky repository of objects that related to Dutch colonialism. His two-part installation juxtaposed a historical re-creation of a curiosity cabinet restored to its original arrangement (using an antique lithograph of an identical cabinet as a blueprint), with another cabinet substituting objects owned and chosen by veterans still living in the home. Dion's activity transformed a fruitless effort to objectify an essentially unclassifiable group of static objects into a "living" museum in which the remaining veterans and their personal associations played a crucial role.

In 1993, the Museum of Contemporary Art in Ghent presented Rendez(–)vous, a series of "curated" mini-exhibitions using a collection of favorite personal objects donated by the local citizenry. In an open invitation, residents of Ghent brought their valued mementos to the museum and told the stories behind the objects. The museum, in turn, offered the objects to artists Ilya Kabakov, Henk Visch, Jimmie Durham, and Huang Yong Ping, who were asked to discover new relationships between the objects through exhibitions of their making. Like other installations using permanent collections, Rendez(–)vous considers the function of the museum in structuring our relation to art and to culture.

In a slight twist on artists working with collections to create their own art, the Austrian Museum of Applied Arts in Vienna (MAK) invited ten contemporary artists to reinstall the museum's permanent collection (1986–1993). The MAK project brought these artists and its curators together in order to bring new perspectives to the objects in the collection. According to the museum's director, Peter Noever, the artists pursued personal display and interpretation strategies, while remaining mindful of their primary task – to add a contemporary dimension to the viewing experience without "self presentation."[25] The artists in this project achieved a parity with the curatorial staff.

What are the implications of such activities? From dissecting the museum apparatus to mastering it on its own terms, artists have not only returned to the museum as a site of activity but have also reshaped the institution in permanent ways that will affect the ways audiences see collections in the future.

Yet these types of projects and installations – The Museum Looks at Itself or The Artist Looks at the Museum – have formed a veritable movement within museums that students may well find termed "museumism" in the next edition of H. W. Janson's *History of Art*. This genre, "built on the museum's ruins," has increasingly become politically neutralized, now coexisting comfortably within the archetypal white cube it intended to critique.[26] In short, as a result of being called art, acquired for the collection, and exhibited like a Matisse or a Chippendale chair, artwork that laid political and ethical landmines to explode the ideological apparatus of museums is often defused.

Although critical in nature, these museum-based works have had to avoid direct discussion of the relation of a commissioning museum to issues of race, a subject that most museums would prefer to sidestep.[27] This should hardly be surprising, for, as Maurice Berger has pointed out, "most art museums offer little more than lip service to the issue of racial inclusion. Art that demonstrates its 'difference' from the

mainstream or that challenges dominant values is rarely acceptable to white curators, administrators, and patrons."[28]

Fred Wilson's *Mining the Museum* attempts to address this challenge by examining the ideological apparatus of the museum in general and by exploring how one museum in particular has ignored the histories of people of color. Wilson's method, as an artist-in-residence, was to study closely the Maryland Historical Society's collection of art and artifacts, read extensively in the society's archives, and then install objects of his choosing so as to raise questions about the ways museums represent (or fail to represent) African-Americans and Native Americans. The entire third floor of the society was given over to the installation, which featured well over one hundred objects.

Mining the Museum examined how the Maryland Historical Society defines itself and how this self-definition determines whose history has been included (or excluded) in its narrative of Maryland history. It also addressed how those excluded have come to view the museum. The project dealt with the power of objects to speak when the "laws" governing museum practices are expanded and the artificial boundaries museums build are removed. It considered how deconstructing the museum apparatus can transform it into a space for ongoing cultural debate.

Wilson's exhibit represented a departure from the "museumism" genre. For it is one thing to talk about race and museums in an alternative space or a hip commercial gallery, but it is quite another to address it in an established museum by using its own collection and its own history.

Wilson's insights into the ways museums shape our understanding of cultural artifacts first surfaced in his Rooms with a View: The Struggle Between Culture, Content, and Context in Art, an exhibition he curated for the Bronx Council of the Arts in 1987–88. Each of three distinct spaces in the installation simulated display environments referring to different types of museums: ethnographic, Victorian "salon," and the minimalist space of a contemporary gallery. In each room Wilson placed different works by thirty artists, surrounded by the accoutrements appropriate to the specialized space. The "ethnographic museum" grouped objects according to type, with vague labels identifying the artistic medium but not the maker. The "Victorian museum" gave the objects a rarefied disposition, suggesting precious, antique objets d'art set on ornate pedestals. The "white cube gallery" gave the works the necessary "cutting-edge" mystique to certify them as contemporary art. The new contexts so thoroughly transformed the audience perceptions of the artwork that Wilson decided to take on the museum itself in his own work. Describing his reasons for choosing the museum as his aesthetic preoccupation, Wilson said, "It is there that those of us who work toward alternative visions receive our so-called 'inspiration.' It is where we get hot under the collar and decide to do something about it."[29]

His next series of installations employed a mock exhibition format, using reproductions and artifacts that he coyly manipulated to parody curatorial practices. Wilson acquired his "museum collections" from street vendors and occasionally castoffs from the deaccessioning process through which museums cleared their basements of Victorian exhibition gear, politically incorrect dioramas, and taxidermic objects. Wilson's working method made "use [of] the whole environment of the museum as my palette, as my vocabulary. I sort of look at everything and try to distill it and re-use it [to] squeeze it of its meaning and try to reinvent [it]."[30]

Visitors to *The Other Museum*, (1990–91) at White Columns and the Washington Project for the Arts viewed African trade masks blindfolded with the flags of French

and British colonizers. Others were labeled "stolen from the Zonge tribe," highlighting how museum euphemisms whitewash the acquisition of such objects. These "spoils" were displayed in dramatic colored spaces with theatrical lighting, sometimes animated with the addition of video special effects.[31] This method, according to Wilson, illustrated how the aesthetization by museums "anesthetizes their historic importance...certainly covers up the colonial history...which keeps imperial attitudes going within the museum."[32] The project also displayed "The Last Ancestor from the Last Excavation of the Last Sacred Burial Site," "The Vertebrae of the Last Large Mammal," and "The Last Murdered Black Youth," created just after the murder of Yusuf K. Hawkins in Bensonhurst, Brooklyn. Wilson used the face of one of the Scottsboro boys in "Murdered Black Youth" because he "was interested in the connection between abuse of African-American men over a period of years, over a history of the United States and of course now with Rodney King it's all the more poignant."[33]

Wilson's *Primitivism: High and Low* (1991), at Metro Pictures Gallery, parodied two controversial exhibitions at the Museum of Modern Art, Primitivism in 20th Century Art and High and Low, in addressing how museums think of "the cultural other," that is, nonwhite, non-Western peoples and their histories. A group of skeletons, "friendly natives," were labeled "Someone's Mother," "Someone's Sister," and so on to recall the controversy over returning human remains to native populations and the loss of humanity that necessarily occurs when museums exhibit them as mere objects. In "Picasso/Who Rules?" the figures in a reproduction of Picasso's *Les Demoiselles d'Avignon* wore tribal masks. Viewers peering into their eyes were met by eyes of two Senegalese people and Wilson on a videotape asking such questions as, "If my contemporary art is your traditional art, is my art your cliché?" and, "If your contemporary art is my traditional art, is your art my cliché?" "If the world is so small," Wilson asked, "how can we come up with a new way of looking at art using all the philosophies and...histories about art to create something really new and vibrant?"[34]

Another of Wilson's pieces, *Guarded View*, posed black mannequins in museum security uniforms on a display platform, a reminder of the invisible role played by people of color in museums. Remarked Wilson, "The majority of museum guards... tend to be African-American...Many of the museums on the East Coast pride themselves, and get...funds...for having such large minority employment. But actually all the employment is in the guards, and the fact that they're in that level of the museum and not on the upper [management and governance] levels, affects the kind of artwork that's displayed and the kind of visitor that comes through the door."[35] A year later, Wilson created a performance on the same theme at the Whitney Museum of American Art. Invited by the museum to give a tour to the staff and docents, he greeted them and arranged to meet them elsewhere in the museum. Changing into a guard's uniform, Wilson took up a post in the room where the group was waiting for the artist they had met just a few minutes earlier. He was suddenly invisible to them; the docents paced in the galleries anxiously looking for him, walking by him time and again. Wilson exposed his ploy by identifying himself to them later. This performance proved that the point of *Guarded View* was irrefutably accurate.

Mining the Museum was a departure from Wilson's working method in several ways. The project would provide him an opportunity to take his museological message into a traditional historical museum, working with actual artifacts for the first time. The

participating institutions would also regard Wilson not only as an "artist" but as a project director on staff, with control over the final conception and design of his "exhibition." Nor would Wilson create a "generic" museumist installation; his product would explore the specific history of the host institution. And, finally, the project was intended to provoke dialogues *within* museums, not only *about* them.

The idea for *Mining the Museum* first arose in May 1991, when The Contemporary, a young "roving museum," was about to open an exhibition in a former Greyhound terminal abutting the Maryland Historical Society's parking lot. Its staff had an informal meeting with the executive director of the society, who spoke openly about his desire to bring his traditional historical institution "up-to-date." He expressed the need to reflect current concerns and public interests, and he was seeking ways to develop an audience that reflected the cultural diversity of the community. He made an off-the-cuff suggestion that The Contemporary and the Maryland Historical Society – two very different institutions, indeed – might someday find an opportunity to work together.

Not long afterward, The Contemporary invited Wilson to Baltimore to create an installation using the permanent collection of one of the city's museums. This type of project ideally suited the mission of The Contemporary, which aims to disrupt expectations and definitions of museums with each project it undertakes. Opting to program without a collection or permanent space yet calling itself a "museum," it has mounted exhibitions in an abandoned bus garage, an old Buick dealership, a deserted dance hall, and the bed of a 1959 Chevy pickup truck.

Wilson visited many of Baltimore's museums, but he chose the historical society, remarking later that when he walked through the front door the first time he said to himself, "This is it." The Contemporary returned to the Maryland Historical Society, suggesting they jointly sponsor a year-long residency by the artist with a view toward presenting a collaborative project for the American Association of Museums conference. The Contemporary intended for *Mining the Museum* to be designed to address the "crisis of identity" facing museums in the most direct way possible and to offer a particular, localized model for change.

The "meaning" of *Mining the Museum* cannot be separated from the museum in which it took place. Incorporated in 1844, the Maryland Historical Society was founded to collect, preserve, and study objects and documents related to the state's history "in reference to any remarkable event or character, especially biographical memoirs and anecdotes of distinguished persons." This mission included histories of "colonization, slavery and abolition" and "any facts or reasoning that may illustrate the doubtful question of the origin of the North American tribes."[36] Yet the museum intended to tell those histories from the point of view of the society's all-male founding board. They conceived of the institution as "a club...serving their social and intellectual needs." Its first exhibitions were presented exclusively for members. In keeping with "the social aspects of the original Society...membership has expanded" in this century, according to a past president writing in 1987, "to include women and children."[37]

The Maryland Historical Society is similar to many of the nation's first historical societies, which appeared in the decade just after the American Revolution. These institutions, founded by amateur historians and naturalists from "distinguished" families, were created as a response to the circuslike environment of dime museums.[38]

Thus, the Maryland Historical Society's early collecting efforts reflect a "gentleman's" interests of the antebellum era, focusing first on honoring the memory of

Maryland's revolutionary statesmen, since the institution's founding members were the descendants of the state's patriots and military heroes. Greek vases, models of ships, seashells, butterflies and phenomena of the natural world, coins, autographs, diaries, maps, genealogical tables, and family papers were also donated. Portraits of these statesmen, business leaders, and other members of the social, political, and cultural elite stand guard in the galleries.[39]

Today, the collection on display strictly follows the Winterthur tradition, with furniture, silver, and other domestic objects exhibited as "decorative arts." Their preciousness is enhanced by the cosmetic assistance of lighting, fine-fabric backdrops, and various mounting devices that elevate them above and beyond the reach of visitors. Although the chief curator is committed to collecting contemporary material culture, there is little to none in evidence on a regular basis. Women are represented by handicrafts, period fashions, historical portraits, and a collection of paintings by Sarah Miriam Peale. Scant attention is paid to nonaffluent or nonwhite communities. No reference is made to the civil rights riots that devastated Baltimore in 1968–69. In fact, reference to the African-American experience comes by way of two vitrines devoted to jazz musician Eubie Blake, where an outdated push-button device plays a minute's worth of his music on cue. The slave system that divided the state in the Civil War is but briefly cited in a room entitled "Blue against Grey." The life of freed blacks is referenced in a painting in the maritime collection of Isaac Myers, the first African-American owner of a Maryland shipyard. The Darnall Children's Museum, filled with dioramas and interactive puzzles for young audiences on important events in Maryland history, contains virtually the only other mention of people of color in the museum. The teaching section includes information about the underground railroad, slavery, and native populations. This, then, was the situation to be mined or "undermined" by Wilson when he began regular visits to the museum in the fall of 1991.

When staff from The Contemporary presented the idea of working with Wilson to the society's director, they sought agreement on the following ground rules. The Maryland Historical Society would not refuse Wilson access to any part of the collection and would accommodate whatever requests he made, and Wilson would become part of the project staff, wearing whichever hats were required: curator, registrar, archivist, director, or trustee. He was ultimately given the office space of the president of the board of directors as a "studio" for his residency, a symbolic gesture that did not elude him.

It was critical to the project's success that both institutions be willing to relinquish their control as part of the collaborative process. Rather than work with existing staff who already had a set vision of the collection, The Contemporary arranged that Wilson be assisted in his research by independent volunteers with expertise in African-American local and state history, astronomy, and museum history. The result was that Wilson excavated important new information about objects and, in several cases, discovered objects not known to exist by any museum staff. Close to one hundred individuals ultimately worked with the artist.

The museums broke with the usual practice of having the education staff create didactic materials before the opening. Relinquishing power also meant making no assumptions about what the audience needed or wanted to know about *Mining the Museum*. Thus, several weeks into the exhibition schedule audience "experts" were polled. Guards, volunteer guides, the receptionist, and the gift shop manager were asked to help make a list of the most commonly asked questions about the installation. From their responses, a simple photocopied handout was developed.

Wilson's manipulation of the museum, and of the audience's assumptions, began at the entrance to the building. The signage for *Mining the Museum* juxtaposed the expected with the unexpected through the guise of familiar museum language. A red, green, and black exhibition banner hung beside the official museum sign announced to "other" audiences that "another" history was now being told inside. Then, in a brief videotape shown in the lobby, Wilson defined the museum as a place "where anything can happen," a space designed to "make you think, to make you question." He asked the visitors to consider what had changed as a result of his mining the museum.

The video also functioned as a "signed curator's statement." The artist declared that the installation represented *his* vision of the Maryland Historical Society. In various statements, he has emphasized the need for museums to validate the personal perspective. "Whether they admit it or not, curators bring who they are to the creation of exhibitions." It is personal history that forms the basis of a lingering engagement with the past. Objects, he argues, become "generic and lifeless" outside this context. To develop *Mining the Museum*, Wilson himself began with his own history. As he described his working process, "I go in with no script, nothing whatsoever in my head. I try to get to know the community that the museum is in, the institution, the structure of the museum, the people in the museum from the maintenance crew to the executive director. I ask them about the world, the museum, and their jobs, as well as the objects themselves. I look at the relationship between what is on view and what is not on view. I never know where the process will lead me, but it often leads me back to myself, to my own experiences."[40] Wilson's fear of imposing a personal moral statement on others led him to use the questioning process as the organizing principle of his work so that the visitor looks at *Mining the Museum* and asks "Where am *I* in all this?" in relation to Wilson's vision.

When the audience exited the elevator, they literally stepped into Wilson's artwork. In the first room, a silver-and-gold "Truth Trophy awarded until 1922 for Truth in Advertising" encapsulates the issues at the heart of *Mining the Museum*. The trophy, surrounded by "acrylic mounts, maker unknown, c. 1960s," sits between three white pedestals bearing white marble busts of Napoleon Bonaparte, Henry Clay, and Andrew Jackson (none of whom had particularly significant impact on Maryland history) and three vacant black pedestals labeled Harriet Tubman, Benjamin Banneker, and Frederick Douglass (all Marylanders). Where are the busts of these prominent personages? Did no one see fit to "collect" or commemorate them? Whose truth is on exhibit at the Maryland Historical Society? Whose history is being told? Who writes it? Who owns it?

In an adjoining room, Wilson addresses his Native American heritage. Cigar store Indians turn their backs to the viewer and confront photographs of "real" Indians. A label, "Portraits of Cigar Store Owners," implies that the lumbering wooden figures tell us more about the stereotypes held by their owners than about Native Americans.[41] In a case labeled "Collection of Numbers," arrowheads are used as display devices to exhibit acquisition numbers, a reversal of the usual hierarchy. The museum's compulsion to amass objects, privileging their collecting, cataloging, and classifying, says far more about the pathology and value systems of the curators than about native communities. Thus, Wilson also establishes that *Mining the Museum* will explore not *what* the objects mean but *how* they mean.[42]

In the next room, Wilson literally gives "voice" to those left out of the museum's historical narrative and restores their identities. When a viewer steps toward four

dimly lit paintings, spotlights and hidden sound effects are triggered to highlight the African-American children represented. A boy asks, "Am I your brother? Am I your friend? Am I your pet?," alluding to both the metal collar he wears and the biblical quotation, "Am I my brother's keeper?"[43] Two black boys tucked into the upper and lower portions of a painting of white children (a stock device for balancing the central composition in classical group portraiture) whisper, "Who am I? Where did I come from? Where did I go? What do I dream?" A girl standing at the periphery of a family portrait asks, "Who combs my hair? Who calms me when I'm afraid?" "Who is she?" the audience is compelled to ask. Like Toni Morrison's *Beloved*, "Everyone knew what she was called, but nobody anywhere knew her name."[44] Seen in faint profile, her ghostly form is a mere wash of thinly applied pigment, transparent, insubstantial.[45]

The fractured surface of an unknown portrait of a white man by Henry Bebie is lit from behind by the videotape of a black man. The video tells the story of the unknown sitter: he is the son of the white master who raped his enslaved mother who, as the voice says, "nobody knows" is inside.[46] By choosing to display this damaged picture, Wilson violates another museum taboo. Damaged goods are an institutional shame hidden in the recesses of vaults, discreetly out of public view. The exposure of this private shame functions as a metaphor for the hidden shame of the animated figure whose torn white surface can no longer conceal the black face within. Initially, museum guides wanted to avoid discussion of this object in their tours of *Mining the Museum*. However, during a training session one guide, a doctor who had been a docent for many years and whom they had taken as white, revealed that the picture also told *his* story. Thereafter, the guides included the Bebie portrait.

By seeking to "recover" the history of the individuals represented in these works, Wilson made some startling discoveries about other pieces installed in the same room. The identities of slaves depicted in a rare painting of workers in the fields of a plantation were added to the label when an inventory book listing their names along with other household items and animals owned by the plantation was retrieved from the society's archives. The same inventory book appears later in the exhibition, opened beneath a replica slave ship. Joshua and Easter, whom we can identify in the painting, are listed alongside oxen and chickens, each valued for their utility in the household. Oxen, in fact, cost more than slaves.

Enlarging a detail of a black figure in the background of a photograph, *Picnic at Wye House*, the artist discovered that the scene depicted a reunion of former slaves and their owners. One man had worked in the kitchen, established himself as a caterer, and returned to service the affair.

But despite his excavations, many of the individuals represented in the images chosen by Wilson could not be identified. Wilson saw this as an opportunity to pose unanswerable questions and to invite imaginative conjecture. Engravings of Baltimore, for example, were covered lightly with glassine, obscuring the views of the city except for a tiny circle cut out to reveal the African-American figures depicted. The viewer begins to ask the questions voiced by the "talking" paintings: Who are they? Where did they come from? Where did they go? A portrait of a well-known white family by the African-American artist Joshua Johnson is labeled in French "*Où est mon visage?*" [Where is my face?], a reference to the paucity of information known about this free man of color who painted portraits in Baltimore from 1795 to 1825 and who was believed to be from the French West Indies.[47] In watercolors depicting the daily activities of slaves by Benjamin Latrobe, Wilson uses the names "Easter"

and "Joseph." From family account books, he assigned possible identities to these individuals whom Latrobe chose to observe but not to name. An Ernst Fisher painting is given two labels, *Country Life* and "Frederick Serving Fruit." Asking "Where am I in this painting?" Wilson inserts himself in the place of the black serving boy who is "seen" or not seen, depending on which label we choose to apply. In this way, Wilson's process of "naming" is linked to his astute consciousness of the ways texts frame our vision of museum objects and, in the process, elide the identities of those its ideological boundary does not contain.

In subsequent areas of the installation labeled "Metalwork 1793–1880," "Modes of Transport," and "Cabinetmaking 1820–1960," Wilson illustrates how museum classification, by hygenically separating history into clean compartments, creates a tidy structure of institutional denial. "Metalwork" juxtaposes Baltimore repoussé silver with iron slave shackles, making the point that a luxury economy was built on the system of slavery.[48] "Modes of Transport" examines who traveled in colonial Maryland, why, and how. The room features a sedan chair displayed beside a model slave ship and a painting depicting a similar chair in use. Selective lighting on the painting highlights who carried whom in the once lavishly decorated chair. (Wilson was emphatic about leaving the dust that had gathered on the poorly conserved chair while in storage. He again makes the point that the issue of "quality...the hidden dagger of 'my taste,'" is used as an excuse for avoiding the exhibition of such an object.) A Ku Klux Klan hood, discovered in an unknown house in nearby Towson and given by an "anonymous donor," takes the place of pram linens in an antique baby carriage. A nearby photograph shows black nannies pushing similar prams, rearing their future oppressors.[49]

Wilson also uses labels to reveal the strange historical coincidences between objects that are assumed to be unrelated. The rhetorical similarities between language used to describe tolling for ducks and tracking runaways seem hardly coincidental when placed beside a broadside that tells how one escaped slave "decoyed" another. The artist reinforces the point by surrounding a toy figure of a running black soldier in a Zouave uniform with oversized duck decoys. Within the blood-red room, placed on similarly hued damask, this figure is "targeted" by an obscenely large punt gun. The perimeter of the space is ringed by photographic enlargements of broadsides posted for the return of runaways. Raised off the surface of the broadsides are phrases used to identify the slaves, all describing the results of physical maltreatment: "his shin occasioned by a kick," "he hesitates when spoken to." They serve as a reminder of the difficult road to freedom taken by Richard, Ned, Job, and Easter, whose life the viewer has glimpsed in the fields of Perry Hall and on the Latrobe Plantation.

The brutality of the decoy room, with its curious shift in scale, dominating diagonal positioning of the punt gun, and dramatic red walls, signals an abrupt change in pitch from the cool grays and colonial greens in the first third of the installation. Wilson now brings the violence of forced servitude into close focus. Just beyond the decoy room a modest arrangement depicts a woman field hand toiling under the whip of an *Overseer Doing His Duty*. Beneath, the original broadside offering a reward for Easter's return rests beside an iron bootjack used to scrape and remove dirty boots before entering the home. Cast in the form of a woman on her back with legs splayed, arms outstretched, and an unpainted black metal face, Wilson reminds us how Easter's body bore the heel of her master, both literally and figuratively.

Within the same space, a whipping post, used until 1938 in front of the Baltimore city jail, is raised on a platform, surrounded by period chairs of different styles. Each

chair was chosen to suggest a distinct social class: clergy, middle class, blue blood, businessman. The chairs gaze voyeuristically at the crucifix-like shape on a raised platform.[50] Many visitors commented on the strange resemblance of its austere form and rugged texture to contemporary assemblages. Read in this way, Wilson illustrates again how aestheticizing objects represses the pain and complexity dwelling within them. By labeling the room "Cabinetmaking 1820–1960," he uses this section of the installation, with the whipping post that had been in storage for years alongside fine antique cabinets, to remind us how truly perverse the museum classification system can be.

In a sense, the whipping post acts as a threshold between the first red passage and a second. The second passage inverts the hierarchy of power, shedding light on active resistance by blacks to the slave system. Slide projections, flashing like rapid gunfire, spray the names of these rebellious slaves over the red walls, exaggerating the violent tenor of the room. An arcadian view of Harper's Ferry abuts John Brown's pikes. The room depicts an inversion of the power relations between slave and master described on the other side of the wall. To emphasize this inversion, Wilson again juxtaposes disproportionately large and small objects. Another black toy, this time a crudely made, gigantic figure of a shrunken old black man, is placed within the tiny domestic setting of a dollhouse.[51] Around him, small white dolls appear to have been the subjects of a massacre. Another black figure stands watch in a doorway. Our relationship to dollhouse figures is usually one in which the viewer has a sense of dominance and control over the arrangement of rooms and the fictive activities within them. However, in Wilson's dollhouse, the outsized figure disrupts that control and becomes a container for apprehension and fear.[52] Here, the small running figure targeted by the punt gun takes on the grotesque proportions of a nightmare in a scene reminiscent of Nat Turner's rebellion. Panic over a "negro uprising," chronicled in a diary on display, provides insight into the mythological proportions the rebellious slave took on in the white imagination.[53]

By 1831, word of Nat Turner's rebellion in the Dismal Swamp area of Virginia had spread throughout Maryland. Fearful of the consequences of the uprisings, a state-appointed commission recommended the forced repatriation of Maryland blacks to Liberia. The decision was rejected by free-black leadership, who stated in 1831 that they believed "the land in which we were born is our only 'true and appropriate home' and when we desire to remove we will apprise the public of the same in due season." The commission's recommendation was never implemented successfully. Six years later, Liberia had a settlement of only two hundred repatriated blacks.[54]

The next room is a blue corridor displaying a basket, a jug, and a rocking chair made by enslaved African-Americans with objects made by Africans from Liberia. The blue suggests water, perhaps the passage over the ocean of enslaved blacks from Africa and back again.

Before *Mining the Museum*, only the jug, made by the slave Melinda, had been exhibited, and few had seen the Liberian objects until Wilson inadvertently discovered them after finding registrar's cards suggesting the society owned objects from Africa. In fact, when Wilson stumbled on them, it was virtually the first time the wooden tourist box with its ticket of passage to Africa had been seen by the museum staff since being given to the society in the mid-nineteenth century. Yet, given the paucity of objects in the collection that were representative of the African-American experience, let alone the diaspora, one must ask, Why did these items pass into the collection at all?

It is not widely known that the Maryland Historical Society had close ties to the Colonization Society, the group responsible for establishing a colony in Liberia for the return of freed slaves. According to the society's curator Mary Ellen Hayward:

> The Colonization Society movement suggested a new life in Africa as a solution to the growing problem of free blacks. Founded on a national level in 1817 and vigorously supported by many prominent Baltimoreans, colonization wrapped racist sentiments in a moral package that was always doomed to failure. Until 1832, Maryland had a part in the national effort, sending manumitted slaves and free black volunteers to the new settlement of Monrovia in Liberia on the west coast of Africa. In that year, the state chartered a separate Maryland colony to be known as "Maryland in Liberia" and set aside $20,000 for 1832 and up to $200,000 over the next twenty years to facilitate the "removal of coloured people" to Africa.[55]

In fact, many of the founders of the historical society were members of the Colonization Society, a fact that goes unmentioned in much historical society literature. The question must be raised: What was the connection between the early collecting policies of the society and the political position of its founding board with regard to the "problem of freed blacks"? Why *was* the historical society actually founded?[56]

At the end of the corridor hangs a painting of *Maryland in Liberia* by John H. B. Latrobe, "the prime mover in the organization of the society" and president for more than twenty years.[57] What function might this bucolic piece of exotica, with its frilly palm fronds, friendly natives, and landscape we might call "Africa on the Chesapeake," have served? What does his representation of the colony tell us about the Colonization Society's "vision" for Liberia and its vision for the Maryland Historical Society? Did the society's founders intend for the museum to function as a space in which they might persuade others of their politics on matters of race?[58]

The blue corridor is in some ways the most conventional space in *Mining the Museum*. Wilson has neither employed theatrical effects nor parodied museum techniques as he has elsewhere in the installation. And yet it is one of the most affecting in the exhibition. The woven shawl, straw basket, and cane seat of a chair used to rock another woman's children all give voice to a shared history born in Africa, but they also speak to the unbridgeable divide that persisted between native Africans and those born of enslaved Africans in America.[59]

The final section focuses on the "aspirations and dreams and achievements of African Americans in and outside of slavery."[60] The centerpiece, an astronomical journal kept by Benjamin Banneker, is one of the few objects in the collection made by a well-known African-American. Banneker was hired by Thomas Jefferson to help survey Washington, D.C. His journal contains a letter sent by Banneker to Jefferson urging him to abolish slavery and stating that his life's work was not only about mathematics but also about trying to save his people. "Sir I freely and Chearfully acknowledge, that I am of the African race."

Assisted by an astronomer from the Hubble Space Telescope Center at the Johns Hopkins University, Wilson studied the journal and located software that could generate images of the night sky as Banneker saw it. This was loaded into an IBM computer, a dutifully labeled relic. Wilson employed slide projections of the astronomer's drawings of the evening skies so that other pages from Banneker's journal could be read. This otherworldly environment emphasizes the second function of the

journal as a diary in which Banneker could keep track of his dreams. His tormented apparitions, placed in wall texts around the projections, tell the story of how a distinguished free black was no less immune to the oppression of the slavery system than were his enslaved brothers and sisters. The exhibition ends with a globe used in Banneker's time: by formally and metaphorically echoing the opening Truth Trophy, the installation comes full circle.

An eight-year-old child visiting the exhibition said of *Mining the Museum*, "I like Fred Wilson, he asks more questions than he answers." Put another way, by questioning how omissions from cultural and historical narratives occur, Wilson provides a strategy for the audience to reclaim the terrain of the museum for itself. His placement of the Truth Trophy argues, as cultural critic Dick Hebdige has stated, "The intellectual, the critic, the artist can no longer claim to have privileged access to the Truth or even to knowledge, at least to the knowledge that counts."[61] What remains is the possibility of "mining" knowledge, prospecting for precious, invisible details, exploding historical myths and undermining the ideological foundations that support them, in order to make cultural experiences "mine" by participating in the process of writing and presenting history.

But an ethics of questioning should lead to *further* questioning, and especially to self-questioning. To conclude, one must ask, What is next? Where will *Mining the Museum* lead?[62] Will the project now spawn a series of exhibitions that lack the ethical or epistemological imperative of the original? Often the admission of a dysfunctional past is used to disarm adversarial criticism. If reform is only skin deep, it can be easily co-opted by a recalcitrant establishment. If this should happen, what does it imply for real reform of museum practice, for real ideological change?

"The question of color," wrote James Baldwin, "takes up much space in these pages, but the question of color, especially in this country, operates to hide the graver question of the self."[63] Museums, by implication, need not only mine the history they have repressed but also explore their own roles in that repression. The first step is for museums to look within themselves, to explore their own histories, and to ask, as Fred Wilson did, "Where am I here?" But if they are to hear the answers, they must also begin to listen to voices other than their own, voices that continue to demand their own answers to the question "Where am *I* in the museum?"

Notes

1 Carol Duncan and Alan Wallach, "The Universal Survey Museum," *Art History* 3, no. 4 (December 1980), pp. 448–69.

2 See Alan Wallach, *Chronicle of Higher Education*, January 1992, pp. B2–B3.

3 In a curious way, Jesse Helms probably succeeded better than museologists, curators, and theorists in drawing public attention to the museum as a politically charged space of contention.

4 As Louis Althusser argued, it is the ideological apparatus of cultural institutions that "may be not only the stake, but also the site of class struggle, and often of bitter forms of class struggle." See Louis Althusser, "Ideology and Ideological State Apparatuses," in his *Lenin and Philosophy and Other Essays* (New York: Monthly Review, 1971), pp. 127–86.

5 Mieke Bal has brought this perspective to bear on museums. Remarking on the tone of self-congratulation evident in the *Official Guide to the American Museum of Natural History* (1984), for example, she theorizes, "The emphatic and repeated representation of the extent of the institution's ambition signals a certain unease about itself, a lack of self-evidence that

harbors the conflicts out of which it emerged and within which it stands, an 'unsettlement.' There is nothing surprising about this anxiety: the museum is a product of colonialism in a *post*colonial era." This unsettlement bespeaks the museum's fear of being "an endangered self," frantically engaging in "the museal preservation of a project ruthlessly dated and belonging to an age long gone whose ideological goals have been subjected to extensive critique." The museum is being forced to undergo intensive self-reflection "on and of its own ideological position and history." See Mieke Bal, "Telling, Showing, Showing Off," *Critical Inquiry* 18, no. 3 (Spring 1992), p. 558.

6 For a description of the project see, e.g., Jerry Adler, "The Great Hall of Bacteria," *Newsweek*, December 12, 1992, p. 84.

7 However, such projects are not without their critics. Ironically the impassioned debate that followed the exhibit's opening created strange bedfellows: one group of protesters was angered over the derogatory representation of the colonials, while others felt slighted by the omission of any African response to imperialism. For an extended discussion of the exhibition and the ensuing controversy, see Simon Ottenberg, "Into the Heart of Africa," *African Arts*, July 1991, pp. 79–82.

8 Kenneth E. Silver, "Past Imperfect," *Art in America*, January 1993, p. 43.

9 In an as-yet-unpublished essay about the history of the Parrish Art Museum, Alan Wallach discusses the relationship among Samuel Parrish's political aspirations, his agenda for the development of the town of Southampton, and the charter of the museum.

10 Peter Vergo, *The New Museology* (London: Reaktion, 1989), pp. 3–4.

11 The first extensive publication to take up the issue of the artist in the museum was *Museums by Artists*, ed. A. A. Bronson and Peggy Gale (Toronto: Art Metropole, 1983). The Desire of the Museum (New York: The Whitney Museum of American Art, 1989), an exhibition organized by Catsou Roberts, Timothy Landers, Jackie McAllister, Benjamin Weil, and Marek Wieczorek, also included a broad range of artists whose work imputes an "unconscious" to the museum, where different desires and struggles for meaning compete. The Carnegie International 1991, organized by Lynne Cooke and Mark Francis, invited artists, many of whom had created museum-related works in the past, to take as their subject the International itself or the Carnegie Museum and its collections. A three-volume publication that includes an anthology of "museumist" writings is currently in preparation. The set, *Values on Display: Contemporary Art Exhibitions in a Postmodern Age; Values on Display: Thinking About Exhibitions;* and *Values on Display: Art About Exhibitions*, is being edited by Bruce Ferguson, Reesa Greenberg, and Sandy Nairn.

The number of artist-looks-at-museum projects has continued to increase. My discussion here is intended to provide only a cursory review of the range of these projects over the past several years. Since accounts of many of these are discussed at length elsewhere, I have attempted to provide examples of less well known projects by Wilson's contemporaries whenever possible.

12 Roberta Smith, "Paying Homage to Irreverence," *New York Times*, July 16, 1993, p. C1.

13 See, e.g., Daniel Buren, "Function of the Museum." and "Function of the Studio," in *Museums by Artists*, ed. A.A. Bronson and Peggy Gale (Toronto: Art Metropole, 1983).

14 See Ann Rorimer, *A Forest of Signs* (Los Angeles: Museum for Contemporary Arts, 1989), p. 147.

15 Bruce Kurtz, ed., "Conversation with Robert Smithson on April 22, 1972," in *The Writings of Robert Smithson*, ed. Nancy Holt (New York: University Press, 1979), p. 200.

16 See Brian O'Doherty, *Inside the White Cube: The Ideology of the Gallery Space* (Santa Monica, Calif.: Lapis Press, 1976).

17 Craig Owens, "From Work to Frame," in his *Beyond Recognition: Representation, Power, and Culture* (Berkeley and Los Angeles: University of California Press, 1992), p. 132.

18 Lynne Cooke and Mark Francis, *Carnegie International 1991*, vol. 1 (Pittsburgh: Carnegie Museum of Art, 1991), p. 14.

19 See Gary Indiana, "Orshi Drozdik's 'Adventure in Technos Dystopium,'" in *Orshi Drozdik, "Adventure in Technos Dystopium"* (Budapest: Ernst Museum, 1990), p. 17.

20 See Judith Barry in *Carnegie International 1991* (Pittsburgh: Carnegie Museum of Art, 1991), pp. 54–55. In fact, the entire Carnegie International commissioned artists to consider the exhibition museologically. Christian Boltanski actually created a museum of the Carnegie International.

21 Alan G. Artner, "Beginning Again: A Soviet Artist Finds Painting Is No Longer Enough," *Chicago Tribune*, July 25, 1993, p. 21.

22 See Ralph Rugoff, "Inside the White Clinic," *Parkett* 32, 1992, pp. 150–53; Ralph Rugoff, "Planned Obliscence," *L. A. Weekly*, June 21, 1991, pp. 39–40; and the brochure of the Museum of Jurassic Technology, Los Angeles, California.

23 Statement by Daniel Robbins in *Raid the Icebox 1* (Providence: Museum of Art, Rhode Island School of Design, 1970), p. 15.

24 Statement by the artists in the catalog *At Home with the Collection: Simon Grennan and Christopher Sperandio* (Peoria, Ill.: Lakeview Museum of the Arts and Sciences, 1991), p. 9.

25 See *MAK – Austrian Museum of Applied Arts* (Vienna and Munich: Prestel-Verlag, 1993), p. 19.

26 See Douglas Crimp, "On the Museum's Ruins," in *The Anti-Aesthetic: Essays in Postmodern Culture*, ed. Hal Foster (Seattle: Bay Press, 1983).

27 Although some "museumist" artwork has dealt with issues of race, most artists have not been given the latitude to explicitly tie the issue to the presenting museum's policies. Hans Haacke's study of the social structures of the Guggenheim, caused his Guggenheim retrospective to be canceled. *The Year of the White Bear* (1992), a performance piece by Coco Fusco and Guilliermo Gómez-Peña for the National Museum of Natural History, dealt with the exhibition of Latin American cultures in ethnographic and natural history museums in general. It is worth noting that the curators of The Desire of the Museum were limited by the Whitney Administration in their self-reflexive design for this highly politicized "museumist" exhibition. See Roberta Smith, "The Whitney Interprets Museum's Dreams," *The New York Times*, Sunday, July 23, 1989, Arts & Leisure Section, pp. 31+.

28 Maurice Berger, "Are Art Museums Racist?," in *How Art Becomes History* (New York: HarperCollins, 1992), p. 149.

29 From "Sites of Criticism, a Symposium," *Acme Journal* 1, no. 2 (1992), p. 27.

30 From an unpublished lecture by the artist at the Seattle Art Museum, January 1993, p. 5.

31 One mask urged viewers to "don't just look at me, speak to me. I am alive."

32 Fred Wilson, unpublished and undated notebooks.

33 Unpublished lecture by the artist at the Seattle Art Museum, January 1993, p. 8.

34 Ibid., p. 14.

35 Ibid., p. 13.

36 *Maryland Historical Society Annual Report*, 1850. Extract from the society's circular letter, pp. 15–17.

37 Brian Topping, "President's Report," *Annual Report of the Maryland Historical Society, 1986–87*, p. 347.

38 These makeshift sideshows–cum–vaudeville amusements featured cabinets of curiosities, scientific oddities, wax dummies, freaks, and "rational amusements" masquerading as scientific lectures, which "offered the visiting countryman and the pious city dweller a curious form of theatrical entertainment beneath a transparently thin veneer of culture and learning." Set up in vacant shops and fair booths, the "easily comprehended entertainment" of the dime museum proliferated in rural and urban towns across the country. More serious venues such as Charles Willson Peale's Museum and Gallery in Baltimore, John Scudder's American Museum, and Daniel Drake's Western Museum were "forced to introduce more and more sensational novelties" to compete for audiences. By 1850, Peale's museum, unsuccessful in its efforts to keep aloft, had been sold to P. T. Barnum.

See Brooks McNamara, "'A Congress of Wonders': The Rise and Fall of the Dime Museum," *Emerson Society Quarterly* 20, 3rd quarter (1974), pp. 216–32.

39 The Maryland Historical Society is located just off Mount Vernon Place, a French-inspired town square with monuments and allegorical sculptures ringed by the now-restored former residences of the city's nineteenth-century elite. The society also straddles the Howard Street corridor, the city's former commercial district. The street linking these two quarters of "Old Baltimore" is the main conduit to west Baltimore, the historically black section of the city. In effect, the society is on axis with the "two Baltimores," placing it in a challenging position from which to reconcile its mission with regard to its definitions of history and audience.

40 Donald Garfield, "Making the Museum Mine: An Interview with Fred Wilson," *Museum News*, May/June 1993, p. 49.

41 This use of photographs "of ourselves, by ourselves," was a strategy Wilson first began experimenting with in The Other Museum at Gracie Mansion. In that exhibition, photographs of Native Americans and African-Americans from the turn of the century taken by members of their own communities were placed side by side with those taken by anthropologists.

42 The "orientation" map in the Native American space was originally part of a temporary decoy exhibition on the third floor when Wilson began his residency. He asked that the map, labeled with the names of Maryland gunning clubs, remain in place for his installation. The labels identifying the location of Native American tribes living in colonial Maryland were added by the artist. This arrangement foreshadows the violent tenor of the later red rooms that also make use of artifacts from the same decoy exhibit.

43 *Eleanor Darnall*, a pendant painting in the collection of the boy's sister and her mastiff by Justus Englehardt Kuhn, remained on view in the colonial galleries of the historical society during *Mining the Museum*. Beside it, Wilson left a "clue" – an actual dog collar mounted high on the wall, in a space corresponding to that worn by the enslaved boy in the painting Wilson chose for his installation. A registrar's tag noted that the painting had been removed by Wilson. This and other clues related to the "talking paintings" encouraged viewers to go back and forth between the installation and the permanent collection on the first and second floors to consider how the two different contexts shaped the meaning of the works.

44 Toni Morrison, *Beloved* (New York: Plume, 1988), p. 274.

45 On the second floor, next to the portrait of the Danells children, Wilson's clues replace the labels that name the white children with those naming the African-American children, Thomas and Manuel Paez. Archival documents show that the tuition of two African-American boys from South America was paid by Commodore Danells. The boys mentioned in the documents were dismissed from Saint Mary's College after one year because of their race. It is a fair conjecture, although not yet confirmed, that these are the boys represented in the painting.

46 Wilson's experimentation with talking images began with a room in *The Colonial Collection*, which he called the "Bwana Memorial Gallery of African Art." A spotlight over a trade mask triggered blinking eyes and moving lips, as Wilson has described it, "sort of semi-Disney-like but I like to think of it as sort of ghostlike....A voice would start to speak... 'Don't just look at me; speak to me. I'm still alive.'" Similarly the use of video behind an object was used in the same room, in which Wilson "spliced together many films of Africa of various words between the Zulu and the British – so you'd get right up and see sort of a history of that mask," through its own eyes.

47 The French quote is also a reference to "Where am I in all this?," the question that determined the trajectory of *Mining the Museum*. The most complete catalog of Johnson's work is *Joshua Johnson: Freeman and Early American Portrait Painter* (Baltimore: Maryland Historical Society and the Abby Aldrich Rockefeller Folk Art Center, Colonial Williamsburg Foundation, 1987).

48 Blacks in Baltimore worked primarily in "service" jobs and in the crafts, although a small percentage of freemen performed skilled jobs. It is feasible that either the silver or the shackles could have been made by a freed black. See Leroy Graham, "Joshua Johnson's Baltimore," in ibid. Beside the "metalwork" vitrine, a circular cabinet contained a mannequin's hand holding a Civil War-period postcard with a stock likeness of George Washington. Printing on the card forms a halo around the image stating, "One of the Rebels . . . Southern Gentleman and Slaveholder." The Confederate version of American history had been quick to justify the slave system by co-opting the patriotic residents of Mount Vernon and Monticello, suggesting that, like the owners of the silver factories, they were or would have been sympathetic to the Southern cause.

49 Wilson recalled in his lecture at the Seattle Art Museum that the staff of the Maryland Historical Society had been unable to locate the Klan hood that was documented in the registrar's files. "It had sort of disappeared in the collection. So finally by looking for something else, they found the hood. . . . I was always finding things like that, and they said, 'Well, we just don't know what to do with things like that.' I said, 'I know what to do with that.' " At this point in the installation the viewer has already become accustomed to Wilson's vision. When he creates a beautiful display of elegant arrangements on damask surfaces, visitors said they found it difficult not to "read" other, nonaesthetic meanings into them. Installation details that are supposed to be "invisible" are suddenly full of significance. Wilson was thoroughly amused when a blinking faux security device attached by the registrar to the Klan hood to discourage vandalism was interpreted by some visitors as part of the artist's arrangement. Later, it was removed.

50 Although stored with "cabinetry" since it was acquired in 1960, the whipping post had never been exhibited. One of the society's building staff could recall stories of it being used and was visibly upset by Wilson's decision to bring it up from storage.

51 The figure was acquired as part of a set of two, one male and one female, sitting opposite each other on a piece of wood with a basket between them. Little is known about their history, function, or fabrication.

52 For a fuller metaphorical analysis of disruption in scale, see Susan Stewart, *On Longing: Narratives of the Miniature, the Gigantic, the Souvenir, the Collection* (Durham, N.C.: Duke University Press, 1993).

53 For a provocative investigation of this subject, see bell hooks, "Representing Whiteness in the Black Imagination," *Cultural Studies*, ed. Lawrence Grossberg, Cary Nelson, and Paula Treichler (New York: Routledge, 1992), pp. 338–46. hooks notes that, "socialized [conversely] to believe the fantasy, that whiteness represents goodness and all that is benign and non-threatening, many white people assume this is the way black people conceptualize whiteness. They do not imagine that the way whiteness makes its presence felt in black life, most often as terrorizing imposition, a power that wounds, hurts, tortures, is a reality that disrupts the fantasy of whiteness as representing goodness."

54 Quoted in Mary Ellen Hayward, "Baltimore 1795–1825," in *Joshua Johnson, Freeman and Early American Portrait Painter*, p. 31.

55 Ibid.

56 According to sociologists Pierre Bourdieu and Alain Darbel, museums are founded because "sanctification of art . . . fulfills a vital function by contributing to the consecration of the social order. So that cultured people can believe in barbarism and persuade the barbarians of their own barbarity, it is necessary and sufficient for them to succeed in hiding both from themselves and from others the social conditions which make possible not only culture as a second nature, in which society locates human excellence, and which is experienced as a privilege of birth, but also the legitimated hegemony (or the legitimacy) of a particular definition of culture. Finally, for the ideological circle to be complete, it is sufficient that they derive the justification for their monopoly of the instruments of appropriation of cultural goods from an essentialist representation of the division of their

society into barbarians and civilized people." See Alain Darbel and Pierre Bourdieu, *The Love of Art* (Stanford, Calif.: Stanford University Press, 1992), pp. 111–12.

57 Harold R. Manakee, "A Quarter-Century of Growth at the Maryland Historical Society," *Maryland Historical Magazine*, March 1965, p. 57.

58 In fact, the first meetings of the board were held in the Pratt House in rooms used by the Colonization Society. The Pratt House was donated to the historical society in 1919. This is a subject that demands further scholarly investigation elsewhere.

59 According to the registrar's records, the attributions of the woven basket and the rocking chair to enslaved persons are based on oral histories that were passed down in the families of their former owners.

60 Fred Wilson, unpublished lecture at the Seattle Art Museum, April 1992, p. 18.

61 Dick Hebdige, "A Report on the Western Front," in *Art in Modern Culture: An Anthology of Critical Texts*, ed. Francis Frascina and Jonathan Harris (New York: HarperCollins, 1992), p. 340.

62 Wilson has gone on to create installations using permanent collections in museums as diverse as the Seattle and Indianapolis Art Museums, in Warsaw, and in Cairo. On April 21, 1993, The Contemporary opened Catfish Dreamin' by Alison Saar, a traveling sculpture on wheels that was installed on the bed of a pickup truck. The project is touring more than eighty sites in urban and rural neighborhoods in four mid-Atlantic states over five months. The Contemporary has undergone its own self-study to identify specific means to include the "findings" of *Mining the Museum* in its long-range plans. In April 1993, immediately after *Mining the Museum* closed, the Maryland Historical Society opened the decorative arts exhibition Classical Taste in Maryland. From January 14 to August 14, 1994, the society presents You Make History, an exhibition celebrating its 150-year anniversary. The exhibition invites the audience to decide the future of the museum's collecting policies and practices through a series of participatory exercises. In May 1993, Charles Lyle resigned his directorship, saying he "felt it was a good time for the institution to look in new directions and for me to pursue other interests." See "Charles Lyle Leaves State Historical Society after 3 Years as Director," *Baltimore Sun*, May 6, 1993, p. 10E.

63 Quoted in Henry Louis Gates, Jr., *Loose Canons: Notes on the Culture Wars* (Oxford: Oxford University Press, 1992), p. 131.

Chapter 39 | Le Corbusier
Other Icons | The Museums

There are good museums, and bad. Then there are those with the good and bad together. But the museum is a sacred entity which debars judgement.

The birth of the museum: 100 years ago; the age of humanity: 40 or 400,000 years.

To see your happy smile, dear lady, as you say 'My daughter is at the museum', you would appear to feel you are one of the pillars of the world!

The museums are a recent invention; once there were none. So let us admit that they are not a fundamental component of human life like bread, drink, religion, orthography.

True enough, there is good in the museums; but let us risk a devastating deduction: the museum allows one to reject it all, because once the full story is known, it becomes clear that everything has its time and place and that nothing from the past is directly of use to us. For our life on this world is a path on which we can never retrace our steps. This is so clear that I can conclude with an immutable law: in their tendentious incoherence, the museums provide no model; they offer only the elements of judgement. The strong in spirit always get out of them, they understand and recognize the poison, and the opiate does not interest them; they see clearly, and do not slide pitifully down the precipice.

But should social reality be considered only in terms of the strong in spirit? It is a dangerous limitation. The phenomenon of nature manifests itself in the form of a pyramid, a hierarchy: at the summit there are the aces; lower down in ever-increasing waves, those of less excellent, inferior quality. The ratio is quickly evident: for every 10 units of height there is a single example of excellence at the summit and 100 of middling or mediocre quality at the bottom; for 100 units of height there are 10 of excellence at the top and 10,000 mediocrities at the bottom, etc., and the space in between is occupied by the mass of intermediate quality. Those at the top are supported there by the presence of the lower levels, graded in ascending order.

Le Corbusier, "Other Icons: The Museums" from *The Decorative Art of Today*, translated and introduced by James I. Dunnett, pp. 15–23. Cambridge, Mass.: MIT Press, 1987. First published in Le Corbusier, *L'art décoratif d'aujourd'hui* (Paris: Editions G. Crès, 1925); second edition published 1958 by Editions Vincent & Freal, Paris, © 1959 by Foundation Le Corbusier. English translation © 1987 by Architectural Press. Reproduced by permission of MIT Press. (Reprinted without illustrations.)

The pyramid expresses a hierarchy. Hierarchy is the organisational law of the world, both natural and human.

So it is important to consider whether the museums help or hinder appreciation of the principle of hierarchical gradation.

THE MUSEUM REVEALS THE FULL STORY, AND IT IS THEREFORE GOOD:
IT ALLOWS ONE TO CHOOSE, TO ACCEPT OR REJECT.

Let us imagine a true museum, one that contained everything, one that could present a complete picture after the passage of time, after the destruction by time (and how well it knows how to destroy! so well, so completely, that almost nothing remains except objects of great show, of great vanity, of great fancy, which always survive disasters, testifying to vanity's indestructible powers of survival). In order to flesh out our idea, let us put together a museum of our own day with objects of our own day; to begin:

A plain jacket, a bowler hat, a well-made shoe. An electric light bulb with bayonet fixing; a radiator, a table cloth of fine white linen; our everyday drinking glasses, and bottles of various shapes (Champagne, Bordeaux) in which we keep our Mercury, our Graves, or simply our *ordinaire*... A number of bentwood chairs with caned seats like those invented by Thonet of Vienna, which are so practical that we use them ourselves as much as do our employees. We will install in the museum a bathroom with its enamelled bath, its china bidet, its wash-basin, and its glittering taps of copper or nickel. We will put in an Innovation suitcase and a Roneo filing cabinet with its printed index cards, tabulated, numbered, perforated, and indented, which will show that in the twentieth century we have learnt how to classify. We will also put in those fine leather armchairs of the types developed by Maples: beneath them we might place a label saying: 'These armchairs, invented at the beginning of the XXth century, were a real innovation in the art of furniture design; furthermore, they were a good example of intelligent research into comfort: but at that time what was done best was not yet what was most highly prized; bizarre and expensive furniture was still preferred which constituted an index of all the kinds of carving and colouring that had graced the more showy furniture of earlier epochs.' In this section of the museum we would have no hesitation in displaying other labels explaining that all objects on exhibition had performed some real function; in this way one would come to appreciate a new phenomenon characteristic of this period, namely that the objects of utility used by the rich and by the poor were not very different from one another, and varied only in their finish and quality of manufacture.

Clearly, this museum does not yet exist. Such a museum would be truly dependable and honest; its value would lie in the choice that it offered, whether to approve or reject; it would allow one to understand the reasons why things were as they were and would be a stimulant to improve on them.

Tourists on their way to climb Vesuvius sometimes stop in the museums of Pompeii and Naples, and there they eagerly look at the sarcophagi incrusted with ornament.

But Pompeii, as a result of a miraculous event, constitutes the single true museum worthy of the name. To confirm its value for the education of the masses, one can only hope to see the immediate establishment of a second Pompeian museum, of the modern epoch: societies have already been formed for this purpose; they have put together the displays in the Pavillon de Marsan, the museum of contemporary decorative arts; there they certainly give some indication of the present century, but

it is only partial and fragmentary. The inhabitant of another planet who suddenly landed there would be more likely to think he was at Charenton [a well-known lunatic asylum].

THE MUSEUM IS BAD BECAUSE IT DOES NOT TELL THE WHOLE STORY. IT MISLEADS, IT DISSIMULATES, IT DELUDES. IT IS A LIAR.

The objects that are put in the showcases of our museums are sanctified by this fact: they are said to be collectable, to be rare and precious – valuable, and therefore beautiful. They are pronounced beautiful and held up as models, and thus is established that fatal chain of ideas and their consequences. Where do they come from? From the churches, ever since these espoused magnificence to dazzle, impress, attract, and impose respect for an omnipotent deity. God was in the gold and in the carving; He had failed to keep an appointment with St Francis of Assisi and, many centuries later, had still not come down into the suburbs of our 'tentacle cities'.

These objects also came from the palaces and country houses: to impress, astound, appease the gaudy Punch who jerks somewhere in us all and whom culture catches, ties up and muzzles. We feel very indulgent towards the distant past; we are full of indulgence and very ready to find everything good and beautiful, we who afterwards are so critical of the disinterested and passionate efforts of our contemporaries. We forget too easily that bad taste was not born yesterday; without extensive research, but simply by sticking one's nose into a few old tomes from the eighteenth century, one can become well aware that even at that time people of good taste and position were continually protesting against the profligacy of the arts and crafts, and against the manufacturers of rubbish.

At the Bibliothèque Nationale there is valuable evidence of the decadence that has sometimes been rife, for example: *Fashionable Architecture, Including the Latest Designs for the Decoration of Buildings and Gardens, by the Best Architects, Sculptors, Gardeners, Locksmiths, etc., at Paris, published by Langlois.*

And also *Designs for Various Ornaments and Mouldings, Antique and Modern, Suitable for Architecture, Painting, Sculpture, Goldsmithing, Embroidery, Marquetry, Damask, Joinery, Locksmithing and Other Arts, with the Name of Each Ornament.*

There, engraved on copper, are the most revealing ornaments, the most useless knick-knacks which the Faubourg Saint-Antoine has been able to produce; their date is 1700–1750, Louis XIV–Louis XV.

A Book of Mirrors, Tables and Pedestal-tables designed by Lepautre, A Book of Scroll Ornaments Newly Designed and Engraved by Jean d'Olivar and sold in Paris by Langlois, with the Authority of the King.

Among the chimney-pieces of imitation marble and pier glasses of gilt icing sugar, some have angels, some crowns, some medallions, etc.

What a collection to send the world of its time to sleep! It makes one feel that the bourgeois must date from before the Revolution. The utter lack of taste is stupefying.

In addition there are twenty plates, each one with about thirty friezes, gadroons, rosettes, scotias, astragals, volutes, fleurons, plinths, echini, acanthus leaves, etc. And all this is disgustingly drawn, cheap rubbish, designed as announced, for the engraver and architect, and for the painter. And the architects certainly took their pick, with the expected results: a great deal of old furniture laden with brass ornament, etc. And on what principle are these albums organised? Each plate is divided into four quarters along its two main axes; on either side of the axes there are four segments of mirror,

four segments of vase, four segments of chimney-piece, etc. One can see the matching up from here! Catalogues of monumental masonry are better presented today.

And where have the objects made from these elements ended up? In the homes of high society, with collectors, with antiquarians, and in the museums. Inevitably in such a heap there are some very beautiful things. But what is undeniable is our own automatic admiration and total loss of critical faculties when it comes to the heritage of past centuries. Who was this job lot from the reign of the great kings intended for? For a kind of person for whom we do not have much respect today; so it is disastrous and almost immoral to send our children into the museums to learn a religious respect for objects that are ill-made and offensive. And here again the Conservators would do us an immense service if they agreed to display labels alongside their exhibits declaring for example: 'This armchair or this commode would have belonged to a parvenu grocer living in about 1750, etc.'

The honest ethnographic museum is itself incomplete. This can be explained, and therefore excused: a colonial deep in the virgin forest prefers to bring back, in the limited space available, an object of display belonging to a negro chief or the local deity, rather than to encumber himself with numerous utensils that would give a picture of the cultural condition of the peoples with whom he has come into contact. Admittedly, we are at least as keen that the colonial should bring back the image of a god from the virgin forest as a calabash which served as a bowl or a bottle. But where this question becomes serious is when our educationalists, both in their books and in the schools, disregard the origin and purpose of the objects displayed in the museums, and use them as the basis of their teaching, to urge on their pupils to outdo, if that is possible, examples already exceptional of their kind, and thus encourage them to fill our everyday lives with the impractical showpieces which clutter and distort our existence, leaving it quite simply ridiculous.

ICONOCLASTS AGAIN: MAN, MAN QUITE NAKED.

The naked man does not wear an embroidered waistcoat; so the saying goes!

The naked man – but he is an animal worthy of respect who, feeling a head with a brain on his shoulders, sets himself to achieve something in the world.

The naked man sets himself to think, and by developing his tools, seeks to free himself from the dominance of external circumstance and the necessity for exhausting labour. He uses his tools to make objects of utility, and the purpose of these objects is to lighten the unpleasant tasks of everyday life.

The naked man, once he is fed and housed . . . and clothed, sets his mind to work and focuses his thoughts on what he thinks best and most noble.

The fabulous development of the book, of print, and the classification of the whole of the most recent archaeological era, have flooded our minds and overwhelmed us. We are in an entirely new situation: *Everything is known to us*. Peoples, periods, apogees, declines. We even know the shape of the cranium of the contemporaries of the dinosaurs, and from the slope of the forehead the thoughts which must have occupied them. Whenever a problem arises, we can apply exhaustive analysis to conjure up a picture of what any peoples did or would have done at any period. Ours is certainly an era of documentation.

But the museums have made the arbitrary choice that I have just denounced; this warning should be engraved on their pediments: 'Within will be found the most partial, the least convincing documentation of past ages; remember this and be on

your guard!' Truth is thus re-established, and we can proceed without further comment to our own very different programme. Our own purpose is not to imitate the weaknesses of the weaker classes of earlier ages; we intend our culture to serve some purpose, and spur us on to the best. The museums are a means of instruction for the most intelligent, just as the city of Rome is a fruitful lesson for those who have a profound knowledge of their craft.

The naked man does not wear an embroidered waistcoat; he wishes to think. The naked man is a normally constituted being, who has no need of trinkets. His mechanism is founded on logic. He likes to understand the reasons for things. It is the reasons that bring light to his mind. He has no prejudices. He does not worship fetishes. He is not a collector. He is not the keeper of a museum. If he likes to learn, it is to arm himself. He arms himself to attack the task of the day. If he likes occasionally to look around himself and behind himself in time, it is in order to grasp the reasons why. And when he finds harmony, this thing that is a creation of his spirit, he experiences a shock that moves him, that exalts him, that encourages him, that provides him with support in life.

Part V
Arts, Crafts, Audiences

Introduction

The texts in this section address the collection, selection, and aesthetic classification of objects. The topics addressed here include: how and why objects arrive in the museum; the use of museum arts and crafts as designs on society; how and why the museum may be able to control, advance, and/or retard society's progress; the visitor as element in/viewer of the museum space; how and why we enter the museum, and what might happen to us and to the objects we encounter there; what we bring to the museum and what we take with us when we leave.

In "The Museum as an Art Patron" (1929) John Cotton Dana argues that a good museum must not be built upon a "fixed idea of what a museum should be" (should not be "made-to-order") but must be responsive to the community. He enlists the aid of a short story, "The Queen's Museum" by Frank Stockton, to describe a case in which the Queen's subjects "cheerfully chose to live in jail" rather than visit Her Majesty's collection of "artifacts in which she herself was intensely interested." Dana rejects prestige and/or imitative collections and urges American museums to be responsive to American fine and applied arts: "we should cause museums to grow out of the activities that we are now engaged in." He also points out the museum's power to create through exhibition a public (common?) market for contemporary work, thereby calling attention to its beauty, utility, and overall value.

Dana's "new museum" is in part a reaction to the art museum tradition. In 1909 Benjamin Ives Gilman looked at that tradition, its canonical principles, and its texts, in a paper read at the first meeting of the American Association of Museums, the counterpart of the Museums Association in Great Britain. "Aims and Principles of the Construction and Management of Museums of Fine Art" may be as valuable for its scholarly footnotes as it is for its outline of museum practice. It enables us to form an idea of the text milieu of early museography and museology, which includes Agassiz, Robinson, and Flower as well as a significant number of continental sources. Gilman begins with a definition of artistic quality worthy of inclusion in a survey of aesthetics, and he considers one of the key issues in museum formation and continuation: the ratio of space and resources devoted to exhibition as compared with research or scholarly "investigation." As he notes, this was a problem which occupied

Agassiz in the development of his Museum of Comparative Zoology. Gilman provides his perspective on the ideal design of a museum while also offering the views of other museum professionals. His ongoing concern with the "dual" obligations of the museum – to specialists/professionals and to members of the general public – remains timely.

The term "public" in the denomination "public museum" of art cannot be taken for granted, however; nor can the term "museum": it is a sign which points in many directions. Georges Bataille perhaps does less to identify the body signified in the term "Museum" (1930) than to present a brief turn around its referential possibilities; it may bear some relation to execution (the guillotine), education, materialism or its opposite, but for Bataille the visitor is both subject and object – and perhaps not liberated in either capacity.

In the conclusion to *The Love of Art: European Art Museums and Their Public* (1969) Pierre Bourdieu and Alain Darbel consider the pleasure principle, which they feel has gone unexamined in studies of the museum experience. That principle has something to do with "admiration" but perhaps more to do with "cultivation" or "the interiorization of the cultural arbitrary." The terms "nature" and "culture" become intermingled when, as Bourdieu and Darbel argue: "The contradictions and ambiguities in the relationship of cultivated individuals with their culture are both promoted and sanctioned by the paradox which defines the realization of culture as *naturalization*." Calling for an examination of the "charismatic ideology" made possible by the fact that we ignore "the social conditions which make possible culture and culture become nature," they introduce and juxtapose other key terms, such as "distinction," "heritage," and "hegemony" to consider inclusion, exclusion, "false generosity" (free entry to the public museum), and other matters of class.

How do "things" find their way into a museum collection and what happens to them once they arrive? Philip Fisher offers a poetic but rigorous and intricate analysis of the lives of an object, and the benefits, burdens, and limitations of "public" access, in "Art and the Future's Past" (1991). He begins with "a warrior's sword" and follows the "naïve" object in its dual life as useful weapon (for the warrior) and warning sign to the community ("we go to war tomorrow"), in its role in sacred ritual after the warrior's death, in its value as treasure (the spoils of war) once the society is defeated, and in its presence in a museum once the culture which created it "has been destroyed by a higher civilization." Fisher then goes on to analyze "the socialization of the object" in each of the four stages, but his further objective is to arrive at a new form of "cunning object," one that emerged after the creation of museums. Such objects "have as their single, overt design, the desire to join history" through access to or accession by the museum. Fisher takes us on a tour of museum history and museum installation design, noting how once-naive objects are "resocialized" in their various incarnations, how their voices are suppressed or silenced as they are "converted to art," and how some twentieth-century artists have made art directly out of objects and/or controlled the arrangement and classification of their work by creating "the series" (we might say by controlling the synecdochic function assigned by the museum). His argument leads to the conclusion that "many characteristics of the modern work have to be seen as a kind of foresight on the artist's part" that the work will make its way into the museum.

Malcolm McLeod reminds us in "Museums Without Collections: Museum Philosophy in West Africa" (1999) that "museum collecting, in some cultures, need not be a good or useful activity." This seems a compelling companion-piece to Fisher's

analysis, in that McLeod looks closely at objects in their cultural/social context, at the effect on collection and display of "a people's concept of the past and of time," at museums operating in service to the local community, and at the growing sense in West Africa of the utility of the museum, not to mention the museum as tourist destination, in initiatives addressed to cultural nationalism. He offers a comparative look at a British and American exhibition of African objects (*Asante, Kingdom of Gold*) as contrasted with the Manhyia Palace Museum, Kumasi, Ghana, where the Asante themselves played a major role in funding, collection (including replicas), exhibition, and consideration of the varied constituencies and visitors the museum hoped to serve.

The service of constituencies, and the attendant rituals, classifications, and boundaries of that service, are the subjects of Paul DiMaggio's "Cultural Entrepreneurship in Nineteenth-Century Boston, Part II : The Classification and Framing of American Art" (1982). The entrepreneurs DiMaggio studies were "framing artistic experience" and avoiding the work of living American artists (a problem Dana would later interrogate). They were also engaged in a fierce debate about the use of casts and reproductions, a debate that involved the "cultural capitalists," who had a vested interest in educating the lower classes, and "new professional" aesthetes, who objected to reproductions. This debate takes on another dimension in light of the pragmatic use of replicas by the Asante in the Palace Museum, Ghana, as they negotiate prohibitions and/or objections to the display of their original objects, and urges further analysis of the conflicting demands of authenticity when asserted through objects. In the context of the Museum of Fine Arts, Boston (later Gilman's base of operations) and the Boston Symphony Orchestra, DiMaggio discusses the "narrowing of the audience base" in proportion to the refining of artistic goals, the "classification and framing of high culture," and the "ideology of connoisseurship." In concluding he notes similarities between American and European developments in the sociology of the arts.

In "Women at the Whitney, 1910–30: Feminism/Sociology/Aesthetics" (1999) Janet Wolff begins by telling the story of "the non-materialization" of the exhibition she had been invited to curate at the Whitney Museum of American Art in New York for the series "Collection in Context." Although her focus was to have been works by women artists given pride of place in the Whitney collection when it opened in 1931, she found that the work was in storage and, when she was able to see it, felt it might not merit exhibition. The narrative continues as Wolff subjects her own judgments to analysis and critique and confronts issues of "aesthetic orthodoxy" or "the elevation of modernist and abstract art over realism," "sociological questions of patronage," 1970s feminism versus 1990s feminism, the "social networks" of the art scene, and the "reevaluation" by museums and art critics of the realist and figurative tradition. The complex history Wolff encounters is in part determined by "the relevance and centrality of social relations and networks in the production and reception of art" and the "*masculinist discourse*" of modernism. She also documents her own gradual process of self-reflection and correction, and scholarly and curatorial discovery.

The politics of the museum can be embodied in the autobiographical dimension of the objects it displays, as Maurice Berger explains in "Zero Gravity" (1993), a catalogue essay for *A Museum Looks at Itself: Mapping Past and Present at the Parrish Art Museum 1897–1992* (Southampton, New York). Berger credits curator Donna de Salvo with creating an exhibition which "engaged a rare kind of institutional self-inquiry, displacing the museum from the center of cultural gravity and questioning the myths of unity that hold it together," finding what we might call the antidote to the

universal survey museum approach. He takes the reader through the exhibition, noticing how architecture, the contents and their arrangement in galleries, labeling, and parody challenge visitors to react to a museum which has abandoned its authoritative posture and "blasted the fiction of coherence." Dana's warnings to the museum world might have been addressed to the Parrish at many points in its activities, as the exhibition illustrates.

In the Introduction to the catalogue for *The Museum as Muse: Artists Reflect* (The Museum of Modern Art, New York, 1999), Kynaston McShine illustrates the point that the museum, "as an institution generally, and maybe even The Museum of Modern Art specifically, has had great meaning for contemporary artists, and they often have felt strong emotional connections to it, whether of love or hate." We have encountered related points in the analyses by Dana and Fisher, and with McShine's essay – which includes consideration of works beyond those in the MoMA exhibition – we see other specific facets of the commentary by art(ists) on the museum. McShine offers a historical perspective on the changing relations between artist and museum, and the influence of artist upon artist, as those relations evolved. The viewers/visitors and their active or passive roles in the museum encounter also emerge as crucial subjects in the works McShine discusses, a fact which has a parallel in a general increase in attention among museum professionals to the complexities of that encounter.

The contextualization of objects (art and artifacts) and the experience of the museum visitor are treated as interrelated subjects in "Exhibiting Mestizaje: The Poetics and Experience of the Mexican Fine Arts Center Museum" (1998), as Karen Mary Davalos explains by looking at five examples from the exhibition history of the Mexican Fine Arts Center Museum (MFACM) in Chicago. Starting with a review of the "public" museum in the United States (using Duncan and Wallach's essay for her definition of that term), Davalos finds the "unifying" messages and master narratives we might have come to expect, given the course of museum studies. However, writing from the position of "minorities" and "other 'deviants,'" she then investigates activities mounted by these "communities" and offers a probing and often critical report, seeking to avoid the "celebratory discourse" she discovers in revisionist exhibition and scholarly practices. In preparation for her review of exhibitions at the MFACM, she attends to issues of nationhood and internal politics, "the ambiguities of representational practices," lines of identity-formation and activities at their borders, and community museums; Davalos then turns to the "Mexicano museum" as a "hybrid form" which both repeats museum conventions and subverts them.

With "Resonance and Wonder" (1990) Stephen Greenblatt presents a close metaphysical inspection of the interaction between objects and visitors, one which arguably lends itself to a range of specific museum encounters – "particular, contingent cases, the selves fashioned and acting according to the generative rules and conflicts of a given culture." While Greenblatt acknowledges his primary affiliation with "new historicism" in literary studies, he turns to the study of museums to examine the dynamics of human agency as experienced in the dynamics of the encounter between object and viewer in the museum. In an intricate analysis of the potential operation of "resonance" ("the power of the object displayed to reach out beyond its formal boundaries to a larger world, to evoke in the viewer the complex, dynamic cultural forces from which it has emerged and for which as metaphor or more simply as synecdoche it may be taken by a viewer to stand") and "wonder" ("the power of the object displayed to stop the viewer in his tracks, to convey an arresting sense of

uniqueness, to evoke an exalted attention"), Greenblatt moves from traditional installation techniques, which inhibit if not prohibit resonance, to the State Jewish Museum in Prague, which offers an example of a "resonant museum," and to recent putative attempts to "turn our museums from temples of wonder into temples of resonance." Some balance between resonance and wonder appears to be the synthesis advocated in Greenblatt's analysis, but every reader/visitor will arguably assign their own definitions and values to those terms before deciding on the appropriate ratio.

The museum–audience relationship is placed in historical context by Eilean Hooper-Greenhill in "Changing Values in the Art Museum: Rethinking Communication and Learning" (2000). While many museums may still follow the traditional "modernist" transmission-based model, in which visitors are assumed to be "uninformed receivers" of the authoritative facts and histories conveyed by the museum, Hooper-Greenhill argues that museum practice has also turned (willingly, idealistically, hesitantly, or otherwise) toward a "constructivist" model which borrows from developments in theories of learning and communication, as well as post-modernist and post-colonial theory, to regard knowledge as "plural, fluid, brought into being by the processes of knowing." This revision extends to the content as well as the form of museums and their exhibitions, and Hooper-Greenhill draws examples from recent exhibitions of indigenous cultures to illustrate that histories "are being rewritten from new perspectives," the past "is being re-memoried to privilege different events," and some previously "silent voices" are being heard. The effects of these revisions on the experience of "resonance and wonder" are interesting to contemplate and call for ongoing study.

The concluding text for this section, and this collection of *Museum Studies*, is Barbara Kirshenblatt-Gimblett's "Secrets of Encounter" (1994, 1998). The analysis brings objects, objectives, and visitors together in the "theater of secrecy" or "hiding and showing" that may define the exhibition, the catalogue, and the symposium, or perhaps the museum studies anthology – a range of phenomena which "keep our attention from wandering to what is not shown." Her title is in part inspired by the exhibition *Secrecy: African Art That Conceals and Reveals* (The Museum for African Art, New York, 1993), one of several "reflexive" museum projects which include the much analyzed *Art/Artifact* exhibition. The art/artifact distinction is perhaps at the heart of this exhibition of *Secrecy*, where "curators play at the intersection of art and anthropology, where converging interests have helped propel African objects far beyond contexts for which they were made," and where the pleasure principle seems to be excited by the prospect of knowing that meaning hovers in the object but is not subject to full disclosure.

This text leaves us at the threshold of what stands undisclosed, and seems to be a fitting conclusion to this collection – as it invites the reader to visit the museum.

Chapter 40 | John Cotton Dana

The Museum as an Art Patron

Some museums have grown; others have been made to order.

In Munich is the National Museum of Bavaria. It has a beautiful home, into which have been gathered objects illustrating the story of the life of man, in what is now Bavaria, for nearly three thousand years.

How the objects that form the museum came to be brought together I do not know; but one sees at a glance that here is no made-to-order collection, but one that has come out of the very life of the Bavarian people as they have slowly climbed to their present high estate.

The museum that is made to order, not being a natural product of the activities of the community in which it appears, is the child of a passing fashion, is built about a fixed idea of what a museum should be; does not represent or issue from the life of the people by whom it is brought into being. The National Museum of Bavaria is a series of original documents produced in Bavaria and picturing its history for three thousand years, and can be truly said to have grown. Of many of the museums in Europe the same thing may be said. They present, through the objects in them displayed, much of the domestic, civil, religious, and martial life of the communities in which they are found.

They are by no means all of equal interest, at all times, to the people to whose ancestors they owe their existence. This is partly because the interest taken by any community in the life of previous generations varies from time to time, both in intensity and direction. But a museum that is made of objects which were wrought out, in the course of years, by the hands of a given group of people is each year almost inevitably of increasing value to that group, even if it be, at any given period, not of wide popular interest.

The willful Queen of Frank Stockton's story made a collection of buttonholes, they being artifacts in which she was herself intensely interested. She placed them in a museum building and insisted that her subjects visit them, enjoy them, and take profit from seeing them. She carried her theory so far that most of her subjects having found her museum a quite intolerable bore, cheerfully chose to live in jail rather than make a second visit to it.

John Cotton Dana, "The Museum as an Art Patron" from *Creative Art: A Magazine of Fine and Applied Art* 4 (June 1929), pp. xxiii–xxvi. Public domain.

That queen is fairly typical of the creators of the made-to-order museum. They do not ask what a community wishes to see in a museum. They assume to know what it will do a community good to see, and proceed to supply it. Their collecting proclivities are almost purely the children of precedent. They have noted that the cities of Europe have made vast collections of objects which are ancient, rare, and often beyond price. These collections give prestige to the cities which possess them, are visited by tourists from other countries, and are of value to a few students of the histories of the arts. Those who direct museums in this new country of ours quite illogically draw from the existence of such foreign museums two erroneous conclusions. The first is that these collections have stimulated art production in the communities which have made them, and are the prime predisposing reason why art production has flourished in those communities. The second error follows naturally from the first, and is that similar collections, arbitrarily made in the new cities of a new world, will be primary causes of art production in those new countries. Hence we have in America made-to-order museum collections imitating similar collections in Europe. As one American city after another becomes the home of wealthy citizens, they hasten to gather valuable collections and to house them in buildings of great cost and of a style that convention demands, with the unfortunate result that each newly filled American museum has a collection of ancient, unique, and highly priced objects which is inferior to the one that last preceded it in the collecting process.

II

I venture to repeat my statement. The peoples of the Old World have, each in that period of its life when the urge for the production of beautiful things was upon it, brought forth art objects, in one or many fields, that still arouse joy in those capable of appreciating them. By many and varied ways certain of these beautiful productions came into museums and were there preserved. The proponents of "museums of museum pieces" for American cities say, in effect, "What has been done in the Old World can be done in the New. Museum collections of things old, unique, and costly have there been one of the great proximate causes of the production of art; they will be with us like agencies developing taste and calling forth talent."

The absurdity of this assumption surely need not be presented. No one knows why a people have a desire for beautiful things and an accompanying ability to create them. Even of the Renaissance in Italy it cannot be said that it was caused by the sight of such beauty, fashioned by the Greeks, as came within reach of Italy's vision in the early days of her awakening. Of this, on the other hand, we can be fairly well assured, that artist and craftsman come forth and create and construct only when they can gain, by so doing, a certain due esteem and perhaps, also, a living wage. If the eyes of a people are turned eagerly toward things that have been wrought out in other lands and in ancient times; if the purses of a people are opened wide for the purchase and the fashionable and costly installation of the products of artists of other days, and are opened grudgingly, if at all, for the patronage of men and women of the present day and hour who wish to create beautiful things and ask only for an opportunity to try so to do – then the age of art for that people is surely not at hand.

III

It is not necessary to name any of the cities that have in recent years given hostages to the art productions of the past by the erection of ornate and costly buildings in which the past only is to be given space, and thus have cut themselves off from rendering any aid whatever to the artists of to-day and to-morrow. They are easily found. It may be wise to try to correct, at this point, the impression which these notes may give, that they are purely critical and in no way constructive, by making a few suggestions.

If an American city wishes to be a promoter of interest in, enjoyment of, and appreciation of things in the art field, and thus to stimulate the production of art objects and the development of high technical skill in the arts, let it proceed somewhat as follows:

In the museum building of the city – or if it is already crowded or is remote from the center of the city's daily movement of population or is not adapted to changing displays, then in buildings constructed or rented for the purpose, conveniently located for visitation by average citizens – let it set up a series of exhibits of things currently produced by the artists and workers of its own city and country. Precede and accompany these exhibits by ample statements, in the public press and otherwise, of the reasons why they are to be made and what is hoped to be accomplished by them. This statement can say that the museum of the city is no longer to be simply an object lesson on the achievement of artists, designers, and artisans of other countries and other times; but aims to become, also, a stimulant to improvement in the arts as practiced in our city and our land to-day and to-morrow. It hopes it can add to the story, which has long been told by its collections, of what patronage has induced aspiring artists to produce in other times and other conditions, a series of object lessons telling what art is bringing forth in our own time, by reason of the patronage which is here and now offered to that art. It is aware that popular opinion on art is the child of fashion and convention, and that both fashion and convention in this field are, in the main, products of self-constituted connoisseurs who have imbued with their opinions, first the wealthy and then the people at large. It has long known that while the outgivings of our own studios and workshops are purchased, used, and enjoyed by the people at large, those same outgivings are frankly looked upon as merely American, as not truly artistic, and to be tolerated only until a product entirely in harmony with rare and costly objects found in our museums can be substituted for them. It seems that while our own output may enjoy a certain passing vogue and may be quite freely purchased, it is not put in the same class with objects which have been heretofore shown in the museum, does not arouse the respect granted freely to the latter, calls forth no special respect for the artists, designers, and artisans who have brought it into being, and leads to no special interest in, and no desire to aid the development of, the practice of the arts in our land.

And, the statement of the museum's new purpose can go on to say, the museum feels that it can, by the plan it is here outlining, persuade a few of our fellow citizens to realize that objects produced for enjoyment and use by any people are always capable of being made more interesting, more attractive, and more completely satisfying – and that the way to make them so is for those who purchase and use them, and live with them, to look upon them more critically; to evaluate more often their qualities; to condemn what they find in them that is silly, meaningless, and mere surplus; to praise

in them what they can, and to keep in mind the fact that improvement in design and craftsmanship for objects of any kind never comes as a chance gift of the gods, but out of the desires of the people who are to use them.

IV

Those sentences merely suggest some of the many things that the museum can properly say in its preliminary statements.

As to the things shown in the special exhibits which the museum will hold for the purpose of awakening interest in things designed and made in the city which supports it and in the country of which that city is a part, they will be of such nature and size as conditions indicate. As oil paintings and sculpture come most commonly to the minds of nearly all people when the word "art" is used, and as they involve the fundamentals of well-nigh all of the applied arts, the exhibits may well begin with them. Local artists will be invited to contribute. For some exhibits a jury of selection may be appointed; for others, not. In a large city which has many artists, each exhibit may be confined to a certain range of subjects. The museum should be able to buy at least a few works from each exhibit, if any are found worthy of purchase. If it cannot do this, it can at least award prizes, even if they are no more than written praises of the best critics obtainable. The museum's purpose is, of course, not to support artists who are not worthy of support; but to stimulate interest in, and in due course intelligent appreciation of, the arts of painting and sculpture as practiced in our land. Most American museums of art seem to spend their money and their efforts in an attempt to suppress as far as possible all demonstrations of the presence in their respective cities of interest in painting by local artists.

The last statement applies to interest in local art production of any kind; also it suggests, better than can any enumeration of details, proper methods of exhibiting, or of the selection of objects for exhibit, in what may be called the museum's "art opportunities." "Opportunities" – that is the word which the unrecognized art worker has chiefly in mind when he asks for a little more than downright ignoring. He is not wishing to be supported in his days of effort, on the chance that he may make good his hopes; but only that he be not considered by the museum of the town and proponents of its methods as being unworthy of notice simply because he is a product of his town.

V

The museum exhibits here suggested may begin with painting and sculpture, and go on to the decorative arts, furniture, textiles, ceramics, and all types of manufactured goods in which beauty and use may go hand in hand. It would be an error to go further into the subject of the kinds of things that can be shown in a museum which tries to be a product of present-day artists, designers, and craftsmen. The exhibits should not be large. They should be carefully selected, and so labeled, described and catalogued as to make them easily seen, and their good qualities quickly discovered. The annual expositions of so many different kinds of things as can be crowded into a huge building and are open for a few days only – these have at times been exceedingly useful; but they are not at all what I am trying to suggest.

In almost every line of art and manufacture there is rivalry, not only in the race for cheapness of production, for wearing and other qualities in the products, but also in the search for looks. It is this endeavor of manufacturers to make their output pleasing to the eye that naturally and necessarily brings machine-made goods into the field of art. We are too prone to think that art is an indefinable somewhat which infects the objects gathered in a museum; and that to the touch of art the products of our factories are quite immune! This curious notion prevails in spite of the fact that the persons in a city, who may be moved to appreciation of the rare and costly object which has been acclaimed as artistic, are at most but a few thousand; whereas, the persons who examine with keen interest and with intelligent criticism the countless products of our factories, which are displayed in our stores, are counted by millions. The fact is, of course, that we are as a people studying art, learning to judge and discriminate and choose in well-nigh every moment of our waking lives – and especially when we are selecting things for purchase. But, unfortunately, we do not associate this unceasing practice in art criticism with art, largely, if not chiefly, because we have for so long stupidly accepted as true the claims of the guardians of our museums, and alas! of most of our writers on the arts, that art is something which has attached itself only to the productions of the past, plus a few, a very few, of the things turned out by practicing artists of our own times.

What I have tried to say is that we should cause museums to grow out of the activities that we are now engaged in; and that we should so manage these new museums as to make them a component and helpful part of the efforts of our present-day artists, designers, craftsmen, shop workers, and manufacturers to produce beautiful things, and to add to useful things the somewhat which makes them attractive to the eye. In so doing we shall put into the very field of art the examination, the criticism we all exercise and the choice we all make in selecting even the humblest of pots and pans.

Chapter 41 | Benjamin Ives Gilman[1]

Aims and Principles of the Construction and Management of Museums of Fine Art

Aims

By a museum of fine art is here understood any permanent exhibition restricted to objects possessing artistic quality. By artistic quality is understood the worth a man may give his work for contemplation apart from use.[2]

By the appreciation of fine art is understood the perception of artistic quality. To appreciate a work of art is to see it with the eyes of its maker when he looked upon it and found it good. In appreciation a beholder receives into his own spirit the secret treasure of another's heart, gathered by an observant eye, wrought by a fertile fancy and conveyed by a cunning hand.[3] Artistic production is imaginative utterance; appreciation its understanding.

Unless understood, an utterance misses its purpose, whether of pleasure or profit. Understanding is therefore the normal mental attitude toward utterance. But another attitude of mind is possible. We may seek to know not the utterance itself, but other things in relation to it. To appreciation as knowledge *of* art corresponds investigation as knowledge *about* it.

Hence, any permanent repository of works of fine art has a double function: a primary one, that of securing appreciation for its contents; and a secondary one, that of conducting or at least permitting the investigation of them. Those who approach a work of art seeking to know the aim of the artist are first to be considered in the administration of a museum;[4] those seeking to further their own scientific or technical aims in the examination of a work are to be offered every facility compatible with its paramount right, as speech, to a hearing.

Benjamin Ives Gilman, "Aims and Principles of the Construction and Management of Museums of Fine Art" from *The Museums Journal* (July 1909), pp. 28–44. Public domain.

Principles

I. Simplicity

A museum building should be simple in design, externally and internally.

For a building elaborate in effect competes with the collections for the attention of the visitor and detracts from those of a different spirit from its own. Further, a monumental design complicates the problem of lighting by restricting freedom of fenestration.[5]

The architectural effect of many museum buildings has been obtained at the expense of the works of art they were built to show. All writers on museum topics deprecate this unnecessary sacrifice to rich and imposing façades, domes, stairways, corridors and anterooms and to the exuberant decoration of galleries, agreeing that a museum building should constitute an unobtrusive frame to the picture presented by the collections, and that as such it ought to be made to yield a specific architectural type, with its own distinctive if more modest beauty.[6]

II. Segregation

A museum building designed for large and varied collections should be divided into sections not directly connected, each section to contain no more galleries than can be seen at one visit without undue fatigue; and agreeable resting places should be introduced between the sections.

For: first, galleries should not be thoroughfares. Those who traverse exhibition rooms with the sole aim of getting elsewhere both weary themselves and disturb others. A museum should be so arranged that only those who have some interest in a given section will have occasion to enter it.[7]

Second, small collections are more rewarding to the visitor than large ones. A greater unity of impression is possible with fewer exhibits and the attention is fresher for them.[8]

Third, museum visiting is one of the most fatiguing of occupations. To see a work of art thoroughly is not only an effort of the eyes but in general of the body, in standing, bending, or other muscular tension; to understand it taxes memory and intelligence alike. In proportion as appreciation is more complete, the need of occasional relaxation increases.

The objection that by a system of intermediate vestibules or corridors the distances to be traversed in the museum as a whole are increased, is not valid. Museum fatigue may be said to come solely from standing and looking: the actual walking is rather a relief. The objection that seats in the galleries suffice for rest, overlooks the fact that, although indispensable, they do not afford the mental freedom and diversion necessary to keep the mind of the visitor freshly receptive.

A museum should, if possible, be situated in grounds laid out for use as a park; not only to give opportunity for extension and to obtain protection from noise, dust, and risk of fire, but also on account of the power of natural beauty to draw visitors and put the mind in tune for beautiful works of art; and, further, in order to permit the free use of gardens and courts by visitors in moderate weather as an extension of the facilities for pleasant relaxation afforded in the building.[9]

III. Dual Arrangement

Each section of a museum building should contain two groups of galleries; one for the exhibition of selected objects in a way to promote their appreciation, the other for the installation of remaining objects in a way to facilitate their investigation. The contents of the exhibition galleries should be varied as opportunity offers. The reserve galleries should be connected with an office, a class room, a work room and a special library, and should be open to anyone wishing to enter.

All large collections of prints, coins and textiles fabrics are administered as a store of possessions freely accessible and drawn upon for public exhibition. The extension of this principle to collections of all kinds promises five advantages: –

1 By closely installing much of its contents a museum may add to them without correspondingly enlarging its building. The principle contributes to solve the pressing problem of the growth of museums.
2 A museum provided with reserve galleries is free to acquire any object worthy of permanent preservation, whether suitable for continuous public exhibition or not. The reserve galleries may offer accommodation for objects of unmanageable size, whether great or small, objects of scientific or technical interest chiefly, objects painful or repugnant in motive, and those whose liability to injury from dust, light, change of humidity or temperature, mechanical strain or shock, demands their exhibition under special restrictions or infrequently.
3 In the main galleries the public is offered a rewarding exhibit in place of the more or less wearisome mass of objects commonly shown in museums.
4 In the secondary galleries, the conditions of space, freedom, light, guidance, apparatus, and companionship are such as most favour the purposes of scientific and technical students.
5 The interest of the community in the museum is maintained by changes in its exhibition galleries.[10]

The following negative definitions of the principle of Dual Arrangement may serve to prevent misunderstanding:

1 The principle does not propose to choose for exhibition all objects above a certain quality and leave in reserve all objects below that quality. This would result in an installation permanent as long as the museum standards were unchanged, instead of the varying exhibitions advocated. Doubtless in most collections more or fewer objects would demand to be shown in the exhibition galleries all the time, and these would chiefly be among the finer; and more or fewer could never be wisely removed from the reserve galleries at all, and these would chiefly be among the inferior. In so far the general level of the exhibits would be raised and this would be of advantage to the public taste.[11]
2 The controlling purpose of selection would in all cases be to exhibit together such works as would promote or at least not interfere with each other's appreciation by the public. This is not a decorative purpose aiming at the effectiveness of the galleries, but an artistic purpose, aiming at the effectiveness of the individual works displayed. As hereafter stated under the principle of Harmony, this artistic aim

would in general be best attained by an ethnological and historical choice and grouping of objects.

The aim to arrange scientifically and technically instructive exhibitions, while secondary, should be fulfilled to the utmost limit compatible with bringing out for the visitor the effect intended in each work by the artist.[12]

3 The principle does not propose to exclude either the public from the reserve galleries or scientific and technical students from the exhibition galleries, but to provide for each a place where their peculiar needs, on the one hand of appreciation, on the other of abstract inquiry and practical training, can be more perfectly met than in galleries where both are served together. It aims not to do less but greater justice, both to the art of the past, by providing for its more perfect assimilation by the whole present public, and to science and to the art of the future, by enabling each in its own way to draw more profit from the treasures in museums.

IV. Quality

In adding to its collections the primary aim of a museum of fine art should be the acquisition of works whose artistic quality meets the test of responsible criticism; a secondary aim, the formation of comprehensive exhibits. Every museum owes a special duty to local artists.

Museums and the promotion of art
Consciously or unconsciously an artist adapts his creation to a definite environment. In offering another, museums aim at the security and publicity of the work. They are repositories of works of art either separated from their native surroundings or lost to the world therein. Their two-fold office in the economy of artistic culture is to preserve the art of the past alike from destruction and from oblivion.

To inspire and direct artistic production is not the province of museums but that of life itself. Museums hold up the mirror of the past to the art of the present, as libraries do to its literature.[13]

Critical ability
Connoisseurship in its highest form implies an endowment and training capable of judging a work of art upon both internal and external evidence, both visually and by documents, both technically and scientifically, from the point of view of both maker and beholder, craftsman and historian.[14]

Comprehensive collecting a secondary aim
Comprehensive collections are better for scientific instruction; choice collections are better in themselves. The aim of comprehensive collecting is incompatible both with the purpose to collect works of the first quality and the purpose to show them in the best way. For the ideal of completeness is impossible of realization without the acquisition of secondary material and generally of reproductions; and from a little of every style the content of no one can be adequately gathered.

The necessary incompleteness of any museum of the first order is evident, but not to be regretted.[15]

The duty of museums to local art

The office of preserving good work from being forgotten is one which each museum can best perform for its own neighbourhood. In the case of *genii loci* a museum has a duty not only to preserve but in a measure to make their reputations. It may consider itself not only the guardian but the advocate of indigenous art.[16]

V. Harmony

In the main galleries of a museum those objects should be installed together which best aid each other's appreciation. For this purpose, the arrangement of objects according to the peoples, times, and schools that have produced them is preferable to their classification by the arts they represent.

For products of the same civilisation efficiently aid each other's appreciation by uniting to evoke the spirit which engendered them. The installation together of objects of the same art, or in the same materials, from different civilisations, while it may facilitate scientific and technical study does not contribute to their appreciation.[17]

VI. Reality

Reproductions should not be exhibited with originals.

The grounds for this rule are, first, the radical inferiority of most copies;[18] second, the right of the public to trust in what it sees without the vexing question: "Is this real or imitation?"; third, the right of originals to exemption from this doubt, and from the companionship of radically inferior objects.

Reproductions of works of art

The derivative character of reproductions should be clearly expressed by installing them in separate collections, which should be freely accessible.

Reproductions of environment

To install real works of art upon a reproduced background even if the latter is plainly a reproduction, both confuses the public and dishonours the works of art. A museum should remain frankly a museum, and never approximate a theatre, however its decoration be harmonised with its contents.[19]

VII. Service

A museum of fine art should be active in exhibition as well as in acquisition; seeking primarily to promote public appreciation of its collections by attracting and instructing visitors; and secondarily, to increase and diffuse scientific and technical knowledge of them through research and by aid to students.

The life of a museum consists not only in growth but also and chiefly in influence. The Thorwaldsen Museum, which does not grow at all, is, nevertheless, a permanent vital force in European civilization. That the possessions of a museum should increase is desirable; that they should win new friends is essential.[20]

To these ends the museum should command the services of men competent not only to effect the proper preservation and advantageous exhibition of the collections

and to give wise advice regarding accessions, but to aid both in their appreciation and in their investigation.

Service to visitors

The public whose welfare is served by a museum should be attracted to visit it by the charm of the building and its surroundings, by liberal conditions of admission, by arrangements for comfort and convenience; they should be interested in the collections by their advantageous installation, their sympathetic interpretation and the opportunity to aid in spreading their influence. Concerts, indoors in winter and outdoors in summer, offer a means of attracting visitors and occupying intervals devoted to rest.

In particular a museum of art should, as far as is practicable, be opened free to the public daily during daylight hours. Among desirable accommodations may be mentioned cloak and retiring rooms, convenient and ample for exceptional crowds; a public telephone, an information agency, and a restaurant; handbooks guiding the visitor through the collections, and catalogues, photographs and other reproductions describing and illustrating them; a bulletin chronicling the history of the institution and its possessions; printed information about the exhibits in all the galleries; oral information by lectures on the collections and guidance through them;[21] committees and societies for purposes bearing upon the collections, including the foundation of branch museums, to be formed under the auspices of the museum, and working from it as a centre.

The public service of a museum of fine arts need not be limited to its own collections. A chartered guardian of fine art may fitly lead in efforts to preserve whatever artistic resources its neighbourhood possesses, undertaking to register, study and make known any local treasures of art which their public or private possessors offer for the purpose; recording them by description and photography, gathering and interpreting data about them and arranging for public access to them. In accepting this wider duty a museum would usurp no control over local art, past or present, but would remain within its proper sphere as a conservative force, sheltering certain works of art within its walls and imparting information as to others without.

Service to students

A work of fine art like any other product of man's creative skill is a datum both for science and for the arts concerned in its production. It constitutes a fact of which men of science should take due cognisance in their efforts to add to knowledge. It constitutes, further and therefore, a pedagogic means of which teachers of related subjects should make use for the advantage of their pupils. Again, as an example of a certain branch of human skill, the practitioners of that art should make use of it in the development of their own and others' creative abilities. A museum should facilitate the use of its collections for all these aims. In particular, a museum may offer the services of its officers and the use of its galleries and department rooms for scientific and technical lectures upon its collections, and accord free admission and other special privileges to teachers and students.

The foregoing seven principles may be summarised as follows: –

Museum buildings should be marked by their quiet design (I.), and should consist of units of moderate size (II.), each containing primary and secondary galleries (III.). The collections should aim at excellence rather than comprehensiveness (IV.), and should be arranged by peoples and epochs instead of arts (V.), reproductions being

shown separately (VI.). The museum should be active in attracting visitors, in interpreting objects exhibited, and in aiding scientific and technical students (VII.).[22]

Notes

1 This essay expresses opinions reached in the service of the Museum of Fine Arts, Boston, and formulated during the preparation of plans for the new building of the museum. The paper was read at the first meeting of the American Association of Museums in New York, May 15th, 1906. It had been prepared during the previous winter with the aid of Mr. Matthew S. Prichard, then a colleague. The section on aims restates briefly the æsthetic idea of art museum management advanced by me in two letters to the Boston Evening Transcript of October 12th and 28th, 1899, and argued at length in an essay on "The Distinctive Purpose of Museums of Art," published in the *Museums Journal* for January, 1904. Among the Principles those of Dual Arrangement, Harmony and Reality were stated by Mr. Prichard in his essay on "Current Theories, etc," privately printed in "Communications to the Trustees regarding the new building I." March, 1904. The principle of Dual Arrangement applies to museums of art the division of collections into a series for exhibition and a series for study proposed in 1860 by Professor Louis Agassiz for the Harvard Museum of Comparative Zoölogy, and since common in museums of science.

2 The artistic motive, as the desire to create (to call into being) differs from the practical motive, the desire to employ (to call into action). Creation directly affects only the thing created, employment directly affects other things than that employed. The two impulses, artistic and practical, reach fruition together when intrinsic value is given to an instrument of valuable results.

3 ALBRECHT DUERER. "Daraus wirdet der versammlet heimlich Schatz des Herzen offenbar durch das Werk und die neue Creatur die einer in seinem Herzen schoepft in der Gestalt eines Dings." (In artistic production "the secret treasure of the heart gathered (by observation) is made manifest through the work and the new creation which a man shapes in his heart in the form of a thing.") "On Human Proportion." Excursus at end of Bk. III. Lange and Fuhse. Duerer's Schriftlicher Nachlass. Halle, 1893, p. 277.

4 Dr. WILHELM BODE, General Director of the Royal Museums, Berlin. "To bring about the purest possible artistic enjoyment must always be the first aim of the administration of every art museum." "Kunstmuseen, ihre Ziele und Grenzen." Int. Wochenschrift fur Wissenschaft, Kunst u. Technik, No. 1. 6th April, 1907, p. 21.

5 *Light from the sky.* In order that the lighting of a room shall be adequate for museum purposes, it is necessary that an ample area of sky shall be visible from its windows. For the light reflected from buildings or other objects is much more strongly coloured than light from the sky, and may be regarded as an adulteration to be minimized.

 Dr. A. B. MEYER, formerly Director of the Royal Zoological, Anthropological and Ethnographical Museum, Dresden. "Studies of Museums," reprinted in translation in the Report of the U.S. National Museum for 1903, p. 389.

6 Dr. G. E. PAZAUREK, Director of the Landes-Gewerbe Museum, Stuttgart. "Museumsbauten," Wiener Bauindustrie Zeitung, XV., 1903, p. 343.

 Dr. ADOLF FURTWAENGLER, late professor at the University of Munich and Director of the Glyptothek. "Uber Kunstsammlungen in alter und neuer Zeit," Munchen, 1899, p. 25.

 JOHN RUSKIN. Letter to *The London Times*, of December 29th, 1852, on the National Gallery.

 Sir J. C. ROBINSON, late superintendent of the Art Collections of the South Kensington Museum. Nineteenth Century, 1892, p. 1025.

 Dr. ERNST GROSSE, professor at the University of Freiburg, and Director of the Freiburg Museum. "Every gallery is nothing more nor less than a great frame for the art works it

contains, and like a good frame it should draw no attention at all to itself, either by a too scanty or a too rich decoration." Report of the Mannheim Conference of museum officials, Berlin, 1903, p. 125.

7 The germ of this arrangement is found in the old Pinakothek at Munich (1836), where pictures of the same school are placed in one section consisting of a top lighted gallery for the large pictures and side lighted cabinets for the smaller. The architect, Baron von Klenze, is quoted as saying, "I wish to allow the possibility of arriving at any particular school without going through another, and for this purpose I have a corridor running the whole length of the building, which communicates with each separate room."

EDWARD EDWARDS, formerly of the British Museum. "Administrative Economy of the Fine Arts," London, 1840, p. 269.

Professor W. STANLEY JEVONS, late professor at University College, London. "Methods of Social Reform," p. 59.

Dr. F. A. BATHER, assistant keeper, department of geology, British Museum. Presidential address, *Museums Journal*, 1903, p. 79.

Dr. ALFRED LICHTWARK, director of the Kunsthalle, Hamburg. Report of Mannheim Conference, Berlin, 1903, p. 119.

8 Dr. G. PAULI, director of the Kunsthalle, Bremen. Museumskunde I., 1905, 3, p. 149.

9 Dr. J. LEISCHING, director of the Imperial Austrian Museum of Art and Industry, Vienna. Report of the Mannheim Conference, 1903, p. 134.

Dr. J. H. V. HEFNER-ALTENECK, first director of the Bavarian National Museum, Munich, caused the open space behind the museum to be laid out as a garden and used for the installation of objects (decorative statues, grave monuments) originally intended for out of doors. "Thousands of visitors have expressed their grateful thanks that, apart from the pleasure of seeing these monuments, they were able in the summer months to recuperate here under the open sky or in shady bowers from the fatigue of looking about within the museum." "Entstehung, Zweek und Einrichtung des Bayerischen National Museums in Muenchen," 1890, p. 2.

Professor A. R. WALLACE, "Museums for the people," Macmillan's Magazine, vol. XIX., 1888–9, p. 249.

10 Professor LOUIS AGASSIZ embodied the idea of public and reserve collections in his plan for the museum of comparative zoology at Harvard in 1860. Third Annual Report of the Museum of Comparative Zoölogy: Cambridge, U.S.A. October, 1861; p. 10. See also Bibl. Univ. et Revue Suisse, 47me Année nouv. per. XIV., 1862, pp. 527–40: referred to in Dr. A. B. Mayer's "Studies of Museums," reprinted in translation in Report U. S. National Museum, 1903, p. 325.

Dr. KARL MOEBIUS, late professor of zoölogy in the University of Berlin and Managing Director of the Royal Museum of Natural History, Berlin. "The Proper Arrangement of Great Museums," Deutsche Rundschau, 1891, vol. 68, p. 352 ff.

Dr. G. BROWN GOODE, late assistant secretary of the U. S. National Museum, Washington. "Principles of Museum Administration," 5.B. The Study Series; C. The Exhibition Series, U. S. National Museum, Report, 1897, II., p. 219.

Sir W. H. FLOWER, late director of the British Museum of Natural History, London. "Essays on Museums," London 1898, p. 21.

Professor PATRICK GEDDES, professor of botany, University College, Dundee: president of Edinburgh School of Sociology. "A Study in City Development." p. 164.

L. ALMA TADEMA, R. A. *Le Musée*, vol. I., p. 66.

The Museums Journal, Note on the Museum of Decorative Art, opened 1905 in the Pavilion de Marsan of the Tuileries, Paris, Jan., 1906, p. 245.

Revue Archéologique, Septembre–Octobre, 1905, Correspondence p. 318.

New York Life. "Everybody knows that a large proportion of the contents of most of our art museums, even the very best of them, are a profound bore to the average intelligent

visitor, who seeks to refresh his soul for a little while by the contemplation of these beautiful works." Jan. 11, 1906, p. 54.

Rev. J. G. WOOD, Naturalist and Author. "The Dulness of Museums," Nineteenth Century, Vol. XXI., 1887, p. 394.

Changes of Exhibition.
Handbook to the Ruskin Museum, Sheffield, Eng., 1900, p. xi.

LI CHIH, a Chinese writer of the 11th–12th century, author of the Hua p'in. "No more than three or four pictures by eminent artists should ever be hung in one room. After these have been enjoyed for four or five days, others should be substituted," Quoted by Herbert A. Giles in his History of Chinese Pictorial Art, p. 134.

11 MATTHEW ARNOLD speaks of "inferior work * * * imbedding the first-rate work and clogging it, obstructing our approach to it, chilling, not infrequently, the high-wrought mood with which we leave it." Preface to his anthology of Wordsworth's Poems. London, 1879.

12 Professor CHARLES ELIOT NORTON of Harvard University, has noted that scientific attainment rather than artistic insight is too frequently the aim of study in museums. " . . . the risk of study in a museum is that instead of leading to the perception of beauty, the highest object it can have, it is too generally directed to merely scientific ends, that is, to the attainment of knowledge about the object, instead of to the perception and appreciation of that which makes the object in itself precious or interesting." Letter to the N.E. History Teacher's Association, October, 1904.

G. W. F. HEGEL. " . . . though such (art) scholarship is entitled to rank as something essential still it ought not to be taken for the sole or supreme element in the relation which the mind adopts toward a work of art, and toward art in general. For art-scholarship (and this is its defective side) is capable of resting in an acquaintance with purely external aspects, such as technical or historical details, etc., and of guessing but little, or even knowing absolutely nothing, of the true and real nature of a work of art. It may even form a disparaging estimate of the value of more profound considerations in comparison with purely positive technical and historical information." Philosophy of Fine Art. Translated by B. Bosanquet. Introduction, p. 65.

13 *Museums and Living Art.*

Dr. ADOLF FURTWAENGLER, "Kunstsammlungen aus alter und neuer Zeit," 1899, p. 29.

Dr. GEORGE SANTAYANA, Professor of Philosophy, Harvard University. "The Life of Reason; Reason in Art," 1905, p. 209.

Museums and Art Industry.

Dr. WILHELM BODE, General Director of the Royal Museums, Berlin. Dr. Bode writes of "the expectation of a new development of craftsmanship upon the basis of antique models shared by us all about twenty-five or thirty years ago," and concludes that "the essential condition of a permanent improvement in art industry and of its necessary support is the elevation of public taste." "This is one of the most important functions not only of museums of art industry but of museums of art: for so long as the public looks at works of art only on the practical and not on the artistic side, all progress in museums and schools of art is of little worth." "Functions of Museums of Art Industry," Pan, 1896, p. 124.

Dr. JUSTUS BRINCKMANN, director of the Kunstgewerbe Museum, Hamburg. "In so far as the exhibits offered to craftsmen by the museums (of art industry) were welcomed and exploited as a convenient means of throwing on the market a succession of novelties, they perhaps often contributed to destroy artistic inventiveness and invite to a superficial eclecticism." Guide to the Hamburg Museum of Art Industry, 1894, p. v.

RENÉ JEAN writes as follows of the Museum of Decorative Art in the Tuileries (Pavilion de Marsan); "People have objected that the museum aims at the education of the people

rather than that of the artisan: but what does this criticism amount to? The workman does not control the fashion, but submits to it. To cultivate the taste of the buyer cultivates that of the producer." *Le Musée*, vol. II., No. IV., pp. 195–6. See also the account of this museum with illustrations by Gaston Migeon, Gazette des Beaux Arts, July, 1905.

See also GUSTAVE LARROUMET, late perpetual secretary of the Academy of Fine Arts, Paris, and Professor at University of Paris, in the "Annales Politiques et Litteraires," March 29, 1903: H. DE REGNIER, in the same journal, August 16, 1903: R. DE LA SIZERANNE, Revue des Deux Mondes, 1899, p. 114 f: G. ELPI, writer, Italy, "I Musei," Florence, 1902: HANS DEDEKAM, Director of the Nordenfjeldske Kunstindustrimuseum, Trondhjem, Norway. Norway, Museumskunde I., p. 78: Sir W. M. CONWAY, former Slade professor of Fine Arts, Cambridge, England, "The Domain of Art," p. 24.

14 BERNARD BERENSON, Florence, Italy. "The Study of Italian Art," 1902. "Rudiments of Connoisseurship," pp. 111 ff.

15 Dr. ERNST GROSSE. "For a museum such as we have in mind there is no more foolish extravagance than 'inexpensive' acquisitions of poor work with good names. Such we may gladly leave to those directors and amateurs whose highest ideal consists in 'completing their collections.'" "Aufgabe und Einrichlung einer Städtischen Kunstsammlung," p. 6.

16 A. FOULON DE VAULX, "Dans un Musée de Province." Le Carnet, July, 1902, p. 55. Dr. ALFRED LICHTWARK, "The Immediate Duty," Museumskunde, 1-1, 1905.

17 Dr. JUSTUS BRINCKMANN. Guide to the Hamburg Museum of Art History, 1894, p. vi. W. STANLEY JEVONS. "Methods of Social Reform," p. 57.

THE CROWN PRINCE AND CROWN PRINCESS FREDERIC OF GERMANY, Jahrbuch der Königlich Preussischen Kunstsammulugen, Vol. IV., p. 121, 1883.

LIEUT.-COLONEL G. T. PLUNKETT, C. B. Director of the Dublin Museum of Science and Art, Ireland. "How an Art Museum should be organised." Magazine of Art, Vol. 27, p. 448.

Compare also the opinions on Museum installation expressed by Frantz Jourdain, Paul Adam, Maxime Maufra, Edmond Frank, H. Marechal, and Henri Martin, in *Le Musée* for January, 1907.

18 Dr. GEORGE SANTAYANA. "The known impossibility of adequate translation." "The Sense of Beauty," p. 171.

Professor A. LICHTWARK. "From plaster casts and photographs I anticipate not much good and great disadvantages. Their number and their deficiencies mislead one into superficial contemplation. It is a sorry sight to see a class of girls or gymnasiasts before an exhibition of photographs of the masterpieces of Michael Angelo and of Raphael."

"The flood of reproductions threatens to drown out the seeds of artistic culture as soon as they show themselves. Whoever, after considerable previous study, arrives in Italy will recognise that he is everywhere inclined to overestimate the works of art that he does not know in reproduction, and that it is hard for him to get a fresh and new impression of the great masterpieces through the chaos of reproductions of which his head is full." "Uebungen in der Betrachtung von Kunstwerken," Dresden, 1900, p. 33.

19 J. GUADET, professor at the Ecole des Beaux Arts, Paris. Éléments et Théorie de l'Architecture, pp. 312 ff.

EDMOND HARAUCOURT, Director of the Cluny Museum, Paris. *Le Musée*, vol. II., p. 73.

Dr. J. LESSING, late Director of the Royal Kunstgewerbe Museum, Berlin. "Now-a-days, the demand is often made that not only a general conception of a certain epoch of culture shall be given, but that things shall be installed to look exactly as they used to. Gentlemen, this will not do. Under certain conditions, it is possible: in provincial collections, for example, when a whole interior is shown: but even then one wall must be left out in order to look in, for visitors can hardly actually enter. But for large museums, nothing remains but to adhere in a general way to motives of a certain epoch. In this respect much may be done." Report of the Mannheim Conference, p. 109.

JOSEPH FOLNESICZ, Kustos at the Kunstgewerbe Museum, Vienna. Kunst und Kunsthandwerk, VI., 1903, pp. 57 ff.

20 *The Mannheim Conference* of Museum Officials (Sept., 1903), the first congress of continental museum officials yet held, was called to consider the question: "How shall the influence of museums upon the people generally be increased?"

CHARLES H. CAFFIN. "Museums and their possibilities of greater public usefulness." International Studio, American Studio Talk, p. clxiii., October, 1903.

21 Professor A. FURTWAENGLER, "Kunstsammlungen aus alter und neuer Zeit," p. 27.

The discussion of this question with reports from those who have acted as guides in the museums of Frankfort, Munich and Berlin, occupies pp. 146–84 in the report of the *Mannheim Conference*.

22 On the various subjects of this paper compare also;

A. WEISSMANN, architect, Amsterdam, "Gallery Building." Proceedings of the Royal Society of British Architects, 1907.

R. L. HARTT. "Art Galleries for the plain man." World's Work, November, 1907.

FRANK JEWETT MATHER, JR. "An Art Museum for the People." Atlantic Monthly, December, 1907.

F. W. COBURN, writer on Art, Boston. "The New Museum of Fine Arts" (Boston). New England Magazine, January, 1908.

Burlington Magazine, London. Editorial articles. "Museums," September 15, 1908. "Reorganisation at South Kensington, I." December 10, 1908.

Dr. THEODOR VOLBEHR, Director of the Kaiser Friedrich Museum in Magdeburg. "Die Ausstellungspflichten unserer Museen," Die Woche, No. 50, 12 December, 1908. S. 2149.

Chapter 42 | Georges Bataille

Museum

According to the *Great Encyclopedia*, the first museum in the modern sense of the word (meaning the first public collection) was founded in France by the Convention of July 27, 1793. The origin of the modern museum is thus linked to the development of the guillotine. Nevertheless, the collection of the Ashmolean Museum in Oxford, founded at the end of the seventeenth century, was already a public one, belonging to the university.

The development of the museum has obviously exceeded even the most optimistic hopes of its founders. Not only does the ensemble of the world's museums now represent a colossal piling-up of wealth, but the totality of museum visitors through-out the world surely offers the very grandiose spectacle of a humanity by now liberated from material concerns and devoted to contemplation.

We must realize that the halls and art objects are but the container, whose content is formed by the visitors. It is the content that distinguishes a museum from a private collection. A museum is like a lung of a great city; each Sunday the crowd flows like blood into the museum and emerges purified and fresh. The paintings are but dead surfaces, and it is within the crowd that the streaming play of lights and of radiance, technically described by authorized critics, is produced. It is interesting to observe the flow of visitors visibly driven by the desire to resemble the celestial visions ravishing to their eyes.

Grandville has schematized the relations of container to content with respect to the museum by exaggerating (or so it would appear) the links tentatively formed between visitors and visited. When a native of the Ivory Coast places an axe of neolithic, polished stone within a water-filled receptacle, then bathes in that receptacle and offers poultry to what he takes to be thunder stones (fallen from the sky in a clap of thunder), he but prefigures the attitude of enthusiasm and of deep communion with objects which characterizes the modern museum visitor.

The museum is the colossal mirror in which man, finally contemplating himself from all sides, and finding himself literally an object of wonder, abandons himself to the ecstasy expressed in art journalism.

Georges Bataille, *Museum* (translated from the French [1930] by Annette Michelson) from *October* 36 (Spring 1986), p. 25. Translation © 1986 by October Magazine Ltd and the Massachusetts Institute of Technology.

Chapter 43 | Pierre Bourdieu and Alain Darbel, with Dominique Schnapper

Conclusion to *The Love of Art*

The laws formulated above, if they be true..., may be truisms.
A. R. Radcliffe-Brown, *Structure and Function in Primitive Society*

When, for instance, a man wears a pair of spectacles which are so close to him physically that they are 'sitting on his nose', they are environmentally more remote from him than the picture on the opposite wall. Their proximity is normally so weakly perceived as to go unnoticed.

Heidegger, *Being and Time*

The same people who will no doubt be amazed that so much trouble has been taken to express a few obvious truths will be annoyed at not recognizing in these truisms the flavour, at once obvious and inexpressible, of their experience of works of art. What is the point, they will say, of knowing where and when Van Gogh was born, of knowing the ups and downs of his life and the periods of his work? When all is said and done, what counts for true art lovers is the pleasure they feel in seeing a Van Gogh painting. And isn't this the very thing that sociology desperately tries to ignore through a sort of reductive and disillusioning agnosticism? In fact, the sociologist is always suspected (according to a logic which is not his or her own, but that of the art lover) of disputing the authenticity and sincerity of aesthetic pleasure by simply describing its conditions of existence. This is because, like any kind of love, the love of art is loath to

Pierre Bourdieu and Alain Darbel with Dominique Schnapper, Conclusion to *The Love of Art: European Art Museums and Their Public*, translated by Caroline Beattie and Nick Merriman, pp. 108–13, 173. Cambridge: Polity, 1991. First published in *L'amour de l'art: les musées d'art européens et leur public*. © 1969 by Les Éditions de Minuit. English translation © 1991 by Polity Press. Reproduced by permission of Blackwell Publishing, except in the US, Canada, and the Philippines where permission is granted by Stanford University Press, www.sup.org.

acknowledge its origins and on the whole it prefers strange coincidences, which can be interpreted as predestined, to collective conditions and conditionings.

A vague awareness of the arbitrary nature of admiration for works of art haunts the experience of aesthetic pleasure. The history of individual or collective taste is suffi-cient to refute any belief that objects as complicated as works of learned culture, produced according to rules of construction developed in the course of a relatively autonomous history, should be capable of creating natural preferences by their own power. Only a pedagogic authority can break the circle of 'cultural needs' which allow a lasting and assiduous disposition to cultural practice to be formed only by regular and prolonged practice: children from cultivated families who accompany their parents on their visits to museums or special exhibitions in some way borrow from them their disposition to cultural practice for the time it takes them to acquire in turn their own disposition to practice which will give rise to a practice which is both arbitrary and initially arbitrarily imposed. By designating and consecrating certain works of art or certain places (the museum as well as the church) as worthy of being visited, the authorities invested with the power to impose a cultural arbitrary, in other words, in this specific case, a certain demarcation between what is worthy or unworthy of admiration, love or reverence, can determine the level of visiting of which these works will seem intrinsically, or rather, naturally worthy of admiration and enjoyment. Inasmuch as it produces a culture which is simply the interiorization of the cultural arbitrary, family or school upbringing, through the inculcation of the arbitrary, results in an increasingly complete masking of the arbitrary nature of the inculcation. The myth of an innate taste which owes nothing to the constraints of apprenticeship or to chance influences since it has been bestowed in its entirety since birth, is just one of the expressions of the recurrent illusion of a cultivated nature predating any educa-tion, an illusion which is a necessary part of education as the imposition of an arbitrary capable of imposing a disregard of the arbitrary nature of imposed meanings and of the manner of imposing them.

The sociologist does not intend to refute Kant's phrase that 'the beautiful is that which pleases without concept', but rather he or she sets out to define the social conditions which make possible both this experience and the people for whom it is possible (art lovers or 'people of taste') and thence to determine the limits within which it can exist. The sociologist establishes, theoretically and experimentally, that the things which please are the things whose concept is understood or, more precisely, that it is only things whose concept is understood which can give pleasure. He or she also establishes that, consequently, in its learned form, aesthetic pleasure presupposes learning and, in any particular case, learning by habit and exercise, such that this pleasure, an artificial product of art and artifice, which exists or is meant to exist as if it were entirely natural, is in reality a cultivated pleasure.

If what Kant called 'barbarous taste', that is, popular taste, seems to be at variance with the Kantian description of cultivated taste on all points, and especially in its insistence on relying on concepts,[1] in reality it simply demonstrates clearly the hidden truth of cultivated taste. Just as Hegel set against the ethics of pure intention, the ethos as 'realized ethics', the pure aesthetic can be opposed in the name of the aesthetic realized in cultivated taste which, as a permanent mode of being, is no less than a 'second nature', in the sense that it surpasses and sublimates primary nature. It is because it is the 'realized aesthetic' or, more precisely, culture (of a class or era) become nature, that the judgement of taste (and its accompanying aesthetic pleasure) can become a subjective experience which appears to be free and even won over in the

face of common culture. The contradictions and ambiguities in the relationship of cultivated individuals with their culture are both promoted and sanctioned by the paradox which defines the realization of culture *as naturalization*. If culture is only achieved by denying itself as such, namely as artificial and artificially acquired, then it is understandable that masters of the judgement of taste seem to attain an experience of aesthetic grace so completely free from the constraints of culture (which it never fulfils so completely as when it surpasses it) and showing so little sign of the long and patient process of apprenticeship of which it is the product, that a reminder of the social conditions and conditionings which made it possible seems at the same time both an obvious fact and an outrage.

For culture to fulfil its function of enhancement, it is necessary and sufficient that the social and historical conditions which make possible both the complete possession of culture – a second nature where society recognizes human excellence and which is experienced as a natural privilege – and cultural dispossession, a state of 'nature' in danger of appearing as if it is part of the nature of the people condemned to it, should remain unnoticed.

The deliberate neglect of the social conditions which make possible culture and culture become nature, a cultivated nature with all the appearances of grace and talent but nevertheless learned and therefore 'deserved', is the condition for the existence of the charismatic ideology, which allows culture and especially 'the love of art' to be given the central place they occupy in the bourgeois 'sociodicy'. The heir of bourgeois privileges, not being able to invoke rights of birth (which his or her class historically denied the aristocracy) or the rights of nature, a weapon in the past levelled against nobiliary distinctions which would run the risk of backfiring against bourgeois 'distinction', or the ascetic virtues which allowed the first generation of entrepreneurs to justify their success by their merit, can call on cultivated nature and naturalized culture, on what is sometimes called 'class', by a sort of Freudian slip, on 'education', in the sense of a product of education which seems to owe nothing to education, on '*distinction*', a grace which is merit and a merit which is grace, an unacquired merit which justifies unmerited attainments, namely heritage. In order for culture to fulfil its function of legitimating inherited privileges, it is necessary and sufficient that the link between culture and education, at once obvious and hidden, should be *forgotten* or *denied*. The unnatural idea of a culture given at birth, a cultural gift bestowed on certain people by nature, supposes and produces a blindness to the functions of the institution which ensures the profitability of the cultural inheritance, and legitimates its transmission by hiding the fact that it fulfils this function. The school is in fact the institution which, by its positively irreproachable verdicts, transforms socially conditioned inequalities in matters of culture into inequalities of success, interpreted as inequalities of talent, which are also inequalities of merit.

By symbolically shifting the principle distinguishing them from the other classes in the fields of economy or culture, or rather, by increasing the strictly economic differences created by the pure possession of material goods through the differences created by the possession of symbolic goods such as works of art or through the search for symbolic distinctions in the manner of using these goods (economic or symbolic) – in short, by making a fact of nature everything which defines their 'worth', in other words, to use the word in the sense used by linguists, their *distinction*, a mark of difference which, as Littré said, is separated from the vulgar 'by a character of elegance, nobility and good form' – the privileged classes of bourgeois society replace the difference between two cultures, products of history reproduced by education,

with the basic difference between two natures, one nature naturally cultivated, and another nature naturally natural. Thus, the sanctification of culture and art, this 'currency of the absolute' which is worshipped by a society enslaved to the absolute of currency, fulfils a vital function by contributing to the consecration of the social order. So that cultured people can believe in barbarism and persuade the barbarians of their own barbarity, it is necessary and sufficient for them to succeed in hiding both from themselves and from others the social conditions which make possible not only culture as a second nature, in which society locates human excellence, and which is experienced as a privilege of birth, but also the legitimated hegemony (or the legitimacy) of a particular definition of culture. Finally, for the ideological circle to be complete, it is sufficient that they derive the justification for their monopoly of the instruments of appropriation of cultural goods from an essentialist representation of the division of their society into barbarians and civilized people.

If this is the function of culture, and if the love of art is the clear mark of the chosen, separating, by an invisible and insuperable barrier, those who are touched by it from those who have not received this grace, it is understandable that in the tiniest details of their morphology and their organization, museums betray their true function, which is to reinforce for some the feeling of belonging and for others the feeling of exclusion. In these sacred places of art such as ancient palaces or large historic residences, to which the nineteenth century added imposing edifices, often in the Graeco-Roman style of civic sanctuaries, where bourgeois society deposits relics inherited from a past which is not its own, everything leads to the conclusion that the world of art opposes itself to the world of everyday life just as the sacred does to the profane: the untouchability of objects, the religious silence which imposes itself on visitors, the puritan asceticism of the amentities, always sparse and rather uncomfortable, the quasi-systematic absence of any information, the grandiose solemnity of decor and decorum, colonnades, huge galleries, painted ceilings, monumental stairways, all seem to serve as reminders that the transition from the profane to the sacred world implies, as Durkheim says, 'a veritable metamorphosis', a radical transformation of the mind, that the establishment of relations between two worlds 'is always a delicate operation in itself, demanding great precautions and a more or less complicated initiation', which 'is quite impossible, unless the profane is to lose its specific characteristics and become sacred after a fashion and to a certain degree in itself'.[2] If, by its sacred nature, the work of art requires particular dispositions or predispositions, in return it bestows its sanction on those who satisfy these requirements, on the chosen who are themselves chosen by their ability to respond to its call. To grant the work of art the power to awaken the grace of aesthetic inspiration in all people, however culturally disadvantaged they may be, and to produce through itself the conditions of its own diffusion, in accordance with the principle of the emenational mystics, *omne bonum est diffusivum sui*, is to sanction the attribution of all abilities to the unfathomable fates of grace or to the arbitrary of 'talent', whereas in reality they are always the product of unequal education, and thus it is to regard inherited aptitudes as if they were virtues inherent to the person, simultaneously natural and commendable.

The museum presents to all, as a public heritage, the monuments of a past splendour, instruments for the extravagant glorification of the great people of previous times: false generosity, since free entry is also optional entry, reserved for those who, equipped with the ability to appropriate the works of art, have the privilege of making use of this freedom, and who thence find themselves legitimated in their privilege, that is, in their ownership of the means of appropriation of cultural goods, or to paraphrase

Max Weber, in their *monopoly* of the manipulation of cultural goods and the institutional signs of cultural salvation.

Notes

1 Cf. P. Bourdieu et al., *Photography: A Middle-Brow Art*, tr. Shaun Whiteside (Cambridge: Polity, 1990).
2 E. Durkheim, *The Elementary Forms of the Religious Life*, tr. J. W. Swain (London: George Allen & Unwin, 1915), pp. 39–40.

Chapter 44 | Philip Fisher
Art and the Future's Past

The life of Things is in reality many lives. A warrior's sword, known to him by its feel and balance, and by its sound as it cuts the air, would be known or seen by his community when the sight of the sword strapped on for battle is a recognized sign: we go to war tomorrow. The sight of it is one of the signs of war, terror, and possible defeat, and yet being *his* sword, a sign of the barrier still standing between themselves and defeat. The sword is his as property, but kept sharp and ready by a younger warrior whose right to touch the sword is a sign of his social place.

The sword after the warrior's death becomes a sacred object and no longer enters battle. Now controlled by the priests of the society, it is more often heard of in legends than seen, for it is kept hidden except for ceremonial uses to summon and transmit the spirit of the warrior. It is used for the initiation of young warriors and, like many sacred objects, used medically; one touch being enough to heal wounds, cure disease, or drive off depression. The priests, their ceremonies, those who touch or use the sword under whatever rules and limits: these make up a second life, a second system of access.

In time the society suffers defeat. The sword, along with all valued objects whether sacred, monetary, or human (the attractive women or those men or women useful as slaves), is seized as loot, converted to treasure by the victors for whom it is a souvenir that reminds them of a victory. Now the sword is an object of wealth. A third system of access, that of wealth, inheritance, treasure, and loot along with the permissible displays, including self-glorification, comes into being. A new community of object interdefines one another like the earlier military objects and sacred objects where the sword was found among potions, chants and relics. The objects that make up any society's treasure share social access and, equally, the withholding of access.

Each object becomes what it is only as a part of a community of objects in which it exists, as a hammer does within a toolbox, resting side by side with screwdrivers, nails, pliers, tape measures, screws, and functioning within a construction system in which wood is the primary material and certain skills and techniques are in everyday use. In

Philip Fisher, "Art and the Future's Past" from *Making and Effacing Art: Modern American Art in a Culture of Museums*. Cambridge, Mass.: Harvard University Press, 1991, pp. 3–29, 255–6. © 1991 by Philip Fisher. Originally published by Oxford University Press and used by permission of Oxford University Press, Inc. (Reprinted without illustrations.)

its first life the sword occurs not only on occasions of battle and in the hands of a warrior, but mentally clustered with shields, protective gear, stirrups, helmets, and alongside such alternative weapons as arrows, bows, spears, knives, slings and rocks. It becomes a sword because of what Heidegger has called the equipment or gear context within which it is part of a working order.[1] In the same way a sharp metal implement becomes a scalpel by occurring within the gear context and practices of a modern hospital operating room.

As sacred object, the sword is found near, and given its nature by, a new array of equipment such as priestly costumes, ointments, prayers, and the historical narratives of deeds for which the sword is a relic or souvenir. Finally, as treasure, there are not only precise uses – and the access that the owner, on the one side, and the society whose regard he addresses, on the other, have that make it an object of wealth and display – but also the community of objects within which it is now located. The jewels, rugs, rooms, and servants make the sword part of the equipment that we call treasure. There can be no single piece of treasure that could be understood as such.

In none of these three cases is there any meaning to the question of what the sword is, taken in isolation, as a free-standing thing against a neutral mental background. Only with a cast of persons, a set of uses, with access and the denial of access, and an array that makes it a member of a community of objects that hold together because they work together for certain ends, only then does the sword become an object at all within its culture or within the culture that has seized it as loot. An array of objects is far more than a mere mental category. The objects that are, when taken together, the kit of tools for war, religious life, or civic wealth make those structures possible as actions just as the carpenter's tools make possible the act of building a house; or the surgical implements, sanitary practices and training of surgeons, anesthetists, nurses, and staff make possible the modern act of open-heart surgery.

As a final stage of the sword's existence, all groups of this culture are destroyed by a higher civilization whose learned men take the sword to a museum, where they classify it along with cooking implements, canoes, clothing, statues, and toys as an example of a cultural "style" by contrast to the "artifacts" of other cultures or earlier or later "stages" of this style. In this new community of objects, which the sword could never have joined had it not been *preserved*, – that is, of interest to the earlier military, sacred, and treasure communities which preserved it while allowing other objects of every kind to rust, disappear or be destroyed in the act of conquest, – the sword is defined by a fourth form of access. Now it is looked at, studied, contrasted with other objects, seen as an example of a style, a moment, a level of technical knowledge, a temperament and culture. Art objects make up, just as weapons, sacred objects, and treasure do, an array that outlines and makes possible a sphere of activity and behavior.

Each of the four stages I have described is a socialization of the object based on a community of access chartered by a map of limited rights, demands, and uses for the object. The sword is touched and held in a knowing, determined grip only in the first; it is seen and studied only in the last. Only the first socialization was willed in the design of the object. It had to be a good sword, appropriately long, heavy, well balanced in relation to the style of fighting whether on foot or horseback, with two-handed swings or rapid forward jabs, in fights with typical military opponents, perhaps in this society always a single man, face to face. As the sword is resocialized as sacred object, treasure, and museum specimen, latent characteristics surface and surface elements of one moment become invisible at the next. The weight and balance are no longer known because no one from a later society knows how it was held

in combat. We no longer know if it is a good sword, but we now know that it is a prize specimen. The small, intricate decorations along the blade, frivolous to the warrior, seem to us like a code for the spatial sense of a now vanished society and time.

What many have seen as the essential resocialization of objects in the modern period – the creation of the "history of things" was a product of the Enlightenment. From the mid-18th century on, a point of intersection came into being of new institutions and structures. The invention of museums and histories of art, new spatial arrangements of objects along with a new historical sequencing resocialized the European past by permitting it to rename itself art history, while ignoring those objects unable to be made part of that history.[2]

The objects that became part of these institutional arrangements and practices were naïve objects, like the sword, because they were designed for social purposes before the creation of museums. They were redesigned by the form of access that I am calling the "museum," the critical history and display of the total past.

Almost at once this specific socialization generated the next and all later series of objects, objects that have as their single, overt design, the desire to join history. Once the past had been organized as a past, a new type of cunning object began to appear, one that was no longer naïvely historical. Having to spend even a relatively brief time in the present became a burden that led to a set of strategies to cut short the inconvenience of a useful first life before an object could earn the honorable status of being part of the past. These sentimental objects, as Schiller would have called them, have as their intention to come to rest in history, to become at some future point the past, to enter the museum, to become not things but art.

What strategy does this form of *access* impose on objects seeking to be promoted in rank and value to the future's past? To see the present as history is to estrange our relation to it in the act of imagining it as the future's past. One part of that act of imagination is the attempt to control the sequence of descendants so that we will find, between our ancestors and our descendants, our "place." The name of this historical strategy is the avant-garde, a strategy that assumes the being of objects to be radically historical.

Museum Space

What Germain Bazin has called the Museum Age[3] begins with the opening of existing princely and papal collections and the simultaneous ordering of such collections in a novel, historical, intellectual way. By different doors the public and the historical critic entered at the same moment. The museum became in effect the first teaching machine. One historian has categorized it as a "speaking history of art addressed solely to the intellect of the beholder."[4] With the dislocation of art during the French Revolution and the Napoleonic wars, the great European hoards were scattered, reassembled, and ultimately transferred from private to national collections, where they were located within the new system of exclusion and order. An entire continent's treasure and loot began to be resocialized as art.

In 1723, 1749, and 1772, the Vatican collections were opened. The Sloane Collection, later called the British Museum, opened in London in 1759. In 1781 in Vienna all court-owned pictures were opened to the public three days a week, and, as a climactic act, the founding of the Louvre was decreed July 27, 1793. Collections

looted during the Napoleonic wars were seldom returned to private owners, becoming instead the nuclei of national or state collections.

These museums locate for us one stage in the creation of new forms both of the assembly of objects and of the collective itself in social life, as new and deeply rooted in the realities of the new order as "the mob." This new collective in the face of which all future art will exist and agonize is "the public." It is for the public that society in the new democratic age retraces in social space – by way of the creation of zoos, libraries, parks, museums, and concert halls – the amenities of leisure and privilege once held by a few within the private space of moneyed or aristocratic property. The game preserve becomes the public zoo; the collection of books, the library; the pleasure grounds of large estates turn into public parks, forests, and reserves; private collections are transformed into museums; and the music once heard only in private settings becomes social and democratized in the public concert halls.

Once opened, the treasures became structured by the uses, by the access and demands negotiated between the public and the objects now known as art. It is an essential point that the definition of the demands, the control over these forms of order and access were in the hands of professionals, both critics and historians, who with the force of the Enlightenment and the new organic history behind them, explicitly converted the functions of art in the direction of educational goals. What had been riches became enrichment, became, that is, education and consciousness.

As important as what I am calling the democratization of treasure are two Enlightenment forces: the idea of systematic ordering, which came to be applied to many princely collections; and the use of spatial display as a form of education. Where sensory values once controlled the arrangement within a room, so that pictures, ornate frames, mirrors, furniture, tapestries, and wall coverings completed a visually pleasing total harmony, the new educational arrangement involved an instruction in history and cultures, periods and schools, that in both order and combination was fundamentally pedagogic. Where earlier collections, like that of Dr. Sloane, which would later form the nucleus of the British Museum, tended to include such ill-sorted combinations of objects as antiquities, cut stones, medals, coins, and specimens from natural history (occasionally reaching as far into the rare and marvelous as the collection of bottled fetuses joined by one German prince to his relics, antiquities, armor, and works of art), the newer national collections begin with an essential definition of what is now familiar to us as the "work of art." Curious monsters, supposed unicorn horns, parts of the True Cross, historical battle souvenirs, impressive gems, part company with all of what can now be reconstructed within the system of access known as art. Along with the "work of art" the museum displays and stabilizes the idea of a national culture, an identifiable *Geist*, or spirit, that can be illustrated by objects and set in contrast to other national cultures.

Where Enlightenment forces, with the image of order and education represented by the *Encyclopédie*, held power, all public functions were seen as at least partially instructive. Collections of natural curiosities were no longer arranged according to the dictates of the eye, but according to systems and rules, what Foucault has so brilliantly described as tabulation.[5] Simultaneous with the opening of the galleries is the beginning, in the work of Winckelmann on Greek art, of a systematic, conceptual history.[6] The new history and the opening of the galleries join in the Villa Albani where Winckelmann himself systematically arranged the antiquities by subject, "placing godesses, emperors, and tragic reliefs together."[7] The rooms are no longer

identified by shape or color, that is by the complex sensory harmony, as in the famed Green Room at Munich, but by the overall intellectual pattern that they embodied.

In the Belvedere Palace, the conceptions that Winckelmann had applied to ancient art were transferred to the paintings of Europe. The paintings were chronologically arranged within the three schools of Germany, the Netherlands, and Italy. Lighter frames were used. The paintings, as in the Green Room, came to be separated on the walls, moving from floor to ceiling stacks into, eventually, the modern linear, isolated series that we call an exhibition. "Those who kept to the older method of hanging, which they considered more pleasing to the eye, spoke of the 'murder of the gallery' but representatives of the enlightened bourgeoisie surpassed each other with enthusiastic approval."[8]

It is essential to see that the "subject" of the museum is not the individual work of art but relations between works of art, both what they have in common (styles, schools, periods) and what in the sharpest way clashes in their juxtaposition. The single scroll in a Japanese temple, seen alone in the act of meditation, seen *at rest*, is an object, as far as any can be, in itself. That we walk through a museum, walk past the art, recapitulates in our act the motion of art history itself, its restlessness, its forward motion, its power to link. Far from being a fact that shows the public's ignorance of what art is about, the rapid stroll through a museum is an act in deep harmony with the nature of art, that is, art history and the museum itself (*not* with the individual object, which the museum itself has profoundly hidden in history).

Architecturally, the museum is made up of rooms and paths. Once the pictures face us in a line on the wall we can convert rooms to paths by moving sideways from the entrance around the room, flattening it out, in effect, onto the wall. Viewing the pictures sequentially as we move from room to room, we follow the room numbers, the centuries, the schools. In so far as the museum becomes pure path, abandoning the dense spatial rooms of what were once *homes*, or, of course, the highly sophisticated space of a cathedral, it becomes a more perfect image of history, or rather of the single, linear motion of history preferred since Winckelmann.

Only the Guggenheim Museum has so far reached the ultimate spatial expression: it is pure path, without rooms. After an elevator ride to the top of the building, the visitor moves along its descending spiral ramp, pulled not only forward but down by gravity in what Frank Lloyd Wright has designed as a controlled fall. The Guggenheim is the only museum that actually hurries its visitors along by means of such an inclined ramp. As the museum visitor descends he stands with his back to one of the most spiritually grand bowls of space ever created, a space that in its scale and emptiness glorifies the art even while rivaling it. To enjoy Wright's masterpiece the visitor has to turn his back on the art, and to attend to the art he must neglect the great space behind him.

In the Guggenheim, by an effect partly achieved in the Long Gallery of the Louvre – a corridor really, along which one paces off the history of art, passing the line of masterpieces – the absence of rooms completes the spatial truth of the museum which throughout the 19th century still pretended to be a princely living space, highly decorated, ceremonial, and luxurious, where, along other things, art could be found. In fact, the museum visitor moves along a complex folded wall in such buildings, his back to the space that does not exist for him as "room." This tension between path and room ends when, in contemporary museums, one moves as though in a maze, facing the portable walls that break and turn the path but never complete the archaic rectangles.

In the museum the paintings move apart on white walls. They form one horizontal line. The frames vanish. The secondary decorations of earlier rooms no longer complement or haunt the contents of the pictures (painted ceilings, complex plaster mouldings, textured wall coverings, domestic lighting). In this spacious historical track the public paces off the motion of this history. It is in the museum that one learns to "follow" art.

Resocializing Objects

In his 1923 essay "The Problem of Museums," Paul Valéry wrote of the museum as a "strange organized disorder" which could never have been invented by either a sensuous or a reasonable civilization. He likened the museum to a room where ten orchestras played simultaneously, a room where from all sides the works call out for undivided attention, but where the sense of sight is violated by "that abuse of space known as a collection." For Valéry, the museum is a sign of the fact that the arts of painting and sculpture are now orphans, abandoned by architecture which once housed and gave them meaning as decorative details. Now assembled in this secondary space, each object, jealous and demanding attention, "kills all the others around it."[9]

Following Valéry, no one has written as brilliantly, even if exaggeratedly, of the violent resocialization in which the objects of the past were stripped of their worlds and resettled chronologically in the land of art. In *Being and Time*, Heidegger had spoken of museum objects as "worldless" because in so far as the museum is about the past, it cannot be the objects, still obviously present, that are gone, but their worlds.[10] Malraux writes that, "In the 12th century there could have been no question of contrasting or comparing a Wei statue with a Romanesque statue; on the one hand there was an idol, on the other a Saint."[11] Images were as subject to destruction as to preservation. The early Christian church buried classical art, it did not build museums for it. The preservation of images without belief, loyalty, or memory would be as unthinkable before the museum age as for a contemporary man to carry pictures of someone else's children in his wallet because the photographs he had of his own weren't artistic enough.

As Malraux has written:

> . . . a romanesque crucifix was not regarded by its contemporaries as a work of sculpture; nor Cimabue's Madonna as a picture. Even Phidias' *Pallas Athene* was not, primarily, a statue. The museums have imposed on the spectator a wholly new attitude towards the work of art. For they have tended to estrange the works they bring together from the original functions and to transform even portraits into "pictures." . . . The effect of the museum was to suppress the model in almost every portrait and to divest works of art of their functions. It did away with the significance of Palladium, of Saint and Saviour; ruled out associations of sanctity, qualities of adornment and possession of likeness or imagination. . . . In the past a Gothic statue was a component part of the Cathedral; similarly a classical picture was tied up with the setting of its period, and not expected to consort with works of different mood and outlook . . . whereas the modern gallery not only isolates the work of art from its context but makes it foregather with rival or even hostile works.[12]

Like a crucifix in its cathedral, a portrait has its world where it is linked with roof and bed, silverware and diaries, heirlooms and legends of family life, and not with other

portraits unless they are of other members of the family. A portrait fixes an image and is embraced and animated by what memories or souvenirs remain. Further, it has within family life its complex uses of memory, solemnity, and compulsion. The look or bearing in ancestral portraits is instructive or formative to the children in a house where the ancestors continue to look down from the walls onto the ongoing family life, generation after generation.

The cases of portrait and crucifix are not exceptional. It is difficult to find any objects until those appear after the creation of museums that are entirely without religious, magical, political, or domestic value. No images without powers, without some address to scarcely controllable divine or social energies. In Malraux's words, "Ingres can call one of his pictures a *Virgin*, but it was not *the* virgin that he was vying with, but *with other pictures*; like the bison of Altamira, the Virgin of Amiens belonged to another world."[13]

To abolish context means more than taking the cathedral out of the crucifix. Context includes the signals that permit or deny access. The museum signs that warn us not to touch the sculpture are one example of a denial of access. What is controlled by access is the kind of recognition and the possibilities of demand in the face of an object. It would be an act of madness to enter a museum, and kneel down before a painting of the Virgin to pray for a soldier missing in battle, lighting a candle and leaving an offering on the floor near the picture before leaving. The museum suppresses, not the model, as Malraux claimed, but the practices within which any object becomes, when seen from the side of its social vitality, a tool. As the example of the warrior's sword shows, an object can slip from one set of practices to another, from one social world and set of purposes to another. The same object can be weapon, sacred object, treasure, and archaeological specimen. In each world it has work to do. In each it is available to some people and not to others. Always we discover it within a social script where it is an actor. Early in the sword's life it is part of the script called a battle. Later it reaches the point where it turns up in the equally ritualized social script that we know as a display or an art history lecture where it occurs as an example. In between it can be found in medical or patriotic, educational, or narrative practices. As treasure, where it occurs as an unusually heavy piece of jewelry, it might play an instrumental part in seducing a beautiful woman at a dance, or be pledged to secure a loan.

Such examples as a crucifix, a family portrait, or a sword might seem to suggest that the museum is simply one of the many institutions that carry out Max Weber's idea of rationalization and demystification.[14] Objects formerly charismatic are subjected to classification and a rational approach that, in effect, bureaucratizes them, just as political power has been in the modern state or as knowledge has been within modern science. The museum relation can seem, from this angle, to be one further example of *entzauberung*. This process Walter Benjamin later made popular in discussions of art as the idea of a loss of aura that occurred within the modern system of mass production and mechanical reproduction.[15] The romantic and nostalgic concepts that Benjamin used continued in a sophisticated way a campaign against modernity that had, in the 19th century, a bias towards craft movements and aristocratic resistance to modern society. Is this account of the museum simply another way of restating these descriptions of the loss of some putative fullness of being?

The imaginary history of the sword with which I began was intended to suggest that objects undergo resocialization in many directions, each lifetime of existence being equally full and potent. But several examples from other, more modern, everyday domains of use will make this fact clearer.

In the key days of July 1789 that preceded the fall of the Bastille in France, the crowds of Paris learned of the King's dismissal of his minister Necker on whom the people's faith in reform had depended. When they heard that he had been forced into exile in the middle of the night, the people swarmed through the streets. The crowd went to the museum located in the Boulevard du Temple to seize the bust of Necker and another of the Duke D'Orleans. They covered the busts with crèpe and formed a procession to carry and display them through the streets of Paris, defending them with pikes, swords, and rifles. In the Place Vendome the statues with their honor guard met up with a detachment of Royal Troops who attacked, not the crowd but the bust of Necker, which they shattered.

Necker had not only been dismissed by the King, he had been ordered to leave the country at once without informing anyone. The King hoped in this way to minimize the chance of a rally that would force him to take Necker back. Missing, Necker was replaced by his bust which the people used in the religious style of processions behind the statue of the Virgin. Draped in crèpe, the image undoes his absence, substituting power in the streets, which he and his followers now symbolically control, for the power within the court of which the King had just deprived him. In order to enforce the exile – the absence of Necker – the King's officers must go one step further and destroy his image which in his absence can still function to keep his supporters together.

Several days later, after storming the Bastille, the crowd killed the prison's governor, the Marquis de Launay, and a butcher named Desnot cut off his head with a pocket knife and fixed it to the end of a pike behind which the crowd paraded through the city. The crèpe-draped bust of the missing Necker, which the Guards then broke to ratify the King's order of banishment, and the head of Launay mounted on a pike are two extremes of the activation of images in a political drama. By cutting off Launay's head the crowd had sculpted from his corpse the quickest possible realistic bust without having to call in any artist other than the butcher Desnot with his pocket knife.

This anecdote of the French Revolution offers a political instance of the relation of presence, absence, statue, and power that we are far more familiar with in the religious sphere because the very subject of the religious sphere is the presence of the invisible, the now no longer or not yet present reality. Robin Lane Fox in his book *Pagans and Christians*, a history of their relations in the second and third centuries, has described the settling down of precise images for the different pagan gods. A set of attributes and gestures stabilize over time out of the many anecdotes and reported deeds associated with the god or goddess. These gestures and anecdotes are given stability by sculpture and images. In the same way, out of the many names by which the god or goddess is at first called, one or some small number of what come to be considered "genuine" names finally settles into place as the official name or names by which the god or goddess must be addressed. Rituals freeze into place the name and formula by which the god or goddess must be invoked, and in this idea of invocation is implied the full range of acts of prayer, appeal, blame, challenge, address, dedication, and sponsorship. The work of art, we could say, plays its part because it "envisages" the god, as Fox phrases it. Literally, the statue gives a visage to the divine figure, and its location in a temple creates the place to which one goes to speak directly to the god or make appeals to him. Each act of pilgrimage to the site of the statue becomes in itself an act of homage and reverence to this particular god or goddess as the one who can answer the plea, resolve the dispute, heal

the injury. The statue, in its fixed location, stabilizes and presides over this entire sphere of life.

These statues were not themselves constantly or casually present to be seen. Access was a precise and carefully defined fact. More often than not the statue was hidden from sight and only on certain feast days did it appear in processions. The very mystery of the cult required the only occasional visibility of the statue representing the god or goddess. At the other extreme, Fox relates that Augustus, angry with Poseidon for too prolonged a spell of bad weather, ordered his statue left out of a procession. Finally, in a more everyday realm, protecting statues accompanied litigants into court or into the Emperor's presence when they came as suppliants. In every case the image was an actor in a complex social script. It was never simply standing around to be seen by anyone under any circumstance whatsoever.

In a wide set of social cases there is a close link between death, institutional continuity, and a work of art such as a statue or other image of the founder or some other key figure within a social organization. An image works as an act of replacement in which those who were important to society are claimed to be symbolically present in a physical way by means of a statue, even when absent or deceased. The founder of an institution often remains within it in spite of his death. Such a statue or portrait occurs within a precinct that is literally its own. If there were no fear that the institution itself would become vulnerable if the visible presence did not continue to preside over it, then the statue or portrait itself would cease to function, becoming no more than one more decorative object.

The work exists to make a memory of the origins of the institution an ongoing part of how actions or decisions take place in the present. Such works are site specific in that there is only one location in the world where they work at all. The same is true in an especially intense way for statues commissioned to be part of a burial spot, or for monuments commemorating and listing the names of soldiers from a certain town who died in a war. But it is equally true for the founder's statue in the middle of a college campus or for the bust that we find near the elevator door commemorating the man who built up the business whose headquarters the building is. Outside the space of cemetery, campus, town green, or headquarters these objects lose the social intelligibility built into the image, its scale and expression. They might undergo resocialization or vanish, but to remove them from this one space is to silence them and to efface within them a cluster of attributes that only exist because of the socialization that this one location brings out.

At the edge of the Boston Common, directly across from the State House stands a Civil War monument, a bronze relief done by Saint-Gaudens that pictures Colonel Robert Gould Shaw leading out through the streets of Boston an all black regiment. The bronze relief shines with a duller glow than the gold-leaf dome of the State House that it faces, but the colors are related. The monument stands within a park where, centuries ago, soldiers would have been mustered. A half-mile away, near the opposite corner, but apart from it in Park Square, stands a statue of Lincoln freeing a group of slaves, who are pictured rather humbly at his feet.

These two civic objects, but most of all Saint-Gaudens's bronze relief, with its solemn gaunt white commander on his horse and the rows of determined and noble black faces in rows, define both the abolitionist pride of Boston and, at the same time, the historical catastrophe of slavery and the Civil War that still preside over the American political present. The State House is face to face with this small bronze rectangle across the street. It exists now mostly as a stop for tourists and as a civic fact

of Boston life. But it is also the subject of one of the greatest of recent American poems, Robert Lowell's "For the Union Dead," a poem that tied the civil rights movement of the 1950s and 1960s back to Saint-Gaudens's work, which Lowell imagined sticking like a fish-bone in the city's throat.

Once America is gone and its particular history of Puritan energy, its slavery and its race relations are over; once New England rectitude and the Civil War are all blurred or lost to memory, the Saint-Gaudens bronze relief might find itself in a museum in Brazil or Tokyo. For that is just what has happened to bring the Elgin Marbles to London or the stone reliefs of Assyrian art to Berlin, where we puzzle over Ashurbanipal hunting lions in the Pergamon Museum. The solemnity and violence of these lion hunts, along with their tropical atmosphere, are no less estranged as we see it today, and no less silenced than Saint-Gaudens's relief would be centuries from now in Tokyo.

While all works occur within an organized system of access and resonance in which a script of practices and knowledge holds them in place and lets them work, it is not at all the case that objects could be said simply to lose their worlds. Benjamin's loss of aura and the loss of world that Heidegger speaks of in connection with museums are elegiac concepts that turn away from the building and rebuilding of communities of objects in which new characteristics come into existence by the same process that earlier features are effaced.

There are even objects in which meaning and location are found at last within museum arrays. The relatively small set of paintings that are self-portraits gain an unexpected resonance within this society of objects, a resonance that they were denied earlier. In the museum, in effect, every painting is taken as something of an implicit self-portrait in that what interests us is to read out the character, temperament, artistic career, and world-view of Rembrandt or Manet himself no matter whether the work in front of us is a landscape, a biblical scene, a still life, or a scene of everyday Parisian life. Whatever the objects, we learn more about "Manet" or "Rembrandt" and not simply in a biographical or historical sense. Within so many latent self-portraits the few candid, literal self-portraits seem to have been the only objects that set out to deliver the kind of information that elsewhere is only indirectly available. Without the museum the self-portrait, after the death of the artist, has, as an object, a troubled state.

The self-portrait is the one form of easel painting that resists being owned. It denies in its every detail that a mere owner has any right to it. It is not about him, while existing within a world where there are other painters whom he might have commissioned to make a portrait of himself, had he wanted one. Of course, the death of Rembrandt denied any later client the opportunity of hiring Rembrandt himself to do his portrait, and in that sense the self-portraits that an artist like Rembrandt did paint become, in private collections, the surrogates for a portrait of the owner that the painter, unfortunately, did not live long enough to execute. The place is held by that poor but universal substitute, the painter's own face.

Since the self-portrait of Rembrandt or van Gogh remains stubbornly his own, it cannot be said to be the owner's even in the sense that a landscape by the same painter can be. Such a self-portrait, in the setting of a private home, would raise the question of whether the artist were being claimed as a certain special type of family member or ancestor. This appropriation would be implied because the ordinary social meaning of a portrait displayed in the home founds itself on kinship, even the spiritual kinship of the display of religious images. A portrait within a home cannot be a mere decoration

like a landscape or still-life, two of the forms of painting in the modern period that are particularly comfortable within ownership and domestic display. The late 19th-century output of anonymous, all-purpose nudes by Courbet and Renoir, to name only two, played with this sense in which the owner of the object claims the content as something possessed in the form of property and personal relation.

Once the Rembrandt or van Gogh self-portrait exists in a museum room with several of the painter's other works nearby that we also take as works about Rembrandt or van Gogh since they tell us of his sensibility and interests, then the self-portrait functions almost as a shepherd surrounded by his flock of sheep. In the Louvre we often see the portrait of a painter presiding over the room where it occurs, intensifying the cult of art that depends on the reality of the artist. It does so because it gives evidence of the fact that the painter himself shared exactly this sense of the one real subject of all art: the artist.

The museum is more than a location. It is a script that makes certain acts possible and others unthinkable. For objects assumed into the museum, those practices efface just what existed as the features that were the very essence of the object in its earlier life or lives, each life being, in its turn, dependent on the suppression of yet earlier practices. When we think of an object as having a fixed set of traits we leave out the fact that only within social scripts are those traits, and not others, visible or even real. It is not only that in a museum we do not notice or even know about the balance of the sword. Once it is bolted down in a display and not swung in a certain way we cannot say that balance or imbalance is even a fact about it. Without a class of warriors, trained to fight in certain ways, even the permission to lift and swing the sword could tell us nothing. Only one part of what is canceled within the object by the museum is what Malraux insists on as the model. Rather it is the repertoire of practices that brought out certain features and passed over other possible features. Our access assembles and disassembles what the object is, including the question of whether and in what sense it is an art object. Within a museum culture that has looted a past that had earlier been organized as a religious, civic, and familial past, one of the features of objects that came to be suppressed was the image within it along with those acts, such as memory, instruction, piety, and control that were elicited by those images.

Silencing Objects

The suppression of images took place in three stages. First, in the process already described, images from within the culture, stripped from their context (when the crucifix is taken out of the cathedral, the cathedral is taken out of the crucifix), were silenced. To silence them meant, in part, no longer to attend to the imperatives that radiate out from that content. Most objects have the property that Austin made us aware of in those parts of language that he called Speech Acts. The objects compel behavior just as the shouted words "Wake Up!" do: they wake up the sleeper at whom they are shouted. A crucifix means, among other things, "Genuflect!" Such objects are silenced when, like tools no longer in use, we can just neutrally stand in their presence. Like a former church now converted into luxury apartments, or a cemetery now used as a playground, such objects have been de-consecrated.

A family object such as a wedding ring or a gift of atonement can, and often does, undergo a similar de-consecration, most obviously by the death of the owner. But if desperation drives someone to pawn a wedding ring, the object has suddenly been

regarded as treasure, convertible into so much food, or a train ticket good for so many miles, or a room rent of so many weeks. After someone has died we might see his diary and make a decision whether to publish and sell it as literature or burn it now that its life as a part of the author's private self-relation has ended with his death. The de-consecration of objects, along with the previously latent or even not yet existent features that might let them now perform within a new social script is fundamental to the possibility that they can undergo silencing. The act of silencing is the other side of the act of bringing features into being that cannot be said to have existed before. The metal blade of a two hundred-year-old hand saw might, in the 20th century, become a means by which one is electrocuted. But we would have to say that this new feature of conducting or not-conducting electricity only became a feature once the wider social frame of electrification had occurred. Only when a quality fits into a script that is itself a living script does that quality even exist within an object. The gain and loss of features, from without, even in objects that seem to undergo no change whatsoever, is one essential part of the life of things. The coming of the museum age was like electrification in that it raised about each object within the entire European array of sacred, domestic, and political objects the question of whether it did or did not conduct the new energy known as art, and at the same time, the question of whether it could survive the silencing of those quite different characteristics that had let it work within those earlier social scripts so as to let it stand forth purely as an art object.

After this cultural silencing, and as a second stage, the European museums began to include and exhibit objects converted into art by their presence in a museum, objects from alien societal, religious, and artistic communities. These traditions were not assimilated; that would be a common episode in cultural history like the Roman assimilation of Greece. The Chinese, African, or Indian art was preserved in its difference, in its estrangement, precisely by the museum. Both Bazin and Malraux point out that European collections were the first to include such alien objects as other than curiosities. These objects were not silenced; they were mute. The public did not have to forget their contexts; it was ignorant of them. We do not know what they once signaled – war, love, piety, fear of famine? What religious or ancestral figure's image are we in the presence of? They are mute as images and mute as to use. In what temple or domestic place did they occur? Carried in what processions? Used to cure or destroy or just to frighten away rain clouds? Fixing in memory what enemy or hero? We do not know and, except in a scholarly way, we do not care. It seemed plausible to accept these mute objects precisely because the civilization had already set itself to silence its own objects for the purposes of the new category of art. The new combination completed the process of silencing the first group.

These mute images passed back along the trails of economic conquest; Eastern objects in the second half of the 19th century, the essential exhibition of African objects, decisive for Picasso, in the early 20th century. Like the economy which based wealth for the first time not on its own fertile farmlands or hunting grounds, on its rivers and other resources of the society itself, but instead on the society's ability to gather or loot the minerals and "resources" from the total surface of the globe, so too culture, spoken of as "resources," is a stock that is movable from place to place just as economic resources are, but at the price of surviving as mutes.

The third stage of objects joining the silenced images of our own culture and the mute images of those cultures we know "comparatively" or anthropologically are the "modern" abstract objects, progressively "absent" of images. We usually contrast

these non-representational objects of Modern Art to what we call the realistic, representational, or referential traditions of our own art, but it would be more accurate to see them as the third and not the second sequence of objects. Abstract objects and paintings occur in a sequence that intensifies and completes retroactively the silencing of the first and confirms the proper place of the second, once alien, group. Abstract art is the natural art of a museum culture. Linear ordering and the cancellation of content are the two museum practices that come to be recorded within later art, where it occurs not only as one content among others, but as the essential subject matter.

One question raised by this three-stage sequence and theatrically acted out at the margin of modern art is the question of whether there isn't a simple procedure by which anything can be converted to art. On the one hand the artist might design and execute pseudo-objects, like the many rather disturbing "things" made by the modern sculptor. Once we have moved certain stones from Peru, certain carvings from Nigeria, couldn't we just as easily "find" things that have the look of art down the street or at the beach? The willful act of "finding" art is a clever copy of the anthropological relation whereby certain more and more long-lost members of the human family were found in the 19th and early 20th centuries. A filling out of the census of art occurred at the same time and was completed in the same colonial milieu.

Or, to take a shortcut, the artist could adopt already existing objects, a urinal, a stuffed goat with a tire around its neck, and by signing them, give them a secondary paternity; for it is he who has first "seen" them. In what amounts to a kind of pun on the massive creation of art out of earlier images, this adopted art testifies to the power of the signature and the museum to "silence" the image that the urinal, goat, or tire still stubbornly presents. Clement Greenberg, in a statement to which I shall return, summarized critically this margin of art when he wrote: "The notion of art put to the simplest test of experience, proves to mean not skillful making (as the ancients defined it), but an act of mental distancing – an act that can be performed even without the help of sense perception. . . . Everything can be subjected to such distancing, and thereby converted into something that takes effect as art."[16]

This new meaning of "making" seems an outrage only if we forget that it is false to contrast it to the original artisanal making of crucifixes or portraits. Such objects were made into art later in their histories and by a process of mental distancing and conversion as outrageous as that represented by Duchamp, Picasso, or Rauschenberg who shout what is usually politely whispered: it is the museum that makes art, not craftsmen.

The Frame of Criticism

The specific intellectual concerns the museum embodies are linked to the specialized problems of the historical study of art. Since the historian must authenticate, define economic value, date, and reach precise historical sequences, historians who were faced in general with anonymous objects, developed sophisticated keys to style and period, perhaps the most cerebral of concepts. The image was once a way of acting as though the Virgin were *there*, available for petition, conversation, repentance. In the museum the picture becomes a way of thinking that Piero della Francesca were *there*, as though the Renaissance were *there*, because from the picture we read out world-view, style, moment: the "problem" as art historians would say.

The museum itself permits this reading out by locating the object, now seen as a picture, in a space of other styles and themes. As Malraux has claimed, the museum is a structure for "pitting works of art against each other."[17] In this he follows Paul Valéry, who described a room of sculpture within the museum as "a tumult of creatures each of which demands, without ever obtaining it, the non-existence of all the others."[18] Valéry paints the picture of a chaos of wholes and parts, of grimaces and smiles, of giants and dwarfs, of monsters and heroes, works perfect of their kind next to mutilated or restored fragments; a world where an accidental line of sight forces us to see a distant noble bust between the bronze legs of the statue of an athlete.[19]

Towards the end of *Three American Painters*, Michael Fried suggests that the series of paintings might, in modern art, define the basic unit of work. In the precise, dated series the painter rules out the surrounding chaos by supplying the context, the commentary of neighbors, for the no-longer-intelligible single work.[20] He creates whole sections of history at once, not pictures for the whims of history to supply antecedents and descendants for. In viewing such a sequence a striking effect occurs. Only one picture exists at any instant *as a picture*, the others are temporarily explication, frame, and criticism. The power of the series lies in the skill with which each picture can exchange roles; now a sensory experience, exhaustively commented on by the rest of the series; a moment from now, part of the explication for one of the other pictures. In the series we reach an authentic clarity of the part, the smallest detail of any structure comes in time to replicate the form of the whole: the series is not art, but a miniature art history.

As our approach to art has become more and more intellectualized, the terms of criticism have interiorized themselves to become the terms of art itself. Along the path that defines our access to the work, each work of art has ancestors, or as Gadamer has phrased it, is the answer to a question which we must discover in the prior history of art.[21] To understand the work is to know the question to which it is an answer. Within a horizon of problems and ongoing questions each work is an answer, a solution, a stage of development, and in its turn it raises – and it is this that makes it essential to history – new problems, questions, a new horizon for the next works.[22] It must be, as Fried has put it, "radical" and "fecund"; it must account in a deeply critical way for its past and become seminal for the future. The two define its "place" and it is place that is the essence of intelligibility. Its presence as a work depends on our knowledge of its horizon. The vocabulary of problems and series is, in and of itself, not just an historical, but a museum vocabulary.

The needs of the historical intelligence point finally to a stage beyond the museum, one further intensification of its procedures. Just as each picture has reality as a feature of a museum, so in its turn each museum is a fragment of one ideal museum. As collections become larger they become more intelligible. National galleries are more lucid than a dozen smaller provincial collections. But all museums have gaps, the history each displays is a history with holes, and the public must fill those gaps with memories of other collections. The ideal museum would be at last the complete history in which the path would go from horizon to horizon, each picture answering the questions asked by its neighbors, each intelligible in the visible society of styles and periods.

But this ideal museum would do to the rest of the world what Constable said a National Gallery would do to the distribution of artists in England, "If we must have a national gallery (as they say) it will be the end of art in the small cities of England, and art will cease to exist there as it has ceased in every country that has one."[23]

The ideal museum can be imagined in another way, or so Malraux proposed. If we see the long white wall of the Guggenheim as paper to be folded like an accordion, it becomes the art book, Malraux's museum without walls. With a book we must turn the pages instead of walking to the next picture, but the elements of isolation – one image per page; nextness – the sequence of pages creating the motion of time; and criticism – the use of images as criticism of other images or the juxtaposition of images and historical argument are all perfected in the art book. The total stock of art, no matter where located as "property" (a concept made less and less significant as the skills of reproduction increase) can be sequenced. The book imposes only one further transformation to those the museum has achieved; the objects are dematerialized.

> In our museum without walls, picture, fresco, miniature, and stained glass window seem of one and the same family. For all alike – miniatures, frescos, stained-glass, tapestries, Scythian plaques, pictures, Greek vase paintings, 'details,' and even statuary have become 'colorplates.' In the process they have lost their properties as *objects*, but, by the same token, they have gained something: the utmost significance as to style that they can possibly acquire.[24]

In this stage beyond the museum, which at last fulfills its intention, there is a more radical "capture" of the object. Each photo must be from a certain distance, at a certain angle, under a certain lighting. Selection of details rather than wholes, expansion or contraction of scale (a profile from a coin, expanded, equals on the next page, a reduced monumental face: both are 8″ by 10″), denial of material, all permit access to the object seized by our notion of its meaning in sequence.

However important the art book has been in the last fifty years, Malraux's museum without walls has not brought about a resocialization of art in the decisive way that the museum itself had two hundred years earlier. This can be seen in the works themselves. As I will try to show [in the chapters that follow], many characteristics of the modern work have to be seen as a kind of foresight on the artist's part that the work will find itself eventually within a museum as part of what the future will, it is hoped, take to be the past. What look like features of the work are really features of the wider work (the museum collection) within which it will later find itself. No such thing can be said about the relation of those same works to the art books in which they will also find themselves. Just the opposite. In terms of the art book, modern works are naïve objects, unconscious of the fact that they will be produced in roughly 8″ by 10″ format.

When we think of one of the few painters who is conscious of this modern intimate form of the small, standard-sized work, the extent to which he is an exception is clear at once. Paul Klee produced thousands of works whose format is nearly that of the page. The works, although larger than a page, reduce effortlessly, as though this possibility were built in from the start. Klee is the first art book painter of our culture.

Otherwise the essential modern works are often gigantic, as though they wished to declare that it is not the domestic space of a living room wall, and certainly not that much smaller wall, the white page of an art book, but the museum space to which they are scaled. The public space, the dramatic but distant view, the domination of surrounding objects – these features speak out in the works themselves about the world in which they expect to occur. Scaled down to the page, their features frequently disappear.

For works addressed eventually to both the museum and the art book page, the modern abstract style would seem to be unusually convenient. One of its strengths is a certain mystery of scale. Looking at an abstract painting we often cannot tell what order of space it is about. Does the work magnify a tiny space, in effect blowing it up in a ratio of a hundred or a thousand to one the way photographs from a microscope do? Or is it the reduction of a gigantic space that we are seeing? Every modern visual work exists within our habits of seeing that the photograph, the microscope, and the telescope have leveled so that we are used to imagining in the same few square inches either tens of thousands of miles, hundreds of yards, or less than one ten-thousandth of a square inch.[25] Abstraction occurs within habits of seeing already made sophisticated by these modern possibilities of enlargement and reduction of scale.

But in reality, the abstract painting of the last seventy years has been keenly aware of the traditional facts of monumentality and intimacy, rather than of the merely quantitatively large and small. The monumental and the intimate are more accurately described as alternative instructions about response than they are questions of size. In their monumentality and rhetorical power, abstract works have decisively refused to adapt to the fact of the book to exactly the extent that they have eagerly adjusted themselves to the scale of the public, crowded life of the competitive space of the urban museum. If anything, such works exist in defiance of the book by working for just those effects that cannot survive miniaturization.

Similarly, the force of materials within the modern work, whether monumental or ordinary in size, presents a second obstacle to reproduction. The movement towards sculpture in painting from the time of the Cubist collage, the inclusion of real objects within the painting, the concern with texture and a heavily worked surface are each evidence that the work of art since the invention of the art book has been contrary to the spirit of the museum without walls as a social space for the reproductions of art.

Instead of the painting it has been the photograph that has been most comfortable within the rectangular intimacy of the art book. Embarrassed from the start by the scale of the museum in which it is still pointlessly exhibited, the photograph thrives in the domesticated scale of the art book. The book or the collection of slides, like the phonograph record or tape that replaced the live concert in the 20th century, or the television performance that replaced the theater visit, permits the experience of the work of art to occur at home and at the time of choice for the viewer. This relocation of the experience of art into a sphere of domesticity is equal in importance to the earlier creation of public parks, zoos, museum collections, and concert halls that democratized the privileges and pleasures of an aristocracy for the new category of the public.

Even though one might prefer to look at and experience the paintings of Caspar David Friedrich at night, the museum hours are limited to the "working" hours of the middle of the day. Once a slide or an art book exists, the matching of moods between viewer and work can be perfected. The domestication of all art, its democratic privatization in which a relatively valueless copy makes available book, musical performance, video tape, or slide in the familial setting of the private home carried even further the universalization that the museum had begun. The museum socialized what it still preserved as property or treasure. It eliminated only the owner. The slide or tape eliminated the property itself, the "object" within the art object. At the same time the new means eliminated the commitment of the 18th and 19th centuries to the ideal that important cultural experiences should take place in a public space where we find ourselves side by side with large groups of unrelated strangers who made up, together

with oneself, the social category of the "public."[26] The art book makes art an experience of the lap, of the eye, and of the hand that turns the pages. Most important of all, it makes art an experience for a solitary and immobile person. Sitting down to art, as we sit down to eat, domesticates it in a fundamental way.

The art book, in other words, is a rival technology of experience, and not simply an extension of the museum principle. It permits a totalization of the field that allows those elements that have surfaced to be intellectually placed within the most complete range, the range finally visible as one complex whole – Art. If it is objected that reproductions are ontologically different objects, while museums only relocate the same object in a different world, it should be seen that the estrangement involved in what makes up the "object" is similar in the two cases. The Elgin Marbles, as they are called under their museum name, are fragments of what was originally "something else." The photograph of what was in another place the Sistine Chapel ceiling (almost impossible to *see* on the spot) is likewise the product of an estrangement. It is one of the powers of art to declare new wholes. The *Venus de Milo* is whole without the arms. The famous archaic torso of Apollo described in Rilke's poem is, as a work of art in the museum, a whole, perhaps more moving as a torso than it was as a statue. No one repaints the once brightly colored Greek statues: as museum art they are white. Yet fragments of Greek vases are reconstructed by scholarly detective work into the object they "must have been." The presence of fragmentary wholes in the museum is a reminder of the violence that has seized every naïve object from what was once its world. Is the unpainted, armless, headless torso, its temple lost along with its limbs, a less "dematerialized" object than a photograph; is it any less estranged?

The Museum Candidates

To this point it is the fate of naïve objects that has been described, those objects for which the museum is the heaven for things, the place where they spend their afterlife. After the stabilization of museums as the place of art, and of culture as the use of art, after the historical definition of the past that Winckelmann, Hegel, Wölfflin, and Riegl brought into being, a new and highly ambitious object began to be produced, one that did not have the accidental fate, but rather the destiny of the museum stamped on it from the start. This object which is at first what I would like to call a "candidate" for history, an "applicant" to the museum, is the object that we refer to as "modern" art. In size alone such objects no longer fit any but a public space. If the Cubist painter, in Michael Fried's words, "trues and fares" every shape within the painting to the frame edge, he also trues and fares the paintings themselves to the wall edges of the modern museum. It is a notable fact that the homes of major private collectors like Philip Johnson, Norton Simon, or G. David Thompson, where such objects "rest" before finding final homes in public museums, have architecturally been designed as miniature museums, often adjacent to rather than integrated with the living areas of the house. Where art was once honored to be housed in the homes of the mighty, the mighty are now honored to be permitted to sleep in the house of art. The collector is an intermediary between the artist and the public whose property the art will finally become. Like the Mellon or Frick collections, the Simon "holdings," as we so appropriately call them, are destined for both civic and educational functions.

Far more important as a factor in the existence of these works as "candidates" is the technique for determining the price of a work of art. Unlike the earlier commissions

on which artists lived, the price of a modern work does not directly reflect workman-ship, time, labor, size, cost of materials, or skill. Rather the price is a complex speculation on the work's future as a "past." Price is set by imagining how essential to any future series called art this type of object will be. Its value, like that of a growth stock, involves an act of prophecy. The "price" of a contemporary painting is a function of a prediction of its future, and for this future value to be determined, criticism must move closer and closer to a historicization of the present, determining on the spot what the historical place of new objects might eventually be even as they are produced. Without this speculative, prophetic act of criticism, the object has, as a commodity, no value. The painting is priced this way because it is not yet at its destination, the museum. For a short time the painting will be "at large" until it is ever so slightly "past." Once this probationary period is over, it will come to rest in sequence or will disappear. The initial price is in effect a wager that in a reasonable period of time the object will be priceless, permanent, and guaranteed by the civiliza-tion to be among the ten thousand objects to be kept as little as possible subject to time until the end of man himself. We make an eternal promise to the objects in museums, because unlike the statue of Ozymandias that can be forgotten when *he* is, these images are the past itself and not a set of images tied to the calendar of our belief or memory.

The place of the museum can best be understood by picturing it in contrast to not only the earlier private princely collections but also the modern factory. The museum, in its dedication to uniqueness, to preservation, and to those objects of the past whose useful life is in effect over, came to celebrate just such values, at least in part, because the modern production of objects in the factory system turned out unlimited numbers of identical, replicated objects made to be replaced as soon as they become obsolete. Museums became more and more central exactly in cultures touched most deeply by the modern system of mass-production. The British Museum in London and the Metropolitan Museum in New York represent a new kind of institution. No longer do they provide a visible history of the culture itself: that is, a display of objects rich with symbolic, local significance. Instead they are storage areas for authenticity and unique-ness per se, for objects from any culture or period whatever that were said to be irreplaceable.

On this side, museums are counter-institutions to the factory. As objects became more short-lived and geared to an ongoing series of inventions and improvements that produced, as one side effect, obsolescence, the museum became ever more skilled at preservation; that is, at keeping selected things in a state that would never deterior-ate or change. The modern factory system expands during the same period as both the political nationalism and the democratization of access that dominate the historical period from the Enlightenment to the present.

The description of the alternative model of making that the factory system offered will be the subject of the last part of this book [*Making and Effacing Art* – Ed.] Within a society of museums and factories the making of art had two paths before it. It might mimic the museum's act of effacing, resocializing already existing objects, designing objects that occupy a place within the sequences that came to be known as the development of art. Or, alternatively, art might take as its strategy the active social process by which the everyday objects of modern life were made, the process of a system of production that had left behind the craft processes within which both art and everyday objects had traditionally been made. These two stategies were not opposed. Making and effacing art were both antagonistic and intimately connected processes.

Notes

1 Martin Heidegger, *Being and Time* (New York, 1963) and in his *History of the Concept of Time* (Bloomington, 1986), see section 23.

2 Paul Kristeller, "The Modern System of the Arts," *Journal of the History of Ideas*, XII, (1951): 496–527, and XIII, (1952): 17–46, reprinted in Kristeller, *Renaissance Thought: II, Papers on Humanism and the Arts* (New York, 1965), 163–221.

3 For the general history and theory of the museum, the basic texts are: Germain Bazin, *The Museum Age*, tr. Jane Cahill (New York, 1967); Niels von Holst, *Creators, Collectors, and Connoisseurs* (New York, 1967); Jean Claude Lebensztein, "L'Espace de l'art," *Critique*, 26 (1970) and André Malraux, *Voices of Silence*, trans. Gilbert Stuart (Garden City, N.Y., 1953). Many of the key ideas in Malraux's book along with its stance can be found in the important but very brief essay by Paul Valéry, "Le Problème des musées" which appeared in 1923. Valéry's essay was collected in his *Pièces sur l'art* and in the *Pléiade* edition, Vol. II, pp. 1290–93.

4 Von Holst, *Creators*, 208.

5 Michel Foucault, *The Order of Things: An Archaeology of the Human Sciences* (New York, 1973).

6 Johann Joachim Winckelmann, *Geschichte der Kunst des Alterthums* (1764–68).

7 Von Holst, *Creators*, 210.

8 Ibid., 207.

9 Paul Valéry, "Le Problème des musées," II: 1291.

10 Heidegger, *Being and Time*.

11 Malraux, *Voices*, 604.

12 Ibid., 13–14.

13 Ibid., 615.

14 Max Weber, "*Die drei reinen Typen der legitimen Herrschaft*," in Max Weber, *Soziologie, Universal Geschichtliche Analysen, Politik*, ed. Johannes Winckelmann (Stuttgart, 1973).

15 Walter Benjamin, "The Work of Art in the Age of Mechanical Reproduction," in *Illuminations*, ed. Hannah Arendt (New York, 1969).

16 Clement Greenberg, "Counter Avant-Garde," *Art International*, 15 (1971): 148.

17 Malraux, *Voices*, 14.

18 Valéry, *Le Problème des musées*, II: 1290.

19 Ibid.

20 Michael Fried, *Three American Painters* (Cambridge, 1965).

21 Hans Georg Gadamer, *Truth and Method* (New York, 1982).

22 Hans Robert Jauss, *Towards an Aesthetic of Reception* (Minneapolis, 1982).

23 Constable to John Fisher, 6 Dec. 1822, cited in Bazin, *Museum Age*, 212.

24 Malraux, *Voices*, 44.

25 Svetlana Alpers in her book *The Art of Describing: Dutch Art in the Seventeenth Century* (Chicago, 1983) explored the consequences for the 17th century of such visual practices as those introduced by map making and the new microscope. Each period has its own cluster of acts that structure the fact of seeing in a way that is at least in part novel.

26 Jürgen Habermas, *Strukturwandel der Öffentlichkeit* (Berlin, 1971).

Chapter 45 | Malcolm McLeod

Museums Without Collections | Museum Philosophy in West Africa

Museums are expected to collect things, yet museum collecting, in some cultures, need not be a good or useful activity – it may even be an extremely bad thing, something which helps destroy a culture instead of helping to preserve it. A new museum in Africa commissioned, created and paid for by the people whose culture and history it represents provides an interesting example of this phenomenon. The museum is one in which collections and collecting play a very small part. Its creation and initial success draw attention to the fact that some cultures have ways of preserving and displaying their past which need not involve the formation of museum collections.

Even when museums in other cultures have collections, these may be of little or no use. Anyone who wants to see the stupidity and pointlessness of some collecting should visit the reserve stores of virtually any West African museum. In these stores they will find the collections rotting away, sometimes severely depleted by theft. For the most part the objects they contain are rarely looked at, either by curators or researchers. These institutions do not have current collecting policies, they do not have funds to make acquisitions, they rarely add items to their collections and, in many cases, the items already in the collections seem more an embarrassment than an asset. Most of these collections are dead; decaying vestiges of the museum's own past.

These museums are also characterised by an almost total disjunction between the public displays and the reserve collections: items rarely if ever move between them, they have completely separate existences.

In the last decade or so bodies such as the West African Museums Programme (WAMP) and PREMA (Prevention in Museums in Africa) have worked hard to reanimate African museums and to improve the care of their collections.[1] Yet, in the end, they are still faced with the underlying problem that most of these museums are creations of the colonial era and they have not developed a significant place in the life of the local people. Many of them are visited by more tourists than by citizens of the countries they are supposed to serve. At least one new museum, that at Cape Coast Castle in Ghana which deals with the dreadful history of the slave trade, was

Malcolm McLeod, "Museums Without Collections: Museum Philosophy in West Africa" from Simon J. Knell (ed.), *Museums and the Future of Collecting*, pp. 22–9. Aldershot: Ashgate, 1999. Reproduced by permission of Ashgate Publishing Ltd.

deliberately set up, with vast amounts of US aid, primarily to inform and serve visitors to Ghana rather than local people.

The underlying problem is that these museums have not acquired any significant role in local life. The objects they possess lost their meaning when they were removed from their original context of use; so far, in the museum, they have not developed new meanings. In many cases this 'semantic deficit' has come about because they cannot be used: in the past most of their significance arose through their participation in appropriate activities.

There is good evidence that those few museum displays in West Africa which do attract a fair measure of public interest deal with current areas of popular interest or, in addition, draw on local heirlooms which are loaned to the museum only for brief periods and then returned to their owners before they lose their significance. An example of the former is the exhibition of contemporary and recent textiles organised by Dr Claude Ardouin at the National Museum of Mali and then toured to several other countries in the region, of the latter the displays of family memorabilia mounted in the Republic of Benin. In these exhibitions the objects on display derive their meaning from their current roles in society but, were they to be sundered from those roles by entering the museum's permanent collections, their significance would greatly diminish.

Collecting, that is keeping objects till they become old, or acquiring old objects, is closely related to how we see and try to understand the past. The meaning of objects – and the role of objects in creating meaning – depends upon a people's concepts of the past and of time, and upon the various ways objects can express the past in the present or serve to deny a separate existence of the past. Objects may lose meaning in museums if their role in society is incompatible with the idea of the past that the museums are trying to purvey.

Whatever the root of the problem, we have to accept that museum collections in many parts of Africa have failed to be a useful, or a used, resource. One possible way out of the problem created by basing museums upon virtually meaningless collections is shown by the Manhyia Palace Museum, Kumasi, Ghana.

New museums in Africa are extremely rare. This one was opened in August 1995 and was created as part of the celebrations marking the silver jubilee of the king of the Asante (Ashanti) people, the Asantehene Opoku Ware II. The way this new museum was created illustrates a different attitude to collecting and different ways of bringing the past into the present.

The Asante are the largest and most powerful 'tribal' group in Ghana. They dominated the region between about 1700 and the establishment of colonial rule at the end of the nineteenth century. Their king, or 'Asantehene', remains a figure of great political, ritual and spiritual importance. In the [twentieth] century the Asante nation has had only three kings, Prempeh I (who was exiled by the British in 1896, allowed to return to Kumasi, the Asante capital, in 1924 and died in 1931), his successor Prempeh II, who reigned from 1931 until his death in 1970, and the present monarch, Opoku Ware II. It was the latter who, late in 1994, sanctioned the conversion of the Old Palace, built for Prempeh I and situated within the current palace grounds at Kumasi, into a museum to commemorate his predecessors Prempeh I and Prempeh II, both of whom had lived in, and reigned from, the building.

The importance of the museum to the Asante can be judged by the fact that the project was completed in less than 9 months and that the cost, well over £120,000, an enormous sum in Ghana, was met by the Asante people themselves.

The silver jubilee celebrations in 1995 were a major event attended by hundreds of thousands of Asante, many of whom returned to their country from abroad especially to take part. The jubilee had three major events: a great thanksgiving service in the Anglican Cathedral, the opening of the new Palace Museum by the vice-president of the Republic of Ghana, and a great public ceremony, attended by the president of the republic, at which the king and all the chiefs of Asante paraded and then sat in state with their officials. The last event was attended by about 300,000 people and many more crowded the streets leading to the place where it was held.

Africa is full of dead or dying museums: why should the Asante decide to create a new museum to mark the silver jubilee of their monarch and give it such prominence? There were several reasons. Firstly there was a strong sense of local pride and a desire to mark the ruler's jubilee in some permanent way. The Asante are an intensely proud people, fully conscious of their own glorious imperial past and the vast wealth their land has produced. Even today large amounts of gold regalia remain in the treasuries of the chiefs. Many Asante regard their nation as the dominant group in Ghana. At the same time, in the present decade, many senior Asante chiefs, businessmen and women, teachers and politicians, have begun to feel strongly that Kumasi was not well served by the National Museums and Monuments Board which maintains only a small presence in the city. The main museums in Ghana are on the coast, in the capital, Accra, and at Cape Coast. These attract considerable numbers of tourists, increasing numbers of whom travel to Ghana each year. Kumasi had nothing comparable.

The Asante are very conscious of the financial benefits tourism can bring. It was felt only right and proper that Kumasi should also benefit more from its visitors. Those taking this view also pointed out that Asante culture was, in any case, far more elaborate and rich than that of the other Ghanaian groups who were represented in the museums on the coast. Although many tourists came to Kumasi most of the money they brought stayed in the pockets of the Accra-based firms that brought them. Tourists attended the great public ceremonials at the palace in which the king sat in state but, while the tour operators charged for this, even though anyone can enter freely, the Asante court received nothing.

A museum, it was therefore suggested by those planning the silver jubilee celebrations, would be a way of getting some of these visitors to pay for what they saw. Having a royal museum would also serve to give some physical acknowledgement of Asante cultural predominance.

But the museum was also needed to serve the local community. Many senior Asante feel a need to explain their own culture and history, not only to outsiders and to non-Asante Ghanaians, but also to the Asante generation now at school, many of whom have grown up in Kumasi or other conurbations and have little knowledge of traditional life.

Finally, among those who proposed the new museum, there was a high level of understanding of how museums operate in Europe and North America. Many Asante chiefs and other senior men and women have a good knowledge of overseas museums and exhibitions, having lived or travelled abroad, and, in particular, visited the major exhibition 'Asante, Kingdom of Gold' (1984) at the Museum of Mankind in London or subsequently at the American Museum of Natural History, New York. At both venues the exhibition was opened by the Asantehene Opoku Ware II, who was accompanied by a large retinue of the most senior Asante chiefs. Other Asante made private visits from Ghana to the exhibition. These people had, therefore, a sophisticated grasp of how successful museums can be – if they have the correct ingredients.

If these were the main motives for suggesting the Old Palace should be turned into a museum, it is only proper to add that there was considerable opposition to the idea that such a public facility should be set up within the palace grounds. Many chiefs felt the area was too sacred for outsiders to enter, others worried about the safety of the king. The supporters of the project countered these arguments by drawing attention to the fact that both Buckingham Palace and the White House are open to tourists.

Once the idea of the new museum was accepted, four groups of potential visitors were identified and plans made to serve them all. These groups were: Asante who knew a fair amount about traditional life and culture, younger, less well-informed Asante and other Ghanaians, tourists and, finally, VIPs visiting the king.

The planning committee decided that, to work properly, the museum should have a number of basic elements. Firstly, all visitors, before they entered the museum proper, should be shown a short film explaining Asante history and showing examples of the main Asante ceremonies. The importance of the Old Palace, and of the kings who had lived in it, were clearly stated in this film. As the film was intended to inform both Ghanaians and non-Ghanaians, soundtracks in 'Twi', the local language, and English, were commissioned.

Secondly, it was agreed that the ground floor of the Old Palace should be kept just as it was when Prempeh II died in 1970. After his death virtually all his furniture, books, clothing, photographs, the souvenirs presented by visiting heads of state and other dignitaries, even the files in his in-tray, had been left exactly as they were. It was decided that these, with minimum rearrangement, were to be left so that Asante and other visitors could see how he had lived and worked. This was especially important, not only because he is immensely revered but, for many Asante, it would have been impossible to enter the palace during his lifetime: it was a far too sacred and far too frightening place.

The memorabilia of Prempeh II were to constitute almost the whole collection of the new museum. This was a handy decision because it solved the problem of what to do with these things. In Asante tradition royal property should neither be destroyed nor alienated after its owner's death, yet the things that had been left in the Old Palace had no role in the continuing life of the court.

Thirdly, and perhaps most important in the present context, the question of forming a wider collection relating to Asante culture for the museum was raised – and almost instantly discarded. Nobody on the planning committee could see any point in the museum having collections, indeed, to some, the idea was almost laughable. A museum, it was made clear, was certainly not the place to keep and display valuable old objects relating to Asante history and kingship.

This rejection of a collection as an essential element in a museum relates to Asante ideas about how objects from the past are best treated. In Asante many such objects are carefully preserved, these are mainly items concerned with kingship or with the gods. Each chiefship has one or more officials charged to see that items of regalia are carefully guarded and maintained in good repair and, when they eventually wear out, are replaced by replicas. Many of the greatest objects, such as the elaborate gold-decorated swords on which chiefs swear oaths of loyalty, have detailed histories attached to them which are known to their custodians and other senior court officials. But, in the end, however important and quasi-sacred they may be, these are also 'working' objects, objects which exist to perform some function in the continuing operation of the system of kingly rule.

What role, if any, was there for such things in the museum? Many of the committee could see none. The objects remained in good care, the sort of care that had preserved some of them for hundreds of years, and they were regularly used. They had nothing to do with museums. Eventually, after considerable discussion, it was agreed that some of them should be displayed, but they should never become part of the museum. The reason for displaying them was the acceptance that Ghanaians, who have seen little of traditional court life, and many tourists know that gold regalia, gold-decorated swords, sandals, head bands and staffs are an essential part of the traditional system of rule. They, and especially tourists, might expect to see such things in a royal museum. The planning committee therefore agreed that the upper floor of the new museum should contain six or eight showcases in which such objects could be displayed.

Many Asante and other Ghanaians, of course, often see such things as part of their everyday life and, apart from being rather surprised at seeing them in a glass-fronted case, would show less interest in them than tourists. It was agreed that did not matter: such people would find other things to interest them in the museum.

But, if it was accepted that such objects were to be displayed, where were they to come from? Perhaps the committee should try to borrow them from the chiefs who look after the regalia used at the royal court? But the essential problem was that these items would then have to be taken off display at regular intervals so they could be used. A straightforward solution was then proposed: because a major royal object was always replicated when it wore out, further replicas should be made for displaying to tourists in order to save everyone a lot of time and trouble. Foreign tourists, it was suggested, would not be able to tell the difference between old and new items, and Asante would accept copies or replicas as a normal thing. Eventually a mixture of what we would regard as the 'old, authentic' and the 'new replica' was installed in the museum.

The fourth element in the plans was perhaps more surprising: that high-quality fibreglass effigies of Prempeh I and II and Opoku Ware II and two of the queen mothers should be commissioned and form the heart of the museum. All those involved were adamant that this was essential to the success of the museum: they wanted effigies and without effigies there was little point in proceeding.

The decision made, photographs of the people concerned were assembled and the firm Gems in London set about creating the figures. On arrival at Kumasi they were carefully dressed and adorned with characteristic clothes and jewellery and seated at key points in the museum. Prempeh II's effigy was placed in his old chair in the corner of the room where he used to receive important visitors.

When the museum opened the success of these effigies was instant and enormous. They were a wonder and people were desperate to see them. Other Ghanaian chiefs inquired if they could have similar displays of their predecessors created. The Palace Museum committee quickly ordered two more effigies of other important Asante royal figures. When I revisited the museum in August 1996 it was attracting large numbers of visitors, making a substantial profit and the figures were still the prime attraction to Ghanaian visitors.

There are two contrasting elements in this story. The first is that, in Asante, the types of objects which we, as outsiders, might consider essential for a museum intended to represent Asante culture, and especially kingly rule, are preserved in other ways and are too closely involved in local life to be very meaningful or interesting in a museum context, except to outsiders. The second is that people do want to

use artefacts to conjure up the past and have some form of direct communion with it. In this case they chose life-like effigies of past kings and queen mothers to do this. Of course the Asante museum planners who originally proposed this innovation had seen such things before, both in the Museum of Mankind's 'Asante, Kingdom of Gold' exhibition and at Madame Tussauds but, back in their own land, they were giving effigies a very different role.

If the Palace Museum, or any other new or existing museum in Africa, is to succeed it will only do so if it is rooted in local culture. It will only acquire support if local people see it as having something of interest to them and being relevant to their lives and concerns. Colonial-period museums are largely meaningless to the groups they were set up to serve. The Asante decided that collecting, and the care of collections, had virtually nothing to do with what they were attempting to achieve. Re-creating the past had to be done in other ways.

Of course, it is easy for outsiders brought up in a different tradition to say that what the Asante have created is not a proper museum, and to condemn it as a mere visitor attraction made more showy with wax dummies. However to do so would be to ignore the deep seriousness of this endeavour and the thoughtful way in which the Asante have tried to learn from the failure of other museums in Africa and from what they have seen of museums in Europe and North America. They are trying to find a new way to preserve and explain aspects of their culture that they believe are important and, perhaps, they will succeed where others have failed. Certainly they have not fallen into the trap of thinking that collections are the be-all and end-all of their endeavours.

Note

1 The West African Museums Programme is an international development programme funded by the Rockefeller and Ford Foundations and various governments. The aim is to help museums help themselves by drawing up proper plans, arranging training and advice, etc. WAMP does not simply provide money or assistance: the aim is always that the museums it assists work for themselves. PREMA is organised from ICCROM (International Centre for the Study of the Preservation and the Restoration of Cultural Property) and runs training courses to help African curators to learn the basic principles of conservation, good curatorship and collection use. Its courses, formerly held in Rome, are now held in Africa. WAMP and PREMA are now working closely together.

Chapter 46 | Paul DiMaggio

Cultural Entrepreneurship in Nineteenth-century Boston, Part II | The Classification and Framing of American Art

The organizers and early managers of the Museum of Fine Arts, the Boston Symphony Orchestra and similar institutions throughout the United States were in the business of mapping and defining cultural boundaries. By cultural boundaries, I mean boundaries between cultural forms that also serve to define and to maintain boundaries among people, since shared tastes and cultural experiences provided a fundamental source of feelings of solidarity to participants in social groupings (DiMaggio and Useem, 1977).

Mary Douglas (1966: 138) has written, 'It is my belief that people really do think of their own social environment as consisting of other people joined or separated by lines which must be respected'. The same can be said of cultural forms – varieties of art, leisure, cuisine or sport – that are identified with or monopolized by specific status groups. People perceive such forms as naturally distinct. An orchestra that performed a popular tune on a program of Beethoven would shock its audience. We do not expect to hear chamber music at a rock concert, nor do we expect to see magazine advertisements hanging next to old masters on the walls of an art museum. Such juxtapositions shock because they violate ritual boundaries that emerge out of and reflect the ways in which social groups organize themselves and categorize one another. Cultural categories reflect social distinctions and transform them symbolically from social accomplishments to natural facts.

The strength of the boundaries among artistic genres varies with the importance of those genres to the ritual life of social groups. Strong classifications are highly ritualized. In modern societies, performances and exhibitions are often what Bernstein (1975a: 54) has called 'differentiating rituals', rituals that 'deepen local attachment behaviour to, and detachment behaviour from, specific groups'.[1] Every status group needs elements of a culture that it can call its own. A shared culture plays an important rôle in the ritual life of a group; it also serves as a signalling device, enabling members to recognize other members and to detect outsiders. As Weber noted,

Paul DiMaggio, "Cultural Entrepreneurship in Nineteenth-Century Boston, Part II: The Classification and Framing of American Art" from *Media, Culture and Society* 4 (1982), pp. 303–22.

mastery of the elements of a status culture becomes a source of honor to group members. Particularly in the case of a dominant status group, it is important that their culture be recognized as legitimate by, yet be only partially available to, groups that are subordinate to them.

For Boston's cultural capitalists of the nineteenth century, the organizational separation of high from popular culture (described in DiMaggio, 1982) was necessary, but not adequate. High culture would have to be imbued with sacredness, and, as sacred, removed from contact with profane or popular culture (see Douglas, 1966). The purification of the classification high *v.* popular, the driving of profane culture out of the temples of art, and the ideological and ritual framing of the relationship between the work of art and its public were the necessary sequel. In accomplishing this, Boston's cultural capitalists, and the artists and art historians who assisted them, altered the initial missions of the organizations that they founded and established a partial monopolization (with educated members of the middle class as junior partners) of high culture that has persisted to the present.

During the period between the founding of the Museum of Fine Arts and the Boston Symphony Orchestra and World War I, both institutions followed similar paths of development, albeit with emphases differing as a consequence of their origins and technologies. Each experienced two stages of classification: first, the purification of their programming through the elimination of residual elements of popular genres; second, the further subclassification, within the realm of high art, of specific genres. Individuals active in each also worked to frame the artistic experience by strengthening boundaries between professional and amateur art, and between artist and audience; and by delineating an etiquette of appropriation, a normatively defined attitude towards artistic experience. Ideologically, this process involved the evolution and eventual supremacy of aestheticism and connoisseurship. Organizationally, it entailed a limited but crucial transfer of authority from laymen to professionals (see Zolberg, 1980). In both institutions the processes of classification and framing led to a shift in goals – subtle in the case of the BSO, dramatic and contested at the Museum – away from education. And in both cases, the processes made art less accessible to immigrants and members of the working class.

The Revolution of the Aesthetes

The efforts of segments of the elite and of professionals to classify high culture more carefully in the Museum of Fine Arts were more dramatic than similar efforts at the Orchestra because they required a more striking alteration of its original mission as a fundamentally educational institution. The founders drew inspiration from Ruskin and Jarves, his American disciple, looking towards the industrial museums of England as their models (Harris, 1962: 557). The public was admitted free on one, and later two, days each week; and the collections were used for the instruction of public-school children almost from the beginning.

Yet the record suggests ambivalence on the part of at least some of the trustees towards a strictly educational conception of the museum's purpose. Founder and President Charles Perkins wrote, 'We aim at collecting materials for the education of the nation in art, not at making collections of objects of art.' But he added, 'That must be done at a later stage' (ibid.: 553). The museum founders were pragmatists: They recognized that, lacking original art, they must put something in their museum, and

they were optimistic about the educational value of casts and reproductions.[2] But some, at least, hoped that originals would one day come to form an important part of the collection.

The early museum, however, had much besides what is now defined as high culture to exhibit. The bulk of the holdings consisted of reproductions. Charles Sumner had given a set of curiosities, another donor had provided seven Egyptian mummies, and others had loaned such objects as a Philippine chain cutlass, a buffalo horn, an old sled from Friesland and Zulu weapons (Whitehill, 1970: 9). While the casts remained central, the more Barnumesque items were soon discarded.

The implications of this were not lost on contemporaries: When part of the Sumner collection was deaccessioned, one newspaper writer warned the trustees that 'The common people will turn to [the items] gladly, if they are not appreciated by those of artistic and travel-improved tastes...' (ibid.: 558). The early trustees were not doctrinaire in their efforts to purge the popular, in part because they recognized their own limitations. Thus trustee Martin Brimmer sagely cautioned,

> Judgements of intrinsic merit are nowhere infallible. They vary somewhat with individual tastes; they vary more with the shifting tendencies of the time....What we need is a collection of permanent value, and in forming it, it will be well to avoid too strict an adherence to the theories of the day. The function of the managers of a museum is not criticism, but the collection of materials for the criticism of others. (Harris, 1962: 554)

Nonetheless, Brimmer noted, those managers 'should carefully guard against the inroad of pictorial rubbish'.

Part of the framing of artistic experience involved a strengthening of the boundaries between artist and amateur. In the visual arts, as in music, one way to create distance between the profane audience and sacred art would be to avoid the work of living American artists, particularly those of a commercial stamp. In the early days, the Museum was open to a range of American artists: Stuart and Boston's Dr William Rimmer exhibited there; and, in 1881, there were exhibitions of the work of Washington Allston, American wood engravings, Christmas cards, and colored glass. Annual contemporary-art exhibitions enabled local artists to advertise their wares. Yet the locals were dissatisfied with the warmth of the welcome they received, and with the museum's careful avoidance of the commercial. Local professional artists attacked the Museum for banning salesmen and price tags from the contemporary exhibitions. The *Art Amateur* condemned the MFA as 'the latest born pet of our aristocracy of culture', criticizing its expenditures on foreign textiles, furniture, and pottery (ibid.: 558).

'High art' began to become more strongly classified almost as soon as the Museum gained the wherewithal to develop its own collections. As early as 1881, Charles Perkins, in his annual report, complained about the lack of money for acquiring art. A committee of the trustees, reporting two years later, reasserted the emphasis on reproductions, but on pragmatic grounds. Given the Museum's limited resources, the committee noted, it seems 'too plain for argument that we must rely principally upon the liberality of others for original works of art' (Whitehill, 1970: 82). Originals would be purchased only when prices were extremely low for the quality of the work, or when private subventions were available to finance the acquisitions. The committee frankly viewed reproductions as a pragmatic expedient, not an ideal. Even Curator

Edward Robinson, who as Director 15 years later was the champion of the casts, devoted his first annual report to original objects of art.

By the late 1880s, then, a change in emphasis from reproductions to originals awaited only the emergence of the means for obtaining the latter. The Museum's managers would not have to wait long. After almost two decades of financial instability, several major bequests afforded the Museum the opportunity to build upon the gifts of art already received. In 1894, the trustees began to permit the purchase of original art. In just one decade, the Museum, which had spent only $7500 for original art in its first seven years, expended $1,324,000 on new acquisitions (ibid.: 180–214; Carter, 1925: 195–96).

Although the original Museum had expanded in 1890, the sheer volume of the new art had begun to crowd the casts, which had originally inhabited the entirety of the Museum's first floor. The acquisition of land for a new and larger building in Boston's fashionable Fenway district might have allayed the competition for space that was emerging. Instead, the planning process for the new Museum became the occasion for a scarring battle between the supporters of education – the Museum's Director, Edward Robinson (who succeeded General Loring in 1902) and allies among the trustees – and the champions of aestheticism, led by the professional art historians who had entered the Museum as it expanded in the 1890s, and supported by Board President Samuel Warren and several of his colleagues.

To understand the battle lines that formed around the issue of the rôle that casts and reproductions would play in the new building, it is necessary to understand changes in both personnel and ideology that occurred in the 30 years that followed the Museum's founding. The original Museum was sparely staffed. As the collections began to grow, new departments were established and curators hired. With the ascendency of Robinson, a Harvard art historian, to the directorship, the trend towards hiring art historians to these positions accelerated. The first curators were, for the most part, either members of the Brahmin aristocracy (men like Walter Mason Cabot) or outsiders, men with somewhat exotic backgrounds. A few of the latter, like Print Curator Kohler of Harvard, or Curator of the Japanese collection Ernest Fennelosa, a Spanish musician's son who had married the daughter of a Salem China trader, had close Boston connections. Others, like Matthew Prichard, an intimate of Board President Warren's expatriate brother Ned in England, or librarian Almy Morrill Carter, who had gone to Harvard then worked at Princeton for several years, had few Boston ties. These outsiders, whom Prichard later referred to as 'people that chance rained into the place, – German blood, Japanese blood, Jewish blood, English blood as well as Yankee – with no ties to the community' (ibid.: 215), served an important rôle. The cultural capitalists were, in Lewis Coser's terms (1974), a 'greedy' elite. They distrusted individuals not of their class; and when they had to employ them, they sought men who were classless, who belonged to no other party in Boston. Thus Carter recalled of his interview with President Warren,

> I can remember only one question that he asked me: Whom did I know in Boston? I feared that I would lose the job because I had to admit that I knew absolutely no one in the city; but perhaps that was my best recommendation to him and I did receive the appointment . . . (Whitehill, 1970: 181)

The new professionals were, for the most part, aesthetes, raised on the philosophies of Matthew Arnold and Charles Eliot Norton but, as Martin Green (1966) points out,

more interested in finding perfection outside this world than in making the world more perfect. Art, for them, was ineffable and exquisite; the Museum was a temple for the appreciation of art, not an engine of education. Joy, not improvement, was to be its *raison d'être*. As Prichard put it, in an early sally in what Whitehill calls 'the battle of the casts',

> A museum of art, ultimately and in its widest possible activity, illustrates one attitude toward life. It contains only objects which reflect, clearly or dimly, the beauty and magnificence to which life has attained in past times. The fruits of this exalted and transcendent life are gathered within its walls, and it is the standard of this life with the noble intellectual activity it presupposes that a museum of art offers for acceptance by its visitors ... the Museum's equipment is designed particularly to further the enjoyment of the public, and not to prepare artists for their calling. (quoted in Whitehill, 1970: 183)

First of all, the casts had to go, for they profaned the art with which they dwelt. Robinson wished to keep the casts as the museum's centerpiece, as a model educational resource that could be copied throughout the United States. Prichard and his supporters sought to exile them to basement rooms under collections of originals or to another building altogether. Casts, he wrote, are

> engines of education and should not be shown near objects of inspiration. They are data mechanically produced; ... [They] even destroy that contemplation which Mr. Gilman [Benjamin Ives Gilman, the Museum Secretary] calls the 'consummation of a work of art'. (ibid.: 202)

Casts, wrote Prichard, are

> the Pianola of the Arts ... The exhibition halls of our Museum have the same right to be free of mechanical sculpture as the programmes of the Symphony Concerts, which set the standard of musical taste in Boston, have of exemption from mechanical music. (ibid.: 202)

The reformers also sought to purge the Museum of lesser originals. Curator Paul Chalfin urged that the Museum deaccession 371 of its 1101 original paintings, and store another 230, exhibiting 250 to the general public and displaying the rest in special study collections. Prichard advocated this plan more generally:

> Naturally the higher the standard of excellence it is wished to maintain, the larger will be the size of the study series, and the fewer the objects it is possible to show to the public. The air grows rarer the nearer you reach the summit of the mountain. (ibid.: 184)

The art that did remain in view would be reorganized. According to the South Kensington philosophy, separate rooms had been devoted to different kinds of artifacts, in order to facilitate their inspection by craftspersons. By contrast, Prichard advocated the historical classification of objects by period and nationality.

The implications of this new framing of aesthetic experience were unfriendly to the goal of education. The ideology of connoisseurship – the view that nothing should interfere with the direct unmediated communion between the viewer and the work of art – was hostile to interpretation. Benjamin Ives Gilman argued with Robinson that 'in an exhibition of fine art, instruction becomes a means, the end being appreciation'

and that 'the knowledge of art history is not the same as the comprehension of art history, but a very different and immeasurably less important thing'. The Museum, wrote Prichard,

> is dedicated chiefly to those who come, not to be educated, but to make its treasures their friends for life and their standards of beauty. Joy, not knowledge, is the aim of contemplating a painting by Turner or Dupre's 'On the Cliff,' nor need we look at a statue or a coin for aught else than inspiration and the pleasure of exercising our faculties of perception.... [T]he direct aim of art is the pleasure derived from a contemplation of the perfect. (ibid.: 201)

Thus Gilman, when he created the docent program in 1907 urged the instructors to avoid instruction: 'The essential office of the docent is to get the object thoroughly perceived by the disciple. Hence draw attention to the object first; talk about it afterwards, and only if the occasion offers' (ibid.: 295).

Supported by President Warren, Prichard, Gilman and their allies were victorious. Although both Robinson and Prichard resigned from the Museum as a consequence of the struggle, the new Museum embodied the latter's philosophy when it opened in 1909. The casts, which were to have occupied another building (never built) were consigned to the basement, from which they ultimately entered oblivion. Gilman stayed on and Robinson's successor as Director embraced Prichard's views.

The Purification of Boston Music

If the MFA was born in harmony and experienced a traumatic youth, the BSO's difficult infancy was followed by a robust, happy childhood and adolescence. Elite ideas about music were more firmly set than those about visual art in mid-century, and at least a core of Bostonians had experienced pure fine-arts music in the concerts of the Harvard Musical Association and the Handel and Haydn Society (of which Higginson became a trustee in 1882).[3] What is more, Higginson promised less in the way of education and community service than the Museum's incorporators; that the BSO would have an elite constituency was clear from the beginning. Yet the Orchestra's development in the 30 years after its founding resembles that of the Museum's in several important ways: the programs became more highly classified, the boundaries between popular and high-art music and between artist and audience were more firmly drawn, and the musical experience was framed in terms of an ideology similar to the ethic of connoisseurship. These changes, in the aggregate, sealed the Orchestra off from the community as a whole and ensured that it would become more fully a part of the culture of the elite and of middle-class aspirants to elite status.

The form, the repertoire, and the style of the Orchestra were presaged in the writings of Edward Dwight, editor of Boston's *Journal of Music*, to which Higginson contributed while studying music in Vienna. Dwight and Higginson were close, as their correspondence indicates, and Dwight was an active supporter of Higginson's efforts. He himself had lamented, just six months before Higginson announced his project: 'We have a hall, an organ, and an art museum. Now we want an orchestra . . . We are falling behind New York. We will become provincial without it' (Mueller, 1951: 80).

Dwight, influenced by Hegel, believed that music represented a higher-order truth than words or logic. As early as 1852, he had a keen sense of the need for an orchestra to define what, in fact, the best music would be, writing

Very confused, crude, heterogeneous is this sudden musical activity in a young, utilitarian people. A thousand specious fashions too successfully dispute the place of true Art in the favor of each little public. It needs a faithful, severe, friendly voice to point out, steadfastly, the models of the True, the Beautiful, the Divine. (McCusker, 1937: 19–20)

Dwight and the early promoters of fine-arts music were quick to devalue the popular, as well. Theodore Thomas wrote, 'light music, "popular"', so-called, is the sensual side of the art and has more or less the devil in it' (Mueller, 1951: 30). High and popular culture must be separated. When the managers of the Music Hall, which held the Harvard Musical Association's concerts, permitted Barnum to hold a baby show there in 1865, Charles Perkins threatened to withdraw his offered gift of a statue of Beethoven, lest it 'be subjected to the indignity of presiding over a Baby Show'.

We would think Boston sufficiently disgraced by having such an Exhibition held in any low building within its limits – but to have it held in our Music Hall, a place consecrated to the endeavor to elevate the taste of the community, is really intolerable. (McCusker, 1937: 23)

Dwight himself printed Perkins's protest in his journal, adding, 'Let not the master works of the great composers be heard in a building which will ever after merit the name of Barnum's Nursery' (ibid.).

Dwight, perhaps more than his peers, had a keen understanding of the organizational requirements for the institutionalization of his philosophy. Early on, he credited the success, such as it was, of the Harvard concerts to the association's freedom from commercial constraints and interests, and of the susceptibility of musicians to guarantees of regular work. In his appraisal of those concerts, he stressed two other features that were to be bulwarks of the BSO:

2. The guarantee of a nucleus of a fit audience, – persons of taste and culture, subscribing beforehand to make the concerts financially safe, and likely to increase the number by attraction of their own example.
3. Pure programmes, above all need of catering to low tastes; here should be at least one set of concerts in which one might hear only composers of unquestioned excellence, and into which should enter nothing vulgar, coarse, 'sensational,' but only such as outlives fashion. (Howe, 1914: 10–11)

These 'persons of taste and culture' were, in most cases, those of the highest status. It was clear to Dwight, as it was to Higginson, that this group would necessarily represent the core of any audience for 'pure programmes, above all need of catering to low tastes...'. The identification, here, of taste and nobility of spirit and, implicitly, of taste and social standing, is a crucial syllogism that would legitimate the dominant status culture then being consolidated. But as Dwight understood, even with the founding of the Orchestra, the process of the sacralization, beyond a narrow group of aficionados, of symphonic music was not yet complete. It remained for Higginson and the conductors to whom he entrusted the orchestra, to complete the process.

Higginson had high aspirations for his orchestra, particularly for the winter concerts: 'anything unworthy' was to be 'shut out'. Like Brimmer at the Museum, Higginson in his plans sought to exclude the clearly popular without being narrow-minded:

...all the catholicity possible seems to me good. I do not like Wagner's music, and take little interest in much of the newer composers, but I should not like to bar them out of our programmes. People of education equally objected to the later compositions of Beethoven as those of a lunatic. Possibly they are right. (Howe, 1914: 30–31)

In the Orchestra's first year, Henschel, an advocate of mixed programs, attempted to keep the concert's second half decidedly light. Each concert would include a Beethoven symphony, but also a solo and a second part to be 'short and of considerable lighter popular character' (Henschel in ibid.: 39). The first concert included a solo by vocalist Miss Annie Louise Cary, as well as some ballet music by Schubert. In a benefit concert for a deceased musician's family, later that year, Henschel himself joined his wife in a vocal duet, 'Oh, that we two were maying'. As Mueller writes, Henschel

> was not averse to musical titbits, which could be instantly enjoyed by the audience, and generally designed his program with appetizing deserts at the end. (Mueller, 1951: 99)

But if Henschel did not purify his concerts of vocal and popular songs to the degree that later conductors would, he did make some strides in that direction. Indeed, he was frequently criticized for his inclusion of Wagner and Brahms in the repertoire. A New York critic called him 'a veritable Brahmin in his passion for Brahms', and a Bostonian remarked, on the occasion of an all-Wagner memorial that marked Wagner's demise, 'The programme was gloomy enough in all conscience, and the necessity for its performance gave one more cause for regret at the composer's death' (Howe, 1914: 80). Higginson did not commence popular summer concerts under Henschel (although he would under the stricter Gericke). Indeed, he forbade his players from playing dance music on days that they were committed to the Orchestra – effectively forbidding such employment, since this prohibition included weekends.

To Henschel fell the difficult responsibility of enforcing discipline upon his restive minions. He enforced punctual appearance at rehearsals and concerts, and banned private discussions during rehearsals. It was left to Henschel's successor, the stern Gericke, to finish what he had begun.

Gericke arrived from Austria to replace Henschel in 1884. He quickly clashed with some of the established players, and recalled, many years later

> I was not popular in the Orchestra, especially as they did not yet understand why I should ask for better playing and more exact work than had been done heretofore. Before I came to Boston the members of the Orchestra had been used to a great deal of freedom... (Howe, 1914: 111)

After the first season, Higginson sent him to Europe to find replacements for some of the older players, whom he regarded as unfit. He came back with 20 European musicians. The purge of the local men caused serious dissension, and Gericke recalled that 'The remaining old members took the part of the dismissed ones, and opposed me where they could' (ibid.). There was criticism in the press as well. One critic wrote, in the Thanksgiving edition of his newspaper,

> We are thankful that Mr. Gericke, in his sweeping discharges, did not discharge Mr. Higginson. We are thankful that one or two Americans are still left in our Symphony Orchestra, so that the United States language may be reserved from oblivion. (ibid.: 124)

As the Museum of Fine Arts would turn to outsiders – both of nationality and of temperament – for professional staff, so the Orchestra turned to Europe for its conductors and musicians. The work of framing an aesthetic experience – of separating the artistic and the mundane – required the strengthening of boundaries between audience and performer. It would not do for Bostonians to see their kinsman or acquaintances on stage: professionalism was vital not just for the quality of the performance but for the strength of its frame, as well. Only outsiders with few ties to Boston could be trusted to implement the strict changes that were in store. Gericke played the rôle of eunuch, serving the Orchestra without distraction. Desperately homesick on his arrival, the conductor was grasped quickly to the bosom of Higginson and his comrades at the Tavern Club, where, he recalled, 'I found kindred spirits and some good and staunch friends, who did their best to help me over my first difficulties' (ibid.: 108). Yet despite the influx of Europeans, the BSO was not a mere carbon copy of European institutions. As Mueller notes, the American orchestras enlarged the scope of their conductors' authority well beyond that enjoyed by their European counterparts (Mueller, 1951: 317).

Gericke initiated a level of classification that the Orchestra had not experienced under Henschel. Just as the Museum's aesthetes would cordon off the profane casts to basement rooms, Gericke, with Higginson's support, purged the winter concerts of light music, consigning it to a series of summer 'Pops' programs. 'My predecessor', wrote Gericke,

> had always given some light music in the second part of every concert and the audience was used to this and liked it. But, as Mr. Higginson wanted to bring the concerts to a higher standard, and as the name of the Orchestra was "The Boston Symphony Orchestra," I did not see the reason why the programme should not be put thoroughly on a classical basis . . . (Howe, 1914: 108)

In addition to curtailing light music, Gericke occasionally broke with precedent to omit solo performers, particularly vocalists, from the program.[4]

The Orchestra, as Higginson conceived it, was classical in orientation. But Higginson was a practical man, and he hoped that his offspring would some day become self-supporting. In his initial plan, he included the provision of light-music concerts, including dance music, in the summer. This was not surprising, given the popularity in this period of band music, which combined marches, arias, classical numbers and dance tunes. Yet Higginson showed some ambivalence towards his plan during the first few years. As early as 1883, Higginson was urged by the manager of the Music Hall to institute a summer series. The BSO's manager, Charles Ellis, wrote Higginson of a proposition

> to decorate Music Hall with plants, etc., making a kind of garden of it, and will either rent it to us at a low rate, or for a percentage of receipts sharing the risk with us. I believe such a series would go. (Perry, 1921: 301)

Higginson was unconvinced. In his original memorandum he had written

> I do not know whether a first-rate orchestra will choose to play light music or whether it can do so well. I do not believe that the great opera-orchestra in Vienna can play waltzes as Strauss's men play them, although they know them by heart and feel them all through their toes and fingers – simply because they are not used to such work – and I know that

such work is in a degree stultifying. My judgment would be that a good orchestra would need, during the winter season, to keep its hand in by playing only the better music, and could relax in summer, playing a different kind of thing. But I should always wish to eschew vulgar music, i.e. such trash as is heard in the theatres, sentimental or sensational nonsense; and on the other side I should wish to lighten the heavier programs with good music, of a gayer nature.

The emergence of the Pops as a profane and profitable summer supplement to the austere winter programs represented a kind of watershed in the classification of high and popular genres. These light concerts were not only less strongly classified than the winter series, but also consciously less strongly framed: consumption of alcohol and tobacco was permitted (indeed, the one year that a liquor license was not forthcoming the series was cancelled), and quiet and decorum were not demanded. (Their repertoire, similar to Henschel's light programs in the 1880s, diverged more markedly from the regular concerts in later years.)

By now, the format and style of the Orchestra were set. Gericke's romantic successors, Nikisch and Pauer, continued his campaign against soloists, abandoning the practice of including vocalists (practitioners of a form decreed beneath the purely orchestral by Dwight and his followers) almost entirely. Dr Muck, conductor until his dismissal amid charges of disloyalty during World War I, carried the classification of genres beyond the segregation of high and low to an even more rigorous level. Just as the art historians at the Museum reclassified their collections in terms of historical and national genres, Muck segregated his concerts by genre, contending that 'The classic and the frankly romantic should no more be thrown together in a single concert than they should in a single room of an Art Museum' (Johnson, 1950: 48–49).[5]

The classification of fine-arts and popular music, and the eventual subclassification, within classical music, of the romantic and the classical, were accompanied by an effort, on the part of Higginson, to frame the concert experience, to purge it, as far as possible, of commercial elements and to sacralize the concert as a ritual occasion. This effort was consonant with the Dwightian view of music as spiritual and otherworldly. In his description of the first Beethoven concerts in Boston, Dwight established a model for aesthetic experience similar to that espoused by the Museum's aesthetes:

> Some may yet remember how young men and women of the most cultured circles, whom the new intellectual dayspring had made thoughtful and ... impressible to all appeals of art and beauty, used to sit through the concert in the far-off upper gallery, or the skyparlor, secluded in the shade, and give themselves up completely to the influence of the sublime harmonies that sank into their souls ... (Cooke, 1898: 65–68)

Thus Charles Eliot wrote that 'common enjoyment of immortal music' was an 'exalting and binding influence ... the best expression of public prosperity, social joy, and religious transport' (Perry, 1921: 322). And Higginson's friend William James urged the concert-goer

> never to suffer one's self to have an emotion at a concert without expressing it afterward in some active way. Let the expression be the last thing in the world – speaking genially to one's aunt, or giving up one's seat in the horsecar if nothing more heroic offers – but let it not fail to take place. (Mueller, 1951: 293)

The identification of art and refinement, of the beautiful and the moral, came naturally to the cultural capitalists: it applied both to the content and to the reception of art. Higginson, an avid theatre-goer throughout his life, as a student in Paris, condemned the vulgarity of Mounet Sully's famous Hamlet as 'brutal and horrid. The French may like it, but it is absolutely out of character. . . . It is burlesque' (Perry, 1921: 397). Similarly, he would try to purge the vulgar and the commercial from the halls of the Orchestra, to frame the concert as a spiritual and ritual event.

Part of this effort involved the strengthening of boundaries between the performer and the audience, the former transported, the latter receptive and subdued. In part, this was achieved by such devices as the darkening of the audience during perform-ances, which was initiated in 1908 (Johnson, 1950: 48–49). In part, this was achieved, as we have seen, through the introduction of strangers as the conveyors of music, and the purge of the locals. And in part, this was accomplished through the provision of professional standards to which amateurs could not hope to aspire, an event that, as Mueller has written,

> drove a fatal wedge between the lay audience, which during the choral days had shuttled rather easily back and forth across the footlights and the highly trained orchestral body from which they were barred. (Mueller, 1951: 28)

After 1885, there would be no more solicitations to 'Ladies and Gentlemen desirous of singing in the chorus' for special concerts printed in the concert bulletins.

Yet the early concerts did not meet entirely the standard that Dwight had set for them. In the first few years, crowds thronged the concert hall. Henschel recalled times at which, 'I myself, in the hall, had difficulty to reach the conductor's desk, as every available space, even on the platform, was occupied by the audience' (Howe, 1914: 53). In cities that lacked the example that the Musical Association concerts had provided Boston, profanations of the musical atmosphere were even more common. Dwight wrote of Theodore Thomas's tenure in New York in 1875 that

> Not a week passes without some scathing rebuke from him to those illbred and ignorant people who keep up a continued buzzing during the performance of the music to the annoyance of all decent folk.

In Chicago, where Thomas ultimately settled, the level of deportment was even worse. A reporter thought it remarkable that Thomas's rendition of Beethoven's *Eroica* 'was received and followed with the closest attention and there was noticeably less conver-sation than on previous occasions. Perhaps', he added, this was due to 'the fact that few beyond the truly musical were present . . . because of bad weather' (Mueller, 1951: 354). At the Metropolitan Opera, which, in New York, was far more popular than the Philharmonic, middle-class Germans battled for a decade with upper-class patrons who preened and conversed in their boxes during performances (Brenneise, n.d.).

Even in Boston, the development of concert manners was an element of framing no less important than the separation of performer and patron to the ritual sanctity of the occasion. The advent of concert notes in the mid-1880s was accompanied by their loud rustling by many audience members, to the detriment of the enjoyment of others. The notes consistently implored the patrons, from 1884 on, to refrain from early exits while music was being performed.[6] (In 1900, an intermission was added to permit attenders to promenade and chat.) By the late 1890s, the management was

confident enough to print and enforce a public statute banning the wearing of large hats in places of public performance. Before long, even the convention of applauding was called into question, as Philip Hale paraphrased with approval, in the concert notes, the contention of a Viennese critic who found applause appropriate only

> after vociferous endings, after pieces of a lively, festive warlike heroic character, but not after such a work as Beethoven's 'Coriolanus'. He portrays the average hearer during the performance of the overture, who sees with staring eyes, as in a magic looking-glass, the mighty shade of Coriolanus pass slowly by him; tears fall from the hearer's eyes, his heart thuds, his breath stops, he is as one in a cataleptic trance; but as soon as the last note is sounded, he is again jovially disposed, and he chatters and criticizes and applauds. (BSO Concert Notes, 18 May 1914)

Throughout the early years, Higginson tried repeatedly to eliminate elements of commercialism in the Orchestra's affairs. The expectations for such an assemblage were far from clear. (The Orchestra's manager recalled of their first tour that one local house manager expected the players to parade through town to drum up business [Howe, 1914: 134].) Higginson took great pains to eliminate the scalpers who, in the early years, commonly sold tickets at twice their price, auctioning off many of the best seats himself to combat this practice. And he ended the tradition, in concerts, of hanging an enormous gilt sign over the piano advertising its manufacturer, antagonizing the dealer who had loaned the instrument free of charge (ibid.: 79).

Classification, Framing and Social Class

The movement towards a stronger classification of artistic contents and the development of ideological and normative frames for the experience of art led, in both the Museum and the Orchestra, to an identification of those institutions with the social classes that patronized them and to a narrowing of their audience base. Initiated, to varying degrees, in the interests of popular education, each saw its educational mandate diluted as the artistic component of its mission was clarified and strengthened.

The Museum, despite its democratic beginnings, had never been a popular institution in the sense that Boston's theatres or even the Lowell lectures, in earlier years, were popular. Yet in its Copley Square building it did attract steady crowds, many of them Italian immigrants according to contemporaries. The move to the more exclusive Fens, if it was not calculated to cultivate a more exclusive clientele, was at least guaranteed to do so. Despite the enormous increase in Boston's population over this period, the Museum's attendance figures show only a modest rise: 158,000 in the first year, a new high of 183,000 in 1882, another high of 300,000 in 1895, during the first flush of spectacular acquisitions, down to 194,000 the next year. Despite a rise in attendance when the new building opened in 1910 (the first full year of operation), the 1895 figure was not soon reached again; 1914 attendance was still at the level of the late 1880s.

Indeed, the trustees were displeased by the press of visitors, who were concentrated on free weekend days. 'It is certain', they warned in 1882, 'that nothing contributes so much to the real enjoyment of, and the good to be derived from a work of art as freedom from oppressive interruption in the process of examining it' (Whitehill,

1970: 60). While their charter obliged them to let the public in for free, in other respects the Museum seems to have become more exclusive. I have noted (DiMaggio, 1982) the remarkable decline in the breadth of its fund-raising base between 1873 and 1888. When the trustees needed support for their new building a decade later, they did not even bother with a public appeal. This insular quality is reflected as well in other fund-raising strategies, such as the expensive soirées at which male models presented tableaux vivants for the entertainment of patrons in the 1880s, or the membership campaigns of the 1890s and thereafter.

The most serious indictment of the Museum's exclusiveness came from Matthew Prichard, in a private letter to Mrs Isabella Stewart Gardner on the occasion of Samuel Warren's death. When Warren took over the Museum's presidency at the turn of the century, wrote Prichard,

> the institution was despicable and despised. A few families had a special cult for it, regarded it as their appanage, practiced their influence on it, discussed together their activity in its past, their aspirations for its future; on Sundays it was visited by loquacious Italians, but on week days the temple was closed to all save the initiated who appeared to bully the director and oversee their family tombs. For it was recognized that one room belonged to this family and another to that. They had a prescriptive right to arrange and contribute what they would and exclude the rest, by right of birth they were experts in their corner or corridor and would hesitate to visit another lot in the cemetary unaccompanied by the representative of its tribal chief. To understand the Museum . . . it would be necessary to study savage customs, for it was the last sanctuary (unless the Athenaeum was another) of the Boston aborigines, and totem and taboo, animism and magic, custom, rite, precedent, and mystery were imprinted all over it. An unseen wall of sanctification defended it from the impure and profane. (Whitehill, 1970: 212–213)

This, to be sure, is the analysis of a bitter man. Yet it captures an irony essential to an understanding of the rôle that art historians played in the development and evolution of high art. What Warren achieved was the transition from a patrimonially to a professionally administered organization: Robinson's successors would have to put up with somewhat less close scrutiny and less intense meddling by trustees than he had to accommodate. Yet the professionals to whom these 'popes and hierarchs', as Prichard called them, delegated a portion of their power, were themselves distinctly upper class in their associations and their values. They achieved a level of classification and separation of high from popular art that the trustees themselves could not. The banishing of the casts and the ascension of aestheticism did not represent an art historians' coup: it was achieved with the full knowledge and cooperation of the trustees. Yet this transition, which occurred in other American museums at about the same time (see Zolberg, 1974, 1980), was a critical one, essential for the creation of a high culture.

The Orchestra, from the beginning, had less of a commitment to education than did the Museum. The framing of an aesthetic experience for members of 'the most cultured circles', as Dwight called them, had certain implications for the class composition of the Orchestra's audiences. A letter-writer to a Boston newspaper complained,

> I saw but few whom I should believe to be poor or even of moderate means. . . . Full dress was to be seen on every hand. I should be very glad to take my family to hear these educating and refining concerts, but I have not the means to go in full dress; neither can I afford to pay a speculator double the price for tickets . . . (Howe, 1914: 76)

While Higginson's defenders stressed the appearance of an occasional Italian immi-
grant in the audience, others like a writer for the *Transcript*, noted the vogue of the
concerts for the socially prominent:

> Where have all these symphony-concert goers been during the last ten years, that they
> have hidden themselves so completely from the public view?...Cheap prices have had
> some effect, but not so much as many persons suppose. 'Fashion' is an ugly word to use in
> connection with art matters, but all matters have their nether side. (ibid.: 54)

A sense of the Orchestra's rôle in Boston society can be gained from the report of a
correspondent for the Boston Traveller on the BSO's second performance in New
York:

> Many surprises marked the evening, not the least of which was the character of the
> audience; in place of the faces of foreign type which accompany one everywhere in
> cosmopolitan New York, here right alongside was one of the loveliest of old New England
> grandmammas, with a bevy of nephews and nieces; in the next row a group of fine fellows,
> New Yorkers, it may be, but Harvard men undoubtedly, while it was such a pleasure to see
> all about the faces with which one felt a kinship. This is written not in disparagement of
> those truly musical people, the Germans ... but only to show, it may be to others who,
> like the writer, have been really homesick for the sight of a family face when for any cause
> brought into promiscuous company in New York. (ibid.: 124)

The relative affluence of the BSO audience is reflected by the advertisements that
appeared in the concert notes throughout this period. The bulletins for 1889 and
1890, for example, advertised imported women's gloves, fine art, Oriental carpets
from India ('the special attention of CONNOISSEURS [*sic*] is invited'), imported
furs, dresses, and Parisian corsets, imported coffee, carriages and pleasure vehicles,
diamonds and gems, and pianos and organs, as well as musical supplies and after-
concert treats. (By contrast, Pops concert brochures mixed advertisements for such
items as summer homes in the Berkshires, carriage rentals and Mason and Hamblin
pianos with a larger number of advertisements for tobacco products, beer, candy and
suspenders.)

In his initial plans, Higginson stressed the importance of low-priced tickets and the
hope that his concerts would educate a wide public. Indeed, inexpensive concerts of
classical music had been offered in Boston as early as the 1830s, when the Handel and
Haydn Society had offered some free performances; and in 1868 the city of Boston
presented 14 free concerts of mixed programs for the city's poor. In 1881, the *Musical
Record*, which had praised the Higginson plan, called on the city to

> make use of the vast auditoriums which will soon be available, for another series of free in-
> door concerts, limiting the privilege to the deserving poor, and making the distribution
> of tickets by means of the police, who are best qualified to judge as to the needs of
> applicants in their respective precincts. (27 August 1881: 757)

Faith in the power of music was strong in Boston, and there was some expectation that
it should be shared with the public at large. A newspaper writer attacked the Handel
and Haydn Society in the 1880s for neglecting 'to make a single attempt to cultivate a
wider appreciation of oratorio music by affording the general public an opportunity of
hearing repetitions of their performances at popular prices' (Johnson, 1965: 149).

Thus Higginson's plan for low-priced concerts was one consistent both with Boston's musical history and with the temper of the time.

Yet between his initial description of the Orchestra and its debut nine months later, the top-priced tickets had been increased from 50 to 75 cents (while the less expensive remained an affordable 25 cents). And with the institution of the auction for tickets in 1884, even these prices effectively were raised. As the Orchestra's reputation grew, auction prices rose alongside it. By 1900, the most expensive seats averaged almost $25.00 per concert (Johnson, 1950: 25). Low-priced tickets became so scarce that a critic wrote that 'the hoi polloi, for whom Mr. Higginson has been ostentatiously posed as a patron, will have to put up with the leavings' (Howe, 1914: 83).

An inspection of handbills from the period reveals that BSO prices were about half those of other classical organizations when tickets could be obtained outside of the auction. Seats at the most expensive operatic performances ranged from $1.50 to $3.00. Chamber concerts generally cost from 50 cents to $1.50. The New York Symphony Orchestra charged from 50 cents to $2.00 for tickets when it played in Boston. Comic and English-language opera seats ran from 25 to 75 cents; and John Philip Sousa's band concerts brought from 25 cents to $1.00 per seat. Tickets to purely popular performances (for example, those at the 'Museums' and vaudeville theatres) could cost as little as a dime. Thus the BSO's ticket policies, for all the claims that were made for them, represented, at best, a reform, not a revolution.

In fact, Higginson became notably less concerned with education as his project became a success. At first, he sought to entice 'the poorer people' with low prices; in the rancorous early years, his supporters defended the concerts as 'an educational institution'. Yet, by 1889, Higginson had narrowed his ambitions so far as education was concerned. Addressing those who had criticized his concerts because they were attended only by the rich and had urged him to make an effort to accommodate the poor, Higginson said

> If a series of concerts was offered at low prices only to the 'truly poor,' do you suppose that any one but the truly rich would frequent them? . . . And why should I pick out one kind of an audience? The sunshine and green fields and all beautiful things are given to all men, and not alone to the truly poor or to the young or to the old. Even so with music . . . (ibid.: 146)

Thus in the Orchestra, as in the Museum, the classification of high culture and the framing of aesthetic experience were accompanied by an insulation of the institution not just from popular art but from the masses themselves. In this process, Higginson, like the trustees of the Museum of Fine Arts, was a principal. Higginson never tired of calling attention to the freedom that he permitted his conductors. In 1888 he wrote to a German friend helping him recruit a successor to Gericke

> I have never exercised any supervision; I have never urged him, and I am not in a position to do so. You know very well that I am a busy man, and have many cares on my mind; that I must keep this orchestra matter before me, but I cannot give it much daily care or thought: I cannot go and see that the conductor is busy with his work day after day, week after week. . . . He is free and unfettered in all these matters . . . He is as free as a man can well be in this world . . . (ibid.: 155)

Higginson did permit his conductors considerable autonomy; he probably meddled far less than others of the early pioneers. Yet it is equally clear that he was the architect

of all but the musical programs, and that, even over these, he kept a watchful eye. As he lectured his men in 1914,

> I watch the musicians almost too much, for it often interferes with my pleasure, thinking about whether they are playing their best, and listening for the various points instead of listening for the whole. Whenever I go to a concert, there is always a sense of responsibility on my mind. (Perry, 1921: 295)

The Classification and Framing of High Culture in America

I have argued that Boston's cultural capitalists – the men who founded and nurtured the Museum of Fine Art and the Boston Symphony Orchestra – were creating a high culture in the interest of their class. In pointing out the extent to which this high culture was created systematically and formally through organizations that served to separate it and its public from popular culture and from the populace itself, I do not mean to claim that a conscious conspiracy occurred, nor that there were no tensions between the drive for exclusivity and other values that Boston's elites held dear. Nor should the recognition that high culture, as we know it, was the creation of a status group lessen our appreciation of the accomplishments of those who have worked in high-culture genres.

At the institutional level, the struggle to create a high culture was a fumbling and contentious one. Yet it was one that the Brahmins and elite status groups in other American cities had to undertake if they were to become a true upper class. To understand the attraction of a high culture, defined as it was, to an upper class like Boston's, and to the middle class that embraced culture even more fervently than they, consider the affinities between the ideology of aestheticism that shaped both the Orchestra and the Museum during this period and the cultural needs of America's urban elites.

The key to aestheticism, to the ideology of connoisseurship, is its essential ambiguity. Visual art and music, the aesthetes taught, were not susceptible to mere words. The symphony, wrote one critic, 'does not depend for its force on its definability' (Philip Goep, quoted in Mussulman, 1971: 47). To see art as expressing the ineffable, as beyond words, to define the relationship of the viewer or listener to the work of art as a transcendant one, sullied by description or interpretation, is to make art ultimately the property of those with the status to claim that their experience is the purest, the most authentic. The aesthetes, from Dwight to Prichard and Gilman, spoke for a culture beyond that of politics or science, where merit was visible or decided by popular vote. In seeking the transcendant, the aesthetes placed the experience of art beyond verification or reason. As Martin Green has observed, culture in Boston became 'etherialized.... [T]he idea of culture swelled as it became emptier...' (Green, 1966: 108). Whatever the merits of aestheticism as a philosophy, in practice it placed the mantle of art upon those with the leisure to become familiar with it, the ties to professional critics and art historians to be instructed in it, to learn an attitude towards it, to adopt it as their own. The experience of Culture – high Culture – became an exercise in the implicit. And Boston's dominant status group, with its multiplicity of interconnections and its rich symbolic life, was uniquely situated to capture the implicit, to make it its own, to stitch art into the fabric of its communal life, as no other group could. Even the middle-class worshippers at the shrine of art

could only hope to grasp a shred of culture to differentiate themselves from the masses beneath them.[7] They could not hope to challenge the elite on its own ground. The professionals, the critics, the art historians, the musicians and the rest were crucial, in part for providing a vocabulary for the understanding of art, but, even more important, for legitimizing the stature of the elites who monopolized their attentions and their services. As Dwight's writings illustrate, in the aesthete's view, the identification of taste with moral stature, and of morality with class position, is all too easy. In high culture, the upper classes of late-nineteenth-century America found both a common currency and a refuge from the slings and arrows of the troubled world around them.[8]

Yet the creation of high culture was attended by tensions, some internal and some external. The institutions that the cultural capitalists created required resources to survive and to grow. In the case of the Museum, the need for resources drew it, once the great legacies of the eighties and nineties had inflated its budget and its needs, to the public purse. In 1912, the trustees sought support from Boston's government of the kind that the Metropolitan Museum had received from New York. They were rebuffed, but in the process they developed programs to bring children from the tenements to the museums, and to bus immigrants from the North and West Ends, and they expanded their attention to education (albeit with a view of education that could only serve the already educated). These reforms were not pivotal ones – the trips from the slums were abandoned after two months for want of funds – but they serve to illustrate the sensitivity of the Museum's managers to their formal mandate, even after the educational mission of the seventies effectively had been discarded.

Similarly, the Orchestra could never free itself entirely from the force of the market. Throughout his tenure as its patron, Higginson was driven repeatedly to commercial considerations, no matter how much he abhorred them. The Pops concerts were initiated in order to provide additional income and year-round support for the players who, in the first years, had often defected to other cities during the summer months. And he embraced the flamboyant Nikisch, whose romanticism appalled the more dignified followers of Dwight. When Gericke returned for a second term, Boston found him too cold, and attendance fell off. Higginson induced him to yield, on occasion, to guest conductors and, Howe suggests, was not entirely sorry to see him depart. Just as American museums have, throughout their histories, been pressed towards public service by their need for the cooperation, if not the subventions, of government, so symphony orchestras are urged continually towards the market as the solution to their financial difficulties.

The effort to create a high culture was an imperfect one, yet one that set out a potent ideological and a potent organizational model. We have seen that managers of the Orchestra and the Museum were citing one another's institutions as standards for their own by 1910. Even the theatre, which, commercially successful, could not easily be fitted into a high culture frame, was subject to criticism according to the elite model. Thus the middle-class Twentieth-Century Club, reporting on its investigation of Boston theatre in 1910, focused its criticisms on the promiscuous mingling of high and popular culture on the Boston stage. 'It is notable', they say,

> that the different theatre managements, exclusive of those giving burlesque and vaude-
> ville, make no attempt to establish a permanent clientele, a fundamental need in the
> conduct of any other business. It is difficult, for instance, to understand what prompted
> the Shuberts, after opening their new theatre with two weeks of Shakespeare ... to put on

for their second attraction as commonplace a musical comedy as "The Midnight Sons".
(Twentieth Century Club, 1910: 3)

Equally vexing to them was the tendency, in vaudeville houses, towards 'further breaking down . . . those barriers that separate the audience from the performer upon the stage'. In this regard, they sought to prevent the appearance of a barefoot dancer in Boston.

> Equally undesirable, and evidencing the same tendency in a form perhaps still more to be deprecated, have been the attempts made by certain managers further to remove the barrier between performer and audience by sending members over the footlights at every performance . . . One of the most sensational illusions has been the sending of a balloon or aeroplane out over the heads of the audience, carrying one or two girls singing . . . (ibid.: 30)

The need for strong classifications to preserve the purity of art, and for the need of boundaries between performer and public, was by this time evident to these middle-class reformers.

Conclusions

In providing an historical sketch of the processes of classification and framing as they occurred at the Museum of Fine Arts and the Boston Symphony Orchestra, I have been able to do little more than scratch the surface of the cultural changes that were occurring in Boston and other American cities of that period. The undergrowth of amateur art associations and singing societies, the other, less successful ventures in institution building (like the Boston Opera), the serious stage, and, perhaps most important, the world of literature all deserve detailed treatment that they have not received here. *A fortiori*, the commercial cultural organizations that grew up every-where during this period – the fairs, the vaudeville and burlesque houses, eventually the movie houses – and the less formal settings where the folk cultures of Boston's immigrants and Yankees alike were expressed. In looking closely at two institutions in which high culture was differentiated and sealed from other genres, we must not forget that this occurred within a rich and changing cultural context. In this respect, Boston's theatres, caught as they were between culture and commerce, between the aspirations of middle-class reformers and the desires for entertainment of working people and the less progressive members of the middle class, may be a particularly rich field for study.

This treatment, as well, has only suggested the link between elite social structure and the development of high culture in Boston. A closer look at the multiple elite networks – those of kinship, commerce, clubs and stewardship – might enable us better to understand why some efforts succeeded while others failed, and better to fathom the intra-class division of labor between the cultural and hegemonic insti-tutions that Ronald Story (1981) has described.

The value of the explanation advanced herein may be tested in comparative work on other American cities of this period. Research on Chicago, with its newer, more commercial, less socially integrated, less cultured elite, shows similarities and differ-ences to the Boston case (see Horowitz, 1976; Zolberg, 1980; see also Couch, 1976,

on New York). I do not expect that the institutionalization of high culture took the same course in all American cities; only that the variations among them are comprehensible in terms of the categories and scheme of analysis laid out here.

Finally, it will be important to compare the American experience to that of the European countries, with their differing class structures and richer cultural histories. Certainly, culture in England was in flux in the nineteenth century, as Williams (1965), Thompson (1966) and Wolff (1982) have documented. In a fascinating essay, Gaye Tuchman (1982) has argued that, in the literary arena at least, the British sought consciously to define the high-art novelistic genre at about the same time that Perkins, Brimmer and Higginson were organizing their cultural ventures in New England. Sennett (1978: 205–208) notes the consolidation of concert and theatre manners throughout Europe in the second half of the nineteenth century. And William Weber (1976) has argued that Europe's nineteenth-century aristocracy embraced the rising bourgeoisie in a musical coalition with the symphony as its focus. Thus class and culture seem as closely associated in Europe as in America at this time, even if the particulars of that association differed.

As is usually the case, then, more research is needed. But, I believe, there are already some lessons that sociologists and historians with an interest in culture can draw from the story told here. The first is that we must stop viewing, once and for all, 'high culture' as a distinctive kind of cultural product, and recognize that high and popular culture are, at one level, historically evolved systems of classification whose strength, substance and significance vary constantly; and, at another, separate systems of production and distribution with systematically different consequences for the art that passes through them. The illusory search for genres that are somehow more 'high-cultural' than others renders the sociologist the victim of ideologies that he or she should be studying. Recognizing that ideas about high and popular culture are ideological classifications embodied in organizational forms that give them flesh permits us to study the causes of variation in the classifications themselves and, perhaps, to begin to understand taste, not simply as an aspect of demand, but as something which, over a longer term and less through conscious design, is as much a social production as is a work of art itself.

Notes

1 I draw here, and throughout, on Basil Bernstein's work on the classification and framing of educational knowledge (1975*b*).
2 Indeed, enthusiasm for reproductions extended to wood-engraving and photography, which Charles Eliot Norton felt could elevate popular taste to unprecedented heights (Vanderbilt, 1959: 145).
3 The Musical Association's programs were notable for their emphasis on symphonies and overtures. They were not, however, austere by the standards of later years. Eleven of 53 selections in their repertoire for the year 1881 were songs, for example 'Faithful Johnny'. By contrast, the Handel and Haydn Society emphasized serious vocal works, if occasionally straying with modern composers like Gounod. The Philharmonic Club, at least in the late 1870s, played exclusively instrumental selections, but many of these were on the light side. The Theodore Thomas concerts, which most observers credit with raising Boston's musical standards, were, in 1871, also instrumental; but Thomas leavened the overtures and concertos (there were few symphonies) with a generous selection of marches and waltzes. The critic William Apthorp, writing in *The Atlantic* in 1873, complained of Thomas that

'His chief object seems to be to present as many novelties as possible' (Mussulman, 1971: 88). Commercial programs, like those of the Redpath Boston Lyceum, were even more mixed. (From pamphlets and handbills in the Yale Music Library's Boston pamphlet collection.)

4 Boston's purely popular institutions at this time still included a smattering of fine-arts music in their own concert repertoires. For example, handbills for Keith and Batcheller's Museum on Washington Street advertise, in 1885, Grand Sacred Concerts, wherein Handel, Wagner and Strauss occasionally appeared amidst a profusion of light vocal numbers. Concert attenders could also take in such exhibits as the Wonder Hall, Punch (a baby bear), a Transparent Turk ('who can be seen through'), performing birds, a monkey that whistled, a talking skull, a 'congress of kittens', Mr. Ricketts ('the jolly fun maker') and 'a troupe of . . . bewitching Asiatics' that included Zola, 'undisputedly the handsomest lady in the world . . . exhibited every hour from 10AM to 10PM' (Yale Music Library Boston pamphlet collection).

5 A similar effort at purification was conducted by the leaders of the Handel and Haydn Society at this time. In 1888, President George Chickering called, in his annual report, for a 'purification of the chorus', a purge, for the first time, of members whose voices were not up to standard. The 'purification' occurred, although it left the Society badly divided. After several years of turmoil, harmony was restored by a new set of officers, who continued the weeding out of the chorus and vowed 'not at present [to] give any more works of new composers . . .' (Perkins and Dwight, 1883–93: 496 ff.; Johnson, 1965: 154–185).

6 Several tones were deployed in attempting to chasten early leavers. In January 1884, audience members who were 'obliged to leave' before the end were simply requested to 'please do so during the last intermission'. Nine months later, they were told that they 'will confer a favor by leaving the Hall' before the beginning of the next piece. In December, 1885 'Management' more pointedly requested 'that no one will disturb both audience and orchestra by leaving the hall during the performance of the . . . Music'. At times in the 1890s such notices were omitted, but backsliding must have occurred: In 1901–02, notes to Gericke's concerts 'urgently requested . . . patrons unable to remain until the close of the concert . . . to leave the hall during a pause in the program' (BSO Concert Notes, various numbers).

7 As one student of this period puts it, 'The majority of the growing middle class . . . constituted perhaps the most serious threat and the greatest challenge. Their motives seemed shallow and materialistic. They continually misappropriated the aims and methods of Culture . . .' (Mussulman, 1971: 29).

8 The other side of the apotheosis of art that occurred during this period, to which I have given little attention, was the devaluation of popular forms. Critic Philip Hale, in the BSO Concert Bulletin of 8 February 1908, wrote of popular songs of the previous century: 'The pleasure in looking over the songs of years ago is a melancholy one. . . . The sentimental ditties that once had the semblance of pathos now provoke sneers and laughter. The comic songs that formerly provoked laughter are now foolish and depressing.'

As late as 1915, President Courtenay Guild of the Handel and Haydn Society predicted that the vogue for popular music would eventually pass: 'Talking machines with the latest song hits are taken as a substitute for concerts, the mania for dancing and syncopated time has cultivated a taste for a sort of barbarous sequence of sounds more worthy of savages than of civilization. . . . It is hardly conceivable that the depraved musical taste can be more than an ephemeral lapse . . .' (Johnson, 1965: 197).

The leaders of the Handel and Haydn Society seemed particularly sensitive to the social implications of their choice of music. In the 1880s, Dwight decried 'the proverbial restlessness of our "modern Athenians", like their old Greek namesakes, always running after "new things". Moreover the very effort made to meet the cry for novelty perhaps only made the matter worse; for if Gounod's "Redemption" drew the largest audience, did it not in the same ratio shake the confidence of the more cultivated and exacting music-lovers in

the soundness of the old and honored institution?' (Perkins and Dwight, 1883–93: 450). A quarter of a century later, the Society's Secretary again noted the danger of impure music to the purity of the audience, since it attracted 'an audience far different in aspect and mood from that of the usual course of concerts...'. Having learned its lesson, 'The Society eschews ultra-modern choral music. It has little liking for contemporary pieces in any vein. It cultivates the ancient classics or oratorio and a few of the moderns, and with them its officers, conductor, chorus and audiences are content. When it forsakes [these works] it takes its chances with a public like no other concerts attract here' (Johnson, 1965: 189–190).

Bibliography

Bernstein, B. (1975*a*). Ritual in education, in *Class, Codes and Control*, vol. 3, London, Routledge and Kegan Paul.

Bernstein, B. (1975*b*). On the classification and framing of educational knowledge, in *Class, Codes and Control*, vol. 3, London, Routledge and Kegan Paul.

Boston Symphony Orchestra (1881–1915). Concert Notes and Programs, Boston, Boston Symphony Orchestra.

Brenneise, H. (n. d.) Art or entertainment? The development of the Metropolitan Opera, 1883–1900, MA thesis, Andrews University.

Carter, M. (1925). *Isabella Stewart Gardner and Fenway Court*, Boston, Houghton Mifflin.

Cooke, G. W. (1898). *John Sullivan Dwight: Brook-Farmer, Editor and Critic of Music*, Boston, Small, Maynard and Company.

Coser, L. A. (1974). *Greedy Institutions: Patterns of Undivided Commitment*, New York, Free Press.

Couch, S. R. (1976). Class, politics, and symphony orchestras, *Society*, vol. 14. no. 1.

DiMaggio, P. (1982). Cultural entrepreneurship in nineteenth-century Boston: the creation of an organizational base for high culture in America, *Media, Culture and Society*, vol. 4, no. 1.

DiMaggio, P. and Useem, M. (1977). Social class and arts consumption: Origins and consequences of class differences in exposure to the arts in America, *Theory and Society*, vol. 5, no. 2.

Douglas, M. (1966). *Purity and Danger: An Analysis of Pollution and Taboo*, London, Routledge and Kegan Paul.

Green, M. (1966). *The Problem of Boston*, New York, W. W. Norton.

Harris, N. (1962). The Gilded Age revisited: Boston and the museum movement, *American Quarterly*, vol. 14, Winter.

Horowitz, H. L. (1976). *Culture and the City: Cultural Philanthropy in Chicago from the 1880s to 1917*, Lexington, University Press of Kentucky.

Howe, M. A. D. (1914). *The Boston Symphony Orchestra: An Historical Sketch*, Boston, Houghton Mifflin.

Johnson, H. E. (1950). *Symphony Hall, Boston*, Boston, Little Brown.

Johnson, H. E. (1965). *Hallelujah, Amen! The Story of the Handel and Haydn Society of Boston*, Boston, Bruce Humphries.

McCusker, H. (1937). *Fifty Years of Music in Boston*, Boston Public Library.

Mueller, J. H. (1951). *The American Symphony Orchestra: A Social History of Musical Taste*, Bloomington, Indiana University Press.

Musical Record (1881–83). Various issues Boston, Oliver Ditson.

Mussulman, J. A. (1971). *Music in the Cultured Generation: A Social History of Music in America, 1870–1900*, Evanston, Illinois, Northwestern University Press.

Perkins, C. C. and Dwight, J. S. (1883–93). *History of the Handel and Haydn Society of Boston, Massachusetts*, Vol. 1, Boston, Alfred Mudge & Son, Printers.

Perry, B. (1921). *Life and Letters of Henry Lee Higginson*, Boston, Atlantic Monthly Press.

Sennett, R. (1978). *The Fall of Public Man*, New York, Vintage.

Story, R. (1981). *The Forging of an Aristocracy: Harvard and the Boston Upper Class, 1800–1870*, Middletown, Connecticut, Wesleyan University Press.

Thompson, E. P. (1966). *The Making of the English Working Class*, New York, Random House.

Tuchman, G. (1982). Culture as material resource, *Media, Culture and Society*, vol. 4, no. 1.

Twentieth Century Club (1910). *The Amusement Situation in Boston*, Boston.

Vanderbilt, K. (1959). *Charles Eliot Norton: Apostle of Culture in a Democracy*, Cambridge, Mass., Harvard University Press.

Weber, W. M. (1976). *Music and the Middle Class in Nineteenth-Century Europe*, New York, Holmes and Meier.

Whitehill, W. M. (1970). *Museum of Fine Arts, Boston: A Centennial History*, Cambridge, Mass., Harvard University Press.

Williams, R. (1965). *The Long Revolution*, Harmondsworth, Pelican.

Wolff, J. (1982). The problem of ideology in the sociology of art: A case study of Manchester in the nineteenth century, *Media, Culture and Society*, vol. 4, no. 1.

Zolberg, V. L. (1974). The Art Institute of Chicago: the sociology of a cultural institution, Ph.D. Dissertation, Department of Sociology, University of Chicago.

Zolberg, V. L. (1980). Conflicting visions in American art museums, *Theory and Society*, vol. 10, January.

Chapter 47 | Janet Wolff

Women at the Whitney, 1910–30 |
Feminism/Sociology/Aesthetics

In October 1994, I was invited by the Whitney Museum of American Art to develop a proposal for an exhibition in the Museum's series "Collection in Context."[1] The series, which began in June, 1993, with an exhibition on *Edward Hopper in Paris*, has consisted of shows "featuring key works in the Whitney Museum's Permanent Collection," with the intention "not to isolate the works exhibited, but rather to set them in two different but related contexts: first, as products of their original time and place; second, in terms of their relevance to contemporary critics and today's audiences."[2] The exhibitions have been conceived and organized by outside curators, scholars, and artists; they are displayed in a single room (about 40 feet by 23 feet in size) on the first floor of the Museum, typically running for about three months each. Other themes of exhibitions in the series include *Gorky's Betrothals, A Year from the Collection, circa 1952, Joseph Cornell: Cosmic Travels,* and *Breuer's Whitney – Anniversary Exhibition*.

My invitation encouraged me to develop a proposal that would bring feminist scholarship to the project. Since my own interests are primarily in art of the early twentieth century, I decided to focus on women artists from that period whose work was prominent in the collection when the Museum opened in November, 1931. It became clear that this would involve looking at social networks and art circles connected with Gertrude Vanderbilt Whitney and her assistant (and later the first Director of the Museum), Juliana Force, and particularly the Whitney Studio Club, which operated from 1918 to 1928. Eventually – this was rather an extended process, depending on visits to New York and finding time between other commitments – I submitted a proposal in January, 1996, suggesting an exhibition of the work of some of these women artists – sixteen works, by fourteen artists. After another delay (and a change of curator at the Whitney), I arranged to go to New York and look at the works themselves. (So far, I had only been able to look at reproductions at the Museum. All the work I was interested in – and this itself is part of the story – had long been in storage in the Whitney's warehouse in downtown Manhattan.) This visit to look at the paintings, which I did in the company of the Curator of the Permanent Collection,

Janet Wolff, "Women at the Whitney, 1910–30: Feminism/Sociology/Aesthetics" from *Modernism/Modernity* 6:3 (September 1999), pp. 117–38. © 1999 by The Johns Hopkins University Press. Reprinted by permission of The Johns Hopkins University Press. (Reprinted without illustrations.)

proved to be more or less decisive. In short, our joint assessment seemed to be that the work simply did not merit exhibition. I postponed the decision for a few months, but more or less abandoned any idea of doing this show – at least at the Whitney Museum – by early 1997.

The story of the non-materialization of the exhibition is, I think, an interesting one, and one that raises many questions. The point is that in retrospect (and actually very soon after these events) I began to question this ostensibly "aesthetic" judgement. On a couple of occasions I showed slides of the work in the context of talks I gave on the subject, and each time at least some of those present expressed real interest in the images and encouraged me to pursue the idea of an exhibition. I started to ask myself what was involved in the assessment of these paintings as uninteresting or second-rate. It occurred to me, too, that the conditions under which we had viewed the works were far from ideal – having them taken from storage and propped on the floor by a couple of the warehouse employees, all the time aware that each request meant more work for them (though they were certainly willing and helpful, and I'm sure this was a normal part of their everyday job). As a novice curator (I had only organized one other exhibition), I was also aware that I was deferring to some extent to the judgment of the Whitney curator who was with me.[3] Looking back on it, I realized that my disappointment in the work was – at least amongst other things – very much a product of my own aesthetic (modernist) prejudices, which coincided with, and were strongly reinforced by, those of the Whitney (here, in the person of the curator). Not long after my visit to New York to view the work, the art critic of the *New York Times* wrote a scathing and sarcastic review of the current exhibition in the "Collection in Context series," which showed the work of Raphael Montañez Ortiz, in which he dismissed the academic pretensions of its curator and responded to his description of the artist, in the accompanying brochure, as "one of the central figures in a now-forgotten international movement" with the comment "It certainly is."[4] The last thing I wanted, of course, was a review of an exhibition of the "Whitney women" which both denigrated the work and at the same time implied that the display of such second-rate work was the consequence of misguided feminist revisionism. But the fact that I was already predicting such a review was, I now think, a measure not so much of my uncertainty in the face of art-world experts, but of my collusion in what has been, for the past half-century, the aesthetic orthodoxy in the history of art – namely, the elevation of modernist and abstract art over realism.[5] The work that I was interested in, and which I proposed including in the small exhibition, was realist painting, in the relatively progressive style of the Ashcan School but not at all influenced by the more avant-garde developments (cubism, fauvism, Futurism) already well established in Europe and visible in the work of other New York artists as early as 1910.[6] It became clear that my project, which started out as the rather unexciting one of feminist retrieval (reclaiming women artists "hidden from history"), might not be about gender at all, since the post-war modernist orthodoxy marginalized realist work by men in just the same way.[7] In this essay, I relate the progress of my research and thought as it developed, and in particular the ways in which the question of gender was superseded first by sociological questions of patronage, networks, and social influence, and then by the broader issue of the historical development of key institutions and their aesthetic ideologies. Finally, inspired by the recent work of feminist scholars of modernism and modernity, I came to see that this was, after all, very much a feminist project, though not in the way I had at first envisaged. If we can characterize feminist revisionism (rediscovering women artists and incorporating them into the

canon) as 1970s feminism, then I would say (at the risk of equally broad generalization) that the Whitney project became one of 1990s feminism – the analysis of gender construction as it operates in the field of modern art and its institutions.[8]

The Whitney Museum of American Art opened in November 1931. Its founding collection consisted of nearly 700 works of art, about 200 of them acquired since January 1930 when plans for the Museum were officially announced.[9] All of these works had been in the collections of Gertrude Vanderbilt Whitney, the Museum's founder, and Juliana Force, her assistant since 1907 and the Museum's first Director (1931–1948), and most had been acquired in the context of the three institutions which had preceded and resulted in the opening of the Museum in 1931 – the Whitney Studio (1914–1918), the Whitney Studio Club (1918–1928), and the Whitney Studio Galleries (1928–1930). The first of these, the Whitney Studio, was founded by Gertrude Vanderbilt Whitney (who had herself been working as a sculptor in a studio in Greenwich Village since 1907), initially as a place to organize an art exhibition for the benefit of war relief (ROES, 111). For the next four years, Whitney and Force organized exhibitions at the Whitney Studio, wide-ranging in their scope, but emphasizing the work of young American artists. In 1918, they found new premises (a brownstone on West Fourth Street), which they opened as the Whitney Studio Club, with Juliana Force as its director. The new Club combined exhibition space with recreational rooms and a library, and it continued an active exhibition program for the next ten years. It was disbanded in 1928, having grown too large, and was replaced by the Whitney Studio Galleries, with the narrower aim of exhibiting and selling work.[10] This in turn was closed in 1930, once the decision was made to found a permanent Museum.

The catalogue of the collection, published at the Museum's opening in 1931, includes about 500 paintings (oil and watercolor), 115 pieces of sculpture, and "drawings, etchings, lithographs and works in other mediums, to the number of seven hundred," all, of course, the work of American artists.[11] Some of the names listed are familiar today, including some "Ashcan" painters and other realists associated with the Art Students' League (George Bellows, William Glackens, Robert Henri, Ernest Lawson, George Luks, Reginald Marsh, Kenneth Hayes Miller, John Sloan, Arthur Davies and Maurice Prendergast) and one or two American modernists (Stuart Davis, and one work each by Marsden Hartley and Georgia O'Keeffe). There is one Edward Hopper, and a few works by Precisionist artists Charles Sheeler, Elsie Driggs, and Charles Demuth. Most striking is the fact that many of the most prominent names in the catalogue (that is, the artists with several works in the collection) are not well known – Arnold Blanch, Lucile Blanch, Ernest Fiene, Emil Ganso, Anne Goldthwaite, Leon Hartl, Joseph Pollet, Paul Rohland, Katherine Schmidt, Niles Spencer, and a few others. These are the names, though, that appear with great frequency in the records of exhibitions held at the Whitney Studio, the Whitney Studio Club and the Whitney Studio Galleries in the sixteen years leading up to the founding of the Museum.[12] In other words, they are the names of the artists supported by Whitney and Force during that period, whose work was often bought at their Whitney exhibitions, and who were, for the most part, active participants in the Club and regular members of the social networks in which Juliana Force in particular operated. They were connected with one another through their artistic training (in many cases, at the Art Students' League) and through social contact and, in some cases, marriage. (The artists Peggy Bacon and Alexander Brook were married to each other, as were Katherine Schmidt and Yasuo Kuniyoshi, all of them central players in

the Whitney enterprise.) Many of them had summer homes in the art colony in Woodstock, in up-state New York, particularly in the period beginning in the early 1920s; Juliana Force herself was a frequent visitor there (*ROES*, 230).[13] What they also had in common was a commitment to a contemporary realist aesthetic, learned in many cases from their teachers at the Art Students' League (Henri, Sloan, and Miller).[14]

I had begun research for this project by identifying the women artists in the Museum's collection who were active in the years leading up to the founding of the Museum in 1931. Since I was using the Museum's card index, which only includes works currently owned by the Museum, this did not give me access to those few women artists whose work has since been de-accessioned – these I discovered later, in looking at the 1931 catalogue and at other records.[15] I also decided to limit my focus to works made in the period, but also *acquired* then (that is, in 1931 or soon after), since my interest was in the events and practices of the Whitney institutions at the time.[16] So, for example, a work by the artist Florine Stettheimer, though painted in 1931, was not included because it was not acquired by the Museum until 1973.[17] I was also well aware that Juliana Force engaged in a program of rather energetic "corrective buying" immediately before the opening of the Museum. The inclusion of one work by Georgia O'Keeffe (*Skunk Cabbage*, 1922), bought by Force in 1931 and followed by the purchase of two more O'Keeffes the next year and a fourth in 1933, has to be seen in a context in which the prospect of a permanent museum of American art, something very different from a private collection or a studio club, forced the recognition of important gaps in the collection and of the necessity to do something about this (*ROES*, 303–4).[18] Avis Berman, a historian of the Whitney Museum and of Juliana Force's role in its development, records the results of Force's hectic "shopping trips" over a period of a couple of years, and of her acquisitions. Particularly interesting was the accommodation reached with Alfred Stieglitz and the American modernist artists associated with his gallery – O'Keeffe, Marin, Hartley, Dove. The absence of friendly relations between Whitney and Stieglitz over the years had long been clear (Stieglitz had opened his first gallery for modern American art, The Photo-Secessionist Gallery, or 291, in 1905), as had the radically different aesthetic commitments of the two institutions and their associated artists. But in 1931 Juliana Force was making a serious attempt to rectify imbalances in the Whitney's collection, which meant the purchase of more avant-garde, European-influenced work. Nevertheless, this last-minute corrective buying, though obviously important in the formation of the Museum, should not obscure either the dominant tendency in the Whitney circle or the particular sociology of artistic production in the pre-1931 period; nor, in the end, did it make a great deal of difference to the continuing practices of the Museum, once founded.

I compiled a list of twenty-four women artists, active in the Whitney circle in the period before the opening of the Museum. Seventeen of these women had work included in the catalogue at the opening of the Museum in 1931. Interestingly, too, eleven of the twenty-four were also included in the 1949 Whitney exhibition which served as a memorial to Juliana Force (who had died the previous year) and which still manifested a predominantly realist aesthetic.[19] (See Appendix.) Most of these artists had an active exhibition record with the various incarnations of the Whitney Studio. They were represented regularly in group shows, and several of them had one-person shows – in some cases, more than once. Molly Luce, Dorothea Schwarcz, Rosella Hartman, and Georgina Klitgaard each had exhibitions of their work.

Katherine Schmidt, Lucile Blanch, Caroline Rohland, and Dorothy Varian had two one-person shows; and Nan Watson had four one-person shows. Peggy Bacon, who exhibited her prints and drawings regularly at other New York galleries in the 1920s and 1930s, was included frequently in the Whitney Studio Club exhibitions.[20] It is clear that women artists were able to thrive in the context of the Whitney Studio Club. According to Berman, women accounted for between 30 and 35 percent of works exhibited in the Whitney exhibitions and the Whitney and Force collections. She quotes Juliana Force's nephew, who stresses his aunt's firm belief in the equality of women: "She believed in applying the same standards to men and women alike. She would never use the once-familiar 'aviatrix' any more than she would say 'painter-ess.' Years later, as a museum director, she refused to hold special exhibits for women artists on the grounds that this was condescending to women" (*ROES*, 134). (This is not to say, however, that the usual processes of gender selectivity were not in play at the time, including in the critical response to the Whitney's activities. The art critic, Henry McBride, reviewing the opening exhibition of the Whitney Museum of American Art in 1931, does not mention a single woman artist by name, but makes a point of listing twelve male artists who are, for him, the stars of the show.)[21]

If the relative success of women artists in the Whitney circle is apparent, then so is the (relatively) gender-neutral decline of their reputations in later years. Soon after the 1949 Memorial Exhibition at the Whitney, in which several of them were still exhibiting work, the museum became far more receptive to European-influenced modern art, including abstraction. The international success of Abstract Expressionism in the 1950s rendered it imperative that *the* Museum of American Art play an active part in exhibiting and acquiring the work. Under the next two Directors after Force's death in 1948 – Herman More (1948–1958) and Lloyd Goodrich (1958–1968) – the Whitney Museum's aesthetic was radically transformed. More wrote, in the foreword of the 1950 Annual Exhibition catalogue: "If modern art in its many forms, such as expressionism, abstraction, and surrealism, predominates in the show, it is because it is the leading movement in art today, and has influenced the greatest number of younger artists."[22] In 1954, the Museum moved from its original location in adjacent town-houses in Greenwich Village to a building on West 54th Street, near the Museum of Modern Art (and in fact owned by the Museum of Modern Art).[23] The display of works in the context of a more "modern" building coincided with the move towards a conception of "modern art" which was defined by the Museum of Modern Art (and originally by its first Director, Alfred Barr) and already more or less established as the art-historical orthodoxy in America and Western Europe. The narrative of this story, elaborated in Barr's famous diagram in the 1936 Museum of Modern Art Catalogue, *Cubism and Abstract Art*, and developed by his successors (critics and curators in New York), traces a line of development from Impressionism and Post-Impressionism, to Cubism, Surrealism and, eventually, Abstract Expressionism (and, thus, from Paris to New York).[24] Among the obvious consequences of the acceptance of this narrative is the marginalization of realism in the twentieth century. After the second World War, the Museum of Modern Art story was not only the dominant one; it was, at least in educated circles in the art world, the only story. The Whitney's belated subscription to this version of the canon, and to the aesthetic which upheld it, had the practical corollary of consigning a good deal of the work of the Whitney Studio Club members to storage. This reassessment affected the work of men as well as women artists. Paintings by Whitney Studio Club artists Alexander Brook, Yasuo Kuniyoshi, and

Guy Pène du Bois suffered the same fate, with the ascendancy of modernism over realism in the post-war Whitney Museum.[25]

During the two decades before the founding of the Whitney Museum, it was still possible to pursue and promote an aesthetic other than the Euro-modernist version. Certainly modernism was already much in evidence in New York during the years of the Whitney Studio and the Whitney Studio Club. Stieglitz's gallery, after all had been founded in 1905, and remained an important exhibition space for modernist painting and photography. The 1913 Armory Show had introduced European avant-garde movements – notably cubism and fauvism – to American audiences, and had also included work by American modernists (Marin, Hartley, Morgan Russell, Davis, and others). In 1920, Katharine Dreier and Marcel Duchamp had founded the Société Anonyme, "America's first museum of modern art," which showed European and American modernist art.[26] In 1927, A. E. Gallatin's Gallery of Living Art opened at New York University, showing Gallatin's own collection of modern art.[27] And the Museum of Modern Art was itself founded in 1929, based on the private collections of European modern art of Lillie Bliss and Mary Sullivan, and Abby Aldrich Rockefeller's collection of American folk and modern art.[28] Several galleries and dealers in New York exhibited modernist art (the Daniel Gallery, the Montross Gallery, the Modern Gallery, Kraushaar's and Wildenstein's among others).[29] Collectors like John Quinn and Duncan Phillips were buying European and American modernist works in the first decades of the century. At the same time, it was entirely possible in this period for a non-modernist aesthetic to flourish alongside these developments. Gertrude Vanderbilt Whitney's taste was for early twentieth-century American realism, of a type that was in fact considered progressive in its time. She bought four of the seven paintings sold at the ground-breaking 1908 Macbeth Gallery exhibition of The Eight – the so-called "Ashcan" painters of realist urban scenes (Henri, Luks, Sloan and others) who were showing work very different from, and opposed to, the prevailing academic traditions. At the Whitney Studio and the Studio Club, she and Juliana Force continued to exhibit the work of such artists, as well as the younger artists who had studied with them. Their taste, then, though not avant-garde, was forward-looking in terms of then current established aesthetic conventions. Their hostility to modernism, too, should not be exaggerated. (Berman suggests that the Whitney Studio Club is better seen as anti-Stieglitz, rather than anti-modern, *ROES*, 223). Whitney herself was involved in planning for the radical 1913 Armory Show. She supported the photographer Edward Steichen in the rather peculiar court case in 1926–27, in which he attempted to convince the U.S. Customs that Brancusi's ultra-modernist sculpture, *Bird in Space*, was in fact art, and therefore exempt from import duty; Whitney took over the appeal and met all Steichen's costs.[30] The Whitney Studio Club also exhibited and supported some modernist artists, including Stuart Davis and Oscar Bluemner, and sponsored individual modernist shows (for example, Mario de Zayas's important Picasso exhibition at the Whitney Studio Club in 1923). But the overall tendency is clear, and all the more so in the light of those concurrent developments in the New York art world. As Adam Weinberg says, "In a cursory examination of the Whitney's exhibition program, publications, and acquisitions from the founding of the Whitney Studio Club in 1918 until Juliana Force's death in 1948, the record does substantiate an overwhelming emphasis on realist artists."[31]

At the Whitney Studio Club, the high visibility of women artists, and their success in terms of exhibition and sales, has to be seen as the product of a complex social network of friendships, patronage, and personal relationships.[32] Both the access to Force and

Whitney (and thus to exhibition and sales) and the shared aesthetic were related aspects of these close interactions. Several of the artists were founder members of the Whitney Studio Club (Schmidt, Varian, Watson, Bacon, Dwight; Isabel Bishop joined in 1920). The Woodstock connection, already referred to, was an important structural feature in the interplay of social and professional relations, as was the shared history of training at the Art Students' League (where Schmidt, Bacon, Varian, Luce and Bishop had studied, as well as Yasuo Kuniyoshi and Alexander Brook).[33] Mabel Dwight worked as secretary-receptionist for Force at the Whitney Studio Club in its early days; Katherine Schmidt ran the Club's evening sketch class for two years; and Alexander Brook (the husband of Peggy Bacon) acted as Force's assistant from 1923 until 1927 (*ROES*, 157, 195–96, 239). The artist Nan Watson (who had four one-person shows, and who had the fourth largest number of works in the collection when the Museum opened in 1931 – a total of eight) was the wife of the critic, Forbes Watson, who not only maintained close connections with the Whitney circle but was also Juliana Force's lover for twelve years, from 1919.[34] A sociology of cultural production and reception in the Whitney circle would certainly focus on the patterns of influence and decision which emerged from these and other connections, as well as on the particular relations between the Whitney artists and the many other New York art institutions (galleries, critics, schools) against which they were defined. It is likely, though, that what now seems the rather unprofessional (though perhaps not so unusual) set of art-world relations in which the Whitney artists operated provided the very conditions in which women could succeed on the same terms as men.

The ascendancy and post-war consolidation of the "Museum of Modern Art narrative" had the effect of producing an impressive collective amnesia in American visual culture. The history of early American art has been, for the past fifty years, the story of the emergence and eventual success of the American avant-garde. The more comprehensive surveys of American art do include discussion of American Impressionism and the "Ashcan" painters, though artists in the Whitney circle are rarely considered.[35] Even in these accounts, though, the realist painters of the "Ashcan" group are often treated as a necessary, but quickly surpassed, stage on the way to modernism. This statement, from a catalogue introduction to a 1997 exhibition of the work of The Eight (the exhibitors in the 1908 exhibition) is a typical account of this relationship:

> By breaking away from and rebelling against the narrow confines of traditional art typically displayed at the National Academy of Design, Henri and his seven colleagues effectively opened the door for more innovation in painting in the United States. By exhibiting more experimental, progressive work to a wide public audience, The Eight helped create an environment more willing and able to accept the shocking trends which would affront the American art community at the Armory Show in 1913. The Eight's exhibition helped build an effective bridge between the art of the nineteenth century and the Modernism of the twentieth.[36]

With the exception of general survey books on American art, until recently most publications dealing with the early twentieth century have focused on American modernism – the Armory Show and its consequences, the Stieglitz artists, and the varieties of American modernism in the 1910s and 1920s.[37] (The 1930s return to realism, for example in work associated with the Works Projects Administration – an agency of the U. S. government created in 1935 to provide jobs, especially in public

works – and with regionalism, is another matter. But even this work, impossible to ignore or write out of American art history, is invariably treated as a sub plot – perhaps even an embarrassing one – to the main story).[38] Internationally, non-modernist American art barely registers in the art-historical community (with one or two exceptions, like Edward Hopper), and the same is true within the US among those whose areas of interest are not specifically the history of American art.[39]

The Whitney Museum itself was so radically transformed in the years after Juliana Force's death that in 1960 a group of realist artists wrote to the Director (then Lloyd Goodrich) about the lack of representational art in the Museum's recent annual exhibition, pointing out that of the 145 paintings included "102 were non-objective, 17 abstract and 17 semi-abstract, leaving only 9 paintings in which the image had not receded or disappeared, whereas in former exhibitions the Whitney Museum showed a much larger cross section of style and method in work in progress."[40] As Adam Weinberg reports, Goodrich's reply admitted that "the abstract trend is dominant, particularly among the younger generation."[41] Although Weinberg is concerned to stress the Whitney's long-standing openness to both realist and modernist (including abstract) art, the context of his essay is evidence of the Museum's postwar collusion in the privileging of modernism. It appears in a catalogue for a 1997 exhibition at the Whitney, the third in a series called *Views from Abroad*, in which museum directors from other countries have been invited to curate work from the Whitney's Permanent Collection. This particular show was organized by Nicholas Serota and Sandy Nairne of the Tate Gallery in London and, as the *New Yorker* put it at the time, "This is American art viewed through eyes used to looking at Francis Bacon and Lucien Freud."[42] The curators entitled the exhibition "American Realities," and a major part of its project was to restore the figurative tradition to visibility. Reflecting on the fact that the Tate had earlier displayed an exhibition of the work of American artists which had been organized by the Museum of Modern Art, Serota explains his interest in its omissions:

> The exhibition played a small but influential part in transforming the European assessment of American art from provincial and peripheral to revolutionary, highly influential, and central to developments worldwide. But this perception clearly obscured the existence of an earlier, prewar cosmopolitanism, which manifested different forms of radical modern figuration . . . This led us on a track of the "real" for "Views from Abroad." Admittedly using the term in an elastic way, we have explored the idea of bringing particular, sometimes neglected, works to critical attention and reviving a broader view of modernism which does not regard an interest in the figure as being, by definition, anti-modern.[43]

Included in the exhibition, therefore, was work by du Bois, Sloan, Soyer, Bishop, Luks, Marsh, and Driggs, alongside the more usual selection of works by early modernists Dove, Hartley, O'Keeffe, and Avery, and postwar modernists Pollock, Rothko, Kline, and Diebenkorn.[44] The exhibition was itself, I believe, an indication of an interesting development in museum practice and associated art-critical discourses (and, not incidentally, art market sales) in the past couple of years, namely the beginning of a reevaluation of the realist and figurative tradition.[45] Despite the signs of this very recent intervention, however, the dominant aesthetic, at the Whitney as elsewhere in the art world, has remained one founded in the story of modernism and its postwar successors. There is some evidence of a certain nervousness about

the revival of the realist tradition, as two minor anecdotes about my own Whitney proposal demonstrate. The first was the suggestion made to me by the Whitney's curator that, although an exhibition of the work of these women artists might not work for the museum, I might propose it to the curator of a museum outside Manhattan.[46] And the second was the rather surprising discovery that a year after my fateful (fatal) visit to New York to view the paintings, the Whitney did in fact mount a version of the show I was proposing, with the two differences that this was an exhibition only of works on paper by those women artists, and that it took place at the Whitney's branch in Champion, Connecticut.[47] It seemed that the work was good enough for the provinces, but it could not (yet) be risked in New York City.

My inquiries into the invisibility of the "Whitney women" had quickly made clear to me that this was not, after all, the feminist project of rediscovering women artists who had been marginalized either in relation to the conditions of cultural production or by the normal practices of art-historical discourse – the project of the recovery of a "hidden heritage."[48] These artists worked on equal terms with men, and apparently with more or less equivalent success and visibility at the time. Their disappearance, both from the Whitney's own display and from official histories of American art in general, was not a matter of gender prejudice either, but rather a consequence of the resolution of competing aesthetic narratives, a resolution which sidelined the work of male realist artists in (almost) the same measure as that of women. In the end, the exhibition I proposed to the Whitney was not a specifically feminist project, but one whose conceptual underpinning had much more to do with foregrounding a sociology of cultural production – the relevance and centrality of social relations and networks in the production and reception of art. As I have said, the decision not to take this further was an aesthetic one, based on an assessment of whether the paintings were worth exhibiting. At the time, I tried to think about this assessment in the light of what we have learned from feminist criticism over the past couple of decades, in an attempt to identify any deeper prejudices which might be gender-related. Feminist art historians have demonstrated the ways in which aesthetic hierarchies are clearly gender-based, with work associated with women (still life and flower painting, for example) invariably being considered "decorative" or "lesser arts."[49] Critical work in feminist aesthetics has alerted us to certain androcentric tendencies in Western philosophy of art (for example, the gendering of the opposition of the beautiful and the sublime, and the inseparability of the practical and the personal – including gender identity – from the aesthetic for the spectator of a work of art).[50] But there was no obvious difference in content or style between the work of the Whitney women and the paintings of Alexander Brook and Yasuo Kuniyoshi, nor did there seem to be any reason to suppose that questions of gender came into the appreciation or judgement of the works. The belated recognition that this was, after all, a feminist project followed instead from my subsequent doubts (and self-doubt) about the privileging of modernism over realism. The point is that the discourse of modernism *is itself a masculinist discourse*. This means that the marginalization of realism, though ostensibly an aesthetic move, is at the same time fundamentally gendered. In this perspective, it does not matter that some of the work thus denigrated happened to be made by men; it is still gendered "feminine" by a discourse which produces modernism as masculine. In the rest of this essay, I shall consider this question of "the gender of modernism" as a way of returning to the Whitney women and the problem of assessing their work.

The recognition that modernism in the visual arts has always had strong masculinist (and often misogynistic) tendencies is by now well established. In an article first published in 1973, Carol Duncan identified a preoccupation with virility in avant-garde painting in the early twentieth century, an obsession which she relates to the contemporary anxieties about the emancipation of women and their increased participation in the public world of work and politics.[51] And much of Griselda Pollock's work has been concerned with addressing the question of "why the territory of modernism so often is a way of dealing with masculine sexuality and its sign, the bodies of women – why the nude, the brother, the bar?"[52] In another context, Andreas Huyssen has explored the nineteenth-century discourses which produced modernism as male, in this case in opposition to a mass culture which was gendered female.[53] These gendered discourses of early modernism were then definitively re-inforced by the post-war narrative of twentieth-century art history, seen from the vantage-point of the international success and prominence of the New York School. As Ann Gibson has recently shown, the invisibility of women and minority artists among the Abstract Expressionists (and there were plenty of these who were active in the late 1940s and early 1950s) is the necessary by-product of the universalizing ideology of this movement and its associated critics.

> This universalism was delivered by men who aspired to be artistic heroes. This claim, to which sympathetic contemporary viewers readily responded and which subsequent historians have made specific, was not seen as the movement's implicit story about itself, that is, as literary, but simply as wondrous fact.... This notion established grounds for the distinction that, in segregated America, only white heterosexual males could attain: generating a universal product that could speak for everyone. Women, African Americans, and avowed homosexuals could not do that because their audiences would not accept their work as universal.[54]

Michael Leja explains the androcentric nature of Abstract Expressionism in terms of the type of subjectivity produced by its discourses, one founded on a new image of "self" (the Modern Man subject, as he calls it) which deployed notions of the "primitive" and the unconscious and which was "profoundly gendered."[55] The point then, as he explains, is

> not to document the exclusion of women from Abstract Expressionism, but rather to examine the processes and mechanisms by which that exclusion was effected then and now. What made Abstract Expressionism so inhospitable to artists who were women...? The answer centers, I believe, on the subjectivity inscribed in Abstract Expressionist art.[56]

The exclusion of women, then is a structural and discursive operation, integral to the production and maintenance of a particular conception of subject and artist.

The re-writing of early twentieth-century American art from the point of view of the 1950s – the project that I have suggested was involved in the transformation of the Whitney's history – can now be seen as more than a matter of aesthetic revision. The privileging of modernism in the earlier period, in the production of a specific lineage for the New York School, was also an exercise in engendering visual culture. In other words, the marginalization of certain kinds of realist and figurative painting is the marginalization of the "feminine," a process which does not necessarily have much to do with the question of whether the work involved is by women or by men. This retroactive strategy has been able to take up and restate those gender discourses

around early modernism, with their own tendency to equate the modern with the masculine. Although, as Rita Felski has argued, the gender of modernity and of modernism was relatively open-ended in the early twentieth century, so that the androcentric discourses could still be contested and countered, and a feminine/feminist "modernism" proposed, there is plenty of evidence of what was to become the dominant narrative, in which the realist/feminine was denigrated in relation to the modernist/masculine. This is clear in the case of the contemporaneous establishment of the Whitney Museum and the Museum of Modern Art. In an important and highly original study of the contrasting display strategies of the two museums and their precursors in the period 1913 to 1939, Evelyn Hankins has demonstrated the ascendancy of the "modern" approach (the museum as white cube) in relation to the "decorative" (moderne), the latter, characteristic of the Whitney's displays, associated in contemporary criticism and discourse with the feminine. In particular, the exhibition of works in the "domestic" setting of the brownstones of the Whitney Studio Club and the Museum itself in its early years, and the employment of Beaux-Arts architects and designers to renovate the buildings, was in stark contrast to the Museum of Modern Art, and it enabled a reading of the Whitney as a feminine space.[57]

The invisibility of the Whitney artists in most histories of twentieth-century American art is after all a feminist issue, inasmuch as the denigration of realism has depended on a fundamentally gendered discursive strategy. I want to conclude by considering the implications of this for the current revival of interest in realist art, which I referred to earlier. The critical challenge to "the Museum of Modern Art story," for example in the 1997 "American Realities" exhibition at the Whitney which reintegrated figurative art into the history of American art, is necessarily also a process of deconstructing the dominant gender hierarchies of modernism and realism. And yet it is striking that there were no women artists from the Whitney Studio Club included among the realists in that show, with the exception of Isabel Bishop and Elsie Driggs, neither of whom was quite typical of the Whitney artists and their work.[58] (The same is true of the blockbuster Whitney exhibition, The American Century, which opened as I was completing work on this essay).[59] It could be that this brings us back to the vexed question of "quality" (and hence full circle to my dilemma when confronted with the paintings).[60] But at the very least it suggests that we look carefully at both the aesthetic and the gender implications of the revival of realism in the late twentieth century, a revival which may, after all, still turn out to be on modernism's terms.

Appendix

Women artists active in the Whitney Studio Club and/or exhibiting regularly at the Whitney Studio, Whitney Studio Club and Whitney Studio Gallery

*Included in the collection, 1931
+ Included in the exhibition, 1949

Peggy Bacon *+	Mabel Dwight*	Jane Peterson
Virginia Beresford	Anne Goldthwaite*	Caroline S. Rohland*+
Pamela Bianco*	Rosella Hartman*+	Katherine Schmidt*+
Isabel Bishop+	Isabella Howland*	Dorothea Schwarcz*
Lucile Blanch*+	Georgina Klitgaard*+	Madeline Shiff

Rose Clark[*] Molly Luce[*]+ Dorothy Varian[*]+
Lucille Corcos Harriette G. Miller Nan Watson[*]+
Elsie Driggs[*] Maud Morgan Marguerite Zorach[*]+

Notes

1 John G. Hanhardt (Curator of Film and Video, Whitney Museum of American Art), Letter to author, 7 October 1994. The Whitney Museum of American Art is hereafter abbreviated as WMAA.
2 Adam D. Weinberg (Curator, Permanent Collection, WMAA), *Hopper in Paris*. Exhibition brochure (New York: WMAA, 1993).
3 *Pictured Women*, Memorial Art Gallery, Rochester, 1995.
4 Michael Kimmelman, "The Return of the Well-trampled Clavier," *New York Times*, 3 January, 1997, A 22.
5 Andrew Hemingway has recently demonstrated how this ideology has rendered all but invisible most American art before 1945 in: "How the Tale of Taste Wags the Dog of History: American Art Pre-1945 and the Problem of Art History's Object" (paper presented at College Art Association meetings, Los Angeles, February 1999).
6 Susan Noyes Platt describes the Ashcan work as "mildly modern" in *Modernism in the 1920s: Interpretations of Modern Art in New York from Expressionism to Constructivism* (Ann Arbor, MI: UMI Research Press, 1985, 1981), 17.
7 Sheila Rowbotham's phrase in *Hidden from History: 300 Years of Women's Oppression and the Fight Against It* (London: Pluto Press, 1973).
8 As Jackie Stacey has insisted, however, such periodization is often quite unfair to early feminist theory, as well as blind to the important continuities in feminist work over the past twenty-five years. See "Feminist Theory: Capital F, Capital T," in Victoria Robinson and Diane Richardson, eds., *Introducing Women's Studies: Feminist Theory and Practice*, 2nd ed. (Basingstoke: Macmillan, 1997), 54–76.
9 Avis Berman, *Rebels on Eighth Street: Juliana Force and the Whitney Museum of American Art* (New York: Atheneum, 1990), 311, 277; hereafter abbreviated in the text as *ROES*.
10 By then, it had more than 400 members, and a long waiting list (*ROES*, 253).
11 Herman More, Curator, "Introduction" to the Catalogue of the Collection (New York: Whitney Museum of American Art, 1931), 11.
12 See *Juliana Force and American Art; A Memorial Exhibition*, September 24–October 30, 1949, Whitney Museum of American Art, Exhibitions 1914–1949 (64–66); and *The Annual and Biennial Exhibition Record of the Whitney Museum of American Art, 1918–1989* (Madison: Sound View Press, 1991).
13 Other "Whitney artists" who had homes in Woodstock, or who spent time there on a regular basis, included Alexander Brook, Peggy Bacon, Dorothy Varian, Rosella Hartman, Arnold and Lucile Blanch, and Eugene Speicher. See Alexander Brook, "The Woodstock whirl," *The Arts* 3 & 4 (June 1923): 415–20; and Karal Ann Marling, "Introduction," *Woodstock: An American Art Colony 1902–1977* (New York: Vassar College Art Gallery, 1977).
14 Schmidt, Bacon, Varian, Luce, Kuniyoshi and Brook were among those who had studied at the Art Students' League.
15 Among those women artists included in the Whitney museum's collection on opening, but since de-accessioned, were Rose Clark, Dorothea Schwarcz, and Molly Luce.
16 In the Whitney's records, works acquired by Whitney and Force before the museum's founding still bear an acquisition date of 1931.
17 The painting is Stettheimer's *Sun*, of 1931.
18 *Skunk Cabbage* was later exchanged for another work by O'Keeffe. It is now in the Montclair Art Museum (*New York Times*, 24 December 1998). Thanks to Nancy Mowll

Mathews, Eugénie Prendergast Curator at the Williams College Museum of Art, for clarifying this for me. Another O'Keeffe *Skunk Cabbage*, which Avis Berman identifies as the Whitney version, is in the collection of the Williams College Museum of Art.

19 *Juliana Force and American Art; A Memorial Exhibition*

20 See *Peggy Bacon: Personalities and Places* (Washington: Smithsonian Institution Press, 1975), Exhibitions (65–71).

21 "Among these who already better their reputations by this event are Edward Hopper, Niles Spencer, Stuart Davis, Louis Eilshemius, Joseph Pollet, Henry McFee, Reginald Marsh, Charles Rosen, Vincent Canadé, Bernard Karfiol, Gaston Lachaise and Cecil Howard." Henry McBridge, "Opening of the Whitney Museum," *New York Sun*, 21 November, 1931; reprinted in *The Flow of Art: Essays and Criticisms* (New Haven & London: Yale University Press, 1975/1997), 281.

22 Quoted in *The Annual & Biennial Exhibition Record of the Whitney Museum of American Art*, 28.

23 *Op. cit.*, 27.

24 See Griselda Pollock, "Modernity and the Spaces of Femininity," *Vision and Difference: Femininity, Feminism and the Histories of Art* (London & New York: Routledge, 1988), 50–90; the diagram is reproduced on 51. Also Carol Duncan, "The Modern Art Museum: It's a Man's World," in *Civilizing Rituals: Inside Public Art Museums* (London & New York: Routledge, 1995), 102–32; Serge Guilbaut; *How New York Stole the Idea of Modern Art: Abstract Expressionism, Freedom, and the Cold War* (Chicago: University of Chicago Press, 1983); Alan Wallach, "The Museum of Modern Art: the Past's Future," in his *Exhibiting Contradiction: Essays on the Art Museum in the United States* (Amherst MA: University of Massachusetts Press, 1998), 73–87.

25 This is not entirely true. Though these artists are certainly not as well known as, say, Arthur Dove or Marsden Hartley, their modernist contemporaries, who have remained in favor throughout the century, it is more likely that their work will be on display in exhibitions of American art than that of their female counterparts. And, with regard to the WMAA's adoption of the Museum of Modern Art aesthetic, Bruce Lineker stresses the continuing attachment to its earlier realist tendencies: "For six decades of American art, the surveys documented the Whitney Museum's consistent support of the Realist tradition. One can also trace in the exhibition program the emergence of abstraction in the 1930s and 1940s, it's [sic] extraordinary success in Abstract Expressionism of the 1950s, and abstraction's subsequent induction into the mainstream vocabulary of American art. However, even when critical attention overwhelmingly shifted toward abstraction, the program retained its original dedication to realism" (*The Annual & Biennial Exhibition Record of the Whitney Museum of American Art*, 11–12).

26 Abraham A. Davidson: *Early American Modernist Painting 1910–1935* (New York: Da Capo Press, 1994/1981), 89. The collection is now at Yale University.

27 Gail Stavitsky, "A. E. Gallatin's Gallery and Museum of Living Art (1927–1943)," *American Art* 7.2, (Spring 1993). The collection was transferred in 1943 to the Philadelphia Museum of Art.

28 Susan Noyes Platt, *Modernism in the 1920s: Interpretatons of Modern Art in New York from Expressionism to Constructivism* (Ann Arbor MI: UMI Research Press, 1985, 1981), 137.

29 Platt, 19–33.

30 Customs officials had listed it under "kitchen utensils and hospital supplies" and charged Steichen $240 duty when he brought the work back from France (*ROES*, 243).

31 Adam Weinberg, "The Real Whitney: the Tradition of Diversity," in Nicholas Serota, Sandy Nairne, Adam Weinberg, eds. *Views from Abroad: European Perspectives on American Art 3 – American Realities*, exhibition catalogue (New York: Whitney Museum of American Art, 1995), 25.

32 This approach is well established among sociologists of culture, who have long insisted on the importance of understanding artistic success and canon-formation in terms of social

relations of cultural production and institutions – patrons, dealers, critics, museums, art schools, art-critical discourses, and so on, which facilitate and enable (and, of course, sometimes obstruct) such success. With regard to gender, feminists have also answered Linda Nochlin's question, "Why have there been no great women artists?" by focusing on the social relations and institutions which exclude, or permit, women's participation in the making of art. Nochlin's 1971 essay of this title is reprinted in Thomas B. Hess and Elizabeth C. Baker, eds. *Art and Sexual Politics* (New York: Collier Books, 1973), 1–39. For an interesting example of a study of social networks and patronage in cultural production in a different context, see David Morgan: "Cultural Work and Friendship Work: the Case of 'Bloomsbury,'" *Media, Culture and Society* 4 (1982): 19–32.

33 Berman suggests that the consequent "top-heaviness of Woodstock on the Whitney exhibition roster and in the permanent collection" was rather unfortunate, and too uncritical on Force's part, *ROES*, 231.

34 Of her eight paintings, four were de-accessioned after Force's death in 1948 (*ROES*, 166).

35 For example, Matthew Baigell, *A Concise History of American Painting and Sculpture* (New York: Harper Collins, 1984); Joshua C. Taylor, *The Fine Arts in America* (Chicago: University of Chicago Press, 1979).

36 Brian Paul Clamp, "The Eight: Bridging the Art of the Nineteenth and Twentieth Centuries," *The Eight* (New York: Owen Gallery, 1997), no pagination. Clamp rightly points out that the group of eight artists does not exactly coincide with the group collectively known as the "Ashcan School."

37 For example, Milton W. Brown, *American Painting: From the Armory Show to the Depression* (Princeton N. J: Princeton University Press, 1955); *Avant-Garde Painting and Sculpture in America 1910–25* (Wilmington: Delaware Art Museum, 1975); Abraham A. Davidson, *Early American Modernist Painting 1910–1935* (New York: Da Capo Press, 1994).

38 Brown, for example, puts it like this: "After the [first world] war, realism continued, with many changes in character, but as a minor and neglected phase of American art." Unusually, Brook, Kuniyoshi and Pène du Bois do appear in his book, though none of the Whitney women do, 167.

39 The issue of the invisibility of much American art within the discipline of art history was addressed by Hemingway, *How the Tale of Art Wags the Dog of History*. A marvellous example of this appears in a recent publisher's catalogue, advertising a recent edition of the reprinted essays of the art critic Henry McBride – one of the most important critics in New York between about 1913 and 1950. The advert gives prominent place to a line from a review of the book by the art historian, Svetlana Alpers, who says: "Until I read this book I had never heard of [McBride], but his collected reviews make for good reading." It says something, of course, about the fate of early twentieth-century art and art criticism that such a sentence stands as a compliment. See "The Henry McBride Series in Modernism and Modernity from Yale University," publisher's catalogue (New Haven: Yale University Press, n. d. [but 1999]), 3.

40 Quoted by Adam D. Weinberg: "The Real Whitney: the Tradition of Diversity," *Views from Abroad: European Perspectives on American Art 3: American Realities* (New York: Whitney Museum of American Art, 1997), 28.

41 *Loc. cit.*

42 *New Yorker*, listings, 15 September 1997.

43 Nicholas Serota, Introduction, *Views from Abroad*, 10.

44 Bishop and Driggs are the only women realists here, and, of the group of twenty-four artists I have been considering, they are the only women whose work has continued to be shown, perhaps with the exception of Marguerite Zorach.

45 Other examples of this new attempt to reinstate realism as serious art include the Whitney's 1995 Florine Stettheimer retrospective and 1998 Edward Hopper retrospective; a major exhibition at the National Museum of American Art in Washington D. C. in 1995,

Metropolitan Lives: The Ashcan Artists and Their New York; an exhibition of the work of Peggy Bacon at the Kraushaar Galleries, New York, from December 1995; an exhibition of the work of Lucille Corcos at the Susan Teller Gallery, New York, in Fall 1997. And – no doubt a more trivial example – the selection of American realist art to hang on the walls of the home of an extremely rich young couple (played by Mel Gibson and Rene Russo) in the movie *Ransom*; see Avis Berman, "In the Script, the Art Says 'They're Rich,' " *New York Times*, 3 November 1996, 43–44.

46 In fact, the Montclair Art Museum, with whose curator I did subsequently exchange letters.

47 *Between the Wars: Women Artists of the Whitney Studio Club and Museum* (New York: Whitney Museum of Modern Art, 1997).

48 The title of one of several volumes published in the 1970s which undertook this task. See Eleanor Tufts, *Our Hidden Heritage: Five Centuries of Women Artists* (New York: Paddington Press, 1974).

49 Rozsika Parker and Griselda Pollock, *Old Mistresses: Women, Art and Ideology* (London & New York: Routledge & Kegan Paul, 1981), ch. 2, "Crafty Women and the Hierarchy of the Arts," 50–81.

50 Paul Mattick Jr, "Beautiful and Sublime: 'Gender Totemism' in the Constitution of Art," and editors' "Introduction," in Peggy Zeglin Brand and Carolyn Korsmeyer, eds., *Feminism and Tradition in Aesthetics* (Pennsylvania: Pennsylvania State University Press, 1995), 27–48.

51 Carol Duncan, "Virility and Domination in Early Twentieth-Century Vanguard Painting," *Artforum* (December 1973); reprinted in Duncan, *The Aesthetics of Power: Essays in Critical Art History* (Cambridge: Cambridge University Press, 1993), 81–108.

52 Griselda Pollock, "Modernity and the Spaces of Femininity," in her *Vision and Difference: Femininity, Feminism and the Histories of Art* (London & New York: Routledge, 1988), 54.

53 Andreas Huyssen, "Mass Culture as Woman: Modernism's Other," in *After the Great Divide: Modernism, Mass Culture and Postmodernism* (Bloomington: Indiana University Press, 1986). On the related topic of the gender of modernity, see Rita Felski, *The Gender of Modernity* (Cambridge: Harvard University Press, 1995), and Barbara L. Marshall, *Engendering Modernity: Feminism, Social Theory and Social Change* (Boston: Northeastern University Press, 1994), both of which identify the recuperative possibilities for women and for feminism within a "masculinized" but complex modernity.

54 Ann Eden Gibson, *Abstract Expressionism: Other Politics* (New Haven & London: Yale University Press, 1997), xxvi.

55 Michael Leja, *Reframing Abstract Expressionism: Subjectivity and Painting in the 1940s* (New Haven & London: Yale University Press, 1993), 258.

56 Leja, 257.

57 Evelyn C. Hankins, "Homes for the Modern: En/Gendering Modernist Display in New York City, 1913–39" (Ph.D. diss., Stanford University, 1999).

58 Bishop has always maintained a certain status in histories of American art, largely because of her importance as a member of the Fourteenth Street School of urban realist painters. Driggs' 1927 painting, *Pittsburgh*, which has remained on view in the WMAA's permanent exhibition, is unlike the work of her Whitney Studio Club contemporaries in its more modernist, Precisionist, style.

59 *The American Century: Art and Culture 1900–1950*, Whitney Museum of American Art, April–August 1999.

60 A disconcerting little aside in a recent article about the Whitney Museum of Modern Art in the late 1990s refers to the uncritical buying policies of Gertrude Vanderbilt Whitney, "who, lore has it, would sometimes purchase a second-rate picture in an artist's show, knowing that the best work would find another buyer" (Arthur Lubow, "The Curse of the Whitney," *New York Times Magazine*, 11 April 1999, 58). See also note 33, above.

Chapter 48 | Maurice Berger

Zero Gravity

[One] use of history is the systematic dissociation of identity. This is necessary because this rather weak identity, which we attempt to support and to unify under a mask, is in itself only a parody: it is plural; countless spirits dispute its possession; numerous systems intersect and compete. The study of history makes one 'happy, unlike the metaphysicians, to possess in oneself not an immortal soul but many mortal ones.' And in each of these souls, history will not discover a forgotten identity, eager to be reborn, but a complex system of distinct and multiple elements, unable to be mastered by the powers of synthesis. . . . The purpose of history . . . is not to discover the roots of our identity, but to commit itself to its dissipation. It does not seek to define our unique threshold of emergence, the homeland to which metaphysicians promise a return; it seeks to make visible all of those continuities that cross us.

Michel Foucault, "Nietzsche, Genealogy, History"

Near the entrance to the exhibition "A Museum Looks at Itself: Mapping Past and Present at the Parrish Art Museum, 1897–1992" several vitrines were installed that contained various documents and articles pertaining to the early years of the museum's history. One display in particular was both fascinating and instructive – a group of essays, letters, and other documents that touched on the politics of the museum's first patron and founder, Samuel Longstreth Parrish. Having retired in 1897 from active law practice at age forty-eight, Parrish devoted the remainder of his life to three abiding passions: Republican party politics, the study of U.S. foreign and domestic policy, and the building of an important art collection and small museum in Southampton, New York. His politics, while problematic, were not at all unusual for their time: commensurate with the thinking of Progressive-Conservative friends such as Theodore Roosevelt and Henry Cabot Lodge (both represented with polite letters in the exhibition), Parrish's treatises on foreign policy centered on the means by which the United States, through various colonialist and imperialist ventures, could make the world a more economically productive and "civilized" place.[1]

Maurice Berger, "Zero Gravity" from Donna de Salvo (ed.), *Past Imperfect: A Museum Looks at Itself* (© 1993), pp. 46–51. Southampton, N.Y.: The Parrish Art Museum, 1993. Reprinted by permission of The New Press. (800) 233–4830. (Reprinted without illustrations.)

Parrish's political tracts were augmented by a document with even broader implications for the exhibition – a transcription of a Sunday evening address given in September 1929 at the museum by the then-president of Columbia University and Parrish friend, Nicholas Murray Butler.[2] The central thesis of Butler's "The New Center of Gravity," as the address was titled, was that economic theory and practice had come for a generation or more to dominate social and cultural discourses. Presented just one month before the stock market crash, Butler's lecture appears disturbingly prescient in retrospect. "Put bluntly," he asserted, "the shift in the position of the center of gravity of human interest has been from politics to economics; from considerations that had to do with forms of government, with the establishment and protection of individual liberty, to considerations that have to do with the production, distribution and consumption of wealth."[3]

Butler's argument, of course, hinges on two questionable assumptions: first, that issues such as government domain and individual rights can be seen as separable from those of wealth and power; and second, that there can ever really be a center of gravity in the messy space of human ideas and events. What is missing from Butler's analysis – avoided so as not to disturb the fragile equilibrium of a worldview essentialized into the oppositional categories of politics and economics – are the discontinuous events, contradictions, and "marginal" episodes or people that make up the story of every society, every culture, indeed, every historical moment.

The fallacies of Butler's argument are, of course, embedded in the ideological discourses of capitalist institutions. Perhaps nowhere is this tendency more evident than in the museum – an institution that demonstrates both the relationship between power and money and the impulse to regroup the diverse artifacts of society into artificially unified narratives. During Parrish's time, the art museum was afforded an important, even central role in the "civilizing mission" of the high-minded protectors of culture; in cities across the United States, museums were being erected as monuments to the monolithic influence of what were seen to be the parent cultures of Western society – ancient Greece and Rome, Renaissance Italy, and the European middle ages. It is astonishing, then, to encounter an exhibition about the legacy of the Parrish Art Museum only to find oneself continually decentered, forced to question complacent assumptions about the aesthetics, architecture, exhibition practices, and patronage of not only this turn-of-the-century institution but museums in general. As conceived by curator Donna De Salvo, "A Museum Looks at Itself" went well beyond the usual "collections" show as it engaged a rare kind of institutional self-inquiry, displacing the museum from the center of cultural gravity and questioning the myths of unity that hold it together.

The experience of "A Museum Looks at Itself" quite literally began with an act of displacement. After passing through the museum's imposing front entrance – a Renaissance-inspired arched loggia set back from the street by a stately frontcourt – and paying the requisite admission fee, visitors were asked to leave the building and reenter through what appeared to be a modest back door but was, in fact, the institution's original entrance. Walking through a manicured garden path flanked by eighteen marble busts of Roman emperors (Florentine copies after originals in the Museums of the Vatican, reproduced for Parrish at the turn of the century), the observant visitor was also afforded a strategic view of some of the building's complex architectural changes, several stages of annexation supervised by architect Grosvenor Atterbury over a sixteen-year period (1897–1913) to accommodate Parrish's growing collection.

The museum's original hall, now known as the Transept Gallery because it intersects the vertical annexes of the building's Latin-cross plan, contained an elegant arrangement of artifacts and documents from the original collection: second-rate Italian Renaissance paintings; casts of sculptural masterpieces from the Renaissance and ancient Rome and Greece; a full-length, late nineteenth-century reproduction of the Bayeux Tapestry (ca. 1050–90); cases filled with political and archival papers; and a section of a long-hidden "composite altarpiece" from the early 1900s (terra-cotta and plaster reliefs cast after works by Andrea and Luca della Robbia, Ghiberti, and Donatello) revealed through a cut in the gallery wall that had concealed it for decades. An adjacent "Family Room" displayed Parrish memorabilia, including letters, genealogies, medical reports, commendations and medals, and portraits of family members – a homage to Parrish's own "Family Cabinet," an important feature of the original museum.

The remaining galleries were equally eclectic, often reflecting the influence of the museum's second guiding force, Rebecca Bolling Littlejohn. Mrs. Littlejohn, who was elected president of the museum in the early 1950s after it suffered years of neglect following Parrish's death in 1932, launched a major campaign to redirect the institution's acquisitions program from European to American art, with special attention given to artists from Eastern Long Island. One gallery, for example, contained significant paintings by American artists Thomas Moran, William Meritt Chase, John Henry Twachtman, George Luks, Fairfield Porter, John Sloan, and Frederick Childe Hassam, each replete with the accession number and year of acquisition stenciled on the wall above. An adjacent room underscored the arbitrariness of the museum's revamped acquisitions policy: exceptional paintings by William Sidney Mount and Martin Johnson Heade, for example, were hung salon-style alongside what are now considered monuments to kitsch such as Walt Kuhn's *Clown in Yellow* (1934). Several more vitrines, filled with photographs and letters of patrons and staff, visitor's registers, and newspaper clippings, addressed the issue of Littlejohn's revitalization of the institution.

The exhibition's one continuous element was a special project created especially for the show by the artist Judith Barry. The work – a small velvet-lined shelf with a tiny parody of a Victorian-era guidebook and a magnifying glass with which to read its minuscule type – was installed in one corner of each gallery. Barry's project functioned on a number of levels. By insisting that visitors bend over the shelves to view tiny objects through a lens, the work deliberately shifted the museum's traditional axis of viewing; the body, now hunched over, was engaged in a hands-on, private, and somewhat disorienting task, much different than the outward-directed, precious phenomenology of most museum exhibitions. The book's tongue-in-cheek title – *A Somewhat Suggestive Guide and Recent Reminiscences of My Return After a Long Absence to the Art Museum of Southampton* (1992) – suggested the potential of its contents to decenter the reader through its fictitious, parodic voice. Ostensibly authored by "Thomas Eammes Heartcrest," Barry's parody is aimed at the bigoted rhetoric of the popular nineteenth-century pseudo-sciences of physiognomy and phrenology. These "disciplines," by examining the shape of the skull and its indentations (phrenology) or by reading facial features (physiognomy), claimed to reveal people's inner natures and desires. Barry reintroduced these spurious disciplines into the institutional setting of the museum – a place where another form of genteel racism, often predicated on such homogenizing and normalizing standards as those of "quality and taste," has been mastered in order to

keep out difference – as a technique for further questioning the museum's unifying myths.[4]

The exhibition culminated in a barrage of questions and commentary in the last room: text panels provoked visitors to think about the nature of the museum and its audience; tables and chairs set up with reading materials introduced them to some of the latest theories on the aesthetics and ideologies of the museum; a suite of engravings from *Harper's Weekly* afforded a "view" of the ideologies of "the nineteenth-century museum through the popular press"; a video program of Pathé Newsreel footage from a 1915 "pilgrims and Indians" pageant celebrating the 275th anniversary of Southampton revealed the not-so-hidden racism of public culture at the turn of the century; and a contemporary installation by artist Fred Wilson – a group of four black mannequins dressed in the security-guard uniforms of major New York art museums – challenged our indifference to those people of color who themselves are ignored by the culture they are relegated to protect.[5]

If the history of museology, as Douglas Crimp has argued, "is a history of all the various attempts to deny the heterogeneity of the museum, to reduce it to a homogeneous system or series," it was the effort of "A Museum Looks at Itself" to do quite the opposite.[6] Through its lavish array of visual tropes and curatorial surprises, the exhibition was, first and foremost, poised to challenge the unquestioned ease by which cultural institutions repress the contradictions and conflicts that threaten their institutional integrity. While the need to systematize and homogenize diverse and often disparate objects into neat categories can enhance the museum's didactic role – after all, the ideal Victorian museum would have no greater goal than the "education of the nation" – such avoidance of difference also serves to distort meaning, foster stereotypes, and create a false sense of aesthetic and intellectual unity.[7] As Eugenio Donato observes:

> The set of objects the Museum displays is sustained only by the fiction that they somehow constitute a coherent representational universe. The fiction is that a repeated metonymic displacement of fragment for totality, object to label, series of objects to series of labels, can still produce a representation which is somehow adequate to a nonlinguistic universe. Such a fiction is the result of an uncritical belief in the notion that ordering and classifying, that is to say the spatial juxtaposition of fragments, can produce a representational understanding of the world. Should the fiction disappear, there is nothing left of the Museum but "bric-a-brac," a heap of meaningless and valueless fragments of objects which are incapable of substituting themselves either metonymically for the original objects or metaphorically for their representation.[8]

Ultimately, the curatorial strategies of the Parrish exhibition – from the display of materials generally not available for public view, to the reminders of the museum's exclusionist policies, to the juxtaposition of the masterpiece with the mundane – attested to "A Museum Looks at Itself's" self-critical approach to the museum's mythic view of culture. The show, while it blasted the fiction of coherence, was not merely an accumulation of bric-a-brac, a heap of meaningless and valueless fragments; rather, its arrangements of diverse objects yielded an entirely new level of meaning: constituted as a sea of dissonant, even fractured moments, the show continually gave voice to the unspoken tensions between triumph and failure, growth and complacency, largess and pettiness that the institutional myths of coherence serve to suppress.[9]

This fictive coherence is, of course, usually achieved through an uncompromising allegiance to political neutrality and aesthetic tidiness. "Museums don't want you to

see what's going on under the surface," observes De Salvo. "It is the mess left in the wake of organizing exhibitions and programs that most museums strive to conceal. 'A Museum Looks at Itself' reveals all the things that are not supposed to be seen."[10] As such, the exhibition simultaneously exposed what was most successful and most failed about the curatorial process: while it moved us with moments of pathos and irony, it also astonished us with revelations about the museum's largess. Despite Parrish's imperialist politics and cultural narrowmindedness, for example, his energetic and wide-reaching search for European models played a considerable role in enriching the cultural life of the Southampton community in which he lived.[11] Parrish's collections of casts and reproductions, as well, seem extraordinarily prescient in hindsight, both as a concession to the shifting attitudes toward cultural authenticity in the age of mechanical reproduction and to the reality that art history was itself increasingly predicated on the study of photographic reproductions.[12] And while Mrs. Littlejohn can be credited with her inspired dedication to our nation's cultural production – a position that contributed in its own modest way to the then nascent field of American art history – another, less flattering, insight emerged in the exhibition about her sometimes provincial taste: during her tenure, the museum virtually ignored a generation of Abstract Expressionist artists, including Jackson Pollock, Lee Krasner, Franz Kline, and Willem de Kooning, who lived and worked on Long Island's East End.

Other paradoxes emerged in more subtle ways. Stenciled on the gallery wall, for example, was Mrs. Littlejohn's contention that if "Parrish were alive today he would himself have had the statuary removed to the grounds. One has to have a living museum and not a mausoleum in this age of interest in the world of art." In light of what the viewer had just learned about Parrish's intransigent cultural and political agenda – a program that went as far as stipulating that the museum remain virtually unaltered after his death as a monument to his museological vision – Littlejohn's historical revisionism, made necessary by the need to appease the institution's conservative old guard, was now tempered by a note of irony. A wall label from 1898 served as another disturbing reminder of how things have changed: its polite offering of a comprehensive catalog of the museum's holdings for "the free use of visitors while in the museum" contrasted sharply with the wire tethers that now anchored books to reading room tables. The tendency of museums to patronize their public was also brought into focus: a visitor's register from the 1950s was placed next to photographs and newspaper accounts of gala fund-raisers, fancy invitations to private museum events, and an oil portrait of Mrs. Littlejohn's dog Bootsie.[13] While there was a certain poignancy in wondering what became of the people represented by the neat, obedient signatures in the register, such empty ciphers of human existence underscored the ironic anonymity of museumgoers who could never really rate with the glamorous denizens and immortalized pooches of high society.

It was the exhibition's self-critical allusions to abandoned conventions that offered some of its most moving moments. The display of the museum's long-ignored holdings of casts and reproductions, for example, was accompanied by a wall text that explained their popularity and eventual decline. In the closing decades of the nineteenth century, such replicas were thought to play an important role in bringing to the United States information about Europe's cultural riches; yet, after the turn of the century, curators began to question their educational and (perhaps more importantly) economic value, concentrating instead on notions of originality and connoisseurship. One of the exhibition's most powerful signifiers of loss, however, was also one of its most mute: several empty pedestals, placed throughout the Transept

Gallery, on which photographs of objects destroyed, stolen, or deaccessioned were placed. These ghostlike ciphers from the original collection – photographs of copies after Praxiteles' *The Faun* and Donatello's *David* or a now-missing silver pitcher from the "Family Cabinet" – emerged as archaeological ruins. Like the overwrought composite relief excavated under the gallery wall or the kitsch objects unearthed in the museum's basement, these memorials to a failed past unmasked the cracks and seams in the façade of institutional mastery and authoritativeness.

In contrast to traditional museum practice, however, these recontextualized ruins advanced a recuperative rather than antiquarian notion of history as they facilitated the "discovering or constituting of meaning in the inertia of the past and in the unfinished totality of the present"; in other words, they helped us to understand how museums can change as we move inexorably toward the twenty-first century.[14] As early as the 1930s Walter Benjamin argued that, in the ruin, history merged physically with its environment to constitute an allegory of growth and decline: " . . . in this guise history does not assume the form of the process of an eternal life so much as that of irresistible decay. Allegory therefore declares itself to be beyond beauty. Allegories are, in the realm of thoughts, what ruins are in the realm of things. . . . In the process of decay, and in it alone, the events of history shrivel up and become absorbed in the setting."[15] Just as Benjamin understood the ruin to be an allegory for the exhaustion of the capitalist vision, the wasted fragments that punctuated the landscape of "A Museum Looks at Itself" were contextualized by their specific historical setting; as such, they were charged with allegorical implications about the aspirations and limitations of the modern museum.

If the exhibition went far in exploring the museum's institutional limitations and failures, however, its greatest triumph was its own introspection; it taught us that institutions themselves, through acts of self-criticism and self-analysis, can overcome the biases and restraints of the past. After wrenching moments of pathos in which the viewer was hit with the reality of how provincial attitudes and shortsightedness can harm an institution, the show's last room proved that a museum could look at itself and question its own notions of what a museum can be. Arriving at the reading room – a space tempered by the presence of Wilson's guards, ciphers of the black body that the white person's eyes usually strive to "break up in [an] act of epistemic violence"[16] – the visitor encountered a wall text that culminated in a series of introspective questions: "How do we define a museum? Whose history does it tell? What should it collect and what criteria should be used? Who is the public? Who are the patrons? Who in the end decides?"

That such questions were being asked of the public at all was a great accomplishment for the Parrish. But De Salvo's purpose in raising these issues went well beyond the politics of inclusion. Ultimately, the exhibition served as a paradigm for examining the myths that keep most museums from reaching out beyond the limited interests of their white, upper-class patrons. In the end, all sectors of the museum's institutional hierarchy, its board of trustees, staff, artists, and public, must confront these questions in order to adapt to the astonishing demographic and global shifts that are redefining national and international culture. Not surprisingly, these issues recently have been broached by artists who have attempted to challenge the museum's power to acquire, define, and even censure their work. Joseph Kosuth, for example, responded to conservative attacks on artistic freedom by creating an installation at the Brooklyn Museum in 1991 that displayed potentially controversial objects from its permanent collection. Kosuth's "The Play of the Unmentionable" exposed the institutional

mechanisms of repression that have permitted societies over thousands of years to mollify, censure, and manipulate the content of artworks. Fred Wilson, invited by The Contemporary and the Maryland Historical Society in Baltimore to create an exhibition from their collection, recontextualized collection objects, in effect deconstructing the museum's own discourses to tell the story of these artifacts from the perspective of a Maryland slave. What made the Parrish show different from these efforts, however, was that its story was told from the perspective of the curator. It is only through such processes of self-inquiry that art institutions can become more responsible to their constituent communities. Exchanging the mythologies of coherence and unity for realizations about how such illusions insulate the museum from dealing with these responsibilities, "A Museum Looks at Itself" serves as a significant model for any other institution wishing to emerge from its comfortable, if imaginary, position at the center of cultural gravity.

Notes

1 In Parrish's view, this end could be achieved through the intervention by developed nations in the economies and governments of less-developed nations. Parrish writes in his *Colonization and Civil Government in the Tropics* (1903), that the "United States has suddenly leaped, at one bound, into a position of overshadowing importance as a leader among nations in the present movement for the advancement of civilization, upon a higher plane of endeavor, throughout the world."

2 Parrish was interested in using his museum as a forum for political inquiry. The 1898 opening of the museum was accompanied by "an informal conference in regard to the future of the United States in view of the questions which have arisen as the result of our war with Spain." Over the years, Butler was asked to present papers on various social topics.

3 Nicholas Murray Butler, "The New Center of Gravity" (New York: Carnegie Endowment, 1929), n.p.

4 For a discussion of Barry's piece, see Ken Silver, "Past Imperfect," *Art in America* 81. 1 (Jan. 1993), p. 47.

5 The contextualization of often disparate artifacts and documents was augmented by the presence of provocative wall texts throughout the exhibition. These curatorial and sociological statements acted as the historical and theoretical coordinates through which viewers could better locate some of the show's overarching concepts.

6 For more on this subject, see Douglas Crimp, "On the Museum's Ruins," *October* 13 (Summer 1980), reprinted in Hal Foster, ed., *The Anti-Aesthetic: Essays on Postmodern Culture* (Port Townsend, Wash.: Bay Press, 1983), pp. 49–50.

7 For more on the educational goals that motivated art museums at the turn of the century, see Wallach, "Samuel Parrish's Civilization" in Donna de Salvo, ed., *Past Imperfect: A Museum Looks at Itself* (Southampton, NY: The Parrish Art Museum, 1993).

8 Eugenio Donato, "The Museum's Furnace: Notes Toward a Contextual Reading of *Bouvard and Pécuchet*," in *Textual Strategies: Perspectives in Post-Structuralist Criticism*, Josúe V. Harari, ed. (Ithaca: Cornell University Press, 1979), p. 223.

9 Douglas Crimp continues in "On the Museum's Ruins" (pp. 49–50): "The faith in the possibility of ordering the museum's 'bric-a-brac' . . . persists until today. Reinstallations like that of the Metropolitan's 19th-century collection of the André Meyer Galleries [in New York], particularly numerous throughout the past decade, are testimonies to that faith. What so alarmed Hilton Kramer in this particular instance is that the criterion for determining the order of aesthetic objects in the museum throughout the era of modernism – the 'self-evident' quality of masterpieces – has been broken, and as a result 'anything goes.'

Nothing could testify more eloquently to the fragility of the museum's claims to represent anything coherent at all."

10 Donna De Salvo in conversation with the author, November 8, 1992.

11 To introduce questions about the politics of the patronage class in this kind of institutional context is to disrupt the myth of the museum's ideological neutrality – a dangerous path for any curator to take. Hans Haacke's plans to include in his 1971 Guggenheim Museum retrospective a controversial work about the real estate holdings of New York real estate kingpin and slumlord Harry Shapolsky, for example, met with a not unsurprising response by Guggenheim director Thomas Messer: the exhibition was canceled and its curator, Edward Fry, was fired after he defended Haacke. For more on this incident, see Brian Wallis, *Hans Haacke: Unfinished Business* (New York: New Museum of Contemporary Art, and Cambridge, Mass.: MIT Press, 1986), pp. 92–97.

12 Ken Silver has observed that shifting attitudes toward cultural authenticity in the age of mechanical reproduction may have contributed to Parrish's interest in casts: "Parrish...seems instinctively to have understood that cultural authenticity is essentially created by its copies: imitation is more than the highest form of flattery, it is the mirror that creates the 'original.' Parrish's preference for copies of European masterpieces rather than original works by American artists – a taste which was, again, typical of his era – suggests just what fertile ground this country has long been for mass production and mass-produced culture." See Silver, "Past Imperfect," pp. 45–47.

13 The "portrait" was painted ca. 1955 by the museum's first full-time director and artist Valetine Arbogast.

14 Michel Foucault, *The Archaeology of Knowledge*, trans. A. M. Sheridan Smith (New York: Pantheon, 1972), p. 11.

15 Walter Benjamin, *The Origin of German Tragic Drama*, trans. John Osborne (London: New Left Books, 1977); as quoted in Craig Owens, "Earthworks," *October* 10 (Fall 1979), p. 129. For more on the museum's relationship to the ruin, see James A. Boon, "Why Museums Make Me Sad," in Ivan Karp and Steven D. Lavine, eds., *Exhibiting Cultures: The Poetics and Politics of Museum Display* (Washington, D.C., and London: Smithsonian Institution Press, 1991), pp. 257–58.

16 Homi Bhabha, "Remembering Fanon," in Barbara Kruger and Phil Mariani, eds., *Remaking History* (Seattle: Bay Press, 1989), p. 135.

Chapter 49 | Kynaston McShine

From *The Museum as Muse: Artists Reflect* | Introduction

Having worked in a museum for virtually my entire career, I have long been pondering the different ways in which artists have made the museum a subject throughout the twentieth century and even earlier, and I have felt that this has provided the basis for an exhibition and publication. As time progressed, I realized that many more artists were dealing with this topic than I had initially thought, and in many more ways. The museum as an institution generally, and maybe even The Museum of Modern Art specifically, has had great meaning for contemporary artists, and they often have felt strong emotional connections to it, whether of love or hate. They have probably spent a lot of time in the Museum and been influenced by individual exhibitions. We have frequently seen what we have shown here being reflected in what we have later received in new art. Most artists' education involves the habit of visiting museums and reflecting on what is seen there. This, of course, also has led artists to think about museum practices.

The fascinating thing about the relationship between artists and museums is that artists have studied every aspect of the museum, as if anatomizing an organism. Although the ways in which they deal with the museum in their work go far beyond any purely pragmatic consideration, their interest is, of course, partly professional: their sense of what the museum means in terms of public acceptance makes many of them eager to be represented in museum collections, and worry if they are absent. Others, meanwhile, question whether their work should be in a museum at all, feeling that to be included is to succumb to the establishment. In either case, artists are often, ultimately, wrestling with the issue of their dependence on the museum to endorse their place in art history. It is the civil institution of today, they feel, that will make them the cultural institutions of tomorrow.

The use of the museum as a subject for art has accelerated during the twentieth century in response both to developments within art and to the altered social role of the museum. In the early part of the century, however, the artist was distanced from the museum, which made little acknowledgment of contemporary art. Russian artists

Kynaston McShine, Introduction to *The Museum as Muse: Artists Reflect*, pp. 11–23. New York: The Museum of Modern Art, 1999. © 1999 by The Museum of Modern Art, New York. Reproduced by permission.

after the Revolution of 1917 were an exception: desiring a total integration of art and life, they harbored the utopian dream of a museum administered by artists, and they brought art to the public on boats and trains and through theater design in ways intended to make the museum and its mission vital parts of everyday life. El Lissitzky, for example, designed an exhibition room for the Hannover Museum (now the Sprengel) in Germany in 1926, preparing detailed plans and drawings. Lissitzky's practice, however, was unique. The Parisian art milieu of the same period was marked by disdain for the museum as a traditional, antiquated, aristocratic authority, lacking understanding of the art of its time. It was Marcel Duchamp who pointed the way in this attitude, poking fun at the museum, puncturing its pomposity, and catalyzing the Dadaists' and Surrealists' relative indifference to it. Independent of authority and tradition, Duchamp and his colleagues were essentially derisive about the kind of history that the museum of that time promoted and constructed.

Curiously, though, it is not possible to ignore Duchamp's role in guiding artists *toward* museums. Despite his irreverent gestures, Duchamp was an essential advisor to the formation of contemporary art collections in the 1920s and 1930s such as those of Katherine S. Dreier and Louise and Walter Arensberg, which eventually led to the placement of works by himself and others in The Museum of Modern Art, the Philadelphia Museum of Art, and the Yale University Art Gallery. This phenomenon of the artist actively fostering a relationship with a museum developed further with the exile of European artists to the United States during World War II; The Museum of Modern Art, along with other institutions, provided financial support to help a number of artists leave Europe and assisted them in finding employment in the United States. In consequence, exiles such as Joseph Albers and Fernand Léger, among others, created a certain energy around these institutions that stimulated a new relationship between museums and artists.

At around the same time, American artists in particular began to realize that museums were not paying adequate attention to them. In 1950 the Irascibles wrote their famous letter of complaint to The Metropolitan Museum of Art, protesting hostility toward the avant-garde in the organization of a large exhibition of American art. Their effort was followed by the Americans series of exhibitions at The Museum of Modern Art and by other exhibitions of new work, leading to a less adversarial relationship between the artist and the museum.

This new relationship in the 1950s, however, was partly undone in the 1960s, when crises in the post-colonial world, exemplified by the Vietnam War, brought with them a basic distrust of society and its institutions. In 1960 The Museum of Modern Art agreed to show Jean Tinguely's *Hommage à New York*, an amazing and elaborate construction designed to self-destruct – as indeed it did, in an event in the sculpture garden that was finally closed down by firemen. By 1969, however, when Yayoi Kusama arranged for six women and two men to shed their clothing and frolic in the pools and among the sculptures on the same site, her intention was subversive rather than collaborative; the event took place without the Museum's consent, and, indeed, Kusama had organized it precisely to protest the institution's *lack* of modernity, its function as, in her words, a "mausoleum of modern art."

Something else changed in the 1960s. Before that decade there was a provincial quality to the art world; British artists were British, French artists were French – artistic activity was nationally compartmentalized. In the 1960s, however, the insular aspect of the art world was altered by travel. The new American painting had a profound impact on Europe, and European artists began to voyage frequently to

the United States; the scene appeared to open up. This increasingly global situation contributed to a more open and relaxed attitude toward art and the art object, which also became more conceptual. The definition of art, and of how it was to be not only created but presented, broadened fundamentally. The result was that by the late 1960s artists had come to feel quite free in relation to the museum. One day they could love it, the next they could hate it, and the next ignore it, as in any family.

Conceptual art, with its fluid notions of the art object, presented a challenge to traditional museum practices. Yet an artist like Marcel Broodthaers was distinctly interested in the museum, and developed a complex series of works around it. From the 1970s on, in fact, a good deal of art took the museum as its central interest, for the range of ideas about and attitudes toward the institution grew and deepened. A variety of techniques came into play; almost any method and medium could be used to address the subject, from installation, video, and more cerebral mediums to traditional photography and even, by the 1980s, traditional painting in oil on canvas. Still, in the 1980s, the museum took a bit of a back seat in the art world. The driving force became an economic well-being involving private money, the gallery structure, and, in Europe, government funding. Non-profit institutions in the United States did not have these kinds of resources, so the intervention of the museum became less necessary in artists' careers; the life of the artist, now potentially lucrative, was sustained by large international exhibitions, by international collecting, by shows in commercial galleries, and by auction sales. The museum was a relatively passive participant in this activity. Nevertheless, the 1980s and 1990s have seen widespread growth in museum expansion and building. Temporary exhibitions at galleries and international venues have been unable to displace the museum's historical role as a storehouse of aesthetic memory.

These historical shifts in patronage are matched by an ambivalence toward the assumed ability of the museum to immortalize the artist in relation to history. Artists have seen the museum as a place that establishes and codifies their place in history; they have also resented the power that it may exert over their lives. Collecting is a byproduct of producing work, and most artists accept its necessity, but some of them are sensitive about the museum's possession of their art. They see patronage as patronizing, and question their dependence on a system based on private or public acquisition. The idea of the public patron is perhaps more offensive to some artists if they see it as representing political affiliations or alignments in conflict with the more progressive attitudes that are often components of the artistic temperament.

This kind of tension is evident in the work of many artists represented in *The Museum as Muse* and also in work that cannot be included here. For even as many artists have struggled to be included in the museum, others have resisted dependence on art-world patronage structures and have developed intricate critiques of museum practices. As an outgrowth of these approaches, many artists have purposely made works that, due to their size, ephemeral materials, or location, are not collectible by museums (nor by the commercial gallery system); still others have chosen to avoid the institution altogether. Although this kind of work is addressed in the present essay, it is by definition generally absent from the exhibition *The Museum as Muse*. Other artists, however, have examined the museum's political structure in works designed for conventional viewing and, particularly, for the expanded and increasingly various audience of The Museum of Modern Art.

The Museum as Muse is designed as a survey of some of the most notable museum-related art. It does not pretend to exhaust the field. Similarly, it does not attempt to

establish a theoretical basis for the multiple focuses of artists. Rather, recognizing the variety of motives and interests that artists have brought to the subject, it illuminates the approaches taken by artists and discusses the aspects of the museum's life on which they have chosen to settle.

The fact that collecting is an obsessional activity both for museums and for private individuals has led me to become intrigued by artist collectors. Not only have some artists formed large art collections (those of Edgar Degas, Pablo Picasso, Andy Warhol, and Arman are only a few such), but more modestly and practically artists' studios have always been the sites of collections of materials they have wanted around them as they worked, for example photographs, *objets*, exotic ephemera, and copies of other art. This practice long predates modernity, but it has relatively recently expanded into the idea of making a museum of one's own, not just to preserve one's own work, in a kind of monument to oneself (for example, the Paris studio of Constantin Brancusi, which he bequeathed, with its contents, to the Musée national d'art moderne, sanctifying his working process along with his sculpture) but to apply museological principles to the production of art.

A prime example must be Marcel Broodthaers's *Musée d'Art Moderne, Département des Aigles (Museum of Modern Art, Department of Eagles)*, a conceptual museum created by the artist in 1968. Broodthaers's museum was a fiction in that it had neither permanent collection nor permanent location. It manifested itself in its various "sections" created between 1968 and 1972. Another must be Claes Oldenburg's *Mouse Museum* (1965–77), a freestanding structure containing a collection of fictionalized objects (some found and altered, others created by the artist) displayed in vitrines: a landscape painting and objects relating to landscape; articles in the form of human beings; food forms; body parts; clothing remnants, cosmetics, and objects of adornment; tools; objects relating to animals; representations of buildings and monuments as well as souvenirs; money containers; smoking articles; and fragments from the artist's studio. The *Mouse Museum* is a comment partly on collecting (the selection's combination of irrationality and obvious system throwing the whole practice into question) and partly on the ingenious, yet inane, mass of mechanically reproduced material that floods our society. And although this may not be immediately apparent to the visitor, the museum's architectural plan is defined by the head of a certain cartoon mouse; so that *Mouse Museum* is also part comic, a parody. Filling this architectural space, the collection figuratively becomes Mickey's brain.

Quite different in mood is Susan Hiller's *From The Freud Museum* (1991–96), an example of the museum as a construct of the artist's imagination. Creating a museum from the "unspoken, unrecorded, unexplained, and overlooked," Hiller's installation comprises fifty cardboard boxes packed with specifically personal objects. But the poetic connotations of these objects are likely to engage the visitor's own experiences and memories as well. One box, titled *Nama.ma (Mother)*, contains a photocopied diagram showing Uluru cave paintings and Australian native earth in different pigments that were collected by the artist, ground into powder, and placed in cosmetic containers. Another box, *Chamin'Ha (House of Knives)*, contains a photocopy of a classic Mayan calendar, glyphs, numerals, day names, and modern obsidian blades, all in a customized cardboard box. The boxes together become a personal epic with biographical, archaeological, and political elements that move the spectator through a gamut of intellectual and emotional tonalities, from the banal and sentimental to the

academic and metaphysical. Meanwhile the work addresses a basic issue of the museum, both for the visitor and the curator: the need for viewers to establish their own rapport with what is presented and to create for themselves a unique, personal poetic experience. Hiller's work may also stimulate them to consider their own activities as curators and collectors in their private lives.

Christian Boltanski's *Archives* (1987) is a group of racks suggesting a museum art-storage room of several hanging screens filled with photographs of 355 anonymous individuals. These people are completely unidentified, but the installation is infused by a sense of morbidity, created partly by the relative darkness (the work is lit only by small lights at the top of each screen) and partly by the idea of storage – as if this museum existed to preserve some unnamed collective memory. Were these people victims of the Holocaust or of some other disaster? As an assembly of data, an archive is often almost abstract in atmosphere, but Boltanski's version is rooted in a sense of loss. His *Vitrine of Reference (II)* (1970), more personal and autobiographical, contains artifacts from his childhood – photographs, a 45 r.p.m. record, a slingshot – but the museological display makes them feel as if they came from a prehistoric civilization.

More romantic than these artists is Joseph Cornell, who made assemblages, dossiers, and constructions to house collections that sentimentally memorialize women he admired – ballerinas, the heroines of novels, and film stars. The nostalgia for the past that breathes through these works parallels the mood of, for example, a museum's period rooms, its rooms of miniatures, and its occasional recreations of a historical space, often a personal one – the living room of an aristocratic household (containing a collection, probably) or some other room furnished to demonstrate a period in history. But those displays are whole environments, as is Oldenburg's expansion of an apparently frivolous collection far beyond any expectation. Hiller similarly lets the "unrecorded and overlooked" take up an attention-getting amount of room. Cornell, on the other hand, follows a principle of compression, focusing the power of the artwork through the sense that a carefully chosen collection is concentrated in a diminutive space.

Cornell greatly admired Duchamp, who worked more compactly still, reproducing his own entire oeuvre as miniatures carefully organized in a valise. What a great conceit it is – to put your life's work into a little briefcase, which is editioned (one edition being partially assembled by Cornell), and so available to numbers of people simultaneously. Duchamp made several full-scale copies of his Readymades over the years, and those works are in visual terms functionally identical to their originals; but the miniaturization of the works in the various versions of the *Boîte-en-valise* (the first appeared in 1941) creates a peculiar class of objects, neither originals nor reproductions, worthy of that peculiar curator Duchamp.

Presaged here, I think, is the issue of the museum's traffic in reproductions, which, as the century proceeds, becomes a major preoccupation in a museum's marketing life. Perhaps schoolchildren in a museum store, buying postcards of works they have just seen, are creating a reference almost equivalent to the one Duchamp provided to his own work: they may feel they now have the work, if on a smaller scale. And of course postcards and posters have become ubiquitous manifestations of the museum, from the student's dorm to the dentist's office. Recognizing this as early as 1919, Duchamp used a color reproduction of one of the icons of painting – Leonardo's *Mona Lisa*, in the Louvre – to allow us a certain irreverence toward a museum-sanctioned artwork: applying a mustache and beard to the *Mona Lisa*'s face, and titling the work

L.H.O.O.Q. (in French, a lubricious pun), he not only plays with gender issues but reminds us that a reproduction is a reproduction. Embellishing the best-known painting in the world, but doing so harmlessly – for how can you vandalize a paper reproduction? – Duchamp desanctifies the object, allowing us a mental proximity to it that we would not otherwise have even in the Louvre, standing before the painting itself. The reproduction is that much closer to our lives.

A recent descendant of Duchamp's work in this respect is the rigorous art of Sherrie Levine, which comprises copies, produced by a variety of different methods, of artworks of the past. Her black-and-white images of paintings by van Gogh (1994) are all photographed from the pages of books. Perhaps Levine can be seen as building her own, somehow poignant collection of the art she desires – a "museum without walls," in André Malraux's term. The 480 *Plaster Surrogates* (1982–89) of Allan McCollum form another collection that, like Levine's van Goghs, has had its content meddled with: each of these 480 "paintings" is a plaster mold in the shape of a painting, including the frame, but with blackness where the image should be. Is the world so full of images that it is redundant to maintain a storehouse of them? McCollum's works address ideas about the aura of the artwork in the age of the mass-produced object. Ironically enough, the Surrogates come close to suggesting that a museum of multiple imageless frames would be somehow viable: beyond our appreciation of a large installation of these works as a visual spectacle in its own right, our memories of paintings, our ideas about what painting is, almost allow us to fill in the blanks.

Another of Duchamp's heirs, dealing this time, as in the *Boîte-en-valise*, with miniaturization, might be the Swiss artist Herbert Distel, who in 1970–77 asked artists around the world to contribute a work to a museum he was creating in a many-drawered cabinet, each drawer divided into compartments. A found object, the cabinet was designed to store silk thread; Edward Kienholz made the base for it. Nearly everyone asked by Distel happily submitted an exquisitely executed miniature. (A few works were donated by others, for example, the piece by Piero Manzoni, who had died before Distel's project began.) The result, *Museum of Drawers*, contains works by 500 artists (or, rather, 501, including Kienholz). Some of the artists are well known – Picasso, for example – while others are more obscure. The museum is usually displayed with several of its drawers removed and open to view in a vitrine. Where Oldenburg and Duchamp created museums of their own work, Distel is here claiming the function of the archetypal curator, creating his own selection of the art of a certain period, if insisting on the slightly unusual condition that it be shrunken to fit in his compact portable case. (At least Distel escapes the need of so many museums for a new building at regular intervals.) A similar wood cabinet, this one made for the occasion, was used by members of the Fluxus movement in 1975–77 to create a museum of Fluxus artists; created almost simultaneously, these two "museums" stand as mini-monuments to the art of their time.

An ancestor of the personal museum is surely the *Wunderkammer*, or cabinet of curiosities, of the eighteenth and nineteenth centuries. In a work painted in 1822, the artist and naturalist Charles Willson Peale depicted himself as the epitome of the gentleman amateur/connoisseur who has amassed a treasury of the marvelous and fabulous. How proudly he shows us his extremely special collection of natural history objects, which symbolizes his status as a man of learning. *The Artist in His Museum* is a great nineteenth-century work tracing the emotions once available to an artist who had created his own museum.

Artists in this century generally show more complex attitudes to the museum than Peale's obvious pride. But the thrill Peale got from nature survives, perhaps against the odds, in Mark Dion, who is fascinated by the idea of the *Wunderkammer* and the miscellaneous specimens it contained. *The Great Chain of Being*, created for *The Museum as Muse*, is a modern *Wunderkammer*, a variety of objects – animal, vegetable, and mineral – that invokes different branches of knowledge and implies an evolution that ends with the human. Dion has a comfortable familiarity with the disciplines of mineralogy and geology, zoology and biology, but utilizes them toward the goal of making art. Like Peale but working in sculpture, he accumulates a variety of materials and displays them in an orderly way, in the process creating a self-portrait.

The Frenchman Daniel Buren has been one of the artists most associated with the use of the museum as subject matter, for example in installations at the Haus Lange and Haus Esters, Krefeld, in 1982. He has also written extensively on museological and artistic theory. Buren, in some sense, appropriates to himself the role of the curator of *The Museum as Muse* by adding to its roster of artworks four de Chirico paintings from the permanent collection of The Museum of Modern Art. By incorporating the permanent collection (the maintenance of which is a separate activity from the preparation of a temporary exhibition) in the show, he engages the visitor's understanding of this Museum as a place. The de Chiricos are installed in the usual mode of the permanent galleries for painting and sculpture; at the same time, in those galleries themselves, Buren frames with his trademark stripes the blank spaces where the paintings usually hang, so that he imposes *The Museum as Muse* on those rooms, where viewers will have come to see something else. The viewer in the permanent collection confronts a situation that is not of the permanent collection, in a certain transference of concept over memory.

It is not, of course, that visitors expect no conceptual intelligence in the permanent collection, but many of them go there to see old favorites and to rehearse a particular, familiar narrative of which that installation gives an account. Most artists are extremely aware of that narrative, if not through their concern for their own place in it, then because artists tend to be interested in art history. For the general public too, one of the pleasures of museum-going – especially to an institution like the Louvre, or the National Gallery in London – is those museums' basically settled nature: the artworks have their more-or-less fixed place. There is a collective memory that we all share of the great museums. It is therefore poignant when Sophie Calle points out how fragile our memories are, in *Last Seen . . .* (1991): at her request, a variety of employees at Boston's Isabella Stewart Gardner Museum – curators, guards, and other museum staff – used their memories of several paintings stolen from the collection to provide descriptions of them. These descriptions, differing not only in their degree of detail but in those details themselves, are incorporated as text in Calle's series, which accordingly undermines our sense of the reliability of our memory of what was there and is not there now. Of course it also speaks of the museum as workplace, of the perceptions that museum staff may have of an object that is a part of their daily business rather than something they travel and pay admission to see. But *Last Seen . . .* finally enters a larger territory: at the same time that its verbal translations of a visual artwork arouse a need to see that work, they prove their own inadequacy as a substitute for it, and as such become an exercise in frustration and unsatisfied desire.

If the museum is a site of a culture's memory, of the story the culture tells itself about where it has been, then the work Fred Wilson has made for this exhibition, *Art in Our*

Time (the title of a show at The Museum of Modern Art in 1939, celebrating the institution's tenth anniversary), explores a memory's memory of itself: the Museum's photographic archive of its own exhibitions and public and private spaces over the years. From this archive Wilson has culled images of a diversity of visitors, of installations in both temporary exhibitions and the permanent collection, of storage rooms, and so on, the whole a fragment of the extraordinary memory that a museum has and embodies. What is not on display in the Museum is as crucial to it as what is: the large collections not on view, the library, the loaned works arriving for an exhibition and leaving after it, the works being considered for acquisition, the works being deaccessioned, the files on artists and on specific objects, the collective memory of the staff – together become an infinite resource. A museum constitutes a less visible framework for the more visible art it exists to preserve; Wilson's work puts part of that frame on view. He shares this interest with Louise Lawler, another artist interested in the context in which the artwork appears, be it the museum, the home, or the auction house. Fascinated by the methods of presentation and the indirect functions to which art is subjected in these places, she documents them photographically, obliquely commenting on the different kinds of value that artworks come to comprise, and on the ways in which these values are expressed.

Lawler, of course, is far from the only artist to photograph the museum; the practice began within fifteen years of the invention of the photographic process in 1839. Once again, though, the attitudes discernible in those early photographs are less ambiguous and intellectually complex than those of an artist like Lawler. Victorian images by Roger Fenton, Stephen Thompson, and Charles Thurston Thompson are more documentary than analytic, recording both spaces and specific objects, and showing an absolute fascination with the special place that the museum was. It was not a religious space, it was not a domestic space, but it was a major place of convocation, of coming together. It was also a little closer in time than we are to the old-fashioned idea of the *Wunderkammer*, and additionally to another of the museum's ancestors, the royal or aristocratic collection of objects of great worth. The public accordingly saw the museum's objects as curiosities and rich marvels. In fact many spectators today still enter the museum with this innocent desire for the marvelous, no matter what form it takes – whether a well-conceived kettle displayed by the architecture and design department or an Alberto Giacometti sculpture. But artists of this century have shown a desire to explore the frame within which that sense of wonder is maintained.

Candida Höfer, for example, photographs museums' empty lobbies and lounges, revealing their blandness, their impersonality, and perhaps even their tastelessness. Her photographs suggest an irony of the contemporary museum: it is often thought of as an arbiter of taste, but it is also a large public institution, a role it may manifest in its architecture, its furniture, its lighting, and its general ambiance. Thomas Struth, similarly, has observed that "many people compare modern museums with train stations," a view to which he contrives a "resistance": his photographs' color and scale bestow on the museum a certain splendor. And the variety of the viewers he shows before large artworks in the galleries demonstrates the richness that art is capable of possessing for diverse people. Struth sees the beauty in the art, in the museum, and in the public. The interesting interplay happens when museum visitors confront a Struth photograph of museum visitors: it is as if they somehow step through the glass and become part of the situation they see. "Therein lies a moment of pause or of questioning," Struth remarked; "Because the viewers are reflected in their activity, they have to wonder what they themselves are doing at that moment."

Photographers other than Struth have been attracted to the spectator, and to the spectator's gaze – to looking at people looking. Given the exposure time needed by nineteenth-century film, this happened somewhat rarely in Victorian photography; Jean-Baptiste Gustave Le Gray's "*Les Demoiselles du Village*" *at the Salon of 1852*, for example, shows a museum hall entirely without visitors. But in the twentieth century it became as easy to capture the museum visitor as the inanimate object. Henri Cartier-Bresson could pursue an interest in people as observers, and in the relationship between viewer and object. Eve Arnold and David Seymour have photographed particularly notable museum visitors (Edward Steichen, Bernard Berenson), but the general visitor, too, became a journalistic subject quite independent of the artwork; Lutz Dille provides a typical example, showing a couple holding slides up to a window on the garden at The Museum of Modern Art. Meanwhile photographers such as Larry Fink and Garry Winogrand found their imaginations grabbed by the museum's evolving aura as a social space. Observing the public behavior emergent as the museum increasingly became a place of socializing as much as of study, these photographers commented on the distance between the basic act of contemplation and some of what now seems to be ordinary museum activity.

Hiroshi Sugimoto's photographs, by contrast, are unpeopled, appearing to show wildlife in its natural habitat. Somehow, though, they seem to heighten the frozen quality that a still photograph necessarily must have, and on scrutiny we awkwardly realize that we are viewing not the vacation shots of a tourist on safari but stuffed animals in the dioramas of a natural history museum. Insisting on the artificiality of the museum experience, where, at least traditionally, there is nothing we come to see that lives and breathes, these images ask us to ponder the relationship between that experience and the world beyond: it is as if there were some creeping artifice in contemporary life, inspiring the artist to take these photographs. Artificiality is taken to an even more peculiar extreme in Christopher Williams's *Angola to Vietnam*** of 1989, a series of photographs of glass flowers in the Botanical Museum at Harvard University. Evoking the exoticism of these flowers – painstakingly accurate reproductions of specimens from around the world – by titling his photographs according to their countries of origin (all nations in which people had gone missing for political reasons during 1985), Williams catches in photography a museum-specific kind of beauty far removed from the experience of a tropical garden. The reproductions are so realistic that you almost have to be told they are glass.

The wonderful thing about photographers roaming in museums is the individual eye's response to the subject. Elliott Erwitt and Zoe Leonard provide idiosyncratic and pointed museum experiences, and Christian Milovanoff gives us an amusingly personalized tour of the Louvre, focusing on a single recurring detail: the feet of the figures in masterpiece paintings. An intellectually provocative sense of humor is also shown by Vik Muniz, who, photographing the marble floor in the garden hall of The Museum of Modern Art, captured it as a series of abstractions resembling and titled after Alfred Stieglitz's much-analyzed Equivalents, photographic studies of clouds. More somber and ominous are Günther Förg's large studies of the Munich Pinakothek, the play of light and shadow on the building's grand staircase evoking a darkness attuned to the architecture's authoritarian style. Jan Dibbets takes a more redemptive approach, photographing natural light in the museum and mounting the photographs in geometrically organized assemblages informed by his love of the light in Dutch painting. The seventeenth-century Dutch artist Pieter Jansz Saenredam, a direct inspiration for Dibbets, painted church light; Dibbets gives us the light of a

contemporary church. His work suggests more reverence for the museum than do many of the later photographs discussed here, which are subtly and not so subtly critical.

Clearly there is a generation of artists whose attitude to the museum seems ambiguous and skeptical. One of these, perhaps, is Lothar Baumgarten, whose *Unsettled Objects* (1968–69) comprises photographic slides of the collection of the Pitt Rivers Museum in Oxford, England, and of individual artifacts contained there. The Pitt Rivers is a Victorian anthropological or natural history museum; the installation has not been significantly updated, and as a visual presentation evokes the past tale of Western culture's attempt, through its museums, to represent the lives of cultures that did not share its taxonomies and informing assumptions. Within each image, Baumgarten inscribes paired terms – "claimed/accumulated," "climatized/confined," "displayed/imagined," "selected/fetishized" – that suggest alternate and often mutually exclusive ways of understanding the anthropologist's museological practice. The issue, in part, is the meanings of the objects displayed – generally utilitarian things – in the terms of the society in which they originated. Never intended to be collected and aestheticized or anesthetized in a vitrine, these objects have been in a way embalmed by museology. The system has paradoxically preserved them while also depriving them of their history and life. "The name," Baumgarten writes, "directs memory – and forgetting."

Invited to prepare a project for *The Museum as Muse*, Michael Asher challenged The Museum of Modern Art by proposing that a list of all of its deaccessions, from its founding to the present day, in painting and sculpture, be made available to the public as a printed booklet. This information is no secret, but has never been compiled in one list, and presenting it as such asserts that a museum is neither static and somehow outside history (as it may sometimes seem) nor incapable of mistakes and misjudgments. Following a demythologizing impulse, Asher does not take into consideration what works may have been acquired, what possibilities opened up, through the deaccessioning of other works, but he does powerfully conjure an imaginary *musée des refusés*.

Richard Hamilton's fiberglass molds of Frank Lloyd Wright's instantly recognizable building for the Solomon R. Guggenheim Museum, reproduced as multiples, in various bright colors, to hang on the wall, divorce us from that institution and its contents and reduce it to a decorative object. Art & Language's series *Index: Incidents in a Museum* (1986–88) also comments on museum architecture and the art it contains: paintings showing the again quite recognizable galleries of New York's Whitney Museum of American Art, designed by the modernist architect Marcel Breuer, they pose questions about the ideological proximity of art and architecture – about the kind of art that the architecture seems to demand. Showing a Whitney gallery containing paintings leaning against the wall, as if in their studio, this group of theoretical artists, whose work is often literary, also aggressively stakes a claim for their own right to be in the museum, and establishes the reciprocal relationship between artist and museum as one of eternal recurrence. These paintings stand as illustrations of their theories and philosophies about the making of art.

Some sense of the museum's darker side, or else a darker way of viewing the museum, dates back to its very beginnings. In 1796, Hubert Robert, an artist who was also the first "curator" at the Louvre and was instrumental in its transition from royal palace to public building, created a wonderful painting of his projected design

for the museum's *Grande Galerie*. The oldest museum open to the public, the Louvre has long represented a summit of grandeur for artists and art audiences; countless artists have used it as their classroom, examining and copying the works displayed there. Many artworks, then, derive from or refer to its holdings. Much of this was yet to come when Robert painted his view of the *Grande Galerie*, but even then, one imagines, the companion piece he made for the painting must have caused a certain shock: perhaps in irreverence, perhaps with France's recent social upheaval in mind, he imagined the gallery in ruins. It is left to the viewer to conjecture whether the ruin stems from neglect, or from some act of violence, or simply from the passage of an enormous span of time. But surely one message of Robert's painting is the ultimate temporariness of even great works of art, and the vanity of the museum's efforts to preserve them.

One suspects that the impulse to imagine the museum in ruins goes hand-in-hand with the artist's dependence on the museum, which becomes a personality either producing or withholding affection. How to circumvent the overbearing parent? Yves Klein, for example, conceived of immaterial art-works – gold foil, for example, that is thrown into the Seine and washed away. Work demanding an individual's physical presence is hard to collect, as when Manzoni signed a woman's naked body as a work of art. (Nakedness, incidentally, is a strategy artists often embrace when trying to challenge curators and trustees.) A Christo project of 1968, represented in this exhibition by drawings and a scale model of the imagined scene, inverts the usual relationship of museum to art: rather than the museum containing the art, the art contains the museum. Christo proposed to wrap The Museum of Modern Art in cloth. He also wanted to block all entrance to the building by filling Fifty-third Street with 441 barrels. It is as if he wished to possess and appropriate the institution, to muffle its powers, to control the possibilities situated in it, to seal up the memory it embodies, and to remove it for a time from the world, implicitly asking whether we could live without it.

Another recourse artists have explored is the production of works that physically challenge or defy the limitations of an institutional building, for example the earthworks produced by Walter de Maria, Michael Heizer, Robert Smithson, and others, works that are both specific to outdoor sites and enormous. Dennis Oppenheim's *Gallery Transplant* (1969) was both large and ephemeral, and dealt with the museum more directly than much of this work: he drew the floor plan of gallery 4 from the Andrew Dickson White Museum (now the Herbert F. Johnson Museum of Art), at Cornell University, in the snow in a bird sanctuary near Ithaca, New York. Oppenheim's piece, however, also reveals some of the contradictions of this kind of art, in that it did result in collectible objects – photographs and a map, which appear in *The Museum as Muse*. Smithson, too, developed a practice adapted to the gallery by placing within it aspects of contemporary nature, ingredients of the landscape – pieces of rock, a "non-site." Yet this involved a certain dislocation of the museum's conceptual premises. Smithson also created plans for the almost inconceivable museum that could have housed his *Spiral Jetty* piece in Utah, and a Smithson drawing, *The Museum of the Void* (1969), shows the museum as an empty space, a tomb.

The desire to stretch the capacities of collecting is not aimed solely at the museum; this art, after all, cannot be acquired by private collectors either, and it stretches the parameters of both art dealers and art historians. But there is a body of recent art that seems hostile to the museum specifically – Edward Ruscha's *The Los Angeles County Museum on Fire* (1965–68), for example, a painting depicting the scene described in

the title. (The work seems in part a wry response to the unpopular and unfriendly building designed in 1964 by William Pereira.) Ruscha's piece might be said to update Robert's *Vue Imaginaire de la Grande Galerie en ruines*, although the mood of the latter painting is more closely echoed by Komar and Melamid's scenes of the Solomon R. Guggenheim Museum and The Museum of Modern Art as ruins in a pastoral setting. A more literal threat was embodied in *Samson*, an installation created by Chris Burden in 1985 at the Henry Art Gallery at the University of Washington, Seattle. Burden linked a 100-ton jack to beams aimed at the museum's load-bearing walls; the jack was also hooked up to a gearbox in a turnstile through which every visitor to the exhibition had to pass. Since every turn of the turnstile marginally expanded the jack, Samson could theoretically have brought the building down. In 1986, similarly, Burden had deep excavations dug below the floor of the Temporary Contemporary building of the Museum of Contemporary Art, Los Angeles. Revealing the concrete footing supporting three columns, Burden literally bared the museum's foundations. Steps enabled visitors to descend into the excavation to observe where the concrete met the earth.

A museum is a corporate body in which no one person has full authority: there is governance, committees that have to be assembled, and clearances that have to be obtained. It is, by definition, a conservative institution, and its bureaucratic and hierarchical situation – its funding as well as its often labyrinthine decision-making process – is something a lot of artists have felt it simpler to ignore and circumvent. Others address a head-on challenge to the institution's internal politics and corporate morality. Hans Haacke, for example, is well known for questioning aspects of museum practices, ethics, and finances, and for highlighting the role that the museum plays in the commerce of art. His *Cowboy with Cigarette* collage (1990) gently asks what could have inspired a tobacco company to sponsor an exhibition on the interplay between Braque and Picasso in early Cubism. In *Seurat's "Les Poseuses" (Small Version), 1888–1975* (1975), Haacke frames and displays biographies of each successive owner of the pointillist picture, documenting its passage through various collections – including those of John Quinn, Henry P. McIlhenny (Curator of Decorative Arts at the Philadelphia Museum of Art), and the European art investment group Artemis – thus representing it through its commercial history.

In the late 1960s in New York, the Art Workers' Coalition tried to make museums sit up: this was a group of artists protesting the institutions' lack of involvement with art by women and minorities. The Coalition was a strong force, particularly at The Museum of Modern Art, which it specifically targeted. A certain amount of this antagonism came out of the general questioning of institutional authority in the 1960s, which we have already noticed; but whatever its sources, it led to an interrogation of the degree to which a museum is implicated in the class structure (a museum's fund-raising demands tend to make some such implication inevitable), and a debate over its politics. Should the Museum, for example, have taken a position on the Vietnam War? The period's questioning of a museum's workings was to be pursued with the rigor of art by Haacke and others.

Vito Acconci's *Service Area*, first enacted in 1970 and revived for *The Museum as Muse*, gently subordinates the institution to the artist: for the duration of the show, Acconci has his mail forwarded to the Museum, which must look after it for him – letting visitors walk away with it would literally be a federal offense. Regularly stopping by to pick up his letters as if he had rented a post office box, Acconci is treating the Museum, he says, "not as a display (exhibition) area but as a place that

provides services: since I've been granted a space in the show, I should be able to use that space for my own purposes, make that space part of my normal life." *Proximity Piece* (1970), also revived for this exhibition, disturbs the museum visitor's expectation of a sort of contemplative privacy: as Acconci has written, the piece involves "standing near a person and intruding on his/her personal space. During the exhibition, sometime each day, I wander through the museum and pick out, at random, a visitor to one of the exhibits: I'm standing beside that person, or behind, closer than the accustomed distance – I crowd the person until he/she moves away, or until he/she moves me out of the way." This transgression of the museum experience ruptures the institution's aura as "rarefied-space/isolation-box/ home-for-museum-pieces."

The strategy is, in a sense, the inverse of Manzoni's in positing an artwork that a museum could not collect (a living woman's body): Acconci is creating an artwork by temporarily invading the museum with his own living presence. In *Oh Dracula* (1974), at the Utah Museum of Art in Salt Lake City, Burden worked similarly by replacing a painting on the wall with a large cloth "chrysalis" into which he then climbed. Invisible inside the cloth, Burden hung on the wall for one full day during ordinary museum hours. A lit candle stood on the floor beneath his head, another beneath his feet. Next to the work was an identifying label similar to those for the paintings around it.

Other manifestations of physical presence disturbing the museum air might include Duchamp playing chess with a nude woman in front of the *Large Glass* (that work's "bride"?) during his retrospective at the Pasadena Museum in 1963. In *The Physical Self*, an exhibition at the Boijmans Van Beuningen Museum, Rotterdam, in 1991–92, the filmmaker Peter Greenaway installed several nude models in vitrines. More recently, in a more accepting atmosphere, the British performance artist Vanessa Beecroft has presented performances in which unclothed or bikini-clad models have simply stood motionless on the museum floor, like mannequins in a store window. The attack on the museum's taboo against the living was taken to an extreme by the late Bob Flanagan, who, in failing health from a chronic and terminal illness, installed himself in his hospital bed with all its accoutrements for the duration of an exhibition held first at the Santa Monica Museum of Art, from December 4, 1992, to January 31, 1993, and then at the New Museum of Contemporary Art, New York, from September 23 to December 31, 1994.

Andrea Fraser's parodistic performances as a docent in different museums are shown on video in *The Museum as Muse*. Fraser seems to question the institution's premises even while accepting them as a reality. Finally, two more artists, through the use of fictional constructs, also manage to play with human presence in the museum without actually being present: Gillian Wearing's video piece *Western Security* (1995) shows a gunfight between cowboy gangs enacted at the Hayward Gallery, London, by amateurs of Westerns; and Janet Cardiff, in a work created for the exhibition, provides an aural guided tour of The Museum of Modern Art. While traditional museum guided tours seek to instruct the public and provide a didactic experience, Cardiff's tours alter the visitor's perception of the ordinary surroundings, simultaneously adding mystery and wonder.

This last group of artists shows a welcome sense of humor about the museum. Also witty is Kate Ericson and Mel Ziegler's *MoMA Whites* (1990), a group of eight jars containing the various white paints, in subtly variant shades, chosen by different curators for the walls of this institution's galleries. *Leaf Peeping* (1988), by the

same artists, is thirty-one jars of latex paint, in colors associated with fall foliage, installed on the wall in a kind of chart of the placement of the trees in The Museum of Modern Art's sculpture garden. Acknowledging the supercharged space that a museum becomes, with every decision on interior and exterior decor provoking much debate, these works refer such choices to the systematic procedures and the principles of seriality that have been so important in various schools of twentieth-century art.

General Idea's sales counter in the shape of the dollar sign, which carries this Canadian group's multiples, is amusing at the expense of the museum's commercial side, the merchandising of which many people are quite critical. Jac Leirner takes aim at the same target, presenting a large wall piece assembled from the shopping bags of museums around the world. Leirner implicitly asks us to compare museum practices – here, marketing and advertising – with the quite cerebral and ambitious art of the past whose approaches and formats (for example the grid) she appropriates. That art too may suffer from her wit, but she emphasizes the fact that the public's expectations of a museum now permanently include the presence of a shop and a range of commercial products. Robert Filliou, by contrast, addresses the museum's temple-like aura, collecting, boxing, and presenting the dust from major artworks as if they were holy relics; but his activity too has its hilarious aspect. Finally, Barbara Bloom's room-sized installation *The Reign of Narcissism* (1988–89) returns us to the idea of the artist's personal museum, but Bloom takes it to its logical extreme: all the images, objects, and artifacts in her collection carry her own likeness. Her fantasy is the ultimate museum that many covet.

Wit and humor are certainly facets in artists' reflections on museum activity, as they may be for the general audience also. But the museum remains an enormously complex body. Whether as members of the public or as staff, we all have a great many expectations of our museum visits, including, generally, the hope of a sublime memory and a pleasurable time; few, though, would say that ordinary pleasure or entertainment was the museum's raison d'être. If, for better or worse, the museum is in fact to remain a crucial site of its culture's memory, that must mean that inside the museum there is work to be done.

Jeff Wall's *Restoration* (1993) dramatizes one relatively uncelebrated aspect of that work. Wall's photographs often describe staged and fictional scenes that reveal intricate relationships to earlier art. Here, however, he articulates his concern with art history in a different way: by documenting the museum's preoccupation with restoration and conservation. This very large photograph (it is over sixteen feet wide) was taken in the conservation laboratory of the Kunstmuseum Lucerne. The transparency – illuminated from the back, as advertisements in public spaces often are – has an extraordinary luminescence, which, with the almost 180-degree field of vision, makes the activity of conservators at work into a near-Cinemascope display.

If the role of viewer risks introducing an element of passivity into our experience in the museum, Wall counteracts that problem by making us strain to grasp this enormous image in its entirety. Meanwhile the conservators are restoring a painting that is itself so enormous – it is a panoramic battle scene – that it swallows them in its spectacle; and we expend a certain effort simply trying to unravel the figures of the workers on their scaffolds from the image on which they toil. The result is a sense of layered, complex activity, a heightened realism, an awareness of the need for decipherment, and an awe at the labor involved in coming to terms with the past and extending its reach into the future.

Although the museum's art restorers generally enter the public eye only on occasions of unusual success or disaster, in *Restoration* Wall gives their work an epic scale, unveiling its heroic dimension. Yet conservation is only one of the museum's tasks, only one of the departments through which the museum performs its role; the security staff, for example, is no less vital to the preservation of the artwork than the conservators are. As a large institution, the museum is a compound organism. For many artists, I suspect, it is Kafka-esque in quality: it is the castle they must penetrate, the bureaucracy they must learn to manage. Having negotiated the paperwork, they must also take on the history laid out in the galleries: artists often disrupt the linear story that those galleries tend to tell. Their responses to what they see there come from a different perspective than that of the curators, and are no less well informed.

It is a peculiar relationship of mutual interdependence, and one in which the curator ends up on a tightrope. Does he represent the artist to the institution or the institution to the artist? Is he an intermediary between the artist and the museum, or the museum's personification? Overall, the relationship between museum and artist is far less adversarial than it was a few decades ago; occasional disruptions aside, the status quo prevails. Museums are allowed to maintain their lofty functions, and artists are allowed to behave in the expected way, their transgressions against the museum being usually consistent with the romantic definition of the artist. Even so, this fascinating cohabitation and coexistence will probably always contain an element of wariness. Like two superpowers that mutually respect each other, even mutually depend on each other, artists and museums nevertheless watch each other vigilantly – as if practicing for the field on which they are engaged together, the miraculous field of visual art.

Chapter 50 | Karen Mary Davalos

Exhibiting Mestizaje | The Poetics and Experience of the Mexican Fine Arts Center Museum

Increasingly since the 1870s, the public museum in the United States has offered visitors a European-centered version of what is referred to as an "American" cultural heritage, a patriotic and sanitized interpretation of the nation's past, and an authoritative account of taste.[1] In the public history museum, commitments to founding fathers, heroes of war, and men of capital create an institution that resembles a shrine to patriarchy and capitalism, excluding the role of internal conflict, inequality, and women in the nation. The large urban art museums in the United States, such as the Metropolitan Museum of Art in New York and the National Museum of American Art in Washington, D.C., claim a commitment to Western civilization, but they equate the West with Greece, Rome, Egypt, or Europe. Even the frenzy to remodel the public art museum so that it includes a new gallery or wing for non-Western art does not challenge the European-centered collection policy or, more important, the message that the entire citizenry traces its heritage to Europe. More revealing, the new galleries and wings do not shake off the evolutionary model of the public museum, in that they refer to non-European art as primitive, traditional, folk, or exotic.[2]

In fact, what is referred to as a public museum is the institution that presently condenses and categorizes history and experience. It is no longer the case that the side show, the circus, and the curio shop enjoy the same authority of the public museum as authors of the nation and educators of the citizenship.[3] According to Neil Harris, American museums in the first half of the nineteenth century were repositories of eclectic collections. Paintings and sculpture stood alongside mummies, mastodon bones and stuffed animals.[4] By the close of the nineteenth century, however, such curio collections as that displayed by Charles Willson Peale had lost their museum status and become instead a side show.

Karen Mary Davalos, "Exhibiting Mestizaje: The Poetics and Experience of the Mexican Fine Arts Center Museum" from Antonio Ríos-Bustamante and Christine Marin (eds.), *Latinos in Museums: A Heritage Reclaimed*, pp. 39–66. Malabar, Fl.: Krieger, 1998. Reproduced by permission of Krieger Publishing Company. (Reprinted without illustrations.)

Like these collections, however, public museums continue to display a variety of objects, but they do so in a way that promotes a unifying message. All objects and peoples are appropriated into a genre of similarity through stories of shared origins and futures. When the public museum admits to difference, it is as if inequalities and conflicts between cultures do not exist, and the visitor is encouraged to view the world as if it "were a vast [landscape] of self-sufficient economies, each one in its own display case, unruffled by the proximity of others."[5] Public museums also classify such potentially troubling objects as foreign and exotic – outside the boundaries of the imagined nation.

Taken together, the narrative and the collections of the public museum make it unusually clear that ethnic minorities, women, homosexuals, the homeless, and other "deviants" – or from my perspective, we – are not part of the citizenship and the nation. The public museum does not collect our histories and experiences, particularly not our art. It does not categorize our cultural products as "American" but marginalizes them, even placing them in the hallways and other makeshift galleries. Native American art is surely the exception, as it has been the core of many collections since and even prior to the Museum Age (1870–1930) – though it has been warehoused or displayed in natural history museums as if it and its producers were akin to plants and animals,[6] not humanity, and certainly not the nation's masculine and patriarchal citizenry.[7] By ignoring history or by dehumanizing Native Americans, the public museum glosses over the truth of the United States, much of which has depended upon our ability to survive social injustice. Thus, as long as the public museum functions as a nation-building institution, it is necessary for us to create our own institutions.

In the 1970s and 1980s, African Americans, Mexican Americans, Puerto Ricans, Asian Americans, and Native Americans began to create their own institutions to represent, interpret, collect, exhibit, or promote the art and culture of their own communities.[8] Many of these institutions were established within the communities and neighborhoods. However, they were more than sites of cultural exhibition and production, as their artistic goals were inseparable from the social, educational, and political goals. At times they functioned as advocates for ethnic communities, often becoming directly involved in community development, political action, and protest.

It is not surprising, therefore, that the discourse surrounding these museums is often celebratory, narrating a heroic act of resistance and affirmation and opposing the public museum. Calling for a new history of the United States, these museums spoke of the experiences of people of color and social injustices such as slavery and genocide. In particular they challenged the public museum's representation of people of color, immigrants, women, and other "deviants" as noncitizens. For some artists and activists, it became necessary to reject, even demonize, the public museum, arguing that those who exhibited in the public museum were sell-outs to their own communities.[9]

Within the Mexican American community, the subject of this essay, Chicano/a scholars and artists have been reluctant to engage questions about how we exhibit or represent ourselves. During the height of the Chicano art movement, it was enough for many artists, activists, and scholars to produce relevant messages for their local communities and to work for change through art and exhibition. At the time it was assumed that self-representation and empowerment avoided the problems of collection and interpretation. Oppositional art was, after all, a contestation of the oppressiveness of capitalism, nationalism, imperialism, or other social injustices. Initially,

however, not all social injustices were valid or authentic for oppositional artists; concerns of women, homosexuals, and biracial people were often excluded. Opposition was constructed as a pure and mutually exclusive condition which assumed the centrality of a masculine and heterosexual experience and celebrated cultures and peoples the public museum and the nation did not. It was unexamined how we could make the mistakes of the public museum, how the promotion of difference could also diminish heterogeneity, how an exhibition devoted to images of social injustice could gloss over inequality, and how self-determination could also recirculate the stereotypes about Chicanos and Mexicanos. In short, how could a counter-hegemonic institution practice nationalism?

Museums as Political Sites

The first premise is that public museums are political sites which disclose how communities are constructed and how nations are imagined. As a site engaged in the politics of representation, it is not enough to describe the "beautiful" objects of a museum nor is it sufficient to announce the success of an exhibition. Cultural critics must examine the complex, multiple, and ambiguous messages signified by Chicano and Mexicano museums. I recommend that awareness in addition to promoting pride, self-determination, and positive cultural identity, the visual narrative in Chicano and Mexicano museums can also recirculate stereotypes about Mexicans.

The description of complexity and multiplicity is not intended to diminish the emotional significance and importance of Mexican museums and exhibitions for Mexicano visitors. It is not my goal to write as if I have discovered a terrible secret of Mexican art/culture exhibition. Rather, I want to explore the ambiguities of representational practices, especially within museums not initially designed for the nation. Therefore, as I examine Mexicano exhibitions, I tread carefully so that as problems and contradictions are uncovered, they do not appear as predictions for behavior or essential experiences of museum-goers. By paying attention to ambiguity, I attempt to bring to light the processes and forces at work in representation and, as Martín-Barbero advocated, to avoid applying binary theoretical models that obscure the complexities of mestizo experience.[10]

In fact, it is to *mestizo* experience, to life on the borders, that I want to look for a new way of thinking about cultures and the sites that organize and interpret cultures: in this case, the museum. Mestizo experience denies the rigid boundaries between cultures and nations usually proposed by public museums or nationalism. Mestizo cultures are more fluid, porous, and flexible than objectivism, popular belief, and dominant ideologies would have us believe. Mestizo experience cannot be considered from one perspective because it always originates from at least two places. In displaying mestizo experience, contradiction appears most clearly because we are so well versed in nation and nationalism. I suggest that we cannot confine Mexicano and Chicano exhibition to one geopolitical or cultural place – this side or *al otro lado*, "us" or "them." *Mestizaje* is both an expression of cultural affirmation and self-determination and a result of domination. It is the combination of these expressions that gives rise to the hybrid forms that are not "co-opted" or "authentic."

Ironically, the original discourse and promotion of mestizaje did not include hybrid experiences beyond the cultural. *Criollos* in New Spain limited their efforts to the recognition and authentication of the mixed heritage that had "created the unique

Mexican people."[11] Their understanding of cultural hybridity (at the time called "racial mixing") excluded gender and sexuality. In fact, in revolutionary Mexico mestizaje was a strategy for nation building, and it "became the ideological symbol of the new regime."[12] I employ Gloria Anzaldúa's notion of mestizaje, however, which invokes hybrid cultures, genders, sexualities, languages, and voices. Located on the border, Anzaldúa's vision of mestizo experience works against nations, fixed identities, and harmony. Focusing on chaos, ambivalence, and the tension produced by culture contact, Anzaldúa insists on recognition of "this place of contradictions"[13] and finds a "way of balancing, of mitigating duality"[14] by opening up to the queer, the "other," the female, and the indigenous.

Marcos Sanchez-Tranquilino and John Tagg put forward that the *pachuco* and *pachuca*, Mexican American urban youth of the 1940s, embodied mestizo hybridity.[15] They argue that the aesthetic style of the pachuco and pachuca – particularly their zoot suits (with wide shoulders and pleated, ballooning pants narrowing at the ankle), their beehive hairstyles, their *caló* language, and their defiant stance – broke boundaries. By dressing, speaking, and walking in ways that did not signify "America" or "Mexico," the pachuco and pachuca expressed "the dualities of rural and urban, Eastside and Westside [of Los Angeles], Mexican and American, and, arguably, feminine and masculine." These dualities were "not pure negation. Not *mestizo* – half and half – but an even greater *mestizaje*. A new space: a new field of identity."[16]

It is precisely this "new field of identity" that causes me to question the distinctions James Clifford made in his travel account of four North-west Coast museums. Clifford suggested that public museums are distinct from community (or in his words, "tribal") museums, arguing that even though all museums are local, majority or public museums are designed to reflect a universal human heritage. Community museums, he contends, express the concerns of a specific population in opposition to the majority:

> (1) [The tribal museum's] stance is to some degree oppositional, with exhibits reflecting excluded experiences, colonial pasts, and current struggles; (2) the art/culture distinction is often irrelevant, or positively subverted; (3) the notion of a unified or linear History (whether of the nation, of humanity, or of art) is challenged by local, community histories; and (4) the collections do not aspire to be included in the patrimony (of the nation, of great art, etc.) but to be inscribed within different traditions and practices, free of national, cosmopolitan patrimonies.[17]

Although his attention to the art/culture subversion is useful, I indicate that the distinction between the "tribal" and the public museum allows us to imagine that these institutions are mutually exclusive. In this chapter I examine the visual narrative of a Mexicano museum, proposing that exhibition styles and interpretive techniques can work within nationalism or recirculate the ideological location of the Mexican immigrant within United States nationalism. More important, the visual narrative of a Mexicano museum might reflect both opposition and accommodation because it borrows display techniques from the art museum and the ethnography museum. In general, my argument differs from Clifford's in that I do not view opposition as a discrete and fixed entity but something that is slippery and porous. I prefer to describe the exhibition of Mexicano art and culture as mestizaje, a hybrid form whose very existence interrogates the binary objectivism that has imagined people and cultures as discrete, seamless wholes.

In addressing mestizaje, this chapter has two goals. The first is concerned with the visual narrative of a Mexicano museum. I examine the complexity, multiplicity, irony, ambiguity, and accommodation expressed in the representation of Mexicano art/culture at the Mexican Fine Arts Center Museum (MFACM).[18] I suggest that although this Mexicano museum is bounded somewhat by the conventions of display and histories of imperialist collecting, it simultaneously works against the powerful conventions of representation to create a hybrid form. The second goal is concerned with the experience of Mexicano museum-goers. What happens when Mexicanos enter an exhibition? The visual narrative of the museum, borne of resistance and accommodation, does not signify one meaning but multiple meanings as each visitor passes through the museum using his or her own history to interpret and experience the objects on display.

Mexican Fine Arts Center Museum: "For Our People" and "For Everyone"

Founded by two educators, Carlos Tortolero and Helen Valdez, the Mexican Fine Arts Center Museum (MFACM) opened its doors on March 27, 1987, in Chicago's Pilsen neighborhood, a predominantly Mexicano community since the mid-1960s.[19] As an institution, however, the MFACM has coordinated and produced exhibitions since its incorporation in 1982. During its first five years, the museum sponsored over twenty-four events and programs, including a folkloric dance concert and exhibition seasons in 1983, 1984, and 1985.[20] The Mexican Fine Arts Center Museum is the first Mexican museum in the Midwest and as of 1996 had produced over thirty-five exhibitions, with shows touring the United States and Mexico. The exhibition season is divided into four areas: the annual exhibition for El Día de los Muertos (the Day of the Dead), contemporary art, traditional art, and Mesoamerican art/artifacts. In addition to the visual arts, the MFACM is also dedicated to the performing arts, music, and dance. Performing artists have included Nobel laureate Octavio Paz, actress Ofelia Medina, critic and writer Carlos Fuentes, and MacArthur fellows Guillermo Gómez-Peña and Sandra Cisneros, as well as the specifically Chicano rock group, Dr. Loco's Rockin' Jalapeño Band.

The MFACM is a nationally recognized museum, particularly because of its outreach and education programs. In 1992 it was selected to participate in the Marshall Field's Chicago Arts Partnerships in Education, a program designed to enhance arts curriculum within the public school system and to create art-centered schools. Working in partnership with local elementary schools in the Pilsen/Little Village area, the MFACM has advocated for and helped establish Orozco Arts Academy, an elementary school devoted to fine arts curriculum. In 1995 the MFACM was identified as a recipient of the National Museum Services Award. Also in that year, the MFACM received a $475,000 grant from the Pew Charitable Trust to plan and launch "*Puentes*: Bridging Cultural Communities," a four-year project to build cross-cultural understanding through collaborations with art institutions in Chicago and Mexico.

Finally, the Center Museum's notion of "promoting Mexican culture" includes advocacy and action for the Mexicano community. The MFACM collaborates with community-based organizations to increase the number of day care centers, to enhance arts curriculum, and to improve education, housing, and the political power of Mexicanos. The museum also functions as a liaison for artists to local arts councils, arts institutions, and publicly funded arts programs.

The MFACM emerged at the moment when Latinos found an opening in Chicago's remaking of itself. Former Mayor Harold Washington, the first African American mayor in the city of Chicago, built a coalition among people traditionally ignored by Chicago's Democratic machine. This coalition, or at the least the discussion of such unity, opened a discourse never before imagined at the political level. Historically Chicago had been conceived of as a black-and-white city, and city politics were established along these lines, which excluded something not black or white. The coalition allowed Mexicanos and other Latinos to expand the black/white discourse. The MFACM is one of several community-based cultural centers and organizations to emerge from the political shift that established Mexicanos as players in the metropolitan arena. During the 1970s and early 1980s, Mexicano leadership demanded and won local and federal funds to support social service centers, drug rehabilitation centers, cultural institutions, and education programs. The Center Museum continues to play an active role in city programs that affect Mexicanos, particularly those in the Pilsen and Little Village neighborhoods.

In fact, the mission statement of the MFACM constructs the institution as a site between cultural groups; that is, mestizaje is the Center Museum's design. Although the primary goal of the museum "has been to conserve and preserve for our people,"[21] both Tortolero and Valdez state that the primary goal supports a secondary goal of outreach to non-Mexicanos. Valdez contends that outreach allows the MFACM to "confirm our reality as a community."[22] The mission statement illustrates how the MFACM imagines itself in the city, the region, and the nation(s):

> The Mexican Fine Arts Center Museum evolved out of a commitment to awaken the City of Chicago to the wealth and breadth of the Mexican culture, as well as to stimulate and preserve the appreciation of the arts of Mexico in the city's large Mexican community.
>
> The Mexican Fine Arts Center Museum is the first Mexican cultural center/museum in the Midwest and the largest in the nation. The Museum has the following goals: to sponsor special events and exhibits that exemplify the rich variety in visual and performing arts found in the Mexican culture; to develop and preserve a significant permanent collection of Mexican art; to encourage the professional development of local Mexican artists; and to offer arts education programs.
>
> The Mexican Fine Arts Center Museum serves as a cultural focus for the more than half a million Mexicans residing in the Chicago area and it also serves as a cultural ally to other Latino cultural groups in the City of Chicago.

As a site for cross-cultural contact, the MFACM is constructed on a metaphorical border between Mexico and the United States. This border exists without nationalist and geopolitical claims. The events sponsored by the MFACM do not come from Mexico or the United States but from "the Mexican culture," which can exist "anywhere Mexicans have gone" [interview with Carlos Tortolero, July 8, 1994]. In addition, the border is a site where conflict is resolved. During an interview with management analysts Michele Nadanyi and Mark Parry, Tortolero explained it this way:

> The museum is for every Mexican in the world, our honor is at stake; we want both the local community and the mainstream world to visit . . . so that we can break down some of the barriers. . . . If only our own people come here, we will have failed in our mission. We really believe that this is a place for everyone.[23]

Though not imagined as one, the Mexican Fine Arts Center Museum is a public museum, "a place for everyone." Similar to the other eight museums on city park property, such as the Adler Planetarium, the Art Institute, the Chicago Historical Society, the DuSable Museum, the Field Museum of Natural History, and the Shedd Aquarium, the Center Museum is a member of the Museums in the Park and receives a proportion of the parks tax levy.[24] In 1994 the MFACM received approximately 38 percent of all its operating funds from the tax levy. In that year members of the Museums in the Park committed to a ten-year capital bonds budget for the MFACM. In addition, it applies for and receives grants from public bodies such as the Illinois Arts Council, the Chicago Department of Cultural Affairs, and the National Endowment for the Arts. Third, admission to the Center Museum is free, which grants visitors not only access but a sense of ownership. It is a museum for the public.

Art and Ethnography Museums: Inscribing Objects and People

In order to understand how the MFACM mixes display techniques and aesthetic styles and thus complicates representation, how art museums and ethnography museums treat objects, how they inscribe objects, and how the message is conveyed through the style of display must be examined.[25] Thus, my focus on the public museum concerns how it produces particular ideas and beliefs and is itself a "product of social and political interests."[26]

Art museums arrange objects individually or in isolation from one another. This display style is generated from the premise that the objects on exhibition represent a unique example of a style or school, the achievement of an individual, or the authoritative example of taste or beauty. Upon viewing an original artistic statement, the student of art feels a thrill of emotion and a heightened sense of being.[27] The "untutored visitor" can understand or appreciate the object if the visitor is permitted to glimpse beauty or fine taste unencumbered by didactic labels and display elements.[28] "Focusing on a single object facilitates the concentration necessary for the aesthetic experience to occur."[29] In fact, nothing – including the color of the walls, the lighting, the identifying labels, the hardware, the security rope, and other architectural elements – should distract the viewer from seeing and experiencing each object one at a time.

In the art museum an object's social location and historical context are erased; the object has no additional meanings, messages, or background outside its aesthetic qualities. As Douglas Crimp pointed out, the object in the art museum refers "only to itself – 'itself' indicating both its material essence and the self-enclosed history of the medium."[30] Therefore the assertion that objects "belong to no particular place" allows curators to pretend that objects simply materialize at the museum's doorstep.[31] It is not necessary to discuss their acquisition, the terms of their collection, or their route from personal object to art market.

Removed from their original historical context, art objects implicate a larger, universal history, suggesting that all visitors (at least those visitors who resemble the image of the nation: men, heterosexuals, and Anglo-Saxons) share origins and experiences with "beauty." The premise of universality is even more apparent in the ethnography museum, which is based on a modern impulse to construct a "continuous evolution from ancient times" to the present.[32] The invention of universal origins conceals conflict, difference, and incompatibility and by default implies that the

objects on display represent the heritage of all current populations. Beyond universalism, however, ethnography museums have little else in common with the art museum.

The significant difference between the art museum and the ethnography museum is that ethnographic exhibitions are driven by interpretive ideas, not form. Objects are employed to convey a particular concept, place, or relationship so that they signify products (or artifacts) of a culture, not the inspiration of specific individuals. Constructed as artifacts and not fine art, objects are displayed along with didactic labels, charts, time lines, tables, or diagrams and *with other* objects. In fact, early ethnographic exhibits were distinguished by their clutter and density of objects. Although labels provide historical and social information, they rarely acknowledge the individual or individuals who created the object, since objects are intended as the achievement of a cultural group. This approach suggests that individuals who create objects are not as important as the curators, anthropologists, or adventurers who "recover" the object or the person who purchases the object. The anonymity of the producers makes it difficult for audiences to visualize living people or to mistake the objects as the essence of the culture group. Both interpretations suggest that the population on display is dead, quantifiable, monographic, and faceless.[33]

This interpretation is closely associated with the ethnography museum's imperialist and nationalist origins. The ethnography museum (and the proto-art museum) was initially designed to display the trophies of imperial conquest, an intention that has translated into a classificatory scheme for civilizations as primitive or advanced, traditional or modern, and savage or human. Sally Price argues that the ethnography museum's concern with classification (primitive, stone age, developing, industrial) serves as an organizing strategy to produce cultural differences and distance, imagining entire populations as "us" or "them."[34]

Mexicano Exhibition: New Messages and Meanings

Exhibitions sponsored and organized by the Mexican Fine Arts Center Museum employ a range of display techniques and interpretive strategies.[35] For example, as in the art museum, objects are frequently isolated on podiums and behind Plexiglas. Displayed like original treasures, objects are set in isolation from one another using light, space, and color. Works are assigned a brief label identifying the artist, the name and date of the work, the medium, and the name of the person or institution who loaned the work. Exhibitions that tour the United States and Mexico locate objects within an international fine arts aesthetic and market. For example, the traveling exhibition "Art of the Other Mexico: Sources and Meanings" (June 18–September 12, 1993) – the first international touring exhibit of Mexicano and Chicano artists that was organized and curated by Mexicanos and Chicanos – inscribed the objects as aesthetic achievements and gained recognition from the international fine arts community. In fact, all objects exhibited at the MFACM – from the paintings created by local schoolchildren, the *retablos* of the nineteenth and twentieth centuries, the sculpture of Juan Soriano, the photographs of Agustin Victor Casasola to the mural-like paintings of Alejandro Romero – are presented as fine art, an attribute invoked in the museum's name.

Similar to the ethnography museum, the MFACM uses techniques to establish the object's social context. Using highly visible and linguistically accessible didactic labels written in both Spanish and English, the MFACM provides information such as the

artist's life history and motivation for creating the object, the symbolism within the object, the intentions of the artist, or the events and feelings portrayed by the object. At the entrance to many exhibits, lengthy explanatory labels provide the visitor with a larger social history of the objects on display. This type of historical information is intended to make objects relevant to visitors, to present information omitted by local school curricula, and to promote a sense of ownership by connecting objects to sociopolitical issues and community concerns. The strategy to connect current political events with the content of the work locates objects in the realm of self and nation, private memory and public action.

At first glance it is ironic that the MFACM borrows aesthetic styles and display techniques from the art museum and the ethnography museum. Not only do these museums have contrary approaches to objects and people, but the Center Museum's concern with self-determination and affirmation are compromised by these approaches. For example, the interpretive strategy of isolating objects and presenting them as individual artistic achievements is curious in a museum that emphasizes community, not individualism. And the strategy of inscribing objects as artifacts – the debris of "dead" cultures – is problematic in a museum that encourages its visitors to view Mexicanos as living constituents in the city of Chicago. Similarly, the display of objects as if they were aesthetic achievements undercuts the premise on which Mexicano and Chicano art is based – that it exists in a particular cultural, political, and social context.[36] Can a Mexicano museum reclaim objects by simply displaying them in a finely appointed gallery? Finally, the interpretive strategy and display techniques of the ethnography museum suggest that peoples and cultures are coherent, bounded, and timeless. By suggesting a monographic or monolithic Mexican culture, does the MFACM undermine its central premise of diversity and complexity?

This study argues that the mixing of aesthetic styles and display techniques produces unanticipated results that rupture the message initially conveyed in the ethnographic or artistic approach to objects. In what follows, I examine select exhibitions at the MFACM: "The Amate Tradition"; "Popular Toys of Mexico"; "Mexico, La Vision del Cosmos"; and "The Day of the Dead." For each exhibition, I discuss how it ruptures the original visual narrative of the public museum by reconfiguring the art/culture distinction, by deterritorializing the nations of Mexico and the United States, and by locating objects in histories of domination and dispersal. In addition, I examine how exhibitions are complex sites of cultural representation that produce a variety of messages and experiences, some of which work in tension with messages of affirmation, liberation, and resistance.

Art/artifact/souvenir

The Center Museum's exhibit of "The Amate Tradition: Innovation and Dissent in Mexican Art" (January 27–May 28, 1995) raised questions about the art/artifact distinction and explodes the two categories by elevating a third category: souvenir. This exhibit showcased contemporary *amate* (bark paper) paintings created by Nahua artists from the Alto Balsas region in the state of Guerrero. Amate painting emerged in the mid-1960s as potters, influenced by commercial markets, changed their medium from ceramics to bark paper. The exhibit recognized that amates are souvenirs, or tourist art, but repositions them as historically and politically situated objects of fine art. As narrative paintings, amates include a range of expressions: private nightmares, personal dramas, reinterpretations of European icons, pastoral utopias, social

commentary, and public protest.[37] Dissenting voices were the center of the exhibition, particularly those that illustrate the "struggle against the planned construction of a hydroelectric dam that would have forced the relocation of forty thousand people" living near San Juan Tetelcingo.[38] Reinterpreting a religious figure, amate artists transform Saint James (Santiago), whose presence in Mexico can be traced to the Spanish conquest, into a "dauntless defender of indigenous rights."[39] Through Santiago, the amate paintings narrate two futures: one in which the dam destroys the inhabitants of the Balsas River basin and another in which the builders of the dam are swept away in an attack led by Santiago. By allowing these objects to retain their political content and by locating them in a specific historical moment, the exhibition played with and challenged the categories of fine art, "tradition," and tourist art.

In addition, the amate paintings were displayed with a retrospective exhibit of Balsas Region ancient and contemporary ceramics and wooden objects, the precursors of amate painting, in order to demonstrate the transition of images from three-dimensional to two-dimensional surfaces. This part of the exhibit traced the production of Balsas Region ceramics from ancient civilization to contemporary practice among families. Focusing on the recent production of ceramics for market, thus for aesthetic rather than utilitarian purposes, the exhibit explored how ceramics became a commodity on the international market beginning in the 1930s as the government, Mexican intellectuals, and commercial and private buyers increased, stimulated, and circulated their production. More important, the exhibition recognized the role of individual expression, family contributions, and government agencies such as FONART (Fondo Nacional por las Artesanías) in the production and circulation of both amate paintings and pottery, thus not allowing the museum visitor to imagine a timeless and pristine "traditional" or masculine culture. Together, the amates and the pottery signify cultural innovation and self-determination among indigenous men and women.

Interestingly, the exhibit had more to offer. Thirty photographs accompany the amate paintings. The Introductory Panel at the MFACM refers to the photographs as "ethnographic"; that is, they are positioned as records of the daily life and environment of the Nahuas, not as the creative work of José Angel Rodriguez, the principal photographer. The introductory panel continues: the photographic "exhibit [is intended] to foster a more profound appreciation for the creative spirit, political awareness and individual identities of Nahua artists who paint on amate."[40] Therefore, unlike conventional ethnographic displays of indigenous people that encourage an evolutionary perspective and anonymity, the photographs affirm the creative, politicized identities of specific Nahua artists. At the same time the photographs are a backdrop for the amate exhibit, referencing the aesthetic achievement and the political and social contexts from which the objects originate. Together, the exhibition contests the public museum's anonymous approach to so-called tourist art, folk art, and indigenous people.

The amate exhibit illustrates that Mexicano exhibition operates on multiple and often conflicting levels. First, the exhibit is a display of art and artifacts. However, it also interrogates the art/culture distinction and suggests an alternative hybrid location for the amate as souvenirs of resistance. Second, the exhibit challenges the assumption that so-called tourist or folk art is apolitical. What remains unanswered is how amate paintings circulate in the cultural memory of Chicago's Mexicanos. Does the Mexicano museum visitor share in the reclaiming of amate paintings as fine art, since for her or him Mexico is not a vacation place but a homeland?

Deterritorializing and recirculating nations

The exhibition "El Juguete Popular Mexicano/Popular Toys of Mexico" (March 1–June 9, 1991) signifies multiple and potentially ambivalent narratives: affirmation/liberation and accommodation/domination. "El Juguete" showcased over one thousand toys of Mexico from the collections of the Museo National de Artes e Industrias Populares and Casa de las Artesanías del Estado de Michoacán. Similar to the amate exhibition, "El Juguete" reinscribed popular art as fine art.

> The toys of Mexico have a distinctive aura of folk fantasy about them. They are also among the most abundant and imaginative in the world. Fashioned from a vast range of materials, they reveal, possibly more than any other craft, the ingenuity and inventiveness of their creators. Yet, because of the ephemeral nature and low commercial value of these objects, toy makers are rarely recognized for their skills. Toys are frequently overlooked for serious study and [we believe] the need to establish a museum exclusively for toys, in Mexico, is apparent.[41]

Text from the exhibit reveals how the MFACM repositioned and affirmed personal and everyday items as objects for serious art collection. However, unlike the amate exhibit, "El Juguete" suggests that emotions are central to exhibition programs, not just artistic ability and skill: toys have a "special place in the hearts of people of all ages."[42]

It is unclear, however, if the exhibition signals a transnational community – Mexicanos and their toys throughout North America – or Mexican nationalism.[43] Hand-crafted toys, along with particular festivals (e.g., El Día de los Muertos), cultural groups (Oaxaceños), and pre-Columbian civilizations (Aztecs), have been promoted by the Mexican government since the Porfiriato in an effort to homogenize an otherwise diverse citizenry.[44] From the start, Mexican nationalism was conceived as necessarily homogeneous, and political and social leaders have tried to diminish or erase Mexico's indigenous diversity. Jesús Martín-Barbero points out how the homogenizing effects of nationalism have resulted in the circulation, collection, and marketability of select popular arts, including toy making, at the expense of other cultural practices. More critically, García Canclini argues that Mexican government agencies sanction particular festivals, objects, and peoples in order to develop capital and the tourist economy.

Given this history, an exhibition of toys is not simply a celebration of the "ingenuity and inventiveness" of artists but a confirmation of the nation: in this case, Mexico. The recirculation of Mexican nationalism is problematic for a cultural institution that challenges national boundaries and questions national authority.[45] Thus, while the exhibit affirms the everyday items and emotions of Mexicanos and thereby recognizes and authorizes toy makers as creators of fine art and as national cultural treasures, the exhibit awkwardly supports a nationalism that denies the existence and identity of the Center Museum's founders and members.

Ambiguity, chaos, and creativity

"Mexico, La Vision del Cosmos: Three Thousand Years of Creativity" (January 31–May 31, 1992) featured over 150 objects on loan from the Field Museum of Natural History, representing over 3,000 years of Mesoamerican or pre-conquest

civilization. Not only does the exhibition invoke a history of conflict and inequality, but the objects resonate with the tension between Western imperialism and objectifying social science.

The exhibition was part of a season of programming dedicated to a revisionist history of the encounter between the Americas and Europe. The text of the introductory panel and exhibition catalog explains the Center Museum's intentions for the exhibition.

> Nineteen ninety-two is a milestone year for people of the Americas. It marks the 500th anniversary of an invasion, not a discovery of the Americas. The fact that many people want to see this event as a discovery and want to celebrate it as such is ludicrous if anyone analyzes the consequences of this encounter. To call it a discovery is to deny both the millions of people who are already living in the Americas and their cultural achievements. The reality, and it is not a pretty one, is that millions of Native Americans of North America, Central America, South America, and the Caribbean were killed or died from the various diseases that were brought from Europe. Hundreds of indigenous cultures were destroyed in the process. Millions of Africans were inhumanely brought over as slaves, with hundreds of thousands dying in a process that endured for over three hundred years. It was both a human and cultural genocide.[46]

One hundred fifty-eight objects are positioned as a recognition of the conflict produced by the cross-cultural contact between the Americas and Europe. In addition, the objects call attention to an unequal relationship and the persistence of indigenous cultures. Moreover, the exhibition suggests that people who celebrate "discovery" are implicated in the "human and cultural genocide" produced by this cultural encounter.

Beyond the interpretive move to relocate objects as a sign of resistance, the design of the exhibition invokes mestizo experience. Thus, pre-Columbian objects address at least two perspectives. First, the objects are described as fine art, as creative achievements. However, they are more than aesthetic accomplishments, as they affirm the taste, skill, and development of Mesoamerican civilizations, demanding equal authority with European fine arts. Second, they are displayed in an ethnographic style with a time line, maps, dioramic murals, and detailed explanatory labels. Operating as artifacts, the objects represent that ancient presence in Mexico, a history that does not depend upon validation from Europe but demands its own criteria.

The MFACM's unique accomplishment of producing this exhibition, however, is complicated by the fact that the exhibition depended on the Field Museum of Natural History's Starr Collection. The objects on display – a small part of the Starr Collection – are a contemporary result of the very encounter to which the Center Museum refers in the introductory panel. During the last decade of the 1800s, Dr. W. D. Powell, the first Southern Baptist missionary to Mexico, excavated and eventually sold the objects on display to Frederick Starr of the University of Chicago. Described as a "business associate" of anthropologist Starr, Powell excavated the objects from ancient graves, an inhumane practice currently challenged by indigenous populations.[47] The objects signify the Spanish conquest and the Field Museum's part in United States imperialism. The objects are artifacts of these unequal encounters.

At the same time the objects – usually in storage at the Field Museum of Natural History – remind us of a past when "the material properties of tribal peoples were classed with strange flora and fauna, as objects of wonder and delight, to be collected as trophies, souvenirs, or amusing curiosities during one's travels to far and distant

lands."[48] The objects have not moved out of a natural history museum and into an art museum, specifically Chicago's Art Institute, because they retain their exotic properties. In fact, catalog essayist Donald McVicker refers to the shaft tomb effigy figures as "prize items in any collection of Prehispanic art."[49] Finally, the Field Museum's requirement of a security guard raises other complications for the Center Museum. From whom does the guard protect these objects? Who can claim ownership of these objects? Descendants of Mesoamerican civilizations, anthropologists, or grave robbers of Mesoamerican civilizations?

Mestizaje, however, denies coherence and completeness. The mestizo space created through the exhibition of Mexicano art and culture is an ambiguous location made of chaos and creativity. That is, Mexicanos create new coordinates when they exhibit themselves and refer to their own cultural products as artifacts, focusing on survival and innovation, not bygone days and peoples. "Mexico, La Vision del Cosmos" is "quite possibly the first time that an exhibit of pre-Columbian artifacts, many of which have never been shown before, has ever been exhibited within a Mexican community in this country."[50] The exhibition is perhaps one of the best examples of "first voice" representation, a practice that recognizes the conventional approach to the interpretation of objects but encourages new meanings, actors, voices, and sources.[51] From the "first voice" perspective, Mexicano exhibits do not necessarily move objects into distant coordinates but closer to Mexicanos. That is, the presentation of objects works not to produce difference between groups but to establish familiar cultural property.

Exhibiting mestizaje: Día de los Muertos practices

A discussion of mestizo experience would not be complete without an examination of Día de los Muertos practices. The Day of the Dead is itself a cultural product that resulted from cross-cultural encounters. It signifies a contact zone between Spanish Catholicism and pre-Columbian cosmologies, and it has more recently been re-invented in the United States as Mexicanos and Chicanos reclaim their cultural heritage. Chicago's first public practice of the Day of the Dead was organized by Clay Morrison in 1981 at the West Hubbard Gallery. The Mexican Fine Arts Center Museum officially recontextualized the practice in 1987 with the opening of their annual Día de los Muertos celebration.

By moving the practice into the Center Museum, the cultural products of and for the Day of the Dead shift in meanings. In the home and at the cemetery, altars and altar makers, usually women, are connected through intimate and personal experiences. The altar is a private space of worship, homage, and faith created out of intimate knowledge and experience with the deceased. In the MFACM the secular combines with the sacred as well as the market. (The Center Museum's store sells *calaveras* and other objects traditionally associated with *ofrendas*.) At the same time the everyday practice of altar making is sanctified as fine art, now referred to as "installations." That is, they provoke both an aesthetic response and a religious experience.

The ofrendas/installations at the MFACM are commemorative, collective, individual, private, and public. Each year several artists, youth groups from schools, and local practitioners create ofrendas/installations that pay homage to family and friends. These personalized works share space with ofrendas/installations that communicate a political message, an innovative practice that challenges concepts of authenticity and tradition. For example, in 1988 Laura Gonzalez created an ofrenda/installation for

the victims of the September 1985 earthquake in Mexico City. In that same exhibition Carlos Cortez created an ofrenda/installation dedicated to the people around the world and throughout history who died because of racial, religious, or cultural intolerance and oppression. Cortez commemorates the Aztecs of Tlatelolco, the Jewish uprising in Warsaw, and the massacre at Wounded Knee. In 1990 Mario E. Castillo created an ofrenda/installation for Vincent Van Gogh on the one hundredth anniversary of his death.

In 1992 the MFACM reconstructed the Day of the Dead and the annual exhibition as part of the season's revisionist project, providing another "Meaning of Día de los Muertos: 500 Years of Resistance" and making it a marker for cultural survival, inequality, and oppression. Crossing back and forth between political (public) and intimate (private) issues, the exhibition did not refer to religious practices or traditional celebrations as apolitical events. Instead, like "Mexico: La Vision del Cosmos," the 1992 Day of the Dead exhibit challenged the "discovery" myth of the Americas and celebrated the ability of indigenous peoples to resist devastation.

> During the last 500 years, many of these indigenous groups have continued to resist their eradication. Mexico in particular is fortunate to still have the contributions of 56 different indigenous groups who have struggled to maintain their rich cultures, languages, and traditions. One of the most beautiful and moving of the traditions which has endured over the centuries is the *Día de los Muertos*. Although contemporary manifestations of this tradition incorporate Catholic elements, it is essentially an indigenous tradition.[52]

The Day of the Dead is repositioned as resistance to the conquest, unmasking the discourse of discovery as another imperialist move. The exhibit also suggests that the Day of the Dead is more than an echo of the past; it is a symbol of a possible future of cultural and human survival. Of course, this exhibit is not without its complexity and ambiguity. The use of strategic essentialism nearly freezes in time "indigenous tradition" while it allows the Center Museum to reclaim an indigenous authenticity and authority in the contemporary practices of Día de los Muertos. That is, claims to an essence may bind and fix indigenous culture, but it also establishes the discourse for indigenous survival and resistance.

Mexicano Museum Visitors as Active Subjects

Mexicano exhibition techniques are powerfully reinscribed by Mexicano visitors who rework, and at times displace, the dominant narrative of the public museum and the nation regarding immigrants. Moving objects into unanticipated spaces and meanings, Mexicano museum-goers dislodge the curator's concerns with fine art or artifact as they employ their own senses and claim the objects for themselves.[53] I suggest that Mexicanos perform the "ritual of citizenship" at the Mexican Fine Arts Center Museum[54] but that this ritual creates a new nation and museum as well as an identity that does not depend on nationhood.

Most Mexicanos learn at a young age that public museums are not made for them but instead are institutions closed off to them. In addition to the cost of museum membership or entrance tickets, the security guards and ropes convey that we don't belong. More important, the language, message, and focus of the public museum excludes us. At the Center Museum, however, Mexicanos are the experts, intimately

familiar with the images, icons, and messages of the objects on display. Their cultural literacy is particularly powerful because the MFACM speaks to them as the site of authority and in the first person: these objects are ours. This authority and sense of entitlement or ownership is a unique experience for Mexicanos, as most public museums erase them. Finally, Mexicanos find within these exhibitions a homespace, a territory of belonging, as they are transformed into owners and creators of a culture.[55] Their citizenship, imagined by the practice of Mexicano exhibition, rewrites the dominant narrative about the American citizen, since it invokes multiple cultures and histories *sin fronteras* (without borders). However, because this homespace is lacking territory, the Mexicano body itself becomes the location for nation, community, and culture.

What are the implications of the new citizen and new nation? What types of actions do mestizo representational practices invoke? I suggest that Mexicanos – moving between their homespace and the geopolitical borders and other places of culture contact – establish themselves as owners of Mexicano exhibitions. A sense of ownership is particularly evident during the opening night of an exhibition, when museum members, artists, and community leaders are invited to an evening reception. I have observed Mexicano visitors act as translators and cultural ambassadors to European Americans and others who are not familiar with the work on display. The tone and stance of the translation are significant. Mexicano museum visitors do not whisper, apologize, or defend the objects but instead speak with confidence and pride as they describe their relationship to the work, its content, and its message. Rarely have I heard self-appointed cultural ambassadors ask for an interpretation from an artist or curator, because in claiming ownership in the work they authenticate their own perspective. That is, these self-appointed cultural ambassadors do not act like docents because they do not tell others what *the* meanings are behind an object. Instead, they convey their own experience and understanding of the object.

These interpretations are not rare as a diverse crowd attends the opening-night receptions at the MFACM, including city officials, diplomats, the Mexican consul, Pilsen and Little Village residents, schoolteachers, students, and working-class families, as well as artists, arts organizers, and arts promoters. A local arts administrator has been known to comment that at the MFACM, especially on opening night, "you never know where you are" since Chicago's racial tension and history of segregation produce monocultural participation at most events, whereas at the MFACM African Americans, European Americans, and Mexicanos are in the same room.

On the weekends Mexicano visitors may not be as vocal in claiming objects as their own, but "mom, dad, and the kids" also make the MFACM a homespace.[56] Families with children often photograph, or increasingly videorecord, objects on display at the Center Museum. Parents often guide their children through exhibits, reading labels, explaining images, and encouraging them to show respect for the MFACM and the objects on display. In fact, the sacredness of the MFACM is signaled by the absence of graffiti and other acts of vandalism, even though many of the surrounding public buildings, stores, and fences in the Pilsen neighborhood are sites of gang- and non-gang-related calligraphy. Substitution of the word "calligraphy" for the word "graffiti" is an attempt to eliminate a political bias or judgment against writing on walls. It is also an attempt to link this type of writing with other types of writing that are equally stylized and enjoy a historical tradition. (See Marcos Sanchez-Tranquilino, "Murales del Movimiento: Chicano Murals and the Discourses of Art and Americanization," pp. 804–811 in Eva Sperling Cockcroft and Holly Barnett-Sanchez [Eds.]

Signs from the Heart: California Murals. Social and Public Art Resource Center, Los Angeles, 1990.)

Making the Center Museum a sacred space also occurs during the annual Día de los Muertos celebration. As stated above, the Day of the Dead is itself a cross-cultural event in that it originates from both pre-Columbian cosmology and European Catholicism. The celebration of the Day of the Dead inside the museum's walls transforms the function of the museum. However, it is the experiences of Mexicanos themselves as they physically encounter ofrendas for the dead which relocate the museum into a sacred place, a place of worship, or a *familia*-centered space. My observations indicate that each of these reconstructions is a claim to ownership and authority in objects and the culture the objects represent.

In 1990, while standing in front of an installation designed by Arturo and José Barrera to commemorate the death of Pilsen's Mexicano youth lost to gang violence, a young woman cried over those she had never met as she remembered her own violent childhood. Her remembrance invoked by the ofrenda works to unite two unrelated experiences. This woman's relationship to the ofrenda is not representative, however, since many museum-goers seek out a particular ofrenda in order to mourn, celebrate, or commemorate a particular life and death. Patricia Martinez's ofrenda/installation to her fifteen-year-old brother was intended as a sacred site because this high school student and Golden Gloves boxer had been shot to death a few months before the opening of the exhibit. Family and friends made a pilgrimage to her ofrenda in order to honor his life and death. People standing before the ofrenda were storytelling, remembering, and crying. This became a common observation because several ofrendas commemorated the premature deaths of local youth.

I have also observed museum-goers engage with objects in ways that suggest historically based ownership. In 1992 I observed a father and daughter standing in front of a special installation addressing the quincentennial created by Ricardo, Paula, and Miguel Linares. The installation featured papier-mâché figures depicting the violent encounter between the Spanish conquistadors and the indigenous people of Mesoamerica. After a few moments the man turned to his daughter and told her about the times when his own father made papier-mâché dolls for him and his brothers and sisters. Storytelling is a common observation at Day of the Dead and other exhibits because parents use the exhibits as a way to demonstrate to their children practices and events from their own past. Through memories of particular experiences, spiritual connections to images, and the positioning of objects as familiar, Mexicanos move objects into a zone of their own complex, multisubject, personal history and home-space.[57]

I have suggested that mestizaje (a metaphor for experience and analysis) is more instructive than familiar geopolitical boundaries and nationalistic discourse for understanding exhibitions at the MFACM. We do not need to designate Mexicanos, objects attributed to Mexicanos, and actions of Mexicanos as either co-opted or resistant, as either American or Mexican, as either modern or traditional; to do so only flattens experience. Mestizaje is a metaphor that allows us to recuperate the heterogeneous and complex experiences of Mexicanos, to examine the porous and fluid zone of contact, to study the multiple and fractured positionality of the subject. That is, mestizaje allows for the study of the subject itself.

In this late capitalist moment, as museums and other institutions can no longer operate as an apparatus of the nation-state, new coordinates and sites for collective

representation must be explored. It is necessary to uncover these new hybrid zones, the unmapped spaces of cultural production that emerge from global reconfiguration. Hybrid spaces, however, are not idyllic; they are rife with conflict and chaos. It is the unresolved conflictive moment that produces originality and creativity, new forms and meanings: mestizaje. Mexicano exhibitions criss-cross and mix techniques of representation and interpretation established by nation-building art and ethnography museums. In the hybrid space the MFACM not only rewrites the narrative of the nation, but allows visitors to reconfigure "the cultural" (and "the national") in ways that are not tied to notions of "us" and "them." Constantly negotiating between cultures, Mexicanos work to create a place that they can call home. The site of their homespace, their bodies, allows them to act as an authority, a familiar, and an expert when they encounter Mexicano exhibitions. Although deterritorialized, Mexicano homespaces can belong only to themselves.

Notes

1 "Public museum" refers to those large museums that are usually publicly owned or financed in part by taxes and public revenues as well as the privately owned universal survey museum intended to represent the public. See Carol Duncan and Alan Wallach, "The Universal Survey Museum" *Art History* 3 (1980), 448–469.

2 Sally Price, *Primitive Art in Civilized Places* (Chicago: University of Chicago Press, 1989); Carol Duncan, "Art Museums and the Ritual of Citizenship," in Ivan Karp and Steven D. Lavine (eds.), *Exhibiting Cultures: The Poetics and Politics of Museum Display* (Washington, DC: Smithsonian Institution Press, 1991).

3 Gary Kulick, "Designing the Past: History-Museum Exhibitions from Peale to the Present," in Warren Leon and Roy Rosenzweig (eds.), *History Museums in the United States: A Critical Assessment* (Urbana and Chicago: University of Illinois Press, 1989); Lawrence Levine, "The Sacralization of Culture," in *Highbrow/Lowbrow: The Emergence of Cultural Hierarchy in America* (Cambridge, MA: Harvard University Press, 1988), 146.

4 Neil Harris, "The Gilded Age Revisited: Boston and the Museum Movement," *American Quarterly* 14 (Winter 1962), 552–554.

5 Néstor García Canclini, *Transforming Modernity: Popular Culture in Mexico*, trans. Lidia Lozano (Austin: University of Texas Press, 1993), 7.

6 Michael M. Ames, *Museums, the Public, and Anthropology: A Study in the Anthropology of Anthropology* (Vancouver: University of British Columbia Press, 1986), 39.

7 Donna Haraway, "Teddy Bear Patriarchy: Taxidermy in the Garden of Eden, New York City, 1908–1936," in Nicholas B. Dirks, Geoff Eley, and Sherry B. Ortner (eds.), *Culture/Power/History: A Reader in Contemporary Social Theory* (Princeton, NJ: Princeton University Press, 1993).

 Patricia Penn Hilden, Shari Huhndorf, and Carol Kalafatic, "Fry Bread and Wild West Shows: the 'New' National Museum of the American Indian" (unpublished manuscript, 1995), demonstrate how the "new museology" changes very little in the history of interpreting Native American cultures. Their astute critique of the George Gustav Heye Center of the National Museum of the American Indian illustrates that even "artistic" approaches to Native American objects signify exotic and noble savages.

8 Elinor Bowles, *Cultural Centers of Color: Report on a National Survey* (Washington, DC: National Endowment for the Arts, 1992), 26. More than three-fourths of the arts organizations were formed in the 1970s and 1980s. Only 6 percent were created in the 1960s. Taking a longer historical perspective, minoritized populations in the United States have been producing their own cultural institutions for centuries. For example, African

Americans have been creating their own places of worship, education, and celebration since the onset of slavery in the Americas. Mexican Americans have been creating their own music (*el corrido*), forms of worship (*el penitente*), and cultural products (*la santera*) since the annexation of northern Mexico in 1848.

9 Malaquias Montoya and Lezlie Salkowitz-Montoya, "A Critical Perspective on the State of Chicano Art," *Metamorfosis* 1980.

10 Jesús Martín-Barbero, *Communication, Culture and Hegemony: From the Media to Mediations*, trans. Elizabeth Fox and Robert A. White (London and Newbury Park, CA: Sage Publications, 1993). See also García Canclini, *Transforming Modernity*, viii.

11 Alan Knight, "Racism, Revolution, and Indigenismo: Mexico, 1910–1940," in Richard Graham (ed.), *The Idea of Race in Latin America, 1870–1940* (Austin: University of Texas Press, 1990), 84.

12 Ibid., 86.

13 Gloria Anzaldúa, *Borderlands/La Frontera: The New Mestiza* (San Francisco: Spinsters/Aunt Lute, 1987), preface.

14 Ibid., 19.

15 Marcos Sanchez-Tranquilino and John Tagg, "The Pachuco's Flayed Hide: The Museum, Identity, and Buenas Garras," in Richard Griswold del Castillo et al. (eds.), *Chicano Art: Resistance and Affirmation, 1965–1985* (Los Angeles: Wight Art Gallery, University of California, 1991).

16 Ibid., 101.

17 James Clifford, "Four Northwest Coast Museums: Travel Reflections" in Ivan Karp and Steven D. Lavine (eds.), *Exhibiting Cultures: The Poetics and Politics of Museum Display* (Washington, DC: Smithsonian Institution Press, 1991), 225–226.

18 Although there are institutions devoted to the display of Chicano and Mexicano art/culture in nearly every metropolitan city in the Southwest, this paper focuses on the MFACM because it is presently the largest and most financially successful Mexican American museum in the United States. See Davalos, "Chicano Art Exhibition as Border Space," Paper presented at Displacing Borders Conference, American Studies Working Group (Berkeley: University of California, March 22, 1995) for an examination of exhibition practices in San Francisco and Los Angeles. I do not suggest that the midwestern location explains mestizo representational practices; on the contrary, I imply that all Chicano and Mexicano exhibition is informed by mestizo experience.

19 Since there are various ethnic identifiers for people of Mexican descent, a note of clarification is required. Not only have people of Mexican descent historically been categorized in various ways by local, regional, and federal governments, but the population itself has created its own ethnic identifiers throughout history. More important, all ethnic identifiers are a contested terrain, and no one enjoys absolute authority over others. In this chapter, I refer to people of Mexican descent in Chicago as Mexicano. Research indicates that this identifier is employed in everyday conversations and family-centered discussions among Chicago's recent immigrants, Mexican Americans, long-term residents who have not become U.S. citizens, as well as mixed-heritage youth. (See Davalos, "Ethnic Identity among Mexican and Mexican American Women in Chicago, 1920–1991," Ph.D. dissertation, Yale University, 1993.) Following academic convention, the ethnic identifier "Chicano" refers specifically to Mexican American populations in the Southwest.

20 Roland Cardona, *Northwest EXTRA*, September 9, 1987.

21 Interview with Carlos Tortolero, July 8, 1994.

22 Quoted in Jay Pridmore, "Hispanic art making a leap into city's consciousness" *Chicago Tribune*, April 22, 1988, Section 7 p. 42.

23 Michele Nadanyi and Mark Parry, "Case 26: Mexican Fine Arts Center Museum," in Douglas J. Dalrymple et al. (eds.), *Cases in Marketing Management* (New York: John Wiley and Sons, 1992), 317.

24 The disbursement of property tax funds for museums on park property was established in 1838 as a development plan to promote the city's arts institutions. The Chicago Park District is a government body formally separate from the City of Chicago but informally connected in that the mayor appoints its Board of Commissioners. Barbara Page Fiske (ed.), *Key to Government in Chicago and Suburban Cook County* (Chicago: University of Chicago Press, 1989), 143.

25 It is beyond the scope of this study to distinguish between ethnography and history museums. For this study, the important distinction is between museums that inscribe objects as art versus those that inscribe objects as cultural artifacts.

26 Carol Duncan, *Civilizing Rituals* (London and New York: Routledge, 1995), 5.

27 Barbara Fahs Charles, "Exhibition as (Art) Form," in Jo Blatti (ed.), *Past Meets Present: Essays about Historic Interpretation and Public Audiences* (Washington, DC: Smithsonian Institution Press, 1987), 97; Ames, *Museums, the Public, and Anthropology*, 37.

28 Mihaly Csikszentmihalyi and Rick E. Robinson, *The Art of Seeing: an Interpretation of the Aesthetic Encounter* (Malibu, CA: J. Paul Getty Museum and the Getty Center for Education in the Arts, 1990), 17.

29 Ibid., 138.

30 Douglas Crimp, *On the Museum's Ruins* (Cambridge, MA and London: MIT Press, 1993), 15.

31 Ibid., 17.

32 Ibid., 18.

33 Barbara Kirshenblatt-Gimblett, "Objects of Ethnography," in Karp and Lavine (eds.), *Exhibiting Cultures*.

34 Sally Price, *Primitive Art in Civilized Places* (Chicago: University of Chicago Press, 1989).

35 The material for this section of the chapter was gathered during five field research periods (May 1990–November 1992, the summers of 1989 and 1994, and brief visits in 1995 and 1996). Formal and open-ended interviews with the MFACM's founders, Carlos Tortolero and Helen Valdez, as well as René H. Arceo Frutos, Encarnación Teruel, and Rebecca D. Meyers, produced a baseline of information. In-depth ethnographic observation and ongoing contact with the Center Museum's staff and administration are supplemented by primary and secondary sources, including materials generated by local media and the Center Museum between 1987 and 1989. Admittedly, the specific exhibitions I discuss do not represent the entire history of the MFACM. I selected examples that are representative of the Center Museum's exhibition goals, are experienced by a large number of people, and are unique in the history of art/culture exhibition.

36 See Tomás Ybarra-Frausto, "The Chicano Movement/The Movement of Chicano Art," in Karp and Lavine (eds.), *Exhibiting Cultures*.

37 Mexican Fine Arts Center Museum, "The Amate Tradition: Innovation and Dissent in Mexican Art," Exhibition brochure, 1995.

38 "Arte y Arte Popular/Art and Popular Art," in Jonathan D. Amith (ed.), *The Amate Tradition: Innovation and Dissent in Mexican Art* (Chicago and Mexico City: Mexican Fine Arts Center Museum and La Casa de Imágenes, 1995), 24.

39 Ibid., 24.

40 MFACM, "Amate", Exhibition panels.

41 MFACM, "El Juguete Popular Mexicano/Popular Toys of Mexico," Exhibition materials, 1991.

42 Ibid., "What Is a Toy?"

43 I am indebted to Alex Saragoza for this perspective.

44 Martín-Barbero, *Communication, Culture and Hegemony*; García Canclini, *Transforming Modernity*, especially pp. 42–47.

45 It must be admitted that from a wider perspective, the MFACM does not exclusively recirculate Mexican nationalism. Indeed, the Amate exhibition recognizes the role of the government in stimulating the production and the marketing of amate. Other exhibitions,

such as "Latino Youth: Living with HIV/AIDS in the Family" (May 15–June 7, 1992) and "Art of the Other México: Sources and Meanings" (June 18–September 12, 1993), offer a critique of official Mexican culture and nationalism. These two exhibitions subvert the homogenizing effects of nationalism by exhibiting and promoting the identity of groups and peoples not sanctioned by official Mexican culture. More important, Latino Youth does not present the romantic or nostalgic image of official Mexican culture but portrays the realities of Mexicano experience.

46 Carlos Tortolero, "Introduction," *Mexico: La Vision del Cosmos: Three Thousand Years of Creativity* (Chicago: Mexican Fine Arts Center Museum, 1992).

47 Laurene Lambertino-Urquizo, "Aztec Ceramics and Colonization," *Mexico: La Vision del Cosmos: Three Thousand Years of Creativity* (Chicago: Mexican Fine Arts Center Museum, 1992), 47; Donald McVicker, "The Field Museum's Collection from México," *Mexico: La Vision del Cosmos*, 65–66.

48 Ames, *Museums, the Public, and Anthropology*, 38.

49 McVicker, "Field Museum's Collection," 65.

50 MFACM, "Mexico, La Vision del Cosmos: Three Thousand Years of Creativity," Exhibition materials, 1992.

51 According to Chicago curator and arts activist Juana Guzman, the phrase does not signify an indigenous voice or an original voice, but instead points to a community's right to interpret itself. Interviews with Juana Guzman, July 1, 1994, and March 29, 1995.

52 MFACM, "Meaning of Día de los Muertos: 500 Years of Resistance," Exhibition materials, 1992.

53 I employ the word "senses" to connote both knowledge and sensory experience.

54 Duncan, "Art Museums and Ritual of Citizenship"; Duncan, *Civilizing Rituals*.

55 The term is a modification of bell hooks's concept of a "homeplace." See bell hooks, "Homeplace: A Site of Resistance," in *Yearnings: Race, Gender, and Cultural Politics* (Boston: South End Press, 1990).

56 Executive Director Carlos Tortolero frequently refers to the MFACM's audience as "mom, dad, and the kids."

57 Private encounters with public representations also occurred during one of the Center Museum's inaugural exhibitions. According to Tortolero, during "Images of Faith/Imagenes de Fe: Religious Art of Mexico, Eighteenth and Nineteenth Centuries" (March 27–May 13, 1987), Mexicanos reinscribed the MFACM as a place of worship by filling the Center Museum's comments book, a blank book provided for visitors' responses to exhibitions, with testimony about the saints. By giving *testimonio* at the MFACM, Mexicanos reclaimed these otherwise historically and culturally distinct objects as their own personal channel between the sacred world and the secular world. Even though the objects were in a museum, Mexicanos used their own senses to experience the objects in familiar ways.

Chapter 51 | Stephen Greenblatt
Resonance and Wonder

The new historicism, like the Holy Roman Empire, constantly belies its own name. The *American Heritage Dictionary* gives three meanings for the term 'historicism':

> 1. The belief that processes are at work in history that man can do little to alter. 2. The theory that the historian must avoid all value judgements in his study of past periods or former cultures. 3. Veneration of the past or of tradition.

Most of the writing labelled 'new historicist', and certainly my own work, has set itself resolutely against each of these positions.

(1) 'The belief that processes are at work in history that man can do little to alter.' This formulation rests upon a simultaneous abstraction and evacuation of human agency. The men and women who find themselves making concrete choices in given circumstances at particular times are transformed into something called 'man'. And this colourless, nameless collective being cannot significantly intervene in the 'processes . . . at work in history', processes that are thus mysteriously alienated from all of those who enact them.

New historicism, by contrast, eschews the use of the term 'man'; interest lies not in the abstract universal but in particular, contingent cases, the selves fashioned and acting according to the generative rules and conflicts of a given culture. And these selves, conditioned by the expectations of their class, gender, religion, race and national identity, are constantly effecting changes in the course of history. Indeed if there is any inevitability in the new historicism's vision of history it is this insistence on agency, for even inaction or extreme marginality is understood to possess meaning and therefore to imply intention. Every form of behaviour, in this view, is a strategy: taking up arms or taking flight are significant social actions, but so is staying put, minding one's business, turning one's face to the wall. Agency is virtually inescapable.

Stephen Greenblatt, "Resonance and Wonder" from Peter Collier and Helga Geyer-Ryan (eds.), *Literary Theory Today* (1990), pp. 74–90. Cambridge: Polity, 1990. © 1990 by Stephen Greenblatt. Reproduced by permission.

Inescapable but not simple: new historicism, as I understand it, does not posit historical processes as unalterable and inexorable, but it does tend to discover limits or constraints upon individual intervention: actions that appear to be single are disclosed as multiple; the apparently isolated power of the individual genius turns out to be bound up with collective, social energy; a gesture of dissent may be an element in a larger legitimation process, while an attempt to stabilize the order of things may turn out to subvert it. And political valencies may change, sometimes abruptly: there are no guarantees, no absolute, formal assurances that what seems progressive in one set of contingent circumstances will not come to seem reactionary in another.

The new historicism's insistence on the pervasiveness of agency has apparently led some of its critics to find in it a Nietzschean celebration of the ruthless will to power, while its ironic and sceptical reappraisal of the cult of heroic individualism has led others to find in it a pessimistic doctrine of human helplessness. Hence, for example, from a Marxist perspective Walter Cohen criticizes the new historicism as a 'liberal disillusionment' that finds that 'any apparent site of resistance ultimately serves the interests of power', while from a liberal humanist perspective, Edward Pechter proclaims that 'anyone who, like me, is reluctant to accept the will to power as the defining human essence will probably have trouble with the critical procedures of the new historicists and with their interpretative conclusions'.[1] But the very idea of a 'defining human essence' is precisely what critics like me find vacuous and untenable, as I do Pechter's counter-claim that love rather than power makes the world go round. Cohen's critique is more plausible, but it rests upon his assertion that new historicism argues that '*any* apparent site of resistance' is ultimately co-opted. Some are, some aren't.

I argued in *Shakespearean Negotiations* that the sites of resistance in Shakespeare's second tetralogy are co-opted in the plays' ironic, complex but finally celebratory affirmation of charismatic kingship. That is, the formal structure and rhetorical strategy of the plays make it difficult for audiences to withhold their consent from the triumph of Prince Hal. That triumph is shown to rest upon a claustrophobic narrowing of pleasure, a hypocritical manipulation of appearances, and a systematic betrayal of friendship, and yet these manifestations of bad faith only contrive to increase the spectators' knowing pleasure and the ratification of applause. The subversive perceptions do not disappear but, in so far as they remain within the structure of the play, they are contained and indeed serve to heighten a power they would appear to question.

I did not propose that all manifestations of resistance in all literature (or even in all plays by Shakespeare) were co-opted – one can readily think of plays where the forces of ideological containment break down. And yet characterizations of this essay in particular, and new historicism in general, repeatedly refer to a supposed argument that any resistance is impossible.[2] A particularizing argument about the subject position projected by a set of plays is at once simplified and turned into a universal principle from which contingency and hence history itself is erased.

Moreover, even the argument about Shakespeare's second tetralogy is misunderstood if it is thought to foreclose the possibility of dissent or change or the radical alteration of the processes of history. The point is that certain aesthetic and political structures work to contain the subversive perceptions they generate, not that those perceptions simply wither away. On the contrary, they may be pried loose from the order with which they were bound up and may serve to fashion a new and radically different set of structures. How else could change ever come about? No one is forced –

except perhaps in school – to take aesthetic or political wholes as sacrosanct. The order of things is never simply a given: it takes labour to produce, sustain, reproduce, and transmit the way things are, and this labour may be withheld or transformed. Structures may be broken in pieces, the pieces altered, inverted, rearranged. Everything can be different than it is; everything could have been different than it was. But it will not do to imagine that this alteration is easy, automatic, without cost or obligation. My objection was to the notion that the rich ironies in the history plays were themselves inherently liberating, that to savour the tetralogy's sceptical cunning was to participate in an act of political resistance. In general I find dubious the assertion that certain rhetorical features in much-loved literary works constitute authentic acts of political subversion; the fact that this assertion is now heard from the left – when in my college days it was more often heard from the right – does not make it in most instances any less fatuous and presumptuous. I wished to show, at least in the case of Shakespeare's histories and in several analogous discourses, how a set of representational and political practices in the late sixteenth century could produce and even batten upon what appeared to be their own subversion.

To show this is the case is not to give up on the possibility of altering historical processes – if this is historicism I want no part of it – but rather to eschew an aestheticized and idealized politics of the liberal imagination.

(2) 'The theory that the historian must avoid all value judgments in his study of past periods or former cultures.' Once again, if this is an essential tenet of historicism, then the new historicism belies its name. My own critical practice was decisively shaped by the America of the 1960s and early 1970s, and especially by the opposition to the Viet Nam War. Writing that was not engaged, that withheld judgements, that failed to connect the present with the past seemed worthless. Such connection could be made either by analogy or causality; that is, a particular set of historical circumstances could be represented in such a way as to bring out homologies with aspects of the present or, alternatively, those circumstances could be analysed as the generative forces that led to the modern condition. In either mode, value judgements were implicated, because a neutral or indifferent relation to the present seemed impossible. Or rather it seemed overwhelmingly clear that neutrality was itself a political position, a decision to support the official policies in both the state and the academy.

To study the culture of sixteenth-century England did not present itself as an escape from the turmoil of the present; it seemed rather an intervention, a mode of relation. The fascination for me of the Renaissance was that it seemed to be powerfully linked to the present both analogically and causally. This two-fold link at once called forth and qualified my value judgements: called them forth because my response to the past was inextricably bound up with my response to the present; qualified them because the analysis of the past revealed the complex, unsettling historical genealogy of the very judgements I was making. To study Renaissance culture, then, was simultaneously to feel more rooted and more estranged in my own values.[3]

Other critics associated with the new historicism – Louis Montrose, Don Wayne and Catherine Gallagher, among others – have written directly and forcefully about their own subject position and have made more explicit than I the nature of this engagement.[4] If I have not done so to the same extent, it is not because I believe that my values are somehow suspended in my study of the past but because I believe they are pervasive: in the textual and visual traces I choose to analyse, in the stories I choose to tell, in the cultural conjunctions I attempt to make, in my syntax, adjectives,

pronouns. 'The new historicism', Jean Howard has written in a lively critique, 'needs at every point to be more overtly self-conscious of its methods and its theoretical assumptions, since what one discovers about the historical place and function of literary texts is in large measure a function of the angle from which one looks and the assumptions that enable the investigation.'[5] I am certainly not opposed to methodological self-consciousness, but I am less inclined to see overtness – an explicit articulation of one's values and methods – as inherently necessary or virtuous. Nor, though I believe that one's values are everywhere engaged in one's work, do I think that there need be a perfect integration of those values and the objects one is studying. On the contrary, some of the most interesting and powerful ideas in cultural criticism occur precisely at moments of disjunction, disintegration, unevenness. A criticism that never encounters obstacles, that celebrates predictable heroines and rounds up the usual suspects, that finds confirmation of its values everywhere it turns, is quite simply boring.

If there is then no suspension of value judgements in the new historicism, there is at the same time a complication of those judgements, what I have called a sense of estrangement. This estrangement is bound up with the abandonment of a belief in historical inevitability, for, with this abandonment, the values of the present could no longer seem the necessary outcome of an irreversible teleological progression, whether of enlightenment or decline. An older historicism that proclaimed self-consciously that it had avoided all value judgements in its account of the past – that it had given us historical reality *wie es eigentlich gewesen* – did not thereby avoid all value judgements; it simply provided a misleading account of what it had actually done. In this sense the new historicism, for all its acknowledgement of engagement and partiality, is slightly less likely than the older historicism to impose its values belligerently on the past, for those values seem historically contingent.

(3) 'Veneration of the past or of tradition.' The third definition of historicism obviously sits in a strange relation to the second, but they are not simply alternatives. The apparent eschewing of value judgements was often accompanied by a still more apparent admiration, however cloaked as objective description, of the past. One of the most oppressive qualities of my own literary training was its relentlessly celebratory character: literary criticism was and largely remains a kind of secular theodicy. Every decision made by a great artist could be shown to be a brilliant one; works that had seemed flawed and uneven to an earlier generation of critics bent on displaying discriminations in taste were now revealed to be organic masterpieces. A standard critical assignment in my student years was to show how a text that seemed to break in parts was really a complex whole: thousands of pages were dutifully churned out to prove that the zany subplot of *The Changeling* was cunningly integrated into the tragic main plot, or that every tedious bit of clowning in *Doctor Faustus* was richly significant. Behind these exercises was the assumption that great works of art were triumphs of resolution, that they were, in Bakhtin's term, monological – the mature expression of a single artistic intention. When this formalism was combined, as it often was, with both ego psychology and historicism, it posited aesthetic integration as the reflection of the artist's psychic integration and posited that psychic integration as the triumphant expression of a healthy, integrated community. Accounts of Shakespeare's relation to Elizabethan culture were particularly prone to this air of veneration, since the Romantic cult of poetic genius could be conjoined with the still older political cult that had been created around the figure of the Virgin Queen.

Here again new historicist critics have swerved in a different direction. They have been more interested in unresolved conflict and contradiction than in integration; they are as concerned with the margins as with the centre; and they have turned from a celebration of achieved aesthetic order to an exploration of the ideological and material bases for the production of this order. Traditional formalism and historicism, twin legacies of early nineteenth-century Germany, shared a vision of high culture as a harmonizing domain of reconciliation based upon an aesthetic labour that transcends specific economic or political determinants. What is missing is psychic, social, and material resistance, a stubborn, unassimilable otherness, a sense of distance and difference. New historicism has attempted to restore this distance; hence its characteristic concerns have seemed to some critics off-centre or strange. 'New historicists', writes Walter Cohen, 'are likely to seize upon something out of the way, obscure, even bizarre: dreams, popular or aristocratic festivals, denunciations of witchcraft, sexual treatises, diaries and autobiographies, descriptions of clothing, reports on disease, birth and death records, accounts of insanity.'[6] What is fascinating to me is that concerns like these should have come to seem bizarre, especially to a subtle and intelligent Marxist critic who is committed to the historical understanding of culture. That they have done so indicates how narrow the boundaries of historical understanding had become, how much these boundaries needed to be broken.

For none of the cultural practices on Cohen's list (and one could extend it considerably) is or should be 'out of the way' in a study of Renaissance literature or art; on the contrary, each is directly in the way of coming to terms with the period's methods of regulating the body, its conscious and unconscious psychic strategies, its ways of defining and dealing with marginals and deviants, its mechanisms for the display of power and the expression of discontent, its treatment of women. If such concerns have been rendered 'obscure', it is because of a disabling idea of causality that confines the legitimate field of historical agency within absurdly restrictive boundaries. The world is parcelled out between a predictable group of stereotypical causes and a large, dimly lit mass of raw materials that the artist chooses to fashion.

The new historicist critics are interested in such cultural expressions as witchcraft accusations, medical manuals, or clothing not as raw materials but as 'cooked' – complex symbolic and material articulations of the imaginative and ideological structures of the society that produced them. Consequently, there is a tendency in at least some new historicist writings (certainly in my own) for the focus to be partially displaced from the work of art that is their formal occasion onto the related practices that had been adduced ostensibly in order to illuminate that work. It is difficult to keep those practices in the background if the very concept of historical background has been called into question.

I have tried to deal with the problem of focus by developing a notion of cultural negotiation and exchange, that is, by examining the points at which one cultural practice intersects with another, borrowing its forms and intensities or attempting to ward off unwelcome appropriations. But it would be misleading to imagine that there is a complete homogenization of interest; my own concern remains centrally with imaginative literature, and not only because other cultural structures resonate powerfully within it. If I do not approach works of art in a spirit of veneration, I do approach them in a spirit that is best described as wonder. Wonder has not been alien to literary criticism, but it has been associated (if only implicitly) with formalism rather than historicism. I wish to extend this wonder beyond the formal boundaries of works of art, just as I wish to intensify resonance within those boundaries.

It will be easier to grasp the concepts of resonance and wonder if we think of the way in which our culture presents to itself not the textual traces of its past but the surviving visual traces, for the latter are put on display in galleries and museums specially designed for the purpose. By resonance I mean the power of the object displayed to reach out beyond its formal boundaries to a larger world, to evoke in the viewer the complex, dynamic cultural forces from which it has emerged and for which as meta-phor or more simply as synecdoche it may be taken by a viewer to stand. By wonder I mean the power of the object displayed to stop the viewer in his tracks, to convey an arresting sense of uniqueness, to evoke an exalted attention.

The new historicism obviously has distinct affinities with resonance; that is, my concern with literary texts has been to recover as far as possible the historical circumstances of their original production and consumption and to analyse the relationship between these circumstances and our own. I have tried to understand the intersecting circumstances not as a stable, prefabricated background against which the literary texts can be placed, but as a dense network of evolving and often contradictory social forces. The idea is not to find outside the work of art some rock to which literary interpretation can be securely chained but rather to situate the work in relation to other representational practices operative in the culture at a given moment in both its history and our own. In Louis Montrose's convenient formula-tion, the goal has been to grasp simultaneously the historicity of texts and the textuality of history.

In so far as this approach, developed for literary interpretation, is at all applicable to visual traces, it would call for an attempt to reduce the isolation of individual 'master-pieces', to illuminate the conditions of their making, to disclose the history of their appropriation and the circumstances in which they come to be displayed, to restore the tangibility, the openness, the permeability of boundaries that enabled the objects to come into being in the first place. An actual restoration of tangibility is obviously in most cases impossible, and the frames that enclose pictures are only the ultimate formal confirmation of the closing of the borders that marks the finishing of a work of art. But we need not take that finishing so entirely for granted; museums can and on occasion do make it easier imaginatively to recreate the work in its moment of openness.

That openness is linked to a quality of artifacts that museums obviously dread – their precariousness. But though it is perfectly reasonable for museums to protect their objects – I would not wish it any other way – precariousness is a rich source of resonance. Thomas Greene, who has written a sensitive book on what he calls the 'vulnerable text', suggests that the symbolic wounding to which literature is prone may confer upon it power and fecundity. 'The vulnerability of poetry', Greene argues, 'stems from four basic conditions of language: its historicity, its dialogic function, its referential function, and its dependence on figuration.'[7] Three of these conditions are different for the visual arts, in ways that would seem to reduce vulnerability: painting and sculpture may be detached more readily than language from both referentiality and figuration, and the pressures of contextual dialogue are diminished by the absence of an inherent *logos*, a constitutive word. But the fourth condition – historicity – is in the case of material artifacts vastly increased, indeed virtually literalized. Museums function, partly by design and partly in spite of themselves, as monuments to the fragility of cultures, to the fall of sustaining institutions and noble houses, the collapse of rituals, the evacuation of myths, the destructive effects of warfare, neglect and corrosive doubt.

I am fascinated by the signs of alteration, tampering, even destructiveness which many museums try simply to efface: first and most obviously, the act of displacement that is essential for the collection of virtually all older artifacts and most modern ones – pulled out of chapels, peeled off church walls, removed from decayed houses, seized as spoils of war, stolen, 'purchased' more or less fairly by the economically ascendent from the economically naive, the poor, the hard-pressed heirs of fallen dynasties and impoverished religious orders. Then too there are the marks on the artifacts themselves: the attempt to scratch out or deface the image of the devil in numerous late-medieval and Renaissance paintings, the concealing of the genitals in sculpted and painted figures, the iconoclastic smashing of human or divine representations, the evidence of cutting or reshaping to fit a new frame or purpose, the cracks or scorch marks or broken-off noses that indifferently record the grand disasters of history and the random accidents of trivial incompetence. Even these accidents – the marks of a literal fragility – can have their resonance: the climax of an absurdly hagiographical Proust exhibition several years ago was a display case holding a small, patched, modest vase with a notice, 'This vase broken by Marcel Proust'.

As this comical example suggests, wounded artifacts may be compelling not only as witnesses to the violence of history but as signs of use, marks of the human touch, and hence links with the openness to touch that was the condition of their creation. The most familiar way to recreate the openness of aesthetic artifacts without simply renewing their vulnerability is through a skilful deployment of explanatory texts in the catalogue, on the walls of the exhibit, or on cassettes. The texts so deployed introduce and in effect stand in for the context that has been effaced in the process of moving the object into the museum. But in so far as that context is partially, often primarily, visual as well as verbal, textual contextualism has its limits. Hence the mute eloquence of the display of the palette, brushes and other implements that an artist of a given period would have employed or of objects that are represented in the exhibited paintings or of materials and images that in some way parallel or intersect with the formal works of art.

Among the most resonant moments are those in which the supposedly contextual objects take on a life of their own, make a claim that rivals that of the object that is formally privileged. A table, a chair, a map, often seemingly placed only to provide a decorative setting for a grand work, become oddly expressive, significant not as 'background' but as compelling representational practices in themselves. These practices may in turn impinge upon the grand work, so that we begin to glimpse a kind of circulation: the cultural practice and social energy implicit in map-making drawn into the aesthetic orbit of a painting which has itself enabled us to register some of the representational significance of the map. Or again the threadbare fabric on the old chair or the gouges in the wood of a cabinet juxtapose the privileged painting or sculpture with marks not only of time but of use, the imprint of the human body on the artifact, and call attention to the deliberate removal of certain exalted aesthetic objects from the threat of that imprint.

For the effect of resonance does not necessarily depend upon a collapse of the distinction between art and non-art; it can be achieved by awakening in the viewer a sense of the cultural and historically contingent construction of art objects, the negotiations, exchanges, swerves, exclusions by which certain representational practices come to be set apart from other representational practices that they partially resemble. A resonant exhibition often pulls the viewer away from the celebration of isolated objects and toward a series of implied, only half-visible relationships and

questions. How have the objects come to be displayed? What is at stake in categorizing them as of 'museum-quality'? How were they originally used? What cultural and material conditions made possible their production? What were the feelings of those who originally held the objects, cherished them, collected them, possessed them? What is the meaning of my relationship to these same objects now that they are displayed here, in this museum, on this day?

It is time to give a more sustained example. Perhaps the most purely resonant museum I have ever seen is the State Jewish Museum in Prague. This is housed not in a single building but in a cluster of old synagogues scattered through the city's former Jewish Town. The oldest of these – known as the Old–New Synagogue – is a twin-nave medieval structure dating to the last third of the thirteenth century; the others are mostly Renaissance and Baroque. In these synagogues are displayed Judaica from the Bohemian and Moravian Jewish communities. In one there is a permanent exhibition of synagogue silverworks, in another there are synagogue textiles, in a third there are Torah scrolls, ritual objects, manuscripts and prints illustrative of Jewish beliefs, traditions, and customs. One of the synagogues shows the work of the physician and artist Karel Fleischmann, principally drawings done in Terezín concentration camp during his months of imprisonment prior to his deportation to Auschwitz. Next door in the Ceremonial Hall of the Prague Burial Society there is a wrenching exhibition of children's drawings from Terezín. Finally, one synagogue, closed at the time of my visit to Prague, has simply a wall of names – thousands of them – to commemorate the Jewish victims of Nazi persecution in Czechoslovakia.

'The Museum's rich collections of synagogue art and the historical synagogue buildings of Prague's Jewish town', says the catalogue of the State Jewish Museum, 'form a memorial complex that has not been preserved to the same extent anywhere else in Europe.' 'A memorial complex' – this museum is not so much about artifacts as about memory, and the form the memory takes is a secularized kaddish, a commemorative prayer for the dead. The atmosphere has a peculiar effect on the act of viewing. It is mildly interesting to note the differences between the mordant Grosz-like lithographs of Karel Fleischmann in the pre-war years and the tormented style, at once detached and anguished, of the drawings in the camps, but aesthetic discriminations feel weird, out-of-place. And it seems wholly absurd, even indecent, to worry about the relative artistic merits of the drawings that survive by children who did not survive.

The discordance between viewing and remembering is greatly reduced with the older, less emotionally charged artifacts, but even here the ritual objects in their glass cases convey an odd and desolate impression. The oddity, I suppose, should be no greater than in seeing a Mayan god or, for that matter, a pyx or a ciborium, but we have become so familiarized to the display of such objects, so accustomed to considering them works of art, that even pious Catholics, as far as I know, do not necessarily feel disconcerted by their transformation from ritual function to aesthetic exhibition. And until very recently the voices of the tribal peoples who might have objected to the display of their religious artifacts have not been heard and certainly not attended to.

The Jewish objects are neither sufficiently distant to be absorbed into the detached ethos of anthropological display nor sufficiently familiar to be framed and encased alongside the altarpieces and reliquaries that fill Western museums. And moving as they are as mnemonic devices, most of the ritual objects in the State Jewish Museum are not, by contrast with Christian liturgical art, particularly remarkable either for their antiquity or their extraordinary beauty. They are the products of a people with a

resistance to joining figural representation to religious observance, a strong anti-iconic bias. The objects have, as it were, little will to be observed; many of them are artifacts – ark curtains, Torah crowns, breastplates, pointers, and the like – the purpose of which was to be drawn back or removed in order to make possible the act that mattered: not vision but reading.

But the inhibition of viewing in the Jewish Museum is paradoxically bound up with its resonance. This resonance depends not upon visual stimulation but upon a felt intensity of names, and behind the names, as the very term resonance suggests, of voices: the voices of those who chanted, studied, muttered their prayers, wept, and then were forever silenced. And mingled with these voices are others – of those Jews in 1389 who were murdered in the Old–New Synagogue where they were seeking refuge, of the great sixteenth-century Kabbalist, Jehuda ben Bezalel, known as Rabbi Loew, who is fabled to have created the Golem, of the twentieth-century's ironic Kabbalist, Franz Kafka.

It is Kafka who would be most likely to grasp imaginatively the State Jewish Museum's ultimate source of resonance: the fact that most of the objects are located in the museum – were displaced, preserved and transformed categorically into works of art – because the Nazis stored the articles they confiscated in the Prague synagogues that they chose to preserve for this very purpose. In 1941 the Nazi *Hochschule* in Frankfurt had established an Institute for the Exploration of the Jewish Question which in turn had initiated a massive effort to confiscate Jewish libraries, archives, religious artifacts and personal property. By the middle of 1942, Heydrich, as Hitler's chief officer with the so-called Protectorate of Bohemia and Moravia, had chosen Prague as the site of the Central Bureau for Dealing with the Jewish Question, and an SS officer, Untersturmführer Karl Rahm, had assumed control of the small existing Jewish museum, founded in 1912, which was renamed the Central Jewish Museum. The new charter of the museum announced that 'the numerous, hitherto scattered Jewish possessions of both historical and artistic value, on the territory of the entire Protectorate, must be collected and stored.'[8]

During the following months, tens of thousands of confiscated items arrived from 153 Jewish communities in Bohemia and Moravia, the dates of the shipments closely co-ordinated with the 'donors'' deportation to the concentration camps. The experts formerly employed by the original Jewish museum were compelled to catalogue the items, and the Nazis compounded this immense task by ordering the wretched, malnourished curators to prepare a collections guide and organize private exhibitions for SS staff. Between September 1942 and October 1943 four major exhibitions were mounted. Since these required far more space than the existing Jewish Museum's modest location, the great old Prague synagogues – made vacant by the Nazi prohibition of Jewish public worship – were partially refurbished for the occasion. Hence in March 1943, for example, in the seventeenth-century Klaus Synagogue, there was an exhibition of Jewish festival and life-cycle observances; 'when Sturmbannführer Günther first toured the collection on April 6, he demanded various changes, including the translation of all Hebrew texts and the addition of an exhibit on kosher butchering'.[9] Plans were drawn up for other exhibitions, but the curators – who had given themselves with a strange blend of selflessness, irony, helplessness and heroism to the task – were themselves at this point sent to concentration camps and murdered.

After the war, the few survivors of the Czech Jewish community apparently felt they could not sustain the ritual use of the synagogues or maintain the large collections. In

1949 the Jewish Community Council offered as a gift to the Czechoslovak government both the synagogues and their contents. These became the resonant, impure 'memorial complex' they are – a cultural machine that generates an uncontrollable oscillation between homage and desacration, longing and hopelessness, the voices of the dead and silence. For resonance, like nostalgia, is impure, a hybrid forged in the barely acknowledged gaps, the cesurae, between words like State, Jewish and Museum.

I want to avoid the implication that resonance must be necessarily linked to destruction and absence; it can be found as well in unexpected survival. The key is the intimation of a larger community of voices and skills, an imagined ethnographic thickness. Here another example will serve: in the Yucatan there is an extensive, largely unexcavated late-Classic Maya site called Coba, the principal surviving feature of which is a high pyramid known as Nahoch Mul. After a day of tramping around the site, I was relaxing in the pool of the nearby Club Med Archaeological Villa in the company of a genial structural engineer from Little Rock. To make conversation, I asked my pool-mate what he as a structural engineer thought of Nahoch Mul. 'From an engineer's point of view,' he replied, 'a pyramid is not very interesting – it's just an enormous gravity structure. But,' he added, 'did you notice that Coca Cola stand on the way in? That's the most impressive example of contemporary Maya architecture I've ever seen.' I thought it quite possible that my leg was being pulled, but I went back the next day to check – I had, of course, completely blocked out the Coke stand on my first visit. Sure enough, some enterprising Mayan had built a remarkably elegant shelter with a soaring pyramidal roof constructed out of ingeniously intertwining sticks and branches. Places like Coba are thick with what Spenser called the Ruins of Time – with a nostalgia for a lost civilization, in a state of collapse long before Cortés or Montejo cut their paths through the jungle. But, despite frequent colonial attempts to drive them or imagine them out of existence, the Maya have not in fact vanished, and a single entrepreneur's architectural improvization suddenly had more resonance for me than the mounds of the 'lost' city.

My immediate thought was that the whole Coca Cola stand could be shipped to New York and put on display in the Museum of Modern Art. And that impulse moves us away from resonance and toward wonder. For the MOMA is one of the great contemporary places not for the hearing of intertwining voices, not for historical memory, not for ethnographic thickness, but for intense, indeed enchanted looking. Looking may be called enchanted when the act of attention draws a circle around itself from which everything but the object is excluded, when intensity of regard blocks out all circumambient images, stills all murmuring voices. To be sure, the viewer may have purchased a catalogue, read an inscription on the wall, switched on a cassette, but in the moment of wonder all of this apparatus seems mere static.

The so-called boutique lighting that has become popular in recent years – a pool of light that has the surreal effect of seeming to emerge from within the object rather than to focus upon it from without – is an attempt to provoke or to heighten the experience of wonder, as if modern museum designers feared that wonder was increasingly difficult to arouse or perhaps that it risked displacement entirely onto the windows of designer dress shops and antique stores. The association of that lighting – along with transparent plastic rods and other devices to create the magical illusion of luminous, weightless suspension – with commerce would seem to suggest that wonder is bound up with acquisition and possession, yet the whole experience of most art museums is about *not* touching, *not* carrying home, *not* owning the marvel-

lous objects. Modern museums in effect at once evoke the dream of possession and evacuate it.[10]

That evacuation is an historical rather than structural aspect of the museum's regulation of wonder: that is, collections of objects calculated to arouse wonder arose precisely in the spirit of personal acquisition and were only subsequently displaced from it. In the Middle Ages and Renaissance we characteristically hear about wonders in the context of those who possessed them (or gave them away). Hence, for example in his *Life of Saint Louis*, Joinville writes that 'during the king's stay at Saida someone brought him a stone that split into flakes':

> It was the most marvellous stone in the world, for when you lifted one of the flakes you found the form of a sea-fish between the two pieces of stone. This fish was entirely of stone, but there was nothing lacking in its shape, eyes, bones, or colour to make it seem otherwise than if it had been alive. The king gave me one of these stones. I found a tench inside; it was brown in colour, and in every detail exactly as you would expect a tench to be.[11]

The wonder-cabinets of the Renaissance were at least as much about possession as display. The wonder derived not only from what could be seen but from the sense that the shelves and cases were filled with unseen wonders, all the prestigious property of the collector. In this sense, the cult of wonder originated in close conjunction with a certain type of resonance, a resonance bound up with the evocation not of an absent culture but of the great man's superfluity of rare and precious things. Those things were not necessarily admired for their beauty; the marvellous was bound up with the excessive, the surprising, the literally outlandish, the prodigious. They were not necessarily the manifestations of the artistic skill of human makers: technical virtuosity could indeed arouse admiration, but so could nautilus shells, ostrich eggs, uncannily large (or small) bones, stuffed crocodiles, fossils. And, most importantly, they were not necessarily objects set out for careful viewing.

The experience of wonder was not initially regarded as essentially or even primarily *visual*; *reports* of marvels had a force equal to the seeing of them. Seeing was important and desirable, of course, but precisely in order to make reports possible, reports which then circulated as virtual equivalents of the marvels themselves. The great medieval collections of marvels are almost entirely textual: Friar Jordanus' *Marvels of the East*, Marco Polo's *Book of Marvels*, Mandeville's *Travels*. Some of the manuscripts, to be sure, were illuminated, but these illuminations were almost always ancillary to the textual record of wonders, just as emblem books were originally textual and only subsequently illustrated. Even in the sixteenth century, when the power of direct visual experience was increasingly valued, the marvellous was principally theorized as a textual phenomenon, as it had been in antiquity. 'No one can be called a poet', wrote the influential Italian critic Minturno in the 1550s, 'who does not excel in the power of arousing wonder.'[12] For Aristotle wonder was associated with pleasure as the end of poetry, and in the *Poetics* he examined the strategies by which tragedians and epic poets employ the marvellous to arouse wonder. For the Platonists, too, wonder was conceived as an essential element in literary art: in the sixteenth century, the Neo-Platonist Francesco Patrizi defined the poet as principal 'maker of the marvellous', and the marvellous is found, as he put it, when men 'are astounded, ravished in ecstasy'. Patrizi goes so far as to posit marvelling as a special faculty of the mind, a faculty which in effect mediates between the capacity to think and the capacity to feel.[13]

Modern art museums reflect a profound transformation of the experience: the collector – a Getty or a Mellon – may still be celebrated, and market value is even more intensely registered, but the heart of the mystery lies with the uniqueness, authenticity and visual power of the masterpiece, ideally displayed in such a way as to heighten its charisma, to compel and reward the intensity of the viewer's gaze, to manifest artistic genius. Museums display works of art in such a way as to imply that no one, not even the nominal owner or donor, can penetrate the zone of light and actually possess the wonderful object. The object exists not principally to be owned but to be viewed. Even the *fantasy* of possession is no longer central to the museum-gaze, or rather it has been inverted, so that the object in its essence seems not to be a possession but rather to be itself the possessor of what is most valuable and endur-ing.[14] What the work possesses is the power to arouse wonder, and that power, in the dominant aesthetic ideology of the West, has been infused into it by the creative genius of the artist.

It is beyond the scope of this brief paper to account for the transformation of the experience of wonder from the spectacle of proprietorship to the mystique of the object – an exceedingly complex, overdetermined history centring on institutional and economic shifts – but I think it is important to say that at least in part this transformation was shaped by the collective project of Western artists and reflects their vision. Already in the early sixteenth century, when the marvellous was still principally associated with the prodigious, Dürer begins, in a famous journal entry describing Mexican objects sent to Charles V by Cortés, to reconceive it:

> I saw the things which have been brought to the King from the new golden land: a sun all of gold a whole fathom broad, and a moon all of silver of the same size, also two rooms full of the armour of the people there, and all manner of wondrous weapons of theirs, harness and darts, wonderful shields, strange clothing, bedspreads, and all kinds of wonderful objects of various uses, much more beautiful to behold than prodigies. These things were all so precious that they have been valued at one hundred thousand gold florins. All the days of my life I have seen nothing that has gladdened my heart so much as these things, for I saw amongst them wonderful works of art, and I marvelled at the subtle *ingenia* of men in foreign lands. Indeed, I cannot express all that I thought there.[15]

Dürer's description is full of the conventional marks of his period's sense of wonder: he finds it important that the artifacts have been brought as a kind of tribute to the king, that large quantities of precious metals have been used, that their market value has been reckoned; he notes the strangeness of them, even as he uncritically assimilates that strangeness to his own culture's repertory of objects (which include harness and bedspreads). But he also notes, in perceptions highly unusual for his own time, that these objects are 'much more beautiful to behold than prodigies'. Dürer relocates the source of wonder from the outlandish to the aesthetic, and he understands the effect of beauty as a testimony to creative genius: 'I saw amongst them wonderful works of art, and I marvelled at the subtle *ingenia* of men in foreign lands.'

It would be misleading to strip away the relations of power and wealth that are encoded in the artist's response, but it would be still more misleading, I think, to interpret that response as an unmediated expression of those relations. For Dürer gives voice to an aesthetic understanding – a form of wondering and admiring and knowing – that is at least partly independent of the structures of politics and the marketplace.

This understanding – by no means autonomous and yet not reducible to the institutional and economic forces by which it is shaped – is centred on a certain kind of looking, a looking whose origins lie in the cult of the marvellous and hence in the art work's capacity to generate in the spectator surprise, delight, admiration and intimations of genius. The knowledge that derives from this kind of looking may not be very useful in the attempt to understand another culture, but it is vitally important in the attempt to understand our own. For it is one of the distinctive achievements of our culture to have fashioned this type of gaze, and one of the most intense pleasures that it has to offer. This pleasure does not have an inherent and necessary politics, either radical or imperialist, but Dürer's remarks suggest that it originates at least in respect and admiration for the *ingenia* of others. This respect is a response worth cherishing and enhancing. Hence, for all of my academic affiliations and interests, I am sceptical about the recent attempt to turn our museums from temples of wonder into temples of resonance.

Perhaps the most startling instance of this attempt is the transfer of the paintings in the Jeu de Paume and the Louvre to the Musée d'Orsay. The Musée d'Orsay is at once a spectacular manifestation of French cultural *dépense* and a highly self-conscious, exceptionally stylish generator of resonance, including the literal resonance of voices in an enormous vaulted railway station. By moving the Impressionist and Post-Impressionist masterpieces into proximity with the work of far less well-known painters – Jean Béraud, Guillaume Dubuffe, Paul Sérusier, and so forth – and into proximity as well with the period's sculpture and decorative arts, the museum remakes a remarkable group of highly individuated geniuses into engaged participants in a vital, conflict-ridden, immensely productive period in French cultural history. The reimagining is guided by many well-designed informative boards – cue cards, in effect – along, of course, with the extraordinary building itself.

All of this is intelligently conceived and dazzlingly executed – on a cold winter day in Paris, the museum-goer may look down from one of the high balconies by the old railway clocks and savour the swirling pattern formed by the black and gray raincoats of the spectators below, as they pass through the openings in the massive black stone partitions of Gay Aulenti's interior. The pattern seems spontaneously to animate the period's style – if not Manet, then at least Caillebotte; it is as if a painted scene had recovered the power to move and to echo.

But what has been sacrificed on the altar of cultural resonance is visual wonder centred on the aesthetic masterpiece. Attention is dispersed among a wide range of lesser objects that collectively articulate the impressive creative achievement of French culture in the late nineteenth century, but the experience of the old Jeu de Paume – intensive looking at Manet, Monet, Cézanne and so forth – has been radically reduced. The paintings are there, but they are mediated by the resonant contextualism of the building itself and its myriad objects and its descriptive and analytical plaques. Moreover, many of the greatest paintings have been demoted, as it were, to small spaces where it is difficult to view them adequately – as if the design of the museum were trying to assure the triumph of resonance over wonder.

But is a triumph of one over the other necessary? I have, for the purposes of this exposition, obviously exaggerated the extent to which these are alternative models for museums (or for the reading of texts): in fact, almost every exhibition worth the viewing has strong elements of both. I think that the impact of most exhibitions is likely to be greater if the initial appeal is wonder, a wonder that then leads to the desire for resonance, for it is easier to pass from wonder to resonance than from resonance to

wonder. Why this should be so is suggested by a remarkable passage in his *Commentary on the Metaphysics of Aristotle* by Aquinas's teacher, Albert the Great:

> wonder is defined as a constriction and suspension of the heart caused by amazement at the sensible appearance of something so portentous, great, and unusual, that the heart suffers a systole. Hence wonder is something like fear in its effect on the heart. This effect of wonder, then, this constriction and systole of the heart, spring from an unfulfilled but felt desire to know the cause of that which appears portentous and unusual: so it was in the beginning when men, up to that time unskilled, began to philosophize.... Now the man who is puzzled and wonders apparently does not know. Hence wonder is the movement of the man who does not know on his way to finding out, to get at the bottom of that at which he wonders and to determine its cause.... Such is the origin of philosophy.[16]

Such too, from the perspective of the new historicism, is the origin of a meaningful desire for cultural resonance, but while philosophy would seek to supplant wonder with secure knowledge, it is the function of new historicism continually to renew the marvellous at the heart of the resonant.

Notes

1 Walter Cohen, 'Political Criticism of Shakespeare', in *Shakespeare Reproduced: The Text in History and Ideology*, ed. Jean E. Howard and Marion F. O'Connor (New York and London: Methuen, 1987), p. 33; Edward Pechter, 'The New Historicism and its Discontents: Politicizing Renaissance Drama', *PMLA* 102:3 (May, 1987), p. 301.

2 'The new historicists and cultural materialists', one typical summary puts it, 'represent, and by representing, reproduce in their *new* history of ideas, a world which is hierarchical, authoritarian, hegemonic, unsubvertable.... In this world picture, Stephen Greenblatt has poignantly asserted, there can be no subversion – and certainly not for *us*!' (C. T. Neely, 'Constructing the Subject: Feminist Practice and the New Renaissance Discourses', *English Literary Renaissance*, 18 (1988), p. 10.) Poignantly or otherwise, I asserted no such thing; I argued that the spectator of the history plays was continually tantalized by a resistance simultaneously powerful and deferred.

3 See my *Renaissance Self-Fashioning: from More to Shakespeare* (Chicago: University of Chicago Press, 1980), pp. 174–5: 'We are situated at the close of the cultural movement initiated in the Renaissance; the places in which our social and psychological world seems to be cracking apart are those structural joints visible when it was first constructed.'

4 Louis Adrian Montrose, 'Renaissance Literary Studies and the Subject of History', in *English Literary Renaissance*, 16 (1986), pp. 5–12; Don Wayne, 'Power, Politics, and the Shakespearean Text: Recent Criticism in England and the United States', in *Shakespeare Reproduced: The Text in History and Ideology*, ed. Jean E. Howard and Marion F. O'Connor (New York and London: Methuen, 1987), pp. 47–67; Catherine Gallagher, 'Marxism and the New Historicism', in *The New Historicism*, ed. Harold Veeser (New York and London: Methuen, forthcoming).

5 Jean E. Howard, 'The New Historicism in Renaissance Studies', in *Renaissance Historicism: Selections from 'English Literary Renaissance'*, ed. Arthur F. Kinney and Dan S. Collins (Amherst: University of Massachusetts Press, 1987), pp. 32–3.

6 Cohen, 'Political Criticism of Shakespeare', pp. 33–4.

7 Thomas Greene, *The Vulnerable Text: Essays on Renaissance Literature* (New York: Columbia University Press, 1986), p. 100.

8 Quoted in Linda A. Altshuler and Anna R. Cohn, 'The Precious Legacy', in David Altshuler (ed.), *The Precious Legacy: Judaic Treasures from the Czechoslovak State Collections* (New York: Summit Books, 1983), p. 24. My sketch of the genesis of the State Jewish Museum is largely paraphrased from this chapter.

9 Ibid., p. 36.

10 In effect that dream of possessing wonder is at once aroused and evacuated in commerce as well, since the minute the object – shoe or dress or soup tureen – is removed from its magical pool of light, it loses its wonder and returns to the status of an ordinary purchase.

11 Joinville, *Life of Saint Louis*, in *Chronicles of the Crusades*, trans. M. R. B. Shaw (Harmondsworth: Penguin, 1963), p. 315.

12 Quoted in J. V. Cunningham, *Woe or Wonder: The Emotional Effect of Shakespearean Tragedy* (Denver: Alan Swallow, 1960; orig. edn 1951), p. 82.

13 B. Hathaway, *Marvels and Commonplaces: Renaissance Literary Criticism* (New York: Random House, 1968), pp. 66–9. Hathaway's account of Patrizi is taken largely from Bernard Weinberg, *A History of Literary Criticism in the Italian Renaissance*, 2 vols (Chicago: University of Chicago Press, 1961).

14 It is a mistake then to associate the gaze of the museum-goer with the appropriative male gaze about which so much has been written recently. But then I think that the discourse of the appropriative male gaze is itself in need of considerable qualification.

15 Quoted in Hugh Honour, *The New Golden Land: European Images of America from the Discoveries to the Present Time* (New York: Pantheon Books, 1975), p. 28.

16 Quoted in Cunningham, *Woe or Wonder*, pp. 77–8.

Chapter 52 | Eilean Hooper-Greenhill

Changing Values in the Art Museum |
Rethinking Communication and Learning

The Myth of the Museum

Five to ten on a warm but humid Saturday morning in May. Outside the British Museum in London a queue of people has formed. Other people sit on the benches in the forecourt and under the great pillars. The sun shines. There is a slight buzz of anticipation, as though waiting for the lights to go down in the cinema. People are meeting friends, chatting, checking guide-books, eating ice-cream, pointing at the pigeons, and generally warming up for the occasion.

The doors are open, but we are denied entry. The uniformed warders are very firm about that, and we have to sit outside with the stubby-toed pigeons and yesterday's cigarette ends. The minutes pass. The (unused) crowd barriers say: 'Do not climb on the barriers', and 'Do not feed the birds'. Finally, the queue begins to move, rather ponderously, like a huge snake.

The museum holds its breath before another busy day. The galleries have been cleaned and polished, the objects have been chosen, classified and laid out in order, and each box-like space is empty except for its guardian poised and standing at the ready in their sub-military uniforms. Everything is in its place, correctly arranged and positioned, one guardian in each space, surrounded by objects from the past that wait to be observed and interpreted. There is a sense of an event waiting to happen, of a show about to be enacted. And within seconds, the crowds catch me up, and the show is on!

The British Museum has become a museum archetype. With its classical columns, triangular pediment, the stairs that need to be climbed before entry, this type of large stone building is the image of 'The Museum' held by many at both a popular and a theoretical level. It is an image that can sustain a range of interpretations: of culture and civilisation; of dust, decay, and neglect; of power and control. In spite of the many and fundamental changes to museums in the last twenty years, it is an enduring image.

Eilean Hooper-Greenhill, "Changing Values in the Art Museum: Rethinking Communication and Learning" from *International Journal of Heritage Studies* 6:1 (March 2000), pp. 9–31.

People in Britain asked to describe 'a museum', describe exactly this kind of building, and this is common across all cultures and ethnic groups in Britain. The typical imagined contents of such a museum include: ' "Kings and Queens", crowns, suits of armour, weapons and "broken pots and rocks" '.[1]

In many ways, this view of museums has achieved the status of myth. It bears very little relationship to the range and variety of museums that now exist, and it is generally uninformed about the actual experience of people who visit or use museums, or of those who work in them. It is an essentialist image, which acknowledges neither the range of pleasures that may be gained from visiting museums, nor the complexities of the challenges facing museums today. 'The Museum' is also powerful as an ideal, as aspiration, to which many museum workers themselves subscribe.

Many art museums see themselves as rather special places, separate from the mundane world of the everyday, places that preserve the best of the past, and places that are appreciated by cultured and sophisticated people. The values that underpin professional practices in museums such as these are those of preservation and conservation, of scholarship, and of displays based on aesthetic approaches to the laying out of knowledge.[2] These museums are expected to be authoritative, informative, and to be their own best judge of what counts as appropriate professional practice.

The mythical museum exists mainly in the imagination. The reality that lies behind these aspirations may not be so grand, so pure, so monolithic. Many museums suffer from lack of funding, lack of sufficient expertise, poor management, unclear philosophies, and from trying to do too much, too quickly, and with insufficient resources. However, for many art-museum professionals, the mythical museum remains a standard to be aspired to, and represents a goal to be achieved, and this has become problematic. This professional direction is one that looks backwards rather than forwards, and inwards rather than outwards. It is based on attitudes, values and perceptions that have developed in isolation from other social and cultural institutions, and from an assumption that the definitions of civilisation, culture and communication that these values enshrine are absolute, and confer an accepted social function for art museums.

However, this is no longer the case. The values described above are no longer sufficient to sustain museums. In many parts of the world they are being questioned on a daily basis, both from within museums and from without. Today, we are witnessing an enormous cultural change, which shifts the ground on which art museums have stood so firmly for so long. Changes in social structures, in cultural allegiances and in personal identities go hand in hand with changes in the nature, control and functions of knowledge. Today, museums are subject to diverse demands to enable them to play valid roles in new worlds. Art museums must demonstrate their viability and argue their value in new contexts where former values are no longer taken for granted.

What specific challenges face art museums? At the end of the 20th century it is clear that large-scale social, political and cultural changes are in process. Some writers characterise these shifts as a move from the modern period into the post-modern period; others insist that modernity is an unfinished project, and therefore the current period must be seen as one of late modernity.[3] However it is analysed, it is clear that we are in a period of paradigmatic change that is affecting all social structures, relationships and values. Museums, expository spaces charged with garnering, caring for and exhibiting those objects that symbolise some of our deepest feelings and hopes, are one of the most vulnerable of institutions at this time of radical change.

Museums are challenged today to justify their existence, and this justification is frequently requested in hard economic terms. Questions are asked about what role museums can play in the national economic life of society. How can museums contribute to national or local income generation? What part do museums play in providing employment, or in education, or in alleviating social problems? The funding of museums needs to be argued for, frequently in competition with other calls on resources. If museums cannot identify and articulate their value in ways that can be appreciated by those disbursing funds, those funds will not be forthcoming.[4] These questions take on a particular urgency as participation surveys demonstrate the audience for art museums is less democratic than for other museums, and that on the best evidence available, less than one quarter of the population of Europe visits art museums.[5]

In many museums, reductions in funding have led to a need to generate increased revenue through attracting increased audiences. This leads in the first instance to an emphasis on marketing, but it soon becomes clear that there is a need to go beyond marketing and to think more analytically about the experience that is offered to visitors. We need to consider the museum as a communicator.

In beginning to consider the museum as a communicator, we realise that we are just at the beginning of finding the answers. We still understand very poorly what this role might be and how to conceptualise it. We understand even less what professional strategies might need to be put in place in order to develop a more egalitarian and coherent approach to communication. In some ways, it is peculiarly difficult to begin to develop the museum as a communicator, as the theory and the practice go hand in hand. The theoretical analysis of the roles a museum might play depends on what has already been achieved in practice. Theory and practice are inter-dependent. But, in addition, for those who are struggling to find new ways forward, concepts from communication studies, learning theory, philosophy and museum studies can offer a new vocabulary – a vocabulary of action – ways to describe the new working practices and staff roles that are emerging.

The development of the museum as a communicator is a form of action research,[6] where the museum curator/educator reflects upon her own practice, and in the process of this reflection, asks ever more penetrative questions that themselves force a more thoughtful and insightful practice. The progressive focusing as action research continues acts to make the curator/educator more self-critical, more self-aware, and hungry for more ideas to take the practice forward.[7]

In beginning to approach the analysis of the museum as a communicator, I have found it necessary to draw on a range of fields of study. First, it is important to address communication theory. Here I have found two clearly defined ways of thinking about communication, communication as a process of transmission and communication as a part of culture.[8] Although it is perhaps unwise to reduce the complex processes of communication to two approaches, this has been helpful in considering the strengths and weaknesses of actual museum practice.

Analysing museum communication as either a process of information transmission or as one among many cultural processes, also enables us to relate these approaches to educational theory. Both accounts of communication have clear views on the 'audience' or 'partner' in communication. Both approaches are in fact based upon ways of explaining learning and teaching. The transmission approach to communication is based on a behaviourist view of teaching, while the cultural approach to communication is supported by a constructivist explanation of learning.

In thinking about the museum as a communicator, both learning theory and communication theory have things to teach us. Cultural theory, which examines the social structures of modernism and post-modernism and alerts us to the politics of communication deepens our analysis, and enables the critique of the museum as a communicator to be placed in a wider theoretical arena.

Modernism and the Modernist Museum

Museums are creations of the Enlightenment, institutions that came into being in the period that we now characterise as the Modern period. During the Modern period, reason, rationality, was invoked to supplant the superstitions and subjective knowledges of earlier times.[9] Attempts were made to construct knowledge that could be relied upon at all times and in all places; grand narratives (meta-narratives[10]) were developed that stood as valid outside the context of the site from which they were spoken; institutions such as museums were established to spread out, as though upon a table, those things which could be observed, measured, classified, named, and which presented a universally valid and reliable picture of the world.[11]

The Enlightenment inherited the dream of Descartes – the attempt to escape from the confinements of tradition and the already known and to base all knowledge on what could be deduced from reason alone. It was thought that the use of pure unprejudiced reason would guarantee untainted objective knowledge. Reason thus became the new authority, supplanting that of the written texts of the ancients. However, this belief in an objective reality is itself one of the meta-narratives that the Enlightenment invented: reason itself was and is subject to the limits of contemporary knowledge.[12] Enlightenment thought, long considered the only method of constructing a 'true' world-view is now under siege from, among others, all those whom this 'true' world-view disadvantaged.

The epistemic structures[13] of the Enlightenment were premised on a split between mind and body, with the privileged organ being the mind. This binary split acted to structure the landscape of Western thought and experience. These binary pairs, which are still in many ways the 'common sense'[14] of our world, can be observed in everyday concepts such as: mental/manual, male/female, black/white, light/dark. Just as the mind became the privileged point within the mind/body binary, so, within each of the other binary pairs, one half is accorded greater value than the other. These mental structures, the structures which have dominated our thoughts, have of course dominated our daily lives too, in providing 'reasons' for those social facts that are presented as 'natural'. One of the social structures that emerged to mediate these cultural values was the museum. During the late 18th and early 19th centuries in Europe, pre-existing museum models based on the private princely and scholarly 'cabinets of the world'[15] were reinvented as open public museums.

The 19th-century public museum was tasked with the production and dissemination of knowledge. Its epistemological identity was constructed through a range of collection-related disciplines (art, natural history, geology, archaeology, ethnography). It was intended, at least in part, to convert raw humanity to civil society, to create docile bodies.[16]

The modernist museum was intended to be encyclopaedic, to draw together a complete collection, to act as a universal archive. It was structured through deep-rooted binary divisions. Its spaces were divided between those that were private and

those that were public. The private spaces were the spaces for knowledge production, irrevocably separated from the public spaces for knowledge consumption. The private spaces were spaces where specialist knowledge was deployed, where scholarly research was carried out, and where products such as exhibitions and catalogues were fashioned. The bodies occupying these spaces were highly specialised and differentiated, each with its own necessary mental freight which justified its presence within these austere spaces. The public spaces, on the other hand, were available, in theory at least, to the mass of the general public; undifferentiated bodies that assembled to partake of the specialist information laid out for them in the galleries. The galleries were spaces of consumption, of viewing and learning. In many ways they were also spaces of controlled behaviour, guarded and surveyed by warders who would eject those who behaved in an unruly fashion.

The 19th-century museum, in actuality, took many forms, but the ideal to which most aspired can be closely related to the model sketched above. Those institutions that were established by proud city fathers or by nations newly celebrating their political identities saw themselves as separate from the mundane world of the everyday, as standing for higher, purer values. They offered opportunities of self-improvement, of inspiration and of civic celebration. This ideal was to prove the dominant model of a museum until the last quarter of the 20th century. This is the image of the museum that has been internalised by many today, and these are the working practices that create and sustain this image of 'The Museum' that provide the 'common sense' of many museum professionals still.

The Modernist Museum and the Transmission Model of Communication

The modernist museum adopts a particular stance towards its visitors. The communicative aim of the modernist museum is to enlighten and to educate, to lay out knowledge for the visitor such that it may be absorbed. The information offered is that of the academic discipline from which the collections are viewed. Thus in art galleries, the paintings are grouped in order to materialise 'art history'. The educational aim of the museum is to transfer or transmit information about 'art history'.

Underlying this approach to communication is a particular view of knowledge, and of learning. The 'transmission' model of communication understands communication as a linear process of information-transfer from an authoritative source to an uninformed receiver. Knowledge is seen as objective, singular and value-free. The receiver of the message to be communicated is conceptualised as open to the reception of the message, which is received more or less efficiently, and in the same way by all.

The transmission view of communication is defined by terms such as 'imparting', 'transmitting', and 'sending'. A geographical metaphor is used, that of sending information across space, from one point to another. This is a metaphor of transportation – the sending of signals and messages over a distance for the purposes of control. The model focuses on the technological processes of communication.

The basics of the model are straightforward; a communicator (sender or transmitter), sends a message through a medium to a receiver. The focus is on the technical act of transferring data from a source to a receiver, with the telephone system as an example. One of the first depictions of the model of communication as transmission was that of Lasswell, who famously once said that any act of communication could be

understood by answering the question: Who? Says what? In which channel? To whom? With what effect?[17]

This approach to understanding communication is severely limited. It is based upon technical processes, and ignores the social and cultural aspects of these processes. It does not explain well the extremely complex relationships that structure acts of understanding between people. The secular metaphors of transmission, for example, hide the links to religious practices, those of evangelism and conversion. Movements of people in space were frequently impelled by desires to extend 'civilisation' through the implantation of Christianity. This moral component, of purportedly improving patterns of life, of making things 'better' for others by the giving of new information, is deeply embedded in this understanding of communication. It can be found in 19th-century paternalism, in gender relations, in forms of education.

In the transmission-model approach, the processes of communication are reduced to a single, one-way, linear trajectory.[18] The receiver of the message is considered only in so far as a judgement is made in relation to the correct reception of the message. The selection and control of meaning lie with the communicator, who is therefore the power broker in the transaction. In this approach, evaluation or feedback is likely to be limited and, where it exists, is used to judge correct reception.

This approach to communication is based upon a behaviourist explanation of education.[19] Behaviourism proposes that learning takes place through a response following a stimulus. Students are 'empty vessels to be filled', and the role of the teacher, as a knowledgeable individual and authoritative person, is to structure the subject matter to be mastered so that the learners may absorb it.[20] Sometimes called the banking approach to education,[21] this approach to teaching and learning sees the school as separate from the world outside and does not view the 'knowledge' that learners bring with them into the learning situation as relevant. The content to be learnt is structured according to the internal logic of the subject matter, with few concessions to the experience or knowledge of the learners. Knowledge is conceptualised as something that can be transferred from one mind to another. The approach to teaching is didactic and structured through the setting of measurable goals. Examinations are used to judge how effective the information transfer has been.

The transmission approach assumes that the communicator defines the content of the message, and that this is received without modification by the receiver, who, in this process, is rendered cognitively passive. Each individual receiver/learner is understood to receive the same message in the same way. Underlying this approach is, as we have seen, a behaviourist view of learning, with individuals conceived as atomistic. Atomism asserts that people are separate individuals constituted by their own unique states of consciousness, and by their own capacities and needs. It views the self as a monad, an impermeable integral entity radically different from all others, and, at the extreme, cut off from all others. The atomistic view of the self ignores the degree to which the self is inflected through experience, has the capacity to change and modify itself through learning, and may objectively consider and develop itself. In other words, people are seen as individuals without curiosity, without capacity to change, and as merely the absorbers of external stimuli.[22]

The transmission model of communication can be used to explain the moral imperative that underlay much of the use of culture during the 19th century. As museums were established, one of their most prominent functions lay in the field of education. Education was understood as a process of imparting information and,

through this, values, such as to constitute the subject as an ideal citizen.[23] One of the characteristics of museum education during this period was a moral, sometimes proselytising dimension.[24]

The transmission model also explains rather well the approaches frequently taken by museums to the development of exhibitions. The curator as scholar, expert on the collections and knowledgeable about the relevant discipline, leads the project, chooses the objects[25] for display and decides what to say in the text panels and labels. The audience for the exhibition is rarely defined beyond the catch-all 'general public'. A generalised mass audience is envisioned. There is no research into the levels of information that this 'general public' might bring with it into the museum, and there is no investigation into the experience of this abstracted mass visitor. Lest it be thought that these processes belong only in the museums of the past, let me assure you that some (many) art museums today still use this approach, and are still unaware of who visits them and why they might come.

Many of the values of the modernist museum can be explained by the transmission approach to communication. These include naturalised assumptions of separation from the quotidian, an emphasis on scholarly values which focus on collection research, the ordering of a display according to the structures of an academic discipline, a lack of audience research, and a consequent ignorance of visitors and their worlds. As a communicator, the modernist museum is subject to the same criticisms which have already been identified in relation to the model itself. In the modernist museum, communication is considered from the perspective of a technical process only; which paintings shall we hang, in which arrangement, with which attached texts? The social and cultural aspects of the process are not considered. The communication process is one-way. The focus on exhibition technology excludes the visitor, proceeding with no consultation as to whether the selected approaches will be familiar or unfamiliar, or will be accessible to those who do not already recognise the display codes and the art historical references.[26] In this approach to communication, as the transmission model reveals, the curator is the power broker, and visitors are disempowered. If no audience research is undertaken, the actual experience of visitors is unknown, as is, indeed, their very identity.

The adequacy of this approach to communication has been seriously called into question by communication theorists. In communication studies, frequently using television as the field for research, the concept of 'the active audience' has developed.[27] The transmission model of communication, based on the stimulus/response model of education, assumed the possibility of a universal effect on the targets (receivers) of the message, who were thought to be open to the persuasions of the mass media. Following a range of research studies of these assumed 'effects', it was gradually realised that people were not merely passive absorbers of the media. The media–audience relationship was found to be complex and multi-faceted, mediated by factors external to the technical process of information transfer. By the 1970s, new explanations were being developed to analyse the media audience, which focused on the range of responses and interpretations in which media audiences actively engaged. In those few museums in Britain which carried out audience research on a consistent basis, it would take until the 1990s to be able to admit that in the development of exhibitions that would communicate effectively 'the initial emphasis was entirely on the subject matter and the efficient transmission of information, and it was only later that we began to understand and respond to the meaning of a museum visit to the visitor'.[28]

The Challenges of the Post-modern World:
Narrative, Voice and Interpretation

Society is changing. The modernist structures that we inherited from the 19th century are under attack. Many of the challenges to traditional values challenge the core values of the museum, and the art museum in particular. The post-modern, post-colonial world has meant a thorough review of social organisations, and one of these is the museum.

The challenges to the art museum focus on two areas, both of which are essential to its identity. Both relate to the prevailing contemporary challenge to modernist authority. The first concerns what is said and who says it, issues of narrative and voice. The second relates to who is listening, and is an issue of interpretation, understanding and the construction of meaning.

The art museum works from the epistemological perspective of art history. This is taken as a given. The task of the museum is to make art historical narratives visible on the walls of the museum. The narrative itself is constructed from within the parameters drawn up by the classic texts. The role of the curator is to work ever more deeply within these parameters, to research the histories, contexts and meanings of the specific artefacts in the collections, and to care for and display the collections. The parameters of the narrative from which the collections and displays are constructed have, in the past, rarely been challenged from within the museum. The curatorial voice was the only one to be heard.

This voice has been challenged from outside the museum. The demand from feminist art historians to revise the art historical canon has been heard, although not always accommodated.[29] In the post-colonial period, the questioning has intensified and is coming from more than one direction. In white settler societies, for example, where specific definitions of civilisation, informed by European traditions and values, were imposed as part of colonialism, the voices of indigenous peoples demand a hearing. In New Zealand, Maori have successfully demanded that their cultural treasures be re-valued. This has meant that Maori objects have been taken out of the natural history and ethnographic collections in which they were formerly classified, and are now placed within new contexts where they are able to assert their own aesthetic and cultural identity. Similar re-classifications and re-evaluations are also happening in South Africa and Canada. Histories are being rewritten from new perspectives and the past is being re-memoried to privilege different events. Formerly silent voices are being heard, and new cultural identities are being forged from the remains of the past.

These processes of the re-memorialising and rewriting of the past affect museums deeply. Museums uphold specific accounts of the past through the objects they chose to collect, and the expository juxtapositions they choose to make. Museums and their collections embody and exhibit social values. Values necessarily operate to discriminate, to emphasise and downplay, to make visible and to put away. These processes of valorisation are highly visible in relation to those cultural groups who are overtly concerned with asserting their identities. The Lakota Sioux, for example, have recently succeeded in claiming an item from their past from the ethnographic collections of Glasgow Museums in Scotland. After much discussion, it has been agreed that the Ghost Dance Shirt which has been in Kelvingrove Museum will be repatriated.[30] These dramatic and high-profile events can disguise the central issue, which is one of

how museums represent the past, and in consequence the present. This is an issue that operates across a broad spectrum of museums, including the art museum. Issues of narrative and voice lead to questions of the construction of knowledge, and the relationship between knowledge construction and power.

The second challenge is that of interpretation. As institutions become more aware of their audiences,[31] patterns of consumption begin to be mapped, but it quickly becomes clear that closely related to patterns of participation are patterns of interpretation and meaning.

At an exhibition of African sculpture I observed a black visitor scratching fiercely and angrily at one of the labels. Carrying a small child on his back, he knelt down carefully next to the label which was placed at the lower edge of a large glass case. Muttering, 'This is sick: rub it out', he proceeded to scrape at it with his nails. The woman accompanying him, tried to restrain him. This was more than simple vandalism; this was the act of a man who disagreed with the text, an active contestation of the story that was being told, by, as it happens, a white curator, describing the sculpture from his (and it was a man) Euro-centric perspective.

There are many assumptions built into my interpretation of this observation. I assumed the man was angry from his actions and body language; I read him as claiming an African heritage because of his dress codes and dreadlocks; I read his action in the context of post-colonial and post-modernist writings, and especially those of Stuart Hall, who describes how meaning continues to unfold beyond the arbitrary closure which makes it, at any moment, possible.[32] Hall has also pointed out how Africa was the unspoken presence in the Caribbean of his childhood, but how in the past twenty years, an Afro-Caribbean identity has become historically available to people who simultaneously discover themselves to be both 'black' and the 'children of "slavery"'.[33]

These subjectivities, these questions of cultural identity, are unknown to and unconsidered by many curators. However, the decision to visit a museum or to stay away is informed by the meaning constructed from an experience, or the anticipation of such meaning. For many who have not been successful learners, the overt educational remit of museums is not attractive, and for those who do not feel comfortable with formal social structures, the authoritative style of museum buildings and spaces do not offer the comfortable leisure pastime they seek.[34] And for those whose histories are told from a perspective they find alien, the museum represents a space to avoid or to challenge.

The second approach to understanding communication, the cultural approach, focuses more closely on how meaning is made. It approaches the processes of communication more broadly than the transmission model allows, and sees communication as an integral part of culture as a whole. It is to this second approach that I will now turn.

Communication as Culture

The second approach works from an integrated perspective that acknowledges from the start the relevance of voice and the importance of interpretation. The second approach sees communication as integral to the whole of culture, and insists on the constructed character of both culture and communication. However, this second approach is itself inflected in a number of different directions depending on what

basic assumptions are made about how culture is defined and how social relations are conceptualised.

Culture can be understood in a number of ways. Modernism makes a distinction between 'high' and 'low' culture, with culture *per se* being synonymous with canonical and elevated values, and set apart from the processes of the everyday. 'Low' or 'mass' culture, from this perspective, is the antithesis of 'true' culture, being debased, watered down, populist, and trivial. A second view of culture takes a rather more anthropological approach, seeing culture as the patterning of all aspects of daily life. This expanded view of culture as a whole way of life has positive elements, but fails adequately to identify those practices and institutions that are principally concerned with meaning and signification. Raymond Williams's definition of culture as a 'realised signifying system' seeks to focus specifically on those aspects of social life that work to construct meaning.[35] If we understand culture in this way, as a materialised system for constructing meaning, then communication is an integral element. Culture is understood as constructed through processes of communication, and both social life and individual identity would be impossible without communication.[36]

Carey describes communication as a series of processes and symbols whereby reality is produced, maintained, repaired and transformed.[37] 'Reality' has no finite identity, but is brought into existence, is produced, through communication. As beliefs and values are represented through cultural symbols (words, maps, models), so 'reality' is constructed. Symbolic systems (art, journalism, common sense, mythology, science, museums) shape, express and convey our attitudes and interpretations of our experience.

Carey[38] also describes communication as a form of secular ritual, as a process of sharing, participation, fellowship and association. He locates the roots of the word communication in 'commonality', 'commonness', 'communion', and 'community' and links this to sacred ceremonies as ritual, and to religion, but in the form of the prayer, the mutual communicative ritual, rather than missionary work or the sermon. This emphasis on harmony betrays a non-conflictual view of social life, and Carey's analysis lacks any acknowledgement of the relationship of power to communication. He ignores, therefore, the politics of communication. Giroux criticises this definition of culture as a field of shared experiences as one developed within Western ethnocentric terms. He insists on a broader stance that goes beyond this imagined social harmony to acknowledge difference. The concept of difference has been developed within post-colonial studies to make visible the relative inscriptions of power in and between zones of culture. A focus on cultural borderlands, those liminal contact zones between different cultures, raises questions about relations of equality and inequality, struggle and history, narrative, voice and interpretation. From Giroux's perspective, culture is a site of multiple and heterogeneous borders, where different histories, languages, experiences and voices intermingle amidst diverse relations of power and privilege.[39]

This more developed cultural model understands communication as a set of negotiated processes of making meaning as part of the complex and unequal culture of everyday life. It accepts that there are many, sometimes conflicting, perspectives from which to explain the world. In the consumption of culture, the active interpretive strategies for the perception and processing of knowledge and the differentiated agenda that participants bring to cultural experiences are acknowledged.

Processes of Interpretation

The cultural approach to communication emphasises the importance of interpretive strategies in the construction of meaning. Some elements of the philosophical approach known as hermeneutics[40] offer a preliminary analysis of some of the processes of interpretation.

Much of the focus of hermeneutics, or interpretive philosophy, concerns how understanding can be achieved. Interpretation is seen as a process of making confused meanings clearer; it is concerned with coming to a fuller understanding of how things mean. The range of meanings includes desires, emotions, which are bound up with the level and type of culture and with language.[41] Gadamer is particularly interesting for museums in his thoughts on how meaning is made from objects. He uses the 'hermeneutic circle' to discuss and describe the way in which meaning is made. The process of making meaning moves both between the whole and the part of the object and between the present and the past, simultaneously. A dialogue is established between the whole and the part, the past and the present, which enables continual checking and rechecking, revising ideas, trying new ones and rejecting of those that do not work. Gadamer emphasises the significance of prior knowledge in the encounter.[42]

The process of constructing meaning from a painting, for example, is circular and dialogic. We are in a question-and-answer mode, a continuous process as the answers build on those questions that have already been asked and answered. This circular movement involves both the whole and the part, but also the present and the past. Meaning is constructed through this circular action, with modifications to the sense we construct being made constantly. The trajectory, or route, of the conversation, is in large part determined by what is already known, by prior knowledge. Thus in constructing meaning from a Van Gogh painting of a sunflower, different levels of information will result in different complexities of interpretation. Someone with little prior knowledge of the artist or art history will see the painting as a flower painting. Someone with a detailed knowledge of the artist's work would be able to place the picture in relation to the rest of his work, to compare subject matter and technique with other artists of the period, and so on.[43]

The process of constructing meaning is like holding a conversation. No interpretation is ever fully completed. There is always more to say, and what is said may always be changed. The hermeneutic circle remains open to these possibilities and, in this sense, meaning is never static.

Meaning is never static in another sense too. All interpretation is necessarily historically situated. Our own position in history, our own culture, affects meaning. Meaning is constructed through and in culture. Perception (what we see), memory (what we choose to remember) and logical thinking (the sense we choose to attribute to things) differ culturally because they are cultural constructs.[44] Prior cultural and historical knowledge and experience contribute to differentiated meanings.

In the museum context, the concept of 'interpretation' is generally deployed to discuss matters of design and display, with the emphasis being on the work of museum personnel, who decide on the interpretive approach. In fact, interpretation, as understood within museums, is less common in art museums than in museums of other types, where interpretive display technologies might include photographs and graphics, interactive exhibits, sound and handling material. However, whenever it is

used in the museum context, interpretation is something which is done for others – to point out the significance of certain works, for example, or to construct a display-based narrative. The cultural approach to communication acknowledges the significance of the symbolic systems constructed through technologies and events such as exhibitions. However, it also works from the premise that participants in any act of communication are active in the construction of their own interpretations of experience. Here, the concept of 'interpretation' is used to refer to the strategies and the results of explications that are carried out by individuals themselves. Vitally, art museums need to acknowledge that a major sense of 'interpretation' is that of an active process of making meaning, where preferred individual interpretive strategies are used, and where prior knowledge and historical and cultural background play a part in assigning significance. Research remains to be done to investigate how far the interpretive strategies of art curators in selecting specific works, constructing specific narratives and using specific display technologies influence the interpretive processes and strategies of individual visitors.

Constructivist Learning Theories and Active and Differentiated Meaning-making

Hermeneutic philosophy is close to constructivist learning theories. Both hermeneutics and constructivism propose that knowledge is constructed through active interpretations of experience. Knowledge is not a single, self-contained body of facts that can be transmitted, unchanged, from one individual to another. Knowledge is plural, and fluid, brought into being by the processes of knowing.

Both hermeneutics and constructivism assert that knowers, or learners, are active in the process of making sense of experience (including the formal or informal experience of learning). Both mental and bodily action are important in learning processes, and learners will use differentiated learning strategies both to perceive and to process information and experience. Individual learners will combine concrete and abstract modes of perception, and active and reflective processes of accommodating and assimilating knowledge, according to their preferred approach to learning.[45]

Within constructivist theory any discussion of education focuses on the processes of learning rather than the processes of teaching. The role of the teacher is to provide stimulating environments for learning that take account of the existing knowledge of the learner, and that enable both the use of prior knowledge and the development of new knowledge. Effective learning environments enable and encourage the range of learning styles that learners may prefer, encompass a range of both concrete and abstract modes of perception, and offer opportunities for a wide range of intelligences and abilities to be both deployed and developed.[46] Constructivism recognises that where appropriate environments are not provided, some learners will be disadvantaged, and this accounts for the emphasis on learning rather than teaching.

Within constructivist learning theory, the teacher is also seen as a learner. The teacher needs to work in a collaborative and consultative way, jointly with other learners, to develop new approaches to learning processes. Working as a group to solve problems and explore ideas, concepts and processes, teachers balance the responsibility to take a lead with the delight of shared discovery.[47]

Both hermeneutics and constructivism suggest that knowing is culturally inflected, and that in this sense knowledge is relative. Different perspectives on the same events,

different emphases on what is significant, different depths of analysis, and the use of different contextual factors all combine to complicate simple 'facts'. The importance of multi- and inter-cultural issues are fully recognised.[48]

In the analysis of communication as culture, one further strand needs to be drawn out, and that is the importance of interpretive communities. Although each of us is active in interpreting our own experience, using our individual strategies, capabilities, and preferred learning styles, the interpretation that we make is not ours alone. It is mediated, tested and developed within the context of communities of interpretation. Constructivist learning theory tells us that learning is both personal and social.[49] The concept of 'interpretive communities' enables a focus on how this social aspect to learning might be understood.

Interpretive communities

The meanings constructed from information and experience emerge from a complex network of mediation. Personal interpretations are forged through social and cultural environments, through local communities and through location in social structures. Although none of these elements is immutable, meanings and interpretations do have social dimensions. Individual meaning-making is tested in the context of interpretive communities. What we 'know' is produced through interpretations of individual experience, but also through the testing and refining of our interpretation within significant communities.

Stanley Fish[50] defines an 'interpretive community' as those who share the same strategies for reading texts and assigning meaning:

> Interpretive communities are made up of those who share interpretive strategies for writing texts, for constituting their properties and assigning their intentions.[51]

These strategies exist prior to the act of reading and therefore determine the shape of what is read. The interpreting reader, acting with purposes and concerns, which have emerged through pre-existing experience and learning, determines what counts as the facts to be observed.[52]

> Systems of intelligibility constrain and fashion us and furnish us with categories of understanding with which we fashion the entities to which we then point.[53]

An interpretive community can be identified where the same systems of intelligibility are being used, where the same categories of understanding are employed and the same entities are recognised. The visitor to the exhibition on African art that I described earlier can perhaps be understood as coming from a different interpretive community from that of the exhibition curator. He disagreed with the systems of intelligibility that the curator employed to interpret at least one of the displayed objects and, therefore, wished to erase the accompanying text.

Fish wishes to show how meaning is not inherent in the text (or, in the case of this paper, the object or exhibition), but is brought into being through the interpretive strategies used by the reader (viewer, visitor). These meanings, however, are not relative or subjective, but are to some extent controlled by the validation accorded them by the relevant interpretive community. The challenge for interpreters, or communicators, is to test their interpretations against those of respected interpretive

communities. If the interpretation is accepted by such a community, it will stand, at least for the moment.

Fish points out that the concept of interpretive communities stands between the ideal of the perfect agreement that would, if it were possible, depend on objective external texts, and the interpretive anarchy and extreme relativism that would be realised if interpretation were completely random.

Fish suggests that interpretive communities increase and decrease and that individuals may move from one to another. While alignments are not permanent, they are always there, providing just enough stability for interpretive battles to go on, and just enough shift and slippage to ensure that they are never settled.[54] Interpretive communities are no more stable than texts because interpretive strategies are not natural nor universal but learned. The ability to interpret is constitutive of being human; there is no moment before we learn to interpret – we are born into an interpretive context.

The cultural model shows communication to be a much more unreliable business than we are used to thinking. In the transmission model, communicators handed over ready-made or prefabricated meanings. However, if there are no fixed meanings, and if interpretive strategies are learned and not natural, what do communicators (writers, speakers) do?

Fish's answer to this question is that communicators give hearers and readers the opportunity to make meanings by inviting them to put into execution a set of strategies. It is presumed that the invitation will be recognised, and this presumption rests on a projection by the communicator of the moves she would make if she were confronted by the sounds she hears or marks she sets down.[55]

However, these interpretive strategies will be employed only if they are already in place. The opportunity to make meaning will be recognised only if the strategies exist to respond to it. And only those within the same interpretive community will have the relevant interpretive strategies. A writer, communicator, hazards her projection, not because of the something 'in' the marks, but because of something she assumes to be in the reader – something similar to what she perceives within herself. The very existence of the 'marks' is a function of an interpretive community, for they will be recognised, made, only by its members. Those outside the interpretive community will employ a different set of strategies, and may, therefore, find themselves unable to recognise the appropriate strategies for the specific communicative event.

Fish is working in the context of reading written texts. Although there is a good deal to say about the difference between written texts and the collections and spaces of art museums, the idea of interpretive communities is a fruitful one for the understanding of the experience of visitors to art museums. A first question to ask is: do art museums attract their own interpretive communities, who use the same interpretive strategies as the community of professional museum people? If so, at what level and to what degree are these strategies used? If an art curator has a doctorate in art history and several years of experience as a curator, and uses the interpretive strategies that feel comfortable, does that mean that all visitors, in order to benefit fully from a visit to an art gallery, need the same level of expertise? Do art museums represent a self-perpetuating community? What would be necessary to open the art museum to new audiences who might belong to different interpretive communities? What might their systems of intelligibility be, and how would they assign meaning?

Many of these questions relate to the contemporary situation of art museums. They focus on issues of access, of learning and teaching, of visitor research. However, they also have broader implications. If we accept the developed and complex approach to

communication as culture, and think about art museums as cultural borderlands where power and knowledge are unequally deployed, the questions above resonate within the context of the politics of museum communication. My experience in a crowded exhibition in London in the middle of the 1990s demonstrates how opposing world-views exist, and it shows how museums and galleries are active in creating them. It demonstrates the power of the museum to legitimate particular narratives. Museum professionals are not always conscious of the power that they wield, but this power is very real in constructing 'reality', in shaping consciousness. It is time for museum professionals to acknowledge and address the power of museums, to accept that museums are necessarily implicated in cultural politics, and that, therefore, professional practices' and decisions have political dimensions.

Towards New Professional Values and Strategies

The developed cultural model approach to communication, combined with constructivist theories of learning, suggest ways forward for art museums but also offer significant difficulties. For many curators, these intellectual approaches challenge the values on which their professional careers have been built, and this perceived attack on professional identity is felt deeply and personally. However, many curators in many museums, including some art museums, have embraced the possibilities that the new approaches provide, and have found innovative, creative and imaginative new ways of working. At present, while the old orthodoxies are being firmly overturned, new ones are not yet fully in place. This offers the chance to invent new definitions of curatorial professionalism, new museum–audience relationships and new identities for museums. The positive outcomes of embracing and taking control of change far outweigh a more fearful and defensive approach.

There are some guidelines for the paths that change will follow. The emphasis is on the review and reconceptualisation of the museum–audience relationship, and the direction of change is to bring these two poles much closer together. The degree of proximity and the strategies used to link the two will vary with each museum, as each institution searches out the most appropriate approaches for its own needs. Some strategies are already becoming established, although much of the thrust of change is coming from outside the art-museum field. In many ways, science and history museums are further ahead than art museums but, on the other hand, some of the most interesting and radical new developments are taking place in art museums. Change is taking place on four fronts, which can be summarised as, firstly, the introduction of new professional roles; secondly, the concept of differentiated audiences; thirdly, the emergence of new voices; and fourthly, the development of new narratives.

In many museums of all types, new professional roles have been introduced in the last twenty years. In the past, curatorial authority, scholarship and professional judgement have been the drivers of the museum; today the driving position is shared with new professional roles – those of the educator, the marketing officer, the interpretive planner and the outreach officer.[56]

Today's museum professionals share many different kinds of specialist knowledge, which includes knowledge of the collections, but also knowledge of both traditional and new audiences. They come from diverse backgrounds, and have a range of methods and approaches. They are united in their aim to serve their audiences through making the art museum experience relevant, educational and inspirational.

A second point of change is the recognition of differentiated audiences. Museum visitors are no longer thought of as an abstract mythical body 'the general public', but are seen to be made up of many individuals, who have characteristics, agendas and desires that can be researched. Many museums and galleries have carried out visitor research for some years and have an accurate picture of the nature of their audience.[57] This picture generally breaks down into a range of groups, classified by age, where they have come from, and their purpose for coming. From this we can extrapolate these main groups; children, often but not always in school parties, students, family groups, older people, people with disabilities, local people, tourists, people with a range of cultural or religious backgrounds.

Using this demographic information, exhibition developers are now beginning to plan their exhibitions to suit different interests and experience. Specific museum spaces might be planned for different audiences so that across the museum as a whole many different groups will find something of interest and relevance. This differentiated provision is also assessed over time, so that a run of temporary exhibitions might appeal to a range of different cultural groups in the local community. In Leicester in recent years, for example, we have seen art exhibitions focusing on the interests and material culture of the Chinese, Gujarati, Ukrainian, and Jain communities. In the development of these exhibitions, partnerships are formed with the various communities, which has resulted in donations, loans, educational programmes, translations of texts, and the avoidance of mistakes due to ignorance.[58]

A third point of change is the introduction of new voices, and this, of course, is a consequence of the acknowledgement of the diversity of museum visitors, and of the potential audience. In the past, it has been the perspectives and desires of the curator that have been paramount; today, the perspectives and desires of audiences must be researched and acknowledged. Art museums that accept and adopt the cultural model of communication have built multi-skilled professional teams, and have engaged in visitor research and incorporated the findings into their professional practice. Assumptions about the knowledge visitors bring to exhibitions are tested, and the success of exhibitions is evaluated against complex criteria that focus on the experience of visitors rather than just on visitor numbers. Different learning styles are planned for, and the specific needs of target groups are researched. These museums have responded creatively to the new demands and expectations and are valued and cherished by their communities.

This approach means considerable changes in the processes of exhibition development. One idea that facilitates the increased awareness of the audience is to introduce an 'audience advocate' onto the exhibition development team.[59] They should have an equal voice with the content and design advocate. Evaluation[60] will become necessary throughout the development process. A range of strategies throughout the development process will enable exhibition plans to be tried, tested and researched.

One example will suffice to show how this kind of approach results in a very different exhibition, and one that has been proved, through external evaluators, to be extremely successful.[61] *Start*, at Walsall Museum and Art Gallery, was an art exhibition for a specific audience – children aged from three to five years. The approach to such young visitors was carefully researched and piloted, with the help of educational experts. The collections for the exhibition were chosen to reflect the known world of pre-school children (flowers, activities, animals, children). The exhibition was laid out to become a space that would be recognised by parents and carers. Low circular barriers acted both as seats for weary adults, and to form booths for

specific activities for the children. These activities included story telling (about Epstein's dog, Frisky), creating a picture out of fuzzy felt (based on Van Gogh's *Sunflowers*), experimenting with different lighting on a bronze bust, and manipulating a specially commissioned sculpture. The learning styles used by pre-schoolers (enactive and concrete) were facilitated by the exhibition design, and existing experience was acknowledged, and used as a base for development.

The final point of change is that of the development of new narratives within the museum, which accept the fact that the grand authoritative meta-narratives of modernism are daily questioned and challenged. Constructivist theory suggests that today's learners want a range of ways of learning, to include facts and the voice of experts, but not exclusively limited to this.

Visitors demand a chance to pick and choose from a range of possibilities, a chance to explore and make up their own minds, to test their own interpretations against the experts, and an insight into the disagreements and conflicts between experts. If visitors are offered the evidence from which to draw conclusions, given access to data, including previous and conflictual interpretations of the data, they are able to adopt a problem-solving approach to learning. Demonstrating ways of analysing artefacts, of decoding silver-marks, or assessing stylistic detail, or of comparing one painting with another, opens up opportunities of increasing deductive thinking, of developing distinctions, of stimulating an interest. New narratives are likely to be less complete, more fragmentary, and to consist of the elements of many narratives which can be combined in a range of ways, rather than to be the complete finished story. Opportunities for testing the validity of constructed narratives will also be needed, perhaps by showing the narratives accepted by one or more interpretive communities.

The Peopling of London at the Museum of London included an exhibition, but used this as the centrepiece of a much broader project.[62] The aim of this exhibition was to show how varied had been the cultural and ethnic diversity of London's population over a very long period of time, and to present a view of London's history that incorporated this variety. A range of focus groups was set up to identify the differentiated interests and to define the historical parameters and approaches; an historical researcher from one of the Asian communities who was familiar with the local archive materials was appointed. In selecting the objects for display, curators were asked to view the collections tangentially, to see which objects might link to the different cultural groups to be represented. A cutlass made at Hounslow, a district of London, by a German blade-smith was used to demonstrate the significant impact of German settlers on London's early development.[63] Some objects told the story directly of some of the communities, for example books written in the 18th century by former slaves, and some images showed visitors heroes from different communities. A large number of 'focus weeks' were organised by the communities concerned, which were held in the museum but entirely managed by the communities. These were occasions to talk, dance, hold exhibitions, and generally celebrate community identity.

The development of new narratives in art museums demands new ways of thinking about collections and audiences, and new ways of integrating the two. The challenges of narrative, voice and difference go to the heart of the power relationships that currently operate in art museums. Finding ways to integrate audiences and their worlds means finding new ways of balancing power and knowledge. The function of the museum as a communicator cannot be separated from cultural issues of knowledge, power, identity, and language.

Power is necessarily effective, but it is not monolithic, and it is not always stable. There are always other ways of doing and saying, and at moments of challenge and change, other powers may come into play. Museums are at a point of change. The possibility of cultural re-opening, of reinterpretation, of re-negotiation, is deeply exciting. Museums today have the opportunity to push at existing borders, to change current relationships, to manipulate and break down old orthodoxies, to enable a broader, more inclusive approach to a more inclusive society. Through developing their communicative functions in creative and innovative partnerships with their audiences, art museums can become vital new institutions for the 21st century.

Notes

1 P. Desai & A. Thomas, *Cultural diversity: attitudes of ethnic minority populations towards museums and galleries*, London: Museums and Galleries Commission, 1998, pp. 19–20.
2 See E. Hooper-Greenhill, *Museums and the shaping of knowledge*, London: Routledge, 1992, pp. 167–90.
3 H. Bertens, *The idea of the postmodern*, London: Routledge, 1995; S. Best & D. Kellner, *Postmodern theory: critical interrogations*, Basingstoke: Macmillan, 1991; J. Fornas, *Cultural theory and late modernity*, London: Sage, 1995.
4 See two reports from the UK which demonstrate the necessity of these arguments over the last ten years: V. C. T. Middleton, *New visions for independent museums*, 1990, and *New visions for museums in the 21st century*, 1998, both published by AIM, the Association of Independent Museums, Chichester.
5 J. M. D. Schuster, 'The public interest in the art museums' public', in S. Pearce (ed.), *Art in museums: new research in museum studies* 5, London: Athlone, pp. 109–42. See also my own paper in the same volume, 'Audiences: a curatorial dilemma'.
6 This is an idea from educational research that has potential for development within other professional spheres. See, for example, C. O'Hanlon, *Professional development through action research: international educational perspectives*, London: Falmer Press, 1996; and O. Zuber-Skerritt (ed.) *New directions in action research*, London: Falmer Press, 1996.
7 See E. Hooper-Greenhill (ed.) *Improving museum learning*, Nottingham: East Midlands Museums Service, 1996. This small publication records the results of a three-year action research project with museum curator/educators in the UK. The project focused on developing methods for evaluating the educational role of the museums, which included learning through displays, learning from objects, and learning from prepared written materials such as Teachers' Packs.
8 J. W. Carey, *Communication as culture: essays on media and society*, Boston: Unwin Hyman, 1989, pp. 13–36.
9 Best & Kellner, op. cit., note 3; W. Wheeler, *The Enlightenment Effect, a Signs of the Times discussion paper*, April 1997; Signs of the Times, PO Box 10684, London N15 6XA, UK.
10 J.-F. Lyotard, 'Answering the question: what is post-modernism?', in C. Jencks (ed.), *The post-modern reader*, London: Academy Editions, 1992, pp. 138–50.
11 Hooper-Greenhill, op. cit., note 2.
12 Ibid., pp. 9–12.
13 Ibid., pp. 12–18.
14 C. Belsey, *Critical practice*, London and New York: Methuen.
15 Hooper-Greenhill, op. cit. pp. 105–32.
16 In 1805, Martin Archer Shee, later to become the President of the Royal Academy, referred to the arts as: 'those softeners of human life, those refiners of the rough, drossy ore of humanity...', quoted in J. Minihan, *The nationalisation of culture*, London: Hamish Hamilton, 1977; and see E. Hooper-Greenhill, 'The museum in the disciplinary

society', in S. Pearce (ed.) *Museum studies in material culture*, Leicester: Leicester University Press, 1989, pp. 61–72.

17 J. Morgan & P. Welton, *See what I mean: an introduction to visual communication*, London and New York: Arnold, 1986, pp. 4–6.

18 The simple model of communication is sometimes also called the 'bulls-eye' or 'hypodermic needle' model.

19 D. McQuail & S. Windahl, *Communication models for the study of mass communication*, London and New York: Longman, 1993, pp. 58–61.

20 G. Hein, *Learning in the museum*, London: Routledge, 1998, pp. 19–21.

21 P. Friere, *Pedagogy of the oppressed*, Harmondsworth: Penguin, 1972, pp. 45–69.

22 B. Fay, *Contemporary philosophy of social science: a multicultural approach*, Oxford: Blackwell, 1996, pp. 30–49.

23 T. Bennett, *The birth of the museum*, London: Routledge, 1995, pp. 99–102.

24 S. Koven, 'The Whitechapel Picture Exhibition and the politics of seeing', in D. J. Sherman & I. Rogoff (eds) *Museum culture: histories, discourses, spectacles*, London: Routledge, 1994, pp. 22–48.

25 I include paintings and other fine art artefacts within my use of this expression.

26 P. Bourdieu & A. Darbel, with D. Schnapper, *The love of art: European art museums and their public* (trans. C. Beattie & N. Merriman), Cambridge: Polity Press, 1991.

27 See, for example, D. Morley, 'Theories of consumption in media studies', in D. Miller (ed.) *Acknowledging consumption: a review of new studies*, London: Routledge, pp. 296–328.

28 R. S. Miles & A. F. Tout, 'Impact of research on the approach to the visiting public at the Natural History Museum, London', in E. Hooper-Greenhill (ed.) *The educational role of the museum*, 1st edn, London: Routledge, 1994, pp. 101–6.

29 See, for example, N. Broude & M. D. Garrard (eds) *Feminism and art history: questioning the litany*, New York: Harper & Row, 1982.

30 See S. Maddra, 'The Wounded Knee Ghost Dance Shirt', *Journal of Museum Ethnography*, Vol. 8, 1996, pp. 41–58; 'Sioux to be given "ghost shirt"', *The Independent*, 20 November 1998, p. 11.

31 L. Hutcheon, *The politics of post-modernism*, London: Routledge, 1989, p. 9.

32 S. Hall, 'Cultural identity and diaspora', in P. Williams & L. Chrisman (eds), *Colonial discourse and post-colonial theory: a reader*, New York: Harvester/Wheatsheaf, 1993, p. 397.

33 Ibid., p. 398.

34 Hood, 'Staying away – why people choose not to visit museums', *Museum News*, Vol. 61, No. 4, 1983, pp. 50–7.

35 See J. McGuigan, *Culture and the public sphere*, London: Routledge, 1996, p. 6.

36 This approach to communication stands in direct opposition to the transmission view which, with its basis in behaviourist psychology and functional explanations of social processes, has been the predominant paradigm in American social science. The cultural approach to communication can be closely linked to British cultural studies, which developed in part as an alternative way of analysing and explaining society and culture.

37 J. Carey, *Communication as culture: essays on media and society*, Boston: Unwin Hyman, 1989, p. 23.

38 Ibid., pp. 13–36.

39 H. Giroux, *Border crossings: cultural workers and the politics of education*, New York and London: Routledge, 1992, pp. 16–19.

40 W. Dilthey, 'The rise of hermeneutics', in P. Connerton (ed.) *Critical sociology*, Harmondsworth: Penguin, 1976, pp. 104–16. See also S. Gallagher, *Hermeneutics and education*, Albany, NY: SUNY Press, 1992.

41 C. Taylor, 'Hermeneutics and politics', in Connerton, op. cit., note 40, pp. 164–5.

42 H.-G. Gadamer, 'The historicity of understanding', in Connerton, op. cit., note 40, pp. 117–33.

43 McGuigan, op. cit., note 35, p. 33.

44 J. U. Ogbu, 'The influence of culture on learning and behaviour', in J. Falk & L. D. Dierking (eds) *Public institutions for personal learning: establishing a research agenda*, Washington, DC: American Association of Museums, 1995, pp. 79–96.

45 B. McCarthy & S. Leflar, *4mat in action: creative lesson plans for teaching to learning styles with right/left mode techniques*, Excel; C. F. Gunther, 'Museum-goers: life-styles and learning characteristics', in E. Hooper-Greenhill (ed.) *The educational role of the museum*, London: Routledge, 1994, pp. 286–97.

46 H. Gardner, *Frames of mind; the theory of multiple intelligences*, London: Paladin Books, 1983; H. Gardner, *The unschooled mind: how children learn and how schools should teach*, London: Fontana, 1993.

47 E. Sotto, *When learning becomes teaching: a theory and practice of teaching*, London: Cassell.

48 R. Young, *Intercultural communication: pragmatics, genealogy, deconstruction*, Philadelphia: Avon.

49 J. Falk & L. Dierking, *The museum experience*, Whalesback, 1992.

50 S. Fish, *Is there a text in this class? The authority of interpretive communities*, Cambridge, MA and London: Harvard University Press, 1980.

51 Ibid., p. 171.

52 Ibid., p. 8.

53 Ibid., p. 332.

54 Ibid., p. 172.

55 Ibid., pp. 172–3.

56 Outreach is still a confused concept in many museums. It generally refers to work with audiences that is done off-site – outside the museum, including workshops in prisons, schools, hospitals, and other community venues. Partnerships are formed with social services and education. Sometimes outreach collections are established, consisting of material that can be safely used outside the museum premises, although this is more difficult with art museums. Excellent outreach programmes have been established at the Tate Galleries in London and Liverpool.

57 S. Bicknell & G. Farmelo, *Museum visitor studies in the 90s*, London: Science Museum, gives a good overview. S. Davies, *By popular demand: a strategic analysis of the market potential for museums and galleries in the UK*, London: Museums and Galleries Commission, shows how collective market research can be used. See J. Falk, 'Visitors: who does, who doesn't and why', *Museum News*, March/April 1998, pp. 38–43, for a general picture of museum visiting in America, and T. Bennett, 'That those who run may read', in E. Hooper-Greenhill (ed.) *The educational role of the museum*, 2nd edn, London: Routledge, 1999, pp. 241–54.

58 See E. Hooper-Greenhill (ed.), *Cultural diversity: developing museum audiences in Britain*, Leicester and London: Leicester University Press, 1997, for further discussion of the issues involved and a range of case studies.

59 E. Hooper-Greenhill, *Museum and gallery education*, Leicester: Leicester University Press, 1991, pp. 187–93.

60 E. Hooper-Greenhill, *Museum, media, message*, London: Routledge, 1995, pp. 189–293 offers a range of case studies in evaluation.

61 Walsall Museum and Art Gallery, *Just like drawing in your dinner – START: the first interactive art gallery experience designed for three to five year-olds*, Walsall Museum and Art Gallery, Walsall.

62 See N. Merriman, 'The *The Peopling of London* project', in E. Hooper-Greenhill (ed.), *Cultural diversity: developing museum audiences in Britain*, Leicester: Leicester University Press, 1997, pp. 119–48.

63 P. Panayi, 'Germans in London', in N. Merriman (ed.) *The peopling of London: fifteen thousand years of settlement from overseas*, London: Museum of London, 1993, p. 111.

Chapter 53 | Barbara Kirshenblatt-Gimblett

Secrets of Encounter

The Museum for African Art inaugurated its new name and location with *Secrecy: African Art That Conceals and Reveals*, which opened on 12 February 1993. The Broadway storefront space, redesigned by the architect Maya Lin, marks a dramatic change of venue from the Upper East Side brownstone of the former Center for African Art. Situated now in Soho's lively art district, on the same block as the New Museum of Contemporary Art and the Guggenheim's downtown branch, the Museum for African Art attracted more visitors on its first Saturday than in an entire week uptown.

Under the inspired direction of Susan Vogel, the Museum for African Art has established a singular track record for mounting reflexive exhibitions and provoking the visitor to consider display as a subject in its own right.[1] Starting with two premises – little that we see in museums was made to be seen there and African "artifacts" are art – the museum's exhibitions have challenged viewers to question curatorial authority (*Perspectives: Angles on African Art*) and to think about how the installation itself produces meaning (*Art / Artifact*). In this spirit, the stated aim of *Secrecy* is "not to reveal secrets, but rather to show how certain works of art serve to protect and maintain secret knowledge." By exploring the logic and procedures of concealment, the exhibition stresses cognitive processes and epistemological implications, rather than the mystery of the dark continent and related tropes of African otherness. Respect for what must not be revealed and humility in the face of what cannot be known guide the interpretation of objects. Here again, the curators play at the intersection of art and anthropology, where converging interests have helped propel African objects far beyond contexts for which they were made.

Visually compelling masks, figures, textiles, and architectural elements created in sub-Saharan Africa in the nineteenth and twentieth centuries and borrowed from

Barbara Kirshenblatt-Gimblett, "Secrets of Encounter" from *Destination Culture: Tourism, Museums, and Heritage*, pp. 249–56, 311. Berkeley and Los Angeles: University of California Press, 1998. Originally published in the *Journal of American Folklore* 107 (1994). © 1998 by Barbara Kirshenblatt-Gimblett. Reproduced by permission of the University of California Press. (Reprinted without illustrations.)

private and public collections (the museum does not have its own collection) are organized into six sections, each of which explores a question:

How does art conceal and reveal secret knowledge?
How does art mark physical and social boundaries?
How does art express the secrets held by each gender?
How does art identify owners of secret knowledge?
How does art transmit secret knowledge?
Can we ever really understand another culture's secrets?

Satisfied by the tactile pleasure and elegant geometry of a raffia pile cloth (Kuba, Zaire), the visitor is drawn into the theme of secrecy by the way this object answers the first question: its woven pattern conceals and reveals secret knowledge by means of visual coding. The religious altars, figures, and masks in this section use other devices. The result? A display of the *repertoire of principles* for signaling the presence of something withheld, principles that attract the museum visitor to the object and keep her at a distance. An already compelling visual experience becomes even more elusive.

The choice to exhibit the objects as art, by themselves in dramatically lit vitrines, is a strategic one and achieves several objectives. It satisfies an uptown crowd whose primary interest is in the objects as art and who may not be entirely comfortable in the new location. And it establishes parity with what counts as art down the road. But the exhibition also demonstrates that to exhibit objects as art does not mean leaving them to stand entirely on their own. Lucid text panels and labels, none of them obtrusive, develop the exhibition themes in ways that direct the viewer's gaze back to the object, to look again, to inspect more closely. As the exhibition unfolds, one comes to understand better the workings of secrets, if not the secrets themselves, until in the last gallery the tables are turned and the Dogon of Mali become an exemplar of how secrecy has shaped Western perceptions of African art and by extension the very exhibition the visitor has just seen.

By way of summation at the symposium that coincided with the opening of the exhibition, I was asked to address the themes of "research, ethnography, and writing secrecy." Though these themes are signaled in the final gallery, the rest of the exhibition deals exclusively with secrecy in traditional African societies. Most of the objects, however, were made and used during the colonial period. As the late J. Ndukaku Amankulor protested during the symposium, characterization of African associations as "secret societies" is a colonial invention, part of a strategy to weaken them, the better to administer the colony. Although the exhibition is sharply focused and sets out complex issues clearly, greater attention to secrets of encounter would have made the exhibition even more reflexive and provocative. Catalog essays dealing with secret resistance in wall paintings by Sotho-Tswana women or Dogon tourist art suggest the richness of these themes.

As it is, the show's primary concern is the secrets that members of any given traditional African society keep from each other, not those they keep from ethnographers, art historians, colonial administrators, or tourists. Nor those that "we" keep from "them" by using languages that are not shared, writing that they may not read, and specialized discourses, whether art historical, ethnographic, semiotic, poststructuralist, or whatever else. And then there are the secrets we keep from each other, secrets about the transnational circulation of objects and the information about them

that increases their value in global markets – the secrets of dealers, auction houses, collectors, curators, ethnographers, art historians, critics, and last but not least the anonymous lenders to the exhibition, to say nothing of the trade secrets protecting all the technologies in the building.

So we may well ask, just who is so preoccupied with secrecy? Enlightenment values – the very word *enlightenment* – place a premium on illumination, on full disclosure, on open access to knowledge and truth. The logical extension of these values is the information-glut society and the sinister notion that the most valuable fact about you is your telephone number, because of the access it provides to so much other information already stored in vast databases – the nightmare of no secrets.

Three questions guided my deliberations: How is our preoccupation with secrecy played out in the exhibition, catalog, and symposium? How are secrets displayed and discussed without being revealed? And how is that process enabled by the status of these objects as art? As discussed in the previous chapter, convergences between the avant-garde and twentieth-century ethnography have altered the relationship of art museum audiences to Roland Barthes's third, or obtuse, meaning, the result of signifiers whose signified is inaccessible or evacuated, if it ever existed.[2] The avant-garde, which opened the way for these objects from Africa to be accepted and shown as art, also gave us art that does not need to be "understood" to be enjoyed. "Understanding" might even be an impediment. The absence of a bottom line makes irrelevant such questions as "What does it mean?" or "What is it about?" or even "Is it art?" The point is the experience, the play of signifiers, the challenge. Remember, the New Museum and the Guggenheim are just down the road.

By making secrecy a semiotic problem, the exhibition at the Museum for African Art shifts our attention to how secrets work and away from what they mean. This strategy has several effects. First, by treating secrecy as a type of communication rather than as a source of esoteric information, the exhibition universalizes its message. Second, with reference to the specific objects on display, those who know their secrets do not have to reveal them, and those who do not know their secrets can get away with incomplete knowledge. The exhibition's interpretive strategy is itself a secret of encounter, one that is structured by the status of secrecy as a double sign, a split sign, and an asymmetrical sign.

Each secret announces itself twice, first to state "this is a secret" and then to relate the stated term to the hidden term. The first signification is a metasign, a sign of a sign. As a sign of Secrecy, rather than as a secret, the exhibition is itself a metasign – it takes upon itself the role of announcing that the objects on display are secrets. The second announcement establishes the character of secrecy as a split sign that exposes the signifier and defers the signified. By exhibiting only half the sign – the arts and techniques of concealment, the masks, marks, wrappings, bundles, codes, camouflage, distractions, ambiguities, accumulations, understatements, and containers – the exhibition keeps the secret. It says, half a sign is better than no sign, and for the purposes of writing and exhibiting secrecy, half a sign is all you need.

But there are troubling corollaries of the split sign, and they have to do with the issue of encounter. In the effort to keep our attention on the metasign, we are told in various contexts that information is less important than the idea of withholding it, that the content of secrets is often trivial. But trivial to whom? To those who keep the secrets? Or to ethnographers and art historians – and museum visitors? The claim of triviality is important as a distraction that enables the display, for whether or not the secret is knowable, the claim of triviality establishes that it is not *worth* the effort to

find out. Ethnographic etiquette requires that we be satisfied with this state of affairs. One could say that playing with the metasign of secrecy is a consolation prize. Focusing on the metasign also deflects us from what we do not have a right to know, what is not our business. Hence the trope of disappointment when, after great effort, the secret turns out to be a tempest in a teacup.

The split also creates asymmetry, for the signifier may be overcoded or undercoded, spectacular in its elaboration or barely discernible if at all apparent, an undecipherable code in full view or object that gives little if any indication that anything is hidden. The signified may indeed turn out to be trivial, or it may take a lifetime to fully discover and understand what the hidden term means. Given the priority of visual interest in the display of objects and our own preoccupation with concealment, it follows that this exhibition should focus on elaborated signifiers, on objects that make a show of hiding. When coupled with the triviality claim, these objects hyperbolize the asymmetry of the sign of secrecy and keep our attention from wandering to what is not shown.

In the theater of secrecy, hiding and showing are mutually constitutive, as the exhibition, catalog, and symposium make clear. One is necessary for the other, even though they may not be equally elaborated. This peekaboo writ large creates critical discontinuities in a field of awareness, thereby giving shape not only to social life but also to knowing and to aesthetic experience. Little dramas of hiding and showing structure our perception and attention. They create channels and pathways for transmission. They regulate the rhythm, pace, range, and distribution of value.

The riddle, like secrecy, is a little drama of the split sign, whose completion is transacted in an encounter of concealing and revealing. But learning riddles is also one of the ways that children learn proverbs, many of which are also riddles. One is easily converted into the other. What is better than no loaf? Half a loaf. It is in the conversion that we can see how the location of the sign's split shifts – from inside the form of the proverb (which is where the riddle is created) to the structure of proverb performance as a social art of metaphor and indirection. Proverbs, like secrets, state only the signifier. The other half of the sign must be inferred, not stated. Catalog contributors and symposium participants made thoughtful links between the theme of secrecy guiding the exhibition of objects and enigma, dilemma tales, arithmetic puzzles, and divination.[3]

Other dramas in the theater of secrecy are confessions, and revelations that produce new secrets. Theater itself requires, for performative effect, that a line be drawn between what is shown and what is not and that revelations be carefully timed. Magic depends for the success of its illusion on hiding its methods and confuses the relations of causes and effects to that end. Bunraku, the art of Japanese puppet theater, reveals and conceals the manipulators. They are hooded and clad in black but manipulate the puppets in full view.

In a word, secrecy is inherently performative. The Museum for African Art performs a secret of encounter by deferring the meaning of particular secrets indefinitely. That visitors should find that deferral pleasurable, rather than frustrating, is enabled by the history of how these objects have come to be exhibited as art. For visitors who have come to enjoy the undecipherability – the obtuse meanings – of much contemporary art, objects from other worlds are gold mines of obtuse meaning. These are the conditions in this exhibition that enable the paradox of showing secrets without revealing them.

Notes

1 See Mary Nooter Roberts and Susan Vogel et al., *Exhibition*-ism: *Museums and African Art* (New York: Museum for African Art, 1994).
2 Roland Barthes, "The Third Meaning: Research Notes on Some Eisenstein Stills," in *Image – Music – Text*, comp. and trans. Steven Heath (New York: Hill and Wang, 1977), 52–68.
3 See Mary H. Nooter et al., *Secrecy: African Art That Conceals and Reveals* (New York: Museum for African Art; Munich: Prestel, 1993). On the riddle's "existential expressivity," see Galit Hasan-Rokem and David Shulman, eds., *Untying the Knot: On Riddles and Other Enigmatic Modes* (New York: Oxford University Press, 1996).

Selected Bibliography

This list does not include works by the authors represented in the anthology; see the individual Notes on Contributors for texts by these authors.

Museology and Related Theory

Aagaard-Mogensen, Lars. *The Idea of the Museum: Philosophical, Artistic, and Political Questions.* Lewiston/Queenston, NY: E. Mellen, 1988.

Afigbo, A. E. and S. I. O. Okita. *The Museum and Nation Building.* Owerri, Imo State, Nigeria: New Africa Publishing Co., 1985.

Ames, Michael M. "Biculturalism in Exhibitions." *Museum Anthropology* 15, 2 (1991): 7–15.

—— *Cannibal Tours and Glass Boxes: The Anthropology of Museums.* 2nd edn. Vancouver: University of British Columbia Press, 1992.

—— *Museums, the Public and Anthropology: A Study in the Anthropology of Anthropology.* Vancouver: University of British Columbia Press; New Delhi: Concept Publishing Co., 1986.

Anderson, Benedict. *Imagined Communities: Reflections on the Origin and Spread of Nationalism.* Rev. edn. London and New York: Verso, 1991.

Appadurai, Arjun, ed. *The Social Life of Things.* Cambridge: Cambridge University Press, 1986.

Bakhtin, Mikhail M. *The Dialogic Imagination.* Ed. Michael Holquist. Trans. Caryl Emerson and Michael Holquist. Austin: University of Texas Press, 1981.

Barnard, Malcolm. *Art, Design and Visual Culture: An Introduction.* New York: St. Martin's, 1998.

Barrett, Michèle et al., eds. *Ideology and Cultural Production.* New York: St Martin's, 1979.

Barzun, Jacques. "Museum Piece, 1967." *Museum News* 46, 7 (Apr. 1968): 17–21.

Baudrillard, Jean. *The System of Objects.* Trans. James Benedict. London and New York: Verso, 1996.

Benjamin, Walter. "Eduard Fuchs: Collector and Historian." *The Essential Frankfurt School Reader.* Ed. Andrew Arato and Eike Gebhardt. New York: Continuum, 2000. 225–53; 356–62.

—— "Unpacking My Library: A Talk About Book Collecting." *Illuminations.* Trans. Harry Zohn. Ed. Hannah Arendt. New York: Schocken Books, 1968. 59–67.

—— "The Work of Art in the Age of Mechanical Reproduction." *Illuminations.* Trans. Harry Zohn. Ed. Hannah Arendt. New York: Schocken Books, 1968. 217–51.

Bennett, Tony. *The Birth of the Museum: History, Theory, Politics*. London and New York: Routledge, 1995.

—— "The Exhibitionary Complex." *New Formations* 4 (1988): 73–102.

Berger, John. *Ways of Seeing*. London: British Broadcasting System and Penguin Books, 1972.

Berger, Maurice, ed. *Modern Art and Society: An Anthology of Social and Multicultural Readings*. New York: Icon, 1994.

Berger, Peter L. and Thomas Luckmann. *The Social Construction of Reality: A Treatise in the Sociology of Knowledge*. Harmondsworth, Middlesex: Penguin, 1985.

Bhabha, Homi. *The Location of Culture*. London and New York: Routledge, 1994.

——, ed. *Nation and Narration*. London and New York: Routledge, 1990.

Boswell, David and Jessica Evans, eds. *Representing the Nation: A Reader: Histories, Heritage and Museums*. London and New York: Routledge in association with the Open University, 1999.

Burgin, Victor. *In/Different Spaces: Place and Memory in Visual Culture*. Berkeley: University of California Press, 1996.

Burke, Kenneth. *A Grammar of Motives*. Berkeley: University of California Press, 1945.

Carr, David. "In the Contexts of the Possible: Libraries and Museums as Incendiary Cultural Institutions." *RBM: A Journal of Rare Books, Manuscripts, and Cultural Heritage* 1, 2 (Winter 2001): 117–33.

Carrier, David. "Art Museums, Old Paintings, and Our Knowledge of the Past." *History and Theory* 40 (May 2001): 170–89.

Cassou, Jean. "Art Museums and Social Life." *Museum* 2.3 (1949): 155–8.

Cassuto, Leonard. *The Inhuman Race: The Racial Grotesque in American Literature and Culture*. New York: Columbia University Press, 1997.

Chapin, David and Stephan Klein. "The Epistemic Museum." *Museum News* 71, 4 (July/Aug. 1992): 60–1; 76.

Clifford, James. *The Predicament of Culture: Twentieth-Century Ethnography, Literature, and Art*. Cambridge, MA: Harvard University Press, 1988.

—— and George E. Marcus, eds. *Writing Culture: The Poetics and Politics of Ethnography*. A School of American Research Advanced Seminar. Berkeley: University of California Press, 1986.

Collins, Richard et al., eds. *Media, Culture, and Society: A Critical Reader*. London and Beverly Hills: Sage, 1986.

Crary, Jonathan. *Techniques of the Observer: On Vision and Modernity in the Nineteenth Century*. Cambridge, MA: MIT Press, 1990.

Crimp, Douglas. *On the Museum's Ruins*. Cambridge, MA: MIT Press, 1993.

Csikszentmihalyi, Mihaly and Rick E. Robinson. *The Art of Seeing: An Interpretation of the Aesthetic Encounter*. Malibu: J. Paul Getty Museum and Getty Center for Education in the Arts, 1990.

Danto, Arthur C. *After the End of Art: Contemporary Art and the Pale of History*. 1995 Bollingen Series 35, 44. Princeton: Princeton University Press, 1997.

Dorner, Alexander. *The Way Beyond "Art."* New York: New York University Press, 1958.

Doy, Gen. *Black Visual Culture: Modernity and Post-Modernity*. London and New York: I. B. Tauris, 2000.

The End(s) of the Museum. Thomas Keenan et al. Barcelona: Fundació Antoni Tàpies, 1996.

Esolen, Gary. "Dialectic for the Muses." *Museum News* 61, 1 (Sept./Oct.1982): 29–31.

Fabian, Johannes. *Time and the Other: How Anthropology Makes its Object*. New York: Columbia University Press, 1983.

Fanon, Franz. *The Wretched of the Earth*. Trans. Constance Farrington. New York: Grove Press, 1963.

Ferguson, Russell, et al., eds. *Conversations in Post-modern Art and Culture*. Cambridge, MA: MIT Press; New York: New Museum of Contemporary Art, 1990.

——et al., eds. *Out There: Marginalization and Contemporary Cultures*. New York: New Museum of Contemporary Art; Cambridge, MA: MIT Press, 1990.

Foucault, Michel. *The Order of Things: An Archaeology of the Human Sciences*. London: Tavistock, 1970.

Gates, Christopher T. "Democracy and the Civic Museum." *Museum News* 80, 3 (May/June 2001): 47–55.

Gellner, Ernest. *Nations and Nationalism*. Oxford: Blackwell, 1983.

Genette, Gérard. *Narrative Discourse: An Essay in Method*. Trans. Jane E. Lewin. Ithaca, NY: Cornell University Press, 1980.

Gombrich, Ernst. "The Museum: Past, Present and Future." *Ideals and Idols: Essays on Values in History and Art*. Oxford: Phaidon, 1979. 189–204.

Goodman, Nelson. "The End of the Museum?" *The New Criterion* 2, 2 (Oct. 1983): 9–14.

Gottdiener, Mark. *Post-modern Semiotics: Material Culture and the Forms of Post-modern Life*. Oxford and Cambridge, MA: Blackwell, 1995.

Graburn, Nelson H., ed. *Ethnic and Tourist Arts: Cultural Expressions from the Fourth World*. Berkeley: University of California Press, 1976.

Graña, César. "On the Sociology of Museums." *Meaning and Authenticity: Further Essays on the Sociology of Art*. New Brunswick: Transaction Pubs., 1989. 69–84.

——"The Private Lives of Public Museums." *Trans-action* 4, 5 (April 1967): 20–5.

Haacke, Hans. "Museums, Managers of Consciousness." *Hans Haacke: Unfinished Business*. Ed. Brian Wallis. New York: The New Museum of Contemporary Art; Cambridge, MA: MIT Press, 1986. 60–73.

Halpin, Marjorie M. "'Play it Again, Sam': Reflections on a New Museology." *Museum International* 49, 2 (1997): 52–6.

Hammad, Manar. "Semiotic Reading of a Museum." *Museum* 39 (1987): 56–60.

Haraway, Donna Jeanne. *Primate Visions: Gender, Race, and Nature in the World of Modern Science*. New York: Routledge, 1989.

Harbison, Robert. *Eccentric Spaces*. Cambridge, MA: MIT Press, 2000.

Harris, Neil. *Cultural Excursions: Marketing Appetites and Cultural Tastes in Modern America*. Chicago: University of Chicago Press, 1990.

——"Exhibiting Controversy." *Museum News* 74, 5 (Sept./Oct. 1995): 36–9, 57–8.

Healy, Chris. *From the Ruins of Colonialism: History as Social Memory*. Cambridge and New York: Cambridge University Press, 1997.

Hein, Hilde S. *The Museum in Transition: A Philosophical Perspective*. Washington, D.C.: Smithsonian Institution Press, 2000.

Hendon, William S. *Analyzing the Art Museum*. New York: Praeger, 1979.

Heywood, Ian and Barry Sandywell, eds. *Interpreting Visual Culture: Explorations in the Hermeneutics of the Visual*. London and New York: Routledge, 1999.

Hiller, Susan, ed. *The Myth of Primitivism: Perspectives on Art*. London and New York: Routledge, 1991.

Hobsbawm, Eric. *Nations and Nationalism since 1780: Programme, Myth, Reality*. Cambridge and New York: Cambridge University Press, 1990.

——and Terence Ranger, eds. *The Invention of Tradition*. Cambridge and New York: Cambridge University Press, 1983.

Horne, Donald. *The Great Museum: The Re-Presentation of History*. London: Pluto Press, 1984.

Hüllen, Werner. "Reality, the Museum, and the Catalogue: A Semiotic Interpretation of Early German Texts of Museology." *Semiotica* 80, 3–4 (1990): 265–75.

Huyghe, René. *Art and the Spirit of Man*. Trans. Norbert Guterman. New York: Abrams, 1962.

Iser, Wolfgang. *The Act of Reading: A Theory of Aesthetic Response*. Baltimore and London: Johns Hopkins University Press, 1978.

Jenks, Chris, ed. *Visual Culture*. London and New York: Routledge, 1995.

Kammen, Michael G. *Mystic Chords of Memory: The Transformation of Tradition in American Culture*. New York: Knopf, 1991.

Kirstein, Peter N. "The Atomic Museum." *Art in America* 77 (June 1989): 44–57.

Krauss, Rosalind. "The Cultural Logic of the Late Capitalist Museum." *October* 54 (Fall 1990): 3–17.

LaCapra, Dominick. *Representing the Holocaust: History, Theory, Trauma*. Ithaca, NY: Cornell University Press, 1994.

Langer, Susanne. *Feeling and Form: A Theory of Art*. New York: Scribner's, 1953.

Lee, Sherman, ed. *On Understanding Art Museums*. Englewood Cliffs, NJ: Prentice-Hall, 1975.

Lumley, Robert, ed. *The Museum Time-Machine: Putting Cultures on Display*. London and New York: Routledge, 1988.

Macdonald, Sharon, ed. *The Politics of Display: Museums, Science, Culture*. London and New York: Routledge, 1998.

—— and Gordon Fyfe, eds. *Theorizing Museums: Representing Identity in a Changing World*. Oxford: Blackwell, 1996.

Maleuvre, Didier. *Museum Memories: History, Technology, Art*. Stanford, CA: Stanford University Press, 1999.

Malraux, André. *Museum Without Walls*. Trans. Stuart Gilbert and Francis Price. Garden City, NY: Doubleday, 1967.

Martin, Calvin, ed. *The American Indian and the Problem of History*. New York: Oxford University Press, 1987.

Martin, Paul. *Popular Collecting and the Everyday Self: The Reinvention of Museums?* London and New York: Leicester University Press, 1999.

Martinez, Katharine and Kenneth L. Ames, eds. *The Material Culture of Gender, the Gender of Material Culture*. Winterthur, DE: Henry Francis du Pont Winterthur Museum; Hanover: University Press of New England, 1997.

"McLuhanism in the Museum." Excerpt of Seminar, Museum of the City of New York, 1967. *Museum News* 46, 7 (Mar. 1968): 11–18.

Mirzoeff, Nicholas. *An Introduction to Visual Culture*. London and New York: Routledge, 1999.

——, ed. *Visual Culture Reader*. London and New York: Routledge, 1998.

Mitchell, W. J. T., ed. *The Language of Images*. Chicago: University of Chicago Press, 1980.

—— *The Last Dinosaur Book: The Life and Times of a Cultural Icon*. Chicago: University of Chicago Press, 1998.

—— *Picture Theory: Essays on Verbal and Visual Representation*. Chicago: University of Chicago Press, 1994.

Moore, Kevin. *Museums and Popular Culture*. London and Washington, D.C.: Cassell, 1997.

Nead, Lynda. *The Female Nude: Art, Obscenity and Sexuality*. London and New York: Routledge, 1992.

Nochlin, Linda. *The Politics of Vision: Essays on Nineteenth-Century Art and Society*. New York: Harper and Row, 1989.

—— *Realism*. Harmondsworth: Penguin, 1971.

—— *Women, Art, and Power: and Other Essays*. New York: Harper and Row, 1988.

O'Doherty, Brian. *Inside the White Cube: The Ideology of the Gallery Space*. Expanded edn. Berkeley: University of California Press, 1999.

——, ed. *Museums in Crisis*. New York: G. Braziller, 1972.

Otten, Charlotte M., ed. *Anthropology and Art: Readings in Cross-Cultural Aesthetics*. Austin: University of Texas Press, 1971, 1976.

Papadakis, Andreas C., ed. *New Museology*. London: Academy Editions; New York: St. Martin's, 1991.

Pearce, Susan M., ed. *Interpreting Objects and Collections*. London and New York: Routledge, 1994.

——, ed. *Objects of Knowledge*. London: Athlone Press, 1990.

Phillips, Ruth B. and Christopher B. Steiner, eds. *Unpacking Culture: Art and Commodity in Colonial and Post-colonial Worlds.* Berkeley and Los Angeles: University of California Press, 1999.

Pocock, J. G. A. *Politics, Language, and Time: Essays on Political Thought and History.* 1st edn. New York: Atheneum, 1971.

Pointon, Marcia, ed. *Art/Apart: Art Institutions and Ideology Across England and North America.* Manchester and New York: Manchester University Press, 1994.

Prince, David R. "The Museum as Dreamland." *International Journal of Museum Management and Curatorship* 4 (1985): 243–50.

Prior, Nick. *Museums and Modernity: Art Galleries and the Making of Modern Culture.* Oxford and New York: Berg, 2002.

"Problems of the Museum of Contemporary Art in the West." Special Issue of *Museum* 24, 1 (1971).

Prown, Jules D. "Mind in Matter: An Introduction to Material Culture Theory and Method." *Interpreting Objects and Collections.* Ed. Susan Pearce. London and New York: Routledge, 1994. 133–8.

—— "The Truth of Material Culture: History or Fiction?" *History from Things: Essays on Material Culture.* Ed. Steven Lubar and W. David Kingery. Washington, D.C.: Smithsonian Institution Press, 1993. 1–19.

—— and Kenneth Haltman, eds. *American Artifacts: Essays in Material Culture.* East Lansing, MI: Michigan State University Press, 2000.

Read, Herbert. *A Coat of Many Colours: Occasional Essays.* London: G. Routledge and Sons, 1945.

Robertson, Bryan. "The Museum and the Democratic Fallacy." *Art in America* 59, 4 (July–Aug., 1971): 58–65.

The Role of Museums in Today's Latin America. Round Table, UNESCO, Santiago (Chile), 1972. Special Issue of *Museum* 25, 3 (1973).

Rosenberg, Harold. "The Museum Today." *The De-definition of Art: Action Art to Pop to Earthworks.* New York: Horizon Press, 1972. 233–42.

Roth, Michael S. and Charles G. Salas, eds. *Disturbing Remains: Memory, History, and Crisis in the Twentieth Century.* Los Angeles: The Getty Research Institute, 2001.

Ruffins, Faith Davis. "The Exhibition as Form: An Elegant Metaphor." *Museum News* 64 (Oct. 1985): 54–9.

Rutherford, Jonathan, ed. *Identity: Community, Culture, Difference.* London: Lawrence and Wishart, 1990.

Sahlins, Marshall. *Culture and Practical Reason.* Chicago: University of Chicago Press, 1976.

Simpson, Moira G. *Making Representations: Museums in the Post-Colonial Era.* London and New York: Routledge, 1996.

Smith, Shawn Michelle. *American Archives: Gender, Race and Class in Visual Culture.* Princeton: Princeton University Press, 1999.

Stam, Deirdre C. "The Informed Muse: The Implications of 'The New Museology' for Museum Practice." *Museum Management and Curatorship* 12 (1993): 267–83.

Stewart, Susan. *On Longing: Narratives of the Miniature, the Gigantic, the Souvenir, the Collection.* Baltimore: Johns Hopkins University Press, 1984.

—— "Death and Life, in That Order, in the Works of Charles Willson Peale." *Visual Display: Culture Beyond Appearances.* Ed. Lynne Cooke and Peter Wollen. Dia Center for the Arts Discussions in Contemporary Culture Number 10. Seattle: Bay Press, 1995.

Stocking, George W., ed. *Objects and Others: Essays on Museums and Material Culture.* Madison: University of Wisconsin Press, 1985.

Stockton, Frank. *The Queen's Museum.* New York: Scribner's, 1906.

Takaki, Ronald T. *Iron Cages: Race and Culture in Nineteenth-Century America.* 2nd edn. New York: Oxford University Press, 2000.

Taylor, Francis Henry. *Babel's Tower: The Dilemma of the Modern Museum*. New York: Columbia University Press, 1945.

Torgovnick, Marianna. *Gone Primitive: Savage Intellects, Modern Lives*. Chicago: University of Chicago Press, 1990.

Veblen, Thorstein. *The Theory of the Leisure Class*. New York: Modern Library, 2001.

Vergo, Peter, ed. *The New Museology*. London: Reaktion, 1989.

Vizenor, Gerald. "Socioacapuncture: Mythic Reversals and the Striptease in Four Scenes." *The American Indian and the Problem of History*. Ed. Calvin Martin. New York: Oxford University Press, 1987. 180–91.

Wagner, Roy. *The Invention of Culture*. Chicago: University of Chicago Press, 1981.

Weber, Max. *Selections in Translation*. Ed. W. G. Runciman. Cambridge and New York: Cambridge University Press, 1978.

Williams, Patrick and Laura Chrisman, eds. *Colonial Discourse and Post-Colonial Theory: A Reader*. New York and London: Harvester Wheatsheaf, 1993.

Williams, Raymond. *The Country and the City*. New York: Oxford University Press, 1973.

—— *Keywords: A Vocabulary of Culture and Society*. New York: Oxford University Press, 1976.

Yount, Sylvia. "Braving (and Bridging) the Great Divide: The Academy and the Museum." *American Art* 15, 3 (Fall 2001): 2–7.

Zeidler, Anita L. and John R. Surber. "Understanding Topic, Structure, and Importance of Information in a Visual and Verbal Display." *Journal of Experimental Education* 67, 2 (1999): 114–32.

Zolberg, Vera L. "Tensions of Mission in American Art Museums." *Nonprofit Enterprise in the Arts: Studies in Mission and Constraint*. Ed. Paul J. Di Maggio. New York: Oxford University Press, 1986. 184–98.

Primary Texts and Histories

A Cabinet of Curiosities: Five Episodes in the Evolution of American Museums. Introduction by Walter Muir Whitehill. Charlottesville: University Press of Virginia, 1967.

Acland, Henry W. *The Oxford Museum*. 4th edn. Oxford: James Parker and Co., 1867.

—— and John Ruskin. *The Oxford Museum*. London: George Allen, 1893.

Adam, Thomas R. *The Civic Value of Museums*. New York: American Association for Adult Education, 1937.

—— *The Museum and Popular Culture*. New York: American Association for Adult Education, 1939.

A Grand Design: The Art of the Victoria and Albert Museum. Ed. Malcolm Baker and Brenda Richardson. New York: Harry N. Abrams with the Baltimore Museum of Art, 1997.

Alderson, William T., ed. *Mermaids, Mummies, and Mastodons: The Emergence of the American Museum*. Washington, D.C.: American Association of Museums, 1992.

Alexander, Edward P. *The Museum in America: Innovators and Pioneers*. Walnut Creek, CA: Alta Mira Press, 1997.

—— *Museum Masters: Their Museums and Their Influence*. Nashville: American Association for State and Local History, 1983.

—— *Museums in Motion: An Introduction to the History and Function of Museums*. Nashville: American Association for State and Local History, 1979.

Allwood, John. *The Great Exhibitions*. London: Cassell and Collier Macmillan, 1977.

Altick, Richard D. *The Shows of London*. Cambridge, MA: Belknap Press, 1978.

Anon. "The Spectator at the World's Fair." *The Outlook* 109 (Jan.–Apr. 1915): 895–7.

Arnoldi, Mary Jo. "Where Art and Ethnology Met: The Ward African Collection at the Smithsonian." *The Scramble for Art in Central Africa*. Ed. Enid Schildkrout and Curtis A. Keim. Cambridge: Cambridge University Press, 1998. 193–216.

Badger, Reid. *The Great American Fair: The World's Columbia Exposition and American Culture.* Chicago: N. Hall, 1979.

Barnum, Phineas Taylor. *P. T. Barnum Papers, 1843–1890.* New York Public Library, Special Collections.

Bather, F. A. "How May Museums Best Retard the Advance of Science?" *Science* ns 5, 122 (Apr. 30, 1897): 677–83.

Benedict, Burton. *The Anthropology of World's Fairs: San Francisco's Panama Pacific International Exposition of 1915.* Berkeley: Lowie Museum of Anthropology, Scolar Press, 1983.

——— "International Exhibitions and National Identity." *Anthropology Today* 7, 3 (June 1991): 5–9.

Berkhofer, Robert F. *The White Man's Indian: The History of an Idea from Columbus to the Present.* 1st edn. New York: Knopf, 1978.

Bibliography of Museums and Museology. Compiled by William Clifford and Helen J. Baker. New York: Metropolitan Museum of Art, 1923.

Braunholtz, H. J. "History of Ethnography in the Museum after 1753 (Part I)" and "History of Ethnography in the Museum 1753–1938 (Part II)." *The British Museum Quarterly* XVIII, 3–4 (1953): 90–3; 109–20.

Brigham, David R. *Public Culture in the Early Republic: Peale's Museum and Its Audience.* Washington, D.C. and London: Smithsonian Institution Press, 1995.

Brownlee, David B. *Building the City Beautiful: The Benjamin Franklin Parkway and the Philadelphia Museum of Art.* Philadelphia: The Museum; University of Pennsylvania Press, 1989.

Burt, Nathaniel. *Palaces for the People.* Boston: Little, Brown, 1977.

Burton, Anthony. *Vision and Accident: The Story of the Victoria and Albert Museum.* London: V and A Publications, 1999.

Cahill, Holger. "Newark: The Museum and American Contemporary Art." *Creative Art* 4 (Jan.–June 1929): xxxv–xxxix.

Carrick, Alice Van Leer. *Collector's Luck; or, A Repository of Pleasant, and Profitable Discourses Descriptive of the Household Furniture and Ornaments of Olden Time.* Garden City, NY: Garden City Publishing, 1937.

Caygill, Marjorie and Christopher Date. *Building the British Museum.* London: Trustees of the British Museum and British Museum Press, 1999.

Coleman, Laurence Vail. *The Museum in America: A Critical Study.* 3 vols. Washington, D.C.: American Association of Museums, 1939.

——— *Museum Buildings.* Washington, D.C.: American Association of Museums, 1950– .

Conn, Steven. *Museums and American Intellectual Life, 1876–1926.* Chicago: University of Chicago Press, 1998.

——— "Where is the East: Asian Objects in American Museums, from Nathan Dunn to Charles Freer." *Winterthur Portfolio* 35, 2/3 (Summer/Autumn 2000): 157–73.

Connolly, Louise, ed. *The Educational Value of Museums.* Newark: The Newark Museum Association, 1914.

Coolidge, John. *Patrons and Architects: Designing Art Museums in the Twentieth Century.* The Anne Burnett Tandy Lectures in American Civilization, no. 2. Fort Worth, TX: Amon Carter Museum, 1989.

Crook, J. Mordaunt. *The British Museum.* New York: Praeger, 1972.

Darwin, Charles. *On the Origin of Species.* Ed. Gillian Beer. Oxford: Oxford University Press, 1996.

Davis, Douglas. *The Museum Transformed: Design and Culture in the Post-Pompidou Age.* New York: Abbeville Press, 1990.

DeBeer, G. R. "Early Visitors to the British Museum." *The British Museum Quarterly* XVIII, 2 (1953): 27–32.

Dennett, Andrea. *Weird and Wonderful: The Dime Museum in America.* New York: New York University Press, 1997.

Dickens, Charles. *American Notes; and, Pictures from Italy.* London: Chapman and Hall; New York: Scribner's, 1898.

Elsner, John and Roger Cardinal, eds. *The Cultures of Collecting.* Cambridge, MA: Harvard University Press, 1994.

Fernie, Eric. *Art History and Its Methods: A Critical Anthology.* London: Phaidon, 1995.

Francis, David R. *The Universal Exposition of 1904.* St. Louis: Louisiana Purchase Exposition Company, 1913.

Fryer, Peter. *Staying Power: The History of Black People in Britain.* London and Sydney: Pluto Press, 1984.

Gallatin, A. E. "The Gallery of Living Art, New York University." *Creative Art* 4, 3 (Jan.–June 1929): xl–xliv.

Gardiner, Elizabeth M. "The Library of the Smaller Museum." *Proceedings of the American Association of Museums* IV (May 31–June 10, 1910): 78–84.

Garnham, Trevor. *Oxford Museum: Dean and Woodward.* London: Phaidon, 1992.

Gebhard, Bruno. "Man in a Science Museum of the Future." *Museum* II, 3 (1949): 162–6.

Goode, George Brown. "Museum-History and Museums of History." *A Memorial of George Brown Goode, Together with a Selection of His Papers on Museums.* Washington, D.C.: Government Printing Office, 1901. 65–81.

—— *The Origins of Natural Science in America: The Essays of George Brown Goode.* Ed. Sally Gregory Kohlstedt. Washington, D.C. and London: Smithsonian Institution Press, 1991.

—— "The Principles of Museum Administration." *A Memorial of George Brown Goode.* Washington, D.C.: Government Printing Office, 1901. 193–241.

Greenleaf, William. *From These Beginnings: The Early Philanthropies of Henry and Edsel Ford, 1911–1936.* Detroit: Wayne State University Press, 1964.

Halsey, Richard Townley Haines. *The Homes of Our Ancestors, as Shown in the American Wing of the Metropolitan Museum of Art New York, From the Beginnings of New England Through the Early Days of the Republic.* Garden City, NY: Doubleday, Page, 1925.

Hamilton, J. G. deRoulhac. "The Ford Museum." *The American Historical Review* 36, 4 (July 1931): 772–5.

Harris, John S. *Government Patronage of the Arts in Great Britain.* Chicago: University of Chicago Press, 1970.

Harris, Neil et al. *Grand Illusions: Chicago's World's Fair of 1893.* Chicago: Chicago Historical Society, 1993.

Hauser, Arnold. *The Social History of Art.* 2 vols. New York: Knopf, 1951.

Hawthorne, Nathaniel. *Our Old Home and English Note-Books.* Vol. II. Boston: Houghton Mifflin, 1891.

Hazlitt, William C. *The Coin Collector.* London: G. Redway, 1896.

Hoare, Rev. George T. *The Village Museum: or, How to Gather Profit with Pleasure.* London: Routledge, Warnes, and Routledge, 1859.

Hooper, Franklin W. "Industrial Museums for Our Cities." *Proceedings of the American Association of Museums* VII (June 3–5, 1913): 6–10.

Hoving, Thomas. *The Chase, The Capture: Collecting at the Metropolitan.* New York: Metropolitan Museum of Art, 1975.

—— *Making the Mummies Dance.* New York: Simon and Schuster, 1993.

Howe, Winifred E. *A History of the Metropolitan Museum of Art, with a Chapter on the Early Institutions of Art in New York.* 2 vols. New York: Metropolitan Museum of Art / Arno Press, 1913–1946.

Impey, Oliver and Arthur MacGregor. *The Origins of Museums: The Cabinet of Curiosities in Sixteenth- and Seventeenth-Century Europe.* Oxford: Oxford University Press, 1985.

Im Thurn, E. F. "Anthropological Uses of the Camera." *Journal of the Anthropological Institute of Great Britain and Ireland* 22 (1893): 184–203.

Jacknis, Ira. *The Storage Box of Tradition: Kwakiutl Art, Anthropologists, and Museums, 1881–1981.* Washington, D.C.: Smithsonian Institution Press, 2002.

James, Henry. *The American Scene.* Bloomington: Indiana University Press, 1968.

Jameson, Anna. *Handbook to the Public Galleries of Art in and near London: With Critical, Historical, and Biographical Notices of the Painters and Pictures.* London: J. Murray, 1845.

Jevons, William Stanley. "The Use and Abuse of Museums." *Methods of Social Reform.* New York: A. M. Kelley, 1965 [reprint of 1883 edition].

Kennedy, H. A. *Local Museums: Notes on Their Building and Conduct.* Oxford: Oxford University Press, 1938.

Kenyon, Sir Frederic G. *Museums and National Life.* Oxford: Clarendon Press, 1927.

Key, Archie F. *Beyond Four Walls: The Origins and Development of Canadian Museums.* Toronto: McClelland and Stewart, 1973.

Kimball, Fiske. "The Museum of the Future." *Creative Art* 4, 4 (1929): xxxvii–xlii.

Kinchin, Perilla et al. *Glasgow's Great Exhibitions: 1888, 1901, 1911, 1938, 1988.* Wendlebury [England]: White Cockade, 1988.

Kohlstedt, Sally Gregory. "Entrepreneurs and Intellectuals: Natural History in Early American Museums." *Mermaids, Mummies, and Mastodons: The Emergence of the American Museum.* Ed. William T. Alderson. Washington, D.C.: American Association of Museums, 1992. 23–39; 90–1.

Kunhardt, Philip B. and Peter W. Kunhardt. *P. T. Barnum: America's Greatest Showman.* New York: Knopf, 1995.

Lerman, Leo. *The Museum: One Hundred Years and the Metropolitan Museum.* New York: Viking Press, 1969.

Lewis, Geoffrey. "Museums and Their Precursors: A Brief World Survey." *Manual of Curatorship: A Guide to Museum Practice.* Oxford: Butterworth-Heinemann, 1992.

Looking Forward Through the Past. Dearborn, MI: Edison Institute, 1935.

Low, Theodore L. *The Museum as a Social Instrument.* New York: Metropolitan Museum of Art for the American Association of Museums, 1942.

Lutchmansingh, Larry D. "Commodity Exhibitionism at the London Great Exhibition of 1851." *Annals of Scholarship* 7, 2 (1990): 203–16.

Macdonald, Anne L. *Feminine Ingenuity: Women and Invention in America.* New York: Ballantine Books, 1992.

MacGregor, Arthur, ed. *Tradescant's Rarities: Essays on the Founding of the Ashmolean Museum, 1683 with a Catalogue of the Surviving Early Collections.* Oxford: Clarendon Press, 1983.

Mancini, J. M. "'One Term is as Fatuous as Another': Responses to the Armory Show Reconsidered." *American Quarterly* 51, 4 (Dec. 1999): 833–70.

Maxwell, Anne. *Colonial Photography and Exhibitions: Representations of the 'Native' and the Making of European Identities.* London: Leicester University Press, 1999.

McCabe, James Dabney. *The Illustrated History of the Centennial Exhibition: Held in Commemoration of the One Hundredth Anniversary of American Independence. With a Full Description of the Great Buildings and All the Objects of Interest Exhibited in Them....* Cincinnati: Jones Brothers and Co., 1876.

McClellan, Andrew. *Inventing the Louvre: Art, Politics, and the Origins of the Modern Museum in Eighteenth-Century Paris.* Cambridge: Cambridge University Press, 1994.

McOuat, Gordon. "Cataloguing Power: Delineating 'Competent Naturalists' and the Meaning of Species in the British Museum." *British Journal for the History of Science* 34 (2001): 1–28.

Merriman, Nick. *Beyond the Glass Case: The Past, the Heritage, and the Public in Britain.* Leicester: Leicester University Press, 1991.

Miers, Sir Henry. *A Report on the Public Museums of the British Isles (Other than the National Museums)* [To the Carnegie United Kingdom Trustees]. Edinburgh: T. and A. Constable, 1928.

Miller, Daniel. "Things Ain't What They Used to Be." Special Issue [on Material Culture] of *RAIN (Royal Anthropological Institute News)* 0.59 (Dec. 1983): 5–7, 1.

Miller, Edward. *That Noble Cabinet: A History of the British Museum.* Athens, OH: Ohio University Press, 1974.

Minihan, Janet. *The Nationalization of Culture: The Development of State Subsidies to the Arts in Great Britain*. New York: New York University Press, 1977.

Morris, William. *Hopes and Fears for Art*. New York: Longman's, Green, and Co., 1901.

Mumford, Lewis. "The Marriage of Museums." *Findings and Keepings: Analects for an Autobiography*. New York: Harcourt Brace Jovanovich, 1975.

Murray, David. *Museums, Their History and Their Use, With a Bibliography and List of Museums in the United Kingdom*. 3 vols. Glasgow: James MacLehose and Sons, 1904.

Museums in Modern Life: Seven Papers Read Before the Royal Society of Arts in March, April, and May 1949. London, 1949.

Myers, Charles S. "The Future of Anthropometry." *Journal of the Anthropological Institute of Great Britain and Ireland* 33 (Jan.–June, 1903): 36–40.

The National Gallery. By the Editors of Architectural Design. London: AD Editions; New York: St. Martin's, 1986.

Oleson, Alexandra and Sanborn C. Brown. *The Pursuit of Knowledge in the Early American Republic: American Scientific and Learned Societies from Colonial Times to the Civil War*. Baltimore and London: Johns Hopkins University Press, 1976.

Orosz, Joel. *Curators and Culture: The Museum Movement in America, 1740–1870*. Tuscaloosa and London: University of Alabama Press, 1990.

Orvill, Miles. *The Real Thing: Imitation and Authenticity in American Culture, 1880–1940*. Chapel Hill, NC: University of North Carolina Press, 1989.

Osborn, Henry Fairfield. "The Museum of the Future." *The American Museum Journal* (Nov. 1911): 223–6.

Pachter, Marc and Frances Wein, eds. *Abroad in America: Visitors to the New Nation, 1776–1914*. Reading, MA: National Portrait Gallery/Addison-Wesley, 1976.

Parker, John Henry. *The Ashmolean Museum: Its History, Present State, and Prospects*. Oxford: J. Parker and Co., 1870.

Pearce, Susan M. *On Collecting: An Investigation into Collecting in the European Tradition*. London and New York: Routledge, 1994.

Pitt-Rivers, A. Lane-Fox. *The Evolution of Culture and Other Essays*. Oxford: Clarendon Press, 1906.

Pomian, Krzysztof. *Collectors and Curiosities: Paris and Venice 1500–1800*. Trans. Elizabeth Wiles-Portier. Cambridge: Polity Press, 1990.

Potterton, Homan. *The National Gallery, London*. London: Thames and Hudson, 1977.

Purbrick, Louise. "The South Kensington Museum: The Building of the House of Henry Cole." *Art/Apart: Art Institutions and Ideology Across England and North America*. Ed. Marcia Pointon. Manchester and New York: Manchester University Press, 1994. 69–86.

The Quest for Identity: American Art Between World's Fairs, 1876–1893. Detroit: The Detroit Institute of Arts, 1983.

Rainger, Ronald. *An Agenda for Antiquity: Henry Fairfield Osborn and Vertebrate Paleontology at the American Museum of Natural History, 1890–1935*. Tuscaloosa: University of Alabama Press, 1991.

Rea, Paul M. "A Contribution to Early Museum History in America." *Proceedings of the American Association of Museums* ix (July 6–9, 1915): 53–65.

The Reason Why the Colored American Is Not in the World's Columbian Exposition: The Afro-American's Contribution to Columbian Literature. Ed. Robert W. Rydell. Urbana and Chicago: University of Illinois Press, 1999.

Richards, Charles R. *Industrial Art and the Museum*. New York: Macmillan, 1927.

Ripley, Sidney Dillon. *The Sacred Grove: Essays on Museums*. New York: Simon and Schuster, 1969.

Rivet, Paul. "Organization of an Ethnological Museum." *Museum* 1, 1–2 (1948): 70; 112–13.

Rydell, Robert W. *All the World's a Fair: Visions of Empire at American International Expositions, 1876–1916*. Chicago: University of Chicago Press, 1984.

—— *World of Fairs: The Century-of-Progress Expositions.* Chicago: University of Chicago Press, 1993.

—— and John E. Findling, Kimberly D. Pelle, eds. *Fair America: World's Fairs in the United States.* Washington, D.C.: Smithsonian Institution Press, 2000.

—— and Nancy E. Gwinn, eds. *Fair Representations: World's Fairs and the Modern World.* Amsterdam: VU University Press, 1994.

Sandhurst, Phillip T. et al. *The Great Centennial Exhibition, Critically Described and Illustrated.* Philadelphia and Chicago: P. W. Ziegler and Co., 1876.

Sara Yorke Stevenson: February 19, 1847 to November 14, 1921: A Tribute from the Civic Club of Philadelphia. Ed. Frances Anne Wister. Philadelphia: 1922.

Schofield, Robert E. "The Science Education of an Enlightened Entrepreneur: Charles Willson Peale and His Philadelphia Museum, 1784–1827." *American Studies* 30, 2 (1989): 21–40.

Schulz, Eva. "Notes on the History of Collections and of Museums." *Interpreting Objects and Collections.* Ed. Susan Pearce. London and New York: Routledge, 1994. 175–87.

Sellers, Charles Coleman. *Charles Willson Peale.* Rev. edn. New York: Scribner's, 1969.

Sheets-Pyenson, Susan. *Cathedrals of Science: The Development of Colonial Natural History Museums During the Late Nineteenth Century.* Kingston, Ontario: McGill-Queen's University Press, 1988.

Stein, Roger B. "Charles Willson Peale's Expressive Design: *The Artist in His Museum.*" *Reading American Art.* Ed. Marianne Doezema and Elizabeth Milroy. New Haven: Yale University Press, 1998. 38–78.

Stocking, George W. *The Ethnographer's Magic and Other Essays in the History of Anthropology.* Madison: University of Wisconsin Press, 1992.

—— "Introduction: The Basic Assumptions of Boasian Anthropology." *A Franz Boas Reader: The Shaping of American Anthropology, 1883–1911.* Ed. George W. Stocking. Chicago: University of Chicago Press, 1982. 1–20.

—— *Victorian Anthropology.* New York and London: The Free Press, 1987.

Thomas, David Hurst, ed. *Columbian Consequences.* 3 vols. Washington, D.C.: Smithsonian Institution Press, 1989–1991.

Thompson, M. W. *General Pitt-Rivers: Evolution and Archaeology in the Nineteenth Century.* Bradford-on-Avon: Moonraker Press, 1977.

Tomkins, Calvin. *Merchants and Masterpieces: The Story of the Metropolitan Museum of Art.* New York: Henry Holt, 1989.

Trennert, Robert A. "Fairs, Expositions, and the Changing Image of Southwestern Indians, 1876–1904." *New Mexico Historical Review* 62, 2 (April, 1987): 127–50.

Tucker, Louis Leonard. "'Ohio Show-Shop': The Western Museum of Cincinnati, 1820–1867." *A Cabinet of Curiosities: Five Episodes in the Evolution of American Museums.* Charlottesville: University Press of Virginia, 1967. 73–105.

Tuwan, Janina. "Ethnographical and Ethnological Museums and the Public." *Museum* 2, 3 (1949): 180–3.

Vernon, Horace M. and K. Dorothea Vernon. *A History of the Oxford Museum.* Oxford: Clarendon Press, 1909.

Visitor's Catalogue of the Museum of the Peabody Academy of Science, Salem, Mass. Salem: Peabody Academy of Science, 1879.

Vogel, Morris J. *Cultural Connections: Museums and Libraries of Philadelphia and the Delaware Valley.* Philadelphia: Temple University Press, 1991.

Weimann, Jeanne Madeline. *The Fair Women.* Chicago: Academy Chicago, 1981.

Weschler, Lawrence. *Mr. Wilson's Cabinet of Wonder.* New York: Pantheon Books, 1995.

West, Patricia. *Domesticating History: The Political Origins of America's House Museums.* Washington, D.C.: Smithsonian Institution Press, 1999.

Whitehill, Walter Muir. *Museum of Fine Arts, Boston: A Centennial History.* Cambridge, MA: Belknap Press of Harvard University Press, 1970.

Whitman, Walt. "Song of the Exposition." *Leaves of Grass*. New York: Modern Library, 1993. 245–58.

Wilson, David Mackenzie. *The British Museum: Purpose and Politics*. London: British Museum Publications, 1989.

Wittlin, Alma S. *The Museum, Its History and Its Tasks in Education*. London: Routledge and Kegan Paul, 1949.

—— *Museums: In Search of a Usable Future*. Cambridge, MA: MIT Press, 1970.

Wright, Frances. *Views of Society and Manners in America: In a Series of Letters from that Country to a Friend in England, During the Years 1818, 1819, and 1820. By an English-woman*. New York: E. Bliss and E. White, 1821.

Yanni, Carla. *Nature's Museums: Victorian Science and the Architecture of Display*. Baltimore: Johns Hopkins University Press, 2000.

Museum/Exhibition Practice

Alt, M. B. and K. M. Shaw. "Characteristics of Ideal Museum Exhibits." *British Journal of Psychology* 75 (1984): 25–36.

Altshuler, Bruce. *The Avant-Garde in Exhibition: New Art in the 20th Century*. Berkeley: University of California Press, 1994.

American Association of Museums. *Code of Ethics for Museums, 2000*. Washington, D.C.: American Association of Museums, 2000.

America's Museums. Special Issue of *Daedalus* 128, 3 (Summer 1999).

Anderson, David. *A Common Wealth: Museums and Learning in the United Kingdom*. London: Department of National Heritage, 1997.

Anderson, Jay. "Living History: Simulating Everyday Life in Living Museums." *American Quarterly* 34, 3 (Fall 1982): 290–306.

Anderson, Maxwell. "Notes on the Mission of the Whitney Museum of American Art." *American Art* 13, 2 (Summer 1999): 84–6.

Arnold, John et al., eds. *History and Heritage: Consuming the Past in Contemporary Culture*. Dorset: Donhead, 1998.

Austin, Joy Ford. "Their Face to the Rising Sun: Trends in the Development of Black Museums." *Museum News* 60, 3 (Jan.–Feb. 1982): 28–32.

Bann, Stephen. *The Clothing of Clio: A Study of the Representation of History in Nineteenth-Century Britain and France*. Cambridge: Cambridge University Press, 1984.

Barker, Emma, ed. *Contemporary Cultures of Display*. New Haven: Yale, The Open University, 1999.

Bitgood, Stephen C. and Ross J. Loomis. "Introduction: Environmental Design and Evaluation in Museums." *Environment and Behavior* 25 (Nov. 1993): 683–97.

Blatti, Jo, ed. *Past Meets Present: Essays About Historic Interpretation and Public Audiences*. Washington, D.C.: Smithsonian Institution Press, 1987.

Bois, Yve-Alain. "La Pensée Sauvage." *Art in America* 73, 4 (April 1985): 178–89.

Boylan, Patrick J., ed. *Museums 2000: Politics, People, Professionals and Profit*. London and New York: Museums Association in conjunction with Routledge, 1992.

Burcaw, G. Ellis. *Introduction to Museum Work*. 3rd edn. Nashville: American Association for State And Local History and Alta Mira Press, 1997.

Carnes, Alice. "Showplace, Playground or Forum? Choice Point for Science Museums." *Museum News* 64, 4 (April 1986): 29–35.

Clavir, Miriam. *Preserving What is Valued: Museums, Conservation, and First Nations*. Vancouver: University of British Columbia Press, 2002.

Clifford, James. "Histories of the Tribal and the Modern." *Art in America* 73, 4 (April 1985): 164–77; 215.

Cossons, Neil. "The New Museum Movement in the United Kingdom." *Museum* 35, 2 (1983): 83–9.

Curating: The Contemporary Museum and Beyond. Ed. Anna Harding. Special Issue of *Art and Design* 12, 1–2 (1997).

Davis, Peter. *Ecomuseums: A Sense of Place*. London and New York: Leicester University Press, 1999.

Dean, David. *Museum Exhibition: Theory and Practice*. London and New York: Routledge, 1997.

Democracy: A Project/By Group Material. Ed. Brian Wallis. New York: Dia Foundation; Seattle: Bay Press, 1990.

Desmond, Stewart. "Risk and Reward: The Story of 'Without Sanctuary.'" *Museum News* 80, 2 (March/April 2001): 42–7.

Dictionarium Museologicum; Dictionary of Museology. Budapest: Hungarian Esperanto Association, 1986.

Dubin, Steven C. *Displays of Power: Memory and Amnesia in the American Museum*. New York: New York University Press, 1999.

Edson, Gary. *Museum Ethics*. London and New York: Routledge, 1997.

——and David Dean. *The Handbook for Museums*. London and New York: Routledge, 1994.

Eichstedt, Jennifer L. and Stephen Small. *Representations of Slavery: Race and Ideology in Southern Plantation Museums*. Washington and London: Smithsonian Institution Press, 2002.

Environmental Design and Behavior in Museums. Ed. Stephen C. Bitgood and Ross J. Loomis. Special Issue of *Environment and Behavior* 25, 6 (November 1993).

Erwitt, Elliott. *Museum Watching*. London: Phaidon, 1999.

Falk, John H. *Leisure Decisions Influencing African American Use of Museums*. Washington, D.C.: American Association of Museums, 1993.

——and Lynn D. Dierking. *Learning from Museums: Visitor Experiences and the Making of Meaning*. Walnut Creek, CA: Alta Mira Press, 2000.

——and Lynn D. Dierking. *The Museum Experience*. Washington, D.C.: Whalesback Books, 1992.

Feigen, Richard. *Tales from the Art Crypt: The Painters, the Museums, the Curators, the Collectors, the Auctions, the Art*. New York: Knopf, 2000.

Garfield, Donald. *African American Heritage Tourism and Community Development*. Washington, D.C.: Partners for Livable Communities, 2000.

Gell, Alfred. "Vogel's Net: Traps as Artworks and Artworks as Traps." *Journal of Material Culture* 1, 1 (1996): 15–38.

George, Gerald. *Visiting History: Arguments Over Museums and Historic Sites*. Washington, D.C.: American Association of Museums, 1990.

Glaser, Jane R. and Artemis A. Zenetou, eds. *Gender Perspectives: Essays on Women in Museums*. Washington and London: Smithsonian Institution Press, 1994.

—— and —— *Museums: A Place to Work: Planning Museum Careers*. London and New York: Routledge, 1996.

Glueck, Grace. "The Ivory Tower Versus the Discotheque." *Art in America* 59, 3 (May–June 1971): 80–5.

Gómez-Peña, Guillermo. *Temple of Confessions: Mexican Beasts and Living Santos*. A Project by Guillermo Gómez-Peña and Roberto Sifuentes in Collaboration with Norma Medina et al. New York: Power House Books, 1996.

Greenaway, Frank. "National Museums." *Museums Journal* 83, 1 (June/July 1983): 7–12.

Greenberg, Reesa et al., eds. *Thinking About Exhibitions*. London and New York: Routledge, 1995.

Gulliford, Andrew. *Sacred Objects and Sacred Places: Preserving Tribal Traditions*. Boulder: University Press of Colorado, 2000.

Gurian, Elaine Heumann. *Institutional Trauma: Major Change in Museums and its Effect on Staff.* Washington, D.C.: American Association of Museums, 1995.

Harrison, Julia. " 'The Spirit Sings' and the Future of Anthropology." *Anthropology Today* 4, 6 (Dec. 1988): 6–9.

Hein, George. *Learning in the Museum.* London: Routledge, 1998.

—— and Mary Alexander. *Museums: Places of Learning.* Washington, D.C.: American Association of Museums, 1998.

Hein, Hilde S. *The Exploratorium: The Museum as Laboratory.* Washington, D.C.: Smithsonian Institution Press, 1990.

Henderson, Amy and Adrienne L. Kaeppler, eds. *Exhibiting Dilemmas: Issues of Representation at the Smithsonian.* Washington, D.C.: Smithsonian Institution Press, 1999.

Henderson, Justin. *Museum Architecture.* Gloucester, MA: Rockport Publishers, 1998.

Henry, Carole. "How Visitors Relate to Museum Experiences: An Analysis of Positive and Negative Reactions." *Journal of Aesthetic Education* 34, 2 (Summer 2000): 99–106.

Higonnet, Anne. "A New Center: The National Museum of Women in the Arts." *Museum Culture: Histories, Discourses, Spectacles.* Ed. Daniel J. Sherman and Irit Rogoff. Minneapolis: University of Minnesota Press, 1994. 250–64.

Implementing the Native American Graves Protection and Repatriation Act (NAGPRA). Resource Report. Washington, D.C.: American Association of Museums, 2001.

Kaplan, Flora E. S., ed. *Museums and the Making of 'Ourselves': The Role of Objects in National Identity.* Leicester: Leicester University Press, 1994.

Karp, Ivan and Steven D. Lavine, eds. *Exhibiting Cultures: The Poetics and Politics of Museum Display.* Washington, D.C.: Smithsonian Institution Press, 1991.

Karp, Ivan, Christine Mullen Kreamer, and Steven D. Lavine, eds. *Museums and Communities: The Politics of Public Culture.* Washington, D.C.: Smithsonian Institution Press, 1992.

Knell, Simon J., ed. *Museums and the Future of Collecting.* Aldershot: Ashgate, 1999.

Kräutler, Hadwig, ed. *New Strategies for Communication in Museums: Proceedings of ICOM/CECA '96.* Wien: WUV-Universitätsverlag, 1997.

Krech, Shepard and Barbara A. Hail, eds. *Collecting Native America, 1870–1960.* Washington, D.C.: Smithsonian Institution Press, 1999.

Kroeger, Otto. "Exhibiting our Differences." *Exhibitionist* (Spring 1995): 29–31.

Kurin, Richard. *Reflections of a Culture Broker: A View from the Smithsonian.* Washington, D.C.: Smithsonian Institution Press, 1997.

Leinhardt, Gaea, Kevin Crowley, and Karen Knutson, eds. *Learning Conversations in Museums.* Mahwah, NJ: Lawrence Erlbaum, 2002.

Leon, Warren and Roy Rosenzweig, eds. *History Museums in the United States: A Critical Assessment.* Urbana and Chicago: University of Illinois Press, 1989.

Lester, Joan. "A Code of Ethics for Curators." *Museum News* 61, 3 (Feb. 1983): 36–40.

Lewis, Samella. "Beyond Traditional Boundaries: Collecting for Black Art Museums." *Museum News* 60, 3 (Jan.–Feb. 1982): 41–7.

Linenthal, Edward T. *Preserving Memory: The Struggle to Create America's Holocaust Museum.* New York: Viking Penguin, 1995.

Livesay, Thomas A. "The Impact of the Federal Repatriation Act on State-Operated Museums." *Arizona State Law Journal* 24, 1 (Spring 1992): 293–301.

Loewen, James E. *Lies Across America: What Our Historic Sites Get Wrong.* New York: The New Press, 1999.

Lowenthal, David. *The Past is a Foreign Country.* Cambridge and New York: Cambridge University Press, 1985.

—— "White Elephants and Ivory Towers: Embattled Museums?" *Museum Management and Curatorship* 18, 2 (1999): 173–81.

Lubar, Steven and W. David Kingery, eds. *History From Things: Essays on Material Culture.* Washington, D.C.: Smithsonian Institution Press, 1993.

——and Kathleen M. Kendrick. *Legacies: Collecting History at the Smithsonian*. Washington, D.C.: Smithsonian Institution Press, 2001.

Luke, Timothy. *Museum Politics: Power Plays at the Exhibition*. Minneapolis: University of Minnesota Press, 2002.

Lumley, Robert. "The Debate on Heritage Reviewed." *Towards the Museum of the Future: New European Perspectives*. Ed. Roger Miles and Lauro Zavala. New York: Routledge, 1994. 57–69.

McDermott, Catherine. "Entering Into a New Age of Museology: London's Science Museum." *Visual Communication* 1, 1 (2000): 92–6.

McLean, Kathleen, ed. *Recent and Recommended: A Museum Exhibition Bibliography with Notes from the Field*. Washington, D.C.: National Association for Museum Exhibition, 1991.

McManus, Paulette M. "Memories as Indicators of the Impact of Museum Visits." *Museum Management and Curatorship* 12, 4 (Dec. 1993): 367–80.

——"Reviewing the Reviewers: Towards a Critical Language for Didactic Science Exhibitions." *The International Journal of Museum Management and Curatorship* 5 (1986): 213–26.

Messenger, Phyllis Mauch, ed. *The Ethics of Collecting Cultural Property: Whose Culture? Whose Property?* 2nd edn. Albuquerque: University of New Mexico Press, 1999.

Meyer, Karl E. *The Art Museum: Power, Money, Ethics*. New York: Morrow, 1979.

Mihesuah, Devon A., ed. *Repatriation Reader: Who Owns American Indian Remains?* Lincoln, NE: University of Nebraska Press, 2000.

Miles, Roger S. "Museum Audiences." *International Journal of Museum Management and Curatorship* 5 (1986): 73–80.

"Museum Architecture." Special Issues of *Museum News*, 2 parts (51, 1 and 3) (Sept. and Nov. 1972).

Museum Policy and Procedures for Nazi-Era Issues. Resource Report. Washington, D.C.: American Association of Museums, 2001.

Museum Visitor Studies in the 90s. Ed. Sandra Bicknell and Graham Farmelo. London: Science Museum, 1993.

Museums Association. *Codes of Ethics*. London: Museums Association, 1997.

Museums By Artists. A. A. Bronson and Peggy Gale, eds. Toronto: Art Metropole, 1983.

Native American Graves Protection and Repatriation Act. Public Law 101–601. United States. 101st Congress. [available @ www.legal.gsa.gov]

Newsome, Barbara Y. and Adele Z. Silver, eds. *The Art Museum as Educator: A Collection of Studies as Guides to Practice and Policy*. Berkeley: University of California Press, 1978.

Olander, William. "Material World." *Art in America* 77 (Jan. 1989): 122–8; 167.

Parr, Albert Eide. "Museums and Realities of Human Existence." *Museum News* 45, 4 (Dec. 1966): 24–9.

——"Museums of Memories and Expectations: The Communication of History." *Museum News* 61, 2 (Nov.–Dec. 1982): 46–7; 80.

Pavoni, Rosanna. "Towards a Definition and Typology of Historic House Museums." *Museum International* 53, 2 (2001): 16–21.

Pearce, Susan M. *Collecting in Contemporary Practice*. London: Sage, 1998.

——(ed.) *Exploring Science in Museums*. London and Atlantic Highlands, NJ: Athlone, 1996.

——(ed.) *Museums and the Appropriation of Culture*. London: Athlone Press, 1994.

——*Museums, Objects and Collections: A Cultural Study*. Leicester: Leicester University Press, 1992.

——(ed.) *Museum Studies in Material Culture*. Leicester: Leicester University Press, 1989.

Phelan, Marilyn E. *Museums and the Law*. Nashville: American Association for State and Local History, 1982.

Pinna, Giovanni. "Introduction to Historic House Museums." *Museum International* 53 (2001): 4–9.

Pitman, Bonnie, ed. *Presence of Mind: Museums and the Spirit of Learning*. Washington, D.C.: American Association of Museums, 1999.

Price, Sally. *Primitive Art in Civilized Places*. 2nd edn. Chicago: University of Chicago Press, 2001.

Quigley, Christine. *Skulls and Skeletons: Human Bone Collections and Accumulations*. Jefferson, NC and London: McFarland, 2001.

Quimby, Ian M. G., ed. *Material Culture and the Study of American Life*. Winterthur Museum. New York: Norton, 1977.

Reilly, Bernard F. Jr. "Merging or Diverging? New International Business Models from the Web." *Museum News* 80 (Jan.–Feb. 2001): 48–55; 84, 86.

Report of the Panel for a National Dialogue on Museum/Native American Relations (Feb. 28, 1990). *Arizona State Law Journal* 24, 1 (Spring 1992): 487–500.

Rice, Danielle. "Museum Education Embracing Uncertainty." *Art Bulletin* 77 (March 1995): 15–20.

Riding-In, James. "Repatriation: A Pawnee's Perspective." *Repatriation Reader: Who Owns American Indian Remains?* Ed. Devon A. Mihesuah. Lincoln, NE: University of Nebraska Press, 2000. 106–20.

Roberts, Lisa. *From Knowledge to Narrative: Educators and the Changing Museum*. Washington, D.C.: Smithsonian Institution Press, 1997.

Rosenzweig, Roy and David Thelen. *The Presence of the Past: Popular Uses of History in American Life*. New York: Columbia University Press, 1998.

Rushing, Byron. "Afro-Americana: Defining It, Finding It, Collecting It." *Museum News* 60, 3 (Jan.–Feb., 1982): 33–40.

Schouten, Frans. "The Future of Museums." *Museum Management and Curatorship* 12 (1993): 381–6.

—— "Museum Education – a Continuing Challenge." *Museum* 39, 4 (1987): 240–3.

Schroeder, Fred E. H., ed. *Twentieth-Century Popular Culture in Museums and Libraries*. Bowling Green: Bowling Green University Popular Press, 1981.

Schuster, J. Mark. "Neither Public Nor Private: The Hybridization of Museums." *Journal of Cultural Economics* 22 (1998): 127–50.

Selbach, Gérard. "A Common Art Market: The Tale of Two Continents." Unpublished conference paper presented at the European Association for American Studies (EAAS) Conference, "The United States of/in Europe: Nationhood, Citizenship, Culture." Bordeaux, France: March 22–25, 2002.

Senie, Harriet F. and Sally Webster, eds. *Critical Issues in Public Art: Content, Context and Controversy*. Washington, D.C.: Smithsonian Institution Press, 1998.

Serrell, Beverly. *Exhibit Labels: An Interpretive Approach*. Walnut Creek, CA: Alta Mira Press, 1996.

—— *Paying Attention: Visitors and Museum Exhibitions*. Washington, D.C.: American Association of Museums, 1998.

Sherman, Daniel J. and Irit Rogoff, eds. *Museum Culture: Histories, Discourses, Spectacles*. Minneapolis: University of Minnesota Press, 1994.

Silver, Stuart. "Almost Everyone Loves a Winner: A Designer Looks at the Blockbuster Era." *Museum News* 61, 2 (Nov.–Dec., 1982): 24–35.

Smith, Roberta. "Over Time and Space, The Power of the Pot." *New York Times*, Jan. 4, 2002: E39, 48.

Solomon-Godeau, Abigail. "Going Native." *Art in America* 77 (July 1989): 118–29; 161.

Steiner, Charles K. *The Accessible Museum: Model Programs of Accessibility for Disabled and Older People*. Washington, D.C.: American Association of Museums, 1992.

Steiner, Christopher B. *African Art in Transit*. Cambridge: Cambridge University Press, 1994.

Stern, Phillipe. "Museography at the Musée Guimet." *Museum* 1, 1–2 (1948): 54–6; 104–5.

Sudbury, Patrick and Terry Russell, eds. *Evaluation of Museum and Gallery Displays*. Liverpool: Liverpool University Press, 1995.

Tabah, Agnes. *Native American Collections and Repatriation*. Resource Report. Washington, D.C.: American Association of Musuems, 1993.

Taha, Halima. *Collecting African American Art: Works on Paper and Canvas*. New York: Crown, 1998.

Thelen, David. "Learning Community: Lessons in Co-Creating the Civic Museum." *Museum News* 80, 3 (May/June 2001): 56–9; 68–9; 71; 73; 92; 94–5.

Thomas, Selma and Ann Mintz, eds. *The Virtual and the Real: Media in the Museum*. Washington, D.C.: American Association of Museums, 1998.

Trigger, Bruce. Reply to Julia D. Harrison ["'The Spirit Sings' and the Future of Anthropology"]. *Anthropology Today* 4, 6 (Dec. 1988): 9–10.

Walsh, John and Deborah Gribbon. *The J. Paul Getty Museum and Its Collections: A Museum for the New Century*. Los Angeles: Getty Trust Publications, 1997.

Walsh, Kevin. *The Representation of the Past: Museums and Heritage in the Post-Modern World*. London and New York: Routledge, 1992.

Weil, Stephen E. *Making Museums Matter*. Washington, D.C.: Smithsonian Institution Press, 2002.

—— *Rethinking the Museum and Other Meditations*. Washington, D.C.: Smithsonian Institution Press, 1990.

West, W. Richard et al. *The Changing Presentation of the American Indian: Museums and Native Cultures*. Seattle: University of Washington Press; Washington, D.C.: National Museum of the American Indian, Smithsonian Institution, 2000.

Words of Wisdom: A Curator's Vade Mecum on Contemporary Art. Ed. Carin Kuoni. New York: Independent Curators International (ICI), 2001.

Wright, Charles A. Jr. "The Mythology of Difference: Vulgar Identity Politics at the Whitney." *Art, Activism, and Oppositionality: Essays From Afterimage*. Ed. Grant H. Kester. Durham, NC: Duke University Press, 1998. 76–93.

Wright, David W. "Idealised Structures in Museums of General Technology." *Museums Journal* 83, 2–3 (Sept.–Dec., 1983): 111–19.

Wright, Gwendolyn, ed. *The Formation of National Collections of Art and Archaeology*. Washington, D.C.: National Gallery of Art, University Press of New England, 1996.

Ybarra-Frausto, Tomás. "Rasquachismo: A Chicano Sensibility." *Chicano Aesthetics: Rasqua-Chismo*. Phoenix, AZ: Movimiento Artistico del Rio Salado (MARS), 1989. 5–8.

Young, Alfred F. "A Modest Proposal: A Bill of Rights for American Museums." *The Public Historian* 14, 3 (Summer 1992): 67–75.

Zamudio, Raul. Introduction. Special Issue. On Latin American Art. *PART* 5 (Winter 2000). available @ http://web.gsuc.cuny. edu/dsc/part.html

Exhibition Catalogues

African Masterpieces from the Musée de l'Homme. Susan Vogel and Francine N'Diaye. New York: The Center for African Art, Harry N. Abrams, 1985.

The American Century: Art and Culture, 1900–1950. Ed. Barbara Haskell. New York: Whitney Museum of American Art, W. W. Norton, 1999.

The American Century: Art and Culture, 1950–2000. Ed. Lisa Phillips. New York: Whitney Museum of American Art, W. W. Norton, 1999.

Art/Artifact: African Art in Anthropology Collections. Arthur Danto et al. New York: Center for African Art, 1988.

Documenta 11, Platform 5: Exhibition/Catalogue. Ed. Okwui Enwezor et al. Ostfildern-Ruit: Hatje Cantz, 2002.

The Guennol Collection: Cabinet of Wonders. Ed. Diana Fane and Amy G. Poster. Brooklyn: Brooklyn Museum of Art, 2000.

Harlem on My Mind: Cultural Capital of Black America, 1900–1968. Metropolitan Museum of Art. Ed. Allon Schoener. Introduction by Candice Van Ellison. New York: Random House, 1968.

Harlem Renaissance: Art of Black America. The Studio Museum in Harlem (1987); New York: Harry N. Abrams, 1994.

High and Low: Modern Art [and] Popular Culture. Ed. Kirk Varnedoe and Adam Gopnik. New York: Museum of Modern Art, Harry N. Abrams, 1990.

Into the Heart of Africa. Toronto: Royal Ontario Museum, 1989.

Mining the Museum: An Installation. Fred Wilson. Ed. Lisa G. Corrin. Baltimore: The Contemporary; New York: New Press, 1994.

The Museum as Muse: Artists Reflect. Kynaston McShine. New York: Museum of Modern Art, 1999.

New American Art Museums. Helen Searing. New York: Whitney Museum of American Art, 1982.

1993 Biennial Exhibition. Whitney Museum of American Art. New York: Harry N. Abrams, 1993.

Past Imperfect: A Museum Looks at Itself. Donna M. de Salvo. Southampton, NY: Parrish Art Museum in association with the New Press, 1993.

"Primitivism" in 20th Century Art: Affinity of the Tribal and the Modern. Ed. William Rubin. New York: Museum of Modern Art, 1984.

Sensation: Young British Artists from the Saatchi Collection. Essays by Brooks Adams, et al. London: Thames and Hudson, Royal Academy of Arts, 1997.

The Spirit Sings: Artistic Traditions of Canada's First Peoples. Calgary: Glenbow Museum; Toronto: McClelland and Stewart, 1987.

Te Maori: Maori Art from New Zealand Collections. Ed. Sidney Moko Mead. The American Federation of Arts, 1984.

To Conserve a Legacy: American Art from Historically Black Colleges and Universities. Ed. Richard J. Powell. Andover, MA; New York: Addison Gallery of American Art; The Studio Museum in Harlem, 1999.

The West as America: Reinterpreting Images of the Frontier, 1820–1920. Ed. William H. Treuttner. Washington, D.C. and London: Smithsonian Institution Press, 1991.

Museum Futures

Alberch, Pere. "The Identity Crisis of Natural History Museums at the End of the Twentieth Century." *Towards the Museum of the Future: New European Perspectives*. Ed. Roger Miles and Lauro Zavala. New York: Routledge, 1994. 193–8.

Finlay, Ian. *Priceless Heritage: The Future of Museums*. London: Faber and Faber, 1977.

Hedin, Marika. "Transmitting the Intangible: Thoughts on a Future Nobel Museum." *The Kenyon Review and Stand Magazine* 23, 2 (March 2001): 256–68.

Imagining the Future of the Museum of Modern Art. Studies in Modern Art 7. Ed. Barbara Ross. New York: Museum of Modern Art, 1998.

Lampugnani, Vittorio Magnago and Angeli Sachs, eds. *Museums for a New Millennium: Concepts, Projects, Buildings*. Munich, London and New York: Prestel, 1999.

Miles, Roger and Lauro Zavala, eds. *Towards the Museum of the Future: New European Perspectives*. New York: Routledge, 1994.

Museums for a New Century: A Report of the Commission on Museums for a New Century. Washington, D.C.: American Association of Museums, 1984.

Museums for the New Millennium. Washington, D.C.: American Association of Museums/ Center for Museum Studies, Smithsonian Institution, 1997.

Museums for the 21st Century. Society of Museum Archaeologists, Conference Proceedings, Liverpool 1997. Ed. G. T. Denford. Winchester: Society of Museum Archaeologists, 1998.

Newhouse, Victoria. *Towards a New Museum*. New York: Monacelli Press, 1998.

Searing, Helen. *Equal Partners: Men and Women Principals in Contemporary Architectural Practice*. Northampton, MA: Smith College Museum of Art, 1998.

Stephens, Suzanne, ed. *Building the New Museum*. New York: The Architectural League of New York, 1986.

Trulove, James Grayson. *Designing the New Museum: Building a Destination*. Gloucester, MA: Rockport Publishers, 2000.

Weil, Stephen E. *A Cabinet of Curiosities: Inquiries Into Museums and Their Prospects*. Washington, D.C.: Smithsonian Institution Press, 1995.

General Reference

Knell, Simon J., ed. *A Bibliography of Museum Studies*. Brookfield, VT: Ashgate Publishing, 1994.

Screven, C. G., ed. *Visitor Studies Bibliography and Abstracts*. 4th edn. Chicago: Screven and Associates, 1999.

Shapiro, Michael Steven and Louis Ward Kemp, eds. *The Museum: A Reference Guide*. New York: Greenwood Press, 1990.

Woodhead, Peter and Geoffrey Stansfield. *Keyguide to Information Sources in Museum Studies*. 2nd edn. London: Mansell/Cassell, 1994.

Index

Note: Authors included in the anthology are not listed in the index unless cited by other authors.

architecture (*continued*)
 as ritual structure 64, 305
 and scale 450–1
 as subject of art 509, 515
 as unobtrusive frame for art 420,
 425–6 n.6, 426 n.7
archives 19, 188, 313, 324, 388, 393, 510,
 512, 549, 559, 572
Ardouin, Claude 456
Arensberg, Walter 507
argument
 arrangement as 294–5, 307–9
 in exhibition 203
 history as 349
Aristotle
 catharsis 94–7, 101
 Poetics 94, 551
Arman 509
Armory Show (1913) 488–9
Arnold, Eve 514
Arnold, Matthew 464
art
 abstract 447–8, 451, 484
 of Africa in exhibition 135
 American, demotion/elevation of 463,
 500
 applied 221, 249, 417, 427 n.13
 appreciation vs investigation of 419,
 421–2, 427 n.12
 censorship of 386–7
 collection and feminism 263
 conceptual, and museum 383, 507
 critical 262
 decorative 250, 290–5
 defined 78–9, 81
 domestic 290–1
 ethnographic museum and 178, 186
 figurative 490
 fine arts tradition 249, 419
 as form of forgetting 296
 global system, market 384, 503, 507–8
 and historical consciousness 324
 and identity 299, 381, 521–40
 industrial arts 221, 252–9, 417
 installation art 508
 installation of art work 322–3, 547
 love of 381, 431–5
 meaning of 81
 museum as condition for 415–16, 448
 national 219, 266, 295–301, 500, 521–2
 nature of 419
 oppositional 522–3
 and realism 484–5, 488, 490–3, 495 n.25

 as record of experience 296, 299
 representational 490
 as simulacrum 78
 sociology and 486, 491
 and value 320, 381, 419, 452–3
 versus artifact 412–13, 448, 525, 529–31
 and viewer reception 195, 381, 431
 work of 73, 452–3
 world relations 489
Art Amateur 463
Art & Language (series) 515
Art/Artifact 382, 576
art book 450, 452
art circles 483
art criticism 421–2, 430, 439, 448–53, 483
art history
 African art and 183, 185
 and canon-formation 260, 269, 409, 473,
 495–6 n.32, 563
 causality and 81
 and class 462, 464
 as construct 311, 438, 448, 476
 critical 381
 of domestic art 290
 feminism and 262, 483–9, 563
 gender and 267, 483–97
 history of great men and 58
 history of the state and 63–6
 interpretive methods 81
 and modernist, abstract art 483–97
 and museum 506–7, 560
 and museumism 387
 parallels to ethnography 133
 rationalization of experience of art 58
 rewriting traditional narratives of 9,
 498–505
 texts as doctrine 54
Art Inside Out 382–3
Art Institute of Chicago 384, 527, 533
 Dept. of Education 382–3
art market
 and African art 100, 577–8
 America vs Britain and 265, 267–8
 and museum 265, 268, 384, 409, 448,
 452–3, 517, 552
 and sale of Holbein's *Christina of*
 Denmark 260, 265
 and supply 229
art museums
 aims and principles of 419–29, 552, 557
 American art and 291
 architecture and 420
 art history and 57–8

defined 419
directors of 303
double function of 419, 466
dual arrangement in 420, 425 n.1
national art and 298, 301
public 53, 263–4
and reorganization of experience of art 57
ritual forms in 68 n.15, 195
as spatial puzzles 74
traditions and display 527
as visual texts 74
Art of the Other Mexico 528–9, 539–40 n.45
Art Students' League 485–6, 489, 494 n.14
Art Workers' Coalition 517
Arthos, John 156 n.4
artifact (*see also* object)
colonization, imperialism and 190, 304, 406
critical function of 214–15, 275, 318–20, 362–74, 375–80, 389–98, 414, 499–500, 504 n.5
vs document 362, 375–6
epistemological role of 362–3
ethnographic museums and 177–8, 210
evoking ideas through 199, 338–40, 389–98, 515
as "fact" 321, 324
as fetish 385
hybrid status of 80
innovative use of 323–4, 389–98, 504, 510
interpretive problems and 335–47, 528–9
memory and 322
museum as 247
precarious 546
religious 249
Renaissance humanism and 26, 33
ritual 195
slave trade and 189
as text 196, 283
typical 93, 275
unique 80
values and 381
artist
as collector 509
as curator 381–402, 412, 422, 511
and museum-as-subject 506–20
artistic genius 542, 544, 552–3
as ideal 78
and 19th-century individualism 64
and the state 64
Arts Review 243
Asad, Talal 194
Asante

colonialism in 456–7
King, Asantehene Opoku Ware II, jubilee celebrations and 456–60
objects and exhibition 184, 456–60
Asante, Kingdom of Gold 411, 457, 460
ascetic presentation 20
Ashcan School 484–5, 488–9, 494 n.6, 496 n.36 (*see also* "The Eight")
Asher, Michael 383–4, 515
Ashmolean Museum 3, 40–1, 48 n.90, 49–50 n.110, 386, 430
At Home with the Collection 386
Atterbury, Grosvenor 281, 294, 313, 499
atomic bomb, issues of representation and, *see Enola Gay*
Atwater, Caleb 165–6
audience (*see also* visitor)
active 562
communication and 556–74
competition for 232–3
concern for expectations of 320
definition of 382
distancing of 462, 469, 471, 478
history of 413
interaction 323
misconceptions about 182–3, 185–91
rapt attention of musical 472
transcendence by 476
"audience advocate" 571
Augustine, Saint 26
Aulenti, Gay 553
aura 442, 511, 517–18
Austin, J. L., Speech Act theory 446
Austrian Museum of Applied Arts in Vienna (MAK) 387
authenticity
of collections 126, 280
stamp of 210, 213
authority, museum as place of 51, 127, 191, 211, 243, 305, 413
autoethnography 102
avant-garde 438, 484, 486, 488–9, 578
Avery, Milton 490
axis
of loss 96
of recovery 96
of viewing 500

Bachelard, Gaston
de familiarization and *dis* identification 96, 99
resonance–reverberation doublet 95, 97–8, 101

catalogue
 and exhibition 184, 186–8, 194, 243, 302,
 352, 386, 406, 486–7, 489–90, 502,
 532–3, 547–8, 550, 560, 577–9
 as little museum 30
 as standing treatise 228
 as storia 31
ceilings
 at Louvre 62–4
 at Metropolitan Museum of Art 66, 295
censorship, of art, on exhibit 386–7
Center for African Art (NY) 382
Central Jewish Museum (Prague) 549
A Century of Progress International Exposition
 (Chicago, 1933) 282
ceremonial practices 52–4
ceremonial programme 65
ceremonial space 56
Cesi, Federico 31, 33, 35, 38
Chalfin, Paul 465
chaos 146
Chartier, Roger 34
Chase, William Meritt 500
Châtelet-Lange, Liliane 26
Chemistry Conference 266
Chicago Historical Society 527
Chicano/a 522 (*see also* Mexican
 Americans)
Chigi, Flavio 38
children, and museums 307–9, 529, 531,
 571–2
Chinese philosophy 34
Christo 516
chronological order 75–6, 277
church (*see also* religion)
 architecture of, and museums 52–3
 Christianizing mission and collections 34
 crisis of knowledge and museum 43
 display of objects and museum 52
 Reformation and collections 33–6
 relation to museum 19, 21, 83 n.3, 385
 science and 47 n.75
 secular as distinct from sacred 53
 secular appropriates sacred 195, 198, 364,
 385, 403, 434, 437, 441–2, 446–7,
 462, 471, 473, 561, 565
 secular combines sacred 533–5, 540 n.57
Cicero 27, 29, 32
cimilarchio 32
Circa 1492 215
Circa 1952 483
Cisneros, Sandra 525
Citizen Kane 288

civic nature of museum 37–42, 54, 72, 76,
 84 n.10, 303, 337, 437, 444
civic piety 337
civil rights, American museums and 120–1,
 391
Civil War
 and modern nation-state 65
 monuments to 444–5
civilization (*see also* Western civilization)
 civilizing mission and museum 499, 561
 decline of 19
 and expositions and fairs 274–6, 278
 and idea of museum 53, 61–3, 434, 437,
 498–9, 504 n.1 and n.2
Clamp, Brian Paul 496 n.36
Clark, Sir Kenneth 74
Clark, Rose 494
class
 British aristocracy vs American wealth 267
 and British history 350
 conflict 236
 construction of self and 80, 348, 541
 control of culture and 65, 267, 461–82,
 503, 517
 education and 246 n.35, 433
 elevation of 239–40
 eugenics and 237–8
 on exhibit 248, 250, 391, 394–5
 fading of distinctions 88, 320
 illusion of classless society and museum 59
 and Metropolitan Museum, American
 Wing 294–5
 national history of 261
 open/free hours and 239
 patron 52, 267, 499
 production of work of art and 81
 race and slavery and 216–17, 391
 socialism and 238–9
 surveillance and 368
 transcendence of 239
 unity 235–6, 238
 working 238
classicism
 ciborium of 337
 longing for identification with, and
 museum 20
 museum as sanctuary of 20
 priority of 61
Clay, Henry 392
Clemens, Claude 23, 35
Clifford, James 194
 on allegory of salvage 97
 on appropriation 209

on debates and museums 186
on the limits of representation 93
on the listener in *Heart of Darkness*
 11 n.12
on Musée de l'Homme 210
on "tribal museums" 524
on truth in ethnography 7
Clinton, William J. 118
Cloisters 281–2, 285
Club Med Archaeological Villa 550
Coalition for the Truth About Africa 181
Coast Survey 161
Coba (Yucatan) 550
Cohen, Walter 542, 545
Cold War, and museums 326
collaboration, in exhibition 391–8
collage 451
collecting/collections
 access, virtual 200
 and architecture 273, 287, 420, 440–1
 and autobiography 286–7, 343, 411
 and casts 285–6, 411, 500, 502, 505 n.12
 Catholic church and 33–6
 as cognitive activity 29, 307–9, 405–6
 "Collection in Context" *see* Whitney
 Museum of American Art
 and colonialism 182, 184, 186, 188–91,
 238, 406, 498
 comprehensive 422, 428 n.15, 449–50
 corrective buying 486
 cultural prohibitions against, and
 Africa 455–60
 descriptive models of 29
 as destructive 455–60
 and determination of evidence 352–3
 domestic nature of 36, 38, 414, 493
 encyclopedic aim of 23, 28–36, 43, 366,
 559–60
 and ethics 182, 184
 and gender 37, 263, 269 n.5, 522
 and hermeticism 26–9, 34
 humanism and 23, 30–3, 35–6, 38–9,
 41–3
 ideal of completeness and 422
 imitative 415
 and interpretation 452
 Islamic and *al waaf* 10 n.6
 Jesuits and 33–4, 359–60, 361 n.7
 and knowledge of central Africa 98
 and libraries 35, 317
 Medieval and Renaissance learning
 and 24–33, 36, 39–40, 42
 mental structures of 29

and nations 229, 238, 287, 521–2
obsessive 509
ordering of 228, 420
and period room 285
politics of 35
prestige of 415
princely 75, 299, 453
in Renaissance 20, 23–4, 33
resistance of objects 1, 307–9, 516
responsibility to 85, 303
self-image in 286
as sociological process 37
study of 303
syntax and grammar of 24
as theme of exhibition 181, 183, 186, 188,
 313, 382–3, 387, 516–17
tropes of 40
uncatalogued 202
uncollected 522
vocabulary of 24, 29–30, 37
Zurich method 282
collections-in-order 209–10
Collin, Rev. Nicholas 150–1
Colonial Exposition (1887) 135
colonial rooms 377
Colonial Williamsburg 194, 199, 282–4,
 286, 340, 379
colonialism (*see also* imperialism) 208–15,
 455, 460, 498, 550
 art and museums before, after 136, 456–7,
 460, 577
 colonial subjects and 238
 colony vs nation 234
 developing countries and museums 90
 and eugenics 237–8
 exhibitions and 98, 181–9, 233, 241,
 248–51, 382, 387–9, 397–8 n.5,
 400 n.46, 406, 576–80
 and house museums, Latin America 359
 museum as showcase and 175–6
 preservation and 241
Colonization Society 396, 402 n. 8
Columbian Institute 161
Comenius, J. 34, 39
commercialization 342, 519
commodification of art 229, 530, 550–1
commonality of feeling 218
communication (*see also* education)
 of beliefs and values in museum 51
 models of 558–75
 objects and 185
community
 and definition of museum 85–6, 305

designer, as narrator 304 (*see also* display; narrative)

desire 108, 415–16, 512, 554

The Desire of the Museum 382–3, 398 n.11, 399 n.27

d'Este, Isabella 37–8

d'Este, Leonello 27

deToqueville, Alexis 163

Detroit Institute of Art 281

developing countries 90–1

Dewey, John 146

de Zaya, Mario 488

dialectic
 and active vs contemplative moods 27
 art/commodity 384
 merits of, in presentation of history 7
 and representation 96
 and social reality 370
 solid vs continuous 209
 and structure of museum 24
 theory/exhibition 128, 195
 and visual experience and social forces 51

dialogic museum 8, 546

dialogical encounter 566
 in ethnographic museum 96–7, 100

dialogue
 exhibition as 184–5, 188–9, 390–8
 need for greater 320

diaspora 101

Dibbets, Jan 514–15

Dickens, Charles 159

didacticism 42, 127, 190–1, 250, 313, 466, 518, 527, 561

Diderot, Denis 34–5, 47 n.69, 56

Diebenkorn, Richard 490

difference
 civilized vs "native" 94, 501
 construction of 275–6, 278, 500–1, 528, 545
 cultural 209, 215, 223, 242, 275, 283, 375–6, 401–2 n.56
 as media 213
 racial 218, 242, 387–8
 role of 94, 98, 313, 545, 565, 572
 useful vs decorative 250

Dille, Lutz 514

dime museum 390–1, 399 n.38

Dion, Mark 387, 512

Dionisotti, Carlo 37

dioramas 184, 382–3, 388, 514, 532

directors, of museums 303–6

disciplinary machinery 73, 545

disciplinary object, and work of art 78

discipline
 of populations 74, 362
 self-discipline 365

disciplines 73, 110, 112, 500, 512, 559–60, 573–4 n.16

disclaimers, verbal vs visual 189

discourse
 feminist 491–2
 masculinist 491–2
 of origination 242
 specialized 577

discrimination 221

discursive masculinization 265

disinterestedness 262

Disney effects 74, 177, 190, 341–2, 400 n.46

display
 anti-theatrical 423
 art-historical 527
 and certainty 155
 comparative method 256
 contextual method 258, 421–3, 428 n.19, 442, 528–9, 546–8
 decontextual method 527
 historical method 465
 innovative 321, 323, 324, 381–402, 510, 528–37
 period room and 377
 prohibition against 455–60
 as subject 576

dissonance, comic 251

Distel, Herbert 511

distinction, class 433, 461

distortion 16, 318–34, 378 (*see also* memory)

diversity 301, 306, 390, 529, 571

docents 466
 and innovative exhibit 322–3, 384, 389, 518
 narratives and 184, 371, 535

documents 311, 350, 375, 498, 500, 502–3, 504 n.5

doing codes 53

domestic archaeology 283, 286–7

domestic space 36, 38, 47 n.78, 451

domesticity, ideal of 286

Donatello 500, 502–3

Donato, Eugenio 501

Donnino, Alfonso 41

donors 188, 266–7, 271 n.29, 272 n.53, 303, 549

Douglas, Mary 462–3

Douglass, Frederick 392

Dove, Arthur 490

emplotment, of evolutionary narratives 78–9
encounter, dynamics of 412
encyclopedic designs 1–4, 23, 26, 28–36, 43, 75–6
encyclopedic paradigms 29
Enlightenment
 American Wing and 294
 commensurability 73, 75, 147
 and epistemic structures 559
 feminism and 261
 individuality and 261
 installation practice 17, 57, 78, 439
 institutions during 72
 on reason 153, 195, 559
 and resocialization of objects 438
 and subject positions 79, 544
 and systematic ordering 439
 on universal access to knowledge 76, 439, 453, 578
 Washington, D.C. and 161
Enola Gay 319, 328–34, 334 n.24 and n.30
 (*see also* Smithsonian Institution; National Air and Space Museum)
 Hiroshima and Nagasaki, images of bombing 329
epistemology (*see also* knowledge)
 and exhibit intentions 186
 and grids and screens in museum 77
Ericson, Kate 518–19
erosion 22
Erwitt, Elliott 514
Escorial 35
Essex Institute 279–80, 291–2
estrangement
 from conventional museum critiques 71
 of museum visitor 9, 92
 and New Historicism 544
ethics
 of collecting 182, 320
 colonialism, imperialism and 232
 imperatives in museum practice 4
 national 265
 and order in museum 79
 of questioning 397
ethnicity
 and exclusion 339, 472
 fairs, expositions and 275
ethnocentric risk 137
ethnocentrism 167, 179
ethnography
 arrangement of specimens 139–42, 256, 388
 built 194

and classification 234–5, 242, 528–9, 532–3, 563–4
collections and nation 232, 234, 238, 242, 527
and colonialism 231–4, 406
curator and nation 240, 242
and deconstruction 191, 194–5
development of 127, 174–9, 180 n.3
display and 175–80, 243, 256, 258, 577
dynamics of identification 96
and ethnographic thickness 550
geographical vs typological organization 234–5
and Great Britain 253
and humanism 214
importance of surroundings 139–40, 256, 258
and international fairs, expositions 273, 278
lessons in 94
museums of 133–8, 139–42, 527–9
and national collections 255
and objectivity 242–3
opinion of primitive cultures 136
organization of collections 252–9
and public education 175–6, 231–4
and race and culture 234, 242, 527
and reassurance–threat doublet 95
sociological phenomena 139
technological idea 140
and theme village 279, 337
and tribal arrangement of objects 140–2, 234, 532
uninformative formulae 178
and viewer reception 92–102
and Western historicism 209, 527
and work of museum 193, 244 n.8
ethnology
 and groupings in art museums 421–2
 history of, and art history 133, 136
ethnomuseographic performance 95
ethno-taxonomies 149
etymology, of museum as term 2–4, 23–50
eugenics 237, 245–6 n.32
Evans, R. J. W. 33
evidence
 and collections 352–3
 interpretation of 4, 354
 juxtapositions of 351
 use of as political act 349–50
evolution 170 (*see also* Darwin)
 of culture 257
 ethnology museums and 134–5, 176, 235

and wonder 553, 555 n.14
Geary, Christaud 186
Geddy, James 379
Geertz, Clifford 94, 157 n.5
Geffrye Museum (London), *Putting on the Style* 113
genealogical strings 77
genealogy
 and evolutionary/progress 75–6, 371
 order, continuity and 75, 369–73, 543
 personal 350, 500
gender
 and art history 262, 267, 483–97
 and citizenship 268
 and collecting 37, 483–97, 517
 and curatorship 271 n.23 and n.24, 483–97
 and donors 266–7, 271 n.29
 and exhibition 104–16, 116 n.2, 248, 382, 391, 483–97
 as fragile construction 110, 541
 and labor 268, 339–40, 390
 and museology 260–72
 museum as microcosm of relations 261
 and museum space 37, 260–72
 and narrative 107
 and national art 260
 and order 79
 politics, and history of museum 261, 269, 561
 and production of work of art 81
 and public museums 40, 260–72, 521
 representation of roles 107, 391
 and sexual codes 107
 and studio 48 n.85
"General Idea" 519
Genette, Gérard 5
genii loci 423
genocide, representation of 117–20, 122, 328, 330, 522, 532
genre 491
 distinctions, class 462
 distinctions, forms 470
George, Lloyd, People's Budget (1909) 264, 271–2 n.32
Gericke, Wilhelm 468–70, 475, 477, 480 n.6
German Historical Museum (DHM) (Berlin) 326–8
Germany
 and formalism and historicism 545
 importance of museums in 324–8
 and Nazism 548–9
 as virtual museum 326

Gesner, Conrad 26, 29, 31, 33, 35–6
Getty, J. Paul 552
Geyl, Pieter 349
Ghiberti 500
Giacometti, Alberto 513
Gibson, Ann 492
Gide, André 20
Giganti, Antonio 28, 44 n.27
Gilman, Benjamin Ives 465–6
Gilroy, Paul, on the Black Atlantic 99, 101
Giovio, Paolo 27
Gipes, Lawrence 385
Giroux, H. 565
Glackens, William 485
Glasgow Museums 563–4
Glassie, Henry 379
Gleaton, Tony 101–2
Gliddon, George Robins 167–8
global market 215
 and patrimony 200
globalization
 and art 301
 and historic house museums 9
Glyptothek (Munich) 55, 65
Goep, Philip 476
Goethe, Johann Wolfgang von 53, 68 n.13
Goffman, Erving 342
Golden Gate International Exposition (1939–40) 282
Golden Gate Park Memorial Museum 280, 377
Goldhagen, Daniel 328
Goldthwaite, Anne 485, 493
Gómez-Peña, Guilliermo 399 n.27, 525
Gonzalez, Laura 533
Goode, George Brown 317
Goodrich, Lloyd 487, 490
Gorée Museum of Slavery 120
Gorky's Betrothals 483
Grand Sacred Concerts (Boston) 480 n.4
Great Chain of Being 366, 369
Great Encyclopedia (*Encyclopédie*) 430, 439
Great Exhibition of the Works and Industry of All Nations ("Crystal Palace") (1851) 221, 225, 247–8, 273–5, 282
Green, Constance 160
Green, Martin 464–5, 476
Greenaway, Peter 518
Greenberg, Clement 448
Greenblatt, Stephen 95–6, 98, 208–9
Greene, John C. 156 n.1
Greene, Thomas 546
Greenfield Village (Michigan) 282–8, 340

and gender 266, 268
and national treasure 264, 533
Oxford English Dictionary 3

Paik, Nam June, *Megatron/Matrix* 301
palace, museum as 52, 62
paleolithic origins of museum 3–4
Palestinian Life and Remembrance Museum
 (Palestinian Authority)
 and *nakba*/national catastrophe of
 exile 117–18
 *Deir Yassin Remembered Information
 Centre* 117–18
palimpsest
 museum as 2
 work of art as 79–80
pamphlet, unreliability and 324
pandechion 23, 32, 41
Pandemonium 155
Panic of 1837 160
Pannini 57
panopticon 73, 363, 365, 369
pansophic vision 26, 33
Paradise 194
Paris International Exposition of 1889 135,
 273
parousia 19
Parrish, Samuel L. 498–505 (*see also A
 Museum Looks at Itself*)
Parrish Art Museum 383, 398 n.9, 498–505
 (*see also A Museum Looks at Itself*)
Parry, Mark 526–7
past (*see also* history; memory; natural history)
 challenges to 353–4
 concept of, and collecting, Africa 456
 as constructed 311, 564
 desire to inhabit 286
 detritus of 324–5
 false sense of 380, 403
 frozen 356
 future's past, art as 438, 452–3, 519
 idolatry of 20, 416
 national 276–7, 521
 "natural" 363
 paleontological 366–7
 as read through the present 357, 375
 redundant 349
 as refuge 19
 repository of 24, 422
 representation of British 348–55
 representation in fairs, expositions 276–7
 representation in house museum 356–61,
 375–80

and retrospective return 357
suppressed 446
usable 349
"pathetic" exhibit 321
patriarchy 521
patrimony 21, 76, 200, 260, 266, 269
patriotism 125, 312, 390–1, 442
 artistic 263–4, 366
 and folk museums 241, 254
 and gender 264–7
 and historiography 337, 348
 and house museums 359
 and national museums 130, 254, 260–72,
 457, 521
 and natural history 150–3, 367
Patrizi, Francesco 551
patronage 40, 52, 130–1, 260–2, 384, 484,
 489, 499, 503, 508
 of local arts 415–18
Pauley, Thomas H., representations of the
 bicentennial 342
pavilions
 at fairs, expositions 273–4, 279
 as logotype 274
Paz, Octavio 525
Peabody Essex Museum 121
Peabody Museum of Archaeology and
 Ethnology 382
peace
 and consumption of culture 21
 museums 121
Peale, Charles Willson
 "The Artist in His Museum" 155, 313,
 362–3, 365–9, 370, 511–12
 and cultural nationalism 125
 "The Exhumation of the Mastodon" 366
 and Linnaen system 154
 "The Long Room" 366
 natural history museum 129–30, 362,
 365–6, 386, 399 n.38, 521
 political designs 154–5, 362–3, 365–9,
 370
 on relations, nature and society 144–5,
 148
 rhetorical modes, use of 125
 taxonomy 154
Peale, Rembrandt 303
Peale, Sarah Miriam 391
Peale, Titian 162
Pearson, Karl 237
Pechter, Edward 542
pedagogical ends 75
peep-show, presentations 282